A Dictionary of Japanese Artists

日本美術人名辞典

LAURANCE P. ROBERTS

A Dictionary of

JAPANESE ARTISTS

Painting, Sculpture, Ceramics, Prints, Lacquer

with a foreword by John M. Rosenfield

Tokyo · Weatherhill · *New York*

FIRST EDITION, 1976
SECOND PRINTING, 1977

Published by John Weatherhill, Inc., 149 Madison Avenue, New York, N. Y. 10016, with editorial offices at 7-6-13 Roppongi, Minato-ku, Tokyo 106, Japan. Protected by copyright under terms of the International Copyright Union; all rights reserved. Printed in Korea and first published in Japan.

Library of Congress Cataloging in Publication Data: Roberts, Laurance P / A dictionary of Japanese artists. / Bibliography: p. / Includes index. / 1. Artists—Japan—Biography. 1. Title. / N7358.R6 / 709'.2'2 [B] / 76-885 / ISBN 0-8348-0113-2

Contents

Foreword

Since the discovery a century ago of the unbounded richness of Japanese pictorial arts, Western collectors and scholars have keenly felt the need of a comprehensive dictionary of Japanese artists written in a Western language. Confronted again and again by the works of obscure block-print designers or *nanga* painters, scholars have longed for a detailed reference book to provide basic biographical data and a guide to scholarly literature. To fulfill this need, Laurance Roberts has labored for nearly a decade, compiling information from Japanese and foreign-language publications, checking the data with Japanese and foreign scholars and arranging the work to be of maximum use to the Western reader.

Only scholars specializing in Japanese art will realize how fragile some of this information can be. Many artists' names are known only through seals and inscriptions which can be read or interpreted in different ways. Evidence for birth and death dates is often unclear or contradictory. The biographies of the more prominent artists are shrouded in legend and apocryphal tales which have been neither confirmed nor convincingly denied. Moreover, Japanese art history is divided into many subdisciplines, each bristling with its own special intricacies, each a veritable microcosm of artists' schools and families. No single mind can totally master such an array of data or explore each scholarly problem to its definitive conclusion. No one realizes this more deeply than Laurance Roberts, who nonetheless had the courage to provide, for the first time in the West, a comprehensive biographical dictionary that will serve as a framework for any future efforts of this kind. Specialists are invited to write the author and publisher to provide corrections or supplementary data for use in later editions.

As one who has had the privilege of observing Mr. Roberts and his wife, Isabel, working on this project in museums and libraries on three continents, I feel keenly indeed the debt that is owed to them. Their labors have been selfless, unremitting, and in the highest ideals of humanistic scholarship.

JOHN M. ROSENFIELD
Abby Aldrich Rockefeller
Professor of Oriental Art
Harvard University

Preface

As a dictionary of Japanese artists, the present book has to do primarily with names. The European and American scholars who have worked in the field of Japanese studies will probably agree that no single problem can be more baffling than that of the Japanese name, and they are well aware of the pitfalls that await both foreigners *and* Japanese when faced with the pronunciation of almost any name. The reading of Japanese names is not an accurate science, but I have tried to get as accurate a reading as possible, depending on written sources and the advice of my Japanese assistants, and have given alternate readings where it seemed advisable. This is not the place to go into all aspects of this problem, but a brief summary of the general situation may provide some useful information. The best *vade mecum* for travel through this particular labyrinth is P. G. O'Neill's *Japanese Names* (Weatherhill, New York and Tokyo, 1972).

As regards surnames, in old Japan the situation was much the same as in medieval Europe: only the highest classes or the specially privileged were allowed the distinction. Not until 1870 were commoners permitted to adopt family names. But unlike the Westerner, the Japanese has always been willing to change his name for another because, among other reasons, he has changed his profession or has been adopted by someone else. In the world of art, the great family names of Kanō, Tosa, Utagawa, Torii, and others were clearly and firmly handed down, not only to the direct heirs but also to deserving and particularly talented pupils who were sometimes even allowed to use the family name to show they had been accepted into the school if not always adopted into the family itself. Very often, therefore, the artist will have had another name than the one by which he has come down in history. In the beginning the artists were generally either members of the aristocracy or the Buddhist priesthood and would use either a nom de plume known as an *azana* (art name), which was often no more than an alternate reading of the artist's given name, or a *gō*, often in the form of an elaborate literary pun. While some artists were satisfied with a single *gō*, many felt the need for a different name for each aspect of their work, and some found they could use several score. Many of these *gō* have endings of *-sai* and *-dō*, meaning "studio" or "hall," which can be added or left off at will.

A great number of these early artists are known to us today, either from literary records kept by temples or from contemporary journals or as signatures found on works of art, but many of them may be no more than names, with no skeletons on which to hang any flesh. However, as research continues and more works come to light, more of these names are turning into identifiable individuals, and in some cases what has for long been thought to be two separate artists melds into one figure, or, on the other hand, what was considered as one man's oeuvre may now be divided among two or even three artists. The present book contains many of these shadowy figures as well as the ones about whom everything is known. One assumes that the flow from unknown to known will move ever faster. To those happy hunters who will uncover the facts and hence enlarge the list, may the book be a useful tool. But no one knows better than the author how many are the sins of omission in it, the lacunae to be filled.

Many of the minor painters are better known in the West than in Japan, having been collected by early visitors, while the printmakers were for a long time either ignored or belittled by Japanese critics and collectors. As a result, only recently have Japanese scholars begun to add to the knowledge and bibliography in both these fields. On the other hand, the Japanese contemporary artist has remained, with few exceptions, little known in the West, and as one searches through the myriad publications in this area, it does seem at times that the criterion for judgment is more apt to depend on the number and kind of organizations—a contemporary substitute for the traditional family schools—to which the artist belongs than on the quality of his work. In an attempt to cope with this particular problem, a separate list of many such post-Restoration organizations and societies has been provided (see Appendix 2), with some indication, when possible, of the purpose for which each was founded.

Since it was necessary to establish a cut-off date, this dictionary limits itself to artists who were born before 1900, or, if born later, who died before 1972. In addition to painters, it includes sculptors, printmakers, potters, and lacquer artists. None of these categories will be found to be complete, and every scholar will undoubtedly regret the omission of some favorite, but the whole should provide a reasonably comprehensive survey.

The following notes will be of help to anyone who makes use of the dictionary.
There are three sections in which one can look for an artist:
1) The main body of the dictionary, which alphabetically lists each artist under the name by which he is most commonly known. This is usually a personal name in the case of artists who died before 1900 or a family name in the case of later artists.
2) The Index of Alternate Names, which gives, in alphabetical order, all alternate names shown in the dictionary, together with cross-references to main entries.
3) The Character Index, which lists all names in *kanji* according to the radical system of Andrew N. Nelson's *Modern Reader's Japanese-English Character Dictionary,* together with their readings.
In short, when the reading of an artist's name is known, look first in the dictionary proper. If it is not found there, then look in the Index of Alternate Names for a cross-reference to a main entry. If only the characters of a name are known, look in the Character Index.

Each entry in the body of the dictionary gives, when known or when different from the entry heading, the family name and given name of the artist (*N.*), as well as the *azana* (*A.*), the familiar name or nickname (*F.N.*), and the *gō*, with the *kanji* for all names. In certain instances the priest name, the studio name, the store name, or the posthumous name will also appear. Biographical information (*Biog.*) appears after the name or list of names.

Where possible, the biographical notes are followed by a list of the public collections (*Coll.*) in which the artist's work can be seen (the attributions in all cases are those of the owners) and a bibliography (*Bib.*) for further information and illustrations.

ix

In those cases where a number of fully accredited works by an artist are known to be in specific public collections, any works merely attributed to such an artist in a public collection have *not* been listed. In cases where the whole body of work is conjectural, attributions have been listed to give the student some idea of what is considered as possible work by the artist under consideration.

The collections are listed by the first word in the name of each, the full name being given in the alphabetical listing contained in Appendix 1. If the names of two or more collections begin with the same word, a parenthetical numeral is used to indicate which one is meant. These parenthetical numerals correspond to those given in the list of collections. Thus "Museum (3)," for example, would refer to the Museum of Fine Arts, Boston.

In similar fashion the bibliographical references are keyed into the Bibliography, which consists of three sections: 1) a compilation in alphabetical order of all books referred to in the text, 2) an alphabetical list of all journals and serial publications designated in the text by alphabetical code, and 3) a list of dictionaries and encyclopedias to which no reference is made in the text. Under the entry for each artist in the body of the dictionary, the items in the first section of the Bibliography are referred to by either the surname of the author or, when no author is named, the first word of the title. In author listings, in the case of more than one publication by the same author, a parenthetical number follows to indicate which publication is meant—for example, "Tajima (3)" would refer to Tajima Shiichi: *Maruyama-ha Gashū*. In title listings, where duplication occurs, a parenthetical numeral is used to indicate which title is meant—for example, "*Nihon* (4)" would refer to *Nihon no Bunjinga* (catalogue), Tōkyō National Museum. Items from the second section of the Bibliography are listed by an alphabetical code followed by the number of the volume—for example, "NBT 7" would refer to volume 7 of the *Nihon Bijutsu Taikei*. Artists for whom there is no bibliographical reference in the text will generally be found in one or more of the dictionaries and encyclopedias listed in the third section of the Bibliography.

Some inaccuracies may have crept into these references, since it is sometimes impossible to determine in publications without *kanji* which of two or more artists with names read alike and of the same general period was intended. Again, in some cases, given the Japanese system of reckoning a person's age and the vagaries of the lunar calendar, it has been well nigh impossible to supply an accurate date without a variation of a year or two more or less.

In the interest of logic and consistency, macrons are used throughout the book to indicate Japanese long vowels, except in the case of common nouns like "daimyo" and "shogun," which are considered as Anglicized words. Although at first it may seem strange to the Western reader to see names like Tokyo and Kyoto written with macrons, there is no other way to avoid the hopeless confusion that would result if such names were written one way in English contexts and another way in Japanese contexts.

Where romanized names of artists are identical (except possibly for the presence or absence of macrons), they are arranged in chronological order.

Finally, a word of warning: there is no pretense on the part of the author that either the list of artists or any single entry is complete. The Bibliography has been weighted toward the Western reader whose knowledge of Japanese may be somewhat limited, and early or hard-to-find publications have been omitted. Some of the public collections could not (or would not) make available the records of Japanese artists in their holdings.

Acknowledgments

It is always difficult, since there is no practical way of putting everyone in a circle so all can be mentioned at the same moment, to thank the many people and institutions who have had a part in the preparation of any work that has taken as long as this one. During the eight years I worked on *A Dictionary of Japanese Artists,* help and encouragement came from many quarters. May the finished product justify the aid and comfort so generously given me.

Thanks should go, not only from the author but also from anyone to whom the book is of help, to the publisher Meredith Weatherby and his editor Ralph Friedrich for suggesting this work, for their patience while it was being compiled, and for the care and precision with which they have edited it.

To Professor Rensselaer W. Lee of Princeton University, Professor John Rosenfield and the late Professor Benjamin Rowland of Harvard University, and Dr. Lawrence Sickman of the Atkins Museum–Nelson Gallery in Kansas City, my deepest appreciation of their constant support and interest.

That the work ever got finished is due to the generous assistance given me by the American Philosophical Society, which at the beginning of this project made it possible for me to do much of the necessary research in Japan and later financed technical help in the United States; to the JDR III Fund under its distinguished director Porter McCray, which enabled me to do further work in Japan and to obtain invaluable Japanese help elsewhere; and to Princeton University, which invited me to come as a Visiting Fellow in the spring of 1969, thereby making it possible for me not only to use the excellent Oriental library at the university but also to visit the American museums with Oriental collections. To the head of a private foundation who unasked and with the greatest comprehension came to my aid at two crucial moments, my very special gratitude.

At the Boston Museum, Professor Money Hickman and Mr. Chomyo Horioka were endlessly patient in answering my questions about items in the museum's collection and about bibliographical tangles. The Fogg Museum staff allowed me to use the Oriental library without restriction through all this seemingly endless period. Dr. Thomas Lawton of the Freer Gallery gave me great help, as did Dr. James Harle and Dr. Oliver Impey at the Ashmolean Museum, and the staff of the Harvard Yenching Library granted me full use of their treasure-trove. To members of those other museum staffs in the United States, Europe, and Japan who so willingly and cheerfully responded to my queries, my warmest thanks.

Without Mr. Mikio Katō and his associates at the International House of Japan, the work would certainly have progressed even more slowly, and much might never have got done at all. Mr. Shōji Yamanaka provided me with important information on items in Japanese temple collections; Mrs. Michiko Aoki of Cambridge never faltered for four years under the boring burden of my requests for answers to knotty problems of biography and the almost insoluble one of the pronunciation of Japanese names; Mrs. Tsuneko Sadao, matching the motto of the New York postmen, came through the hottest summer in a century and the coldest winter on record in Cambridge to help me in the last tremendous effort to finish the manuscript. To Mr. Henry Harrison I owe a particular debt for his help with the very complicated subject of the Zen artists. For all that was done by these—and so many others everywhere—so willingly and so well, I am forever grateful.

That there are not more mistakes in this work (and for those that remain I take full blame) is due to my wife. She kept the complicated files with meticulous accuracy, she typed all the drafts of the entire text, and never did she let the mountainous volume of work or the innumerable details overwhelm her. My thanks to her know no bounds.

As for the other members of my family and my friends, who against almost hopeless odds tried to understand what I was doing, I offer my apologies for what must often have seemed willful neglect of them and my appreciation of their sympathy with my foolhardiness in having undertaken such a task.

A Dictionary of Japanese Artists

A

Adachi Gen'ichirō[1] (1889–). **Biog.**: Western-style painter. Born in Ōsaka. Studied first at the Kyōto Municipal School of Fine Arts and Crafts and the Kansai Bijutsuin; later, in Tōkyō, at the Taiheiyō Kenkyūsho; also twice in Europe. Member of Shun'yōkai. Known also as a mountain climber. Delicate, unpretentious style. **Bib.**: Asano, NBZ 6.
[1]足立源一郎

Ai Mitsu[1] (1907–46). *N.*: Ishimura Nichirō.[2] *Gō*: Ai Mitsu.[3] **Biog.**: Western-style painter. Born in Hiroshima-ken. After graduating from high school, studied at an art school in Ōsaka where he first called himself Aikawa Mitsurō,[4] eventually shortening it to Ai Mitsu. Later to Tōkyō, to study at the Taiheiyō Kenkyūsho. Became an ardent follower of Europe's avant-garde movements despite all adverse criticism. An occasional exhibitor at the Teiten, the Nineteen Thirty Association, the Nikakai and the Dokuritsu Bijutsu Kyōkai. One of the most interesting Western-style painters of his time; at his best, as in his self-portraits, showed himself a painter with a tortured but honest and personal style. **Coll.**: National (5). **Bib.**: Asano, Miyagawa, NB (H) 24, NBZ 6, NKKZ 11, SBZ 11, Tanaka (7a) 44.
[1]靉光 [2]石村日郎 [3]靉光 [4]靉川光郎

Aigai[1] (1796–1843). *N.*: Takaku (Takahisa) Chō.[2] *A.*: Shien.[3] *F.N.*: Akisuke.[4] *Gō*: Aigai,[5] Gakubaisai,[6] Joshō,[7] Sekisō,[8] Sorin Gaishi.[9] **Biog.**: *Nanga* painter. Born in Shimotsuke in eastern Japan. In 1816 to Edo. Became pupil and protégé of Tani Bunchō. Also studied Chinese literary men's painting of the Ming and Ch'ing periods as well as older Chinese paintings. Traveled extensively in the northern part of Japan, where he made a living selling sketches and paintings. Settled in Kyōto for a while, copying ancient paintings in shrines and temples. Finally returned to Edo. Among his pupils: Takahisa Ryūko (whom he adopted) and Taniguchi Aizan. Influenced by styles of I Fu-chiu and Ikeno Taiga, specialized in landscapes done in close imitation of Chinese models; particularly famous as a painter of bamboo. One of most polished Japanese *bunjinga* painters; did much to promote the school in eastern Japan. **Coll.**: Ashmolean, Honolulu. **Bib.**: K 228, 370, 583, 622, 634, 823; Mitchell; Morrison 2; Murayama (2); NB (S) 4; Tajima (13) 7; Umezawa (2).
[1]靉厓 [2]高久徵 [3]子遠 [4]秋輔 [5]靉厓
[6]学梅斎 [7]如樵 [8]石巢 [9]疎林外史

Aimi[1] (fl. beginning 10th c.). *N.*: Kose no Aimi.[2] **Biog.**: Painter. A court artist, said to have been a painter of Buddhist subjects. Also said to have been the son of Kose no Kanaoka. His name, like that of so many artists of this period, exists in records but can be identified with no known work. Any information about him comes from the genealogical chart found in the *Daijoin Jisha Kojiki* of 1472. **Bib.**: Morrison 1.
[1]相覧（相見） [2]巨勢相覧（相見）

Aiseki (Sō Aiseki)[1] (?–1837?). *Priest name*: Shinzui.[2] *Gō*: Aiseki.[3] **Biog.**: *Nanga* painter. Born in Kii Province. Member of the Ōbaku sect. Studied under Noro Kaiseki; later, on his own, closely studied works by famous artists of Yüan and Ming China as well as of Japan. One of the three famous *seki* painters (so called after the last character of their names) of the early 19th century, the other two being his teacher Kaiseki and Nagamachi Chikuseki. Good at both *sumi-e*

and slightly colored *suiboku*. **Coll.**: Art (1a), British. **Bib.**: *Japanese* (1a).
[1]愛石（僧愛石） [2]真瑞 [3]愛石

Aizan[1] (1816–99). *N.*: Taniguchi Teiji.[2] *Gō*: Aizan,[3] Ōsetsu Suisō,[4] Shikan.[5] **Biog.**: *Nanga* painter. Born in Etchū Province; traveled in Kyūshū, where he came in contact with certain Chinese artists; then to Edo to study under Takahisa Aigai; finally settled in Kyōto. Important member of the Chinese-influenced art circles in the Kansai region. In charge of the *nanga* division of the Kyōto Prefectural School of Painting when it opened in 1880. Specialized in landscapes, but also painted *kachōga*. **Coll.**: Ashmolean. **Bib.**: Asano, Mitchell, NBZ 6, Uyeno.
[1]靉山 [2]谷口貞二（貞治） [3]靉山 [4]鴨折水荘 [5]士幹

Akagi Yasunobu[1] (1889–1955). **Biog.**: Western-style painter. Born in Shizuoka-ken. In 1906 to Tōkyō; became a pupil of Ōshita Tōjirō. Studied at the Nihon Suisaiga Kenkyūsho and the Taiheiyō Kenkyūsho. In 1909 exhibited for the first time at the Bunten; later with the Teiten, Nikakai, Kōfūkai. In 1913 a founding member of the Nihon Suisaigakai. From 1921 to 1941 taught in Tōkyō at Bunka Gakuin Institute; after 1942, at Women's Art School. His style is rather academic. **Coll.**: National (5). **Bib.**: Asano.
[1]赤城泰舒

Akamatsu Rinsaku[1] (1878–1953). **Biog.**: Western-style painter. Born in Okayama-ken. In 1899 graduated from the Tōkyō School of Fine Arts, having exhibited while a student with the Hakubakai. About 1903 worked as illustrator for the Ōsaka Asahi Press and taught in various Ōsaka schools. In 1908 showed for the first time with the Bunten. Won first prize at the Fifth Naikoku Kangyō Hakurankai. Member of the Hakubakai and then of the Kōfūkai. Style academic, with touches of impressionism. **Coll.**: Tōkyō (2). **Bib.**: Asano, Harada Minoru, *Kurashina* (2), NB (S) 30.
[1]赤松麟作

Akamatsu Unrei[1] (1892–1958). **Biog.**: Japanese-style painter. Born in Ōasak. First studied *nanga* painting on his own; later a pupil of Himeshima Chikugai. Exhibited with the Bunten in 1915; later with the Teiten and, after the Pacific War, with the Nitten. Member of the Nihon Nangain. Active supporter of Japanese-style painting. **Coll.**: National (5). **Bib.**: Asano.
[1]赤松雲嶺

Akatsuka Jitoku[1] (1871–1936). *N.*: Akatsuka Heizaemon.[2] *Gō*: Jitoku.[3] **Biog.**: Lacquerer. Born in Tōkyō. Learned *makie* technique from his father, Japanese-style painting from a Kanō artist, oil painting at the Hakubakai. In 1930, made a member of the Imperial Fine Arts Academy. His work is traditional, graceful, elegant. **Coll.**: National (4), Walters. **Bib.**: Boyer, Herberts, Jahss, NBZ 6, Ragué, Yoshino.
[1]赤塚自得 [2]赤塚平左衛門 [3]自得

Akinobu[1] (1773–1826). *N.*: Kanō Akinobu.[2] *F.N.*: Senjirō;[3] later, Geki.[4] *Gō*: Daigensai,[5] Sosen.[6] **Biog.**: Kanō painter. Descendant of Kanō Soyū Hidenobu; sixth-generation head of the Saruyamachi Kanō line. Employed by the shogunate as *omote eshi*. **Coll.**: Museum (3). **Bib.**: *Nikuhitsu* (1) 1.
[1]彰信（章信） [2]狩野彰信（章信）
[3]仙次郎 [4]外記 [5]大玄斎 [6]素川

Amakusa Shinrai[1] (fl. late 19th to early 20th c.). **Biog.**: Japanese-style painter. Graduated from Tōkyō School of

Fine Arts in 1897; later taught there. Subjects sometimes taken from Japanese legends. Delicate Japanese style, with some Western influence. **Coll.**: Tōkyō (2). **Bib.**: *Kurashina* (1).

<div align="center">¹天草神來</div>

Amenomiya Jirō¹ (1889–). **Biog.**: Western-style sculptor. Born in Ibaraki-ken; worked in Tōkyō. Graduated in 1920 from the Tōkyō School of Fine Arts. Pupil of Kitamura Seibō. An exhibitor and judge at the Teiten; later showed with various government exhibitions. Member of the Nitten and the Nihon Chōkokukai. In 1957, awarded Japan Art Academy prize. Academic in style. **Bib.**: Asano.

<div align="center">¹雨宮治郎</div>

Anayama Shōdō¹ (1890–). **Biog.**: Japanese-style painter. Born in Yamanashi-ken. Graduated from the Tōkyō School of Fine Arts in 1912. Active in promoting the Shinkō Yamato-e-kai; exhibited there as well as at government shows. Founding member of Nihongain in 1938. **Coll.**: National (5). **Bib.**: Asano.

<div align="center">¹穴山勝堂</div>

Anchi (Yasutomo)¹ (fl. 1700–1716). **N.**: Kaigetsudō Anchi.² *Studio name:* Chōyōdō.³ **Biog.**: Ukiyo-e painter, printmaker. Lived and worked in Edo. Possibly the son of Kaigetsudō Ando; the only immediate follower of Ando to have his own studio name. (See Kaigetsudō entry for general discussion of the problem of this group of artists and their style.) About twenty of Anchi's paintings have survived. His prints, of which there are so far seven known designs, are always of tall, graceful courtesans. **Coll.**: Art (1), British, Idemitsu, Metropolitan, Museum (3). **Bib.**: Binyon (1); Fujikake (3) 2; Gentles (2); Hillier (1); Jenkins; Lane; Ledoux (4); Michener (1); Morrison 2; Narazaki (2); Shibui (1); Stern (2); Tajima (7) 3; Takahashi (3), (5); UG 28; *Ukiyo-e* (3) 3; Vignier 1.

<div align="center">¹安知 ²懐月堂安知 ³長陽堂</div>

Ando (Yasunobu)¹ (fl. early 18th c.). **N.**: Okazaki Genshichi² *Gō:* Ando,³ Kaigetsudō Ando,⁴ Kan'unshi.⁵ **Biog.**: Ukiyo-e painter. Lived in Asakusa, Edo. The details of his life are unknown, save that he was banished from Edo to Ōshima in 1714 for his part, presumably that of a go-between, in an affair between the Lady Ejima (the principal lady-in-waiting to the shogun's mother) and the actor Ikushima Shingorō. It is not even certain if Ando is the correct reading of his name, for it may also be read Yasunobu. Ando designed no prints. (See under Kaigetsudō entry for general discussion of this school.) Painted in bright colors and with heavy black outlines—with much emphasis on textile patterns—tall, stately, and gorgeously dressed courtesans placed against a neutral background; these figures represent all that was seductive, fashionable, and magnificent in the entertainment world and stand as the symbol of the ukiyo-e school in the early 18th century. **Coll.**: Atami, British, Cleveland, Detroit, Freer, Honolulu, Idemitsu, Kanagawa, Kimbell, Museum (3), Nelson, Tōkyō (1). **Bib.**: AA 6; Binyon (3); *Exhibition* (1); Ficke; Fontein (1); *Freer*; Fujikake (3) 2; GNB 17; Hillier (1); *Images*; Jenkins; K 27, 135, 366, 388, 443, 447, 661; Kondō (6); Kurth (2); Lane; Ledoux (4); Lee (2); M 18, 124; Michener (1); Morrison 2; Narazaki (2), (3); NBZ 5; *Nikuhitsu* (1) 1; Noma (1) 2; OA 13; Paine (4); Shimada 3; Stern (2); Tajima (7) 3; Takahashi (3), (5); *Ukiyo-e* (3) 3; Vignier 1.

<div align="center">¹安度 ²岡崎源七 ³安度 ⁴懐月堂安度 ⁵翰運子</div>

Andō Nakatarō¹ (1861–1912). **Biog.**: Western-style painter. Born and lived in Tōkyō. Pupil of Takahashi Yuichi at his private school, the Tenkai Gakusha. In 1896, with Kuroda Seiki and others, founded the Hakubakai. Served as juror for the Fourth Naikoku Kangyō Hakurankai. An important figure in the spread of Western-style painting in Japan. Specialized in portraits. **Bib.**: Asano, NB (H) 24, NBZ 6.

<div align="center">¹安藤仲太郎</div>

Andō Shō¹ (1892–1945). **Biog.**: Sculptor. Born in Kagoshima. In 1922 graduated from Tōkyō School of Fine Arts. While still a student, began exhibiting at the Teiten and in 1925 received the grand prix. Member of the Tōdai Chōsokai. His principal work the statue of Saigō Takamori (one of the leaders of the Satsuma clan at the time of the Meiji Restoration) in front of the Kagoshima City Hall. **Bib.**: Asano, NBZ 6.

<div align="center">¹安藤照</div>

Ankei¹ (fl. beginning 18th c.). **N.**: Okazaki Genshichi.² *Gō:* Ankei,³ Kaigetsudō Ankei.⁴ **Biog.**: Ukiyo-e painter. Said to have been the founder of the Kaigetsudō school, but no work by him can be identified at present. Is sometimes confused with Kaigetsudō Ando, since the grass script for *do* can also be read as *kei*. (See under Kaigetsudō entry for a discussion of this school.)

<div align="center">¹安慶 ²岡崎源七 ³安慶 ⁴懐月堂安慶</div>

Ansen¹ (1659–1717). **N.**: Kanō Harunobu.² *Gō:* Ansen.³ **Biog.**: Kanō painter. Son of and successor to Kanō Ikkei Yoshinobu in the Negishi Miyukimatsu line. Worked for the shogunate. **Coll:** Victoria.

<div align="center">¹安仙 ²狩野春信 ³安仙</div>

Ansen¹ (fl. c. 1781–1803). **N.**: Kanō Jishin.² *Gō:* Ansen.³ **Biog.**: Kanō painter. Son of and successor to Kanō Ryōshin Eishin of the Negishi Miyukimatsu line, following him in 1785 and retiring in 1802.

<div align="center">¹安仙 ²狩野自信 ³安仙</div>

Ansen¹ (1809–92). **N.**: Kanō Takanobu.² *Gō:* Ansen,³ Kaishunsai.⁴ **Biog.**: Kanō painter. Born in Edo. Descendant of Kanō Ikkei; 13th generation of the Negishi Miyukimatsu branch of the Kanō family. Studied under Kanō Isen'in Naganobu of the Kobikichō Kanō. Served the Tokugawa shogunate as *goyō eshi*. Said to have been particularly skillful in the use of the gold-powder technique.

<div align="center">¹晏川 ²狩野貴信 ³晏川 ⁴皆春斎</div>

Aōdō Denzen¹ (1748–1822). **N.**: Nagata Zenkichi.² *F.N.:* Chūta.³ *Gō:* Aō Chinjin,⁴ Aōdō Denzen,⁵ Denzen,⁶ Jotan,⁷ Seizandō.⁸ **Biog.**: *Yōga* painter, printmaker. Born in Sukagawa, Iwashiro Province. Pupil of the Maruyama painter Gessen; some sources say he learned Western-style painting and copperplate etching from a Dutchman in Nagasaki as well as from Shiba Kōkan. Served Lord Matsudaira as an official painter. Also a printmaker (specializing in views of Edo) and even made anatomical drawings. As a printmaker, developed a technique of his own, coating the copperplates with lacquer rather than wax and resin as did Shiba Kōkan. Worked generally in the Western style. To Westerners, he is more of a curiosity than a good artist. **Coll.**: Homma; Kōbe; Tōkyō (1), (2). **Bib.**: BK 49, 51; Fujikake (3) 3; GNB 25; K 172, 376; M 65, 187; Mody; Moriya; NB (H) 24; NB (S) 36; NBZ 5; Nishimura; Noma (1) 2; *Pictorial* (2) 2; SBZ 10; Sullivan.

<div align="center">¹亜欧堂田善 ²永田善吉 ³仲太 ⁴亜欧陳人
⁵亜欧堂田善 ⁶田善 ⁷如且 ⁸星山堂</div>

Aoki Daijō¹ (1891–). **Biog.**: Japanese-style painter. Born in Ōsaka. Graduate of Kyōto Municipal School of Fine Arts and Crafts. Organizer of a number of local art associations and an active member of Ōsaka art circles. A sensitive painter of figures, landscapes, and *kachōga*. **Bib.**: Asano.

<div align="center">¹青木大乗</div>

Aoki Shigeru¹ (1882–1911). **Biog.**: Western-style painter. Born in Kurume. At 17 to Tōkyō; studied first at Koyama Shōtarō's school, Fudōsha, and later, under Kuroda Seiki at the Tōkyō School of Fine Arts, from which he graduated in 1904. While still a student, showed with the Hakubakai, receiving a first prize. Left Tōkyō; lived in Ibaraki and Tochigi prefectures and finally, almost as a nomad, in Kyūshū, where he died in obscurity. Little recognized during his short life, though his painting *Harvest of the Sea* (Bridgestone Art Museum) was selected as the most outstanding

Western-style painting at the Meiji-Taishō retrospective exhibition in 1927. During the 30s and 40s his name was once again forgotten, until he was rediscovered in the postwar period. Short-lived but important exponent of the romantic tendency in the Meiji era. Worked in a rather impressionist technique; pre-Raphaelite in sentiment. **Coll.:** Bridgestone; Ohara (1); Nagaoka; National (5); Tōkyō (1), (2). **Bib.:** Asano; BK 134, 136, 140, 192, 217; Harada Minoru; *Kurashina* (2); M 66; *Masterpieces* (4); Miyagawa; NB (H) 24; NB (S) 30; NBT 10; NKKZ 4; Noma (1) 2; SBZ 11.

¹青木繁
Aoki Sotokichi¹ (1877–). **Biog.:** Sculptor. Born in Kanazawa. Graduated from the Tōkyō School of Fine Arts in 1901; became an assistant professor there. Founded the Tōdai Chōsokai in Tōkyō. Late in his career, returned to Kanazawa to promote arts and crafts; became principal of the Technological High School of Ishikawa-ken.

¹青木外吉
Aoyama Kumaji¹ (1886–1932). **Biog.:** Western-style painter. Born in Hyōgo-ken; lived in Tōkyō. Studied at Tōkyō School of Fine Arts. Traveled and lived in Europe for some time. Exhibited first with the Bunten, then with the Teiten, eventually becoming a member of the hanging committee of the latter. Also a member of the Hakubakai. His painting, which owes much to Puvis de Chavannes and the School of Paris, is often enveloped in a general mistiness. **Coll.:** National (5). **Bib.:** Asano, NBZ 6, SBZ 11.

¹青山熊治
Aoyama Yoshio¹ (1894–). **Biog.:** Western-style painter. Born in Yokosuka. In 1911 entered Nihon Suisaiga Kenkyūsho; pupil of Ōshita Tōjirō. In 1925 to France to study under Henri Matisse; while there, continued to show his work with the Shun'yōkai and was accepted as a member of the society. On his return to Japan in 1935, transferred to the Kokugakai. Served as a juror for the early Nitten exhibitions. His style is rather expressionist.

¹青山義雄
Arai Kampō¹ (1878–1945). **N.:** Arai Kanjūrō.² **Gō:** Kampō.³ **Biog.:** Japanese-style painter. Born in Tochigi-ken. As a youth, studied with Mizuno Toshikata. Frequent exhibitor with the Bunten and the Inten. Member of the Kojikai. Interested first in historical subjects, then in Buddhist ones. Went to India to copy the Ajanta cave frescoes; also copied the ones in Central Asia and those in the Kondō at the Hōryū-ji, Nara-ken. Best known for his copies of Buddhist paintings; his own religious work tends to be rather sentimental. **Coll.:** National (5). **Bib.:** Asano, NBZ 6.

¹荒井寛方 ²荒井寛十郎 ³寛方
Arai Shōri¹ (1895–). **N.:** Arai Katsutoshi.² **Gō:** Shōri.³ **Biog.:** Japanese-style painter. Studied under Kajita Hanko and Yasuda Yukihiko. Exhibitor at the Inten. Works in a pleasantly decorative manner. **Coll.:** National (5). **Bib.:** Asano.

¹新井勝利 ²新井勝利 ³勝利
Arai Tatsuo¹ (1904–55). **Biog.:** Western-style painter. Born in Ōita-ken. In Europe from 1933 to 1937. On his return to Japan became a member of the Dokuritsu Bijutsu Kyōkai. His work was exhibited in Europe and the United States from 1952 to 1955. **Coll.:** Kanagawa; National (4), (5). **Bib.:** NBZ 6.

¹荒井竜男
Arakawa Kisai¹ (1824–1905). **Biog.:** Sculptor. Born in Izumo Province. First worked in metal, then shifted to wood. His principal work, a portrayal of the Sixteen Rakan, is in the Tōkyō National Museum. **Coll.:** Tōkyō (1).

¹荒川亀斎
Arakawa Toyozō¹ (1894–). **Biog.:** Potter. Born in Tajima in Gifu-ken. First studied painting in Kyōto. In 1922, turned to ceramics, studying with Miyanaga Tōzan. In 1930, as an assistant to Kitaōji Rosanjin at the Hoshigaoka kiln at Okaya, Kani-machi, Gifu-ken, discovered the site where Shino and

Seto wares had been made in the Momoyama period. Established himself there, producing tea bowls, sakè bottles, and flower vases. Member of the Nihon Kōgeikai. In 1955 was designated a Living National Treasure. Leading figure in the revival of Shino and Black Seto. His work is much appreciated by present-day tea masters. **Coll.:** National (4), University (2). **Bib.:** Koyama (1a), Lee (3), *Masterpieces* (4), Munsterberg (2), NBT 6, Okada, STZ 16, Sugimura, TZ (K) 4.

¹荒川豊蔵
Araki Juppo¹ (1872–1944). **N.:** Araki Teijirō.² **Gō:** Juppo,³ Kinko.⁴ **Biog.:** Japanese-style painter. Born in Nagasaki-ken. Went to Tōkyō; became pupil and adopted son of Araki Kampo. An exhibitor and juror at the Bunten; then an exhibitor at the Teiten. His work is closer to the Shijō school than to the Chinese-inspired style of his master. Noted for his strong, sure brushwork. **Coll.:** National (5). **Bib.:** Asano, Elisséev, Morrison 2, NBZ 6.

¹荒木十畝 ²荒木悌二郎 ³十畝 ⁴琴湖
Araki Kampo¹ (1831–1915). **N.:** Araki (originally Tanaka)² Yoshi.³ **F.N.:** Kōzaburō.⁴ **Gō:** Kampo,⁵ Tatsuan.⁶ **Biog.:** Japanese-style painter. Born and lived in Tōkyō. Pupil of Araki Kankai who, recognizing his ability, adopted him at 16. Also studied Western-style painting with Kawakami Tōgai and Kunisawa Shinkurō but in 1884 returned to his original style. Professor at the Tōkyō School of Fine Arts. Received prizes for his work from the third Naikoku Kangyō Hakurankai and at French and American world's fairs. Frequent juror for the Bunten. Member of Nihon Bijutsu Kyōkai, Royal Society of Arts in London, and Art Committee of the Imperial Household. Most of his later work consisted of figures and *kachōga* showing the influence of Okamoto Shūki. His style is generally close to that of Chinese Ch'ing painting, but with some Western realism. **Coll.:** Tōkyō (1), (2). **Bib.:** Asano, *Kurashina* (1), Mitchell, Morrison 2, NB (S) 17, NBZ 6, Uyeno.

¹荒木寛畝 ²田中 ³荒木吉 ⁴光三郎 ⁵寛畝 ⁶達庵
Arihara Kogan¹ (1829–1922). **N.:** Arihara (originally Furuya)² Shigetoshi (Shigehisa).³ **Gō:** Kogan,⁴ Kyūjōō,⁵ Sekinan-ken.⁶ **Biog.:** Japanese-style painter. Born in Edo; son of a samurai. Studied painting under the Tosa artist Arai Shōshun. Exhibited with the Naikoku Kaiga Kyōshinkai, the Nihon Bijutsu Kyōkai, and the Naikoku Kangyō Hakurankai; member of the Nihongakai. Received commissions from the imperial household.

¹在原古玩 ²古屋 ³在原重寿 ⁴古玩 ⁵鳩杖翁 ⁶昔男軒
Arihisa¹ (fl. c. 1325). **N.:** Kose no Arihisa.² **Biog.:** Kose painter. Third son of Kose no Ariyuki. Is recorded as having held position of *azukari* at court and, later, of having been attached as *dai busshi* to the Tō-ji, Kyōto. No paintings by him are known to exist. **Bib.:** Moriya.

¹有久 ²巨勢有久
Ariie¹ (fl. c. 1323). **N.:** Kose (originally Ki)² no Ariie.³ **Biog.:** Kose painter. Perhaps son of Kose no Mitsuyasu (at best, a shadowy figure); brother of Kose no Ariyasu. Member of the Kose school of Buddhist painters at the Tō-ji, Kyōto. Recorded as having produced many *butsuga*. The scroll *Jizō Engi* in the Tōkyō National Museum is attributed to him. **Coll.:** Tokugawa, Tōkyō (1). **Bib.:** Okudaira (1).

¹有家 ²紀 ³巨勢有家
Arima Satoe¹ (1893–). **Biog.:** Western-style painter. Born in Kagoshima; resident of Tōkyō, where she studied under Okada Saburōsuke. From 1914 on, showed at government exhibitions. Member of the Kōfūkai and the Nitten. Her later style shows some fauve influence. **Coll.:** National (5).

¹有馬さとえ
Arimune¹ (fl. late 12th c.). **N.:** Kose no Arimune.² **Biog.:** Kose painter. May have been a son of Kose no Kaneshige; is generally considered the tenth-generation of the Kose main line. Served the court as Edokoro *azukari*. Is known

to have worked on sketches for the screen made in 1184 for the new emperor's accession ceremony; however, like many of these Kose artists, his name exists in records but can be identified with no specific work.

¹有宗　²巨勢有宗

Arishige[1] (fl. c. 1300). *N.:* Kose no Arishige.[2] **Biog.:** Kose painter. May have been a son of Kose no Ariyuki. Held various court positions.

¹有重（有茂）　²巨勢有重（有茂）

Arishima Ikuma[1] (1882–1974). *N.:* Arishima Mibuma.[2] *Gō:* Ikuma.[3] **Biog.:** Western-style painter. Born in Yokohama. Graduate of Tōkyō Foreign Language School, then studied under Fujishima Takeji. Went abroad for further study in painting. Member of the Issuikai, the Nitten, and the Nihon Geijutsuin. His style is generally expressionist. **Coll.:** National (5). **Bib.:** Asano, NB (H) 24, NBZ 6.

¹有島生馬　²有島壬生馬　³生馬

Ariyasu (Tomoyasu)[1] (fl. c. 1335). *N.:* Kose (originally Ki)[2] no Ariyasu (Tomoyasu).[3] **Biog.:** Kose painter. May have been second son of that shadowy figure Ki no Mitsuyasu; younger brother of Kose no Ariie. On becoming a painter, adopted the name of the famous Kose school of Buddhist artists attached to the Tō-ji, Kyōto. Represented fifteenth generation of Kose main line. The scroll *Kōya Daishi Gyōjō Zuga* owned by the Jizō-in, Wakayama-ken, is attributed to him. **Coll.:** Jizō-in (1). **Bib.:** Okudaira (1).

¹有康　²紀　³巨勢有康

Ariyuki[1] (fl. c. 1260). *N.:* Kose no Ariyuki.[2] **Biog.:** Kose painter. Son of Ryūkei. An artist of this period and school who seems to be known only from the Kose genealogy and from his having held a court position as a painter of *butsuga*. **Bib.:** Morrison 1.

¹有行　²巨勢有行

Asahi Gyokuzan[1] (1843–1923). **Biog.:** Japanese-style sculptor. Born in Asakusa, Edo. Early in life became a Buddhist priest, but at 24 gave up the monastic existence to become an ivory carver. Taught at Tōkyō School of Fine Arts; member of the Teiten. Made his large figures by joining many small pieces together: incredibly intricate and versatile work. His style was one of total realism. **Bib.:** Asano, M 203, *Masterpieces* (3), NB (S) 41, NBT 2, NBZ 6, Noma (1) 2, Uyeno.

¹旭玉山

Asai Chū[1] (1856–1907). *N.:* Asai Chū.[2] *Gō:* Mokugo,[3] Mokugyo.[4] **Biog.:** Western-style painter. Born in Kazusa Province; moved to Tōkyō, later to Kyōto. Pupil of Kunisawa Shinkurō at his private school Shōgidō in 1875, and of Antonio Fontanesi the next year at the Kōbu Daigaku Bijutsu Gakkō. In 1888, with Kawamura Kiyo-o and others, set up the Meiji Bijutsukai. In 1898 taught at the Tōkyō School of Fine Arts. Served as a war artist in the Sino-Japanese war. From 1900 to 1902 in France, living first in Paris, then in Grez (near Paris), where he did some of his best work; exhibited at the Paris Exposition of 1900. On his return moved to Kyōto and became professor at the Kyōto Kōgei Gakkō; also took a leading part in Kyōto art circles as director of the Kansai Bijutsuin and founder of the Shōgoin Yōga Kenkyūsho. Among his pupils were Ishii Hakutei, Umehara Ryūzaburō, and Yasui Sōtarō. A leading painter of his time, most influential in the development of Western-style painting in Japan. At first used a heavy palette, but it became lighter and less muddy after his time in France. Also painted in water colors. His quite poetic work is in the manner of the Barbizon school. **Coll.:** Bridgestone; Kyōto (1); Nagaoka; National (5); Tōkyō (1), (2). **Bib.:** *Asai Chū;* Asano; BK 188, 201; Elisséev; Harada Minoru; *Kurashina* (2); M 101, 229; *Masterpieces* (4); Mitchell; Miyagawa; NB (H) 24; NB (S) 30; NBT 10; NBZ 6; NKKZ 1; Noma (1) 2; SBZ 11; Uyeno.

¹浅井忠　²浅井忠　³黙語　⁴木魚

Asai Hakuzan[1] (1842–1907). *N.:* Asai Ryū.[2] *A.:* Shishō.[3] *Gō:* Haichiku Dōjin,[4] Hakuun Sankyaku,[5] Hakuzan,[6] Ryūtō,[7] Shōhaku,[8] Soun,[9] Unkyaku.[10] **Biog.:** *Nanga* painter. Born in Awa Province. Studied first under the Shijō artist Dodo Hirotoshi, then with the *nanga* painters Taniguchi Aizan and Nukina Kaioku. Later to Nagasaki and worked under Kinoshita Itsuun. Was also a poet and calligrapher. Specialized in landscapes and *kachōga*. **Coll.:** Ashmolean. **Bib.:** Mitchell.

¹浅井白山　²浅井龍　³子祥　⁴排竹道人　⁵白雲山客　⁶白山　⁷龍塘　⁸小白　⁹蘇雲　¹⁰雲客

Asai Ichimō (Ichigō)[1] (1836–1916). *N.:* Asai Ichimō (Ichigō).[2] *Gō:* Sōsentei Ichimō.[3] **Biog.:** Kutani potter. Younger brother of the well-known Kutani potter Takeuchi Ginshū. Studied under Iidaya Hachiroemon. Particularly well known as an expert in the elaborate type of decoration known as *kinrande*. **Coll.:** Tōkyō (1). **Bib.:** NB (S) 41, NBZ 6, Uyeno.

¹浅井一毫　²浅井一毫　³相鮮亭一毫

Asakura Fumio[1] (1883–1964). **Biog.:** Western-style sculptor. Born in Ōita-ken. Graduate of Tōkyō School of Fine Arts in 1907; later taught there, where he had much influence on the younger artists. Became famous in 1908 when he won a prize at the second Bunten exhibition. Leading sculptor in government exhibition circles; member of the Art Committee of the Imperial Household and the Japan Art Academy. Given the Order of Cultural Merit in 1948. His style one of academic realism. **Coll.:** Asakura, National (5), Tōkyō (1). **Bib.:** Asano, GNB 28, M 203, *Masterpieces* (4), NBT 10, NBZ 6, Uyeno.

¹朝倉文夫

Ashihiro[1] (fl. c. 1820). *N.:* Harukawa Ashihiro.[2] **Biog.:** Ukiyo-e printmaker. Worked in Ōsaka. Pupil of Asayama Ashikuni. Specialized in Kabuki subjects. **Coll.:** Musées, Victoria. **Bib.:** Crighton, *Ukiyo-e* (3) 19.

¹芦広　²春川芦広

Ashikuni[1] (c. 1775/9–1818). *N.:* Asayama.[2] *F.N.:* Nunoya Chūzaburō.[3] *Gō:* Ashikuni,[4] Kyōgadō,[5] Ran'eisai,[6] Ransai,[7] Roshū,[8] Seiyōsai.[9] **Biog.:** Ukiyo-e printmaker. Lived in Ōsaka. About 1807 began to work as a book illustrator. May have been responsible, as a bookseller, for assembling and publishing works of Hokusai and Toyokuni. First recorded single-sheet actor print dated 1811. Designed some forty illustrated books; only about a dozen prints by him are known, almost all published during last four years of his life. Had a number of pupils, including Ashimaro, Ashitomo, and Ashiyuki. A minor artist of limited talent. **Coll.:** Musées, Philadelphia, Rhode Island, Victoria. **Bib.:** Fujikake (3) 3, Hillier (7), Keyes, NHBZ 3, Strange (2), *Ukiyo-e* (3) 19.

¹芦国　²浅山　³布屋忠三郎　⁴芦国　⁵狂画堂　⁶蘭英斎　⁷蘭斎　⁸蘆洲　⁹青陽斎

Ashitaka (Ashihisa, Ashinao)[1] (fl. c. 1817). **Biog.:** Ukiyo-e printmaker. Worked in Ōsaka. Pupil of Asayama Ashikuni. Made actor prints. **Bib.:** Keyes, *Ukiyo-e* (3) 19.

¹芦尚

Ashitomo[1] (fl. 1804–30). Ukiyo-e printmaker. Worked in Ōsaka. Pupil of Asayama Ashikuni. Specialized in actor prints. **Coll.:** Philadelphia. **Bib.:** Keyes, NHBZ 3.

¹芦友（あし友）

Ashiyuki[1] (fl. first half 19th c.). *Gō:* Ashigadō,[2] Ashiyuki,[3] Gigadō (1818–32),[4] Nagakuni (1814–21).[5] **Biog.:** Ukiyo-e printmaker. Worked in Ōsaka. Pupil of Asayama Ashikuni. Prolific producer of theatrical prints and posters. At his best, a good artist of the Ōsaka school and a leader in some of the advances made by that school: first to make much use of the horizontal format; first in Ōsaka to employ *gofun*, first to exploit use of color blocks without outlines, and may have been first to use small-figure *surimono* style. **Coll.:** British, Minneapolis, Musées, Newark, Philadelphia,

Victoria. **Bib.:** Binyon (1), Crighton, Hillier (7), Keyes, NHBZ 3, Strange (2), *Ukiyo-e* (3) 19.

[1]芦幸（芦雪，芦ゆき） [2]芦画堂 [3]芦幸 （芦雪，芦ゆき） [4]戯画堂 [5]長国

Ataka Yasugorō[1] (1883–1960). Western-style painter. Born in Niigata-ken. In 1910 graduated from the Tōkyō School of Fine Arts. Traveled abroad in the 1920s. Frequent exhibitor at the Bunten and the Teiten. In 1928 was commissioned to work at the Meiji Shrine. In 1956 to China on a cultural mission. Member of Sōgenkai. Worked in an academic manner. **Bib.:** Asano.

[1]安宅安五郎

Atomi Gyokushi (Tamae)[1] (1859–1943). *N.:* Atomi Katsuko.[2] *Gō:* Fugen'an,[3] Gyokushi (Tamae).[4] **Biog.:** Japanese-style painter. Daughter of a samurai of Shingu. Studied under Hasegawa Gyokuhō, then under Mochizuki Gyokusen Shigemine. From 1878 to 1886 taught at a girls' high school in Kyōto. Then moved to Tōkyō and opened a private art school in Kanda. Exhibited with the Nihon Bijutsu Kyōkai in 1889, later becoming a member of the society and a prize winner at its exhibitions. Specialized in painting cherry blossoms. **Coll.:** Museum (3), National (5), Worcester. **Bib.:** Asano.

[1]跡見玉枝 [2]跡見勝子 [3]不言庵 [4]玉枝

Atomi Kakei[1] (1840–1926). *N.:* Atomi Tatsuno.[2] *Gō:* Fugen,[3] Kakei,[4] Mokka,[5] Seisei.[6] **Biog.:** Japanese-style painter. Born in Ōsaka. After receiving a classical education, she studied painting under Maruyama Ōritsu and, later, under Nakajima Raishō and Hine Taizan. In 1875 founded a girls' school in Tōkyō. **Bib.:** Asano.

[1]跡見花蹊 [2]跡見竜野 [3]不言 [4]花蹊 [5]木花 [6]西成

Atomi Tai (Yutaka)[1] (1884–1953). **Biog.:** Western-style painter. Born in Tōkyō. Given private painting lessons by Kuroda Seiki; later studied at Tōkyō School of Fine Arts. In 1907, showed at first Bunten. In 1912, with Nakasawa Hiromitsu, Yamamoto Morinosuke, and Miyake Katsumi, established the Kōfūkai, with which he exhibited. Also took part in government exhibitions. Member of the Hakubakai. Particularly good at landscapes. **Bib.:** Asano.

[1]跡見泰

Atsunobu[1] (1640–1718). *N.:* Kanō Atsunobu.[2] *Gō:* Juseki.[3] **Biog.:** Kanō painter. Son of Kanō Sosen Nobumasa; third in the Saruyamachi Kanō line. **Coll.:** Museum (3).

[1]敦信 [2]狩野敦信 [3]寿石

B

Baba Fuji[1] (1906–56). **Biog.:** Japanese-style painter. Born in Kagawa-ken. Graduated from Tōkyō School of Fine Arts in 1928. Joined Ochiai Rōfū's Meirō Bijutsu Remmei. In 1948 exhibited, for the first time, with the Inten; in 1955 became a member of that group.

[1]馬場不二

Baidō[1] (1816–80). *N.:* Asano Nagamura.[2] *A.:* Inkyō.[3] *Gō:* Baidō,[4] Chikō.[5] **Biog.:** *Nanga* painter. Born in Edo, son of a samurai of the Asano clan of Harima. Became magistrate of Uraga and Kyōto; in 1867 resigned from his position with the *bakufu.* Known as an able member of the *nanga* school. **Bib.:** BK 35.

[1]梅堂 [2]浅野長祚 [3]胤卿 [4]梅堂 [5]池香

Baiei[1] (1652–1700). *N.:* Kanō Tomonobu.[2] *F.N.:* Ichigaku.[3] *Gō:* Baiei.[4] **Biog.:** Kanō painter. Elder son of Kanō Shunsetsu; younger brother of Kanō Shunshō. Served the shogunate as *omote eshi.* Founder of the Fukugawa school of Kanō artists.

[1]梅栄 [2]狩野知信 [3]一学 [4]梅栄

Baigai[1] (1749–1804). *N.:* Totoki Shi (Tamō).[2] *A.:* Shiu,[3] Suenaga.[4] *F.N.:* Hanzō.[5] *Gō:* Baigai,[6] Kotei,[7] Seimuken,[8] Tenrinkaku.[9] **Biog.:** *Nanga* painter. Born in Ōsaka. Educated in Edo in Chinese classics, calligraphy, and painting, becoming a recognized Confucian scholar and literary man. In Kyōto, studied painting with Ikeno Taiga and Minagawa Kien. In 1784 summoned to Nagashima, Ise Province, by Lord Masuyama Sessai to open a school for children of samurai. In 1790, given leave to visit Nagasaki but overstayed his permit and lost his job; returned to Ōsaka. His skillful paintings are close to Taiga's but more romantic. **Coll.:** Center, Tōkyō (1), University (2). **Bib.:** *Cent-cinquante,* K 673, Mitchell, Morrison 2, NB (S) 4, Rosenfield (2), SBZ 10, Shimada 2.

[1]梅厓 [2]十時賜 [3]子羽 [4]季長 [5]半蔵 [6]梅厓 [7]顧亭 [8]清夢軒 [9]天臨閣

Baiitsu[1] (1783–1856). *N.:* Yamamoto Shinryō.[2] *A.:* Meikei.[3] *Gō:* Baiitsu,[4] Baika,[5] Gyokuzen,[6] Shun'en,[7] Tendō Gaishi,[8] Yūchiku Sōkyo.[9] **Biog.:** *Nanga* painter. Born in Nagoya. Protégé of Kamiya Ten'yū, wealthy collector of Chinese paintings in Nagoya. Learned Chinese painting techniques of Ming and Ch'ing dynasties. In 1803, with Nakabayashi Chikutō, moved to Kyōto; studied under Yamada Kyūjō and Yamamoto Rantei and sometimes collaborated with Uragami Shunkin. Taught many pupils. He and Chikutō were considered two best *nanga* painters working in Nagoya, where he had returned in 1854 under the patronage of the Owari clan. A prolific painter, working with great rapidity; many of his works still extant. Painted in a naturalistic way in the *bunjinga* manner; noted for his sure composition and clear colors. **Coll.:** Art (1a), Ashmolean, Freer, Honolulu, Los Angeles, Fine (M. H. De Young), Umezawa, University (2), Worcester. **Bib.:** BK 38, 39, 138; Cahill; *Cent-cinquante; Freer;* GNB 18; Hillier (2), (4) 3; *Japanese* (1a); *Japanische* (2); K 132, 309, 325, 341, 355, 362, 377, 385, 399, 413, 472, 706, 712, 728, 737, 790, 793, 796, 816, 827, 836, 885, 888, 894, 937; KO 40; *Kōrin* (2); Mayuyama; Minamoto (1); Mitchell; Mizuo (3); Morrison 2; Murayama (2); NB (H) 23; NB (S) 4; NBT 5; NBZ 5; *Nihon* (3); OA 13; *One* (2); SBZ 10; Shimada 2; Tajima (9) 2; Tajima (12) 12, 13, 15, 16, 19; Tajima (13) 7; Umezawa (2); Yonezawa.

[1]梅逸 [2]山本親亮 [3]明卿 [4]梅逸 [5]梅華 [6]玉禅 [7]春園 [8]天道外史 [9]友竹艸居

Baiju[1] (?–1771). *N.:* Kanō Tanenobu.[2] *Court title:* Naiki.[3] *Gō:* Baiju.[4] **Biog.:** Kanō painter. Third son and pupil of Kanō Baiken Tominobu, succeeding him in 1767 as head of the Kanasugi Kanō line.

[1]梅寿 [2]狩野胤信 [3]内記 [4]梅寿

Baiju[1] (1847–99). *N.:* Kunitoshi[2] (originally Yamamura).[3] *F.N.:* Kiyosuke.[4] *Gō:* Baiju,[5] Baiju Hōnen,[6] Baiō.[7] **Biog.:** Ukiyo-e printmaker, illustrator. Lived in Tōkyō and Yokohama. Pupil of Kunisada. A late print designer of the Yokohama school, specializing in the illustration of books; often worked in collaboration with his fellow students. **Coll.:** Fine (California), Musées, Ōsaka (1). **Bib.:** Nonogami.

[1]梅樹（梅寿） [2]国利 [3]山村 [4]清助 [5]梅樹（梅寿） [6]梅樹邦年 [7]梅翁

Baikan[1] (1784–1844). *N.:* Sugai Gaku[2] (or Tomoyoshi).[3] *A.:* Gakuho,[4] Shōkei.[5] *Gō:* Baikan,[6] Baikan Sanjin,[7] Tōsai.[8] **Biog.:** *Nanga* painter. Born in Sendai. Went to Edo to study under Tani Bunchō, then to Kyōto, and finally to Nagasaki, where he studied under the Chinese painter Chiang Chia-pu.

Returned to Sendai after he was 40 and served the Date clan as official painter. Famous locally. Specialized in landscapes. **Bib.**: Brown, K 703, Mitchell, Mody, NB (S) 4, Tajima (13) 7, Umezawa (2).

¹梅関（梅館）　²菅井岳　³智義　⁴岳輔
⁵正卿　⁶梅関（梅館）　⁷梅関山人　⁸東斎

Baikei¹ (1750–1803). *N.*: Kaburagi Seiin.² *A.*: Kunchū.³ *F.N.*: Yajūrō.⁴ *Gō*: Baikei.⁵ **Biog.**: Nagasaki painter. Born in Nagasaki. Pupil of Araki Gen'yū. Later to Edo. Good painter of *kachōga* and portraits, working in the style of Shen Nan-p'in. **Coll.**: Kōbe, Victoria. **Bib.**: Mitchell, *Pictorial* (2) 5.

¹梅渓　²鏑木世胤　³君青　⁴弥十郎　⁵梅渓

Baiken¹ (?–1674). *N.*: Kanō Tominobu.² *Gō*: Baiken.³ **Biog.**: Kanō painter. Son of Kanō Baiun Tamenobu; pupil of Kanō Mitsunobu; member of the Kanasugi Kanō school.

¹梅軒　²狩野富信　³梅軒

Baiken¹ (fl. late 18th c.). *N.*: Kanō Kazunobu.² *F.N.*: Denjirō.³ *Gō*: Baiken.⁴ **Biog.**: Kanō painter. A grandson of Kanō Baiken Tominobu, member of the Kanasugi branch of the Kanō school. Retired in 1799, but date of his death unknown.

¹梅軒　²狩野員信　³伝次郎　⁴梅軒

Baiō¹ (fl. mid-19th c.). *N.*: Katō Masatsugu.² *A.*: Shōtei.³ *Gō*: Baikaen,⁴ Baiō.⁵ **Biog.**: Japanese-style painter. Specialized in pictures of plum blossoms. **Bib.**: Mitchell.

¹梅翁　²加藤正継　³蕉亭　⁴梅花園　⁵梅翁

Bairei¹ (1844–95). *N.*: Kōno (originally Yasuda)² Naotoyo.³ *A.*: Shijun.⁴ *F.N.*: Kakusaburō.⁵ *Gō*: Bairei,⁶ Chōandō,⁷ Hoppo,⁸ Kakurokuen,⁹ Kinsen Charyō,¹⁰ Kōun,¹¹ Kōun Shinsho,¹² Kumo no Ie,¹³ Musei Shioku,¹⁴ Nyoi Sanshō,¹⁵ Ōmu,¹⁶ Rokuryū,¹⁷ Sanshu Kashitsu,¹⁸ Seika Zembō,¹⁹ Seiryūkan,²⁰ Shumpūrō,²¹ Zaigoan.²² **Biog.**: Japanese-style painter. Born and lived in Kyōto. First, at 8, pupil of the Maruyama painter Nakajima Raishō; then, at 27, of the Shijō artist Shiokawa Bunrin. Following the tradition of the *nanga* school, studied under Nakanishi Kōseki and Maeda Chōdō. With Gennyo, abbot of the Higashi Hongan-ji, toured Kyūshū and central Japan, leaving many sketches. In 1878 began to work toward the establishment of an art school that opened in 1880 as the Kyōto Prefectural School of Painting. In 1881, left the school and opened his own studio to students; ten years later retired from teaching. In 1893 became a member of the Art Committee of the Imperial Household. In 1894 commissioned to paint murals in the Higashi Hongan-ji. A leader in Kyōto art circles, where he organized and promoted many art groups; his true greatness lies in his educational work. Among his many students: Takeuchi Seihō, Kikuchi Hōbun, Kawai Gyokudō. His work, often marked by strong brush strokes, has considerable traditional charm and sensitivity. He produced *kachōga* and landscapes with a faint touch of Western realism. Also noted for his impromptu sketches and designs of flower subjects made for woodblock prints. **Coll.**: Kyōto (2), Museum (3), National (5), Tōkyō (1), Victoria. **Bib.**: Asano, BK 62, *Dessins*, Elisséev, Hillier (2), K 459, Minamoto (1), Mitchell, Morrison 2, NB (S) 17, NBZ 6, Uyeno.

¹楳嶺　²安田　³幸野直豊　⁴思順　⁵角三郎
⁶楳嶺　⁷長安堂　⁸北圃　⁹鶴鹿園　¹⁰金仙茶寮
¹¹香雲　¹²香雲深處　¹³雲の家　¹⁴無聲詩屋
¹⁵如意山樵　¹⁶鶯夢　¹⁷六柳　¹⁸三守蝸室
¹⁹晴蝸禅房　²⁰青龍館　²¹春風楼　²²在五菴

Bairi Sanjin¹ (?–1798). *N.*: Terajima (originally Sue)² Bō.³ *A.*: Chūki.⁴ *Gō*: Bairi Sanjin.⁵ **Biog.**: *Nanga* painter. Originally in the tile-manufacturing business; left the business to his son and became a painter. A man of taste, loving landscapes and flowers, he usually gave his paintings away or kept only enough of them to satisfy his simple needs. **Coll.**: Ashmolean. **Bib.**: Umezawa (2).

¹梅里山人　²陶　³寺島卯　⁴仲己　⁵梅里山人

Baisetsudō¹ (fl. 1751–64). **Biog.**: Ukiyo-e printmaker. Produced small-scale prints of Kyōto actors, often using lacquer. Had a seal reading Sadamichi.² **Bib.**: Fujikake (3) 2.

¹梅雪堂　²貞道

Baishō¹ (1729–1808). *N.*: Kanō Moronobu.² *Gō*: Okinobu;³ later, Baishō,⁴ Kuninobu,⁵ Sakanobu,⁶ Zuiryūsai.⁷ **Biog.**: Kanō painter. Son of Kanō Baishun; member of the Fukugawa Kanō branch. Worked in Kyōto. Teacher of Azuma Tōyō. **Bib.**: NBT 5, Paine (2) 1.

¹梅笑　²狩野師信　³興信　⁴梅笑
⁵国信　⁶栄信　⁷瑞鳳斎

Baishun¹ (1684–1743). *N.*: Kanō Kyokushin.² *F.N.*: Ichigaku.³ *Gō*: Baishun,⁴ Shinchisai.⁵ **Biog.**: Kanō painter. Adopted son of Kanō Baiei; member of the Fukugawa Kanō school.

¹梅春　²狩野旭信　³一學　⁴梅春　⁵真治斎

Baitei¹ (1734–1810). *N.*: Ki (Ki no) Tokitoshi². *F.N.*: Ki (Ki no) Bin.³ *A.*: Shikei.⁴ *Gō*: Baika.⁵ Baitei,⁶ Gan'iku,⁷ Kyūrō,⁸ Kyūrō Sanjin.⁹ **Biog.**: *Nanga* painter. Also a competent *haiku* poet. Born in Kyōto. Said to have been a pupil of Yosa Buson; after moving to Ōtsu, was known as "Ōtsu Buson." Painted excellent landscapes; also portraits and *kachōga*. The book *Kyūrō Gafu*, published in 1795, contains line prints after drawings by him. **Coll.**: Ashmolean, British, Museum (3). **Bib.**: Brown, Hillier (2), Holloway, Mitchell, OA 13.

¹楳亭　²紀時敏　³紀敏　⁴子恵　⁵楳華
⁶楳亭　⁷巌郁　⁸九老　⁹九老山人

Baiu¹ (fl. c. 1840). *N.*: Satō Shi.² *A.*: Shikan.³ *F.N.*: Gennai⁴. *Gō*: Baiu.⁵ **Biog.**: Painter. Pupil of Tani Bunchō. **Coll.**: Ashmolean. **Bib.**: Mitchell.

¹梅宇　²佐藤矢　³子幹　⁴源内　⁵梅宇

Baiun¹ (1657–1715). *N.*: Kanō Tamenobu.² *Gō*: Baiun.³ **Biog.**: Kanō painter. Son of Kanō Ujinobu of the Odawarachō Kanō line; founder of the Kanasugi branch of the Kanō school. **Coll.**: Victoria.

¹梅雲　²狩野為信　³梅雲

Baiun II¹ (?–1813). *N.* Kanō Yukinobu.² *Gō*: Baiun II.³ **Biog.**: Kanō painter. Son and pupil of Kanō Baiken Kazunobu, whom he succeeded in 1799 as head of the Kanasugi Kanō line.

¹梅雲二代　²狩野行信　³梅雲二代

Baizan¹ (1773–1857). *N.* Matsuno Eikō.² *Priest name:* Junkei.³ *Gō*: Baizan,⁴ Muga Dōjin,⁵ Sekkōsai.⁶ **Biog.**: Painter. As a priest, lived first at the Joman-ji in Owari Province and later at the Tenju-an in Mino Province. Received title of *hōgen*. Specialized in *kachōga* and pictures of animals. **Coll.**: Musées.

¹梅山　²松野栄興　³純恵
⁴梅山　⁵無我道人　⁶雪香斎

Bankei¹ (1622–93). *Priest name:* Eitaku.² *Gō*: Bankei.³ **Biog.**: *Zenga* painter. An important Zen monk of the early Edo period; the first abbot of the Ryūmon-ji at Hamada, his birthplace, he was later transferred by imperial command to the Myōshin-ji. In 1690, awarded the title of Butchi Kōsai Zenji. In painting, studied under a Chinese master at Nagasaki. Like so many Zen monks of the period, a painter of Zen themes in bold rough ink. **Bib.**: Awakawa, Brasch (2).

¹盤珪　²永琢　³盤珪

Bankei¹ (1801–78). *N.*: Ōtsuki Seisō.² *A.*: Shikō.³ *F.N.*: Heiji.⁴ *Gō*: Bankei.⁵ **Biog.**: Painter. Also a political figure. As a child, studied painting under a Chinese master. In 1842, appointed a member of the official interpreters' group at Nagasaki. In 1862 moved to Sendai, where he taught school. During the Meiji Restoration was imprisoned for political activity. In 1871 moved to Tōkyō, where he was active as a painter for the rest of his life. **Bib.**: Mitchell.

¹磐渓　²大槻清崇　³士廣　⁴平次　⁵磐渓

Banri (Manri)¹ (fl. early 19th c.). **Biog.**: Ukiyo-e printmaker.

Life unknown. Work shows influence of Torii Kiyonaga. **Coll.:** British. **Bib.:** Binyon (1), NHBZ 4.

¹万里

Bansui[1] (fl. mid-19th c.). *N.:* Akagawa Tarō.[2] *Gō:* Bansui,[3] Kaho,[4] Tōju,[5] **Biog.:** *Nanga* painter. Born in Yamaguchiken. About 1855 to Edo to study Chinese classics (and, perhaps, to become active in the Restoration movement) with Fujimori Kōan. A landscape painter.

¹晩翠 ²赤川太郎 ³晩翠 ⁴瓜畝 ⁵冬樹

Bashō[1] (1644–94). *N.:* Matsuo Munefusa.[2] *F.N.:* Chūzaemon.[3] *Gō:* Bashō,[4] Fūra,[5] Hyōchūan,[6] Mumeian,[7] Tōsei.[8] **Biog.:** Painter, poet. Born in Iga Province. The most distinguished *haikai* poet in Japan, studied *suiboku* painting under Morikawa Kyoroku, who was his pupil in *haikai*. Painting remained always a hobby. As a poet, used many other *gō*. **Coll.:** Hirado, Idemitsu, Metropolitan.

¹芭蕉 ²松尾宗房 ³忠左衛門 ⁴芭蕉
⁵風蘿 ⁶瓢中庵 ⁷無名庵 ⁸桃青

Beisanjin[1] (1744–1820). *N.:* Okada Koku.[2] *A.:* Shigen.[3] *F.N.:* Hikobei.[4] *Gō:* Beiō,[5] Beisanjin.[6] **Biog.:** *Nanga* painter. Born in Ōsaka. Made his living as a rice merchant; also served the lord of Tsu as a Confucian scholar, having studied Chinese literature and history as a youth. Studied painting independently only when he was middle-aged; hence his paintings date from the second half of his life. A friend of Tanomura Chikuden and Uragami Gyokudō. His house was a gathering place for scholars and artists. One of most influential *nanga* painters. Father of Okada Hankō. His works, almost all landscapes, are in the traditional *nanga* style but are yet very personal and, even when they appear to be merely rough sketches, are actually carefully thought out. Generally used little color. **Coll.:** Dayton, Fine (M. H. De Young), Musée (2), Ōsaka (2), Seattle, Stanford. **Bib.:** Cahill; *Cent-cinquante;* GNB 18; K 354, 394, 478, 645, 683, 706, 732, 741, 798, 864, 878, 891, 896, 935; Mayuyama; Mitchell; Morrison 2; Murayama (2); NB (H) 23; NBT 5; NBZ 5; *Nihon* (2), (3); SBZ 10; Shimada 2; Tajima (13) 7; Yonezawa.

¹米山人 ²岡田国 ³子彦（士彦）
⁴彦兵衛 ⁵米翁 ⁶米山人

Bokkei (Bokukei)[1] (fl. mid-15th c.). *N.:* An'ei Tōrin.[2] *Priest name:* Hyōbu Bokkei.[3] *Gō:* Bokkei (Bokukei),[4] Suibokusai.[5] **Biog.:** Muromachi *suiboku* painter. A Zen monk at the Daitoku-ji, Kyōto. Contemporary of Ikkyū and member of his circle. As Bokkei was often drunk, Ikkyū called him Suiboku (literally, "drunken ink"). Amused by this wordplay on *suiboku*[7] (ink painting), he started calling himself Suibokusai (the second *gō* listed above). Also closely linked with Jasoku and perhaps may be the same person. Otherwise, little is known of his life. The painting in the Shinju-an and attributed to him shows a strong, individual brush technique. **Coll.:** Daitoku-ji (Shinju-an), Umezawa. **Bib.:** Akiyama (2), Awakawa, BG 43, Fontein (2), GNB 11, K 51, KO 8, Matsushita (1), NB (S) 13, NBT 4, Rosenfield (2), SBZ 7, Tanaka (2), YB 41, Yoshimura.

¹墨溪（墨谿） ²安栄桃林 ³兵部墨溪
⁴墨溪（墨谿） ⁵酔墨斎 ⁶酔墨 ⁷水墨

Bokurin Guan[1] (c. 1750–1830). **Biog.:** *Suiboku* painter. Born in Tango, Kyōto-fu. Worked in the manner of Mu-ch'i, specializing in paintings of monkeys. **Coll.:** Umezawa.

¹墨林愚庵

Bokusai[1] (?–1492). *N.:* Shōtō.[2] *A.:* Motsurin (Botsurin).[3] *Gō:* Bokusai.[4] **Biog.:** Muromachi *suiboku* painter. Trained as a Zen priest in the Tenryū-ji, Kyōto. In 1452 was Ikkyū's disciple at the Shūon-an (where he later became chief priest) and then at the Shinju-an, at the Daitoku-ji, Kyōto. Perhaps studied painting with Shūbun and Sōtan. His sketch of Ikkyū, now in the Tōkyō National Museum, may have been done from life; if so, was one of the first such portraits in the history of Japanese painting. **Coll.:** Daitoku-ji (Shinju-an), Shūon-an, Tōkyō (1). **Bib.:** AAA 20; Awakawa; BK

113; HS 1; *Kunstschätze;* M 134, 262; Matsushita (1), (1a); *National* (1); NB (S) 13; NKZ 1; SBZ 7; YB 41.

¹墨斎 ²紹等 ³没倫 ⁴墨斎

Bokusai[1] (1765–1849). *N.:* Nagayama Kōin.[2] *A.:* Shiryō.[3] *Gō:* Bokusai,[4] Gorei,[5] Kōen.[6] **Biog.:** Shijō painter. Born in Akita; lived in Ōsaka. Pupil of Matsumura Goshun. Also a talented writer of *kyōka* and a Confucian scholar. Specialized in *kachōga*. **Coll.:** Ashmolean, Museum (3), Rhode Island, Victoria. **Bib.:** Hillier (4) 3, Mitchell, Morrison 2.

¹牧斎 ²長山孔寅 ³子亮（士亮） ⁴牧斎 ⁵五嶺 ⁶紅園

Bokusen[1] (1736–1824). *N.:* Maki Shin'ei (Nobumitsu).[2] *F.N.:* Suke-emon.[3] *Gō:* Bokusen,[4] Gekkōtei,[5] Hokusen,[6] Hokutei,[7] Hyakusai,[8] Tokōrō,[9] Utamasa.[10] **Biog.:** Ukiyo-e painter, printmaker. Lived in Nagoya; when Hokusai came there in 1812, lived with him and helped him in drawing the designs for the first volume of Hokusai's *Manga*. Later, made prints on his own from copperplates. Also a pupil of Kitagawa Utamaro; hence his *gō* Utamasa. **Coll.:** Ashmolean, Musées. **Bib.:** Binyon (3), Mitchell, *Nikuhitsu* (2).

¹墨僊 ²牧信盈 ³助右衛門 ⁴墨僊 ⁵月光亭 ⁶北僊 ⁷北亭 ⁸百斎 ⁹斗岡楼 ¹⁰歌政

Bokusen[1] (1835–81). *N.:* Yamaoka Tatsuyoshi.[2] *F.N.:* Kumahiko.[3] *Gō:* Bokusen.[4] **Biog.:** *Nanga* painter. Son of a samurai from Nagoya. Pupil of Suzuki Hyakunen. Did charming *kachōga* in quite a Chinese manner accompanied by fine calligraphy. **Bib.:** *Dessins.*

¹墨仙 ²山岡達義 ³熊彦 ⁴墨仙

Bokushō[1] (fl. late 15th c.). *N.:* Shūsei (Shūshō).[2] *A.:* Isan.[3] *Gō:* Bokushō.[4] **Biog.:** Muromachi *suiboku* painter. Zen priest. Came from Suō Province; lived in Kyōto at the Shōkoku-ji and the Nanzen-ji and (perhaps) later in Kyūshū, where he may have been head priest at a temple. An admirer of Mu-ch'i; an associate of Sesshū, with whose painting his has something in common. A talented artist. **Coll.:** Shōkoku-ji (Jishō-in). **Bib.:** GNB 11; K 385, 618; Matsushita (1a); *Muromachi* (1); NKZ 5.

¹牧松 ²周省 ³惟参 ⁴牧松

Bompō[1] (c. 1348–c. 1420). *Priest name:* Bompō.[2] *Gō:* Chisoku-ken,[3] Gyokukei;[4] later, Gyokuen,[5] Shōrin.[6] **Biog.:** Muromachi *suiboku* painter. Also a Zen priest, a poet, a calligrapher. Went to Kamakura to study under priest Gidō Shūshin; became head priest of the Tōshō-ji, Kamakura, devoting himself to Chinese poetry and using *gō* of Gyokuen for his painting. Became the religious successor to Zen monk Shun'oku Myōha (1311–88) at the Kennin-ji, Kyōto; from 1413 to 1420 was abbot at the Nanzen-ji, Kyōto, where he taught religious theory to the Ashikaga shogun Yoshimochi. Later, lived in retirement at Ōmi. His painting teacher is not known; probably saw the works of the famous Chinese painter of orchids P'u-ming, but never went to China. Highly esteemed by his contemporaries. Specialized in rocks and orchids. **Coll.:** Freer, Fujita, Ōkura, Rokuō-in, Tōkyō (1). **Bib.:** ACASA 16; *Art* (1a); BCM 50; BK 15; Fontein (1), (2); *Freer;* GNB 11; HS 3; K 49, 384, 515, 634, 690, 768, 955; KO 14; M 195; Matsushita (1); NB (S) 13, 69; Shimada 1; Tanaka (2); Yashiro (1).

¹梵芳 ²梵芳 ³知足軒 ⁴玉桂 ⁵玉畹 ⁶少林

Bōsai (Hōsai)[1] (1752–1826). *N.:* Kameda Chōkō.[2] *A.:* Kōryū,[3] Sairyū.[4] *F.N.:* Bunzaemon.[5] *Gō:* Bōsai (Hōsai),[6] Zenshindō.[7] **Biog.:** Painter, printmaker. Also an author. Born and lived in Edo. His painting, which he pursued as a hobby, was much influenced by Yüan art; better known as a Confucian scholar and a writer than as an artist. **Coll.:** British. **Bib.:** Brown, *Dessins,* Holloway, K 441, Mitchell, Strange (2).

¹鵬斎 ²亀田長與 ³公龍 ⁴穉龍 ⁵文左衛門 ⁶鵬斎 ⁷善身堂

Buhei[1] (1799–1870). *N.:* Buhei.[2] *Studio name:* Kashiwaya Buhei.[3] *Go:* Mokuhaku.[4] **Biog.:** Potter. Born in Nara, son of a shopkeeper. Learned the technique of Kyō-yaki (typi-

fied by Nonomura Ninsei); eventually became outstanding potter of Akahada-yaki (made at Akahada, Kōriyama, Nara-ken). Produced excellent copies of the fine tea bowls made by the famous potters of earlier generations as well as replicas of Ninsei's well-known pieces. A versatile artist, also made tea bowls and water jars decorated with figures made in a naive style as well as producing quantities of porcelain statuettes. **Bib.:** Munsterberg (2).

¹武兵衛 ²武兵衛 ³柏屋武兵衛 ⁴木白

Buichi[1] (fl. mid-19th c.). *N.:* Kita Buichi.[2] *Gō:* Tansai.[3] **Biog.:** *Nanga* painter. Born in Edo. Son and pupil of Kita Busei. It is said his best paintings were done when he was drunk. **Bib.:** Mitchell.

¹武一 ²喜多武一 ³探斎

Bummei[1] (?–1813). *N.:* Oku Teishō (Sadaaki).[2] *A.:* Hakki.[3] *F.N.:* Junzō.[4] *Gō:* Bummei,[5] Rikuchinsai,[6] Seika.[7] **Biog.:** Maruyama painter. Lived in Kyōto. One of Ōkyo's ten famous pupils. A pleasant Maruyama-school painter, specializing in figures and *kachōga*. **Coll.:** Ashmolean, Victoria. **Bib.:** Brown, Hillier (4) 3, Mitchell, Morrison 2, Tajima (3) 2.

¹文鳴 ²奥貞章 ³伯煕 ⁴順蔵 ⁵文鳴 ⁶陸沈斎 ⁷栖霞

Bumpei[1] (fl. mid-19th c.). *N.:* Matsudaira Ken.[2] *Gō:* Bumpei.[3] **Biog.:** Kishi painter. Pupil of Kishi Ganku. Also a poet. A painter of landscapes, figures, dragons, and tigers. **Bib.:** Morrison 2.

¹文平 ²松平献 ³文平

Bumpō[1] (1779–1821). *N.:* Kawamura Ki.[2] *A.:* Shunsei.[3] *Gō:* Basei,[4] Bumpō,[5] Chikurikan,[6] Goyū,[7] Hakuryūdō,[8] Shuyōkan,[9] Yūmō.[10] **Biog.:** Kishi painter. Lived in Kyōto. Pupil of Kishi Ganku, following his rather independent style. Also a *haiku* poet, producing many *haiga*. Painted landscapes, figures, *kachōga;* produced highly original illustrated books, such as *Bumpō Gafu* and *Bumpō Sansui Gafu.* His style was much influenced by the Chinese school. **Coll.:** Ashmolean; British; Musées; Museum (1), (3); Royal (1); Rietberg; Stanford; Victoria. **Bib.:** Brown; Hillier (2), (4) 3; Holloway; *Kunst;* Mitchell; Morrison 2.

¹文鳳 ²河村亀 ³駿声 (俊声) ⁴馬声 ⁵文鳳 ⁶竹裏館 ⁷五遊 ⁸白変堂 ⁹首陽館 ¹⁰有毛

Bunchō[1] (fl. 1765–92). *N.:* Ippitsusai Seishi.[2] *F.N.:* Kishi Uemon.[3] *Gō:* Bunchō,[4] Hajintei,[5] Sōyōan.[6] **Biog.:** Ukiyo-e painter, printmaker. A samurai, in later life was persuaded by his samurai friends to abandon printmaking. Lived in Edo. First studied Kanō painting; later influenced by Harunobu. In 1770, collaborated with Katsukawa Shunshō to produce *Ehon Butai Ōgi,* an illustrated book in three volumes of half-length fan portraits of stage celebrities. His paintings are rare and are considered by some experts as better than his prints. A designer of *hoso-e* and *chūban* of actors and *bijin;* his actor prints are less violent and robust than those of Shunshō, but have somewhat the same depiction of individual facial characteristics. A rather individual, distinguished artist far better known as a print designer than a painter. Great elegance of drawing, with delicate line and subtle color; the best of his female figures very graceful. A highly personal style with mannerist tendencies. **Coll.:** Albertina; Allen; Art (1), (1a); Ashmolean; Atami; British; Brooklyn; Cincinnati; Cleveland; Fine (California); Fitzwilliam; Fogg; Freer; Honolulu; Metropolitan; Minneapolis; Musée (2); Museum (1), (3); Nelson; Newark; Östasiatiska; Österreichisches; Portland; Rhode Island; Riccar; Rietberg; Staatliche; Tōkyō (1); Victoria; Waseda; Worcester; Yale. **Bib.:** Binyon (1), (3); BK 30; Ficke; Fujikake (3) 2; GNB 17; Hillier (4) 1, (7); *Japanese* (1a); *Japanische* (2); K 242, 836; Kikuchi; *Kunst;* Lane; Ledoux (1); Michener (1), (3); Morrison 2; Narazaki (2); NBZ 5; NHBZ 3; *Nikuhitsu* (1) 2; Noguchi (1); SBZ 10; Schmidt; Shibui (1);

Stern (2); Takahashi (2), (6) 6; UG 1, 17, 28; *Ukiyo-e* (3) 7; Vignier 3; Waterhouse.

¹文調 ²一筆斎誠之 ³岸右衛門 ⁴文調 ⁵巴人亭 ⁶桑楊庵

Bunchō[1] (1763–1840). *N.:* Tani Masayasu;[2] later, Tani Bunchō.[3] *A.:* Shihō.[4] *F.N.:* Bungorō.[5] *Gō:* Bun'ami,[6] Gagakusai,[7] Ichijo,[8] Muni,[9] Shazanrō,[10] Shōsō.[11] **Biog.:** *Nanga* painter. Born to a samurai family in Edo; his father, Tani Rokkoku, a well-known poet and a vassal of Lord Tayasu, second son of the eighth Tokugawa shogun. First studied Kanō painting with Katō Bunrei and Kitayama Kangan; then studied the *nanga* style under Watanabe Gentai and Kushiro Unsen; also studied all other types of painting currently practiced in Japan: Tosa, ukiyo-e, Western-style, and, under a Chinese painter in Nagasaki, the Chinese mode. A connoisseur of paintings; known as the author of *Honchō Gasan,* which contains reproductions of his copies of old Japanese paintings. Also wrote *Bunchō Gadan* (Treatise on Painting). In the end, known as a *nanga* artist, but his works are wildly eclectic. Famous also for his realistic portraits. One of the most important painters of his period, with a tremendous influence on his contemporaries. **Coll.:** Allen; Ashmolean; British; Brooklyn; Cleveland; Fine (California); Fogg; Freer; Honkō-ji; Ishiyama-dera; Kōbe; Museum (1), (3); Nezu; Ōsaka (2); Rietberg; Seattle; Tōkyō (1), (2); University (2); Victoria; Worcester. **Bib.:** AA 14; BK 8, 16, 30, 47, 86; Brown; Cahill; GNB 18, 25; Grilli (1); Hillier (4) 3; K 61, 90, 92, 134, 152, 160, 220, 224, 232, 254, 261, 265, 273, 279, 322, 326, 395, 444, 457, 482, 498, 502, 506, 524, 560, 567, 644, 660, 662, 666, 682, 731, 805, 837, 856, 877, 930; KO 36; M 18, 187, 227; Minamoto (1); Mitchell; Moriya; Morrison 2; Murayama (2); NB (H) 23; NB (S) 4; NBT 5; NBZ 5; *Nihon* (3); NKZ 28, 64, 77; Noma (1) 2; OA 13; *One* (2); Paine (4); *Pictorial* (2) 2; SBZ 10; Shimada 2; Tajima (9) 1, 2; Tajima (12) 3, 6, 8, 15; Tajima (13) 7; UG 17; Umezawa (2); Yonezawa.

¹文晁 ²谷正安 ³谷文晁 ⁴子方 ⁵文五郎 ⁶文阿弥 ⁷画学斎 ⁸一恕 ⁹無二 ¹⁰写山楼 ¹¹蜒叟

Bunchō[1] (fl. c. 1764–1801). *N.:* Yanagi Bunchō.[2] *Gō:* Nanryūsai.[3] **Biog.:** Ukiyo-e printmaker, illustrator. Made actor prints and illustrations for books. First studied Kanō painting, then became a pupil of Ippitsusai Bunchō. **Bib.:** NHBZ 3.

¹文朝 ²柳文朝 ³南竜斎

Bunchū[1] (1823–76). *N.:* Tani Bunchū.[2] **Biog.:** *Nanga* painter. Grandson of Tani Bunchō, son of Tani Bunji. A minor artist. **Bib.:** Mitchell.

¹文中 ²谷文中

Bunga[1] (fl. mid-19th c.). *N.:* Yasoshima Kane.[2] *Gō:* Bunga.[3] **Biog.:** *Nanga* painter. She was a pupil of Tani Bunchō. **Bib.:** Mitchell.

¹文雅 ²八十島嘉根 ³文雅

Bunha[1] (1780–1845). *N.:* Hayashi Naoyuki.[2] *Gō:* Bunha,[3] Hōshū.[4] **Biog.:** Painter. Born in Ōsaka. Pupil of Nakai Rankō. Specialized in figures and *kachōga*.

¹文坡 ²林直之 ³文坡 ⁴方洲

Bun'ichi[1] (1787–1818). *N.:* Tani Bun'ichi.[2] *Gō:* Chisai.[3] **Biog.:** *Nanga* painter. Son of a doctor in Edo. Adopted by his father-in-law, Tani Bunchō, whose pupil he was. Painted landscapes and *kachōga*. His work shows some Maruyama influence. **Coll.:** Philadelphia. **Bib.:** Hillier (4) 3, K 98, Mitchell, Morrison 2.

¹文一 ²谷文一 ³痴斎

Bunji[1] (?–1850). *N.:* Tani Yoshinori.[2] *Gō:* Bunji,[3] Hyōsho.[4] **Biog.:** *Nanga* painter. Son and pupil of Tani Bunchō. A much less able artist than his father. **Bib.:** Mitchell, Morrison 2.

¹文二 ²谷義宣 ³文二 ⁴萍所

Bunkyō[1] (1767–1830). *N.:* Sakuragawa Jihinari.[2] *Gō:* Bunkyō,[3] Sakura Bunkyō.[4] **Biog.:** Ukiyo-e printmaker, illustra-

tor. Also an author, using the name of Sakuragawa Jihinari. Perhaps a potter as well. Said to have been a pupil of Hosoda Eishi. An illustrator of storybooks; designed only a few prints of *bijin* and a set of *Eight Views of Fukagawa*. **Coll.:** Honolulu, Victoria. **Bib.:** Binyon (3).

 [1]文橋 [2]桜川慈悲成 [3]文橋 [4]桜文橋
Bunrei[1] (1706–82). *N.:* Katō Taiyū.[2] *F.N.:* Orinosuke.[3] *Gō:* Bunrei,[4] Yosai.[5] **Biog.:** Kanō painter. Sixth son of Katō Yasutsune, a feudal lord of Iyo Province. Adopted by a Katō relative; was brought to Edo, where he entered the shogun's service. In 1753, resigned and studied painting. Specialized in portraits, but also painted landscapes and *kachōga*. An amateur artist of high quality; best known as the teacher of Tani Bunchō. **Coll.:** Metropolitan, Museum (3), Victoria. **Bib.:** Mitchell, Morrison 2.

 [1]文麗 [2]加藤泰郁 [3]織之助 [4]文麗 [5]豫斎
Bunrin[1] (1808–77). *N.:* Shiokawa Bunrin.[2] *A.:* Shion.[3] *F.N.:* Zusho.[4] *Gō:* Chikusai,[5] Kachikusai,[6] Kibutsuan,[7] Kibutsu Dōjin,[8] Kibutsu Koji,[9] Sensei,[10] Tōsai,[11] Unshō.[12] **Biog.:** Shijō painter. Lived in Kyōto. Pupil of Okamoto Toyohiko; also learned the *nanga* manner and something of Western painting. Specialized in landscapes. His painting, somewhat heavier and more Western than that of his contemporaries, set the style for painting in Kyōto in the early Meiji era. **Coll.:** Art (1), Ashmolean, Fogg, Freer, Imperial (1), Metropolitan, Museum (3), Tōkyō (1), Victoria. **Bib.:** AA 14, Asano, Fenollosa, K 75, Mitchell, Morrison 2, NB (S) 17, NBZ 6, Tajima (12) 15.

 [1]文麟 [2]塩川文麟 [3]子温 [4]図書
 [5]竹斎 [6]可竹斎 [7]木仏菴 [8]木仏道人
 [9]木仏居士 [10]泉聲 [11]答斎 [12]雲章
Bunrō[1] (fl. 1800–1810). **Biog.:** Ukiyo-e printmaker. Perhaps at first a pupil of Ippitsusai Bunchō; influenced by Utamaro. A minor artist of the Utamaro circle. **Coll.:** Allen, British, Honolulu, Musées, Östasiatiska, Tōkyō (1). **Bib.:** Binyon (1), Boller, Ficke.

 [1]文浪
Bunryūsai[1] (fl. c. 1675). *N.:* Kajikawa.[2] *Gō:* Bunryūsai.[3] **Biog.:** Lacquerer. Third-generation head of the Kajikawa school. Known to have worked for the shogunate about 1675. An outstanding craftsman, producing particularly fine *togidashi* work. Frequently used Kanō Tan'yū's designs. **Bib.:** Jahss.

 [1]文竜斎 [2]梶川 [3]文竜斎
Bunryūsai[1] (fl. late 18th c.). *N.:* Torii Bunryūsai.[2] **Biog.:** Ukiyo-e printmaker. A minor figure, known only as the teacher of Hosoda Eishi.

 [1]文竜斎 [2]鳥居文竜斎
Bunryūsai[1] (fl. c. 1820). *N.:* Kajikawa.[2] *Gō:* Bunryūdō,[3] Bunryūsai.[4] **Biog.:** Lacquerer. A well-known artist of the later Kajikawa school. **Coll.:** Museum (3), Victoria. **Bib.:** Herberts, Jahss.

 [1]文竜斎 [2]梶川 [3]文竜堂 [4]文竜斎
Bunsai[1] (fl. 19th c.). *N.:* Koma Bunsai.[2] **Biog.:** Lacquerer. Second son of Koma Kansai I. Studied painting under Tani Bunchō. Famous for his black lacquer, both carved and plain. Also produced imitations of cloisonné in lacquer. **Coll.:** Walters. **Bib.:** Boyer, Herberts, Jahss.

 [1]文斎 [2]古満文斎
Bunsai[1] (fl. mid-19th c.). *N.:* Yabe Bufuku.[2] *A.:* Sadakuni.[3] *Gō:* Bunsai.[4] **Biog.:** *Nanga* painter. Pupil of Tani Bunchō. A minor artist. **Bib.:** Mitchell.

 [1]文斎 [2]矢部武服 [3]定国 [4]文斎
Bunsei[1] (fl. mid-15th c.). **Biog.:** Muromachi *suiboku* painter. His biography not clear; a tradition says that he lived at the Daitoku-ji, Kyōto. From the late 17th century, was confused with Josetsu,[2] who had a seal reading "Bunsei." His name was rescued from oblivion about forty years ago by the Japanese art historian Fukui Rikichirō. Only about half a dozen paintings bearing his seal are generally ac-

cepted as being by him; one of these is a portrait of the abbot of the Daitoku-ji and is dated 1452. One of the distinguished painters of early Muromachi *suiboku* school, doing Zen portraits and landscapes in a style close to that of Tenshō Shūbun. **Coll.:** Daitoku-ji, Museum (3), Yamato. **Bib.:** BK 77, 102; *Exhibition* (1); GNB 11; K 144, 388, 668; Lee (3); M 222, 252; Matsushita (1), (1a); Mayuyama; NB (S) 13; NBZ 3; NKZ 2; Paine (3), (4); Rosenfield (2); *Selected;* SBZ 7; Shimada 1; Tanaka (2); Watanabe; YB 32.

 [1]文清 [2]如拙
Bunsen[1] (fl. c. 1530). *N.:* Yanagihara.[2] *Priest name:* Sonshun.[3] *Gō:* Bunsen.[4] **Biog.:** Muromachi *suiboku* painter. Studied under Kanō Motonobu. Lived at the Hōon-in, Bodai-san-ji, Yamato Province. Became a famous priest-painter, producing fine pictures of dragons, tigers, plum blossoms, and bamboo, as well as portraits of Daruma. **Coll.:** Museum (3). **Bib.:** HS 3, Matsushita (1a).

 [1]文筌 [2]柳原 [3]尊俊 [4]文筌
Bunshin[1] (fl. c. 1850). *N.:* Kojima Bunshin.[2] **Biog.:** *Nanga* painter. Native of Edo. Pupil of Tani Bunchō. **Bib.:** Morrison 2.

 [1]文信 [2]小島文信
Bunsui[1] (?–c. 1890). *N.:* Sakakibara Nagatoshi.[2] *Gō:* Bunsui.[3] **Biog.:** *Nanga* painter. Born in Kyōto. Taught at the Tōkyō School of Fine Arts. Painted in manner of Tani Bunchō. **Coll.:** Tōkyō (1).

 [1]文翠 [2]榊原長敏 [3]文翠
Buntai[1] (?–1867). *N.:* Tōzaka Masao.[2] *F.N.:* Matsujirō.[3] *Gō:* Buntai.[4] **Biog.:** *Nanga* painter. Pupil of his grandfather, Tōzaka Bun'yō. Lived and worked in Edo. **Bib.:** Mitchell.

 [1]文岱 [2]遠坂正雄 [3]松次郎 [4]文岱
Bun'yō[1] (1783–1852). *N.:* Tōzaka Chikao.[2] *A.:* Yoshio.[3] *F.N.:* Shōji.[4] *Gō:* Bun'yō,[5] Jūyūen,[6] Setsudō,[7] Suiboku Zenro.[8] **Biog.:** *Nanga* painter. Lived in Edo. Samurai in the service of a local daimyo. Pupil of Tani Bunchō. Painter of figures and *kachōga*. Among the better known of Bunchō's pupils. Also a skillful artist in *yamato-e* style, as well as competent in Chinese manner of painting. **Coll.:** Museum (3). **Bib.:** Mitchell, Morrison 2.

 [1]文雍 [2]遠坂親夫 [3]穆夫 [4]庄司 [5]文雍
 [6]十友園 [7]雪堂 [8]水墨禅盧
Bun'yū (Fumitomo)[1] (1823–1900). *N.:* Kokubu Sadatane.[2] *A.:* Chūji.[3] *F.N.:* Tomitarō.[4] *Gō:* Bun'yū (Fumitomo),[5] Sanshū,[6] Sōshō,[7] Suiboku,[8] Unri.[9] **Biog.:** Shijō painter. Born in Kyōto. Pupil of Matsumura Keibun. Active in government affairs at the time of the Meiji Restoration. A painter of landscapes and *kachōga*. **Coll.:** Victoria.

 [1]文友 [2]国分定胤 [3]中二 [4]富太郎
 [5]文友 [6]三洲 [7]雙松 [8]水牧 [9]雲裡
Busei[1] (1776–1856). *N.:* Kita Busei.[2] *A.:* Shishin.[3] *Gō:* Gosei-dō,[4] Kaan,[5] Kakuō.[6] **Biog.:** *Nanga* painter. Lived in Edo; pupil of Tani Bunchō. Particularly appreciated old Chinese and Japanese paintings, of which he made many copies. Though by training a *nanga* artist, also painted in the Kanō style, much influenced by Kanō Tan'yū. **Coll.:** Ashmolean, Museum (3), Newark, Victoria. **Bib.:** BK 34, Brown, Mitchell, Morrison 2.

 [1]武清 [2]喜多武清 [3]子慎 [4]五清堂 [5]可庵 [6]鶴翁
Buson[1] (1716–83). *N.:* Yosa (originally Taniguchi)[2] Nobuaki.[3] *A.:* Shinshō.[4] *Gō:* Busei,[5] Buson,[6] Chōko,[7] Chōkyo,[8] Chōsō,[9] Gasendō,[10] Hajin,[11] Hakuundō,[12] Hekiundō,[13] Rakujitsuan,[14] Saichō,[15] Sanka,[16] Sansōdō,[17] Sha Shunsei,[18] Shain[19] (used only late in life), Shikoan,[20] Shimei,[21] Shunsei,[22] Tōsei Saichō,[23] Undō,[24] Unsai,[25] Yahan'o,[26] Yahantei.[27] **Biog.:** *Nanga* painter. Also a poet, is now as well known for his poetry as for his painting, but in his lifetime made his living as a painter. Born in Settsu, his father probably a rich farmer. At 22 went to Edo; studied *haiku* under Hayano Hajin. After Hajin's death in 1742, led a vagabond life until

he settled in the small village of Yosa in 1754, where he stayed until 1757 and from which he took his name. During this period, probably became acquainted with the painting of Shen Nan-p'in and other original Chinese paintings; also influenced by Hanabusa Itchō. Then mostly in Kyōto, becoming a fully mature artist and recognized with Ōkyo as one of the two leading Kyōto painters. As a poet, ranks next to Bashō; produced many *haiga*, and all his paintings have a literary content. A sympathetic painter, representing the *nanga* ideal in being both poet and painter. With Taiga, brought *nanga* school to its full development. Above all, a good landscape painter. Less humorous than Taiga but yet gay and witty, frequently allowing touches of caricature to creep into his work. **Coll.:** Baltimore; Cleveland; Fine (M. H. De Young); Fogg; Freer; Homma; Honolulu; Itsuō; Kyōto (2); Museum (2), (3); Seattle; Tōkyō (1); Umezawa; University (2); Victoria; Worcester; Yamagata, **Bib.:** Akiyama (5); *Art* (1a); BK 15, 49, 111, 170; Brown; *Bunjinga; Buson;* Cahill; *Cent-cinquante;* Covell (1); Fontein (1); *Freer;* GNB 18; Grilli (1); Holloway; *Japanische* (2); K 47, 87, 96, 119, 120, 148, 234, 240, 247, 271, 298, 344, 378, 388, 404, 451, 471, 477, 489, 492, 505, 537, 547, 549, 559, 566, 574, 590, 600, 612, 629, 649, 656, 706, 718, 725, 726, 764, 771, 812, 813, 818, 836, 841, 856, 869, 870, 888, 890, 892, 931;

KO 4, 14, 19, 28, 37; *Kokuhō* 6; Lee (1); M 72, 78, 93, 148, 175, 231; Mayuyama; Mitchell; Mizuo; Moriya; Morrison 2; Murase; Murayama (2); NB (H) 23; NB (S) 4; NBT 5; NBZ 5; *Nihon* (4), (5); NKZ 68, 73; Noma (1) 2; *One* (2); Paine (2) 2; Rosenfield (2); SBZ 10; *Shijō-ha;* Shimada 2; Suzuki (6); Tajima (9) 1; Taijima (12) 5, 10, 17, 19, 20; Tajima (13) 7; Umezawa (2); Watson (2); Yonezawa.

[1]蕪村 [2]谷口 [3]与謝信章 [4]信章 [5]蕪菁 [6]蕪村 [7]長康 [8]趙居 [9]朝滄 [10]雅仙堂 [11]巴人 [12]白雲堂 [13]碧雲洞 [14]落日庵 [15]宰鳥 [16]三果 [17]三草堂 [18]謝春星 [19]謝寅 [20]紫弧庵 [21]四明 [22]春星 [23]東成宰鳥 [24]雲堂 [25]雲斎 [26]夜半翁 [27]夜半亭

Buzen[1] (1734–1806). *N.:* Sumie (originally Osada Dōkan)[2] Michihiro.[3] *A.:* Shizen.[4] *F.N.:* Sozō.[5] *Gō:* Buzen,[6] Dōkan,[7] Mōrōsai,[8] Shingetsu,[9] Shinrōsai,[10] Sumiesai.[11] **Biog.:** Painter. Born in Ōsaka. At first a sailor; then, liking the arts, studied sculpture and painting, the latter with Tsukioka Settei. Also studied the landscapes of Ikeno Taiga. A bon vivant and a writer of Chinese verse. Died poor. An original painter, outside all schools. **Coll.:** Musée (2), Museum (3). **Bib.:** AA 14, Mitchell, Morrison 2, *Nikuhitsu* (1) 2.

[1]武禅 [2]長田道観 [3]墨江道寛 [4]子全 [5]荘蔵 [6]武禅 [7]道寛 [8]朦朧斎 [9]心月 [10]心朧斎 [11]墨江斎

C

Charakusai[1] (fl. 1804–18). *Gō:* Charakusai,[2] Seikoku.[3] **Biog.:** Ukiyo-e printmaker. Worked in Kyōto; a minor member of the Kamigata school. Specialized in *ōkubi-e* of actors, using the technique of *kappa-suri* and working in an exaggerated manner. **Bib.:** NHBZ 3.

[1]茶楽斎 [2]茶楽斎 [3]清谷

Chiden[1] (fl. late 15th to early 16th c.). *Studio name:* Tan'an.[2] *Gō:* Chiden.[3] **Biog.:** Muromachi *suiboku* painter. Little known of his life: may have been a priest at the Shōkoku-ji, Kyōto. Apparently died young, which would account for the scarcity of his known works. According to Tōhaku's *Tōhaku Gasetsu,* he was the son of an artisan, trained by his father in decorative handicrafts, invited by Sōami to be his pupil. Also supposed to have studied styles of Mu-ch'i and Yü Chien. Specialized in *kachōga,* painting with a brilliant brush technique. **Coll.:** Daitoku-ji, Jihō-ji, Museum (3), Tōkyō (1). **Bib.:** *Au-delà;* BK 16; Fontein (2), (3); GNB 11; Hisamatsu; HS 4, 5, 7; K 42, 662, 713; KO 35; M 38; Matsushita (1a); Mayuyama; *Muromachi* (1); NB (S) 13; P 2; Shimada 1.

[1]智傳 [2]単庵 [3]智傳

Chigusa Saemondaibu[1] (fl. early 15th c.). **Biog.:** Sculptor. A carver of Nō masks. His name appears as the artist in the inscription on a Nō mask belonging to the Narazuhiko-jinja, Nara, along with the date 1413. **Coll.:** Narazuhiko-jinja. **Bib.:** *Muromachi* (1).

[1]千草左衛門大夫

Chiharu[1] (1777–1859). *N.:* Takashima Chiharu.[2] *Gō:* Teiko,[3] Yūsai.[4] **Biog.:** Tōsa painter. Lived first in Ōsaka, moving later to Edo. Well versed in ancient court practices and ceremonies. **Coll.:** Fitzwilliam, Victoria.

[1]千春 [2]高島千春 [3]鼎湖 [4]融斎

Chijun[1] (fl. 12th c.). **Biog.:** Buddhist painter. Received title of *hōgen* in 1143, *hōin* in 1154. According to literary records, is said to have painted a *mandara* in 1149 and to have done pillar paintings for the Kongō-in at Toba as well as a *Shaka.*

[1]智順

Chikaharu[1] (fl. second half 19th c.). *N.:* Hasegawa Takejirō.[2] *Gō:* Chikaharu,[3] Kaiōsai,[4] Keishū.[5] **Biog.:** Ukiyo-e printmaker. Pupil of Toyohara Kunichika; sometimes called himself Toyohara[6] after his master. Designed actor prints.

Generally considered a member of the Yokohama school. **Bib.:** *Nikuhitsu* (2); Nonogami.

[1]周春 [2]長谷川竹次郎 [3]周春 [4]魁鶯斎 [5]恵洲 [6]豊原

Chikanobu (Shūshin)[1] (1660–1728). *N.:* Kanō Chikanobu (Shūshin).[2] *F.N.:* Ukon.[3] *Gō:* Josen,[4] Taigūsai.[5] **Biog.:** Kanō painter. Born in Musashi Province. Eldest son of Kanō Tsunenobu, elder brother of Kanō Minenobu; his mother a daughter of Kanō Yasunobu. In 1678, entered the service of the shogunate. In 1681, worked with his father at Edo Castle. In 1713, succeeded his father as third-generation head of the Kobikichō branch of the Kanō school. In 1719, received honorary title of *hōgen;* in the same year, on command of the shogun, painted a *byōbu* to be given to a Korean emissary. Is said to have painted another screen presented to the king of the Ryūkyū Islands. One of his pupils was Toriyama Sekien, teacher of Kitagawa Utamaro. **Coll.:** Metropolitan, Museum (3), Tōkyō (1). **Bib.:** *Kanō-ha,* Morrison 1, *Rakuchū.*

[1]周信 [2]狩野周信 [3]右近 [4]如川 [5]泰寓斎

Chikanobu[1] (fl. 1716–35). *N.:* Matsuno Chikanobu.[2] *Gō:* Hakushōken.[3] **Biog.:** Ukiyo-e painter. Whether he is an independent artist or this name is a pseudonym for a still unidentified ukiyo-e painter is not yet certain; he is, however, the best painter among those who worked in the Kaigetsudō style but did not identify themselves with that school. **Coll.:** Seattle. **Bib.:** Fuller; *Japanese* (2); K 42; M 18; Morrison 2; *Nikuhitsu* (1) 1, (2); Shimada 3; Takahashi (3); *Ukiyo-e* (3) 3.

[1]親信 [2]松野親信 [3]伯照軒 (柏笑軒)

Chikanobu[1] (fl. early 19th c.). *N.:* Kitagawa Chikanobu.[2] **Biog.:** Ukiyo-e printmaker. Pupil of Utamaro. Specialized in prints of *bijin* but also produced some prints of the Dutch at Deshima. **Coll.:** Tōkyō (1). **Bib.:** NHBZ 4.

[1]千歌信 (千歌述) [2]喜多川千歌信 (千歌述)

Chikashige[1] (fl. second half 19th c.). *N.:* Morikawa Chikashige[2] (originally Otojirō).[3] *Gō:* Ichibaisai,[4] Kichōsai.[5] **Biog.:** Ukiyo-e printmaker. Pupil of Toyohara Kunichika. Specialized in actor prints. **Coll.:** Musées, Victoria.

[1]周重 [2]守川周重 [3]音次郎 [4]一梅斉 [5]喜蝶斎

Chikkei (Chikukei)[1] (fl. c. 1835). *N.:* Kikugawa Chikkei (Chikukei).[2] **Biog.:** Painter. Lived in Ōsaka. A minor artist.

Pupil of Nakai Rankō. **Coll.**: Philadelphia. **Bib.**: Keyes, Mitchell.

¹竹溪　²菊川竹溪

Chikkei (Chikukei)[1] (1816–67). *N.*: Nakabayashi Seigyō (Narishige).[2] *A.*: Shōfu.[3] *F.N.*: Kingo.[4] *Gō*: Chikkei (Chikukei).[5] **Biog.**: *Nanga* painter. Elder son of Nakabayashi Chikutō. Pupil of his father and Yamamoto Baiitsu, from whom he learned the *nanga* style. Rather a good realistic painter of landscapes and figures. **Coll.**: Art (1a). **Bib.**: *Japanese* (1a); K 403, 465, 503, 510, 642, 721; KO 36; Mitchell; Tajima (12) 15.

¹竹溪　²中林成業　³緝夫　⁴金吾　⁵竹溪

Chikkoku (Chikukoku)[1] (1790–1843). *N.*: Yoda Kin.[2] *A.*: Shichō,[3] Shukunen.[4] *Gō*: Chikkoku (Chikukoku),[5] Eikasai,[6] Ryokansai,[7] Sankokuan.[8] **Biog.**: *Nanga* painter. Pupil of Tani Bunchō, teacher of Takahisa Ryūko. Painted landscapes and *kachōga*. **Coll.**: Museum (3), Victoria. **Bib.**: Mitchell.

¹竹谷　²依田瑾　³子長　⁴叔年　⁵竹谷
⁶盈科斎　⁷凌寒斎　⁸三谷庵

Chikuden[1] (1777–1835). *N.*: Tanomura Kōken[2] (or Ken).[3] *A.*: Kun'i.[4] *F.N.*: Kōzo.[5] *Gō*: Chikuden,[6] Hosetsuro,[7] Kachikuyūsō Shujin,[8] Kōtō Shijin,[9] Kyūjō Senshi,[10] Ransui Kyōkaku,[11] Setsugetsu Shodō.[12] **Biog.**: *Nanga* painter. Born in Takeda, Bungo Province. Second son of Hisada Nakagawa, physician to Lord of Oka. Trained as a doctor, but gave up practice at 23. Taught ethics and history at school controlled by Lord of Oka, becoming historian of Bungo Province. In 1813, resigned to devote himself to artistic pursuits. Studied painting under Watanabe Hōto in Bungo, poetry in Kyōto, and visited Tani Bunchō in Edo; but studied mainly by himself, including Chinese painting of Ming and Ch'ing periods. A large corpus of work. Never painted for sale; gave his work to friends. Poet, calligrapher; versed in tea ceremony, flower arrangement, incense identification; student of Zen. Friend of Rai San'yō and Aoki Mokubei. Wrote a book on painting: *Sanchūjin Jōzetsu.* Even though his work is uneven, he is in the first rank of *nanga* painters; in true *nanga* fashion he achieved a combination of poetry and painting. His rather conservative style is notable for its fine lines, light colors, calm and harmonious composition. **Coll.**: Ashmolean, Idemitsu, Museum (3), Nara, Neiraku, Staatliche. **Bib.**: BK 21; *Bunjinga;* Cahill; *Cent-cinquante;* Covell (1); Fontein (1); GNB 18; Hillier (4) 3; K 120, 147, 165, 222, 290, 327, 332, 342, 350, 357, 364, 393, 401, 412, 419, 433, 449, 457, 468, 475, 481, 490, 501, 506, 512, 516, 538, 570, 577, 623, 634, 640, 654, 680, 696, 697, 698, 699, 706, 709, 714, 725, 772, 781, 813, 828, 861, 879, 886, 895; KO 28; M 69, 92, 121, 175; Moriya; Morrison 2; Mitchell; Murayama (2); NB (H) 23; NB (S) 4; NBT 5; NBZ 5; *Nihon* (2), (3), (4), (5); NKZ 71, 80; Noma (1) 2; OA 13; *One* (2); SBZ 10; Schmidt; Suzuki (7); Tajima (9) 1; Tajima (12) 12, 14, 16, 18; Tajima (13) 7; TBS 7; Togari; Umezawa; Yonezawa.

¹竹田　²田能村孝憲　³憲　⁴君彝　⁵行蔵　⁶竹田
⁷補拙盧　⁸花竹幽窓主人　⁹紅荳詞人　¹⁰九畳仙史
¹¹藍水狂客　¹²雪月書堂

Chikudō[1] (?–1825). *N.*: Ki Nei.[2] *A.*: Seifu.[3] *Gō*: Chikudō.[4] **Biog.**: *Nanga* painter. Pupil of Murakami Tōshū. Although he was famous in his day, little is known of his life. The *Chikudō Gafu* is one of the loveliest *nanga* albums of color prints. Skilled painter of landscapes and figures. **Coll.**: Ashmolean. **Bib.**: Brown, Holloway, Mitchell, OA 13, Toda (1).

¹竹堂　²紀寧　³清夫　⁴竹堂

Chikudō[1] (1826–97). *N.*: Kishi Shōroku.[2] *A.*: Shiwa.[3] *F.N.*: Hachirō.[4] *Gō*: Chikudō.[5] **Biog.**: Japanese-style painter. Son of a retainer of the daimyo of Hikone. Lived in Kyōto. Studied first under Kanō Eigaku, then with Kishi Renzan,

who adopted him as his son. In 1896, appointed to the Art Committee of the Imperial Household. Specialized in landscapes and animals, particularly tigers. His style, based on that of Ōkyo, comes close to the Shijō manner, but with modern touches and considerable traces of Western realism. A competent artist. Much admired by the Japanese. **Coll.**: Ashmolean, Museum (3), Tōkyō (1). **Bib.**: Asano; Brown Elisséèv; K 115, 688, 707; Mitchell; Morrison 2; NBZ 6; NB (S) 17; SBZ 11; Uyeno.

¹竹堂　²岸昌禄　³子和　⁴八郎　⁵竹堂

Chikuha[1] (1799–1843). *N.*: Nishi Hakuju.[2] *A.*: Saikyō.[3] *F.N.*: Kan'emon.[4] *Gō*: Chikuha.[5] **Biog.**: Painter. Lived and worked in Ōsaka. Of little importance. **Bib.**: Mitchell.

¹竹坡　²西白受　³彩郷　⁴勘右衛門　⁵竹坡

Chikuitsu[1] (1814–86). *N.*: Inoue Reitoku.[2] *F.N.*: Genzō,[3] Suezō.[4] *Gō*: Chikuitsu.[5] **Biog.**: Son of a samurai who was a minor vassal of the shogunate in Edo. Went to Nagasaki to learn gunnery, but shifted to study of painting. Pupil of Watanabe Kazan. Good at *kachōga* and landscapes.

¹竹逸　²井上令徳　³玄蔵　⁴季蔵　⁵竹逸

Chikuō[1] (fl. mid–17th c.). *N.*: Katsuta Teikan[2] (or Sadanori).[3] *A.*: Shisoku.[4] *F.N.*: Inosuke,[5] Okinojō.[6] *Gō*: Chikuō,[7] Shūyūsai,[8] Suichikuan,[9] Tōhin,[10] Yōkei.[11] **Biog.**: Kanō painter. Lived in Edo. Studied under Kanō Naganobu. In 1630 became *goyō eshi* to the *bakufu*. A pleasant style, of no great originality. **Coll.**: Museum (3). **Bib.**: K 144, 630, 634, 685, 924.

¹竹翁　²勝田貞寛　³定則　⁴士則　⁵伊之助　⁶沖之丞
⁷竹翁　⁸秋友斎　⁹翠竹庵　¹⁰東浜　¹¹陽渓

Chikusa[1] (1774–1844). *N.*: Igarashi Shuzen.[2] *A.*: Kyohō.[3] *Gō*: Chikusa,[4] Seisho,[5] Tatsusai.[6] **Biog.**: *Nanga* painter. Son and pupil of Igarashi Gensei; also studied under other well-known artists. A good painter of *suiboku* landscapes; considered a better artist than his father. **Bib.**: Mitchell.

¹竹沙　²五十嵐主膳　³巨寶　⁴竹沙　⁵静所　⁶達斎

Chikuseki[1] (1747–1806). *N.*: Nagamachi Ki.[2] *A.*: Kin'ō.[3] *Gō*: Chikuseki,[4] Kinken.[5] **Biog.**: *Nanga* painter. Born in Sanuki Province. Pupil of Tatebe Ryōtai. Then studied the manner of Shen Nan-p'in and, in Ōsaka, under the tutelage of Kimura Kenkadō, examined old Chinese paintings. Toward end of his life, in Edo, wrote poetry. With Kaiseki and Sō Aiseki, one of three famous *seki* painters. His style combines *nanga* elements with considerable realism. **Coll.**: Cincinnati. **Bib.**: K 771, 960; Mitchell.

¹竹石　²長町徹　³琴翁　⁴竹石　⁵琴軒

Chikusō[1] (1763–1830). *N.*: Morikawa Seikō.[2] *A.*: Rikichi.[3] *Gō*: Chikusō,[4] Ryōō.[5] **Biog.**: Painter. Lived in Ōsaka. Specialized in painting bamboo, working in the *nanga* manner. **Coll.**: Ashmolean. **Bib.**: Hillier (4) 3, Mitchell.

¹竹窓　²森川世黄　³離吉　⁴竹窓　⁵良翁

Chikutō (Chikudō)[1] (1776–1853). *N.*: Nakabayashi Nariaki (Narimasa, Seishō).[2] *A.*: Hakumei.[3] *F.N.*: Daisuke.[4] *Gō*: Chikutō (Chikudō),[5] Chūtan,[6] Taigen'an,[7] Tōzan Inshi.[8] **Biog.**: *Nanga* painter. Born in Nagoya; son of a doctor. Protégé of Kamiya Ten'yū, a wealthy collector of Chinese paintings in Nagoya. At 20 established his own studio, living frugally in a small temple. Interested in classical literature; moved to Kyōto in 1803 with Yamamoto Baiitsu to join Rai San'yō's circle. Studied painting under Yamada Kyūjō; collaborated with Uragami Shunkin. As author of many Chinese-style treatises on painting, is regarded as the theorist of the *nanga* school. Also well known for his many illustrated books, particularly the *Chikutō Gafu* of 1800 and 1815. Painter of *kachōga* and quiet, tranquil landscapes; brushwork inclined to be rather stiff and brittle. **Coll.**: Art (1), (1a); Ashmolean; British; Center; Freer; Seattle; Victoria. **Bib.**: BK 38, 48; Brown; Cahill; *Cent-cinquante;* GNB 18; *Japanese* (1a); K 88, 134, 275, 279, 347, 389, 417, 425, 469, 504, 552, 767, 889; *Kunst;* M 266; Mitchell; Morrison 2; Murayama (2); NB (H) 23; NB (S) 4; *Nihon*

(3); OA 13; *One* (2); Rosenfield (2); Shimada 2; Tajima (9) 2, (13) 7; Umezawa (2); Yonezawa.

¹竹洞 ²中林成昌 ³伯明 ⁴大助 ⁵竹洞
⁶冲澹 ⁷太原庵 ⁸東山隠士

Chikuun¹ (fl. c. 1680). *N.:* Kanō Motohide.² *Gō:* Chikuun.³ **Biog.:** Kanō painter. Served Lord Matsudaira of Fukui.

¹竹雲 ²狩野元英 ³竹雲

Chikuun¹ (1820–88). *N.:* Yamamoto Chikuun.² **Biog.:** *Nanga* painter. Also a carver of seals. His name and work were quite forgotten until recently. **Bib.:** K 765, Umezawa (2).

¹竹雲 ²山本竹雲

Chikuyō¹ (fl. early 16th c.). **Biog.:** Muromachi *suiboku* painter. Perhaps a Zen priest, but details of his life and even his family name are unknown. Used a seal which can be read "Gekka." Produced many black-and-white drawings and some paintings. **Bib.:** BK 63, K 565, Matsushita (1a).

¹筑陽

Chikyoku¹ (1824–78). *N.:* Koike Shisetsu.² *Gō:* Chikyoku.³ **Biog.:** *Nanga* painter. Born in Noto Province, she went to Edo to study painting. Served the daimyo of Aizu during the time of the wars preceding the Meiji Restoration; when the clan was defeated, she was saved by saying she was a painter. After the Restoration, traveled all over Japan. A good *nanga* artist.

¹池旭 ²小池紫雪 ³池旭

Chin Jukan¹ (1835–1906). **Biog.:** Satsuma potter. In 1874 moved the last of the Satsuma kilns from Kagoshima to Naeshirogawa. Active in improving the quality of the ware and in promoting overseas trade. A well-known member of the Satsuma school. **Coll.:** Tōkyō (1). **Bib.:** NB (S) 41, NBZ 6, Uyeno.

¹沈寿官

Chinchō (Chinjū)¹ (1679–1754). *N.:* Torii (originally Manaka)² Motonobu (Okinobu).³ *F.N.:* Ōta Bengorō.⁴ *Gō:* Chinchō,⁵ Chūshin,⁶ Ejōsai,⁷ Hanegawa.⁸ **Biog.:** Ukiyo-e painter, printmaker. Son of a samurai. Born in Kawaguchi; lived in Edo. Pupil of Torii Kiyonobu; influenced by Okumura Masanobu. Made prints only when the spirit or necessity moved him. His work is quite rare but of much distinction. **Coll.:** Art (1), Tōkyō (1). **Bib.:** AAA 21, Binyon (3), Ficke, Gunsaulus (1), Hillier (7), Kikuchi, Kurth (4), Lane, Morrison 2, NHBZ 2.

¹珍重 ²真中 ³鳥居元信 (信信) ⁴太田弁五郎
⁵珍重 ⁶冲信 ⁷絵情斎 ⁸羽川

Chin'ei¹ (fl. mid to late 18th c.). **Biog.:** Lacquerer. Worked in Nagasaki. Used the *chinkin-bori* technique for the decoration of his *inrō*. **Bib.:** Herberts, Jahss.

¹珍栄

Chingaku¹ (1822–88). *N.:* Awashima (originally Kobayashi)² Ujihei.³ *F.N.:* Jōzō.⁴ *Gō:* Chingaku,⁵ Nampeidō.⁶ **Biog.:** *Nanga* painter. Worked in Edo. Pupil of Ōnishi Chinnen. Became a priest, using the name Kitsubon.⁷ Interested in depicting the manners and customs of foreigners in Japan during the early Meiji era. **Coll.:** Victoria. **Bib.:** Mitchell.

¹椿岳 ²小林 ³淡島氏平 ⁴城三
⁵椿岳 ⁶南平堂 ⁷吉梵

Chingyū¹ (1743–1822). *Priest name:* Zuikō.² *Gō:* Chingyū.³ **Biog.:** Zen painter. Born in Higo Province. At 14 left home to begin his religious career. Is known to have lived at the Zenkyū-in in Matsumoto, the Ryūtai-ji in Mino, the Mammatsu-ji in Edo and, for a time, in Nagasaki studying painting under Shen Nan-p'in. Also a poet. Painted Zen subjects in a characteristically rough style. **Bib.:** NB (S) 47.

¹珍牛 ²瑞岡 ³珍牛

Chinkai¹ (1091–1152). *N.:* Fujiwara no Chinkai.² **Biog.:** Painter. Born in Kyōto. An important theologian, calligrapher, and painter of Buddhist subjects. Served as priest in the Zenrin-ji, Yamashiro; later became chief of instruction at the Daigo-ji, Kyōto. Made iconographic drawings and paintings, especially of *mandara* (the Princeton Museum of

Art owns an iconographic drawing of Monju copied in 1202 after a work by Chinkai); also repaired older paintings (*Sakyamuni Preaching on the Vulture Peak,* in the Museum of Fine Arts, Boston, was partly restored by him in 1148). No original works by him are known to exist, but works attributed to him are in the Daigo-ji, Kōzan-ji, Tō-ji, and Kōdai-ji in Kyōto. **Coll.:** Daigo-ji, Kōdai-ji, Kōzan-ji (1), Tō-ji. **Bib.:** Rosenfield (1), (2).

¹珍海 ²藤原珍海

Chinkei¹ (fl. c. 1475). **Biog.:** Sculptor. Member of the Tsubai Bussho. His name is on two statues in the Jonen-ji, Kyōto, with dates of 1474 and 1476 respectively. **Coll.:** Jonen-ji. **Bib.:** *Muromachi* (2).

¹珍慶

Chinkei¹ (fl. 18th c.). **Biog.:** Lacquerer. Used the *chinkin-bori* technique to decorate his *inrō*. **Bib.:** Herberts, Jahss.

¹珍系

Chinnen¹ (1792–1851). *N.:* Ōnishi Chinnen.² *A.:* Taiju.³ *F.N.:* Yukinosuke.⁴ *Gō:* Kaō.⁵ Sonan,⁶ Unkadō.⁷ **Biog.:** Shijō painter. Lived in Edo. A samurai attached to the Tokugawa government, in charge of the rice granaries. Studied painting under Watanabe Nangaku and Tani Bunchō. Designer of many albums of colored woodcuts such as *Azuma no Teburi* (1829) and the superb *Sonan Gafu* (1834). A typical Shijō artist, his *kachōga*, figures, and landscapes show much facility and wit. **Coll.:** Ashmolean, Cleveland, Museum (3), Newark, Portland, Staatliche, Victoria. **Bib.:** Brown; Fontein (1); Hillier (2), (4) 3; Holloway; Morrison 2; Mitchell; Schmidt.

¹椿年 ²大西椿年 ³大寿 ⁴行之助
⁵霞翁 ⁶楚南 ⁷運菴堂

Chinzan¹ (1801–54). *N.:* Tsubaki Hitsu.² *A.:* Tokuho.³ *F.N.:* Chūta.⁴ *Gō:* Chinzan,⁵ Hekiin Sambō,⁶ Kyūan,⁷ Shikyūan,⁸ Takukadō.⁹ **Biog.:** *Nanga* painter. Born and lived in Edo. A samurai attached to the Tokugawa government. Studied first under Kaneko Kinryō, then under Tani Bunchō, and finally under Watanabe Kazan, whose best pupil he was. Became teacher of Shōka, Kazan's son, after Kazan's death. Painted portraits of his master and many other people. His paintings have traces of Western perspective, learned from Kazan, but his themes—usually flowers—are purely Japanese. **Coll.:** Honolulu; Ōkura; Stanford; Tōkyō (1), (2); University (2); Victoria. **Bib.:** BK 62, 65, 100; *Dessins;* GNB 18; K 108, 218, 283, 306, 315, 375, 398, 414, 499, 520, 525, 529, 534, 551, 558, 622, 633, 652, 690, 691, 695, 699, 706, 711, 718, 719, 723, 727, 733, 737, 754, 758, 760, 768, 786, 788, 819, 823; M 18, 61; Mitchell; Morrison 2; Murayama (2); NB (H) 23; NB (S) 4; NBT 5; NBZ 5; *Nihon* (3); *One* (2); Shimada 2; Tajima (9) 2; Tajima (12) 15, 16; Tajima (13) 7; Umezawa (2); Yonezawa.

¹椿山 ²椿弼 ³篤甫 ⁴忠太 ⁵椿山 ⁶碧蔭山房
⁷休庵 ⁸四休庵 ⁹琢華堂

Chisen¹ (?–1792). *N.:* Hayashi (originally Matsubayashi)² Gen.³ *A.:* Chisen.⁴ *Gō:* Chisen,⁵ Shōrin,⁶ Shōrin Sanjin.⁷ **Biog.:** Nagasaki painter. Born in Nagasaki. Traveled widely, staying at various times in Kyōto and Ōsaka; finally settled in Edo. Pupil of Kumashiro Yūhi. Painted *kachōga* in the style of Shen Nan-p'in. **Bib.:** Mitchell.

¹稚瞻 ²松林 ³林儼 ⁴稚瞻 ⁵稚瞻 ⁶松林 ⁷松林山人

Chishō¹ (814–91). *N.:* Wake Enchin.² *Priest name:* Chishō Daishi.³ **Biog.:** Painter. An eminent priest and probably a Buddhist painter living at Kōyasan. The famous *Red Fudō* belonging to the Myōō-in, Kōyasan, was for a long time ascribed to him, but the painting is now thought to be later than the span of his life. **Bib.:** *One* (2), Yashiro (1).

¹智證 ²和気円珍 ³智證大師

Chitei (Munesada)¹ (fl. second half 11th c.). *N.:* Hata no Chitei (Munesada).² **Biog.:** Painter. Lived in Settsu. Nothing known of his life, though the name Hata signifies Korean descent. According to the Hōryū-ji archives, in 1069 from

February to May did some wall paintings of the life of Shōtoku Taishi in the Edono of the Jōgū-in at the Hōryū-ji. (These were placed on screens in 1788 and are now in the Tōkyō National Museum.) Also mentioned as the artist who painted the statue of Shōtoku Taishi by Enkai (dated 1069, in the Hōryū-ji). His work in the Tōkyō National Museum, while still retaining some T'ang influence, yet shows the emergence of the *yamato-e* style, especially in the arrangements of the interior scene and in the placing and movement of the figures. **Coll.:** Hōryū-ji, Tōkyō (1). **Bib.:** Akiyama (1), Fontein (1), K 415, *National* (1), NB (H) 10.

¹致貞 ²秦致貞

Chiyo¹ (1703–75). *Nun's name:* Chiyo.² *Gō:* Soen.³ **Biog.:** Painter. Born near Kanazawa. In painting, perhaps a pupil of Sakaki Hyakusen; studied *haiku* under Kitakataya Hansui. Became a nun in 1754. Well known as a writer of *haiku* and as an occasional painter of *haiga*. **Bib.:** Rosenfield (1a).

¹千代 ²千代 ³素園

Chōan (Nagayasu)¹ (1569–1610). *N.:* Kōami Kyūjirō.² *Gō:* Chōan (Nagayasu).³ **Biog.:** Kōami lacquerer. Son of Kōami Chōsei. Seventh-generation head of the Kōami line, succeeding his father in 1603. Ordered by Hideyoshi to supply the articles and furniture necessary for the enthronement of the emperor Goyōzei. Also worked for Ieyasu. Died in a fall from his horse on the way to work for Hidetada. **Bib.:** Herberts, Jahss, Ragué, Yoshino.

¹長晏 ²幸阿弥久次郎 ³長晏

Chōbei¹ (fl. 1615–24). *N.:* Aogai Chōbei.² **Biog.:** Lacquerer. Said to have learned from the Chinese in Nagasaki the technique of using nacre decoration embedded in lacquer. The name *aogai-nuri* (blue-shell lacquer) was given to this technique; Chōbei evidently took his surname from this. No piece by him has been identified. **Bib.:** Herberts, Ragué, Speiser (2).

¹長兵衛 ²青貝長兵衛

Chōbei¹ (fl. 1661–81). *N.:* Tatsuke Takatada.² *Gō:* Chōbei.³ **Biog.:** Lacquerer. Worked in Kyōto. Known for having made an exact copy (now in the Tōkyō National Museum) of a writing set that belonged to the Ashikaga shogun Yoshimasa. It should be noted that another lacquer artist Tatsuke Chōbei, with the given name of Hirotada,⁴ was active at the same time. **Coll.:** Izumo, Tōkyō (1). **Bib.:** Casal, Feddersen, Herberts, Jahss, Kümmel, M 188, Ragué.

¹長兵衛 ²田付高忠 ³長兵衛 ⁴広忠

Chōdō¹ (1817–78). *N.:* Maeda Konomi² (or Sekiitsu).³ *A.:* Minoru,⁴ Seigyū.⁵ *F.N.:* Sekitarō.⁶ *Gō:* Chōdō,⁷ Handen.⁸ **Biog.:** *Nanga* painter. Born in Awa Province; lived in Kyōto. Pupil of Nakajima Raishō and then of Yamamoto Baiitsu. Specialized in landscapes and *kachōga*. **Coll.:** Ashmolean. **Bib.:** Mitchell.

¹暢堂 ²前田果 ³碩一 ⁴実
⁵青牛 ⁶碩太郎 ⁷暢堂 ⁸半田

Chōdō¹ (fl. 1820–40). *N.:* Takada Tei.² *A.:* Shiho.³ *F.N.:* Kōjūrō.⁴ *Gō:* Chikusenkyo,⁵ Chōdō.⁶ **Biog.** Painter. Lived and worked in Ōsaka. Specialized in landscapes and *kachōga*. **Bib.:** Mitchell.

¹樗堂 ²高田定 ³子保 ⁴幸十郎 ⁵竹泉居 ⁶樗堂

Chōen¹ (fl. 1105–50). **Biog.:** Sculptor. Eldest son of Ensei. Member of Sanjō Bussho in Kyōto. Dominant figure in sculptural world of his time; worked on many statues for temples and for the nobility. Became abbot of the Seisui-ji in 1129. Given title of *hokkyō* in 1105, *hōgen* in 1114, *hōin* in 1132. Also an able painter. No known work exists, but is said to have worked in the style of Jōchō. **Bib.:** Kuno (1).

¹長円

Chōga¹ (fl. c. 1200). *N.:* Takuma Chōga.² **Biog.:** Takuma painter. Son of Takuma Tamehisa. Received title of *hōin*. Specialized in Buddhist subjects; is recorded as having painted a portrait of Hōnen Shōnin in addition to pictures of various Buddhist deities including an *Amida with Twelve Heavenly Guardians* and an *Amida Triad*.

¹澄賀 ²宅磨澄賀

Chōga¹ (fl. c. 1253–70). *N.:* Takuma Chōga.² **Biog.:** Takuma painter. Attached to the Daigo-ji, Kyōto. Received title of *hōin*. According to literary records, in 1253, painted a Buddhist picture at a meeting in the Hosshō-ji for which he won a prize; in 1260–63, painted a *chinsō* of Gottan Funei (Chinese: Wu-an P'u-ning), a Zen monk from Sung China, a portrait now preserved in the Shōden-ji, Kyōto, and showing mastery of Sung brush strokes; c. 1270, painted *The Sixteen Rakan,* probably a copy of a Sung painting. Specialist in Esoteric Buddhist subjects. By some critics considered more important artistically than Eiga. **Coll.:** Daigo-ji, Freer, Shōden-ji. **Bib.:** BI 44, Fontein (2), K 683, Morrison 1, NB (S) 69, NBT 4, Shimada 1, Tanaka (2).

¹長賀 ²宅磨長賀

Chōgen¹ (1572–1607). *N.:* Kōami Nagato.² *Gō:* Chōgen.³ **Biog.:** Lacquerer. Member of the Kōami school; second son of Kōami Chōsei, younger brother of Chōan. Began study of tea ceremony at 16. From literary sources it is known that he worked for the tea master Furuta Oribe. **Bib.:** Herberts, Jahss, Ragué, Yoshino.

¹長玄 ²幸阿弥長玄 ³長玄

Chohei¹ (fl. 1789–1801). *N.:* Nomura Jirobei.² *Gō:* Chohei,³ Seishūhan.⁴ **Biog.:** Lacquerer. Younger brother of Nomura Kukei. Worked in Edo. Frequently used inlay of shell, nacre, and other materials; also a skillful *tsuishu* artist. Many forgeries of his work. His style somewhat like that of Ritsuō. **Coll.:** Metropolitan, Victoria. **Bib.:** Herberts, Jahss.

¹樗平 ²野村次良兵衛 ³樗平 ⁴青秀畔

Chōhō (Naganori)¹ (?–1622). *N.:* Kōami Chōhō (Naganori).² **Biog.:** Lacquerer. Fourth son of Kōami Chōsei; became head of the ninth generation of the Kōami family. Worked for a while in Edo for Tokugawa Ieyasu, but eventually entered the priesthood and retired from his profession. A talented *makie-shi*. **Bib.:** Herberts, Jahss.

¹長法 ²幸阿弥長法

Chōhō (Nagafusa)¹ (1628–82). *N.:* Kōami Chōhō (Nagafusa).² **Biog.:** Lacquerer. Son of Kōami Chōjū, with whom he collaborated. Eleventh-generation head of the Kōami line. Worked for the shogun Ietsuna. Retired to become a priest, using Chōan³ as his name. **Bib.:** Herberts, Jahss.

¹長房 ²幸阿弥長房 ³長安

Chōjirō¹ (1516–92). *N.:* Tanaka (originally Sasaki)² Chōjirō.³ *Gō:* Chōyū.⁴ **Biog.:** Raku potter. May have been the son of a Korean or Chinese potter naturalized in Japan and a Japanese mother, but details of his life unknown. Founder of the Raku style of pottery. At first probably a tile-maker, but about 1580 (under Sen no Rikyū's inspiration) began to produce the hand-molded, thickly glazed soft pottery tea bowls that from the time of Tanaka Jōkei have been called Raku ware. Patronized by Hideyoshi and Sen no Rikyū; the latter gave him the family name of Tanaka when he himself was given the name of Sen by Hideyoshi. One is cautioned to beware of giving all pieces with the Chōjirō seal to Chōjirō; it is possible they may be by other hands. **Coll.:** Atami, Freer, Fujita, Gotō, Hakone, Hatakeyama, Itsuo, Metropolitan, Royal (1), Tokugawa, Tōkyō (1). **Bib.:** Castile; *Ceramic* (1); Franks; Fujioka; GNB 19; Hayashiya; Hisamatsu; Jenyns (2); K 787; Koyama (1a), (3), (4) 6, (5) 2; Lee (2); M 51, 168, 170; Mikami; Miller; NB (S) 14; NBZ 4; Okuda (2); STZ 3, 7; Yamada; YB 35.

¹長次郎(朝次郎) ²佐々木 ³田中長次郎
(田中朝次郎) ⁴長祐

Chōjū (Nagashige)¹ (1599–1651). *N.:* Kōami Chōjū (Nagashige).² *F.N.:* Shinjirō.³ **Biog.:** Kōami lacquerer. Also a sculptor. Fifth son of Kōami Chōsei. In 1623 became head of the tenth generation of this family to serve the Tokugawa shogunate. Famous for the "Hatsune" set of lacquer

furniture (named after a character in the *Genji Monogatari* and now in the Tokugawa Museum, Nagoya), which he made as part of the dowry of Chiyohime, eldest daughter of the shogun Iemitsu, when she married Tokugawa Mitsumoto, lord of Owari, in September 1639. Also made lacquer furniture for the empress Meishō on the orders of Iemitsu. His work is very elaborate, virtuoso *makie* with designs in the Kanō tradition and the lacquer in relief. **Coll.:** Museum (1), Tokugawa. **Bib.:** Feddersen, Jahss, Kümmel, M 188, Noma (1) 2, Okada, Ragué, Sawaguchi, Yamada, Yoshino.

¹長重 ²幸阿弥長重 ³新次郎

Chōkan¹ (fl. c. 1700). **Biog.:** Lacquerer. A naturalized Korean; lived in Nagasaki. Well known for his *tsuishu* ware. **Bib.:** Herberts, Jahss.

¹張寛

Chōkan¹ (fl. c. 1775). *Gō:* Buei,² Chōkan,³ Kakukakusai.⁴ **Biog.:** Lacquerer. Lived and worked in Edo. **Bib.:** Herberts, Jahss.

¹張寛 ²武永 ³張寛 ⁴覚々斎

Chōkan¹ (1791–1863). *N.:* Sano Chōkan² (originally Nagahamaya Jisuke).³ **Biog.:** Lacquerer. Born in Kyōto. Traveled extensively in Japan, studying different lacquer techniques. Is said to have invented a purple lacquer. His specialty was *shin-nuri,* a technique using black lacquer only. A highly skilled artist. **Bib.:** Herberts, Jahss, Ragué, Sawaguchi.

¹長寛 ²佐野長寛 ³長浜屋治助

Chōkei¹ (fl. c. 1372). **Biog.:** Sculptor. A sculptor of *chinsō,* of which there is one dated 1372 in the Hōkai-ji, Kamakura. **Coll.:** Hōkai-ji. **Bib.:** *Pictorial* (1) 3, SBZ 7.

¹朝慶

Chōki¹ (fl. mid-18th c.). *N.:* Miyagawa Chōki.² **Biog.:** Ukiyo-e painter. Pupil of Miyagawa Chōshun; perhaps his son. A painter of *bijin;* few works survive. Style like that of his master, though more effete. **Coll.:** Freer, Idemitsu, Ōkura, Tōkyō (1). **Bib.:** Kondō (1), (2); Lane; Morrison 2; *Nikuhitsu* (2); Stern (4); Tajima (7) 2; *Ukiyo-e* (3) 3.

¹長亀 ²宮川長亀

Chōki¹ (fl. late 18th to early 19th c.). *N.:* Momokawa.² *Gō:* Chōki,³ Eishōsai,⁴ Shikō,⁵ Shōtei.⁶ **Biog.:** Ukiyo-e painter, printmaker. Considerable uncertainty about this artist; much variance in dates given for his activity: 1786–1808 (Tōkyō National Museum); 1785–1805 (Stern); 1789–95, the period of his dated prints and illustrations (Lee). According to some, pupil and adopted son of Toriyama Sekien. Worked in two distinct styles under two different *gō:* as Chōki in the style of Torii Kiyonaga, with an added heaviness of form; as Shikō, in manner of Utamaro, evolving an elegant distinguished style of his own. (This difference in styles has led some critics to feel two artists might be involved.) Mannerist in style, his best work—some seven or eight of the finest of all ukiyo-e designs—has great delicacy, refinement, superb color; however, prints and illustrations of much less distinction also bear his signature. **Coll.:** Allen; Andrew; Art (1), (1a); Ashmolean; British; Brooklyn; Cincinnati; Cleveland; Fitzwilliam; Honolulu; Metropolitan; Minneapolis; Musée (2); Musées; Museum (1), (3); Newark; Östasiatiska; Portland; Rhode Island; Riccar; Rietberg; Staatliche; Stanford; Tōkyō (1); Victoria; Worcester. **Bib.:** Binyon (1); Boller; Brown; Crighton; Fontein (1); Fujikake (3) 3; Gentles (2); Hempel; Hillier (7), (9); *Japanese* (1a); Kikuchi; *Kunst;* Kurth (3); Lane; Ledoux (5); Lee (2); Meissner; Michener (3); Morrison 2; Narazaki (2); NHBZ 4; Schmidt; Stern (2); Shibui (1); Tajima (7) 3; Takahashi (2); Takahashi (6) 8, 9; UG 28; Vignier 5.

¹長喜 ²百川 ³長喜 ⁴栄松斎 ⁵子興 ⁶松亭

Chōkichi (Nagayoshi)¹ (fl. 15th c.). **Biog.:** Muromachi *suiboku* painter. An artist whose identity has not yet been

clearly established. Two theories: he was a painter who followed the style of Shūbun and a contemporary of Kanō Motonobu, or even earlier; or he was the same person as Kanō Motonobu, Kanō Masanobu's eldest son, since he also used a seal in the shape of an incense burner. The first assumption is probably the more likely. His works resemble and have been confused with those of Kanō Masanobu as well as with those of Kanō Gyokuraku. **Coll.:** Fujita, Museum (3). **Bib.:** Matsushita (1a); Tajima (12) 6, (13) 4.

¹長吉

Chōkichi¹ (fl. late 18th c.). *Gō:* Chōkichi,² Ryūsetsusai.³ **Biog.:** Lacquerer. A good *inrō* artist, whose work is rare. **Bib.:** Herberts, Jahss.

¹長吉 ²長吉 ³柳雪斎

Chōko¹ (fl. early 17th c.). *N.:* Hayama Nisuke.² *Gō:* Chōko.³ **Biog.:** Painter. Little known about him. A military retainer of the Ryūzōji family of Hizen Province. Is known to have decorated the walls of Kumamoto Castle for the famous soldier Katō Kiyomasa (1562–1611). Traditionally said to be a follower of Sesshū, but the screens in the Boston Museum of Fine Arts show him as an independent artist. **Coll.:** Museum (3). **Bib.:** Paine (2) 2.

¹潮湖 ²葉山二介 ³潮湖

Chokuan¹ (fl. 1596–1610). *N.:* Soga Chokuan.² *F.N.:* Mokusuke.³ *Gō:* Shin'yo.⁴ **Biog.:** Soga painter. Lived in Sakai in Izumi. Little known about his life; it is possible that Chokuan and his son, Nichokuan, invented a lineage tracing their descent from Soga Jasoku. Founder of the Soga school. Specialized in the painting of falcons to accord with the military taste of the time. A conventional artist, using rich color and strong lines. **Coll.:** Henjōko-in; Hōki-in; Kitano; Metropolitan; Musée (2); Museum (3); Myōhō-in (Rengeō-in); Tōkyō (1), (2); University (2). **Bib.:** AA 14; Akiyama (4); BB 15; BK 35, 68; GNB 13; HS 5, 6; K 39, 45, 179, 231, 339, 365, 465, 937; KO 31; Mayuyama; Minamoto (2); Morrison 1; NB (H) 14; NBT 5; NBZ 4; NKZ 8, 33; *One* (2); Paine (2) 1, (4); SBZ 8; Tajima (12) 8, (13) 4; Yamane (1a).

¹直庵 ²曽我直庵 ³杢助 ⁴心誉

Chokuō¹ (fl. early 17th c.?). *N.:* Tamura Chokuō.² **Biog.:** Soga painter. An artist whose identity has not yet been fully established. Known as a pupil of Soga Chokuan. A screen ascribed to him shows a hawk on a tree, in color on a gold ground; very bold and decorative. **Coll.:** Museum (3). **Bib.:** BK 63, KO 29.

¹直翁 ²田村直翁

Chōkyū (Nagasuku)¹ (1661–1723). *N.:* Kōami Chōkyū (Nagasuku).² *Gō:* Chōdō (Nagamichi),³ Chōkō (Nagayoshi).⁴ **Biog.:** Lacquerer. Son of Kōami Chōhō. Twelfth-generation head of the Kōami line. Worked for the shogun Yoshimune. **Bib.:** Herberts, Jahss.

¹長救 ²幸阿弥長救 ³長道 ⁴長好

Chōnyū¹ (1714–70). *N.:* Tanaka Sōkichi.² *Studio name:* Kichizaemon.³ *Gō:* Tsuisai.⁴ **Biog.:** Raku potter. Eldest son of Sanyū. In 1728, given the name Kichizaemon and succeeded his father to become seventh-generation head of the Raku line of potters. Retired in 1762; became a monk and took the name of Chōnyū. One of the best of the Raku potters. His generous-sized bowls, usually with a black glaze, have rims that turn slightly inward. **Coll.:** Tōkyō (1), Victoria. **Bib.:** Castile, Jenyns (2), NB (S) 14.

¹長入 ²田中惣吉 ³吉左衛門 ⁴槌斎

Chora¹ (1729–80). *N.:* Miura Motokatsu.² *F.N.:* Kambei.³ *Gō:* Chora.⁴ **Biog.:** *Haiga* painter. Born in Toba. Lived first in Yamada; after 1772, in Kyōto. Amateur painter, far better known for his calligraphy and poems. Sketchy, delicate, sensitive painting. **Bib.:** Brasch (1a), *Japanische* (2).

¹樗良 ²三浦元克 ³勘兵衛 ⁴樗良

Chōsei[1] (1010–91), **Biog.**: Sculptor. One of leading pupils of Jōchō. Broke away from the Shichijō Bussho to found the Sanjō Bussho of Buddhist sculpture. The Kōryū-ji, Kyōto, owns an Antera Taishō and a Makora Taishō (two of the Jūni Shinshō), the latter dated by a document saying they were made in 1064 for the temple. In 1065, given title of *hokkyō* for his services in making statues for the Hōjō-ji; in 1070 promoted to *hōgen* for his work at the Gogan-ji; in 1077 to *hōin*. His work at the Kōryū-ji shows him to be a distinguished sculptor. **Coll.**: Kōryū-ji. **Bib.**: *Art* (1a): *Heian* (2); K 717, 874; *Kokuhō* 3; Kuno (1); Mōri (1a); *National* (2); SBZ 11; Watson (1); Yashiro (1).

<div align="center">[1]長勢</div>

Chōsei (Nagakiyo)[1] (1529–1603). *N.*: Kōami Chōsei (Nagakiyo).[2] **Biog.**: Kōami lacquerer. Son of Kōami Sōhaku; sixth-generation head of the Kōami line. Worked for Hideyoshi. Was given the honorary rank of *hokkyō*. **Bib.**: Herberts, Jahss.

<div align="center">[1]長清 [2]幸阿弥長清</div>

Chōshō[1] (fl. early 19th c.). *Gō*: Chōshō,[2] Ichirakusai.[3] **Biog.**: Ukiyo-e printmaker. Pupil of Chōki. **Coll.**: British, Victoria. **Bib.**: Binyon (1), Ficke.

<div align="center">[1]長松 [2]長松 [3]一楽斎</div>

Chōshun (Nagaharu)[1] (1683–1753). *N.*: Miyagawa Chōshun (Nagaharu),[2] (originally Hasegawa Kiheiji).[3] *F.N.*: Chōzaemon.[4] **Biog.**: Ukiyo-e painter. Born in Miyagawa (from which he took his name) in Owari Province; lived and died in Edo. May have been a minor official in the *bakufu*. Said to have been called in by a Kanō painter to do repair work at Nikkō; on his not being paid, an altercation ensued in which his son killed the Kanō man. For his part in this, Chōshun was banished from Edo, only being allowed to return a year before he died. One of the few ukiyo-e artists who did not design prints. Specialized in *bijinga*. Early work shows Tosa influence, but his greatest debt is to Hishikawa Moronobu and Kaigetsudō Ando. A delicate distinguished painter and beautiful colorist. **Coll.**: Allen, Andrew, Art (1), Atami, Freer, Fujita, Idemitsu, Metropolitan, Museum (3), Newark, Tōkyō (1), Victoria, Yamato. **Bib.**: AA 14; BK 1, 28; *Exhibition* (1); *Freer;* Fujikake (3) 2; GNB 17, 24; Hillier (1), (4) 1; Jenkins; K 8, 14, 21, 40, 52, 66, 112, 145, 184, 210, 665, 680, 861, 928; KO 36; Kondō (2), (6); Lane; M 14; Morrison 2; Narazaki (2), (3); NBZ 5; *Nikuhitsu* (1) 1, (2); *One* (2); Paine (3); Rosenfield (2); SBZ 9; *Selected;* Shimada 3; Stern (4); Tajima (7) 2, (13) 6; Takahashi (5); UG 1, 28; *Ukiyo-e* (3) 3; YB 28.

<div align="center">[1]長春 [2]宮川長春 [3]長谷川喜平次 [4]長左衛門</div>

Chōso (Chōshū)[1] (fl. c. 1370). **Biog.**: Sculptor. Known for his *chinsō*. Received title of *hokkyō*. His work shows the hard, smoothed-out stiff surfaces typical of the Muromachi-period sculptures. **Coll.**: Fusai-ji. **Bib.**: Minamoto (1), *Pictorial* (1) 3, SBZ 7.

<div align="center">[1]朝宗</div>

Chōsui[1] (fl. second half 19th c.). **Biog.**: Ukiyo-e printmaker. Specialized in *surimono*. **Coll.**: British, Musées, Rhode Island, Victoria. **Bib.**: Binyon (1).

<div align="center">[1]長水</div>

Chōyū[1] (fl. c. 1394–1427). **Biog.**: Sculptor. A Buddhist *busshi* known from his name on inscribed statues, the dates of his activity in Kamakura being deduced from these inscriptions. His work shows much Chinese influence, little of the contemporary style of Nara and Kyōto. **Coll.**: Kakuon-ji. **Bib.**: *Kamakura,* Kuno (3), Miyama, *Muromachi* (2), NBZ 3, Rosenfield (2).

<div align="center">[1]朝祐</div>

Chōyū[1] (fl. late 14th to early 15th c.). *N.*: Kose no Chōyū.[2] **Biog.**: Kose painter. Son of Kose no Gen'yū. Served as a

priest attached to the Daijō-in, Kōfuku-ji, Nara. Held title of Chikuzen Hōgen.[3]

<div align="center">[1]重有 [2]巨勢重有 [3]筑前法眼</div>

Chōzen (Nagayoshi)[1] (1589–1613). *N.*: Kōami Chōzen (Nagayoshi).[2] **Biog.**: Lacquerer. Third son of Kōami Chōsei. Became head of the eighth generation of the Kōami family in 1611. **Bib.**: Herberts, Jahss.

<div align="center">[1]長善 [2]幸阿弥長善</div>

Chōzō[1] (1797–1851). *N.*: Makuzu Chōzō.[2] **Biog.**: Potter. Born in Kyōto. Son of a pottery dealer. Opened a workshop about 1830 at Makuzugahara, from which he took his name; his wares came to be known as Makuzu-yaki. Also well known as a successful copier of Ninsei's work. His style a mixture of Korean, Chinese, and Japanese (Raku); made much use of an ivy motif in his designs. **Coll.**: Tōkyō (1). **Bib.**: NB (S) 71.

<div align="center">[1]長造 [2]真葛長造</div>

Chūan Bonshi[1] (fl. first half 15th c.). *Gō*: Chikutensō,[2] Chūan,[3] Matsuya.[4] **Biog.**: Painter. Disciple of the great scholar Shun'oku Myōha at the Shōkoku-ji, Kyōto; later a Zen priest at the Tenryū-ji; also connected with the Nanzen-ji. Held Buddhist title of *bonshi*. Josetsu's famous painting *Catching a Catfish with a Gourd* carries an inscription by him. Specialized in Buddhist subjects painted in ink. **Bib.**: BK 69.

<div align="center">[1]仲安梵師 [2]竹天叟 [3]仲安 [4]松屋</div>

Chūan Shinkō[1] (fl. c. 1444–57). *Gō*: Chūan,[2] Isoku Dōjin,[3] Kōseidō,[4] Kyūka Sanjin,[5] Shinkō.[6] **Biog.**: Muromachi *suiboku* painter. A Buddhist priest, living in the Sairai-an of the Kenchō-ji, Kamakura. One of few *suiboku* artists of his period known to have worked in Kamakura. Shōkei is said to have been his pupil. A good painter, producing landscapes and other typical Zen themes in a manner inspired by the Chinese paintings that had been brought from the mainland to Kamakura by traveling monks. **Coll.**: Freer, Museum (2), Nezu, Seattle, Tōkyō (1). **Bib.**: *Au-delà;* Fontein (1), (2); *Freer;* K 43, 77, 112, 264, 461, 624, 797; M 52; Matsushita (1), (1a); Mayuyama; *Muromachi* (1); NB (S) 13; Shimada 1; Tajima (12) 20.

<div align="center">[1]仲安真康 [2]仲安 [3]意足道人 [4]康西堂
[5]九華山人 [6]真康</div>

Chūbei[1] (fl. 1751–72). *N.*: Tanida Chūbei.[2] **Biog.**: Lacquerer. Lived in Edo. About 1760 may have entered the service of Lord Hachisuka, daimyo of Awa Province. Invented an elaborate technique, designing figures, flowers, birds, and animals in white, yellow, brown, and green lacquers—as well as in oil paints—on a red lacquer ground to create somewhat conventional designs with a Rimpa flavor. Few of his elegant, charming works (known as Tanida-nuri) remain; they are much prized, particularly in Shikoku. An independent artist. **Coll.**: Tōkyō (1). **Bib.**: Herberts, Jahss, M 188, Ragué, SBZ 10, Yoshino.

<div align="center">[1]忠兵衛 [2]谷田忠兵衛</div>

Chūen[1] (fl. mid-12th c.). **Biog.**: Sculptor. Son and pupil of Ken'en. Member of the En school of the Sanjō Bussho. Received Buddhist rank of *hokkyō* in 1139.

<div align="center">[1]忠円</div>

Chūshin[1] (1336–1405). *N.*: Zekkai Chūshin.[2] **Biog.**: Painter, calligrapher. A minor artist, better known for his calligraphy than for his painting.

<div align="center">[1]中津 [2]絶海中津</div>

Chūyu[1] (fl. 1673–81). *N.*: Ogata Chūyu.[2] *F.N.*: Nihei.[3] *Gō*: Zenhaku.[4] **Biog.**: Kanō painter. Pupil of Kanō Tan'yū; follower of Sesshū's style. Served the Kuroda family in Chikuzen Province as official painter. His landscapes are pleasantly free in manner. **Bib.**: *Kanō-ha.*

<div align="center">[1]仲由 [2]尾形仲由 [3]仁兵衛 [4]善伯</div>

D

Daiō Gyokushū[1] (1688–1769). **Biog.**: *Zenga* painter. Little known about him; probably a Zen monk. Of his two known paintings, one, according to the inscription, was painted by holding the brush in his mouth; it shows the typical, intentionally rough and naive *zenga* manner. **Bib.**: Brasch (2).

<div align="center">[1]大応玉洲</div>

Dairei[1] (fl. c. 1840). *N.:* Magata Kankō.[2] *A.:* Bunjō.[3] *Gō:* Dairei.[4] Painter. Pupil of Nakabayashi Chikutō. Later studied Chinese Yüan and Ming paintings. *Kachōga* and landscapes his speciality. **Bib.**: Mitchell.

<div align="center">[1]台嶺 [2]勾田實宏 [3]文饒 [4]台嶺</div>

Deme[1] (fl. Momoyama to Edo period). A family of sculptors. Sankōbō (q.v.), the founder of this family of artists, came from Deme in Echizen; hence the name. Two branches: the Echizen[2] Deme and the Ōno[3] Deme. The former is the main branch; the latter eventually moved to Kyōto. Specialized in Nō masks. Important members of the Echizen branch:

Jirozaemon Mitsuteru,[4] the founder (fl. early 16th c.)

Gensuke Hidemitsu,[5] third generation

Genkyū Mitsunaga[6] (?–1672)

Important members of the Ōno branch:

Zekan Yoshimitsu,[7] first generation (fl. c. 1616)

Yūkan Mitsuyasu,[8] second generation (?–1652)

Tōhaku Mitsutaka,[9] fourth generation (fl. c. 1715)

Tōsui Mitsunori,[10] fifth generation

Bib.: Kongō, Perzyński.

<div align="center">[1]出目 [2]越前 [3]大野 [4]二郎左衛門満照 [5]源助秀満
[6]元休満永 [7]是閑吉満 [8]友閑満康 [9]洞白満喬
[10]洞水満矩</div>

Denki[1] (1784–1827). *N.:* Yasuda Denki.[2] *Gō:* Tōgaku.[3] **Biog.**: *Yōga* painter. Born in Sukagawa in Iwashiro. Painter to Lord Matsudaira Sadanobu of Shirakawa. Learned both *nanga* and Western-style painting, the latter under Aōdō Denzen. Also produced engravings after Western prints. His style is the curious mixture of outward Western traits and basic Japanese feeling that constitutes the *yōga* manner. **Coll.**: Kōbe. **Bib.**: GNB 25, Mody, NB (S) 36, Nishimura, *Pictorial* (2) 2.

<div align="center">[1]田騏 [2]安田田騏 [3]東嶽</div>

Dōan[1] (?–1571). *N.:* Yamada Yorikiyo.[2] *Priest name:* Dōan.[3] *F.N.:* Tarozaemon.[4] *Gō:* Junsei.[5] **Biog.**: Muromachi *suiboku* painter. Born to a branch of the Tsutsui family in Yamato. Lived in Fukuzumi. Was given a fief and called Lord Yamada. Killed in the fighting that took place in 1571. Apparently made a close study of Shūbun and Sesshū; later came to appreciate Sung paintings and began to work in the Sung style. Also known to have been a good sculptor in wood; about 1570 repaired the head of the Daibutsu in the Tōdai-ji, Nara. Many attributions, few genuine works. He seems to have been a lively amateur painting in the Zen tradition, specializing in *kachōga* and figures. **Coll.**: Denver; Kamakura; Museum (3); Staatliche; Tōkyō (1), (2). **Bib.**: BK 41; GNB 11; HS 8, 9, 11, 12; K 41, 78, 247, 279, 663, 679, 924; Mayuyama; Morrison 1; NBT 4; NBZ 3; NKZ 18; Rosenfield (2); Schmidt; Tanaka (2).

<div align="center">[1]道安 [2]山田順清 [3]道安 [4]太郎左衛門 [5]順清</div>

Dōan II[1] (?–1573). *N.:* Yamada Yorisada.[2] *Gō:* Dōan,[3] Juntei.[4] **Biog.**: Muromachi *suiboku* painter. Member of a branch of the Tsutsui family; known as Lord Iwakake in Yamato. Probably the son of Dōan, whose name he took as a *gō*. Known to have been a good portrait painter. **Coll.**: Museum (3). **Bib.**: K 924, Morrison 1.

<div align="center">[1]道安二世 [2]山田順定 [3]道安 [4]順定（順貞）</div>

Dōan III[1] (fl. c. 1610). *N.:* Yamada Yoritomo.[2] *F.N.:* Tarozaemon.[3] *Gō:* Dōan,[4] Junchi.[5] **Biog.**: *Suiboku* painter.

Lord of Yamada; his clan was a branch of the Tsutsui family; no other information about his life. Reputed to have been a good artist.

<div align="center">[1]道安三世 [2]山田順智 [3]太郎左衛門 [4]道安 [5]順智（順知）</div>

Dōchō (Michinaga)[1] (1410–78). *N.:* Kōami (originally Toki)[2] Shirozaemon.[3] *Gō:* Dōchō (Michinaga).[4] **Biog.**: Kōami lacquerer. Founder of the Kōami school, which specialized in a type of lacquer with designs in relief. Worked for the shogun Yoshimasa. Said to have used designs by Nōami, Sōami, and Tosa Mitsunobu. No piece of lacquer can be definitely attributed to him; however, the Otokoyama writing box in the Tōkyō National Museum may be by him or his son Dōsei. **Coll.**: Tōkyō (1). **Bib.**: Herberts, Jahss, Noma (1) 2, Ragué, Sawaguchi.

<div align="center">[1]道長 [2]土岐 [3]幸阿弥四良左衛門 [4]道長</div>

Dōei[1] (1640–1708). *N.:* Hayashi Dōei.[2] **Biog.**: Nagasaki painter.

<div align="center">[1]道栄 [2]林道栄</div>

Dōhachi[1] (1783–1855). *N.:* Takahashi Mitsutoki.[2] *Priest name:* Nin'ami.[3] *Gō:* Dōhachi,[4] Hora Sanjin.[5] **Biog.**: Potter. Studied under Okuda Eisen in Kyōto. In 1824 became a monk, calling himself Nin'ami. Founded the San'yō kiln in Sanuki. The most important potter of the late Edo period, the best Kyōto potter after Ninsei. Enjoyed patronage of the Kyōto aristocracy. Influenced not only the potters producing Takamatsu ware in Sanuki but also those making Mushiake ware in Bizen. Enormously versatile: made porcelain in imitation of Shonzui ware and pottery of Raku, Shigaraki, and Iga type, as well as some with decoration in the manner of Kenzan, largely for tea-ceremony use. Was followed by three generations, all using the name Takahashi Dōhachi. **Coll.**: Ashmolean, Atami, British, Brooklyn, Freer, Gotō, Hakone, Idemitsu, Itsuō, Metropolitan, Museum (3), Rijksmuseum (1), Tōkyō (1). **Bib.**: *Art* (2); *Ceramic* (1); Fujioka; GNB 19; Hayashiya; Jenyns (1), (2); M 235; Mikami; Miller; Minamoto (3); Munsterberg (2); NB (S) 14, 28, 41, 71; NBT 6; NBZ 5; *Nihon* (1), (8); Okuda (1) 8, (2); Satō; SBZ 10; *Sōtatsu* (3); STZ 5; TZ (K) 30.

<div align="center">[1]道八 [2]高橋光時 [3]仁阿爾 [4]道八 [5]法螺山人</div>

Dohan (Nobushige, Norishige)[1] (fl. 1710–16). *N.:* Kaigetsudō Dohan (Nobushige, Norishige).[2] **Biog.**: Ukiyo-e painter, printmaker. His real name is not known, nor are any of the details of his life. One of the pupils and followers of Kaigetsudō Ando. (See under Kaigetsudō entry for a discussion of the group.) As a painter, less skillful than the other members of the group, but more (twelve in all) of his prints are known. They are always of large size and show the tall, stately, gorgeously clad courtesans who were the sole subject of the school; the best of these prints are excellent. **Coll.**: Art (1), Atami, Honolulu, Idemitsu, Kimbell, Metropolitan, Rhode Island, Riccar, Tōkyō (1), University (2), Victoria, Yale. **Bib.**: Binyon (3); Fujikake (3) 2; Gentles (2); GNB 24; Hillier (1); *Images;* Jenkins; Kikuchi; Lane; Ledoux (4); M 18; Michener (1), (3); Morrison 2; Narazaki (2); NBT 5; NHBZ 2; Shibui (1); Shimada 3; Stern (2); Tajima (7) 3; Takahashi (6) 1; *Ukiyo-e* (3) 3; Vignier 1.

<div align="center">[1]度繁 [2]懐月堂度繁</div>

Dōho[1] (?–1678). *N.:* Igarashi Dōho.[2] **Biog.**: Igarashi lacquerer. Son of Igarashi Hosai. Best-known artist of the family; represented the fifth generation. During early 17th century moved from Kyōto to Kanazawa and entered service of Lord Maeda. Eventually returned to Kyōto, where he died. Produced an intricate complicated raised lacquer which came to be known as Kaga-makie and developed into a famous local craft of Kanazawa. His works show a great

clarity of style. Adopted Kisaburō[3] (fl. late 17th c.), a brother of Kōami Kiyosaburō, who became Dōho II. Almost impossible to distinguish between the work of these two men. **Coll.**: Atami, Hatakeyama, Tōkyō (1). **Bib.**: Herberts, Jahss, M 71, NBT 7, Ragué, Sawaguchi, SBZ 9, Yoshino.

¹道甫 ²五十嵐道甫 ³喜三郎
Dōin Shōju[1] (fl. early 15th c.). **Biog.**: Muromachi *suiboku* painter. Also a priest. Known only from his portrait of Shun'oku Myōha in the Rokuō-in, Kyōto. **Coll.**: Rokuō-in. **Bib.**: *Muromachi* (1), NB (S) 69, SBZ 7.

¹道隠昌樹
Dokutan[1] (1628–1706). *Priest name:* Shōkei.[2] *Gō:* Dokutan.[3] **Biog.**: *Zenga* painter. Received his early religious training as a member of the Rinzai sect; later became a disciple of Ingen Ryūki and joined the Ōbaku sect, of which he became the fourth leader. Skilled painter of Buddhist subjects. Worked in a vigorous though not characteristically rough *zenga* style; used considerable color. Had great influence on subsequent Ōbaku-sect artists. **Bib.**: BO 113, NB (S) 47.

¹独湛 ²性瑩 ³独湛
Dōmi[1] (fl. late 16th to early 17th c.). *N.:* Kanō Yosuke.[2] *Gō:* Dōmi.[3] **Biog.**: Kanō painter. Pupil of Kanō Mitsunobu. A Christian convert, was known to have visited Kyūshū, and perhaps Nagasaki, in 1592. Records show he was working in Kyōto in 1602; in 1603 left for Manila. Painted *namban* pictures. **Coll.**: Kimbell. **Bib.**: KO 21, Takamizawa.

¹道味 ²狩野与助 ³道味
Dōmoto Inshō[1] (1891–). **Biog.**: Japanese-style painter. Born and works in Kyōto. Graduate of Kyōto Municipal School of Fine Arts and Crafts; studied under Nishiyama Suishō; showed at government exhibitions and with the Nitten. Winner of the Imperial Fine Arts Academy Prize in 1925. In Europe in 1952. Member of the Japan Art Academy; received Order of Cultural Merit in 1961. Painted the walls in the Shitennō-ji, Ōsaka, and those in the central pagoda at the Kongōbu-ji, Kōyasan. A versatile and quite eccentric artist, working in the Japanese style as well as a number of Western manners. **Coll.**: Daigo-ji (Sambō-in), Dōmoto, Kongōbu-ji, Kyōto (1), Museum (3), National (5), Shitennō-ji. **Bib.**: Asano, Kondō (6), Mizuo (2), NBT 10, NBZ 6, Sullivan.

¹堂本印象
Donchō[1] (fl. 7th c.). **Biog.**: Painter. A Korean priest-painter from the kingdom of Koguryo in Korea who became a naturalized Japanese. Skilled in the making of paper and the preparation of ink and colors, he introduced these techniques to Japan in 610. None of his works remain, but he is considered important historically. **Bib.**: Akiyama (2), Paine (4).

¹曇徴
Donkei[1] (fl. c. 1825). *N.:* Ōhara Donkei.[2] **Biog.**: Shijō painter. Pupil of Shibata Gitō. **Bib.**: Morrison 2.

¹呑鯨 ²大原呑鯨
Donkyō[1] (?–1810). *N.:* Ōhara Yoku.[2] *A.:* Unkei.[3] *F.N.:* Sakingo.[4] *Gō:* Bokusai,[5] Donkyō.[6] **Biog.**: *Nanga* painter. Born in Tsugaru in Mutsu Province; lived in Kyōto until late in life when he traveled to Matsumae, where he is said to have died. Studied by himself, following the style of the Ming painter Chang Jui-t'u (Japanese: Chō Zuito), a mid-late Ming artist of the Wu school. Specialized in landscapes and *kachōga*.

¹呑響 ²大原翼 ³雲卿 ⁴左金吾 ⁵墨斎 ⁶呑響
Dōnyū[1] (1599–1656). *N.:* Tanaka.[2] *Priest name:* Dōnyū.[3] *F.N.:* Kichibei.[4] *Studio name:* Kichizaemon.[5] *Gō:* Nonkō.[6] **Biog.**: Raku potter. Son of Tanaka Jōkei; third-generation head of the Raku school. Upon retiring, became a priest and took name of Dōnyū. Closely associated with the tea master Senno Sōtan,[7] who gave him a bamboo flower vase that bore the name Nonkō; Dōnyū used the name as a *gō*;

(The original inscription "Nonkō" on the vase was done with a knife; hence it had to be written in *kana*.) One of the most famous and versatile of the Raku potters, established traditional Raku ware. Also developed technique of glaze on glaze. Noted for bright luster of his glaze, often black, and its thick flow over the rim of his bowls; work sometimes shows the influence of Kōetsu. **Coll.**: Freer, Fujita, Gotō, Idemitsu, Metropolitan, Nezu, Seattle, Tōkyō (1), Victoria. **Bib.**: Castile; *Ceramic* (1); *Freer;* Fujioka; Hisamatsu; Jenyns (2); K 856; Koyama (1), (1a), (3), (5) 2; Lee (3); Mayuyama; Mikami; Miller; NB (S) 14; *Nihon* (8); Okuda (2); STZ 7.

¹道入 ²田中 ³道入 ⁴吉兵衛 ⁵吉左衛門 ⁶ノンコウ ⁷千宗旦
Dōsei (Michikiyo)[1] (1432–1500). *N.:* Kōami Dōsei (Michikiyo).[2] **Biog.**: Kōami lacquerer. Eldest son of Kōami Dōchō. Served as official lacquerer to Ashikaga Yoshimasa, who commissioned him to make a set of *makie* furniture and utensils to present to the emperor Gotsuchimikado on his accession in 1464. Received title of *hokkyō;* one of few lacquer artists so honored. No identifiable work known. **Bib.**: Herberts, Jahss, Ragué, Sawaguchi.

¹道清 ²幸阿弥道清
Dōshi[1] (fl. 17th c.). *N.:* Kondō Dōshi.[2] **Biog.**: Lacquerer. Worked for the tea master Kobori Enshū. Invented *iji-iji-nuri*. **Bib.**: Herberts, Jahss.

¹道志 ²近藤道志
Doshin (Nobutatsu, Noritatsu)[1] (fl. 1700–1716). *N.:* Kaigetsudō Doshin (Nobutatsu, Noritatsu).[2] **Biog.**: Ukiyo-e painter, printmaker. Produced paintings and prints of courtesans in the bold and stately manner of the Kaigetsudō school. **Coll.**: British, Metropolitan, Museum (3), Suntory, Tōkyō (1), Worcester. **Bib.**: Fujikake (3) 2; Gentles (2); Hillier (3), (4) 1; Jenkins; Lane; Ledoux (4); Morrison 2; Michener (1); Narazaki (12); NHBZ 2; *Nikuhitsu* (1) 1, 2; Shibui (1); Stern (2); Tajima (7) 3; Takahashi (3), (5).

¹度辰 ²懐月堂度辰
Dōshō[1] (1653–93). *N.:* Kondō Masunao (Ekishō).[2] *F.N.:* Koheiji.[3] *Gō:* Dōshō.[4] **Biog.**: Kanō painter. Lived in Edo. Served Lord Tosa of the Yamanouchi family. Pupil of Kanō Tōun Masunobu; allowed to use the Kanō name as an artist. A minor exponent of the school. **Coll.**: Museum (3).

¹洞蕭 ²近藤益尚 ³小平次 ⁴洞蕭
Dōshō[1] (fl. 1772–80). *N.:* Ōnogi Senzō.[2] *Gō:* Dōshō,[3] Shibayama Dōshō.[4] **Biog.**: Lacquerer. A farmer, came from Shibayama, Awa Province, to Edo, where he worked as an artist in lacquer. Founded the Shibayama school. Succeeded by his grandson Ekisei (Yasumasa).[5] **Coll.**: Metropolitan. **Bib.**: Casal, Herberts, Jahss, M 188.

¹道笑 ²大野木専蔵（仙蔵） ³道笑 ⁴芝山道笑 ⁵易政
Doshu (Nobutane, Noritane)[1] (fl. c. 1715). *N.:* Kaigetsudō Doshu (Nobutane, Noritane).[2] **Biog.**: Ukiyo-e painter. Nothing is known of his life, nor even the proper reading of his name, which can also be read as Nobutane or Noritane. One of the group of artists using the name Kaigetsudō (q.v.); probably the best pupil of Kaigetsudō Ando. Made only paintings—six of which are known—of tall, stately, beautifully dressed courtesans placed against a neutral background, in the manner of Ando. The best of these rank with Ando's work. **Coll.**: Tōkyō (1). **Bib.**: Hillier (1), Lane, Morrison 2, Stern (2), Takahashi (3), *Ukiyo-e* (3) 3.

¹度種 ²懐月堂度種
Doshū (Nobuhide, Norihide)[1] (fl. c. 1715). *N.:* Kaigetsudō Doshū (Nobuhide, Norihide).[2] **Biog.**: Ukiyo-e painter. Nothing is known of his life, nor even the proper reading of his name: it can also be read Nobuhide or Norihide. One of the group of painters using the name Kaigetsudō (q.v.); a follower of Kaigetsudō Ando. Like Doshu, made only paintings—three of which are known—of tall stately elab-

orately dressed courtesans, placed against a neutral background in the manner of Ando. Because of the similarity of his name and the closeness of his manner to Doshu, their work has frequently been confused. **Bib.:** K 629, Lane,

Morrison 2, Stern (2), Tajima (7) 3, Takahashi (3), *Ukiyo-e* (3), 3.

¹度秀　　²懐月堂度秀

E

Ebihara Kinosuke[1] (1904–70). **Biog.:** Western-style painter. Born in Kagoshima. Studied at the Kawabata Gagakkō, then with Arishima Ikuma. In Europe from 1923 to 1934, where he received training from Fujita Tsuguji and exhibited at the Salon d'Automne and the Salon des Independants. In 1935, became a member of the Dokuritsu Bijutsu Kyōkai. After 1945, exhibited at the São Paulo Biennial and the Guggenheim Museum in New York. In 1960 received the Mainichi Award. His work is in the abstract-expressionist manner. **Coll.:** National (5). **Bib.:** Asano.

¹海老原喜之助

Ehō[1] (fl. 15th c.). *Priest name:* Ehō Tokutei.[2] **Biog.:** Muromachi *suiboku* painter. A Zen priest. When young, studied under Shūbun; later, a follower of the Mu-ch'i style. Specialized in figure paintings. **Bib.:** K 487.

¹慧龍　　²慧龍徳鼎

Ei Kyū[1] (1911–60). *N.:* Sugita Hideo.[2] *Gō:* Ei Kyū.[3] **Biog.:** Western-style painter, printmaker. Born in Miyazaki. Studied for a time in Tōkyō; active in avant-garde art organizations. Surrealist in style. **Coll.:** National (5). **Bib.:** Asano.

¹瑛九　　²杉田秀夫　　³瑛九

Eibun[1] (fl. early 19th c.). *N.:* Sugawara Toshinobu.[2] *Go:* Eibun,[3] Ikkikusai.[4] **Biog.:** Ukiyo-e painter, printmaker. Pupil of Hosoda Eishi. **Bib.:** *Nikuhitsu* (2).

¹栄文　　²菅原利信　　³栄文　　⁴一掬斎

Eichō[1] (fl. early 19th c.). *N.:* Takada.[2] *Gō:* Bunwasai,[3] Eichō.[4] **Biog.:** Ukiyo-e painter, printmaker. Pupil of Hosoda Eishi. His work, especially his painting, shows some influence of his master but more of Hokusai. **Bib.:** Binyon (3), *Nikuhitsu* (2).

¹栄晁　　²高田　　³文和斎　　⁴栄晁

Eiga[1] (fl. c. 1312–16). *N.:* Takuma Arinobu.[2] *Gō:* Eiga.[3] **Biog.:** Takuma painter. Perhaps the grandson of Takuma Ryōga; a member of the Takuma school of Buddhist painters, especially known for his paintings in color of Rakan (Fujita Art Museum) which were probably based on Chinese Yüan models. Also worked in ink alone, and hence can be considered one of the forerunners of the Muromachi *suiboku* school. **Coll.:** Chōmyō-ji, Daiju-ji, Freer, Fujita, Tokiwayama. **Bib.:** BI 44; *Chūsei; Freer; Japanese* (1); K 3, 68, 397, 465, 664; *Masterpieces* (1); Morrison 1; NB (S) 69; NBZ 3; Paine (4); Shimada 1; Tajima (12) 4, 17; Tajima (13) 2; Tanaka (2).

¹栄賀　　²宅磨有信　　³栄賀

Eigaku[1] (1790–1867). *N.:* Kanō Eigaku.[2] *A.:* Kōrei.[3] *Court title:* Nuidononosuke.[4] *Gō:* Bansui,[5] Sanryō.[6] **Biog.:** Kanō painter. Born in Kyōto. Studied the Kanō style under his father-in-law, Kanō Eishun, by whom he was adopted. As a member of the Kyō Kanō school, became a leading Kanō painter in the late Edo period and worked in the Kyōto Imperial Palace. His painting is rich and decorative, retaining also some elements of Shijō technique and style. **Coll.:** Imperial (1) (Otsune Goten), Museum (3), Sennyū-ji. **Bib.:** Mitchell, Morrison 1, Okamoto (1).

¹永岳　　²狩野永岳　　³公嶺　　⁴縫殿助　　⁵晩翠　　⁶山梁

Eigen[1] (?–1704). *N.:* Kanō (originally Ōta)[2] Akinobu.[3] *Gō:* Eigen.[4] **Biog.:** Kanō painter. Son and pupil of Kanō Eiun. Succeeded his father in the service of Lord Matsudaira of Izumo.

¹永玄　　²太田　　³狩野秋信　　⁴永玄

Eigyō[1] (fl. c. 1830–44). *Gō:* Eigyō,[2] Genjusai.[3] **Biog.:** Ukiyo-e printmaker. Pupil of Hosoda Eishi in the last years of the master's life. Specialized in *bijinga*. **Bib.:** *Nikuhitsu* (2).

¹栄暁　　²栄暁　　³玄珠斎

Eihaku[1] (1687–1764). *N.:* Kanō Kiyonobu.[2] *Court title:* Nuidononosuke.[3] *Gō:* Eihaku,[4] Sanryō.[5] **Biog.:** Kanō painter. Son and pupil of Kanō Eikei; fifth-generation head of the Kyō Kanō school. Later studied under Kanō Eishuku. A mediocre artist. **Bib.:** Morrison 1.

¹永伯　　²狩野清信　　³縫殿助　　⁴永伯　　⁵山亮

Eii[1] (fl. c. 1775). **Biog.:** Kanō painter. No details of his life known. **Coll.:** Museum (3).

¹栄意

Eiin[1] (fl. c. 1383). **Biog.:** Yamato-e painter. Known so far only from his signature, which appears on a painting *The God of Kashima,* dated 1383 and belonging to the Kasuga Shrine, Nara. **Coll.:** Kasuga. **Bib.:** *Pictorial* (1) 3.

¹英印

Eijō[1] (1731–87). *N.:* Kanō Nagatsune.[2] *Court title:* Nuidononosuke.[3] *Gō:* Eijō,[4] Sanryū.[5] **Biog.:** Kanō painter. Son of Kanō Eiriku; was taken into the Kyō Kanō school on the early death of Kanō Eiryō. *Goyō eshi* to the imperial court.

¹永常　　²狩野永常　　³縫殿助　　⁴永常　　⁵山隆

Eiju[1] (1659–1736). *N.:* Kanō (originally Fujita)[2] Shunshin.[3] *F.N.:* Uheiji.[4] *Gō:* Eiju.[5] **Biog.:** Kanō painter. Pupil of Kanō Eishuku. Received title of *hokkyō.* For a time, served daimyo of northern Japan as official painter; later lived in Edo.

¹永寿　　²藤田　　³狩野俊信　　⁴字平次　　⁵永寿

Eiju[1] (fl. c. 1790). *Gō:* Chōtensai,[2] Eiju,[3] Eijusai.[4] **Biog.:** Ukiyo-e printmaker. A not very interesting pupil of Hosoda Eishi, his subject matter is from the entertainment world. His work quite rare. **Coll.:** Staatliche, Tōkyō (1). **Bib.:** Binyon (3), Ficke, Kikuchi, Schmidt.

¹栄寿　　²鳥嶹斎　　³栄寿　　⁴栄寿斎

Eikai[1] (fl. late 12th to mid-13th c.). **Biog.:** Sculptor. Said to have been a pupil of Kaikei; member of Shichijō Bussho. His name appears in an ink inscription, dated 1254, on a Jizō Bosatsu in the Chōmei-ji, Shiga-ken, from which it may be deduced that he had connections with the Kōfuku-ji, Tōdai-ji, and Yakushi-ji, in Nara. In 1197 was recorded as working with Jōkei and two other sculptors on the subsidiary figures in the Hondō of the Tōdai-ji. **Coll.:** Chōmei-ji. **Bib.:** Kuno (1), (2); Warner (1).

¹栄快

Eikai[1] (1803–74). *N.:* Satake Eishi.[2] *Gō:* Aisetsu,[3] Aisetsurō,[4] Eikai,[5] Kyūseidō,[6] Shūson,[7] Ten'ei,[8] Tensui,[9] Yūhōshi.[10] **Biog.:** Japanese-style painter. Born in Aizu. Moved to Edo; studied under Tani Bunchō and, for a time, with Sakai Hōitsu. Later served to Hikone to serve the local feudal lords, the Ii family. Received rank of *hokkyō.* A skillful painter, at his best in landscapes. His style a combination of those of his two masters: the free *nanga* and the more decorative Rimpa. **Coll.:** Ashmolean, Museum (3), Victoria. **Bib.:** Asano, Mitchell, Morrison 2, NBZ 6.

¹永海　　²佐竹衛司　　³愛雪　　⁴愛雪楼　　⁵永海　　⁶九成堂　　⁷周村　　⁸天永　　⁹天水　　¹⁰幽宝子

Eikei[1] (1662–1702). *N.:* Kanō Nagataka.[2] *Court title:* Nuidononosuke.[3] *Gō:* Chūkanshi,[4] Eikei,[5] Yūshōken.[6] **Biog.:** Kanō painter. Born in Kyōto. Son and pupil of Kanō Einō; succeeded his father as fourth-generation head of the Kyō Kanō school. Patronized by the imperial family;

said to have done some *fusuma* and doors for the Katsura Villa. A mediocre painter. **Bib.:** Morrison 1.

¹永敬 ²狩野永敬 ³縫殿助 ⁴仲簡子 ⁵永敬 ⁶幽賞軒

Einō[1] (1631–97). *N.:* Kanō Yoshinobu.[2] *A.:* Hakuju.[3] *Court title:* Nuidononosuke.[4] *Gō:* Baigaku,[5] Einō,[6] Ichiyō-sai,[7] Kyoō,[8] Sansei,[9] Sokenken.[10] **Biog.:** Kanō painter. Lived in Kyōto. Pupil of his father Kanō Sansetsu. Became third-generation head of the Kyō Kanō school. Fair reputation as a painter of landscapes and *kachōga* but far better known as the author of *Honchō Gashi* (History of Japanese Paintings), published c. 1678 and one of the earliest histories of painting. **Coll.:** Museum (3). **Bib.:** AA 14; K 76, 348, 608, 647; Morrison 1; NB (S) 20; *Rakuchū;* Tajima (12) 19; Yamane.

¹永納 ²狩野吉信 ³伯受 ⁴縫殿助 ⁵梅岳
⁶永納 ⁷一陽斎 ⁸居翁 ⁹山静 ¹⁰素絢軒

Eiri[1] (fl. c. 1790–1800). *N.:* Hosoda (?).[2] *Gō:* Chōkyōsai,[3] Eiri,[4] Rekisentei,[5] Shikyūsai.[6] **Biog.:** Ukiyo-e painter, printmaker. An artist about whom there has been much confusion. Has been considered as three men using respectively the *gō* Chōkyōsai, Rekisentei, and Shikyūsai as well as the *gō* Eiri; or perhaps as one man, a student of Hosoda Eishi (from whom he took the name Hosoda), who used successively these *gō*, at the same time changing the characters but not the reading of the *gō* Eiri. The artist who did the famous portrait of the novelist Santō Kyōden is generally thought to have been Eiri when he was using the *gō* of Reki-sentei. He is also thought to have been the maker of some quite charming prints of *bijin*. Under the *gō* of Shikyūsai, seems to have produced little of importance. Some splendid portraits and *bijinga* carry the *gō* Eiri. **Coll.:** Allen, Ashmolean, British, Fitzwilliam, Grunwald, Honolulu, Minneapolis, Musées, Nelson, Riccar, Staatliche, Tōkyō (1), Victoria, Worcester, Yale. **Bib.:** Binyon (1), (3); Boller; GNB 17; Hempel; Hillier (3), (4) 1, (7); Kikuchi; *Kunst;* Lane; Ledoux (5); Michener (1); Morrison 2; Narazaki (2); NHBZ 4; *Nikuhitsu* (1) 2; Schmidt; Shibui (1); Takahashi (6) 9; UG 28.

¹栄里（永里，永鯉，永梨） ²細田 ³鳥橋斎
⁴栄里（永里，永鯉，永梨） ⁵礫川亭 ⁶鴨嶋斎

Eiri[1] (fl. early 19th c.). **Biog.:** Ukiyo-e printmaker, illustrator. May be the same man as Rekisentei Eiri,[2] as the *gō* are similar. But this artist also used a *gō* of Busentei,[3] under which he produced prints in the manner of Hokusai.

¹永暉 ²栄里 ³武川亭

Eiri[1] (fl. early 19th c.). *N.:* Kikugawa (originally Fuyuki)[2] Eiri.[3] **Biog.:** Ukiyo-e painter, printmaker. Pupil of Kikugawa Eizan. **Bib.:** *Nikuhitsu* (2).

¹英里 ²冬木 ³菊川英里

Eiriku[1] (fl. c. 1730). *N.:* Kanō (originally Tarao)[2] Akinobu.[3] *Gō:* Eiriku.[4] **Biog.:** Kanō painter. Pupil of Kanō Eishuku.

¹永陸 ²多羅尾 ³狩野章信 ⁴永陸

Eiryō[1] (1739–69). *N.:* Kanō Nagayoshi.[2] *Court title:* Nuidononosuke.[3] *Gō:* Eiryō,[4] Sanseisai.[5] **Biog.:** Kanō painter. Adopted son of Kanō Eihaku. Member of the Kyō Kanō school, official painter to the imperial court. A painting in the Yasaka-jinja, Kyōto, carries his signature and the date 1762. **Coll.:** Yasaka-jinja. **Bib.:** Morrison 1.

¹永良 ²狩野永良 ³縫殿助 ⁴永良 ⁵山晟斎

Eiryū[1] (fl. 1789–1800). *N.:* Nakamura.[2] *Gō:* Eiryū,[3] Katsudō.[4] **Biog.:** Ukiyo-e printmaker. Another dim figure in the ukiyo-e world. Known to have been a pupil of Hosoda Eishi. Produced prints of *bijin*. **Coll.:** Staatliche, Tōkyō (1). **Bib.:** Kikuchi, Schmidt.

¹栄隆 ²中邑 ³栄隆 ⁴葛堂

Eisen[1] (1753–1811). *N.:* Okuda Tsunenori.[2] *F.N.:* Shige-emon.[3] *Gō:* Eisen,[4] Rikuhōzan.[5] **Biog.:** Potter. Born and worked in Kyōto; his ancestors came from China and were adopted into the Okuda family. A wealthy dilettante, retired early from the family pawnshop business; took up

ceramics, studying under Rokubei. Is credited with introducing porcelain to Kyōto, where, in general, only enameled pottery had been made before; is considered, with Hozen, Mokubei, and Dōhachi, one of the four best studio potters of his period. Reproduced late Ming South China porcelains (so-called Swatow ware, known in Japan as *gosu-aka-e*) decorated with underglaze blue and overglaze red and green enamels; also occasionally imitated *kōchi* ware (South China pottery with green, yellow, and aubergine glazes). Kiln at either Awataguchi or Kan'inji; produced charcoal braziers, incense boxes, trays, plates. Dōhachi, Mokubei, and Kasuke among his pupils. Used no seal, but inscribed or engraved his name on his work: plain inscription in red pigment *over* the glaze, engraving *under* the glaze. His influence great; his work now popular, with many imitations. His porcelains dull and thick, with unglazed spots and rough surfaces, edges and base heavy; painting, usually of birds, flowers or floral patterns, quite strong. **Coll.:** Center, Fine (California), Freer, Idemitsu, Seattle, Tōkyō (1). **Bib.:** AAA 26; *Ceramic* (1); Gorham; Jenyns (1); Koyama (1a); Mikami; Miller; Munsterberg (2); NB (S) 28, 71; NBT 6; *Nihon* (1), (8); Satō; SBZ 10; STZ 4, 5; TZ (K) 30.

¹頴川 ²奥田庸徳 ³茂右衛門 ⁴頴川 ⁵陸方山

Eisen[1] (1790–1848). *N.:* Ikeda Yoshinobu.[2] *A.:* Konsei.[3] *F.N.:* Zenjirō;[4] later, Teisuke.[5] *Gō:* Eisen,[6] Hokugō,[7] Hokutei,[8] Ippitsuan,[9] Kakō,[10] Keisai,[11] Kokushunrō,[12] Mumeiō.[13] **Biog.:** Ukiyo-e painter, printmaker, illustrator. Son of the calligrapher Shigeharu. Lived in Edo. Pupil first of the minor Kanō artist Hakkeisai, then of the ukiyo-e artist Kikugawa Eizan. Author of *Zoku Ukiyo-e Ruikō*, a re-editing of the main source books for the history of ukiyo-e. An erratic, uneven, prolific artist; specialized in *bijinga,* erotica, and landscapes. Some of the last he did in collaboration with Hiroshige, the *Kiso Kaidō* (Sixty-nine Stations of Kisō Highway) being one such set. His work varies from the refined and elegant to the vulgar, and much of his designing is hasty and superficial. **Coll.:** Albertina, Allen, British, Brooklyn, Cincinnati, Detroit, Fitzwilliam, Freer, Herron, Honolulu, Kōbe, Metropolitan, Minneapolis, Musée (1), National (3), Nelson, Newark, Östasiatiska, Österreichisches, Portland, Rhode Island, Riccar, Rietberg, Staatliche, Stanford, Suntory, Tōkyō (1), University (2), Victoria, Worcester, Yale. **Bib.:** Binyon (1); Boller; Brown; Crighton; Fujikake (3) 3; GNB 17, 24; Hillier (4) 1, (7), (9); Kikuchi; KO 26; *Kunst;* Lane; M 18; Meissner; Michener (3); Morrison 2; Narazaki (2); NBZ 5; NHBZ 5; *Nikuhitsu* (2); *Pictorial* (2) 4; Robinson (2); SBZ 10; Schmidt; Shibui (1); Stewart; Suzuki (4); Takahashi (2), (5); Tamba (2a); UG 20, 28; *Ukiyo-e* (2) 10, (3) 16.

¹英泉 ²池田義信 ³混声 ⁴善次郎 ⁵呈介 ⁶英泉
⁷北豪 ⁸北亭 ⁹一筆庵 ¹⁰可候 ¹¹渓斎（涇斎）
¹²国春楼 ¹³無名翁

Eisen'in[1] (1696–1731). *N.:* Kanō Furunobu (Hisanobu).[2] *F.N.:* Shōzaburō.[3] *Gō:* Eisen,[4] Eisen'in.[5] **Biog.:** Kanō painter. Lived in Edo. Son and pupil of Kanō Chikanobu; became head of fourth generation of the Kanō family at Kobikichō. In 1711, appointed as artist to the shogun's court. By order of the emperor, copied the old paintings in the imperial collection and painted *byōbu* for the emperor. Received title of *hōgen*. Adopted Jusen, son of Kanō Zuisen. **Coll.:** Museum (3). **Bib.:** *Kanō-ha*.

¹栄川院 ²狩野古信 ³庄三郎 ⁴栄川 ⁵栄川院

Eisen'in II[1] (1730–90). *N.:* Kanō Sukenobu (Michinobu).[2] *F.N.:* Shōzaburō.[3] *Gō:* Eisen,[4] Eisen'in,[5] Hakugyokusai.[6] **Biog.:** Kanō painter. Born and lived in Edo; son of Kanō Eisen'in Furunobu; became fifth-generation head of Kanō artists at Kobikichō. Received title of *hōgen* in 1762. Especially favored by the shogunate and was made a vassal directly under the shogun and artist to the *bakufu* in 1763; during his lifetime the school received a mansion at Take-

kawachō. In 1780 was given title of *hōin* and took name of Eisen'in. Was officially ranked next to Kanō Tsunenobu in ability among the Kobikichō painters. **Coll.:** Museum (3). **Bib.:** *Kanō-ha.*

¹栄川院 ²狩野典信 ³庄三郎 ⁴栄川 ⁵栄川院 ⁶白玉斎
Eishi¹ (1756–1829). *N.:* Hosoda (originally Fujiwara)² Jibukyō Tokitomi.³ *F.N.:* Kuzaemon (Kyūzaemon),⁴ Yasaburō.⁵ *Gō:* Chōbunsai,⁶ Eishi.⁷ (On paintings used Hosoi,⁸ not Hosoda.) **Biog.:** Ukiyo-e painter, printmaker. Born of a samurai family of the Fujiwara clan. Lived in Edo. Studied first under Kanō Eisen'in Sukenobu, then under Torii Bunryūsai. Appointed to high court rank. Working in Kanō style, was granted the artist's name of Eishi by Tokugawa Ieharu; about 30, left Ieharu's service and, though he changed to the ukiyo-e style, was allowed to keep the name of Eishi. In prints, specialized in *bijinga* of great refinement, at first under the influence of the Torii school; later his figures even surpassed those of Utamaro in elegance and elongation. Also did a few landscapes and compositions with literary references. Left a large number of prints, not all of first quality. Always more of a painter than a printmaker, abandoned prints completely about 1800. His paintings among the finest of the ukiyo-e school: tall figures; flowing drapery, elegant line, bright colors. **Coll.:** Allen; Art (1); Ashmolean; Atami; British; Brooklyn; Cincinnati; City; Detroit; Fine (California, De Young); Fitzwilliam; Fogg; Freer; Grunwald; Herron; Honolulu; Idemitsu; Metropolitan; Minneapolis; Musée (1), (2); Musées; Museum (1), (3); Nelson; Newark; Östasiatiska; Österreichisches; Philadelphia; Portland; Rhode Island; Riccar; Rietberg; Rijksmuseum (2); Staatliche; Stanford; Suntory; Tōkyō (1); University (1), (2); Victoria; Worcester; Yale. **Bib.:** AA 14; Binyon (1); Boller; Crighton; Fujikake (3) 3; GNB 17; Hillier (1), (3), (4) 1, (7); K 79, 103, 258, 487, 689, 734, 790; *Kanō-ha;* Kikuchi; *Kunst;* Lane; Ledoux (5); Lee (2); Meissner; Michener (3); Morrison 2; Narazaki (2); NBZ 5; NHBZ 4; *Nikuhitsu* (1) 2, (2); OA 13; *One* (2); OZ 1912–13; Rosenfield (2); Schmidt; Shibui (1); Shimada 3; Stern (2), (4); Tajima (7) 5, (13) 6; Takahashi (2), (6) 8; UG 19, 20, 28; *Ukiyo-e* (2) 6, (3) 11; Vignier 5.

¹栄之 ²藤原 ³細田治部郷時富 ⁴久左衛門 ⁵弥三郎 ⁶鳥文斎 ⁷栄之 ⁸細井
Eishin¹ (fl. 1795–1817). *N.:* Toyogawa Eishin.² *Gō:* Chōensai.³ **Biog.:** Ukiyo-e printmaker. Pupil of Hosoda Eishi. A few prints known, all of *bijin* and some of *ōkubi-e* format. Rather an attractive artist. **Coll.:** Museum (1), Riccar, Tōkyō (1), Victoria. **Bib.:** Ficke, NHBZ 4, *Nikuhitsu* (2), Tajima (7) 5, Takahashi (6) 9.

¹栄深 ²豊川栄深 ³鳥園斎
Eishō¹ (fl. mid-15th c.). *Priest name:* Dozō (Tokura) Eishō.² **Biog.:** Muromachi *suiboku* painter. A temple artist who also worked for the Ashikaga shogunate. His seal is on a painting in the Shōkoku-ji, Kyōto. He may be the same artist as Dozō Eisū (q.v.), whose name is also on a painting in the Gyokuryū-in, Shōkoku-ji, Kyōto. **Coll.:** Shōkoku-ji. **Bib.:** M 166.

¹栄松 (栄昌) ²土蔵栄松 (土蔵栄昌)
Eishō¹ (fl. c. 1710). *N.:* Kanō Eishō.² *F.N.:* Matsunojō.³ **Biog.:** Kanō painter. Said to have been second son and pupil of Kanō Einō and younger brother of Kanō Eikei. Became chief painter of the Edokoro of the Higashi Hongan-ji, Kyōto.

¹永梢 ²狩野永梢 ³松之丞 (松之尉)
Eishō¹ (fl. 1780–1800). *N.:* Hosoda Eishō.² *Gō:* Chōkōsai,³ Shōeidō.⁴ **Biog.:** Ukiyo-e painter, printmaker. Life unknown except that, with Hosoda Eiri, was a pupil of Hosoda Eishi. Produced few paintings, many prints; specialized in *ōkubi-e* and *bijinga,* the latter less idyllic, more robust and lifelike than Eishi's. **Coll.:** Albertina, Allen, Ashmolean, Baltimore, British, Fitzwilliam, Grunwald, Honolulu, Musée (2),

Musées, Newark, Östasiatiska, Österreichisches, Portland, Riccar, Rietberg, Staatliche, Tōkyō (1), University (2), Victoria, Worcester, Yale. **Bib.:** Binyon (1), Boller, Crighton, Fujikake (3) 3, GNB 17, Hempel, Hillier (7), K 734, Kikuchi, *Kunst,* Kurth (3), Lane, Morrison 2, Narazaki (2), NBZ 5, NHBZ 4, *Nikuhitsu* (2), SBZ 10, Schmidt, Shibui (1), Tajima (7) 5, Takahashi (6) 9, UG 28.

¹栄昌 ²細田栄昌 ³鳥高斎 (鳥交斎) ⁴昌栄堂
Eishō¹ (fl. late 18th c.). *N.:* Toki Eishō.² *A.:* Hakka.³ *Gō:* Kikei,⁴ Saibi.⁵ **Biog.:** Maruyama painter. Born and worked in Kyōto. Pupil of Maruyama Ōkyo. A good painter of *kachōga.* **Bib.:** Jahss, Tajima (6) 2.

¹瑛昌 ²土岐瑛昌 ³伯華 ⁴亀渓 ⁵濟美
Eishō¹ (fl. early 19th c.). *Gō:* Eishō,² Ikkansai.³ **Biog.:** Ukiyo-e painter, printmaker. Pupil of Hosoda Eishi. Specialized in depicting the women of the teahouses and gay quarters. **Bib.:** *Nikuhitsu* (2).

¹栄尚 ²栄尚 ³一貫斎
Eishō¹ (fl. mid-19th c.). *N.:* Kikugawa Kōitsu.² *Gō:* Eishō.³ **Biog.:** Ukiyo-e printmaker. Pupil of Kikugawa Eizan, from whom he took his surname. (Kōitsu may be a *gō* rather than his given name.) Was also a writer of Kyōgen. **Coll.:** Fitzwilliam, Victoria.

¹英章 ²菊川光一 ³英章
Eishuku¹ (1675–1724). *N.:* Kanō Toshinobu² (or Akinobu,³ then Morinobu).⁴ *Gō:* Eishuku,⁵ Tanzen Koji,⁶ Zuishōsai.⁷ **Biog.:** Kanō painter. Son of Kanō Ukyō Tokinobu. On the death of his father, was adopted by his grandfather Kanō Eishin Yasunobu as successor to the position of *goyō eshi* to the *bakufu,* thus becoming the ninth-generation head of the Nakabashi Kanō school. Received rank of *hōgen.* **Coll.:** Fogg, Museum (3). **Bib.:** *Nikuhitsu* (1) 1.

¹永叔 ²狩野敏信 ³明信 ⁴主信 ⁵永叔 ⁶濟然居士 ⁷瑞趐斎
Eishun¹ (fl. c. 1369–1418). *N.:* Tosa Eishun.² **Biog.:** *Yamato-e* painter. Said to have been a son of Tosa Mitsuaki, but really known only as one of the six painters—the others: Rokkaku Jakusai, Awataguchi Takamitsu, Tosa Yukihiro, Tosa Mitsukuni, Tosa Yukihide—of the scroll *Yūzū Nembutsu Engi,* dated 1414, now in the Seiryō-ji, Kyōto. This scroll carries on the old *yamato-e* painting tradition in a rather stiff, formal manner. **Coll.:** Seiryō-ji. **Bib.:** K 169, NKZ 32, Tajima (12) 10.

¹永春 ²土佐永春
Eishun (Nagaharu)¹ (fl. 1704–63). *N.:* Hasegawa Mitsunobu² (originally Eishun, or Nagaharu).³ *Gō:* Baiōken,⁴ Shōsuiken.⁵ **Biog.:** Ukiyo-e painter, printmaker. A minor artist of the Kaigetsudō school, working, probably in Edo, in the formula set by Ando. **Coll.:** Center, Kimbell, Nelson, Portland, Staatliche, Tōkyō (1). **Bib.:** Hillier (3), (4) 1; *Japanese* (2); Jenkins; K 876; Kaneko; Kikuchi; Lane; Ledoux (4); M 18; NHBZ 2; *Nikuhitsu* (2); Shimada 3; UG 28; *Ukiyo-e* (3) 3.

¹永春 ²長谷川光信 ³永春 ⁴梅翁軒 ⁵松翠軒
Eishun¹ (1769–1816). *N.:* Kanō Eishun.² *Gō:* Samboku.³ **Biog.:** Kanō painter. Adopted son of Kanō Eijō, member of the Kyō Kanō school. Worked in the Kyōto Imperial Palace.

¹永俊 ²狩野永俊 ³山朴
Eishunsai¹ (?–1765). *N.:* Kushibashi Masamitsu.² *Gō:* Eishunsai.³ **Biog.:** Kanō painter. Lived in Ōsaka. Teacher of Yamamoto Joshunsai and Mori Yōshin. **Bib.:** Morrison 2.

¹栄春斎 ²櫛橋正盈 ³栄春斎
Eison (Eizon)¹ (fl. mid-16th c.). **Biog.:** Muromachi *suiboku* painter. Known only through his seals. Fond of painting turnips. His style close to that of Sesson. **Bib.:** M 166, Matsushita (1a), NB (S) 63.

¹栄存
Eisū¹ (fl. mid-15th c.?). *Priest name:* Dozō Eisū.² **Biog.:**

Muromachi *suiboku* painter. A Zen priest. Almost nothing known about him, including the period in which he lived. On the *Kugyo Shaka* painting in the Gyokuryū-in of the Shōkoku-ji, Kyōto, there is an inscription saying it was painted by him at the age of 73. He may, however, be the same artist as Dozō Eishō (q. v.), who also has a painting in the same temple. Evidently a follower of Shūbun's technique and style. **Coll.:** Shōkoku-ji (Gyokuryū-in). **Bib.:** M 166, Matsushita (1a).

¹栄崇 ²土蔵栄崇

Eisui¹ (fl. 1790–1823). *N.:* Hosoda Eisui.² *Gō:* Ichirakusai,³ Ichirakutei.⁴ **Biog.:** Ukiyo-e printmaker. Little known about his life. A commoner, without a family name, was probably allowed to use his master's name, as he was quite an important pupil of Hosoda Eishi. Worked as a book illustrator until 1823. In single sheets, excelled in delicately drawn *ōkubi-e* of young girls: the "pin-ups" of the Yoshiwara. **Coll.:** Allen, Andrew, Baltimore, British, Fitzwilliam, Musées, Nelson, Newark, Portland, Riccar, Staatliche, Tōkyō (1), University (2), Victoria, Worcester, Yale. **Bib.:** Binyon (1), Boller, Crighton, Ficke, Fujikake (3) 3, GNB 17, Hillier (7), Kikuchi, *Kunst*, Lane, NHBZ 4, Schmidt, Stern (2), Takahashi (6) 9, UG 28.

¹栄水 ²細田栄水 ³一楽斎 ⁴一楽亭

Eisuke¹ (fl. 18th c.). *N.:* Tatsuke Eisuke.² **Biog.:** Lacquerer. Lived in Kyōto. Worked for the daimyo of Satsuma. Noted for his *inrō* with designs of animals. **Bib.:** Herberts, Jahss.

¹栄助 ²田付栄助

Eitaku¹ (1843–90). *N.:* Kobayashi Tokusen.² *F.N.:* Hidejirō (Shūjirō),³ *Gō:* Eitaku,⁴ Issensai,⁵ Sensai.⁶ **Biog.:** Japanese-style painter. Born in Edo. At 13 became a pupil of Kanō Eitoku Tatsunobu; a few years later was employed by the Ii family, the lords of Hikone, as their official painter and was given status of samurai. In 1860 his master was assassinated; wandered throughout Japan, returning finally to Nihombashi in Edo. Edited several textbooks on painting; also did illustrations for the *Yokohama Mainichi Shimbun*. Specialized in historical subjects and figures. As Eitoku's pupil, worked first in the Kanō tradition; later studied the *nanga* manner; finally developed his own style of realistic painting. **Coll.:** Rhode Island. **Bib.:** Asano, Hillier (4) 3, Mitchell, NB (S) 20, NBZ 6.

¹永濯 ²小林徳宣 ³秀次郎 ⁴永濯 ⁵一鮮斎 ⁶鮮斎

Eitoku¹ (1543–90). *N.:* Kanō Kuninobu² (later Mochishige,³ then Shigenobu).⁴ *F.N.:* Genshirō.⁵ *Gō:* Eitoku.⁶ **Biog.:** Kanō painter. Son and pupil of Kanō Shōei, grandson of Kanō Motonobu; fifth-generation head of the main Kyōto Kanō line. Lived in Kyōto. Worked as *goyō eshi* for Nobunaga and Hideyoshi, painting screens for the castle at Azuchi (1576–79) and Juraku-dai in Kyōto (1587), both of which were later destroyed. First great master of the Momoyama period and one of the important figures in the history of Japanese art; his contemporaries were either his pupils or influenced by him. Received honorary titles of *hōgen* and *hōin*. Most of his paintings perished in the burning of the castles and palaces for which he worked; only a handful of paintings are securely identified, and many are attributions. Originated a new and magnificent type of wall decoration in keeping with the scale and grandeur of the new palaces and castles of the Momoyama period, combining the decorative qualities of the Tosa school with the ink painting of the Kanō school: a style marked by the use of gold ground, strong black ink, strong colors, immense scale, and a great decorative sense. **Coll.:** British; Daitoku-ji (Jukō-in); Freer; Musées; Museum (3); Nanzen-ji; Seattle; Stanford; Tōkyō (1), (2); Uesugi; Victoria; Yoshimizu-jinja. **Bib.:** Akiyama (3), (4); BB 15; Binyon (2); BK 24, 36; Covell (2); Fontein (1); *Freer*; GNB 13; Gray (2); Grilli (1); Hillier (1); HS 3, 4, 8; K 13, 48, 123, 142, 152, 208, 335, 418, 638, 862, 902, 903; Kondō (2); Lee (1); M 110; Matsushita

(1); Minamoto (2); Moriya; Morrison 1; Nakamura (2); NB (H) 14; NB (S) 13; NBT 5; NBZ 4; *Nikuhitsu* (1) 1; Noma (1) 2; OA 13; Okamoto (1); *One* (2); Paine (2) 1, (4); *Rakuchū:* SBZ 8; Shimada 2; Tajima (12) 1, 4, 5, 8, 12; Tajima (13) 4; Tanaka (9); Yamane (1a).

¹永徳 ²狩野州信 ³茂重 ⁴重信 ⁵源四郎 ⁶永徳

Eitoku II¹ (1740–94). *N.:* Kanō Takanobu.² *F.N.:* Shirojirō.³ *Gō:* Eitoku,⁴ Seibunsai.⁵ **Biog.:** Kanō painter. Born in Edo; eldest son and pupil of Kanō Terunobu. Served the shogunate as the twelfth-generation head of the Nakabashi Kanō family. Received title of *hōgen*. Specialized in *kachōga*, landscapes, and portraits.

¹永徳二代 ²狩野高信 ³四郎次郎 ⁴永徳 ⁵成文斎

Eitoku¹ (1814–91). *N.:* Kanō Tatsunobu.² *F.N.:* Kumagorō.³ *Gō:* Eitoku,⁴ Seisetsusai.⁵ **Biog.:** Kanō painter. Born in Edo; son and pupil of Kanō Isen'in, head of the seventh generation of the Kobikichō branch of the Kanō family; adopted by Kanō Kuninobu and eventually succeeded him as head of the fifteenth generation of the Nakabashi branch of the main Kanō line. After the Meiji Restoration, was associated with the Imperial Museum and a number of other important projects for the promotion and protection of traditional Japanese arts. Served as a juror for the Naikoku Kangyō Hakurankai. **Bib.:** Asano, NBZ 6.

¹永徳 ²狩野立信 ³熊五郎 ⁴永悳 ⁵晴雪斎

Eiun¹ (?–1697). *N.:* Kanō (originally Ōta)² Sadanobu.³ *Gō:* Eiun.⁴ **Biog.:** Kanō painter. Pupil of Kanō Eishin Yasunobu; was given permission to take Kanō name. Served Lord Matsudaira of Izumo Province. Received the title of *hokkyō*.

¹永雲 ²太田 ³狩野定信 ⁴永雲

Eizan¹ (fl. late 18th c.). *N.:* Harukawa Eizan.² **Biog.:** Ukiyo-e printmaker. Pupil of Hosoda Eishi; teacher of Harukawa Goshichi.

¹栄山 ²春川栄山

Eizan¹ (1787–1867). *N.:* Kikugawa (originally Ōmiya)² Toshinobu.³ *F.N.:* Mangorō,⁴ Tamegorō.⁵ *Gō:* Chōkyūsai,⁶ Eizan.⁷ **Biog.:** Ukiyo-e painter, printmaker. Lived in Edo; son of Kikugawa Eiji, a maker of fans and Kanō-style painter. Taught first by his father, then by Suzuki Nanrei and Iwakubo Hokkei; also influenced by Utamaro and Hokusai. His paintings, quite in Kanō manner, commonly signed Eizan Toshinobu. From the early 1800s until he retired about 1830, became the leading designer of *bijinga* (based on Utamaro's late style) and actor prints as well as erotica. Groups of women and children also among his favourite subjects. Founder of the so-called Kikugawa style. His work, though competent enough, shows the gradual decline in ukiyo-e figure work that took place in the late Tokugawa period, and much of it is banal. At its best quite good; at the worst very poor. **Coll.:** Albertina, Allen, Art (1), Ashmolean, Baltimore, British, Cincinnati, City, Detroit, Fine (California), Fitzwilliam, Fogg, Honolulu, Minneapolis, Musée (1), Musées, Museum (1), Nelson, Newark, Östasiatiska, Portland, Rhode Island, Riccar, Rietberg, Staatliche, Stanford, Suntory, Tōkyō (1), Victoria, University (2), Worcester. **Bib.:** Binyon (1), (3); Fujikake (3) 3; Hillier (3), (4) 1, (7); Kikuchi; *Kunst*; Meissner; Morrison 2; *Nikuhitsu* (1) 2; Schmidt; Shibui (1); Tajima (7) 5; Takahashi (2), (6) 10; Tamba (2a); UG 28; *Ukiyo-e* (3) 16.

¹英山 ²大宮 ³菊川俊信 ⁴万五郎 ⁵為五郎 ⁶重九斎 ⁷英山

Emosaku (Uemonsaku)¹ (fl. late 16th to early 17th c.). *N.:* Yamada Emosaku (Uemonsaku).² *Gō:* Koan,³ Unhōsai (Umpōsai),⁴ Yūan.⁵ **Biog.:** *Yōga* painter. Born in Nagasaki. Trained in Western-style painting at the academy run by the Jesuit Nicoláo. Entered the service of the daimyo of Shimabara; took part in the Shimabara revolt. Later was sent to Edo under the supervision of Matsudaira Nobutsune,

who had suppressed the revolt and spared Emosaku presumably because of his reputation as a painter. As a Christian, was imprisoned for a while, but was persuaded to apostatize and became a *bakufu* petty official in charge of reporting on Christian activities; soon returned to Christianity and painted many Christian symbols in the guise of Buddhist portraits (so-called hidden Christian icons). For this, was placed under house arrest for life. As he is believed to have been the first exponent of Western painting in Japan, most Western-style paintings of the late 16th to early 17th century are generally and usually quite mistakenly attributed to him. **Bib.:** BK 39, Sullivan.

¹右衛門作 ²山田右衛門作 ³古庵 ⁴雲鵬斎 ⁵祐庵

Endō Kyōzō[1] (1897–). **Biog.:** Japanese-style painter. Born in Tōkyō. Graduated from Tōkyō School of Fine Arts in 1921; the same year began teaching at Women's Art School. Helped found the Shinkō Yamato-e-kai, exhibiting with it until it was disbanded in 1931, after which he showed with the Teiten and then the Bunten. **Coll.:** Staatliche. **Bib.:** Asano, Schmidt.

¹遠藤教三

Endō Shūgaku[1] (1846–1911). *N.:* Endō Shin.[2] *Gō:* Shūgaku.[3] **Biog.:** *Nanga* painter. Born in Awa Province. A physician who studied painting under the local *nanga* artist, Shiba Shūson. **Bib.:** *Awa.*

¹遠藤秋岳 ²遠藤蓁 ³秋岳

En'en[1] (fl. late 10th to early 11th c.). *N.:* Fujiwara.[2] *Priest name:* En'en.[3] **Biog.:** Buddhist painter. Son of Fujiwara no Yoshikane. Became a monk at the Onjō-ji, Kyōto, rising to rank of *ajari.* The first high-ranking priest to establish a reputation as a good artist, specialized in Buddhist themes, painted presumably in the *yamato-e* manner. No known work by him exists today.

¹延円 ²藤原 ³延円

Engen[1] (?–1096). **Biog.:** Buddhist painter. Recorded as having painted a *mandara* in 1083; was made *hokkyō* at about the same time.

¹延源

En'i[1] (fl. late 13th c.). **Biog.:** *Yamato-e* painter. Life unknown; probably a priest and may have belonged to the group of Edokoro painters specializing in pictures relating to the Jōdo sect. His name and his title *hōgen* appear in the inscription, dated 1299, at the end of one of the twelve scrolls (eleven are owned by the Kankikō-ji, Kyōto; one by the Tōkyō National Museum) of the *Ippen Shōnin Eden,* which illustrates the life of the itinerant priest Ippen, who died in 1289 and was the founder of the Ji sect, an outgrowth of the Jōdo sect. Moriya Kenji says En'i followed Ippen on his preaching journeys and painted these scrolls ten years after Ippen died. The *Nihon Emakimono Zenshu,* referring to these scrolls as the *Ippen Hijiri-e,* says they are by three different hands (scrolls 1–3, 4–7, 8–12), all under En'i's supervision. The scrolls are noted for their quiet charm and their realistic portrayal of landscape and architecture. **Coll.:** Kankikō-ji, Tōkyō (1). **Bib.:** Akiyama (2); *Art* (1a); BK 205; *Exhibition* (1); G 1938, 1939, 1942; Hase; Ienaga; K 73, 148, 206, 334, 912; *Kokuhō* 4; Moriya; Morrison 1; Munsterberg (1); NEZ 10; Okudaira (1), (1a); *One* (2); P 1; Paine (4); SBZ 6; Seckel (2); Tajima (12), 2, 6, 12; Tajima (13) 2; Tanaka (2), (4) 22; Toda (2).

¹円伊

Enjaku[1] (fl. mid-14th c.). **Biog.:** *Yamato-e* painter. Recorded, along with Sōshun, as the painter in 1343 of the four scrolls of the *Shinran Shōnin Eden,* now in the Higashi Hongan-ji, Kyōto. Known as the *Kōei-bon* (because it was painted in the second year of Kōei) or the *Hongan-ji Shōnin Den-e,* it is considered the oldest extant work with this title. Black lines predominate in the painting, but colors are skillfully used. **Coll.:** Higashi. **Bib.:** Okudaira (1).

¹円寂

Enkai[1] (fl. 11th c.). **Biog.:** Sculptor. Member of Jōchō school. A Buddhist priest at the Shigisan-ji (a nickname for the Chōgosonshi-ji) between Ōsaka and Nara. As a sculptor called himself Busshi Sō Jōnyobō Enkai.[2] Known from the inscription, dated 1069, on the charmingly youthful and elegant seated statue of Shōtoku Taishi owned by the Hōryū-ji. An "orthodox" sculptor of considerable technical ability. **Coll.:** Hōryū-ji. **Bib.:** Fontein (1), Kuno (1), Minamoto (1), Paine (4).

¹円快 ²仏師僧浄如房円快

Enkin[1] (fl. mid-8th c.). Also known as Enkinshi[2] (*shi* denoting "master"). **Biog.:** Sculptor. Known from inscriptions on masks in the Shōsō-in collection that are in a simple, realistic style. **Coll.:** Shōsō-in. **Bib.:** Harada, Kleinschmidt.

¹延均 ²延均師

Enkū[1] (1628–95). **Biog.:** Sculptor. Born in Hajima, Gifu-ken; died in Gifu-ken. Traveled as beggar, priest, and itinerant carver of rough-hewn wooden Buddhist and Shintō deities, leaving his images, which he made for the local peasants, at temples and shrines largely in the prefectures of Gifu and Aichi. His figures sometimes corresponded to traditional iconography, sometimes not. Unnoticed until recently, his work is now much in vogue and frequently faked. His style akin to 20th-century Western expressionism: unfinished, rough—known in Japanese as "hatchet carving"—but very telling and the complete antithesis of the contemporary sculpture at Nikkō. **Coll.:** Senkō-ji, Taihei-ji (Kannondō), Takayama, Yakuo-in, Yakushidō (1). (For other temples and shrines see the catalogue *Japanische Kunst des späten Zen.*) **Bib.:** Ebara; *Japanische* (1); K 836; Kuno (1), (3); M 187; Maruyama; NBT 2; NBZ 4; Noma (1) 2; SBZ 9.

¹円空

Enkyō[1] (1749–1803). *N.:* Nakamura Jūsuke (Shigesuke).[2] *Gō:* Enkyō,[3] Kabukidō Enkyō.[4] **Biog.:** Ukiyo-e printmaker. However, his real profession was that of writer of plays, comic books, and "chapbooks," which he produced under his name Nakamura Jūsuke (Shigesuke). Worked as a printmaker for one year, in 1796, making *yakusha-e*—only seven prints are known—in the style of Sharaku, whom he greatly admired. (According to some traditions, Sharaku is said to have used a *gō* Kabukidō; Kurth therefore says Enkyō is the name used by him after he had become unpopular and was trying to make a last bid for fame. However, the exaggeration of Enkyō's prints when compared with Sharaku's militates against this theory.) **Coll.:** Art (1), British, Fitzwilliam, Riccar. **Bib.:** Binyon (1), (3); Boller; Fujikake (3) 2; Hillier (1), (7); Kikuchi; Kurth (1), (5); NHBZ 4; Shibui (1); Stern (2); UG 3.

¹艶鏡 ²中村重助 ³艶鏡 ⁴歌舞伎堂艶鏡

Ensai[1] (fl. c. 1840). *N.:* Kunieda Kiyū.[2] *A.:* Kunsei.[3] *F.N.:* Kumejirō.[4] *Gō:* Ensai,[5] Ryōun.[6] **Biog.:** Nagasaki painter. Born in Edo. Pupil of Yamazaki Toretsu. **Bib.:** Mitchell.

¹遠斎 ²国枝基有 ³君靖 ⁴久米次郎 ⁵遠斎 ⁶凌雲

Ensei[1] (?–1134). **Biog.:** Sculptor. Pupil and perhaps son of Chōsei; member of the Sanjō Bussho; attached to the Kiyomizu-dera, Kyōto. Participated in many of the important sculptural undertakings of his time in Kyōto, but today his work cannot be identified. Was given rank of *hokkyō;* then in 1101 promoted to *hōgen* and in 1102 to *hōin.* His fame was such that many of the sculptors in his workshop later assumed names containing the character *en*[2]. **Bib.:** BK 30, *Kokuhō* 3, Kuno (1).

¹円勢 ²円

Enshi[1] (fl. c. 1785–95). *N.:* Enshi.[2] *Gō:* Angyūsai.[3] **Biog.:** Ukiyo-e printmaker. Life unknown; perhaps a pupil of Katsukawa Shunshō. Work shows influence of Kiyonaga and Eishi. **Coll.:** British, Musées, Riccar, Tōkyō (1). **Bib.:** Binyon (1), (3); Kurth (3); UG 3.

¹円志 ²円志 ³闇牛斎

Enshin[1] (fl. late 10th to early 11th c.). **Biog.:** Painter. A very

shadowy figure, known only from literary sources. May even be the name used by two different artists. **Bib.**: BG 70.

¹円心

Enshū¹ (fl. late 18th to early 19th c.). *N.*: Koma Enshū.² **Biog.**: Lacquerer. A minor member of the Koma family of lacquer artists. **Coll.**: Walters. **Bib.**: Boyer, Herberts, Jahss.

¹遠舟 ²古満遠舟

Enshun¹ (fl. late 12th c.). **Biog.**: Sculptor. From literary records, known to have been a member of the aristocracy. Actual works by him have not yet been located. Adopted by the sculptor Chōen; pupil of Ken'en.

¹円春

Entaku¹ (1643–1730). *N.*: Katō Moriyuki.² *Gō:* Entaku.³ **Biog.**: Kanō painter. Born in Aizu. A samurai, served as official painter to the Matsudaira clan of Aizu (a branch of the Tokugawa family) and introduced the Kanō school there. One of Tan'yū's four great pupils. An eccentric, worked only for his peers. **Coll.**: Victoria. **Bib.**: Morrison 1.

¹遠沢 ²加藤守行 ³遠沢

Eri¹ (852–935). **Biog.**: Sculptor. A priest, disciple of Shōbō, the abbot of the Daigo-ji. Not known whether he was actually a sculptor or only supervised the making of sculpture, working at the Tō-ji. The Yakushi Nyorai, dated 907, in the Yakushidō at the Daigo-ji is locally said to be by him, but some writers say no work can definitely be assigned to him. It is known that in 927, ten years after the Tōdai-ji

Kōdō burned down, Eri was charged with the task of overseeing the repair of various statues, chiefly the Senju Kannon and its two attendants. **Coll.**: Daigo-ji (Yakushidō). **Bib.**: K 848, Kuno (1), SBZ 5, Yashiro (1) 1.

¹会理

Eryū (Keiryū)¹ (fl. early 16th c.). **Biog.**: Muromachi *suiboku* painter. His work shows the influence of both Sesshū and the incipient Kanō school. **Bib.**: BK 63, Matsushita (1a).

¹恵隆

Etō Jumpei¹ (1898–). **Biog.**: Western-style painter. Born in Ōita-ken; works in Tōkyō. Graduate of the Tōkyō School of Fine Arts; student of Okada Saburōsuke. Has shown at government exhibitions and with the Nitten. Member of the Kōfūkai and the Nitten. Style rather academic, with a touch of influence from Derain. **Coll.**: National (5).

¹江藤純平

Etsujin (Atsujin)¹ (1758–1836). *N.*: Endō Sadanori.² *A.*: Fuminori,³ Izunosuke.⁴ *Gō:* Chikurinsha,⁵ Etsujin (Atsujin),⁶ Fugen'an,⁷ Fuzan'ō,⁸ Seiemon,⁹ Yūan.¹⁰ **Biog.**: *Haiga* painter. Born in Sendai; served Lord Date of Sendai. Known particularly as a *haiku* poet and a fencer. His paintings are graceful and simple, at times resembling those of Buson; his *haiku* are frequently humorous.

¹曰人 ²遠藤定矩 ³文規 ⁴伊豆之介 ⁵竹林舎
⁶曰人 ⁷不間庵 ⁸富山翁 ⁹清右衛門 ¹⁰柚庵

F

Fudeya Tōkan¹ (1875–1950). *N.*: Fudeya Gisaburō.² *Gō:* Hakumurō,³ Taikyodō,⁴ Tōkan.⁵ **Biog.**: Japanese-style painter. Born in Otaru, Hokkaidō. Graduated from department of Japanese painting of Tōkyō School of Fine Arts in 1900; pupil of Hashimoto Gahō. An exhibitor with and member of Inten; also exhibited at the Bunten. Tended to paint rather romantic scenes from Japanese legends. **Coll.**: National (5). **Bib.**: Asano.

¹筆谷等観 ²筆谷儀三郎 ³白夢楼 ⁴太虚堂 ⁵等観

Fūgai¹ (1568–1650). *Priest name:* Fūgai Ekun.² *Gō:* Fūgai Dōjin,³ Fūgai Mokushitsu,⁴ Manatsuru Fūgai,⁵ Odawara Fūgai.⁶ **Biog.**: *Zenga* painter. One of two artists (cf. Fūgai Honkō) working under this name. Born in Tsuchishio-mura, Kōzuke Province; became resident priest at the Jogan-ji in Sagami, the first and only temple where he held office. Spent rest of his life as an eccentric wandering priest of the Sōtō sect; tradition says he died at the Kōrin-ji in Komagome (present Bunkyō-ku, Tōkyō) and was buried there. For most of his life his only shelter is thought to have been various caves in Kamisoga; hence his name Tō Fūgai⁷ (Cave Fūgai). May have studied under the painter-priest Motsugai Jōhan. In spite of this almost wholly legendary background, a monument was erected to him in 1628 at the site of the cave called Fūgai-tō in Kamisoga, Izu. Fond of drawing Daruma and Hotei in the wild, free manner, bordering on caricature, of the *zenga* school. **Coll.**: Denver, Staatliche. **Bib.**: *Au-delà;* Awakawa; Brasch (2); Hillier (1); M 135, 166; NB (S) 47.

¹風外 ²風外慧薫 ³風外道人 ⁴風外黙室
⁵真鶴風外 ⁶小田原風外 ⁷洞風外

Fūgai¹ (1779–1847). *N.*: Taira.² *Priest name:* Fūgai Honkō.³ *F.N.*: Azuma Taiji.⁴ *Gō:* Entsū-ji Fūgai,⁵ Fūgai,⁶ Kōjaku-ji Fūgai,⁷ Kōyū,⁸ Shun'en.⁹ **Biog.**: *Nanga* painter. Born near Ise. At 8 entered Buddhist priesthood; studied under priest Genrō of the Kōshō-ji; became a major figure in the Sōtō sect. In 1818, resident priest at the Entsū-ji; in 1833 moved to the Kōjaku-ji in Mikawa, leaving there in 1841. Frequently visited Matsue, where he studied Ikeno Taiga's style by copying the paintings left by Taiga at the Tenrin-ji. Produced elegant work, with superb contrast between color and subtle

black ink. **Coll.**: Eihei-ji, Kōjaku-ji, Kōkoku-ji, Myōgun-ji, Philadelphia, Shōraku-ji. **Bib.**: BO 101, 104; Ihara; M 135, 166; NB (S) 47.

¹風外 ²平 ³風外本高 ⁴東泰二 ⁵円通寺風外
⁶風外 ⁷香積寺風外 ⁸好幽 ⁹春円

Fuinsai¹ (fl. 1765–80). **Biog.**: Ukiyo-e printmaker. Worked in Ōsaka. Apparently influenced by Maruyama Ōkyo; like him, produced *megane-e* (scenes for peep shows). Also copied Western scenes from imported sketchbooks. **Bib.**: NHBZ 3.

¹不韻斎

Fuji Gazō (Masazō)¹ (1853–1916). **Biog.**: Western-style painter. Studied Western-style painting at the Kōbu Daigaku Bijutsu Gakkō in Tōkyō. Teacher of Kume Keiichirō. In 1885 to France for further study; married a Frenchwoman. Next to the United States as designer for a ceramic firm near New York, where he died. **Coll.**: Tōkyō (1). **Bib.**: Asano, NB (S) 30, NBZ 6.

¹藤雅三

Fujii Kambun¹ (1888–). **Biog.**: Lacquerer. Born in Tōkyō. Specialist in *chinkin-bori*. **Bib.**: Ragué.

¹藤井観文

Fujii Kōyū (Kōsuke)¹ (1882–1958). **Biog.**: Western-style sculptor. Born in Tōkyō. Studied with Morikawa Toen; then at the Tōkyō School of Fine Arts, graduating in 1907. Showed with success at the Bunten, the Inten, and, after 1945, with the Nitten. Member of the Japan Art Academy. In later life occasionally did realistic animals or scenes taken from everyday life, all under the influence of Meunier and Rodin; but his major work consisted of rather sensual bronze nudes which at times show the influence of Maillol. **Coll.**: National (5). **Bib.**: GNB 28, NBT 10, NBZ 6, *Posthumous* (1), Uyeno.

¹藤井浩祐

Fujikawa Yūzō¹ (1883–1935). **Biog.**: Western-style sculptor. Born in Takamatsu to a family of lacquerers. After graduating from the Tōkyō School of Fine Arts in 1908, left for Paris, where he became first a pupil of and later an assistant to Rodin. Returned to Japan in 1916; in 1919 helped organize the sculpture section of the Nikakai. Introduced Rodin's work to Japan. Member of the Imperial Fine Arts Academy.

His sensitive work reflects his master's influence. **Coll.:** Kanagawa, National (5), Tōkyō (1). **Bib.:** Asano, GNB 28, *Masterpieces* (4), Munsterberg (1), NB (H) 24, NBT 10, NBZ 6, SBZ 11.

¹藤川勇造
Fujimaki Yoshio¹ (1909–35). **Biog.:** Western-style printmaker. Born in Gumma-ken. His prints, sometimes depicting sad, poetic scenes, show the influence of cubism. **Bib.:** NBZ 6, NHBZ 7, UG 11.

¹藤牧義夫
Fujimaro¹ (1790–1850). *N.:* Kitagawa Fujimaro.² *Gō:* Hōshū,³ Kōkasai,⁴ Shihō.⁵ **Biog.:** Ukiyo-e painter, printmaker. Known only by a number of *bijinga*. From the style of his figures, influenced by Utamaro, but the backgrounds show elements of Kanō and even *nanga* influence. **Coll.:** Allen, Tōkyō (2). **Bib.:** Hillier (1); Morrison 2; *Nikuhitsu* (1) 2, (2); Tajima (7) 5.

¹藤麿 ²北川藤麿 ³芳州 ⁴紅霞斎 ⁵紫峰
Fujimori Shizuo¹ (1891–1943). **Biog.:** Printmaker. Born in Kyūshū. Friend of Onchi Koshirō and a close follower, but his work was never abstract. With Onchi, founded the magazine *Tsukubae*. An early expressionist. **Coll.:** Fine (California). **Bib.:** NBZ 6, UG 14.

¹藤森静雄
Fujinobu¹ (fl. 1750–70). *N.:* Yamamoto Fujinobu.² **Biog.:** Ukiyo-e printmaker. An artist about whom there is considerable confusion. Thought to have been a pupil of Nishimura Shigenaga; much influenced by Harunobu. Prints with this signature seem always to have been published by the well-known ukiyo-e publisher Yamamoto (Maruya) Fusanobu (q.v.), thereby giving rise to the theory that Fujinobu was the pseudonym of the publisher. Prints by this artist, generally in the style of Harunobu, are very rare. **Coll.:** Allen, British, Honolulu, Musée (1), Victoria. **Bib.:** Binyon (3), Ficke, Hillier (9), Michener (3), Waterhouse.

¹藤信 ²山本藤信
Fujishima Takeji¹ (1867–1943). **Biog.:** Western-style painter. Born in Kagoshima. At 15 started his career by studying Shijō painting with Kawabata Gyokushō. In 1890 shifted to study of Western-style painting at Tōkyō School of Fine Arts under Matsuoka Hisashi. Also a pupil of Nakamaru Seijūrō, Soyama Sachihiko, and Yamamoto Hosui. First showed with the Meiji Bijutsukai. In 1896, became a member of the Hakubakai and an assistant professor at his alma mater. In 1905 to Europe; studied with Fernand Cormon and Carolus-Duran. Traveled and painted in Italy. Returned to Japan in 1910; became professor at Tōkyō School of Fine Arts. In 1937, member of Imperial Art Academy and received Order of Cultural Merit. Active in both Bunten and Teiten. His style, much influenced by Manet, also shows touches of fauvism; skillful at rendering light and atmosphere. His paintings done in Europe, worked in broad brush strokes, have the immediacy of much impressionist work; those of later years more decorative. Had great influence on Western-style painting in Japan; is considered one of best Japanese painters in oil. **Coll.:** Bridgestone, Kyōto (1), Nagaoka, National (5), Ohara (1), Tōkyō (2). **Bib.:** Asano, BK 192, Harada Minoru, Kondō (6), *Kurashina* (2), *Masterpieces* (4), Miyagawa, Munsterberg (1), NB (H) 24, NB (S) 30, NBT 10, NBZ 6, NKKZ 3, SBZ 11, Uyeno.

¹藤島武二
Fujita Bunzō¹ (1861–1934). **Biog.:** Western-style sculptor. Studied in Tōkyō with Vincenzo Ragusa at the Kōbu Daigaku Bijutsu Gakkō, where his fellow student and future colleague was Ōkuma Ujihiro. Subsequently taught at the Tōkyō School of Fine Arts; later founded an art school for women. Represented the official style, making many portraits in a strictly Western academic and realistic manner. **Bib.:** Asano, NBZ 6, NB (H) 24.

¹藤田文藏

Fujita Tsuguji (Tsuguharu)¹ (1886–1968). **Biog.:** Western-style painter. Born in Tōkyō. Graduated from Tōkyō School of Fine Arts in 1910. In 1913 to France to stay for 16 years; returned briefly to Japan but after 1930 lived in France for various periods, becoming a naturalized Frenchman in 1955. Often considered as a member of the prewar School of Paris; one of the few Japanese painters working in the Western manner to have an international reputation. In Japan, a member of the Nikakai; in France, of the Salon d'Automne. In 1942 received Asahi Culture Prize. Specialized in female figures, but also did still lifes and landscapes; his scenes are French, his models European, his line Japanese. Painted in a delicate high-keyed palette. His pictures have a feline quality. **Coll.:** Bridgestone, Fine (California), Herron, Honolulu, Musée (3), Nagaoka, National (5), Ohara (1), Rhode Island, Tōkyō (2). **Bib.:** Asano, *Masterpieces* (4), Miyagawa, NB (H) 24, NBT 10, NBZ 6, NKKZ 7, SBZ 11.

¹藤田嗣治
Fujiwara Kei¹ (1899–). **Biog.:** Bizen potter. Also a poet. Born in Bizen. In 1932 built a kiln at Bizen and since then has devoted himself to the study of Bizen ware, sharing the leadership in the Bizen style with Kaneshige Tōyō. Member of Nihon Kōgeikai; a Living National Treasure. Works with Bizen clay; his work, though following the old Bizen tradition, yet has a fresh contemporary spirit. **Coll.:** National (4). **Bib.:** Adachi, Lee (3), *Masterpieces* (4), Munsterberg (2), STZ 16.

¹藤原啓
Fukada Chokujō¹ (1861–1947). *N.:* Fukada.² *A.:* Shisen.³ *Gō:* Chokujō,⁴ Shūgetsu.⁵ **Biog.:** Japanese-style painter. Born in Ōtsu, Shiga-ken. In Kyōto, studied under Morikawa Sōbun and taught briefly at a painting school. In 1886 moved to Ōsaka to teach and paint. Specialized in landscapes, *kachōga*, and fish.

¹深田直城 ²深田 ³子簽 ⁴直城 ⁵秋月
Fukae¹ (fl. c. 970). *N.:* Kose no Fukae.² **Biog.:** Kose painter. Son of Kose no Kimmochi. Specialized in Buddhist subjects.

¹深江 ²巨勢深江
Fukazawa Sakuichi¹ (1896–1946). **Biog.:** Printmaker. Produced prints and book jackets first in a Western style, later in a Japanese style. **Bib.:** UG 14.

¹深沢索一
Fukuda Bisen¹ (1875–1963). *N.:* Fukuda Shūtarō.² *Gō:* Bakusen,³ Bisen.⁴ **Biog.:** Japanese-style painter. Born in Hyōgo-ken. Pupil of Kubota Beisen and Hashimoto Gahō; began exhibiting in 1900. Member of Kokuga Gyokuseikai and an adviser of the Bijutsu Kenseikai. In 1909 to China to study Chinese painting, especially the work of Shih T'ao. Produced screens for the Daikaku-ji and the Jingo-ji in Kyōto; for the Minatogawa-jinja in Kōbe did a ceiling painting as well. Specialized in landscapes. **Coll.:** Daikaku-ji, Jingo-ji, Minatogawa-jinja.

¹福田眉仙 ²福田周太郎 ³麦仙 ⁴眉仙
Fukuda Heihachirō¹ (1892–1972). **Biog.:** Japanese-style painter. Born in Ōita-ken, worked in Kyōto. Studied at Kyōto College of Fine Arts, where he later became a professor. In 1919, showed with the first exhibition of the Teiten; subsequently with the Nitten. Winner of Mainichi Art Prize in 1949. Member of Japan Art Academy. Received Order of Cultural Merit in 1961. One of most important and independent figures in the contemporary Japanese-style painting world. His later work an interesting and attractive blend of Japanese and Western modes. **Coll.:** Kyōto (1), National (5). **Bib.:** Asano, *Masterpieces* (4), Nakamura (1), NB (H) 24, NBT 10, NBZ 6, SBZ 11, Yokokawa.

¹福田平八郎
Fukuda Kinkō¹ (?–1904). *N.:* Fukuda Han (Susumu).² *A.:* Kunjō.³ *F.N.:* Hanjirō.⁴ *Gō:* Chikuen,⁵ Kinkō.⁶ **Biog.:** Na-

gasaki painter. Pupil of a son of Kumashiro Yūhi; the last Nagasaki-school painter to study the style of Shen Nan-p'in.

¹福田錦江 ²福田範 ³君常 ⁴範二郎 ⁵竹園 ⁶錦江

Fukuda Kōko[1] (1883–1959). *N.:* Fukuda Kōji.[2] *Gō.:* Kōko,[3] San'ōshi.[4] **Biog.:** *Nanga* painter. Born in Tōkyō. In 1897 became a pupil of Satake Eiko. In 1899 exhibited with Nihon Bijutsu Kyōkai; after 1914 with the Bunten. In 1930 joined the Nihon Nangain under the leadership of Komuro Suiun. In 1938 established the Nanga Remmei (Nanga League) and, after 1945, helped revive the Nihon Nangain. **Coll.:** National (5). **Bib.:** Asano.

¹福田浩湖 ²福田浩治 ³浩湖 ⁴三応子

Fukuda Suikō[1] (1895–). **Biog.:** Japanese-style painter. Born and worked in Kyōto. Graduate of the Kyōto Municipal School of Fine Arts and Crafts. Pupil of Nishiyama Suishō. Exhibitor at government shows and the Nitten. Traditional style. **Coll.:** National (5).

¹福田翠光

Fukui Kōtei[1] (1856–1938). *N.:* Fukui Shinnosuke.[2] *Gō:* Kōtei,[3] Tenshindō.[4] **Biog.:** Japanese-style painter. First studied Western-style painting; then became a pupil of Kawabata Gyokushō. Juror of the Nihongakai. In 1900 with Hirafuku Hyakusui and Yūki Somei established the Museikai. Taught at the Tōkyō School of Fine Arts. In 1907, in 14 1/2 hours, painted a picture for each one of 1,224 guests at a summer party: a remarkable feat of dexterity. An able painter of *kachōga* and landscapes. **Bib.:** Asano, BK 184, Morrison 2.

¹福井江亭 ²福井信之助 ³江亭 ⁴天真堂

Fukuoka Seiran[1] (1879–1954). *N.:* Fukuoka Yoshio.[2] *Gō:* Seiran.[3] **Biog.:** Japanese-style painter. Born in Kumamoto-ken. In 1903 graduated from Tōkyō School of Fine Arts, Japanese-style painting division. In 1927 became a teacher at the Ōsaka Art School and in 1935 a member of the Seiryūsha. **Coll.:** National (5). **Bib.:** Asano.

¹福岡青嵐 ²福岡義雄 ³青嵐

Fukuzawa Ichirō[1] (1898–). **Biog.:** Western-style painter. Born in Gumma-ken. After studying at Tōkyō University, turned to sculpture and worked from 1918 to 1919 under Asakura Fumio. To France in 1924, remaining there as a student of painting for six years. On his return, joined the Dokuritsu Bijutsu Kyōkai (where he exhibited surrealist paintings he had done in France); in 1939 helped found the Bijutsu Bunka Kyōkai. Frequent prize winner at foreign exhibitions during the 50s. In 1956, received the Education Minister's Prize for Fostering the Arts. His work first influenced by French postimpressionism; later showed the more violent and abstract tendencies of the times. **Coll.:** Kanagawa, National (5). **Bib.:** Asano, Kung, NB (H) 24, NBT 10, NBZ 6, SBZ 11.

¹福沢一郎

Fukuzō[1] (fl. 1394–1427). **Biog.:** Lacquerer. Said to have revived the Negoro-nuri technique. **Bib.:** Herberts, Jahss.

¹福蔵

Fumai[1] (1751–1818). *N.:* Matsudaira Harusato.[2] *Gō:* Fumai,[3] Ichiichisai,[4] Ikkanshi.[5] **Biog.:** Painter, potter. Also tea master. Seventh-generation head of Matsudaira family, feudal lords of Izumo; relative of the Tokugawa; noted for his good government of the Matsue fief. In 1806, retired from office to study tea ceremony under Hanjūan Kōtaku. Eventually started his own school: Sekishu-ryū Fumai-ryū.[6] Also studied Zen, receiving the Zen name Sōnō.[7] A tea hut called the Fumai-ken[8] at the Gokoku-ji, Tōkyō, is attributed to him. Better known as a tea master than as an artist. His paintings are in the *zenga* manner; as a potter, working near Matsue, made Rakuzan ware.

¹不昧 ²松平治郷 ³不昧 ⁴一々斎 ⁵一閑子
⁶石州流不昧流 ⁷宗納 ⁸不昧軒

Furukawa Ryūsei[1] (1894–1968). **Biog.:** Western-style printmaker. Born and lived in Tochigi-ken. In 1924 graduated from the Tōkyō School of Fine Arts, Japanese-style painting department; having studied printmaking by himself, in the same year exhibited with the Nihon Hanga Kyōkai. In 1927 showed for the first time with the Shun'yōkai. Long a member of both these associations and a frequent exhibitor. His rather delicate nostalgic prints, frequently of street scenes, are related to Western postimpressionism. **Coll.:** Cincinnati. **Bib.:** Kawakita, NHBZ 8, UG 4.

¹古川龍生

Fusanobu[1] (fl. 1750–70). *N.:* Tomikawa (originally Yamamoto)[2] Fusanobu.[3] *F.N.:* Kyūzaemon.[4] *Gō:* Fusanobu,[5] Ginsetsu,[6] Hyakuki.[7] *Store name:* Maruya.[8] **Biog.:** Ukiyo-e printmaker. Born in Nihombashi, Edo; moved to Hongō, Edo. Studied under Nishimura Shigenaga. A dealer in *nishiki-e* and a publisher in Ōdemma-chō, Edo. After his firm went bankrupt, turned to printmaking. May possibly be the same artist as Fujinobu (q.v.). Illustrated a few small books and made a few attractive *hosoban* prints. **Coll.:** Allen, Art (1), Tōkyō (1). **Bib.:** Binyon (3), Gunsaulus (1), Hillier (1), Kikuchi.

¹房信 ²山本 ³富川房信 ⁴九左衛門
⁵房信 ⁶吟雪 ⁷百亀 ⁸丸屋

Fusataka[1] (fl. 18th c.). *N.:* Kajikawa Fusataka.[2] **Biog.:** Lacquerer. Probably fourth-generation head of the Kajikawa family of lacquer artists. Served the shogunate. **Bib.:** Herberts, Jahss.

¹房高 ²梶川房高

Fusatane[1] (fl. 1849–70). *N.:* Utagawa (originally Murai)[2] Seima.[3] *Gō:* Fusatane,[4] Ippyōsai,[5] Isshōsai,[6] Ōsai.[7] **Biog.:** Ukiyo-e printmaker. Pupil of Utagawa Sadafusa. Specialized in *bijinga* and landscapes. Influenced by Hiroshige. A mediocre artist. **Coll.:** Musées, Newark, Riccar, University (2), Victoria, Worcester. **Bib.:** Binyon (3), Crighton, Nonogami.

¹房種 ²村井 ³歌川静馬 ⁴房種
⁵一飄斎 ⁶一笑斎 ⁷桜斎

Fuse Shintarō[1] (1899–1965). **Biog.:** Western-style painter. Born in Miyagi-ken. Went to Tōkyō to study under Nakamura Fusetsu. Joined the Taiheiyō Gakai in 1902; when this became an accredited art school, joined the teaching staff. Exhibited with the Teiten.

¹布施信太郎

Fuyō[1] (1722–84). *N.:* Kō (originally Ōshima)[2] Mōhyō.[3] *A.:* Juhi.[4] *F.N.:* Ikki,[5] Kondō Saigū.[6] *Gō:* Chūgakugashi,[7] Fumin Sambō,[8] Fuyō,[9] Hyōgaku Sanjin,[10] Kantan no Kyo (Kantōkyo),[11] Kō Fuyō.[12] **Biog.:** *Nanga* painter. Born in Kai; worked in Kyōto; died in Edo. A Confucian scholar and man of letters, serving Lord Shishido in his later years. Intimate friend of Ikeno Taiga. Studied Yüan and Ming paintings, developing his own style. Did only a few paintings and those mediocre, but was skilled in seal engraving. **Coll.:** Ashmolean. **Bib.:** K 515, 717, 740; Mitchell; OA 13.

¹芙蓉 ²大島 ³高孟彪 ⁴孺皮 ⁵逸記
⁶近藤斎宮 ⁷中summary畫史 ⁸富岻山房 ⁹芙蓉
¹⁰氷壑山人 ¹¹茜苕居 ¹²高芙蓉

Fuyō[1] (1749–1816). *N.:* Suzuki Yō.[2] *A.:* Bunki.[3] *F.N.:* Shimbei.[4] *Gō:* Fuyō,[5] Rōren.[6] **Biog.:** *Nanga* painter. Also skilled in writing prose and poetry. Born in Shinano; went to Edo and is said to have studied under Tani Bunchō. Also studied Chinese painting. Later served Lord of Awa. Specialized in landscapes and figures. **Coll.:** British, Denver, Museum (3), Victoria. **Bib.:** *Dessins*, Holloway, Mitchell, Morrison 2.

¹芙蓉 ²鈴木雍 ³文熙 ⁴新兵衛 ⁵芙蓉 ⁶老蓮

Fūyō[1] (fl. 1789–1801). *Gō:* Hōgokujin,[2] Fūyō.[3] **Biog.:** Ukiyo-e printmaker. Details of life unknown. Made prints of *bijin* and Chinese figures, showing the influence of Kiyonaga. **Coll.:** Albertina, Musées, Tōkyō (1).

¹風養 ²峯谷人 ³風養

G

Gako[1] (1816–70). *N.:* Suzuki Takeshi (Yū).[2] *A.:* Yūhi.[3] *F.N.:* Zenzō.[4] *Gō:* Gako,[5] Gako Sanjin,[6] Ichiō,[7] Kakō Shinsho,[8] Suiun Sambō,[9] Tōdai Sanroku.[10] **Biog.:** *Nanga* painter. Born in Shimōsa Province; went to Edo, where he studied first under Tani Bunchō and, after Bunchō's death, with another *nanga* painter. A skillful painter of landscapes and *kachōga.* **Bib.:** Mitchell.

[1]鷺湖　[2]鈴木雄　[3]雄飛　[4]漸造　[5]鷺湖　[6]我古山人
[7]一鷺　[8]花香深処　[9]水雲山房　[10]東台山麓

Gakuō[1] (fl. 1504–20). *Gō:* Gakuō.[2] *Posthumous name:* Zōkyū.[3] **Biog.:** Muromachi *suiboku* painter. A Zen priest about whom little is known. Came from Ise. Friend of the priest Ryōan Keigo (whose inscriptions appear on many of Gakuō's paintings) at the Tōfuku-ji, Kyōto. Was honored with posthumous title of Zōkyū. Influenced by style of Shūbun, Sōtan, and the Southern Sung school, though his work shows a greater emphasis on color than on line. **Coll.:** Freer, Baltimore, Metropolitan, Tōkyō (1). **Bib.:** BI 61; BK 82; *Freer;* GNB 11; HS 5, 6, 11; K 81, 206, 300, 312, 391, 417, 440, 523, 651, 661; Matsushita (1), (1a); Mayuyama; Morrison 1; *Muromachi* (1); NB (S) 13; NBT 4; NBZ 3; NKZ 21; Shimada 1; Tajima (13) 3; Tanaka (2).

[1]岳翁　[2]岳翁　[3]藏丘

Gakusen[1] (1820–87/99). *N.:* Ōba[2] (originally Miyoshi).[3] *A.:* Ōkaku.[4] *F.N.:* Kichishirō.[5] *Gō:* Gakusen,[6] Nankō,[7] Tampakuan Mutoku.[8] **Biog.:** Japanese-style painter. Born in Nagato Province. Studied first under a local artist; later to Kyōto to study under Oda Kaisen. Returned home at 30; became a samurai in the service of the Mōri clan. After the Meiji Restoration, resumed career as an artist in Tōkyō. In 1882 served as a juror for the first Naikoku Kaiga Kyō-shinkai; at the second, exhibited his work and won a prize. The date of his death uncertain. One of the many artists who worked on the decoration of the Meiji-era Imperial Palace. A good painter of landscapes and *kachōga.* **Bib.:** Mitchell, NBZ 6.

[1]学僊（学仙）　[2]大庭　[3]三好　[4]王鶴　[5]吉四郎
[6]学僊（学仙）　[7]南江　[8]淡白庵無徳

Gakutei[1] (1786?–1868). *N.:* Yashima (originally Sugawara)[2] Harunobu[3] (later Sadaoka).[4] *A.:* Hōkyō.[5] *F.N.:* Maruya Onokichi.[6] *Gō:* Gakutei,[7] Gakutei Gogaku,[8] Gakuzan,[9] Gogaku,[10] Horikawa Tarō (used as an author),[11] Ichirō,[12] Kaguradō,[13] Kōen,[14] Nanzan,[15] Ryōsa,[16] Shingakudō,[17] Shinkadō,[18] Yōsai,[19] Yōtei.[20] **Biog.:** Ukiyo-e printmaker. Native of Edo, but lived in Ōsaka in the 30s. Studied under Tsutsumi Shuei and Iwakubo Hokkei; much influenced by Hokusai. Also a *kyōka* poet, putting his own poems on his prints. Known as the adapter from Chinese to Japanese of *Hsi-yu Chi* (Journey to the West), a 16th-century novel, with illustrations. More famous in Japan as a writer than an artist; popular in his time. A good craftsman, made many excellent *surimono* and book illustrations. His landscapes of Ōsaka are quite delicate and decorative. **Coll.:** Albertina, Allen, Ashmolean, British, Brooklyn, Fitzwilliam, Fogg, Freer, Honolulu, Metropolitan, Minneapolis, Musée (2), Musées, Nelson, Newark, Philadelphia, Portland, Rhode Island, Rijksmuseum (1), Staatliche, Tōkyō (1), Victoria, Worcester. **Bib.:** ARTA 9; Binyon (1), (3); Crighton; *Dessins;* Ficke; Keyes; *Kunst;* Meissner; Michener (3); Morrison 2; *Nikuhitsu* (2); Robinson (2); Schmidt; UG 14.

[1]岳亭（岳鼎）　[2]菅原　[3]八島春信　[4]定岡　[5]鳳卿
[6]丸屋斧吉　[7]岳亭（岳鼎）　[8]岳亭五岳　[9]岳山　[10]五岳
[11]堀川多楼　[12]一老　[13]神楽堂　[14]黄園　[15]南山
[16]梁左　[17]神応堂　[18]神歌堂　[19]陽斎　[20]陽亭

Ganhi (Gampi)[1] (fl. late 18th c.). *N.:* Hirowatari Gi.[2] *A.:* Ganhi (Gampi).[3] *F.N.:* Tōichi.[4] *Gō:* Getchūsai,[5] Koshū.[6]

Biog.: Nagasaki painter. Lived in Nagasaki. Pupil of Kumashiro Yūhi. **Coll.:** Musées, Victoria. **Bib.:** Mitchell.

[1]厳斐　[2]広渡儀　[3]厳斐　[4]稲一　[5]月仲斎　[6]湖秀

Gankei[1] (1811–48). *N.:* Kishi Gankei.[2] *A.:* Shizen.[3] *Gō:* Taigaku.[4] **Biog.:** Kishi painter. Eldest son of Kishi Gantai. Lived and worked in Kyōto. **Bib.:** Mitchell, Morrison 2.

[1]岸慶　[2]岸慶　[3]士善　[4]台岳

Ganku[1] (1749/56–1838). *N.:* Kishi (originally Saeki Masaaki)[2] Ku (Koma).[3] *A.:* Funzen.[4] *F.N.:* Utanosuke.[5] *Gō:* Dōkōkan,[6] Ganku,[7] Kakandō,[8] Kayō,[9] Kotōkan,[10] Kyūsōrō,[11] Tansai,[12] Tenkaikutsu.[13] **Biog.:** Kishi painter. Born in Kanazawa. In 1773 to Kyōto; became a retainer of Prince Arisugawa; in 1804 entered imperial court as an official and was appointed Echizen no Suke (honorary governor of Echizen). From 1809 to 1813 lived in Kanazawa; finally settled at Iwakura, near Kyōto, and changed family name of Saeki to Kishi. First studied Kanō style painting; then worked in the manner of Shen Nan-p'in; finally, under influence of Maruyama and Shijō schools, changed his original manner, developed a rather rough and vigorous style, and founded the Kishi school. (Pictures painted prior to 1804 and signed Utanosuke Ganku are rare.) Great technical skill; a famous painter of animals, especially tigers, which have an almost Western weight and solidity. **Coll.:** Art (1), Ashmolean, Detroit, Freer, Itsuō, Manshu-in, Metropolitan, Museum (3), Newark, Royal (1), Stanford, Victoria. **Bib.:** Brown; Fenollosa; Hillier (4) 3; K 117, 151, 164, 191, 258, 262, 362, 466, 527; Mitchell; Morrison 2; NBZ 5; *One* (2); Paine (2) 1; Shimada 2; Tajima (12) 3, 8, 9, 13, 14, 20; Tajima (13) 6.

[1]岸駒　[2]佐伯昌明　[3]岸駒　[4]賁然　[5]雅楽之助
[6]同巧館　[7]岸駒　[8]可観堂　[9]華陽　[10]虎頭館
[11]鳩巣楼　[12]篁斎　[13]天開屈

Ganrei[1] (1816–83). *N.:* Kishi Rei.[2] *A.:* Sakon Shōsō,[3] Shitei.[4] *Gō:* Ganrei,[5] Hokuhō,[6] Umpō.[7] **Biog.:** Kishi painter. Born in Kyōto. Son of Kishi Gantai, pupil of his father and his brother Gankei. After 1868 moved to Tōkyō, living there for the rest of his life. Received court rank of Sakon Shogen. Skilled painter of figures and *kachōga.* **Coll.:** Ashmolean, Museum (3). **Bib.:** Mitchell, Morrison 2.

[1]岸礼　[2]岸礼　[3]左近将曹　[4]士弟　[5]岸礼　[6]北鵬　[7]雲峰

Ganryō[1] (1798–1852). *N.:* Kishi Ryō[2] (originally Hamaya Gorō,[3] then Saeki Ryō).[4] *A.:* Shiryō.[5] *F.N.:* Utanosuke.[6] *Gō:* Ganryō,[7] Gaunrō.[8] **Biog.:** Kishi painter. Pupil, nephew, then adopted son of Kishi Ganku. Like his uncle, a retainer of Prince Arisugawa and attached to the imperial court. (His *gō* Ganryō is the Sino-Japanese reading of Kishi Ryō.) A minor follower of Ganku, painting figures and *kachōga.* **Coll.:** Ashmolean, Metropolitan, Musée (2), Museum (3), Victoria. **Bib.:** AA 14, Brown, Mitchell, Morrison 2.

[1]岸良　[2]岸良　[3]浜谷五郎　[4]佐伯良
[5]士良　[6]雅楽之助　[7]岸良　[8]画雲楼

Gansei[1] (1827–67). *N.:* Kishi Sei.[2] *Gō:* Gansei,[3] Sampō.[4] **Biog.:** Kishi painter. Third son and pupil of Kishi Gantai. Lived and worked in Kyōto. **Bib.:** Mitchell, Morrison 2.

[1]岸誠　[2]岸誠　[3]岸誠　[4]三峰

Ganshō[1] (1798–1859). *N.:* Kamada (Kamata) Shikan.[2] *Gō:* Ganshō,[3] Shūitsu.[4] **Biog.:** Shijō painter. First a pupil of Mori Sosen, then of Nakai Rankō. An able painter of figures, *kachōga,* and animals.

[1]巌松　[2]鎌田子寛　[3]巌松　[4]秀一

Gantai[1] (1782–1865). *N.:* Kishi (originally Saeki)[2] Tai.[3] *A.:* Kogaku,[4] Kunchin.[5] *F.N.:* Chikuzennosuke.[6] *Gō:* Dōkōkan,[7] Gantai,[8] Shisui,[9] Takudō.[10] **Biog.:** Kishi painter. Lived in Kyōto. Son and pupil of Kishi Ganku. In 1809, with his father to Kanazawa, spending a year there in work on the painting for the new Kanazawa Castle. Later given

title of Echizen no Kami. Painted landscapes, *kachōga,* and animals, especially tigers. With his brother Renzan kept alive the painting tradition of his father. **Coll.:** Ashmolean, Imperial (1), Museum (3), Victoria. **Bib.:** Brown; Hillier (4) 3; Mitchell, Morrison 2; Tajima (12) 6, 12, 14, 16, 18; Tajima (13) 6.
¹岸岱 ²佐伯 ³岸岱 ⁴虎岳 ⁵君鎮 ⁶筑前介
⁷同功房 ⁸岸岱 ⁹柴水 ¹⁰卓堂

Gasui¹ (fl. 1804–17). *N.:* Tate (Tachi) Sensuke² (originally Junsuke).³ *Gō:* Gasui.⁴ **Biog.:** Lacquerer. First studied painting in Kyōto. Then at Wajima, on the Noto Peninsula, became famous for his *chinkin-bori* lacquer. Also known for his *haiku.* **Bib.:** M 188, Ragué.
¹雅水 ²館専助 ³順助 ⁴雅水

Geiami¹ (1431–85). *N.:* Nakao Shingei.² *Gō:* Gakusō,³ Geiami.⁴ **Biog.:** Muromachi *suiboku* painter. Also a poet. Son and pupil of Nōami; father of Sōami. Lived in Kyōto. All three served the Ashikaga shogunate as *dōbōshu,* or attendants in charge of miscellaneous personal and artistic affairs of the shoguns. The three together are known as the Ami school of painting. Geiami's painting *Viewing the Waterfall* in the Nezu Museum is dated 1480. His style, based on that of Shūbun, is noted for the strongly contrasting darks and lights, and his subjects are secular. **Coll.:** Museum (3), Nezu. **Bib.:** GNB 11; Hisamatsu; HS 4; K 29, 114; Matsushita (1); Morrison 1; NB (S) 13, 63; NBZ 3; Noma (1) 1; *One* (2); Shimada 1; Tajima (12) 2, 13; Tajima (13) 3; Tanaka (2); Yashiro (1) 2.
¹芸阿彌 ²中尾真芸 ³学叟 ⁴芸阿彌

Gejō Keikoku¹ (1842–1920). *N.:* Gejō (Shimojō) Masao.² *Gō:* Keikoku.³ **Biog.:** *Nanga* painter. Born in Yonezawa, Yamagata-ken, as the son of a daimyo. Served in the navy; on retirement in 1897 became a member of the House of Peers. Lived in Tōkyō. Noted as an expert on Chinese Sung painting. Member of Nihon Bijutsu Kyōkai, acting as juror for its exhibiting agency, the Tenrankai; served on the board of what is now the Tōkyō National Museum. Specialized in landscapes. **Bib.:** Asano, NBZ 6.
¹下條桂谷 ²下條正雄 ³桂谷

Gekko (Getsuko)¹ (fl. late 18th to early 19th c.). *N.:* Chin (originally Ōtomo)² Kiyoshi.³ *Gō:* Gekko (Getsuko).⁴ **Biog.:** Nagasaki painter. Born and worked in Nagasaki. Pupil of Kumashiro Yūhi. Eventually took the new family name of Chin so his complete name would make the poetic phrase "to sink into the moonlit lake."⁵ Specialized in painting animals. **Coll.:** Art (1), Kōbe. **Bib.:** Mody, *Pictorial* (2) 5.
¹月湖 ²大友 ³沈清 ⁴月湖 ⁵沈月湖

Gekkōsai¹ (fl. c. 1840). *N.:* Ishida Tadashi.² *A.:* Jobi.³ *F.N.:* Hambei (Hanbei).⁴ *Gō:* Gekkōsai.⁵ **Biog.:** Painter. Lived in Edo. Son of the playwright Santō Kyōden. Specialized in Buddhist painting. **Bib.:** Mitchell.
¹月香斎 ²石田正 ³如眉 ⁴半兵衛 ⁵月香斎

Gembei¹ (fl. c. 1670–97). *N.:* Ikeda Gembei.² **Biog.:** Lacquerer. Born in Echizen. In 1670 entered service of lord of Tsugaru; in 1685 was sent to Edo to study under Seikai Kanshichi; unfortunately died before completing his studies. **Coll.:** Tōkyō (1), (2). **Bib.:** Herberts, Jahss, Ragué, Sawaguchi, Yoshino.
¹源兵衛 ²池田源兵衛

Gempin¹ (1587–1671). *N.:* Chin (Chinese: Ch'en) Gempin.² *Gō:* Chizan,³ Gempin,⁴ Kihaku Sanjin,⁵ Kikuhideken,⁶ Shōan.⁷ **Biog.:** Potter. A Chinese who came to Japan to escape from the political disorder in China. Served the lord of Owari (cadet house of Tokugawa family) in 1638. Worked in the Annamese style, painting poems and pictures under a pale-blue transparent glaze. **Coll.:** Freer, Metropolitan. **Bib.:** Jenyns (2).
¹元贇 ²陳元贇 ³芝山 ⁴元贇
⁵既白山人 ⁶菊秀軒 ⁷升庵

Gempo¹ (fl. c. 1815). *N.:* Somada (Somata) Gempo.² **Biog.:** Lacquerer. Lived at the Daisho-ji, Kaga. An outstanding craftsman. Produced wares with minute patterns made up of square-cut pieces of nacre and thin plates of gold and silver cut in scalene triangles. **Coll.:** Tōkyō (1). **Bib.:** Jahss, Yoshino.
¹玄甫 ²杣田玄甫

Genchin¹ (?–1795). *N.:* Yoshida.² *Gō:* Genchin.³ **Biog.:** Kanō painter. Lived in Kyōto, near the Kiyomizu-dera. Received titles of *hokkyō* and *hōgen.*
¹元陳 ²吉田 ³元陳

Genchō¹ (fl. 10th c.). *F.N.:* Asuka Genchō,² Gangōji Genchō.³ **Biog.:** Painter. Known from documents. Is said to have drawn figures on the background of an embroidered *mandara* belonging to the Tōdai-ji when it was being repaired.
¹玄朝 ²飛鳥玄朝 ³元興寺玄朝

Genchū¹ (1752–1813). *N.:* Matsui Daizō.² *Gō:* Genchū,³ Kazan.⁴ **Biog.:** Painter. Born in Nagasaki. Son and pupil of Matsui Keitoku. Also studied Chinese Ming and Ch'ing painting on his own. Specialized in landscapes and *kachōga.* **Coll.:** Kōbe. **Bib.:** *Pictorial* (2) 2.
¹元仲 ²松井代蔵 ³元仲 ⁴霞山

Gen'emon¹ (fl. c. 1644–47). *N.:* Kobayashi Gen'emon.² *Studio name:* Kagiya.³ **Biog.:** Potter. The first-generation head of the Kobayashi family of potters who worked at Awataguchi, Kyōto. From the third generation on, the family used the *gō* of Kinkōzan.⁴
¹源右衛門 ²小林源右衛門 ³鍵屋 ⁴錦光山

Gen'emon¹ (1791–1863). *N.:* Aoya Gen'emon.² **Biog.:** Kutani potter. Pupil of Honda Teikichi. Employed in the revival of the Kutani kiln organized by Toyoda Den'emon, a rich merchant of Daishōji and an amateur poet and painter. This merchant's store name, Yoshidaya, was given to the Kutani kiln at the time of Gen'emon's activity. Later worked at the nearby Rendaiji kiln, producing wares similar to the Yoshidaya; also made Raku-type pottery. **Coll.:** Museum (3). **Bib.:** BMFA 45, Jenyns (1), NB (S) 71.
¹源右衛門 ²粟生屋源右衛門

Genga¹ (fl. early 16th c.). **Biog.:** Muromachi *suiboku* painter. Member of Sōtan's circle. Beyond this, nothing known of his life. Left several fan pictures with miscellaneous themes. **Coll.:** Freer, Metropolitan. **Bib.:** KO 24, Matsushita (1a), *Muromachi* (1), NB (S) 63.
¹元賀

Gengendō¹ (1786–1867). *N.:* Matsumoto Yasuoki.² *F.N.:* Gihei.³ *Gō:* Gengendō.⁴ **Biog.:** *Yōga* printmaker. Pupil of Nakaya Isaburō. Also influenced by the engravings of Aōdō Denzen and Shiba Kōkan. Produced copperplate engravings of Edo and Ōsaka in a rather Western manner. **Bib.:** Fujikake (3) 3, NBZ 6.
¹玄々堂 ²松本保居 ³儀平 ⁴玄々堂

Gengyo¹ (1817–80). *N.:* Miyagi Gengyo.² *Gō:* Baiso Gengyo,³ Baisotei,⁴ Fūen,⁵ Katōshi,⁶ Suisenshi.⁷ **Biog.:** Ukiyo-e printmaker. Held an official position under the *bakufu.* Among his prints are many depicting foreigners in Japan. **Coll.:** Philadelphia. **Bib.:** *Foreigners.*
¹玄魚 ²宮城玄魚 ³梅素玄魚 ⁴梅素亭
⁵楓園 ⁶蜊蚪子 ⁷水仙子

Genjō (Kurokami)¹ (856–933). *N.:* Fujiwara no Genjō (Kurokami).² **Biog.:** Painter. Known from literary records as a poet and courtier as well as a painter.
¹玄上 ²藤原玄上

Genju¹ (fl. second half 14th c.). *Priest name:* Taikyo.² *Gō:* Genju.³ **Biog.:** Muromachi *suiboku* painter. A Zen priest, disciple of Yakuō Tokken (1248–1319); later went to China for further Zen study. On his return lived for a while at the Fukugen-ji near Kōbe. Is known to have traveled to Kamakura in 1374. His paintings are extremely rare. **Coll.:** Yale. **Bib.:** AAA 20.
¹元寿 ²大虚 ³元寿

Genkei[1] (fl. mid-12th c.). **Biog.**: Sculptor. Son of Chōsei. Member of the Sanjō Bussho. Received title of *hokkyō*. His oeuvre is unknown today.

¹兼慶

Genkei[1] (fl. late 12th to early 13th c.). **Biog.**: Sculptor. Pupil of Kōkei. According to the inscription, Genkei and Dai Busshi Jōkei made the statue of Miroku Bosatsu, dated 1212, in the Kōfuku-ji, Nara, perhaps under the direction of Unkei. Rank of *hokkyō*. **Coll.**: Kōfuku-ji (1). **Bib.**: *Butsuzō, Kokuhō* 4, OZ 13.

¹源慶

Genkei[1] (fl. c. 1208–17). **N.**: Kose no Genkei.[2] **Biog.**: Kose painter. Said to have been son and pupil of Kose no Kaneshige and younger brother of Kose no Arimune. As a young man, took Buddhist vows. Eventually received honorary rank of *hōgen*. About 1208, according to literary records, worked on the *Shin Mandara* of the Taima-dera, Nara, with Takuma Ryōga, and in 1217 on another *mandara* for the same temple.

¹源慶 ²巨勢源慶

Genkei[1] (1648–1710). *Priest name:* Shōun.[2] **F.N.**: Kyūbei (Kyūhei).[3] **Gō**: Genkei.[4] **Biog.**: Sculptor. First worked as a lay sculptor of Buddhist images in Kyōto. Then became a disciple of Priest Tetsugen in Settsu. Made an oath, during a pilgrimage, to carve 500 Rakan statues; founded a temple to house these but died before the building was completed. Sometimes known as Shōun Zenji.[5] His work shows influence of Ming art. **Coll.**: Detroit, Rakkan-ji. **Bib.**: Kuno (1), (3).

¹元慶 ²松雲 ³九兵衛 ⁴元慶 ⁵松雲禅師

Genkei[1] (1698–1766?). **N.**: Araki Shuhō.[2] **A.**: Genkei.[3] **Biog.**: Nagasaki painter. Lived in Nagasaki; pupil of Watanabe Shūseki and Uesugi Keiō. Served as interpreter for the Dutch and as one of the *kara-e mekiki* for the local government. Often painted, quite amusingly, the Dutch ships at Nagasaki. **Coll.**: Kōbe. **Bib.**: Kuroda, Mody, *Pictorial* (2) 2.

¹元慶 ²荒木秀邦 ³元慶

Genki[1] (fl. 1664–98). **N.**: Kita Genki.[2] **F.N.**: Chōbei.[3] **Biog.**: *Yōga* painter. Lived in Nagasaki. Specialized in portraits of daimyo, warriors, Chinese interpreters, and priests, all done in a rather Western manner. **Coll.**: Cleveland, Kōbe, Kōfuku-ji (2). **Bib.**: BK 12, Mody, NBZ 5, NB (S) 47, *Pictorial* (2) 5.

¹元規 ²喜多元規 ³長兵衛

Genki[1] (1747–97). **N.**: Komai Ki.[2] **A.**: Shion.[3] **F.N.**: Yukinosuke.[4] **Gō**: Genki.[5] **Biog.**: Maruyama painter. Lived in Kyōto. One of Maruyama Ōkyo's ten best pupils. Used the name Genki because he claimed descent from the Minamoto (or Gen) family. Specialized in flowers and animals; was also celebrated for his exquisite paintings of women in Chinese dress—the so-called court-lady pictures—which show in subject matter the influence of the then popular contemporary Chinese style. **Coll.**: Daijō-ji (2), Freer, Metropolitan, Museum (3), University (2), Victoria. **Bib.**: Hillier (4) 3; K 12, 178, 286, 448, 478, 560, 581, 759, 945; Minamoto (1); Mitchell; Morrison 2; NBZ 5; *Nikuhitsu* (1) 2; *One* (2); Shimada 2; Tajima (3) 2; Tajima (12) 12, 14; Tajima (13) 6.

¹源琦 ²駒井源琦 ³子輯 ⁴幸之助 ⁵源琦

Genkoku[1] (fl. c. 1840). **N.**: Tō Gempi.[2] **A.**: Genkoku.[3] Painter. Native of Bizen Province. **Bib.**: Mitchell.

¹玄谷 ²藤玄費 ³玄谷

Genkyū[1] (fl. late 16th c.). **Biog.**: Painter. An assistant to Kanō Eitoku; worked in his master's style. **Bib.**: BK 51, 249.

¹元久

Genkyū[1] (fl. late 17th c.). **N.**: Yamamoto Genkyū.[2] **Biog.**: Sumiyoshi painter. Pupil of Sumiyoshi Gukei and Kanō Yasunobu. Worked in Kyōto. **Bib.**: *Rakuchū*.

¹元休 ²山本元休

Gennai[1] (1726–79). **N.**: Hiraga Kunitomo.[2] **Gō**: Fukunai

Kigai,[3] Fūrai Sanjin,[4] Gennai,[5] Kyūkei,[6] Mukonsō,[7] Shinra Banshōō,[8] Shōraishi,[9] Tenjiku Rōnin.[10] **Biog.**: *Yōga* painter. Also known as a botanist and writer of fiction. Born in Sanuki; sent by his lord on Shikoku to study the Dutch language and Western science at Nagasaki, where he also learned oil painting. First Japanese artist to be influenced by the importation to Nagasaki of European art by the Dutch traders. In 1773 invited to Akita to advise on copper mining; introduced oil painting to members of the Satake clan and particularly to their retainer Odano Naotake, establishing the Akita *ranga* style: a combination of the realism of 18th century China and the perspective and chiaroscuro of Dutch engravings. Much knowledge of contemporary Western culture; made Western art popular in Japan. Portraits of Dutch women his specialty. His style, really a naive aping of contemporary Western prints, of interest more as a curiosity than for its artistic merit. **Coll.**: Kōbe. **Bib.**: GNB 25, M 195, NB (H) 24, NBZ 5, Noma (1) 2, OZ 1929, *Pictorial* (2) 2, Rosenfield (1a), SBZ 10, Sohō, Sullivan, YB 49.

¹源内 ²平賀国倫 ³福内鬼外 ⁴風來山人 (風來散人) ⁵源内 ⁶鳩渓 (休慧) ⁷無根皇 ⁸森羅万象翁 ⁹松籟子 ¹⁰天笠浪人

Genroku[1] (fl. 1710–40). **N.**: Okumura Genroku.[2] **Biog.**: Ukiyo-e printmaker. Pupil and probably adopted son of Okumura Masanobu. Confusion in the past over the similarity of signatures between the *gō* of Masanobu and that of this artist; now generally agreed that all prints signed Genroku belong definitely to the younger man. After Masanobu started his business as a print publisher, Genroku joined him and seems to have stopped designing prints. The peak of his activity was from 1723 to 1724. **Coll.**: Riccar, Staatliche. **Bib.**: *Images*, Jenkins, Schmidt, Shibui (1).

¹源六 ²奥村源六

Gensei[1] (fl. c. 1162). **Biog.**: Sculptor. Known for a pair of door guardians, dated 1162, in the Takano-jinja. **Coll.**: Takano-jinja. **Bib.**: *Heian* (2).

¹厳成

Gensei[1] (1740–84). **N.**: Igarashi Chūben.[2] **Gō**: Gensei,[3] Hengen.[4] **Biog.**: Painter. Son and pupil of Igarashi Shummei. Specialized in figure painting.

¹元誠 ²五十嵐仲勉 ³元誠 ⁴片原

Gensen[1] (1689–1755). **N.**: Kanō Masanobu (Hōshin, Katanobu, Sukenobu).[2] **Gō**: Gensen.[3] **Biog.**: Kanō painter. Son and pupil of Kanō Tōshun Tominobu. Succeeded his father in the service of the shogunate as an *omote eshi*, representing the third generation of the Surugadai branch of the Kanō family. Produced pleasantly stately landscapes. **Coll.**: Museum (3). **Bib.**: *Kanō-ha*.

¹元仙 ²狩野方信 ³元仙

Genshi[1] (?–1792). **N.**: Yasuda Genshi.[2] **F.N.**: Kaemon,[3] Shinzō.[4] **Gō**: Sotei.[5] **Biog.**: Painter. Worked in Nagasaki. Pupil of Ishizaki Gentoku.

¹元糸 ²安田元糸 ³嘉右衛門 ⁴新藏 ⁵素亭

Genshin[1] (942–1017). **N.**: Genshin.[2] **F.N.**: Eshin Sōzu.[3] **Biog.**: A learned priest and, possibly, a painter. The author of a celebrated religious work *Ōjōyōshū* (Essentials of Salvation), which encouraged the faithful to seek salvation by calling on the name of Buddha. His teachings a forerunner to those of the Jōdo sect. The famous *Raigō*, kept in the Kōyasan Treasure House, was traditionally attributed to him but for many years has been considered to be of the late Fujiwara period. No other paintings can definitely be ascribed to him. In the West, he is generally known as Eshin Sōzu. **Bib.**: Akiyama (2); K 158, 224; Moriya; Morrison 1; NB (S) 43; *One* (2); Paine (4); Tajima (12) 12, 13, 14, 19.

¹源信 ²源信 ³恵心僧都

Genshirō[1] (fl. c. 1720–40). **N.**: Kiyomizu Genshirō.[2] **Biog.**: Ukiyo-e printmaker. Life unknown. Works rare, only one print known. **Coll.**: British. **Bib.**: Binyon (1), (3).

¹元四郎 ²清水元四郎

Genshō[1] (c. 1146–1206). *F.N.*: Kankambō.[2] *Gō*: Genshō.[3] **Biog.**: Buddhist painter. A monk of the Shingon sect; was trained at the Tō-ji, Kyōto, and the Kanjū-ji, southeast of Kyōto. Lived for a while at the Daigo-ji, near Kyōto; eventually became *ajari* of the Getsujō-ji on Kōyasan, where he died. One of a group of monks who sought to unify the various sects of Esoteric Buddhism. Copied sutras and religious paintings for Kōyasan. At some later date these were bound together and acquired such names as *Sentoku Zuzō* and *Mandara Zuzō*. His name is on a number of iconographic drawings and preliminary studies—presumably for use in a Buddhist-painting workshop—some of which are now in the Daigo-ji. **Coll.**: Daigo-ji, Gotō, Kōzan-ji (1). **Bib.**: K 59, 173; *Kokuhō* 3; M 210; NB (S) 33; NBT 4; Rosenfield (2); Shimada 1.

¹玄証 ²閑観房 ³玄証

Genshō[1] (1731–78). *N.*: Ishizaki Motoaki.[2] *A.*: Shiboku.[3] *F.N.*: Bunjūrō (Monjūrō).[4] *Gō*: Genshō.[5] **Biog.**: Nagasaki painter. Born in Nagasaki. Pupil, then adopted son of Ishizaki Gentoku. At 24 entered the family profession and was eventually appointed *kara-e mekiki*. His paintings generally depict the Dutch at Nagasaki. **Coll.**: Kōbe. **Bib.**: Mody, *Pictorial* (2) 2.

¹元章 ²石崎元章 ³士朴 ⁴文十郎 ⁵元章

Genshū[1] (1676–1735). *N.*: Watanabe Fumiaki.[2] *A.*: Bummei,[3] Hachirobei.[4] *Gō*: Genshū,[5] Shinsai.[6] **Biog.**: Nagasaki painter. Born in Nagasaki; son of Watanabe Shūgaku, under whom he studied. Served as *kara-e mekiki* to the *bakufu*.

¹元周 ²渡辺文明 ³文明 ⁴八郎兵衛 ⁵元周 ⁶真斎

Genson[1] (fl. mid-13th c.). *N.*: Kose no Genson.[2] **Biog.**: Kose painter. Son and pupil of Kose no Genkei. After his father's death, continued the work, with Takuma Ryōga, on the *Shin Mandara* of the Taima-dera. It is also recorded that in 1243 he worked with the sculptors Ryūen and Inshō on a commission for the ailing empress. Received rank of *hōin*.

¹源尊 ²巨勢源尊

Gentai (Genzui)[1] (1749–1822). *N.*: Watanabe (originally Uchida)[2] Ei.[3] *A.*: Enki.[4] *F.N.*: Matazō.[5] *Gō*: Gentai (Genzui),[6] Rinroku Sōdō,[7] Shōdai,[8] Shōdō,[9] Suigu.[10] **Biog.**: *Nanga* painter. Lived and worked in Edo. Adopted by his teacher Watanabe Sōsui. Teacher of Tani Bunchō. Painted landscapes and *kachōga*. An artist of great ability. **Bib.**: Hillier (4) 3, Mitchell, Morrison 2, Tajima (13) 7.

¹玄對 ²内田 ³渡辺英 ⁴延輝 ⁵又蔵 ⁶玄對
⁷林麓草堂 ⁸松台 ⁹松堂 ¹⁰酔愚

Gentan[1] (1778–1840). *N.*: Shimada (originally Tani)[2] Gentan.[3] *F.N.*: Kampo,[4] Kiin.[5] **Biog.**: Painter. Said to have been born in Edo; a younger brother of Tani Bunchō. Adopted by the Shimada family of Tottori, served Lord Ikeda. Associated with the painter Gotō Tōrei. Painted *kachōga* in a rather tight, hard manner. **Coll.**: Kōbe, Museum (3). **Bib.**: K 699, Mitchell, *Pictorial* (2) 2.

¹元旦 ²谷 ³島田元旦 ⁴寛輔 ⁵季允

Gentarō[1] (fl. late 17th to early 18th c.). *N.*: Seikai (originally Ikeda)[2] Gentarō.[3] **Biog.**: Lacquerer. Son of Ikeda Gembei. An apprentice to Seikai Kanshichi in Edo. On completion of his studies was called back to Tsugaru by the local lord; changed his name to Seikai and entered the family lacquer business. Invented Tsugaru-nuri, a technique developed by his descendants to its present form. **Coll.**: Tōkyō (1), (2). **Bib.**: Ragué, Sawaguchi.

¹源太郎 ²池田 ³青海源太郎

Gentoku[1] (?–1770). *N.*: Ishizaki (originally Nishizaki)[2] Kiyoemon.[3] *A.*: Keiho.[4] *F.N.*: Kiyoemon.[5] *Gō*: Gentoku,[6] Shōzan.[7] **Biog.**: Nagasaki painter. Studied Chinese Yüan and Ming paintings; also took lessons from Ohara Keizan. In 1736 given position of *kara-e mekiki* to the *bakufu*. Teach-

er of Ishizaki Yūshi. Specialized in landscapes and *kachōga*. His paintings are often copies of Western prints. **Bib.**: Mody.

¹元徳 ²西崎 ³石崎清右衛門 ⁴慶甫
⁵清右衛門 ⁶元徳 ⁷昌山

Gen'ya[1] (fl. mid-16th c.). *N.*: Kano Gen'ya.[2] **Biog.**: Kanō painter. Pupil of Kanō Motonobu and Shōei; said to have been the teacher of the young Kanō Eitoku. A good artist. **Coll.**: Museum (3). **Bib.**: *Chūsei*, Matsushita (1a).

¹玄也 ²狩野玄也

Gen'yū[1] (fl. late 14th c.). *N.*: Kose no Gen'yū.[2] **Biog.**: Kose painter. Son of Kose no Sen'yū. Served as a priest at the Daijō-in, Kōfuku-ji, Nara. Held title of Mikawa Hōshi.[3]

¹源有 ²巨勢源有 ³三河法師

Gen'yū[1] (1728/32–1794/99). *N.*: Araki (originally Nakayama)[2] Gen'yū,[3] *A.*: Shichō.[4] *F.N.*: Tamenoshin.[5] *Gō*: Enzan.[6] **Biog.**: Painter. Lived in Nagasaki. Was adopted by Araki Genkei, one of the four *kara-e mekiki* to the *bakufu*. Studied Confucianism, Buddhism, and literature; in painting was a pupil of Ishizaki Gentoku and was taught to paint in the Western manner by a Dutchman. In 1766 was given the position of one of the *kara-e mekiki*.

¹元融 ²中山 ³荒木元融 ⁴士長 ⁵為之進 ⁶円山

Geppō[1] (1760–1839). *N.*: Yamaoka.[2] *Priest name:* Shinryō.[3] *Gō*: Geppō,[4] Kikkan (Kikukan).[5] **Biog.**: *Nanga* painter. Also a *haiku* poet. Retainer of the daimyo of Nansen (Wakayama); later became a priest, changing his name to Shinryō. Became 34th abbot of the Sōrin-ji, Kyōto. Pupil of Ikeno Taiga; considered third in the Taiga line after Shukuya. Painted landscapes and *kachōga*. **Coll.**: Ashmolean, Museum (3), Victoria. **Bib.**: Brown, Mitchell, Morrison 2.

¹月峯 ²山岡 ³辰亮 ⁴月峯 ⁵菊間 （菊澗）

Gessai[1] (1787–1864). *N.*: Numata Masatami.[2] *A.*: Shii.[3] *F.N.*: Hanzaemon.[4] *Gō*: Gessai,[5] Ryōun,[6] Utamasa.[7] **Biog.**: Painter, printmaker. First studied under Maki Bokusen, then under Hokusai during the latter's time in Nagoya. In the 1840s turned away from ukiyo-e to study under Chō Gesshō and then the *nanga* manner under Yamamoto Baiitsu. Gave up painting in 1853. **Bib.**: Brown, Mitchell, UG 19.

¹月斎 ²沼田政民 ³士彝 ⁴半左衛門
⁵月斎 ⁶凌雲 ⁷歌政

Gessai II[1] (fl. mid-19th c.). *N.*: Haniwara.[2] *F.N.*: Kunai.[3] *Gō*: Gessai,[4] Utamasa.[5] **Biog.**: Ukiyo-e painter, printmaker. Nothing known of his life but that he was the pupil and successor to Numata Gessai (q.v.). **Coll.**: Freer. **Bib.**: UG 19.

¹月斎二代 ²埴原 ³宮内 ⁴月斎 ⁵歌政

Gessan[1] (fl. c. 1600–1623). *N.*: Kano Shikibu.[2] *Gō*: Gessan,[3] Rinshū.[4] **Biog.**: Kanō painter. Born and worked in Kyōto. Third son of Kanō Ryōfu, who was a great-grandson of Motonobu. Screens by him in the Museum of Fine Arts, Boston, are in the manner of the hawk paintings by Tōbun. **Coll.**: Museum (3). **Bib.**: Paine (2) 1.

¹月山 ²狩野式部 ³月山 ⁴隣秋

Gessen[1] (1721–1809). *N.*: Tanke Genzui.[2] *A.*: Gyokusei (Gyokujō).[3] *Gō*: Gessen,[4] Jakushō Shujin.[5] **Biog.**: Maruyama painter. Born in Nagoya. Became a priest at the Jakushō-ji at Ise Yamada. First a pupil of Sakurai Sekkan, then of Maruyama Ōkyo, as well as of Yosa Buson while living at the Chion-in, Kyōto. Also studied the technique of earlier Chinese paintings and of Sesshū. Sold his pictures for exorbitant sums, all of which were spent on the enlargement of his temple, providing it with a library and building a road to it. His work shows the influences of his various masters; it is also often quite amusing. **Coll.**: Ashmolean, Chion-in, Jakushō-ji, Jingū. **Bib.**: Hillier (4) 3; Mitchell; Morrison 2; NBZ 5; OA 13; Tajima (12) 14, 20; Tajima (13) 6; *Ukiyo-e* (3) 20.

¹月僊 ²丹家玄瑞 ³玉成 ⁴月僊 ⁵寂照主人

Gesshin[1] (1800–1870). *N.*: Wada Kōki.[2] *Priest name:* Kūsō.[3] *F.N.*: Fusakichi.[4] *Gō*: Ajibō,[5] Ashuku,[6] Gesshin,[7] Gozan

(Gosan),[8] Kaiun,[9] Kongōkutsu,[10] Muun.[11] **Biog.**: Maruyama painter. Pupil of Mori Tetsuzan. Took Buddhist orders when his wife died in 1841. About 1854 became head priest at the Shinkō-in, Nishigamo, Kyōto. Gave refuge to Reizei Tamechika during the wars between the shogunate and the loyalists. As a painter, specialized in Buddhist subjects.

¹月心 ²和田弘毅 ³空相 ⁴房吉 ⁵阿字坊 ⁶阿閦
⁷月心 ⁸呉山 ⁹海雲 ¹⁰金剛窟 ¹¹無雲

Gesshō[1] (1772–1832). *N.*: Chō Yukisada (Gyōtei).[2] *A.*: Genkei.[3] *F.N.*: Kaisuke,[4] Shinzō.[5] *Gō*: Gesshō,[6] Suikadō.[7] **Biog.**: Painter, illustrator. Born in Ōmi Province; son of a calligrapher and mounter of paintings. Pupil of Ichikawa Kunkei; later, in Kyōto, studied under Tanke Gessen and Matsumura Goshun. Moved to Nagoya in 1798 and for a short time was Nagasawa Rosetsu's assistant; then, on his own, studied earlier Chinese paintings. Became a famous local painter of his time. Also illustrated such books as *Zoku Koya Bunko, Fugyo Gaso,* and *Shin Koya Bunko.* As a painter, specialized in figures and *kachōga.* His work was praised by Tani Bunchō. **Coll.**: Ashmolean, Museum (3). **Bib.**: Brown, Holloway, Mitchell, Turk.

¹樵 ²張行貞 ³元啓 ⁴快助 ⁵晋蔵
⁶月樵 ⁷酔霞堂 (酔花堂)

Gessō[1] (1774–1865). *N.*: Taniguchi Seidatsu.[2] *A.*: Mōsen.[3] *F.N.*: Bunzaburō.[4] *Gō*: Chizetsuan,[5] Gessō.[6] **Biog.**: Painter. Born in Ise. Pupil of the Maruyama painter Tanke Gessen. In later years, to Edo, where he lived at Shiba Takanawa, serving the Satsuma daimyo. Good at landscapes, portraiture, and *kachōga.* **Bib.**: Brown, Mitchell, Morrison 2.

¹月窓 ²谷口世達 ³孟泉 ⁴文三郎 ⁵痴絶庵 ⁶月窓

Getsurei[1] (fl. c. 1862). *N.*: Kawaguchi Naoshichi.[2] *Gō*: Getsurei.[3] **Biog.**: Maruyama painter. Pupil of Tanke Gessen. **Bib.**: Morrison 2.

¹月嶺 ²川口直七 ³月嶺

Gibokusai[1] (fl. early 16th c.). *A.*: Shinzaburō.[2] *Gō*: Gibokusai.[3] **Biog.**: Kanō painter. Lived in Kyōto; pupil of An'ei Bokkei. **Bib.**: K 52, M 166.

¹戯墨斎 ²新三郎 ³戯墨斎

Gichin[1] (fl. c. 1810). *N.*: Hashii Gichin.[2] *A.*: Koryū.[3] *Gō*: Katsuzan.[4] **Biog.**: Painter. Specialized in *kachōga.* **Bib.**: Mitchell.

¹儀陳 ²橋井儀陳 ³古隆 ⁴葛山

Ginkō[1] (fl. 1874–97). *F.N.*: Adachi Heishichi.[2] *Gō*: Adachi Ginkō,[3] Ginkō,[4] Shinshō Ginkō,[5] Shōsai Ginkō,[6] Shōunsai Ginkō.[7] **Biog.**: Ukiyo-e printmaker. Life unknown. Good at *nishiki-e* and actors' portraits as well as battle scenes. Served as an illustrator during the Sino-Japanese war. **Coll.**: Musées, Victoria. **Bib.**: NHBZ 7, Nonogami.

¹吟光 ²安達平七 ³安達吟光 ⁴吟光
⁵真匠銀光 ⁶松斎吟考 ⁷松雲斎銀光

Gishō[1] (1802–73). *N.*: Mori Shisei.[2] *Gō*: Gishō,[3] Rikyō.[4] **Biog.**: Painter. Born in Kyōto. Pupil of Keibun. Specialized in figures and *kachōga.* **Coll.**: Museum (3). **Bib.**: Mitchell.

¹義章 ²森子成 ³義章 ⁴李卿

Gitō[1] (1656–1730). *Priest name:* Daishin Gitō.[2] **Biog.**: *Zenga* painter. Born in Kyōto to the Shimomura family. A Zen monk; entered the Daitoku-ji at 11, was ordained in 1683, became head of the Kōtō-an in 1686 and 274th abbot of the whole temple in 1706. Wrote on the different Buddhist sects. A proficient painter in the abbreviated, witty, suggestive *zenga* manner, using both ink and light colors. **Bib.**: Awakawa, Brasch (2), Rosenfield (1a).

¹義統 ²大心義統

Gitō[1] (1780–1819). *N.*: Shibata Gitō.[2] *A.*: Ichū.[3] *F.N.*: Kitarō.[4] *Gō*: Kinkai,[5] Kinsho.[6] **Biog.**: Shijō painter. Born in Bizen; moved to Kyōto. Studied under Matsumura Goshun. Became an important member of the Shijō school,

painting landscapes and *kachōga.* **Coll.**: Ashmolean, Museum (3). **Bib.**: Hillier (4) 3, Mitchell, Tajima (13) 6.

¹義董 ²柴田義董 ³威仲 ⁴喜多郎 ⁵琴海 ⁶琴渚

Gobei[1] (fl. c. 1880). *N.*: Kanda Gobei.[2] **Biog.**: Lacquerer. Specialized in picnic boxes of Shunkei-nuri. **Bib.**: Herberts, Jahss.

¹五兵衛 ²神田五兵衛

Gochō[1] (1739–1835). *Priest name:* Kaichō.[2] *Gō*: Dōryū,[3] Gochō,[4] Hachiman Yonsen Bonnō Shujin,[5] Hankon Mokusan Inshi,[6] Issuitei,[7] Juan Sanjin,[8] Maboku Sanjin,[9] Mushotoku Dōnyū,[10] Roteijin.[11] **Biog.**: *Zenga* painter. Priest of the Tendai sect. Son of a priest of the Shingon sect, was taken at 16 to the Jufuku-ji, Higo, to study under the master Gokyoku, upon whose death, in 1776, Gochō became abbot of that temple. Traveled much to Kyōto and Edo; friend of Sengai and Chingyū. Produced rough, powerful paintings on Zen themes. Also known as a calligrapher. **Bib.**: Awakawa; BO 95, 168.

¹豪潮 ²快潮 ³洞竜 ⁴豪潮 ⁵八万四千煩悩主人
⁶繁根木山隠士 ⁷一睡亭 ⁸寿安山人 ⁹磨墨山人
¹⁰無所得道入 ¹¹露亭人

Gōda Kiyoshi[1] (1862–1938). *N.*: Gōda (originally Tajima)[2] Kiyoshi.[3] **Biog.**: Western-style painter, printmaker. Born and lived in Tōkyō; studied at Tōkyō School of Fine Arts. In 1880 in France where, encouraged by Yamamoto Hōsui, studied Western-style wood engraving. On his return in 1887 introduced this technique to Japan, making prints after Yamamoto Hōsui's designs and doing the illustrations for school books, newspapers, and magazines. Helped establish the Hakubakai. Exhibitor at early Bunten shows. Held a prominent place in the world of Western-style painting and printmaking in Japan. His style shows considerable Barbizon influence. **Coll.**: Tōkyō (2). **Bib.**: Asano, Harada Minoru, *Kurashina* (2), NB (S) 30.

¹合田清 ²田島 ³合田清

Gogaku[1] (1730–99). *N.*: Fukuhara Genso.[2] *A.*: Shiken,[3] Taisho.[4] *F.N.*: Daisuke.[5] *Gō*: Gakuseidō,[6] Gogaku,[7] Gyokuhō.[8] **Biog.**: *Nanga* painter. Born in Bingo Province; lived in Ōsaka. Pupil of Ikeno Taiga; also studied Yüan and Ming painting. Among his pupils were Hamada Kyōdō, Hayashi Rōen, and Kanae Shungaku. Specialized in landscapes and figures. **Coll.**: Ashmolean, Seattle. **Bib.**: Mitchell, Morrison 2.

¹五岳 ²福原元素 ³子絢 ⁴太初
⁵大助 ⁶楽聖堂 ⁷五岳 ⁸玉峰

Gogaku[1] (1773–1841). *N.*: Moro Kinchō.[2] *A.*: Chūryū.[3] *Gō*: Gogaku,[4] Hōsetsu.[5] **Biog.**: Painter. Lived in Edo. Received honorary title of *hokkyō.* **Bib.**: Mitchell.

¹吾岳 ²茂呂金朝 ³仲竜 ⁴吾岳 ⁵蓬雪

Gogaku[1] (1811–93). *N.*: Hirano Bunkei.[2] *Gō*: Gogaku,[3] Kochiku.[4] **Biog.**: *Nanga* painter. A Zen priest at the Gansei-ji in Hida, Bungo Province. Studied *nanga* painting on his own, following the style of Tanomura Chikuden. Specialized in landscapes. It is known that a number of paintings ascribed to him were forged by the owner of the *tōfu* shop in front of the temple. **Bib.**: Asano, NBZ 6.

¹五岳 ²平野聞慧 ³五岳 ⁴古竹

Gokō[1] (1827–85). *N.*: Fujita Ken.[2] *A.*: Kenshō.[3] *Gō*: Gokō.[4] **Biog.**: *Nanga* painter. Born a samurai in Toyama. Having been interested from childhood in painting, studied with a Kanō master as a young man in Edo. Served in Toyama in an official capacity until 1868, when he retired to devote himself to painting. In 1884, served as juror for the second exhibition of the Zenkoku Kaiga Kyōshinkai. **Bib.**: Mitchell.

¹呉江 ²藤田憲 ³憲章 ⁴呉江

Gōkoku[1] (1850–97). *N.*: Kinugasa (originally Ōhashi)[2] Shinkō.[3] *A.*: Shinkei.[4] *Gō*: Gōkei,[5] Gōkoku,[6] Tenchū Sanjin.[7] **Biog.**: Japanese-style painter. Born in Kurashiki. Studied poetry and painting. Moved to Kyōto; continued

his studies under Nakanishi Kōseki; finally to Edo, where he studied literature as well as painting under Satake Eikai. From 1874 to 1876 in China; on his return held a minor government post, from which he resigned to devote himself entirely to painting and writing. In 1890 exhibited at the Naikoku Kangyō Hakurankai. A founding member of the Nihon Nanga Kyōkai in 1897. Author of many books. Fond of hiking, left many sketches of mountain scenes. Landscapes, figures, and birds-and-flowers were his subjects. **Bib.**: Asano, Mitchell.

[1]豪谷 [2]大橋 [3]衣笠縉侯 [4]紳卿
[5]豪渓 [6]豪谷 [7]天柱山人

Gōkura Senjin[1] (1892–). **N.**: Gōkura Yoshio.[2] **Gō**: Senjin.[3] **Biog.**: Japanese-style painter. Born in Toyama-ken. Graduated from the Japanese-style painting department of the Tōkyō School of Fine Arts in 1915; went the following year to America. Exhibited for the first time with the Inten in 1921; thereafter showed fairly frequently with them. After 1945 taught at the Tama University of Arts (Tōkyō). Served as juror for the Nihon Bijutsuin. Quite delicate, colorful painting, at times deliberately archaic. **Coll.**: National (5). **Bib.**: Asano.

[1]郷倉千靱 [2]郷倉吉雄 [3]千靱

Gokyō[1] (fl. c. 1795). **Biog.**: Ukiyo-e printmaker. Pupil of Hosoda Eishi; possibly an amateur. His pleasing but rare works are in his master's style. **Coll.**: Musées, Riccar, Staatliche, Victoria. **Bib.**: Binyon (3), Ficke, Schmidt, Takahashi (6) 10, UG 3.

[1]五郷

Gomi Seikichi[1] (1886–1954). **Biog.**: Western-style painter. Born in Morioka. Graduated in 1913 from the Western-painting department of the Tōkyō School of Fine Arts; in the same year received a prize at the Bunten exhibition. Later exhibited with the Kōfūkai. **Coll.**: Meiji-jingū. **Bib.**: Asano.

[1]五味清吉

Gomon[1] (1809–60). **N.**: Miura Korezumi (Tadazumi).[2] **A.**: Sōryō,[3] Sōsuke.[4] **F.N.**: Sōsuke.[5] **Gō**: Gomon,[6] Karyō,[7] Shūsei.[8] **Biog.**: *Nanga* painter. Born and lived in Nagasaki; pupil of Watanabe Kakushū and of Ishizaki Yūshi. Later influenced by Chinese paintings of the Ming and Ch'ing dynasties. Served as *kara-e mekiki* to the *bakufu*. With Kinoshita Itsuun and Hidaka Tetsuō, considered one of the three great Nagasaki painters. Specialized in landscapes and *kachōga*. **Coll.**: Ashmolean. **Bib.**: Umezawa (2).

[1]梧門 [2]三浦惟純 [3]宗亮 [4]惣助
[5]総助 [6]梧門 [7]荷梁 [8]秋声

Gorei[1] (1806–76). **N.**: Maekawa Akira.[2] **A.**: Shigyoku.[3] **F.N.**: Chōbei.[4] **Gō**: Gorei,[5] Hōsai.[6] **Biog.**: Shijō painter. Born in Kyōto. Pupil of Shibata Gitō, then of Matsumura Keibun. Painter of figures and *kachōga*. **Bib.**: Morrison 2, Rosenfield (1a).

[1]五嶺 [2]前川晃 [3]子玉 [4]長兵衛 [5]五嶺 [6]泡斎

Gorō[1] (fl. mid–15th c.). **Biog.**: Lacquerer. Worked in Nara. Specialized in tea-ceremony objects; is said to have invented the *natsume*. **Bib.**: Herberts, Jahss.

[1]五郎

Gorodayū[1] (1577–1663). **N.**: Shonzui.[2] **Gō**: Gorodayū,[3] Rishuntei.[4] **Biog.**: Potter. A controversial character whose dates, identity, and even existence are questioned. Said to have gone to China, returning about 1617 bringing with him to Hizen the materials for making porcelain. Hence credited with being the "father of Japanese porcelain," even though his imported materials were soon exhausted and the making of porcelain ceased. Is also identified with Takahara Goroshichi (q.v.), another claimant to be the first maker of porcelain in Japan. It is also said that Shonzui is the Japanese reading of the name of the Chinese potter who filled the order for the porcelain materials. So far, no documentary evidence

concerning him has been found; the dates given for him are traditional. The work attributed to him is primarily blue-and-white. **Coll.**: Fujita, Hatakeyama, Metropolitan. **Bib.**: BMFA 45, Gorham, Jenyns (1), Matsumoto (2), *Two*.

[1]五郎太夫 [2]祥瑞 [3]五郎太夫 [4]李春亭

Gorohachi[1] (fl. 1615–24). **N.**: Takahara (Takehara) Goro-hachi.[2] **Biog.**: Potter. A name known today only from its association with a type of rice bowl. As so little information about him exists, it has sometimes been assumed that this was another name for Goroshichi. There is to date no proof of this, and it is equally possible, given the names, that this potter was a successor to Goroshichi. **Coll.**: Freer, Tokugawa.

[1]五郎八 [2]高原（竹原）五郎八

Goroshichi[1] (fl. early 17th c.). **N.**: Takahara (Takehara) Goroshichi.[2] **Biog.**: Potter. According to the Sakaida family archives (which are certainly not contemporary) he was a Korean in the service of Hideyoshi, having been brought to Japan by Katō Kiyomasa. After the fall of Ōsaka, fled to Kyūshū and in 1624 joined the Sakaida family at Arita; became the teacher of Kakiemon I. His claim to have been the first to make Japanese porcelain is far less substantial than that of Ri Sampei; he must also be compared to the other claimants to this title: Shonzui Gorodayū and Shinkai Soden. The wares attributed to him are of proto-porcelain, decorated in underglaze blue only. **Coll.**: Freer. **Bib.**: Jenyns (1), Koyama (1a).

[1]五郎七 [2]高原（竹原）五郎七

Goseda Hōryū[1] (1827–92). **N.**: Goseda (originally Asada)[2] Iwakichi.[3] **F.N.**: Denjirō,[4] Genjirō,[5] Hanshichi,[6] Jūjirō,[7] Kinjirō,[8] Yaheiji.[9] **Gō**: Hōryū.[10] **Biog.**: Western-style painter. Born in Kii Province, son of a low-ranking samurai; lived in Yokohama and Tōkyō. Studied Kanō painting under Higuchi Tangetsu, then ukiyo-e under Utagawa Kuniyoshi; became acquainted with Western-style painting in Nagasaki and took lessons in oil painting from Charles Wirgman in Yokohama. Specialized in portraits. An artist of no particular competence, his style either one of rather repellent photographic realism or half Western and half Japanese. **Coll.**: Tōkyō (1), (2). **Bib.**: Asano; BK 201, 213; *Kurashina* (2); NBZ 6.

[1]五姓田芳柳 [2]浅田 [3]五姓田岩吉 [4]伝次郎 [5]源次郎
[6]半七 [7]重次郎 [8]金次郎 [9]彌平次 [10]芳柳

Goseda Hōryū II[1] (1864–1943). **Biog.**: Western-style painter. Adopted son of Goseda Hōryū. Studied oil painting under Charles Wirgman. Exhibited with the Naikoku Kangyō Hakurankai and the Meiji Bijutsukai. Painter of landscape, genre, and historical subjects, especially of important figures of the Meiji era. **Coll.**: Tōkyō (1). **Bib.**: BK 213.

[1]五姓田芳柳二世

Goseda Yoshimatsu[1] (1855–1915). **Biog.**: Western-style painter. Born in Edo; son of Goseda Hōryū. Lived in Yokohama and Tōkyō. With his father, a pupil of Charles Wirgman; then, in 1876, of Antonio Fontanesi at the Kōbu Daigaku Bijutsu Gakkō. In 1878 traveled in the suite of the emperor Meiji in the Hokuriku district, painting scenes of famous places along the way. From 1880 to 1887 in France, where he studied under J. L. Bonnat. A prize winner at the first Naikoku Kangyō Hakurankai exhibition. As he was ill for the last part of his life, most of his work dates from the late 1870s to 1900. Painted in both oil and water color, specializing in portraits, landscapes, and French genre scenes. His style a modest, competent, realistic, academic one. **Coll.**: Tōkyō (2). **Bib.**: Asano; BK 188, 206, 213; Harada Minoru; *Kurashina* (2); M 65; NB (H) 24; NB (S) 30; NBZ 6; SBZ 11; Uyeno.

[1]五姓田義松

Gosei[1] (fl. c. 1804–44). **N.**: Sunayama.[2] **Gō**: Gosei,[3] Hōtei.[4] **Biog.**: Ukiyo-e painter, illustrator. Painter of *bijinga*, il-

lustrator of comic books. **Coll.**: Metropolitan, Victoria. **Bib.**: *Nikuhitsu* (2).

¹五清 ²砂山 ³五清 ⁴抱亭
Goshichi[1] (fl. late 18th to early 19th c.). *N.*: Harukawa (originally Aoki)[2] Hōshū.[3] *Studio name:* Kamiya.[4] *F.N.*: Kamesuke.[5] *Gō:* Goshichi,[6] Hōrai Sanjin Kiyū.[7] **Biog.**: Ukiyo-e printmaker. Born in Edo; moved to Kyōto about 1818. Pupil of Harukawa Eizan, from whom he took his name. Produced both *surimono* and actor prints in a style showing he was a late follower of the Utamaro manner. **Coll.**: British, Fitzwilliam, Philadelphia, Rhode Island, Victoria, Worcester. **Bib.**: Binyon (1), (3); Hillier (7); Keyes.

¹五七 ²青木 ³春川蓬州 ⁴神屋
⁵亀助 ⁶五七 ⁷蓬萊山人亀遊
Gōshin[1] (fl. 1334–49). *N.*: Fujiwara no Gōshin.[2] **Biog.**: *Yamato-e* painter. Descendant of Fujiwara no Takanobu; son, or grandson, of Tamenobu. Became a priest at the Enryaku-ji. One of his few authenticated paintings is the portrait of Emperor Hanazono in the Chōfuku-ji, Kyōto, which bears an inscription saying it is by him. Another painting, the *Tennō Sekkan Daijin Ei*, in the Imperial Household Collection, is attributed to him and to Tamenobu. The last important painter of portraits in the manner of his ancestors, working in the tradition of Takanobu. A famous artist in his time. **Coll.**: Chōfuku-ji. **Bib.**: Fontein (1), Ienaga, *Kokuhō* 4, NBT 4, NKZ 3, Okudaira (1), Paine (4), Tajima (12) 7.

¹豪信 ²藤原豪信
Goshun[1] (1752–1811). *N.*: Matsumura Toyoaki.[2] *A.*: Hakubō,[3] Impaku,[4] Yūho.[5] *F.N.*: Bunzō,[6] Kaemon.[7] *Gō:* Gekkei,[8] Goshun,[9] Hyakushōdō,[10] Katen,[11] Shōutei,[12] Sompaku,[13] Sonjūhaku,[14] Sonseki.[15] **Biog.**: Shijō painter. Born in Owari; lived in Settsu and Kyōto. Studied first with Ōnishi Suigetsu; later, a pupil of Yosa Buson, with whom he also studied *haiku,* using at that time the *gō* Gekkei. After 1781, adopted *gō* Goshun. Following Buson's death, strongly influenced by Ōkyo. Eventually created his own style, founding the Shijō school (named after the street in which he lived), which tried to combine the realism of Ōkyo with the idealism of the *nanga* school. Skilled in *haiku* and calligraphy. Among his students were Matsumura Keibun and Okamoto Toyohiko. One of the greatest of the later Edo-period painters; his school had an enormous influence on 19th-century Japanese art. His pleasant work more intimate and spontaneous, less monumental than that of Ōkyo; used larger brushes, applying them more obliquely than Ōkyo. **Coll.**: Art (1a), Ashmolean, Daigo-ji, Daijō-ji (2), Fine (M. H. De Young), Honolulu, Itsuō, Kōzo-ji, Metropolitan, Museum (3), Myōhō-in, Nezu, Okayama, Philadelphia, Seattle, Staatliche, Tōkyō (1), University (2), Victoria, Yakushi-ji. **Bib.**: BK 62, 216; GNB 18; Hillier (1), (2), (3), (4) 3; *Japanese* (1a); *Japanische* (2); K 19, 63, 80, 93, 157, 174, 201, 226, 228, 233, 243, 249, 256, 266, 281, 288, 294, 324, 340, 349, 358, 380, 454, 460, 487, 513, 540, 552, 616, 620, 719, 733, 750, 822, 852, 869, 944, 945; *Kunst;* Mitchell; Mizuo (3); Moriya; Morrison 2; Murase; NB (H) 24; NB (S) 39; NBT 5; NBZ 5; *Nihon* (3); Noma (1) 2; *One* (2); Paine (2); SBZ 10; *Shijō-ha;* Shimada 2; Tajima (11); Tajima (12) 4, 5, 10, 13, 16, 18, 19; Tajima (13) 6.

¹呉春 ²松村豊昌 ³伯望（伯房） ⁴允伯 ⁵裕甫（祐甫）
⁶文蔵 ⁷嘉右衛門 ⁸月渓 ⁹呉春 ¹⁰百昌堂 ¹¹可転
¹²蕉雨亭 ¹³存白 ¹⁴存充白 ¹⁵孫石
Gotō Kōshi[1] (1893–1929). **Biog.**: Western-style painter. Born in Tōkyō. Studied at the Nihon Suisaiga Kenkyūsho under a variety of teachers. From 1922 on, exhibited with the Teiten. Became a member of the Nihon Suisaigakai and the Kōfūkai. **Bib.**: Asano.

¹後藤工志
Gotō Naoshi[1] (1882–1957). **Biog.**: Sculptor. Son and pupil of

Gotō Sadayuki; student at the Tōkyō School of Fine Arts. In 1915 first exhibited at the Bunten; in 1916 a prominent exhibitor at the Teiten, as well as juror for this show. Specialized in portraiture. **Bib.**: Asano.

¹後藤良
Gotō Sadayuki[1] (1849–1903). **Biog.**: Sculptor. Born in Kii Province. A cavalryman, became interested in making figures of horses. Studied sculpture in bronze and wood with Takamura Kōun, Western painting under Kunisawa Shinkurō, and photography. Generally produced monumental sculpture groups of horses: a pioneer in his field. **Bib.**: Asano.

¹後藤貞行
Gotō Yoshikage[1] (1894–1922). *N.*: Gotō Seijirō.[2] *Gō:* Hōsai,[3] Yoshikage.[4] **Biog.**: Printmaker. An Ōsaka artist, follower of Utagawa Yoshitaki, who worked for a time in Tōkyō. **Bib.**: NHBZ 7.

¹後藤芳景 ²後藤清次郎 ³豊斎 ⁴芳景
Goyōzei[1] (1571–1617; reigned 1586–1611). **Biog.**: Emperor and painter. Like many emperors, an amateur artist of little importance. Worked in a detailed manner, in a combination of Tosa and *nanga* styles. **Bib.**: K 614.

¹後陽成
Guan[1] (fl. late 15th to early 16th c.). **Biog.**: Muromachi *suiboku* painter. A priest-painter whose work shows he was perhaps acquainted with Chinese Yüan paintings; influenced by Mu-ch'i. Particularly skillful ink sketches of monkeys. Above all his pictures, a line or two of poetry written by himself. **Coll.**: Hompō-ji. **Bib.**: Matsushita (1a), Morrison 1, Tajima (12) 3.

¹愚庵
Gukei[1] (fl. 1361–75). *Posthumous name:* Ue (Ukei).[2] *Priest name:* Gen'an.[3] *Gō:* Gukei.[4] **Biog.**: Muromachi *suiboku* painter. A Zen priest and an important artist, only recently identified. Pupil of Tesshū Tokusai (who had been to China) and active in the Kamakura *suiboku* circle. His paintings vary in theme from orthodox Buddhist subjects to Zen themes, and include landscapes and *kachōga,* following, in the main, the Southern Sung style; his figure work more constrained than his landscape. Belongs to the formative period in the development of Japanese ink-monochrome painting; his style close to that of Yü Chien. **Note**: In his seal the name Gukei is written with the same characters as given in the first and fourth references below. In his written signature[5] the *kei* is a different character. His works that have his signature do not have his seal and vice versa. **Coll.**: Daijō-ji (1), Manju-ji (1), Tōkyō (1), Yamato. **Bib.**: BCM 50; BG 49; Fontein (2); GNB 11; K 125, 707, 762, 824; M 73; Matsushita (1); *Muromachi* (1); NB (S) 69; Tanaka (2); YB 34, 46.

¹愚谿 ²右恵 ³幻庵 ⁴愚谿 ⁵愚溪
Gukei[1] (1631–1705). *N.*: Sumiyoshi Hirozumi.[2] *Priest Name:* Gukei.[3] *Court title:* Naiki.[4] **Biog.**: Sumiyoshi painter. Son of Sumiyoshi Jokei. Lived in Edo. In 1682 appointed *oku eshi* to the shogun Tsunayoshi. Received honorary title of *hōgen.* With his father, painted an elaborate pictorial history of the shrine of Ieyasu, the *Tōshōgū Engi;* his studies of the *Heike Monogatari* are a valuable record of the illustrations of that work. A painter of manners and customs in a Tosa-like style with, however, Kanō brushwork. Also considered a pioneer ukiyo-e artist. **Coll.**: Atami, Freer, Musées, Shōren-in, Shūgakuin, Stanford, Tōkyō (1). **Bib.**: K 23, 50, 131, 248, 667, 740, 823, 828; Morrison 1; NBT 5; NBZ 4; *Nikuhitsu* (1) 1; *Rakuchū;* Rosenfield (1a); SBZ 9; Tajima (12) 5; Yamane.

¹具慶 ²住吉広澄 ³具慶 ⁴内記
Gukyoku (Gugoku)[1] (1363–1452). *N.*: Reisai.[2] *Priest name:* Gukyoku (Gugoku).[3] **Biog.**: Painter, calligrapher. Born in Yamashiro, near Kyōto. Served at various temples; became 149th abbot of the Tōfuku-ji, Nara. An amateur who

learned the style of Mu-ch'i. In 1449, to China; left a self-portrait there that is said to carry an inscription by him. Also well known as a calligrapher: excelled in grass writing. His works, reputed to protect buildings from fire, were widely appreciated in his day. Began to paint in China ink only, a departure from earlier Buddhist painting. **Coll.:** Kōzan-ji (2). **Bib.:** GNB 11; K 264, 292, 644, 665, 680, 693, 728, 933.

[1]愚極 [2]禮才 [3]愚極

Gyōbu[1] (fl. late 17th to early 18th c.). *N.:* Gyōbu.[2] *Gō:* Tarō.[3] **Biog.:** Lacquerer. Invented a new technique of *nashiji-nuri,* using irregularly shaped and larger than usual flakes of gold leaf. This work came to be known as Gyōbu-nashiji. Worked in Edo. **Bib.:** Herberts, Jahss, Sawaguchi.

[1]刑部 [2]刑部 [3]太郎

Gyodai[1] (fl. first half 19th c.). *N.:* Satō Masuyuki.[2] *Gō:* Gyodai.[3] **Biog.:** Shijō painter, printmaker. Worked in Ōsaka. Pupil of Matsumura Goshun. It is possible that this is the same artist as Masuyuki (q.v.). Specialized in *surimono.* **Coll.:** Musées, Victoria. **Bib.:** *Kunst;* Mitchell.

[1]魚大 [2]佐藤益之 [3]魚大

Gyōgen (Gyōgon)[1] (fl. late 13th c.). *N.:* Kose no Gyōgen (Gyōgon).[2] **Biog.:** Kose painter. Son of Kose no Gyōson. Patronized by the Ichijō-in, Kōfuku-ji, Nara. Given the title of *hōgen,* was called Mimbu Hōgen.[3] The painting by him of a Shintō goddess, dated 1295, in the Yakushi-ji, Nara, shows much Chinese influence. **Coll.:** Yakushi-ji. **Bib.:** *Pictorial* (1) 2, SBZ 6.

[1]堯厳 [2]巨勢堯厳 [3]民部法眼

Gyōkai[1] (1109?–1180?). *N.:* Fujiwara no Gyōkai.[2] **Biog.:** Painter. Said to have been a son of Fujiwara no Motomitsu and brother of Fujiwara no Chinkai. Lived on Mount Hiei, Kyōto. Also said to have been made chief painter at the Tō-ji, Kyōto. No works known.

[1]行海 [2]藤原行海

Gyōkai[1] (fl. early 13th c.). **Biog.:** Sculptor. Member of Shichijō Bussho. A follower of Kaikei, with whom he collaborated on the Shaka Nyorai, dated 1221, in the Daihōon-ji, Kyōto. Also said to have done several of the figures in the Sanjusangendō, Kyōto. Received rank of *hokkyō* in 1216 and some years later that of *hōgen.* **Coll.:** Daihōon-ji, Myōhō-in (Rengeō-in). **Bib.:** *Art* (2), GNB 9, Mōri (1a), NBZ 3, SBZ 6.

[1]行快

Gyokkei (Gyokukei)[1] (1785–1857). *N.:* Nomura Gyokkei (Gyokukei).[2] **Biog.:** Painter. Born in Atsuta, near Nagoya. Interested in painting as a child, finally went to Kyōto in 1807 to work as a servant for Matsumura Goshun for six years, studying painting with him at the same time. Returned to Atsuta to work as an artist. **Bib.:** Mitchell.

[1]玉渓 [2]野村玉渓

Gyokkei[1] (fl. c. 1873). *Gō:* Yūtokusai.[2] **Biog.:** Lacquerer. Specialized in *inrō.* **Coll.:** Victoria. **Bib.:** Herberts, Jahss.

[1]玉溪 [2]有得斎

Gyokudō[1] (1745–1820). *N.:* Uragami Hitsu[2] (originally Ki Tasuku).[3] *A.:* Kumpo (Kimisuke).[4] *F.N.:* Hyōemon.[5] *Gō:* Gyokudō,[6] Gyokudō Kinshi,[7] Ryosai.[8] **Biog.:** *Nanga* painter. Born in Bizen to ancient samurai family of Ki (sometimes called himself Ki no Gyokudō). Served Ikeda Masaka, lord of the Bizen branch of the Ikeda family; during this service, often had occasion to go to Edo, where he learned to play the *koto* and studied painting, poetry, and the Chinese classics. Gave up office in 1794, devoting himself to art and music, wandering and drinking, carrying a *koto* (hence name Gyokudō Kinshi, or Gyokudō the *koto* player) and brushes, playing and painting as he went. Finally settled in Kyōto, joining Aoki Mokubei's circle; intimate friend of Tanomura Chikuden. Only recently appreciated, today he is often faked. His paintings generally undated, but were nearly all done after 1794. Represents a

second flowering of the *nanga* school. His landscapes are variations on theme of tall mountains and remote village huts. The ink is rough, the brush strokes spontaneous, the mountains light and feathery; work at times close to eccentric Chinese painters, done in ink and light colors. The paintings, with their witty arbitrary compositions, have great charm: the most individual of the *nanga* school. Best at small-scale paintings. **Coll.:** Art (1), Cleveland, Detroit, Fine (M. H. De Young), Freer, Fuse, Idemitsu, Kyōto (2), Museum (3), Ohara (1), Okayama, Philadelphia, Tōkyō (2), Umezawa. **Bib.:** *Art* (1a); BK 19, 31, 95, 96, 104; Cahill; *Cent-cinquante;* Covell (1); *Exhibition* (1); Fontein (1); GNB 18; *Japanische* (2); K 345, 369, 380, 463, 678, 706, 713, 716, 726, 742, 754, 784, 794, 807, 810, 830, 883, 890; KO 30, 32, 34; *Kokuhō* 6; Lee (1); M 36, 175; *Masterpieces* (2), (4); Mayuyama; Mitchell; Miyake; Mizuo (3); Moriya; Murayama (2); NB (H) 23; NB (S) 4; NBZ 5; *Nihon* (2), (3), (4), (5); Noma (1) 2; Rosenfield (2); SBZ 10; Shimada 2; Suzuki (9); Umezawa (2); Yonezawa.

[1]玉堂 [2]浦上弼 [3]紀弼 [4]君輔 [5]兵右衛門 [6]玉堂 [7]玉堂琴士 [8]穆ος

Gyokudō[1] (fl. 1830–50). *N.:* Kurihara Ei.[2] *A.:* Baison.[3] *F.N.:* Ginzō.[4] *Gō:* Gyokudō,[5] Rankai.[6] **Biog.:** Painter. Lived in Edo. Specialized in landscapes and *kachōga.* **Bib.:** Mitchell.

[1]玉堂 [2]栗原英 [3]梅村 [4]銀蔵 [5]玉堂 [6]蘭海

Gyokuei[1] (1730–1804). *N.:* Kanō Arinobu.[2] *Gō:* Chōboku-sai,[3] Gyokuei.[4] **Biog.:** Kanō painter. Third son of Kanō Gyokuen Hidenobu, who was head of the Okachimachi Kanō line; adopted by his older brother Kanō Kyūhaku III. Served the shogunate as *omote eshi.*

[1]玉栄 [2]狩野在信 [3]長墨斎 [4]玉栄

Gyokuen[1] (1683–1743). *N.:* Kanō Hidenobu (or Suenobu).[2] *F.N.:* Geki.[3] *Gō:* Gyokuen.[4] **Biog.:** Kanō painter. Little known of his life. Adopted into the Kanō family by Kanō Kyūseki; eventually became head of the Okachimachi branch. Served as *goyō eshi* to the Tokugawa shogunate; one of the teachers of Toriyama Sekien. **Coll.:** Museum (3).

[1]玉燕 [2]狩野秀信（季信）[3]外記 [4]玉燕

Gyokuen[1] (fl. third quarter 19th c.). **Biog.:** Ukiyo-e printmaker. Worked in Kyōto, producing *surimono.* **Coll.:** British, Musées. **Bib.:** Binyon (1), Keyes.

[1]玉園

Gyokuhō[1] (1822–79). *N.:* Hasegawa Shiei.[2] *A.:* Shishin.[3] *Gō:* Gyokuhō,[4] Tōsai.[5] **Biog.:** Shijō painter. Born in Kyōto. Pupil of Matsumura Keibun. Specialized in portraits and *kachōga.* **Coll.:** Ashmolean, Metropolitan, Museum (3), Victoria. **Bib.:** Hillier (4) 3, Mitchell, Morrison 2.

[1]玉峰 [2]長谷川師盈 [3]士進 [4]玉峰 [5]等斎

Gyokuō[1] (fl. c. 1840). *N.:* Dodo (Momo) Gyokuō.[2] *Gō:* Shinzō.[3] **Biog.:** Lacquerer. Grandson of Dodo Gyokusen. At 19 entered service of Lord Maeda of Kaga. Also worked for the Imperial Palace in Kyōto and for the Nabeshima family in Saga. At 51 known to have gone to Edo. Specialized in *makie.* **Bib.:** Herberts.

[1]玉翁 [2]百々玉翁 [3]新蔵

Gyokuon[1] (fl. c. 1840). *N.:* Gyokuon Toyoko.[2] **Biog.:** Maruyama painter. She was born in Bingo Province. Pupil of Hatta Koshū. Painted landscapes, figures, and *kachōga.* **Coll.:** Museum (3).

[1]玉韞 [2]玉韞豊子

Gyokuraku[1] (fl. 1550–90). *N.:* Kanō Tamanobu.[2] *Gō:* Gyokuraku,[3] Sōyū.[4] **Biog.:** Kanō painter. An artist about whom there is considerable uncertainty. Said to have been the younger brother (or sister) of Kanō Shuboku and nephew (or niece) of Kanō Motonobu; but there is also a theory, based on the evidence of the brush strokes but not generally accepted, that this painter was a man who may have been

the same person as Kanō Sōyū Hidenobu. Whoever the painter was, he obviously studied under Kanō Motonobu and was influenced by him. It is also known that this artist was employed as an official painter by Hōjō Ujimasa, one of the barons ruling the Odawara area during the age of warring provinces, and died in Odawara in 1590, the year the town fell to Hideyoshi. Specialized in landscapes, figures, and *kachōga*. **Coll.:** Art (2), Museum (3), Staatliche, Tokugawa, University (2). **Bib.:** *Ausgewählte, Chūsei*, M 101, Matsushita (1a), NB (S) 63, Shimada 1, Tajima (12) 9, YB 48.

¹玉楽 ²狩野玉信 ³玉楽 ⁴宗祐

Gyokuran[1] (1728–84). *N.:* Ikeno Machi.[2] *Gō:* Gyokuran,[3] Kattankyo,[4] Shōfū Kattankyo.[5] **Biog.:** *Nanga* painter. Born in Kyōto. Studied under Ikeno Taiga, whom she married in 1746. One of the best women painters of the *nanga* school, known for her small-scale paintings in the manner of her husband. Her style is soft, mild, graceful, utterly charming. **Coll.:** Tōkyō (1), Victoria. **Bib.:** *Japanische* (2); K 649, 758, 779, 885; Mitchell; *Nihon* (3); Umezawa (2).

¹玉瀾 ²池野町 ³玉瀾 ⁴葛覃居 ⁵松風葛覃居

Gyokurin[1] (1751–1814). *Priest name:* Gyokurin.[2] *Gō:* Bokukundō.[3] **Biog.:** *Nanga* painter. A disciple of the priest Gyokuō. Specialized in painting bamboo in *sumi*. **Coll.:** Museum (3). **Bib.:** Hillier (4) 3, Mitchell.

¹玉潾 ²玉潾 ³墨君堂

Gyokusen[1] (1692–1755). *N.:* Mochizuki Shigemori[2] (later Gen).[3] *A.:* Shusei.[4] *F.N.:* Tōbei.[5] *Gō:* Getsuan.[6] Getsugen,[7] Gyokuan,[8] Gyokusen,[9] Seian,[10] Senrisen.[11] **Biog.:** Painter. A samurai; lived in Kyōto. Studied, but not very seriously, under Tosa Mitsunari and, later, Yamaguchi Sekkei; also studied Chinese painting. A forerunner of the *nanga* school, despite his Tosa and Kanō background. **Coll.:** Museum (3). **Bib.:** BK 127, Morrison 2.

¹玉蟾 ²望月重盛 ³玄 ⁴守静 ⁵藤兵衛 ⁶月庵 ⁷月玄 ⁸玉庵 ⁹玉蟾 ¹⁰静庵 ¹¹千里川

Gyokusen[1] (?–1775). *N.:* Dodo (Momo) Gyokusen.[2] *F.N.:* Zenjirō.[3] **Biog.:** Lacquerer. Born in Kyōto; son of a samurai. Pupil of the tea master Kitamura Yōken. Followed the family tradition of producing *makie* ware. **Coll.:** Victoria. **Bib.:** Herberts, Jahss.

¹玉泉 ²百々玉泉 ³善次郎

Gyokusen[1] (1744–95). *N.:* Mochizuki Makoto[2] (or Shige-katsu[3] or Shigesuke).[4] *A.:* Shusei.[5] *Gō:* Gyokusen.[6] **Biog.:** Painter. Born in Kyōto. Son and pupil of Mochizuki Gyokusen Shigemori. At first used his father's *gō* Gyokusen, the first of the *gō* noted below, but later changed the second character. Specialized in portraiture and *kachōga*, working in his father's style. **Bib.:** Morrison 2.

¹玉仙 ²望月眞 ³重勝 ⁴重祐 ⁵守静 ⁶玉蟾 (玉仙)

Gyokusen[1] (1794–1852). *N.:* Mochizuki Shigeteru.[2] *A.:* Shiei.[3] *Gō:* Gyokusen.[4] **Biog.:** Shijō painter. Born and worked in Kyōto. His father, Mochizuki Gyokusen Makoto, died when he was a baby; so he became first a member of the household of Murakami Tōshū, then of Kishi Ganku. An admirer of Matsumura Goshun's painting, studied the Shijō style; went to Edo and Nagasaki before settling down in Kyōto to become a distinguished painter of *kachōga* and landscapes. **Coll.:** Museum (3), Victoria. **Bib.:** Morrison 2.

¹玉川 ²望月重輝 ³子英 ⁴玉川

Gyokushitsu[1] (1572–1641). *N.:* Sonobe Sōhaku.[2] *Priest name:* Gyokushitsu.[3] *Gō:* Dōminshi.[4] **Biog.:** *Zenga* painter. Well-known Zen priest, 147th abbot of the Daitoku-ji, Kyōto. **Bib.:** NB (S) 47.

¹玉室 ²園部宗珀 ³玉室 ⁴瞳眠子

Gyokushū[1] (1600–1668). *N.:* Itō Sōban.[2] *Gō:* Gyokushū,[3] Ragetsushi,[4] Seika,[5] Shunsui,[6] Yūyū Jizai.[7] **Biog.:** *Zenga*

painter. A Zen priest, 185th abbot of the Daitoku-ji, Kyōto. **Bib.:** NB (S) 47.

¹玉舟 ²伊藤宗璠 ³玉舟 ⁴蘿月子 ⁵青霞 ⁶春睡 ⁷優遊自在

Gyokushū[1] (1746–99). *N.:* Kuwayama Shisan[2] (earlier Fumitaka[3] or Shikan).[4] *A.:* Meifu,[5] Shizan.[6] *F.N.:* Sanai.[7] *Gō:* Chōudō,[8] Gyokushū,[9] Kakusekien,[10] Kasetsudō,[11] Myōkō Koji.[12] **Biog.:** *Nanga* painter. Born in Kii Province to a *gōshi* (yeoman) family; moved to Edo as a youth. Pupil and intimate friend of Ikeno Taiga. Acquainted with the work of Shen Nan-p'in and I Fu-chiu. Noted for his books on art: *Gyokushū Gashū* (Gyokushū's Tastes in Art) and *Kaiji Higen* (Humble Opinions on Pictorial Art). A prolific artist, better known today for his art criticism than for his painting. His work combines the Chinese landscape style with a Japanese-inspired decorative pattern. **Bib.:** BK 128; Cahill; GNB 18; *Japanische* (2); K 353, 706, 712, 747, 815, 851, 962; KO 34, 35; NB (S) 4; *Nihon* (3); Umezawa (2); Yonezawa.

¹玉洲 ²桑山嗣燦 ³文爵 ⁴士幹 ⁵明夫 ⁶子残 ⁷左内 ⁸聴雨室 ⁹玉洲 ¹⁰鶴跡園 ¹¹珂雪堂 ¹²明光居士

Gyokuzan[1] (1737–1812). *N.:* Okada Shōyū (Naotomo).[2] *A.:* Shitoku.[3] *Gō:* Gyokuzan,[4] Kinryōsai.[5] **Biog.:** Ukiyo-e painter, illustrator. Lived in Ōsaka. Studied with Tsukioka Settei and Shitomi Kangetsu; independently investigated many other styles. Specialized as an illustrator of such books as the *Ise Monogatari;* also did the illustrations for the *Taikōki* (Biography of Toyotomi Hideyoshi). Received rank of *hokkyō*. Has sometimes been confused with the painter Ishida Gyokuzan (q.v.). Foremost book-illustrator of Ōsaka. **Coll.:** Ashmolean, Philadelphia, Stanford. **Bib.:** Brown, Keyes, Morrison 2.

¹玉山 ²岡田尚友 ³子徳 ⁴玉山 ⁵金陵斎

Gyokuzan[1] (fl. 1789–1803). *N.:* Omura Gyokuzan.[2] **Biog.:** Lacquerer. Pupil of Koma Koryū. Worked for the shogun. **Bib.:** Herberts, Jahss.

¹玉山 ²尾村玉山

Gyokuzan[1] (fl. 1789–1804). *N.:* Tachibana Gyokuzan.[2] *Gō:* Jitokusai.[3] **Biog.:** Lacquerer. Lived in Edo. Pupil of Koma Kyūzō IV. Frequently worked in cherry bark. **Coll.:** Walters. **Bib.:** Boyer, Herberts, Jahss.

¹玉山 ²橘玉山 ³自得斎

Gyokuzan[1] (fl. late 18th to early 19th c.). *N.:* Ishida Shūtoku.[2] *A.:* Shishū.[3] *Gō:* Gyokuzan.[4] **Biog.:** Painter. Born in Ōsaka; pupil of Okada Gyokuzan. Later moved to Edo. A painter of landscapes and *kachōga;* his works were reproduced in woodcuts and illustrated in books.

¹玉山 ²石田修徳 ³子秀 ⁴玉山

Gyokuzan[1] (fl. c. 1810). *N.:* Okamoto Tei.[2] *Gō:* Gyokuzan.[3] **Biog.:** Painter. Lived in Sendai. Specialized in landscapes. **Bib.:** Mitchell.

¹玉山 ²岡本禎 ³玉山

Gyōmei[1] (fl. late 12th c.). **Biog.:** Sculptor. Life unknown. A Bugaku mask with an inscription carrying his name and the date 1173 is at the Itsukushima-jinja. **Coll.:** Itsukushima-jinja. **Bib.:** Noma (4).

¹行明 (行命)

Gyōsei (Kōsei)[1] (fl. c. 1360). **Biog.:** Sculptor. Perhaps the son of Kōsei,[2] close to him in style. His Jūichimen Kannon in the Matsuno-o-dera, Nara, is dated 1362. **Coll.:** Matsuno-o-dera. **Bib.:** *Muromachi* (2).

¹行成 ²康成

Gyosei[1] (fl. c. 1800). *N.:* Kōami Gyosei.[2] **Biog.:** Kōami lacquerer. A good artist whose works are rare. **Coll.:** Museum (2). **Bib.:** Feddersen, Herberts, Jahss.

¹魚清 ²幸阿弥魚清

Gyōshin[1] (fl. c. 1250). **Biog.:** Sculptor. The statue of Shaka in the Ryōgen-in, Kyōto, has an inscription with his signature

and the date 1250. **Coll.:** Daitoku-ji (Ryōgen-in). **Bib.:** GNB 9, M 68.

¹行心

Gyōson¹ (1057–1135). **Biog.:** Painter. Son of Minamoto Motohira. Became a Buddhist priest at 12; lived at the Enjō-ji, of which he became abbot in 1120. Known only from literary sources; is said to have been self-taught as a painter and to have made a model portrait of Kakinomoto Hitomaro that was widely copied by later generations.

¹行尊

Gyōson¹ (fl. c. 1255). *N.:* Kose no Gyōson.² **Biog.:** Kose painter. Son of Kose no Yūson, grandson of Kose no Nagamochi. Buddhist priest attached to the Ichijō-in, Kōfuku-ji, Nara; given title of *hokkyō*. Specialized in Buddhist subjects. Recorded as having painted a *mandara* at the Hōryū-ji in 1255.

¹堯尊 ²巨勢堯尊

Gyōyū¹ (fl. c. 1252). *N.:* Kose no Gyōyū.² **Biog.:** Kose painter. Son of Kose no Yūson. A priest attached to the Daijō-in, Kōfuku-ji, Nara. Received title of *hōgen* and was called Chikuzen Hōgen.³

¹堯有 ²巨勢堯有 ³筑前法眼

H

Hachirōemon¹ (1805–52). *N.:* Iidaya Hachirōemon.² **Biog.:** Kutani potter. Born in Kanazawa, son of a textile designer. A decorator of Kutani ware, he introduced rather blatant figure and bird designs in gold and red into the Kutani repertory. His designs are today considered of questionable artistic merit. **Bib.:** Jenyns (1), NB (S) 71.

¹八郎右衛門 ²飯田屋八郎右衛門

Hachizō¹ (?–1654). *N.:* Hachizō² (earlier Hassan).³ **Biog.:** Potter. This is the Japanese name of a Korean, Pal San, who was ordered by Lord Kuroda Nagamasa in 1600 to establish a kiln at the foot of Takatori mountain, Kurate-gun, Fukuoka; hence he may be regarded as the father of Takatori ware. Said to have gone to Kyōto, and there been influenced by Kobori Enshū; it is more probable this influence on Takatori ware came after Hachizō's death. In his time the ware was described as being "an unpretentious pottery of simple, solid shapes and glazes similar to Karatsu ware." **Bib.:** BMM 32, Jenyns (2), Koyama (1).

¹八蔵 ²八蔵 ³八山

Haisen¹ (1787–1867). *N.:* Kusaba Ka.² *A.:* Reihō.³ *F.N.:* Sasuke.⁴ *Gō:* Gisai,⁵ Gyokujo Sanjin,⁶ Gyokujo Sansho,⁷ Haisen,⁸ Katei,⁹ Sakutō,¹⁰ Takueidō.¹¹ **Biog.:** *Nanga* painter. Born in Saga. A Confucian scholar who at 23 accompanied his master Lord Nabeshima to Edo, where he studied under the Confucianist Koga Seiri. More or less a self-taught artist; learned the Shen Nan-p'in style from Egoshi Kinga in Nagasaki, but later shifted to the *nanga* school. Specialized in painting bamboo in ink monochrome.

¹佩川 ²草場韡 ³棣芳 ⁴礎助 ⁵宜斎 ⁶玉女山人
⁷玉女山樵 ⁸佩川 ⁹可亭 ¹⁰素絢 ¹¹濯纓堂

Hakkakusai¹ (fl. early 19th c.). **Biog.:** Lacquerer. Many of his designs were based on Hiroshige's prints. **Bib.:** Herberts, Jahss.

¹白鶴斎

Hakkei (Hakukei)¹ (fl. c. 1840). *N.:* Oguri Hakkei (Hakukei).² *A.:* Shifuku.³ *Gō:* Sesshū.⁴ **Biog.:** Shijō painter. Born in Nagoya. Moved to Kyōto to study under Okamoto Toyohiko. A skillful painter of landscapes and *kachōga*. **Bib.:** Mitchell.

¹伯圭 ²小栗伯圭 ³士復 ⁴雪州

Hakkeisai¹ (fl. late 18th to early 19th c.). *N.:* Kanō Hakkeisai.² **Biog.:** Kanō painter. Known as the teacher of Ikeda Eisen.

¹白珪斎 ²狩野白珪斎

Hakuei¹ (fl. early 19th c.). *N.:* Fukuchi² (originally Hatsune).³ *A.:* Shibun.⁴ *F.N.:* Chōzō.⁵ *Gō:* Hakuei,⁶ Keichūrō.⁷ **Biog.:** Shijō painter. Born in Kyōto. Pupil of Hatta Koshū. Worked in Edo. Specialized in landscapes; a skillful colorist. **Bib.:** Brown, *Dessins,* Mitchell.

¹白暎 ²福智 ³初音 ⁴士文 ⁵長蔵 ⁶白暎 ⁷桂中樓

Hakuen¹ (fl. 1850–70). *N.:* Hirose Akira.² *Gō:* Hakuen.³ **Biog.:** Japanese-style painter. Son and pupil of Hirose Junko. Also a *haiku* poet.

¹柏園 ²広瀬明 ³柏園

Hakuin¹ (1685–1768). *N.:* Nagasawa Ekaku.² *Priest name:* Hakuin.³ *F.N.:* Toshijirō.⁴ **Biog.:** *Zenga* painter, calligrapher. Also a priest. Born and died in Hara, Suruga Province. At 15 entered the Zen temple Shōin-ji, Hara, where he studied with Tanrei and was given Buddhist name of Ekaku. The temple remained his base throughout his long life of teaching and traveling. In 1717, became abbot of the Myōshin-ji, Kyōto; later moved to a series of temples and finally, in 1758, founded the Ryūtaku-ji in Izu. One of the most important Zen masters of his time, is credited with reinvigorating the Rinzai sect. With Sengai, epitomizes late Zen painting. Subjects include portraits of Zen masters, Buddhist themes, self-portraits, flowers, animals, and landscapes, all done in his spontaneous, sometimes humorous, sometimes serious, frequently deliberately inept, always expressive, and wildly individual style. Renounced all rules: a free and audacious brush. Best paintings all from his old age. There also exist a few wooden figures made by him. **Coll.:** Brooklyn, Daikō-ji, Dairyū-ji, Empuku-ji, Fogg, Herron, Hōrin-ji, Keiun-ji, Museum (3), Myōkō-ji, Ryūgaku-ji, Ryūtaku-ji, Seattle, Shōfuku-ji, Shōin-ji, Zenshō-ji. **Bib.:** *Au-delà;* Awakawa; BO 77, 78, 79, 90; Brasch (1), (2); Fontein (1), (2); Hillier (2); Hisamatsu; *Japanische* (1); K 803, 804, 808; M 134, 166; Mayuyama; Munsterberg (4); NB (S) 47; Rosenfield (2); Takeuchi; Umezawa (2).

¹白隠 ²長沢慧鶴 ³白隠 ⁴牛次郎

Hakuju¹ (1679–1766). *N.:* Kanō Takenobu.² *F.N.:* Okanojō.³ *Gō:* Hakuju.⁴ **Biog.:** Kanō painter. Adopted by Kanō Juseki Atsunobu; became fourth in the Saruyamachi Kanō line. Followed Kanō Eitoku's manner.

¹伯寿 ²狩野武信 ³岡之丞 ⁴伯寿

Hakukō¹ (fl. early 19th c.). *N.:* Matsuoka Hakukō.² *A.:* Hikokan.³ *Gō:* Geppo.⁴ **Biog.:** Painter. Lived in Yamato Province. **Bib.:** Mitchell.

¹伯高 ²松岡伯高 ³彦幹 ⁴月甫

Hakuryū¹ (1833–98). *N.:* Sugawara Motomichi (Gendō)² (originally Michio).³ *Gō:* Bonrin,⁴ Hakuryū,⁵ Hakuryū Sanjin,⁶ Nihon Inshi,⁷ Nikkyō Inshi.⁸ **Biog.:** Japanese-style painter. Born in Uzen Province. A mountain ascetic and Zen priest. Studied painting under Kumasaka Tekizan, then under a master who specialized in *kachōga*. In 1869 to Tōkyō; after seeing the paintings of Okuhara Seiko, worked in the *nanga* style. Made quite a name as a landscape painter, receiving many awards at various exhibitions. **Bib.:** Asano, Mitchell, NBZ 6, NB (S) 17, Umezawa (2), Uyeno.

¹白竜 ²菅原元道 ³道雄 ⁴梵林 ⁵白竜
⁶白竜山人 ⁷日本隠士 ⁸日橋隠士

Hakusai¹ (1719–92). *N.:* Itō Hakusai.² *F.N.:* Masuya Gen-

zaemon.³ **Biog.:** Painter. Younger brother of Itō Jakuchū. Also a *haiku* poet. **Bib.:** *Jakuchū.*

¹白歳 ²伊藤白歳 ³桝屋源左衛門

Hakusei¹ (fl. first half 18th c.). *N.:* Kanō Inshin.² *Gō:* Hakusei.³ **Biog.:** Kanō painter. Son and pupil of Kanō Sosen; member of the Kanda Kanō school.

¹伯清 ²狩野因信 ³伯清

Hakuun¹ (1764–1825). *Given name:* Yoshinori.² *Priest name:* Ryōzen Kyōjun.³ *Gō:* Hakuun,⁴ Shōdō Hakuun.⁵ **Biog.:** Painter. Born in Kyōto. A priest, first served Lord Matsudaira in Fukushima, then served at various temples in Akita. In painting, his training was eclectic ranging from the study of the so-called Southern Sung school of China to Western-style painting. A friend of the leading Shijō and *nanga* painters of the day. **Coll.:** Hogaku-ji. **Bib.:** GNB 25, Nishimura, Umezawa (2).

¹白雲 ²良順 ³良善教順 ⁴白雲 ⁵松堂白雲

Hakuun Egyō¹ (1223–97). **Biog.:** Painter. A Zen priest, once a disciple of the famous Zen master Enni, who became abbot of the Ritsukyū-an at the Tōfuku-ji, Kyōto. A very few ink monochrome paintings are attributed to him. **Bib.:** BCM 50, Nakamura (3).

¹白雲恵暁

Hakyō¹ (1764–1826). *N.:* Kakizaki Hirotoshi.² *A.:* Seyū.³ *F.N.:* Shōgen.⁴ *Gō:* Hakyō,⁵ Kyōu.⁶ **Biog.:** Maruyama painter. Born in Matsumae. Brother of a feudal lord in Hokkaidō, was adopted into the Kakizaki family, who were retainers of that lord. Studied painting under Tatebe Ryōtai and Kusumoto Shiseki, from whom he learned the Nagasaki style, and under Maruyama Ōkyo in Kyōto. A friend of Ohara Donkyō, who gave him the *gō* of Hakyō. A rather realistic painter of birds, flowers, insects, and fish. **Bib.:** K 427, 768.

¹波響 ²蠣崎広年 ³世祐 ⁴将監 ⁵波響 ⁶杏雨

Hamada Kan¹ (1898–). **Biog.:** Japanese-style painter. Born in Hyōgo-ken, resident of Kyōto. Graduate of the Kyōto Municipal School of Fine Arts and Crafts. Pupil of Takeuchi Seihō. Exhibitor at government shows and with the Nitten. An imaginative approach enlivens his traditional style. **Coll.:** National (5).

¹浜田観

Hamada Saburō¹ (1892–). **Biog.:** Sculptor. Born in Hakodate. Graduated in 1918 from the Tōkyō School of Fine Arts. First exhibited in 1926 at the Teiten, continuing as a frequent exhibitor at government shows. After 1945 showed with the Nitten, becoming a member in 1966. **Bib.:** Asano.

¹浜田三郎

Hamada Shigemitsu¹ (1886–1947). **Biog.:** Western-style painter. Born in Kōchi-ken. Studied at Taiheiyō Kenkyūsho. Pupil of Mitsutani Kunishirō and Nakamura Fusetsu. In 1912 joined the Fusainkai; in 1914 showed with the Inten and the Nikakai. Toured Europe in 1921–23. In 1932 became a member of Nikakai. Lived in Nara, specializing in paintings of deer. **Bib.:** Asano.

¹浜田葆光

Hamada Shōji¹ (1894–). **Biog.:** Potter. Born in Kawasaki, Kanagawa-ken. Graduate of the Ceramic Department of Tōkyō Technological High School; fellow student with Kawai Kanjirō at the Kyōto Ceramic Research Institute. From 1920 to 1923, worked and studied with the English potter Bernard Leach at St. Ives, Cornwall. In 1924 returned to Japan and settled at Mashiko, Tochigi-ken, making it eventually a center of the folk-art movement. With Kawai and Yanagi Sōetsu, founded the Nihon Mingeikan in Tōkyō. Most celebrated potter of his time and foremost exponent of the folk-art movement. In 1955 named a Living National Treasure. His work, which is never signed, consists of articles for ordinary use, generally glazed a rich brown, olive green, gray, or black and decorated with abstract or naturalistic patterns in ash or iron glaze; sometimes the glaze is allowed to drip at random over the body of the vessel, or salt is put in the kiln to produce new colors. His style derives from Japanese folk pottery, Yi-dynasty Korean ceramics, and the English slip wares of Bernard Leach. **Coll.:** Art (1a), Ashmolean, Duncan, Fogg, National (4), Nelson, Newark, Ohara (2), Philadelphia, Royal (2), Tōkyō (1), University (2). **Bib.:** Adachi, *Japanese* (1a); Koyama (1), (1a); *Masterpieces* (4); Miller; Munsterberg (2), (3); NB (H) 24; NBT 6; NBZ 6; Noma (1) 2; Okada; SBZ 11; STZ 16; Sugimura; *Works* (1); Yanagi (3).

¹浜田庄司

Hambei (Hanbei)¹ (fl. c. 1660–92). *N.:* Yoshida Sadakichi.² *Gō:* Hambei (Hanbei).³ **Biog.:** Ukiyo-e illustrator. Little known of his life. One of earliest ukiyo-e illustrators known by name, and one of the most prolific and clever, dominating the world of book illustration in Kyōto and Ōsaka. Among his works are illustrations for the novels of Saikaku as well as erotic books. His style resembles that of Moronobu, whose contemporary he was. **Coll.:** Philadelphia. **Bib.:** Binyon (3), Brown, Keyes, Lane.

¹半兵衛 ²吉田定吉 ³半兵衛

Hamboku (Hanboku)¹ (1825–68). *N.:* Murayama Shō.² *A.:* Kei.³ *F.N.:* Shūichirō.⁴ *Gō:* Hamboku (Hanboku),⁵ Katei.⁶ **Biog.:** *Nanga* painter. Born in Echigo; to Edo to study under Hasegawa Rankei. Also went to Nagasaki to study Ming and Ch'ing painting. A loyalist, committed suicide while being hunted down by the Tokugawa shogunate. **Bib.:** Umezawa (2).

¹半牧 ²村山椒 ³馨 ⁴秀一郎 ⁵半牧 ⁶荷亭

Hammu (Hanmu)¹ (1817–85). *N.:* Iwase Hirotaka.² *Gō:* Hammu (Hanmu),³ Karyū,⁴ Kinsen,⁵ Rin'oku.⁶ **Biog.:** *Nanga* painter. Born in Kii Province. First studied *yamato-e* under Tanaka Totsugen and Ukita Ikkei. Later became a follower of the *nanga* school; probably self-taught. Good at landscapes and orchid-bamboo designs.

¹半夢 ²岩瀬広隆 ³半夢 ⁴可隆 ⁵琴泉 ⁶林屋

Hanko¹ (fl. late 18th c.). *N.:* Katsuno Hanko.² **Biog.:** Nagasaki painter. Born in Nagasaki. Popularly called Nagasaki Hanko.³ A painter of *kachōga* and animals in color and of bamboo in ink alone. **Coll.:** Nagasaki. **Bib.:** Mody.

¹范古 ²勝野范古 ³長崎范古

Hankō¹ (1782–1846). *N.:* Okada Shuku.² *A.:* Shiu.³ *F.N.:* Hikobei,⁴ Uzaemon.⁵ *Gō:* Dokushōrō,⁶ Hankō,⁷ Kanzan,⁸ Musei.⁹ **Biog.:** *Nanga* painter, calligrapher. Born and lived in Ōsaka. Son and pupil of Okada Beisanjin; like him, briefly served Lord Tōdō of Tsu as a Confucian scholar. At 43 resigned from this post and joined the intellectual circles of Ōsaka, studying Ming and Ch'ing painting on his own. Specialized in rather misty landscapes, somewhat in the manner of Mi Fei, but also did figures with a strong sense of caricature. **Coll.:** Art (1a), Ashmolean, British, Fine (M. H. De Young), Seattle, University (2). **Bib.:** Binyon (1); Cahill; *Cent-cinquante;* GNB 18; Hillier (2); *Japanese* (1a); K 673, 706, 735, 736, 753, 763, 776, 847, 924; Mitchell; Morrison 2; Murayama (2); NB (H) 23; NB (S) 4; NBZ 5; *Nihon* (2), (3); OA 13; *One* (2); SBZ 10; Shimada 2; Tajima (9) 2, (12) 17, (13) 7; Yonezawa.

¹半江 ²岡田粛 ³子羽 ⁴彦兵衛 ⁵宇左衛門 ⁶独松楼 ⁷半江 ⁸寒山 ⁹無聲

Hankō¹ (1804–64). *N.:* Fukuda Kitsu.² *A.:* Kitsujin.³ *F.N.:* Kyōzaburō.⁴ *Gō:* Gyōmusei,⁵ Gyōsai,⁶ Hanko,⁷ Hankō,⁸ Shōin Sonsha.⁹ **Biog.:** *Nanga* painter. Born in Mitsuke, near Iwata. Went to Edo; studied under Watanabe Kazan (even looked after Kazan's son after his father's death) and became one of his most distinguished followers. Specialized in landscapes. **Bib.:** Mitchell, Morrison 2, Murayama 2.

¹半香 ²福田佶 ³吉人 ⁴恭三郎 ⁵暁夢生 ⁶暁斎 ⁷盤湖 ⁸半香 ⁹松隠村舎

Hansaburō¹ (fl. 1688–1703). **Biog.:** Lacquerer. A skilled

artist, producing plain lacquer wares as well as pieces with inlaid decoration of nacre. **Bib.:** Herberts, Jahss.

¹半三郎
Hanshun¹ (1035–1112). **Biog.:** Buddhist painter. A figure known only from records. A high-ranking priest attached first to the Kōfuku-ji, Nara, and then to the Tō-ji, Kyōto. Painter of Buddhist themes.

¹範俊
Hanshun¹ (fl. early 12th c.). **Biog.:** Buddhist painter. Known only from temple records as having been attached to the Kōfuku-ji, Nara, and having received rank of *hokkyō* in 1103.

¹範舜
Hansuke¹ (fl. 19th c.). *N.:* Kawamoto Hansuke.² **Biog.:** Seto potter. Several generations of potters using this name worked at Seto in the 19th century. The best known is the artist of the fourth generation. **Coll.:** Tōkyō (1). **Bib.:** GNB 19, STZ 6.

¹半助 ²川本半助
Han'u¹ (1804–47). *N.:* Uchihashi Yoshihira.² *Gō:* Chikuri,³ Han'u.⁴ **Biog.:** *Nanga* painter. Born perhaps in Nagasaki; son of Yamamoto Chikuun. Pupil of Ishizaki Yūshi. With Hidaka Tetsuō and Kinoshita Itsuun, considered one of the famous Nagasaki *bunjinga* painters of his time.

¹半雨 ²打橋喜衡 ³竹里 ⁴半雨
Hanzan¹ (1743?–90?). *N.:* Mochizuki Hanzan.² *Gō:* Haritsu II,³ Ritsuō II.⁴ **Biog.:** Lacquerer. Worked in Edo. Most talented of Ogawa Ritsuō's followers. Also studied pottery making. His lacquer, like that of Ritsuō, is encrusted with ceramics and mother-of-pearl, but his style is less daring, more delicate and detailed. **Coll.:** British, Freer, Rijksmuseum (2), Metropolitan, Victoria. **Bib.:** Herberts, Jahss, Morrison 1, M 188, Ragué, Sawaguchi, SBZ 10, Speiser (2).

¹半山 ²望月半山 ³破笠二代 ⁴笠翁二代
Hanzan¹ (fl. 1850–82). *N.:* Matsukawa Yasunobu.² *A.:* Gikyō.³ *F.N.:* Takaji.⁴ *Gō:* Chokusui,⁵ Hanzan,⁶ Kakyo,⁷ Suieidō.⁸ **Biog.:** Ukiyo-e printmaker. Born and worked in Ōsaka. In 1882, employed to copy the ancient paintings owned by the Shigi-ji in Kawachi Province but died before completing the task. Specialized in *surimono;* also a distinguished illustrator of many books. **Coll.:** British, Metropolitan, Musées, Newark, Philadelphia, Victoria, Worcester. **Bib.:** Binyon (1), Brown, Hillier (7), Keyes, Mitchell, Morrison 2.

¹半山 ²松川安信 ³義卿 ⁴高二
⁵直水 ⁶半山 ⁷霞居 ⁸翠栄堂
Hara Bushō¹ (1866–1912). *N.:* Hara Kumatarō.² *Gō:* Bushō.³ **Biog.:** Western-style painter. Born in Okayama. Studied under Tamura Soritsu at Kyōto Prefectural School of Painting, graduating in 1882. Taught at various schools in the Kyōto area. In 1896 to Tōkyō. From 1904 to 1907 studied in London. An invalid much of his life, left few paintings. Worked rather in the manner of John S. Sargent, specializing in portraits. **Bib.:** Asano, Harada Minoru, NB (S) 30.

¹原撫松 ²原熊太郎 ³撫松
Hara Zaisen¹ (1849–1916). *N.:* Hara Zaisen.² *Gō:* Shōtō.³ **Biog.:** Japanese-style painter. Born in Kyōto; son and pupil of Hara Zaishō. From 1880 taught at Kyōto Prefectural School of Painting (after 1894, the Kyōto Municipal School of Fine Arts and Crafts). From 1882 on exhibited with the Naikoku Kaiga Kyōshinkai. Somtimes worked for the Imperial Household Office. Active in Kyōto art circles. Commissioned to do a painting of the funeral of the emperor Meiji. **Bib.:** Asano, Mitchell, Morrison 2, NB (S) 17, NBZ 6.

¹原在泉 ²原在泉 ³松濤
Harada Naojirō¹ (1863–99). **Biog.:** Western-style painter. Born and worked in Tōkyō. Pupil of Takahashi Yuichi at his school Tenkai Gakusha. In 1884 to Europe; studied under Gabriel Max in Germany. In 1887 returned to Japan: opened the private school Shōbikan, where Wada Eisaku and Oshita

Tojiro were among his pupils. One of of founders Meiji Bijutsukai. His competent paintings reflect official academic German style of late 19th century. **Coll.:** Bridgestone; Kyōto (1); National (5); Tōkyō (1), (2). **Bib.:** Asano, BK 188, Harada Minoru, *Kurashina* (2), NB (H) 24, NB (S) 30, NBT 10, NBZ 6, Uyeno.

¹原田直次郎
Haran¹ (fl. c. 1840). *N.:* Takahashi Koku.² *A.:* Chūgō.³ *Gō:* Haran.⁴ **Biog.:** Painter. Lived in Edo. **Coll.:** Victoria. **Bib.:** Mitchell.

¹波籃 ²高橋克 ³中剛 ⁴波籃
Haruga¹ (fl. c. 1804–30). *N.:* Koikawa Haruga.² **Biog.:** Ukiyo-e printmaker. Pupil of Utamaro II. Followed the late style of Toriyama Utamaro. **Coll.:** Victoria.

¹春峨 ²恋川春峨
Haruji (Harutsugu)¹ (fl. 1760–70). **Biog.:** Ukiyo-e printmaker. Probably a minor pupil of Harunobu. Seems to have signed his small-scale prints with the first of the two *kanji* writings given below and his pillar prints with the second. Possibly the first is an early signature and the second a later one. Worked in the manner of Harunobu. **Coll.:** British, Victoria. **Bib.:** Ficke, Morrison 2, UG 3, Waterhouse.

¹春次 (春治)
Harumachi¹ (1744–89). *N.:* Koikawa Harumachi² (originally Kurahashi Kaku).³ *F.N.:* Juhei.⁴ *Gō:* Kakuju Sanjin,⁵ Sakenoue no Furachi⁶ (his pseudonym as a satirical writer), Shunchō,⁷ Shunchōbō.⁸ **Biog.:** Ukiyo-e printmaker, illustrator. Also a novelist. A samurai serving Lord Matsudaira of Suruga; took the name Harumachi from the location of his daimyo's mansion in Edo. Pupil of Toriyama Sekien. Punished for satirizing the Kansei reforms, he committed suicide. Made a few prints of warriors and actors. Wrote and illustrated the first *kibyōshi*, the *Kinkin Sensei Eiga no Yume* (Master Gold's Dreams of Glory). As a writer, known under the name of Koikawa Harumachi. At one time was confused with Utamaro II. **Bib.:** Ficke, Kurth (2), Morrison 2, NHBZ 3, Tajima (7) 3.

¹春町 ²恋川春町 ³倉橋格 ⁴壽平 ⁵格壽山人
⁶酒上不埒 ⁷春町 ⁸春町坊
Harumasa¹ (fl. 1684–1703). *N.:* Shiomi Harumasa.² **Biog.:** Lacquerer. Worked in Kyōto. Said to have been the father of Shiomi Masanari. A skillful artist. **Bib.:** Herberts, Jahss.

¹春政 ²塩見春政
Harumasa¹ (fl. 1800–1820). *N.:* Koikawa Harumasa.² *Gō:* Banki,³ Banki Harumasa.⁴ **Biog.:** Ukiyo-e painter, printmaker. His rare prints are usually pillar prints of *bijin*. Also produced illustrations for storybooks. Influenced by Utamaro. **Coll.:** British, Staatliche, Victoria. **Bib.:** Binyon (1), Ficke, *Nikuhitsu* (2), Schmidt.

¹春政 ²恋川春政 ³晩器 ⁴晩器春政
Harunobu¹ (1724–70). *N.:* Suzuki (originally Hozumi)² Harunobu.³ *F.N.:* Jihei.⁴ *Gō:* Chōeiken,⁵ Shikojin.⁶ **Biog.:** Ukiyo-e painter, printmaker. Lived in Edo. His early works, of actors, show the influence of Ishikawa Toyonobu, Nishikawa Sukenobu, and the Torii artists rather than of his reputed master Nishimura Shigenaga; they are of little distinction. In 1765, taking full advantage of the newly invented technique of polychrome printing, began issuing prints in a delightful and daring variety of colors. No longer of the actors of his earlier period, they showed an enchanted world of young girls, men, and charming courtesans that captivated the Edo public. In the five remaining years of his life, published over 500 prints and dominated the ukiyo-e world. Even though he can be criticized on the grounds of too much sentimentality and cloying sweetness, he must be given full marks for the new direction in subject matter and for his brilliant use of the new technique of printing. Widely known as he is for his prints of the innocent young, is equally well known for his erotica, printed in the same delectable

colors but designed with a lustiness that contrasts strongly with his other work. Produced two kinds of painting: one with scarcely a trace of his print technique, using free brushwork and on paper; the other, far greater elaboration of color scheme and finish, usually on silk. One of the most influential masters of the ukiyo-e, to this day remains one of the most attractive members of the school. **Coll.:** Albertina; Allen; Andrew; Art (1), (1a); Ashmolean; Atami; Baltimore; Bibliothèque; British; Brooklyn; Cincinnati; City; Cleveland; Denver; Detroit; Fine (California); Fitzwilliam; Fogg; Freer; Herron; Honolulu; Kōbe; Metropolitan; Minneapolis; Musée (1), (2); Musées; Museu (1); Museum (1), (3); National (2); Newark; Östasiatiska; Österreichisches; Philadelphia; Portland; Rhode Island; Riccar; Rietberg; Rijksmuseum(1); Springfield; Staatliche; Tōkyō(1); Toledo; University (1), (2); Victoria; Wadsworth; Worcester; Yale. **Bib.:** Binyon (1), (3); BK 84; Blunt; Boller; Brown; Crighton; Ficke; Fontein (1); Fujikake (1a), (3) 2; Gentles (1), (2); GNB 17, 24; Hillier (1), (3), (4) 1, (7), (8), (9), (10); *Hyaku-go-jū*; *Japanese* (1a); K 655, 656, 657, 887; Kikuchi; Kondō (4), (6); *Kunst;* Kurth (6); Lane; Ledoux (2); M 233; Meissner; Michener (1), (3); Morrison (2); Narazaki (2), (13) 1; NB (S) 68; NBT 5; NBZ 5; NHBZ 2; *Nikuhitsu* (1) 2; Noguchi (1); Noma (1) 2; *One* (2); OZ 1920–22, 1925, 1929; *Pictorial* (2) 4; Rumpf (1); SBZ 10; Schmidt; Shibui (1); Stern (2); Takahashi (2), (4), (5); Tajima (7) 3, (13) 6; Takahashi (6) 2, 3; TBS 10; UG 1, 11, 12, 26, 27, 28, 29; *Ukiyo-e* (2) 2, (3) 5; Vignier 2; Waterhouse; Yoshida (1), (2).

<div align="center">¹春信　²穂積　³鈴木春信　⁴治兵衛
(次兵衛)　⁵長栄軒　⁶思古人</div>

Haruwaka[1] (fl. mid–16th c.). **Biog.:** Sculptor. Known as a carver of masks. Is also thought to have been a Nō actor. **Bib.:** Noma (4).

<div align="center">¹春若</div>

Hasegawa Eisaku[1] (1890–1944). *N.:* Hasegawa Eisaku.[2] *Gō:* Hōshū.[3] **Biog.:** Sculptor. Born in Tōkyō. Became a pupil of the sculptor Yoshida Hōmei[4] and started using the *gō* Hōshū. Exhibited with the Tōkyō Chōkōkai, Nihon Bijutsu Kōkai, and Nihon Bijutsu Kyōkai. In 1909 left Yoshida Hōmei's studio to become an independent sculptor and perhaps stopped using *gō* of Hōshū. In 1935 founded the Tōhō Chōsoin. **Coll.:** National (5). **Bib.:** Asano.

<div align="center">¹長谷川栄作　²長谷川栄作　³芳州　⁴吉田芳明</div>

Hasegawa Haruko[1] (1895–1967). **Biog.:** Western-style painter. Born in Tōkyō; her father a lawyer. Graduated from a girls' high school in Tōkyō in 1912; became a pupil of Kaburagi Kiyokata and, later, of Umehara Ryūzaburō, from whom she learned the technique of oil painting. In 1929 to Paris to study under contemporary artists there; back to Japan in 1931. Member of Kokugakai. Also worked as an illustrator. **Bib.:** Asano.

<div align="center">¹長谷川春子</div>

Hasegawa Kiyoshi[1] (1891–). **Biog.:** Western-style printmaker. Born in Yokohama. Studied oil painting under Okada Saburōsuke and Fujishima Takeji. Began making woodcuts and copperplates about 1912. In 1918 to France; lives, works, and exhibits in Paris. Member of the Shun'yōkai and the Nihon Hanga Kyōkai. In 1935 received the French Légion d'Honneur. School of Paris in style; frequently depicts realistic objects against a black ground. **Coll.:** Fine (California). **Bib.:** Asano; Kawakita (1); NBT 10; NBZ 6; NHBZ 7, 8; UG 4, 11.

<div align="center">¹長谷川潔</div>

Hasegawa Noboru[1] (1886–). **Biog.:** Western-style painter. Graduate of Tōkyō School of Fine Arts; while still a student, exhibited with the Bunten. On graduation, to France; came under the influence of Renoir. In 1916 returned to Japan; took an active part in the field of Western-style painting, becoming a member of the Shun'yōkai and exhibiting with the Teiten and, after 1945, the Nitten. Member of the

Nitten and the Nihon Bijutsuin. His style shows the influence of both Renoir and Van Gogh. **Bib.:** Asano, NBZ 6.

<div align="center">¹長谷川昇</div>

Hasegawa Roka[1] (1887–1967). *N.:* Hasegawa Ryūzō.[2] *Gō:* Roka.[3] **Biog.:** Painter. Born in Kanagawa-ken. In 1921 graduated from department of Japanese-style painting of the Tōkyō School of Fine Arts. To Europe, staying for seven years; engaged in making copies of paintings found in Central Asia. In 1927 returned to Japan. Became member of Shinkō Yamato-e-kai; exhibited with Teiten and Inten. Returned several times to Europe, studying fresco painting in Italy on one of these trips. Worked on a great wall painting at a church at Civitavecchia, Italy, illustrating the lives of some 26 Japanese Christian martyrs. Given Christian name of Luke (Japanese: Roka) and received an Italian award and the honorary citizenship of Rome. Known also as a scholar of history of costume. In 1960 given Kikuchi Kan Prize. **Bib.:** Asano.

<div align="center">¹長谷川路可　²長谷川竜三　³路可</div>

Hasegawa Saburō[1] (1906–57). **Biog.:** Western-style painter. Born in Yamaguchi-ken. From 1929 to 1932 in America and France, where he exhibited at the Salon d'Automne. Back in Japan, active in organizing avant-garde art societies. Died in San Francisco, where he had gone to speak on Far Eastern art. **Coll.:** National (4). **Bib.:** Asano, NB (H) 24, NBZ 6.

<div align="center">¹長谷川三郎</div>

Hasegawa Toshiyuki[1] (1891–1940). **Biog.:** Western-style painter. Born in Kyōto. To Tōkyō in 1921 to learn oil painting. Lived a 19th-century-style Bohemian life, hence known as "Japanese Van Gogh." Exhibited at one time or another with the Teiten, the Nikakai, the 1930 Association, the Issuikai. His style very School of Paris. **Coll.:** Bridgestone, National (5). **Bib.:** Asano, NBZ 6, NKKZ 11, SBZ 11.

<div align="center">¹長谷川利行</div>

Hasegawa Yoshioki[1] (1891–). **Biog.:** Sculptor. Born in Toyama-ken. Graduated in 1915 from the Tōkyō School of Fine Arts. A constant exhibitor at all major shows. Member of the Nitten. Specialized in figures of athletes in motion. **Coll.:** National (5). **Bib.:** Asano.

<div align="center">¹長谷川義起</div>

Hashiguchi Goyō[1] (1880?–1921). *N.:* Hashiguchi Kiyoshi.[2] *Gō:* Goyō.[3] **Biog.:** Painter, printmaker. The last great ukiyo-e artist. Born in Kagoshima. First studied Japanese-style painting with Hashimoto Gahō, then Western-style painting under Kuroda Seiki. Graduated in 1905 at the top of his class in Western-style painting from the Tōkyō School of Fine Arts. Turned to printmaking in 1915, producing only a few prints, almost all of traditional *bijin.* Painted in both Western and Japanese manners. His prints technically among the finest ever made, but artistically rather lifeless and dull. **Coll.:** Allen, Fine (California), Honolulu, Minneapolis, Museum (3), National (5), Nelson, Newark, Riccar, Tōkyō (1), University (1). **Bib.:** Asano; Fujikake (1); Hillier (9); Kondō (6); Michener (1), (3); NBZ 6; NHBZ 7; Takahashi (1), (2); UG 1, 4, 22.

<div align="center">¹橋口五葉　²橋口清　³五葉</div>

Hashiichi[1] (1817–82). *N.:* Hashimoto Ichizō.[2] *Gō:* Hashiichi,[3] Suiami.[4] *Signature:* Hashiichi.[5] **Biog.:** Lacquerer. Son of Hashimoto Matajirō, a decorator of sword scabbards. First followed his father's profession, but after the act of 1870 that forbade the wearing of swords, turned to the manufacture of other lacquer objects. Invented *take-nuri,* a lacquer coating that gives the appearance of bamboo; the technique is still practiced in Tsuruoka, Niigata-ken. Adopted one of his pupils, who succeeded him, taking the name of Hashiichi II (1856–1924). **Coll.:** Tōkyō (1). **Bib.:** Herberts, Jahss, NBZ 6, Sawaguchi, Yoshino.

<div align="center">¹橋市　²橋本市蔵　³橋市　⁴酔阿弥　⁵はし一</div>

Hashimoto Chōshū[1] (1899–1960). **Biog.**: Sculptor. Born in Fukushima-ken, worked in Tōkyō. Studied under Yamazaki Chōun. Showed at government exhibitions and with the Nitten. Awarded the Japan Art Academy Prize in 1954. Generally carved Buddhist figures in a soft and sentimental manner. **Coll.**: National (5).

<div align="center">[1]橋本朝秀</div>

Hashimoto Eihō[1] (1866–1944). **N.**: Hashimoto Ken (Kan).[2] **Gō**: Eihō.[3] **Biog.**: Japanese-style painter. Born in Edo. Son of Hashimoto Gahō. Pupil of his father and Shimomura Kanzan. At a very early age began exhibiting at fairs and art exhibitions. From 1907 on, showed with the Bunten; from 1914 on, with the Nihon Bijutsuin, becoming a member of this in 1921. **Coll.**: Museum (3), National (5). **Bib.**: Asano.

<div align="center">[1]橋本永邦 [2]橋本乾 [3]永邦</div>

Hashimoto Gahō[1] (1835–1908). **N.**: Hashimoto Masakuni.[2] **Gō**: Gahō,[3] Kokkisai,[4] Shōen,[5] Suigetsu Gasei,[6] Togansai.[7] **Biog.**: Japanese-style painter. Born in Edo; son of Hashimoto Seien Osakuni, who served the Matsudaira family at Kawagoe as painter. Studied Kanō painting first under his father, then under Kanō Shōsen'in at the Kobikichō Kanō studio. In 1859 obtained permission to open his own school. During the difficult times of the Restoration, painted fans for export to China for a living; also became professor of design at the Naval School. On its inauguration in 1889, became professor at Tōkyō School of Fine Arts; was in charge of the painting department, teaching the Kanō style, until he resigned in 1898. An important teacher; Yokoyama Taikan, Kawai Gyokudō, Shimomura Kanzan, Hishida Shunsō among his pupils. In 1890 appointed as first court artist. In 1898 one of the founders of the Nihon Bijutsuin. Frequently served as juror for official exhibitions. Member of the Art Committee of the Imperial Household. With Kanō Hōgai worked to reform Kanō school (with help and encouragement from Fenollosa and Okakura) and founded the Kangakai. The last of the Kanō painters in the Naonobu line, the father of the revival of Japanese-style painting. His best works date from 1890 to 1895 and consist largely of landscapes and genre scenes. His manner is the antithesis of Western-style painting, but he borrowed the perspective and shading of the West to give his landscapes more space and volume. **Coll.**: Fogg; Freer; Metropolitan; Museum (3); National (5); Philadelphia; Tōkyō (1), (2); Yamatane. **Bib.**: Asano, BK 111, Elisséev, Hashimoto, *Gahō-shu*, K 835, *Kanō-ha, Kurashina* (1), M 79, Mitchell, Morrison 1, NB (H) 24, NB (S) 17, NBT 10, NBZ 6, Noma (1) 2, Paine (2) 2, SBZ 11, Sullivan, Umezawa (1), Uyeno, Yashiro (1) 2.

<div align="center">[1]橋本雅邦 [2]橋本雅邦 [3]雅邦 [4]克己斎
[5]勝園 [6]酔月画生 [7]十雁斎</div>

Hashimoto Heihachi[1] (1887–1935). **Biog.**: Sculptor. Born in Mie-ken. Private pupil of Satō Chōzan; exhibited at the Inten. Led a solitary life on Mount Asama in Mie-ken. Worked in wood, in a rough independent style. **Coll.**: Tōkyō (2). **Bib.**: Asano, GNB 28, *Masterpieces* (4), NBZ 6, NB (H) 24, SBZ 11.

<div align="center">[1]橋本平八</div>

Hashimoto Kansetsu[1] (1883–1945). **N.**: Hashimoto Kan'ichi.[2] **Gō**: Kansetsu.[3] **Biog.**: Japanese-style painter. Born in Kōbe; worked in the Kansai district. Member of the second generation of the modern Kyōto school. Studied first under Takeuchi Seihō; later, on his own, studied *nanga* style and ancient Chinese and Japanese paintings. In 1921 studied in Europe. Made many trips to China. Member of the Art Committee of the Imperial Household and of the Imperial Art Academy; constant exhibitor at the Bunten. In 1939 received Asahi Culture Prize. His style a mixture of East and West: usually East in the background and in the brush strokes, West in the realism of the figures. **Coll.**: Kyōto (1); Metropolitan;

Museum (3); National (4), (5); Tōkyō (2), Yamatane. **Bib.**: Asano, *Masterpieces* (4), NB (H) 24, NBT 10, NBZ 6, SBZ 11.

<div align="center">[1]橋本関雪 [2]橋本貫一 (関一) [3]関雪</div>

Hashimoto Kunisuke[1] (1884–1953). **Biog.**: Western-style painter. Born in Tochigi-ken. Graduated from department of Western-style painting of the Tōkyō School of Fine Arts in 1903, then studied at the Hakubakai. From 1907 exhibited with the Bunten. At some point studied in Paris. During World War II lived in Nagano-ken, contributing to the promotion of art in that area. **Bib.**: Asano.

<div align="center">[1]橋本邦助</div>

Hashimoto Okiie[1] (1899–). **Biog.**: Printmaker. Born in Tottori-ken. In 1924 graduated from Tōkyō School of Fine Arts; worked as a teacher until 1955. Became interested in prints about 1932. In 1936 attended Hiratsuka Un'ichi's short course in woodblock printing given at Nihon Bijutsu Gakkō in Totsuka, Tōkyō. Active for many years as a member of the Nihon Hanga Kyōkai and the Kokugakai: also exhibited with the Bunten and Nitten, winning many prizes. Known especially for his views of gardens and ruined castles. His work is a happy combination of the traditional Japanese and the modern manner of the period before 1940. **Coll.**: Andrew, Fine (California), National (5), Nelson, Worcester. **Bib.**: Fujikake (1), Kawakita (1), Michener (3), NHBZ 8, Statler.

<div align="center">[1]橋本興家</div>

Hashimoto Seisui[1] (1876–1943). **N.**: Hashimoto Sōjirō.[2] **Gō**: Seiso;[3] later, Seisui.[4] **Biog.**: Japanese-style painter. Born in Onomichi. To Tōkyō to study with Hashimoto Gahō, by whom he was eventually adopted. From 1909 showed with the Bunten; in 1916 at the Inten. **Coll.**: National (5). **Bib.**: Asano.

<div align="center">[1]橋本静水 [2]橋本宗次郎 [3]正素 [4]静水</div>

Hata Senrei[1] (1865–1929). **N.**: Hata Tsunenaga.[2] **A.**: Shieki.[3] **Gō**: Hanzō Gaishi,[4] Senrei.[5] **Biog.**: Japanese-style painter. Born in Kyōto; son of a samurai in the service of the imperial court. Pupil of Suzuki Hyakunen. Received prizes at several exhibitions such as those of the Naikoku Kaiga Kyōshinkai and the Nihon Bijutsu Kyōkai. Member of the latter and of the Teikoku Kaiga Kyōkai, serving as a committee member for both of these societies. Some of his paintings were purchased by the Imperial Household Office. Specialized in landscapes. **Bib.**: Asano.

<div align="center">[1]畑仙齢 [2]畑経長 [3]子益 [4]半象外史 [5]仙齢</div>

Hata Teruo[1] (1887–1943). **Biog.**: Japanese-style painter. Born in Kyōto. In 1904 graduated from the Kyōto Municipal School of Fine Arts and Crafts. Led a wandering, rather Bohemian life. An artist of considerable skill. **Coll.**: National (4). **Bib.**: Asano.

<div align="center">[1]秦テルヲ</div>

Hatakeyama Kinsei[1] (1897–). **Biog.**: Japanese-style painter. Born in Ishikawa-ken; resident of Tōkyō. Graduate of Tōkyō School of Fine Arts. Pupil of Yūki Somei. Showed at government exhibitions and with the Nitten. Paints flowers and fruit in a pleasant broad style. **Coll.**: National (5). **Bib.**: Asano.

<div align="center">[1]畠山錦成</div>

Hatsuyama Shigeru[1] (1897–1973). **Biog.**: Printmaker. Worked in Tōkyō. Trained first in a dye shop. In painting studied both Kanō and ukiyo-e styles. First illustrated children's books; in the mid-20s turned to woodcuts. An exhibitor with the Nihon Hanga Kyōkai. His delicate and very decorative prints convey a mood of fantasy. **Coll.**: Cincinnati, Fine (California), National (5). **Bib.**: Kawakita (1), Michener (3), NHBZ 8, Statler, UG 11.

<div align="center">[1]初山滋</div>

Hattori Aritsune[1] (1890–1957). **N.**: Hattori Ken'ichi.[2] **Gō**: Aritsune.[3] **Biog.**: Japanese-style painter. Born in Nagoya. After graduating from the Tōkyō School of Fine Arts in 1915,

became a pupil of Matsuoka Eikyū and joined his two groups of the Shinkō Yamato-e-kai and the Kokugakai, both of which advocated a revival of the *yamato-e* school of painting. From 1925 exhibited at the Teiten, becoming a juror in 1933. Specialized in portraiture in the *yamato-e* style. Was well versed in ancient manners and customs of Japan. **Coll.**: National (5). **Bib.**: Asano.

¹服部有恒 ²服部謙一 ³有恒

Hayami Gyoshū[1] (1894–1935). *N.*: Hayami (originally Makita)[2] Eiichi.[3] *A.*: Kōzen.[4] *Gō*: Gyoshū.[5] **Biog.**: Japanese-style painter. Born and worked in Tōkyō. In 1914 took his mother's family name Hayami. At 15 a pupil of Matsumoto Fūko. With Imamura Shikō, Kobayashi Kokei, Maeda Seison, and Yasuda Yukihiko, one of Okakura Tenshin's "second-generation" artists. In 1911 exhibited with the Kojikai; later with the Inten. Member of Nihon Bijutsuin; in 1918 founding member of the Kokuga Sōsaku Kyōkai. In 1930 traveled in Europe. His work includes many portraits. When young, favored traditional *yamato-e* style but also experimented with the Rimpa manner, combining realistic detail with a decorative placing of forms. Later turned to an almost photographic realism, as in his well-known painting of a *maiko*. Finally worked in a more *nanga* manner. **Coll.**: National (5), Staatliche, Tōkyō (1), Yamatane. **Bib.**: Asano, *Ausgewählte,* Kondō (6), M 11, *Masterpieces* (4), Miyagawa, Nakamura (1), NB (H) 24, NBT 10, NBZ 6, NKKZ 20, Noma (1) 2, SBZ 11, Yashiro (1).

¹速水御舟 ²蒔田 ³速水栄一 ⁴浩然 ⁵御舟

Hayashi Shigeyoshi[1] (1896–1944). **Biog.**: Western-style painter. Born in Ōita-ken. First studied at the Kyōto Municipal School of Fine Arts and Crafts, then at the Kansai Bijutsuin. In 1920 became a pupil of Kanokogi Takeshirō. Exhibited with the Nikakai. In Europe from 1928 to 1930. From 1943 a juror for the Bunten. Also a member of the Dokuritsu Bijutsu Kyōkai, which he helped to found in 1930. **Bib.**: Asano, NBZ 6.

¹林重義

Hayashi Shizue[1] (1895–1945). **Biog.**: Western-style painter. Born in Ueda. Self-taught. An early exhibitor with the Nikakai. In Europe from 1921 to 1925; on his return showed with the Shun'yōkai and the Bunten, for which he was also a juror. Had no artistic affiliations in the last years of his life. **Coll.**: Kanagawa, National (5). **Bib.**: Asano, NBZ 6.

¹林倭衛

Hayashi Tadaichi[1] (1895–1972). **Biog.**: Painter, printmaker. Born and worked in Tōkyō. **Coll.**: National (5).

¹林唯一

Hayashi Takeshi[1] (1896–). *N.*: Hayashi Takeomi.[2] *Gō*: Takeshi.[3] **Biog.**: Western-style painter. Born in Tōkyō. Studied at Nihon Bijutsu Gakkō. In Europe in the 1930s, having taught earlier at the Tōkyō University of Arts. Exhibitor with the Nikakai; founding member of the Dokuritsu Bijutsu Kyōkai and helped organize the 1930 Association. Winner of the Mainichi Art Prize in 1949, the Japan Art Academy Prize in 1958, the Order of Cultural Merit in 1967. His style reflects the French postimpressionist tendencies. Still lifes like those of Braque in design and of Matisse in color; but influences well absorbed. Work characterized by simplicity and understatement. **Coll.**: National (5), Ohara (1). **Bib.**: Asano, NB (H) 24, NBT 10, NBZ 6, SBZ 11.

¹林武 ²林武臣 ³武

Hazama Inosuke[1] (1895–). **Biog.**: Western-style printmaker. Studied oil painting at Hongō Gakai Kenkyūsho. Visited Europe twice: 1921–29 and 1933–34. Studied under Henri Matisse. His style that of School of Paris. **Coll.**: National (5). **Bib.**: Asano, Fujikake (1), NBZ 6, NHBZ 7.

¹硲伊之助

Hazan[1] (1693–1777). *N.*: Ohara Kokushō.[2] *A.*: Shisho.[3] *F.N.*: Kampachi.[4] *Gō*: Hazan,[5] Keisai,[6] Keishūsai.[7] **Biog.**:

Nagasaki painter. Born in Nagasaki. Son and pupil of Ohara Keizan. In 1726 became attached to the training school for Chinese interpreters and went to work as an accountant in the service of the Nagasaki government, a post he held until 1776. Produced good ink paintings of dragons.

¹巴山 ²小原克紹 ³子緒 ⁴勘八
⁵巴山 ⁶敬斎 ⁷敬修斎

Hazan[1] (1827–94). *N.*: Hattori Hazan.[2] *A.*: Jiboku.[3] *F.N.*: Kenzō.[4] **Biog.**: Painter. Born in Shimōsa Province; son of a farmer. Moved to Edo. Apparently had no painting teacher. Sketched the landscapes he saw on his travels, his style based on Chinese models. **Bib.**: Mitchell.

¹波山 ²服部波山 ³自牧 ⁴謙蔵

Heishū[1] (1728–1801). *N.*: Ki Tokumin.[2] *A.*: Seikyō.[3] *Gō*: Heishū,[4] Nyorai Sanjin.[5] **Biog.**: Painter. Also Confucian scholar, literary man, economist. An amateur painter in the Southern Sung manner. **Bib.**: K 655.

¹平洲 ²紀徳民 ³世馨 ⁴平洲 ⁵如来山人

Hemmi Takashi[1] (1895–1944). **Biog.**: Printmaker. Born in Wakayama. Graduate of the Tōkyō Kōgei Gakkō (Polytechnic School). Member of Nihon Hanga Kyōkai. A minor print artist; also a poet. **Bib.**: Fujikake (1); NBZ 6; UG 11, 14.

¹逸見享

Hida Shūzan[1] (1877–1945). *N.*: Hida Masao.[2] *Gō*: Gekkyo[3], Shūzan.[4] **Biog.**: Japanese-style painter. Born in Ibaraki-ken. Pupil of Takeuchi Seihō and Kubota Beisen; also studied under Hashimoto Gahō. Showed at the Bunten and, later, at the Teiten; member and juror of the latter. Traditional, competent, sensitive artist. **Coll.**: National (5). **Bib.**: Asano, Elisséev.

¹飛田周山 ²飛田正雄 ³月居 ⁴周山

Hidari Jingorō[1] (fl. late Momoyama to early Edo period). **Biog.**: The real man was a carpenter and an architect in castle building, patronized by Hideyoshi and Ieyasu. However, out of his name there was created in the late Edo period a legendary figure, said to have been a sculptor of great talent, who carved many pieces of early Edo sculpture, even the famous Sleeping Cat at Nikkō.

¹左甚五郎

Hidemaro[1] (fl. early 19th c.). *N.*: Kitagawa Hidemaro.[2] *Gō*: Shōrinsai.[3] **Biog.**: Ukiyo-e printmaker. Pupil of Utamaro, whom he assisted with the illustrations for the famous book *Seirō Ehon Nenjū Gyōji* (Picture Book of the Green Houses and Their Ceremonies Throughout the Year), published in 1804. **Coll.**: British, Cleveland, Grunwald, Minneapolis, Musées, Newark, Östasiatiska, Philadelphia, Tōkyō (1), University (2), Victoria, Worcester. **Bib.**: Binyon (1), (3); Keyes; Kikuchi; Tamba (2a); UG 6.

¹秀麿 ²喜多川秀麿 ³松林斎

Hidenobu[1] (1588–1672). *N.*: Kanō Hidenobu.[2] *F.N.*: Hayato.[3] *Gō*: Genshun (Mototoshi).[4] **Biog.**: Kanō painter. Son of Kanō Ryōshō. Worked in Edo as *goyō eshi* to the shogunate. A minor Kanō artist. **Coll.**: Daigo-ji (Sambō-in). **Bib.**: Mizuo (2), Yamane (1a).

¹秀信 ²狩野秀信 ³隼人 ⁴元俊

Hidenobu (Eishin)[1] (fl. c. 1764–81). *Gō*: Hidenobu (Eishin),[2] Ungeisai.[3] **Biog.**: Ukiyo-e painter. Worked in Ōsaka. **Coll.**: Philadelphia, Victoria. **Bib.**: Keyes.

¹英信 ²英信 ³雲鯨斎

Hidetaka[1] (fl. 18th c.). *N.*: Kajikawa Hidetaka.[2] **Biog.**: Lacquerer. Son of Kajikawa Fusataka; fifth-generation head of the Kajikawa family. Worked in Edo for the shogunate. **Coll.**: Metropolitan. **Bib.**: Herberts, Jahss.

¹英高 ²梶川英高

Hidetsugu[1] (fl. late 15th to early 18th c.). A line of lacquerers. A number of lacquer artists of this name during this period, all of whom worked for the great contemporary tea masters. Specialized in *natsume*.

Hidetsugu I (fl. late 15th c.). *N.:* Shinoi.[2] *F.N.:* Yagorō.[3] *Gō:* Zensai.[4] Worked in Nara.

Hidetsugu II (fl. late 16th c.). *N.:* Shinoi[5] (or Noro).[6] *F.N.:* Yagorō.[7] *Gō:* Yoji,[8] Zenkyō.[9] Employed by Hideyoshi and Sen no Rikyū. Given honorary title of *tenka-ichi* for his fine lacquer work.

Hidetsugu III (fl. beginning 17th c.). *Gō:* Zenshō.[10] Worked for Furita Oribe.

Hidetsugu IV (fl. early 17th c.). *Gō:* Rinsai.[11] Master lacquerer. Made *natsume* for Kobori Enshū. His boxes are characterized by top and bottom sections of equal depth.

Hidetsugu V (fl. mid-17th c.). *Gō:* Yosai.[12]

Hidetsugu VI (fl. early 18th c.). *Gō:* Chōan.[13]

Bib.: Herberts, Jahss.

[1]秀次 [2]篠井 [3]弥五郎 [4]善斎 [5]篠井 [6]野呂 [7]弥五郎 [8]与次 [9]善鏡 [10]善紹 [11]林斎 [12]与斎 [13]長菴

Hideyori[1] (fl. c. 1540). *N.:* Kanō Jōshin[2] (or Shōshin).[3] *Gō:* Hideyori.[4] **Biog.:** Kanō painter. Lived in Kyōto. Said to have been second son of Kanō Motonobu, but may have been confused with a son called Sueyori[5] because of the close resemblance of the *kanji.* Sueyori's name, however, never appears on paintings. The only thing known about Hideyori's life and career is that he received title of *hokkyō.* His fame comes from one painting: *Maple Viewing at Mount Takao,* in which the rocks and trees are in the Kanō manner, while the genre scene of maple viewing is in rich bright colors. This work is considered a precursor of the ukiyo-e school. **Coll.:** Tōkyō (1). **Bib.:** Binyon (2); Fontein (1); Fujikake (3) 1; GK 11; GNB 13; Grilli (1); K 774; *Kokuhō* 6; Kondō (2), (6); M 199, 209; Matsushita (1a); Morrison 1; Narazaki (3); NB (S) 13; NBT 5; *Nikuhitsu* (1) 1; Noma (1) 2; P 2; Paine (4); *Rakuchū;* SBZ 3, 8; Tajima (7) 1; Tanaka (9); Yamane (1a).

[1]秀頼 [2]狩野常真 [3]紹信（承信） [4]秀頼 [5]季頼

Higashiyama[1] (fl. c. 1850). *Priest name:* Giryō.[2] *Gō:* Higashiyama.[3] **Biog.:** *Nanga* painter. Said to have been the son of Yamaoka Geppō; lived, as did his father, at the Sōrin-ji, Higashiyama, Kyōto. **Coll.:** Museum (3).

[1]東山 [2]義亮 [3]東山

Hikaimoto Shichirō[1] (fl. late 15th c.). **Biog.:** Sculptor. A carver of Nō masks. This name appears, as that of the maker, in the inscription, which also carries the date of 1493, on the inside of a Nō mask belonging to the Katte-jinja, Nara. There is a second mask, dated in the same year, with an inscription stating it was made by Hikakimoto Shichirō.[2] **Coll.:** Katte-jinja. **Bib.:** *Muromachi* (1).

[1]ヒカ井モト七郎 [2]ヒカキモト七郎

Hikobei[1] (fl. 1624–43). *N.:* Kajikawa Hikobei.[2] **Biog.:** Kajikawa lacquerer. Worked for the shogunate, making *inrō.* Seems to have been founder of the Kajikawa school but was eclipsed by his more talented son Kyūjirō. **Coll.:** Nelson. **Bib.:** Herberts, Jahss, Ragué, Yoshino.

[1]彦兵衛 [2]梶川彦兵衛

Hikokuni[1] (fl. 1818–30). **Biog.:** Ukiyo-e printmaker. An Ōsaka artist. Probably a pupil of Ashikuni. His work also shows some influence from the Utagawa school. **Coll.:** Musées, Victoria.

[1]彦国

Himeshima Chikugai[1] (1840–1928). *N.:* Himeshima Jun.[2] *A.:* Shijun.[3] *Gō:* Chikugai,[4] Gen'yō Kinto,[5] Gochiku Sōdō,[6] Tezuka Sanshō.[7] **Biog.:** Japanese-style painter. Born in Kyūshū. Before the Meiji Restoration, a feudal retainer in Fukuoka about to enter on a military career with painting as his hobby. After the Restoration, moved to Tōkyō and devoted himself entirely to painting. Later went to Ōsaka, where he became an important figure among the *nanga* painters. Mizuta Chikuho and Akamatsu Unrei among his

pupils. Noted for his *kachōga* and his rendering of bamboo. **Coll.:** Victoria. **Bib.:** Asano.

[1]姫島竹外 [2]姫島純 [3]子純 [4]竹外 [5]玄洋釣徒 [6]吾竹草堂 [7]帝塚山樵

Himi[1] (fl. c. 1504). **Biog.:** Sculptor. Known as a carver of masks. **Bib.:** Noma (4).

[1]氷見

Hirafuku Hyakusui[1] (1877–1933). *N.:* Hirafuku Teizō.[2] *Gō:* Hyakusui.[3] **Biog.:** Japanese-style painter. Born in Akita-ken, son of the painter Hirafuku Suian. Lived and worked in Tōkyō. Studied under Kawabata Gyokushō; graduated from and became professor at Tōkyō School of Fine Arts. Frequent exhibitor and prize winner at the Nihon Bijutsu Kyōkai, the Bunten, and the Teiten. In 1900, with Fukui Kōtei and Yūki Somei, established the Museikai. Member of Imperial Fine Arts Academy and of Kinreisha, which he helped establish in 1917. Also famous as a *waka* poet. Skillful painter of landscapes, figures, and *kachōga;* his sketches spontaneous and natural. An amusing, delicate genre painter whose decorative style has little Western influence; at the end of his life rather close to *nanga* school, influenced by Southern Sung painting. Also a good illustrator. **Coll.:** National (5); Tōkyō (1), (2); Yamatane. **Bib.:** Asano; BK 27, 184; *Cent-cinquante; Kurashina* (1); *Masterpieces* (4); Mitchell; Miyagawa; NB (H) 24; NB (S) 4, 17; NBT 10; NBZ 6; NKKZ 21; Odakane (1); SBZ 11.

[1]平福百穂 [2]平福貞蔵 [3]百穂

Hiraga Kamesuke[1] (1884–1971). **Biog.:** Western-style painter. Born in Mie-ken. To Amerlica in 1906; graduated from the Art School of the University of California in 1915. In 1925 to Paris, where he showed for many years in a variety of salons. A resident of France. **Coll.:** National (5). **Bib.:** Asano.

[1]平賀亀祐

Hiragushi Denchū[1] (1872–). **Biog.:** Japanese-style sculptor. Born in Okayama-ken. Began his career as a dollmaker. In 1897 moved to Tōkyō; studied under Takamura Kōun. As a member of Kōun's circle, helped to found the Nihon Chōkokukai; a constant exhibitor with that group. Also showed at the first Bunten. Leading member of the reestablished Nihon Bijutsuin. Taught at the Tōkyō School of Fine Arts. Member of the Japan Art Academy; in 1962, awarded the Order of Cultural Merit. Carried on tradition of Japanese wood sculpture, specializing in quite realistic and brightly colored portraiture, often of actors. **Coll.:** Hatakeyama, Jingū, Museum (3), National (5), Tōkyō (2). **Bib.:** Asano; BK 190; GNB 28; *Masterpieces* (3), (4); NB (H) 24; NBT 2; NBZ 6; SBZ 11; Yashiro (1); YB 31.

[1]平櫛田中

Hirai Baisen[1] (1889–). *N.:* Hirai Hidezō.[2] *Gō:* Baisen.[3] **Biog.:** Japanese-style painter. Born and worked in Kyōto. Graduate of Kyōto Municipal School of Fine Arts and Crafts. Exhibitor at the Bunten, where, in the late-Meiji era, his historical painting was awarded a prize. An important figure in the Kyōto art world. **Coll.:** Museum (3), National (5). **Bib.:** Asano, Elisséev.

[1]平井楳仙 [2]平井秀三 [3]楳仙

Hiraki Masatsugu[1] (1858–1943). **Biog.:** Western-style painter. Born in Edo; a samurai retainer of the Iwakura clan. Pupil of Goseda Hōryū; later worked in the atelier established by Gengendō, making lithographs. In 1887 showed at the Naikoku Kangyō Hakurankai; in 1907 with the Bunten. Became a member of the Meiji Bijutsukai in 1890. Taught at various institutions. Made illustrations of plants for scientific study. **Bib.:** Asano.

[1]平木政次

Hiraoka Gompachirō[1] (1883–1943). **Biog.:** Western-style painter. Born in Tōkyō. Studied at Hakubakai; pupil of Suzuki Kason and Takeuchi Seihō. Frequent exhibitor and

prize winner at the Bunten; member of the Kōfūkai. Also worked as a theatrical director. **Bib.:** Asano, Mitchell.

¹平岡権八郎

Hirata Shōdō[1] (1882–). **Biog.:** Japanese-style painter. Born in Tōkyō. Pupil of Kawai Gyokudō. Graduated in 1906 from the Tōkyō School of Fine Arts. Constant exhibitor and frequent prize winner at government exhibitions. Member of several associations for the promotion of Japanese-style painting. **Coll.:** National (5). **Bib.:** Asano.

¹平田松堂

Hiratsuka Un'ichi[1] (1895–). **Biog.:** Painter, printmaker. Born in Matsue. In 1913, when Ishii Hakutei visited Matsue, took lessons in oil painting from him, following him to Tōkyō for further study. Also studied at the Hongōgakai Kenkyūsho under Umehara Ryūzaburō; in addition studied printmaking. An important figure in the print world since he first showed his work at the Nikakai in 1916. Frequent exhibitor after 1945 at the Nitten and the Tōkyō Print Biennial. In 1931 helped found the Nihon Hanga Kyōkai. Became a member of the Kokugakai in 1930 and head of its print section in 1931. In 1927 published a book on the technique of printmaking. In 1935, with establishment of Department of Printmaking at Tōkyō School of Fine Arts, was appointed professor of woodblock printing. In 1943 engaged by Peking National University of Arts as professor of printmaking. In 1950 founded the Hiratsuka Print Institute, a school for printmakers. A pioneer of the modern print movement, one of the foremost woodcut artists. Prolific and successful, best known for his black-and-white prints of classical Japanese architecture, particularly Buddhist temples, done in a rough kind of "pointillism." His later work is abstract. All of it characterized by a great contrast between black and white. **Coll.:** Cincinnati, Fine (California), Musées, National (5), Newark. **Bib.:** Asano; Fujkake (1); Kawakita (1); Michener (1), (4); Munsterberg (1); NBZ 6; NHBZ 7, 8; SBZ 11; Statler; UG 4, 11, 14.

¹平塚運一

Hiroaki[1] (fl. 1673–80). **N.:** Shimada Hiroaki.[2] **Biog.:** Painter. Pupil of Sumiyoshi Jokei. No other details known. **Coll.:** Art (1a). **Bib.:** *Japanese* (1a).

¹広明 ²島田廣明

Hirochika (Hirokane, Hirokata)[1] (c. 1439–92). **N.:** Tosa Hirochika (Hirokane, Hirokata).[2] *Priest name:* Kyōzō.[3] **Biog.:** Tosa painter. Said to have been a son of Tosa Mitsuhiro and nephew of Tosa Yukihide. As chief exponent of the Tosa school, in 1439 was made Edokoro *azukari* and given title of Tosa no Kami. Later retired to become a priest. **Coll.:** Freer, Museum (3), Staatliche. **Bib.:** Akiyama (5); *Ausgewählte; Chūsei; Freer;* K 174, 935; Morrison 1; OA 17; OZ 1939–40; Paine (4); Shimada 1.

¹広周 ²土佐広周 ³経増

Hirokage[1] (fl. 1855–65). **N.:** Utagawa Hirokage.[2] **Biog.:** Ukiyo-e printmaker. Life unknown, save that he was a pupil of Hiroshige. **Coll.:** Allen, British, Musées, Philadelphia, Victoria. **Bib.:** Binyon (1), (3); Crighton; *Foreigners.*

¹広景 ²歌川広景

Hiromasa[1] (1787–1857). **N.:** Yamana Hiromasa[2] (originally Yukimasa).[3] *F.N.:* Daisuke.[4] **Biog.:** Sumiyoshi painter. Pupil of Sumiyoshi Hiroyuki. From time to time carried out commissions for the *bakufu* and for various feudal lords. **Bib.:** Asano.

¹広政 ²山名広政 ³行政 ⁴大輔

Hiromori[1] (1705–77). **N.:** Sumiyoshi Hiromori.[2] *F.N.:* Sōjirō.[3] *Priest name:* Kakei[4] or Keishi[5] or Shizen.[6] *Court title:* Naiki.[7] **Biog.:** Sumiyoshi painter. Son of Sumiyoshi Hiroyasu. With his son Hiroyuki and grandson Hironao, served the shogunate in Edo as *goyō eshi.* Their judgment in disputed questions of connoisseurship were supreme in their day; their certificates are frequently found attached to

early pictures of the Tosa and allied schools. An artist of great delicacy and charm. **Bib.:** Gray (2), Morrison 1.

¹広守 ²住吉広守 ³総次郎 ⁴賀慶 ⁵慶至 ⁶至全 ⁷内記

Hironao[1] (1781–1828). **N.:** Sumiyoshi Hironao.[2] *Court title:* Naiki.[3] *Gō:* Ganchū.[4] **Biog.:** Sumiyoshi painter. Son and pupil of Sumiyoshi Hiroyuki, older brother of Sumiyoshi Hirotsura. Like his father and grandfather, Hiromori, in the service of the Tokugawa *bakufu* as *goyō eshi,* art critic, and connoisseur. **Bib.:** Morrison 1, Tajima (12) 20.

¹広尚 ²住吉広尚 ³内記 ⁴頑中

Hironari[1] (fl. c. 1710). **N.:** Hachiya Hironari.[2] *Gō:* Keiga.[3] **Biog.:** Painter, illustrator. Pupil of Sumiyoshi Hirozumi. Illustrated books on armor.

¹広成 ²蜂屋広成 ³慶賀

Hironatsu[1] (1650–1731). **N.:** Sumiyoshi Hirotsugu[2] (later Hironatsu).[3] *F.N.:* Kuranosuke.[4] *Priest name:* Kakushū.[5] *Gō:* Ganseki.[6] **Biog.:** Sumiyoshi painter. Second son of Sumiyoshi Jokei. As a priest, founded the Shōfuku-ji at Takamatsu in Iyo. Specialized in Buddhist subjects. **Bib.:** K 131, Tajima (12) 7.

¹広夏 ²住吉広次 ³広夏 ⁴内蔵允 ⁵鶴洲 ⁶頑石

Hironobu[1] (?–1730). **N.:** Kanō Hironobu.[2] *F.N.:* Kuhachirō.[3] *Gō:* Enshun.[4] **Biog.:** Kanō painter. Second son and pupil of Kanō Hakuen; member of the Kanda line of the Kanō school.

¹広信 ²狩野広信 ³九八郎 ⁴円俊

Hironobu[1] (fl. c. 1851–70). **N.:** Kinoshita Hironobu.[2] *Gō:* Ashinoya,[3] Gohotei,[4] Goyōtei,[5] Hakusui,[6] Hakusuisai,[7] Tōrin.[8] **Biog.:** Ukiyo-e printmaker. Probably a pupil of Hirosada. Made prints of actors and Ōsaka comic genre scenes. **Coll.:** Musées, Philadelphia, Victoria. **Bib.:** Keyes.

¹広信 ²木下広信 ³芦野家 ⁴五蒲亭 ⁵五葉亭 ⁶白水 ⁷白水齋 ⁸東林

Hironobu II[1] (1844–?). **N.:** Kinoshita Hironobu[2] (originally Hirokuni).[3] *Gō:* Ashimi,[4] Hakuhō,[5] Ryūtō.[6] **Biog.:** Ukiyo-e printmaker. An Ōsaka artist; pupil of Kinoshita Hironobu, from whom he took his name. His work received favorable mention at the Naikoku Kaiga Kyōshinkai in 1884. **Coll.:** Musées, Victoria.

¹広信二代 ²木下広信 ³広国 ⁴芦水 ⁵白峰 ⁶柳塘

Hirosada[1] (fl. 1819–65). **N.:** Utagawa Hirosada.[2] *Gō:* Gosōtei.[3] **Biog.:** Ukiyo-e printmaker. Pupil of Utagawa Kunimasu. Worked in Ōsaka. It is possible this is the same artist as Utagawa Sadahiro (q.v.). **Coll.:** British, Musées, Philadelphia, Victoria, Yale. **Bib.:** Binyon (1), Crighton, Hillier (7), Keyes, NHBZ 3, Strange (2).

¹広貞 ²歌川広貞 ³五粽亭

Hirose Katsuhei[1] (1877–1920). **Biog.:** Western-style painter. Born in Hyōgo-ken. Pupil first of Yamamoto Hōsui, then of Kuroda Seiki. Graduate of the extension course of the Tōkyō School of Fine Arts. Exhibited with the Hakubakai in 1897, then with the Kōfūkai (of which he was a member), and finally with the Bunten.

¹広瀬勝平

Hirose Tōho[1] (1875–1930). **N.:** Hirose Hitoshi.[2] *Gō:* Tōho.[3] **Biog.:** Japanese-style painter. Born in Kōchi-ken. Pupil of Araki Kampo. From 1899 exhibited with a number of official groups such as the Nihon Bijutsu Kyōkai, of which he became a member. Also served as a member of the committee of the Nihongakai and, in 1928, as a juror for the Teiten. Some of his works were purchased by the imperial household.

¹広瀬東畝 ²広瀬済 ³東畝

Hiroshige[1] (1797–1858). **N.:** Andō Hiroshige.[2] *F.N.:* Tokutarō;[3] later, Jūbei,[4] Jūemon,[5] Tokubei.[6] *Gō:* Ichiryūsai,[7] Ichiyūsai,[8] Ryūsai,[9] Tōkaidō Utashige.[10] **Biog.:** Ukiyo-e painter, printmaker. Lived in Edo; son of an official of the fire department assigned to Edo Castle. Early interested in art, his first teacher Okajima Rinsai; then tried unsuccessfully to enter Utagawa Toyokuni's studio; at about 14

became a pupil of Utagawa Toyohiro. Also studied *nanga* painting under Ōoka Umpō; interested in Western art and the work of the Shijō school. Gave up his hereditary position in the fire department to his son, leaving himself free to devote himself to painting and designing prints. In 1812, took name of Hiroshige. In 1833, the year following a trip on the Tōkaidō, produced his famous *Tōkaidō Gojūsan Tsugi* (Fifty-three Stations on the Tōkaidō). Gradually gave up figure prints for landscapes and *kachōga;* subject matter provided by many trips throughout Japan. Enormous production of single sheets, prints in series, sketches, paintings: about 8,000 known items. Delightful, charming, dexterous artist of Japanese life and topography; deservedly popular in the West, more than any other printmaker responsible for the Westerner's view of "quaint Japan." The prints and sketches show great technical virtuosity, a naturalistic viewpoint; the paintings are rather dull, less interesting. **Coll.:** Albertina; Albright-Knox; Allen; Andrew; Art (1), (1a), (2); Ashmolean; Atami; Baltimore; British; Brooklyn; Cincinnati; City; Cleveland; Dayton; Denver; Detroit; Fine (California); Fitzwilliam; Fogg; Freer; Grunwald; Hakone; Herron; Honolulu; Los Angeles; Metropolitan; Minneapolis; Musée (1), (2), (3); Musées; Museum (1), (2), (3), (5); National (3); Nelson; Newark; Ōkura; Östasiatiska; Philadelphia; Portland; Rhode Island; Riccar; Rietberg; Rijksmuseum (1), (2); Smith; Staatliche; Suntory; Tōkyō (1), (2); University (1), (2); Victoria; Worcester, Yale. **Bib.:** AA 6; Binyon (1), (3); Boller; Brown; Crighton; Ficke; Fontein (1); *Freer;* Fujikake (3) 3; GNB 17, 24; Hillier (1), (2), (3), (4) 2, (7); *Japanese* (1a); K 78, 203, 214, 237, 443, 636, 664, 700, 774, 864, 873; Kikuchi; *Kunst;* Lane; Ledoux (3); M 228; Meissner; *Memorial;* Michener (3); Morrison 2; Narazaki (1), (2), (4), (5), (9), (13) 6; NB (S) 68; NBT 5; NBZ 5; NHBZ 5; *Nikuhitsu* (1) 2, (2); Noguchi (2); Noma (1) 2; *One* (2); Robinson (1), (2); SBZ 10; Schmidt; Shibui (1); Shimada 3; Stern (2), (4); Strange (1), (2); Suzuki (3); Tajima (7) 4, (12) 16, (13) 6; Takahashi (1), (2), (6) 3; Tamba (1), (2a); TBS 5; Uchida; UG 12, 14, 18; *Ukiyo-e* (2) 11, (3) 18; Vignier 6.

 ¹広重　²安藤広重　³徳太郎　⁴十兵衛　⁵十右衛門
 ⁶徳兵衛　⁷一立斎　⁸一幽斎（一遊齋）　⁹立斎
 ¹⁰東海道歌重

Hiroshige II¹ (1826–69). *N.:* Suzuki (originally Morita)² Chimpei.³ *Gō:* Hiroshige II,⁴ Ichiryūsai,⁵ Ichiyūsai,⁶ Kisai,⁷ Ryūsai,⁸ Ryūshō (Risshō),⁹ Shigenobu.¹⁰ **Biog.:** Ukiyo-e printmaker. Pupil and adopted son of Andō Hiroshige; probably assisted in some of the late work of his master. At first used *gō* of Shigenobu; when his master died in 1858, married his daughter and took his name. About 1865 his marriage was dissolved; retired to Yokohama, once again using the *gō* Shigenobu and also signing Ryūshō, painting pictures on tea boxes and lanterns intended for export. His work varies; his prints, at best, a good imitation of his master's but much is hasty and superficial; his paintings almost as fine as Hiroshige's. **Coll.:** Allen, Ashmolean, Baltimore, British, Brooklyn, Detroit, Fine (California), Fitzwilliam, Freer, Minneapolis, Musées, Nelson, Newark, Philadelphia, Portland, Rhode Island, Staatliche, Stanford, Tōkyō (1), University (2), Victoria, Worcester, Yale. **Bib.:** Binyon (1), (3); Ficke; *Foreigners;* Kikuchi; Morrison 2; Meissner; Nonogami; Schmidt; Shibui (1); Takahashi (1), (2); Tamba (2a), (3); UG 18.

 ¹広重二世　²森田　³鈴木鎮平　⁴広重二世　⁵一立斎
 ⁶一幽斎　⁷喜斎　⁸立斎　⁹立祥　¹⁰重宣

Hiroshige III¹ (1843–94). *N.:* Andō Tokubei.² *F.N.:* Gotō Torakichi.³ *Gō:* Hiroshige II,⁴ Isshōsai,⁵ Shigemasa,⁶ Shigetora.⁷ **Biog.:** Ukiyo-e printmaker. Pupil of Andō Hiroshige. After Hiroshige II's retirement to Yokohama about 1865, began calling himself Hiroshige III and using his master's surname

of Andō. A printmaker of little artistic importance, but interesting from a topographical point of view, as his special subject was the building of the railroads. **Coll.:** British, Fine (California), Musées, Philadelphia, Victoria. **Bib.:** Binyon (1), (3); Ficke; *Foreigners;* Morrison 2; NHBZ 7; Nonogami; Takahashi (1); Tamba (2a); UG 18.

 ¹広重三世　²安藤徳兵衛　³後藤寅吉
 ⁴広重　⁵一笑斎　⁶重政　⁷重寅

Hiroshima Kōho¹ (1889–1951). *N.:* Hiroshima Shintarō.² *Gō:* Kōho.³ **Biog.:** Japanese-style painter, printmaker. Born in Tokushima-ken. Graduated from the Japanese painting department of the Tōkyō School of Fine Arts in 1912. Exhibitor and juror at the Nitten. Organized the Tōkyō Hangakai in 1916. Showed there and at the Teiten as well as at the Nihon Sōsaku Hanga Kyōkai. His prints show some Western influence. A mediocre artist. **Coll.:** National (5). **Bib.:** Asano, NB (H) 24, NBZ 6, NHBZ 7, UG 4.

 ¹広島晃甫　²広島新太郎　³晃甫

Hirotaka¹ (fl. c. 1010). *N.:* Kose no Hirotaka.² *Gō:* Hirochika (Hirosane).³ **Biog.:** Kose painter. Son or grandson of Kose no Kimmochi; next in importance to Kanaoka. Began as a priest. Recorded as being a distinguished court painter of his time, noted for his Buddhist subjects. Several pictures attributed to him, but none so far positively identified as his. **Bib.:** Akiyama (2); Ienaga; Morrison 1; Paine (4); Tajima (12) 14, 18, 19.

 ¹弘高（広貴，広高，博孝）　²巨勢弘高（巨勢広貴，
 巨勢広高，巨勢博孝）　³弘実

Hiroteru¹ (fl. early 19th c.). *N.:* Watanabe Hiroteru.² **Biog.:** Sumiyoshi painter. Pupil of Sumiyoshi Hiroyuki.

 ¹広輝　²渡辺広輝

Hirotoshi¹ (?–1856). *N.:* Dodo Eifu.² *Gō:* Hirotoshi,³ Ryōka.⁴ **Biog.:** Shijō painter. Born in Kyōto. Pupil of Yamawaki Tōki. Painter of landscapes. **Coll.:** Victoria.

 ¹広年　²百百永夫　³広年　⁴菱華

Hirotsura¹ (1793–1863). *N.:* Sumiyoshi Hirosada.² *Court title:* Naiki.³ *Gō:* Hirotsura.⁴ **Biog.:** Sumiyoshi painter. Younger son of Sumiyoshi Hiroyuki. Served as *goyō eshi* to the Tokugawa shogunate. The Sumiyoshi family ranked below the Kanō family at the court until Hirotsura's time, when, due to his merit as a painter, the status of his family was made equal to that of the Kanō. Had many students, including Yamana Kangi and Morizumi Kangyō. First studied traditional Tosa painting; later combined this technique with a new element of vivid movement. His work in the Kyōto Imperial Palace is, however, quite dull. **Coll.:** Imperial (1) (Shishinden). **Bib.:** Morrison 1; Okamoto (1); Tajima (12) 16.

 ¹弘貫　²住吉広定（住吉弘定）　³内記　⁴弘貫

Hiroyasu¹ (1666–1750). *N.:* Sumiyoshi Hiroyoshi.² *A.:* Genshun.³ *F.N.:* Sakenosuke;⁴ later, Kuranosuke.⁵ *Priest name:* Shiseki.⁶ *Court title:* Naiki.⁷ *Gō:* Hiroyasu.⁸ **Biog.:** Sumiyoshi painter. Son of Sumiyoshi Gukei. Served as *oku eshi* to the Tokugawa shogunate. Best known as the teacher of his son Hiromori. **Bib.:** Morrison 1.

 ¹広保　²住吉広芳　³元俊　⁴酒之助
 ⁵内蔵允　⁶至石　⁷内記　⁸広保

Hiroyuki¹ (1755–1811). *N.:* Sumiyoshi Hiroyuki.² *Court title:* Naiki.³ *Gō:* Keikin'en.⁴ **Biog.:** Sumiyoshi painter. Son of Itaya Hiromasa; adopted by Sumiyoshi Hiromori. In 1781 appointed *goyō eshi* to the Tokugawa shogunate. In 1809, painted *byōbu* sent as official presents to Korea. With his father Hiromori and his son Hironao, famous as a connoisseur of ancient Japanese paintings. Specialized in genre subjects. **Coll.:** Tokugawa. **Bib.:** BK 267, Hillier (4) 3, K 71, Morrison 1.

 ¹広行　²住吉広行　³内記　⁴景金園

Hisakuni¹ (fl. late 15th to early 16th c.). *N.:* Fujiwara Hisakuni.² *F.N.:* Kamonnosuke.³ **Biog.:** *Yamato-e* painter. There is great confusion surrounding Fujiwara Hisakuni and Fuji-

wara Hisanobu (q.v.). By some scholars they have been thought to be the same person and the author of two sets of scrolls: the *Boki Ekotoba* of 1482 in the Nishi Hongan-ji and the *Shinnyodō Ekotoba* of 1524 in the Shinshō Gokuraku-ji, Kyōto; others mention only Hisakuni as the painter of the first and seventh scrolls of the *Boki Ekotoba* and of the *Shinnyodō Ekotoba;* still others say he painted only the latter. Given the time span between the dates of the two sets of scrolls, there is considerable justification for the theory that two artists are involved: Hisakuni and Hisanobu. Whatever the ultimate solution, it is agreed he was a famous painter and a contemporary of Tosa Mitsunobu. **Coll.:** Nishi Hongan-ji, Shinshō Gokuraku-ji. **Bib.:** *Muromachi* (1), Okudaira (1).

¹久国 ²藤原久国 ³掃部介

Hisanobu (fl. late 15th to early 16th c.). *N.:* Fujiwara Hisanobu.² *F.N.:* Kamonnosuke.³ **Biog.:** *Yamato-e* painter. Confusion enwraps Fujiwara Hisanobu and Fujiwara Hisakuni (q.v.). Some authorities say Hisanobu is the painter of the first and seventh scrolls of the *Boki Ekotoba* of 1482 in the Nishi Hongan-ji and also of the *Shinnyodō Ekotoba* (dated 1524) in the Shinshō Gokuraku-ji, Kyōto; others give him only the former work. However they agree in considering him an important artist and a contemporary of Tosa Mitsunobu. **Coll.:** Nishi Hongan-ji, Shinshō Gokuraku-ji. **Bib.:** Binyon (2), *Chūsei,* Ienaga, *Muromachi* (1), Okudaira (1), Toda (2).

¹久信 ²藤原久信 ³掃部助

Hisanobu¹ (fl. c. 1801–15). *Gō:* Hisanobu,² Hyakusai,³ Kanto.⁴ **Biog.:** Ukiyo-e printmaker. Perhaps a follower of Utagawa Toyohisa. Influenced by Utamaro. **Coll.:** British, Musées, Newark, Portland, Tōkyō (1). **Bib.:** Binyon (1), (3).

¹久信 ²久信 ³百斎 ⁴貫斗

Hisataka¹ (fl. second half 14th c.). *N.:* Kose no Hisataka.² **Biog.:** Kose painter. Third son of Kose no Arihisa.

¹久高 ²巨勢久高

Hisataka¹ (fl. 18th c.). *N.:* Kajikawa Hisataka.² **Biog.:** Lacquerer. Minor member of the Kajikawa family. **Coll.:** Freer, Metropolitan. **Bib.:** Herberts, M 188.

¹久高 ²梶川久高

Hisayuki¹ (fl. late 14th c.). *N.:* Kose no Hisayuki.² **Biog.:** Kose painter. Son of Kose no Yukitada, with whom he is recorded as having worked from 1374 to 1379 on the *Kōbō Daishi Gyōjō Emaki* (Scroll of the Deeds of Priest Kūkai). In 1379 also worked on the *Sonshō Mandara* for the Tō-ji, which might be interpreted as proof that he inherited his father's position as Edokoro *azukari* at the Tō-ji.

¹久行 ²巨勢久行

Hisen¹ (1755–95). *N.:* Mamura Chōzō.² *Gō:* Hisen,³ Kōun Sanjin,⁴ Rokō.⁵ **Biog.:** Nagasaki painter. Studied style of Shen Nan-p'in under Kumashiro Yūhi. Father of Araki Kunsen. **Coll.:** Nagasaki.

¹斐瞻 ²真村長蔵 ³斐瞻 ⁴耕雲山人 ⁵蘆江 (蘆口)

Hishida Shunsō¹ (1874–1911). *N.:* Hishida Mioji.² *Gō:* (early) Seiten,³ Shūkō;⁴ (later) Shunsō.⁵ **Biog.:** Japanese-style painter. Born in Nagano-ken; lived in Tōkyō. In 1895 graduated from Tōkyō School of Fine Arts, where Okakura Tenshin served as director and where he studied under Hashimoto Gahō. In 1896 appointed instructor at his alma mater; in 1898 resigned to found, with Okakura and some of his classmates, the Nihon Bijutsuin. Study trip to India in 1903; to USA, England, and France in 1904. In spite of his early death, holds an important position in the development of modern Japanese-style painting. Member of Japan Art Academy. At request of the Imperial Household Museum, copied old paintings held by shrines and temples. With his friend Yokoyama Taikan, experimented with technique known as *mōrōtai bossen* (the so-called dimness style). In his painting, discarded use of outline, relying in the Western

manner on color and chiaroscuro for modeling; his style, within Japanese limits, quite realistic. His *kachōga* have considerable quality; his paintings of Buddhist subjects are less successful. His early work romantic, sometimes sentimental; his later work slightly realistic, and, finally, almost mystic. **Coll.:** Museum (3); National (5); Tōkyō (1), (2); Yamatane. **Bib.:** *Art* (1a); Asano; BK 97, 101; K 775, 835; *Kurashina* (1); M 9; *Masterpieces* (4); Miyagawa; Nakamura (1); NB (H) 24; NB (S) 17; NBT 10; NBZ 6; NKKZ 16; Noma (1) 2; SBZ 11; Tanaka (7a) 17; Uyeno.

¹菱田春草 ²菱田三男治 ³晴天 ⁴秋江 ⁵春草

Hitomi Shōka¹ (1887–). *N.:* Hitomi Yūichi.² *Gō:* Shōka.³ **Biog.:** Japanese-style painter. Born in Kyōto. Studied in several Kyōto art schools. In 1909 first showed at the Bunten, winning an honorable mention. After 1921 belonged to the Nihon Nangain. Specialized in *kachōga*. **Bib.:** Asano.

¹人見小華 ²人見勇市 ³小華

Hōchū¹ (fl. late 18th to early 19th c.). *N.:* Nakamura Tatsuji.² *Gō:* Hōchū;³ later Hōchū⁴ (with different *kanji*), Kakō.⁵ **Biog.:** Rimpa painter. Also *haiku* poet. Born in Kyōto; lived in Ōsaka. Much influenced by Kōrin. In early 1800s in Edo, preparing *Kōrin Gafu,* a book on Kōrin's paintings. Made excellent use of the *tarashikomi* technique, whereby one color is applied with a wet brush and another put over it before it has dried. A charming Rimpa artist. **Coll.:** Tōkyō (1). **Bib.:** Hillier (4) 3; Holloway; *Japanische* (2); K 880; *Kōrin-ha* (1); M 107; Mitchell; Mizuo (2a), (4); *Rimpa;* Stern (3).

¹方仲 (芳中) ²中村達二 ³方仲 ⁴芳中 ⁵花紅

Hōen¹ (1804–67). *N.:* Nishiyama Seishō.² *A.:* Shitatsu.³ *Gō:* Chiichi,⁴ Hōen,⁵ Kan'ei.⁶ **Biog.:** Shijō painter. Lived in Ōsaka. Pupil of Matsumura Keibun. Specialized in *kachōga* and figures. One of best Shijō painters of his time. **Coll.:** Art (1), Ashmolean, British, Itsuō, Metropolitan, Museum (3), Victoria. **Bib.:** Fenollosa; *Kunst;* Mitchell; Morrison 2; *Shijō-ha;* Tajima (11); Tajima (12) 11, 14, 18; Tajima (13) 6.

¹芳園 ²西山成章 ³士達 ⁴知一 ⁵芳園 ⁶完瑛

Hōgai¹ (1828–88). *N.:* Kanō Enshin.² *F.N.:* Kōtarō.³ *Gō:* Hōgai,⁴ Shōkai,⁵ Shōrin.⁶ **Biog.:** Japanese-style painter. Born in Yamaguchi, son of an artist called Seiko, who had been a pupil of Isen'in and who served the Mōri clan as official painter. Came to Edo at 19, entered the Kobikichō Kanō studio studying under Kanō Shōsen'in. Using the *gō* Shōkai, painted until political turmoil in Edo prior to the Restoration made it impossible. Lived in poverty until discovered by Fenollosa, with whose help and that of Okakura Tenshin, he and Hashimoto Gahō established the Kangakai. Also worked to found the Tōkyō School of Fine Arts, which finally opened in February 1889, just after his death. Prominent in the reestablishment of Japanese-style painting in the Meiji period. Member of Nihon Bijutsuin. Like Gahō, painted in reformed Kanō manner, often on Buddhist themes. His works often seem a mixture of East and West, for under Fenollosa's direction he learned the technical methods of Western painting; hence his figures, even Buddhist ones, were studied from life, and there is much use of chiaroscuro and bright color. **Coll.:** Chōfu, Fogg, Freer, Museum (3), National (5), Nelson, Philadelphia, Tōkyō (2), Yale, Yamatane. **Bib.:** Asano; BK 12, 87, 184, 286; Elisséev; *Hōgai;* K 2, 30, 206, 433, 835; *Kanō-ha;* Kurashina (1); NB (H) 24; NB (S) 17; NBT 10; NBZ 6; Noma (1) 2; SBZ 11; Umezawa (1); Uyeno; Yashiro (1) 2, (4).

¹芳崖 ²狩野延信 ³幸太郎 ⁴芳崖 ⁵勝海 ⁶松隣

Hōgi¹ (1804–62). *N.:* Morimura Yaku.² *F.N.:* Jirobei.³ *Gō:* Hōgi,⁴ Keikai,⁵ Kōsui Sambō,⁶ Ōyo,⁷ Shinjitsuan,⁸ Shōkō.⁹ **Biog.:** Rimpa painter. Lived in Edo. Also a poet and calligrapher, often combining his painting and poetry. His

style a mixture cf Rimpa and *bunjinga* somewhat in the manner of Hōitsu. **Bib.:** K 881, Mitchell, Mizuo (3).

¹抱儀 ²守村約 ³治郎兵衛 ⁴抱儀 ⁵経解 ⁶交翠山房 ⁷鷗嶼 ⁸真実菴 ⁹松篁

Hōgyoku[1] (fl. c. 1840). *N.:* Yamada Shin'en.[2] *A.:* Shishoku.[3] *Gō:* Hōgyoku,[4] Junsai,[5] Keikadō,[6] Seiki.[7] **Biog.:** Painter. Lived in Edo. **Coll.:** Ashmolean, Fitzwilliam, Victoria. **Bib.:** Mitchell.

¹抱玉 ²山田眞淵 ³子飾 ⁴抱玉 ⁵絢斎 ⁶瓊華堂 ⁷青歸

Hōhei[1] (?–1807). *N.:* Satake Seii.[2] *Gō:* Hōhei,[3] Kibun Shujin,[4] Kibunseki Shujin.[5] **Biog.:** *Nanga* painter. Born in Shinano; went to Kyōto and studied under Ikeno Taiga. Little known of his life save that he traveled much, finally settling in Numata, Gumma-ken, where he probably died. Considerable talent; his work at times rather rough, slightly eccentric, quite humorous. **Coll.:** Tōkyō (1). **Bib.:** M 100, NB (S) 4.

¹蓬平 ²佐竹正夷 ³蓬平 ⁴亀文主人 ⁵亀文石主人

Hōitsu[1] (1761–1828). *N.:* Sakai Tadamoto.[2] *A.:* Kishin.[3] *Gō:* Hoitsu,[4] Keikyo Dōjin,[5] Kuzentō,[6] Nison'an,[7] Niwabyōshi,[8] Ōson,[9] Toryū,[10] Ukaan.[11] **Biog.:** Rimpa painter. Born in Edo, second son of Lord Sakai of Himeji Castle in Harima Province. To Kyōto to study. An eclectic painting education: began in Kanō school; then under Utagawa Toyoharu of the ukiyo-e school, Watanabe Nangaku of the Maruyama school, Sō Shiseki of the *nanga* school; finally, on the advice of Tani Bunchō, took up the Rimpa style. Also well versed in the classics, poetry, and the Nō. In 1797 became a Buddhist priest; spent the last 21 years of his life in seclusion, painting and studying the life and works of Kōrin. (From 1707 the Sakai family had supported Kōrin with a daily allowance for a number of years and had a large collection of his work.) Published two influential books— *Kōrin Hyakuzu* (1815) and *Kenzan Iboku Gafu* (1823)—of woodcuts after paintings by Kōrin and Kenzan, as well as a book of his own work, *Ōson Gafu.* His style owes something to the realism of Ōkyo, but much more to Kōrin's decorative manner, which he revived: a liquid style, with the dramatic contrasts of Kōrin combined with particularly clear colors, elegant and refined. **Coll.:** Andrew; Art (1), (2); Ashmolean; Atami; Brooklyn; British; Cleveland; Fitzwilliam; Fogg; Freer; Herron; Itsuō; Lake Biwa; Metropolitan; Museum (1), (3); Nelson; Newark; Ōkura; Philadelphia; Rhode Island; Rietberg; Staatliche; Stanford; Seattle; Tōkyō (1); Umezawa; University (2); Victoria; Worcester; Yamatane. **Bib.:** AA 6; AAA 21; BK 40, 59, 90; Brown; *Exhibition* (1); *Freer;* Gray (2); Grilli (1); Hillier (1), (3), (4) 3; K 11, 19, 23, 57, 83, 91, 106, 114, 124, 139, 161, 173, 191, 209, 218, 224, 229 323, 345, 375, 387, 392, 406, 410, 417, 434, 442, 456, 463, 471, 499, 526, 546, 551, 558, 802, 936, 943; KO 13, 32, 35, 39; *Kōrin-ha* (1), (2); Lee (1); M 1, 208, 215; Mayuyama; Minamoto (2); Mitchell; Mizuo (2a), (4); Morrison 2; *National* (1); NBT 5; NBZ 5; Noma (1) 2; *One* (2); *Rimpa;* Rosenfield (2); SBZ 10; Shimada 2; *Sōtatsu-Kōrin* (3); Stern (3); Tajima (2) 4, 5; Tajima (12) 4, 8, 9, 15, 18, 19, 20; Tajima (13) 5.

¹抱一 ²酒井忠因 ³暉眞 ⁴抱一 ⁵軽拳道人 ⁶狗禅等 ⁷二尊庵 ⁸庭拍子 ⁹鶯村 ¹⁰屠竜 ¹¹雨華庵

Hōji[1] (fl. c. 1785). *N.:* Matsumoto Hōji.[2] *A.:* Shūsuke.[3] *F.N.:* Hōji Dōjin.[4] **Biog.:** Painter. Born in Ōsaka. Studied under Yosa Buson. Known for his paintings of frogs, of which animals he was a collector. **Bib.:** Mitchell.

¹奉時 ²松本奉時 ³周助 ⁴奉時道人

Hōji[1] (1813–85). *N.:* Tanaka Hōji.[2] *F.N.:* Kimbei.[3] *Gō:* Keikyo.[4] **Biog.:** Rimpa painter. Born and lived in Edo. Before the Restoration, served as an official of the *bakufu.* Studied under Sakai Hōitsu, from whom he got his rather

watered-down version of the Rimpa style. **Coll.:** Tōkyō (1). **Bib.:** Elisséèv, Morrison 2.

¹抱二 ²田中抱二 ³金兵衛 ⁴軽拳

Hokkai[1] (fl. c. 1780). *N.:* Tsuda Ōkei.[2] *A.:* Keibun.[3] *F.N.:* Oribe Zakuroen.[4] *Gō:* Hokkai.[5] **Biog.:** Painter. Worked in the manner of Shen Nan-p'in. **Coll.:** Kōbe. **Bib.:** *Pictorial* (2) 5.

¹北海 ²津田応圭 ³奎文 ⁴織部柘榴園 ⁵北海

Hokkei[1] (1780–1850). *N.:* Iwakubo Tatsuyuki.[2] *F.N.:* Hatsugorō (Shogorō);[3] later, Kin'emon.[4] *Gō:* Hokkei,[5] Kien,[6] Kikō,[7] Kyōsai,[8] Totoya (Uoya) Hokkei.[9] **Biog.:** Ukiyo-e painter, printmaker. Lived in Edo. Originally a fishmonger (hence name of Totoya). First studied painting under Kanō Yōsen'in; later a pupil of Katsushika Hokusai, becoming one of his best followers. Produced only a few single-sheet prints, but many illustrations for collections of satirical poems and, especially, *surimono* of fine design and excellent printing. His work rivals that of his master. **Coll.:** Allen, Ashmolean, British, Brooklyn, Cincinnati, City, Cleveland, Fitzwilliam, Fogg, Grunwald, Honolulu, Kanagawa, Kōbe, Metropolitan, Minneapolis, Musée (2), Musées, Museu (1), Museum (1), Nelson, Newark, Ōstasiatiska, Portland, Rhode Island, Riccar, Rietberg, Staatliche, Tōkyō (1), Victoria, Worcester, Yale. **Bib.:** Binyon (1); Boller; Brown; Crighton; Fujikake (3) 3; Hillier (1), (2), (3), (4) 2, (9); K 735; Meissner; Michener (3); Mitchell; Morrison 2; *Nikuhitsu* (1) 2, (2); *Pictorial* (2) 4; Schmidt; Shibui (1); Tajima (7) 4; Tamba (2a).

¹北渓 ²岩窪辰行 ³初五郎 ⁴金右衛門 ⁵北渓 ⁶葵園 ⁷葵岡 ⁸拱斎 ⁹トトヤ (魚屋) 北渓

Hokki (Hokuki)[1] (fl. early 19th c.). *N.:* Katsushika[2] (originally Edogawa).[3] *Gō:* Hokki (Hokuki),[4] Sumpō.[5] **Biog.:** Ukiyo-e printmaker. Pupil of Hokusai, from whom he took the name Katsushika. Used the *gō* Hokki after 1820. A minor figure, working in an exaggerated style. **Coll.:** Musées, Victoria. **Bib.:** NHBZ 6.

¹北輝 ²葛飾 ³江戸川 ⁴北輝 ⁵寸法

Hōko[1] (1824–94). *N.:* Amano Shun.[2] *A.:* Kichita.[3] *Gō:* Hōko.[4] **Biog.:** Painter. Born in Iyo Province. To Kyōto; became a pupil of Nakabayashi Chikutō. Good at landscapes and *kachōga.* **Bib.:** Mitchell.

¹方壺 ²天野俊 ³吉太 ⁴方壺

Hokuba[1] (1771–1844). *N.:* Arisaka[2] (originally Hoshino).[3] *F.N.:* Gorohachi.[4] *Gō:* Hokuba,[5] Shūen,[6] Shunshunsai,[7] Shunshuntei,[8] Teisai,[9] Teisai Hokuba.[10] **Biog.:** Ukiyo-e painter, printmaker, illustrator. Born and lived in Edo. One of the outstanding pupils of Katsushika Hokusai. A good painter as well as printmaker. A prolific artist; designed many *surimono;* illustrated a number of books (especially *kyōka*), and is known chiefly for his paintings of *bijin.* Worked first in Kanō style, then influenced by Hokusai but still retained something of Kanō qualities; a delicate, quite charming manner. **Coll.:** Allen, Ashmolean, British, Fitzwilliam, Idemitsu, Kōbe, Metropolitan, Musées, Nelson, Newark, Portland, Staatliche, Tōkyō (1), Victoria, Worcester. **Bib.:** Binyon (1), (3); Hillier (2), (3), (4) 2; *Japanese* (2); K 785; Meissner; Mitchell; Morrison 2; *Nikuhitsu* (1) 2, (2); *Pictorial* (2) 4; Rosenfield (2); Schmidt; Shimada 3; Tajima (7) 4; UG 20, 28.

¹北馬 ²有坂 ³星野 ⁴五郎八 ⁵北馬 ⁶秋園 ⁷駿々斎 ⁸駿々亭 ⁹蹄斎 ¹⁰蹄斎北馬

Hokuchō[1] (fl. 1822–30). *N.:* Inoue.[2] *Gō:* Hokuchō,[3] Shunsho,[4] Shunshosai Hokuchō.[5] **Biog.:** Ukiyo-e printmaker. Pupil of Hokushū. Worked in Ōsaka. From 1824 used *gō* Hokuchō, usually signing Shunshosai Hokuchō. A competent but limited artist. **Coll.:** Musées, Newark, Philadelphia, Victoria. **Bib.:** Crighton, Keyes, NHBZ 3.

¹北頂 ²井上 ³北頂 ⁴春曙 ⁵春曙斎北頂

Hokuei[1] (fl. 1829–37). *Gō:* Hokuei,[2] Sekka,[3] Sekkarō,[4]

Shumbaisai,[5] Shumbaitei,[6] Shunkō,[7] Shunkōsai,[8] Shun'yōsai.[9] **Biog.:** Ukiyo-e printmaker. Worked in Ōsaka. Pupil of Shunkō Hokushū; with other pupils of Hokushū, settled in Ōsaka and played a prominent part in a group of designers of theatrical color prints. Together with pupils of Kunisada, known as the Ōsaka group. After 1829, used *gō* Hokuei, usually signing Shunkōsai Hokuei; also used a seal reading "Fumoto no Yuki" (Snow at the Foot of the Mountain), a reference to his teacher, who used a seal reading "Mount Yoshino." Good at actor prints and also as an illustrator of storybooks. **Note:** Since many of the references use only the name Hokuei, it is possible to confuse this artist with Tōkōen Hokuei (next entry), who used the same *kanji* for his *gō*. **Coll.:** British, Musée (1), Musées, Philadelphia, Portland, Victoria. **Bib.:** Binyon (1), Crighton, Hillier (7), Keyes, *Kunst*, Morrison 2, NHBZ 3, Strange (2).

¹北英 ²北英 ³雪華 ⁴雪花楼 ⁵春梅斎
⁶春梅亭 ⁷春江 ⁸春江斎 ⁹春陽斎

Hokuei[1] (fl. early 19th c.). *Studio name:* Tōkōen.[2] *Gō:* Hokuei.[3] **Biog.:** Ukiyo-e printmaker. Lived in Edo. Style close to that of Hokusai, whose pupil he was. **Note:** Since many of the references use only the name Hokuei, it is possible to confuse this artist with Shunkōsai Hokuei (preceding entry), since he used the same *kanji* for his *gō*. **Coll.:** Newark, Yale. **Bib.:** NHBZ 3.

¹北英 ²桃谷園 ³北英

Hokuen[1] (fl. c. 1840). *N.:* Sakaki Tanemichi.[2] *A.:* Shiryō.[3] *F.N.:* Yasunosuke.[4] *Gō:* Hokuen,[5] Kōka Kankyaku.[6] **Biog.:** Painter. Lived in Edo. Perhaps a pupil of Satō Masamochi. **Bib.:** Mitchell.

¹北苑 ²榊胤通 ³子亮 ⁴保之助 ⁵北苑 ⁶耕霞閑客

Hokuga[1] (fl. early 19th c.). *N.:* Sanda.[2] *F.N.:* Kosaburō.[3] *Gō:* Hokuga,[4] Hōtei,[5] Manjirō.[6] **Biog.:** Ukiyo-e printmaker, illustrator. Pupil of Hokusai. Specialized in *surimono* with subjects of *bijin* and warriors. A skillful colorist. **Coll.:** Staatliche, Tōkyō (1), Victoria. **Bib.:** Hillier (3), (4) 2; Schmidt.

¹北鵞 ²三田 ³小三郎 ⁴北鵞 ⁵抱亭 ⁶卍楼

Hokuga[1] (fl. c. 1830). *N.:* Katsushika (originally Yamadera)[2] Nobuyuki.[3] *F.N.:* Myōnosuke.[4] *Gō:* Hokuga,[5] Karyōsai.[6] **Biog.:** Painter, printmaker. Pupil of Hokusai and his collaborator on the book *Nikkō-zan Shi*, illustrating the natural history and topography of Nikkō. Produced a few *surimono* in the style of Hokusai. **Coll.:** Fitzwilliam, Newark, Victoria. **Bib.:** *Dessins*, Hillier (4) 2, Morrison 2.

¹北雅 ²山寺 ³葛飾信之 ⁴妙之助 ⁵北雅 ⁶花菱斎

Hokui[1] (fl. 1830–40). *N.:* Fukao.[2] *Gō:* Haku Sanjin,[3] Hokui.[4] **Biog.:** Ukiyo-e printmaker. Pupil of Hokusai; member of the Ōsaka school. An able illustrator; also produced some good *nishiki-e.* Known to have been still alive in 1893. **Coll.:** Ashmolean, British, Musées, Tōkyō (1), Victoria. **Bib.:** Binyon (1), (3); Strange (2).

¹北為 ²深尾 ³白山人 ⁴北為

Hokuichi[1] (fl. 1804–30). *N.:* Katsushika.[2] *Gō:* Hokuichi,[3] Kōgyōsai,[4] Shikōsai.[5] **Biog.:** Ukiyo-e painter, printmaker. Pupil of Hokusai, whose name he took. His prints are almost always of *bijin.* **Coll.:** Ashmolean, British. **Bib.:** Binyon (1), Morrison 2.

¹北一 ²葛飾 ³北一 ⁴工形斎 ⁵紫光斎

Hokuju[1] (fl. 1789–1818). *Given name:* Kazumasa.[2] *Gō:* Hokuju,[3] Shōsai,[4] Shōtei.[5] **Biog.:** Ukiyo-e painter, printmaker. Lived in Edo. One of the best pupils of Katsushika Hokusai. Specialized in highly original landscapes, designed with stylized clouds and almost cubistic mountains, rendered in a slightly Western manner, for he appears to have been influenced by the *ranga* style. Even made one print of the Forum in Rome. **Coll.:** Allen, Art (1), Ashmolean, British, Brooklyn, Honolulu, Kōbe, Musées, Newark, Portland, Rhode Island, Riccar, Staatliche, Tōkyō (1), Victoria, Worcester, Yale. **Bib.:** Binyon (1); Crighton; Fujikake (3)

3; GNB 17; Kikuchi; *Kunst;* Lane; M 102; Meissner; Michener (3); Morrison 2; Narazaki (2); NB (H) 24; NB (S) 36, 68; OA 12; *Pictorial* (2) 4; Schmidt; Shibui (1); Strange (2); Tamba (2a); UG 28.

¹北壽 ²一政 ³北壽 ⁴昇斎 ⁵昇亭

Hokuju[1] (fl. 1830–40). *Gō:* Goryūken,[2] Hokuju,[3] Shun'eisai,[4] Shunshōsai.[5] **Biog.:** Ukiyo-e printmaker. Born and worked in Ōsaka. Pupil of Hokuei Shunkōsai. **Note:** References sometimes confuse this Ōsaka artist with the Edo printmaker of the same name. **Coll.:** Philadelphia. **Bib.:** Keyes.

¹北壽 ²五竜軒 ³北壽 ⁴春英斎 ⁵春松斎

Hokumei[1] (fl. 1804–30). *N.:* Katsushika Hokumei.[2] *Gō:* Gakyōjin,[3] Kyūkyūshin.[4] **Biog.:** Ukiyo-e painter, printmaker. A pupil of Hokusai, she specialized in single standing figures of *bijin;* also illustrated books. A minor artist. **Bib.:** Hillier (4) 2, Morrison 2, *Nikuhitsu* (1) 2.

¹北明 ²葛飾北明 ³画狂人 ⁴九久蜃

Hokurei[1] (fl. c. 1840). *N.:* Irie Kan.[2] *A.:* Bunchō,[3] Kōchō.[4] *F.N.:* Zenkichi.[5] *Gō:* Hokurei.[6] **Biog.:** Painter. Lived in Hakodate. **Bib.:** Mitchell.

¹北嶺 ²入江貫 ³文長 ⁴交長 ⁵善吉 ⁶北嶺

Hokusai[1] (1760–1849). *N.:* Katsushika (originally Nakajima)[2] Tamekazu.[3] *F.N.:* Tokitarō;[4] later, Tetsuzō.[5] *Gō:* Fusenkyo,[6] Gakyōjin,[7] Gakyō Rōjin,[8] Gumbatei,[9] Gyobutsu,[10] Hishikawa Sōri,[11] Hokusai,[12] Iichi,[13] Kakō,[14] Katsukawa Shunrō,[15] Kintaisha,[16] Kuku,[17] Manji,[18] Manjiō,[19] Manji Rōjin,[20] Raishin,[21] Raito,[22] Ryōsen,[23] Shimpaku Sanjin,[24] Shinsai,[25] Shunrō,[26] Sōri,[27] Sōshunrō,[28] Taito,[29] Tatsumasa.[30] (Used over 50 *gō*, of which the above are the most common.) **Biog.:** Ukiyo-e painter, printmaker. Lived largely in Edo. Adopted son of the mirror maker Nakajima Ise. Trained as an engraver; also learned to cut wood blocks for prints, apparently the only artist of his time to do so. At 18 learned to design actor prints from Katsukawa Shunshō; given the *gō* Katsukawa Shunrō, under which he also produced illustrated *kibyōshi.* In 1785 quarreled with Shunshō and was dismissed from his studio. In 1787 began to sign Hishikawa Sōri; about 1797 began to use the *gō* Hokusai. From about 1795 to 1806, under the *gō* Gakyōjin, Hokusai, Kakō, and Sōri, worked in a romantic manner turning out *surimono* and illustrated volumes of verse. Next, under the influence of Chinese-style landscapes in book illustrations by Ōoka Shumboku and others, introduced landscapes in his own works, producing pictures of famous places. In 1814 the remarkable *Manga* volumes began to appear. By 1816, using the *gō* Iichi, was doing some of his finest paintings, including the great landscapes; also the fine *kachōga* prints. In 1817 to Nagoya to work; in 1818 visited Ōsaka and Kyōto. After 1820 all the great sets of prints, such as *Thirty-six Views of Mount Fuji*, began to appear. By 1835, using the *gō* Manji and Gakyō Rōjin among others, worked primarily as a painter. His life unsettled, with frequent changes of residence and two marriages, but even so a prodigious output of prints, sketches, paintings— perhaps 30,000 in all. Many pupils. One of the great draftsmen of the world; worked in many styles, even that of Shiba Kōkan, the exponent of Western perspective. Very daring landscapes and seascapes. Always inventive, fascinating, dexterous. **Coll.:** Albertina; Albright; Allen; Andrew; Ashmolean; Art (1), (1a), (2); Atami; Baltimore; British; Brooklyn; Cincinnati; City; Denver; Detroit; Fine (California); Fitzwilliam; Fogg; Freer; Grunwald; Hakone; Herron; Honolulu; Kōbe; Metropolitan; Minneapolis; Musée (1), (2); Musées; Museu (1); Museum (1), (3); National (3); Nelson; Newark; Okayama; Östasiatiska; Philadelphia; Portland; Rhode Island; Riccar; Rietberg; Rijksmuseum (2); Seattle; Staatliche; Stanford; Tōkyō (1); University (2); Victoria; Worcester; Yale. **Bib.:** AA 6, 14; ARTA 20; Binyon (1), (3); Boller; Bowie; Brown; Crighton; Ficke; Focillon; Fontein (1); Fujikake (3) 3; GNB 17, 24;

Gray (1); Hillier (1), (2), (3), (4) 2, (5), (6), (7); *Hokusai; Japanese* (1a), (2); K 126, 190, 198, 238, 240, 246, 284, 345, 423, 429, 670, 671, 672, 675, 677, 745, 749, 797, 824; Kikuchi; Kondō (6); *Kunst;* Lane; Ledoux (3); M 209; Meissner; Michener (2), (3); *Mizuo* (3); Morrison 2; Nagassé; Narazaki (1), (2), (6), (7), (9), (13) 4; NB (H) 24; NB (S) 68, 74; NBZ 5; NHBZ 5; *Nikuhitsu* (1) 2, (2); Noguchi (3), (3a); Noma (1) 2; OA 13; *One* (2); Ozaki; *Pictorial* (2) 4; Robinson (2); SBZ 10; Schmidt; Shibui (1); Shimada 3; Stern (1), (2), (4); Suzuki (1); Tajima (7) 4; Tajima (12) 12, 17; Tajima (13) 6; Takahashi (2); Tamba (2a); Terry; UG 9, 10, 12, 16, 17, 22, 25, 32; *Ukiyo-e* (2) 8, (3) 15; Vignier 5.

[1]北斎 [2]中島 [3]葛飾為一 [4]時太郎 [5]鉄蔵 [6]不染居
[7]画狂人 [8]画狂老人 [9]群馬亭 [10]魚佛 [11]菱川宗理
[12]北斎 [13]為一 [14]可候 [15]勝川春郎 [16]錦袋舎
[17]九々 [18]卍 [19]卍翁 [20]卍老人 [21]雷震 [22]雷斗
[23]菱川 [24]蠺白山人 [25]辰斎 [26]春郎 [27]宗理
[28]叢春郎 [29]戴斗 [30]辰政

Hokushū[1] (fl. c. 1808–32). *Gō:* Hokushū[2] (from 1818), Sekkatei,[3] Shōkōsai[4] (c. 1811), Shunkō[5] (until 1818), Shunkōsai.[6] **Biog.:** Ukiyo-e printmaker. Owner of a paper store in Ōsaka; said to have been a pupil of Hokusai; known to have studied under Shōkōsai Hambei. All his prints associated with Ōsaka; in his time the leading Ōsaka designer of actor prints, especially of the *ōkubi-e* format, setting the style for such prints. Boldly drawn in a somewhat tight, formal style; good colorist, of great technical skill. Also illustrated many books, the earliest of which, *History of the Forty-seven Rōnin,* was published in Edo in 1808. **Coll.:** British, Cincinnati, Musées, Newark, Philadelphia, Staatliche, Tōkyō (1), Victoria. **Bib.:** Binyon (1), Crighton, Ficke, Fujikake (3) 3, Hillier (7), Keyes, *Kunst,* Morrison 2, NHBZ 3, Schmidt, Strange (2), *Ukiyo-e* (3) 19.

[1]北洲 [2]北洲 [3]雪花亭 [4]松好斎 [5]春好 [6]春好斎

Hokutai[1] (fl. late 18th to early 19th c.). *N.:* Katsushika Hokutai.[2] *Gō:* Eisai,[3] Raito,[4] Shinshinshi.[5] **Biog.:** Ukiyo-e printmaker, illustrator. An early pupil of Hokusai, from whom he probably received the *gō* of Raito. **Coll.:** British, Victoria. **Bib.:** Binyon (1), Hillier (4) 2, Tajima (7) 4.

[1]北岱 [2]葛飾北岱 [3]盈斎 [4]雷斗 [5]辰々子

Hokuun[1] (fl. early 19th c.). *N.:* Katsushika (originally Ōkubo)[2] Gorō.[3] *F.N.:* Bungorō,[4] Kyūgorō.[5] *Gō:* Hokuun,[6] Tōnansei.[7] **Biog.:** Ukiyo-e painter, printmaker. Worked in Nagoya. Began as a carpenter. Later became a pupil of Katsushika Hokusai. Some of the prints attributed to Hokusai are said to have been done by Hokuun, including some of those in Hokusai's *Manga.* Of lesser note than other pupils of Hokusai. **Coll.:** Freer, Newark, Victoria, Worcester. **Bib.:** Binyon (3), Meissner, Morrison 2.

[1]北雲 [2]大久保 [3]葛飾五郎 [4]文五郎
[5]久五郎 [6]北雲 [7]東南斎

Honda Kinkichirō[1] (1850–1921). *N.:* Honda Kinkichirō.[2] *Gō:* Keizan,[3] Kōgai.[4] **Biog.:** Western-style painter. Born and lived in Tōkyō. Pupil of Kunisawa Shinkurō at his teacher's private school, the Shōgidō; after his master's death in 1877 taught there himself. Later was instructor in drawing at a military academy. Prize winner at the Naikoku Kangyō Hakurankai exhibitions. Also a designer of gardens. In painting, specialized in landscapes. **Bib.:** Asano, BK 188, NBZ 6.

[1]本多錦吉郎 [2]本多錦吉郎 [3]契山 [4]江涯

Honda Teikichi (Sadakichi)[1] (1766–1819). **Biog.:** Potter. Born in Hizen Province. Worked first in Kyoto. In 1807 accompanied Aoki Mokubei to the Kutani kiln at Kasugayama, Kanazawa. In 1811 began producing Kutani ware at the Wakasugi kiln. Teacher of Aoya Gen'emon. **Bib.:** BMFA 45, Jenyns (1), NB (S) 71.

[1]本多貞吉

Honda Tenjō[1] (1867–1946). *N.:* Honda Sasuke.[2] *Gō:* Tenjō.[3] **Biog.:** Japanese-style painter. Born in Edo. Graduated from the extension course of the department of Japanese-style painting at the Tōkyō School of Fine Arts, where he studied under Hashimoto Gahō and Kanō Hōgai. Exhibited with the Nihon Kaiga Kyōkai, the Naikoku Kangyō Hakurankai, the Naikoku Kaiga Kyōshinkai and the Nihon Bijutsuin; also, from 1907, with the Bunten. Taught at the Tōkyō School of Fine Arts. **Coll.:** Museum (3), Tōkyō (1). **Bib.:** Asano.

[1]本多天城 [2]本多佐輔 [3]天城

Hōrai[1] (fl. late 15th to early 16th c.). **Biog.:** Sculptor. A carver of Nō masks, whose subtle work retains something of the manner of Tokuwaka's pieces. **Coll.:** Tōkyō (1). **Bib.:** Noma (4).

[1]宝来

Hori Shinji[1] (1890–). **Biog.:** Sculptor. A pupil of Shinkai Taketarō, studied at the sculpture section of the Taiheiyō Gakai. Received awards at the Bunten. Served as juror for the Teiten. His work is realistic, with a touch of Rodin's influence. **Coll.:** Tōkyō (1). **Bib.:** Asano, GNB 28, NBT 10, NBZ 6.

[1]堀進二

Horie Masaaki[1] (1858–1932). **Biog.:** Western-style painter. Studied at the Kōbu Daigaku Bijutsu Gakkō with Fontanesi. His style academic; his palette, in keeping with the new tendencies of the times, became much lighter than that of his teachers. With Soyama Yukihiko taught at a private school where Okada Saburōsuke, Wada Eisaku, and Fujishima Takeji were among the pupils. **Bib.:** Asano, NBZ 6.

[1]堀江正章

Horie Shōshi[1] (1898–1935). **Biog.:** Sculptor. Born in Morioka. Graduated from Tōkyō School of Fine Arts in 1922. From 1920, a constant exhibitor and frequent prize winner at the Teiten. An artist whose promising career was cut short by an early death. His work reflects the tendencies of the School of Paris of the 1920s. **Coll.:** National (5). **Bib.:** Asano, GNB 28, NBZ 6.

[1]堀江尚志

Horii Masakichi[1] (1879–). **Biog.:** Lacquerer. Born in Takaoka. Graduated from the lacquer department of the Prefectural Technological School and also the lacquer department of Tōkyō University of the Arts; assistant professor at the latter from 1907 to 1927. Active in lacquer world, working particularly as a craftsman in gold lacquer. **Coll.:** Tōkyō (2). **Bib.:** *Zōhin.*

[1]堀井政吉

Hosai[1] (fl. early 17th c.). *N.:* Igarashi Hosai.[2] **Biog.:** Lacquerer. Successor to Igarashi Shinsai; father of Igarashi Dōho. Carried on the family tradition of skillful, elegant work. **Bib.:** Jahss, M 188.

[1]甫斎 [2]五十嵐甫斎

Hōshin[1] (1790–1856). *N.:* Ishigaki Sadashige.[2] *A.:* Taikan.[3] *F.N.:* Bunzaemon.[4] *Gō:* Hōshin,[5] Kaan.[6] **Biog.:** Painter. Born and lived in Edo. Pupil of Sakai Hōitsu. Able *kachōga* artist. **Coll.:** Victoria.

[1]抱真 [2]石垣定重 [3]泰寛 [4]文佐衛門 [5]抱真 [6]花庵

Hōsui[1] (1815–64). *N.:* Kaneko Tokuhō.[2] *A.:* Mōkei.[3] *F.N.:* Kenshirō.[4] *Gō:* Hōsui.[5] **Biog.:** Japanese-style painter. Born in Toyohashi (Aichi-ken). Served Lord Tokugawa of Mito. Pupil of Watanabe Kazan. Late in his life went to Kyōto and died there. An able painter of landscapes and *kachōga.*

[1]豊水 [2]金子徳褒 [3]猛卿 [4]健四郎 [5]豊水

Hōtō[1] (1752?–1833). *N.:* Watanabe Nei.[2] *A.:* Bumpō.[3] *Gō:* Hōtō.[4] **Biog.:** *Nanga* painter. Born in Kyūshū. With Fuchino Shinsai, served as official painter to the feudal family of Oka. Pupil of En Kyokkō, teacher of Chikuden.

[1]蓬島 [2]渡辺寧 [3]文邦 [4]蓬島

Hotta Zuishō[1] (1837–1916). **Biog.:** *Nanga* painter; sculptor. Born in Kyōto; after 1868 lived in Tōkyō. An able carver of wood and bamboo as well as a good *nanga* painter. Also

invented a style of lacquer known as Hotta-urushi. **Coll.:** Tōkyō (1). **Bib.:** Jahss.

¹堀田瑞松

Hōun[1] (1810–50). *N.:* Takahashi Hōun.[2] **Biog.:** Japanese-style sculptor. Worked in a traditional manner on a small scale. **Coll.:** Kenchō-ji. **Bib.:** *Pictorial* (1) 4, SBZ 10.

¹鳳雲 ²高橋鳳雲

Hōzan[1] (fl. 17th to 19th c.). *N.:* Unrin'in.[2] *Studio name:* Chawan'ya.[3] *Gō:* Hōzan.[4] The *gō* used by a long line of potters working at Awataguchi, Kyōto. No precise information about the early members of the family. The seventh generation opened a kiln at Awataguchi and began to produce Awata-yaki; the ninth generation was the first to use the *gō* Hōzan. For starred names among the following, see individual entries.

 *Hōzan IX: Yasubei Bunzō[5] (?–1723)
 Hōzan X: Yasuhei[6] (?–1752)
 *Hōzan XI: Bunzō[7] (?–1769)
 Hōzan XII: Kumanosuke[8] (?–1797)
 Hōzan XIII: Yasuemon[9] (?–1818)
 Hōzan XIV: Heibei[10] (fl. early 19th c.)
 *Hōzan XV: Kumanosuke[11] (?–1842)
 *Hōzan XVI: Bunzō[12] (1820–89)
 Hōzan XVII: Kumanosuke[13] (fl. late 19th c.)

Coll.: Freer, Metropolitan, Tōkyō (1). **Bib.:** Jenyns (1), (2); NB (S) 71; NBT 6; *Nihon* (8).

¹宝山 ²雲林院 ³茶碗屋 ⁴宝山 ⁵安兵衛文造
⁶安平 ⁷文造 ⁸熊之助 ⁹安右衛門 ¹⁰平兵衛
¹¹熊之助 ¹²文蔵 ¹³熊之助

Hōzan IX[1] (?–1723). *N.:* Unrin'in.[2] *F.N.:* Yasubei Bunzō.[3] *Gō:* Hōzan.[4] **Biog.:** Potter. Born in Kyōto. Ninth-generation head of the Unrin'in family of potters working at Awataguchi. Served as a priest at the Shintō shrine of Awata Tennō-sha. A Buddhist priest of the Hōzan-ji, Ikomayama, gave him the *gō* Hōzan, which was used by the family as their *gō* from that time on. Worked mostly in pottery decorated in underglaze blue with landscape designs and decorations imitating Delft ware. **Coll.:** Tōkyō (1). **Bib.:** Jenyns (1), (2); *Nihon* (8).

¹宝山九代 ²雲林院 ³安兵衛文造 ⁴宝山

Hōzan XI[1] (?–1769). *N.:* Unrin'in.[2] *F.N.:* Bunzō.[3] *Gō:* Hōzan.[4] **Biog.:** Potter. Eleventh-generation head of the Unrin'in family of potters working at Awataguchi. Also made porcelain, originating what is known as *namban-utsushi, tsuishu-yaki*, and *tsuikoku-yaki*.

¹宝山十一代 ²雲林院 ³文造 ⁴宝山

Hōzan XV[1] (?–1842). *N.:* Unrin'in.[2] *F.N.:* Kumanosuke.[3] *Gō:* Hōzan.[4] **Biog.:** Potter. Fifteenth-generation head of Unrin'in potters. Older brother of Heibei (Hōzan XIV). Teacher of Eiraku Hozen. Produced porcelain.

¹宝山十五代 ²雲林院 ³熊之助 ⁴宝山

Hōzan XVI[1] (1820–89). *N.:* Unrin'in.[2] *F.N.:* Bunzō.[3] *Gō:* Hōzan;[4] later, Hōzan Taihei.[5] **Biog.:** Potter. Sixteenth-generation head of Unrin'in family of potters working at Awataguchi. Specialized in tea-ceremony ware. Served the cloistered imperial prince Shōren'in, whose temple was at Awataguchi and who, in 1857, gave him the name Taihei[6] (Peace).

¹宝山十六代 ²雲林院 ³文蔵 ⁴宝山 ⁵宝山泰平 ⁶泰平

Hōzan[1] (fl. 1822–37). *N.:* Tsuji Yajirō.[2] *Gō:* Hōzan,[3] Hōzan Dōjin.[4] **Biog.:** Painter, illustrator. Lived and worked at Kasaoka in Bitchū Province. **Coll.:** Ashmolean. **Bib.:** Brown, Holloway, Mitchell, Toda (1).

¹鳳山 ²辻弥二郎 ³鳳山 ⁴鳳山道人

Hozen[1] (1795–1854). *N.:* Eiraku (originally Nishimura)[2] Hozen.[3] *F.N.:* Zengorō.[4] **Biog.:** Potter. Worked in Kyōto. Said to have founded the Kiirakuen kiln, the official kiln of the Kii branch of the Tokugawa family, located in Kii Province. With Mokubei and Dōhachi, famous as one of the three master potters of his day. Produced Ninsei-type bowls, *kinrande* ware, Ming three-color ware, Shonzui ware. Rather

naturalistic animal designs in colored enamels, with a gorgeous use of red and gold. Especially good at overglaze enamels, excelling all his contemporaries. **Coll.:** Ashmolean, British, Freer, Itsuō, Metropolitan, Museum (3), Philadelphia, Tōkyō (1), Yale. **Bib.:** *Ceramic* (1); GNB 19, Gorham; Jenyns (1); Koyama (1), (1a); Mikami; Miller; Munsterberg (2); NB (S) 14, 71; *Nihon* (1), (8); Okuda (2); SBZ 10; STZ 5; TZ (K) 30.

¹保全 ²西村 ³永楽保全 ⁴善五郎

Hyakki (Hyakuki)[1] (?–1794). *Store name:* Komatsuya.[2] *F.N.:* San'emon.[3] *Gō:* Hyakki (Hyakuki),[4] Fuchisoku Sanjin,[5] Shōshōken (Komatsuken).[6] **Biog.:** Ukiyo-e printmaker. Originally the owner of a pharmacy. Studied under Nishikawa Sukenobu. His name appears on calendar prints for the year 1765. Known for his *shunga* and prints of hawks. Style close to that of Harunobu. **Coll.:** Art (1), Tōkyō (1). **Bib.:** Ficke, Gentles (1), Kikuchi, NHBZ 2.

¹百亀 ²小松屋 ³三右衛門
⁴百亀 ⁵不知足山人 ⁶小松軒

Hyakunen[1] (1825–91). *N.:* Suzuki Seiju.[2] *A.:* Shikō.[3] *F.N.:* Zusho.[4] *Gō:* Daichin'ō,[5] Gasendō,[6] Hyakunen,[7] Tekiseikaku Shujin,[8] Tōkinrō.[9] **Biog.:** Shijō painter. Lived in Kyōto. Son of Suzuki Tosho, a pioneer Japanese astronomer. Studied first with Yokoyama Kakei, then independently various Chinese and Japanese styles. Influenced by Ōnishi Chinnen. Taught for a while at the Kyōto Prefectural School of Painting. Received awards at the first and second exhibitions of the Naikoku Kaiga Kyōshinkai. Specialized in landscape, following the traditions of the Shijō school, though toward the end of his life he turned to the *nanga* style. **Coll.:** Ashmolean, Museum (3), Philadelphia, University (3), Victoria, Yamatane. **Bib.:** Asano, Mitchell, Morrison 2, NB (S) 17, NBZ 6.

¹百年 ²鈴木世寿 ³子孝 ⁴図書 ⁵大椿翁
⁶画仙堂 ⁷百年 ⁸摘星閣主人 ⁹東金楼

Hyakusen[1] (1698–1753). *N.:* Sakaki Shin'en.[2] *A.:* Hyakusen.[3] *Gō:* Hassendō,[4] Hoshū.[5] **Biog.:** *Nanga* painter. Also a *haiku* poet. Born in Nagoya, son of an apothecary. Lived in Kyōto, where he studied Kanō painting. Later turned to the Chinese literary man's style and became one of the early leaders of the *nanga* school. Copied Chinese paintings that had been imported in the Ming period; wrote several books on Chinese painting. Yosa Buson much influenced by him. Received honorary title of *hokkyō*. Specialized in landscape. Unfortunately, most of his paintings were destroyed by fire some years ago. Unlike most *nanga* artists, made his living as a professional painter. Wide variety, from Chinese-inspired to light, sketchy *haiga*. **Coll.:** Museum (3), Royal (1), University (2). **Bib.:** Cahill; GNB 18; Hillier (2), (3), (4) 3; *Japanische* (2); K 484, 499, 550, 731, 808, 825, 875, 882; Morrison 2; Murayama (2); NB (H) 23; NB (S) 4; NBZ 5; *Nihon* (2), (3); OA 13; Tajima (13) 7; Yonezawa.

¹百川 ²彭城眞淵 ³百川 ⁴八仙堂 (八僊堂) ⁵蓬州

Hyakutake Kenkō[1] (1842–87). *N.:* Hyakutake Kaneyuki.[2] *Gō:* Kenkō.[3] **Biog.:** Western-style painter. Born in Saga-ken. Although a diplomat by profession, managed to study painting in London in 1874 and exhibited at the Royal Academy. In 1876 to Paris, where he worked with Léon Bonnat. Returned to Japan; then posted to the embassy in Rome for several years. Back in Tōkyō again, held a position in the government until his early death. His paintings are generally scenes, particularly of Italy, from "picturesque Europe" done in an academic manner. **Coll.:** Bridgestone, Tōkyō (2). **Bib.:** Asano, BK 206, Harada Minoru, *Kurashina* (2), NB (S) 30, Uyeno.

¹百武兼行 ²百武兼行 ³兼行

Hyōgyoku[1] (fl. c. 1840). *N.:* Matsui Ume.[2] *A.:* Seikō.[3] *Gō:* Hyōgyoku.[4] **Biog.:** Painter. She lived and worked in Edo. **Bib.:** Mitchell.

¹氷玉 ²松井梅 ³清香 ⁴氷玉

Hyōsai[1] (1817–85). *N.:* Kimura Hyōsai.[2] **Biog.:** Lacquerer. Born in Ōmi Province. Studied under Shibata Tōbei in Kyōto. An able artist. Followed by his son Hyōsai II[3]

(Yasaburō),[4] who worked in the late 19th century and was an equally able craftsman. **Bib.:** Herberts, Jahss, NBZ 6, Ragué.
¹表斎　²木村表斎　³表斎二代　⁴弥三郎

I

I Fu-chiu (Japanese: I Fukyu)[1] (fl. first half 18th c.). **Biog.:** Chinese painter. A native of Wuhsing who came to Nagasaki first in 1720 and several times thereafter. Painted landscapes in the Chinese literary man's style, influencing many Japanese artists, particularly Ikeno Taiga; hence regarded as an important figure in the development of the *nanga* school, though not highly considered in China. **Coll.:** Royal (1). **Bib.:** BK 137, BMFA 44, Mitchell, Morrison 2, NBZ 5, OA 13, Paine (4), Umezawa (2), Yonezawa.
¹伊孚九

Ichian[1] (?–c. 1590). *N.:* Kanō Ichian.[2] **Biog.:** Kanō painter. A samurai, serving the Hōjō family. Said to have been the father of Kanō Naizen Ichiō, but his name is known only through literary records, and no works can be identified.
¹一菴　²狩野一菴

Ichidayū[1] (fl. 1624–44). *N.:* Shiihara (Shibara) Ichitarō.[2] **Biog.:** Lacquerer. Brought to Kanazawa by Lord Maeda Koshitsune. With Igarashi Dōho, a descendant of Igarashi Shinsai, did much to improve the local *makie* technique, founding the tradition of Kaga-makie. A highly skilled lacquer artist. Succeeded by his three sons, all of whom were talented musicians: Tōzō[3] (mid-17th c.); Tomonoshin[4] (late 17th c.); and Ichinojō,[5] or Shiihara (Shibara) Ichinoshin[6] (fl. c. 1700). **Bib.:** Herberts, Jahss, Ragué, Sawaguchi, Yoshino.
¹市太夫　²椎原市太郎　³藤蔵　⁴友之進
⁵市之丞　⁶椎原市之進

Ichiga[1] (1798–1855). *N.:* Oki Tei.[2] *A.:* Shigyō,[3] Shikei.[4] *F.N.:* Tansan,[5] Teizō.[6] *Gō:* Ensen,[7] Ichiga.[8] **Biog.:** Kanō painter. Learned the Kanō tradition from Kanō Tanshin Morimichi. Served the Tottori clan. In his old age, became a monk and called himself Tansanʼ[9] or Seisai.[10] Good at landscapes and *kachōga*. **Coll.:** Rhode Island. **Bib.:** Mitchell.
¹一峨　²沖貞　³子仰　⁴子卿　⁵探三　⁶貞蔵
⁷淵泉　⁸一峨　⁹探三斎　¹⁰静斎

Ichigen[1] (1637–1732). *N.:* Sugiyama Heibei.[2] *F.N.:* Koiya Heibei.[3] *Gō:* Chasha,[4] Gountei,[5] Ichigen,[6] Minoō,[7] Saichaan,[8] Sampū,[9] Suijō.[10] **Biog.:** Painter. Born in Edo. Served as a petty official of the Tokugawa *bakufu*. Pupil of Kanō Shōun and, later, of Hanabusa Itchō.
¹一元　²杉山平兵衛　³鯉屋平兵衛　⁴茶舎　⁵五雲亭
⁶一元　⁷簑翁　⁸採茶庵　⁹杉風　¹⁰衰杖

Ichinyū[1] (1640–96). *N.:* Tanaka Sahei[2] (later Kichibei).[3] *Studio name:* Kichizaemon.[4] *Priest name:* Ichinyū.[5] **Biog.:** Raku potter. Fourth-generation of the Raku family; son and heir of Dōnyū. Became a monk in 1691, taking the name of Ichinyū. Is said to have often visited the shrines at Ise, making pottery for them. Initiated the addition of a dash of red to the typical black Raku glaze (very beautiful when the bowl is wet); also started drawing designs on his bowls and using blue-black and brilliant red glazes as well. Said to have been left-handed; therefore the tool mark is left-handed, an important clue in identifying his work. **Coll.:** Hatakeyama, Metropolitan, Victoria. **Bib.:** Castile, Jenyns (2), Miller, NB (S) 14, STZ 7.
¹一入　²田中佐兵衛　³吉兵衛　⁴吉左衛門　⁵一入

Iehiro[1] (1667–1736). *N.:* Konoe Iehiro.[2] *Priest name:* Shinkaku,[3] Yorakuin.[4] *Gō:* Gorakuken,[5] Kyoshūshi,[6] Shōshōdō Shujin.[7] **Biog.:** Painter, calligrapher, and tea master. A court noble of the highest rank. Took orders in

1725. In painting, specialized in rendering bamboo in ink monochrome. **Coll.:** Honolulu. **Bib.:** AA 14, Rosenfield (1a).
¹家煕　²近衛家煕　³眞覚　⁴豫楽院
⁵五楽軒　⁶虚舟子　⁷昭々堂主人

Igarashi[1] (fl. 15th to 17th c.). A school of lacquerers founded in the 15th century by Igarashi Shinsai. One of the oldest and most skillful families of lacquer artists; by mid-15th century was in the service of the Ashikaga shoguns. True Igarashi *makie*—known as *hira-makie* or Kaga-makie— was created under Igarashi Dōho. Their style of lacquer decoration was adopted later by the Kajikawa school. See under individual members:

Shinsai[2] (fl. 1434–90)
Hosai[3] (early 17th c.)
Dōho[4] (c. 1643–78)

Bib.: Casal, Herberts, Jahss, M 71, Ragué, Sawaguchi.
¹五十嵐　²信斎　³甫斎　⁴道甫

Iguchi Kashū[1] (1880–1930). **Biog.:** Japanese-style painter. Pupil of Takeuchi Seihō. Frequent exhibitor at the Bunten. **Bib.:** Asano, Elisséèv.
¹井口華秋

Ihachi[1] (fl. early 18th c.). **Biog.:** Potter. Son of Ninsei, adopted by Ogata Kenzan. Continued Kenzan's style, but without his flair. **Bib.:** Satō.
¹伊八

Ihara Usaburō[1] (1894–). Western-style painter. Born in Tokushima-ken. Graduate of the Tōkyō School of Fine Arts, teaching there for a short time after studying in France from 1925 to 1930. Exhibited at the Salon d'Automne in Paris and with the Teiten. After 1945 organized the Bijutsuka Remmei. His style is rather academic. **Bib.:** Asano; NBZ 6.
¹伊原宇三郎

Iida Misao[1] (1908–36). **Biog.:** Western-style painter. Studied in Ōsaka. Exhibited for the first time in 1931 at the opening exhibition of the Dokuritsu Bijutsu Kyōkai; was awarded a prize and became a member. From a mild fauve style, turned to surrealism. **Bib.:** Asano.
¹飯田操朗

Iijima Kōga[1] (1829–1900). *N.:* Iijima Yoshiaki.[2] *Gō:* Kōga,[3] Kōsodō.[4] **Biog.:** Painter. Born in Edo. Pupil of Oki Ichiga. Worked at the Imperial Palace, Tōkyō. Painted *kachōga* in the Shijō manner. **Coll.:** Victoria. **Bib.:** Mitchell.
¹飯島光峨　²飯島義明　³光峨　⁴後素堂

Ijū[1] (fl. mid-18th c.). *N.:* Konishi Mitsukore.[2] *Gō:* Ijū.[3] **Biog.:** Rimpa painter. Grandson of Ogata Kōrin, but his father had been adopted by the Konishi family in Kyōto. Worked in Kōrin's style. **Bib.:** *Kōrin-ha* (2).
¹以十　²小西光是　³以十

Ikai Shōkoku[1] (1881–1939). *N.:* Ikai Ukichi.[2] *Gō:* Shōkoku.[3] **Biog.:** Shijō painter. Born in Kyōto. Studied under Taniguchi Kōkyo. Graduated from Kyōto Municipal School of Fine Arts and Crafts in 1900; became a teacher at the Kyōto Municipal Junior College of Painting. Member of Kyōto Bijutsu Kyōkai. Also exhibited with the Bunten. Painter of figures, animals, *kachōga*. **Coll.:** Museum (3). **Bib.:** AAA 21, Asano.
¹猪飼嘯谷　²猪飼卯吉　³嘯谷

Ikebe Hitoshi[1] (1886–1969). **Biog.:** Western-style painter. Born and worked in Tōkyō. In 1910 graduated from the Tōkyō School of Fine Arts; studied under Kuroda Seiki. Exhibitor at the Bunten and the Teiten; member of the Issuikai and the Nitten. Worked as a newspaper cartoonist;

specialized in genre painting. His work includes both water colors and Japanese-style painting; his style owes much to the fauves. **Coll.**: National (5). **Bib.**: Asano.

¹池部鈞

Ikeda Keisen¹ (1863–1931). *N.:* Ikeda Katsujirō.² *Gō:* Keisen.³ **Biog.**: *Nanga* painter. Son and pupil of Ikeda Unshō. Born and worked in Kyōto. In 1886 graduated from Kyōto Prefectural School of Painting. One of the important artists in the early stages of the Bunten, exhibiting with it from its first show in 1907. Member of Nihon Jiyū Gakai and Nihon Nangain. An important figure in the Kyōto art world. **Bib.**: Asano.

¹池田桂仙 ²池田勝次郎 ³桂仙

Ikeda Shōen¹ (1888–1917). *N.:* Ikeda (originally Sakaki-bara)² Yuriko.³ *Gō:* Shōen.⁴ **Biog.**: Japanese-style painter. Born in Tōkyō. Wife of Ikeda Terukata. First studied under Mizuno Toshikata, then under Kawai Gyokudō. Exhibited with the Bunten and Ugōkai. Style at times shows the tendencies of a revived ukiyo-e manner. **Coll.**: National (5), Tōkyō (1), Victoria. **Bib.**: Asano, BK 209, Kondō (6), NB (S) 17, NBZ 6.

¹池田蕉園 ²榊原 ³池田百合子 ⁴蕉園

Ikeda Taishin¹ (1825?–1903). **Biog.**: Lacquerer. For many years studied both painting and the making of lacquer; Zeshin's most important pupil and one of best-known lacquer artists of Meiji era. From 1859 recognized as a *makie-shi*. Many pupils, including Umezawa Ryūshin. Member of the Art Committee of the Imperial Household and of the Imperial Fine Arts Academy. His large plaque, done for the Chicago World's Fair, was designed to appeal to foreign taste; more typical of his finer work are smaller pieces with traditional decoration such as plaques with detailed landscape designs. **Coll.**: Metropolitan, Tōkyō (1), Walters. **Bib.**: Boyer; Herberts, Jahss, M 203, NB (S) 41, NBZ 6, Ragué, Speiser (2), Yoshino.

¹池田泰眞

Ikeda Terukata¹ (1883–1921). *N.:* Ikeda Seishirō.² *Gō:* Terukata.³ **Biog.**: Japanese-style painter. Lived and worked in Tōkyō. Pupil first of Mizuno Toshikata, then of Kawai Gyokudō. Frequent exhibitor and prize winner at the Bunten. Also showed at the Inten and with the Ugōkai. Specialized in *bijinga*, rendered in a rather up-to-date ukiyo-e manner. **Coll.**: National (5), Victoria. **Bib.**: Asano, BK 209, NBZ 6.

¹池田輝方 ²池田正四郎 ³輝方

Ikeda Yōson¹ (1895–). **Biog.**: Japanese-style painter. Born in Okayama-ken; worked in Kyōto. Graduate of the Kyōto Municipal School of Fine Arts and Crafts; pupil of Takeuchi Seihō. Exhibitor at various government shows and with the Nitten. Winner of the Japan Art Academy Prize in 1959. His paintings sometimes reveal a novel approach in composition. **Coll.**: National (5).

¹池田遙邨

Ikeda Yūhachi¹ (1886–1963). **Biog.**: Sculptor. Born in Kagawa-ken, son of a farmer. In 1907 graduated from the Tōkyō School of Fine Arts. Exhibited with the Bunten from 1909; in 1920 became a juror for the Teiten. Known for his animal sculpture. **Coll.**: National (5). **Bib.**: Asano, NBZ 6.

¹池田勇八

Ikegami Shūho¹ (1874–1944). *N.:* Ikegami Kunisaburō.² *Gō:* Shūho.³ **Biog.**: Japanese-style painter. Born in Nagano-ken. To Tōkyō; studied under Araki Kampo. Also studied the paintings of the *nanga* school. Exhibited at the Bunten; frequently received prizes and special recognition. A juror for the 1933 Teiten. His paintings, generally *kachōga,* are pleasantly decorative, in a mixture of Shijō and *nanga* styles. **Coll.**: National (5). **Bib.**: Asano, Elisséèv, NBZ 6.

¹池上秀畝 ²池上国三郎 ³秀畝

Ikkan¹ (1578–1657). *N.:* Hirai Ikkan.² *F.N.:* Sasaya.³ *Gō:*

Chōchōshi,⁴ Chōsetsusai (Chōsessai),⁵ Kongō Sanjin.⁶ **Biog.**: Lacquerer. Originally from China; became a naturalized Japanese in 1625. Invented a lacquer technique known as Ikkan-bori. Patronized by the eminent tea master Sen Sōtan. Also known as a calligrapher and painter. Followed by twelve generations, all calling themselves Hirai Ikkan; the eleventh, working in the 19th century, known as Jūkan (Shigeyasu).⁷ **Bib.**: Herberts.

¹一閑 ²飛来一閑 ³笹屋 ⁴蝶々子
⁵朝雪斎 ⁶金剛山人 ⁷重閑

Ikkei¹ (1599–1662). *N.:* Kanō Shigenaga² (or Shigeyoshi).³ *F.N.:* Naizen.⁴ *Gō:* Ikkei.⁵ **Biog.**: Kanō painter. Son of Kanō Naizen Ichiō; pupil of Kanō Mitsunobu. Lived in Odawara. At the age of 27, became *goyō eshi* to the shogunate. Wrote *Tansei Jakuboku-shū* (the first known book of biographies of Japanese painters), and, in 1623, *Kosu-shū* (the first book to discuss Chinese theories of painting). Few of his paintings still exist.

¹一渓 ²狩野重長 ³重良 ⁴内膳 ⁵一渓

Ikkei¹ (1630–1716). *N.:* Kanō Yoshinobu.² *F.N.:* Naizen,³ Shuzen.⁴ *Gō:* Ikkei.⁵ **Biog.**: Kanō painter. Son and pupil of Kanō Ikkei Shigenaga. An official painter for the shogunate, was given an estate by the shogunate at Negishi Miyuki-matsu; his descendants took the name of this estate for their branch of the Kanō school.

¹一渓 ²狩野良信 ³内膳 ⁴主膳 ⁵一渓

Ikkei¹ (1749–1844). *N.:* Hanabusa Nobushige.² *Gō:* Ikkei,³ Sūkei (early),⁴ Yūshōan.⁵ **Biog.**: Hanabusa painter. First a pupil of Kō Sūkoku, later of Hanabusa Issen, whose heir he became and whose name he took. **Coll.**: Museum (3).

¹一珪 ²英信重 ³一珪 ⁴嵩卿 ⁵友松庵

Ikkei¹ (1763–1837). *N.:* Yoshikawa Yoshinobu.² *F.N.:* Koemon.³ *Gō:* Ikkei,⁴ Jikansai,⁵ Yōgen.⁶ **Biog.**: Kanō painter. Born in Nagoya. Son and pupil of Yoshikawa Yōetsu. Had many pupils of his own. Specialized in Buddhist subjects.

¹一渓 ²吉川義信 ³小右衛門 ⁴一渓 ⁵自寛斎 ⁶養元

Ikkei¹ (1795–1859). *N.:* Ukita (originally Toyotomi)² Kiminobu³ or Yoshitame.⁴ *A.:* Shishi.⁵ *F.N.:* Kuranosuke,⁶ Shume.⁷ *Gō:* Ikkei,⁸ Sekinan Shōja,⁹ Tameushi (Igyū).¹⁰ **Biog.**: *Fukko yamato-e* painter. Born and lived in Kyōto. Pupil of Tanaka Totsugen. A loyalist, made a speech questioning the future of Japan and was imprisoned by the shogunate. Served as artist to the imperial court, painting the manners and customs of his day. Also a poet and calligrapher. Much of his work shows a conscious revival of the Kamakura style, but there is also some done in a free and sketchy manner. **Coll.**: Imperial (1), Metropolitan, Sennyū-ji. **Bib.**: *Fukkō Yamato-e;* K 111, 121, 132, 204, 504, 639, 742; Mitchell; Morrison 1; NBZ 4; Tajima (12) 8, (13) 5; Wakita.

¹一蕙 ²豊臣 ³浮田 (宇喜田) 公信 ⁴可為 ⁵士師
⁶内蔵允 ⁷主馬 ⁸一恵 ⁹昔男精舎 ¹⁰為牛

Ikkei¹ (fl. c. 1870). *Gō:* Ikkei,² Isshōsai,³ Shōsai.⁴ **Biog.**: Ukiyo-e printmaker. Pupil of Hiroshige III. His prints are generally of comic scenes of Edo life in the early Meiji era. **Coll.**: Fine (California), Musées, Victoria. **Bib.**: Nonogami.

¹一景 ²一景 ³昇斎 ⁴昇斎

Ikko¹ (1644–1702). *N.:* Hirowatari (originally Suetsugu)² Ikko.³ **Biog.**: Nagasaki painter. Pupil of Hirowatari Shinkai, whose name he was allowed to take. At 24 to Nagasaki, which enabled him to study Chinese paintings. In 1699 appointed *kara-e mekiki* by the *bakufu*.

¹一湖 ²末次 ³広渡一湖

Ikkokusai¹ (1828–99?). *N.:* Ikeda.² *Gō:* Ikkokusai,³ Kinjō Ikkokusai.⁴ **Biog.**: Lacquerer. A *makie* craftsman of Owari. Called himself Kinjō Ikkokusai, the first to use the name of Ikkokusai. Nothing is known about his life. **Bib.**: Casal, Herberts, Sawaguchi.

¹一国斎 ²池田 ³一国斎 ⁴金城一国斎

Ikkokusai II¹ (fl. 1830–44). *N.:* Nakamura (originally Ikeda)²

Issaku.[3] *Gō:* Ikkokusai.[4] **Biog.:** Lacquerer. Son of Ikeda Ikkokusai; samurai of the Owari clan. Before entering employment of lord of Yamaguchi, traveled extensively. Finally moved to Ōsaka; began working in *urushi,* using *gō* of Ikkokusai. Between 1830 and 1843 met Kinoshita Kentarō in either Ōsaka or Hiroshima. Trained him as his successor, allowed him to take name of Ikkokusai, and disappeared. **Bib.:** Casal, Herberts, Sawaguchi.

 [1]一国斎二代 [2]池田 [3]中村一作 [4]一国斎

Ikkokusai III[1] (fl. mid-19th c.). *N.:* Kinoshita Kentarō.[2] *Gō:* Ikkokusai.[3] **Biog.:** Lacquerer. An *urushi* craftsman from Hiroshima, was trained by Ikkokusai II in either Hiroshima or Ōsaka. Invented Ikkokusai-nuri by combining *makie* and carving techniques. Given permission to use *gō* of Ikkokusai by his master. Received a prize at the first Naikoku Kōgyō Hakurankai. **Bib.:** Casal, Jahss, Ragué, Sawaguchi.

 [1]一国斎三代 [2]木下兼太郎 [3]一国斎

Ikku[1] (1766–1831). *N.:* Shigeta Teiichi.[2] *Gō:* Ikku,[3] Jippensha Ikku,[4] Suisai.[5] **Biog.:** Ukiyo-e printmaker. Also an author. Born to a petty official of the branch of the Tokugawa family in Suruga. When young, to Ōsaka to become a theatrical writer. In 1794 to Edo to establish himself as an author. Best known for his famous novel *Hizakurige,* which relates the adventures of two happy-go-lucky travelers on the Tōkaidō road. As a printmaker, known for his book illustrations, particularly the comic ones done for his own picaresque novel. **Coll.:** British, Tōkyō (1). **Bib.:** Binyon (1), Kikuchi, UG 8.

 [1]一九 [2]重田貞一 [3]一九 [4]十返舎一九 [5]酔斎

Ikkyū[1] (1394–1481). *N.:* Sōjun.[2] *A.:* Ikkyū.[3] *Gō:* Kokukei,[4] Kyōunshi,[5] Mukei.[6] **Biog.:** Muromachi *suiboku* painter. According to legend, son of the emperor Gokomatsu but never recognized. At 6 to a Zen monastery; a brilliant pupil. During his 20s a wandering monk; finally admitted as a disciple by Kasō Sōdon, a Zen master at the Daitoku-ji, Kyōto. Wandered again for many years, but in 1474 became abbot of the Daitoku-ji, which had been largely destroyed in the Ōnin Wars. The temple was almost completely rebuilt by the time of his death. An eccentric, revolutionary character of great force and interest: one of the most important Zen masters of his time. Better known for his calligraphy than his painting. **Coll.:** Umezawa. **Bib.:** AA 14; Awakawa; Hisamatsu; K 119, 234, 415, 426; KO 24; Lee (3); NB (S) 69; Rosenfield (2); YB 41.

 [1]一休 [2]宗純 [3]一休 [4]国景 [5]狂雲子 [6]夢閨

Ikkyū[1] (fl. 1805–29). *N.:* Ōkubo Kōko.[2] *A.:* Toshio.[3] *Gō:* Ikkyū.[4] **Biog.:** *Yōga* painter. A samurai, served the lord of the Yokosuka clan. Pupil of Shiba Kōkan. Produced Western-style oils and water colors. **Coll.:** Kōbe. **Bib.:** BK 2, GNB 25, Mody, *Pictorial* (2) 2.

 [1]一丘 [2]大久保好古 [3]敏夫 [4]一丘

Ikushima Saburōza[1] (fl. early 17th c.). **Biog.:** Western-style painter. As a youth, may have lived in Kyūshū and learned Western-style painting from missionaries. Became one of the earliest Japanese artists to work in the Western manner. **Bib.:** *Masterpieces* (3) 1.

 [1]生島三郎左

Ikuta Kachō[1] (1893–). **Biog.:** Japanese-style painter. Lived and worked in Ōsaka. Daughter of Ikuta Nansui. Graduate of Kyōto College of Fine Arts; pupil of Kitano Tsunetomi and Suga Tatehiko. Exhibitor with Nitten. Very competent genre painter of Ōsaka scenes. **Coll.:** National (5); Ōsaka (1), (2). **Bib.:** Asano.

 [1]生田花朝

Ikuta Nansui[1] (1861–1934). **Biog.:** Painter. A literary man, living in Ōsaka, for whom painting was primarily a hobby. **Coll.:** Musées.

 [1]生田南水

Imaizumi[1] (fl. 17th to 20th c.). A line of potters. A family

apparently at first, in the 17th century, of decorators and later of potters of Nabeshima ware. **Bib.:** Jenyns (1).

 [1]今泉

Imaizumi Imaemon[1] (1897–). **Biog.:** Potter. Born in Arita. Son and pupil of Imaemon XI; graduate of the Arita Technological High School. A member of the Nihon Kōgeikai. Named a Living National Treasure. His pottery is in the family—that is, the Iro-Nabeshima—tradition. Also works in the Imari tradition. His works known for their brightly colored realistic floral decoration. **Bib.:** *Masterpieces* (4), Mitsuoka (1), NB (S) 71, STZ 16.

 [1]今泉今右衛門

Imamura Shikō[1] (1880–1916). *N.:* Imamura Jusaburō.[2] *Gō:* Shikō.[3] **Biog.:** Japanese-style painter. Born in Yokohama. To Tōkyō in 1897, becoming a pupil of Matsumoto Fūko. One of the "second-generation" artists to be influenced by Okakura Tenshin. Worked with Yasuda Yukihiko and Kobayashi Kokei to establish a new school of Japanese-style painting based on *yamato-e,* using bright colors, something of the decorative approach of the Rimpa tradition, and European brush strokes in the impressionist manner. With Yukihiko, became a leader in the Kojikai. In 1907 active in the founding of the Kokuga Gyokuseikai and, in 1914, of the Saikō Nihon Bijutsuin and the Sekiyōkai. Showed with the Nihon Bijutsuin. After a trip to India produced his best-known work, *Tropical Country Series* (Tōkyō National Museum), which had great influence when first exhibited in 1914 at the Saikō Nihon Bijutsuin. His work has considerable appeal: attractive, simplified landscapes, at times bordering on the intentionally naive; a successful combination of Eastern and Western modes of painting. **Coll.:** National (5), Tōkyō (1). **Bib.:** Asano; M 11, 21, 70; *Masterpieces* (3), (4); Miyagawa; Nakamura (1); NB (H) 24; NB (S) 4, 17; NBT 10; NBZ 6; NKKZ 20; Noma (1) 2; SBZ 11.

 [1]今村紫紅 [2]今村寿三郎 [3]紫紅

Imanaka Soyū[1] (1886–1959). *N.:* Imanaka Zenzō.[2] *Gō:* Sōkōken,[3] Soyū.[4] **Biog.:** Japanese-style painter. Son of a well-to-do farmer in Fukuoka-ken. Studied under Kawai Gyokudō in Tōkyō. Exhibited for the first time in 1908 at the second Bunten; thereafter showed with the Nihon Bijutsu Kyōkai and other government exhibitions. Able painter of *kachōga* and landscapes. **Coll.:** National (5). **Bib.:** Asano.

 [1]今中素友 [2]今中善蔵 [3]草江軒 [4]素友

Imanishi Nakamichi[1] (1908–47). **Biog.:** Western-style painter. Graduated from the Kawabata painting school; studied at the Dokuritsu Bijutsu Kyōkai in 1930, exhibiting afterwards with that group and receiving a prize from them in 1935. In 1961 given a posthumous exhibition at the Kanagawa Prefectural Museum of Modern Art, Kamakura. **Coll.:** Kanagawa.

 [1]今西中道

Imao Keinen[1] (1845–1924). *N.:* Imao Eikan[2] (originally Isaburō).[3] *Gō:* Eikanshi,[4] Keinen,[5] Ryōji Rakukyo,[6] Shiyū,[7] Yōsosai.[8] **Biog.:** Japanese-style painter. Born and worked in Kyōto. First studied ukiyo-e style with Umegawa Tōkyo; later a pupil of Suzuki Hyakunen; also studied styles other than those of his masters. In 1868 established his own studio and began to teach; after 1880 became a professor at the Kyōto Prefectural School of Painting, In 1904 became a member of the Art Committee of the Imperial Household; in 1907 a juror for the first Bunten; in 1919 a member of the Teikoku Bijutsuin. Involved with a number of other organizations, a frequent exhibitor and prize-winner at various official shows in both Japan and Paris. An important figure in the traditional art circles of Kyōto. His specialty *kachōga,* done in an elaborate and gorgeous manner, with much realistic detail. An eclectic style. **Coll.:** Ashmolean, Metropolitan, Museum (3), Sanzen-in, Tōkyō (1), Yamatane. **Bib.:**

Asano, Brown, Morrison 2, Mitchell, NB (S) 17, NBZ 6, Uyeno.

¹今尾景年　²今尾永歓　³猪三郎　⁴永歓子
⁵景年　⁶聊自楽居　⁷子裕　⁸養素斎

Imei¹ (1731–1808). *Given names:* Shūkei,² Taikei.³ *Gō:* Imei,⁴ Uzan.⁵ **Biog.**: Painter. A monk of the Chūkōgen-in, Shōkoku-ji, Kyōto. First studied painting under Jakuchū, producing paintings of flowers and fowl in his master's manner. Later influenced by Ming and Yüan painting. A charming artist. **Coll.**: Ashmolean, Fogg. **Bib.**: Mitchell.

¹維明（維名）　²周奎　³大奎　⁴維明（維名）　⁵羽山

Impan¹ (fl. 1190–1246). **Biog.**: Sculptor. Pupil and perhaps son of Inson. Member of Shichijō Ōmiya Bussho. From records, known to have worked with Inson in 1191 on the halo for the Vairocana of the Great Buddha Hall at the Tōdai-ji, and also on the Jūichimen Kannon in the Hōshaku-ji, Kyōto. There is a temple record of his having made an Aizen Myōō in 1246, but this statue is not extant either. Received title of *hōin* in 1213. Given permission to work for the Hōshō-ji by Injitsu, who was perhaps his brother. **Bib.**: GNB 9.

¹院範

Impo¹ (1717–74). *N.:* Miyazaki Atsushi;² later, Aya or Ki.³ *A.:* Shijō.⁴ *F.N.:* Jōnoshin (Tsunenoshin).⁵ *Gō:* Impo.⁶ **Biog.**: *Nanga* painter. Born in Owari; his father a Confucian scholar. Family moved to Kyōto when he was 17. Pioneer of the *nanga* school; specialized in painting bamboo. Also known as a Confucian scholar. **Bib.**: Mitchell, Umezawa (2).

¹筠圃　²宮崎淳　³奇　⁴子常　⁵常之進　⁶筠圃

In Genryō¹ (1718–67). *N.:* Zamami Yōshō.² *Gō:* In Genryō.³ **Biog.**: Painter. Born in the Ryūkyū Islands. From 12 years of age brought up at the Imperial Palace in Kyōto. Influenced by both Chinese and Japanese classical painting. Important figure in the history of painting in the Ryūkyū Islands. An able realistic painter of *kachōga* and of landscapes in the *bunjinga* manner.

¹殷元良　²座間味庸昌　³殷元良

Inaba¹ (fl. c. 1775). *N.:* Kōami Nagayasu.² *Gō:* Inaba.³ **Biog.**: Lacquerer. Minor member of the Kōami family. Worked for the shogunate. **Bib.**: Herberts, Jahss.

¹因幡　²幸阿弥長安　³因幡

Inagawa¹ (fl. 18th to 19th c.). A family of lacquerers working in Edo. Particularly noted for its excellent *togidashi* work. Used a seal reading "Nakaharu."² **Coll.**: Nelson, Victoria. **Bib.**: Herberts, Jahss.

¹稲川　²仲春

Inchi¹ (fl. c. 1252). **Biog.**: Sculptor. Known as the sculptor of a seated figure, dated 1252, in the Ninna-ji, Kyōto. **Coll.**: Ninna-ji. **Bib.**: Mōri (1a), NBZ 3.

¹院智

Inchō¹ (fl. mid-12th c.). **Biog.**: Sculptor. Member of the In school. Pupil and perhaps son of Injo. Founded sculptors' workshop called Rokujō Marikōji Bussho. Recorded as having made the statues for the pagoda of the Hōkongō-in, Kyōto. Later became a court sculptor. In 1139 given rank of *hokkyō,* between 1147 and 1155 that of *hōgen,* and eventually that of *hōin.* It is not clear what work of his, if any, remains. **Bib.**: *Kokuhō* 3.

¹院朝

Indō Matate¹ (1861–1914). **Biog.**: Western-style painter. In the 1870s studied under Kawakami Tōgai and at the Tōkyō School of Fine Arts under Fontanesi. In 1878, with Koyama Shōtarō, Asai Chū, Matsuoka Hisashi, Morizumi Yūgyo, Takahashi Genkichi, and others, founded the Jūichikai. Showed at various exhibitions of the Naikoku Kangyō Hakurankai. **Bib.**: Asano, NB (H) 24.

¹印藤真楯

Ineno Toshitsune¹ (1858–1907). *N.:* Ineno Takayuki.² *Gō:* Toshitsune.³ **Biog.**: Painter. Born in Kaga Province. When about 15, to Tōkyō to study under Tsukioka Yoshitoshi;

later became a pupil of Kōno Bairei. Moved to Ōsaka, working as an illustrator first for the Mainichi Press then for the Asahi Press. Teacher of Kitano Tsunetomi.

¹稲野年恒　²稲野孝之　³年恒

Ingen¹ (fl. c. 1310). *F.N.:* Kongō Hossu.² *Gō:* Ingen.³ **Biog.**: Buddhist painter. Recorded as having worked at the Ninna-ji, Kyōto. **Coll.**: Nelson, Tō-ji. **Bib.**: Ono.

¹印玄　²金剛仏子　³印玄

Ingyō¹ (fl. late 18th to early 19th c.). *N.:* Nagasawa.² *Gō:* Ingyō.³ **Biog.**: Ukiyo-e printmaker. Pupil of Taga Ryūkōsai. Member of the Ōsaka school. **Bib.**: UG 8.

¹印暁　²長沢　³印暁

Injitsu¹ (fl. c. 1180 to c. 1215). **Biog.**: Sculptor. Son and pupil of Inson. Member of the In school. Engaged in much of the restoration work of the Kōfuku-ji. By 1183 had been given rank of *hokkyō;* in 1200 made *hōin.* In 1191 is recorded as having worked with his father on the great halo for the Vairocana at the Tōdai-ji. In 1200 made seven statues of Yakushi for an imperial consort who was expecting a child. In 1215 made a Shaka Nyorai for the cloistered emperor Gotoba. In 1213 gave permission to Impan to work for the Hōshō-ji. Like his father, he left no known work that can be assigned to him today. **Bib.**: Kuno (2).

¹院実

Injo¹ (?–1108). **Biog.**: Sculptor. Said to have been the son of Kakujo or of Chōsei; pupil of Kakujo. Founded sculpture workshop called Shichijō Ōmiya Bussho, which became headquarters of the In school. Given honorary rank of *hokkyō* in 1077, of *hōgen* in 1105. No known work by him exists. **Bib.**: Kidder; *Kokuhō* 3; Kuno (1), (2); Mōri (1a).

¹院助

Inkaku¹ (fl. 1114–41). **Biog.**: Sculptor. Pupil and perhaps son of Injo. Member of the Shichijō Ōmiya Bussho; worked in the In school tradition of that workshop. Received title of *hokkyō* in 1130, of *hōgen* in 1132. The Amida Nyorai, dated 1130, in the Hōkongō-in, Kyōto, is the only work known to be by him. **Coll.**: Hōkongō-in. **Bib.**: BB 10, K 941, *Kokuhō* 3, YB 9.

¹院覚

Inkei¹ (?–1179). **Biog.**: Sculptor. Believed to have been a son of Inkaku. Lived at Nishikōji Ōmiya, Kyōto; member of the Shichijō Ōmiya Bussho. In 1167 carved two statues of Amida for the Sairin-ji. Also made various statues for the imperial family. In 1167 received title of *hokkyō;* promoted to *hōgen* between 1170 and 1176. Also had title of *dai busshi.* None of his work is known today. **Bib.**: Kuno (1), (2).

¹院慶

Inken¹ (fl. 1200–1217). **Biog.**: Sculptor. Son of Inshō; member of the In school. In 1200 carved the Amida Triad for the Hōshō-ji; in 1207, the Bugaku mask Sanju for the Tōdai-ji; in 1212 the Niō in the Nandaimon of the Hōshō-ji; in 1215 a statue of Jizō Bosatsu; in 1217, seven statues of Yakushi. **Coll.**: Hōshō-ji, Tōdai-ji. **Bib.**: Kuno (1), (2); SBZ 6.

¹院憲（院賢）

Inken¹ (fl. early 15th c.). **Biog.**: Sculptor. In 1404 carved a standing Shōtoku Taishi for the Jōdo-ji in Onomichi, Hiroshima-ken. Given title of *hōin.* **Bib.**: Kuno (1).

¹院憲

Innō¹ (fl. mid-13th c.). **Biog.**: Sculptor. A Buddhist sculptor of the In school. In 1267 carved the Jie Daishi at the Guhō-ji; received rank of *hokkyō* in the same year. **Coll.**: Guhō-ji. **Bib.**: Kuno (1), (2).

¹院農

Inose Tōnei¹ (1839–1910). *N.:* Inose Jo.² *A.:* Joshin.³ *F.N.:* Chūgorō.⁴ *Gō:* Bankadō,⁵ Chōkotōmurō,⁶ Sensai,⁷ Tōnei.⁸ **Biog.**: *Nanga* painter. Born in Shimōsa; when about 19, to Kyōto to become a pupil of Hine Taizan. Exhibited with the Naikoku Kaiga Kyōshinkai, the Naikoku Kangyō

Hakurankai and the Nihon Bijutsu Kyōkai, serving later as a juror for the last of these. **Bib.:** Asano.

¹猪瀬東寧　²猪瀬恕　³如心　⁴忠五郎
⁵晩香堂　⁶超光騰霧楼　⁷専斎　⁸東寧

Inoue Ryōsai¹ (1828–?). *N.:* Inoue Yoshitaka.² *Gō:* Ryōsai,³ Tōgyokuen Ryōsai.⁴ **Biog.:** Potter. Born in Seto. First started making pottery at Inuyama, near Nagoya; then moved to Edo and, in 1866, opened a kiln at Asakusa, calling himself Tōgyokuen Ryōsai. **Coll.:** Metropolitan. **Bib.:** NBZ 6, STZ 16.

¹井上良斎　²井上良孝　³良斎　⁴東玉園良斎

Inoue Ryōsai II¹ (1888–?). **Biog.:** Potter. The second generation to bear this name. Born in Tōkyō. Studied under Itaya Hazan. Worked first at the kiln of Inoue Ryōsai at Asakusa, but about 1913 moved it to Yokohama. Exhibited with the Teiten, Bunten, and Nitten, serving as a juror for the last. Member of Tōtokai. Produced a traditional white-glaze ware. The designs on his porcelain strongly influenced by the West. **Bib.:** STZ 16, Uyeno.

¹井上良斎二代

Insei¹ (fl. c. 1338). **Biog.:** Sculptor. A *dai busshi,* working in Kyōto. Known for a statue in the Jōdo-ji, Hiroshima, dated 1338. **Coll.:** Jōdo-ji. **Bib.:** *Muromachi* (2).

¹院勢

Inshin¹ (fl. second half 13th c.). **Biog.:** Sculptor. A *dai busshi* of the In school. In 1251 began preparations for the making of Buddhist statues for the Kōfuku-ji. In 1283 carved the Jie Daishi at the Yakushidō, Shiga. **Coll.:** Yakushidō (2). **Bib.:** Kuno (1), (2).

¹院信

Inshō¹ (fl. late 12th c.). **Biog.:** Sculptor. Known to have worked at the Tōdai-ji. According to other temple records, in 1185 made four masks for the Kasuga-jinja and repaired the Senju Kannon of the Kondō at the Tōshōdai-ji. **Coll.:** Kasuga-jinja. **Bib.:** *Heian* (2), Noma (4).

¹印勝

Inshō¹ (fl. late 12th to early 13th c.). **Biog.:** Sculptor. Son of Inchō. Is said to have made, in 1175, Buddhist images for the Kōmyōshin-in as well as a life-size Fudō for the imperial consort; received title of *hokkyō* in the same year. Temple records also state that he made the Jūni Shinshō of the Jingo-ji and the Shitennō for the same temple, as well as an Amida Triad for the Sagadō, also at this temple.

¹院尚（院成，院性）

Inshū¹ (fl. end of 13th c.). **Biog.:** Sculptor. In 1294, assisted by other sculptors, carved a seated Jizō Bosatsu for the Jōkei-in at Kōyasan. Title of *dai busshi;* given honorary rank of *hōin.* **Bib.:** Kuno (1), (2).

¹院修

Inson¹ (1120?–98). **Biog.:** Sculptor. Pupil and perhaps son of Inkaku. A prominent sculptor of his time; member of the Shichijō Ōmiya Bussho. Worked on the restoration of the Tōdai-ji and the Kōfuku-ji in Nara. However, no work can today be identified as his. Received rank of *hokkyō* in 1154 and *hōin* in 1183. **Bib.:** *Kokuhō* 3, Kuno (1), Mōri (1a).

¹院尊

In'yū¹ (fl. late 15th c.). **Biog.:** Sculptor. A Kyōto *dai busshi* and holder of the rank of *hōin.* Known for two figures of Kannon in the Kudara-dera, Shiga, dated 1498 and 1499. **Coll.:** Kudara-dera. **Bib.:** *Muromachi* (2).

¹院祐

Inzan¹ (1751–1814). *N.:* Sugimoto.² *Priest name:* Yuien.³ *Gō:* Inzan.⁴ **Biog.:** *Zenga* painter. Born in Echizen. At 9 began training as a Zen priest; at 16 began studies at the Zuishō-ji in Echizen. Three years later was accepted as a student at the Tōki-an near Edo, returning later to that temple to study with Hakuin's pupil Gasan Jitō. Eventually became an important and successful teacher of Hakuin-style Zen, working in the area around Gifu. Elected abbot of the Myōshin-ji, Kyōto, in 1808; finally retired to the Zuiryō-

ji, Gifu, where he died. All Rinzai sect teachings owe their form and style to either Inzan or another of Gasan's pupils, Takujū Kosen. His paintings are always on Zen themes. An excellent calligrapher, frequently writing inscriptions on other Zen paintings of his time. **Bib.:** Awakawa, NB (S) 47.

¹隠山　²杉本　³惟琰　⁴隠山

Ioki Bun'ya (Bunsai)¹ (1863–1906). *N.:* Ioki Fumiya.² *Gō:* Bun'ya (Bunsai).³ **Biog.:** Western-style painter. Born in Mito; worked in Tōkyō. Pupil of Takahashi Yuichi, Takahashi Genkichi, Asai Chū, Koyama Shōtarō. Far better known as a botanist, specializing in Alpine plants, than as an artist. Produced realistic paintings of flowers and plants. **Coll.:** Tokiwa-jinja. **Bib.:** Asano.

¹五百城文哉　²五百城文哉　³文哉

Ippō¹ (1691–1760). *N.:* Hanabusa.² *Gō:* Ippō,³ Isshō,⁴ Shunsōsai.⁵ **Biog.:** Hanabusa painter. Pupil of Hanabusa Itchō, from whom he took his name and many of whose paintings he copied. Artist of considerable talent. **Coll.:** Museum (3). **Bib.:** Hillier (4) 3, Morrison 1.

¹一蜂　²英　³一蜂　⁴嶂　⁵春窓斎

Ippō II¹ (?–1788). *N.:* Hanabusa.² *Gō:* Ichien;³ later, Sūrin;⁴ finally, Ippō II.⁵ **Biog.:** Hanabusa painter. Son of Hanabusa Ippō; pupil of Kō Sūkoku.

¹一蜂二代　²英　³一蜓　⁴嵩林　⁵一蜂二代

Ippō¹ (1798–1871). *N.:* Mori Keishi.² *A.:* Shikō.³ *F.N.:* Bumpei.⁴ *Gō:* Ippō.⁵ **Biog.:** Shijō painter. Born and lived in Ōsaka. Studied under Mori Tetsuzan, who later adopted him. About 1850, executed some of the paintings for the *fusuma* of the Imperial Palace, Kyōto. An admirable painter of birds, even more so of landscapes; also produced scenes of Ōsaka life rendered in an unconventional manner. **Coll.:** Art (1), Fogg, Museum (3), Victoria, Worcester. **Bib.:** Fenollosa; K 84, 312, 333, 426, 495, 523; Mitchell; Morrison 2.

¹一鳳　²森敬之　³子交　⁴文平　⁵一鳳

Irie Hakō¹ (1887–1948). *N.:* Irie Ikujirō.² *Gō:* Hakō.³ **Biog.:** Japanese-style painter. Born and educated in Kyōto. Member of the Kokuga Sōsaku Kyōkai; an exhibitor at the Bunten. After traveling abroad and painting Western scenes in a Japanese manner, became interested in Buddhist painting. Late in his career became absorbed in copying the wall paintings at the Hōryū-ji. Also made a copy of the *Kitano Temman Engi* in the possession of the Kitano Temman-gū. **Coll.:** Kyōto (1), Museum (3), National (5). **Bib.:** AAA 21, Asano, KO 23, NB (H) 24, NBZ 6.

¹入江波光　²入江幾治郎　³波光

Isaburō¹ (fl. 1822–36). *N.:* Nakao Gen.² *F.N.:* Tan.³ *Gō:* Isaburō,⁴ Ōtotsudō,⁵ Shirantei.⁶ **Biog.:** *Yōga* printmaker. A Kyōto doctor who learned engraving from his studies of Dutch treatises and publications. **Bib.:** NBZ 5.

¹伊三郎　²中尾玄　³端　⁴伊三郎　⁵凹凸堂　⁶芝蘭亭

Isai¹ (1821–80). *N.:* Katsushika (originally Shimizu)² Sōji.³ *Gō:* Isai,⁴ Suirōrō.⁵ **Biog.:** Ukiyo-e painter, printmaker. Born in Edo. Studied under Katsushika Hokusai, who lived for some time in his house. In the 1860s made several prints designed for sale to the Western market. Specialized in genre painting and portraiture. His style very close to that of Hokusai. **Coll.:** Tōkyō (1), Victoria. **Bib.:** Morrison 2.

¹為斎　²清水　³葛飾宗次　⁴為斎　⁵酔楼楼

Isei¹ (fl. mid-16th c.). *Gō:* Isei.² **Biog.:** Kanō painter. Lived in Higo Province. Pupil of Kanō Motonobu. **Bib.:** Matsushita (1a).

¹意精　²意精

Isen'in¹ (1775–1828). *N.:* Kanō Naganobu (Eishin).² *F.N.:* Eijirō.³ *Gō:* Genshōsai,⁴ Isen;⁵ later, Isen'in.⁶ **Biog.:** Kanō painter. Born in Musashi Province. Pupil of his father, Kanō Yōsen'in Korenobu, whom he succeeded as seventh-generation head of the Kobikichō branch of the Kanō school in Edo. Official painter to the shogunate; in 1802, given rank of *hōgen* and in 1816 that of *hōin,* at which time he took the

name of Isen'in. Closely associated with the tea master Matsudaira Fumai. Invented technique of putting gold dust in ink. A painter of considerable talent, following the style of his ancestor Kanō Tsunenobu, often working in a free, sketchy manner. **Coll.:** Art (1), Freer, Metropolitan, Museum (3), Philadelphia, Tōkyō (1), Victoria. **Bib.:** Grilli (1); Hillier (4) 3; *Kanō-ha; Kokuhō* 6; Kondō (1); M 209, 241; Morrison 1; NBZ 4; *Nikuhitsu* (1) 2; Noma (1) 2; SBZ 8.

<center>[1]伊川院　[2]狩野栄信　[3]栄二郎</center>
<center>[4]玄賞斎　[5]伊川　[6]伊川院</center>

Ishibashi Wakun (Kazukuni)[1] (1876–1928). **Biog.:** Western-style painter. Born in Shimane-ken. First studied Japanese-style painting under Kodama Katei; then turned to Western-style. In 1903 to London; entered Royal Academy Art School and eventually became a member of the Royal Academy. On his return to Japan in 1918 was active in government exhibitions; member of hanging committee of the Teiten. His style that of the British academic school. **Bib.:** Asano, NBZ 6, Uyeno.

<center>[1]石橋和訓</center>

Ishigaki Eitarō[1] (1893–1958). **Biog.:** Western-style painter. Born in Wakayama-ken. In 1911 to New York, where he studied at the Art Students' League, taking an active part in the politically conscious art circles. Returned to Japan in 1951. His work much influenced by the Mexican school. **Coll.:** National (4), (5).

<center>[1]石垣栄太郎</center>

Ishiguro Munemaro[1] (1893–1968). **Biog.:** Potter. Born in Niihama, Toyama-ken. Worked at Yase, near foot of Mount Hiei, Kyōto, making his own version of three-color T'ang wares and Sung *temmoku* glazes for which he is famous. A noted collector of Chinese ceramics of the Han and Sung dynasties. In 1955, named a Living National Treasure. **Coll.:** National (4). **Bib.:** Koyama (1), (1a); *Masterpieces* (4); Munsterberg (2); Okada; STZ 16; Sugimura.

<center>[1]石黒宗麿</center>

Ishii Hakutei[1] (1882–1958). **N.:** Ishii Mankichi.[2] **Gō:** Hakutei.[3] **Biog.:** Western-style painter, printmaker. Born in Tōkyō. Studied Japanese-style painting under his father, Ishii Teiko; Western-style with Nakamura Fusetsu. Also studied at the Tōkyō School of Fine Arts under Asai Chū and Fujishima Takeji until ill health forced him to withdraw. In Europe in 1910 and again in 1923. In 1913 helped to found the Nihon Suisaigakai, and in 1914 the Nikakai. In 1936 helped organize the Issuikai. Frequent exhibitor at the Bunten, the Teiten, and the Issuikai shows. Member of the Imperial Art Academy. Worked in both oils and water colors, sometimes in the impressionist manner, sometimes in the manner of Derain and Marquet, sometimes in the Japanese style. Also produced a few prints. Famous as a Western-style painter. **Coll.:** Bridgestone, National (5). **Bib.:** Asano; BK 184, 201; Fujikake (1); Harada Minoru; Mitchell; NB (S) 30; NBZ 6; NHBZ 7; UG 4; Uyeno.

<center>[1]石井柏亭　[2]石井満吉　[3]柏亭</center>

Ishii Kinryō[1] (1842–1926). **N.:** Ishii Shun.[2] **A.:** Kummei.[3] **Gō:** Kinryō.[4] **Biog.:** *Nanga* painter. Born in Bizen. Pupil of Okamoto Shūki; then studied by himself. Lived in Okayama until he was 60, then moved to Ōsaka, where he was much admired as an elder member of the *nanga* school.

<center>[1]石井金陵　[2]石井俊　[3]君明　[4]金陵</center>

Ishii Rinkyō[1] (1884–1930). **N.:** Ishii Kisaburō.[2] **Gō:** Daiwashi,[3] Rinkyō,[4] Shōkadō,[5] Tempū.[6] **Biog.:** Japanese-style painter. Born in Hongō-chō, Chiba-ken; lived in Tōkyō and Chiba-ken. Pupil of Hashimoto Gahō; later a follower of the *nanga* school. An exhibitor and prize winner at the Bunten and the Teiten; a member of many art organizations. His paintings are very much in the free *nanga* manner. **Coll.:** National (5), Yamatane. **Bib.:** Asano, NBZ 6.

<center>[1]石井林響　[2]石井毅三郎　[3]大和子</center>
<center>[4]林響　[5]星華堂　[6]天風</center>

Ishii Tsuruzō[1] (1887–). **Biog.:** Western-style painter, illustrator, sculptor. Born and worked in Tōkyō. Younger brother of Ishii Hakutei. Pupil of Koyama Shōtarō; graduated in 1910 from Tōkyō School of Fine Arts. Became professor of sculpture at Tōkyō University of Arts. Member of Nihon Bijutsuin, Shun'yōkai, Nihon Hanga Kyōkai, and Nihon Suisaigakai. His sculpture has been shown at the Inten, his painting with the Shun'yōkai. Also a noted illustrator. His sculpture shows influence of Rodin; his painting is quite academic, with traces of his early training as a cartoonist. **Coll.:** National (5). **Bib.:** Asano; Fujikake (1); GNB 28; Kawakita (1); NBZ 6; NHBZ 7, 8; SBZ 11; UG 11.

<center>[1]石井鶴三</center>

Ishikawa Gozan[1] (1844–1917). **N.:** Ishikawa Kumatarō (Yūtarō).[2] **Gō:** Gozan,[3] Itsuō,[4] Kansen.[5] **Biog.:** *Nanga* painter. Born in Etchū Province; when about 18, to Nagasaki and studied under Hidaka Tetsuō. About 1867 to China with Nagai Umpei. After returning to Japan lived in Toyama, then Kanazawa and finally Ōsaka. **Coll.:** Victoria.

<center>[1]石川呉山　[2]石川熊太郎　[3]呉山　[4]逸翁　[5]潤泉</center>

Ishikawa Kakuji[1] (1881–1956). **N.:** Ishikawa Kakuji.[2] **Gō:** Hōdō,[3] Sanzanshi.[4] **Biog.:** Sculptor. Born in Yamagata-ken. Graduate of the Tōkyō School of Fine Arts in 1905; also studied at the Taiheiyō Kenkyūsho. Showed at a number of government-sponsored exhibitions; after 1945 was connected with the Nitten. Used both clay and wood as media; acquired considerable fame with his individual technique. **Bib.:** Asano.

<center>[1]石川確治　[2]石川確治　[3]方堂　[4]三山子</center>

Ishikawa Kangen[1] (1890–1936). **N.:** Ishikawa Torahisa.[2] **Gō:** Kangen.[3] **Biog.:** *Nanga* painter. Born in Tochigi-ken. To Tōkyō, where he studied under Satake Eison and, later, Komuro Suiun. Member of and exhibitor with the Nihon Nangain. **Bib.:** Asano.

<center>[1]石川寒巌　[2]石川寅壽　[3]寒巌</center>

Ishikawa Kin'ichirō[1] (1871–1945). **Biog.:** Western-style painter. Born in Shizuoka-ken. Studied under Asai Chū and Kawamura Kiyo-o. Member of Meiji Bijutsukai. To Europe in 1921; on his return joined the Kōfūkai and the Nihon Suisaigakai. Particularly skillful as a water-colorist. **Bib.:** Asano, Mitchell, NBZ 6.

<center>[1]石川欽一郎</center>

Ishikawa Kōmei[1] (1852–1913). **N.:** Ishikawa Kōmei.[2] **F.N.:** Katsutarō.[3] **Biog.:** Japanese-style sculptor. Born into a family of professional ivory carvers at Asakusa, Edo. Trained in Kanō-style painting under Kanō Sosen as well as in the family workshop. First exhibited in 1881 at the Naikoku Kangyō Hakurankai. In 1891 became professor at the Tōkyō School of Fine Arts; served as juror for the early Bunten exhibitions. In 1886, founding member of the Chōkōkai. Also a member of the Art Committee of the Imperial Household. Worked mostly in ivory, occasionally in wood; specialized in relief carving. His style traditional and inclined to be saccharine: a romantic academician. **Coll.:** Tōkyō (1). **Bib.:** Asano, GNB 28, M 203, *Masterpieces* (3), NB (S) 41, NBT 2, NBZ 6, Noma (1) 2, Uyeno.

<center>[1]石川光明　[2]石川光明　[3]勝太郎</center>

Ishikawa Mōkō[1] (fl. 18th c.). **Biog.:** *Yōga* painter. Working with *sumi,* copied Western prints with remarkable fidelity. **Coll.:** Yamato. **Bib.:** GNB 25; M 227, 228.

<center>[1]石川孟高</center>

Ishikawa Ryūjō[1] (1847–1927). **N.:** Ishikawa Mochitari.[2] **Gō:** Ryūjō.[3] **Biog.:** *Nanga* painter. Born in Nagoya. First studied *nanga* style under Nakano Suichiku; later to Kyōto to study Chinese classics as well as painting. Spent most of his life in government service, first in Gifu-ken, later in Taiwan. Visited China twice, in 1900 and 1909. Finally

returned to Nagoya and was active in *nanga* school circles there as well as in Tōkyō.

¹石川柳城　²石川戈足　³柳城

Ishikawa Toraji¹ (1875–1964). **Biog.:** Western-style painter. Born in Kōchi-ken. Pupil of Koyama Shōtarō at his school Fudōsha. Traveled in Europe and America in the early 1900s. On his return, exhibited frequently at the Bunten; later became a juror for the Teiten and the Nitten. Affiliated with the Taiheiyō Gakai and the Shigenkai. In 1952 won the Nihon Geijutsuin Prize. First known for his fresh, bright landscapes; his later paintings reflect the tendencies of the School of Paris. **Coll.:** Musées. **Bib.:** Asano, BK 201, NBZ 6.

¹石川寅治

Ishino Ryūzan¹ (1862–1936). **Biog.:** Potter. A leading late-Meiji-era potter, known for his quite elaborately decorated porcelains. **Bib.:** NB (S) 41, Uyeno.

¹石野龍山

Ishizaki Kōyō¹ (1884–1947). **N.:** Ishizaki Ishiichi (Iyoichi).² *Gō:* Kōyō.³ **Biog.:** Japanese-style painter. Born in Toyama-ken. Pupil of Takeuchi Seihō. Frequent exhibitor at the Bunten and the Teiten, serving as a juror for both these groups. Traveled several times to India for study, and also to France. Second-generation member of the "modern Kyōto school." His paintings are quite decorative, his colors strong; at times, the effect borders on the garish. **Coll.:** Kyōto (1), National (5). **Bib.:** Asano, Elisséèv.

¹石崎光瑶　²石崎猪四一　³光瑶

Ishū¹ (1791–1852). **N.:** Kikuta Hideyuki.² *Gō:* Ishū,³ Shōu.⁴ **Biog.:** Kanō painter. Born in Sendai. Said to have been a descendant of Ogawa Ritsuō. Pupil of Kanō Isen'in; friend of and influenced by Tani Bunchō. Served as official painter to the daimyo of Sendai, but also led a Bohemian life, sketching as he wandered. Skilled in representing Kannon and in *suiboku* painting. Created his own style; a charming colorist. **Coll.:** Allen, Museum (3). **Bib.:** *Kanō-ha.*

¹伊洲　²菊田秀行　³伊洲　⁴松塢（章羽）

Isobe Sōkyū¹ (1897–1967). **Biog.:** Japanese-style painter. Born in Gumma-ken, worked in Tōkyō. Pupil of Kawai Gyokudō. Exhibited at government shows and with the Nitten. Freely brushed landscapes. **Coll.:** National (5).

¹磯部草丘

Isoda Chōshū¹ (1880–1947). **N.:** Isoda (originally Uchida)² Magosaburō.³ *Gō:* Chōshū.⁴ **Biog.:** Japanese-style painter. Born in Tōkyō; adopted by the Isoda family. First studied under a minor Kanō painter; later under Kobori Tomone. In 1898, with Yasuda Yukihiko and Imamura Shikō, established the Kojikai. An exhibitor and prize winner at the Bunten; member of the Teiten. Specialized in historical figures and genre scenes. **Coll.:** National (5). **Bib.:** Asano.

¹磯田長秋　²内田　³磯田孫三郎　⁴長秋

Isohachi¹ (1759–1805). **N.:** Wakasugi Isohachi.² **Biog.:** *Yōga* painter. Born and worked in Nagasaki. A reasonably competent painter in the Western style that was first introduced, generally through the medium of prints, by traders and missionaries in the Momoyama and early Edo periods. **Coll.:** Kōbe, Tōkyō (2). **Bib.:** BK 12, GNB 25, KO 25, Kuroda, NBZ 5, *Pictorial* (2) 2, SBZ 10.

¹五十八　²若杉五十八

Isoi Joshin¹ (1883–1964). **Biog.:** Lacquerer. Born in Takamatsu. Graduate of Kagawa Prefectural School of Technology. A director of the Nihon Mingeikan and professor at Okayama University. Specialized in *kimma-nuri,* in which the designs are engraved in a hairline on a lacquered surface and then filled in with lacquer of other colors. **Coll.:** National (4). **Bib.:** Herberts, *Masterpieces* (4), Ragué, Yoshino.

¹磯井如真

Isomaro¹ (fl. early 19th c.). **Biog.:** Ukiyo-e printmaker. Pupil of Utamaro, producing prints of *bijin* in the manner of his master. **Bib.:** UG 6.

¹磯麿

Issa¹ (1763–1827). **N.:** Kobayashi Yatarō.² *Gō:* Issa.³ **Biog.:** Painter. Born in Kashiwabara (Niigata-ken); lived in Edo from about 1800 until he returned home in 1814. Worked in a free and unconventional style, specializing in *haiga.* **Bib.:** Mayuyama.

¹一茶　²小林彌太郎　³一茶

Issai¹ (1803–76). **N.:** Takahashi Masayori.² *A.:* Shitoku.³ *Gō:* Issai,⁴ Seii.⁵ **Biog.:** Buddhist painter. Born in Kyōto. Pupil of Yamawaki Tōki. Employed by the Daikaku-ji, Saga; received honorary title of *hokkyō.* Good at Buddhist portraiture.

¹一斎　²高橋正順　³至徳　⁴一斎　⁵静意

Issen¹ (1698–1778). **N.:** Hanabusa Sōtaku.² *A.:* Sōhō,³ Sōtaku.⁴ *Gō:* Issen,⁵ Shōkaan.⁶ **Biog.:** Hanabusa painter. Pupil of Hanabusa Isshū, and perhaps his adopted son.

¹一川　²英宗沢　³宗峰　⁴宗沢　⁵一川　⁶松下庵

Isshi¹ (fl. early 15th c.). **F.N.:** Kōzasu.² *Gō:* Isshi.³ **Biog.:** Muromachi *suiboku* painter. A priest-painter, influenced by Minchō and connected with either the Tōfuku-ji in Kyōto or the Kenchō-ji in Kamakura. Vigorous ink paintings of Taoist and Buddhist figures. **Bib.:** K 35; Morrison 1; *Muromachi* (1); NB (S) 13; Tajima (12) 12, 20; Tajima (13) 3.

¹一之　²江蔵主　³一之

Isshi¹ (1608–46). **N.:** Iwakura Fumimori.² *A.:* Isshi,³ Isshi Bunshu (Monju).⁴ *Gō:* Tōkō (Dōkō).⁵ **Biog.:** *Zenga* painter. Born in Kyōto; entered the Shōkoku-ji at 14; at 19 to the Nanshū-ji at Sakai to study Zen under Takuan. Banished to Kaminoyama in 1629, visited Takuan, who had also been banished there, remaining with him for fourteen months of Zen exercises. Became first abbot of the Reigen-in, built by the emperor Gomizuno-o, in the northern part of Kyōto. In 1643 revived the Eigen-ji, near Lake Biwa, and died there. His paintings of Zen figures, which show Takuan's influence, are in the swinging brush technique of *zenga,* but much of his work is more conservative and elegant than is usual in that school and closer to late-Muromachi painting. **Coll.:** Umezawa. **Bib.:** Awakawa, Brasch (2), *Japanische* (1), KO 10, M 166, NB (S) 47, Rosenfield (2), Tokutomi.

¹一絲　²岩倉文守　³一絲　⁴一絲文守　⁵桐江

Isshi¹ (fl. early 19th c.). *Gō:* Isshi,² Rekisentei,³ Rekisentei Isshi,⁴ Shōsekidō,⁵ Shōseki Koji.⁶ **Biog.:** Ukiyo-e painter. In the military service of the shogunate at Koishikawa, Edo. Painted *bijin* under the influence of Hosoda Eishi. Often confused with the Eiri⁷ who used the *gō* Rekisentei. **Bib.:** *Nikuhitsu* (2).

¹一指　²一指　³礫川亭　⁴礫川亭一指　⁵小石堂　⁶小石居士　⁷栄里

Isshō¹ (fl. 1751–63). **N.:** Miyagawa.² *F.N.:* Kiheiji.³ *Go:* Isshō,⁴ Kōhensai.⁵ **Biog.:** Ukiyo-e painter. Life unclear; said to have been a pupil of Miyagawa Chōshun. Exiled for a time to the island of Niijima for his part in Chōshun's dispute over the payment for the restoration work at Nikkō. Specialized in *bijinga* but also did genre scenes. **Note:** This may perhaps be the same artist as Miyagawa Tominobu (q. v.). **Coll.:** Idemitsu, Tōkyō (1), Victoria. **Bib.:** Fujikake (3) 2; Hillier (1); K 291, 708; Morrison 2; *Nikuhitsu* (1) 1, (2); Shimada 3; Tajima (7) 2; *Ukiyo-e* (3) 3.

¹一笑　²宮川　³喜平次　⁴一笑　⁵湖辺斎

Isshō¹ (?–1858). **N.:** Hanabusa Nobutoshi.² *Gō:* Isshō,³ Kashu.⁴ **Biog.:** Hanabusa painter. Second son of Kō Sūkoku; adopted by Hanabusa Ikkei, taking name of Hanabusa.

¹一笑　²英信俊　³一笑　⁴可主

Isshū¹ (1698–1768). **N.:** Hanabusa Nobutane.² *F.N.:* Hikosaburō,³ Yasaburō.⁴ *Gō:* Chōsōō,⁵ Isshū,⁶ Tōsōō.⁷ **Biog.:** Hanabusa painter. Pupil of Hanabusa Itchō; adopted by Hanabusa Isshū.⁸

¹一舟　²英信種　³彦三郎　⁴弥三郎　⁵潮窓翁　⁶一舟　⁷東窓翁　⁸英一蜩

Isshū¹ (fl. c. 1736). **N.:** Hanabusa Nobusuke.² *F.N.:* Gennai.³

Gō: Hyakushō,[4] Isshū;[5] later, Kosōō,[6] Koun.[7] **Biog.:** Hanabusa painter. Second son of Hanabusa Itchō. Said to have served Lord Arima.

[1]鯛（一舟） [2]英信祐 [3]源内 [4]百松
[5]鯛（一舟） [6]湖窓翁 [7]孤雲

Itaya Hazan[1] (1872–1963). **Biog.:** Potter. Born in Shimodate, Ibaraki-ken. In 1889 graduated from the sculpture department of the Tōkyō School of Fine Arts, but soon turned to ceramics, studying Kutani ware in Kanazawa. For a while taught sculpture at Kanazawa Institute of Technology; in 1903 resigned and built his own kiln at Tabata, Tōkyō. First exhibition in 1906; in 1911 and 1912 won top prizes in several exhibitions. Small production, about 20 pieces a year; about 1,000 pieces extant. Professor at Tōkyō Technological High School, director of Tōtokai, member of Japan Art Academy and of the Art Committee of the Imperial Household; first ceramic artist to receive Order of Cultural Merit. Worked only in porcelain. His early pieces show European influence; later work in the Chinese tradition. Noted for his celadons and white wares, often with floral designs in low relief under the glaze, and for his polychrome enamels; also for his *temmoku* bowls. From many illustrations he made for his designs, it is evident part of his inspiration came from cloth-dyeing patterns, particularly Indian and Dutch calico. One of the first early twentieth-century ceramic artists to both design and execute his objects. **Coll.:** Idemitsu; National (4); Tōkyō (1), (2). **Bib.:** BK 240, GNB 28, *Masterpieces* (4), Mitsuoka (1), Munsterberg (2), NBT 6, NBZ 6, Okada, STZ 16, Uyeno.

[1]板谷波山

Itchō[1] (1652–1724). *N.:* Hanabusa (originally Taga)[2] Shinkō.[3] *A.:* Kunju.[4] *F.N.:* Isaburō,[5] Jiemon,[6] Sukenoshin.[7] *Gō:* Chōko,[8] Gyōun,[9] Hokusōō,[10] Hōshō,[11] Ikkan Sanjin,[12] Ippō Kanjin,[13] Itchō,[14] Kansetsu,[15] Kyōundō,[16] Kyūsōdō,[17] Rinshōan,[18] Rintōan,[19] Rokusō,[20] Sasuiō,[21] Sesshō,[22] Shurinsai,[23] Suisaiō,[24] Undō,[25] Ushimaro,[26] Waō.[27] **Biog.:** Hanabusa painter, printmaker. Born in Ōsaka; second son of the doctor Taga Hakuan, who served several daimyo. At 15 to Edo; entered Buddhist priesthood with name of Chōko, but was temperamentally unsuited. Studied under Kanō Yasunobu; was soon expelled from the Kanō studio as a rebel against the Kanō tradition. Sought individual patronage of merchants in big cities rather than the official patronage of shogun or daimyo. In 1698, exiled to Miyakejima for making fun of shogun's favorite concubine; allowed to continue painting while there, using the name Shima Itchō,[28] and to sell his works. (These paintings are especially prized in Japan.) Pardoned in 1709; returned to Edo, living in Fukagawa. Typical of Genroku period in love of pleasure; led a Bohemian life. An excellent recorder of the contemporary life, painted topical subjects: street scenes, strolling singers, habitués of the Yoshiwara. Also a good poet, having learned the art of *haiku* from his friend Bashō, and many of his paintings have literary allusions. Eventually founded his own school. One of most original painters to come out of the Kanō school: cheerful, lighthearted style, between Kanō and ukiyo-e, without the latter's limitations of subject matter; a fresh lively manner in his sketches. A delightful painter of deserved fame. **Coll.:** Allen; Art (1); Ashmolean; Atami; British; Freer; Honolulu; Idemitsu; Metropolitan; Musées; Museum (3); Ōkura; Philadelphia; Seattle; Tōkyō (1), (2); University (2); Victoria; Worcester. **Bib.:** ARTA 6; Binyon (2); Boller; Grilli (1); *Hanabusa;* Hillier (1), (2), (3), (4) 3; K 10, 33, 55, 76, 82, 85, 93, 99, 130, 135, 140, 206, 222, 229, 304, 310, 320, 342, 494, 511, 514, 595, 654, 716, 920; Moriya; Morrison 1; Narazaki (3); NBZ 4; *Nikuhitsu* (1) 1; *One* (2); Paine (2) 2, (4); Sansom (1); Stern (4); SBZ 9;

Shimada 3; Tajima (7) 5; Tajima (12) 7, 9, 13, 15, 17, 18; Tajima (13) 5; Yamane (1a).

[1]一蝶 [2]多賀 [3]英信香 [4]君受 [5]猪三郎 [6]治右衛門
[7]助之進 [8]朝湖 [9]暁雲 [10]北窓翁 [11]宝蕉 [12]一閑散人
[13]一蜂閑人 [14]一蝶 [15]澗雪 [16]狂雲堂 [17]旧草堂
[18]隣松庵 [19]隣濤庵 [20]六巣 [21]蓑翠翁 [22]雪蕉
[23]狩林斎 [24]翠蓑翁 [25]雲堂 [26]牛麿 [27]和央 [28]島一蝶

Itchō II[1] (1677–1737). *N.:* Hanabusa (originally Taga)[2] Nobukatsu.[3] *F.N.:* Chōhachi,[4] Chōhachi Itchō,[5] Mohachi.[6] *Gō:* Itchō II,[7] Ritsuyo.[8] **Biog.:** Hanabusa painter. First (or perhaps adopted) son and pupil of Hanabusa Itchō. **Coll.:** Museum (3). **Bib.:** Morrison 1.

[1]一蝶二代 [2]多賀 [3]英信勝 [4]長八
[5]長八一蝶 [6]茂八 [7]一蝶二代 [8]栗余

Iten[1] (1472–1554). *Priest name:* Iten.[2] *Gō:* Kisetsu.[3] *Posthumous name:* Sōsei.[4] **Biog.:** Muromachi *suiboku* painter. A monk first at the Daitoku-ji, then at the Sōun-ji in Odawara; eventually became 83rd abbot of the Daitoku-ji. Patronized by the emperor Gokashiwabara. In 1522 received the title of Shōsō Daikō Zenshi. **Bib.:** NB (S) 63.

[1]以天 [2]以天 [3]機雪 [4]宗清

Itō Keinosuke[1] (1897–). **Biog.:** Western-style painter. Born in Hyōgo; worked in Nishinomiya. Pupil of Okada Saburōsuke. Worked at the Académie Colarossi in Paris while in Europe from 1928 to 1932. On his return, exhibited with the Bunten; became a member of the Shun'yōkai. Active in Kansai art circles. His style shows the influence of the prewar School of Paris. **Bib.:** Asano.

[1]伊藤慶之助

Itō Kōun[1] (1879–1939). *N.:* Itō Tsunetatsu.[2] *Gō:* Kōun.[3] **Biog.:** Japanese-style painter. Pupil of Murata Tanryō. Exhibited with the Bunten from its first show in 1907; in 1925 became a committee member of the Teiten. Specialized in historical paintings. **Bib.:** Asano.

[1]伊東紅雲 [2]伊東常松 [3]紅雲

Itō Ren[1] (1898–). **Biog.:** Western-style painter. Born in Nagoya. In 1925 graduated from Tōkyō School of Fine Arts; pupil of Okada Saburōsuke. In France from 1927 to 1930. On his return, joined the Dokuritsu Bijutsu Kyōkai; resigned in 1937. Later, a member of the Kokugakai. Taught at his alma mater, then later at the newly established Aichi University of Arts. His style shows the influence of the School of Paris, particularly of Matisse. **Bib.:** Asano, NB (H) 24, NBZ 6.

[1]伊藤廉

Itō Shinsui[1] (1898–1972). **Biog.:** Japanese-style painter, printmaker. Born in Tōkyō; studied under Kaburagi Kiyokata. Influenced by a trip to the South Seas. Produced his first color print in 1916; *Ōmi Hakkei* (Eight Views of Lake Biwa), his most famous series, dated 1917. From 1916 through 1921 worked as an illustrator for magazines and newspapers. Exhibited with the Bunten, the Teiten, and the Nitten. Member of Japan Art Academy and, in 1947, received the academy's prize. In painting, specialized in landscape and genre subjects and, particularly, in *bijinga* done in a delicate, misty neo-Japanese style; considered one of leading *bijin* artists of his day. His straightforward prints are more Western in feeling. **Coll.:** British, Fine (California), Honolulu, Kanagawa, Metropolitan, Minneapolis, Musées, Museum (3), National (5), Riccar, Staatliche. **Bib.:** Asano; Fujikake (1); Hillier (1), (9); Kondō (6); Michener (3); NBZ 6; NHBZ 7; Schmidt; Takahashi (1), (2); UG 4.

[1]伊東深水

Itō Shōha[1] (1877–1968). *N.:* Itō (originally Futami)[2] Sato.[3] *Gō:* Shōha.[4] **Biog.:** Japanese-style painter. Born in Ise. She studied first under Taniguchi Kōkyō and then under Takeuchi Seihō. Exhibited with the Bunten, winning a third prize in 1915. In 1919 joined the Nihon Jiyū Gakai, which

was anti-Teiten; when this was dissolved in 1929, returned to the Teiten. Specialized in genre painting. **Coll.**: Los Angeles, National (5). **Bib.**: Asano, Elisséèv, Lane.

¹伊東小坡 ²二見 ³伊東さと ⁴小坡

Itō Tōzan[1] (1846–1920). **Biog.**: Potter. Born in Awata, Kyōto; worked in Kyōto. First studied painting under the Maruyama artist Koizumi Tōgaku, whose wife was a potter and under whom he studied pottery making. In 1863, with his teacher's approval, became a potter, setting up his own kiln in 1867. Also revived the making of Asahi-yaki at Uji, famous for its tea ceremony utensils. Became a leading figure in the ceramic world of Kyōto. Member of the Art Committee of the Imperial Household. His pottery in the traditional Awata manner; his designs sometimes show his pictorial training. **Coll.**: Museum (3), Tōkyō (1), Victoria. **Bib.**: NB (S) 41, NBZ 6, Uyeno.

¹伊東陶山

Itō Yoshihiko (Yasuhiko)[1] (1867–1942). **N.**: Itō Yoshihiko (Yasuhiko).[2] **Gō**: Jakuō.[3] **Biog.**: Western-style painter. Born and worked in Kyōto. Fond of painting as a child, studied first under Tamura Sōritsu in Kyōto. In 1888 graduated from Kyōto Prefectural School of Painting. Went to Tōkyō; worked briefly with Koyama Shōtarō, then entered Harada Naojirō's school, the Shōbikan. Returned to Kyōto in 1892, taking an active part in the Kyōto art world from then on. Helped organize the Kansai Art Academy, later becoming its director. His painting at the first Bunten received special recognition. A competent academic artist. **Coll.**: Kyōto (1), National (4). **Bib.**: Asano, Harada Minoru, NB (S) 30, NBZ 6.

¹伊藤快彦 ²伊藤快彦 ³若翁

Itsunen (Chinese: I-jan)[1] (1601–68). *Priest name:* Shōyū.[2] **Gō**: Itsunen,[3] Rōun'an.[4] **Biog.**: Nagasaki painter. A Chinese priest who left China at the fall of the Ming dynasty and in 1645 became a naturalized Japanese. Probably a member of the Rinzai Zen sect; eventually became third abbot of the Zen monastery of the Sōfuku-ji in Nagasaki. The best known of the Chinese artists who came to Japan at this time, and, although his influence in painting did not extend beyond Nagasaki, is regarded as the founder of the Nagasaki school. Watanabe Shūseki and Kawamura Jakushi were his pupils. Painted mostly Buddhist images and portraits of priests in a curiously realistic manner. **Coll.**: Kōbe, Mampuku-ji, Sōfuku-ji. **Bib.**: Akiyama (2); BMFA 44; K 789, 833; Mody; NB (S) 47; NBZ 5; *Pictorial* (2) 5; Umezawa (2); Yonezawa.

¹逸然 ²性融 ³逸然 ⁴浪雲庵

Itsuun[1] (1799–1866). **N.**: Kinoshita Shōsai.[2] **A.**: Kōsai.[3]

F.N.: Shiganosuke.[4] *Gō:* Butsubutsushi,[5] Itsuun,[6] Jora Sanjin,[7] Kakōshin,[8] Yōchiku Sanjin.[9] **Biog.**: *Nanga* painter. Born in Nagasaki; went to Kyōto and Edo, then returned to Nagasaki. Finally drowned at sea while traveling from Nagasaki to Edo. Pupil of Ishizaki Yūshi. Also studied the style of the Ming painter Tung Ch'i-ch'ang and mastered the technique of the Chinese painter Chiang Chia-pu (Japanese: Kokaho), who was in Japan at that time. A talented poet and carver of seals. Specialized in landscape, but also produced figures and *kachōga;* a skillful colorist. In his prime, considered with Hidaka Tetsuō and Miura Gomon one of the Three Great Masters of Nagasaki. **Coll.**: Ashmolean, Nagasaki, Worcester. **Bib.**: K 502, Mitchell, Morrison 2, NB (S) 4, NBZ 5, OA 13.

¹逸雲 ²木下相宰 ³公宰 ⁴志雅之助 ⁵物々子
⁶逸雲 ⁷如螺山人 ⁸荷香深 ⁹養竹山人

Ittoku[1] (fl. early 17th c.). **N.**: Tosa Ittoku.[2] **Biog.**: Tosa painter. Little information about him; is assumed to have belonged to the Tosa school and may have been a pupil of Tosa Mitsuyoshi. Said to have specialized in painting quails. Very few works known, all of small size. **Bib.**: K 62, 141, 493, 692; Morrison 1.

¹一得 (一徳) ²土佐一得 (一徳)

Iwahashi Noriaki[1] (1832–83). **Biog.**: Western-style painter. Born in Matsuzaka, Ise Province. Held a government position under the *bakufu.* At the Vienna International Exposition of 1873, became acquainted with printmaking; for a while in Vienna studying etching and lithography. On his return to Japan continued his work in these fields as well as in oil painting and water colors. Juror for the second Naikoku Kangyō Hakurankai. His style is one of European academism. **Bib.**: Asano, BK 206, NBZ 6.

¹岩橋教章

Iwata Masami[1] (1893–). **Biog.**: Japanese-style painter. Born in Niigata-ken; works in Tōkyō. Graduate of the Tōkyō School of Fine Arts; pupil of Matsuoka Eikyū. Has shown at government exhibitions and with the Nitten. Member of the Nitten, the Nihongain and the Nihon Bijutsu Kyōkai. His paintings sometimes deal with historical or archaeological subjects. **Coll.**: National (5). **Bib.**: Asano.

¹岩田正己

Izumo[1] (fl. early 16th c.). **Biog.**: Sculptor. A carver of Nō masks. This name, indicating he was the artist, together with the date 1508, is found on the inside of a Nō mask belonging to the Aburahi-jinsha, Shiga. **Coll.**: Aburahi-jinsha. **Bib.**: *Muromachi* (1).

¹出雲

J

Jakuchū[1] (1716–1800). **N.**: Itō Shunkyo[2] (or Jokin).[3] **A.**: Keiwa.[4] **Gō**: Jakuchū,[5] Tobeian,[6] Tomaiō.[7] **Biog.**: Painter, printmaker. Born and worked in Kyōto. Son of a rich grocer, lived in the Nishiki quarter near the markets; financially free, was able to devote his whole life to painting. Specialized in painting elegant barnyard fowl—keeping many exotic birds in his garden—but also produced Buddhist subjects. Though he studied Kanō painting, was mainly influenced by the Chinese Yüan and Ming paintings of the academic school that he saw at the Shōkoku-ji, where he lived and worked after 1788 when his house in the Nishiki burned down, and for which he did many paintings. A solitary figure in the history of Japanese painting. His pictures were ignored until he was rediscovered in the late 19th century. His birds and flowers are painted with a realism that preceded and at times exceeded that of Ōkyo, but his decorative arrange-

ments and sense of color and design show the influence of Kōrin. Also painted in ink, in a style of willful distortion and daring brushwork, a style totally at variance with his other one for which he is better known. Also made a number of prints in the *ishizuri* technique (designs printed in white reserve on black) and illustrated several books. Note: After 1776, his studio produced many pictures that carry the seal or signature of Jakuchū but are not necessarily by him. **Coll.**: Allen; Art (1); British; Daikōmyō-ji; Denver; Fogg; Kaihō-ji; Kinkaku-ji (Shoin); Kotohira; Kyōto (2); Lake Biwa; Mampuku-ji; Metropolitan; Musée (2); Museum (3); Newark; Philadelphia; Rokuon-ji; Royal (1); Ryōsoku-in; Saifuku-ji; Seattle; Shōkoku-ji; Tōkyō (1), (2); University (2); Worcester. **Bib.**: Akiyama (2), (5); Brown; Fontein (1); GNB 18; *Gomotsu;* Hillier (1), (3), (4) 3; *Jakuchū;* K 19, 129, 153, 191, 313, 432, 453, 559, 657, 859, 880, 932, 944, 955;

KO 34; M 245; Mayuyama; Minamoto (1); Mitchell; Mizuo (3); Morrison 2; NB (S) 39; NBT 5; NBZ 5; Noma (1) 2; *One* (2); Paine (4); SBZ 10; Shimada 2; Suzuki (7a); Tajima (1), (4); Tajima (12), 2, 9, 15, 19; Tajima (13) 6; Toda (1).

¹若冲 ²伊藤春教 ³汝鈞 ⁴景和
⁵若冲 ⁶斗米庵 ⁷斗米翁

Jakuen¹ (fl. late 18th to early 19th c.?). *N.:* Itō Masatoki.² *Gō:* Jakuen.³ **Biog.:** Painter. May have been a son of Itō Jakuchū, whose work his paintings resemble. **Coll.:** Tōkyō (2). **Bib.:** *Jakuchū.*

¹若演 ²伊藤雅時 ³若演

Jakugen¹ (1668–1744). *N.:* Kawamura (originally Ogawa,² then Ueno)³ Michimasa.⁴ *A.:* Ran'ei.⁵ *Gō:* Baikyūken,⁶ Chiō,⁷ Jakugen,⁸ Kazan,⁹ Kōshū.¹⁰ **Biog.:** Nagasaki painter. Original family name Ogawa; adopted by the Ueno family; finally took the name Kawamura from his teacher Kawamura Jakushi. In the Genroku era (1688–1704), served the lords of Nabeshima as official painter; afterwards returned to Nagasaki. Produced landscapes, figures, and portraits. **Coll.:** Kōbe. **Bib.:** *Pictorial* (2) 5.

¹若元 ²小川 ³上野 ⁴河村道昌 ⁵蘭栄
⁶梅久軒 ⁷癡翁 ⁸若元 ⁹華山 ¹⁰畱洲

Jakuhō¹ (1723–80). *N.:* Ashizuka Eishō.² *A.:* Buntoku.³ *F.N.:* Yūshichi,⁴ Yūshichirō.⁵ *Gō:* Gotei,⁶ Jakuhō,⁷ Royū.⁸ **Biog.:** Nagasaki painter. Born in Nagasaki; second son of Kawamura Jakugen, younger brother of Yamamoto Jakurin; pupil of both his father and his brother. Produced *kachōga,* landscapes, portraits, and pictures of fish and insects.

¹若鳳 ²蘆塚英祥 ³文徳 ⁴勇七
⁵勇七郎 ⁶悟亭 ⁷若鳳 ⁸蘆圃

Jakurin¹ (1721–1801). *N.:* Yamamoto (originally Kawamura)² Nagaaki.³ *F.N.:* Tanjirō.⁴ *Gō:* Chōei (Nagahide),⁵ Chōshō,⁶ Jakurin,⁷ Onkosai,⁸ Roseki,⁹ Zuiō.¹⁰ **Biog.:** Nagasaki painter. Son and pupil of Kawamura Jakugen; adopted by the Yamamoto family. Lived and worked in Nagasaki. Specialized in the painting of animals, particularly tigers; also produced landscapes, *kachōga,* and figures.

¹若麟 ²河村 ³山本長昌 ⁴丹次郎 ⁵長英
⁶長昭 ⁷若麟 ⁸温故斎 ⁹魯石 ¹⁰瑞翁

Jakusai¹ (1348?–1424). *N.:* Rokkaku Jakusai.² **Biog.:** *Yamato-e* painter. Worked for the court. May have been a son of Tosa Mitsuaki. His name—together with those of Awataguchi Takamitsu, Tosa Mitsukuni, Tosa Yukihiro, Tosa Eishun, and Kasuga Yukihide—appears on the scroll *Yūzū Nembutsu Engi,* dated 1414 and in the possession of the Seiryō-ji, Kyōto. **Coll.:** Seiryō-ji. **Bib.:** K 21, Okudaira (1), Tajima (12) 1, Toda (2).

¹寂済 ²六角寂済

Jakushi¹ (1630–1707). *N.:* Kawamura Jakushi.² *Gō:* Dōkō,³ Enka Sanjin,⁴ Fukei,⁵ Fūkyōshi,⁶ Rankei,⁷ Shiyō Sanjin.⁸ **Biog.:** Nagasaki painter. Born in Saga. Studied under Itsunen when he was abbot at the Sōfuku-ji in Nagasaki. Specialized in landscapes, figures and *kachōga.* Also a metalworker. **Coll.:** Kōbe, Nagasaki. **Bib.:** *Pictorial* (2) 5, Yonezawa.

¹若芝 ²河村若芝 (河邨若芝) ³道光 ⁴烟霞山人
⁵普馨 ⁶風狂子 ⁷蘭渓 ⁸柴陽山人

Jakuyū¹ (1754–1817). *N.:* Hirashima Yoshikazu.² *A.:* Yoshikazu.³ *F.N.:* Jinzaemon.⁴ *Gō:* Hōkosai,⁵ Jakuyū.⁶ **Biog.:** Nagasaki painter. Born and worked in Nagasaki; son and pupil of Yamamoto Jakurin. A painter of flowering plants, figures, animals, birds.

¹若融 ²平島叔和 ³叔和 ⁴甚左衛門 ⁵方壺斎 ⁶若融

Jakuzui¹ (1758–1827). *N.:* Ueno (originally Kawamura)² Taisuke.³ *A.:* Tōkō.⁴ *Gō:* Jakuzui.⁵ **Biog.:** Nagasaki painter. Born in Nagasaki; second son and pupil of Yamamoto Jakurin. A good painter of *kachōga,* animals, and portraits.

¹若瑞 ²河村 ³上野泰輔 ⁴稲光 ⁵若瑞

Jasoku (Dasoku)¹ (?–1483). *N.:* Soga Sōyo.² *F.N.:* Shikibu.³

Priest name: Fusen.⁴ *Gō:* Jasoku (Dasoku).⁵ *Priest gō:* Sōjō.⁶ **Biog.:** Muromachi *suiboku* painter. Born in Echizen; became a vassal of the Asakura family. Perhaps a pupil of Shūbun in Kyōto while practicing Zen under the leadership of Ikkyū Sōjun, to whom he taught painting. The *fusuma* and other paintings at the Shinju-an, Daitoku-ji, Kyōto, where he lived, are attributed to him. To judge by these works, he was good at portraits, *kachōga,* and *suiboku,* the last characterized by his use of heavy black ink. However, his oeuvre and even his identity are still not clear: Jasoku, Sōjō, and Sōyo have been considered by some as separate individuals. Also, Jasoku may be the same person as Bokkei. In the early Edo period the painter Soga Chokuan claimed descent from him and so gave an ancient, even though false, lineage to his school. **Coll.:** Daitoku-ji (Shinju-an), Museum (3), Umezawa. **Bib.:** AA 14; Akiyama (2); BG 43; Fontein (2); GNB 11; Hisamatsu; HS 3, 4, 5, 7, 9, 13; K 77, 136, 349 405, 735; KO 38, 39; Matsushita (1), (1a); Morrison 1; *Muromachi* (1); NB (S) 13; Okamoto (1); *One* (2); Paine (4); Tajima (12) 1, 4, 5; Tajima (13) 3; Tanaka (2).

¹蛇足 ²曽我宗誉 ³式部 ⁴夫泉 ⁵蛇足 ⁶宗丈

Jichōsai (Nichōsai)¹ (fl. 1781–88). *N.:* Matsuya Heizaburō.² *Gō:* Jichōsai (Nichōsai).³ **Biog.:** Painter, illustrator. Lived in Ōsaka. A sakè brewer, curio dealer, writer of comedies, singer, book illustrator, and an artist known for his *kyōga.* Specialized in portraits of *sumō* wrestlers and theatrical characters. Bold free sketches, almost caricatures. **Coll.:** Musées, Museum (1), Philadelphia. **Bib.:** Brown; Fontein (1); Hillier (3), (4) 3; Holloway; Keyes; Mitchell; NHBZ 3; *Nikuhitsu* (1) 2; Toda (1).

¹耳鳥斎 ²松屋平三郎 ³耳鳥斎

Jigoemon¹ (fl. mid to late 17th c.). *N.:* Hata Yoshinaga.² **Biog.:** Lacquerer. Lived at Jōgahana in Etchū. Apparently went to Nagasaki to study Chinese painting; at the same time may have learned the *mitsuda-e* lacquer technique at the Ohara school, which had been established by Sasaki Matabei³ between 1573 and 1592. Returned to Jōgahana. Became so well known for his lacquer wares that he was summoned by the fifth Maeda daimyo Tsunanori Shōunkō (1643–1724), to Kaga to join the group of artists and intellectuals assembled there. No pieces by him are known today. **Bib.:** Herberts, Jahss, M 188, Ragué, Yoshino.

¹治五右衛門 ²羽田好永 ³佐々木又兵衛

Jigoemon¹ (1729–1805). *N.:* Ohara Jigoemon.² *Gō:* Shigeyoshi.³ **Biog.:** Lacquerer. Descendant of seventh generation of Jigoemon line. (After sixth generation, all members of the family used name Ohara Jigoemon.) Lived and worked at Jōgahana in Etchū. Invented a type of white lacquer, produced by sprinkling silicate powder on lacquer, called "white lacquer of Jōgahana." **Bib.:** Herberts, Jahss, M 188, Yoshino.

¹治五右衛門 ²小原治五右衛門 ³重美 (重義)

Jihei¹ (fl. c. 1764–67). *N.:* Kawamoto Jihei.² **Biog.:** Seto potter. Reconstructed the Asahi and Yūhi kilns near Seto.

¹治兵衛 ²川本治兵衛

Jihei II¹ (fl. late 18th c.). *N.:* Kawamoto Tōhei.² *Gō:* Jihei,³ Kaitōen,⁴ Sosendō.⁵ **Biog.:** Seto potter. Son of Kawamoto Jihei. Brought the technique of making Arita porcelain to Seto. A skillful worker in underglaze blue-and-white. Was followed by several pupils, the last of whom died in 1866. **Bib.:** STZ 6.

¹治兵衛二代 ²川本藤平 ³治兵衛 ⁴魁陶園 ⁵壊仙堂

Jikan¹ (fl. early 16th c.). **Biog.:** Muromachi *suiboku* painter. Worked in the manner of Sesshū. **Bib.:** Matsushita (1a).

¹自閑

Jikiō¹ (fl. late 17th c.). *N.:* Tamura Jikiō.² **Biog.:** Painter. An artist about whom there is considerable confusion. The *Koga Bikō* says his style is close to that of Chikuō and Eishin, in which case he would be a Kanō painter. Tanaka Kisaku (*Bijutsu Kenkyū* 63) thinks this Tamura Jikiō was a

Soga painter rather than a member of the Kanō school, and hence a different artist from the one mentioned in the *Koga Bikō*. **Bib.:** BK 63.

¹直翁 ²田村直翁

Jikkō[1] (1777–1813). *N.:* Hayashi (Rin) Shiyoku.[2] *A.:* Shiyoku,[3] Umpu.[4] *F.N.:* Chōjirō.[5] *Gō:* Chōu,[6] Jikkō,[7] Jūkkō (Sōko).[8] **Biog.:** *Nanga* painter. Born in Mito. A Confucian scholar with an early liking for painting. Went to Edo, became a friend of Tani Bunchō. Widely known as Chōu among the Japanese. Painted views of nature in a bold and sketchy style. Also produced pictures of fish and animals. **Bib.:** *Cent-cinquante,* GNB 18, NB (H) 23, *Pictorial* (1) 4, SBZ 10, Yonezawa.

¹十江 ²林子翼 ³子翼 ⁴雲夫
⁵長次郎 ⁶長羽 ⁷十江 ⁸十江

Jinnaka Itoko[1] (fl. late 19th c.). **Biog.:** Western-style painter. One of the few women to study painting with Fontanesi at the Kōbu Daigaku Bijutsu Gakkō. Became a member of the Jūichikai, along with Koyama Shōtarō, Asai Chū, and Matsuoka Hisashi. Exhibited at the Naikoku Kangyō Hakurankai in 1905, winning an award. **Bib.:** Asano.

¹神中糸子

Jirō[1] (fl. 1334–39). **Biog.:** Sculptor. Member of the Tsubai Bussho. Known for three small Buddhist figures dated respectively 1334, 1335, 1339. **Bib.:** *Muromachi* (2).

¹次郎

Jirōzaemon[1] (fl. 1716–35). *N.:* Tsuishu.[2] *Gō:* Jirōzaemon.[3] **Biog.:** Lacquerer. Worked in Kyōto, specializing in *tsuishu.* Considered by some to be as fine an artist in this medium as Monnyū. **Bib.:** Herberts, Jahss.

¹治郎左衛門 ²堆朱 ³治良左衛門

Jitsusei[1] (fl. 1531–48). **Biog.:** Sculptor. A monk at the Tōdai-ji. His statues in several Nara temples carry dates from 1531 to 1548. His style is the rather simplified, smoothed-out one typical of late Muromachi work. **Coll.:** Saikō-in, Sainen-ji (1), Toden Yakushidō, Tokuyu-ji. **Bib.:** *Muromachi* (2).

¹実清

Jiun[1] (1718–1804). *N.:* Kōzuki Onkō.[2] *Priest name:* Jiun.[3] *Gō:* Hyakufuchi Dōji,[4] Katsuragi Sanjin.[5] **Biog.:** *Zenga* painter. Born in Ōsaka, seventh son of Kōzuki Yasunori, a distinguished scholar of Shintoism, Buddhism, and Confucianism. A well-known Buddhist monk, a great scholar with a wide knowledge of Esoteric Buddhism and the meditative schools, a famous calligrapher who occasionally did some painting. Though he belonged to the Shingon sect, eventually founded a subsect called Shōbōritsu (Discipline of the Correct Doctrine); in 1777 took over the Kōki-ji in Kawachi, which then became the headquarters of this new sect and his residence for most of the rest of his life. His calligraphy and paintings are generally rough and strong, executed with a large dry brush, reflecting far more the influence of Zen than of Shingon Buddhism. **Coll.:** Fogg. **Bib.:** Awakawa, BO 127, Brasch (2), *Cent-cinquante,* Hisamatsu, Kinami, Rosenfield (2).

¹慈雲 ²上月飲光 ³慈雲 ⁴百不知童子 ⁵葛城山人

Jōchi[1] (fl. mid-12th c.). **Biog.:** Buddhist painter. Lived as a monk on Kōyasan. It is recorded that at the founding of the Daidempō-in in 1145 he did some of the pillar paintings. A document in the archives of Kōyasan substantiates the tradition that the painted image of Zennyo Ryūō in the Kongōbu-ji was made by him in 1145. This latter work shows he was influenced by Chinese Sung painting. **Coll.:** Kongōbu-ji. **Bib.:** BI 42, *Emakimono, Heian* (1), Moriya, SBZ 11, Tajima (12) 20, Tanaka (2).

¹定智

Jōchō[1] (?–1057). **Biog.:** Sculptor. Worked in and around Kyōto. Trained by his father Kōshō in carving figures for Fujiwara Michinaga's vast temple the Hōjō-ji (which no longer exists). He became the most esteemed sculptor of his day, receiving rank of *hokkyō* in 1022, the first sculptor to be

so honored—a recognition by Michinaga of his distinguished services at the Hōjō-ji and an important step in the advancement of the position of the sculptor in the social world of the time. In 1048, raised to *hōgen.* In 1053 made the large figure of Amida Nyorai for the Hōōdō of the Byōdō-in at Uji, the only fully authenticated work by him in existence. A leader among *busshi,* set the style (known as the Wa-yō, or Japanese style) for later Heian sculpture. **Coll.:** Byōdō-in (Hōōdō), Kyōto (2), Rokuhara Mitsu-ji. **Bib.:** BG 2; BK 64; GK 6; Glaser; GNB 6; Hasumi (2); K 848; Kidder; *Kokuhō* 3; Kuno (1); Minamoto (1); Mōri (1a); NB (S) 50; NBZ 2; Noma (1) 1, (3) 5; Paine (4); Rosenfield (1); SBZ 11; Tajima (13) 15; Watson (1); Yashiro (1) 1; YB 27.

¹定朝

Jōen[1] (fl. late 13th c.). **Biog.:** Sculptor. Pupil of Kan'en; member of the Sanjō Bussho En school of sculptors. Given title of *hokkyō,* then *hōgen,* Said to have made the statue of Kichijōten at the Kichijō-ji, Ōmi, in 1291.

¹定円

Jōen[1] (1628–73). *N.:* Okamoto.[2] *Priest name:* Jōen.[3] *A.:* Rōzen.[4] *Gō:* Gengen'ō,[5] Gengenshi.[6] **Biog.:** Painter. Born in Ōsaka; lived in Kyōto. A priest-painter and calligrapher, having studied calligraphy under Nakanuma Shōkadō. **Coll.:** Rietberg.

¹乗円 ²岡本 ³乗円 ⁴良然 ⁵玄々翁 ⁶玄々子

Jōga[1] (fl. c. 1295). **Biog.:** Buddhist painter. Member of the Jōdo Shinshū sect, serving as a priest at the Kōraku-ji in Shinano Province. The scrolls of the *Shinren Shōnin Eden* (known locally as the *Zenshin Shōnin-e*), dated 1295, in the Nishi Hongan-ji, Kyōto, and the portrait of Priest Shinran in the Nara National Museum are attributed to him. **Coll.:** Nara, Nishi Hongan-ji. **Bib.:** *Art* (2), NKZ 79.

¹浄賀

Jogen[1] (c. 1773–1824). *N.:* Araki (originally Ichinose)[2] Jogen.[3] *F.N.:* Zenjūrō;[4] later, Zenshirō.[5] **Biog.:** *Yōga* painter. Born in Nagasaki. Adopted by his teacher Araki Gen'yū, who held the position of *kara-mekiki* in Nagasaki. While the Watanabe and Hirowatari families were inspectors in charge of Chinese paintings, the Araki family was in charge of Western painting; thus Jogen was introduced to Western oil-painting technique. Probably became a pupil of Wakasugi Isohachi on Gen'yū's death. Considerable reputation as a connoisseur but only average competence as a painter. Produced portraits, scenes in imitation of Western examples; also miniatures on enamel with gold inlay which were almost exclusively of Japanese themes, but included some illustrations of scenes of foreigners at Deshima. **Coll.:** Kōbe, Nagasaki, Yamato. **Bib.:** BK 12, GNB 25, KO 26, Kuroda, Mody, NBZ 5, Nishimura, *Pictorial* (2) 2, Sullivan.

¹如元 ²一瀬 ³荒木如元 ⁴善十郎 ⁵善四郎

Jōgetsudō (Teigetsudō)[1] (fl. c. 1740–50). **Biog.:** Ukiyo-e printmaker. Pupil or imitator of Okumura Masanobu. Nothing known of his life. His prints are frequently done in lacquer. **Bib.:** *Kunst.*

¹定月堂

Jōkasai[1] (fl. c. 1681–1704). *N.:* Yamada (originally Terada)[2] Jōka.[3] *Gō:* Jōkasai.[4] **Biog.:** Lacquerer. Lived in Edo. Member of the Kajikawa school of lacquerers; worked for the shogunate. In 1682, at the order of the Tokugawa family and working with Kōami Nagafusa, made a large number of *inrō* and incense boxes. Had a great many pupils and followers, all of whom continued to work for the shogunate and to use his name of Jōka or Jōkasai. The last Jōkasai was Tsuneō (Jōō)[5] (1811–79), a skillful craftsman who worked for the shogunate until the Restoration. **Coll.:** Metropolitan, Museum (3), Nezu, Victoria, Walters. **Bib.:** Boyer, Casal, Herberts, Jahss, M 188, Okada, Ragué, Speiser (2), Yamada, Yoshino.

¹常嘉斎 ²寺田 ³山田常嘉 ⁴常嘉斎 ⁵常翁

Jōkei[1] (fl. late 12th to late 13th c.). A name appearing from

1184 for about a hundred years and referring to a family of sculptors. It is not known how many sculptors were included in the family, but most references are either to the first, Dai Busshi Jōkei, or to the Jōkei known as Higo Hokkyō (see both under separate references). Bibliography for both artists is listed hereunder, as it is often unclear which artist is being discussed. **Bib.:** BI 79; Buhot; GK 8; GNB 9; Glaser; Hasumi (2); Kidder; *Kokuhō* 4; Kuno (1), (2) 6; Matsumoto (1); Mōri (1a); NB (H) 11; NB (S) 40, 62; NBZ 3; Noma (1) 1; OZ 4, new series 13; Paine (4); SBZ 6; Tajima (12) 13, (13) 15.

¹定慶

Jōkei¹ (fl. 1184–1212). *F.N.:* Dai Busshi Jōkei.² **Biog.:** Sculptor. Pupil of Unkei and, according to some scholars, his second son, in which case he would be the same person as Kōun. Member of the Shichijō Bussho at Nara. Among the works known to be by him are some Bugaku masks (dated 1184) in the Kasuga-jinja, Nara, and, in the Kōfuku-ji, the Yuima Koji (dated 1196, carved by him, painted by Kōen), the Monju (1196), the Taishakuten (1201), the Bon Ten (1201), the Kongō Rikishi (1201–3), and the Miroku Bosatsu (1212, according to the inscription carved in collaboration with Genkei). His work shows considerable realism, blended with the Chinese Sung sculptural style. **Coll.:** Kasuga-jinja, Kōfuku-ji. **Bib.:** Mōri (1a); Ōoka; Tajima (12) 11, 13. (See also preceding entry.)

¹定慶 ²大仏師定慶

Jōkei¹ (fl. 1224–56). *F.N.:* Higo Hokkyō Jōkei.² **Biog.:** Sculptor. This artist was given the title of *hokkyō* and eventually of *hōin.* The following pieces are by him: Roku Kannon (1224, Daihōon-in), Bishamonten (1224, Tōkyō University of Arts), Shō Kannon (1226, Kurama-dera), Kongō Rikishi (1242, Sekigan-ji), Kongō Rikishi (1256, Ōzō-ji, Gifu). His style shows a clear Sung influence. **Coll.:** Daihōon-in, Kurama-dera, Ōzō-ji, Sekigan-ji, Tōkyō (2). **Bib.:** K 800; Mōri (1a); Tajima (12) 11, 13. (See also first Jōkei entry above.)

¹定慶 ²肥後法橋定慶

Jōkei¹ (1561–1633). *N.:* Tanaka Tsuneyoshi.² *Studio name:* Kichizaemon.³ *Gō:* Jōkei.⁴ **Biog.:** Raku potter. Son of Sōkei, who was probably an assistant to Chōjirō. Hideyoshi gave him a seal with the character *raku*⁵ in memory of Chōjirō, allowing him to use it to mark his pottery. The Raku name and occasionally the seal have been applied ever since to the type of pottery first made by Chōjirō. Jōkei is also known as Raku II,⁶ and the Raku line of potters descends from him. His bowls are strong, powerful, sometimes slightly distorted, with spatula marks showing; frequently used a white glaze. **Coll.:** Tōkyō (1). **Bib.:** Castile; Fujioka; Jenyns (2); K 681; Munsterberg (2); *Nihon* (8); Okuda (1); STZ 3, 7; TZ (K) 6.

¹常慶 ²田中常慶 ³吉左衛門 ⁴常慶 ⁵楽 ⁶楽二代

Jokei¹ (1599–1670). *N.:* Sumiyoshi (originally Tosa)² Hiromichi³ (or Tadatoshi).⁴ *Court title:* Naiki.⁵ *Priest name:* Jokei.⁶ *F.N.:* Nagashigemaru.⁷ **Biog.:** Sumiyoshi painter. May have been the second son of Tosa Mitsuyoshi and younger brother of Tosa Mitsunori; father of Sumiyoshi Gukei. First connected with the Tosa school in Kyōto, but separated from it, establishing his own school in Edo. At the command of the emperor Gosai (r. 1656–63) changed his name to Sumiyoshi on his appointment as official painter at the Sumiyoshi Shrine. Served as *goyō eshi* to the shogunate, producing many scrolls and specializing in genre scenes. Noted for his copies of earlier *yamato-e.* Received titles of *hokkyō* and *hōgen,* taking name of Jokei when given the latter. Late in his life became a monk. Worked in a careful *yamato-e* manner; with his son restored and carried forward the authentic Tosa-school style under the Sumiyoshi name. **Coll.:** Freer; Tōkyō (1), (2). **Bib.:** *Freer;* K 143, 594; Moriya;

Morrison 1; Paine (4); Rosenfield (1a); Shimada 2; Tajima (12) 7.

¹如慶 ²土佐 ³住吉広通 ⁴忠俊
⁵内記 ⁶如慶 ⁷長重丸

Jōki¹ (fl. early 14th c.). **Biog.:** Sculptor. Member of the In school. An artist of the late Kamakura period known for the quite realistic relief of Kōbō Daishi, dated 1302, in the Jingo-ji, Kyōto. Given the honorary title of *hōgen* in 1302. **Coll.:** Jingo-ji. **Bib.:** Kuno (1), (2) 6; Matsumoto (1).

¹定喜

Joki (Nyoki)¹ (fl. 16th c.). *Given name:* Tomotada.² *Gō:* Cho-oku,³ Joki (Nyoki),⁴ Sōgei.⁵ **Biog.:** Muromachi *suiboku* painter. Little known about his life. As almost all the inscriptions on his paintings were done by Chinese, it is assumed he could have been either an immigrant from Ming China who studied under Sesshū or a Japanese who had been to China. His style close to that of Sesshū. **Coll.:** Tōkyō (1). **Bib.:** M 173, 205, 209; Matsushita (1a).

¹如寄 ²知忠 ³樗屋 ⁴如寄 ⁵宗芸

Jōkō¹ (fl. c. 1387). *N.:* Takuma Jōkō.² **Biog.:** Takuma painter. Son of Takuma Tameyuki. Received title of *hōgen.* Recorded as having painted a Jizō for the Kamakura Hokkedō.

¹浄宏 ²宅磨浄宏

Jonan Keitetsu¹ (?–1507). **Biog.:** Muromachi *suiboku* painter. A monk and, eventually, abbot of the Tōfuku-ji. Specialized in pictures of Hotei and of turnips. An inscription by him exists on a painting by Sesshū. His style close to that of Sesshū. **Bib.:** KO 40, Matsushita (1a).

¹汝南慧徹

Jōnin (Seinin)¹ (fl. early 13th c.). *N.:* Jōnin (Seinin).² *Gō:* Enichibō.³ **Biog.:** Takuma painter. A Buddhist priest, disciple and close friend of the distinguished priest Myōe. Details of his life unknown, but believed to have been attached to the Edokoro of the Kōzan-ji, Kyōto. (A diary kept by a priest at that temple records that in 1230 Jōnin took part in an important ritual at the temple.) Known to have copied three scrolls of the *Kegon-kyō* sutra in 1211 and four scrolls of another version of the same sutra in 1222. The portrait of Priest Myōe in the Kōzan-ji is attributed to him. In this painting the artist has applied to the landscape background the free ink-drawing style that had developed among designers of religious copybooks, and the style of this portrait is identical with that of two *gengyō* scrolls of the *Kegon Engi Emaki* also owned by the Kōzan-ji. **Coll.:** Kōzan-ji. **Bib.:** BK 149, *Exhibition* (1), Fontein (1), *Kokuhō* 4, Matsushita (1), Minamoto (1), NBT 4, NEZ 7, Okudaira (1), Paine (4), SBZ 6, Tanaka (2), Toda (2), Yashiro (4).

¹成忍 ²成忍 ³恵日房

Jōryū¹ (fl. 1830–43). *N.:* Mihata Jōryū.² *Gō:* Jōryō.³ **Biog.:** Japanese-style painter. Born and lived in Kyōto. Studied Shijō painting under Okamoto Toyohiko. Specialized in genre painting and *bijinga;* during his lifetime as famous as Utagawa Kunisada. **Coll.:** Freer, Museum (3). **Bib.:** Mitchell, Morrison 2, *Nikuhitsu* (2).

¹乗竜 (上竜) ²三畠乗竜 (三畠上竜) ³乗良

Jōsen¹ (1717–70). *N.:* Kanō Yukinobu.² *F.N.:* Kichinojō.³ *Gō:* Jōsen,⁴ Zuiryūsai.⁵ **Biog.:** Kanō painter. Born in Edo. Son and pupil of Kanō Zuisen. Succeeded his father as *goyō eshi* to the shogunate; became the third-generation head of the Hamachō Kanō line.

¹常川 ²狩野幸信 ³吉之丞 ⁴常川 ⁵随柳斎

Josetsu¹ (fl. 1386?–1428?). **Biog.:** Muromachi *suiboku* painter. Almost nothing known about him. A Zen priest, lived at the Shōkoku-ji, Kyōto; said to have been the teacher of Shūbun. Traditionally and probably rightly called the real founder of Muromachi monochrome painting. The inscription on his famous *Catching a Catfish with a Gourd* in the Taizō-in, Myōshin-ji, Kyōto, states it was painted in the new style for the shogun Yoshimochi, "new style" being assumed to mean

suiboku landscape art, still unfamiliar at that time. Had obviously assimilated Chinese Southern Sung manner of painting. **Coll.:** Cleveland, Fujita, Kennin-ji (Ryōsoku-in), Myōshin-ji (Taizō-in). **Bib.:** Akiyama (2); BK 4, 77; Fontein (2); GK 11; GNB 11; Hisamatsu; HS 7, 8, 9; K 17, 162, 348; *Kokuhō* 6; Lee (1); Matsushita (1); Minamoto (1); Morrison 1; *National* (2); NB (S) 13, 69; NBT 4; NBZ 3; NKZ 26, 61; Noma (1) 1; *One* (2); P 2; Paine (4); Shimada 1; Tajima (12) 4, (13) 3; Tanaka (2); Watanabe; Yashiro (4); Yoshimura.

¹如拙

Jōshin¹ (fl. early 14th c.). **Biog.:** Sculptor. In 1327 finished the relief images of the Shingon Hassō for the Kongōchō-ji, Kōchi-ken. Held the title of *dai busshi* and the honorary rank of *hōgen*. **Coll.:** Kongōchō-ji. **Bib.:** Kuno (1), (2) 6.

¹定審

Jōshin¹ (fl. c. 1660). *N.:* Hibi Munenobu² (Yoshinobu).³ *Gō:* Jōshin.⁴ **Biog.:** Kanō painter. Pupil of Kanō Yasunobu. Given honorary rank of *hokkyō*. **Coll.:** Museum (3). **Bib.:** *Kanō-ha*.

¹常真 ²日比宗信 ³義信 ⁴常真

Joshunsai¹ (?–1781). *N.:* Yamamoto Norihisa.² *Gō:* Joshunsai.³ **Biog.:** Kanō painter. Pupil of Kushibashi Eishunsai, teacher of Mori Sosen. **Bib.:** Morrison 2.

¹如春斎 ²山本典„ ³如春斎

Jounshi¹ (fl. 1720–40). *N.:* Yoshimura Jounshi.² *Gō:* Jounshi.³ **Biog.:** Ukiyo-e painter. A rare and little-known artist. A late follower of the Kaigetsudō style; his work also shows some Kanō influence. **Bib.:** Hillier (4) 1.

¹如雲子 ²吉村如雲子 ³如雲子

Joyō¹ (fl. c. 1820). *N.:* Fukui Joyō.² *A.:* Kakō.³ *Gō:* Shikō.⁴

K

Kaburagi (Kaburaki) Kiyokata¹ (1878–1973). **Biog.:** Japanese-style painter. Born in Tōkyō. At an early age studied ukiyo-e with Taiso Yoshitoshi and Mizuno Toshikata; something of this manner remained in his work. From 1901 to 1912 the leading figure in the Ugōkai; in 1917 helped found the Kinreisha. Exhibited with the Teiten. Member of the Art Committee of the Imperial Household and of the Japan Art Academy; in 1954 received Order of Cultural Merit. First known as an illustrator for newspapers; then became well known as a genre painter, working in the style of color prints of the Edo period. Specialized in *bijinga* and portraits, the latter frequently personalities of the Meiji era, for which he had considerable nostalgia. Also made a few prints. His subjects generally in large scale against the simplest of backgrounds. **Coll.:** Fine (California); Kanagawa; Kōzō-ji; National (5); Tōkyō (1), (2). **Bib.:** Asano, BK 209, Elisséèv, Kondō (6), *Masterpieces* (4), Miyagawa, Nakamura (1), NB (H) 24, NB (S) 20, NBT 10, NBZ 6, NKKZ 21, SBZ 11.

¹鏑木清方

Kachū¹ (fl. c. 1840). *N.:* Ōmura Kin.² *A.:* Ridō.³ *Gō:* Kachū.⁴ **Biog.:** Painter. She lived and worked in Edo. **Coll.:** Victoria. **Bib.:** Mitchell.

¹可中 ²大村今 ³李堂 ⁴可中

Kadō¹ (1812–77). *N.:* Kita Kadō.² **Biog.:** Kishi painter. Born in Mino Province. Pupil of Kishi Ganku. Specialized in painting cherry blossoms. Also known as a connoisseur of antiques. **Coll.:** Museum (3).

¹華堂 ²木田華堂

Kadō¹ (fl. c. 1855). *N.:* Isono Kadō.² **Biog.:** Painter. Pupil of Keibun. **Coll.:** Victoria. **Bib.:** Mitchell.

¹華堂 ²磯野華堂

Biog.: Painter. Lived in Nara. Specialized in *kachōga*. **Bib.:** Mitchell.

¹如蓉 ²福井如蓉 ³遐香 ⁴紫郊

Jozan¹ (1817–37). *N.:* Watanabe Teiko.² *A.:* Shukuho.³ *F.N.:* Gorō.⁴ *Gō:* Jozan.⁵ **Biog.:** *Nanga* painter. Lived in Edo. Son of a samurai; younger brother of Watanabe Kazan. Studied literature under his father, painting under his brother. Talented calligrapher as well as painter. Style resembles that of his brother. **Bib.:** Mitchell.

¹如山 ²渡辺定固 ³叔保 ⁴五郎 ⁵如山

Jukkyoku¹ (?–c. 1781). *N.:* Kanō (originally Kimura)² Jukkyoku.³ *Gō:* Bunjirō.⁴ **Biog.:** Lacquerer. Worked in Edo. His later works are signed Kanō. **Bib.:** Herberts, Jahss.

¹十旭 ²木村 ³狩野十旭 ⁴文次郎

Junko¹ (fl. c. 1830). *N.:* Hirose Junko.² **Biog.:** Painter. Pupil of Kishi Ganku; became a painter of cows and horses.

¹順固 ²広瀬順固

Jusen¹ (1715–31). *N.:* Kanō Genshin.² *Gō:* Jusen.³ **Biog.:** Kanō painter. Son of Kanō Zuisen, adopted by Kanō Eisen'in Furunobu of the Kobikichō branch of the Kanō school.

¹受川 ²狩野玄信 ³受川

Jūsui¹ (fl. 1764–89). *N.:* Shimokawabe (originally Fujiwara)² Gyōkō.³ *Gō:* Jūsui,⁴ Shisenken.⁵ **Biog.:** Ukiyo-e painter, illustrator. Born in Kyōto. Nothing definite known of his life. May have been a pupil of Nishikawa Sukenobu or of Suzuki Harunobu. Known as an illustrator of textbooks and a good genre painter.

¹拾水 ²藤原 ³下河辺行耿 ⁴拾水 ⁵紙川軒

Jūzaemon¹ (fl. 1688–1703). *N.:* Yamasaki Jūzaemon.² **Biog.:** Lacquerer. Specialized in making *inrō* and incense boxes of *tsuishu* lacquer for the shogunate. **Bib.:** Herberts, Ragué.

¹十左衛門 ²山前十左衛門

Kagaku¹ (fl. 1840–50). *N.:* Ozawa (Kozawa) Sadanobu.² *Gō:* Kagaku.³ **Biog.:** Shijō painter. Born in Kyōto. Studied first with Kishi Ganku, then with Yokoyama Kazan. A little-known artist of the Shijō school. **Bib.:** Hillier (4) 3, Mitchell.

¹華岳 ²小沢定信 ³華岳

Kagen¹ (1742–86). *N.:* Niwa Yoshitoki.² *A.:* Shōho.³ *F.N.:* Shinji.⁴ *Gō:* Fukuzensai,⁵ Kagen,⁶ Shaan,⁷ Shūchindō.⁸ **Biog.:** *Nanga* painter. Born in Nagoya. Intimate friend of Ikeno Taiga. Follower of the painting style of the Ming dynasty. A military man by profession, but a good painter of *kachōga* and landscapes. Few remaining works known. **Coll.:** Ashmolean, Victoria. **Bib.:** Brown, Holloway, Mitchell, M 79, NB (S) 4.

¹嘉言 ²丹羽嘉言 ³彰甫 ⁴新治
⁵福善斎 ⁶嘉言 ⁷謝庵 ⁸聚珍堂

Kagen¹ (?–1849). *N.:* Murata Kagen.² *Gō:* Kitsukatsuro,³ Taigaku.⁴ **Biog.:** Painter. Son of an Ōsaka poet. **Bib.:** Mitchell.

¹嘉言 ²村田嘉言 ³吉葛蘆 ⁴太岳

Kagenaga¹ (?–1528). *N.:* Nagao Kagenaga.² *Gō:* Sensai Zenkō.³ **Biog.:** Muromachi *suiboku* painter. Recorded (but mistakenly, given the date of his death) as a pupil of Kanō Shōei. Nothing else seems to be known of him. **Bib.:** Tanaka (2).

¹景長 ²長尾景長 ³泉斎禅香

Kagenobu¹ (fl. c. 1435). *N.:* Kanō (originally Fujiwara)² Kagenobu.³ *F.N.:* Dewajirō.⁴ **Biog.:** Kanō painter. According to Kanō Einō's *Honchō Gashi*, he came from Odawara, liked painting, and served Ashikaga Yoshinori. Is said to have worked with Shūbun in decorating the walls of the

Ashikaga villa at Higashiyama. Received title of *hōgen*. His claim to fame, however, is that he was the father of Kanō Masanobu. As far as is known, no works by him exist. **Bib.**: Morrison 1.

¹景信 ²藤原 ³狩野景信 ⁴出羽次郎

Kagenobu¹ (fl. c. 1597). *N.*: Katō Shirozaemon.² *Gō*: Kagenobu.³ **Biog.**: Potter. Born in Minō Province. Worked at Kujirigama, Toki-gun, Mino. Known as a potter who revived the use of the Karatsu-type kiln: a stepped structure called a *noborigama*.

¹景延 ²加藤四郎左衛門 ³景延

Kagenobu¹ (1642–1726). *N.*: Kanō Kagenobu.² *Gō*: Hakuen,³ Iseisai,⁴ Masanobu,⁵ Tomonobu.⁶ **Biog.**: Kanō painter. Son and pupil of Kanō Yūeiki; member of the Kanda Kanō school. Employed either by the Tokugawa shogunate or by the lord of Kaga. **Coll.**: Museum (3), National (3), Victoria.

¹景信 ²狩野景信 ³伯円 ⁴意清斎 ⁵方信 ⁶友信

Kagetane¹ (fl. 16th c.). *N.*: Kagetane.² *A.*: Hyōbu.³ **Biog.**: Muromachi *suiboku* painter. Studied under Sesshū.

¹景種 ²景種 ³兵部

Kahō¹ (?–1853). *N.*: Tate Shun.² *A.*: Kon'yō.³ *F.N.*: Shunzō.⁴ *Gō*: Kahō,⁵ Shōrai Gajin.⁶ **Biog.**: Painter. Lived in Edo. Son and brother of well-known poets. **Coll.**: Museum (3). **Bib.**: Mitchell.

¹霞舫 ²館僑 ³昆陽 ⁴俊蔵 ⁵霞舫 ⁶松籟画人

Kaian¹ (1813–80). *N.*: Megata Morimichi (Shudō)² or Megata Uryū.³ *A.*: Shichō,⁴ Shisō.⁵ *F.N.*: Kenzaburō,⁶ Shōbei,⁷ Taijirō,⁸ Tatewaki.⁹ *Gō*: Bōgakurō,¹⁰ Bunson,¹¹ Kaian,¹² Kaiō.¹³ **Biog.**: Nanga painter. Born and worked in Shizuoka-ken. Pupil of Tani Bunchō. Specialized in *kachōga* and landscapes. **Bib.**: Mitchell.

¹介庵 ²目賀田守道 ³目賀田宇隆 ⁴士蝶 ⁵士藻 ⁶謙三郎 ⁷庄兵衛 ⁸帯次郎 ⁹帯刀 ¹⁰望岳楼 ¹¹文村 ¹²介庵 ¹³介翁

Kaibi¹ (fl. c. 1850). *N.*: Tanaka Jutoku.² *F.N.*: Gihei.³ *Gō*: Kaibi.⁴ **Biog.**: *Nanga* painter. Lived in Ōsaka. Pupil of Noro Kaiseki. **Coll.**: Ashmolean, Victoria. **Bib.**: Mitchell.

¹介眉 ²田中樹徳 ³義兵衛 ⁴介眉

Kaigaku¹ (fl. c. 1840). *N.*: Takenaka Shigetoki.² *A.*: Katen.³ *F.N.*: Teizō.⁴ *Gō*: Kaigaku,⁵ Kinryō.⁶ **Biog.**: Painter. Lived and worked in Edo. **Bib.**: Mitchell.

¹海岳 ²竹中茂辰 ³花顛 ⁴貞蔵 ⁵海岳 ⁶金竜

Kaigetsudō¹ (fl. 18th c.). A school of painters and printmakers working in the ukiyo-e style, specializing in large-scale paintings and prints of courtesans. It is generally assumed that Ando was the founder of this school and that his style was closely copied by a small group of artists all using the name Kaigetsudō in their signatures. So closely do the paintings and the few rare prints that remain resemble each other that it was formerly assumed that the various signatures were all names of the same artist. Closer study, however, has convinced the scholars that the names Anchi, Dohan, Doshin, Doshu, and Doshū represent different artists and that their use of the name Kaigetsudō followed by characters meaning "last leaf" indicates that they were Ando's pupils or followers. See under individual artists. **Bib.**: Binyon (3), Gunsaulus (1), Hillier (7), Kurth (2), Lane, Ledoux (4), M 18, Michener (1), Stern (2), Takahashi (3).

¹懐月堂

Kaikai¹ (1738–90). *N.*: Satake Teikichi (Sadakichi).² *A.*: Ōken.³ *F.N.*: Hikoshirō.⁴ *Gō*: Baishurō,⁵ Kaikai,⁶ Kaikaidō,⁷ Zachi.⁸ **Biog.**: *Nanga* painter. Born in Kyōto. Pupil of Ikeno Taiga; other details of his life unknown. Left a few *suiboku* paintings. **Coll.**: Royal (1). **Bib.**: AAA 25.

¹嚕々 ²佐竹貞吉 ³応謙 ⁴彦四郎 ⁵売酒郎 ⁶嚕々 ⁷嚕々堂 ⁸坐馳

Kaikei¹ (fl. c. 1185–1220). *Priest name:* An'ami Butsu.² *Gō*: Kaikei.³ **Biog.**: Kamakura sculptor. Adopted son and pupil of Kōkei, brother of Unkei. Member of the Shichijō Bussho in both Nara and Kyōto. Closely associated with the monk

Shunjōbō Chōgen, who was instrumental in rebuilding the Tōdai-ji after the great fire of 1180, commissioning many works from him. More than 20 pieces known to be by him survive, among them the statue of Hachiman as a Buddhist priest (1201) in the Hachimanden, Tōdai-ji; the Kongō Rikishi (done in collaboration with Unkei between 1199 and 1203) in the Nandaimon, Tōdai-ji; the Miroku (1189) in the Museum of Fine Arts, Boston; the Miroku (1192) in the Hondō, Sambō-in, Daigo-ji; and the Amida (1211) in the Tōju-in, Okayama-ken. One of the foremost sculptors of his time; very active throughout the Kansai during the early Kamakura Buddhist revival. His style, known as the An'ami style, is a combination of Kamakura realism with Fujiwara delicacy and grace; more suave and elegant than that of his brother. Influenced by Chinese painting of the Sung dynasty, the bodies are slim, the draperies and patterns delicate. **Coll.**: Daigo-ji (Sambō-in), Daigyō-ji, Daihōon-in, Empuku-ji, Fujita, Henjōkō-in, Jōdo-ji (2), Kongōbu-ji, Kongō-in, Kōrin-ji, Kōzō-ji, Kyōto (2), Monju-in, Museum (3), Rokuhara Mitsu-ji, Saihō-in, Shin Daibutsu-ji, Shōju-in, Tōdai-ji (Nandaimon, Nembutsudō, Shunjōdō, Yawataden), Tōju-in, Tōkyō (2), Zuishin-in. **Bib.**: *Art* (2); ARTA 22; BB 2, 13; BG 71; BI 47; BK 56, 57; Buhot; Fontein (3); GK 8; Glaser; GNB 9; Hasumi; HU 28; K 600, 734, 735, 888; Kidder; Kobayashi (1); *Kokuhō* 4; Kuno (1), (2) 6; M 14, 68; Matsumoto (1); Mayuyama; Mōri (1), (1a); NB (H) 11; NB (S) 40; NBZ 3; Imaizumi (2); Ōoka; OZ 4; Paine (4); Rosenfield (2); SBZ 6; Tajima (12) 2, 6, 13; Tajima (13) 15; Warner (1); Watson (1); YB 4.

¹快慶 ²安阿弥仏 ³快慶

Kain¹ (fl. early 19th c.). *N.*: Hirose Jishō.² *Gō*: Kain,³ Suisokuen.⁴ **Biog.**: Nagasaki painter. First studied the Kanō manner; then became a pupil of Mikuma Katen. Specialized in painting cherry blossoms. **Coll.**: Museum (3), Victoria. **Bib.**: Morrison 2.

¹花隠 ²広瀬自勝 ³花隠 ⁴睡足園

Kainoshō Tadaoto¹ (1894–). **Biog.**: Japanese-style painter. Graduated in 1915 from the Kyōto College of Fine Arts, having studied under Kawakita Kahō. Exhibited with the Kokugakai from 1918, becoming a member in 1926. Later showed with the Teiten. **Bib.**: Asano, NBZ 6.

¹甲斐荘楠音

Kaioku¹ (1778–1863). *N.*: Nukina (originally Yoshii)² Hō³. *A.*: Kummo,⁴ Shizen.⁵ *F.N.*: Seizaburō (Masasaburō),⁶ Yasujirō (Taijirō).⁷ *Gō*: Hōchiku Shujin,⁸ Kaikyaku,⁹ Kaioku,¹⁰ Kaisen,¹¹ Kaisō (after 60),¹² Sankandō,¹³ Shūō,¹⁴ Shuseidō,¹⁵ Shūsō,¹⁶ Sūō (after 70),¹⁷ Tekishūō.¹⁸ **Biog.**: *Nanga* painter. Son of a samurai in the service of the daimyo of Tokushima, Awa Province. Studied calligraphy and Kanō-style painting in Tokushima, Buddhism at Kōyasan. Traveled to Nagasaki to study *bunjinga* under Hidaka Tetsuō; to Edo to study Confucianism and Chinese-style painting. Finally settled in Kyōto, establishing his own school. Taught Confucianism while working as a painter and writer; by the end of his life was the epitome of the classical Confucian scholar. One of the greatest calligraphers of the end of the Edo period, an authority on the history of calligraphy. His landscape paintings are generally in the Chinese manner. **Coll.**: Art (1a), British, Honolulu, Tōkyō (2). **Bib.**: GNB 18; *Japanese* (1a); K 774, 939; Mitchell; Morrison 2; Murayama (2); NB (H) 23; NB (S) 4; NBT 5; *Nihon* (3); One (2); Rosenfield (2); SBZ 10; Shimada 2; Tajima (9) 2; Tajima (12) 14, 15; Tajima (13) 7; Yonezawa.

¹海屋 ²吉井 ³貫名苞 ⁴君茂 ⁵子善 ⁶政三郎 ⁷泰次郎 ⁸方竹主人 ⁹海客 ¹⁰海屋 ¹¹海仙 ¹²海叟 ¹³三咸堂 ¹⁴菘翁 ¹⁵須静堂 ¹⁶菘叟 ¹⁷菘翁 ¹⁸摘菘翁

Kaiseki¹ (1747–1828). *N.*: Noro Ryū (Takashi).² *A.*: Daigoryū,³ Ryūnen,⁴ Shōrei.⁵ *F.N.*: Kuichirō.⁶ *Gō*: Chōko,⁷ Chōmei,⁸ Daigaku Shōsha,⁹ Jūyū,¹⁰ Kaiseki,¹¹ Konsai,¹²

Shiheki Dōjin,[13] Waibai.[14] **Biog.:** *Nanga* painter. Born in Wakayama, Kii Province, to a family of commoners who had once been samurai. Studied first under Kuwayama Gyokushū; then, in 1760, to Kyōto to study under Ikeno Taiga. In 1797 returned to Wakayama to serve the lord of Kii. With Sō Aiseki and Nagamachi Chikuseki, one of the three *seki* (so called after the last character of their names) of early-19th-century *nanga* painting and generally considered the best. His concept of painting stated in his book *Shihekisai-gawa*. Left many landscape sketches from his travels in the Japanese mountains; his paintings executed toward the end of his life show the direct influence of the orthodox landscape style of Ch'ing China and are rather dull and dry. **Coll.:** Art (1a), Royal (1), Tōkyō (1). **Bib.:** BK 71, 72, 74; Cahill; *Cent-cinquante; Japanese* (1a); *Japanische* (2); K 335, 353, 390, 453, 651, 726, 924; Mitchell; Morrison 2; Murayama (2); NB (S) 4; *Nihon* (3); *One* (2); Tajima (13) 7.

[1]介石 [2]野呂隆 [3]第五隆 [4]隆年 [5]松齡
[6]九一郎 [7]澄湖 [8]澄明 [9]台嶽樵者 [10]十友
[11]介石 [12]混斎 [13]四碧道人 [14]矮梅

Kaisen[1] (1785–1862). *N.:* Oda Ei.[2] *A.:* Kyokai.[3] *F.N.:* Ryōhei.[4] *Gō:* Hyakukoku (Hyakkoku),[5] Kaisen.[6] **Biog.:** Maruyama, then *nanga* painter. Born in Nagato Province to a family of dyers. When 22, moved to Kyōto; pupil of Matsumura Goshun. Later with Rai San'yō to Kyūshū, where for five years he studied early Chinese painting and Confucianism. Specialized in landscapes, figures, *kachōga;* a skillful colorist, an able *suiboku* painter. **Coll.:** Ashmolean, Chōfu, Itsuō, Museum (3), Ōsaka (2), Victoria. **Bib.:** BK 38; Brown; K 387; Mitchell; Morrison 2; OA 13; Tajima (12) 18, 19; Tajima (13) 7.

[1]海僊 [2]小田瀛 [3]巨海 [4]良平 [5]百谷 [6]海僊

Kaiyū[1] (fl. second half 14th c.). *N.:* Kose no Kaiyū.[2] **Biog.:** Kose painter. Son of Kose no Yukiari. Priest at the Daijō-in, Kōfuku-ji, Nara. Received title of *hokkyō.*

[1]快有 [2]巨勢快有

Kaizen[1] (1834–76). *N.:* Nishimura Sōzaburō.[2] *Gō:* Kaizen.[3] **Biog.:** Potter. Worked in Kyōto. Adopted by 12th-generation Eiraku Hozen, with whom he collaborated. Also worked with Wazen. **Bib.:** NB (S) 71.

[1]回全 [2]西村宗三郎 [3]回全

Kaji Tameya[1] (?–1894). **Biog.:** Western-style painter. Born in Kii Province; lived in Tōkyō. In 1873 to America; later to Germany, where he studied oil painting. Returned to Japan in 1889; member of the hanging committee for the third Naikoku Kangyō Hakurankai. Later transferred his activity to the Meiji Bijutsukai. Portraits his specialty. **Bib.:** Asano, BK 188.

[1]加地為也

Kajikawa[1] (fl. 17th to 19th c.). One of most talented families of lacquer artists, specializing in *inrō*. Worked for the Tokugawa shogunate from the 17th to the 19th century. Almost impossible to assign any individual pieces to the different members of this family. Skilled in every form of lacquering; sometimes collaborated with lacquer artists of the Shibayama family; often used encrustations of metal or nacre made by artists working in these fields. Kajikawa lacquer generally of high artistic quality and fine workmanship, though some of the later pieces tend to be somewhat overornate. For starred names among the following, see individual entries.

*Kajikawa I: Hikobei[2] (fl. 1624–43)
*Kajikawa II: Kyūjirō[3] (fl. 1637?–82)
*Kajikawa III: Bunryūsai[4] (fl. c. 1675)
*Kajikawa IV: Fusataka[5] (fl. 18th c.)
*Kajikawa V: Hidetaka[6] (fl. 18th c.)
*Kajikawa VI: Bunryūsai[7] (fl. c. 1820)
 Kajikawa VII: Hidenobu[8] (fl. 19th c.)

Coll.: Brooklyn, Metropolitan, Walters, Victoria. **Bib.:** Boyer, Casal, Herberts, Jahss, M 188, Ragué, Sawaguchi.

[1]梶川 [2]彦兵衛 [3]久次郎 [4]文竜斎
[5]房高 [6]英高 [7]文竜斎 [8]秀信

Kajita Hanko[1] (1870–1917). *N.:* Kajita Jōjirō.[2] *Gō:* Hanko.[3] **Biog.:** Japanese-style painter. Lived in Tōkyō; son of the famous metalsmith Masaharu. Pupil of a Shijō artist Nabeta Gyokuei and the Maruyama painter Suzuki Kason; later established his own style. Member of the Nihon Kaiga Kyōkai and the Nihon Bijutsuin. In 1898 became head instructor at the Technological School at Toyama. Also illustrated novels and served as a war artist in the Sino-Japanese war. Produced competent, rather sentimental painting in the Shijō tradition with delicate line and subdued color and showing traces of Western influence. **Coll.:** Tōkyō (1), Victoria. **Bib.:** Asano; Kondō (6); M 48, 202; NB (H) 24; NB (S) 17; NBZ 6; Uyeno.

[1]梶田半古 [2]梶田鋥次郎 [3]半古

Kajiwara Hisako[1] (1896–). **Biog.:** Japanese-style painter. Born in Kyōto. She studied under Kikuchi Keigetsu and exhibited with the Nitten. A painter of flowers and of young women in a delicate traditional Japanese style. **Coll.:** National (5). **Bib.:** Asano, Elisséèv, Kondō (6).

[1]梶原緋佐子

Kakei (Kagei)[1] (fl. c. 1740–50). *N.:* Shirai Sōken[2] (originally Tatebayashi Rittoku).[3] *Gō:* Kakei (Kagei),[4] Kakukō Yashi,[5] Kingyū Sanjin,[6] Kiusai,[7] Taisei,[8] Tsurugaoka Itsumin.[9] **Biog.:** Rimpa painter. Born in Kaga. Details of his life unclear, but seems to have been a physician in the service of the lord of Kaga. Later went to Edo, where he may have studied under Kōrin or Kenzan and where he became famous. Also spent some time in Kamakura. A good painter, specializing in flowers and working in a style much influenced by Kōrin. **Coll.:** Cleveland, Itsuō, Tōkyō (2). **Bib.:** BCM 51; BK 135; K 65, 791; *Kōrin-ha* (1), (2); Mizuo (2a); Lee (2); Mayuyama; Morrison 2; NBZ 5; *Rimpa;* Shimada 2; *Sōtatsu-Kōrin* (3); Stern (3); Tajima (2) 3.

[1]何㫋 [2]白井宗謙 [3]立林立徳 [4]何㫋 [5]鶴岡野史
[6]金牛山人 [7]喜雨斎 [8]太青 [9]鶴岡逸民

Kakei[1] (1816–64). *N.:* Yokoyama Shimpei.[2] *A.:* Mōtan.[3] *Gō:* Kakei.[4] **Biog.:** Painter. Son and pupil of Yokoyama Kazan. Lived in Kyōto. Specialized in landscapes and *kachōga*. **Coll.:** Museum (3). **Bib.:** Mitchell.

[1]華渓 [2]横山信平 [3]孟坦 [4]華渓

Kakiemon[1] (fl. 17th to 20th c.). A family of potters, working in Arita. Produced a type of porcelain to which the name Kakiemon was given; the delicate designs, inspired by K'ang Hsi enameled porcelains, are in colored overglaze enamels on a white-glaze ground. There are no set standards for judging the work of the different generations. It can, however, be said that Kakiemon IV (1641–79) lacked the ability of Kakiemon I (1596–1666) and that his work was cruder. Under Kakiemon VI (1690–1735) and his guardian Shibuemon (younger brother of Kakiemon V) the ware revived; much richer designs, more geometric style introduced, glazes more lustrous. Any wares with date marks are limited to 1695–99. Another decline after 1735. **Bib.:** *Ceramic* (1), Hayashiya (1), Jenyns (1), K 689, KO 14, Koyama (1), Munsterberg (2), NB (S) 71, Okuda (2).

[1]柿右衛門

Kakiemon I[1] (1596–1666). *N.:* Sakaida Kakiemon.[2] **Biog.:** Potter. Originator of the Kakiemon type of porcelain decoration. According to the Kakiemon genealogy (the acceptance of which is a matter of dispute) lived and worked in Nangawara, west of Arita. At 19 was making Karatsu pottery under tutelage of his father; then joined forces with other Kyūshū potters who were developing Imari ware with blue underglaze decoration. Worked under Takahara Goroshichi for a while. Finally became the first Japanese potter, as foreman to Toshima Tokuemon, to produce *iro-e* (multi-

colored painting) porcelain which, as a type, is called by his name. There is considerable question about the exact date when the first such pieces were made, with a range from 1640 to 1660 suggested. **Coll.**: Museum (3), Tōkyō (1). **Bib.**: BMFA 45, 46; *Ceramic* (1); Hayashiya (1); Jenyns (1); K 689; KO 14; Koyama (1), (1a); Mikami; Miller; Noma (1) 2; Okuda (2); TOCS 1937–38.

[1]柿右衛門　[2]酒井田柿右衛門
Kakōsai[1] (fl. 19th c.). **Biog.**: Lacquerer. One of three lacquer artists whose name can be read Kakōsai. **Bib.**: Herberts.

[1]可光斎
Kakōsai[1] (fl. 19th c.). *N.*: Shōri.[2] *Gō:* Kakōsai.[3] **Biog.**: Lacquerer. Member of the Kajikawa school. Frequently worked in collaboration with one of the Shibayama artists. Used a seal in the form of a vase with handles. **Bib.**: Herberts, Jahss.

[1]可可斎　[2]松里　[3]可可斎
Kakōsai[1] (fl. 19th c.). *N.*: Shōzan.[2] *Gō:* Kakōsai.[3] **Biog.**: Lacquerer. A well-known maker of *inrō*. **Coll.**: Metropolitan, Walters, Victoria. **Bib.**: Boyer, Casal, Herberts, Jahss.

[1]可交斎　[2]松山　[3]可交斎
Kakuchō[1] (?–1034). *N.*: Sumiyoshi Kakuchō.[2] **Biog.**: Buddhist painter. Said to have been the son of a certain Sumiyoshi Aritake. Became a Buddhist priest under Eshin. Lived at the Ryōgon-in, Yokokawa, on Mount Hiei; received title of *ajari*. Recorded as a famous Buddhist painter, but no authenticated works are known to exist.

[1]覚超　[2]住吉覚超
Kakuden[1] (fl. c. 1436). **Biog.**: Sculptor. A Kyōto *dai busshi*, holder of the honorary rank of *hōgen*. Known for a statue of Aizen Myōō in the Seishō-ji, Kyōto, dated 1436. **Coll.**: Seishō-ji. **Bib.**: *Muromachi* (2).

[1]覚伝
Kakue[1] (1207–98). **Biog.**: Painter. Nothing known of his life. His name is found on *chinsō* in the manner of those done by Shūi, though somewhat earlier in date. **Bib.**: BK 75, NBT 4.

[1]覚慧
Kakuen[1] (1031–98). *N.*: Fujiwara no Kakuen.[2] *F.N.*: Uji Sōjō.[3] **Biog.**: Painter. Sixth son of Fujiwara no Yorimichi. Became a tonsured monk, entered the Onjō-ji, and later became abbot of Tendai sect at the Enryaku-ji, Mount Hiei. Said to have been an able painter and the teacher of Kakuyū.

[1]覚円　[2]藤原覚円　[3]宇治僧正
Kakuen[1] (1306?–?). **Biog.**: Sculptor. A *busshi* known only from an inscription on a seated Batō Kannon, which states that he made the figure in 1353 when 48 years old. The statue is in the realistic tradition of the Kei school, indicating that Kakuen may have been associated with Kōshun and his son Kōsei. **Bib.**: Rosenfield (2).

[1]覚円
Kakuhan[1] (1095–1143). *N.*: Taira Han.[2] *F.N.*: Yachitoshi.[3] *Priest name:* Shōkaku,[4] Shōkakubō.[5] *Posthumous name:* Kōkyō Daishi.[6] *Gō:* Kakuhan.[7] **Biog.**: Buddhist painter. Member of the Takuma school. Born in Hizen Province; third son of Taira Kanemoto, a descendant of Emperor Kammu. When about 16, took Buddhist vows. While holding important positions at various temples, learned painting from Takuma Tametō. In 1692, received posthumous title Kōkyō Daishi. Said to have excelled at portraiture and Buddhist icons; however, no authenticated works are known to exist.

[1]覚鑁　[2]平鑁　[3]弥千歳　[4]正覚
[5]正覚坊　[6]興教大師　[7]覚鑁
Kakujo[1] (1019–77). **Biog.**: Sculptor. Son and pupil of Jōchō. Established the sculpture workshop known as Shichijō Bussho, which reached its peak in the 13th century. Received honorary rank of *hokkyō* in 1067, of *hōgen* in 1070.

Impossible to identify any surviving works. **Bib.**: Kidder, *Kokuhō* 3, Kuno (1), Mōri (1a).

[1]覚助
Kakukei[1] (fl. early 14th c.). **Biog.**: Painter. A Buddhist priest whose painting was deeply influenced by the Chinese style of the Sung and Yüan periods. Specialized in *chinsō;* his best-known work is a portrait of the priest Kakushin, dated 1315, owned by the Kōkoku-ji, Wakayama-ken. **Coll.**: Kōkoku-ji. **Bib.**: BCM 50.

[1]覚恵
Kakukō[1] (1802–57). *N.*: Murata Munehiro.[2] *A.:* Bunkei.[3] *F.N.:* Sōbei.[4] *Gō:* Kakukō.[5] **Biog.**: Nagasaki painter. Born in Nagasaki. Pupil of Watanabe Kakushū. Said to have painted Shintoist icons; specialized in landscapes, portraits, flowers.

[1]鶴皐　[2]村田宗博　[3]文卿　[4]宗兵衛　[5]鶴皐
Kakumyō[1] (fl. 12th c.). *Priest name:* Kakumyō,[2] Shinga.[3] *F.N.:* Tayūbō.[4] *Gō:* Saibutsu.[5] **Biog.**: Buddhist painter. When young, studied at the Kōfuku-ji, Nara. Founded the Kōraku-ji, Shinano, which became a gathering place for painters. Another early Japanese artist whose biography is known though no works by him can be identified.

[1]覚明　[2]覚明　[3]信賀　[4]太夫坊　[5]西仏
Kakunin[1] (1082–1148). **Biog.**: Buddhist painter. A monk at the Tōdai-ji, Nara. Supervised the painting of a set of Jūniten, done in bright colors, and a set of the Go Dai Myōō for the Tō-ji to replace earlier sets (said to have been painted by Kōbō Daishi) that had been destroyed in the fire of 1127. **Coll.**: Tō-ji. **Bib.**: *Exhibition* (1), Minamoto (1), Paine (4), Yashiro (1) 1.

[1]覚仁
Kakunyo[1] (1270–1351). *Priest name:* Kakunyo.[2] *Gō:* Gōsetsu.[3] **Biog.**: Buddhist painter. At 17 became a priest, having studied Chinese classics and Tendai Buddhism; eventually became third abbot of the Hongan-ji. As a painter, is said to have specialized in Buddhist subjects.

[1]覚如　[2]覚如　[3]毫摂
Kakurei[1] (fl. 1804–17). *N.:* Yamaato Gien.[2] *A.:* Kungyo.[3] *Gō:* Kakurei.[4] **Biog.**: Maruyama painter. Born in Ōsaka. Went to Kyōto to study under Maruyama Ōkyo, becoming one of Ōkyo's ten famous pupils. Particularly able painter of *kachōga* and portraits. **Coll.**: Ashmolean. **Bib.**: Mitchell, Morrison 2.

[1]鶴嶺　[2]山跡義淵　[3]君魚　[4]鶴嶺
Kakusen[1] (fl. first half 19th c.). *N.:* Okada Gi.[2] *A.:* Minsoku.[3] *Gō:* Kajitsuken,[4] Kakusen.[5] **Biog.**: *Nanga* painter. Grandson of Okada Kanrin. **Bib.**: Mitchell.

[1]鶴川　[2]岡田儀　[3]民則　[4]佳日軒　[5]鶴川
Kakushū[1] (1778–1830). *N.:* Watanabe Shūjitsu.[2] *A.:* Gensei.[3] *Gō:* Kakushū,[4] Kyoi Shujin.[5] Kyoidō,[6] Shimbundō.[7] **Biog.**: Nagasaki painter. As a child, pupil of his father, Watanabe Shūsen; later studied the recently introduced *bunjinga* under Mamura Hisen. In 1802 given position of *kara-e mekiki* in Nagasaki. Copied famous Chinese paintings as well as those of his ancestor Watanabe Shūseki. A painter of landscapes, figures, *kachōga*. His book *Nagasaki Gajin Den* is a sourcebook for the history of the Nagasaki school. **Coll.**: Kōbe. **Bib.**: Kuroda, *Pictorial* (2) 5.

[1]鶴洲　[2]渡辺秀実　[3]元成　[4]鶴州
[5]居易主人　[6]居易堂　[7]親文堂
Kakushun[1] (fl. mid-13th c.). **Biog.**: Sculptor. Known only from an insciption on a statue of Shaka Nyorai in the Gankō-ji, Gifu, dated 1244. His style shows that he was influenced by the Unkei school. **Coll.**: Gankō-ji. **Bib.**: Minamoto (1).

[1]覚俊
Kakutei[1] (?–1785). *Priest name:* Jōkō.[2] *A.:* Eitatsu,[3] Kaigen.[4] *Gō:* Baisō,[5] Bokuō Dōjin,[6] Gojian,[7] Hakuyō Sanjin,[8] Joryō,[9] Jubeiō,[10] Kakutei,[11] Nansōō.[12] **Biog.**: Nagasaki painter. Born in Nagasaki. First, a priest at the Seifuku-ji

and pupil of Kumashiro Yūhi. Later a Zen priest at the Shiun-in, Ōbakusan-ji, near Kyōto. Died in Edo. Specialized in *kachōga*, working in the Shen Nan-p'in style, using *sumi* and a palette of light colors. A skillful artist. **Bib.**: Mitchell.

¹鶴亭 ²浄光 ³恵達 ⁴海眼 ⁵梅窓 ⁶墨翁道人 ⁷五字庵
⁸白羊山人 ⁹如量 ¹⁰寿米翁 ¹¹鶴亭 ¹²南窓翁

Kakutei[1] (1807–79). *N.*: Tamaki Kampei.[2] *Gō*: Ichigen,[3] Kakutei[4] (used exclusively after 1868), Kinkō,[5] Kyūsai.[6] **Biog.**: Nagasaki painter. Born in Nagasaki. Employed by the Meiji government in the Dutch export-import office. Taught at the Nagasaki Normal School from 1874 to 1878. A self-taught artist; studied both Chinese-style painting and Western-style oil painting. **Coll.**: Kōbe. **Bib.**: K 708, *Pictorial* (2) 5.

¹鶴亭 ²玉木官平 ³一源 ⁴鶴亭 ⁵錦江 ⁶九皐

Kakuyū[1] (1053–1140). *Priest name:* Kakuyū.[2] *F.N.*: Toba Sōjō.[3] **Biog.**: Painter. Son of the court noble Minamoto no Takakuni; sent as a boy to study under the abbot of the Onjō-ji, Lake Biwa. At 30 became abbot of the Shitennō-ji, where he worked for twelve years to restore the temple. Then retired to the Onjō-ji for thirty-two years. From 1127, active in court affairs. In 1131 made abbot of the Shōkongō-ji, built on the grounds of the detached palace at Toba; in 1132 given rank of *sōjō*—hence his popular name Toba Sōjō. His name traditionally associated with the *Chōjū Giga*, the famous scroll of animal caricatures, owned by the Kōzan-ji, Kyōto, but there is no proof for this attribution, and the scrolls are not all the work of one hand or even of the same period: the first and second are of the 12th, the third and fourth of the 13th century. Further, the old attribution to him of the *Shigisan Engi* belonging to the Chōgosonshi-ji, Nara, is also not accepted today. **Bib.**: *Art* (1a); *Emakimono; Exhibition* (1); Ienaga; K 10, 22, 46, 115, 129, 133, 213, 263; *Kokuhō* 3; Lee (1); Morrison 1; NEZ 3; NKZ 55, 72; Okudaira (1); *One* (2); P 1; Paine (4); Tajima (12) 1, 4, 13; Toda (2); Yashiro (1) 1, (4).

¹覚猷 ²覚猷 ³鳥羽僧正

Kambara Tai[1] (1898–). *N.*: Kambara Yasushi.[2] *Gō*: Tai.[3] **Biog.**: Western-style painter. Born and worked in Tōkyō. An early exhibitor at the Nikakai; took an active part in the advanced art movements of the 20s. Work shows the influence of the fauves, with some tendency towards abstraction. **Bib.**: Asano, NBZ 6.

¹神原泰 ²神原泰 ³泰

Kamei Shiichi[1] (1843–1905). *N.*: Kamei Matsunosuke.[2] *Gō*: Shiichi.[3] **Biog.**: Western-style painter. Born in Edo. Pupil of Yokoyama Matsusaburō, who later became a photographer, and of Kunisawa Shinkurō. An early exponent of Western painting; exhibited at the third Naikoku Kangyō Hakurankai. Painted scenes of Japanese life and history. **Coll.**: Museum (3), Tōkyō (1). **Bib.**: Asano, BK 188, NBZ 6.

¹亀井至一 ²亀井松之助 ³至一

Kamoshita Chōko[1] (1890–). **Biog.**: Japanese-style painter. Studied at the Tōkyō School of Fine Arts; also studied *yamato-e* and historical painting under Matsumoto Fūko. An exhibitor with the Bunten and the Teiten. **Coll.**: National (5). **Bib.**: Asano.

¹鴨下晃湖

Kan'a[1] (fl. c. 1345). **Biog.**: Sculptor. Known only for a Jūichimen Kannon in the Entsū-ji, Yamaguchi. **Coll.**: Entsū-ji. **Bib.**: NBZ 3.

¹観阿

Kanai Bungen[1] (1886–1962). *N.*: Kanai Fumihiko.[2] *Gō*: Bungen.[3] **Biog.**: Western-style painter. Born in Tōkyō; grandson of Kanai Ushū. Graduated from Tōyō University. Studied Western painting at the Kawabata Gagakkō; at the same time learned the *nanga* style under a *nanga* painter. Finally developed his own style. From 1919 exhibited with the Teiten. In 1924, when the Enjusha was established,

joined it as editor of its journal *Bijutsu Shin-ron*. After 1948 joined the Ōgenkai. **Bib.**: Asano.

¹金井文彦 ²金井文彦 ³文彦

Kanaoka[1] (fl. late 9th to early 10th c.). *N.*: Kose (originally Ki)[2] no Kanaoka.[3] **Biog.**: *Yamato-e* painter. An aristocrat with imperial connections; took his name from the province of Kose. Appointed Edokoro *azukari*. The documents relate that he painted portraits of the great Confucian scholars in 880 for the imperial palace and later some *fusuma* with figures of Chinese sages, also for the palace; all these were destroyed by fire. Said to have been the founder of the *yamato-e* school of painting as well as of the Kose school of court painters (the latter being the first of many such family schools of professional painters in Japan), which lasted from the Heian to the Kamakura period. Records of his time speak almost exclusively of his secular work, and though he was considered the greatest painter of his time, it is difficult to know what his work was like, since none of his paintings now survive. Many legends speak of the realism of his painting; was probably the first to paint Buddhist subjects in a purely Japanese style. **Bib.**: Akiyama (2), AO 3, Ienaga, Morrison 1, NB (H) 10, Paine (4), Tajima (12) 2.

¹金岡 ²紀 ³巨勢金岡

Kanashima Keika[1] (1892–). *N.*: Kanashima Masata (Shōta).[2] *Gō*: Keika.[3] **Biog.**: Japanese-style painter. Born in Hiroshima-ken; works in Kyōto. In 1911 became a pupil of Takeuchi Seihō. From 1918 an exhibitor at government shows; after 1945 showed with the Nitten. In 1934 served as juror for the Teiten. In 1952 received the Education Minister's Prize for Fostering the Arts; in 1953, the Japan Art Academy Prize. Member of the Nitten and the Japan Art Academy. Good painter of *kachōga* and animals, working in a light, pleasant manner with certain modern touches added to his more recent work. **Coll.**: National (5). **Bib.**: Asano, NBZ 6.

¹金島桂華 ²金島政太 ³桂華

Kanayama Heizo[1] (1883–1964). **Biog.**: Western-style painter. Born in Kōbe. Graduate of Tōkyō School of Fine Arts in 1907; studied in Europe from 1911 to 1915. On returning to Japan, active in official exhibitions, showing with the Bunten and the Teiten and serving as juror for the latter; also showed with the Nitten. His style one of romantic realism, rather than in the manner of Whistler. **Coll.**: National (5). **Bib.**: Asano, SBZ 11.

¹金山平三

Kanazawa Hidenosuke[1] (1895–1967). **Biog.**: Western-style painter. Born in Akita-ken. Graduate of Tōkyō School of Fine Arts. Pupil of Okada Saburōsuke. Member of Kōfūkai; exhibitor with the Teiten and the Nitten. In 1952 became a juror of the Nitten and in 1966 a council member of that group.

¹金沢秀之助

Kanazawa Shigeharu[1] (1887–1960). **Biog.**: Western-style painter. Born in Tōkyō. Graduated from the Department of Western Painting, Tōkyō School of Fine Arts, in 1912. In 1914 showed for the first time, at the eighth Bunten. In 1924, with Kumaoka Yoshihiko, Makino Torao and Saitō Yori, established the Enjusha. In 1941 became one of the founders of the Sōgenkai. **Coll.**: Kanagawa. **Bib.**: Asano.

¹金沢重治

Kanchiku[1] (?–1731). *N.*: Arai Jōshō (Tsunetsugu).[2] *Gō*: Chosuidō,[3] Chosuisai,[4] Kanchiku.[5] **Biog.**: Kanō painter. Born in Ashikaga, lived in Edo. One of Kanō Tsunenobu's four best pupils.

¹寒竹 ²新井常償 ³樗翠堂 ⁴樗翠斎 ⁵寒竹

Kanda Sōbei[1] (fl. late 18th c.). **Biog.**: Potter. Born in Settsu Province. Between 1781 and 1788 established a kiln at Sanda near Arima and invited Kyōto and Hizen potters to work there. About 1801 the material for making a celadon

glaze was found at Sanda, and Sanda celadon wares eventually became quite famous. **Bib.:** Jenyns (1).

¹神田宗兵衛
Kan'ei[1] (1833–97). *N.:* Nishiyama Ken.[2] *F.N.:* Ken'ichirō.[3] *Gō:* Kan'ei.[4] **Biog.:** Shijō painter. Son and pupil of Nishiyama Hōen. Lived and worked in Ōsaka. Served the Akashi clan as a Confucian scholar. A skillful painter of landscapes and *kachōga;* his work follows the Shijō manner. **Coll.:** Fujita, Tekisui, Victoria, Worcester. **Bib.:** Mitchell.

¹完瑛 ²西山健 ³健一郎 ⁴完瑛
Kaneko Kuheiji[1] (1895–). **Biog.:** Western-style sculptor. Born in Kyōto. Studied under Hasegawa Eisaku; then in France from 1922 to 1926 under Bourdelle. On his return to Japan, became a member first of the Kokugakai, then of the Shinseisaku Kyōkai; finally became independent. His work shows the influence of his teachers plus something of Epstein's manner. **Coll.:** National (5). **Bib.:** Asano, GNB 28.

¹金子九平次
Kan'en[1] (fl. late 12th c.). **Biog.:** Sculptor. Son of Myōen. Recorded as having been very active, but none of his work is presently identifiable.

¹寛円
Kaneshige[1] (fl. c. 1157). *N.:* Kose (originally Ki)[2] no Kaneshige.[3] **Biog.:** Kose painter. Son of Kose no Masumune. Ninth-generation head of the main line of the Kose family of painters.

¹兼茂 ²紀 ³巨勢兼茂
Kaneshige Tōyō[1] (1896–1967). **Biog.:** Bizen potter. Born in Bizen-machi, Okayama-ken. Stimulated art of Bizen ware to new and vigorous achievement, sharing leadership in this field with Fujiwara Kei. Traveled in America and Europe. Member of the Nihon Mingeikan. In 1956 designated a Living National Treasure in recognition of his Bizen ware. Specialized in objects for tea-ceremony use. Followed his ancestors' tradition: worked in Bizen manner, with Bizen clay, restoring simplicity of Ko Bizen ware. **Coll.:** Nelson, University (2). **Bib.:** Koyama (2), Lee (3), *Masterpieces* (4), Munsterberg (2), STZ 16, Sugimura.

¹金重陶陽
Kaneyasu[1] (fl. early 13th c.). **Biog.:** Painter. An artist known so far only from records stating that he actually visited the scenic sites he depicted, an indication of the tendency toward realistic landscape painting in the 13th century. **Bib.:** Ienaga.

¹兼康
Kangan (Kangen)[1] (1767–1801). *N.:* Kitayama (Hokuzan) Mōki[2] or Ma Mōki.[3] *A.:* Bunkei.[4] *F.N.:* Gonnosuke.[5] *Gō:* Kangan (Kangen).[6] **Biog.:** Painter. Lived in Edo. A naturalized Chinese, son and pupil of an immigrant Chinese painter Ma Tao-ling (Japanese: Ma Dōryō),[7] who had the task of repairing the observatory instruments for the *bakufu* and thus had access to Westerners, from whom he learned Western languages and painting. Kangan was at one time the teacher of Tani Bunchō. His landscapes are in a style close to that of Ch'ing China; his Western works were praised by the Dutch, who said some reminded them of Van Dyck. **Coll.:** Kōbe. **Bib.:** BK 54, K 669, *Pictorial* (2) 2, Umezawa (2).

¹寒巌 ²北山孟熙 ³馬志熙 ⁴文奎
⁵権之助 ⁶寒巌 ⁷馬道良
Kangetsu[1] (1747–97). *N.:* Shitomi Tokki.[2] *A.:* Shion.[3] *F.N.:* Genji,[4] Genjirō.[5] *Gō:* Iyōsai,[6] Kangetsu,[7] Seigadō.[8] **Biog.:** Painter, illustrator. Born in Ōsaka. Pupil of Tsukioka Settei and great admirer of Sesshū; also studied the technique of ancient Chinese and Japanese painting. Well known as a poet and calligrapher and, in the mid 1770's, as the proprietor of the Chigusaya bookshop. Achieved rank of *hokkyō.* Specialized in figures and landscapes, working in an eclectic manner. **Bib.:** Brown, Keyes, Morrison 2.

¹関月 ²蔀徳基 ³子温 ⁴原二 ⁵原二郎
⁶霞揚斎 ⁷関月 ⁸青莪堂
Kangyo (Tsurana)[1] (1809–92). *N.:* Morizumi Sadateru[2]

(originally Teruyoshi).[3] *A.:* Shisai.[4] *F.N.:* Tokujirō.[5] *Gō:* Kaishunsai,[6] Kangyo (Tsurana),[7] Kiseiken,[8] Shunsai.[9] **Biog.:** Sumiyoshi painter. Lived in Ōsaka. Pupil of Watanabe Hiroteru and, later, of Sumiyoshi Hirotsura. Exhibited at the Naikoku Kaiga Kyōshinkai and the Naikoku Kangyo Hakurankai. Member of the Art Committee of the Imperial Household. Specialized in historical subjects. A notable figure painter. **Bib.:** Asano, Morrison 1, NBZ 6.

¹貫魚 ²守住定輝 ³輝義 ⁴士斎 ⁵徳次郎
⁶回春斎 ⁷貫魚 ⁸寄生軒 ⁹春済
Kangyū[1] (?–1843). *N.:* Shitomi Tokufū.[2] *A.:* Shien.[3] *Gō:* Iyōsai,[4] Kangyū.[5] **Biog.:** Painter. Son and pupil of Shitomi Kangetsu. Lived in Ōsaka. **Bib.:** Mitchell.

¹関牛 ²蔀徳風 ³子優 ⁴黄揚斎 ⁵関牛
Kankai[1] (1789–1860). *N.:* Araki Shun.[2] *A.:* Kyokō.[3] *Gō:* Hōsei Gajin,[4] Kankai,[5] Tatsuan.[6] **Biog.:** *Nanga* painter. Lived in Edo. Pupil of Katagiri Tōin.

¹寛快 ²荒木舜 ³挙公 ⁴蓬生画人 ⁵寛快 ⁶達庵
Kankan[1] (1770–99). *N.:* Tani (originally Hayashi)[2] Hama.[3] *Gō:* Kankan,[4] Suiran.[5] **Biog.:** *Nanga* painter. Wife of Tani Bunchō, under whom she studied. Lived in Edo. An excellent landscape artist and one of the famous women painters of the Edo period. **Bib.:** K 644, Umezawa (2).

¹幹幹 ²林 ³谷波満 ⁴幹幹 ⁵翠蘭
Kankanshi[1] (1752–1827). *N.:* Kitashiro Yaehachi. *Priest name:* Tennyo.[3] *A.:* Shunzan;[4] later, Ryōmu.[5] *Gō:* Kankanshi.[6] **Biog.:** *Nanga* painter. Born in Tokushima. When very young, became a tonsured priest at the Kannon-ji, Tomita, Tokushima. Studied for a while in Kyōto and Nara, where he came under the guidance of Priest Jiun. By 1811, back to Tokushima to live by himself in a small hut, first at Hiwasa Yakuoji, later at Nakada, Komatsushima; in the latter place was under the patronage of the Tada family, probably the local daimyo. Called himself Kankanshi (leisurely-living man) from his life of leisurely painting. Quite a prolific painter of *bunjinga,* which he usually gave away, asking the recipients to clean his pond and refill it with fresh water—hence his nickname of Kansui Oshō.[7] **Coll.:** Fogg. **Bib.:** Awa.

¹閑閑子 ²北代八重八 ³天如 ⁴峻山
⁵良夢 ⁶閑閑子 ⁷換水和尚
Kankei[1] (fl. mid-14th c.). **Biog.:** Sculptor. Lived and worked in Nara. Perhaps the founder of the Tsubai Bussho. In 1355 received rank of *hokkyō.* In 1340 sculpted the Kichijōten at the Kōfuku-ji; in 1355 the Shitennō for the Jōdō, Hōryū-ji; in 1364 the Jizō Bosatsu at the Manju-ji in Mie-ken. **Coll.:** Hōryū-ji (Jōdō), Kōfuku-ji, Manju-ji (2). **Bib.:** *Muromachi* (2).

¹寛慶
Kanō Kōga[1] (1897–1953). **Biog.:** Japanese-style painter, printmaker. Born in Wakayama-ken. Graduated from the Tōkyō School of Fine Arts in 1919. Became a pupil of Matsuoka Eikyū, one of the founders of the Shinkō Yamatoe-kai; exhibited with this society as well as with the Teiten. **Bib.:** Asano, Schmidt.

¹狩野光雅
Kanō Natsuo[1] (1828–98). *N.:* Kanō Natsuo[2] (originally Fushimi Toshirō).[3] *F.N.:* Jisaburō.[4] **Biog.:** Japanese-style sculptor, metalworker. Born in Kyōto. Studied first under the little-known sculptor Ikeda Takatoshi; later was adopted into Kanō family. Moved to Tōkyō; worked independently. Taught at the Tōkyō School of Fine Arts; member of the Art Committee of the Imperial Household. Specialized in figures and birds; also a noted designer of coins. **Coll.:** Tōkyō (1). **Bib.:** M 180, 185, 192; NB (S) 41; NBZ 6.

¹加納夏雄 ²加納夏雄 ³伏見寿朗 ⁴治三郎
Kanō Sanraku[1] (1898–). *N.:* Kanō Kunio.[2] *Gō:* Sanraku,[3] Sanrakuki.[4] **Biog.:** Japanese-style painter. Born in Hyōgo-ken, works in Tōkyō. Studied first at the Kyōto Municipal School of Fine Arts and Crafts as a pupil of Yamamoto Shunkyo. In 1919 moved to Tōkyō, became a pupil of

Kawabata Ryūshi, and for a time exhibited with the Inten. Also showed with the Seiryūsha, of which he was a member, and the Tōkyō Biennial. His style is traditional. **Coll.:** National (5). **Bib.:** Asano.

¹加納三楽 ²加納邦夫 ³三楽 ⁴三楽輝

Kanō Tanrei[1] (1857–1931). *N.:* Kanō Morizumi[2] (originally Araki Jōtarō).[3] *Gō:* Tanrei.[4] **Biog.:** Japanese-style painter. Born in Uzen Province. To Tōkyō to study under Kanō Tambi Moritaka, who represented the last generation of the Kajibashi Kanō line. After the Restoration, active as a Kanō painter; showed at several exhibitions sponsored by the government, receiving prizes. Member of the committee of the Nihon Bijutsu Kyōkai and the Nihongakai. Did a number of paintings for imperial buildings.

¹狩野探令 ²狩野守純 ³荒木丈太郎 ⁴探令

Kanō Tomonobu[1] (1843–1912). *N.:* Kanō Tomonobu.[2] *Gō:* Isseisai,[3] Shunsen.[4] **Biog.:** Painter. Born in Edo. Son of Kanō Tōsen Nakanobu, eighth-generation head of the Hamachō Kanō line. After his father's early death, studied under Kanō Shōsen'in of the Kobikichō Kanō, along with Hashimoto Gahō and Kanō Hōgai. Appointed as *goyō eshi* to the Tokugawa shogunate. After the Restoration entered the *Bansho Shirabesho* (Foreign Literature Investigating Office), where he studied Western painting. Was also a pupil of Charles Wirgman. Became a teacher at Kaisei Gakkō and Daigaku Yobimon (a preparatory school); in 1888 made assistant professor at Tōkyō Art School. Worked in a rather sketchy late-Kanō manner; good brushwork. **Bib.:** Asano, *Kanō-ha*, NBZ 6.

¹狩野友信 ²狩野友信 ³一青斎 ⁴春川

Kanokogi Takeshirō[1] (1874–1941). *N.:* Kanokogi Takeshirō.[2] *Gō:* Futō Sanjin.[3] **Biog.:** Western-style painter. Born in Okayama-ken. Studied first under Matsubara Sangorō; then to Tōkyō to study under Koyama Shōtarō at his school the Fudōsha. When 31, to France to study with Jean-Paul Laurens. Eventually had his own school in Kyōto. Helped introduce Western painting to the Kansai district. A juror for the Bunten and later for the Teiten; member of the Taiheiyō Gakai and the Kansai Bijutsuin. Handled Western subjects in a late-19th-century Western academic style. **Coll.:** Kyōto (1). **Bib.:** Asano, BK 201, Harada Minoru, NB (S) 30, NBT 10, NBZ 6, SBZ 11, Uyeno.

¹鹿子木孟郎 ²鹿子木孟郎 ³不倒山人

Kanrin[1] (1775–1849). *N.:* Okada Bukō[2] (or Ren).[3] *A.:* Sekiho,[4] Shihō.[5] *F.N.:* Chūjirō.[6] *Gō:* Kanrin,[7] Teiin.[8] **Biog.:** *Nanga* painter. Lived in Edo. Said to have been pupil of Tani Bunchō. Specialized in *kachōga,* which he rendered with much taste. Few paintings by him are known. Painter of considerable merit, his work also shows some influence of the Nagasaki school. **Coll.:** Ashmolean, Museum (3). **Bib.:** BK 46, Brown, *Dessins,* Mitchell, Morrison 2.

¹閑林（寒林） ²岡田武功 ³練 ⁴石圃
⁵子豊 ⁶忠次郎 ⁷閑林（寒林） ⁸梯蔭

Kanrin[1] (1813–87). *N.:* Kobayashi Sui.[2] *Gō:* Kanrin.[3] **Biog.:** Painter. First studied with Tsubaki Chinzan. Later retired to live at the Heikan-ji, Kanagawa. **Bib.:** Mitchell.

¹寒林 ²小林翠 ³寒林

Kansai[1] (fl. late 18th c.). *N.:* Ishikawa Ryūsuke.[2] *A.:* Kōjō.[3] *Gō:* Kansai,[4] Nikyō Gaishi,[5] Rōkodō,[6] Shinten'ō.[7] **Biog.:** *Nanga* painter. Born in Echigo Province. Pupil of Igarashi Shummei; intimate friend of Kameda Bōsai and Kushiro Unsen. Specialized in painting landscape and bamboo.

¹侃斎 ²石川竜助 ³公乗 ⁴侃斎
⁵二橋外史 ⁶老香堂 ⁷信天翁

Kansai[1] (?–1792). *N.:* Koma Kansai[2] (originally Sakanouchi Jūbei).[3] *Gō:* Tansai,[4] Tansō.[5] **Biog.:** Lacquerer. Born in Edo. Adopted into the Koma family; was the first to bear the name of Kansai: the artist who brought the work of the Koma school back to its original high standard. A pupil of Koma Koryū. His son, Koma Kansai II (1766–1835), is

said to have been the finest artist of the family; was the teacher of Zeshin. In 1824 retired as a priest, and Koma Kansai III succeeded to the name. It is, so far, quite impossible to say which one of these three artists made which of the many pieces, usually *inrō,* signed Koma Kansai. **Coll.:** British, Metropolitan, Tōkyō (1), Victoria, Walters. **Bib.:** Boyer, Casal, Herberts, Jahss, K 5, M 188, Noma (1) 2, Ragué, Yamada, Yoshino.

¹寛哉 ²古満寛哉 ³坂内重兵衛 ⁴坦哉 ⁵坦叟

Kansai[1] (1814–94). *N.:* Mori (originally Ishida)[2] Kōshuku.[3] *A.:* Shiyō.[4] *F.N.:* Naotarō.[5] *Gō:* Banzan,[6] Gasammaisai,[7] Kansai,[8] Tōkei (early).[9] **Biog.:** Japanese-style painter. Born in Hagi; lived in Kyōto. Son of a nurse of the Ishida samurai family; pupil and adopted son-in-law of Mori Tetsuzan. Because of his Ishida connections, was a staunch Loyalist and therefore in trouble with the *bakufu* in the last days of the shogunate. In the early Meiji era, opened a school in Kyōto where he taught the traditions of the Shijō school; Yamamoto Shunkyo among his pupils. To further the taste for the Japanese style, helped found the Jounsha in 1865. Member of the Nihon Bijutsuin and of the Art Committee of the Imperial Household. Skilled in all subjects. It is said that he never repeated himself—hence, if duplicate pictures are found, one is probably a forgery. Produced charming Japanese landscapes, with slight touches of Western realism. **Coll.:** Ashmolean, Fogg, Imperial (1), Itsuō, Museum (3), Newark. **Bib.:** Asano; Elisséèv; K 344, 432, 461, 467, 511, 801; Mitchell; Morrison 1; NB (S) 17; NBZ 6; Uyeno.

¹寛斎 ²石田 ³森公粛 ⁴子容 ⁵尚太郎
⁶晩山 ⁷画三昧斎 ⁸寛斎 ⁹桃渓

Kansei[1] (fl. c. 1377). **Biog.:** Painter. Also a priest, with rank of *hokkyō.* Known from a scroll in the Tōdai-ji of portraits of four sages, dated 1377 and showing Chinese influence as well as *yamato-e* elements. **Coll.:** Tōdai-ji. **Bib.:** *Chūsei.*

¹観盛

Kansen[1] (1747–92). *N.:* Kanō Hidenobu (Yasunobu).[2] *Gō:* Kansen,[3] Seihasai.[4] **Biog.:** Kanō painter. Born in Edo. Eldest son and pupil of Kanō Jōsen. Served the shogunate as *oku eshi;* became the fourth-generation of the Hamachō Kanō line.

¹閑川 ²狩野昆信 ³閑川 ⁴青坡斎

Kanshi[1] (fl. 1764–80). *Gō:* Kanshi,[2] Tōensai.[3] **Biog.:** Ukiyo-e painter. Known for a few fine paintings of *bijin.* **Bib.:** Fujikake (3) 3; UG 321.

¹寛志 ²寛志 ³東燕斎

Kanshichi[1] (fl. 1680–1700). *N.:* Seikai (or Aogai)[2] Taro-zaemon.[3] *Gō:* Kanshichi.[4] **Biog.:** Lacquerer. Known for his designs of rippled waves in blue on a gold ground, from which his name Seikai (Blue Sea) was taken. **Coll.:** Tōkyō (2). **Bib.:** Herberts, Jahss.

¹勘七 ²青貝 ³青海太郎左衛門 ⁴勘七

Kanshin[1] (fl. c. 1446). *Priest name:* Shiba Hōgen.[2] *Gō:* Kanshin.[3] **Biog.:** *Yamato-e* painter. A priest who lived in Nara. Became official painter at the Kasuga-jinja; received rank of *hōgen.* His name is on the scroll *Tenjin Engi,* dated 1446, which is in the Sata-jinja, Ōsaka. **Coll.:** Sata-jinja. **Bib.:** *Pictorial* (1) 3, SBZ 7.

¹観深 ²芝法眼 ³観深

Kanshū[1] (fl. Muromachi period). **Biog.:** Muromachi *suiboku* painter. An obscure artist about whom nothing is known save that he left a number of copies of paintings by other artists. **Bib.:** M 166.

¹喚舟

Kanshun[1] (fl. c. 1300). **Biog.:** Painter. Member of the Edokoro of the Kōfuku-ji, Nara; known for his painting of a *Kasuga-jinja Mandara.* **Bib.:** NBT 4, SBZ 6.

¹観舜

Kansui[1] (1830–87). *N.:* Matsuoka Masakuni[2] (or Kōkun).[3] *A.:* Kishin.[4] *F.N.:* Kitsushirō.[5] *Gō:* Kansui,[6] Renchi,[7] Shōseki.[8] **Biog.:** Painter. Born in Mimasaka (Okayama-ken)

to a samurai family. To Edo to study painting under Igarashi Chikusa. His subjects included landscapes, birds-and-flowers, and, particularly, lotus flowers. **Coll.:** Victoria. **Bib.:** Mitchell.

¹環翠　²松岡正訓　³光訓　⁴季慎
⁵橘四郎　⁶環翠　⁷蓮痴　⁸松石

Kantei (Gantei)¹ (fl. second half 15th c.). *Priest name:* Kantei (Gantei).² **F.N.:** Nara Hōgen.³ **Biog.:** Muromachi *suiboku* painter. A priest, said to have been attached to the Tōshōdai-ji, Nara. Little known of his life save that he received the rank of *hōgen*. Perhaps a disciple of Shūbun. Studied style of the Chinese Sung painter Liang K'ai. His work resembles that of Jasoku, but he is a less able painter. **Coll.:** British; Brooklyn; Fujita; Matsunaga; Museum (3); Tōkyō (1), (2). **Bib.:** HS 2, 13; K 105, 167, 346, 544, 561, 647, 810; KO 27; Matsushita (1), (1a); Morrison 1; NB (S) 13; Shimada 1; Tajima (12) 8.

¹鑑貞　²鑑貞　³奈良法眼

Kanzan¹ (fl. late 18th to early 19th c.). *N.:* Fukushima Masayuki.² **F.N.:** Chūkan.³ *Gō:* Kanzan.⁴ **Biog.:** *Nanga* painter. Lived in Kyōto. A painter of landscapes and illustrations of legendary tales. **Coll.:** Museum (3). **Bib.:** Mitchell.

¹関山　²福島正之　³仲貫　⁴関山

Kanzan¹ (fl. early 19th c.). *N.:* Matsumoto Harukiyo.² *A.:* Shirō.³ *Gō:* Kanzan.⁴ **Biog.:** Painter. Lived in Ōsaka. Pupil of Matsumura Goshun. **Bib.:** Mitchell.

¹観山　²松本春清　³子郎　⁴観山

Kanzan¹ (fl. mid-19th c.). *N.:* Mori.² *Gō:* Kanzan.³ **Biog.:** Japanese-style painter. Lived and worked in Ōsaka. Pupil of Mori Ippō. An illustrator of Ōsaka scenes. An excellent painter. **Coll.:** Ōsaka (2). **Bib.:** Morrison 2.

¹関山　²森　³関山

Kaō¹ (?–1345). **Biog.:** 14th c. *suiboku* painter. His identity, although he was a founder of the Muromachi *suiboku* school and one of the most important early *suiboku* painters, is still uncertain. Most probably he was the monk Kaō Shūnen (Sōnen).² He was born in Chikuzen Province; became a Zen monk; went to China c. 1318 and stayed there for ten or fifteen years; was later in Kyōto, first at the Manju-ji, then the Nanzen-ji, where he became the 18th abbot, and finally the Kennin-ji, where he died. In the past, has been confused with Ryōsen³ and Ryōzen,⁴ but it now seems he had no connection with either of them. Used two seals: one reading Kaō,⁵ the other Ninga.⁶ It is assumed he was a high-ranking Zen priest, for there are no inscriptions on his paintings such as those usually made by priests of a rank higher than the artist. One of the first Japanese artists to depict Zen subjects in ink alone. Figure studies and *kachōga* ascribed to him are among the finest of the period. **Coll.:** Cleveland, Freer, Museum (3), Tōkyō (1), Umezawa, Yamato. **Bib.:** *Art* (1a); Awakawa; BCM 50; BG 49; *Exhibition* (1); *Freer;* GK 11; Hisamatsu; HS 12; KO 25; *Kokuhō* 6; Lee (3); Matsushita (1), (1a); Mayuyama; Minamoto (1); Morrison 1; Munsterberg (4); *Muromachi* (1); NB (S) 13, 69; NBT 4; *One* (2); P 2; SBZ 3; *Selected;* Shimada 1; Tajima (12) 12, (13) 3; Tanaka (2); Yashiro (4); YB 46.

¹可翁　²可翁宗然　³良詮　⁴良全　⁵可翁　⁶仁賀

Kaō¹ (fl. c. 1790). *N.:* Shibata Yasunobu.² *Gō:* Kaō,³ Tōensai.⁴ **Biog.:** Ukiyo-e painter. Specialized in *bijinga*. **Bib.:** *Nikuhitsu* (2).

¹花翁　²柴田保信　³花翁　⁴東艶斎

Kasamatsu Shirō¹ (1898–). **Biog.:** Painter, printmaker. Studied painting with Kaburagi Kiyokata. His prints date from 1919; one of the few contemporary printmakers to carve his own blocks and do his own printing. His subjects in painting included landscape and portraits; in prints he specialized in landscapes, particularly views of Tōkyō. **Coll.:** Fine (California), National (5). **Bib.:** Fujikake (1), UG 4.

¹笠松紫浪

Kasei¹ (fl. late 15th c.). **Biog.:** Muromachi *suiboku* painter. Known only from his seal. Generally painted landscapes. Style shows influence of Sesshū. **Bib.:** Matsushita (1a).

¹家清

Kaseki¹ (fl. 1661–72). **Biog.:** Sculptor. A monk. His smooth, rather slick work in the Jōshin-ji, Tōkyō, was done between 1664 and 1667. **Coll.:** Jōshin-ji. **Bib.:** Kuno (3), SBZ 9.

¹珂碩

Katada Tokurō¹ (1889–1934). **Biog.:** Western-style painter. Born in Ōita-ken; lived in Tōkyō. Graduated from Tōkyō School of Fine Arts in 1912. A frequent exhibitor and prize winner, even while still a student, at the Bunten; served as juror for the Teiten. Died by his own hand. His style at first that of Western academic realism; later followed the fauve manner. **Coll.:** Bridgestone. **Bib.:** Asano, Elisséèv, NBZ 6.

¹片多徳郎

Katanobu¹ (1729–80). *N.:* Kanō Katanobu.² *Gō:* Juseki.³ **Biog.:** Kanō painter. Adopted son and pupil of Kanō Hakuju, became fifth in the Saruyamachi Kanō line. As was usual for members of this Kanō branch, followed the manner of Eitoku.

¹賢信　²狩野賢信　³寿石

Katayama Nampū¹ (1887–). *N.:* Katayama Kumaji.² *Gō:* Nampū.³ **Biog.:** Japanese-style painter. Born in Kumamoto. Studied with Takahashi Kōko and Yokoyama Taikan. Showed first with the Bunten; then, from its beginning in 1914, with the reorganized Inten. An early member of the Nihon Bijutsuin. A careful painter of landscapes, *kachōga*, and particularly fish; his work at times very decorative. **Coll.:** National (5). **Bib.:** Asano; NBZ 6.

¹堅山南風　²堅山熊次　³南風

Katei¹ (1799–1887). *N.:* Hagura Ryōshin.² *Gō:* Katei.³ **Biog.:** Painter. Son of a priest attached to the Inari Shrine at Fushimi. Pupil of the priest Geppō and, later, of Okamoto Toyohiko. **Bib.:** Mitchell.

¹可亭　²羽倉良信　³可亭

Katen¹ (1730–94). *N.:* Mikuma Shikō.² *A.:* Kaidō.³ *F.N.:* Shukei.⁴ *Gō:* Kaidō,⁵ Katen.⁶ **Biog.:** Nagasaki painter. Also a poet. Worked in Nagasaki, where he was a pupil of Ōtomo Gekkō. To Kyōto to study under Ikeno Taiga, of whom he did a portrait. Drew from nature, specializing in pictures of cherry blossoms. **Bib.:** BK 28, 51; Mitchell; Morrison 2.

¹華顚　²三熊思考　³介堂　⁴主計　⁵海棠　⁶花顚

Katō Eishū¹ (1873–1939). **Biog.:** Japanese-style painter. Born in Aichi-ken. Studied first at Nagoya under Okumura Sekiran; then with Kōno Bairei at the Kyōto Municipal School of Fine Arts and Crafts. On Bairei's death became a pupil of Kishi Chikudō and then of Takeuchi Seihō. An exhibitor with the Bunten and the Teiten, becoming a member of the latter in 1928. **Bib.:** Asano, Elisséèv.

¹加藤英舟

Katō Gennosuke¹ (1880–1946). **Biog.:** Western-style painter. Born in Kyōto; son of a dealer in Buddhist vestments whose store name was Tōgen. Studied first under Itō Yoshihiko; when Asai Chū came to live in Kyōto about 1902, became his pupil. Worked mainly in Kyōto, making a considerable effort to help found the Kansai Bijutsuin. From 1907 exhibited with the Bunten. A good water-color artist.

¹加藤源之助

Katō Hajime¹ (1900–1968). **Biog.:** Potter. Born in Aichi-ken. Worked at the Gifu-ken Ceramic Experimental Center. Professor at Tōkyō University of Fine Arts. Active in the Inten; member of the Nihon Mingeikan. Operated his own kiln, which he built in 1939 near Yokohama. In 1961 named a Living National Treasure. Known for his colors and use of gold; his specialty gold designs on a pale green

ground. **Coll.:** Art (1), Tōkyō (1). **Bib.:** AAA 21; FC 9; Koyama (1), (1a); M 5; *Masterpieces* (4); Mitsuoka (1); Munsterberg (2); NBZ 6; STZ 16; Sugimura.

¹加藤土師萌

Katō Kensei[1] (1894–1966). *N.:* Katō Kitōta.[2] *Gō:* Kensei.[3] **Biog.:** Sculptor. Born in Hokkaidō. A graduate of the Tōkyō School of Fine Arts, where he studied in the Western-painting department as well as in the sculpture division. Later became a professor there. In 1954–55 traveled through Europe and America. Member of and juror for the Nitten. Awarded Japan Art Academy Prize in 1952. His style influenced by Maillol. **Coll.:** Kanagawa, Tōkyō (2). **Bib.:** Asano, NBZ 6, GNB 28.

¹加藤顕清 ²加藤鬼頭太 ³顕清

Katō Seiji[1] (1887–1942). **Biog.:** Western-style painter. Born in Aichi-ken. Graduated from the Tōkyō School of Fine Arts, Department of Western Painting, in 1910. From 1907 exhibited with the Bunten. Traveled in Europe from 1920 to 1922. Member of the Kōfūkai. A fair landscape painter. **Bib.:** Asano.

¹加藤静児

Katō Tōkurō[1] (1898–). **Biog.:** Potter. Born in Seto, Aichi-ken. Trained as a potter from boyhood. His wares are in the Oribe and Seto manner. Also made archaeological investigations of the Koseto (Old Seto) kilns; edited a dictionary of ceramic terms. A talented restorer of Old Seto wares. **Bib.:** *Masterpieces* (4), STZ 16.

¹加藤唐九郎

Katō Tomotarō[1] (1851–1916). **Biog.:** Potter. Born in Seto, Aichi-ken, to a family of potters. At 23 to Tōkyō to study under Inoue Ryōsai. Later to a training school organized by the Austrian government where he learned to produce underglaze blue cheaply. In 1882 established his own kiln called Yūgyokuen. Invented purple, yellow, and vermilion (*tōjukō*) glazes. In 1900 appointed a member of the Art Committee of the Imperial Household. His wares are decorated in underglaze blue and overglaze enamels, with designs close to the contemporary Japanese-style bird-and-flower painting. **Coll.:** Metropolitan; Tōkyō (1), (2). **Bib.:** BK 240, GNB 28, M 203, NB (S) 41, Uyeno.

¹加藤友太郎

Katsumasa[1] (fl. 1716–35). *N.:* Kishikawa Katsumasa.[2] **Biog.:** Ukiyo-e printmaker. Nothing known of his life save that he was connected with the Torii school of artists. **Coll.:** Art (1), Tōkyō (1). **Bib.:** Ficke, Kikuchi.

¹勝政 ²岸川勝政

Katsunō[1] (fl. c. 1805). **Biog.:** Ukiyo-e printmaker. Designed stenciled figure prints that were published in Kyōto. **Bib.:** Keyes, *Ukiyo-e* (3) 19.

¹括嚢

Katsunobu[1] (fl. 1716–35). *Studio name:* Baiyūken.[2] *Gō:* Katsunobu.[3] **Biog.:** Ukiyo-e painter, printmaker. Stylistically related to the later followers of the Kaigetsudō school. Worked in two styles: the more graceful one would seem to indicate some connection with Nishikawa Sukenobu. **Bib.:** M 18, Takahashi (3), *Ukiyo-e* (3) 3.

¹勝信 ²梅祐軒 ³勝信

Katsunobu[1] (fl. 1716–35). *N.:* Kondō Katsunobu.[2] **Biog.:** Ukiyo-e printmaker. Seems to have been connected with the Torii school; perhaps a pupil of Kondō Kiyoharu. Known for some *urushi-e*. **Coll.:** Art (1), Idemitsu, Museum (3), Tōkyō (1). **Bib.:** Ficke, Gunsaulus (1), Kikuchi, *Nikuhitsu* (1) 1, Shimada 3.

¹勝信 ²近藤勝信

Katsushige[1] (?–1673). *N.:* Iwasa Katsushige.[2] *F.N.:* Gembei.[3] *Gō:* Matabei II.[4] **Biog.:** Tosa painter. Lived in Fukui; son and pupil of Iwasa Matabei. Vassal of Lord Matsudaira. Painted manners and customs, both contemporary and past. Recorded as having painted the cranes on the *fusuma* in Fukui Castle when it was repaired in 1669. His

style much like his father's. **Coll.:** Tōkyō (1). **Bib.:** K 357, 478, 691; Morrison 2; Tajima (12) 13.

¹勝重 ²岩佐勝重 ³源兵衛 ⁴又兵衛二代

Katsuta Shōkin[1] (1879–1963). *N.:* Katsuta Yoshio.[2] *Gō:* Kenshisō,[3] Shōkin.[4] **Biog.:** Japanese-style painter. Born in Kawagoe. Studied first under a *nanga* painter, then under Hashimoto Gahō. In 1905 graduated from the Tōkyō School of Fine Arts. From 1906 to 1907 taught at a fine-arts school in India. A prize winner and later a juror at the Bunten; exhibited with the Teiten and the Nitten. His style a mixture of Kanō and *nanga*. **Coll.:** National (5). **Bib.:** Asano, Elisséèv.

¹勝田蕉琴 ²勝田良雄 ³研思荘 ⁴蕉琴

Katsuta Tetsu[1] (1896–). **Biog.:** Japanese-style painter. Born and works in Kyōto. Graduate of both the Tōkyō School of Fine Arts and the Kyōto Municipal School of Fine Arts and Crafts. Pupil of Yamamoto Shunkyo. Member of the Nihon Bijutsu Kyōkai; exhibitor at government shows and with the Nitten. His style is tradititonal. **Coll.:** National (5).

¹勝田哲

Kawabata Gyokushō[1] (1842–1913). *N.:* Kawabata Gyoku-shō.[2] *Gō:* Keitei,[3] Shōō.[4] **Biog.:** Shijō painter. Born in Kyōto to a family of lacquer artists. First studied the Maruyama style with Nakajima Raishō. In 1866 left Kyōto for Tōkyō to study Western painting under Charles Wirgman. However, soon returned to Japanese-style painting and became leading figure in Tōkyō art circles and, in 1890, professor in charge of the painting division espousing the Shijō school at the Tōkyō School of Fine Arts. In 1909 founded Kawabata painting school; had many pupils who later became well known. Member of Nihon Bijutsu Kyōkai and the Imperial Art Commission (the predecessor of the Commission for the Protection of Cultural Properties). Considered the last great representative of the Shijō school, although in his last years sought to combine Chinese, Japanese, and Western elements in his painting. His work quite delicate, making use of a Japanese technique in a realistic manner. A competent artist. **Coll.:** Ashmolean; Metropolitan; Museum (3); Tōkyō (1), (2); Victoria. **Bib.:** Asano, Elisséèv, K 7, Kawabata, *Kurashina* (1), M 202, Morrison 2, Mitchell, NB (S) 17, NBZ 6, Uyeno.

¹川端玉章 ²川端玉章 ³敬亭 ⁴璋翁

Kawabata Ryūshī[1] (1885–1966). *N.:* Kawabata Shōtarō.[2] *Gō:* Ryūshi.[3] **Biog.:** Japanese-style painter. Born in Wakayama; worked in Tōkyō. Studied at the Hakubakai and the Taiheiyō Kenkyūsho. First painted in a Western manner, but after a trip to America in 1912, where he was much influenced by the traditional Oriental painting in the Museum of Fine Arts in Boston, changed his style and took up pure Japanese-style painting. Member of Nihon Bijutsuin. Until 1928 showed with the Inten. In 1929, with other painters, organized the influential Seiryūsha and showed at their exhibitions. In 1930 awarded Asahi Culture Prize and in 1959 the Order of Cultural Merit. Made a few prints. His work, on a large scale, is bold and striking, with some traces of Western influence. **Coll.:** National (5), Ryūshi, Tōkyō (1), Victoria, Yamatane. **Bib.:** Asano, Grilli (1), *Masterpieces* (4), Miyagawa, NB (H) 24, NBT 10, NBZ 6, NKKZ 24, SBZ 11, UG 4.

¹川端竜子 ²川端昇太郎 ³竜子

Kawabata Yanosuke[1] (1893–). **Biog.:** Western-style painter. Born and worked in Kyōto. Graduate of Keiō University. Studied in Paris from 1922 to 1925 under Charles Guérin at the Académie Colarossi. On his return to Japan became an exhibitor and occasional prize winner at the Shun'yōkai. Taught at the Kyōto Municipal School of Fine Arts and Crafts. His style reflects his foreign training. **Bib.:** Asano.

¹川端弥之助

Kawabe Mitate[1] (1837–1905). *N.:* Kawabe Mitate.[2] *Gō:* Bokuryūtei,[3] Karyō,[4] Kōsodō,[5] Rogai,[6] Toda no Sha.[7]

Biog.: Tosa painter. Born in Kyūshū to a samurai family. Studied Tosa painting on his own. After the Meiji Restoration became an assistant Shintō priest at Ise. Made a number of copies of paintings in the Shōsō-in. The subjects of his own paintings are largely historical. **Coll.:** Tōkyō (1). **Bib.:** Asano, Mitchell, Morrison 1, NB (S) 17, NBZ 6.

¹川辺御楯 ²川辺御楯 ³墨流亭 ⁴花陵
⁵後素堂 ⁶鷺外 ⁷都多の舎

Kawachi Ieshige¹ (fl. 1610-50). *N.:* Kawachi (originally Iseki)² Ieshige.³ **Biog.:** Sculptor. Fourth generation of Iseki family of mask carvers living in Ōmi Province near Kyōto. Moved to Edo about 1610. Said to have been the best mask carver, particularly of female masks, of his time. **Coll.:** Tokugawa. **Bib.:** Katayama, Noma (1) 2, Suzuki (5).

¹河内家重 ²井関 ³河内家重

Kawaguchi Kigai¹ (1892-1966). *N.:* Kawaguchi Magotarō.² *Gō:* Kigai.³ **Biog.:** Western-style painter. Born in Wakayama-ken. In 1911 to Tōkyō to study at the Taiheiyō Kenkyūsho; in 1912 transferred to the Western-painting division of the Nihon Bijutsuin. In 1917 to Europe, returning to Japan in 1922 to exhibit at the Nikakai. In 1923 to France again, for another six years; pupil of André Lhote and Fernand Léger. In 1929 again exhibited with Nikakai, won a prize, and became a member. In 1930 transferred to the newly founded Dokuritsu Bijutsu Kyōkai, which he left in 1943. In 1947 joined the Kokugakai but soon left this group to pursue his own way. His later works largely abstract. **Coll.:** Kanagawa, National (5), Ohara (1). **Bib.:** Asano, NB (H) 24, NBT 10, NBZ 6.

¹川口軌外 ²川口孫太郎 ³軌外

Kawai Eichū¹ (1875-1921). *N.:* Kawai Rokunosuke.² *Gō:* Eichū.³ **Biog.:** Japanese-style painter. Born in Tōkyō. Studied the ukiyo-e style under Migita Toshihide. From about 1901 showed at various exhibitions such as those of the Nihon Bijutsu Kyōkai Rekishi Fuzokugakai (Historical and Genre Painting Association) and Naikoku Kangyō Hakurankai. Became member of the Ugōkai and Nihon Bijutsu Kyōkai. Worked for the Tōkyō Asahi Press as a painter for the pictorial edition of the paper. Showed with the Bunten in 1914-15, receiving prizes and thus establishing himself as an important artist. A painter of genre scenes with an ukiyo-e touch. **Bib.:** Asano, BK 209, NBZ 6.

¹河合英忠 ²河合六之助 ³英忠

Kawai Gyokudō¹ (1873-1957). *N.:* Kawai Yoshisaburō.² *Gō:* Gyokushū;³ later, Gyokudō.⁴ **Biog.:** Japanese-style painter. Born in Aichi-ken; worked largely in Tōkyō. To Kyōto at 15 to study under Mochizuki Gyokusen and Kōno Bairei; later to Tōkyō to become a pupil of Hashimoto Gahō. Exhibited with Bunten, serving as a member of the selection committee for the first show in 1907, and later with the Teiten. In his later years taught at the Tōkyō School of Fine Arts. Member of the Art Committee of the Imperial Household and of the Imperial Art Academy. In 1940, awarded Order of Cultural Merit and received Asahi Culture Prize. A few of his paintings and a reconstruction of his studio have been attractively installed at the Gyokudō Art Museum. A deservedly popular artist. For a time, worked in Gahō's version of Kanō painting; then his style became more delicate and poetic, with a dash of realism derived from the Shijō school and Western etchings and aquatints. His later work, consisting of idyllic landscapes and snow scenes (for which he is particularly noted), rendered in delicate contour lines and light washes of color. **Coll.:** Gyokudō; Kōzō-ji; Museum (3); National (5); Ryōkan; Staatliche; Tōkyō (1), (2); Yamatane. **Bib.:** Asano, *Ausgewählte*, Elisséev, *Gyokudō*, M 85, *Masterpieces* (4), Miyagawa, Morrison 2, Nakamura (1), NB (H) 24, NB (S) 17, NBT 10, NBZ 6, NKKZ 18, Noma (1) 2, SBZ 11, Uyeno.

¹川合玉堂 ²川合芳三郎 ³玉舟 ⁴玉堂

Kawai Kanjirō¹ (1890-1966). **Biog.:** Potter. Born in Shi-

mane-ken. Graduate of Faculty of Ceramics of Tōkyō Higher Technological School. Worked in the Municipal Laboratory of Ceramic Art in Kyōto. Friend of Hamada Shōji. Closely associated with folk-art movement; at one time, director of Nihon Mingei Kyōkai. One of the great potters of modern Japan, with an international reputation. Early pottery based on Korean wares of Yi dynasty; colors: gray, brown, blue. Recent work much more abstract. **Coll.:** Art (1), (1a); Brooklyn; Fogg; Hakodate; Kyōto (1); Museum (3); National (4), (5); Ohara (2); University (2). **Bib.:** *Exhibition* (2); GNB 28; *Japanese* (1a); Koyama (1), (1a); *Masterpieces* (4); Mitsuoka (1); Munsterberg (2); NB (H) 24; NBT 6; NBZ 6; Noma (1) 2; STZ 16.

¹河井寛次郎

Kawai Shinzō¹ (1867-1936). **Biog.:** Western-style painter. Born in Ōsaka, son of a clothes merchant. Studied first in Ōsaka, then in Kōbe. When about 25, to Tōkyō to study under Goseda Hōryū and, later, under Koyama Shōtarō. In 1900 to America; in 1901 to Paris, where he stayed for three years studying at the Académie Julian. Returned to Japan in 1904. In 1907, with Ōshita Tōjirō, Maruyama Banka, and others, founded Nihon Suisaiga Kenkyūsho. Exhibited with the Bunten in 1907, 1909, 1912. In 1909 moved to Kyōto; became a member of Kansai Bijutsuin, exhibiting mainly with this society and with the Taiheiyō Gakai. **Bib.:** Asano, BK 201, NBZ 6.

¹河合新蔵

Kawakami Kuniyo¹ (1886-1925). **Biog.:** Sculptor. Born in Tōkyō. Grandson of Kawakami Tōgai. Studied first with Takamura Kōun. In 1906 graduated from Tōkyō School of Fine Arts. An early exhibitor at the Bunten, later at the Inten. Member of the Fusainkai. Worked in a smoothed-out, simplified manner. **Bib.:** Asano, NBZ 6.

¹川上邦世

Kawakami Ryōka¹ (1887-1921). **Biog.:** Western-style painter. Born in Niigata-ken. To Tōkyō, where he studied at the Taiheiyō Kenkyūsho. Member of the Fusainkai. Exhibited with the Nikakai. An avant-garde painter for his time. **Bib.:** Asano, NBZ 6.

¹川上涼花

Kawakami Sumio¹ (1895-1972). **Biog.:** Western-style printmaker. Born in Yokohama. Lived for a while in North America. Taught school for many years in Tochigi-ken. Member of the Nihon Hanga Kyōkai and Kokugakai. A well-known print artist, at one time under influence of Henri Matisse. His work took its subject matter from the fashion for things Western in both the late 16th century and again in the early Meiji era: motifs from bizarre elements of Meiji Japan introduced by the West. **Coll.:** Fine (California), National (5), Newark. **Bib.:** Asano; Fujikake (1); Kawakita (1); NBZ 6; Statler; UG 11, 14.

¹川上澄生

Kawakita Handeishi¹ (1878-1963). **Biog.:** Potter. Born in Mie-ken. A bank director who, at age of 30, took up ceramics as a hobby, building a kiln at his house in Chitoseyama in Tsu and specializing in the production of tea-ceremony utensils. Also turned out Korean-style and *aka-e* wares. His Shino-type tea bowls have great originality. **Bib.:** *Contemporary, Masterpieces* (4).

¹川喜田半泥子

Kawakita Kahō¹ (1875-1940). *N.:* Kawakita Gennosuke.² *Gō:* Kahō.³ **Biog.:** Japanese-style painter. Born in Kyōto. Pupil of Kōno Bairei and, later, of Kikuchi Hōbun. Frequent exhibitor and prize winner at the Bunten shows. Often painted scenes from Japanese legends in a mixture of the late Shijō manner and Western realism. **Bib.:** Asano, Elisséev.

¹川化霞峰 ²川北源之助 ³霞峰

Kawakita Michisuke¹ (1850-1907). **Biog.:** Western-style painter. Lived in Tōkyō. Studied under Kawakami Tōgai.

From 1889 to 1897 traveled in Europe and studied in Paris. Member of the hanging committee of the International Exhibition in Paris in 1900. Worked in an impressionist manner. **Coll.:** Tōkyō (2). **Bib.:** Asano.

¹河北道介

Kawamura Kitarō[1] (1899–1966). **Biog.:** Potter. Born in Kyōto; worked in Aichi-ken. Exhibited with the Bunten. A prize winner at the 1937 Paris World's Fair. **Bib.:** NBZ 6, STZ 16.

¹河村喜太郎

Kawamura Kiyo-o[1] (1852–1934). **Biog.:** Western-style painter. Born and lived in Tōkyō. Pupil of Kawakami Tōgai. In 1871 sent by Japanese government to Europe and America; studied oil painting at the Art School in Venice. Returned to Japan in 1881; in 1889 helped establish the Meiji Bijutsu-kai. An admirer of Zeshin, learned to paint in lacquer. His preferred subjects flowers and still lifes, but also did some landscapes and some charming sketchlike paintings. Worked in an outwardly Western academic manner but still Japanese in feeling. **Coll.:** Tōkyō (1), (2). **Bib.:** Asano, BK 188, Elisséev, Harada Minoru, *Kurashina* (2), NB (H) 24, NB (S) 30, NBZ 6, SBZ 11, Uyeno.

¹川村清雄

Kawamura Manshū[1] (1880–1942). *N.:* Kawamura Manzō.[2] *Gō:* Manshū.[3] **Biog.:** Japanese-style painter. Born and worked in Kyōto. Pupil of Yamamoto Shunkyo. Exhibitor with the Bunten; member of the jury of the Teiten and of the Art Committee of the Imperial Household. Taught at Kyōto Prefectural School of Painting. Well-known painter of the modern Kyōto school with the mixture of Japanese and Western feeling that marks that school; quite romantic. **Coll.:** Kyōto (1), National (5). **Bib.:** Asano, Elisséev, NBZ 6.

¹川村曼舟 ²川村万蔵 ³曼舟

Kawamura Nobuo[1] (1892–). **Biog.:** Western-style painter. Born in Kumamoto. Studied at the Taiheiyō Kenkyūsho; became a member of the Taiheiyō Gakai in 1943. Exhibited with the Bunten and the Teiten. **Bib.:** Asano, NB (H) 24, NBZ 6.

¹川村信雄

Kawamura Seizan[1] (1890–1967). **Biog.:** Potter. Worked in Kamakura, specializing in blue-and-white wares. **Coll.:** Kyōto (1). **Bib.:** BK 240, NBZ 6, Okada.

¹河村靖山

Kawamura Ukoku[1] (1838–1906). *N.:* Kawamura Ōshin.[2] *A.:* Kōkei,[3] Morikuni.[4] *F.N.:* Shinsuke.[5] *Gō:* Aichiku Sōdō,[6] Musei Koji,[7] Rikurenshi,[8] Shimei,[9] Taihaku Sambō,[10] Ukoku,[11] Zuishi Sambō.[12] **Biog.:** *Nanga* painter. Born in Edo. Son of a samurai, went with his father to Niigata, where he studied Chinese classics. About 27, became a government official in Nagasaki, where he also studied painting under Kinoshita Itsuun and Hidaka Tetsuō. After the Restoration served as a justice of the Supreme Court until 1898, when he retired to concentrate on his painting. Helped to found the Nihon Nanga Kyōkai. **Bib.:** Asano, Mitchell.

¹川村雨谷（川村烏黒）²川村応心 ³広卿 ⁴守国
⁵新介 ⁶愛竹草堂 ⁷無生居士 ⁸陸蓮子 ⁹紫溟
¹⁰太白山房 ¹¹烏黒（雨谷）¹²瑞芝山房

Kawanari[1] (783–853). *N.:* Aguri Kawanari[2] or Kudara no Kawanari.[3] **Biog.:** Painter. A courtier, said to be the descendant of a naturalized Korean (hence his name, Kudara being the old term for Paekche). Recorded as being one of the distinguished painters of the early Heian period, specializing in landscapes and figures. He is, however, one of the number of early Japanese artists known only through literary references, none of whose works survive and whose dates are only traditional. **Bib.:** AO 3, Ienaga, Moriya, Morrison 1, NB (H) 10.

¹河成 ²余（餘）河成 ³百済河成

Kawanishi Hide[1] (1894–1965). **Biog.:** Printmaker. Born in

Kōbe. A self-taught printmaker. Member of the Nihon Hanga Kyōkai and of the Kokugakai. His prints, often of flowers and circuses but also landscapes and interiors, consist of flat, bright, decorative designs rendered in primary colors. Known particularly for his *One Hundred Views of Kōbe*. **Coll.:** Fine (California), National (5), Newark, Philadelphia. **Bib.:** Asano, Fujikake (1), Kawakita (1), NHBZ 8, NBZ 6, Statler, UG 11.

¹川西英

Kawanobe Itchō[1] (1830–1910). **Biog.:** Kōami lacquerer. Born in Asakusa, Tōkyō. Studied under an artist of the Kōami school, which was attached to the shogunate, and became the last of the masters of this school. In 1896, appointed as a court artist; in 1897 became professor at the Tōkyō School of Fine Arts. About that time made a set of lacquer furniture for the imperial household. Had two sons: Ikkō (1852–1926) and Bunchō (1861–1909), who were both excellent lacquer artists and who worked with their father. A traditional artist, producing *makie* in the Kōami style. **Coll.:** Tōkyō (1), (2). **Bib.:** GNB 28, Herberts, Jahss, NB (S) 41, NBZ 6, Ragué, Uyeno, Yoshino.

¹川之辺一朝

Kawasaki Rankō[1] (1882–1918). *N.:* Kawasaki Kikuko.[2] *Gō:* Rankō.[3] **Biog.:** Japanese-style painter. Born in Ehime-ken. In 1899 she went to Kyōto to study under Kikuchi Hōbun; in 1901 became a pupil of Terazaki Kōgyō in Tōkyō. In 1914 exhibited at the Bunten, and eventually with various other organizations, receiving a number of prizes. An able painter of *kachōga* and *bijinga*. **Bib.:** Asano.

¹川崎蘭香 ²川崎菊子 ³蘭香

Kawasaki Senko[1] (1835–1902). *N.:* Kawasaki Chitora.[2] *F.N.:* Genroku;[3] later, Tomotarō.[4] *Gō:* Senko,[5] Tomonoya.[6] **Biog.:** Japanese-style painter. Born in Nagoya, son of a samurai. Studied under the Shijō-school painter Numata Gessai. Later to Kyōto to become a pupil of Tosa Mitsubumi, painting some of the screens in the Sentō Palace as his master's assistant. Made a thorough study of old manners and customs, visiting temples and shrines in the Kyōto-Ōsaka area. In 1878 to Tōkyō; became an official at the Ministry of Finance, serving later as an official of the Tōkyō Imperial Museum (present Tōkyō National Museum). In 1882 exhibited with the Naikoku Kaiga Kyōshinkai. Later was made principal of Arita Arts and Crafts school; after three years returned to Tōkyō to teach at the Tōkyō School of Fine Arts. Member of the Nihon Bijutsuin and of the commission that was the predecessor to that of the Protection of Cultural Properties. **Bib.:** Asano.

¹川崎千虎 ²川崎千虎 ³源六 ⁴鞆太郎 ⁵千虎 ⁶鞆之舎

Kawasaki Shōko[1] (1886–). **Biog.:** Japanese-style painter. Born in Gifu-ken; works in Tōkyō. In 1910 graduated from the Tōkyō School of Fine Arts. Studied with Kawasaki Senko and Kobori Tomone. Showed at government exhibitions and with the Nitten. His paintings show considerable Western influence. **Coll.:** National (5). **Bib.:** Asano, NBZ 6.

¹川崎小虎

Kawase Chikushun[1] (1894–). **Biog.:** Potter. Resident of Kyōto. Studied the technique of Seto ware; his work largely in the Shonzui style. **Bib.:** STZ 16.

¹川瀬竹春

Kawase Hasui[1] (1883–1957). *N.:* Kawase Bunjirō.[2] *Gō:* Hasui.[3] **Biog.:** Printmaker. First studied Japanese-style painting under Kaburagi Kiyokata; later studied Western-style painting at the Hakubakai. In 1919 turned exclusively to woodblock printing. Visited every place of scenic interest in Japan. In 1956 named a Living National Treasure. Tremendous output of landscape prints in a realistic and detailed style, strongly influenced by Western painting. **Coll.:** Allen, Art (1), Cincinnati, Fine (California), Fogg, Minneapolis, Musées, Museum (3), National (5), Newark,

Riccar, Staatliche, Tōkyō (1). **Bib.:** AAA 21, Asano, Fuji-kake (1), Munsterberg (1), NBZ 6, NHBZ 7, Schmidt, UG 4.

¹川瀬巴水 ²川瀬文治郎 ³巴水

Kawashima Riichirō¹ (1886–1971). **Biog.:** Western-style painter. Born in Tochigi-ken. In 1910 graduated from the Corcoran Art School in Washington, D.C. Then to Paris until 1919, when he returned to Japan. Founding member of the Kokugakai, working to establish the Western-style division of this society. Became a juror for the Bunten, a member of the Nihon Bijutsuin, professor at Women's Art College, Tōkyō. His style is rather decorative. **Coll.:** National (5). **Bib.:** Asano, NBZ 6.

¹川島理一郎

Kayō¹ (1813–77). **N.:** Nakajima Tomikazu.² **A.:** Shitsubun.³ **Gō:** Kayō.⁴ **Biog.:** Painter. Worked in Kyōto. **Coll.:** Victoria.

¹華陽 ²中島富寿 ³質文 ⁴華陽

Kayō¹ (fl. c. 1840–60). **N.:** Shirai Kagehiro.² **A.:** Shijun.³ **Gō:** Baisen,⁴ Baisen Garō,⁵ Kayō.⁶ **Biog.:** Kishi painter. Born in Echigo Province; lived in Kyōto. Pupil of both Kishi Ganku and Kishi Gantai. To some extent, an eclectic painter, specializing in birds and animals. Famous for his book *Gajō Yōryaku* (Brief Account of Pictorial Matters). **Coll.:** Ashmolean. **Bib.:** Mitchell, Tajima (12) 19.

¹華陽 ²白井景広 ³子潤 ⁴梅泉 ⁵梅泉画楼 ⁶華陽

Kayukawa Shinji¹ (1896–). **Biog.:** Japanese-style painter. Born in Sakai. Studied with Tsuchida Bakusen; graduated from the Kyōto College of Fine Arts and Crafts. In 1918 showed at the first exhibition of the Kokuga Sōsaku Kyōkai; continued exhibiting with that society until it dissolved in 1928. In 1929 showed with the Inten. **Coll.:** National (4). **Bib.:** Asano.

¹粥川伸二

Kazan¹ (1784–1837). **N.:** Yokoyama Isshō.² **A.:** Shunrō.³ **Gō:** Kazan.⁴ **Biog.:** Shijō painter. Lived and worked in Kyōto. First a pupil of Hijikata Tōrei and Kishi Ganku; later turned to Matsumura Goshun and the Shijō school. Specialized in figure painting and *kachōga*, amalgamating both Kishi and Shijō schools in his style. **Coll.:** Ashmolean, Museum (3), Victoria. **Bib.:** Fenollosa; Hillier (4) 3; K 123; Mitchell; Morrison 2; Paine (2) 2; Tajima (12) 8, 10.

¹華山 ²横山一章 ³舜朗 ⁴華山

Kazan¹ (1793–1841). **N.:** Watanabe Sadayasu.² **A.:** Hakuto,³ Shian.⁴ **F.N.:** Noboru.⁵ **Gō:** Gūkaidō,⁶ Kazan,⁷ Kintonkyo,⁸ Sakuhi Koji,⁹ Zenrakudō,¹⁰ Zuian Koji.¹¹ **Biog.:** Painter. Born in Edo, son of a samurai. Served Lord Miyake, of the impoverished Tawara clan. In 1838 imprisoned on false charges by the Tokugawa government; death sentence commuted to permanent house arrest; committed suicide on October 11, 1841. Poet, scholar, patriot, national hero as well as painter. Member of Shoshikai, a group that met to study Dutch learning; a promoter of Western knowledge in Japan. At 17, pupil of Tani Bunchō, from whom he learned technique of painting flowers in the style of the early Ch'ing period; then studied under the *nanga* painter Kaneko Kinryō. Also learned Western-style painting. *Bunjinga* his most typical work, but also did portraits—working from preliminary sketches—of scholars and literary men that show some Western influence. His sketches of landscapes and his *kachōga*, not too far from the *nanga* style, are deft and amusing. Also adopted Western laws of chiaroscuro and perspective but used only Japanese painting media; gave volume to his figures by means of shading and anatomical drawing. Really outside any mainstream of Japanese painting: independent, naturalistic artist, one of most distinguished of his period. **Coll.:** Art (1a); Ashmolean; Baltimore; British; Fitzwilliam; Freer; Kazan; Saikō-ji; Tōkyō (1), (2); Victoria. **Bib.:** *Art* (1a); Binyon (1); BK 18, 22, 33, 64, 83, 86, 105, 106, 107, 114, 120, 129, 132; Brown; *Bunjin-*

ga; Cahill; *Exhibition* (1); Fontein (1); *Freer;* Fujimori; GK 12; GNB 18; Hillier (2), (3), (4) 3; *Japanese* (1a); *Japanische* (2); K 100, 117, 137, 141, 210, 211, 225, 226, 230, 235, 239, 245, 252, 277, 288, 291, 297, 302, 311, 352, 383, 411, 431, 438, 443, 448, 452, 456, 484, 494, 500, 514, 532, 535, 541, 550, 557, 564, 579, 582, 587, 593, 600, 605, 624, 635, 643, 645, 667, 687, 706, 723, 739, 764, 765, 770, 812, 831, 867, 871, 873, 927; *Kazan;* KO 11; *Kokuhō* (6); Kondō (6); Lee (1); M 18, 46, 49, 262; Meissner; Mitchell; Mori (2); Morrison 2; Murayama (2); NB (H) 23, 24; NB (S) 4; NBT 5; NBZ 5; *Nihon* (2), (3); Noma (1) 2; *One* (2); Sansom (2); SBZ 10; Shimada 2; Suganuma; Tajima (9) 1; Tajima (12) 14, 17, 18, 19, 20; Tajima (13) 7; Tanaka (1a); TBS 13; Umezawa (2); Yashiro (2); YB 12, 17; Yonezawa.

¹華山 ²渡辺定静 ³伯登 ⁴子安 ⁵登 ⁶寅絵堂 ⁷崋山 ⁸金敦居 ⁹昨非居士 ¹⁰全楽堂 ¹¹隨安居士

Kazunobu (Isshin)¹ (fl. c. 1740). **N.:** Kanō (originally Wada)² Shigenojō.³ **F.N.:** Jōnosuke,⁴ Kumenosuke.⁵ **Gō:** Chinshidō,⁶ Hakuchisō,⁷ Hakusan Yajin,⁸ Kazunobu (Isshin),⁹ Ribo Sanjin,¹⁰ Risshi,¹¹ Shōunsai,¹² Shōunsai Risshi.¹³ **Biog.:** Kanō painter. Son and pupil of Kanō Shōun. Served the daimyo of Chikuzen Province. **Coll.:** Museum (3), Stanford.

¹一信 ²和田 ³狩野茂之丞 ⁴條之助 ⁵久米之助 ⁶珍止堂 ⁷白雉叟 ⁸薄散野人 ⁹一信 ¹⁰里薄散人 ¹¹立止 ¹²松雲斎 ¹³松雲斎立支

Kazunobu¹ (1816–63). **N.:** Hayami Kazunobu.² **F.N.:** Toyojirō,³ **Gō:** Ken'yūsai.⁴ **Biog.:** Kanō painter. Pupil of Kanō Sōsen Toshinobu; eventually allowed to use the Kanō name. Undertook to paint 100 pictures of Rakan for the Zōjō-ji, Shiba, Edo, but died when only 90 were done.

¹一信 ²逸見一信 ³豊次郎 ⁴顕幽斎

Kazuo¹ (fl. c. 1820). **N.:** Matsumoto Kazuo.² **Gō:** Senkaku-dō.³ **Biog.:** Painter. Lived in Ōsaka. Illustrations of his work are found in the book *Suiga Shinan*, published in 1818. **Bib.:** Mitchell.

¹一雄 ²松本一雄 ³仙鶴堂

Keibun¹ (1779–1843). **N.:** Matsumura Naoji.² **A.:** Shisō.³ **F.N.:** Kaname (Yōjin).⁴ **Gō:** Kakei,⁵ Keibun.⁶ **Biog.:** Shijō painter. Lived in Kyōto. Studied with his older brother Matsumura Goshun as well as with Maruyama Ōkyo. Also versed in the art theories of the Ming and Ch'ing dynasties. Served as an attendant to Prince Shinnin, who had taken Buddhist vows; lived at the Myōhō-in, Kyōto, which owns many of his paintings. From 1818 until his death, one of Kyōto's leading artists: made the position of the Shijō school secure. The equal of Goshun as an artist, noted particularly for his *kachōga*, which were often drawn from nature. **Coll.:** Art (1), Ashmolean, British, Honolulu, Itsuō, Metropolitan, Museum (3), Myōhō-in, Nezu, Stanford, University (1), Victoria, Worcester. **Bib.:** BK 216; Brown; *Dessins;* Hillier (2), (3), (4) 3; K 592, 595, 681, 731, 861; Minamoto (1); Mitchell; Moriya; Morrison 2; NBZ 5; *One* (2); Paine (2) 1; *Shijō-ha;* Tajima (11); Tajima (12), 7, 11, 16; Tajima (13) 6.

¹景文 ²松村直治 ³子藻（士藻） ⁴要人 ⁵華渓 ⁶景文

Keichū¹ (1785–1819). **N.:** Matsui Jimpachirō.² **Gō:** Keichū,³ Kenzan.⁴ **Biog.:** Nagasaki painter. Born in Nagasaki. Son and pupil of Matsui Genchū. Painted in a Japanese style to which he added a number of Western touches. **Coll.:** Kōbe. **Bib.:** *Pictorial* (2) 2.

¹慶仲 ²松井甚八郎 ³慶仲 ⁴硯山

Keidō¹ (fl. c. 1840). **N.:** Masuda Keidō.² **F.N.:** Buzaemon.³ **Biog.:** Nanga painter. **Bib.:** Mitchell.

¹桂堂 ²増田桂堂 ³武左衛門

Keien¹ (fl. early 13th c.). **Biog.:** Sculptor. Member of the En school. Title of *dai busshi*. Said to have carved the seated Amida Nyorai at the Kongōrin-ji in 1226. **Coll.:** Kongōrin-ji. **Bib.:** Kuno (1), (2) 6.

¹経円

Keien[1] (1811–80). *N.:* Hashimoto Ken.[2] *A.:* Shiken,[3] Chikai Gyofu.[4] *Gō:* Keien.[5] **Biog.:** *Nanga* painter. Born in Ōsaka. Pupil of Okada Hankō. Good at landscapes and *kachōga*.
¹桂園 ²橋本賢 ³子賢 ⁴茅海漁夫 ⁵桂園

Keiga[1] (fl. early 19th c.). *N.:* Kawahara Keiga.[2] **Biog.:** Nagasaki painter. Lived in Nagasaki. Allowed to enter Deshima, painted European family groups and individual portraits. The figures and the furniture on which they sit are done in much detail but placed against a neutral background. Also did many botanical illustrations for Dr. Siebold's publication *Nippon*. Much influenced by Dutch miniatures. His style, more Japanese than Western, is not without a certain naive charm. **Coll.:** British, Kōbe, Nagasaki, Tōkyō (2). **Bib.:** BK 12, 65; GNB 25; K 685, 687; Kuroda; NBZ 5; Nishimura; *Pictorial* (2) 2, 3; Sullivan.
¹慶賀 ²川原慶賀

Keigaku[1] (fl. 1850–60). *N.:* Harada Keigaku.[2] **Biog.:** Shijō painter. Native of Kawagoe. His paintings often accompanied *haiku*. **Coll.:** Ashmolean, Musées, Rhode Island, Victoria. **Bib.:** Mitchell.
¹圭岳 ²原田圭岳

Keiho[1] (1674–1755). *N.:* Takada Takahisa.[2] *Gō:* Chikuin,[3] Chikuinsai,[4] Keiho,[5] Koraku,[6] Miken Gōō.[7] **Biog.:** Kanō painter. Born in Ōmi Province. Studied under the priest Kokan and Kanō Eikei in Kyōto. Teacher of Soga Shōhaku and Tsukioka Settei. Received honorary rank of *hokkyō* and, later, of *hōgen*. **Coll.:** Museum (3). **Bib.:** Mitchell, Morrison 1, Paine (2) 1.
¹敬甫 ²高田隆久 ³竹隠 ⁴竹隠斎
⁵敬甫 ⁶湖楽 ⁷眉間毫翁

Keii[1] (1760–1814). *N.:* Itaya Hironaga.[2] *Gō:* Keii.[3] **Biog.:** Sumiyoshi painter. Son and pupil of Itaya Keishū Hiromasa; younger brother of Sumiyoshi Hiroyuki. Served as *goyō eshi* to the shogunate court, using the *gō* Keii[4] as his Buddhist name when he entered the court. **Bib.:** Mitchell.
¹慶意 (桂意) ²板谷広長 ³慶意 (桂意) ⁴桂意

Keinin[1] (fl. mid-13th c.). *N.:* Sumiyoshi Keinin.[2] **Biog.:** Yamato-e painter. His name (which later painters and students of art history mistook for Keion)[3] and that of his son Shōjumaro appear in the postscript of the Kamakura-period scroll *Kako Genzai Inga-kyō* (Sutra of Cause and Effect) as the illustrators of the scrolls that were finished in 1254. These scrolls show the stiff composition of the Nara-period scrolls that furnished the subject matter, but the line is far more free. **Coll.:** Gotō, Nezu. **Bib.:** *Illustrated* (2), (3); Lee (1); Paine (4); SBZ 6; Tajima (13) 2.
¹慶忍 ²住吉慶忍 ³慶恩

Keiō[1] (?–1717). *N.:* Uesugi.[2] *F.N.:* Kurōji.[3] *Gō:* Keiō,[4] Ri Keiō.[5] **Biog.:** Painter. Born in Nagasaki. Pupil of Watanabe Shūseki. In 1708 became assistant inspector of the paintings being imported into Nagasaki. An able painter of *kachōga* and landscapes.
¹桂翁 ²上杉 ³九郎次 ⁴桂翁 ⁵李桂翁

Keion[1] (fl. late 12th to early 13th c.). *N.:* Sumiyoshi Keion.[2] **Biog.:** Yamato-e painter. Also known as Sumiyoshi Hōgen.[3] Probably a mythical person. Contemporary scholars now believe the attribution of scrolls to Keion was made by the Sumiyoshi school artists in the *Yamato Nishiki,* compiled in the 19th century, for the name Keion does not appear in old literary sources, and it is therefore believed it was created by Sumiyoshi artists to make their lineage complete. He has also been confused with Keinin (q.v.). Further, in the past, the *Heiji Monogatari* scrolls in the Tōkyō National Museum and the *Taima Mandara Engi* in the Kōmyō-ji, Kamakura, were attributed to him, but without foundation. **Bib.:** *Kokuhō* 4; Minamoto (1); Morrison 1; Okudaira (1); *One* (2); Tajima (12) 4, 5, 10; Tajima (13) 2; Toda (2).
¹慶恩 ²住吉慶恩 ³住吉法眼

Keiri[1] (fl. mid-19th c.). *Gō:* Keiri,[2] Kyōichi.[3] **Biog.:** Ukiyo-e printmaker. Minor pupil of Iwakubo Hokkei. **Coll.:** Rhode Island, Staatliche. **Bib.:** *Kunst,* Schmidt.
¹渓里 ²渓里 ³拱一

Keisai[1] (1764–1824). *N.:* Kuwagata (originally Akabane)[2] Shōshin (Tsuguzane).[3] *F.N.:* Sanjirō.[4] *Gō:* Keisai,[5] Kitao Masayoshi,[6] Masayoshi,[7] Shōsai.[8] **Biog.:** Ukiyo-e painter, printmaker, illustrator. Born in Suruga Province; when very young adopted by a farmer called Akabane Genzaemon. Pupil of Kitao Shigemasa; worked until 1797 as an ukiyo-e artist under the *gō* Kitao Masayoshi designing numerous prints and book illustrations. In 1797 became official painter to the daimyo of Tsuyama; was given some training by Kanō Eisen'in, took his grandmother's name of Kuwagata, and began to work in the Kanō manner. Eventually retired to become a lay monk. Made his name by a panoramic view of Edo, the first of its kind. His prints of flowers noted for their delicacy of design and color. Having begun as an orthodox ukiyo-e artist, ultimately developed an individual style of drawing and produced sketches—some of which foretell Hokusai—of many places in Edo; some of these were also done in the Kanō manner. His work is full of charm and wit. **Coll.:** Allen; British; Fitzwilliam; Freer; Honolulu; Kōbe; Musée (1), (2); Musées; Newark; Portland; Rhode Island; Riccar; Rietberg; Rijksmuseum (1); Staatliche; Tōkyō (1); University (2); Victoria; Worcester. **Bib.:** AA 14; ARTA 6; Binyon (1), (3); Boller; Brown; *Dessins;* Fujikake (3) 3; GNB 17; Hillier (2), (3), (4) 3, (7); Holloway; K 63, 110; Kikuchi; Lane; Mitchell; Morrison 2; Narazaki (2); NHBZ 3; *Nikuhitsu* (1) 2; OZ 1; *Pictorial* (2) 4; Schmidt; Shimada 3; Stern (4); Takahashi (2), (5).
¹蕙斎 ²赤羽 ³鍬形紹真 ⁴三次郎
⁵蕙斎 ⁶北尾政美 ⁷政美 ⁸松阜

Keisai[1] (fl. c. 1820). *N.:* Ōnishi In.[2] *A.:* Shukumei.[3] *Gō:* Issa Enkaku,[4] Keisai,[5] Shōchi Dōjin,[6] Yūkei.[7] **Biog.:** *Nanga* painter. Lived in Edo. Pupil of Tani Bunchō, teacher of Okamoto Shūki, father of Chinnen. A painter of *kachōga.* **Coll.:** Art (1), Museum (3), Victoria. **Bib.:** Brown, Mitchell.
¹圭斎 ²大西允 ³叔明 ⁴一簑烟客
⁵圭斎 ⁶小痴道人 ⁷幽渓

Keiseki[1] (fl. c. 1860). *N.:* Uozumi Ki.[2] *A.:* Shikō.[3] *Gō:* Keiseki.[4] **Biog.:** *Nanga* painter. Born in Echigo Province; lived and worked in Ōsaka. **Coll.:** Victoria. **Bib.:** Mitchell.
¹荊石 ²魚住毅 ³子剛 ⁴荊石

Keisetsusai (Keisessai)[1] (fl. early 16th c.). **Biog.:** Muromachi *suiboku* painter. Studied with, or was much influenced by, Kenkō Shōkei. Worked in the pure Muromachi *sumi* tradition in Kamakura. **Bib.:** M 166; Matsushita (1), (1a); NB (S) 13, 63.
¹啓拙斎

Keishaku[1] (fl. mid-15th c.). **Biog.:** Muromachi *suiboku* painter. A monk-painter, known only from his signature on two paintings. **Bib.:** Brasch (2), NB (S) 63.
¹啓釈

Keishin[1] (1772–1820). *N.:* Kanō Keishin.[2] *F.N.:* Mangiku.[3] *Gō:* Juseki.[4] **Biog.:** Kanō painter. Son of Kanō Sosen Akinobu; seventh in the Saruyamachi line of the Kanō school.
¹圭信 ²狩野圭信 ³万菊 ⁴寿石

Keishō (Kagemasa)[1] (?–1707). *N.:* Shunshō (originally Yamamoto)[2] Kagemasa.[3] *Gō:* Keishō (Kagemasa).[4] **Biog.:** Lacquerer. Son of Shunshō; became head of second generation of this family of lacquer artists. Worked in Kyōto. Followed by his son Seikō (Masayuki)[5] (1654–1740). **Coll.:** Metropolitan, Museum (3), Victoria. **Bib.:** Herberts, Jahss.
¹景正 ²山本 ³春正景正 ⁴景正 ⁵政幸

Keishū[1] (fl. second half 14th c.). **Biog.:** Sculptor. Member of the Tsubai Bussho. Carved the statue of Kōbō Daishi, dated 1375, at the Hōryū-ji, a work in which he was assisted by the

priest-sculptor Shunkei. Given rank of *hokkyō*. **Coll.**: Hōryū-ji. **Bib.**: *Muromachi* (2).

¹慶秀

Keishū¹ (1729–97). *N.*: Itaya (originally Sumiyoshi)² Hiromasa³ (or Hiroyoshi).⁴ *Gō*: Keishū.⁵ **Biog.**: Sumiyoshi painter. Lived in Edo. Pupil of Sumiyoshi Hiromori, whose surname he took until he had established himself and took the name of Itaya. On becoming a monk, used the *gō* of Keishū;⁶ later changed this to Keishū.⁷ In 1773, appointed *goyō eshi* to the Tokugawa *bakufu*. **Coll.**: Atami, Seattle.

¹慶舟 (桂舟)　²住吉　³板谷広当　⁴広慶
⁵慶舟 (桂舟)　⁶慶舟　⁷桂舟

Keishū¹ (1786–1831). *N.*: Itaya Hirotaka.² *Gō*: Keishū;³ later, Keishū.⁴ **Biog.**: Sumiyoshi painter. Served the shogunate. Was given title of *hōgen*.

¹慶舟 (桂舟)　²板谷広隆　³慶舟　⁴桂舟

Keishun¹ (fl. mid-13th c.). **Biog.**: Sculptor. Pupil of Unkei. Member of the Shichijō Bussho. Carved the Amida Nyorai, dated 1240, in the Sonju-ji, Mie-ken. **Coll.**: Sonju-ji. **Bib.**: NB (H) 11.

¹慶俊

Keisō¹ (fl. early 16th c.). **Biog.**: Muromachi *suiboku* painter. An artist identified so far only by his signature. It is possible this is a *gō* of another painter. **Bib.**: M 166; Matsushita (1a); NB (S) 13, 63.

¹啓宗

Keison¹ (fl. late 15th to early 16th c.). *Gō*: Keison,² Kyūgetsusai.³ **Biog.**: Muromachi *suiboku* painter. Said to have been a pupil of Kei Shoki, but in fact little is known about him. An artist of the Kamakura school, but only an adequate painter. **Coll.**: Hompō-ji, Metropolitan, Tokiwayama, Umezawa. **Bib.**: *Chūsei; Japanese* (1); K 422, 436; M 166; Matsushita (1), (1a); NB (S) 13, 63.

¹啓孫　²啓孫　³休月斎

Keitei¹ (1793–1881). *N.*: Amemori Moritora.² *A.*: Koretora (Suiin).³ *F.N.*: Zenshirō.⁴ *Gō*: Hakusui,⁵ Keitei,⁶ Suibokusai,⁷ Taiō,⁸ Taketsubo.⁹ **Biog.**: Shijō painter. Born in Kyōto. Studied under Matsumura Keibun and Nishimura Nantei. Painter of landscapes and *kachōga*.

¹敬亭　²雨森盛寅　³惟寅　⁴善四郎　⁵白水
⁶敬亭　⁷酔墨斎　⁸退翁　⁹竹坪

Keitoku¹ (1721–82). *N.*: Matsui Genchū.² *A.*: Genchū.³ *F.N.*: Junsuke.⁴ *Gō*: Keitoku,⁵ Kōzan.⁶ **Biog.**: Painter. Born in Nagasaki. Pupil of Ishizaki Gentoku. Father of Genchū.

¹慶徳　²松井元仲　³元仲　⁴潤助 (順助)　⁵慶徳　⁶広山

Keiu¹ (1723–91). *N.*: Awataguchi Naoyoshi² (originally Kondō Gorobei).³ *Gō*: Keiu.⁴ **Biog.**: Sumiyoshi painter. Pupil of Sumiyoshi Hiromori. Worked for the Tokugawa *bakufu*.

¹慶羽　²粟田口直芳　³近藤五郎兵衛　⁴慶羽

Keiu¹ (1779–1821). *N.*: Awataguchi Naoki² (or Nao-oki).³ *Gō*: Keiu;⁴ later, Keiu.⁵ **Biog.**: Painter. Son and pupil of Awataguchi Naotaka. Employed by the shogunate. Painted figures and *kachōga*. A minor artist. **Coll.**: Victoria.

¹慶羽 (桂羽)　²粟田口直起　³直興　⁴慶羽　⁵桂羽

Keiu¹ (fl. c. 1840). *N.*: Matsuoka Katsuoki.² *A.*: Aiai.³ *F.N.*: Senzō.⁴ *Gō*: Keiu.⁵ **Biog.**: Painter. Lived in Edo. Also known as a calligrapher and poet. **Bib.**: Mitchell.

¹鶏雨　²松岡勝興　³愛々　⁴専蔵　⁵鶏雨

Keiun¹ (1778–1807). *N.*: Kanō Raishin.² *Gō*: Keiun.³ **Biog.**: Kanō painter. Son and pupil of Kanō Ryūkei Tomonobu; member of the Odawarachō line. **Coll.**: Museum (3).

¹渓雲　²狩野来信　³渓雲

Keizan¹ (?–1733). *N.*: Ohara Keizan.² *Gō*: Kakō.³ **Biog.**: Nagasaki painter. Born in Tamba Province. At an early age to Edo to study Kanō painting under Kanō Tōun. About 1700 to Nagasaki where he had been appointed *kara-e meki-ki;* began to paint in the Chinese manner, studying under Watanabe Shūseki and Hirowatari Shinkai. Also a pupil

of the priest-painter Rankei Jakushi. Tried unsuccessfully to establish a style of his own in landscape and portraiture. Specialized in *kachōga*. **Coll.**: Kōbe. **Bib.**: Mitchell, *Pictorial* (2) 5.

¹慶山　²小原渓山　³霞光

Keizan¹ (fl. c. 1780). *N.*: Koshiba Shuten.² *Gō*: Keizan.³ **Biog.**: Kanō painter. Born in Osaka. A minor follower of the Kanō tradition. **Coll.**: Museum (3).

¹景山　²小柴守典　³景山

Ken'en¹ (fl. 1114–55). **Biog.**: Sculptor. Second son and pupil of Ensei, younger brother of Chōen. Member of Sanjō Bussho; very active in his field. Famous in his lifetime. Received rank of *hokkyō* in 1114, *hōgen* in 1130, *hōin* in 1136. There are records of a number of pieces having been done by him, but the only extant figure thought to be by him is the seated Amida Nyorai (dated 1137) in the Anrakuju-in of the Imperial Palace, Kyōto. This work, in the style of Jōchō, is sensitive and elegant. **Coll.**: Imperial (1) (Anrakuju-in). **Bib.**: *Heian* (2), *Kokuhō* 3, Okudaira (2), YB 21.

¹賢円 (兼円)

Ken'en¹ (fl. 14th c.). **Biog.**: Sculptor. Member of the Sanjō Bussho, working in the style of the En school. By 1365 had received rank of *hōin*. The Hōkai-ji in Kanagawa has three works by him: a Jizō Bosatsu (dated 1365), a Bonten, and a Taishakuten. **Coll.**: Hōkai-ji.

¹憲円

Kenkadō¹ (1736–1802). *N.*: Kimura Kōkyo.² *A.*: Seishuku.³ *F.N.*: Kō,⁴ Kotarō.⁵ *Gō*: Kenkadō,⁶ Sonsai;⁷ later, Sonsai.⁸ **Biog.**: *Nanga* painter. An Ōsaka brewer who was also an amateur painter, a naturalist, a bibliophile, an engraver of seals, a patron of artists, and a collector. As a shopkeeper, used the name Tsuboiya Takichi⁹ (or Kichizaemon).¹⁰ Studied painting under Ōoka Shumboku, Yanagisawa Kien, and Ikeno Taiga. It is said that he collected Taiga's work and that Chikuden admired his paintings. **Coll.**: Victoria, Yale. **Bib.**: K 697, 868; Mayuyama; Mitchell; Murayama (2); NB (S) 4; Tajima (13) 7; Yonezawa.

¹蒹葭堂　²木村孔恭　³世粛　⁴鴒　⁵小太郎　⁶蒹葭堂
⁷巽斎　⁸遜斎　⁹壷井屋太吉　¹⁰吉左衛門

Kenkei¹ (fl. 1077–1121). **Biog.**: Sculptor. Son and pupil of Chōsei. Presumably a member of the Sanjō Bussho, which was founded by his father. Received title of *hokkyō* in 1077. No authenticated works by him are known. **Bib.**: *Butsuzō*, Machida.

¹兼慶

Kenkō¹ (fl. second half 13th c.). **Biog.**: Sculptor. To judge from his works known to date, which are in temples in Chiba-ken, he was a local artist working in the Kamakura tradition. Two of his figures are dated 1256 and 1285 respectively. The major interest in his work lies in the fact it was produced so far from the main contemporary centers of sculptural activity. **Coll.**: Raifu-ji, Tamon-in, Tempuku-ji. **Bib.**: BK 274.

¹賢光

Kensai¹ (1802–56). *N.*: Hirai Shin.² *A.*: Kimpu.³ *F.N.*: Genjirō,⁴ Jiroku.⁵ *Gō*: Kensai,⁶ Sankoku Sanshō.⁷ **Biog.**: *Nanga* painter. Born in Tōtōmi Province. Pupil of Tani Bunchō, Watanabe Kazan, Takahisa Aigai. His landscapes are in the style of Aigai, his *kachōga* influenced by Kazan. **Bib.**: Mitchell.

¹顕斎　²平井忱　³欽夫　⁴元次郎
⁵治六　⁶顕斎　⁷三谷山樵

Kensei¹ (fl. early 16th c.). **Biog.**: Painter. Life unknown. Said to have used brushes called *mokuhitsu*—made of bamboo and capable of making either broad or fine lines depending on the direction of the stroke. Also said to have been adept at writing Sanskrit.

¹賢正

Kenseki¹ (1798–1874). *N.*: Saitō Yoshi.² *A.*: Kōchi.³ *F.N.*: Gensaku.⁴ *Gō*: Gun'atei,⁵ Hakuwan Gyochō,⁶ Kenseki,⁷

Kyōjuan,[8] Nan'otsu,[9] Rinsai,[10] Tozan Seinō.[11] **Biog.:** Japanese-style painter. Born in Kazusa Province, son of a fisherman. Pupil of Suzuki Nanrei, using *gō* of Nan'otsu, then later of Takaku Aigai, using *gō* of Rinsai. Studied Chinese Ming and Yüan painting on his own. A connoisseur of old paintings. Specialized in landscapes and *kachōga*. **Bib.:** Mitchell.

[1]拳石 [2]斎藤義 [3]公知 [4]源作 [5]群蛙亭 [6]白湾漁長 [7]拳石 [8]拱寿庵 [9]南乙 [10]粦斎 [11]兎山清農

Ken'ya[1] (1825–89). **N.:** Miura Tōtarō.[2] **Gō:** Ken'ya,[3] Tenrokudō.[4] **Biog.:** Potter. Born in the Kantō district; moved to Edo. A versatile artisan: for a while earned his living as a maker of clay dolls; at one time engaged in a shipbuilding project for the Tokugawa shogunate, going in 1854 to Nagasaki; in 1869 produced the first bricks in Japan; in 1875 began making pottery at the Chōmei-ji in Mukōjima, Tōkyō; designed a type of hair ornament called Ken'ya-dama (Ken'ya jewels), which was widely sold. Also made a pottery with overglaze enamels to which lacquer was occasionally applied in the manner of Ogawa Ritsuō. Though the influence of Kenzan is apparent in much of his work, he refused to be included in the Kenzan succession. **Coll.:** Freer, Metropolitan, Royal (1), Tōkyō. **Bib.:** GNB 28; Herberts; Jahss; Leach; Munsterberg (2); NB (S) 41; NBZ 6; *Nihon* (1), (8); STZ 6; Uyeno.

[1]乾也 [2]三浦藤太郎 [3]乾也 [4]天禄堂

Ken'ya[1] (fl. c. 1900). **N.:** Ogata (originally Urano)[2] Shigekichi.[3] **Gō:** Kensai,[4] Ken'ya.[5] **Biog.:** Potter. About 1900 adopted by the Ogata family; became Kenzan VI. Pupil of Miura Ken'ya; like his master, worked in a mild version of the Kenzan manner. The famous English potter Bernard Leach was his pupil. **Coll.:** Tōkyō (1). **Bib.:** Leach.

[1]乾哉 [2]浦野 [3]尾形茂橘 [4]乾哉 [5]乾哉

Kenzan[1] (1663–1743). **N.:** Ogata Koremasa (Iin).[2] **F.N.:** Gompei,[3] Shinsei.[4] **Gō:** Furyū,[5] Karaku Sanjin,[6] Kenzan,[7] Kyōchō Itsumin,[8] Reikai,[9] Shisui,[10] Shōkosai,[11] Shūseidō[12] Tōin,[13] Tōzen.[14] **Biog.:** Rimpa potter, painter. Also a calligrapher and tea master. Born in Kyōto to a family of rich, cultured cloth merchants. Younger brother of Kōrin, with whom he often collaborated, producing the pottery that Kōrin then decorated. Studied Ninsei's technique, working first in this style; later a pupil of Hon'ami Kūchū. Set up a kiln at Omuro, near the Ninna-ji; later established one at Narutaki, north of Kyōto, working there with his brother from 1699 to 1712. In 1731 moved to Edo; then to Sano in Shimotsuke Province. Japan's greatest ceramist: first of a long line of potters using the *gō* Kenzan, influenced entire school of Kyōto potters. Endlessly imitated, with disagreement over attribution: ceramics painted blackish brown generally accepted; those in enamel colors sometimes questioned. Generally worked in pottery, applying the decoration under the glaze, but also made porcelain decorated with overglaze enamels. His style combined decorative quality of Rimpa school with freedom of Zen painting. Often wrote inscriptions on his pieces, which were then decorated with floral forms or landscapes. His paintings, of which there are only a few and done during his Edo period, much influenced by his brother but less accomplished technically, are unpretentious. **Coll.:** Art (1a), Atami, Brooklyn, Cleveland, Fine (De Young), Freer, Fujita, Gotō, Hakone, Hatakeyama, Honolulu, Itsuō, Kimbell, Matsunaga, Metropolitan, Musée (2), Musées, Museum (3), Nelson, Nezu, Ōkura, Ōsaka (2), Philadelphia, Seattle, Stanford, Tekisui, Tokugawa, Tōkyō (1), Umezawa, Yamato. **Bib.:** AA 14; BI 9, 34, 35; BK 85, 184, 188; *Ceramic* (1); Feddersen; *Freer;* Fujioka; GNB 14, 19; Hayashiya (1); Hisamatsu; *Japanese* (1a); Jenyns (2); K 54, 69, 131, 170, 185, 189, 250, 420, 488, 808, 834, 891, 895; *Kenzan;* KO 9, 16, 24, 25, 26, 39; *Kōetsu-ha; Kōrin-ha* (1), (2); Koyama (1), (1a), (3), (5) 7; Leach; Lee (1); M 1, 235; Mayuyama; Mikami; Miller;

Minamoto (3); Mitsuoka (1), (2); Mizuo (2a), (3), (4); Morrison 2; Munsterberg (2); Murayama (1); NB (S) 14, 28, 71; NBT 5, 6; NBZ 5; *Nihon* (1), (8); Noma (1) 2; Okuda (2); P 4; *Rimpa;* Rosenfield (2); Satō; SBZ 9; *Selected;* Shimada 2; *Sōtatsu-Kōrin* (3); Stern (3); STZ 5, 7; Tajima (2) 3, (13) 5; TBS 11; TZ (K) 7; Yamada; Yashiro (4); YB 1, 21, 22, 23, 29, 33.

[1]乾山 [2]尾形惟允 [3]権平 [4]深省 [5]扶陸 [6]華洛山人 [7]乾山 [8]京兆逸民 [9]霊海 [10]紫翠 [11]尚古斎 [12]習静堂 [13]陶隠 [14]逃禅

Kenzan II[1] (?–1768). **N.:** Ogata Ihachi.[2] **Gō:** Kenzan II.[3] **Biog.:** Potter. Natural son of Ninsei; adopted by Ogata Kenzan. Worked as Kenzan's assistant; was allowed to take the name of Kenzan II. **Bib.:** Jenyns (2), Leach, STZ 3.

[1]乾山二代 [2]尾形亥八 [3]乾山二代

Kenzan[1] (?–1873). **N.:** Sanada Choku.[2] **A.:** Shikō.[3] **F.N.:** Einosuke.[4] **Gō:** Kenzan.[5] **Biog.:** Painter. Lived in Edo. An official of the shogunate. **Bib.:** Mitchell.

[1]謙山 [2]真田直 [3]子行 [4]栄之助 [5]謙山

Kichi[1] (fl. 15th c.). **Biog.:** Muromachi *suiboku* painter. Life unknown; perhaps a pupil of Sesshū. **Coll.:** Victoria.

[1]幾馳

Kichiemon[1] (fl. 16th to 19th c.). A name used by a family of Kyōto potters. The first member is said to have been active during the Tenshō era (1573–92); worked at Mimuro, Kyōto, using a special kind of clay and specializing in unglazed pots. His wares were popular with tea masters of the time. During the Hōreki era (1751–64) a Kichiemon potter was invited by the lord of Mito (the Tokugawa cadet house) to work on his property called Kōrakuen. The ware produced there came to be known as Kōrakuen-yaki and was marked by round seals reading either "Kōraku"[2] or "Kōrakuen-sei."[3] The first member of the Kichiemon family to use the name Minato[4] is said to have been the brother of the fourth-generation Raku potter Ichinyū. Minato ware is a light-colored pottery with yellow, green, and aubergine glazes and with designs often molded in relief and outlined with fine lines. **Coll.:** Freer. **Bib.:** Jenyns (2), Koyama (1a).

[1]吉右衛門 [2]後楽 [3]後楽園製 [4]湊

Kidō Rigyōfu[1] (fl. Muromachi period). **Biog.:** Muromachi *suiboku* painter. There is no information to date about this artist-priest save that he seems to have studied Kaō's style. **Bib.:** BCM 50, M 166, NB (S) 69.

[1]寄堂李堯夫

Kiei-shi[1] (fl. mid-8th c.). **Biog.:** Sculptor. This name appears in an inscription on the back of a Gigaku mask in the Shōsō-in, saying this was the carver of the mask and giving the date 752. **Coll.:** Shōsō-in. **Bib.:** Harada, Kleinschmidt, Noma (4), *Shōsō-in,* Warner (4).

[1]基永師

Kien[1] (1706–58). **N.:** Yanagisawa Rikyo[2] (Ryū Rikyō).[3] **A.:** Kōbi.[4] **F.N.:** Gondayū,[5] Gonnosuke,[6] Kyūzaemon,[7] Tatewaki,[8] Zusho.[9] **Gō:** Chikkei (Chikukei),[10] Gyokkei (Gyokukei),[11] Kien.[12] **Biog.:** *Nanga* painter. His father one of the chief retainers of the wealthy, influential Yanagisawa clan, daimyo of Kōriyama. Lived first in Edo; in 1727 moved to Kōriyama, where he eventually died. An important *nanga* painter and man of letters, said to have been eminent in the sixteen noble accomplishments: calligraphy, sword connoisseurship, poetry, tea ceremony, painting, incense smelling, etc. Also studied Confucianism, Buddhism, and medicine. Interested in painting from age of 9; first a student of the Kanō school, then of the Nagasaki school under a pupil of Watanabe Shūseki and, later, of *nanga* painting under Gion Nankai; also studied Chinese Yüan and Ming painting, and was obviously acquainted with *The Mustard-Seed Garden*. Few of his pictures remain, but there are many forgeries. His specialty was bamboo, often rendered in *shitōga;* also produced stylized Chinese-type landscapes. His paintings of flowers in either a fine miniature-like manner

or in the regular *nanga* style are realistic. His colors bright and rich, used in a manner close to the tight Ming academic tradition. **Coll.:** Tōkyō (2). **Bib.:** BK 127; Brown; Cahill; GNB 18; K 119, 122, 203, 482, 610, 759, 814, 841, 843, 862, 864; M 73; Mitchell; Minamoto (1); Moriya; Morrison 2; Murayama (2); NB (H) 23; NBT 5; NBZ 5; *Nihon* (2), (3); OA 13; Paine (4); Rosenfield (2); Tajima (12) 10, (13) 7; Umezawa (2); Yonezawa.

¹淇園 ²柳沢里恭 ³柳里恭 ⁴公美 ⁵権太夫 ⁶権之助
⁷九左衛門 ⁸帯刀 ⁹図書 ¹⁰竹渓 ¹¹玉桂 ¹²淇園

Kien¹ (1734–1807). *N.:* Minagawa Gen.² *A.:* Hakkyō (Hakukyō).³ *F.N.:* Bunzō.⁴ *Gō:* Donkaishi,⁵ Kien,⁶ Kyōsai,⁷ Sessai,⁸ Yūhisai.⁹ **Biog.:** *Nanga* painter. Lived in Kyōto; son of a famous scholar of Chinese literature and philosophy. Known as a Confucian scholar and an author as well as a painter. Studied painting under Mochizuki Gyokusen Shigemori, later under Maruyama Ōkyo; finally, after studying old Chinese paintings, turned to the *nanga* school. An important figure in Kyōto and Ōsaka artistic and intellectual circles; an early *nanga* painter. Specialized in landscape, orchids, bamboo. **Coll.:** Ashmolean, Royal (1). **Bib.:** Mitchell, Murayama (2), OA 13.

¹淇園 ²皆川愿 ³伯恭 ⁴文蔵 ⁵呑海子
⁶淇園 ⁷笻斎 ⁸節斎 ⁹有斐斎

Kigai¹ (fl. c. 1840). *N.:* Takahashi Chōkan.² *A.:* Kankō.³ *Gō:* Kigai.⁴ **Biog.:** Painter. Lived in Edo. Given honorary rank of *hokkyō*. **Bib.:** Mitchell.

¹機外 ²高橋長寛 ³観広 ⁴機外

Kigyoku¹ (1732–56). *N.:* Kurokawa Yasusada.² *A.:* Shiho.³ *F.N.:* Kangorō,⁴ Mangorō.⁵ *Gō:* Kigyoku,⁶ Shōrakan,⁷ Shōzan Shoshi.⁸ **Biog.:** Nagasaki painter. Born and lived in Edo. Also known as a calligrapher. First a pupil of Kanō Kyūshin Takanobu; later a follower of Okamoto Zen'etsu; eventually became one of the ablest followers of Shen Nan-p'in. Much patronized in his lifetime. Small production —generally of birds-and-flowers, animals, trees, all very Chinese in style—because of his short life. **Coll.:** Tōkyō (1). **Bib.:** Mody, Tajima (13) 7.

¹亀玉 ²黒川安定 ³子保 ⁴観五郎
⁵万五郎 ⁶亀玉 ⁷松蘿館 ⁸商山処士

Kihō¹ (1778–1852). *N.:* Kawamura (originally Takeuchi)² Shun.³ *A.:* Goitsu.⁴ *Gō:* Chikurikan,⁵ Kihō.⁶ **Biog.:** Painter, illustrator. Lived in Kyōto. Adopted son and pupil of Kawamura Bumpō. Skillful painter of landscapes, figures, *kachōga*; an amusing artist whose style seems to owe something to the Shijō school. **Coll.:** Ashmolean, Museum (3). **Bib.:** Brown, Holloway, Mitchell.

¹琦鳳 ²竹内 ³河村駿 ⁴五逸 ⁵竹裏館 ⁶琦鳳

Kihō (Gihō)¹ (fl. early 19th c.). *N.:* Yamada Kihō (Gihō).² *A.:* Kinto.³ *F.N.:* Yamasaburō.⁴ *Gō:* Chōtei.⁵ **Biog.:** Painter. Given honorary title of *hokkyō*. **Bib.:** Mitchell.

¹岐鳳 ²山田岐鳳 ³鈞徒 ⁴山三郎 ⁵長江

Kiitsu (Kiichi)¹ (1796–1858). *N.:* Suzuki Motonaga.² *A.:* Shien.³ *F.N.:* Tamesaburō.⁴ *Gō:* Hitsuan,⁵ Isandō,⁶ Kaikai,⁷ Kiitsu (Kiichi),⁸ Niwabyōshi,⁹ Seisei,¹⁰ Shukurinsai.¹¹ **Biog.:** Rimpa painter. Born in Ōmi Province; son of a dyer who later transferred his shop to Edo. Adopted by Suzuki Reitan, a samurai attached to the Himeji daimyo. Worked first as a dyer, inventing a technique of dyeing with purple (*murasakizome*). Then became a pupil of Sakai Hōitsu. By 1825 was working in the field of book illustration; in 1826, with his master, prepared for publication *Kōrin Hyakuzu* (Collection of 100 Works by Kōrin). Also a good *haiku* poet. His painting eclectic in style: influenced by the Rimpa, Shijō, Tosa, and ukiyo-e schools. His colors more opaque than those of Sōtatsu, his edges sharper. **Coll.:** Andrew, Art (1), Freer, Herron, Honolulu, Itsuō, Metropolitan, Museum (3), Ōkura, Victoria, Yale. **Bib.:** Hillier (3), (4) 3; K 79, 103, 359, 779, 822, 881; *Kōrin-ha* (2); Lee (2); Mitchell; Mizuo

(2a), (3), (4); Morrison 2; *Rimpa; Sōtatsu-Kōrin* (3); Stern (3); Tajima (2) 5, (12) 15, (13) 5.

¹其一 ²鈴木元長 ³子淵 ⁴偽三郎 ⁵必庵 ⁶為三堂
⁷唫々 ⁸其一 ⁹庭拍子 ¹⁰菁々 ¹¹祝琳斎

Kikaku¹ (1661–1707). *N.:* Enomoto (originally Takeshita)² Yoshinori.³ *F.N.:* Gensuke.⁴ *Gō:* Bungōan,⁵ Hōshinsai (for calligraphy),⁶ Kikaku,⁷ Kyōjidō,⁸ Kyōraidō,⁹ Raikeishi,¹⁰ Rasha,¹¹ Rokubyōan,¹² Shinsai,¹³ Shinshi,¹⁴ Shōsen,¹⁵ Yūchikukyo,¹⁶ Zenzaian.¹⁷ **Biog.:** Painter. Also a poet: one of Bashō's ten *haiku* disciples. Studied painting under Hanabusa Itchō. Produced many *haiga*.

¹其角 ²竹下 ³榎本順哲 ⁴源助 ⁵文合菴 ⁶宝晋斎
⁷其角 ⁸狂而堂 ⁹狂雷堂 ¹⁰雷桂子 ¹¹螺舎 ¹²六病庵
¹³晋斎 ¹⁴晋子 ¹⁵渋川 ¹⁶有竹居 ¹⁷善哉菴

Kikuchi Chūtarō¹ (1859–1944). **Biog.:** Printmaker. Born in Edo. First studied with Kunisawa Shinkurō. In 1882 graduated from the Kōbu Daigaku Bijutsu Gakkō, having studied under Ragusa. Served as a juror for the Meiji Bijutsukai in 1895. Joined the Hakubakai in 1896. **Bib.:** Asano.

¹菊池鋳太郎

Kikuchi Hōbun¹ (1862–1918). *N.:* Kikuchi Tsunejirō.² *A.:* Kōki.³ *Gō:* Hōbun.⁴ **Biog.:** Shijō painter. Born in Ōsaka; lived in Kyōto. Adopted by the Kikuchi family; pupil of Kōno Bairei. Taught at the Kyōto Municipal School of Fine Arts and Crafts; frequent exhibitor with and juror for the Bunten; member of the Teiten. A leading painter in Kyōto: one of founders of modern Kyōto school. Produced charming landscapes and *kachōga* in a traditional style. **Coll.:** Museum (3), Sanzen-in, Victoria. **Bib.:** Asano, Mitchell, NB (S) 17, NBZ 6, Okamoto (1), Uyeno.

¹菊池芳文 ²菊池常次郎 ³広紀 ⁴芳文

Kikuchi Keigetsu¹ (1879–1955). *N.:* Kikuchi Kanji.² *Gō:* Keigetsu.³ **Biog.:** Painter. Born in Nagano-ken. First studied *nanga* painting in Kyōto under Kodama Katei; then Shijō painting under Kikuchi Hōbun, by whom he was later adopted. Traveled in Europe from 1922 to 1923. Exhibited with the Bunten. Member of Art Committee of the Imperial Household, Imperial Art Academy, Japan Art Academy. Specialized in portraits. His style, a combination of Western and Japanese elements, marked by gorgeous colors and a certain intentional naiveté. **Coll.:** Kyōto (1); National (4), (5). **Bib.:** Asano, Kondō (6), *Masterpieces* (4), NB (H) 24, NBT 10, NBZ 6, SBZ 11, YB 30.

¹菊池契月 ²菊池完爾 ³契月

Kikuetsu¹ (fl. 14th c.). **Biog.:** Muromachi *suiboku* painter. A monastic artist working in the Sung and Yüan styles. **Bib.:** BCM 50, ZNBT 7.

¹菊悦

Kikusha¹ (fl. late 19th c.). *N.:* Tanoue Kiku.² *Gō:* Kikusha.³ **Biog.:** Painter. Nothing known of her life save that she was a nun. **Coll.:** Fogg.

¹菊舎 ²田上菊 ³菊舎

Kimei¹ (1834–91). *N.:* Nakano.² *Gō:* Hōrindō,³ Kimei,⁴ Seiseisai.⁵ **Biog.:** Painter. Born in Edo. Pupil of Suzuki Kiitsu, whose style he followed. **Bib.:** Mitchell.

¹其明 ²中野 ³方琳堂 ⁴其明 ⁵晴々斎

Kimmochi¹ (fl. mid-10th c.). *N.:* Kose no Kimmochi.² **Biog.:** Kose painter. Perhaps son of Kose no Aimi and younger brother of Kose no Kintada; contemporary of Asukabe Tsunenori. While the latter was considered by the court to be an important painter, Kimmochi was rated a minor artist. Given an official title; served as a court painter. No works known. **Bib.:** Morrison 1.

¹公望 (公茂) ²巨勢公望 (巨勢公茂)

Kimura Buzan¹ (1876–1942). *N.:* Kimura Shintarō.² *Gō:* Buzan.³ **Biog.:** Japanese-style painter. Born in Ibaraki-ken to the family of a retainer of a daimyo. At first, studied with Kawabata Gyokushō; then, in 1896, graduated from the Tōkyō School of Fine Arts, where he came under the influence of Okakura Tenshin. Active in both the original

Nihon Bijutsuin and in its revived form, where he was both an exhibitor and a prize winner. For half his career, specialized in *kachōga* that at times show a relation to the French decorative arts of the early 1900s; later, inclined to Buddhist subjects and large overdramatic compositions. **Coll.**: Museum (3), Tōkyō (1). **Bib.**: Asano, NBZ 6.

[1]木村武山 [2]木村信太郎 [3]武山

Kimura Gorō[1] (1899–1935). **Biog.**: Sculptor. Worked in wood, in a rough-cut style. **Bib.**: NBZ 6.

[1]木村五郎

Kimura Kōu[1] (1842–1912). *N.*: Kimura Nagaaki.[2] *A.*: Shitoku.[3] *Gō*: Rikuzan;[4] later, Kōu,[5] Sekiten,[6] Shiseki Sambō,[7] Shōshuseki,[8] Yūfukudō.[9] **Biog.**: *Nanga* painter. Born in Sendai; son of a samurai. At first studied under a minor Shijō painter Kusano Tōkun; used the *gō* Rikuzan. Later studied under a *nanga* painter. Traveled extensively in Japan; finally settled in Tōkyō in 1880 and began to use *gō* of Kōu. Exhibited with the Naikoku Kangyō Hakurankai, the Nihon Kaiga Kyōshinkai, the Nihon Bijutsu Kyōkai, eventually becoming a member of the last. **Coll.**: Victoria.

[1]木村香雨 [2]木村長明 [3]子徳 [4]陸山 [5]香雨
[6]石顚 [7]芝石山房 [8]小朱石 [9]幽馥堂

Kimura Shōhachi[1] (1893–1958). **Biog.**: Western-style painter. Born in Tōkyō. Studied at the Hakubakai. In 1911 helped found the Fusainkai and in 1915 the Sōdosha. Joined the Shun'yōkai when it was founded in 1922; exhibited with it from 1923 until he died. Also showed with the Nihon Bijutsuin. An art critic and writer on art as well as a painter. Specialized in scenes of Tōkyō, working in a fauve manner. **Coll.**: National (5). **Bib.**: Asano, NB (H) 24, NBZ 6, *Posthumous* (1).

[1]木村荘八

Kinga[1] (fl. c. 1830). *N.*: Egoshi Ryū.[2] *A.*: Monkoku.[3] *F.N.*: Rokubei.[4] *Gō*: Kinga,[5] Shūho.[6] **Biog.**: Nagasaki painter. Follower of the Kumashiro painters Yūhi, Yūhibun, Yūhimei.

[1]錦賀 [2]江越竜 [3]紋轂 [4]六兵衛 [5]錦賀 [6]繡浦

Kingyokusen[1] (fl. early 16th c.). *Given name*: Ju.[2] *A.*: Kyūnan.[3] *Gō*: Kingyokusen.[4] **Biog.**: Kanō painter. A member of the circle of Kanō Motonobu. **Coll.**: Museum (3). **Bib.**: Matsushita (1a).

[1]金玉仙 [2]寿 [3]宮南 [4]金玉仙

Kinjō[1] (1811–63). *N.*: Kanae Gen.[2] *A.*: Shigyoku.[3] *Gō*: Kinjō.[4] **Biog.**: *Nanga* painter. Also a poet. Son of Kanae Shungaku. Studied painting with Okada Hankō and Kaneoka Sessō. Teacher of Mori Kinseki. **Bib.**: Mitchell.

[1]金城 [2]鼎鉉 [3]子玉 [4]金城

Kinka Sanjin[1] (fl. early 16th c.). **Biog.**: Muromachi *suiboku* painter. Known only as the painter of a White-robed Kannon in a style close to that of the Minchō school. It is possible this name is the *gō* of another artist of the same period. **Bib.**: Matsushita (1a), Rosenfield (2).

[1]金華山人

Kinkei[1] (fl. early 15th c.). *Given name*: Ryōbin.[2] *Gō*: Kinkei,[3] Kinkei Dōjin.[4] **Biog.**: Muromachi *suiboku* painter. Little known of his life, save that he studied under Shūbun and knew the work of Mu-ch'i. His few remaining works show that he sometimes painted *kachōga* in the rigid and less realistic manner that appeared in Japanese painting in the 15th century. **Bib.**: K 679, 847; Matsushita (1a); Rosenfield (2).

[1]金鈴 [2]良敏 [3]金鈴 [4]金鈴道人

Kinkoku[1] (1761–1832). *N.*: Yokoi Myōdō.[2] *Gō*: Kinkoku,[3] Kōmori Dōjin.[4] **Biog.**: *Nanga* painter. Also a *haiku* poet, sculptor, seal engraver, and potter. Born in Ōtsu. A monk of the Jōdo sect, committed to austerity and hardship and perhaps also to dissipation, became the typical wandering artist-ascetic. Pupil (?) of Yosa Buson, whose landscapes his paintings resemble; but his style is much rougher, more vigorous. Almost excessively prolific, produced a great deal

of uneven work in which the influences of other *nanga* painters and even of ukiyo-e can be found. **Coll.**: Ashmolean, British, Museum (3), Tōkyō (1), University (2). **Bib.**: Cahill, M 79, Mitchell, *Nihon* (3), Rosenfield (2).

[1]金谷 [2]横井妙憧 [3]金谷 [4]蝙蝠道人

Kinkoku[1] (1811–73). *N.*: Yamamoto Ken.[2] *A.*: Shijō.[3] *F.N.*: Satsuemon.[4] *Gō*: Chichisai,[5] Kandō,[6] Kinkoku,[7] Shōkarō.[8] **Biog.**: *Nanga* painter. Samurai in the service of Lord Kamei of Iwami. First studied locally under Tako Issai; then to Edo to study under Watanabe Kazan. Specialized in landscape and figures; considered best of Kazan's pupils in figure painting. **Coll.**: Victoria. **Bib.**: M 61, Mitchell, Morrison 2.

[1]琴谷 [2]山本謙 [3]子譲 [4]察右衛門
[5]癡々斎 [6]観堂 [7]琴谷 [8]消夏楼

Kinkōzan[1] (fl. 17th to 20th c.). *N.*: Kobayashi.[2] *Studio name*: Kagiya.[3] *Gō*: Kinkōzan.[4] The *gō* used by the third and succeeding generations of the Kobayashi family of potters who specialized in Awata-yaki. The typical pieces with the Kinkōzan stamp have a warm, creamy glaze decorated with blue and green enamels. See under individual entries below. **Coll.**: Freer, Metropolitan, Victoria. **Bib.**: Jenyns (2), Uyeno.

[1]錦光山 [2]小林 [3]鍵屋 [4]錦光山

Kinkōzan[1] (fl. 1744–60). *N.*: Kobayashi Kihei[2] (later Mohei).[3] *Studio name*: Kagiya.[4] *Gō*: Kinkōzan.[5] **Biog.**: Potter. Third-generation head of the Kobayashi family. Began to work at Iwakura, northeast of Edo, but about 1750 moved to Awataguchi and inherited his father's business. In 1756, appointed official potter to the Tokugawa shogunate, from which he received the *gō* Kinkōzan. Supplied the shogunate with tea-ceremony objects. **Coll.**: Freer, Metropolitan. **Bib.**: Jenyns (2).

[1]錦光山 [2]小林喜兵衛 [3]茂兵衛 [4]鍵屋 [5]錦光山

Kinkōzan II[1] (fl. late 18th c.). *N.*: Kobayashi Kihei.[2] *Studio name*: Kagiya.[3] *Gō*: Kinkōzan.[4] **Biog.**: Potter. Fourth-generation head of the Kobayashi family at Awata. Introduced what is known as Oranda-utsushi (an imitation of Delft ware). Also produced copies of Omuro ware. **Bib.**: Jenyns (2).

[1]錦光山二代 [2]小林喜兵衛 [3]鍵屋 [4]錦光山

Kinkōzan III[1] (fl. early 19th c.). *N.*: Kobayashi Kihei.[2] *Studio name*: Kagiya.[3] *Gō*: Kinkōzan.[4] **Biog.**: Potter. Fifth-generation head of the Kobayashi family at Awata. Began the production of Mimuro-utsushi. **Bib.**: Jenyns (2).

[1]錦光山三代 [2]小林喜兵衛 [3]鍵屋 [4]錦光山

Kinkōzan IV[1] (fl. mid-19th c.). *N.*: Kobayashi Sōbei.[2] *Studio name*: Kagiya.[3] *Gō*: Kinkōzan.[4] **Biog.**: Potter. Sixth-generation head of the Kobayashi family at Awata. Started the production of porcelain. Also, in 1877, began making pottery for export. As the export business flourished, hired many potters and began making products of lesser quality for the export market. However, left several nice pieces from his own hand.

[1]錦光山四代 [2]小林宗兵衛 [3]鍵屋 [4]錦光山

Kinkōzan V[1] (1867–1927). *N.*: Kobayashi Sōbei.[2] *Studio name*: Kagiya.[3] *Gō*: Kinkōzan.[4] **Biog.**: Potter. Seventh-generation head of the Kobayashi family at Awata. Added gold and silver to the decoration of his wares; popular with the Western market. **Coll.**: Philadelphia. **Bib.**: BK 240.

[1]錦光山五代 [2]小林宗兵衛 [3]鍵屋 [4]錦光山

Kinoshita Mokutarō[1] (1885–1945). *N.*: Kinoshita Mokutarō[2] (originally Ōta Masao).[3] **Biog.**: Painter. Born in Shizuoka-ken. A versatile man: doctor by profession, graduate of Tōkyō University Medical School; also known as a poet, playwright, and detective-story writer as well as a painter. Much interested in Chinese art; author of a book on Chinese sculpture.

[1]木下杢太郎 [2]木下杢太郎 [3]太田正雄

Kinoshita Takanori[1] (1894–). **Biog.**: Western-style painter. Born in Tōkyō. Studied at Kyōto University Law School as

well as in the Liberal Arts Department of Tōkyō University. Later turned to painting as a career. Went abroad twice, from 1921 to 1923 and from 1928 to 1935. Exhibited with the Nikakai, Shun'yōkai, and Bunten, serving as juror for the last in 1941. After 1945 an exhibitor and occasionally a juror at the Nitten. In 1926 took part in the establishment of the 1930 Association; in 1936 was one of the founders of the Issuikai. An academic painter. **Coll.**: Kanagawa, National (5). **Bib.**: Asano, NB (H) 24, NBZ 6.

<div align="center">¹木下孝則</div>

Kinoshita Yoshinori[1] (1898–). **Biog.**: Western-style painter. Born in Tōkyō. Younger brother of Kinoshita Takanori. Graduated from Tōkyō Technological College. Became interested in oil painting and went to Europe for study from 1928 to 1932. On returning to Japan, joined the Nikakai, in which he was a frequent exhibitor and prize winner. Withdrew from this society in 1936 to help found the Issuikai. After 1945, exhibitor with the Nitten and professor at Tōkyō Women's Art College. In 1950 received the Education Minister's Prize for Fostering the Arts. His style is one of detailed realism. **Bib.**: Asano, NBZ 6.

<div align="center">¹木下義謙</div>

Kinouchi Yoshi[1] (1892–). **Biog.**: Sculptor. Born in Mito. Pupil of Asakura Fumio. In 1921 to France for 15 years, studying at the Académie des Grandes-Chaumières and with Antoine Bourdelle and exhibiting at various salons. Returned to Japan; exhibited with the Nikakai. Member of Shinjukai. In 1951 won the Mainichi Art Prize and the first prize at the Gendai Nihon Bijutsuten. An exhibitor with the Bunten and the Teiten from 1916. Works in terra cotta in a style reminiscent of the School of Paris of the 1920s. Some influence from Maillol. **Coll.**: National (5). **Bib.**: Asano, GNB 28, NBT 10, Yanagi (1a).

<div align="center">¹木内克</div>

Kinryō[1] (?–1817). **N.**: Kaneko Inkei.[2] **A.**: Kunshō.[3] **Gō**: Jitsuutei,[4] Kinryō.[5] **Biog.**: *Nanga* painter. Lived in Edo. Pupil of Tani Bunchō, teacher of Watanabe Kazan. Good at *kachōga*. **Bib.**: Mitchell, Mody, Morrison 2, Yonezawa.

<div align="center">¹金陵 ²金子允圭 ³君璋 ⁴日雨亭 ⁵金陵</div>

Kinsui[1] (fl. early 19th c.). **N.**: Takakuwa Yokyō.[2] **A.**: Sadagorō.[3] **Gō**: Kinsui.[4] **Biog.**: Painter. Retainer of the daimyo of Kaga Province. **Bib.**: Mitchell.

<div align="center">¹錦水 ²高桑與共 ³定五郎 ⁴錦水</div>

Kintada (Kimitada)[1] (fl. c. 950). **N.**: Kose (originally Ki)[2] no Kintada (Kimitada).[3] **Biog.**: *Yamato-e* painter. Probably son of Kose no Aimi; pupil of Kose no Kanaoka. Known as one of the distinguished court painters of the Heian period. Said to have painted screens for the imperial palace. **Bib.**: Morrison 2.

<div align="center">¹公忠 ²紀 ³巨勢公忠</div>

Kinzan[1] (1733–1814). **N.**: Murai Chun.[2] **A.**: Dainen.[3] **Gō**: Chinju,[4] Kinzan.[5] **Biog.**: *Nanga* painter. Born in Kumamoto. Probably a self-taught artist. Specialized in landscapes and flower paintings. **Coll.**: Victoria.

<div align="center">¹琴山 ²村井枬 ³大年 ⁴椿寿 ⁵琴山</div>

Kirei[1] (1770–1835). **N.**: Kameoka Mitsushige.[2] **A.**: Shikyō.[3] **F.N.**: Kijūrō.[4] **Gō**: Kirei.[5] **Biog.**: Maruyama painter. Born and lived in Kyōto. One of Ōkyo's ten famous pupils. Specialized in *kachōga* and landscapes. **Bib.**: Hillier (4) 3, Tajima (3) 2.

<div align="center">¹規礼 ²亀岡光茂 ³子恭 ⁴喜十郎 (規十郎) ⁵規礼</div>

Kiritani (Kirigaya) Senrin[1] (1876–1932). **N.**: Kiritani (Kirigaya) Chōnosuke.[2] **Gō**: Senrin.[3] **Biog.**: Japanese-style painter. Born in Niigata-ken. To Tōkyō; studied first under Tomioka Eisen and later under Hashimoto Gahō. In 1907 graduated from the extension course in Japanese painting at the Tōkyō School of Fine Arts. In 1917 to India to study Buddhist images; returned in 1918. Good painter of Buddhist sub-

jects; also made some competent sketches of Indian landscapes.

<div align="center">¹桐谷洗鱗 ²桐谷長之助 ³洗鱗</div>

Kisan[1] (fl. late 16th c.). **Biog.**: Lacquerer. Specialized in *natsume,* serving as official lacquerer to Furuta Oribe, the great tea master. **Coll.**: Hatakeyama. **Bib.**: Fujioka.

<div align="center">¹記三 (紀三)</div>

Kishida Ryūsei[1] (1891–1929). **Biog.**: Western-style painter. Born in Tōkyō. Studied painting at the Hakubakai under Kuroda Seiki; while still young, exhibited with the Bunten. In 1912 helped found the short-lived avant-garde group Fusainkai; in 1914 one of the founders of the Nikakai, in 1915 of the Sōdosha. In 1922 became a member of the Shun'yōkai; an important figure in the Tōkyō art circles of his day. Best known for a series of portraits of his daughter Reiko, done between 1918 and 1924 as she was growing up; these are largely in an academic manner but with some influence from Derain. In his later years experimented with expressionism, Japanese-style painting, and ukiyo-e prints: an eclecticism typical of the period. **Coll.**: Bridgestone, Nagaoka, National (5), Ohara (1), Tōkyō (1). **Bib.**: Asano, Harada Minoru, *Kishida, Masterpieces* (4), Miyagawa, NB (H) 24, NBT 10, NBZ 6, NHBZ 7, NKKZ 5, SBZ 11, Sullivan.

<div align="center">¹岸田劉生</div>

Kishinami Hyakusōkyo[1] (1889–1952). **N.**: Kishinami Sadakazu.[2] **Gō**: Seizan;[3] later, Hyakusōkyo.[4] **Biog.**: *Nanga* painter. Born in Gumma-ken. Son and pupil of Kishinami Ryūkei. Later to Tōkyō, where he studied under Komuro Suiun. In 1906 exhibited with the Nihon Bijutsu Kyōkai, receiving third prize. After 1918 showed continuously with Bunten and Teiten, and, after 1925, with the Nangakai, of which he became a member in 1933. In 1921 to China; in 1929 to Europe for study. Particularly noted as a painter of fish; one of his scrolls, *Gyorui Zukan* (Catalogue of Fish), presented to Emperor Hirohito. **Bib.**: Asano.

<div align="center">¹岸浪百艸居 ²岸浪定司 ³静山 ⁴百艸居</div>

Kishinami Ryūkei[1] (1855–1935). **N.**: Kishinami Seishi (Seiji).[2] **Gō**: Ryūkei.[3] **Biog.**: *Nanga* painter. Born in Edo. Pupil of Tazaki Sōun. Member of Nihon Bijutsu Kyōkai and an able painter in the *nanga* tradition. **Coll.**: Victoria.

<div align="center">¹岸浪柳渓 ²岸浪静司 ³柳渓</div>

Kisuke (Kamesuke)[1] (fl. early 19th c.). **N.**: Toki Kisuke (Kamesuke).[2] **Studio name**: Kinkodō,[3] Tambaya.[4] **Gō**: Kasuke.[5] **Biog.**: Potter. As a young man, studied under a puppetmaker in the vicinity of Kyōto. Later became a pupil of Okuda Eisen. Invited to work at the Sanda kiln in the vicinity of Ōsaka and at Seto. Specialized in small celadon pieces, such as incense burners and figures of animals, known as Mitaseiji. Wrote a guide to pottery, *Tōki Shinan,* which was published in 1830. **Coll.**: Tōkyō (1). **Bib.**: GNB 19, NB (S) 71, NBZ 5.

<div align="center">¹亀祐 ²土岐亀祐 ³欽古堂 ⁴丹波屋 ⁵嘉介</div>

Kita Renzō[1] (1876–1949). **Biog.**: Western-style painter. Born in Gifu-ken. Studied first under Yamamoto Hōsui; later became a pupil of Kuroda Seiki. In 1898 graduated from Tōkyō School of Fine Arts. Member of Hakubakai. From 1910 to 1914 head of the stage-design department of the Teikoku Gekijō (Imperial Theater). In Europe from 1927 to 1930. Principal work: paintings in the Meiji Kaigakan. **Coll.**: National (5). **Bib.**: Asano, NB (H) 24, NBZ 6.

<div align="center">¹北蓮蔵</div>

Kita Takeshirō[1] (1897–1970). **N.**: Kita Takeshirō.[2] **Gō**: Jōjōshi,[3] Kansen.[4] **Biog.**: Sculptor. Studied at the Kawabata Gagakkō and under Tobari Kogan. Member of and exhibitor with the Nihon Bijutsuin. In 1959 received the Education Minister's Prize for Fostering the Arts. An academic style. **Bib.**: Asano.

<div align="center">¹喜多武四郎 ²喜多武四郎 ³茸茸子 ⁴寒泉</div>

Kitade Tōjirō[1] (1898–1969). **Biog.**: Potter. Born in Hyōgo-

ken. Graduated from Kansai University, then from Ōsaka Art School. Pupil of Itaya Hazan and Tomimoto Kenkichi; also studied old ceramic techniques. Professor at Kanazawa Junior Art School. A traditional craftsman, but his work is not without a certain freshness of spirit. **Bib.:** NBZ 6.

¹北出塔次郎

Kitagawa Tamiji[1] (1894–). **Biog.:** Painter, printmaker. Born in Shizuoka. In 1913 to United States; studied under John Sloan at the Art Students' League. Later to Mexico, studying at the Mexican Art School and teaching at various other art schools. Returned to Japan in 1936. From 1955 to 1956 in Mexico and Europe. Member of Nikakai. In 1964 won the Mainichi Art Prize. His oils, water colors, and prints are all much influenced by the Mexican school of the 20s and 30s. **Coll.:** National (5). **Bib.:** Asano, Kawakita (1), NBZ 6, NHBZ 8.

¹北川民次

Kitajima Sen'ichi[1] (1887–1948). Western-style painter. Born in Saga-ken. In 1912 graduated from the Tōkyō School of Fine Arts; in 1913 showed with the Bunten. In France from 1920 to 1922 exhibiting at the Salon d'Automne. In 1925 his show at the Teiten (of which he eventually became a member) received special mention. **Bib.:** Asano.

¹北島浅一

Kitamura Masanobu[1] (1889–). **Biog.:** Sculptor. Born in Niigata. Son and pupil of Kitamura Shikai; later studied under Shinkai Taketarō at the Taiheiyō Kenkyūsho. Exhibitor and prize winner at the Bunten; also showed at other official exhibitions. Served as juror for the Bunten and, in 1922, for the Teiten. After 1945 a juror for and member of the Nitten. A conservative artist, working generally in marble. **Coll.:** National (5). **Bib.:** Asano, NBZ 6.

¹北村正信

Kitamura Seibō[1] (1884–). **Biog.:** Western-style sculptor. Born in Nagasaki. Graduate of the Kyōto Technological College and, in 1912, of the Tōkyō School of Fine Arts. Later taught at both institutions. Also studied with Shirai Uzan. An exhibitor and prize winner at the Bunten; later an exhibitor at the Teiten and Nitten. Member of the Japan Art Academy. In 1958 received Order of Cultural Merit. His monumental "Peace Statue" in the International Peace Park in Nagasaki is in the manner of Bourdelle. **Coll.:** National (5). **Bib.:** Asano, GNB 28, NBZ 6.

¹北村西望

Kitamura Shikai[1] (1871–1927). **Biog.:** Sculptor. Born in Nagano. From childhood engaged in family profession of decorating temples and shrines, an occupation requiring some sculptural skill. In 1893 became a pupil of the ivory carver Shimamura Toshiaki; then, under the influence of Ogura Sōjirō and Shinkai Taketarō, turned to Western-style sculpture. In 1900 to France, where he studied for a year. Exhibitor at the Bunten, teacher at the Taiheiyō Kenkyūsho. Specialized in marble carving, working in an academic style with some influence from Rodin. **Coll.:** National (5). **Bib.:** Asano, GNB 28.

¹北村四海

Kitani Chigusa[1] (1890–1947). **Biog.:** Japanese-style painter. She was a pupil of Kitano Tsunetomi. Later established the Chigusakai, teaching many students. Exhibited with both the Bunten and Teiten. An able painter of *bijin*.

¹木谷千種

Kitano Tsunetomi[1] (1880–1947). *N.:* Kitano Tomitarō.[2] *Gō:* Tsunetomi,[3] Yosamean.[4] **Biog.:** Japanese-style painter. Born in Kanazawa; worked in Ōsaka. Pupil of Ineno Toshitsune. An exhibitor with the Bunten, winning a prize in 1911; then with the Inten, of which he became a member in 1917. Painted the *bijin* of the Meiji and Taishō eras in a Japanese manner with some slight Western influences. **Coll.:** National (5), Ōsaka (2). **Bib.:** Asano, Kondō (6), NBZ 6.

¹北野恒富 ²北野富太郎 ³恒富 ⁴夜雨庵

Kitaōji Rosanjin[1] (1883–1959). *N.:* Kitaōji Fusajirō.[2] *Gō:* Rosanjin.[3] **Biog.:** Painter, potter, lacquerer. Also calligrapher, engraver of seals, collector, gourmet. Born in Kyōto to a family serving the Kamigamo Shrine. A troubled childhood, but by 20 an acknowledged master of archaic Chinese seal characters and something of a calligrapher. In 1915 learned pottery making at Kanazawa from Seika Suda. In 1917 moved to Kita Kamakura, where he lived for the rest of his life and where he had his kiln. From 1925 to 1936 ran the Hoshigaoka restaurant in Sannō, Tōkyō—a gourmet center for government and financial leaders—making the pottery used there. Said that dishes were "the kimonos of good food." In 1954 toured the world, exhibiting in Europe and America. In pottery, worked in the manner of the Shino, Seto, Oribe, Bizen, Shigaraki, Karatsu, and Iga potters as well as that of Kenzan. Produced porcelains in manner of Ming blue-and-white and *aka-e*. One of the great traditional potters of his day, member of no school or group. His work, however, not an academic copy but the expression of his extraordinary and eccentric personality. Signed almost all his pieces except the tea-ceremony bowls. **Coll.:** Art (1), (1a); Fine (De Young); Metropolitan; Museum (3); National (4), (5); Newark; Ōstasiatiska; Philadelphia; Seattle. **Bib.:** *Ceramic* (2), FC 6, *Japanese* (1a), KO 2, Koyama (1), Lee (3), *Masterpieces* (4), Munsterberg (2), NB (H) 24, NBT 6, NBZ 6, Okuda (2), *Rosanjin*, STZ 16.

¹北大路魯山人 ²北大路房次郎 ³魯山人

Kitawaki Noboru[1] (1901–51). **Biog.:** Western-style painter. Born in Nagoya. Moved to Kyōto as a young man; studied Western-style painting under Kanokogi Takeshirō and, later, under Tsuda Seifū. First exhibited with the Nikakai in 1932, receiving special recognition. Also showed with the Dokuritsu Bijutsukai and the Modern Art Kyōkai. In 1939 served as a founding member of the Bijutsu Bunka Kyōkai. Very active in Kyōto avant-garde art circles. Since he had learned something of the fauve style in his student days, his work became more contemporary than that of his academic teachers; at times almost surrealistic. **Coll.:** Kyōto (1), National (5). **Bib.:** Asano, NB (H) 24, NBZ 6, SBZ 11.

¹北脇昇

Kitazawa Rakuten[1] (1876–1955). *N.:* Kitazawa Yasuji.[2] *Gō:* Rakuten.[3] **Biog.:** Painter, cartoonist. Born in Tōkyō. Graduated from Taikōkan Art Institute. In 1905 began to edit a magazine of cartoons, which became a forerunner of modern comic books. Later worked for Jiji Shimpō Press. From 1927 to 1929 studied the art of the cartoon in France and exhibited in London. President of Japan Cartoon Society. **Bib.:** Asano.

¹北沢楽天 ²北沢保次 ³楽天

Kitō Kamejirō[1] (1897–1952). **Biog.:** Western-style painter. Born in Nagoya, where he studied Western-style painting. Exhibited with the Inten. To France 1923–28. A member of the Shun'yōkai from 1926 to 1934; then showed with the Shin Bunten. **Bib.:** Asano.

¹鬼頭甕二郎

Kitō Nabesaburō[1] (1899–). **Biog.:** Western-style painter. Resident of Nagoya. Pupil of Okada Saburōsuke and Tsuji Hisashi. Showed at government exhibitions and, after 1945, with the Nitten, of which he became a member. Also joined the Kōfūkai, winning a prize from it in 1927. In 1955 awarded the Japan Art Academy Prize. In 1963 became a member of the Nihon Geijutsuin. His style is academic. **Coll.:** National (5). **Bib.:** Asano.

¹鬼頭鍋三郎

Kitsukawa Reika[1] (1875–1929). *N.:* Kitsukawa Hitoshi.[2] *F.N.:* Saburō.[3] *Gō:* Reika.[4] **Biog.:** Japanese-style painter. Lived in Tōkyō. Studied first under a minor Kanō artist, then with Yamana Tsurayoshi. Later studied the *yamato-e* style of Tamechika by himself, establishing his own quite individual manner. Exhibited with the Bunten and the Teiten, serving

as juror for the latter's exhibitions. Member of the Kinreisha, associate member of the Imperial Fine Arts Academy. Painted scenes from Japanese history and legends, rendering them with a fine line and in light color. **Bib.:** Asano, NB (H) 24, NBZ 6, SBZ 11.

¹吉川霊華　²吉川準　³三郎　⁴霊華

Kiyobei (Seibei)[1] (fl. first half 18th c.). *N.:* Ebiya Kiyobei.[2] *Gō:* Ebikiyo,[3] Ebisei.[4] **Biog.:** Potter. Member of the Kyōto ceramic world. His name is well known, but his works cannot be identified. Teacher of Rokubei. **Bib.:** Jenyns (1).

¹清兵衛　²海老屋清兵衛　³海老清　⁴海老清

Kiyochika[1] (fl. c. 1751). *N.:* Torii Kiyochika.[2] **Biog.:** Ukiyo-e printmaker. Pupil of Torii Kiyomitsu. **Coll.:** Minneapolis.

¹清近　²鳥居清近

Kiyohara Sei[1] (1896–1956). *N.:* Kiyohara Hitoshi.[2] *Gō:* Sei,[3] Sei Sōjin.[4] **Biog.:** Japanese-style painter. Born to a rich farmer in Ibaraki-ken. Graduated from Mito Middle School. Then to Tōkyō to become a pupil of Matsumoto Fūko. On Fūko's death in 1923 worked under various painters such as Imamura Shikō, Hayami Gyoshū, and Omoda Seiju. Later became a pupil of Katayama Nampū. Exhibited several times with Inten, winning prizes, and became a member in 1956. Received the Taikan-shō (a prize given in the name of Yokoyama Taikan) three times.

¹清原斉　²清原斉　³斉　⁴斉草人

Kiyohara Tama[1] (1861–1939). *N.:* Kiyohara Tama.[2] *Gō:* Eleonora Ragusa. **Biog.:** Western-style painter. Born in Tōkyō. Lived first in Italy, then in Tōkyō. First studied Japanese-style painting; then Western-style painting under Vincenzo Ragusa, whose surname she took as part of her *gō.* Traveled in Italy, living for a while at Palermo. Won first prize at a Venice Biennale. Specialized in still lifes.

¹清原玉　²清原玉

Kiyoharu[1] (fl. 1700–1730). *Gō:* Kiyoharu,[2] Ryūsōshi.[3] **Biog.:** Ukiyo-e painter. His name is known only from signatures on paintings. It has been thought possible that he is the same artist as Kondō Kiyoharu (q.v.). Style close to that of Torii Kiyonobu. **Bib.:** Hillier (3), (4) 1; Jenkins.

¹清春　²清春　³流草子

Kiyoharu[1] (fl. 1700–1730). *N.:* Torii Kiyoharu.[2] **Biog.:** Ukiyo-e painter, printmaker. Sometimes confused with Kondō Kiyoharu and Ryūsōshi Kiyoharu (q.v.). Thought to have been a pupil of Torii Kiyonobu. His prints of *bijin* and actors, often in the *hosoban* format and with lacquer added, are in the Torii style. **Bib.:** Hillier (4) 1.

¹清春　²鳥居清春

Kiyoharu[1] (fl. c. 1704–20). *N.:* Kondō Kiyoharu.[2] *F.N.:* Sukegorō.[3] **Biog.:** Ukiyo-e painter, printmaker. Also a writer. Possibly one of three artists, all working at the same time, using the name Kiyoharu. (See Ryūsōshi Kiyoharu and Torii Kiyoharu above). Some art historians have sought to identify this artist with Torii Kiyoharu, but no proof for this exists. May have been a pupil of Torii Kiyonobu. His paintings, which are quite rare, are generally of *bijin.* Probably best known as an illustrator of books. **Coll.:** Allen, Art (1). **Bib.:** Gunsaulus (1), Hillier (4) 1, Jenkins, Kurth (4), Lane, Morrison 2, Stern (2).

¹清春　²近藤清春　³助五郎

Kiyohiro[1] (fl. 1737–76). *N.:* Torii Kiyohiro.[2] *F.N.:* Shichinosuke.[3] **Biog.:** Ukiyo-e printmaker. A distinguished member of the Torii school, even though there is considerable confusion about his identity. Nothing is known of his life, or even his real name, and the guesses as to his master include Kiyonobu II, Kiyomasu II, and Kiyomitsu. Specialized in prints of actors and of young men and women in genre scenes done with considerable charm and freshness, in a style close to that of Toyonobu and Kiyomitsu. Made both small and large prints, the latter quite striking but all rather rare. Most active in the 1750s and 1760s. Almost all his best prints are *benizuri-e,* but also made two- and three-

color prints. **Coll.:** Allen, Art (1), Ashmolean, British, Brooklyn, Cincinnati, Denver, Grunwald, Honolulu, Metropolitan, Minneapolis, Musée (2), Musées, Nelson, Newark, Östasiatiska, Portland, Riccar, Rietberg, Staatliche, Tōkyō (1), Victoria, Worcester, Yale. **Bib.:** Binyon (1), (3); Boller; Crighton; Fujikake (3) 2; Ficke; GNB 17; Gunsaulus (1); Hillier (7), (9); Kikuchi, *Kunst;* Ledoux (4); Michener (1), (3); Narazaki (2); NHBZ 2; Schmidt; Shibui (1); Stern (2); Takahashi (2), (6) 1; UG 28; Waterhouse.

¹清広　²鳥居清広　³七之助

Kiyohisa[1] (fl. c. 1764–72). *N.:* Torii Kiyohisa.[2] **Biog.:** Ukiyo-e printmaker. Pupil of Kiyonaga and Kiyomitsu. Nothing known of his life. Specialized in *beni-e* of actors and theatrical scenes. **Coll.:** Allen, Kōbe. **Bib.:** Binyon (3), Ficke, Morrison 2, *Pictorial* (2) 4.

¹清久　²鳥居清久

Kiyokuni[1] (fl. 1818–30). *Gō:* Jushodō,[2] Kiyokuni.[3] **Biog.:** Ukiyo-e printmaker. Pupil of Toyokawa Yoshikuni. Made *ōkubi-e* of actors in the Ōsaka special manner of *kappa-suri.*

¹清國　²寿曙堂　³清國

Kiyokuni[1] (fl. 1831–55). *N.:* Torii Kiyokuni.[2] **Biog.:** Ukiyo-e printmaker. Second son of Torii Kiyomitsu II. **Coll.:** Musées, Victoria.

¹清國　²鳥居清國

Kiyomasa[1] (fl. 1789–1800). *N.:* Torii Kiyomasa.[2] *F.N.:* Tamekichi.[3] **Biog.:** Torii printmaker. Details of his life unknown save that he was a pupil of Torii Kiyonaga. His prints of *bijin* are quite rare. **Coll.:** Ashmolean, Kanagawa, Musées. **Bib.:** NHBZ 3.

¹清政　²鳥居清政　³為吉

Kiyomasu[1] (fl. c. 1696–1716). *N.:* Torii Kiyomasu.[2] *F.N.:* Shōjirō.[3] **Biog.:** Ukiyo-e printmaker. There has been some tendency to confuse this Kiyomasu with Torii Kiyonobu, some scholars saying that Kiyonobu used this name after 1714, but he is now generally thought to have been either the eldest son, or a younger brother, of Kiyonobu. Obviously talented and apparently died young. Illustrated books and albums and designed prints of actors, courtesans, theatrical scenes, legendary subjects, and birds and flowers. His style very close—at times almost indistinguishably so—to that of Kiyonobu, but more subtle and graceful and without some of the vigor. **Coll.:** Allen, Art (1), British, Cincinnati, Fitzwilliam, Fogg, Honolulu, Kanagawa, Metropolitan, Minneapolis, Musée (2), Museum (3), Österreichisches, Portland, Riccar, Rietberg, Staatliche, Tōkyō (1), Victoria, Worcester, Yale. **Bib.:** Binyon (1); Crighton; Fontein (1); Fujikake (3) 2; Gentles (2); GNB 17, 24; Gunsaulus (1); Hillier (1), (7), (9); *Images;* Jenkins; Kikuchi; *Kunst;* Lane; Ledoux (4); Michener (3); Morrison 2; Narazaki (2); NBT 5; NHBZ 2; *Nikuhitsu* (2); SBZ 9; Schmidt; Shibui (1); Stern (2); Tajima (7) 3; Takahashi (5); UG 19; *Ukiyo-e* (3) 2; Vignier 1.

¹清倍　²鳥居清倍　³圧二郎

Kiyomasu II[1] (1706–63). *N.:* Torii Kiyomasu.[2] *F.N.:* Hanzaburō.[3] **Biog.:** Ukiyo-e painter, printmaker. There are two theories about this artist. The most generally accepted is that he and Kiyonobu II (q.v.) are the same person: a son of Kiyonobu who, on his father's death in 1729, assumed his name. The other is that he was the adopted son-in-law of Kiyonobu and on his father-in-law's retirement in 1727 took his name. There are numerous prints, almost all of actors and theatrical scenes, carrying both names and all produced between 1728 and 1752. A skilled but uneven printmaker of *tan-e, urushi-e,* and *beni-e,* but his compositions are generally trite and uninteresting. **Coll.:** Art (1), British, Brooklyn, Fitzwilliam, Grunwald, Honolulu, Metropolitan, Musei (1), Museum (1), Nelson, Newark, Östasiatiska, Portland, Rhode Island, Riccar, Rietberg, Staatliche, Tōkyō (1), Worcester, Yale. **Bib.:** Crighton; Ficke; Gunsaulus (1); Hillier (1), (7);

Kunst; Kurth (4); Lane; Ledoux (4); Michener (3); NHBZ 2; Schmidt; Shibui (1); Stern (2); Waterhouse.

¹清倍二代 ²鳥居清倍 ³半三郎

Kiyomitsu¹ (1735–85). *N.:* Torii Kiyomitsu.² *F.N.:* Kamejirō.³ **Biog.:** Ukiyo-e painter, printmaker. Lived in Edo. Son and pupil of Kiyonobu II; third of the Torii line and most prominent print designer until eclipsed by Harunobu. Like all the Torii artists, specialized in scenes from plays and pictures of actors and *bijin;* the last are often depicted in or coming from the bath, and the prints are usually accompanied by poems. Also an illustrator of theater programs and novels. Work prolific, variable in quality; some particularly effective *hashira-e*. His production mostly in two or three colors, though there are some few polychrome prints, a technique in which he was a pioneer. Much of his work monotonous and fussy. **Coll.:** Allen; Art (1); Ashmolean; British; Cincinnati; City; Cleveland; Denver; Fine (California); Fitzwilliam; Honolulu; Kōbe; Metropolitan; Minneapolis; Musée (2); Musées; Museum (1), (3); Nelson; Newark; Östasiatiska; Portland; Rhode Island; Riccar; Rietberg; Staatliche; Tōkyō (1); Victoria; Worcester; Yale. **Bib.:** Binyon (1), (3); Crighton; Ficke; Fujikake (3) 2; GNB 17; Gunsaulus (1); Hillier (7); K 396; Kikuchi; *Kunst;* Lane; Ledoux (4); Michener (3); Morrison 2; Narazaki (2); NBZ 5; NHBZ 2, 3; *Pictorial* (2) 4; Schmidt; Shibui (1); Stern (2); Tajima (7) 3; Takahashi (2), (5); *Ukiyo-e* (3) 6; Waterhouse.

¹清満 ²鳥居清満 ³亀次郎

Kiyomitsu II¹ (1787–1868). *N.:* Torii Kiyomitsu.² *F.N.:* Shōnosuke.³ *Gō:* Kiyomine,⁴ Seiryūken.⁵ **Biog.:** Ukiyo-e painter, printmaker. Grandson of Torii Kiyomitsu; fifth in the Torii line. Lived in Edo; pupil of Torii Kiyonaga. As a young man, made prints under *gō* of Kiyomine; these are generally considered his best work. His subject chiefly *bijin,* actors, and scenes from plays. Later works carry name of Kiyomitsu II. **Coll.:** Allen, Brooklyn, Honolulu, Musées, Östasiatiska, Rhode Island, Riccar, Staatliche, Tōkyō (1), Victoria. **Bib.:** Crighton; Ficke; Hillier (7); Kikuchi; Morrison 2; NHBZ 3; Schmidt; Stewart; Takahashi (2), (6) 9; Tamba (2a); UG 28.

¹清満二代 ²鳥居清満 ³庄之助 ⁴清峯 ⁵清竜軒

Kiyomitsu III¹ (1832–92). *N.:* Torii Kiyoyoshi.² *F.N.:* Kameji;³ later, Eizō.⁴ *Gō:* Kiyomitsu.⁵ **Biog.:** Ukiyo-e painter, printmaker. Born in Edo; son of Torii Kiyomitsu II. After his father's death in 1868 succeeded to his position, becoming sixth-generation head of the Torii family and calling himself Kiyomitsu III. Specialized in portraits of actors and genre scenes. **Bib.:** Asano.

¹清満三代 ²鳥居清芳 ³亀二 ⁴栄蔵 ⁵清満

Kiyomoto¹ (1645–1702). *N.:* Torii (originally Kondō)² Shōshichi.³ *Gō:* Kiyomoto.⁴ **Biog.:** Painter. Lived first in Ōsaka, then in Edo, where he died. An actor of women's roles in the Ōsaka theater, playing under the name of Torii Shōshichi; perhaps also a painter of theatrical signs. In 1687 moved to Edo. Unsuccessful on the stage, took name of Kiyomoto and became a flourishing painter of theatrical signs. Best known, however, as the father and teacher of Kiyonobu and hence founder of the Torii line of printmakers and the source of its close connection with the theater. No known work survives. **Bib.:** Binyon (1), (3); Michener (1); Morrison 2; NHBZ 2; *Nikuhitsu* (2); Tajima (7) 3.

¹清元 ²近藤 ³鳥居庄七 ⁴清元

Kiyonaga¹ (1752–1815). *N.:* Torii (originally Sekiguchi)² Shinsuke.³ *F.N.:* Ichibei.⁴ *Gō:* Kiyonaga.⁵ **Biog.:** Ukiyo-e painter, printmaker. Born in Uraga, son of a bookseller and publisher. To Edo in 1765; became a pupil of Torii Kiyomitsu. On the death of his teacher, was adopted by the Torii family, inheriting the estate and becoming the last major member of the Torii school. From 1781 to 1788 the great ukiyo-e master; a tremendous influence on all artists of the

last 15 years of the 18th century. It seems that about 1790 he gave up print designing but continued to paint. Great originality as a draftsman and colorist. An enormous number of prints, generally of *bijin* or stylish young men shown in the teahouses, shops, and streets of Edo but also of actors together with their accompanying artists such as musicians and chanters. His prints well designed, with calm, graceful figures; the carefully rendered details of the interiors give a good picture of late-18th-century Edo life. Considerable influence from Harunobu, Koryūsai, and Shigenaga. **Coll.:** Albertina; Allen; Andrew; Art (1), (1a); Ashmolean; Atami; British; Brooklyn; Cincinnati; City; Cleveland; Denver; Detroit; Fine (California); Fitzwilliam; Fogg; Freer; Grunwald; Herron; Honolulu; Kōbe; Metropolitan; Minneapolis; Musée (1), (2); Musées; Museum (1), (3); Nelson; Newark; Östasiatiska; Österreichisches; Philadelphia; Portland; Rhode Island; Riccar; Rietberg; Rijksmuseum (1); Staatliche; Suntory; Tōkyō (1); Toledo; University (2); Victoria; Worcester; Yale. **Bib.:** Binyon (1), (3); Blunt; Boller; Crighton; Fontein (1); Fujikake (3) 3; Gentles (2); GNB 17, 24; Hillier (1), (3), (4) 1, (7), (9); Hirano; *Japanese* (1a); K 300, 456, 509; Kikuchi; KO 35; *Kunst;* Lane; Ledoux (4); Lee (2); M 71; Meissner; Michener (3); Mizoguchi; Mizuo (3); Morrison 2; Narazaki (2), (8), (13); NBT 5; NBZ 5; NHBZ 3; *Nikuhitsu* (1) 2; Noma (1) 2; *Pictorial* (2) 4; SBZ 10; Schmidt; Shibui (1); Shimada 3; Stern (2), (4); Tajima (7) 3, (13) 6; Takahashi (2), (5), (6) 5; Tamba (2a); UG 9, 28; *Ukiyo-e* (2) 4, (3) 9; Vignier 3.

¹清長 ²関口 ³鳥居新助 ⁴市兵衛 ⁵清長

Kiyonobu¹ (1664–1729). *N.:* Torii Kiyonobu.² *F.N.:* Shōbei.³ **Biog.:** Ukiyo-e painter, printmaker. Son of Torii Kiyomoto. Born in Ōsaka; in 1687 moved to Edo with his father, whose pupil he was. Much influenced by Hishikawa Moronobu and the Kaigetsudō. With the family tradition as painters of Kabuki posters, it is natural that his prints, black-lined and hand-colored, are largely of scenes from plays and of actors. Regarded as the founder of the Torii school, with its close relationship to the theater, which dominated the print field for nearly 75 years until the appearance of Katsukawa Shunshō. In 1700 published two great books of prints: *Fūryū Yomo no Byōbu* and *Keisei Ehon.* His paintings are very rare. His style, noted for its dramatic and powerful sweep of line, was particularly suited to the *kamban.* **Coll.:** Allen, Art (1), Ashmolean, Atami, Baltimore, British, Brooklyn, Chōfuku-ji, Freer, Honolulu, Kanagawa, Kotohira, Metropolitan, Musée (2), Musées, Museum (3), Nelson, Newark, Östasiatiska, Österreichisches, Philadelphia, Portland, Rhode Island, Riccar, Rietberg, Staatliche, Tōkyō (1), Victoria, Worcester, Yale. **Bib.:** Binyon (1), (3); Brown; Crighton; Fujikake (3) 2; Gentles (2); GNB 24; Hillier (1), (7); Jenkins; K 390, 418, 669, 683; Kikuchi; Kondō (1), (7); *Kunst;* Kurth (4); Lane; Ledoux (4); M 146; Michener (3); Morrison 2; Narazaki (2), (8); NHBZ 2; *Nikuhitsu* (1) 1; SBZ 9; Schmidt; Shibui (1); Shimada 3; Stern (2), (4); Tajima (7) 3, (12) 20; Takahashi (2), (5), (6) 1; UG 19; *Ukiyo-e* (3) 2; Vignier 1.

¹清信 ²鳥居清信 ³庄兵衛

Kiyonobu II¹ (1706–63). *N.:* Torii Kiyonobu.² *F.N.:* Shōbei.³ **Biog.:** Ukiyo-e printmaker. According to one theory, the same artist as Kiyomasu II (q.v.), but prints exist under both names, and he is generally thought to have been the son of Kiyonobu who, on his father's death in 1729, took his name. Became titular head of the Torii school in 1750; is said to have retired in 1752 as a printmaker. A skillful artist producing prints of actors and theatrical scenes in *tan-e, urushi-e,* and *beni-e;* his compositions often banal and uninteresting. **Coll.:** Art (1), British, Honolulu, Kanagawa, Metropolitan, Nelson, Östasiatiska, Philadelphia, Riccar, Rietberg, Staatliche, Tōkyō (1), Worcester. **Bib.:** Binyon (3); Gunsaulus (1); Hillier (7); *Images;* Jenkins; *Kunst;* Lane;

Ledoux (4); Michener (3); NHBZ 2; Schmidt; Shibui (1); Stern (2); Takahashi (2), (5); Waterhouse.

¹清信二代　²鳥居清信　³庄兵衞

Kiyosato¹ (fl. c. 1760). *N.:* Torii Kiyosato.² **Biog.:** Ukiyo-e printmaker. Pupil of Torii Kiyomitsu. His *hosoban* actor prints in *benizuri-e* are very rare. **Coll.:** Art (1), Riccar, Tōkyō (1). **Bib.:** Gunsaulus (1), Kikuchi.

¹清里　²鳥居清里

Kiyoshige¹ (fl. 1720–60). *N.:* Torii Kiyoshige.² *Gō:* Seichōken.³ **Biog.:** Ukiyo-e painter, printmaker. Lived in Edo; pupil of Torii Kiyonobu, influenced by Okumura Masanobu. Specialized in *bijinga* and actor prints; also produced illustrations for *kibyōshi* and *kuro-hon* ("yellow" and "black" books). His earlier prints are hand-colored; the later ones printed in two colors. There are also some powerful actor prints done in ink outline alone or with boldly dramatic hand coloring. A strong yet graceful quality marks his work. **Coll.:** Allen, Art (1), Atami, Honolulu, Metropolitan, Rhode Island, Riccar, Rietberg, Staatliche, Tōkyō (1), Worcester. **Bib.:** Boller, Binyon (3), Ficke, Fujikake (3) 2, Gunsaulus (1), Hillier (7), Kikuchi, *Kunst,* Michener (3), NHBZ 2, Schmidt, Shibui (1), Stern (2).

¹清重　²鳥居清重　³清朝軒

Kiyosuke¹ (fl. 1716–35). *N.:* Somada (Somata) Seisuke.² **Biog.:** Lacquerer. Lived in Etchū Province. Appointed *makie-shi* by the lord of Toyama. Specialized in a technique involving inlay of nacre which came to be known as *aogaizaiku;* eventually the name Somada came to be widely accepted as a term for *aogai* wares. Kiyosuke was the first of several generations to use this name. **Coll.:** Museum (3). **Bib.:** Casal, Herberts, Jahss, Ragué Sawaguchi.

¹清輔　²杣田清輔

Kiyotada¹ (fl. c. 1720–50). *N.:* Torii Kiyotada.² **Biog.:** Ukiyo-e painter, printmaker. Lived and worked in Edo. Said to have been a pupil of Torii Kiyonobu; one of best followers of the early Torii school; his work also influenced by Okumura Masanobu. His drawing is noted for its clarity and crispness. **Coll.:** Allen, Art (1), Atami, British, Honolulu, Idemitsu, Kōbe, Metropolitan, Riccar, Staatliche, Tōkyō (1), Victoria. **Bib.:** Binyon (1), (3); Ficke; Fujikake (3) 2; Gunsaulus (1); Hillier (1), (4) 1, (7); *Images;* Jenkins; Kikuchi; *Kunst;* Kurth (4); Ledoux (4); Michener (3); Morrison 2; NHBZ; *Pictorial* (2) 4; Schmidt; Shibui (1); Stern (2); UG 28.

¹清忠　²鳥居清忠

Kiyotada II¹ (fl. early 19th c.). *N.:* Torii (originally Yamaguchi)² Kiyotada.³ *F.N.:* Zen'emon.⁴ **Biog.:** Ukiyo-e printmaker. A pharmacist by profession, printmaker by avocation. Pupil of Torii Kiyonaga.

¹清忠二代　²山口　³鳥居清忠　⁴善右衞門

Kiyotada III¹ (fl. 1817–25). *N.:* Torii (originally Yamaguchi)² Kiyotada.³ *F.N.:* Zen'emon.⁴ *Gō:* Sanreidō.⁵ **Biog.:** Ukiyo-e printmaker. Born in Edo; son of Kiyotada II. Pupil of Kiyomitsu II. Sold the pharmacy business inherited from his father and became a printmaker, specializing in actor prints and *kamban.* Also a calligrapher. **Bib.:** Morrison 2.

¹清忠三代　²山口　³鳥居清忠　⁴善右衞門　⁵三礼堂

Kiyotomo¹ (fl. 1720–40). *N.:* Torii Kiyotomo.² **Biog.:** Ukiyo-e printmaker. Worked in Edo. Probably a pupil of Torii Kiyonobu; produced good hand-colored actor prints in the Torii tradition. **Coll.:** Art (1), Honolulu, Rhode Island, Rietberg, Tōkyō (1). **Bib.:** Binyon (3), Ficke, Gunsaulus (1), Hillier (7), Jenkins, Kikuchi, Kurth (4), Lane, Michener (3), Morrison 2, NHBZ 2, Shibui (1).

¹清朝　²鳥居清朝

Kiyotsune¹ (fl. 1757–79). *N.:* Torii Kiyotsune.² *F.N.:* Nakajimaya Daijirō.³ **Biog.:** Ukiyo-e printmaker, illustrator. Born in Edo; son of a publisher of theatrical programs. Pupil of Torii Kiyomitsu, influenced by Harunobu. Special-

ized in theatrical prints, with slender graceful figures. At first worked in two or three colors; after 1764, adopted full-color printing. **Coll.:** Allen, Art (1), Ashmolean, Baltimore, British, Brooklyn, Detroit, Honolulu, Kōbe, Musées, Nelson, Newark, Östasiatiska, Portland, Riccar, Rietberg, Tōkyō (1), University (2), Worcester. **Bib.:** Binyon (1), (3); Ficke; Fujikake (3) 2; Gunsaulus (1); Hillier (7); Kikuchi; Ledoux (4); Morrison 2; NHBZ 2; *Nikuhitsu* (2); *Pictorial* (2) 4; Stern (2); UG 28; *Ukiyo-e* (3) 8; Waterhouse.

¹清経　²鳥居清経　³中島屋大次郎

Kō¹ (fl. mid-19th c.). *N.:* Kinoshita Kō.² *F.N.:* Yūnosuke.³ *Gō:* Shōritsu,⁴ Shūtō.⁵ **Biog.:** Nagasaki painter. Adopted son of Kinoshita Itsuun. Pupil of Ishizaki Yūshi; also studied Chinese painting of the Ch'ing period. **Coll.:** Victoria. **Bib.:** Mitchell.

¹衡　²木下衡　³勇之助　⁴小笠　⁵秋塘

Kōami¹ (fl. 15th to 20th c.). A family of lacquer artists, working first in Kyōto as court lacquerers and then, from the time of Chōjū (1599–1621) until 1723, in Edo under the patronage of the shogunate. Said to have been the first to make use of painters' designs for their work, which is generally *takamakie* in the classical style. For starred names among the following, see individual entries. See also Chōgen (1572–1607).

*Kōami I: Dōchō (Michinaga)² (1410–78)
*Kōami II: Dōsei (Michikiyo)³ (1432–1500)
*Kōami III: Sōzen⁴ or Sōkin (Munekane)⁵ (1452–1527)
*Kōami IV: Sōshō (Sōsei, Munemasa)⁶ (1479–1553)
*Kōami V: Sōhaku (Munenori)⁷ (1484–1557)
*Kōami VI: Chōsei (Nagakiyo)⁸ (1529–1603)
*Kōami VII: Chōan (Nagayasu)⁹ (1569–1610)
*Kōami VIII: Chōzen (Nagayoshi)¹⁰ (1589–1613)
*Kōami IX: Chōhō (Naganori)¹¹ (?–1622)
*Kōami X: Chōjū (Nagashige)¹² (1599–1651)
*Kōami XI: Chōhō (Nagafusa)¹³ or Chōan¹⁴ (1628–82)
*Kōami XII: Chōkyū (Nagasuku)¹⁵ or Chōkō (Nagayoshi)¹⁶ or Chōdō (Nagamichi)¹⁷ (1661–1723)
Kōami XIII: Shōhō (Masamine)¹⁸ (fl. 18th c.)
Kōami XIV: Dōgai¹⁹ (fl. 18th c.)
Kōami XV: Chōkō (Nagataka)²⁰ or Nagayoshi²¹ (fl. late 18th c.)
Kōami XVI: Chōshū (Nagachika)²² or Chōin (Nagamoto)²³ (fl. 18th c.)
Kōami XVII: Chōki (Nagateru)²⁴ (fl. 19th c.)
Kōami XVIII: Chōkō (Chōgyō, Nagayuki)²⁵ (fl. 19th c.)
Kōami XIX: Chōken (Nagataka)²⁶ (fl. 19th c.)

Bib.: BK 98, Casal, Herberts, Jahss, Noma (1) 2, Ragué, Sawaguchi, Speiser (2).

¹幸阿弥　²道長　³道清　⁴宗全　⁵宗金　⁶宗正　⁷宗伯　⁸長清　⁹長晏　¹⁰長善　¹¹長法　¹²長重　¹³長房　¹⁴長安　¹⁵長好　¹⁶長好　¹⁷長道　¹⁸正峰　¹⁹道該　²⁰長孝　²¹長好　²²長周　²³長因　²⁴長輝　²⁵長行　²⁶長賢

Kobayakawa Kiyoshi¹ (1897–1948). **Biog.:** Japanese-style painter. Born in Fukuoka. Pupil of Kaburagi Kiyokata. In 1924 exhibited with Teiten for first time; continued as a regular exhibitor with this group. Member of Nihongakai. Specialized in *bijinga.* **Coll.:** Museum (3), National (5). **Bib.:** Asano, Fujikake (1).

¹小早川清

Kobayashi Kahaku¹ (1895–1943). *N.:* Kobayashi Shigeo.² *Gō:* Kahaku.³ **Biog.:** Japanese-style painter. Born in Ōsaka. In 1911 to Tōkyō to study under Imamura Shikō; after his teacher's death, worked under Yasuda Yukihiko. His work accepted for exhibition in 1918 at the Inten; became a member in 1924. Also showed with the Bunten and the Teiten. His carefully painted pictures are pleasantly decorative. **Coll.:** National (5). **Bib.:** Asano.

¹小林柯白　²小林茂雄　³柯白

Kobayashi Kanji¹ (1892–). **Biog.:** Japanese-style painter. Born in Nagasaki-ken. Graduated from the Kyōto College

of Fine Arts; then studied with Araki Juppo. Showed at various government exhibitions. **Coll.**: National (5). **Bib.**: Asano.

[1]小林観爾
Kobayashi Kiyochika[1] (1847–1915). **Biog.**: Ukiyo-e painter, printmaker. Born in Edo; son of a minor government official. Studied Western oil painting under Charles Wirgman, Japanese-style painting with Kawanabe Kyōsai and Shibata Zeshin. Influenced by imported lithographs and etchings, turned to woodblock printing. Had a considerable success, particularly between 1876 and 1881, but after 1881 the style in which he worked lost its popularity. Also a book, magazine, and newspaper illustrator; reported and depicted the Sino-Japanese War of 1894–95. In his prints, produced views of contemporary Tōkyō as it changed under the impact of Western influences as well as landscapes and *kachōga* in a style that combined the Japanese and the Western manners: ukiyo-e in subject matter and color; Western in perspective, source of light, and shading. Although he was unable to revitalize the ukiyo-e style, he is considered the last of the important ukiyo-e printmakers. **Coll.**: Allen, Andrew, Cincinnati, Fine (California), Honolulu, Los Angeles, Minneapolis, Museum (3), Naritasan, Nelson, Rhode Island, Riccar, Tōkyō (1), Victoria. **Bib.**: Asano; Binyon (3); Fujikake (1); Hillier (1); *Japanese* (3); Kikuchi; Lane; Meissner; Michener (1), (3); Narazaki (2); NB (H) 24; NHBZ 7; Nonogami; Sansom (2); SBZ 10; Takahashi (1), (2); Tamba (2a); UG 32; *Ukiyo-e* (2) 12, (3) 18; Yoshida (1a).

[1]小林清親
Kobayashi Kokei[1] (1883–1957). **N.**: Kobayashi Shigeru.[2] **Gō**: Kokei.[3] **Biog.**: Japanese-style painter. Born in Niigata; worked in Tōkyō. When 12, began to study painting. In 1898 became a pupil of Kajita Hanko. In 1912 showed with the Bunten; after 1914 was associated with the Saikō Nihon Bijutsuin. In 1922–23 to Europe, where he studied classic Chinese painting. From 1944 to 1951 taught at Tōkyō School of Fine Arts. In 1944 made a member of the Art Committee of the Imperial Household and also of the Imperial Art Academy. In 1950 received Order of Cultural-Merit. One of the "second-generation" artists to be influenced by Okakura Tenshin. His subject matter Japanese genre themes; also idealized female figures represented without a background. A leading latter-day Japanese-style painter reinterpreting classic Japanese painting to create a style in part *yamato-e*, in part Western, with delicate line, clear color, great simplicity. **Coll.**: Atami, Kyōto (1), National (5), Tōkyō (1), Yamatane. **Bib.**: Asano; Imaizumi (1); Kawakita (2); Kondō (6); M 11, 85, 88; *Masterpieces* (4); Miyagawa; Munsterberg (1); Nakamura (1); NB (H) 24; NBT 10; NBZ 6; NKKZ 23; Noma (1) 2; SBZ 11; Sullivan; Tanaka (7a) 20; Yashiro (1) 2.

[1]小林古径　[2]小林茂　[3]古径
Kobayashi Mango[1] (1870–1947). **Biog.**: Western-style painter. Born in Kagawa-ken. Studied under Harada Naojirō, Kuroda Seiki, Andō Nakatarō; also at the Tōkyō School of Fine Arts. First exhibited with the Naikoku Kangyō Hakurankai, then at the first Bunten; received prizes at both. Traveled and studied in Germany, France, and Italy just before 1914. Returned to teach at the Tōkyō School of Fine Arts. Early member of Hakubakai. In later years active in government exhibitions; member of the Art Committee for the Imperial Household, the Kōfūkai, the Nihon Geijutsuin. His manner one of academic realism with impressionist touches. **Coll.**: National (5); Tōkyō (1), (2). **Bib.**: Asano, BK 192, Harada Minoru, *Kurashina* (2), NB (H) 24, NB (S) 30, NBZ 6.

[1]小林万吾
Kobayashi Shōkichi[1] (1887–1946). **Biog.**: Western-style painter. Born in Tōkyō. Graduated from Tōkyō School of

Fine Arts in 1903, having studied under Kuroda Seiki. Exhibitor with and member of Hakubakai. In 1912 helped found the Kōfūkai. Later taught at various girls' schools. **Bib.**: Asano.

[1]小林鐘吉
Kobayashi Tokusaburō[1] (1884–1949). **N.**: Kobayashi Tokusaburō[2] (originally Fujii Yoshitarō).[3] **Biog.**: Western-style painter. Born in Fukuyama, Hiroshima-ken; worked in Tōkyō. Adopted by his uncle Kobayashi Tokutarō. Graduate of Tōkyō School of Fine Arts in 1909. In 1912 took part in founding Fusainkai. In 1913 became stage director of Geijutsuza (Art Theater). Studied French at Tōkyō Foreign Language School, graduating in 1918. Exhibited in 1919 with the Inten; in 1923 with the Shun'yōkai. From 1924 to 1933 taught art at a Tōkyō high school. In 1926, made a member of Nikakai and Shun'yōkai. During World War II moved to Hakone, where he died. In his early career followed the fauves; later changed to a realistic style. **Coll.**: Kanagawa, National (5). **Bib.**: Asano, NBZ 6.

[1]小林徳三郎　[2]小林徳三郎　[3]藤井嘉太郎
Kobayashi Wasaku[1] (1888–). **Biog.**: Western-style painter. Born in Yamaguchi-ken; worked in Hiroshima. First studied Japanese-style painting at the Kyōto Municipal School of Fine Arts and Crafts; then, about 1910, turned to Western-style painting, studying with Umehara Ryūzaburō and Nakagawa Kazumasa. Member of and exhibitor with the Shun'yōkai, winning a prize in 1926, until 1934, when he joined the Dokuritsu Bijutsu Kyōkai. To Europe in 1928. In 1952 won the Education Minister's Prize for Fostering the Arts. His style reflects the influence of Umehara. **Coll.**: National (5). **Bib.**: Asano, NB (H) 24, NBZ 6.

[1]小林和作
Kōben[1] (fl. late 12th to early 13th c.). **Biog.**: Sculptor. Said to have been third son and pupil of Unkei. Member of the Shichijō Bussho. Named *hokkyō* in 1215, later *hōgen*. The Tentōki in the Kōfuku-ji, Nara, contained a document saying it was carved by Kōben in 1215; this is the only known work by him, though the companion Ryūtōki is sometimes attributed to him. This figure is an excellent example of the Kamakura tendency toward the grotesque. **Coll.**: Kōfuku-ji. **Bib.**: Buhot; *Exhibition* (1); GK 8; Glaser; GNB 9; Hasumi (2); Kidder; Kobayashi (1); *Kokuhō* 4; Kuno (1), (2) 6; Lee (1); Mōri (la); NB (H) 11; NBZ 3; Ōoka; OZ (new series) 13; SBZ 6; Tajima (12) 3, (13) 15; Warner (1); Watson (1).

[1]康辨
Kōboku[1] (fl. first half 16th c.). **Biog.**: Muromachi *suiboku* painter. Other than a few references in the *Koga Bikō*, nothing known about his life. A Kantō artist, working in the style of Shōkei, producing stiff, mannered paintings. **Coll.**: Tōkyō (1). **Bib.**: Matsushita (1a), *Muromachi* (1), NB (S) 63, Rosenfield (2).

[1]興牧
Kobori Tomone[1] (1864–1931). **N.**: Kobori (originally Sudō)[2] Keizaburō.[3] **Gō**: Tomone,[4] Tsurunoya.[5] **Biog.**: *Yamato-e* painter. Born in Tochigi-ken; lived in Tōkyō. Pupil of Kawasaki Senko. An exhibitor and prize winner at various exhibitions in the 1880s; later served as juror for the Bunten. Taught at the Tōkyō School of Fine Arts in the section devoted to Tosa painting after the resignation of Shimomura Kanzan. Founding member of the Nihon Bijutsuin; member of the Art Committee of the Imperial Household, of the Imperial Fine Arts Academy, and of the Committee for the Protection of Cultural Property. Attempted unsuccessfully to revive the *yamato-e* school. Specialized in historical and warlike subjects rendered in a rather overblown *yamato-e* manner but with considerable brilliance. **Coll.**: Tōkyō (2). **Bib.**: Asano, *Kurashina* (1), Morrison 1, NB (S) 17, NBZ 6, Uyeno.

[1]小堀鞆音　[2]須藤　[3]小堀桂三郎　[4]鞆音　[5]弦酒舎

Kōbun[1] (1793–1863). *N.:* Yoshimura Kōbun.[2] *A.:* Kun'yū.[3] *Gō:* Ranga,[4] Ryōsai.[5] **Biog.:** Painter. Born in Kyōto. Son of Yoshimura Kōkei. **Bib.:** Mitchell.

 [1]孝文 [2]吉村孝文 [3]君郁 [4]蘭雅 [5]了斎

Kōchō[1] (fl. mid-12th c.). **Biog.:** Sculptor. Son and pupil of Kōjo. Member of Shichijō Bussho, Nara. Given rank of *hokkyō* in 1154, *hōgen* in 1164. Recorded as having carved figures for the Rengeō-in; presumably worked in the style of Jōchō. No work known to be by him is extant. **Bib.:** Mōri (1a).

 [1]康朝

Kōchō[1] (fl. early to mid-19th c.). *N.:* Ueda Kōchō.[2] *A.:* Yūshū.[3] *Gō:* Suiun.[4] **Biog.:** Shijō painter, illustrator. Born in Ōsaka. Pupil of Matsumura Goshun, influenced by Matsumura Keibun. Among his many illustrated books are *Kōchō Gafu* and *Suiun Ryakuga.* Also known as a calligrapher. **Coll.:** Ashmolean, British, Museum (3). **Bib.:** Brown, Holloway, Mitchell.

 [1]公長 [2]上田公長 [3]有秋 [4]水雲

Kōchoku[1] (1803–62). *N.:* Nagayama.[2] *Gō:* Kōchoku;[3] later, Chikugai.[4] **Biog.:** Shijō painter. A pupil of Nagayama Bokusai, who had been a pupil of Goshun. Also designed *surimono.* **Bib.:** *Kunst.*

 [1]孔直 [2]長山 [3]孔直 [4]竹外

Kodama Katei[1] (1841–1913). *N.:* Kodama Michihiro.[2] *A.:* Shiki.[3] *Gō:* Katei,[4] Ridō,[5] Ridōjin,[6] Uka.[7] **Biog.:** *Nanga* painter. Lived in Nagano-ken. Pupil of Tanomura Chokunyū in Kyōto. After studying Zen Buddhism at a temple in Odawara and traveling all over Japan, returned to his own province and lived in retirement. Received a prize at the 1885 Naikoku Kaiga Kyōshinkai. Painted landscapes and *kachōga* in the *nanga* manner. **Bib.:** Asano, NB (S) 17, Uyeno.

 [1]児玉果亭 [2]児玉道弘 [3]子毅
 [4]果亭 [5]里堂 [6]里堂人 [7]迂果

Kodama Kibō[1] (1898–1971). *N.:* Kodama Shōzō.[2] *Gō:* Kibō.[3] **Biog.:** Japanese-style painter. Born in Hiroshima-ken. Pupil of Kawai Gyokudō. Exhibited with Teiten for first time in 1921. Member of Nihon Nangain; committee member of Nitten. Also member of Japan Art Academy, winning the Academy Prize in 1952. In 1957 traveled in Europe. **Coll.:** National (5). **Bib.:** Asano.

 [1]児玉希望 [2]児玉省三 [3]希望

Kodera Kenkichi[1] (1887–). **Biog.:** Western-style painter. Born in Gifu-ken. In 1911 graduated from Tōkyō School of Fine Arts. Two years later began exhibiting with the Bunten, later with the Teiten. In Europe in 1922 and again in 1927. Eventually an exhibitor with and member of the Kōfūkai and the Nitten. His style owes something to Derain. **Bib.:** Asano.

 [1]小寺健吉

Kōdō[1] (1663–1733). *Priest name:* Genchō.[2] **Biog.:** *Zenga* painter. Trained in China as a priest of the Rinzai sect of Zen Buddhism. Came to Japan in 1721; eventually joined the Ōbaku sect, of which he became the twelfth leader. A proficient *suiboku* painter, following the style of Dokutan. **Bib.:** NB (S) 47.

 [1]杲堂 [2]元昶

Kōei[1] (fl. second half 19th c.). **Biog.:** Ukiyo-e printmaker. Worked in Kyōto. Specialized in *surimono.* **Coll.:** British, Musées. **Bib.:** Binyon (1).

 [1]公栄

Kōen[1] (1207–85?). **Biog.:** Sculptor. Perhaps son of Kōun, grandson of Unkei. Worked at Shichijō Bussho, Nara; after Tankei's death, the leader and most active member of the Kei school. In 1251 received titles of *shō busshi* and *hōgen.* Some 30 of his works are known to exist. According to the inscription, in 1254 assisted in making the Senju Kannon in the Rengeō-in, Myōhō-in, along with Kōsei and under the leadership of Hōin Tankei. In 1256 succeeded Tankei as *dai busshi* and carved the Senju Kannon in the

Kōdō, Tōdai-ji. In 1259 carved an Emma-ō, Taizan-ō, Shimyō, and Shiroku for the Byakugō-ji, Nara. The two Devas in the Jōso-in of the Eikyū-ji, Nara, are dated 1264; the statue of the Deva in the Atami Museum, 1267. The Daijō-in, Kōfuku-ji, owns a Monju and four attendants of 1273; the Jingo-ji, Kyōto, an Aizen Myōō of 1275. His earlier figures are life-size; those after 1267, smaller. A follower of Unkei's style, his work marked by bold poses and violent display of emotion, with the drapery carved in deep folds. Realistic elements of portraiture. Great influence on subsequent Japanese sculptors. **Coll.:** Atami; Byakugō-ji; Eikyū-ji; Jingo-ji; Kannon-ji (1); Kōfuku-ji (1); Myōhō-in (Rengeō-in); Tōdai-ji (Kōdō). **Bib.:** BK 2; GNB 9; Hasumi (2); Herberts; Jahss; Kidder; *Kokuhō* 3, 4; Kuno (1), (2); M 137; Mōri (1a); NB (S) 40; PTN 3.

 [1]康円

Kōen[1] (fl. early 16th c.). **Biog.:** Sculptor. Known for a seated statue dated 1514 in the Ennō-ji, Kamakura, and another dated 1512 in the Kannon-ji, Tōkyō. **Coll.:** Ennō-ji, Kannon-ji (2). **Bib.:** *Muromachi* (2), NB (S) 40, NBZ 3.

 [1]弘円

Kōetsu[1] (fl. late 15th to early 16th c.). *Given name:* Kōetsu.[2] *Gō:* Tōkansai. **Biog.:** Muromachi *suiboku* painter. A Zen priest, lived in Kamakura. According to the *Koga Bikō,* studied under Shūbun. Also worked under Shōkei, whose style he followed in the use of ink alone and brittle nail-head brush strokes. **Coll.:** Tōkyō (1). **Bib.:** K 645, Matsushita (1a), NB (S) 13, Tajima (13) 3, YB 35.

 [1]興悦 [2]興悦 [3]傚閑斎

Kōetsu[1] (1558–1637). *N.:* Hon'ami Kōetsu.[2] *F.N.:* Jirosaburō.[3] *Gō:* Jitokusai,[4] Kūchūan,[5] Ōhōsha,[6] Taikyoan,[7] Tokuyūsai.[8] **Biog.:** Painter, potter, lacquerer. Also calligrapher, landscape gardener, tea master, poet: one of greatest artists of early 17th century. Lived at Takagamine, on the outskirts of Kyōto. where in 1615 the shogun Ieyasu granted him some land. His ancestors were swordsmiths; he worked for a while as connoisseur of swords for the local daimyo. Was asked, but never accepted the shogun's invitation, to serve as cultural adviser to the shogunate. Collaborated with Suminokura Soan (1571–1632) in designing and publishing a series of books that included complete Nō plays and selections from classical literature. Wrote poems on scrolls decorated by him or his collaborators: a wonderful combination of pictorial elements and calligraphy. In painting, studied style of Kanō Eitoku; in pottery, pupil of Donyū. With Nonomura Sōtatsu, with whom he often worked to produce scrolls and paintings, founded the strikingly decorative Rimpa school, stylistically based on the *yamato-e* manner of the Heian and Kamakura periods, technically on the *haboku* tradition. Is now regarded more as the spiritual father of the school, for he was primarily a calligrapher, and his influence came through the artistic community he established at Takagamine. In painting, made use of a gold ground, bright colors, a flat surface, and wet washes of opaque or slightly translucent pigments, with calligraphy playing an important part in the design. In pottery, preferred a delicate thin-walled Raku ware; his tea bowls supposedly were made after he was 40. As a lacquerer, probably providing designs only, worked in the new decorative style, introducing inlays of lead and pewter. An important, though self-taught, calligrapher, having studied ancient Chinese calligraphy, using Japanese "running" style. **Coll.:** Atami, Cleveland, Detroit, Freer, Gotō, Hatakeyama, Hompō-ji, Honolulu, Itsuō, Matsunaga, Metropolitan, Musée (2), Museum (3), Ōkura, Seattle, Staatliche, Stanford, Suntory, Tōkyō (1), Umezawa, Yamatane, Yamato. **Bib.:** AA 6, 14; *Ausgewählte;* BCM 53; BK 85, 93, 102, 121, 204; Casal; Feddersen; Fontein (1); *Freer;* Fujioka; GK 12; GNB 19; Hayashiya (1), (2); Hisamatsu; K 62, 207, 562, 748, 865, 887, 897, 922; KO 16, 30, 32, 39; *Kōetsu-ha;*

Kokuhō 6; *Kōrin-ha* (2); Koyama (1a), (3), (5) 2; Leach; Lee (1), (2); M 1, 34, 51, 135, 144, 163, 205; Mayuyama; Mikami; Miller; Minamoto (3), (4); Mizuo (2a), (4); Morrison 2; Munsterberg (2); NB (S) 14, 63, 71; NBT 5, 7; NBZ 5; Noma (1) 2; OA 7; Okuda (2); *One* (2); P 2, 4; Paine (4); Ragué; *Rimpa;* Rosenfield (1a), (2); SBZ 8, 9; *Selected;* Shimada 2; *Sōtatsu-Kōrin* (3); Stern (3); STZ 7; Tajima (12) 9, 14; Tajima (13) 5; TZ (K) 6; Yamada; Yashiro (3), (4); YB 6, 11, 35, 45.

¹光悦　²本阿弥光悦　³次郎三郎　⁴自徳斎
⁵空中庵　⁶鷹峰舎　⁷大虚庵　⁸徳友斎

Kōfu[1] (1759–1831). *N.:* Ueda (originally Sakagami)[2] Kō.[3] *A.:* Seisai.[4] *Gō:* Kōfu,[5] Seisai Sambō.[6] **Biog.:** Shijō painter. Born and lived in Kyōto until late in life, when he moved to Ōsaka. Followed first the style of Maruyama Ōkyo, then of Matsumura Goshun. Specialized in *kachōga* and landscapes. **Coll.:** Ashmolean, Museum (3), Victoria. **Bib.:** Mitchell.

¹耕夫　²阪上　³上田幸　⁴清菜　⁵耕夫　⁶清菜山房

Kōga (Takamasa)[1] (1791–1864). *N.:* Mori Takamasa.[2] *F.N.:* Hachisuke,[3] Umon.[4] *Gō:* Gyokusen,[5] Kaō,[6] Kikutei,[7] Kōga,[8] Sankōdō,[9] Shisentei,[10] Sodō.[11] **Biog.:** Japanese-style painter. Born in Nagoya. Studied under Yoshikawa Ikkei, Nakabayashi Chikutō, Maki Bokusen, and, later, Tosa Mitsuzane. Member of the Kyōto school. Had many pupils. **Coll.:** Freer.

¹高雅　²森高雅　³蜂助　⁴右門　⁵玉僊　⁶蝦翁
⁷菊亭　⁸高雅　⁹三光堂　¹⁰紫川亭　¹¹素堂

Koga Harue[1] (1895–1933). **Biog.:** Western-style painter. Born in Fukuoka-ken. Studied at the Taiheiyō Kenkyūsho and the Nihon Suisaiga Kenkyūsho; also under Ishii Hakutei. Exhibited in 1922 with the Nikakai, becoming a member in 1929. Influenced first by André Lhote, then by Paul Klee. His work varies from surrealism to a manner somewhere between Lhote and Derain. **Coll.:** Bridgestone, Kanagawa, National (5), Ohara (1). **Bib.:** Asano, *Masterpieces* (4), NB (H) 24, NBT 10, NBZ 6, NKKZ 9, SBZ 11.

¹古賀春江

Kōgan Gengei[1] (1748–1821). **Biog.:** *Zenga* painter. Born in Echigo Province. A Zen monk who received some of his training from Hakuin. In 1789 became 21st abbot of the Kōgen-ji in Tamba Province. Fond of painting Kanzan and Jittoku. Has been ranked with Sengai as a *zenga* painter, but this seems to inflate his talent unreasonably. His rather numerous paintings are done in an abrupt and at times abstract manner. **Bib.:** Awakawa, Brasch (2), NB (S) 47.

¹弘岩玄猊

Kogetsu[1] (1761–99). *N.:* Hirowatari Kogetsu.[2] *A.:* Seiki.[3] *F.N.:* Hachiemon.[4] **Biog.:** Nagasaki painter. Son and pupil of Hirowatari Koshū. Also studied under Mamura Hisen. Served as *kara-e mekiki* in Nagasaki. **Coll.:** Kōbe, Museum (3). **Bib.:** *Pictorial* (2) 5.

¹湖月　²広渡湖月　³清輝　⁴八右衛門

Kōgi[1] (fl. mid-11th c.). **Biog.:** Painter. Buddhist priest at the Onjō-ji (Mii-dera). Recorded as having been well known as a painter during his life.

¹興義

Kōgyoku[1] (1814–70). *N.:* Saitō Yono.[2] *Gō:* Chōō,[3] Kōgyoku.[4] **Biog.:** Painter. At 10, pupil of Watanabe Kazan. After his death, studied with Satake Eikai. Married a samurai of the Matsushita family, after which she produced no significant painting.

¹香玉　²斎藤よの　³聴鴬　⁴香玉

Kōho[1] (?–1660). *N.:* Kanō Akinobu.[2] *F.N.:* Yaemon.[3] *Gō:* Chōunkyo,[4] Kōho.[5] **Biog.:** Kanō painter. Eldest son and pupil of Kanō Kōi. Served the daimyo of the Kishū clan. **Bib.:** Morrison 1.

¹興甫　²狩野顕信　³弥右衛門　⁴朝雲居　⁵興甫

Kōho[1] (fl. early 19th c.). *N.:* Yamada Kōtoku.[2] *A.:* Shōsuke.[3]

Gō: Kōho.[4] **Biog.:** Painter. Lived in Nara. Specialized in figure painting. **Bib.:** Mitchell.

¹耕甫　²山田光徳　³正助　⁴耕甫

Kohyō[1] (fl. c. 1810). *N.:* Kikuya Kohyō.[2] *A.:* Genki.[3] *Gō:* Katsuha.[4] **Biog.:** Painter. Lived in Nara. Specialized in *kachōga*. **Bib.:** Mitchell.

¹古馮　²菊谷古馮　³元机　⁴葛破

Kōi[1] (c. 1569–1636). *N.:* Kanō Sadanobu.[2] *Priest name:* Shimpo.[3] *A.:* Chūri.[4] *F.N.:* Saemon,[5] Yahei,[6] Yazaemon.[7] *Gō:* Kōi.[8] **Biog.:** Kanō painter. Born in Ashikaga. Details of his life unclear. Known to have served the Tokugawa clan in Kii Province and to have brought up Kanō Takanobu's three sons: Tan'yū, Naonobu, and Yasunobu. Pupil of Kanō Mitsunobu; perhaps, later in his career, influenced by the works of Mu-ch'i and Sesshū. With Sanraku, the most important Kanō artist of the early Tokugawa period, introducing a new and lighter style of Kanō painting. Known as a fine painter of *kachōga,* few of which remain. Has been much overshadowed by Tan'yū. **Coll.:** Chion-in, Honolulu, Kempuku-ji, Museum (3), Nijō, Seattle, Shōtaku-in, Tōkyō (1). **Bib.:** BI 50; K 29, 94, 103, 139, 235, 287, 340, 399, 423, 433, 598, 601, 728; Morrison 1; NB (H) 14; NBZ 4; NKZ 20; Okamoto (1); *One* (2); Paine (2) 2, (4); Shimada 2; Tajima (12) 11, 14, 17; Tajima (13) 5; Yamane (1a).

¹興以　²狩野定信　³心甫　⁴中里　⁵左衛門
⁶弥兵衛　⁷弥左衛門　⁸興以

Koide Narashige[1] (1887–1931). **Biog.:** Western-style painter. Born in Ōsaka; lived in Ōsaka and Tōkyō. In 1906 joined the Japanese-style painting department of the Tōkyō School of Fine Arts; later transferred to the Western-style section, studying under Kuroda Seiki and Nagahara Kōtarō, and graduated in 1914. At first, painted in the manner of Kishida Ryūsei but, after a short stay in France in 1921, changed his style, abandoning his somber color scheme and painting in a more contemporary manner. In 1923 became a member of the Nikakai, having exhibited with that group since 1919. In 1924 founded in Ōsaka the Shinanobu-bashi Western-Style Painting Institute, where he taught oil painting. His painting, like that of so much of his time, influenced by Derain. **Coll.:** Bridgestone, Nagaoka, National (5), Ohara (1). **Bib.:** Asano; BK 223, 228; *Masterpieces* (4); Miyagawa; NB (H) 24; NBT 10; NBZ 6; NKKZ 9; SBZ 11; Tanaka (7a) 36.

¹小出楢重

Koito Gentarō[1] (1887–). **Biog.:** Western-style painter. In 1911 graduated from the metalworking department of the Tōkyō School of Fine Arts. In order to study painting, again entered the school but never finished the course. An exhibitor and occasionally a juror at the Bunten; also showed with the Nitten, which he later joined. Member of the Kōfūkai and the Japan Art Academy. Winner of the Japan Art Academy Prize in 1953; received the Order of Cultural Merit in 1965. His earlier paintings show great attention to realistic detail; the later ones reflect the influence of such artists of the School of Paris as Derain. **Coll.:** National (5); Tōkyō (1), (2). **Bib.:** Asano, *Masterpieces* (4).

¹小絲源太郎

Koizumi Katsuji[1] (1883–1945). **Biog.:** Japanese-style painter. Born in Tōkyō. In 1907 graduated from the Tōkyō School of Fine Arts, Japanese-painting section. In 1917 showed at the Bunten for the first time. In 1925 exhibited with the Teiten, becoming a juror in 1934. In 1938 joined the Nihonga-in. Also served as juror for the Bunten. **Coll.:** National (5). **Bib.:** Asano.

¹小泉勝爾

Koizumi Kishio[1] (1893–1945). **Biog.:** Printmaker. Born in Shizuoka. Studied painting at the Suisaiga Kenkyūsho; then turned to printmaking. Exhibited at the first show of the Nihon Sōsaku Hanga Kyōkai in 1919. Known for his series of views of Tōkyō and of Mount Fuji done in a rather

simplified Western manner. **Coll.:** Fine (California), National (5). **Bib.:** Asano; Fujikake (1), NBZ 6, NHBZ 7, UG 4.

¹小泉癸巳男
Kojima Torajirō¹ (1881–1929). **Biog.:** Western-style painter. Born and worked in Okayama. Graduated from Tōkyō School of Fine Arts in 1904; went to France for the first time in 1908, studying under Aman-Jean and Raphael Collin and exhibiting at the Salon. Helped to form the Ohara collection in Kurashiki, going to France again in 1917 and 1927. Became a member of the hanging committee of the Teiten. His style is impressionist. **Coll.:** Ohara (1). **Bib.:** Asano, Harada Minoru, NB (H) 24, NB (S) 30.

¹児島虎次郎
Kojima Zentarō¹ (1892–). **Biog.:** Western-style painter. Resident of Tōkyō. Studied at the Taiheiyō Kenkyūsho, at the Nihon Bijutsuin Art Studio, and with Yasui Sōtarō. In 1922 to France and Italy for further study, returning in 1925. Joined the 1930 Association when it was founded in 1926. Exhibited at first with the Nikakai, winning its prize in 1927. After 1931 exhibitor and member of the Dokuritsu Bijutsu Kyōkai. His work is quite decorative. **Bib.:** Asano, NB (H) 24, NBZ 6.

¹小島善太郎
Kojima Zenzaburō¹ (1893–1962). **Biog.:** Western-style painter. Born in Fukuoka; to Tōkyō to study under Okada Saburōsuke. In 1921 exhibited with the Nikakai, receiving its award the following year. In Europe from 1924 to 1928. Became a member of the Nikakai in 1928; two years later resigned to help found the Dokuritsu Bijutsu Kyōkai, exhibiting afterwards with that group. In 1962 received the Mainichi Award. His style at first partly fauve, partly Picasso; later, reflects School of Paris of the 20s, particulary Derain. **Coll.:** Kanagawa, Nagaoka, National (5), Ohara (1). **Bib.:** Asano, *Masterpieces* (4), NB (H) 24, NBT 10, NBZ 6, SBZ 11.

¹児島善三郎
Kōjo¹ (fl. 1116–55). **Biog.:** Sculptor. Son and pupil of Raijō. Member of Shichijō Bussho, Nara. Received rank of *hokkyō* in 1116, *hōgen* in 1139, *hōin* by 1154. Often collaborated with Ken'en. Presumably worked in the style of Jōchō, but no work by him is known.

¹康助
Kokan¹ (1653–1717). *Priest name:* Myōyo.² *Gō:* Kokan,³ Koshū.⁴ **Biog.:** Kanō painter. Also designed illustrated books. Pupil first of Kanō Yasunobu, then of Kanō Einō; also studied Sesshū's style. Served as a priest at the Hōon-ji, Kyōto, and at various Nara temples. Specialized in Buddhist subjects and landscapes. **Coll.:** Museum (3), Myōshin-ji.

¹古磵 ²明誉 ³古磵 ⁴虚舟
Kokan¹ (1747–1818). *N.:* Shiba Shun.² *A.:* Kungaku.³ *F.N.:* Andō Kichijirō⁴ (or Katsusaburō).⁵ *Gō:* Fugen Dōjin,⁶ Harushige,⁷ Kōkan,⁸ Rantei,⁹ Shumparō,¹⁰ Suzuki Harushige.¹¹ **Biog.:** *Yōga* and ukiyo-e painter, printmaker. Born in Edo. Studied under Sō Shiseki, Suzuki Harunobu, Hiraga Gennai. In 1783 became first Japanese painter to try copperplate engraving: *View of Mimeguri*. Learned about oil painting and etching from books he saw in Nagasaki. Felt native culture was exhausted; became interested in Western art, on which he wrote an essay—the first such article in Japan—saying it was superior to Chinese and Japanese painting because it depicted light and shade and was useful for explanatory book illustrations. His *yōga* work is a strange mixture of European and Japanese elements, too amateurish to be important as art but important as a symptom of restlessness, dissatisfaction, and need for change. His writings include a book of memoirs, *Shumparō Hikki*, and a travel book on Nagasaki with illustrations of foreign residents and their houses. Used the ukiyo-e *gō* of Suzuki

Harushige from about 1769 to 1775, skillfully imitating Harunobu's style. It is said that he designed a number of prints and paintings to which he added Harunobu's signature after Harunobu's death—works that were accepted as genuine by his contemporaries. However, his ukiyo-e style was marked by a greater use of Western-style perspective, and his figures are often less delicate; rather mediocre work. Ended as a *nanga* painter. **Coll.:** Art (1); Atami; British; Brooklyn; Center; Fine (California); Freer; Kōbe; Homma; Honolulu; Itsukushima-jinja; Metropolitan; Museum (3); Myōō-ji; Nelson; Portland; Riccar; Rijksmuseum (2); Seattle; Staatliche; Tōkyō (1), (2); Victoria; Waseda; Yamato. **Bib.:** BI 70; Binyon (1), (3); BK 265, 266; Brown; French; Fujikake (3) 3; Gentles (1); GNB 25; Hillier (3), (4) 3, (9); K 219, 336, 385, 544, 570, 667, 726 838; Kikuchi; KO 28, 30, 35, 37, 38; M 187, 195, 230, 233; Mayuyama; Michener; Mitchell; Mody; Moriya; Morrison 2; Narazaki (2); NB (H) 24; NB (S) 36; NBZ 5; NHBZ 2, 7; *Nikuhitsu* (1) 2, (2); Nishimura; Noma (1) 2; OZ, new series 5; *Pictorial* (2) 2; Rosenfield (2); Sansom (2); Schmidt; Shiba (1); *Shiba* (2); Shibui (1); Shimada 3; Stern (4); Sullivan; Tajima (12) 17, 20; Takahashi (5); UG 25; *Ukiyo-e* (3) 15; Waterhouse; YB 49, 52.

¹江漢 ²司馬峻 ³君岳 (君嶽) ⁴安藤吉次郎 ⁵勝三郎 ⁶不言道人 ⁷春信 ⁸江漢 ⁹蘭亭 ¹⁰春波楼 ¹¹鈴木春信
Kōkei¹ (fl. late 12th c.). **Biog.:** Sculptor. Father of Unkei. Member of Shichijō Bussho in both Kyōto and Nara. Did much to develop new realistic style of Kamakura period; founder of the Kei school. In 1183 received honorary rank of *hokkyō*, in 1194 that of *hōgen*. Only authenticated works by him are those made in 1180 in the Nan'endō, Kōfuku-ji, Nara: Fukūkensaku Kannon, Hossō Rokuso, Shitennō, Patriarch Gempin; however, there is also a Gigaku mask at the Tōdai-ji signed Kōkei and dated 1196. **Coll.:** Kōfuku-ji (Nan'endō), Tōdai-ji. **Bib.:** GK 8; GNB 9; Glaser; Hasumi (2); K 746, 749; Kidder; Kleinschmidt; *Kokuhō* 4; Kuno (1), (2) 6; M 29; Mōri (1a); NB (H) 11; Ōoka; SBZ 6; Tajima (13) 15; Warner (4); Yashiro (1) 2.

¹康慶
Kōkei¹ (1769–1836). *N.:* Yoshimura Kōkei.² *A.:* Mui.³ *F.N.:* Yōzō.⁴ *Gō:* Ranryō,⁵ Ryūsen.⁶ **Biog.:** Maruyama painter. Lived in Kyōto. One of Maruyama Ōkyo's ten famous pupils. In the service of the Nishi Hongan-ji, for which he painted a series of screens. Specialized in *kachōga*. **Coll.:** Andrew, Ashmolean, Museum (3), Nishi Hongan-ji. **Bib.:** Doi (6), Hillier (4) 3, K 514, Mitchell, NB (H) 14, Tajima (3) 2.

¹孝敬 ²吉村孝敬 ³無違 ⁴要蔵 ⁵蘭陵 ⁶竜泉
Kōkei¹ (?–1860). *N.:* Ueda Kōkei.² *A.:* Shōfu.³ *Gō:* Hyakushū.⁴ **Biog.:** Shijō painter. Son of Ueda Kōchō, whose style of painting he continued. **Bib.:** Brown, Mitchell.

¹公圭 ²上田公圭 ³肖孚 ⁴百洲
Kōken¹ (1835–83). *N.:* Sumiyoshi (originally Endō)² Naiki.³ *Gō:* Kōken.⁴ **Biog.:** Sumiyoshi painter. Worked in Edo. Adopted by Sumiyoshi Hirotsura, whose pupil he was. A good painter of *kachōga* and landscapes.

¹広賢 ²遠藤 ³住吉内記 ⁴広賢
Kōkin¹ (1803–75). *N.:* Yoshida Heikichi.² *F.N.:* Kijūrō,³ Tange.⁴ *Gō:* Kōkin,⁵ Seika.⁶ **Biog.:** Japanese-style painter. Born in Etchū Province to a family of wealthy farmers. Studied first under Kino Hironari, then under Nukina Kaioku. Worked in Kyōto. Specialized in figures and flowers; also painted landscapes. A decorative artist. **Coll.:** Imperial (1). **Bib.:** Mitchell.

¹広均 (公均) ²吉田平吉 ³喜十郎 ⁴丹下 ⁵広均 (公均) ⁶栖霞
Kokushō (Kunimatsu)¹ (fl. c. 1500). *N.:* Kanō Kokushō

(Kunimatsu).[2] **Biog.:** Kanō painter. Son and pupil of Kanō Masanobu, younger brother of Kanō Motonobu. Overshadowed by his older brother, he is yet accounted an able painter of figures and *kachōga*. **Bib.:** Morrison 1.

¹国松 ²狩野国松

Koma[1] (fl. 17th to 19th c.). One of the most important schools of lacquerers, noted for the neatness, elegance, high finish, and subdued gold ground of its work. Also distinguished by the application of colored lacquer in such a manner that when looked at directly it seems to be gold but, when seen from the side, takes on a red cast. The members of this school also invented a rich vermilion lacquer with a high metallic finish. The artists of this school had no seal, and many of them used the same *gō*. No accurate genealogy. For starred names among the following, see individual entries. See also Kansai[2] and Koryū.[3]

*Koma I: Kyūi[4] (?–1663)

*Koma II: Kyūzō[5] (?–1715) or Kyūhaku I[6] or Yasuaki (Ammei)[7] or Yasunaru (Anko)[8] or Yasutada (Ankyō)[9]

*Koma III: Kyūzō II[10] (?–1732) or Kyūhaku II[11] or Yasuaki (Anshō)[12]

*Koma IV: Kyūzō III[13] (?–1758).

*Koma V: Kyūzō IV[14] (1762–94) or Kyūhaku III[15]

Koma VI: Kansuke[16] (?–1795) or Kuhaku (Kyūhaku) I[17]

Koma VII: Rokuemon[18] (?–1803) or Kuhaku (Kyūhaku) II[19]

*Koma VIII: Kyūzō V[20] (?–1816) or Kuhaku (Kyūhaku) IV[21] or Kyūi II[22]

Koma IX: Genzō[23] (?–1842) or Genki[24]

Koma X: Seibei I[25] (?–1858)

Koma XI: Seibei II[26] (?–1847)

Bib.: Casal, Herberts, Jahss, K 5, Ragué, Sawaguchi, Speiser (2), Yoshino.

¹古満 ²寛哉 ³巨柳 ⁴休意 ⁵休蔵 ⁶休伯一代
⁷安明 ⁸安巨 ⁹安匡 ¹⁰休蔵二代 ¹¹休伯二代
¹²安章 ¹³休蔵三代 ¹⁴休蔵四代 ¹⁵休伯三代
¹⁶勘助 ¹⁷休伯一代 ¹⁸六兵衛門 ¹⁹休伯二代
²⁰休蔵五代 ²¹休伯四代 ²²休意二代 ²³源蔵
²⁴源亀 ²⁵清兵衛一代 ²⁶清兵衛二代

Komin[1] (1808–70). *N.:* Nakayama Yūkichi.[2] *Gō:* Komin,[3] Sensen.[4] **Biog.:** Lacquerer. Born in Terajima (present Sumida-ku, Tōkyō); moved to Edo when young; became a pupil of Hara Yōyūsai. Teacher of Ogawa Shōmin. Received honorary title of *hokkyō*. He and Shibata Zeshin the two prominent *makie-shi* at the end of the Tokugawa shogunate. An expert craftsman, particularly skilled in making copies of old lacquer wares. **Coll.:** Collections, Metropolitan, Stanford, Tōkyō (1), Walters. **Bib.:** Boyer, Herberts, Jahss, NBT 7, Ragué, SBZ 10, Yoshino.

¹胡民 ²中山祐吉 ³胡民 ⁴泉々

Kōmo Tōzan[1] (1882–). **Biog.:** Lacquerer. His works are in the traditional *makie* technique. **Bib.:** Jahss, Ragué.

¹河面冬山

Komura Taiun[1] (1883–1938). *N.:* Komura Gonzaburō.[2] *Gō:* Taiun.[3] **Biog.:** Japanese-style painter. Born in Shimane-ken; worked in Kyōto. Pupil of Yamamoto Shunkyo and Tsuji Kakō. An exhibitor and prize winner at the Bunten; member of the jury for the Teiten. His style a conscious imitation of Chinese Ming painting. **Bib.:** Asano, Elisséev.

¹小村大雲 ²小村権三郎 ³大雲

Komuro Suiun[1] (1874–1945). *N.:* Komuro Teijirō.[2] *Gō:* Chōjin,[3] Chōyo Sanjin,[4] Kareian,[5] Suiun.[6] **Biog.:** *Nanga* painter. Born in Gumma-ken. Pupil of Tazaki Sōun; after his teacher's death went to Tōkyō. An exhibitor and prize winner at the Nihon Bijutsu Kyōkai; also an early exhibitor at the Bunten, which he later served as juror. In 1921, with Yano Kyōson, founded the Nihon Nangain. Member of the Imperial Art Academy and the Art Committee of the Imperial Household. An important late *nanga* painter, pro-

ducing rich, decorative work. **Coll.:** National (5). **Bib.:** Asano, Elisséev, NBZ 6.

¹小室翠雲 ²小室貞次郎 ³徴人
⁴長与山人 ⁵佳麗庵 ⁶翠雲

Kondō Kōichiro[1] (1884–1962). *N.:* Kondō Hiroshi (Kō).[2] *Gō:* Kiitchō,[3] Kōichiro.[4] **Biog.:** Japanese-style painter. Born in Yamanashi-ken. Entered the Department of Western Painting of the Tōkyō School of Fine Arts; studied under Wada Eisaku; graduated in 1910. Exhibited with the Hakubakai and with the Bunten, receiving favorable notices at the latter in 1914. Meanwhile, worked as a cartoonist for the *Yomiuri Shimbun* and the *Asahi Shimbun*. In 1919, having turned to Japanese-style painting, showed with the Inten; received much favorable criticism; became a member; however, resigned in 1936 and remained independent of all art groups for the rest of his life. In the 1930s went twice to Europe. His interesting paintings, though done in ink, have much Western feeling about them and a great preoccupation with the problem of rendering light. **Coll.:** National (5). **Bib.:** Asano, *Masterpieces* (4), Mitchell, NBT 10, NBZ 6.

¹近藤浩一路 ²近藤浩 ³木市腸 ⁴浩一路

Kōnen[1] (fl. c. 1840). *N.:* Sekine Yoshikatsu.[2] *A.:* Kōnen.[3] *F.N.:* Kennosuke,[4] Tetsuzō.[5] **Biog.:** Painter. Born and worked in Edo. Pupil of Ōnishi Chinnen. **Coll.:** Victoria. **Bib.:** Mitchell.

¹孔年 ²関根義勝 ³孔年 ⁴謙之助 ⁵鉄蔵

Konishi Kaiun[1] (?–1900). *N.:* Konishi Takashi.[2] *Gō:* Kaiun.[3] **Biog.:** Painter. Born in Sendai; served as official painter to the lord of Sendai. In 1860 to Kyōto; then to Nagasaki, and finally to China to stay for about 8 years. Lived in a number of places: Itsukushima, Tōkyō, Hokkaidō, northeastern Japan. From 1882 exhibited with the Naikoku Kaiga Kyōshinkai. Painted in a pale, monochrome *nanga* manner.

¹小西皆雲 ²小西巍 ³皆雲

Kōno Shūson[1] (1890–). **Biog.:** Japanese-style painter. Born in Aichi-ken. Studied with Tachika Chikuson. Exhibited in 1930 with the Teiten; then with the Bunten. Member of the pre–World War II Nihon Nangain; since 1960 has served as board chairman of the Nippon Nangain. **Coll.:** National (5). **Bib.:** Asano.

¹河野秋邨

Kōno (Kawano) Tsūsei[1] (1895–1950). **Biog.:** Western-style painter. Born in Gumma-ken. Self-taught. Exhibited first with the Nikakai, then with the Sōdosha and the Shun'yōkai, winning a prize at the latter in 1924. Member of the Kokugakai. Also an illustrator of novels. **Bib.:** Asano.

¹河野通勢

Konobu[1] (fl. late 19th c.). *N.:* Hasegawa Konobu.[2] **Biog.:** Ukiyo-e printmaker. Son and pupil of Hasegawa Sadanobu. Worked in Ōsaka. Produced prints of Ōsaka street scenes and public buildings in the late ukiyo-e manner. **Coll.:** Victoria. **Bib.:** NHBZ 3, Nonogami.

¹小信 ²長谷川小信

Konoshima Ōkoku[1] (1877–1938). *N.:* Konoshima Bunjirō.[2] *A.:* Ayami.[3] *Gō:* Ōkoku,[4] Rōroujin,[5] Ryūchisōdō Shujin.[6] **Biog.:** Japanese-style painter. Born in Kyōto. Studied with Imao Keinen. A frequent winner of prizes at the Bunten; juror for both the Bunten and the Teiten. A delicate sensitive artist, known for his paintings of animals, his landscapes, and his *kachōga*. **Coll.:** Idemitsu, Kyōto (1), National (5). **Bib.:** Asano, Elisséev, NB (S) 17, NBZ 6, Uyeno.

¹木島桜谷 ²木島文治郎 ³文質
⁴桜谷 ⁵朧盧迂人 ⁶龍池草堂主人

Kōnyū[1] (1857–1932). *N.:* Tanaka Kōnyū.[2] *Studio name:* Kichizaemon.[3] *F.N.:* Kosaburō;[4] later, Sōjirō.[5] *Posthumous name:* Yoshinaga.[6] *Gō:* Kōnyū,[7] Setsuma.[8] **Biog.:** Raku potter. A son of Keinyū, became head of twelfth generation of the Raku line. In 1870 a pupil of the Sen family of tea masters; the following year succeeded to the name of

Kichizaemon and became head of the Raku family. In 1890 collaborated with Keinyū in the 300th memorial service for Chōjirō. Assisted at the tea ceremonies of the Tokugawa and Mitsui families, but as a potter was creative only in his early years. In 1918 retired to become a monk, taking name of Kōnyū. **Coll.:** Yale. **Bib.:** Castile.

¹弘入 ²田中弘入 ³吉左衛門 ⁴小三郎
⁵惣治郎 ⁶喜長 ⁷弘入 ⁸雪馬

Kōran[1] (1804–79). *N.:* Yanagawa (originally Chō)[2] Keien.[3] *A.:* Dōga,[4] Keien.[5] *Gō:* Kōran.[6] **Biog.:** *Nanga* painter. Born in Mino Province. Wife of Yanagawa Seigen, a well-known Confucian scholar and poet. Studied painting with Naka-bayashi Chikutō, poetry with her husband. **Coll.:** Ashmolean. **Bib.:** K 673, Mitchell.

¹紅蘭 ²張 ³梁川景婉 ⁴道華 ⁵景婉 ⁶紅蘭

Korehisa[1] (fl. 14th c.). *N.:* Kose no Korehisa.[2] **Biog.:** Kose painter. Life unknown save he was given court title of Governor of Hida Province (hence known as Hida no Kami Korehisa),[3] but his name appears on the scroll *Go-sannen Gassen Ekotoba*, dated c. 1347 and now in the Tōkyō National Museum. There is also a *Hōnen Shōnin* scroll by him in the Chion-in, Kyōto. A great reputation as a painter of battle pictures. **Coll.:** Chion-in, Tōkyō (1). **Bib.:** AA 14; K 202; Morrison 1; *National* (1); NKZ 2, 80; Okudaira (1); *One* (2); Tajima (12) 11, (13) 3.

¹惟久 ²巨勢惟久 ³飛騨守惟久

Kōrei[1] (?–1860). *N.:* Komai Bungo.[2] *A.:* Toshikazu.[3] *Gō:* Kōrei,[4] Tōdō.[5] **Biog.:** Shijō painter. Born in Kyōto. Pupil of Yoshimura Kōkei. Known for his figure painting and *kachōga*.

¹孝礼 ²駒井文吾 ³季和 ⁴孝礼 ⁵桃堂

Korenobu[1] (fl. 13th c.). *N.:* Fujiwara no Korenobu.[2] **Biog.:** *Yamato-e* painter. Son of Tametsugu, grandson of Nobu-zane. Lived in Kyōto; served as a court official. It is recorded that in 1276 he was ordered to paint a screen depicting the Thirty-six Poets (Sanjūrokkasen).

¹伊信 ²藤原伊信

Koreshige[1] (?–1034). *N.:* Kose no Koreshige.[2] **Biog.:** Painter. Said to have been a son of Kose no Hirotaka. In 1028 given the position of painter at the imperial court. A minor member of the Kose family.

¹是重 ²巨勢是重

Kōri[1] (fl. c. 1840). *N.:* Hayami Ryōchi.[2] *A.:* Roshū.[3] *F.N.:* Gihei.[4] *Gō:* Kōri.[5] **Biog.:** Painter. Retainer of the Makida daimyo. **Coll.:** Museum (3). **Bib.:** Mitchell.

¹江鯉 ²速見良致 ³魯修 ⁴儀兵衛 ⁵江鯉

Kōrin[1] (1658–1716). *N.:* Ogata Koretomi[2] (originally Ichinojō).[3] *F.N.:* Kariganeya Tōjūrō,[4] Katsuroku.[5] *Gō:* Chōkōken,[6] Dōsū,[7] Hōshuku,[8] Iryō,[9] Jakumei,[10] Kansei,[11] Kōrin,[12] Seiseidō.[13] *Posthumous name:* Dōsū Koji.[14] **Biog.:** Painter, potter, lacquerer, textile designer; member of Rimpa school. Born in Kyōto; lived in Edo. Son of Ogata Sōken, a prosperous Kyōto cloth merchant who had been associated with Kōetsu at Takagamine. Led a spendthrift life; eventually reduced to poverty, retired into nominal priesthood under name of Nichijū. In 1701 received title of *hokkyō* from the court. Said to have studied first under Yamamoto Soken, then under Kanō Tsunenobu and Sumiyoshi Gukei; influenced by Kōetsu and Sōtatsu. Foremost Edo decorative painter, influencing all Japan. His style combines forceful abstract design and keen ob-servation of nature: a talent for pattern and composition. His paintings more carefully executed, with more precise outlines and more evenly applied color, than Sōtatsu's; used fewer geometric shapes, less pronounced axis. They have less depth, with broadly handled backgrounds. In ceramics, worked with his younger brother Kenzan at the Narutaki kiln from 1699 to 1712, painting the designs on the pottery that Kenzan then fired. Uncertain if he actually made lac-quer or only the designs for it; much use of pewter, nacre,

lead to vary textures and add touch of roughness for tea-ceremony taste. **Coll.:** Art (1), Atami, British, Brooklyn, City, Cleveland, Collections, Fogg, Freer, Fujita, Gotō, Hatakeyama, Honolulu, Ishikawa, Itsuō, Kimbell, Metro-politan, Musée (2), Musées, Museum (3), Nezu, Ōkura, Ōsaka (2), Ōstasiatiska, Rijksmuseum (2), Seattle, Staatliche, Stanford, Suntory, Tōkyō (1), Umezawa, University (2), Victoria, Walters, Yamato. **Bib.:** AA 6, 14; Akiyama (3); *Art* (1a); BK 14, 25, 37, 56, 57, 59, 60, 66, 73, 76, 85, 206; Casal; *Exhibition* (1); Fontein (1); *Freer;* GK 12; GNB 14; Gray (2); Grilli (1); Hillier (1); K 32, 57, 70, 81, 88, 89, 102, 117, 125, 127, 142, 145, 155, 165, 172, 177, 181, 188, 197, 199, 201, 203, 216, 221, 225, 228, 233, 236, 241, 264, 289, 292, 299, 312, 315, 337, 340, 352, 377, 382, 417, 430, 436, 472, 518, 533, 558, 641, 788, 814, 842, 862, 864, 865, 868, 884, 886, 889, 892, 895; KO 6, 7, 19, 24, 25, 38, 39; *Kōetsu-ha; Kokuhō* 6; *Kōrin* (1), (2), (3); Koyama (1a); Leach; Lee (1), (2); M 1, 18, 32, 94, 188, 235; Mayuyama; Miller; Minamoto (3); Mizuno; Mizuo (2a), (4); Morrison 2; Murayama (1); NB (S) 28, 53; NBT 5, 7; NBZ 5; *Nihon* (8); NKZ 44, 49, 59, 61; Noguchi (4); Noma (1) 2; Okuda (2); *One* (2); Paine (2) 2, (4); Ragué; Randall; *Rimpa;* Rosenfield (2); SBZ 9; *Selected;* Shimada 2; *Sōtatsu* (3); Speiser (2); Stern (3); STZ 5; Tajima (2) 1, 2; Tajima (12) 4, 5, 9, 19; Tajima (13) 5; Tanaka (7); Yamada; Yamane (1); Yashiro (3); YB 5, 8, 15, 19, 23, 24, 29, 33, 36.

¹光琳 ²尾形惟富 ³市之亟 ⁴雁金屋藤重郎 ⁵勝六
⁶長江軒 ⁷道崇 ⁸方祝 ⁹伊亮 ¹⁰寂明 ¹¹澗声
¹²光琳 ¹³青々堂 ¹⁴道崇居士

Koryū (Kyoryū)[1] (fl. 1764–89). *N.:* Koma Koryū (Kyoryū)[2] (originally Kimura Shichiemon).[3] *Gō:* Koryū (Kyoryū).[4] **Biog.:** Koma lacquerer. Worked in Edo. Pupil and brother-in-law of Koma Kyūzō IV, who allowed him to take the Koma name. Worked primarily for the bourgeoisie. Famous for his fine *togidashi-makie.* **Coll.:** Ashmolean; Brooklyn; Freer; Metropolitan; Museum (2), (3); Nelson; Tōkyō (1); Victoria; Walters. **Bib.:** Boyer, Casal, Herberts, Jahss, K 5, Ragué, Sawaguchi, Speiser (2), Yoshino.

¹巨柳 ²古満巨柳 ³木村七右衛門 ⁴巨柳

Koryūsai[1] (fl. c. 1764–88). *N.:* Isoda Masakatsu.[2] *F.N.:* Shōbei.[3] *Gō:* Haruhiro,[4] Koryūsai.[5] **Biog.:** Ukiyo-e painter, printmaker, illustrator. Born a samurai in the service of the lord of Tsuchiya. Relinquished his rank to become an uki-yo-e artist; moved to Edo. Perhaps a pupil of Nishimura Shigenaga, but much influenced by Harunobu's technique, and as a few early prints exist signed Haruhiro, more apt to have been a pupil of Harunobu. It also seems the name Koryūsai was given him by Harunobu, when he no longer used it himself. In 1781 given honorary rank of *hokkyō*. His output of prints and book illustrations enormous. In 1770 designed his well-known set *Models of Fashion.* Ex-cellent *kachōga* (which are much sought after), *bijinga*, and particularly *hashira-e.* His work marked by the use of a strong orange color; his figures less unworldly than Harunobu's. It is believed that after 1780 devoted himself entirely to painting, in which he worked with considerable freedom of line and under a noticeable Kanō influence. **Coll.:** Albertina; Allen; Art (1), (1a); Ashmolean; Atami; British; Brooklyn; Cincinnati; City; Cleveland; Denver; Fine (California); Fitzwilliam; Fogg; Freer; Grunwald; Herron; Honolulu; Idemitsu; Kōbe; Metropolitan; Min-neapolis; Musée (1), (2); Museum (1), (3); Nelson; Newark; Ōstasiatiska; Österreichisches; Portland; Rhode Island; Riccar; Rietberg; Staatliche; Suntory; Tōkyō (1); Toledo; University (2); Victoria; Worcester; Yale. **Bib.:** AA 14; Binyon (1), (3); Blunt; Boller; Crighton; Fujikake (3) 2; Gentles (1); GNB 17; Hillier (1), (3), (4) 1, (7), (9); *Japanese* (1a); K 100, 317; Kikuchi; *Kunst;* Lane; Ledoux (1); Lee (2); Meissner; Michener (3); Morrison 2; Narazaki (2); NHBZ 3; *Nikuhitsu* (1) 2, (2); *Pictorial* (2) 4; Schmidt;

Shibui (1); Shimada 3; Stern (2), (4); Tajima (7) 3, (13) 6; Takahashi (2), (5), (6) 4; UG 1, 3, 28; *Ukiyo-e* (3) 6; Vignier 2; Waterhouse.

¹湖竜斎　²磯田政勝　³庄兵衛　⁴春広　⁵湖竜斎

Kōryūsai (Kōritsusai)[1] (fl. late 18th to early 19th c.). *N.*: Umehara Kōryūsai (Kōritsusai).[2] **Biog.**: Lacquerer. One of the artists who worked on the decoration of the Tōshō-gū in Nikkō. **Bib.**: Casal, Herberts, Jahss.

¹幸立斎　²梅原幸立斎

Kōsa[1] (?–1637). *N.*: Hon'ami Kōsa.[2] **Biog.**: Rimpa painter. Adopted son of Hon'ami Kōetsu. Following family tradition, was primarily a swordsmith. Probably lived in Kyōto and, later, at the Takagamine artists' colony. Few of his paintings are known, and those are in the style of Sōtatsu. **Coll.**: Itsuō. **Bib.**: K 880, Mizuo (2a).

¹光瑳　²本阿弥光瑳

Kōsai[1] (1373–1446). *Priest name*: Ryūha.[2] *Gō*: Bunkei,[3] Kōsai,[4] Reisen.[5] **Biog.**: Muromachi *suiboku* painter. A priest, received his Zen training at the Kennin-ji and the Nanzen-ji in Kyōto. In painting, a pupil of Oguri Sōtan. Specialized in ink paintings of Kannon. **Bib.**: Akiyama (5), HS 11.

¹江西　²竜派　³文渓　⁴江西　⁵霊泉

Kōsaka Gajin[1] (1877–1953). *N.*: Kōsaka Masanosuke.[2] *Gō*: Gajin.[3] **Biog.**: Painter, printmaker. Born in Kyōto. First studied Japanese-style painting under Kōno Bairei and Yamamoto Shunkyo. In 1895 won a prize at the Naikoku Kangyō Hakurankai. To Tōkyō in 1907 to study Western-style painting at the Hakubakai and the Taiheiyō Ken-kyūsho. In 1922 made his first woodblock prints, exhibiting them with the Nihon Sōsaku Hanga Kyokai. Showed later with the Nihon Hanga Kyōkai and the Kokugakai. A great reputation outside Japan; exhibited in Los Angeles and Paris. Did all his own printing. Prints vary widely; editions small. After 1945 developed the style for which he is best known: abstract designs in black and white, the ink very black and intentionally blurred by being printed on paper dampened more than usual. **Coll.**: National (5). **Bib.**: Asano, Kawakita (1), NHBZ 8, UG 4.

¹上阪雅人　²上阪雅之助　³雅人

Kosaka Shiden[1] (1872–1917). *N.*: Kosaka Harumichi.[2] *A.*: Shijun.[3] *Gō*: Kanshōkyo,[4] Shiden,[5] Ten'onkyo.[6] **Biog.**: *Nanga* painter. Born in Nagano-ken. Pupil of Kodama Katei. An exhibitor and frequent prize winner at the Bunten. His landscapes are executed in a thoroughly competent and pleasant manner. **Coll.**: National (5). **Bib.**: NB (S) 17, NBZ 6.

¹小坂芝田　²小坂晴道　³子順　⁴寒松居　⁵芝田　⁶天恩居

Kosaka Shōdō[1] (1870–99). **Biog.**: Japanese-style painter. Born in Hyōgo-ken. To Kyōto to study Japanese-style painting at the Kyōto Prefectural School of Painting, but did not finish the course. In 1895 to Tōkyō; studied oil painting with Asai Chū. Later taught at the Tōkyō School of Fine Arts. Worked in the frequently found mixture of Japanese decorative approach and Western realistic details: a pleasant artist with considerable technical skill. **Coll.**: Tōkyō (1), (2). **Bib.**: Asano, *Kurashina* (1), NB (S) 17, NBZ 6, Uyeno.

¹小坂象堂

Kose Shōseki[1] (1843–1919). *N.*: Kose Kanaoki.[2] *F.N.*: Hatta Kyūzaemon.[3] *Gō*: Shōseki.[4] **Biog.**: Japanese-style painter. Born in Kyōto. Descendant of the ancient Kose family of Buddhist painters. First studied with Kishi Renzan, then with Nakanishi Kōseki, from whom he learned the *nanga* style. Took part in the government exhibitions of the early Meiji years. In 1878 to China. In 1889 taught at the Tōkyō School of Fine Arts. His paintings, which include Buddhist subjects, are Japanese in design but show Western influence in their use of light and shade. **Coll.**: Tōkyō (1), (2). **Bib.**: Asano, *Kurashina* (1).

¹巨勢小石　²巨勢金起　³八田久左衛門　⁴小石

Kōsei[1] (fl. mid-13th c.). **Biog.**: Kei sculptor. Son of Kōshō. Member of Shichijō Bussho. Received rank of *hokkyō* in 1237, of *hōgen* in 1251. Carved the Jizō Bosatsu in the Nembutsudō of the Tōdai-ji, Nara, in 1237. According to the inscription on the statue, assisted Kōen and Tankei in making the Senju Kannon in the Myōhō-in, Kyōto, a work begun in 1251 and finished in 1254. **Coll.**: Myōhō-in, Tōdai-ji (Nembutsudō). **Bib.**: *Kokuhō* 3, 4; Kuno (1), (2) 6; Mōri (1a).

¹康清

Kōsei[1] (fl. c. 1320–38). **Biog.**: Kei sculptor. Son and pupil of Kōshun. A *dai busshi* of the Shichijō Bussho at Nara; succeeded his father as head of the sculpture workshop at the Kōfuku-ji. Given rank of *hokkyō* in 1338. From 1321 to 1322 worked with Kōshun on the Shitennō at the Yōgo-ji in Hyūga Province. The Monju Bosatsu at the Hannya-ji, Nara, is dated 1324; in 1334 carved a standing Jizō Bosatsu for the Yanagi Kannondō, Nara. His style that of the late Kamakura tradition of the Kei school, increasingly conventional and spiritless. **Coll.**: Hannya-ji, Kimpusen-ji, Kannondō (1), Yōgo-ji. **Bib.**: GNB 9; Kobayashi (1); Kuno (1), (2) 6; Mōri (1a); *Muromachi* (2); Rosenfield (2).

¹康成

Kōseki[1] (1807–84). *N.*: Nakanishi Hisashi.[2] *A.*: Kinen.[3] *Gō*: Chikusō,[4] Kōseki,[5] Senkō.[6] **Biog.**: *Nanga* painter. Born in Ōsaka. Studied first in Ōsaka; then to Kyōto to work under the *nanga* painter Oda Kaisen. A good landscape artist. **Coll.**: Ashmolean. **Bib.**: Asano, Mitchell, NBZ 6.

¹耕石　²中西寿　³亀年　⁴竹叟　⁵耕石　⁶荃岡

Kōsetsu[1] (1800–1853). *N.*: Sakamoto Chokudai.[2] *A.*: Ōu.[3] *F.N.*: Kōzen.[4] *Gō*: Kōson,[5] Kōsetsu,[6] Shōsō Rinsho.[7] **Biog.**: Painter. Lived in Edo. A doctor who studied both botany and Kanō painting. At first did naturalistic studies of flowers and plants, particularly cherry blossoms; later painted orchids in a free, individual manner. **Coll.**: Staatliche. **Bib.**: Mitchell, Schmidt.

¹浩雪　²坂本直大　³桜宇　⁴浩然　⁵香邨　⁶浩雪　⁷甞草林處

Kōsetsu[1] (fl. c. 1840). *N.*: Yamada Isei.[2] *A.*: Seikei.[3] *Gō*: Kōsetsu.[4] **Biog.**: Painter. Born and worked in Edo. **Bib.**: Mitchell.

¹香雪　²山田意誠　³正卿　⁴香雪

Kōshi[1] (?–1635). *N.*: Kanō Okiyuki.[2] *F.N.*: Kan'emon,[3] Suke-emon.[4] *Gō*: Kōshi.[5] **Biog.**: Kanō painter. Probably born in Kii, as his father was a painter in the service of the lord of Kii (a cadet house of the Tokugawa). Pupil of his father. Served the lord of Owari, another Tokugawa cadet house.

¹興之　²狩野興之　³勘右衛門　⁴助右衛門　⁵興之

Koshiba Kinji[1] (1889–1961). **Biog.**: Western-style painter. Born in Tōkyō. After graduating from high school, went to France in 1911 and remained there until 1920, studying at various academies and the Louvre. On his return to Japan, studied under Wada Eisaku, Matsuoka Hisashi, and Mitsutani Kunishirō. Exhibited religious paintings with the Teiten and the Sōgenkai. **Bib.**: Asano.

¹小柴錦侍

Kōshō[1] (fl. 990–1020). **Biog.**: Sculptor. Father of Jōchō. Member of the Shichijō Bussho, Nara. Recorded as having carved many statues for the Hōjō-ji, now nonexistent. Today there is considerable discrepancy as to what, among existing pieces, can be attributed to him. Some scholars say the Fudō Myōō (1006?) in the Dōshū-in, Tōfuku-ji, Kyōto, is the only work that may possibly be by him; others add the Senju Kannon (1012?) in the Kōryū-ji and a Yakushi Nyorai (1013?) in the Kōfuku-ji, Nara. The *yosegi* method of wood sculpture (the fitting together of many small pieces), generally attributed to his son, may have originated with

him. **Coll.**: Kōfuku-ji, Kōryū-ji, Tōfuku-ji (Dōshu-in). **Bib.**: BK 48; K 846, 848; Kuno (1); NB (S) 50.

¹康尚

Kōshō¹ (fl. late 12th to early 13th c.). **Biog.**: Kei sculptor. Said to have been fourth son of Unkei. Member of Shichijō Bussho in both Nara and Kyōto. Served as *daimoku-busshi* (chief of sculptors and craftsmen making Buddhist images) at the Tō-ji, Kyōto. Among the works by him are a Kūya Shōnin (Rokuhara Mitsu-ji), a bronze Amida Nyorai of 1232 (to replace a lost Asuka piece) at the Hōryū-ji, a wooden image of Kōbō Daishi of 1233 (Meidō, Tō-ji), and, perhaps, the lantern bearer Ryutōki (Kōfuku-ji). A sculptor of great technical ability. His work sometimes epitomizes the realistic tendencies of the Kamakura period. **Coll.**: Hōryū-ji (Kondō), Kōfuku-ji, Tō-ji, Myōhō-in (Rengeō-in), Rokuhara Mitsu-ji, Sekkei-ji. **Bib.**: Buhot; GNB 9; K 910; Kidder; *Kokuhō* 4; Kuno (1), (2) 6; Mōri (1a); NB (H) 11; NBZ 3; Paine (4); SBZ 6.

¹康勝

Kōshō¹ (1534–1621). **Biog.**: Sculptor. Lived in Kyōto, serving the Tō-ji as chief sculptor. Seems to have been primarily engaged in the repair and restoration of existing statues in the various buildings of the Tō-ji, as well as at the Toyokuni Shrine, the Shōkoku-ji, the Kongōbu-ji, and the Myōhō-in (Rengeō-in). **Coll.**: Tō-ji. **Bib.**: SBZ 21.

¹康正

Kōshu¹ (fl. 13th c.). **Biog.**: Kose painter. Attained rank of *hōgen*. May have been employed at the Ichijō-ji and the Daijō-ji in Nara. The portrait *Gyōgi Bosatsu-zō* in the Tōshōdai-ji is signed by him. **Coll.**: Tōshōdai-ji. **Bib.** *Chūsei.*

¹幸守

Koshū¹ (1737–84). **N.**: Hirowatari Yaheiji.² **A.**: Genkō.³ **F.N.**: Chūsai.⁴ **Gō**: Koshū.⁵ **Biog.**: Nagasaki painter. Born in Nagasaki; grandson of Hirowatari Ikko, son of Hirowatari Koshun. On his father's death succeeded him as *kara-e mekiki* in Nagasaki. Studied painting under Ishizaki Genshō. **Coll.**: Matsuura.

¹湖秀 ²広渡八平治 ³元厚 ⁴仲斎 ⁵湖秀

Koshū¹ (1760–1822). **N.**: Hatta (Yata) Kiken.² **A.**: Shiei.³ **F.N.**: Kunai.⁴ **Gō**: Koshū.⁵ **Biog.**: Maruyama painter. Lived in Kyōto. First studied with Murakami Tōshū, later with Maruyama Ōkyo. Received title of *hokkyō*. An able painter of figures as well as of flowers and fish. **Coll.**: British, Museum (3). **Bib.**: Brown, Hillier (4) 3, Holloway, Mitchell, Morrison 2.

¹古秀 ²八田希賢 ³子瑩 ⁴宮内 ⁵古秀

Kōshun¹ (fl. 1311–69). **Biog.**: Sculptor. Said to have been a son and pupil of Unjo, sixth son of Unkei (but the dates of their activities belie this) and a member of the Shichijō Bussho. Little really known of his life save he was made head of Kōfuku-ji workshop and was active—to judge from the statues with dated inscriptions indicating he was the sculptor—from 1311 to 1369. Received honorary rank of *hōgen* in 1324 and later was made *hōin*. Among his known works are: a Fudō triad (1311), Jōruri-ji; Jizō Bosatsu (1315), Hōkō-in; Shōtoku Taishi (1320), Atami Museum; Shitennō (1321–22), done with his son Kōsei for the Yōgo-ji; Monju Bosatsu (1324), also with Kōsei for the Hannya-ji; Fugen Emmei Bosatsu (1326), Ryūden-ji; Sōgyō Hachiman (1328), Museum of Fine Arts, Boston; Monju (1348), Daikō-ji; Fudō Myōō (1369), Fukushō-ji; Amida, Cleveland Museum. A competent but at times rather dull sculptor. **Coll.**: Atami, Chōkyū-ji, Cleveland, Daikō-ji, Fukushō-ji, Hannya-ji, Hōkō-in, Jōruri-ji, Museum (3), Ryūden-ji, Yōgo-ji. **Bib.**: BCM 47, 48; BMFA 25; Fontein (3); G 3; GNB 9; *Kokuhō* 4; Kuno (1), (2) 6; Mayuyama; Mōri (1a); *Muromachi* (2); Rosenfield (2).

¹康俊

Koshun¹ (?–1746). **N.**: Hirowatari Bansuke (Tomosuke).² **Gō**: Koshun.³ **Biog.**: Nagasaki painter. Second son and

pupil of Hirowatari Ikko. On the death of his father in 1702, succeeded to the position of *kara-e mekiki* in Nagasaki.

¹湖春 ²広渡伴助 ³湖春

Koson¹ (1801–66). **N.**: Ikeda Sanshin.² **A.**: Shūji.³ **Gō**: Gasenken,⁴ Koson,⁵ Kyūshōken.⁶ **Biog.**: Painter. Born in Echigo Province. At an early age to Edo. First learned the technique of Hōitsu, but after studying Chinese pictures of the Ming dynasty, changed his style and painted only in ink. Compiled the *Shinsen Kōrin Hyakuzu* (a new series of 100 reproductions of Kōrin's work). **Coll.**: Minneapolis, Museum (3), Victoria. **Bib.**: K 275, Mitchell, Morrison 2, Murase.

¹孤村 ²池田三辰 ³周二 ⁴画戦軒 ⁵孤村 ⁶旧松軒

Kosugi Hōan¹ (1881–1964). **N.**: Kosugi Kunitarō.² **Gō**: Hōan,³ Misei.⁴ **Biog.**: Painter. Also known as a poet and essayist. Born in Nikkō. Studied Western-style painting first under Ioki Bun'ya, then at Fudōsha under Koyama Shōtarō. Served as an illustrator in Russo-Japanese War of 1904–5. Showed his decorative paintings at the Bunten; was awarded several prizes. In 1913 to France for a year's study. On his return showed with the Nihon Bijutsuin, of which he was a member from 1914 to 1920, exhibiting thinly painted decorative works somewhat in the manner of Puvis de Chavannes. As one of the founders, an almost constant exhibitor at the Shun'yōkai from its first show in 1923 until 1958. In the 1920s, began to work in ink and colors in a deft and amusing *bunjinga* manner. In his later years, this Japanese style, light and delicate, with frequent touches of humor, almost completely superseded his Western one of oil painting. **Coll.**: Bridgestone, Idemitsu, National (5). **Bib.**: Asano, Harada Minoru, *Hōan, Kosugi Hōan*, Mitchell, NB (H) 24, NB (S) 30, NBT 10, NBZ 6, *Posthumous* (1), Uyeno.

¹小杉放庵 ²小杉国太郎 ³放庵 ⁴未醒

Kotei¹ (1717–73). **N.**: Hirowatari Koheita.² **Gō**: Kotei.³ **Biog.**: Nagasaki painter. Born in Nagasaki. Son of Hirowatari Koshun, probably older brother of Hirowatari Koshū. Succeeded his father as *kara-e mekiki* in Nagasaki.

¹湖亭 ²広渡小平太 ³湖亭

Kōtei¹ (1800–1856). **N.**: Asaoka Kōtei² (originally Kanō Nobuyoshi).³ **F.N.**: Sanjirō.⁴ **Gō**: Heishū,⁵ Sanraku.⁶ **Biog.**: Kanō painter. Born and lived in Edo. Second son and pupil of Kanō Isen'in, younger brother of Kanō Seisen'in Osanobu. In 1820, became son-in-law of Asaoka Koho and was adopted by the Asaoka family. In 1830 appointed *goyō eshi* to the shogun's court; became head of the Edokoro. Only a few extant works, but is famous for his collection of biographies of Japanese painters, the *Koga Bikō*, a work in 48 volumes, the manuscript of which is preserved at the Tōkyō Art School. All subsquent biographies of Japanese painters are indebted to this work. A mediocre artist. **Bib.**: *Kanō-ha.*

¹興禎 ²朝岡興禎 ³狩野信真 ⁴三次郎 ⁵平洲 ⁶三楽

Koteki¹ (?–1746). **N.**: Hirowatari Koteki.² *Priest name:* Jōjitsu.³ **Gō**: Getchō Koteki,⁴ Gyokukosai.⁵ **Biog.**: Nagasaki painter. Born in Nagasaki. Son and pupil of Hirowatari Ikko. Became a priest at the Honkaku-ji. His paintings included *kachōga,* landscapes, and portraits.

¹湖笛 ²広渡湖笛 ³成実 ⁴月澄湖笛 ⁵玉壺斎

Kōun¹ (fl. early 13th c.). **Biog.**: Sculptor. Second son of Unkei; may be the same person as Dai Busshi Jōkei (q.v.). Recorded as having worked with his father at the Tō-ji, the Kōfuku-ji, and the Rokuhara Mitsu-ji. No authenticated works by him can be identified today, though the Zōchōten in the Kōfuku-ji was formerly attributed to him. According to a tradition, much discredited now, is said to have invented the technique of Kamakura-bori, the carving and polishing of layers of red *urushi* over an underlayer of black, applied to a thin piece of wood. **Bib.**: Kuno (2) 6; Mōri (1a); NB (S) 40; OZ 13; Ragué; Sawaguchi; Tajima (12) 11, 13.

¹康運

Kōun[1] (?–1702). *N.*: Kōtari Kōun.[2] *F.N.*: Zen'emon.[3] *Gō:* Jōan,[4] Yūsan.[5] **Biog.**: Kanō painter. One of Tan'yū's four best pupils. In his later years, entered the service of Lord Uesugi. **Coll.**: Museum (3).

¹高雲　²神足高雲　³善右衛門　⁴常庵　⁵幽讃

Kōunsai[1] (1803–65). *N.*: Takeda Seisei[2] (originally Hikokurō).[3] *F.N.*: Iga no Kami.[4] *Gō:* Joun,[5] Kōunsai.[6] **Biog.**: Painter. Member of the Mito clan and a Loyalist. Painted as a hobby; no works by him are known at present.

¹耕雲斎　²武田正生　³彦九郎
⁴伊賀守　⁵如雲　⁶耕雲斎

Kōya[1] (?–1672). *N.*: Kanō Hakuho.[2] *F.N.*: Riemon;[3] later, Gyōbu.[4] *Gō:* Gukei,[5] Guō,[6] Jōyōan,[7] Kōya.[8] **Biog.**: Kanō painter. Second son and pupil of Kanō Kōi. Official painter to the Mito branch of the Tokugawa family. Achieved rank of *hokkyō*. **Coll.**: Museum (3). **Bib.**: K 42, Morrison 1.

¹與也　²狩野伯甫　³利右衛門　⁴刑部
⁵愚渓　⁶愚翁　⁷常陽庵　⁸與也

Koyama Eitatsu[1] (1880–1945). *N.*: Koyama Masaji.[2] *Gō:* Eitatsu.[3] **Biog.**: Japanese-style painter. Born in Tōkyō. Studied first with the Western-style painter Honda Kinkichirō, then with the Japanese-style painter Kobori Tomone. Member of the Kojikai and the Jitsugetsukai; exhibited with the Nihon Kangyō Hakurankai, Nihon Bijutsu Kyōkai, and Nihon Bijutsuin, receiving prizes at all of them. Also showed with the Bunten from 1911 to 1915 and, later, with the Teiten, receiving various medals. **Coll.**: National (5). **Bib.**: Asano.

¹小山栄達　²小山政治　³栄達

Koyama Keizō[1] (1897–). **Biog.**: Western-style painter. Born in Nagano-ken. Studied under Fujishima Takeji, Yasui Sōtarō, and Arishima Ikuma. Then traveled and studied in Europe from 1920 to 1928; worked in Paris under Charles Guérin, exhibiting at the Salon d'Automne. In Europe again in 1937–38. Member of the Nikakai, Shun'yōkai, Issuikai, Nitten, Nihon Geijutsuin, and Japan Art Academy. In 1959 won the Academy Prize. His Western style influenced by the prewar School of Paris; also works in the Japanese manner. **Coll.**: Kanagawa, National (5). **Bib.**: Asano, NBZ 6.

¹小山敬三

Koyama Sanzō[1] (fl. late 19th c. to early 20th c.). **Biog.**: Western-style painter, printmaker. A samurai. Studied Western-style painting at the Kōbu Daigaku Bijutsu Gakkō. In charge of the Western-style painting section of the Kyōto Prefectural School of Painting for a short while after it opened in 1880. **Bib.**: Asano, NBZ 6.

¹小山三造

Koyama Shōtarō[1] (1857–1916). *N.*: Koyama Shōtarō.[2] *Gō:* Senraku.[3] **Biog.**: Western-style painter. Born in Nagaoka; lived in Tōkyō. Pupil first of Kawakami Tōgai; later studied under Fontanesi at the Kōbu Daigaku Bijutsu Gakkō. In 1889, with Asai Chū and others, founded Meiji Bijutsukai. Member of the hanging committee of the Bunten. At his own art school, Fudōsha, taught many pupils who later became famous: Nakamura Fusetsu, Mitsutani Kunishirō, Nakagawa Hachirō, Ishikawa Toraji, Kanokogi Takeshirō, Yoshida Hiroshi, Kosugi Hōan. Served as a war artist during the Sino-Japanese War of 1894–95. Had a great influence on the subsequent generation of Japanese artists working in the Western manner. His own style one of academic realism. **Coll.**: Nagaoka, Tōkyō (2). **Bib.**: Asano, BK 188, Harada Minoru, *Kurashina* (2), M 133, NB (H) 24, NB (S) 30, NBZ 6, Uyeno.

¹小山正太郎　²小山正太郎　³先楽

Koyama Taigetsu[1] (1891–1946). *N.*: Koyama Mitsuzō.[2] *Gō:* Taigetsu.[3] **Biog.**: Japanese-style painter. Born in Tōkyō. Pupil of Matsumoto Fūko. First exhibited with the Inten in 1916; became a member in 1926. His screens of flowers and

trees are fresh and charming. **Coll.**: National (5). **Bib.**: Asano.

¹小山大月　²小山光造　³大月

Kōyo[1] (fl. first half 14th c.). **Biog.**: Kei sculptor. Descendant of Unkei. Member of Shichijō Bussho; served as *dai busshi* at the Tō-ji, where he was in charge of repairing statues; also head of the Shichijō Nishi Bussho, a new school set up to rival the older sculptors' groups. A Dainichi Nyorai, signed by him and dated 1346, is in the Henshō-ji, Mōkashi, Tochigi-ken. His style still shows a trace of the Unkei tradition, and in the inscription of 1346 he calls himself the fifth generation after Unkei. **Coll.**: Henshō-ji. **Bib.**: M 120, *Muromachi* (2).

¹康誉

Kōyō[1] (1717–80). *N.*: Nakayama Kiyoshi[2] (or Teki[3] or Zōsen [Shōsen]).[4] *A.*: Jogen,[5] Shitatsu,[6] Shiwa,[7] Teichū.[8] *F.N.*: Seiemon.[9] *Gō:* Gansei Dōjin,[10] Kōyō[11] (from age of 40), Shōsekisai,[12] Suiboku Sanjin.[13] **Biog.**: *Nanga* painter. Claimed descent from the Minamoto[14] family, sometimes using this as his surname; also called himself by a Chinese pseudonym: Chung Shih (Japanese: Chū Teki).[15] Born in Sakai-machi in Tosa, son of a dealer in antiques and Chinese objects. At 16 began to study painting. To Kyōto; said to have been a pupil of Sakaki Hyakusen, but was largely self-taught by means of woodblock-printed books and albums. Made almost 500 copies of old paintings, notably northern Sung. Also learned much from study of Sesshū. His paintings of this period chiefly of bamboo in monochrome. Studied Confucianism and calligraphy as well. About 1758 to Edo, where his paintings of landscapes and scenes taken from Chinese legend and history as well as his paintings of bamboo and plum trees in the style of Shen Nan-p'in had a considerable success. Many requests to do portraits. After 1772, when his house was destroyed in the great Edo fire, painted in a much simpler style, closer to southern Sung. Scroll of *Rantei Kyokusui*, dated 1778, his most famous picture. In 1775 wrote an excellent book on art, *Gadan Keiroku*, a criticism of the Kanō school, saying too much stress was laid on training by copying. A pioneer *nanga* painter. **Coll.**: Homma, Kamman-ji. **Bib.**: BK 32; *Centcinquante*; K 838, 925; M 222, 225; Murayama (2); NB (S) 4; NBZ 5; *Nihon* (3); PTN 5; Shimada 2; Umezawa (2); Yonezawa.

¹高陽　²中山清　³適　⁴象先　⁵汝玄　⁶子達
⁷子和　⁸廷沖　⁹清右衛門　¹⁰玩世道人
¹¹高陽　¹²松石斎　¹³酔墨山人　¹⁴源　¹⁵仲適

Kōyō[1] (fl. c. 1810). *N.*: Yamamoto Kōyō.[2] *A.*: Buntei.[3] *Gō:* Kakuhō.[4] **Biog.**: Painter. Born in Etchū Province. A good landscape painter. **Bib.**: Mitchell.

¹孔陽　²山本孔陽　³文鼎　⁴鶴峰

Kōyū[1] (fl. 13th c.). **Biog.**: Kei sculptor. Worked in the Kamakura area. Member of Shichijō Bussho, Nara. The statues of the Kings of Hell (usually on exhibition at the Kamakura National Treasure House but owned by the Ennō-ji) have the signature Kōyū and the date 1251. His style shows the influences of the Kei school and of late Sung China. **Coll.**: Ennō-ji. **Bib.**: Buhot, GNB 9, Kuno (1), NBZ 3, Noma (1) 1, SBZ 6.

¹幸有

Kōzan[1] (?–1823). *N.*: Toda Mitsuharu.[2] *A.*: Yūsen.[3] *Gō:* Kōzan.[4] **Biog.**: Painter. An Ōsaka sakè dealer who devoted part of his time to painting. Pupil of Kanae Shungaku. Painted figures and *kachōga*. **Bib.**: Mitchell.

¹黄山　²戸田光春　³游仙　⁴黄山

Kōzan[1] (1780–1847). *N.*: Nonoyama Shōgan.[2] *A.*: Shishō.[3] *F.N.*: Yahei.[4] *Gō:* Kōzan,[5] Rakuraku Koji.[6] **Biog.**: Painter. Also a poet and naturalist. Lived in Edo. Studied under a minor Kanō artist. Achieved rank of *hōgen*. His paintings

show an interest in detailed realism. **Coll.**: Rijksmuseum (2). **Bib.**: Hillier (2).

¹縹山　²野々山正頑　³子祥
⁴弥兵衛　⁵縹山　⁶楽々居士

Kōzan[1] (1784–1866). *N.*: Matsumoto (originally Kamijō)[2] Nori.[3] *A.*: Shinsai.[4] *F.N.*: Bun'emon.[5] *Gō*: Daigaku,[6] Kōzan,[7] Shichisōdō.[8] **Biog.**: *Nanga* painter. Born in Edo. Pupil of Tani Bunchō, influenced by Hōitsu. In his later years became a priest at the Inari-jingū, Fukagawa, Edo; achieved rank of *hōgen*. Specialized in landscapes and *kachōga*. **Coll.**: Museum (3). **Bib.**: Mitchell.

¹交山　²上条　³松本機　⁴真宰
⁵文右衛門　⁶大学　⁷交山　⁸七草堂

Kōzan[1] (1821–69). *N.*: Ishikawa Akira.[2] *A.*: Shikō.[3] *F.N.*: Sōsuke.[4] *Gō*: Bimpatsu Sanjin,[5] Kōzan,[6] Tōmō Bokkyaku.[7] **Biog.**: Painter. Born in Shimotsuke. To Edo; studied under Tani Bunchō. Later traveled in Kyūshū; knew Hidaka Tetsuō and Kinoshita Itsuun, who probably influenced his work.

¹晃山　²石川晃　³士晃　⁴宗助
⁵鬢髪山人　⁶晃山　⁷東毛墨客

Kōzan[1] (fl. 19th c.). *Gō*: Kōzan,[2] Shōhōsai.[3] **Biog.**: Lacquerer. Pupil of Ritsuō. An excellent artist, known for his use of encrusted designs. Also made *netsuke*. **Bib.**: Herberts, Jahss.

¹光山　²光山　³松宝斎

Kōzu Kōjin[1] (1889–). **Biog.**: Western-style painter. Born in Nagano-ken. In 1912 graduated from Tōkyō School of Fine Arts. Exhibited with the Bunten in 1915. In 1920 to Europe; studied at the Royal Academy in London and the Académie Julian in Paris. On returning to Japan joined several small art groups; in 1957 became a member of the Daiichi Bijutsu Kyōkai. **Bib.**: Asano.

¹神津港人

Kubota Beisen[1] (1852–1906). *N.*: Kubota Hiroshi.[2] *A.*: Kampaku.[3] *Gō*: Beisen,[4] Jinkaitōda,[5] Kinrinshi,[6] Kusanoya,[7] Shiroken.[8] **Biog.**: Japanese-style painter. Born in Kyōto. Pupil of Suzuki Hyakunen. Traveled in America, China, Europe. In 1880, with Kōno Bairei, started the Kyōto Prefectural School of Painting and taught there. In 1890, again with Bairei, founded the Kyōto Bijutsu Kyōkai. An illustrator with the army during the Sino-Japanese War, and also for the newspaper *Kokumin Shimbun,* which he helped to establish. Became blind toward the end of his life. His subjects included figures and landscapes and, particularly, historical themes. His style at times quite *nanga*. **Coll.**: Victoria. **Bib.**: Asano, Mitchell, NB (S) 17, NBZ 6.

¹久保田米僊　²久保田寛　³簡伯　⁴米僊
⁵塵芥頭陀　⁶錦鱗子　⁷草の屋　⁸柴楼軒

Kubota Kinsen[1] (1875–1954). *N.*: Kubota Mitsumasa.[2] *Gō*: Kinsen.[3] **Biog.**: Japanese-style painter. Born in Kyōto. Son and pupil of Kubota Beisen. Later studied the paintings of Kōno Bairei and Shiokawa Bunrin. Graduated from Kyōto Municipal School of Fine Arts and Crafts. To Tōkyō to exhibit with the Nihon Bijutsu Kyōkai, the Nihongakai, and the Bunten. A war correspondent during the Sino-Japanese and the Russo-Japanese wars. **Bib.**: Asano.

¹久保田金僊　²久保田満昌　³金僊

Kubota Tōsui[1] (1841–1911). **Biog.**: Shijō painter. Born in Kyōto. Studied first with Yokoyama Seiki, then in Ōsaka with Nishiyama Hōen. In 1887 worked in Tōkyō for the imperial household, painting a screen for one of the imperial palaces; in 1891 did some paintings for the Shiba Detached Palace. Member of the Nihon Bijutsu Kyōkai. In 1904 returned to Ōsaka. **Coll.**: Museum (3).

¹久保田桃水

Kūchū[1] (1601–82). *N.*: Hon'ami Kōho.[2] *A.*: Kōho.[3] *Gō*: Kūchū,[4] Kūchūsai.[5] **Biog.**: Painter, potter, sculptor. Lived in Kyōto. Studied under his father, Hon'ami Kosa, and his grandfather, Kōetsu. Versed in tea ceremony and in the

family profession of judging swords. In painting, a follower of Sōtatsu. A skillful potter of Shigaraki ware, known as Kūchū Shigaraki, as well as of red Raku tea bowls. Author of *Hon'ami Gyōjōki.* The wooden image of his grandfather at the Kōetsu-ji was carved by him. In 1641 received title of *hōgen.* **Coll.**: Freer, Hatakeyama, Matsunaga, Metropolitan, Nezu, Tōkyō (1). **Bib.**: Hisamatsu; K 5, 67; *Kōrin* (1); M 48; Mizuo (2a), (4); Morrison 2; NB (S) 14; Okuda (2); *Rimpa; Sōtatsu* (3); STZ 7; Warner (1).

¹空中　²本阿弥光甫　³光甫　⁴空中　⁵空中斎

Kūkai[1] (774–835). *N.*: Saeki (Saheki).[2] *Priest name:* Jokū,[3] Kyōkai,[4] Mukū;[5] later, Kūkai.[6] *A.*: Kibutsu.[7] *Buddhist title:* Kōbō Daishi.[8] **Biog.**: Painter. A famous Buddhist priest who founded the Shingon sect. A superb calligrapher, he has traditionally been considered a painter and sculptor as well. Two of the seven portraits (five of which were brought from China by Kūkai) of the Seven Patriarchs of the Shingon Sect in the Tō-ji, Kyōto, are traditionally ascribed to him; but no recent scholar has associated his name with any existing painting. **Coll.**: Tō-ji. **Bib.**: *Heian* (1), Morrison 1, Paine (4).

¹空海　²佐伯　³如空　⁴教海　⁵無空
⁶空海　⁷貴物　⁸弘法大師

Kukei (Kyūkei)[1] (fl. 1789–1801). *N.*: Nomura Jirō.[2] *Gō*: Kukei (Kyūkei).[3] **Biog.**: Lacquerer. Worked in Edo. Pupil of Koma VI. Brother of Chohei. **Bib.**: Herberts, Jahss.

¹九圭　²野村次郎　³九圭

Kumagai Morikazu (Moriichi)[1] (1880–). **Biog.**: Western-style painter. Born in Gifu-ken. Graduated from the Tōkyō School of Fine Arts in 1904. An exhibitor first with the Bunten, later with the Nikakai, of which he was a founding member. His paintings, generally small in size, are usually executed in a heavy *impasto* in a somewhat expressionist style. Also works in the Japanese manner. **Coll.**: Ohara (1). **Bib.**: Asano, Kung, NBZ 6.

¹熊谷守一

Kumagai Naohiko[1] (1828–1913). *N.*: Kumagai (originally Yamamoto)[2] Naohiko.[3] *F.N.*: Tōtarō;[4] later, Hyōe,[5] Suehiko.[6] *Gō*: Tokuga.[7] **Biog.**: Japanese-style painter. Born in Kyōto, son of a Shintō priest. Interested as a child in painting; at 14 became a pupil for the next three years of the Shijō painter Okamoto Shigehiko. Later studied painting independently, as well as the traditional manners and customs of Japan. Active in the Meiji Restoration; in 1869 became an official in the government, moving later to Hiroshima in an official capacity. Member of the Art Committee of the Imperial Household. An occasional juror for the Nihon Bijutsu Kyōkai. An able landscape painter. **Coll.**: Museum (3). **Bib.**: Asano, Mitchell, Morrison 2, NBZ 6.

¹熊谷直彦　²山本　³熊谷直彦　⁴藤太郎
⁵兵衛　⁶季彦　⁷篤雅

Kumaoka Yoshihiko[1] (1889–1944). **Biog.**: Painter. Born in Ibaraki-ken. Graduated from the Tōkyō School of Fine Arts in 1913. In 1915 received a prize at the Bunten. After 1919 exhibited with the Teiten, becoming a member of the committee in 1925. Also served as a juror for the Bunten. Received the first Teikoku Bijutsuin Prize. From 1926 to 1929 abroad. On his return became professor at the Teikoku Bijutsu Kenkyūsho. Also exhibited with the Kōfūkai and Taiheiyō Gakai. **Bib.**: Asano, NBZ 6.

¹熊岡美彦

Kume Keiichirō[1] (1866–1934). **Biog.**: Western-style painter. Born in Hizen; lived in Tōkyō. Pupil of Fuji Gazō. In 1886 to France, where he met Kuroda Seiki and studied under Raphael Collin. In 1893 returned to Japan. The next year founded, with Kuroda Seiki, the art school Tenshin Dōjō, and, in 1896, the Hakubakai. From 1898 taught for a short time at the Tōkyō School of Fine Arts. Had many followers. Exhibited with the Bunten. Specialized in landscape, working in an impressionist manner. **Coll.**: Tōkyō (1), (2). **Bib.**:

Asano, BK 188, Harada Minoru, *Kurashina* (2), NB (S) 30, NBZ 6.

¹久米桂一郎

Kuniaki I¹ (fl. 1850–60). *N.:* Hirasawa.² *Gō:* Kuniaki.³ **Biog.:** Ukiyo-e printmaker. A samurai by birth. Pupil of Kunisada. Known for his prints of the foreigners who visited Yokohama. Thought by some scholars to be the same person as Kuniaki II (q.v.). **Coll.:** Fine (California), Musées, Newark, Philadelphia. **Bib.:** Binyon (3), Crighton, *Foreigners*, Succo (2).

¹国明一代 ²平沢 ³国明

Kuniaki II¹ (1835–88). *N.:* Hachisuka² (originally Hirasawa).³ *F.N.:* Onojirō.⁴ *Gō:* Hōsai,⁵ Ippōsai,⁶ Kuniaki.⁷ **Biog.:** Ukiyo-e printmaker. Younger brother of, or perhaps same person as Kuniaki I (q.v.). Adopted by the Hachisuka family. In 1844 became a pupil of Kunisada. Good at prints of actors and *sumō* wrestlers; also an early Yokohama-e print designer. A minor artist. **Coll.:** British, Newark, Philadelphia, Victoria. **Bib.:** Binyon (1), Crighton, *Foreigners*, Succo (2).

¹国明二代 ²蜂須賀 ³平沢 ⁴斧二郎
⁵鳳斎 ⁶一鳳斎 ⁷国明

Kunichika¹ (1835–1900). *N.:* Toyohara (originally Arakawa)² Yasohachi.³ *Gō:* Beiō,⁴ Hōshunrō,⁵ Ichiōsai,⁶ Kachōrō,⁷ Kunichika,⁸ Shima Sanjin,⁹ Sōgenshi.¹⁰ **Biog.:** Ukiyo-e printmaker. Born in Edo. Pupil first of Toyohara Chikanobu (whose name he took), then of Utagawa Kunisada (among the few of Kunisada's pupils who did *not* use the name of Utagawa). Produced prints of actors, sets of views, historical subjects, journalistic illustrations in the late Kunisada tradition, which reflect the declining taste of the public and the worsening color printing. Particularly known for some late *ōkubi-e*. A minor artist, but represents the last of the great ukiyo-e tradition. **Coll.:** Ashmolean; Baltimore; British; Cincinnati; Fine (California, De Young); Musée (1), (2); Musées; Newark; Riccar; Tōkyō (1); Victoria; Waseda. **Bib.:** Binyon (1), (3); Crighton; Hillier (3), (4) 1; Kikuchi; Morrison 2; NBZ 6; NHBZ 6, 7; Succo (2); Takahashi (2); Tamba (2a); UG 28.

¹国周 ²荒川 ³豊原八十八 ⁴米翁 ⁵豊春楼 ⁶一鶯斎
⁷華蝶楼 (花蝶楼) ⁸国周 ⁹志満山人 ¹⁰曹玄子

Kunieda Kinzō¹ (1886–1943). **Biog.:** Western-style painter. Born in Ōsaka. Studied first under Akamatsu Rinsaku. Graduated from Kansai Bijutsuin, where he was a pupil of Kanokogi Takeshirō. Exhibited at the Nikakai in 1914, becoming a member in 1923. Active member of the Nitten, as well as of Ōsaka art organizations. His work shows influence of Cézanne. **Bib.:** Asano, NBZ 6.

¹国枝金三

Kunifusa¹ (fl. 1804–30). *N.:* Utagawa Kunifusa.² *F.N.:* Tasaburō,³ Tsurukichi.⁴ **Biog.:** Ukiyo-e painter, printmaker. Pupil of Toyokuni. **Bib.:** Morrison 2.

¹国房 ²歌川国房 ³多三郎 ⁴鶴吉

Kunihiro¹ (fl. c. 1815–43). *N.:* Utagawa (originally Takigawa)² Kunihiro.³ *Gō:* Ganjōsai,⁴ Kōnantei,⁵ Sanshōtei.⁶ **Biog.:** Ukiyo-e printmaker. Worked in Edo and, to a greater extent, in Ōsaka. Pupil of Toyokuni II. First prints published in 1816. Several of his works are based on drawings or on altered versions of privately issued prints by Asayama Ashikuni. Good actor prints. **Coll.:** Ashmolean, British, Musée (1), Musées, Philadelphia, Victoria. **Bib.:** Binyon (1), (3); Crighton; Keyes; Succo (2); *Ukiyo-e* (3) 19.

¹国広 ²滝川 ³歌川国広 ⁴丸丈斎 ⁵江南亭 ⁶三昇亭

Kunihisa¹ (1832–91). *N.:* Katsuda Hisatarō.² *Gō:* Ichiunsai,³ Kunihisa,⁴ Ritchōrō,⁵ Toyonobu,⁶ Yōryūsai,⁷ Yōsai.⁸ **Biog.:** Ukiyo-e printmaker. Lived in Yokohama. Pupil and son-in-law of Kunisada; collaborated with him, doing the landscape background for his master's figures. An early member of the Yokohama school, specializing in landscape.

Coll.: Ashmolean, Idemitsu, Musées, Newark, Philadelphia, Victoria. **Bib.:** *Foreigners*, Morrison 2, Nonogami, *Nikuhitsu* (2).

¹国久 ²勝田久太郎 ³一雲斎 ⁴国久
⁵立蝶楼 ⁶豊宣 ⁷陽竜斎 ⁸陽斎

Kunikata Rinzō¹ (1883–1966). **Biog.:** Sculptor. Born in Kagawa-ken. Studied at Taiheiyō Kenkyūsho under Shinkai Taketarō. Exhibited with the Bunten; in 1922 served as juror for the Teiten. After 1945, exhibitor at and juror for the Nitten. **Coll.:** National (5). **Bib.:** Asano.

¹国方林三

Kunikazu¹ (fl. c. 1848–68). *N.:* Utagawa Kunikazu.² *Gō:* Isshusai.³ **Biog.:** Ukiyo-e printmaker. Pupil of Kunisada. Produced prints of landscapes and actors. Highly accomplished technician. **Coll.:** Musées, Philadelphia, Victoria. **Bib.:** Crighton, Keyes, Nonogami.

¹国員 ²歌川国員 ³一珠斎

Kunikiyo I¹ (fl. mid-19th c.). *N.:* Utagawa (originally Emori)² Kunikiyo.³ *F.N.:* Yasuzō.⁴ *Gō:* Ichirakusai.⁵ **Biog.:** Ukiyo-e painter, printmaker. Pupil of Toyokuni. Served as a petty official to the shogunate. For some reason, was exiled to Hachijōjima, where he made sketches of the local customs and scenery. **Coll.:** Victoria.

¹国清一代 ²江守 ³歌川国清 ⁴安蔵 ⁵一楽斎

Kunikiyo II¹ (fl. late 19th c.). *N.:* Utagawa Kunikiyo.² *Gō:* Ichirakusai,³ Shōgyorō.⁴ **Biog.:** Ukiyo-e painter. Nothing known of his life save that he was a pupil of Kunisada. **Coll.:** Fine (California).

¹国清二代 ²歌川国清 ³一楽斎 ⁴松魚楼

Kunimaro¹ (fl. late 18th c.). *N.:* Kusamura Kunimaro.² **Biog.:** Ukiyo-e printmaker. Pupil of Toyomaru, from whom he evidently got the name of Kusamura. A rather dim printmaker of *bijinga*. **Coll.:** Victoria. **Bib.:** Crighton.

¹国麿 ²叢国麿

Kunimaro I¹ (fl. 1850–75). *N.:* Utagawa Kunimaro². *F.N.:* Kikukoshi Kikutarō.³ *Gō:* Ichiensai,⁴ Kikuō (for *haiku*),⁵ Shōchōrō.⁶ **Biog.:** Ukiyo-e printmaker. Pupil of Kunisada. A minor member of the Utagawa print circle. Also wrote poetry and illustrated books. **Coll.:** British, Musées, Victoria, Yale. **Bib.:** Binyon (1), Stewart.

¹国麿一代 ²歌川国麿 ³菊越菊太郎
⁴一円斎 ⁵菊兮 ⁶松蝶楼

Kunimaro II¹ (fl. c. 1870). *N.:* Yokoyama Kinji.² *Gō:* Ichiensai,³ Kikusai,⁴ Kunimaro.⁵ **Biog.:** Ukiyo-e printmaker. Pupil of Utagawa Kunimaro. **Coll.:** Philadelphia, Victoria. **Bib.:** Keyes.

¹国麿二代 ²横山近二 ³一円斎 ⁴菊哉 ⁵国麿

Kunimaru¹ (1794–1829). *N.:* Utagawa (originally Maeda)² Kunimaru.³ *F.N.:* Bunji,⁴ Iseya Ihachi.⁵ *Gō:* Gosairō,⁶ Honchōan,⁷ Ichiensai,⁸ Keiuntei,⁹ Kunimaru,¹⁰ Saikarō.¹¹ **Biog.:** Ukiyo-e painter, printmaker. Son of an Edo pawnbroker, lived in Edo. Pupil of Toyokuni. Studied *haiku* with Ōryūan and became noted as a *haikai* poet under the name of Ryūbi.¹² Specialized in portraits of actors and *bijin*. After 1808, illustrated many books. **Coll.:** British, Cincinnati, Fitzwilliam, Honolulu, Musées, Staatliche, Tōkyō (1), Victoria, Waseda. **Bib.:** Binyon (1), Crighton, Kikuchi, Morrison 2, Schmidt, Succo (2).

¹国丸 ²前田 ³歌川国丸 ⁴文治 ⁵伊勢屋伊八 ⁶五彩楼
⁷翻蝶庵 ⁸一円斎 ⁹軽雲亭 ¹⁰国丸 ¹¹彩霞楼 ¹²竜尾

Kunimasa¹ (1773–1810). *N.:* Utagawa Kunimasa.² *F.N.:* Jinsuke.³ *Gō:* Ichijusai.⁴ **Biog.:** Ukiyo-e painter, printmaker. Born in northern Japan. To Edo. Was first apprenticed to a dyer, but eventually became favorite pupil of Toyokuni. His earliest prints date from 1795. Known particularly for his excellent *ōkubi-e* of actors, which have some of the satirical quality of Sharaku and the grace of Toyokuni. Worked as a printmaker until about 1805, sometimes producing prints in collaboration with Toyokuni.

Then gave up painting and turned to the making of masks. Work rare, and much prized by French connoisseurs. **Coll.:** Allen; Art (1); Ashmolean; British; Cincinnati; Cleveland; Fogg; Honolulu; Musées; Newark; Riccar; Rijksmuseum (1), (2); Staatliche; Tōkyō (1); University (2); Victoria; Worcester. **Bib.:** Binyon (1), (3); Crighton; Fujikake (3) 3; GNB 17; Hempel; Hillier (3), (4) 1, (7), (9); Kikuchi; *Kunst;* Lane; Michener (3); Morrison 2; NHBZ 4, 6, 7; *Nikuhitsu* (2); Nonogami; Schmidt; Shibui (1); Stewart; Succo (2); Takahashi (2); UG 28.

¹国政 ²歌川国政 ³甚知 ⁴一寿斎

Kunimasu¹ (fl. 1830–52). *N.:* Utagawa Sadamasu² (after 1848, Kunimasu).³ *Studio name:* Kanaya.⁴ *F.N.:* Wasaburō.⁵ *Gō:* Gochōsai,⁶ Gochōtei,⁷ Ichijuen,⁸ Ichijutei.⁹ **Biog.:** Ukiyo-e printmaker. Lived and worked in Ōsaka. Son of a rich Ōsaka merchant. Pupil of Kunisada, and when his master changed his name to Toyokuni III, changed his name from Sadamasu to Kunimasu. Worked generally in the style of Hiroshige; also made actor prints. At the end of his career, turned to the Shijō manner of painting. **Coll.:** Musées, Philadelphia, Tōkyō (1), Victoria. **Bib.:** Crighton, Keyes, NHBZ 3, Stewart, Strange (2), Turk.

¹国升 ²歌川貞升 ³国升 ⁴金屋 ⁵和三郎
⁶五蝶斎 ⁷五蝶亭 ⁸一樹園 ⁹一樹亭

Kunimatsu¹ (fl. second half 19th c.). *N.:* Utagawa Toyoshige;² later, Kunimatsu.³ *Gō:* Ichiryūsai;⁴ later, Fukudō.⁵ **Biog.:** Ukiyo-e printmaker. Pupil of Toyokuni II and of his father, an Ōsaka printmaker called Kunitsura. Made *nishiki-e;* also did newspaper illustrations. **Bib.:** Nonogami.

¹国松 ²歌川豊重 ³国松 ⁴一竜斎 ⁵福堂

Kunimitsu¹ (fl. 1801–18). *N.:* Utagawa Kunimitsu.² *F.N.:* Kumazō.³ *Gō:* Ichiōsai.⁴ **Biog.:** Ukiyo-e printmaker. Pupil of Toyokuni. Illustrator of books. **Coll.:** British, Herron, Musées, Newark, Tōkyō (1), Victoria. **Bib.:** Binyon (1), (3); Morrison 2; Succo (2).

¹国満 ²歌川国満 ³熊蔵 ⁴一翁斎

Kunimori I¹ (fl. 1818–43). *N.:* Utagawa Kunimori.² *Gō:* Kochōan.³ **Biog.:** Ukiyo-e printmaker. Pupil of Toyokuni II. **Note:** As the *kanji* for this artist and Kunimori II are the same, all references may be confused between the two. **Coll.:** Musées, Newark, Victoria. **Bib.:** NHBZ 6, Strange (2).

¹国盛一代 ²歌川国盛 ³胡蝶庵

Kunimori II¹ (fl. c. 1848–60). *N.:* Utagawa Kunimori.² *Gō:* Ichireisai,³ Ichiryūsai,⁴ Ippōsai,⁵ Shungyōsai.⁶ **Biog.:** Ukiyo-e printmaker. Worked in the style of Kunisada, whose pupil he was. **Note:** As the *kanji* for this artist and for Kunimori I are the same, all references may be confused between the two. **Coll.:** British, Victoria. **Bib.:** Binyon (1), NHBZ 6.

¹国盛二代 ²歌川国盛 ³一麗斎
⁴一竜斎 ⁵一宝斎 ⁶春暁斎

Kunimori Yoshiatsu¹ (1897–1951). **Biog.:** Western-style painter. Born in Hiroshima-ken. Graduate of the Kyōto College of Fine Arts in 1923. Showed at the Shun'yōkai in the mid-20s, frequently winning prizes. In 1947 taught at his alma mater. An exponent of progressive movements. **Bib.:** Asano.

¹国盛義篤

Kunimune¹ (fl. c. 1818). *N.:* Utagawa (originally Yamashita)² Matsugorō.³ *Gō:* Chōbunsai,⁴ Kunimune,⁵ Sanrei.⁶ **Biog.:** Ukiyo-e printmaker. Pupil of Toyokuni. Was followed by Kunimune II (fl. c. 1825–44), who used the same surname and the *gō* of Chōbunsai as well as that of Kunimasa II and was also a pupil of Toyokuni. **Coll.:** Musées. **Bib.:** *Nikuhitsu* (2).

¹国宗 ²山下 ³歌川松五郎 ⁴長文斎 ⁵国宗 ⁶杉嶺

Kuninaga¹ (?–1829). *N.:* Utagawa Kuninaga.² *F.N.:* Kayanosuke.³ *Gō:* Ichiunsai.⁴ **Biog.:** Printmaker. Born in Edo; is said to have been in his 40s when he died. Pupil of Toyokuni. Often made prints of Dutch scenes; also a book illus-

trator, and painter of lanterns. Work rare. A hybrid style: 18th-century Western manner applied to Japanese scenes. **Coll.:** Allen, Ashmolean, British, Kōbe, Musées, Staatliche, Tōkyō (1), Victoria. **Bib.:** Binyon (1), (3); Crighton; Mody; OA 2; *Pictorial* (2) 4; Schmidt; Stewart; Succo (2).

¹国長 ²歌川国長 ³梅干之助 ⁴一雲斎

Kuninaka no Muraji Kimimaro¹ (?–774). **Biog.:** Sculptor. Grandson of a naturalized Korean. Lived in Kuninaka, Nara-ken, and was given surname of Kuninaka no Muraji. Superintended the making of the Daibutsu at the Tōdai-ji, Nara, which was completed in 752. Made vice-director of the *Zō Tōdai-ji Shi* (Office for the Construction of the Tōdai-ji) in 761. Regarded as the most important sculptor of the Nara period. **Coll.:** Tōdai-ji (Kondō). **Bib.:** Kidder, Kuno (1), Yashiro (1) 1.

¹国中連公麻呂

Kuninao¹ (1793–1854). *N.:* Utagawa (originally Kitsukawa)² Taizō.³ *F.N.:* Shirobei.⁴ *Gō:* Dokusuisha,⁵ Enryūrō,⁶ Gosoen,⁷ Ichiensai,⁸ Ichiyōsai,⁹ Kuninao,¹⁰ Ryūendō,¹¹ Sharakuō,¹² Shashinsai,¹³ Tōuntei,¹⁴ Ukiyoan.¹⁵ **Biog.:** Ukiyo-e painter, illustrator. Born in Shinano Province. First studied Chinese Ming and Ch'ing painting; then to Edo to study under Toyokuni. Later became a follower of Hokusai. Illustrated many books. Popular and prolific, his work now rare. Some designs in *nanga* style. **Coll.:** Allen, Ashmolean, British, Fitzwilliam, Musées, Riccar, Tōkyō (1), Victoria, Waseda, Worcester. **Bib.:** Binyon (1), (3); Kikuchi; Mitchell; Stewart; Succo (2).

¹国直 ²吉川 ³歌川鯛蔵 ⁴四郎兵衛 ⁵独酔舎 ⁶煙柳楼
⁷後素園 ⁸一煙斎 ⁹一楊斎 ¹⁰国直 ¹¹柳烟堂 ¹²写楽翁
¹³写真斎 ¹⁴東雲亭 ¹⁵浮世庵

Kuninobu¹ (fl. 1765–86). **Biog.:** Ukiyo-e printmaker. One of several obscure but able artists working in the manner of Harunobu. His work is quite rare. **Coll.:** Art (1), Honolulu, Nelson, Newark, Tōkyō (1). **Bib.:** Ficke, Gentles (1), Michener (3), Morrison 2.

¹国信

Kuninobu¹ (1787–1840). *N.:* Kanō Tanshū² (later Sukekiyo).³ *Gō:* Bokuyōsai,⁴ Kuninobu.⁵ **Biog.:** Kanō painter. Born in Edo. Second son of Kanō Tamboku Morikuni, head of the sixth generation of the Kanō Kajibashi line; adopted by the Nakabashi branch of the Kanō family, of which he eventually became head of the fourteenth generation. Employed by the shogunate as *oku eshi*. Received the title of *hōgen*. **Coll.:** Museum (3).

¹邦信 ²狩野探秀 ³祐清 ⁴牧羊斎 ⁵邦信

Kuninobu¹ (fl. early 19th c.). *N.:* Kaneko Yashirō² (or Sōjirō).³ *Gō:* Ichireisai,⁴ Ichiyōsai,⁵ Isekirō,⁶ Kuninobu,⁷ Yōgakusha.⁸ **Biog.:** Ukiyo-e printmaker. Member of the Utagawa school, pupil of Toyokuni. Wrote and illustrated chapbooks under the name of Shima Sanjin.⁹

¹国信 ²金子弥四郎 ³惣次郎 ⁴一礼斎 ⁵一陽斎
⁶堰堞楼 ⁷国信 ⁸陽岳舎 ⁹志満山人

Kuninobu¹ (fl. mid-19th c.). *N.:* Utagawa Kuninobu.² **Biog.:** Ukiyo-e printmaker. A minor figure, sandwiched in time between two other printmakers to bear this name: Kaneko Kuninobu and Tanaka Kuninobu.

¹国信 ²歌川国信

Kuninobu¹ (fl. c. 1865). *N.:* Tanaka Chūjun.² *Gō:* Kuninobu.³ **Biog.:** Ukiyo-e printmaker. Pupil of Kunisada.

¹国信 ²田中忠順 ³国信

Kunio¹ (fl. 1752–85). *N.:* Tachibana (Suya)² Kunio.³ *F.N.:* Heijūrō.⁴ *Gō:* Hahōsai,⁵ Kōtensai.⁶ **Biog.:** Kanō painter, illustrator. Lived in Ōsaka. Pupil of Tachibana Morikuni, from whom he got his surname. His works have been used as illustrations for picture books. **Bib.:** Brown.

¹国雄 ²酢屋 ³橘国雄 ⁴平十郎 ⁵把芳斎 ⁶皎天斎

Kunisada¹ (1786–1864). *N.:* Tsunoda Kunisada.² *F.N.:* Shōzō.³ *Gō:* Fubō Sanjin,⁴ Fuchōan,⁵ Gepparō,⁶ Gototei,⁷

Hokubaiko,[8] Ichiyūsai,[9] Kinraisha,[10] Kōchōrō,[11] Shōzō,[12] Tōjuen,[13] Toyokuni III,[14] Utagawa Kunisada,[15] Utagawa Toyokuni III.[16] **Biog.:** Ukiyo-e painter, printmaker. Born in Katsushika in Musashi; lived in Edo. At 15, pupil of Toyokuni; took name of Kunisada. In 1807 produced first book illustrations; in 1808 began to make actor prints. After his father's death, inherited the license of the ferry at Itsutsumei and took name Gototei (Fifth Ferry House). In 1833 studied under Hanabusa Ikkei; then the style of Hanabusa Itchō, taking name of Kōchōrō. In 1844 took name of Toyokuni III, by which he is frequently known, though this *gō* had properly belonged to Gosotei Toyokuni; in 1845 retired, calling himself Shōzō. Specialized in illustrations for storybooks and portraits of actors. His few landscape prints quite fine; his *bijinga* generally undistinguished. His early prints his best, with his work growing coarse and violent in obedience to popular 19th-century taste and much of it hastily designed, overcolored, badly printed. **Coll.:** Albertina, Allen, Art (1), Ashmolean, Baltimore, British, Brooklyn, Cincinnati, City, Cleveland, Detroit, Fine (California), Fitzwilliam, Fogg, Grunwald, Herron, Honolulu, Kōbe, Metropolitan, Minneapolis, Musée (1), Musées, Museum (3), Naritasan, National (3), Nelson, Newark, Östasiatiska, Österreichisches, Philadelphia, Portland, Rhode Island, Riccar, Rietberg, Staatliche, Stanford, Suntory, Tōkyō (1), University (2), Victoria, Waseda, Worcester, Yale. **Bib.:** Binyon (1), (3); Boller; Brown; Crighton; GNB 17, 24; Hillier (2), (3), (4) 1, (7); Keyes; Kikuchi; *Kunst;* M 138; Meissner; Michener (3); Mizuo (3); Morrison 2; Narazaki (2); NB (S) 68; NBZ 5; NHBZ 5, 7; *Nikuhitsu* (1) 2; *Pictorial* (2) 4; SBZ 10; Schmidt; Shibui (1); Stewart; Succo (2); Suzuki (4); Tajima (7) 4; Takahashi (2); Tamba (2a); UG 8, 14, 15, 28; *Ukiyo-e* (2) 10, (3) 17.

[1]国貞　[2]角田国貞　[3]庄蔵　[4]富望山人　[5]富眺庵　[6]月波楼
[7]五渡亭　[8]北梅戸　[9]一雄斎　[10]琴雷舎　[11]香蝶楼　[12]肖造
[13]桃樹園　[14]豊国三代　[15]歌川国貞　[16]歌川豊国三代

Kunisada II[1] (1823–80). *N.:* Utagawa (originally Takenouchi)[2] Munehisa.[3] *F.N.:* Masakichi;[4] later, Seitarō.[5] *Gō:* Baidō,[6] Hōraisha,[7] Ichijusai,[8] Ichiyōsai,[9] Kōchōrō,[10] Kunimasa III,[11] Kunisada,[12] Toyokuni IV.[13] **Biog.:** Ukiyo-e printmaker. Pupil of Kunisada. At first signed his prints Baidō Kunimasa III or Kunimasa, pupil of Kōchōrō; in 1846 married his master's daughter, took *gō* of Kunisada II and used with it the *gō* of Kōchōrō and Ichijusai. About 1870, after Kunisada's death, began to use *gō* of Toyokuni IV. His prints, largely done in garish aniline colors, represent the tasteless exaggerated style of late ukiyo-e. **Coll.:** British, Cincinnati, Cleveland, Fitzwilliam, Östasiatiska, Staatliche, Tōkyō (1), Victoria. **Bib.:** Binyon (1), (3); Ficke; *Kunst;* Nonogami; Schmidt; Succo (2).

[1]国貞二代　[2]竹内　[3]歌川宗久　[4]政吉　[5]清太郎
[6]梅堂　[7]宝来舎　[8]一寿斎　[9]一陽斎　[10]香蝶楼
[11]国政三代　[12]国貞　[13]豊国四代

Kunisada III[1] (1848–1920). *N.:* Utagawa (originally Takenouchi)[2] Hidehisa.[3] *Gō:* Baidō Hōsai,[4] Kōchōrō,[5] Kunimasa IV[6] (early), Kunisada III,[7] Toyokuni V.[8] **Biog.:** Ukiyo-e printmaker. Pupil of Kunisada II; took *gō* of Kunisada III in 1889. While using early *go* of Kunimasa IV, also used *gō* of Baidō Hōsai. Late in life called himself Toyokuni IV,[9] though he was, in fact, Toyokuni V. An artist of no importance. **Coll.:** Victoria.

[1]国貞三代　[2]竹内　[3]歌川栄久　[4]梅堂豊斎　[5]香朝楼
[6]国政四代　[7]国貞三代　[8]豊国五代　[9]豊国四代

Kunisato[1] (?–1858). *N.:* Utagawa Kunisato.[2] *F.N.:* Masajirō.[3] *Gō:* Ichiyōsai,[4] Ritsusensai.[5] **Biog.:** Ukiyo-e printmaker. Pupil of Kunisada. **Coll.:** Musées, Newark, Rhode Island, Victoria. **Bib.:** Tamba (2a).

[1]国卿　[2]歌川国郷　[3]政次郎　[4]一曜斎　[5]立川斎

Kunisawa Shinkurō[1] (1847–77). **Biog.:** Western-style painter.

Born in Kōchi-ken; lived in Tōkyō. Started on a military career, but in 1870 resigned from the army. From 1872 to 1874 studied oil painting in London. On his return to Japan founded the private art school Shōgidō, which he directed until his death and at which he taught the technique of oil-painting. Asai Chū and Honda Kinkichirō his most prominent pupils, the latter succeeding him as director of the school. Took part in Japan's first foreign-style exhibition in 1875. An important figure in the art circles of the early Meiji era, more because of his school than his own painting, which was academic and no more than competent. **Coll.:** Tōkyō (1), (2). **Bib.:** Asano, BK 206, Elisséèv, Harada Minoru, *Kurashina* (2), NB (H) 24, NB (S) 30, NBZ 6, Sullivan, *Tōkyō.*

[1]国沢新九郎

Kunitaka[1] (fl. c. 1264–99). *N.:* Tosa Kunitaka.[2] **Biog.:** Buddhist painter. Son (or much younger brother) and pupil of Tsunetaka. Part of the scroll of the *Hōnen Shōnin Eden* in the collection of the Chion-in, Kyōto, is attributed to him. **Coll.:** Chion-in. **Bib.:** *One* (2).

[1]邦隆　[2]土佐邦隆

Kuniteru[1] (1808–76). *N.:* Utagawa (originally Yamashita)[2] Kuniteru.[3] *F.N.:* Hikosaburō,[4] Jin'emon,[5] Sōemon.[6] *Gō:* Ban'an,[7] Kinshō Tōkei,[8] Kōbairō,[9] Naoteru (early).[10] **Biog.:** Ukiyo-e printmaker. Born in Edo. Studied first under Kunisada, then a late pupil of Toyokuni. Began to use *gō* of Kuniteru about 1844. Produced book illustrations and single-sheet prints. A late, poor printmaker, one of the many followers of the Toyokuni tradition. However, in his work outside the ukiyo-e field, showed the influence of Tani Bunchō. **Note:** Since many references to collections and bibliography carry no *kanji,* all such references may refer to this artist or to any one of the other three using the name Kuniteru (q.v.). **Coll.:** British, Cincinnati, Fogg, Newark, Rietberg, Tōkyō (1), Victoria. **Bib.:** Binyon (1), (3); Ficke; NHBZ 7.

[1]国照　[2]山下　[3]歌川国照　[4]彦三郎　[5]甚右衛門
[6]惣右衛門　[7]晩庵　[8]琴松東渓　[9]香梅楼　[10]直照

Kuniteru[1] (fl. mid-19th c.). *N.:* Utagawa (originally Ōta)[2] Kinjirō.[3] *Gō:* Dokusuisha,[4] Gochōtei,[5] Ichiyūsai,[6] Kuniteru,[7] Sadashige,[8] Shinteitei,[9] Yūsai.[10] **Biog.:** Ukiyo-e printmaker. Pupil of Kunisada. When his master used *gō* of Kunisada, Kuniteru called himself Sadashige; when Kunisada became Toyokuni III, called himself Kuniteru. Made actor prints, generally in a style close to that of Kuniyoshi. **Note:** Since many references to collections and bibliography carry no *kanji,* all such references may refer to this artist or to any one of the other three using the name Kuniteru (q.v.). **Coll.:** British, Musées, Rhode Island, Stanford, Victoria. **Bib.:** Crighton, Schmidt.

[1]国輝　[2]大田　[3]歌川金次郎　[4]独酔舎　[5]五蝶亭
[6]一雄斎　[7]国輝　[8]貞重　[9]新貞斎　[10]雄斎

Kuniteru[1] (fl. early Meiji era). *N.:* Utagawa (originally Okada;[2] later, Toyohara)[3] Tōshirō.[4] *Gō:* Ichiyūsai,[5] Kuniteru.[6] **Biog.:** Ukiyo-e printmaker. Born in Edo. Pupil first of Kunisada, then of Kunichika. Good *nishiki-e* artist. **Note:** Since many references to collections and bibliography carry no *kanji,* all such references may refer to this artist or to any of the other three using the name Kuniteru (q.v.). **Coll.:** Musées, Rhode Island, Tōkyō (1), Victoria, Worcester. **Bib.:** NHBZ 6, Nonogami.

[1]国輝　[2]岡田　[3]豊原　[4]歌川藤四郎　[5]一雄斎　[6]国輝

Kuniteru II[1] (1829–74). *N.:* Yamada Kunijirō.[2] *Gō:* Ichiyōsai,[3] Ichiyūsai,[4] Kuniteru,[5] Kunitsuna II,[6] Sadashige,[7] Yōsai.[8] **Biog.:** Ukiyo-e printmaker. Pupil of Kunisada. Depicted the manners and sights of the late Tokugawa and early Meiji ages, particulary the early industrial scenes. **Note:** Since many references to collections and bibliography carry no *kanji,* all such references may refer to this artist or to

any one of the other three using the name Kuniteru (q.v.). **Coll.**: British, Musées, Newark, Rhode Island, Stanford, Victoria. **Bib.**: Crighton, Schmidt.

¹国輝二代 ²山田国次郎 ³一曜斎 ⁴一雄斎
⁵国輝 ⁶国網二代 ⁷貞重 ⁸曜斎

Kunitomi¹ (fl. c. 1804–44). *N.*: Utagawa Kunitomi.² *Gō*: Kasentei,³ Tominobu.⁴ **Biog.**: Ukiyo-e printmaker. Pupil of Toyokuni II. Produced actor prints. Began to use *gō* of Tominobu about 1820. Style a mixture of those of Ikeda Eisen and Kunisada. **Coll.**: Cincinnati, Musée (2), Victoria. **Bib.**: Binyon (3), *Nikuhitsu* (2).

¹国富 ²歌川国富 ³花川亭 ⁴富信

Kunitora¹ (fl. early 19th c.). Utagawa (originally Maeda)² Kunitora.³ *F.N.*: Kumezō.⁴ *Gō*: Bokunenjin,⁵ Ichiryūsai.⁶ **Biog.**: Ukiyo-e printmaker. Pupil of Toyokuni; is said to have worked under his teacher's name. Died in poverty. Work scanty. Somewhat influenced by Hokusai and Shunshōsai Hokuju, his prints also show signs of Western influence in pronounced chiaroscuro. Most important work: *Eight Views of Ōmi*, which is marked by a rather recherché quality reminiscent of artists of the preceeding generation. **Coll.**: British, Fitzwilliam, Honolulu, Kōbe, Musées, Rietberg, Staatliche, Tōkyō (1), Victoria, Worcester. **Bib.**: Binyon (1), Kikuchi, Narazaki (2), NB (S) 36, *Pictorial* (2) 4, Schmidt, Shibui (1), UG 3.

¹国虎 ²前田 ³歌川国虎 ⁴久米蔵 ⁵朴年人 ⁶一竜斎

Kunitoshi¹ (fl. second half 19th c.). *N.*: Utagawa Kunitoshi.² **Biog.**: Ukiyo-e printmaker. Pupil of Kunisada and of Utagawa Kunitsugu. **Coll.**: Musées, Victoria. **Bib.**: *Nikuhitsu* (2).

¹国歳 ²歌川国歳

Kunitsugu¹ (1800–1861). *N.*: Utagawa (originally Nakagawa)² Kunitsugu.³ *F.N.*: Kōzō.⁴ *Gō*: Ichiōsai,⁵ Ōshōtei.⁶ Ukiyo-e printmaker. Pupil of Toyokuni. **Coll.**: British, Staatliche, Tōkyō (1). **Bib.**: Binyon (1), Morrison 2, *Nikuhitsu* (2), Schmidt.

¹国次 ²中川 ³歌川国次 ⁴幸蔵 ⁵一応斎 ⁶桜松亭

Kunitsuna¹ (1805–68). *N.*: Utagawa Kunitsuna.² **Biog.**: Ukiyo-e painter, printmaker. Pupil of Toyokuni. **Coll.**: British, Musées, Newark, Rhode Island, Stanford, Victoria. **Bib.**: Binyon (1), Crighton.

¹国綱 ²歌川国綱

Kuniyasu¹ (1794–1832). *N.*: Utagawa Yasugorō.² *F.N.*: Yasujirō.³ *Gō*: Ippōsai,⁴ Kuniyasu.⁵ **Biog.**: Ukiyo-e printmaker. Born in Edo. Pupil of Toyokuni. Specialized in *surimono, bijinga*, landscapes. For a short time, around 1811, used name of Nishikawa Yasunobu⁶ but soon resumed his old name. Works rare. An amusing artist. **Coll.**: Albertina, Ashmolean, British, Cincinnati, Fitzwilliam, Honolulu, Musée (1), Musées, Newark, Philadelphia, Portland, Riccar, Staatliche, Tōkyō (1), University (2), Victoria, Waseda, Worcester. **Bib.**: Binyon (1), (3), *Foreigners;* Jahss; Kikuchi; Morrison 2; NHBZ 6; *Nikuhitsu* (2); Nonogami; Schmidt; Stewart; Succo (2), Tamba (2a).

¹国安 ²歌川安五郎 ³安次郎
⁴一鳳斎 ⁵国安 ⁶西川安信

Kuniyoshi¹ (1797–1861). *N.*: Utagawa (originally Igusa)² Kuniyoshi.³ *F.N.*: Magosaburō,⁴ Taroemon.⁵ *Gō*: Chōōrō,⁶ Ichiyūsai,⁷ Ryūen.⁸ **Biog.**: Ukiyo-e painter, printmaker. Worked in Edo. Trained first to the family craft of dyer; then, probably, a pupil of Katsukawa Shun'ei. When still a youth, was accepted as a pupil by Utagawa Toyokuni and began to use *gō* of Ichiyūsai Kuniyoshi and Chōōrō. Studied Tosa, Kanō, and Maruyama painting; influenced by Utagawa Kuninao. Then founded his own style, one so popular that it is said the young men of his time often asked him to tattoo his designs on their bodies. Famous for his prints of actors and animals; also specialized, with invention and gusto, in illustrations of heroic episodes in Japanese history (produced an excellent series on the life of Nichiren); the best of his few landscapes equal those of Hiroshige. Had

a taste for the bizarre, the fantastic, the ghoulish. His early style was comparatively simple, with landscape backgrounds in the manner of Hiroshige; later his work became increasingly complex. Occasionally influenced by European models. A most prolific and very uneven artist. **Coll.**: Albertina; Allen; Andrew; Art (1); Ashmolean; British; Brooklyn; Cincinnati; City; Denver; Fitzwilliam; Fogg; Grunwald; Herron; Honolulu; Kanagawa; Kōbe; Metropolitan; Minneapolis; Musée (1), (2); Musées; Museum (1), (2); Naritasan; Nelson; Newark; Ōstasiatiska; Österreichisches; Philadelphia; Portland; Rhode Island; Riccar; Rietberg; Staatliche; Stanford; Tōkyō (1); University (1), (2); Victoria; Waseda; Worcester; Yale. **Bib.**: ARTA 3, 4; Binyon (1), (3); Boller; Crighton; Dailey; *Dessins;* Fontein (1); Fujikake (3) 3; GNB 17, 24; Hillier (2), (3), (7), (9); Kikuchi; *Kunst;* Lane; Meissner; Michener (3); Mitchell; Morrison 2; Narazaki (2); NB (S) 68; NBZ 5; NHBZ 5; *Nikuhitsu* (1) 2, (2); OA 7; *Pictorial* (2) 4; Robinson (3); Schmidt; Shibui (1); Speiser (1); Stern (2); Stewart; Succo (2); Suzuki (4); Takahashi (2); Tamba (2a); UG 2, 14, 28; *Ukiyo-e* (2) 10, (3) 17.

¹国芳 ²井草 ³歌川国芳 ⁴孫三郎
⁵太郎右衛門 ⁶朝桜楼 ⁷一勇斎 ⁸柳燕

Kuniyoshi Yasuo¹ (1893–1953). Western-style painter. Born in Okayama. At 13 to the United States, where he lived, worked, and eventually died and where he is considered an important American expressionist painter. Studied at the Los Angeles Art School; graduated from the Art Students' League, New York. Returned once to Japan in 1931; exhibited with the Nikakai. His work has been seen constantly in American exhibitions. **Coll.**: Bridgestone, Cincinnati, Kanagawa, Museum (4), National (5), Newark, Whitney. **Bib.**: Asano, NBT 10, NBZ 6.

¹国吉康雄

Kuniyuki¹ (fl. mid-19th c.). *N.*: Utagawa Kuniyuki.² **Biog.**: Ukiyo-e painter, printmaker. Nothing known of his life save that he has been listed as a pupil of both Utagawa Kuninobu and Utagawa Toyokuni. **Coll.**: Freer, Victoria. **Bib.**: *Nihon* (9).

¹国幸 ²歌川国幸

Kunkei¹ (1736–1803). *N.*: Ichikawa Teki.² *A.*: Kunkei.³ *F.N.*: Benzō.⁴ *Gō*: Kunkei,⁵ Minryū.⁶ **Biog.**: Painter. Born in Ōmi. As a young man, to Kyōto to study painting; much influenced by Yüan and Ming painting. Teacher of Chō Gesshō. An able painter of *kachōga*, landscapes, and portraits. Is said to have been a skillful imitator of the works of Buson, Taiga, and Jakuchū. **Bib.**: Mitchell.

¹君圭 ²市川適 (迪) ³君啓 ⁴弁蔵 ⁵君圭 ⁶眠竜

Kunkei¹ (1800–1884). *N.*: Yoshikawa Hironobu.² *F.N.*: Harusuke.³ *Gō*: Ekiō,⁴ Kunkei.⁵ **Biog.**: Kanō painter. Born in Edo. Son and pupil of Yoshikawa Ikkei. Painted landscapes and portraits.

¹君渓 ²吉川弘信 ³春助 ⁴益翁 ⁵君渓

Kunsen¹ (1781–1819). *N.*: Araki (originally Mamura)² Shinkei.³ *A.*: Shinkei.⁴ *F.N.*: Shinsuke.⁵ *Gō*: Kunsen,⁶ Richō.⁷ **Biog.**: Nagasaki painter. Born and worked in Nagasaki. Son and pupil of Mamura Hisen, from whom he learned the Shen Nan-p'in style; later adopted by the Araki family. Became a connoisseur of Chinese painting. Able painter of *kachōga* and landscapes. **Coll.**: Kōbe, Nagasaki. **Bib.**: Kuroda, *Pictorial* (2) 2.

¹君瞻 ²真村 ³荒木真敬 ⁴真敬
⁵真助 ⁶君瞻 ⁷里兆 (李晁)

Kunsen¹ (fl. late 18th to early 19th c.). *N.*: Ichikawa Kunsen.² *A.*: Kyūen.³ *F.N.*: Shinzō,⁴ Shunshō.⁵ **Biog.**: Painter. Born in Kyōto. Son of Ichikawa Kunkei. **Bib.**: Mitchell.

¹君泉 ²市川君泉 ³九淵 ⁴晋蔵 ⁵春樵

Kunzan¹ (1728–97). *N.*: Yang Ya (Japanese: Yōga).² *A.*: Hakushō.³ *F.N.*: Ritōta.⁴ *Gō*: Kunzan.⁵ **Biog.**: *Nanga* painter. Born in Nagasaki; son of a Chinese interpreter.

Studied under the Chinese painter Fei Han-yüan, becoming a well-known artist in Nagasaki.

¹君山 ²楊雅 ³伯頌 ⁴利藤太 ⁵君山

Kurata Hakuyō¹ (1881–1938). *N.:* Kurata Jūkichi.² *Gō:* Hakuyō.³ **Biog.:** Western-style painter. Born in Urawa, Saitama-ken; lived in Nagano-ken. Studied under Asai Chū and Kuroda Seiki. Graduated from Tōkyō School of Fine Arts in 1901. Exhibited with the Bunten and the Inten. Member of Nihon Bijutsuin; founding member of the Taiheiyō Gakai and of the Shun'yōkai. Pastoral themes form his subject matter. **Bib.:** Asano, NBZ 6.

¹倉田白羊 ²倉田重吉 ³白羊

Kuri Shirō¹ (1886–1953). **Biog.:** Western-style painter. Born in Tōkyō. When young, a pupil of Wada Eisaku. In 1910 graduated from the Tōkyō School of Fine Arts. From 1911 to 1912 traveled in France, Italy, England, and India. While still in art school, exhibited with the Bunten. In 1914 became a juror for the Nikakai, but left this society the following year.

¹九里四郎

Kurihara Gyokuyō¹ (1886–1922). *N.:* Kurihara Fumiko.² *Gō:* Gyokuyō.³ **Biog.:** Painter. Born in Nagano. Graduated from Tōkyō Women's Art School in 1909; afterwards taught there. Studied under Terazaki Kōgyō. An exhibitor with the Bunten, receiving an honorable mention at the eighth exhibition; also showed with the Tatsumi Gakai. Worked in a modernized *yamato-e* style, specializing in *bijinga*. **Bib.:** Asano, Elisséev.

¹栗原玉葉 ²栗原文子 ³玉葉

Kurihara Shin¹ (1894–1966). *N.:* Kurihara Nobukata.² *Gō:* Shin.³ **Biog.:** Western-style painter. Born in Ibaraki-ken. Graduated from the Ibaraki-ken Normal School in 1912. Studied painting under Ishii Hakutei. From 1918 to 1928 taught arts and crafts at an elementary school in Tōkyō. In 1928 to France; traveled round Europe until 1931, when he returned to Japan and showed the work he had done abroad at the Nikakai. In 1932 became an associate of the Nikakai and a member in 1936. In 1947 left this society, joining the Dai Nikikai. From 1945 to 1959 professor of art at Niigata University. In 1957 the Japanese representative at the São Paulo Biennial. Worked in a realistic manner. **Bib.:** Asano.

¹栗原信 ²栗原信賢 ³信

Kuroda Jūtarō¹ (1887–1970). **Biog.:** Western-style painter. Born in Ōtsu. Studied under Asai Chū and Kanokogi Takeshirō at the Kansai Bijutsuin. First exhibited with the Nikakai in 1914. Worked in Kyōto, teaching at the Kyōto Municipal School of Fine Arts and Crafts. Went abroad from 1916 to 1918 and again from 1921 to 1923, when he studied with André Lhote. On his return joined the Nikakai, shifting after the war to the Dai Nikikai. His style influenced by his time in France. **Coll.:** National (5). **Bib.:** Asano, NBZ 6.

¹黒田重太郎

Kuroda Seiki¹ (1866–1924). *N.:* Kuroda Kiyoteru.² *Gō:* Seiki.³ **Biog.:** Western-style painter. Born in Kagoshima. Adopted by his uncle, Viscount Kuroda, who sent him to Paris in 1884 to study law; interest in art led him to study the plein-air manner at a French academy under Raphael Collin. In 1893 returned to Japan; in 1894 opened, with Kume Keiichirō, his art school, the Tenshin Dōjō. In 1896, with Kume Keiichirō and Andō Nakatarō, founded the Hakubakai. In 1897 became the first professor of Western-style painting at Tōkyō School of Fine Arts. In 1910 became first member of the Art Committee of the Imperial Household in Western-style painting. Appointed to Imperial Fine Arts Academy in 1919; became its president in 1923. With Asai Chū and Yamamoto Hōsui, served as war correspondent in the Sino-Japanese conflict. Portraits, flower pieces, and landscapes among his subjects. His style rather impressionist, combining Japanese sentiment and Western technique; his work only competent, but his influence very important

in development of Western art in Japan. Called "father of oil painting in Japan" and was instrumental in introducing impressionism. **Coll.:** Bridgestone; Kagoshima; National (5); Tōkyō (1), (2); Waseda. **Bib.:** Asano; BK 6, 24, 88, 101, 102, 113, 115, 118, 130, 132, 133, 177, 188, 192; Harada Minoru; Kondō (6); Kumamoto; *Kurashina* (2); M 204; *Masterpieces* (4); Miyagawa; Munsterberg (1); NB (H) 24; NB (S) 30; NBT 10; NBZ 6; NKKZ 2; Noma (1) 2; SBZ 11; Sullivan; Tanaka (7a) 30; Uyeno; Wada; YB 15.

¹黒田清輝 ²黒田清輝 ³清輝

Kusamitsu Nobushige¹ (1892–). **Biog.:** Western-style painter. Born in Shimane-ken. In 1916 graduated from the Tōkyō School of Fine Arts. Studied with Wada Sanzō. Exhibited with the Teiten in the late 1920s, frequently receiving special recognition; also showed with the Bunten and the Nitten. In 1955 joined the Shinseki Bijutsu Kyōkai. **Bib.:** Asano.

¹草光信成

Kusube Yaichi¹ (1897–). **Biog.:** Potter. Born and works in Kyōto. Studied early Chinese monochrome and blue-and-white porcelain. Has exhibited with the Bunten and the Teiten. Great variety in his work: monochrome, colored designs, gold ground, blue-and-white, some molded patterns, overglaze enamels. **Coll.:** Museum (3), National (4). **Bib.:** *Ceramic* (3), *Masterpieces* (4), STZ 16.

¹楠部弥弌

Kyōdō¹ (1766–1814). *N.:* Hamada (originally Nawa)² Seiken.³ *A.:* Shichō.⁴ *Gō:* Chisen,⁵ Kian,⁶ Kyōdō.⁷ **Biog.:** *Nanga* painter. An Ōsaka man, adopted by a doctor named Hamada. Turned to painting, studying under Fukuhara Gogaku and also investigating Yüan and Ming painting. Figures, landscapes, birds-and-flowers among his subjects.

¹杏堂 ²名和 ³浜田世憲 ⁴子徴 ⁵痴仙 ⁶希庵 ⁷杏堂

Kyōen¹ (fl. early 13th c.). **Biog.:** Sculptor. *Busshi* of the En school. Known from the inscription as the sculptor of a rather crude *kakebotoke* dated 1228 in the Shōrin-ji, Kyōto. **Coll.:** Shōrin-ji. **Bib.:** BI 58, Mōri (1a).

¹経円

Kyōkai¹ (1001–93). *N.:* Fujiwara no Kyōkai.² **Biog.:** Buddhist painter. Son of Fujiwara no Noriyuki. Another of the early Japanese painters known so far only from historical records, with no concrete evidence of their work. Took his Buddhist vows at the Kōfukuji; later moved to Kōyasan, where he lived until his death. Is said to have made several hundred paintings of Fudō, a feat that made him known to his contemporaries and hence to later generations, though no identifiable painting by him exists today.

¹教懐 ²藤原教懐

Kyokan¹ (fl. early 17th c.). **Biog.:** Potter. Born in Korea. After Hideyoshi's Korean campaigns, immigrated to Japan in the train of Lord Matsuura of Hirado and, according to tradition, established the Hirado kilns.

¹巨関

Kyokka (Kyokuka)¹ (1747–1819). *N.:* Shimizu Ben.² *A.:* Shishō.³ *F.N.:* Ren.⁴ *Gō:* Kyokka (Kyokuka).⁵ **Biog.:** Painter. Born in Edo. Studied under Tani Bunchō. Later developed his own style. Specialized in *kachōga*. **Bib.:** Hillier (4) 3, Mitchell.

¹曲河 ²清水晁 ³子章 ⁴連 ⁵曲河

Kyokkō (Kyokukō)¹ (?–1833). *N.:* Fuchigami² (or En).³ *Gō:* Kyokkō (Kyokukō).⁴ **Biog.:** Painter. Family name abbreviated to En to make it appear Chinese. Studied under Ōnishi Suiko; teacher of Watanabe Hōto. Good painter of landscapes and portraits; also produced flower paintings in the style of Shen Nan-p'in. **Coll.:** Ashmolean. **Bib.:** Mitchell.

¹旭江 ²淵上 ³淵 ⁴旭江

Kyokkō (Kyokukō)¹ (fl. c. 1840). *N.:* Koike Korenori.² *A.:* Shiyoku.³ *Gō:* Kansendō,⁴ Kyokkō (Kyokukō).⁵ **Biog.:**

Painter. Born in Nagasaki; lived in Edo. Pupil of Hayashi Chisen. **Bib.:** Mitchell.

¹曲江 ²小池惟則 ³子翼 ⁴甘泉堂 ⁵曲江

Kyokuzan¹ (?–1883). *N.:* Tōdaya Tokuji.² *Gō:* Kyokuzan,³ Saiunrō Kyokuzan.⁴ **Biog.:** Potter. Born in Kanazawa. Son of Tōdaya Tokuemon, who had studied under Aoki Mokubei. Kyokuzan worked at the Minzan (Kutani) kiln, using two seals: one reading "Saiunrō Kyokuzan," the other "Kutani Kyokuzan."⁵ Teacher of Suwa Sozan. In early Meiji era, when Lord Maeda of Kaga was about to close the family kiln, Kyokuzan took over and produced a good many *aka-e* wares, mainly for everyday use, that he called Mukaiyama, marking them with a seal reading "Mukaiyama."⁶ **Bib.:** NB (S) 71.

¹旭山 ²任田屋徳次 ³旭山
⁴彩雲楼旭山 ⁵九谷旭山 ⁶向山

Kyoroku¹ (1656–1715). *N.:* Morikawa Hyakuchū.² *A.:* Ukan.³ *F.N.:* Gosuke.⁴ *Gō:* Josekishi,⁵ Kikuabutsu,⁶ Kyoroku,⁷ Ragetsudō,⁸ Rokurokusai.⁹ **Biog.:** Kanō painter. Served Lord Ii of Hikone as a painter. Studied *haikai* under Bashō. Studied painting under Kanō Yasunobu. A solid Kanō artist whose paintings were much appreciated by the *haikai* poets. **Coll.:** Tōkyō (1), Victoria. **Bib.:** K 168, 389, 480, 712.

¹許六 ²森川百仲 ³羽官 ⁴五助 ⁵如石子
⁶菊阿仏 ⁷許六 ⁸蘿月堂 ⁹碌々斎

Kyōsai (Gyōsai)¹ (1831–89). *N.:* Kawanabe Nobuyuki.² *F.N.:* Shūsaburō;³ later, Tōiku.⁴ *Gō:* Baiga,⁵ Baiga Dōjin,⁶ Baiga Kyōsha,⁷ Chikamaro,⁸ Gaki,⁹ Hata Kyōsha,¹⁰ Kyōsai (Gyōsai),¹¹ Kyōsha Gaishi,¹² Nyoku (Joku) Nyūdō,¹³ Raisui,¹⁴ Shōshōan (Seiseian),¹⁵ Shōshō Kyōsai,¹⁶ Shōshōsai (Seiseisai),¹⁷ Shuransai,¹⁸ Suiraibō.¹⁹ **Biog.:** Kanō painter, printmaker, illustrator. Born in Shimōsa Province, son of a samurai. Studied as a child under Utagawa Kuniyoshi; then in Tōkyō under Maemura Tōwa and, later, Kanō Tōhaku Chinshin, who gave him the name of Tōiku when he was 19, and was admitted to the Kanō house. Separated from the school at 27, becoming an independent painter and settling in the Hongō area of Tōkyō. Loved sakè, as is shown by his *gō* Shuransai, and is said to have done some of his best work under its influence. Exhibited at the Vienna International Exposition in 1873 and at that of Paris in 1883. His distinguished painting, largely in late-Kanō manner, includes some excellent bird studies and is often marked by a wild, eccentric humor. Left many lively sketches of great dexterity of draftsmanship and copies of works by other artists. Also made a few prints, many of which are of ravens, in a bold simple style, and caricatures full of fantasy and invention. His illustrated books include *Kyōsai Gaden, Kyōsai Gafu,* and *Kyōsai Manga.* **Coll.:** Allen; Art (1); Ashmolean; British; Brooklyn; Cincinnati; Cleveland; Fine (California, De Young); Fitzwilliam; Freer; Honolulu; Metropolitan; Musée (2); Musées; Museum (1), (3); Newark; Rhode Island; Rijksmuseum (2); Tōkyō (1); Victoria; Worcester; Yale. **Bib.:** Asano; Binyon (1), (2), (3); Boller; Brown; Conder; Crighton; *Dessins;* Ficke; Hillier (1), (2), (3), (4) 3, (7); K 876; *Kanō-ha; Kunst;* Lane; Ledoux (5); Mitchell; Morrison 1; NB (S) 17; NBZ 6; NHBZ 5, 6; *Nikuhitsu* (1) 2; Nonogami; Stewart; UG 16.

¹暁斎 ²河鍋陳之 ³周三郎 ⁴洞郁 ⁵売画 ⁶売画道人
⁷売画狂者 ⁸周麿 ⁹画鬼 ¹⁰畑狂者 ¹¹暁斎
¹²狂者外史 ¹³如空入堂 ¹⁴雷酔 ¹⁵惺々庵 ¹⁶惺々狂斎
¹⁷惺々斎 ¹⁸酒乱斎 ¹⁹酔雷坊

Kyosen¹ (fl. mid-18th c.). *N.:* Kikurensha Kyosen.² *Gō:* Kyosen,³ Jōsai Sanjin.⁴ **Biog.:** Ukiyo-e printmaker. A *haikai* poet, once said to have been a samurai whose name was Ōkubo Jinshirō.⁵ Has also been considered as a printer who worked for Harunobu, as his name appears on several Harunobu prints, and who designed a few prints on his own. But nothing has been clearly established as to the facts of his life. The present view is, generally speaking, that the seal on some of the Harunobu prints is that of Kikurensha Kyosen, a leader of a circle of aesthetes who commissioned many of the 1765 calendar prints as well as other prints. **Coll.:** British, Tōkyō (1). **Bib.:** Ficke, Hillier (1), Kikuchi, *Kunst,* Meissner, *Nikuhitsu* (1) 2, Waterhouse.

¹巨川 ²菊簾舎巨川 ³巨川 ⁴城西山人 ⁵大久保甚四郎

Kyōsho¹ (1785–1840). *N.:* Tachihara Nin.² *A.:* Enkei.³ *F.N.:* Jintarō.⁴ *Gō:* Gyokusōsha,⁵ Kōan Shōshi,⁶ Kyōsho,⁷ Tōken.⁸ **Biog.:** *Nanga* painter. Born in Mito. Son of the samurai Suiken, a noted Confucian scholar and historian, who directed the academy of literature founded by the Mito branch of the Tokugawa family. Pupil of Tani Bunchō and Tanke Gessen; also studied Ming and Ch'ing paintings. Intimate friend of Tsubaki Chinzan and Watanabe Kazan. Worked chiefly in Edo, patronized by Tokugawa Noriaki. A fine calligrapher. Painted *kachōga* (some of which are quite splendid) and delicate landscapes in a very Ch'ing landscape style; made sketches of persons and places in a rather sharp manner. **Coll.:** Tōkyō (1). **Bib.:** BK 96; *Centcinquante;* GNB 18; K 373, 393, 420, 423, 440, 458, 476, 487, 509, 531, 548, 553, 562, 584, 598, 621, 630, 641, 679, 706, 727, 751, 782, 819, 826, 878, 940; Mitchell; Mizuo (3); Morrison 2; Murayama (2); NB (H) 23; NB (S) 4; NBT 5; NBZ 5; Tajima (12) 13, (13) 7; Umezawa (2); Yonezawa.

¹杏所 ²立原任 ³遠卿 ⁴甚太郎 (任太郎)
⁵玉琤舎 ⁶香案小史 ⁷杏所 ⁸東軒

Kyōson¹ (1805–68). *N.:* Takahashi Kyūkō.² *A.:* Keiu.³ *F.N.:* Sōemon.⁴ *Gō:* Enjin Sōdō,⁵ Kyōson,⁶ Sōsetsu.⁷ **Biog.:** *Nanga* painter. Born in Mino. Pupil of Nakabayashi Chikutō. A good painter of landscapes and *kachōga.*

¹杏村 ²高橋九鴻 ³景羽 ⁴惣右衛門
⁵遠塵草堂 ⁶杏村 ⁷爪雪

Kyōsui¹ (1816–67). *N.:* Iwase Hyakkaku.² *A.:* Baisaku.³ *F.N.:* Umesaku.⁴ *Gō:* Kyōsui,⁵ Santōan.⁶ **Biog.:** Ukiyo-e painter, illustrator. Son of the writer Kyōzan. Lived in Kyōto. Painted quite charming genre scenes, generally using lacquer. Also produced lacquer *inrō* and *netsuke.* Known as a writer. **Bib.:** Herberts, Jahss, *Nikuhitsu* (2).

¹京水 ²岩瀬百嶽 ³梅朔 ⁴梅作 ⁵京水 ⁶山東庵

Kyōu¹ (1810–84). *N.:* Hoashi En.² *A.:* Chidai.³ *F.N.:* Yōhei,⁴ Yūtarō (Kumatarō).⁵ *Gō:* Chōshū,⁶ Hannō,⁷ Kyōu.⁸ **Biog.:** *Nanga* painter. Born to a rich farmer at Hetsugi, Bungo Province. In 1824 became a pupil of Tanomura Chikuden. Also studied Confucianism under many scholars. About 1830 to Ōsaka and Kyōto; studied under Uragami Shunkin. Returned to Kyūshū, becoming a famous local *bunjinga* artist. Early paintings in style of Chikuden; later followed Yüan and Ming styles. In 1879 lost sight of one eye and stopped painting. Also an author. **Coll.:** Ashmolean, Victoria. **Bib.:** Asano; K 418, 468, 727, 803, 955; Mitchell; NB (S) 4; NBZ 6.

¹杏雨 ²帆足遠 ³致大 ⁴庸平
⁵熊太郎 ⁶聴秋 ⁷半農 ⁸杏雨

Kyozan¹ (fl. late 18th c.). *N.:* Sakai Chūbei.² *Gō:* Haritsu III,³ Kyozan,⁴ Rissō (Ritsusō),⁵ Sanritsu,⁶ Shizan.⁷ **Biog.:** Lacquerer. Pupil of Mochizuki Hanzan. A close follower of Ogawa Ritsuō's style. **Bib.:** Herberts, Jahss.

¹巨山 ²酒井忠兵衛 ³破笠三代
⁴巨山 ⁵笠窓 ⁶蓑笠 ⁷子山

Kyōzen¹ (fl. c. 1040–75). **Biog.:** Buddhist painter. A famous priest and painter of Buddhist subjects, he is recorded as having worked for the Fujiwara family, for the Kōfuku-ji (portraits of the patriarchs of the Hossō sect), and for the Hōjō-ji (a temple that no longer exists). However, it is unlikely that any of his work is extant.

¹教禅

Kyūemon¹ (1641–1715). *N.:* Morita Mitsuhisa.² *Gō:* Kyūemon.³ **Biog.:** Potter. Born in Tosa. Worked at the Odo

kiln in Ozu, Kōchi, under Kuno Shōhaku, becoming head of the kiln when Shōhaku left.

¹久右衛門　²森田光久　³久右衛門
Kyūen[1] (1622–98). *N.:* Kanō Kiyonobu.[2] *Court title:* Konaiki,[3] Naiki.[4] *Gō:* Kyūen.[5] **Biog.:** Kanō painter. Son of Kanō Kyūhaku Naganobu (founder of the Okachimachi Kanō line), younger brother of Kanō Kyūhaku Masanobu; pupil of both. Founder of the Azabu Ipponmatsu Kanō branch.

¹休円　²狩野清信　³古内記　⁴内記　⁵休円
Kyūhaku[1] (1595–1662). *N.:* Kanō Masanobu.[2] *F.N.:* Saemon.[3] *Gō:* Kyūhaku.[4] **Biog.:** Kanō painter. Eldest son and pupil of Kanō Kyūhaku Naganobu. Sometimes known as Kyūhaku II.[5] Served the shogunate as *goyō eshi;* became second-generation of the Okachimachi Kanō line. Received title of *hokkyō.*

¹休白　²狩野昌信　³左衛門　⁴休白　⁵休白二代
Kyūhaku[1] (?–1715). *N.:* Koma Kyūzō.[2] *Gō:* Kyūhaku,[3] Shōkasai,[4] Yasuaki (Ammei),[5] Yasunaru (Anko),[6] Yasutada (Ankyō).[7] **Biog.:** Koma lacquerer. Though second in the Koma line, the artist who firmly established the family tradition for lacquer of fine quality and great taste. In 1681, appointed lacquerer to the shogunate. In 1689, with Kōami Chōkyū, was in charge of the lacquer department during the building of the Tōshō-gū at Nikkō. The name Yasutada (Ankyō) appears among several later generations of this lacquer family. **Coll.:** City; Collections; Freer; Metropolitan; Museum (1), (3); Nelson; Nezu; Tōkyō (1); Victoria. **Bib.:** Feddersen, Herberts, Jahss, K 5, M 188, Ragué, Sawaguchi, Speiser (2), Yoshino.

¹休伯　²古満久蔵　³休伯　⁴松花斎　⁵安明　⁶安巨　⁷安匡
Kyūhaku III[1] (fl. c. 1743). *N.:* Kanō Jushin.[2] *Gō:* Kyūhaku III.[3] **Biog.:** Kanō painter. Son and pupil of Kanō Gyokuen, who was head of the Okachimachi branch of the Kanō family.

¹休伯三代　²狩野寿信　³休伯三代
Kyūho[1] (fl. early to mid-18th c.). *N.:* Tsuda Kyūho.[2] **Biog.:** Painter. Also a poet and priest. Lived in the Izu area when not traveling round Japan. Known for his paintings of tigers. **Coll.:** Museum (3).

¹休甫　²津田休甫
Kyūho[1] (fl. 1789–1801). *N.:* Nomura Kyūho.[2] *F.N.:* Genzaburō.[3] **Biog.:** Lacquerer. Pupil of Koma Kansuke. Worked in Edo. Succeeded Nomura Kukei as head of the Nomura family of lacquerers. **Bib.:** Herberts, Jahss.

¹休甫　²野村休甫　³源三郎
Kyūi[1] (?–1663). *N.:* Koma Kyūi.[2] **Biog.:** Koma lacquerer. Worked for the shogun Iemitsu who, in 1636, appointed him official lacquerer to the shogunate. Founder of the Koma school, which continued working under the shogunate's patronage for eleven generations. Famous for his *inrō.* His work neat and elegant. **Coll.:** Tōkyō (1). **Bib.:** Herberts, Jahss, K 5, M 188, Ragué, Sawaguchi, Yoshino.

¹休意　²古満休意
Kyūjirō[1] (1637?–82). *N.:* Kajikawa Tomohide.[2] *Gō:* Kyūjirō.[3] **Biog.:** Kajikawa lacquerer. Lived and worked in Edo. Son and pupil of Hikobei (Kajikawa I). Though known as Kajikawa II, is generally considered to have been the founder of the school; his name used by at least nine successors. Worked for the shogunate, receiving an honorary title in recognition of his skill. Probably the most famous artist of the Kajikawa school; the finest *inrō* maker of his time. Particularly noted for his *gyōbu-nashiji* and his fine black

lacquer. All his work beautifully finished, with a preference for *kirigane* technique. **Bib.:** Herberts, Jahss, M 188, Ragué, Sawaguchi, Yoshino.

¹久次郎　²梶川儔英　³久次郎
Kyūjo[1] (1744–1802). *N.:* Tō (originally Ido)[2] Kōryō[3] (or Naomichi).[4] *A.:* Chūgyo.[5] *F.N.:* Heisuke.[6] *Gō:* Kōroen,[7] Kōsen Koji,[8] Kyūjo,[9] Tōkyūjo,[10] Tonkashitsu,[11] Tonsai.[12] **Biog.:** Nagasaki painter. Lived in Edo; a samurai attached to the shogunate. Pupil of Sō Shiseki. **Coll.:** Kōbe. **Bib.:** Mitchell, Mody, *Pictorial* (2) 5.

¹九如　²井戸　³董弘梁　⁴直道　⁵仲漁　⁶平助　⁷黄盧園
⁸広川居士　⁹九如　¹⁰董九如　¹¹遯菴室　¹²遯菴
Kyūjō[1] (1747–93). *N.:* Yamada Hanzō.[2] *A.:* Yoshio.[3] *Gō:* Kyūjō,[4] Unshō.[5] **Biog.:** *Nanga* painter. Born in Owari Province. Pupil of Sō Shiseki; teacher of Nakabayashi Chikutō. Painted landscapes, birds, and animals after early Chinese models. **Bib.:** Mitchell.

¹宮常　²山田半蔵　³吉夫　⁴宮常　⁵雲障
Kyūkō[1] (1805–54). *N.:* Aone Kai.[2] *A.:* Sekifu.[3] *Gō:* Kyūkō.[4] **Biog.:** Painter. Lived and worked in Kyōto. **Bib.:** Mitchell.

¹九江　²青根介　³石夫　⁴九江
Kyūkō[1] (fl. c. 1818–54). *N.:* Inoue Tatsu.[2] *Gō:* Kyūkō.[3] **Biog.:** Printmaker. Worked in Kyōto, producing copperplate prints of famous Kyōto scenes. **Coll.:** Musée (2). **Bib.:** Fujikake (3) 3.

¹九皐　²井上達　³九皐
Kyūkoku[1] (fl. early 19th c.). *N.:* Nomura Kyūkoku.[2] *Gō:* Sanjin.[3] **Biog.:** Lacquerer. Particularly skillful at *chinkinbori.* Follower of Ogawa Ritsuō's style. **Bib.:** Herberts, Jahss.

¹九国　²野村九国　³散人
Kyūseki[1] (1653–1721). *N.:* Kanō Tomonobu.[2] *F.N.:* Kyūnai (Kunai),[3] Saemon.[4] *Gō:* Kyūseki.[5] **Biog.:** Kanō painter. Son and pupil of Kyūhaku II; became third-generation of the Okachimachi branch of the Kanō line. Carried on the painting tradition of this school.

¹休碩　²狩野友信　³宮内　⁴左衛門　⁵休碩
Kyūzan[1] (1655–1724). *N.:* Kanō Korenobu.[2] *F.N.:* Mokkōnosuke.[3] *Court title:* Naiki.[4] *Gō:* Kyūzan.[5] **Biog.:** Kanō painter. Son of Kanō Kyūhaku Masanobu; adopted by his uncle Kanō Kyūen Kiyonobu to succeed as heir to the Azabu Ipponmatsu Kanō family. Served the shogunate as *omote eshi.*

¹休山　²狩野是信　³木工之助　⁴内記　⁵休山
Kyūzō[1] (1568–93). *N.:* Hasegawa Kyūzō.[2] *Priest name:* Dōjun.[3] **Biog.:** Hasegawa painter. Son and pupil of Hasegawa Tōhaku. His work is close to that of his father. **Coll.:** Chishaku-in, Kiyomizu-dera, Tōkyō (1). **Bib.:** Covell (2); Gray (2); K 16, 48, 521, 564, 850; M 64, 209; Mizuo (1); NB (H) 14; NBZ 4; Noma (1) 2; Okamoto (1); SBZ 8; Yamane (1a); Yashiro (1).

¹久蔵　²長谷川久蔵　³道淳
Kyūzō I-V (fl. 18th c.). *N.:* Koma Kyūzō.[2] A name borne by five generations of the Koma school of lacquerers (q.v.). For Kyūzō I, see Kyūhaku I. Kyūzō II—also known as Kyūhaku II or Yasuaki (Anshō)—who died in 1732, was appointed court lacquerer in 1715. The third, who died in 1758, was appointed a court artist in 1754. The fourth, also known as Kyūhaku III, was made court artist in 1762, worked on the restoration of the Tōshō-gū in Nikkō in 1778, and died in 1794. The fifth, also known as Kuhaku IV or Kyūi II, died in 1816. **Bib.:** Herberts, Jahss, K 5.

¹休蔵　²古満休蔵

M

Machida Kyokkō (Kyokukō)[1] (1879–1967). *N.:* Machida Harunosuke.[2] *Gō:* Kyokkō (Kyokukō).[3] **Biog.:** Japanese-

style painter. Born in Nagano-ken. To Kyōto at age of 17; became a pupil of Utsumi Kichidō. Later to Tōkyō to study

under Terazaki Kōgyō and also with Kuroda Seiki at the Hakubakai. In 1900 exhibited with Nihon Kaiga Kyōkai, in 1907 with the Naikoku Kangyō Hakurankai and the Bunten. In 1911 to Europe, returning in 1913 by way of India. Became an exhibitor with the Teiten, serving as juror in 1925. After 1945 was associated with the Nitten. Work includes landscapes, portraits, *kachōga,* and paintings of animals. **Coll.:** National (5). **Bib.:** Asano, NB (S) 17.

¹町田曲江 ²町田春之助 ³曲江

Mae Taihō¹ (1899–). **Biog.:** Lacquerer. Born in Wajima. Continues the tradition of *chinkin-bori* for which Wajima, on the Noto Peninsula, is famous. Designated a Living National Treasure in 1955. **Bib.:** Herberts, Jahss, Ragué, Sugimura, Yoshino.

¹前大峰

Maeda (Maeta) Kanji¹ (1896–1930). **Biog.:** Western-style painter. Born in Tottori-ken; lived in Tōkyō. In 1921 graduated from the Tōkyō School of Fine Arts; the next year exhibited with the Nikakai. From 1922 to 1925 in Europe. On his return showed with the Teiten, serving as a juror for that group in 1929. In 1926, with a number of other artists, founded the 1930 Association. His drawings show influence of conservative French style of early 20th century; his paintings have outward characteristics of Derain and de Segonzac. **Coll.:** Kanagawa; Nagaoka; National (4), (5); Ohara (1); Tōkyō (1). **Bib.:** Asano, *Masterpieces* (4), NB (H) 24, NBT 10, NBZ 6, SBZ 11.

¹前田寛治

Maeda Seison¹ (1885–). **N.:** Maeda Renzō.² **Gō:** Seison.³ **Biog.:** Japanese-style painter. Born in Gifu-ken. In 1901 to Tōkyō to study under Kajita Hanko. Allied himself with Yasuda Yukihiko and Kobayashi Kokei in a movement that centered round the artists' discussion group Kojikai to create a new school of Japanese painting. With Imamura Shikō, Kobayashi Kokei, Hayami Gyoshū, Yasuda Yukihiko, was one of Okakura Tenshin's "second-generation" artists. From 1906 participated in various painters' groups, showing with the Bunten and the Nihon Bijutsuin. On Okakura's death in 1913 helped reorganize the Nihon Bijutsuin of which he was a member. From 1922 to 1923 in Europe. In 1929 received Asahi Culture Prize. In 1937 became a member of the Imperial Art Academy; in 1955 given Order of Cultural Merit. After 1945 taught at Tōkyō University of Fine Arts. Specialized at first in historical and legendary subjects and in genre scenes; later, detailed studies of figures in armor. After 1945 concentrated on genre scenes, portraits, scenes of Japanese festivals. Worked in a soft misty pastel manner as well as producing decorative paintings in strong colors. His style a sometimes not too happy mixture of Japanese techniques and a detailed Western realism; his work is uneven, at its best when most in Japanese manner with Western realism kept in check. Also an eloquent defender of Japanese-style painting. **Coll.:** Atami; Futaarasan; Jingū; Kyōto (1); National (5); Ōkura; Tōkyō (1), (2); Waseda. **Bib.:** Asano, M 70, *Masterpieces* (4), Miyagawa, Munsterberg (1), Nakamura (1), NB (H) 24, NB (S) 17, NBT 10, NBZ 6, NKKZ 24, Noma (1) 2, SBZ 11, Tanaka (7a) 26.

¹前田青邨 ²前田廉造 ²青邨

Maekawa Bunrei¹ (1837–1917). **N.:** Maekawa.² **A.:** Shishū.³ **Gō:** Bunrei.⁴ **Biog.:** Japanese-style painter. Born and worked in Kyōto. Specialized in figures and *kachōga.* **Coll.:** Museum (3). **Bib.:** Mitchell.

¹前川文嶺 ²前川 ³子緝 ⁴文嶺

Maekawa Sempan¹ (1888–1960). **N.:** Maekawa Sempan² (originally Ishida Shigesaburō).³ **Biog.:** Printmaker, illustrator. Born in Kyōto; worked in Tōkyō. At 16 studied Western oil painting under Asai Chū at the Kansai Bijutsuin; also worked under Kanokogi Takeshirō. In 1912 moved to

Tōkyō; soon became known for his cartoons and illustrations in newspapers and magazines. At same time, became interested in woodblock printing. In 1918 helped found the Nihon Sōsaku Hanga Kyōkai, showing at the first, second, and fourth exhibitions. In 1931 one of the founders of the Nihon Hanga Kyōkai. An exhibitor with the Shun'yōkai, the Shin Bunten, the Nitten. At first his work reflected some of the German expressionist tendency of the day; later it became slightly more abstract. Subjects taken mainly from the life and customs of the Tōhoku district, done with cheerful, kindly satire. **Coll.:** Art (1), Fine (California), Kanagawa, National (5), Newark. **Bib.:** Asano; Fujikake (1); Kawakita (1); Michener (3), (4); NHBZ 7, 8; NBZ 6; *Posthumous* (1); Statler; UG 4, 11, 14.

¹前川千帆 ²前川千帆 ³石田重三郎

Makino Torao¹ (1890–1946). **Biog.:** Western-style painter. Born in Takada. Graduated from Tōkyō School of Fine Arts in 1913. Showed with the Bunten and Teiten. Active in forming small art groups, such as the Ōgensha, which was founded in 1933, and in art education. His work under influence of School of Paris of the 20s, especially Derain. **Coll.:** Nagaoka, National (5). **Bib.:** Asano, NBZ 6.

¹牧野虎雄

Mangetsudō¹ (fl. c. 1760). **Biog.:** Ukiyo-e printmaker. This is a signature found on rare prints in late Masanobu style, some of which are actually pirated editions of Masanobu's work. It is possible this is not an individual artist but a name used by a publisher for his pirating activities. **Coll.:** Art (1), British, Honolulu, Riccar, Staatliche, Tōkyō (1). **Bib.:** Fujikake (3) 2, Gunsaulus (1), Hillier (7), Kikuchi, Lane, Michener (3), Schmidt, Takahashi (2), UG 28, Waterhouse.

¹万月堂

Mano Kitarō¹ (1871–1958). **Biog.:** Western-style painter. Born in Nagoya. To Tōkyō to study English; soon became a painting pupil of Harada Naojirō. Later changed from oil painting to water color. In 1907, with Ōshita Tōjirō, established Nihon Suisaiga Kenkyūsho; in 1913 helped found the Nihon Suisaigakai. In 1921 traveled round Europe; in 1923 made a tour of Oceania, including Australia; about 1932 to China, Korea, Taiwan. Much interested in landscape; generally exhibited sketches made on his many trips. **Bib.:** Asano, NBZ 6.

¹真野紀太郎

Manzan Dōhaku¹ (1636–1715). **Biog.:** *Zenga* painter. A Zen monk whose painting style is marked by an almost rococo type of brushwork. Espoused the cause of the Sōtō sect, helping to restore it to importance. **Bib.:** Brasch (2).

¹卍山道白

Maruyama Banka¹ (1867–1942). **N.:** Maruyama Kensaku.² **Gō:** Banka.³ **Biog.:** Western-style painter. Born in Nagano-ken. In 1883 began to study under Kodama Katei; in 1884 to Tōkyō to study Western painting at the Kaiga Gakusha and in 1888 at the Shōgidō. In 1889 to Europe and America. After returning to Japan worked to establish the Taiheiyō Gakai, exhibiting with this society as well as with the Meiji Bijutsukai. From 1907 showed with the Bunten. In 1907, with Ōshita Tōjirō and others, founded the Nihon Suisaiga Kenkyūsho. In 1911 again to Europe. In 1918 one of the founders of the Shin Nihonga Kyōkai. Also known as a mountain climber. **Bib.:** Asano, BK 201, Mitchell, NBZ 6.

¹丸山晩霞 ²丸山健作 ³晩霞

Masafusa¹ (fl. mid-18th c.). **N.:** Okumura Masafusa.² **Gō:** Bunshi.³ **Biog.:** Ukiyo-e printmaker, illustrator. An Ōsaka man, working largely in the provinces. Pupil of Okumura Masanobu. Work very rare. **Coll.:** British. **Bib.:** Binyon (1), (3); Morrison 2.

¹政房 ²奥村政房 ³文志

Masafusa¹ (fl. 1751–81.) **N.:** Okamoto Masafusa.² **Gō:** Sekkeisai.³ **Biog.:** Ukiyo-e printmaker, illustrator. Made prints of *bijin* and actors. Some of his figures, with their

plump cheeks and soft rounded forms, foretell the Ōsaka style. **Bib.**: Fujikake (3) 2, Keyes, NHBZ 3.

¹昌房 ²岡本昌房 ³雪圭斎

Masakage[1] (fl. 19th c.). *N.*: Shiomi Masakage.[2] **Biog.**: Lacquerer. Member of the Shiomi family of lacquer artists. **Bib.**: Herberts, Jahss.

¹政景 ²塩見政景

Masakazu (Masasada)[1] (?–1886). *Gō*: Baien,[2] Masakazu (Masasada),[3] Ōen.[4] **Biog.**: Ukiyo-e printmaker. Pupil of Kunisada II. **Coll.**: Musées, Rhode Island, Victoria.

¹政員 ²梅筵 ³政員 ⁴桜園

Masamochi[1] (1809–57). *N.*: Satō Masamochi.[2] *F.N.*: Risaburō.[3] *Gō*: Hokumei.[4] **Biog.**: Painter. Born in Edo. Studied under Haruki Nanko; later followed the manner of Tani Bunchō and, finally, that of the ukiyo-e school. **Bib.**: Mitchell.

¹正持 ²佐藤正持 ³理三郎 ⁴北渓

Masamune Tokusaburō[1] (1883–1962). **Biog.**: Western-style painter. Born in Okayama-ken. To Tōkyō at 18. First a pupil of Terazaki Kōgyō; then entered the Western painting division of the Tōkyō School of Fine Arts, graduating in 1907. Two years later showed with the Bunten. In 1914 to France to study, returning in 1916 and becoming a member of the Nikakai. From 1921 to 1924 again in Europe. In 1943, a juror of the Shin Bunten. After 1945 left Nikakai to found the Dai Nikikai. Great admirer of Tomioka Tessai, writing a book on his work. His style shows the influence of the School of Paris. **Bib.**: Asano, NBZ 6.

¹正宗徳三郎

Masanari (Masazane, Seisei)[1] (1647–1722). *N.*: Shiomi Masanari (Masazane, Seisei).[2] *F.N.*: Kobei.[3] **Biog.**: Painter, lacquerer. Born and worked in Kyōto. Pupil of Yamamoto Shunshō Harumasa. A talented Kanō painter; a lacquer artist of great refinement, delicate workmanship, extraordinary clarity and transparency of color. Particularly skillful in his designs of animals. Noted for minute workmanship in *togidashi-makie* of such quality that after his death Shiomi-makie became a synonym for good *togidashi-makie*. His works are frequently forged. Followed by Yūji[4] (Masanari II, 1681–1764). In 1725 his descendants moved to Edo. **Coll.**: Ashmolean; Hatakeyama; Metropolitan; Museum (2), (3); Nezu; Tōkyō (1); Victoria; Walters. **Bib.**: Boyer, Casal, Feddersen, Herberts, Jahss, M 188, Ragué, Yoshino.

¹政誠 ²塩見政誠 ³小兵衛 ⁴友治

Masanobu[1] (1434–1530). *N.*: Kanō (originally Fujiwara)[2] Hakushin.[3] *F.N.*: Ōinosuke,[4] Shirojirō.[5] *Gō*: Masanobu,[6] Shōgen,[7] Yūsei.[8] (Used this last *gō* after taking Buddhist vows.) **Biog.**: Kanō painter. Descended from a warrior family; came from village of Kanō in Izu Province to Kyōto to serve the shogun Yoshimasa. Pupil of his father Kanō Kagenobu; also of Shūbun and Sōtan, whom he succeeded as official painter to the shogun. Studied works of Ma Yüan and Hsia Kuei. Traditionally said to have founded the Kanō school, but it really owes its existence to his son Kanō Motonobu. Received title of *hōgen*. Only a few of his paintings survive. A secular painter (up to this time almost all artists had been Buddhist priests or aristocrats) and among the first to paint nature for its own beauty. Style based on Shūbun, but more decorative: clear expression, clean brush strokes, balanced composition, traditional Chinese themes. **Coll.**: British, Daitoku-ji (Shinju-an), Museum (3), Victoria. **Bib.**: Akiyama (2); Binyon (2); BK 117, 141; Fontein (1); GK 11; GNB 11; HS 1, 10, 12; K 1, 4, 5, 38, 56, 112, 125, 434, 586; *Kokuhō* 6; Lee (1); Matsushita (1); Morrison 1; NBT 4; NKZ 73; *One* (2); Paine (4); Tajima (12) 1, 4, 7, 13; Tajima (13) 4; Tanaka (2); Watanabe; Yashiro (1); Yamane (1a).

¹正信 ²藤原 ³狩野伯信 ⁴大炊助 ⁵四郎次郎
⁶正信 ⁷性玄 ⁸祐勢（友清，祐盛）

Masanobu[1] (1686–1764). *N.*: Okumura Shimmyō (Chika-

tae).[2] *F.N.*: Genroku;[3] later, Gempachi.[4] *Gō*: Baiō,[5] Bunkaku,[6] Hōgetsudō,[7] Masanobu,[8] Shidōken,[9] Tanchōsai.[10] **Biog.**: Ukiyo-e painter, printmaker. Also a publisher. Lived in Edo. One of most important figures in ukiyo-e circles; an innovator who influenced entire course of ukiyo-e. Studied for a while with Torii Kiyonobu, but was largely self-taught; influenced by Hishikawa Moronobu. Proprietor of a shop handling illustrated books and prints. Books illustrated by him dated as early as 1701; in 1724 began to publish his own prints; later, those of his pupil Okumura Toshinobu. May have been first to change from hand coloring to color printing after the process was invented in 1741; invented the *hashira-e*, the *uki-e* (or bird's-eye-view pictures), first to introduce use of lacquer in the *urushi-e*. Set the fashion for *bijinga*: single-sheet portraits of famous beauties, rendered with much elegance. Also a painter, but few paintings known. **Coll.**: Allen; Art (1); Ashmolean; Atami; British; Brooklyn; Cincinnati; Cleveland; Fitzwilliam; Fogg; Freer; Fujita; Honolulu; Idemitsu; Kanagawa; Kōbe; Metropolitan; Minneapolis; Musée (1), (2); Museum (1), (3); Nelson; Newark; Östasiatiska; Österreichisches; Portland; Rhode Island; Riccar; Rietberg; Staatliche; Suntory; Tōkyō (1); University (2); Victoria; Worcester; Yale. **Bib.**: AO 5; Binyon (1), (3); Boller; Brown; Crighton; *Freer;* Fujikake (3) 2; Gentles (2); GNB 17; Gunsaulus (1); Hillier (1), (7), (9); Jenkins; K 67, 922; Kikuchi; Kondō (2); *Kunst;* Kurth (4); Lane; Ledoux (4); M 228, 233; Michener (1); Morrison 2; Narazaki (2), (3); NB (H) 24; NB (S) 68; NBZ 5; NHBZ 2; *Nikuhitsu* (1) 1; OA 9; *One* (2); Paine (4); *Pictorial* (2) 4; SBZ 9; Schmidt; Shibui (1); Shimada 3; Stern (2), (4); Tajima (7) 4, (13) 6; Takahashi (2), (5), (6) 1; UG 28; *Ukiyo-e* (3) 2; Vignier 1; Waterhouse.

¹政信 ²奥村親妙 ³源六 ⁴源八 ⁵梅翁
⁶文角 ⁷芳月堂 ⁸政信 ⁹志道軒 ¹⁰丹鳥斎

Masanobu[1] (fl. c. 1751–79). *N.*: Ueda Masanobu.[2] **Biog.**: Ukiyo-e painter, printmaker. One of several ukiyo-e artists working under this *gō* at the same time and about whom there is almost no information. **Coll.**: Tōkyō (1). **Bib.**: Kikuchi.

¹政信 ²上田政信

Masanobu[1] (1761–1816). *N.*: Iwase (or Haida)[2] Sei.[3] *A.*: Yūsei.[4] *F.N.*: Denzō;[5] later, Jintarō.[6] *Gō*: Kitao Masanobu,[7] Masanobu,[8] Rissai,[9] Santō Kyōden (as a writer).[10] **Biog.**: Ukiyo-e painter, printmaker. Also a novelist. Born and lived in Edo. Brilliant pupil of Kitao Shigemasa. Using *gō* Masanobu, painted famous *bijin;* as a printmaker and illustrator of his own novels used *gō* Kitao Masanobu. In 1783–4 a remarkable publication—one of most splendid examples of ukiyo-e printing—appeared: *Yoshiwara Keisei Shin Bijin Awase Jihitsu Kagami*, an album of seven color prints twice normal size of *ōban,* showing courtesans of the Yoshiwara. But in 1785, under the *gō* of Santō Kyōden his novel *Edo Umare Uwaki no Kabayaki* was published; with this his literary reputation was made, and he gave up printmaking for a literary career. Owned a tobacco accessory shop at Kyōbashi: a meeting place for famous artists, actors and writers. His painting has much freshness and vitality; his prints, of which the single sheets are quite rare, are generally rather gorgeous. **Coll.**: Allen; Art (1); Ashmolean; Atami; British; Cincinnati; Fitzwilliam; Freer; Honolulu; Metropolitan; Musée (1), (2); Musées; Museum (1), (3); Newark; Philadelphia; Portland; Riccar; Staatliche; Tōkyō (1); Victoria; Worcester; Yale. **Bib.**: Binyon (1), (3); Brown; Fujikake (3) 3; Hillier (1), (2), (3), (4) 1, (7); *Japanese* (2); K 699, 866; Kikuchi; *Kunst;* Lane; M 4; Michener (1), (3); Morrison 2; Narazaki (2); NHBZ 3; Nikuhitsu (1) 2; OA 13; Schmidt; Shibui (1); Shimada 3; Stern (2), (5); Tajima (7) 4; Takahashi (2), (5), (6) 6; UG 28.

¹政演 ²拝（灰）田 ³岩瀬醒 ⁴醒星 ⁵伝蔵 ⁶甚太郎
⁷北尾政演 ⁸政演 ⁹葎斎 ¹⁰山東京伝

Masatada[1] (1625–94). *N.:* Kobori Masatada.[2] *Gō:* Hōsetsu.[3] **Biog.:** Painter. Much better known as a tea master. His paintings generally landscapes or *kachōga*. **Coll.:** Museum (3).

¹政尹　²小堀正尹　³篷雪

Masatoshi[1] (fl. 1655–74). *N.:* Ukiyo Masatoshi.[2] **Biog.:** Genre painter. Specialized in "Kambun Beauties." No biographical information available. It is possible this is a *gō* for an artist who wished to remain anonymous in the field of genre painting, a subject generally felt to be unsuitable for the classical artist of the period. Several other artists used the name Ukiyo (Floating World) as a means of hiding their identity. **Bib.:** Narazaki (3).

¹正歳　²浮世正歳

Masatsugu[1] (fl. 1765–80). *N.:* Terasawa Masaji.[2] *Gō:* Masatsugu.[3] **Biog.:** Ukiyo-e printmaker. Also an illustrator. Pupil of Hidenobu (Eishin). His subject matter included actor prints, *bijin,* and erotica. **Bib.:** Keyes, NHBZ 3.

¹昌次　²寺沢昌二　³昌次

Masayoshi (Seigi)[1] (fl. 1751–63). *N.:* Suzuki Shōzaemon.[2] *Gō:* Masayoshi (Seigi).[3] **Biog.:** Lacquerer. Lived and worked in Kyōto. Noted for his *inrō.* **Bib.:** Herberts, Jahss.

¹正義　²鈴木正左衛門　³正義

Masayuki[1] (fl. c. 1716–30). *N.:* Miyagawa Masayuki.[2] **Biog.:** Ukiyo-e painter, printmaker. A minor pupil of Miyagawa Chōshun. His work, in the style of his master, is of good quality but rare. **Bib.:** *Nikuhitsu* (2), Tajima (7) 2.

¹正幸　²宮川正幸

Mashimizu Zōroku[1] (1822–77). *N.:* Mashimizu (originally Shimizu)[2] Zōroku.[3] *F.N.:* Tasaburō.[4] *Gō:* Hyakuju,[5] Sōkan,[6] Tahei;[7] later, Zōroku.[8] **Biog.:** Potter. Born near Kyōto; son of Shimizu Gen'emon. To Kyōto, when he was very young, to study under his uncle Wake Kitei. Also studied tea ceremony. Opened his own kiln to make tea-ceremony wares. After the Restoration, continued his experiments, with the government's encouragement, in earlier techniques, imitating the styles of earlier potters. His pieces shown in foreign expositions. **Coll.:** Tōkyō (1). **Bib.:** Jenyns (2), NBZ 6.

¹真清水蔵六　²清水　³真清水蔵六　⁴田三郎（太三郎）
⁵百寿　⁶宗缶　⁷大兵衛　⁸蔵六

Mashimizu Zōroku II[1] (1861–1942). *N.:* Mashimizu Zōroku.[2] *F.N.:* Jutarō.[3] *Gō:* Deizō,[4] Shunsen.[5] **Biog.:** Potter. Active in Kyōto from 1912 until shortly before his death. Noted as an imitator of Ninsei's wares. **Bib.:** Jenyns (2), NBZ 6.

¹真清水蔵六二代　²真清水蔵六　³寿太郎　⁴泥蔵　⁵春泉

Masuda Gyokujō[1] (1881–1955). *N.:* Masuda Tamaki.[2] *Gō:* Chōkyū Gabō,[3] Gyokujō.[4] **Biog.:** Japanese-style painter. Born in Miyagi-ken. Pupil of Kawabata Gyokushō. In 1904 graduated from Tōkyō School of Fine Arts; in 1909 became a teacher at the Kawabata Art School and in 1910 at the Women's Art School. Exhibited primarily with the Nihon Bijutsu Kyōkai. His paintings included landscapes, portraits, and *kachōga.* **Coll.:** National (5).

¹益田玉城　²益田珠城　³長久画房　⁴玉城

Masumune[1] (fl. early 12th c.). *N.:* Kose (originally Ki)[2] no Masumune.[3] **Biog.:** Painter. Said to have been a son of Kose no Muneshige, the Edokoro *azukari* at the imperial court. Given an official title as assistant governor of Dewa Province. Reputed to have been a less able artist than his father.

¹益宗　²紀　³巨勢益宗

Masunobu[1] (fl. 1740–50). *N.:* Tanaka Masunobu.[2] *Gō:* Sanseidō.[3] **Biog.:** Ukiyo-e printmaker. Nothing known of his life. Perhaps a pupil of Torii Kiyomasu, but his work is more in the manner of Okumura Masanobu. Often confused with Masunobu Zenshinsai (q.v.), who worked in the style of Harunobu. **Note:** It is not easy to be certain if references are to this Masunobu or to Masunobu Zenshinsai, since the *kanji* for the name Masunobu are the same. **Coll.:** Art (1), British, Kōbe, Nelson, Portland, Tōkyō (1), Yale. **Bib.:**

Binyon (1), Ficke, Gentles (1), Hillier (4) 1, Kikuchi, Michener (3), *Pictorial* (2) 4.

¹益信　²田中益信　³三晴堂

Masunobu[1] (fl. c. 1770–75). *Gō:* Masunobu,[2] Zenshinsai.[3] **Biog.:** Ukiyo-e printmaker. Worked in the style of Harunobu. Has often been confused with Tanaka Masunobu, but the difference in style and the fact that no prints have been found to bridge the gap of twenty years between the two styles lead to the belief that two different artists are involved. **Note:** It is not easy to be certain if references are to this Masunobu or to Tanaka Masunobu, since the *kanji* for the name Masunobu are the same. **Coll.:** British, Honolulu. **Bib.:** Ficke, Hillier (4) 1, Kikuchi, Michener (3), Morrison 2, *Nikuhitsu* (2), Waterhouse.

¹益信　²益信　³善辰斎

Masunobu[1] (fl. 1849–53). *Gō:* Ittōsai,[2] Masunobu.[3] **Biog.:** Ukiyo-e printmaker. Pupil of Utagawa Kunimasu; worked in Ōsaka. Specialized in *ōkubi-e* of actors. **Coll.:** Philadelphia. **Bib.:** Keyes.

¹升信　²一刀斎　³升信

Masuyuki[1] (fl. c. 1810). *N.:* Satō Masuyuki.[2] *A.:* Shiki.[3] *Gō:* Suiseki.[4] **Biog.:** Illustrator. An illustrator of books, working in Ōsaka. Specialized in genre scenes and *kachōga.* This may be the same artist as Gyodai (q.v.). **Coll.:** Ashmolean. **Bib.:** Brown, Holloway, Mitchell, Toda (1).

¹益之　²佐藤益之　³士亀　⁴水石

Masuzu Shunnan[1] (1849–1916). *N.:* Masuzu Naoshi.[2] *Gō:* Shunnan.[3] **Biog.:** *Nanga* painter. Born in Edo to a samurai of the Shizuoka clan. In 1867 entered the Yushima Seidō, the *bakufu*-sponsored Confucian school. Some time after the Restoration studied English, French, Italian. Taught at the Cadet School, Junior Division, until 1875, when he became a pupil of Noguchi Yūkoku and studied *nanga* painting. In 1884 exhibited with the Naigai Hakurankai, receiving favorable mention. In 1907 exhibited with the Bunten, serving as a juror for this society from 1908 to 1913. Worked for the Tōkyō Imperial Palace. A traditional artist. **Bib.:** Asano, NBZ 6, Umezawa (2).

¹益頭峻南　²益頭尚志　³峻南

Matabei[1] (fl. 16th c.). *N.:* Sasaki Matabei.[2] **Biog.:** Lacquerer. Lived in Kyūshū. Founded Ohara school of lacquer artists. **Bib.:** Jahss.

¹又兵衛　²佐々木又兵衛

Matabei[1] (1578–1650). *N.:* Iwasa Matabei.[2] *Gō:* Dōun,[3] Hekishōkyū,[4] Shōi (Katsumochi),[5] Un'ō.[6] **Biog.:** Painter. Illegitimate son of Araki Murashige, daimyo of Itami, who served Nobunaga and who was forced by him to commit suicide. Grew up in Kyōto under mother's name of Iwasa. Studied under Tosa Mitsunori and probably under Kanō Shōei. About 1616 lived in Fukui, painting for the daimyo Lord Matsudaira. In 1637 to Edo to work for Tokugawa Iemitsu; died there. Once called the "father of ukiyo-e," though some scholars now consider Hishikawa Moronobu as the founder of the school. In any event, some of his paintings depict genre subjects, scenes of historic events, and illustrations of Japanese or Chinese classic tales. Is generally thought to have established a definite figure type with large heads and carefully delineated features. Painter of much individuality, neither Tosa nor Kanō, though his work shows Kanō influence and he called himself a Tosa painter on the painting of the Thirty-six Poets in the Tōshō-gū at Kawagoe. **Coll.:** Allen, Andrew, Art (1), Atami, British, Center, Freer, Idemitsu, Myōshin-ji, Tokugawa, Tōkyō (1), Tōshō-gū (Kawagoe). **Bib.:** ARTA 29; BI 2, 42; BK 225, 230; Boller; *Freer;* Fujikake (1), (3) 1; NBZ 4; GNB 24; Gray (2); Hillier (1); Hisamatsu; K 1, 2, 16, 104, 106, 132, 269, 283, 295, 303, 307, 391, 450, 477, 484, 491, 505, 631, 643, 659, 673, 686, 689, 818, 846, 924, 927, 936, 955, 960; KO 34; Kondō (2), (6); Moriya; Morrison 2; NBT 5; NBZ 4; NKZ 17; Noma (1) 2; OA 13; *One* (2); Paine (4); SBZ 9; Shimada 3; Tajima

(7) 1; Tajima (12) 3, 5, 12, 13, 14, 17, 19; Tajima (13) 6; *Ukiyo-e* (3) 1; Yamane (1a).

[1]又兵衛　[2]岩佐又兵衛　[3]道蘊　[4]碧勝宮　[5]勝以　[6]雲翁

Matahei[1] (fl. early 18th c.). *N.*: Ōtsu (or Ukiyo)[2] Matahei.[3] **Biog.**: Painter, printmaker. An equivocal character. Said to have been the first painter of Ōtsu-e. Has sometimes been confused with Iwasa Matabei or one of his descendants; the difference in dates makes the former impossible. To avoid such confusion, was often called Nidaime Matahei.[4] **Coll.**: Musées, Victoria. **Bib.**: Morrison 2.

[1]又平　[2]浮世　[3]大津又平　[4]二代目又平

Matora (Shinko)[1] (1794–1833). *N.*: Ōishi (originally Koizumi)[2] Jumpei.[3] *A.*: Monkichi;[4] later, Komonta.[5] *F.N.*: Jutarō,[6] Shichiemon.[7] *Gō*: Haisha,[8] Matora (Shinko),[9] Shōkoku.[10] **Biog.**: Tosa painter, illustrator. Born in Nagoya, son of a doctor. Later took the name of Ōishi, claiming descent from Ōishi Yoshio of the Forty-seven Rōnin. Pupil of Chō Gesshō and Watanabe Shūkei; also studied Tosa style, probably on his own. Lived and worked for a short time in Edo, later in Ōsaka. Good at historical themes, with a remarkably accurate knowledge of historical and costume details. **Coll.**: Ashmolean, British, Fitzwilliam, Victoria, Worcester. **Bib.**: Binyon (1), Brown, Holloway, Mitchell, Morrison 2, *Nikuhitsu* (2), Strange (2), Toda (1).

[1]真虎　[2]小泉　[3]大石順平　[4]門吉　[5]小門太
[6]寿太郎　[7]七衛門　[8]柄舎　[9]真虎　[10]樵谷

Matsubara Sangorō[1] (1864–?). **Biog.**: Western-style painter. Born in Okayama-ken. Studied first with Goseda Hōryū, then with Kanokogi Takeshirō and Mitsutani Kunishirō. Eventually established his own school in Ōsaka, which became important in spreading the cult of Western-style painting in the Kansai. Helped found the Kansai Bijutsuin. Took part in many Kansai exhibitions as both exhibitor and juror. **Bib.**: Asano, NBZ 6.

[1]松原三五郎

Matsubayashi Keigetsu[1] (1876–1963). *N.*: Matsubayashi Keigetsu[2] (originally Itō Atsushi).[3] *A.*: Shikei.[4] *Gō*: Gyokukō Itsujin,[5] Kōgaikyo Shujin.[6] **Biog.**: *Nanga* painter. Born in Yamaguchi-ken. To Tōkyō to study under Noguchi Yūkoku. Exhibited with the Bunten and the Nitten. A great supporter of the *nanga* group. President of the Nihon Nangain and the Nihon Bijutsu Kyōkai. Member of Art Committee of the Imperial Household and the Japan Art Academy. In 1959 received Order of Cultural Merit. Introduced a new emphasis on realism, following the tradition of Watanabe Kazan and Tsubaki Chinzan. **Coll.**: National (5), Tōkyō (1), University (2). **Bib.**: Asano, M 108, NBZ 6.

[1]松林桂月　[2]松林桂月　[3]伊藤篤
[4]子敬　[5]玉江逸人　[6]香外居主人

Matsuda Gonroku[1] (1896–). **Biog.**: Lacquerer. Born in Kanazawa; works in Tōkyō. In 1919 graduated from the lacquer department of the Tōkyō School of Fine Arts, where he had studied under Shirayama Shōsai. Taught at the Tōkyō University of Arts. Member of Japan Art Academy and Nihon Mingeikan. Has been designated a Living National Treasure. Works in traditional techniques and with classic designs, particularly in *makie-e*; also uses crushed eggshell as one of his inlays. **Coll.**: National (4), Tōkyō (2). **Bib.**: Adachi, GNB 28, Herberts, Jahss, *Masterpieces* (4), NBZ 6, Ragué, Sugimura, Yoshino.

[1]松田権六

Matsuda Naoyuki[1] (1898–). **Biog.**: Sculptor. Born in Kanazawa. Graduated in 1922 from the Tōkyō School of Fine Arts. First showed in 1921 with the Teiten; from then on a constant exhibitor at government shows and prize winner as well as juror. Eventually became a juror for the Nitten and a teacher in Kyōto. **Bib.**: Asano.

[1]松田尚之

Matsuda Ryokuzan[1] (1837–1903). *N.*: Matsuda (originally Matsumoto)[2] Atsutomo.[3] *F.N.*: Kamenosuke;[4] later,

Yatarō.[5] *Gō*: Gengendō II,[6] Rankōtei,[7] Ryokuzan,[8] Seisendō.[9] **Biog.**: Printmaker. Son and pupil of Matsumoto Gengendō, from whom he learned the technique of etching. Worked in the printing department of the Meiji government, producing maps and money. Also made prints of famous places in Kyōto and Tōkyō. **Bib.**: NBZ 6.

[1]松田緑山　[2]松本　[3]松田敦知　[4]亀之助　[5]弥太郎
[6]玄々堂二代　[7]蘭香亭　[8]緑山　[9]清泉堂

Matsui Noboru[1] (1854–1933). **Biog.**: Western-style painter. Born in Hyōgo-ken. An early-Meiji Western-style artist; studied at Kawakami Tōgai's school. One of the founders of the Meiji Bijutsukai and a juror at its exhibitions. His style one of academic realism. **Bib.**: Asano, BK 188, NBZ 6.

[1]松井昇

Matsumoto Fūko[1] (1840–1923). *N.*: Matsumoto Takatada.[2] *Gō*: Angadō,[3] Fūko,[4] Yōga.[5] **Biog.**: Japanese-style painter. Lived in Tōkyō. First a pupil of Oki Ichiga, then of Satake Eikai and Kikuchi Yōsai in succession. Member of the Imperial Fine Arts Academy. Served as juror for the first four exhibitions of the Bunten. Among his better known pupils were Imamura Shikō, Takahashi Kōko, and Hayami Gyoshū. His style a combination of traditional ones. **Bib.**: Asano, Mitchell, Morrison 2, NBZ 6, Uyeno.

[1]松本楓湖　[2]松本敬忠　[3]安雅堂　[4]楓湖　[5]洋峨

Matsumoto Itchō (Ichiyō)[1] (1893–1952). **Biog.**: Japanese-style painter. Born in Kyōto. Graduate of the Kyōto College of Fine Arts; pupil of Yamamoto Shunkyo and Kawamura Manshū. Received special mention at the eighth and ninth Teiten exhibitions; later served as juror for this group. After 1945, taught at his alma mater and acted as juror for the Nitten. His paintings are noted for their beautiful color and their romanticism, as well as for their strong tendency toward the *yamato-e* style. **Coll.**: Kyōto (1), National (5). **Bib.**: Asano.

[1]窠本一洋

Matsumoto Ryōzan[1] (?–1867). *N.*: Matsumoto.[2] *Gō*: Ryōzan.[3] **Biog.**: Sculptor. Specialized in Buddhist subjects, working in a continuation of the sweetly decorative style made popular at Nikkō. **Coll.**: Shinshō-ji (Fudōdō). **Bib.**: *Pictorial* (1) 4, SBZ 10.

[1]松本良山　[2]松本　[3]良山

Matsumoto Shisui[1] (1887–). *N.*: Matsumoto Hidejirō.[2] *Gō*: Shisui.[3] **Biog.**: Japanese-style painter. Born in Tochigi-ken; worked in Tōkyō. Studied Western-style painting under Kuroda Seiki and Japanese-style painting under Kawai Gyokudō. An exhibitor with government shows and with the Nitten. Member of the Nihongain and the Nihon Bijutsu Kyōkai. His paintings show considerable Western influence. **Coll.**: National (5). **Bib.**: Asano.

[1]松本姿水　[2]松本秀次郎　[3]姿水

Matsumoto Shunsuke[1] (1912–48). **Biog.**: Western-style painter. Born in Tōkyō. Studied at the Taiheiyō Kenkyūsho. Exhibited with Nikakai from 1935 to 1943; received a special award from that organization in 1940. In 1947 joined the Jiyū Bijutsuka Kyōkai. Showed in the first and second exhibitions sponsored by the *Mainichi Shimbun*, the Rengo Bijutsuten. His paintings have a generally realistic and rather bold posterlike quality. **Coll.**: Kanagawa, National (5), Ohara (1). **Bib.**: Asano.

[1]松本竣介

Matsumura Baisō[1] (1885–1934). *N.*: Matsumura Jin'ichirō.[2] *Gō*: Baisō.[3] **Biog.**: Japanese-style painter. Pupil of Imao Keinen; graduate of Kyōto College of Fine Arts. From 1909 exhibited with the Bunten until he founded the Jiyū Gadan and stopped showing with any government-sponsored organization. **Bib.**: Asano.

[1]松村梅叟　[2]松村乍一郎　[3]梅叟

Matsunami Hoshin[1] (1882–1954). **Biog.**: Lacquerer. Born in Kanazawa. Studied lacquer techniques at the Meiji Lacquerware Factory. Served in the lacquer department of the

imperial household. Specialized in dried lacquer, generally making objects for tea-ceremony use. In 1952 was named a Living National Treasure. **Bib.**: *Masterpieces* (4), Ragué.

¹松波保真

Matsuoka Eikyū[1] (1881–1938). *N.*: Matsuoka Teruo.[2] *Gō*: Eikyū.[3] **Biog.**: Japanese-style painter. Pupil of Hashimoto Gahō. Graduate of the Tōkyō School of Fine Arts, eventually teaching there. Active in promoting the Shinkō Yamato-e-kai and the Kokugakai; a frequent exhibitor with both the Bunten and the Teiten. Member of the Imperial Art Academy. Specialized in pictures of historical subjects rendered in a modern version of *yamato-e* painting. **Coll.**: Meiji, National (5), Staatliche, Yamatane. **Bib.**: Asano, M 52, NB (H) 24, NBZ 6, Schmidt.

¹松岡映丘 ²松岡輝夫 ³映丘

Matsuoka Hisashi[1] (1862–1944). **Biog.**: Western-style painter. Born in Okayama; worked in Tōkyō. Studied at the Kōbu Daigaku Bijutsu Gakkō. In 1880 to Europe; graduated from the Rome Art Academy in 1887. Back in Japan, became one of the founders in 1888 of the Meiji Bijutsukai. Taught at several schools; served as a juror for the Bunten. Left some charming plein-air views of Europe, particularly of Italian scenes. His style is the European academic one of his student years. **Coll.**: Tōkyō (2). **Bib.**: Asano, BK 188, Harada Minoru, *Kurashina* (2), NB (H) 24, NB (S) 30, NBZ 6, Uyeno.

¹松岡寿

Meiki[1] (fl. c. 1840). *N.*: Yamazaki Kageyoshi.[2] *A.*: Meiki.[3] *F.N.*: Kinzaburō.[4] *Gō*: Settendō.[5] **Biog.**: Painter. Lived and worked in Edo. **Bib.**: Mitchell.

¹明暉 ²山崎景義 ³明暉 ⁴金三郎 ⁵接天堂

Meimon[1] (fl. c. 1820–40). *N.*: Suzuki Seki.[2] *A.*: Ichizen.[3] *Gō*: Meimon,[4] Tambokusai.[5] **Biog.**: *Nanga* painter. Also known as a poet. Son of a merchant in Awa Province. Studied painting in Kyōto. Later to Edo, where he was a pupil of Suzuki Fuyō, who adopted him. Good at landscapes and figures. **Coll.**: Museum (3). **Bib.**: Mitchell.

¹鳴門 ²鈴木積 ³一善 ⁴鳴門 ⁵淡墨斎

Michinobu[1] (fl. 1720–40). *N.*: Hanekawa (originally Ōoka)[2] Tōei.[3] *F.N.*: Dennai.[4] *Gō*: Kagetsu,[5] Michinobu.[6] **Biog.**: Ukiyo-e painter, illustrator. An Ōsaka artist, pupil of Nishikawa Sukenobu. Painted genre scenes, illustrated several books. His work almost the equal of Sukenobu's. **Bib.**: Lane.

¹道信 ²大岡 ³羽川藤永 ⁴伝内 ⁵夏月 ⁶道信

Migita Toshihide[1] (1863–1925). *N.*: Migita Toyohiko.[2] *Gō*: Bansuirō,[3] Gosai,[4] Ichieisai,[5] Toshihide.[6] **Biog.**: Painter, printmaker. Born in Ōita-ken. Went to Tōkyō when still young to study first ukiyo-e under Tsukioka Yoshitoshi then Western-style painting under Kunisawa Shinkurō. Teacher of Kawai Eichū. Specialized in portraiture, particularly rather saccharine *bijinga*. Also a newspaper illustrator. **Coll.**: Musées, Victoria. **Bib.**: Crighton, Morrison 2.

¹右田年英 ²右田豊彦 ³晩翠楼 ⁴梧斎 ⁵一頴斎 ⁶年英

Miki Sōsaku[1] (1891–1945). **Biog.**: Sculptor. Born in Fukushima-ken. At 16 to study woodcarving with Yamamoto Zuiun. First showed in 1916 with the Bunten; from then on a frequent exhibitor, prize winner and juror at government shows. A founding member in 1931 of the Nihon Mokuchō-kai, remaining with it until 1940. **Bib.**: Asano.

¹三木宗策

Mikishi (Migishi) Kōtarō[1] (1902–34). **Biog.**: Western-style painter. Born in Hokkaidō; died in Nagoya. Exhibited from 1923 to 1930 with the Shun'yōkai, later with the Dokuritsu Bijutsu Kyōkai. Style at first quite wild; later changed to a lyrical surrealism. **Coll.**: Kanagawa. **Bib.**: Asano, NB (H) 24, NBT 10, NBZ 6, NKKZ 11, *Posthumous* (1), SBZ 11.

¹三岸好太郎

Mimino Usaburō[1] (1891–). **Biog.**: Western-style painter. Born in Ōsaka; worked in Tōkyō. Studied at the Hakubakai

and then at the Tōkyō School of Fine Arts under Kuroda Seiki and Fujishima Takeji. Member of the Kōfūkai and the Nitten. His style expressionist. **Coll.**: National (5).

¹耳野卯三郎

Mimpei[1] (1796–1871). *N.*: Kashū Mimpei.[2] **Biog.**: Potter. Born in Inada-mura, Awaji; son of a manufacturer of soy sauce. Tried all sorts of artistic disciplines; about 1818 left the family business to devote himself entirely to pottery making. With artistic and financial help from Ogata Shūhei (Dōhachi's younger brother) he invented several kinds of glazes. About 1830 helped found the Awaji kiln, where he produced excellent stoneware and porcelain in the Kyōto manner. **Coll.**: Freer, Idemitsu, Metropolitan, Museum (3), Tōkyō (1). **Bib.**: Fujioka; Jenyns (1), (2); Munsterberg (2); *Nihon* (1); STZ 5.

¹珉平 ²賀集珉平

Minakami (Mizukami) Taisei[1] (1877–1951). *N.*: Minakami (Mizukami) Yasuo.[2] *Gō*: Taisei.[3] **Biog.**: Japanese-style painter. Born in Fukuoka-ken. Studied first with Araki Bokusen, later under Terazaki Kōgyō. In 1906 graduated from the Japanese-style painting division of the Tōkyō School of Fine Arts. Taught for a while at a girls' school. From 1897 exhibited with the Nihon Kaiga Kyōkai and other groups; after 1914 with the Bunten. In 1926 became a member of the Teiten. **Coll.**: National (5). **Bib.**: Asano.

¹水上泰生 ²水上泰生 ³泰生

Minami Kunzō[1] (1883–1950). **Biog.**: Western-style painter, printmaker. Born in Hiroshima. Graduated from Tōkyō School of Fine Arts in 1907. Spent next three years in Europe, largely in Paris; later to India. Taught at his alma mater; active in government exhibitions. Member of Nihon Bijutsuin and of the Kōfūkai as well as an early member of the Nihon Sōsaku Hanga Kyōkai. A mildly impressionistic painter with a touch of pointillism in his work. His prints are quite Western in style. **Coll.**: National (5). **Bib.**: Asano, Elisséev, Fujikake (1), Harada Minoru, NB (H) 24, NB (S) 30, NBZ 6, NHBZ 7, UG 4, Uyeno.

¹南薫造

Minamoto no Makoto[1] (810–66). **Biog.**: Painter. Son of Emperor Saga. Known from contemporary records as a painter of horses and a calligrapher.

¹源信

Minchō[1] (1352–1431). *Given name:* Kitsuzan (Kichizan).[2] *F.N.*: Chōdensu.[3] *Gō*: Hasōai,[4] Minchō.[5] **Biog.**: Muromachi *suiboku* painter. Born on Awaji Island. A Zen priest at the Tōfuku-ji, Kyōto, where he was a disciple of the famous priest Daidō Ichii and an important figure in early Muromachi painting. Known as Chōdensu from his official title *Densu* (warden). More of a professional than the usual priestly amateur, made many copies of ancient Chinese paintings. In Buddhist subjects, a follower of Li Lung-mien and Yen Hui, continuing the style of the Southern Sung and Kamakura periods; in his portraits, realistic; in landscape, influenced by the new monochrome style of the Muromachi period based on Chinese landscapes of the Sung, Yüan, and early Ming periods, marking the transition from the old to the new aesthetic system of Buddhist art. (The landscape *Hermitage by a Mountain Brook* in the Konchi-in, Nanzen-ji, Kyōto—traditionally ascribed to him—is somewhat in the Chinese Ma-Hsia style.) **Coll.**: Atami, Nanzen-ji (Konchi-in), Nara, Nezu, Rokuō-in, Tenshō-ji, Tōfuku-ji, Tōkyō (1). **Bib.**: AA 14; *Au-delà; Exhibition* (1); Fontein (1), (2); GNB 11; HS 3, 6, 8, 13; K 30, 37, 82, 104, 177, 187, 259, 495, 540, 554, 849; *Kokuhō* 6; Lee (1); M 67; Matsushita (1); Minamoto (1); Morrison 1; *National* (2); NB (H) 12; NB (S) 13, 69; NBT 4; NBZ 3; NKZ 35; Noma (1) 1; *One* (2); P 2; Paine (4); SBZ 7; Tajima (12) 2, 6, 8, 9, 18; Tajima (13) 3; Tanaka (2).

¹明兆 ²吉山 ³兆殿司 ⁴破草鞋 ⁵明兆

Minemaro[1] (fl. 1801–17). **Biog.**: Ukiyo-e painter, printmaker.

Pupil of Utamaro. Produced *nishiki-e* and paintings of *bijin.*
Coll.: Musées. **Bib.:** NHBZ 4.

¹峰麿

Minenobu[1] (1662–1708). *N.:* Kanō Minenobu.[2] *F.N.:* Kichinosuke;[3] later, Chikara.[4] *Gō:* Kakuryūsai,[5] Zuisen,[6] Zuisen'-in.[7] **Biog.:** Kanō painter. Second son and pupil of Kanō Tsunenobu. Appointed to the shogun's court as *goyō eshi* and, in 1707, on command of the shogun, changed his name to Matsumoto[8] and his *gō* to Yūsei.[9] With a stipend from the shogun, founded the Hamachō branch of the Kanō school. **Coll.:** Museum (3), Tōkyō (1). **Bib.:** *Kanō-ha,* Morrison 1.

¹岑信（峯信）　²狩野岑信（狩野峯信）　³吉之助　⁴主税
⁵覚柳斎　⁶随川　⁷随川院　⁸松本　⁹友盛（友清）

Minkō[1] (fl. 1764–72). *N.:* Tachibana Masatoshi.[2] *Gō:* Gyokujuken,[3] Minkō.[4] **Biog.:** Ukiyo-e painter, printmaker. Born in Ōsaka. Started life as an embroiderer, living first in Kyōto and Ōsaka, where he studied under Nishikawa Sukenobu. In 1762 went to Edo and became a follower of Harunobu. Produced calendar prints and *nishiki-e;* also a book illustrator. In 1770 published *Saiga Shokunin Burui,* two volumes of double-page pictures illustrating various craftsmen at work; admirable color, drawing a mixture of Kanō and ukiyo-e. Much too highbrow for the taste of his time, hence never famous. **Coll.:** Art (1), British, Museum (3), Rietberg, Victoria. **Bib.:** Binyon (3), Boller, Brown, Gentles (1), Morrison 2, Waterhouse.

¹珉江（岷江）　²橘政敏　³玉樹軒　⁴珉江（岷江）

Minsei[1] (fl. 1810–18). *N.:* Ōhara.[2] *Gō:* Minsei,[3] Tōya.[4] **Biog.:** Painter. Born in Nara; lived in Ōsaka. A competent artist, producing landscapes and figure paintings. **Coll.:** Ashmolean. **Bib.:** Mitchell.

¹民声　²大原　³民声　⁴東野

Minwa[1] (?–1821). *N.:* Aikawa Hidenari.[2] *A.:* Shichin.[3] *Gō:* Aikawatei,[4] Minwa,[5] Setsuzan.[6] **Biog.:** Ukiyo-e painter, illustrator. Born in Ōsaka. First studied with Kishi Ganku; later turned to ukiyo-e. Illustrated several books including the *Engaku Kihan.* **Coll.:** Ashmolean. **Bib.:** Brown, Holloway, Mitchell.

¹珉和（岷和）　²合川秀成　³士陳
⁴合川亭　⁵珉和（岷和）　⁶雪山

Minzan[1] (fl. c. 1780). *N.:* Oka Kan.[2] *A.:* Shishō.[3] *F.N.:* Rigenta.[4] *Gō:* Minzan.[5] **Biog.:** Nagasaki painter. Studied under Sō Shiseki. **Coll.:** Kōbe. **Bib.:** *Pictorial* (2) 5.

¹岷山　²岡煥　³子章　⁴利源太　⁵岷山

Minzan[1] (1772–1844). *N.:* Takeda Shūhei.[2] *Gō:* Minzan.[3] **Biog.:** Potter. Born in Harima, Sanuki Province, as the eleventh son of a samurai. Went to Kanazawa in 1814 to serve Lord Maeda. Heard about the dying Kasugayama kiln, started by Aoki Mokubei, and urged Lord Maeda to invite skilled potters to restore it. While engaged in the restoration of the kiln, designed pottery and even had his own kiln at his house. Inscribed two characters on his work, reading "Minzan." A versatile person, was also known as a sculptor under the name of Yūgetsu.[4] **Coll.:** Metropolitan. **Bib.:** NB (S) 71, STZ 6.

¹民山　²武田秀平　³民山　⁴友月

Mitsuaki[1] (fl. c. 1345–75). *N.:* Tosa Mitsuaki.[2] **Biog.:** *Yamato-e* painter. Said to have been a son of either Takashina Takakane or of Tosa Yoshimitsu; may have been son of the former, adopted son of the latter. Lived in Kyōto. An ambiguous character by whom no known work exists, though the scrolls of the life of Kōbō Daishi in the Boston Museum of Fine Arts were once attributed to him, as is the portrait of Ono no Komachi in the Hatakeyama Museum. **Coll.:** Hatakeyama, Museum (3). **Bib.:** BMFA 36, Gray (2), Morrison 1, Tajima (12) 11.

¹光顕　²土佐光顕

Mitsuaki[1] (1848–75). *N.:* Tosa Mitsuaki.[2] **Biog.:** Tosa painter. Son and pupil of Mitsubumi. Lived in Kyōto; like his father, held a position at court. Worked in the revived *yamato-e* style, following his father's manner. **Bib.:** Morrison 1.

¹光章　²土佐光章

Mitsuatsu[1] (1734–64). *N.:* Tosa Tōmanmaru.[2] *Gō:* Mitsuatsu.[3] **Biog.:** Tosa painter. Eldest son and pupil of Tosa Mitsuyoshi. Eventually became a court painter. Few works known.

¹光淳　²土佐藤満丸　³光淳

Mitsubumi[1] (1812–79). *N.:* Tosa Nobumaru.[2] *A.:* Shihei.[3] *Gō:* Kansui,[4] Mitsubumi.[5] **Biog.:** Tosa painter. Second son of Tosa Mitsuzane; adopted by Tosa Mitsutomi. An official of the Inner Palace Guards. A Kyōto artist. Worked in the style of the revived *yamato-e* school. **Bib.:** Mitchell, Morrison 1, Uyeno.

¹光文　²土佐延丸　³子炳　⁴韓水　⁵光文

Mitsuchika[1] (?–1725). *N.:* Tosa Mitsuchika.[2] *F.N.:* Kunai.[3] *Priest name:* Ryōsen.[4] *Gō:* Mitsuchika,[5] Sokensai.[6] **Biog.:** Tosa painter. Son and pupil of Tosa Mitsuoki.

¹光親　²土佐光親　³官内　⁴了仙　⁵光親　⁶素絢斎

Mitsuhide[1] (fl. 1303–21). *N.:* Tosa (or Fujiwara no)[2] Mitsuhide.[3] **Biog.:** *Yamato-e* painter. Perhaps the son and pupil of Tosa Kunitaka, but little known of his life. Recorded as being a painter of *makimono* of court life. Is said to have painted the *Sagoromo Monogatari* in the Tōkyō National Museum. **Coll.:** Tōkyō (1). **Bib.:** Morrison 1.

¹光秀　²藤原　³土佐光秀

Mitsuhiro[1] (fl. c. 1430–45). *N.:* Tosa Mitsuhiro.[2] **Biog.:** Tosa painter. Son of Tosa Yukihiro, younger brother of Yukihide. Little known about him. The *Shikkongōjin Engi* in the Tōdai-ji, Nara, is attributed to him. **Coll.:** Tōdai-ji. **Bib.:** Okudaira (1).

¹光弘　²土佐光弘

Mitsuhiro[1] (1579–1638). *N.:* Karasumaru Mitsuhiro.[2] *Priest name:* Hōun'in,[3] Sōzan.[4] *Gō:* Taiō,[5] Uyūshi.[6] **Biog.:** Painter, calligrapher. Born in Kyōto. Seventh-generation of the noble family Karasumaru; pursued his family's traditional court career, serving the first three Tokugawa shoguns as a skillful diplomat between the shogunate and the court. Also a major poet, well versed in tea ceremony and calligraphy. **Coll.:** Tōkyō (1). **Bib.:** *Rimpa,* Rosenfield (1a).

¹光広　²烏丸光広　³法雲院　⁴宗山　⁵泰翁　⁶烏有子

Mitsuhisa[1] (fl. c. 1532–55). *N.:* Tosa Chiyo.[2] *Gō:* Mitsuhisa.[3] **Biog.:** Tosa painter. Daughter and pupil of Tosa Mitsunobu; wife (?) of Kanō Motonobu. Primarily an illustrator of storybooks, poetry books, and scrolls; particularly famous for her illustrations of the *Genji Monogatari.* **Coll.:** Tōkyō (1), Victoria.

¹光久　²土佐千代　³光久

Mitsukiyo[1] (1808–62). *N.:* Tosa Mitsukiyo.[2] *A.:* Shiei.[3] *F.N.:* Shigematsu.[4] *Gō:* Kyōsui.[5] **Biog.:** Tosa painter. Son and pupil of Tosa Mitsuzane. Held various positions at court; is known for his work in the Kyōto Imperial Palace at the time of its reconstruction in 1855. An adequate artist of the 19th-century Tosa school. **Coll.:** Imperial (1). **Bib.:** Morrison 1, Okamoto (1).

¹光清　²土佐光清　³子縹　⁴繁松　⁵鏡水

Mitsukuni[1] (fl. 1394–1427). *N.:* Tosa Mitsukuni.[2] **Biog.:** *Yamato-e* painter. Known because his name—together with those of Tosa Eishun, Tosa Yukihiro, Awataguchi Takamitsu, Rokkaku Jakusai, and Kasuga Yukihide—is found on the scroll *Yūzū Nembutsu Engi,* dated 1414 and owned by the Seiryō-ji, Kyōto. May have been Tosa Eishun's son. **Coll.:** Seiryō-ji. **Bib.:** Tajima (12) 11, Toda (2).

¹光国　²土佐光国

Mitsumasa[1] (1795–1856). *N.:* Somada (Somata) Mitsumasa.[2] *F.N.:* Yaheita.[3] **Biog.:** Lacquerer. Born in Toyama-ken; worked in Edo. Famous for his *inrō* in the Somada style with nacre inlay to which he added *kirigane* of gold and silver. Succeeded by his brother Somada Mitsuaki,[4] who carried on

the family tradition. **Coll.:** Tōkyō (1). **Bib.:** Herberts, Jahss, M 188, *Pictorial* (1) 4, SBZ 10.

¹光正　²杣田光正　³弥平田　⁴杣田光明

Mitsumoto¹ (fl. 1530–69). *N.:* Tosa Mitsumoto.² **Biog.:** Tosa painter. Elder son and pupil of Tosa Mitsushige. Following his father, became chief painter of the Edokoro (in 1541, according to tradition). Few works survive. It is possible that his branch of the Tosa school died with him when he was killed in battle. **Coll.:** Kotohira.

¹光元　²土佐光元

Mitsunaga¹ (fl. c. 1173). *N.:* Tokiwa (or Fujiwara no)² Mitsunaga.³ **Biog.:** *Yamato-e* painter. Said to have been eldest son of Takachika. Otherwise little known of his life, and no work can be reliably ascribed to him. Among the many paintings attributed to him are: *Ban no Dainagon,* in the Sakai collection and the scroll most apt to be by him; *Nenjū Gyōji* (Pictorial Representation of Annual Rites and Ceremonies), today known only in copies, one of which was made by Sumiyoshi Jokei; *Jigoku Zōshi* (Scroll of Hells), in the Nara National Museum, Tokyo National Museum, Seattle Art Museum; *Yamai no Zōshi* (Scroll of Illnesses), in a private collection; *Gaki Zōshi* (Scroll of Hungry Ghosts), in the Tōkyō National Museum and the Kyōto National Museum; and *Kibi Daijin Nittō,* in the Boston Museum of Fine Arts. Known in Japanese art history as the most outstanding artist of the late 12th century: with Mitsunobu and Mitsuoki, the "Three Brushes" of the Tosa school. If he had anything to do with the above scrolls, he should be noted for the liveliness of his figure drawing and his ability to paint large groups in action. **Coll.:** Kyōto (2), Museum (3), Nara, Seattle, Tōkyō (1). **Bib.:** BK 82; BMFA 31; *Exhibition* (1); Ienaga; K 1, 51, 55, 70, 81, 176, 182, 205, 210; *Kokuhō* 3, 4; Moriya; Morrison 1; NEZ 4; NKZ 52; Okudaira (1), (1a); *One* (2); Paine (4); Seckel (2); Tajima (12) 10, 14, 15, 17; Yashiro (1) 1.

¹光長　²藤原　³常盤光長

Mitsunari (Mitsushige)¹ (1646–1710). *N.:* Tosa Mitsunari (Mitsushige).² *Priest name:* Jōsan.³ **Biog.:** Tosa painter. Son of Tosa Mitsuoki. Succeeded to his father's official position; served as Edokoro *azukari* from 1681 to 1696. Like his father, specialized in painting quails. Less of an artist than his father, but an accomplished painter. **Coll.:** British, Hatakeyama, Metropolitan, Nezu, Seattle, Stanford, Suntory, Tōkyō (1). **Bib.:** K 639, Morrison 1, NB (S) 52, Rosenfield (1a), Tajima (12) 3.

¹光成　²土佐光成　³常山

Mitsunobu¹ (1434–1525). *N.:* Tosa Mitsunobu.² **Biog.:** Tosa painter. May have been the son of Tosa Mitsuhiro. Served as Edokoro *azukari,* producing *emaki,* Buddhist paintings, portraits. Among the scrolls known to be by him are: *Kiyomizu-dera Engi* (Tōkyō National Museum); *Kitano Tenjin Engi* (Kitano-jinja, Kyōto); *Yūzū Nembutsu Engi* (Zenrin-ji, Kyōto); the fourth scroll, dated 1497, of the *Ishiyama-dera Engi* (Ishiyama-dera, Ōtsu); *Seikō-ji Engi* (Tōkyō National Museum); *Hyakki Yakō Emaki* (Shinju-an, Daitoku-ji, Kyōto). Though present criticism rates his ability less highly than was once the case, he is traditionally regarded as the most important member of the Tosa family and the restorer of the family's past glory. With Mitsunaga and Mitsuoki, the "Three Brushes" of the Tosa school. In spite of rising popularity of Kanō school and taste for paintings in ink after Sung and Yüan manners, maintained native tradition of color and action; some of his paintings of Kyōto and its suburbs date as early as 1506. His figures are tall and slender, with small heads; in his landscapes, the mountains, hills, and rocks are covered with small dots to suggest plant growth. **Coll.:** British, Daitoku-ji (Shinju-an), Ishiyama-dera, Jōfuku-ji, Kitano, Tōkyō (1), Victoria, Zenrin-ji. **Bib.:** AA 14; ARTA 29; BI 9, 35; BB 16; BK 100, 101, 103, 117,

126; Grilli (1); Ienaga; K 3, 75, 96, 118, 181, 488, 610, 615, 743, 775; Minamoto (1); Moriya; Morrison 1; M 209; NBT 4, 5; NEZ 22; NKZ 64; Okudaira (1a); *One* (2); Paine (4); SBZ 7; Shimada 2; Tajima (12) 4, 13; Tajima (13) 3; Yamane (1a); Yashiro (1) 2.

¹光信　²土佐光信

Mitsunobu¹ (1561/5–1602/8). *N.:* Kanō Mitsunobu.² *F.N.:* Genshirō;³ later, Ukyō,⁴ Ukyōnoshin,⁵ Ukyōnosuke.⁶ **Biog.:** Kanō painter. Lived in Kyōto. Son and pupil of Kanō Eitoku; became sixth generation head of the Kanō school. Worked with his father on the decoration of Azuchi Castle and, after his death, on similar projects for Hideyoshi in various castles, temples, and palaces, all of which have since been destroyed. At the request of Ieyasu, to Edo. Little of his work remains. Forms the link between the Kanō school of the Momoyama period and that of the Edo. His style is less grand, less dramatic than that of his father. **Coll.:** British, Hōnen-in, Museum (3), Nanzen-ji, Onjō-ji (Kangaku-in), Tōkyō (1). **Bib.:** Akiyama (3); *Art* (1a); BB 14; BK 153; K 643, 647, 702, 795, 902, 903; Morrison 1; NB (H) 14; NBZ 4; Paine (4); SBZ 8; Yamane (1).

¹光信　²狩野光信　³源四郎　⁴右京　⁵右京進　⁶右京亮

Mitsunobu¹ (fl. 1730–60). *N.:* Hasegawa Mitsuharu² (later, Mitsunobu).³ *Gō:* Baihōken,⁴ Baiōken,⁵ Baisuiken,⁶ Ryūsuiken.⁷ **Biog.:** Ukiyo-e printmaker. Lived in Ōsaka. Probably a pupil of Nishikawa Sukenobu. Specialized in prints of children and warriors. Nearly all his work seems to have been issued in albums. His style close to that of Sukenobu. **Coll.:** British, Portland, Tōkyō (1). **Bib.:** Crighton, Keyes, Kikuchi, Lane, Ledoux (4).

¹光信　²長谷川光春　³光信　⁴梅峯軒
⁵梅翁軒　⁶梅翠軒　⁷柳翠軒

Mitsunobu¹ (fl. c. 1736–41). *N.:* Shimizu Mitsunobu.² **Biog.:** Ukiyo-e printmaker. Made prints in *hosoban* format of courtesans and festival dolls. Style close to that of Miyagawa Tominobu.

¹光信　²清水光信

Mitsunori¹ (fl. late 12th to early 13th c.). *N.:* Fujiwara no Mitsunori.² **Biog.:** Buddhist painter. Member of the Edokoro and holder of a court rank. According to tradition, a noted painter of Buddhist themes, but his work is known only from records.

¹光範　²藤原光範

Mitsunori¹ (fl. early 17th c.). *N.:* Kanō Mitsunori.² *F.N.:* Shurinosuke.³ **Biog.:** Kanō painter. Son and pupil of Kanō Sanraku. Nothing known of his life; died young. **Bib.:** Morrison 1.

¹光教　²狩野光教　³修理亮

Mitsunori¹ (1583–1638). *N.:* Tosa Genzaemon.² *Priest name:* Sōnin.³ *F.N.:* Genzaemon no Jō.⁴ *Gō:* Mitsunori.⁵ **Biog.:** Tosa painter. Son and pupil of Tosa Kyūyoku Mitsuyoshi, father of Tosa Mitsuoki. Lived first at Sakai in Izumi; near end of his life in Kyōto, where he supplied the court with ceremonial fans. Specialized in genre scenes, working only on a miniature scale. A charming, traditional, delicate painter. **Coll.:** Detroit, Freer, Hatakeyama, Tōkyō (1), Victoria. **Bib.:** *Freer;* K 56, 518, 606; Morrison 1; Shimada 2; *Tosa.*

¹光則　²土佐源左衛門　³宗仁　⁴源左衛門尉　⁵光則

Mitsuoki¹ (1617–91). *N.:* Tosa Mitsuoki.² *Priest name:* Jōshō.³ *F.N.:* Tōmanmaru.⁴ *Gō:* Shunkaken.⁵ **Biog.:** Tosa painter. Son and pupil of Tosa Mitsunori. Lived first in Sakai. In 1634 to Kyōto, where he was made Edokoro *azukari* in 1654. In 1681, passing his position on to his son Mitsunari, became a priest and took the name of Jōshō; named *hōgen* in 1685. Produced splendid *netsuke,* always in wood, under the *gō* of Shūzan.⁶ Many forgeries of both his paintings and his *netsuke.* With Mitsunaga and Mitsunobu, known as the Sampitsu (Three Brushes) of the Tosa school. Revived the Tosa school, which had been in eclipse since the

early 16th century, bringing to it the Kanō brushwork and some of the largeness of design of that school as well as the manner of the late Ming and early Ch'ing realistic sketches; also slightly influenced by the Rimpa school. A style of great elegance, soft cool colors, purity of line. Specialized in painting quails. **Coll.:** Art (1a); British; Chion-in; Fogg; Freer; Hoppō; Kanju-ji; Kitano; Metropolitan; Newark; Nezu; Stanford; Tōkyō (1), (2); Victoria. **Bib.:** Gray (2); *Japanese* (1a); K 14, 45, 54, 61, 71, 118, 132, 260, 267, 276, 287, 326, 390, 440, 559, 632, 758, 776, 789, 799, 849; KO 33; Minamoto (1); Morrison 1; NBZ 4; Okamoto (1); *One* (2); Paine (4); Ryerson; SBZ 9; Tajima (12) 3, 10, 12; Tajima (13) 5; Yamane (1a).

[1]光起 [2]土佐光起 [3]常昭 [4]藤満丸 [5]春可軒 [6]周山

Mitsusada[1] (1738–1806). *N.:* Tosa Shigematsu.[2] *A.:* Shikyō.[3] *Gō:* Mitsusada.[4] **Biog.:** Tosa painter. Second son of Tosa Tōmanmaru Mitsuyoshi, younger brother of Mitsuatsu. In 1754, became Edokoro *azukari*. In the 1760s painted *fusuma* for the court, and in 1789, when the Kyōto Imperial Palace was being remodeled, was again called on to paint *fusuma*. Left a number of admirable copies of ancient Chinese paintings. An adequate painter and a staunch exponent of the Tosa tradition, creating a temporary revival of the Tosa school. **Coll.:** Chion-in, Imperial Palace (1), Metropolitan, Victoria. **Bib.:** Hillier (4) 3, Morrison 1.

[1]光貞 [2]土佐茂松 [3]士享 [4]光貞

Mitsushige[1] (fl. late 14th c.). *N.:* Tosa (originally Fujiwara no)[2] Mitsushige.[3] **Biog.:** Tosa painter. Son and pupil of Tosa (Fujiwara no) Yukimitsu. Member of the Edokoro. Records of the time list his work in some detail, but none of it has so far been identified. **Bib.:** Morrison 1.

[1]光重 [2]藤原 [3]土佐光重

Mitsushige (Mitsumochi)[1] (1496–c. 1559). *N.:* Tosa Mitsushige (Mitsumochi).[2] **Biog.:** Tosa painter. Son and pupil of Tosa Mitsunobu, father of Tosa Mitsumoto and Tosa Mitsuyoshi. On the death of his father in 1525 became Edokoro *azukari*. Painted Buddhist subjects for the Daigo-ji. In 1531 painted the *Taima-dera Engi* and a year later one of his finest works, the *Kuwanomi-dera Engi*. In May 1550 was commissioned by Lord Sasaki Yoshihide to do a painting of a dog chase for the Kannon-ji in Shiga-ken. The *Hase-dera Engi* is attributed to him. Less talented than his father, whose style he con:inued, but an able artist. **Coll.:** Hase-dera, Kuwanomi-dera, Metropolitan, Suntory, Taima-dera, Victoria. **Bib.:** Akiyama (3); *Chūsei;* K 54, 73, 92, 120, 824; Minamoto (1); Morrison 1; *Muromachi* (1); NBZ 4; NKZ 17; Okudaira (1); SBZ 9; Tajima (12) 8; Yamane (1a); YB 48.

[1]光茂 [2]土佐光茂

Mitsusuke[1] (1675–1710). *N.:* Tosa Mitsutaka.[2] *F.N.:* Tōmanmaru.[3] *Priest name:* Jōshin.[4] *Gō:* Mitsusuke.[5] **Biog.:** Tosa painter. Son and pupil of Tosa Mitsunari, grandson of Mitsuoki. Member of the Edokoro. Little known because his output was small. A good painter of portraits and *kachōga*. **Coll.:** Art (1), Suntory. **Bib.:** K 599; Morrison 1.

[1]光祐 [2]土佐光高 [3]藤満丸 [4]常心 [5]光祐

Mitsutani Kunishirō[1] (1874–1936). **Biog.:** Western-style painter. Born in Okayama-ken; lived in Tōkyō. Studied at Koyama Shōtarō's private school Fudōsha. Exhibited with Meiji Bijutsukai. Traveled to Europe in 1900 and again in 1911–14. Member of the Taiheiyō Gakai (where he also taught) and of the Imperial Fine Arts Academy; served as juror for the Bunten. In 1932 was awarded Asahi Culture Prize. His style at first quite academic; on his return from Europe in 1914 it changed to one closer to contemporary French trends and was much influenced by Matisse. **Coll.:** Bridgestone; Ohara (1); Tōkyō (1), (2). **Bib.:** Asano, BK 201, Harada Minoru, M 63, NB (S) 30, NBT 10, NBZ 6, SBZ 11, Uyeno.

[1]満谷国四郎

Mitsutoki[1] (1764–1819). *N.:* Tosa Mitsutoki.[2] *A.:* Shichū.[3] *Gō:* Nan'en,[4] Nankan.[5] **Biog.:** Tosa painter. Son and pupil of Tosa Mitsuatsu. Held the position of a minor court artist. Carried on the Tosa manner of his father.

[1]光時 [2]土佐光時 [3]子中 [4]南淵 [5]南潤

Mitsutomi[1] (?–1849). *N.:* Tosa Mitsutomi.[2] **Biog.:** Tosa painter. Son and pupil of Tosa Mitsutoki. Given court title of Sakon Shōgen in recognition of his position as Edokoro *azukari*.

[1]光禄 [2]土佐光禄

Mitsutsugu[1] (fl. 1716–36). *N.:* Uno Mitsutsugu.[2] **Biog.:** Lacquerer. A samurai in the service of the lord of Hikone. An able artist, producing works of considerable refinement. **Bib.:** Herberts, Jahss.

[1]満継 [2]宇野満継

Mitsuyasu[1] (fl. late 13th c.). *N.:* Kose (originally Ki)[2] no Mitsuyasu.[3] **Biog.:** Painter. At best, a shadowy figure; the old genealogy of the Kose family mentions him as the son of Kose no Nagamochi and thirteenth generation of the Kose family of Buddhist painters. Modern research has uncovered no trace of his actual existence, but tradition says he painted the scroll *Jizōson Reiken Emaki*.

[1]光康 [2]紀 [3]巨勢光康

Mitsuyoshi[1] (1539–1613). *N.:* Tosa Hisayoshi (or Gyōbu).[2] *F.N.:* Genzaemon.[3] *Priest name:* Kyūyoku.[4] *Gō:* Kyūyoku.[5] **Biog.:** Tosa painter. Lived in Kyōto. Pupil, and perhaps younger son, of Tosa Mitsushige. Became head of the Tosa school in 1569 on the death of Mitsumoto in battle; given rank of Edokoro *azukari*. Later became a priest and moved to Sakai in Izumi. Produced many *kachōga* as the demand for court paintings declined. Most of his paintings are small in scale, though a few large ones are known. **Coll.:** Brooklyn, Kyōto (2), Metropolitan, Tōkyō (1), Victoria. **Bib.** BK 25; K 695, 736, 749, 823; Morrison 1; NBZ 4; Shimada 2; Yamane (1a).

[1]光吉 [2]土佐久吉（刑部） [3]源左衛門 [4]久翌 [5]久翌（休翌）

Mitsuyoshi[1] (1700–1772). *N.:* Tosa Mitsuyoshi[2] (originally Tōmanmaru).[3] *Priest name:* Jōkaku.[4] **Biog.:** Tosa painter. Son of Tosa Mitsusuke, grandson of Tosa Mitsunari. Served the court as official painter. Toward the end of his life, became a priest. A good painter, working in the style of Mitsunari. **Coll.:** Musée (2), Kyōto, (2). **Bib.:** Morrison 1.

[1]光芳 [2]土佐光芳 [3]藤満丸 [4]常覚

Mitsuzane[1] (1780–1852). *N.:* Tosa Mitsuzane.[2] *A.:* Shisei.[3] *Gō:* Kakusai.[4] **Biog.:** Tosa painter. Lived in Kyōto. Son and pupil of Tosa Mitsusada. Became Edokoro *azukari;* received a number of official titles. Considered as one of the best of the late Tosa-school artists. **Bib.:** Mitchell.

[1]光孚 [2]土佐光孚 [3]子正 [4]鶴阜

Miura Chikusen[1] (1853–1915). *N.:* Miura Chikusen[2] (originally Watanabe Masakichi).[3] **Biog.:** Potter. Lived and worked in Kyōto. Studied under Takahashi Dōhachi. Established his own kiln in 1883. Became known first for his celadon ware and later for his imitations of various foreign wares. Translated the *T'ao Shuo,* the famous book on Ch'ing-dynasty porcelains. Succeeded by three generations of potters. **Bib.:** Jenyns (1), Uyeno.

[1]三浦竹泉 [2]三浦竹泉 [3]渡辺政吉

Miyagawa Kōzan[1] (1842–1916). *N.:* Miyagawa Toranosuke.[2] *Gō:* Kōzan.[3] **Biog.:** Potter. Came from a family of traditional Kyōto potters. Studied blue-and-white technique, transmutation glazes, and other innovations. Worked in Yokohama, in a great variety of techniques, producing pottery (known as Ōta ware from the name of his kiln site) for export. Exhibited at various world's fairs, winning a number of prizes. One of the best known Meiji potters, with a great reputation both at home and abroad. In 1896 became a member of the Art Committee of the Imperial Household

and an official of the Imperial Household Museum. **Coll.:** Philadelphia. **Bib.:** BK 189, 240; GNB 28; NB (S) 41; NBZ 6; Uyeno.

¹宮川香山 ²宮川虎之助 ³香山
Miyake Gogyō¹ (1864–1919). *N.:* Miyake.² *F.N.:* Seizaburō.³ *Gō:* Gogyō.⁴ **Biog.:** Shijō painter. Born in Kyōto; lived in Kamaza. Pupil of Morikawa Sōbun. From 1907 exhibited with the Bunten; also showed with the Naikoku Kangyō Hakurankai as well as with other groups. Member of the Kyōto Bijutsu Kyōkai. Awarded several prizes. **Coll.:** Ashmolean. **Bib.:** Asano, Mitchell, NBZ 6.

¹三宅呉暁 ²三宅 ³清三郎 ⁴呉暁
Miyake Hōhaku¹ (1893–1957). *N.:* Miyake Seiichi.² *Gō:* Hōhaku.³ **Biog.:** Japanese-style painter. Born in Kyōto. Graduate of the Kyōto Municipal School of Fine Arts and Crafts. Pupil of Yamamoto Shunkyo. Frequent exhibitor with the Bunten, Teiten, and Nitten. **Coll.:** Kyōto (1), National (5).

¹三宅鳳白 ²三宅清一 ³鳳白
Miyake Kokki (Katsumi)¹ (1874–1954). **Biog.:** Western-style painter. Born in Tokushima-ken. Studied under Harada Naojirō. Also traveled and studied in Europe and America, including a period at the Yale Art School. With Ōshita Tōjirō, a pioneer in the field of water colors. Frequent exhibitor and occasional prize winner at the Bunten; served as juror for the Teiten. In 1912 helped found the Kōfūkai. In 1950 received Japan Art Academy Prize. Painting rather realistic, but with an impressionist palette. **Coll.:** National (5), Tōkyō (2). **Bib.:** Asano, *Kurashina* (2), NBZ 6, Uyeno.

¹三宅克巳
Miyamoto Jūryō¹ (1895–). **Biog.:** Sculptor. Born in Tōkyō. Learned fundamentals of sculpture at the Taiheiyō Kenkyū-sho and at the Nihon Bijutsuin Kenkyūsho, studying particularly with Ishii Tsuruzō. Has exhibited at the Inten and taken an active part in its sculptural activities. **Bib.:** Asano.

¹宮本重良
Miyanaga Tōzan¹ (1868–1941). **Biog.:** Potter. Teacher of Arakawa Toyozō. A well-known artist of the late Meiji and Taishō eras. **Coll.:** Kyōto (1). **Bib.:** NBZ 6.

¹宮永東山
Miyanohara Ken¹ (1898–). **Biog.:** Potter. Born in Kagoshima-ken. Studied under Itaya Hazan and Miyagawa Kōzan. A lecturer and teacher at the Tōkyō Teachers' College. Member of the Nitten. A frequent jury member for exhibitions. His work noted for its colored glazes and naturalistic decoration. **Bib.:** NBZ 6, STZ 16.

¹宮之原謙
Miyazaka Katsu (Masaru)¹ (1895–1953). **Biog.:** Western-style painter. Born in Nagano-ken. In 1919 graduated from Tōkyō School of Fine Arts. Studied in France from 1923 to 1927. After his return to Japan exhibited with and became a member of the Kokugakai as well as of the 1930 Association. After 1945 showed with the Nitten. Worked with bright colors. **Bib.:** Asano, NBZ 6.

¹宮坂勝
Mizukoshi Shōnan¹ (1888–). **Biog.:** Japanese-style painter. Born in Kōbe. Graduate of the Kyōto School of Fine Arts and Crafts. Pupil of Yamamoto Shunkyo, Takeuchi Seihō, and Kikuchi Hōbun. Has shown at government exhibitions, with the Nihon Nangain, and at the Tōkyō Biennial. His work is lively, amusing, and very much in the *nanga* manner. **Bib.:** Asano.

¹水越松南
Mizuno Toshikata¹ (1866–1908). *N.:* Mizuno Kumejirō.² *Gō:* Toshikata.³ **Biog.:** Japanese-style painter, illustrator. Lived in Tōkyō. First learned woodblock printing from Taiso Yoshitoshi, then studied Japanese-style painting with Watanabe Shōtei. Also studied decoration of ceramics. Member of the Nihon Bijutsu Kyōkai and Nihon Bijutsuin,

frequently serving as a juror for these groups. Among his pupils were Ikeda Terukata, Ikeda Shōen, and Kaburagi Kiyokata. Painted genre subjects in a modified ukiyo-e manner with Shijō-style background. **Coll.:** Allen, Ashmolean, Cincinnati, Fine (California), Musées, Tōkyō (1), Victoria. **Bib.:** Asano, Elisséèv, Morrison 2, NB (S) 17, NBZ 6, Takahashi (1), Uyeno.

¹水野年方 ²水野粂次郎 ³年方
Mizuta Chikuho¹ (1883–1958). *N.:* Mizuta Chūji.² *Gō:* Chikuho.³ **Biog.:** Japanese-style painter. Born in Ōsaka. In 1897 became a pupil of Himeshima Chikugai. His exhibits at the Bunten frequently received honorable mention. Served as juror for the Teiten. A founder and supporter of the Nihon Nangain. An important figure in the Kansai Japanese-style painting world. His work quite *nanga* in manner. **Coll.:** Kyōto (1), National (5). **Bib.:** Asano, Elisséèv.

¹水田竹圃 ²水田忠治 ³竹圃
Mochizuki Gyokusen¹ (1834–1913). *N.:* Mochizuki Shigemine.² *A.:* Naoichi,³ Shuichi.⁴ *F.N.:* Shunzō.⁵ *Gō:* Gyokkei,⁶ Gyokusen.⁷ **Biog.:** Japanese-style painter. Lived in Kyōto. Son and pupil of Mochizuki Shigeteru. When barely twenty, worked in the Imperial Palace. Teacher of Kawai Gyokudō. In 1880 helped found the Kyōto Prefectural School of Painting. Exhibited with the Naikoku Kaiga Kyōshinkai and the Naikoku Kangyō Hakurankai, winning many prizes. Member of the Art Committee of the Imperial Household. Specialized in *kachōga*, working in the Japanese manner but with considerable Western realism added. From 1888 to 1891 painted two series: *One Hundred Famous Places of Kyōto* and *One Hundred Waterfalls.* **Bib.:** Asano, Mitchell, Morrison 2, NBZ 6.

¹望月玉泉 ²望月重岑 ³直--
⁴主一 ⁵駿三 ⁶玉渓 ⁷玉泉
Mochizuki Kimpō¹ (1846–1915). *N.:* Mochizuki (originally Hirano)² Manabu.³ *Gō:* Kimpō,⁴ Shōkai.⁵ **Biog.:** Japanese-style painter. Born in Ōsaka. Studied first under a Maruyama artist, then under the Shijō painter Nishiyama Kan'ei. Lived for a short while in Sapporo; in 1890 to Tōkyō to establish himself as an independent artist. Showed with several official exhibition groups during the early Meiji era; from 1908 served as a juror for the Bunten. Specialized in *kachōga* and paintings of animals, particularly of badgers. **Coll.:** Museum (3). **Bib.:** NBZ 6.

¹望月金鳳 ²平野 ³望月学 ⁴金鳳 ⁵小蟹
Mochizuki Shunkō¹ (1893–). **Biog.:** Japanese-style painter. Born in Yamanashi-ken; worked in Tōkyō. In 1919 graduated from the Tōkyō School of Fine Arts. Pupil of Yūki Somei. Showed with the Teiten, the Nitten, and the Tōkyō Biennial. Member of the Nihon Bijutsu Kyōkai and founding member of the Nihongain. In 1957 won the Japan Art Academy Prize. Worked in a traditional manner. **Coll.:** National (5). **Bib.:** Asano.

¹望月春江
Moei (Shigenaga)¹ (fl. 1804–29). *N.:* Nakaōji Shigenaga.² **Biog.:** Lacquerer. Produced fine *togidashi* ware. **Coll.:** Metropolitan. **Bib.:** Herberts, Jahss.

¹茂永 ²中大路茂永
Mokuan¹ (fl. 1323–45). *Priest name:* Reien.² *N.:* Yüan³ (Chinese). *Gō:* Mokuan.⁴ **Biog.:** Muromachi *suiboku* painter. With Kaō, considered founder of Muromachi *suiboku* school. By 1323 ordained as priest at a Zen temple in Kamakura. Spent many of his active years in China; known to have been there between 1326 and 1329 and to have died there about 1345. Visited many famous Ch'an monasteries, studying Zen Buddhism and Zen painting. Uncertain if Japanese- or Chinese-trained as a painter; Tōhaku, in the *Gasetsu,* said he was Japanese, though all other writers of the time said he was Chinese, and he was even known as

"Mu-ch'i reborn." Much appreciated by the Chinese; the few paintings that have survived all bear colophons by Chinese priests. Frequently painted in light washes of ink with dabs of intense black for emphasis; subtle brushwork of great technical skill. **Coll.:** Atami, Freer, Museum (3). **Bib.:** Akiyama (2); BCM 50; BK 19, 70; *Exhibition* (1); Fontein (1), (2); *Freer;* GNB 11; Hisamatsu; HS 2, 8, 10; K 578, 779, 805, 806; KO 22; Matsushita (1); NB (S) 13, 69; NBT 4; NBZ 3; Paine (4); Shimada 1; Tanaka (2); Watanabe; YB 31.

¹黙庵 ²霊淵 ³淵 ⁴黙庵

Mokuan (Chinese: Mu-an)[1] (1611–84). *Priest name:* Shōtō.[2] *Gō:* Mokuan (Mu-an).[3] **Biog.:** Painter. Priest of the Rinzai sect in China, where he was a disciple of Ingen Ryūki, following him to Japan in 1655 to help found the Ōbaku Zen sect. Lived for a while at the Fukusai-ji, Nagasaki. In 1664 became second abbot of the Mampuki-ji in Uji. Later lived in Edo, where he eventually converted the shogun Ietsuna to Zen Buddhism. As a painter produced *suiboku* noted for an atmosphere of unworldliness; worked sometimes in the *nanga* style. His vigorous calligraphy highly prized; known as one of the "Three Brushes" of the Ōbaku sect. **Bib.:** Awakawa, BO 105, NB (S) 47.

¹木庵 ²性瑫 ³木庵

Mokuan[1] (fl. 18th c.). *N.:* Ishima.[2] *Gō:* Bokusai,[3] Mokuan,[4] Mokusai.[5] **Biog.:** Kanō painter. Lived in Nagoya, serving the lord of Nagoya as falcon master. Pupil of Kanō Kōeki. A minor artist. **Bib.:** M 119.

¹牧庵 ²伊島 ³卜斎 ⁴牧庵 ⁵牧斎

Mokubei[1] (1767–1833). *N.:* Aoki Gensa.[2] *A.:* Seirai.[3] *F.N.:* Yasohachi;[4] later, Kiya Sahei.[5] *Gō:* Hyakuroku Sanjin,[6] Kokikan,[7] Kukurin,[8] Mokubei,[9] Rōbei,[10] Teiunrō.[11] **Biog.:** *Nanga* painter, potter. Also a calligrapher and scholar. Born and died in Kyōto. Son of a restaurant owner. In pottery a pupil of Okuda Eisen; as a painter, studied the paintings of the Chinese Ming and Ch'ing dynasties and was influenced by Ikeno Taiga. Better known in his lifetime as a potter, having decided to become one on reading a copy of the *T'ao Shuo*. In 1801 in the service of the lord of Kii as a potter and in 1807 of the lord of Kaga, where he opened the Kasugayama kiln. In 1806 visited the Kutani kilns, spurring the potters on to better work; in 1808 founded the kiln at Awata, Kyōto, for the prince Shoren'in no Miya. Worked in polychrome enamels, imitating Chinese Ming three-color ware, late Ming blue-and-white, celadons, K'ang-hsi *famille noire,* and so-called Cochin-China ware (*kōchi* in Japanese). Most of these wares were made for *sencha*. A large output in an individual style, not mere imitation. From 1824 more active as a *nanga* painter. Gained renown for his *senkō-sansui* (landscapes in the "embroidered" Chinese style) in ink, ochre, reddish brown, and dark blue. Regarded by his friend Chikuden as the only true *bunjinga* painter other than Taiga. Today his reputation rests largely on his paintings, even though they do not form a coherent body of work and many were dashed off and given to his friends in exchange for poems or calligraphy. They are generally tall, narrow landscapes, executed with fluid washes and crisp lines. **Coll.:** Ashmolean, Freer, Idemitsu, Kyōto (2), Metropolitan, Nelson, Nezu, Ohara (2), Philadelphia, Seattle, Staatliche, Tōkyō (1), Yamato. **Bib.:** *Ausgewählte; BK 89, 108; Cahill; Cent-cinquante; Ceramic* (1); Covell (1); *Exhibition* (1); Fontein (1); Fujioka; GNB 18, 19; Hillier (3), (4) 3; Jenyns (1); K 320, 350, 395, 404, 450, 455, 466, 524, 534, 538, 553, 628, 682, 706, 754, 822, 829, 849, 865, 867, 883; Koyama (1a), (5) 7; M 8, 175; Miller; Mitchell; Munsterberg (2); Murayama (2); NB (H) 5, 18, 23; NB (S) 4, 71; NBT 5, 6; NBZ 5; *Nihon* (2), (3), (4), (5), (8); Noma (1) 2; OA 13; Okuda (2); P 2, 4; Rosenfield (2); Satō; SBZ 10; Schmidt; *Selected;*

Shimada 2; STZ 5; Tajima (12) 19, (13) 7; TZ (K) 30; YB 9, 44, 47; Yonezawa.

¹木米 ²青木玄佐 ³青来 ⁴八十八
⁵木屋佐兵衛 ⁶百六散人 ⁷古器観
⁸九々鱗 ⁹木米 ¹⁰聾米 ¹¹停雲楼

Mokuhaku[1] (fl. c. 1830–40). **Biog.:** Potter. Worked in Kyōto. His wares are noted for their bright-colored glazes. **Bib.:** NB (S) 71, NBZ 5, *Nihon* (1).

¹木白

Mokujiki[1] (1536–1608). *N.:* Fujiwara Junryō.[2] *Priest name:* Nissai.[3] *A.:* Junryō.[4] *Gō:* Mokujiki,[5] Ōgo,[6] Sosen.[7] **Biog.:** Sculptor. A warrior who became a priest at Kōyasan in 1573. Dissuaded Hideyoshi from destroying the monasteries there. Produced wooden figures carved in a provincial manner. **Coll.:** Hōshō-ji. **Bib.:** Noma (1) 2.

¹木食 ²藤原順良 ³日斎 ⁴順良 ⁵木食 ⁶応其 ⁷楚仙

Mokujiki[1] (1718–1810). *Priest name:* Myōman.[2] *Gō:* Mokujiki.[3] **Biog.:** Sculptor. An itinerant priest. When he received, in middle age, the command to eat only uncooked vegetarian food (known as *mokujiki*) as part of the strictest Buddhist discipline, he vowed to make a pilgrimage throughout the country. Though not a trained artist, he made during his wanderings many figures for local worship which are naive but yet have great sincerity and force. Worked vigorously, until he was 90, in a strong, rough, and amusing style. **Coll.:** Mingeikan, Kannondō (2), Yakushidō (3). **Bib.:** Kuno (1), (3); M 187; NBT 2; NBZ 4; Noma (1) 2; SBZ 9; Seckel (1); Warner (1); Yanagi (1), (2).

¹木食（木喰） ²明満 ³木食（木喰）

Monkan (Bunkan)[1] (1278–1357). *Priest name:* Kōshin.[2] **Biog.:** Buddhist painter. Priest of the Shingon sect. First entered the Daigo-ji; later moved to the Tō-ji. Received rank of *daisōjō*. In 1323 was exiled to Iwōjima by the regent Hōjō Takatoki, but was soon allowed to return. Is recorded as having been a good painter of Buddhist themes.

¹文観 ²弘真

Monnyū[1] (fl. 1464–1501). **Biog.:** Lacquerer. Lived in Kyōto. Is credited with being the first artist to produce *tsuishu* in Japan, copying the Chinese technique from pieces of Chinese carved lacquer that had been imported into Japan under Ashikaga Yoshimitsu (1358–1408). No pieces by him can be identified today. **Bib.:** Herberts, Jahss, Ragué.

¹門入

Mori Hakuho[1] (1898–). *N.:* Mori Kikuo.[2] *Gō:* Hakuho.[3] **Biog.:** Japanese-style painter. Born and works in Tōkyō. Pupil of Araki Juppo. Exhibitor at government shows and with the Nitten; member of the Nitten and the Nihon Bijutsu Kyōkai. Won the Japan Art Academy Prize in 1957. His style quite bold and decorative. **Coll.:** National (5). **Bib.:** Asano.

¹森白甫 ²森喜久雄 ³白甫

Mori Kinseki[1] (1843–1921). *N.:* Mori Shigeru[2] (originally Yū).[3] *A.:* Kichimu.[4] *Gō.:* Kinseki,[5] Tekkyō,[6] Tekkyō Dōjin.[7] **Biog.:** *Nanga* painter. Born in Settsu. Adopted by Mori Zensaku, a government official in Ōsaka. Pupil of Kanae Kinjō. After Kinjō's death studied Western-style painting under Takahashi Yuichi. One of the best-known *nanga* artists in Kansai; did much to establish the *nanga* school in Ōsaka. Specialized in landscapes. **Bib.:** Mitchell.

¹森琴石（森金石） ²森繁 ³熊 ⁴吉夢
⁵琴石（金石） ⁶鉄橋 ⁷鉄橋道人

Mōri Noritake[1] (1884–1963). **Biog.:** Sculptor. Born in Tōkyō. In 1899 studied with Takamura Kōun. In 1903 graduated from the Tōkyō School of Fine Arts, exhibiting that year as well as the following with the Tōkyō Chōkōkai. Won several prizes, including third prize at the 1907 Bunten. In 1912 became a member of the Fusainkai, continuing as an

exhibitor at government shows. In his later years joined the Nitten, showing with that group. **Bib.:** Asano.

¹毛利教武

Mori Yoshitoshi¹ (1898–). **Biog.:** Printmaker. Born in Tōkyō. In 1923 graduated from the department of Japanese-style painting of the Kawabata Gagakkō. From 1949 showed with the Kokugakai; after 1955 took part in the Nihon Hangain exhibition. Style: contemporary folk art. **Coll.:** Art (1). **Bib.:** Kawakita (1), Michener (4), NHBZ 8.

¹森義利

Moriaki¹ (fl. c. 1715). **N.:** Ōta Moriaki.² **Biog.:** Kanō painter. Born in Chikuzen Province. Pupil of Ogata Morifusa. **Coll.:** Museum (3).

¹守章 ²大田守章

Morifusa¹ (fl. c. 1712). **N.:** Kanō Shigenobu² (originally Ogata Morifusa).³ **Gō:** Yūgen.⁴ **Biog.:** Kanō painter. First a pupil of Kanō Tan'yū; apparently studied later under Kanō Eishuku and was allowed to use the Kanō name, calling himself Kanō Yūgen Shigenobu.

¹守房 ²狩野重信 ³尾形守房 ⁴幽元

Morikage¹ (c. 1620–90). **N.:** Kusumi Morikage.² **F.N.:** Hambei (Hanbei).³ **Gō:** Itchinsai,⁴ Mugesai.⁵ **Biog.:** Kanō painter. Born in Kaga; lived mostly in Kyōto. Pupil of Kanō Tan'yū; married a niece of his master; his daughter Kiyohara Yukinobu was also a painter. About 1675 summoned by head of the Kaga clan to Kanazawa, where he stayed until 1680; perhaps produced designs for the potters of the Kutani kilns. Is said to have got into trouble with the shogunate and to have been banished to Sado, where he died. One of Tan'yū's four great pupils, with whose work his own is often confused, but more free and original than his master. Supposedly dismissed from the Kanō school, perhaps for not following the Chinese style encouraged by the Kanō artists. Broad range of subjects: good landscapes, *kachōga*, figures, *genre*, farm life, Buddhist themes. His style frequently recalls black ink and light color of 15th-century masters; occasionally painted in the Tosa manner. A most interesting, individual painter and a fine draftsman. **Coll.:** Chion-in, Cleveland, Fogg, Ishikawa, Minneapolis, Museum (3), Newark, Nezu, Ōkura, Staatliche, Tōkyō (1), Victoria. **Bib.:** *Ausgewählte;* BCM 56; BK 11; Doi (1); GNB 13; Hillier (1), (4) 3; K 24, 50, 66, 96, 106, 110, 121, 158, 172, 184, 186, 205, 221, 341, 359, 406, 426, 437, 541, 554, 568, 592, 613, 623, 634, 698, 743, 809, 833, 898, 923; *Kanō-ha; Kokuhō* 6; M 24; Moriya; Morrison 1; NB (S) 20; NBT 5; NBZ 4; *Nikuhitsu* (1) 1; NKZ 76; Noma (1) 2; *One* (2); Paine (4); *Rakuchū;* Rosenfield (2); SBZ 9; Shimada 2; Tajima (12) 11, 17, 19, 20; Tajima (13) 5; TOCS 1945–46; Yamane (1a).

¹守景 ²久隅 (久須見) 守景 ³半兵衛
⁴一陳斎 ⁵無下斎 (無礙斎)

Morikawa Sōbun¹ (1847–1902). **N.:** Morikawa Eiken.² **A.:** Shisei.³ **Gō:** Kaiyarō,⁴ Kakutei,⁵ Seiryūsai,⁶ Shigeki,⁷ Sōbun.⁸ **Biog.:** Japanese-style painter. Worked in Kyōto. Influenced by Maekawa Gorei and Hasegawa Gyokuhō. Member of the Kyōto Bijutsu Kyōkai; took an active part in Kansai art associations. An exhibitor with various government-sponsored shows. A distinguished painter of landscapes, figures, and *kachōga*. **Coll.:** Ashmolean, Museum (3), Tōkyō (1), Victoria. **Bib.:** Asano, Mitchell, Morrison 2, NB (S) 17, NBZ 6.

¹森川曽文 ²森川英絢 ³士倩 ⁴快哉樓
⁵鶴汀 ⁶清流斎 ⁷茂樹 ⁸曽文

Morikawa Toen¹ (1820–94). **Biog.:** Japanese-style sculptor. Born in Nara-ken. Worked as a sculptor as well as a painter at the Kasuga Shrine, Nara. In his later years specialized in reproducing ancient Japanese sculptures. Also did small figures in wood of Nō actors, animals, and Nara dolls. An exhibitor at the Chicago World's Fair and the Naikoku Kangyō Hakurankai. **Bib.:** Asano, NBZ 6, Uyeno.

¹森川杜園

Morikuni¹ (1679–1748). **N.:** Tachibana (originally Narahara)² Yūzei.³ **F.N.:** Sōbei.⁴ **Gō:** Kōsoken,⁵ Morikuni.⁶ **Biog.:** Kanō painter, illustrator. Also an able writer, leaving quite a few published books. Born in Ōsaka. Studied under Tsuruzawa Tanzan, a pupil of Kanō Tan'yū. As a pupil of Tanzan's, copied many sample pictures of the Kanō school and then printed and published them in the form of a small book. Kanō family enraged, forced Tanzan to disown him. An artist of great versatility with a particular talent for miniatures. **Coll.:** Cincinnati, Detroit, Musées, Museum (3), Rhode Island, Rietberg, Staatliche, Victoria. **Bib.:** ARTA 6, Binyon (2), Boller, Brown, Morrison 1.

¹守国 ²楢原 ³橘有税 ⁴惣兵衛 ⁵後素軒 ⁶守国

Morimasa¹ (fl. 1644–48). **N.:** Kinugasa.² **F.N.:** Hansuke.³ **Gō:** Morimasa.⁴ **Biog.:** Kanō painter. Pupil of Kanō Tan'yū. Served the daimyo of Chikuzen. **Bib.:** *Kanō-ha.*

¹守昌 ²衣笠 ³半助 ⁴守昌

Morimasa¹ (fl. c. 1839). **N.:** Gamō Morimasa.² **Biog.:** Lacquerer. Specialized in *guri-bori*. **Coll.:** Museum (2). **Bib.:** Herberts, Jahss, Ragué.

¹盛雅 ²蒲生盛雅

Morimitsu¹ (fl. 1848–60). **N.:** Kiyokawa Morimitsu.² **Gō:** Hōzan,³ Kan'yūsai.⁴ **Biog.:** Lacquerer. **Coll.:** Walters. **Bib.:** Boyer, Herberts, Jahss.

¹守光 ²清河守光 ³蓬山 ⁴寛遊斎

Morita Sai¹ (1898–). **Biog.:** Japanese-style painter. Born in Hokkaidō; works in Tōkyō. Graduate of the Tōkyō School of Fine Arts. Member of Nitten, showing with that group as well as at government exhibitions. In 1959 won the Japan Art Academy Prize. His style owes much to Western art. **Coll.:** National (5).

¹森田沙夷

Morita Tsunetomo¹ (1881–1933). **Biog.:** Western-style painter. Born in Saitama-ken; lived in Tōkyō. In 1906 graduated from Tōkyō School of Fine Arts; pupil of Koyama Shōtarō and Nakamura Fusetsu. In 1907 showed with the Bunten. From 1914 to 1915 studied in Europe, where he came under the influence of Cézanne's landscapes. Member of the Nikakai and the Shun'yōkai, exhibiting frequently with the latter. Specialized in landscape, working in oil in the manner of Cézanne and in ink with a little color added. Author of several books on painting. **Coll.:** National (5). **Bib.:** Asano, *Cent-cinquante,* NB (S) 4, NBZ 6.

¹森田恒友

Moritsune¹ (fl. c. 1810). **N.:** Yasui Moritsune.² **A.:** Bokuzan.³ **Gō:** Shunchōsai.⁴ **Biog.:** Kanō painter. Lived in Ōsaka. Received title of *hokkyō.* **Bib.:** Mitchell.

¹守常 ²安井守常 ³卜山 ⁴春調斎

Morizumi Yūgyo¹ (1856–1928). **Biog.:** Western-style painter. Son of Morizumi Kangyo. At an early age to Tōkyō to become a pupil of Kunisawa Shinkurō. Studied for a time under Antonio Fontanesi. In 1878 founded Jūichikai. Later returned to Kyōto and taught at various local schools. A minor artist.

¹守住勇魚

Morofusa¹ (fl. 1685–1703). **N.:** Hishikawa Morofusa.² **F.N.:** Kichibei,³ Kichizaemon.⁴ **Biog.:** Ukiyo-e painter, printmaker, illustrator. Lived in Edo. Eldest son and pupil of Hishikawa Moronobu, whose style he followed but with no great success. His paintings are rare; known particularly as an illustrator of erotica. Eventually followed the family tradition, returning to the family business of embroidering and dyeing fabrics. **Coll.:** Musées, Nelson. **Bib.:** Binyon (3); Ficke; Hillier (3), (4) 1; Lane; Morrison 2; NHBZ 2; *Nikuhitsu* (2); Stern (4); Tajima (7) 1; Takahashi (5).

¹師房 ²菱川師房 ³吉兵衛 ⁴吉左衛門

Morohira¹ (fl. late 17th to early 18th c.). **N.:** Hishikawa Morohira.² **Biog.:** Ukiyo-e painter. Probably Hishikawa Moronobu's best pupil; was allowed to take his master's

surname. Famous as a colorist. Only a few works extant. **Coll.**: Art (1), Idemitsu. **Bib.**: K 616, Tajima (7) 1.

¹師平 ²菱川師平
Morohoshi Seishō¹ (1870–?). **N.**: Morohoshi Moriaki.² **F.N.**: Ren'ichirō.³ **Gō**: Chūren,⁴ Gyokuren,⁵ Seishō.⁶ **Biog.**: Japanese-style painter. Born in Chiba-ken. To Tōkyō in 1887 to study with Kawabata Gyokushō, specializing in the Maruyama-Shijō manner. Then entered the Tōkyō School of Fine Arts for a short time. Also influenced by the styles of Watanabe Kazan and Tsubaki Chinzan. Traveled extensively, recording his journeys in water colors. Exhibitor and frequent prize winner at government shows. **Bib.**: Asano.

¹諸星成章 ²諸星盛章 ³連一郎 ⁴仲連 ⁵玉連 ⁶成章
Moroka¹ (1669–1734). **N.**: Ishiyama Motonobu.² **Gō**: Kitō,³ Moroka.⁴ **Biog.**: Kanō painter. Pupil of Kanō Einō. Painted *kachōga* and landscapes as well as comic scenes. Also made sculpture in wood and metal.

¹師香 ²石山基信 ³基重 ⁴師香
Moromasa¹ (c. 1712–72). **N.**: Furuyama Moromasa.² **F.N.**: Shinshichirō;³ later, Shinkurō.⁴ **Gō**: Bunshi,⁵ Getsugetsudō.⁶ **Biog.**: Ukiyo-e painter, printmaker. Lived in Edo. Said to have been son and pupil of Furuyama Moroshige, hence third generation of the Moronobu school. Sometimes used the school name Hishikawa.⁷ Specialized in portraits of famous *bijin* and genre scenes. A follower of Torii Kiyonobu and Okumura Masanobu. An artist of some distinction; his work rare. **Coll.**: Art (1), Fine (California), Kanagawa, Kōbe, Metropolitan, Museum (3), Tōkyō (1). **Bib.**: Fujikake (3) 2; Gunsaulus (1); Hillier (1); Jenkins; K 657; Lane; NHBZ 2; *Nikuhitsu* (1) 1, (2); *Pictorial* (2) 4; Shimada 3; Stern (2); Tajima (7) 1; UG 28.

¹師政 ²古山師政 ³新七郎 ⁴新九郎
⁵文志 (文翅) ⁶月々堂 ⁷菱川
Moronaga¹ (fl. late 17th to early 18th c.). **N.**: Hishikawa Moronaga.² **F.N.**: Okinojō,³ Sakunojō.⁴ Ukiyo-e painter, printmaker. Either the son or son-in-law of Hishikawa Moronobu. His work is rare. **Bib.**: Morrison 2.

¹師永 ²菱川師永 ³冲之丞 ⁴作之丞
Moronobu¹ (c. 1618–94). **N.**: Hishikawa (originally Furuyama)² Moronobu.³ **F.N.**: Kichibei.⁴ **Gō**: Yūchiku.⁵ **Biog.**: Ukiyo-e painter, printmaker, illustrator. Born in Hodamura, Awa Province; died in Edo. Son of a well-known embroiderer and dyer of textiles. At first followed the family business; then about 1658 to Edo as apprentice to an unidentified painter. Studied Tosa, Kanō, Hasegawa, and genre painting. The first illustrated book signed by him is dated 1672; his books (59 bear his name; over 100 are attributed to him) deal with famous historical and literary subjects and the world of the courtesan. His paintings, perhaps done only from 1670, are generally of *bijin* in profile, with long faces and knees slightly bent. Pioneer of the ukiyo-e school; with him the woodblock print no longer only an illustration but also an independent art work. The first to design single-sheet prints. A good painter, an unrivaled illustrator; in depicting the life of the Yoshiwara and the theater, crystallized basic style of ukiyo-e. His prints and book illustrations in black-and-white only. **Coll.**: Allen; Art (1); Ashmolean; Atami; British; Brooklyn; Cincinnati; Denver; Detroit; Fitzwilliam; Freer; Fujita; Herron; Honolulu; Idemitsu; Los Angeles; Metropolitan; Minneapolis; Musée (1), (2); Musées; Museum (1), (3); Nelson; Newark; Ōstasiatiska; Österreichisches; Portland; Rhode Island; Riccar; Staatliche; Tōkyō (1); Victoria; Worcester; Yale. **Bib.**: Binyon (1), (3); Boller; Brown; Crighton; *Exhibition* (1); Ficke; Fontein (1); *Freer;* Fujikake (1), (3) 1; Gentles (2); GNB 17, 24; Gunsaulus (1); Hillier (1), (7); K 17, 62, 74, 174, 219, 229, 363, 378, 697, 703, 813; Kondō (2), (6); *Kunst;* Kurth (4); Lane; Ledoux (4); Michener (3); Morrison (2), (3); *National* (1); NB (S) 68, 71; NBT 5; NBZ 5; NHBZ 2; *Nikuhitsu* (1) 1; Noma (1) 2;

One (2); OZ (new series) 1; Paine (4); SBZ 9; Schmidt; Shibui (1); Shimada 3; Stern (2), (4); Tajima (7) 1, (13) 6; Takahashi (2), (5), (6) 1; UG 28; *Ukiyo-e* (2) 1, (3) 1; Yamane (1a).

¹師宣 ²古山 ³菱川師宣 ⁴吉兵衛 ⁵友竹
Moroshige¹ (fl. 1678–98). **N.**: Furuyama Moroshige² (or Hishikawa Moroshige).³ **F.N.**: Tarobei.⁴ **Biog.**: Ukiyo-e painter, printmaker, illustrator. Lived in Edo. Outstanding pupil of Hishikawa Moronobu; was allowed to use his master's name for a while but later reverted to his own name of Furuyama. Father of Moromasa. Specialized in *bijinga*, but best known for his book illustrations. **Coll.**: Allen, Art (1), Freer, Newark. **Bib.**: Fujikake (3) 2, Gunsaulus (1), Jenkins, K 479, KO 24, Lane, *Nikuhitsu* (2), Tajima (7) 1.

¹師重 ²古山師重 ³菱川師重 ⁴太郎兵衛
Morotane¹ (fl. c. 1716–44). **N.**: Furuyama Morotane.² **Biog.**: Ukiyo-e painter. Pupil of Furuyama Moroshige. Few works, almost all paintings, extant. They show considerable quality and are somewhat in the style of Kiyomasu. **Coll.**: Staatliche. **Bib.**: Binyon (3), Kurth (4), *Nikuhitsu* (2), Schmidt.

¹師胤 ²古山師胤
Morotoki¹ (1077–1136). **N.**: Minamoto no Morotoki.² **Biog.**: Painter. Also a calligrapher, poet and courtier. A figure known only from literary records, he is said to have illustrated the *Genji Monogatari.*

¹師時 ²源師時
Morotsugu¹ (fl. 1741–44). **N.**: Furuyama Morotsugu.² **Biog.**: Ukiyo-e painter. Perhaps a pupil of Furuyama Moroshige (and perhaps took his master's name). A painter of *bijin.* So far, no prints by him are known. **Bib.**: Tajima (7) 1.

¹師継 ²古山師継
Moroyasu¹ (fl. early 18th c.). **N.**: Hishikawa Moroyasu.² **Biog.**: Ukiyo-e painter. A rare and not too competent artist working, to judge from his one known painting, in the Kaigetsudō manner. **Coll.**: Freer. **Bib.**: Stern (4).

¹師保 ²菱川師保
Motohide (Genshū)¹ (fl. late 16th c.). **N.**: Kanō Motohide (Genshū)² or Kanō Motosue (Genki).³ **F.N.**: Jinnojō.⁴ **Gō**: Shinsetsu.⁵ **Biog.**: Kanō painter. Son of Kanō Sōshū. Though little is known of his life, dates of two of his major paintings are known: the *Semmen Namban-ji* (fan picture of a Christian church), now in the Kōbe Museum, was produced between 1578 and 1588; and *Portrait of Oda Nobunaga,* now in the Chōko-ji, Aichi-ken, was painted after 1582. However, there is some confusion over his work, since the seal he used, reading "Motohide," was also used by his father. Received title of *hokkyō.* From his works, he can be judged a delightful artist, working in a manner close to that of Eitoku. **Coll.**: Chōko-ji, *Freer,* Honolulu, Kōbe, Tokiwayama, Tōkyō (2). **Bib.**: BK 36; *Freer; Japanese* (1); K 574, 597, 633, 750; *Namban;* NKZ 69; *Pictorial* (2) 1; *Rakuchū;* Shimada 2; Tanaka (9); *Trésors;* Yamane (1a).

¹元秀 ²狩野元秀 ³狩野元季 ⁴甚之丞 ⁵真説
Motohisa¹ (fl. late Muromachi period). **N.**: Kanō Motohisa.² **Biog.**: Kanō painter. From his style, an adequate but minor follower of Motonobu. Known only from his seal on a pair of sixfold screens (now in a private collection) with 60 fan-shaped paintings. **Bib.**: BK 51.

¹元久 ²狩野元久
Motomitsu¹ (fl. c. 1086–99). **N.**: Fujiwara no Motomitsu² (originally Morimitsu).³ **F.N.**: Kasuga Motomitsu.⁴ **Biog.**: *Yamato-e* painter. Son of either Fujiwara no Kiyotaka or Fujiwara no Yorishige; pupil of Kose no Kimmochi. Traditionally considered as founder of the Tosa, or Kasuga (so called because of his attachment as a painter to the Kasuga-jinja, Nara), school of painting, though there is no real foundation for such a claim. It is recorded that he was working at Kōyasan in 1086, when he painted a portrait of cloistered Prince Shōshin; it is claimed he painted the *Death of the Buddha* in the Kongōbu-ji at the same time. In 1099 was given

honorary title of governor of Yamato Province. A famous painter. **Bib.**: Minamoto (1), Morrison 1, Paine (4), Tajima (12) 4.

¹基光 ²藤原基光 ³盛光 ⁴春日基光

Motonobu[1] (1476–1559). *N.*: Kanō Motonobu.[2] *F.N.*: Ōinosuke,[3] Shirojirō.[4] *Gō*: Eisen,[5] Gyokusen.[6] **Biog.**: Kanō painter. Lived in Kyōto. Eldest son of Kanō Masanobu and true founder of the Kanō school. Received Zen instruction at the Reiun-in, but remained a layman. Married Chiyo, daughter of Tosa Mitsunobu (herself a painter, using *gō* of Mitsuhisa); on his father-in-law's death, succeeded to management of Tosa family business, inheriting the court honors and becoming head of the Edokoro of the Ashikaga shogunate. (Is even recorded as having worked on a pair of screens with Tosa Mitsushige.) At the same time, served as *goyō eshi* to the imperial court. Given title of *hōgen*. No painting actually signed by him is known to exist. Contributed much to making Kanō school of painting the official one of the shogunate, putting it on a solid footing by adapting Chinese traditions of Shūbun and Josetsu to the Japanese spirit. Painted landscapes and *kachōga* in strong ink brush strokes, adding bright color; restored to painting traditional Japanese lyricism and decorative quality, tendencies that became standard Kanō features. His style, a pleasant and easily assimilated one, well adapted to large surfaces: the beginning of great mural painting. **Coll.**: British, Daitoku-ji (Daisen-in), Hakutsuru, Metropolitan, Musée (2), Museum (3), Myōshin-ji (Reiun-in, Tokai-an), Nanzen-ji (Konchi-in), Nelson, Newark, Nezu, Philadelphia, Seattle, Seiryō-ji, Tōkyō (1), Victoria, Yamato. **Bib.**: AA 6, 14; Akiyama (3); *Art* (1a); ARTA 1951; Binyon (2); BK 88, 246, 249, 270, 271, 272; *Exhibition* (1); Fontein (1); Fujikake (3) 1; Hillier (4) 3; HS 4, 10, 13; K 5, 38, 73, 81, 110, 113, 116, 137, 142, 146, 150, 155, 161, 166, 170, 171, 175, 179, 183, 198, 204, 213, 218, 231, 245, 337, 372, 388, 431, 642; KO 2, 39; M 209; Matsushita (1); Mayuyama; Minamoto (1); Morrison 1; NB (H) 14; NB (S) 13; NBT 4; NBZ 3; NKZ 3, 11, 27, 58, 81, 84; Noma (1) 1; *One* (2); Paine (3), (4); *Rakuchū;* SBZ 7; *Selected;* Shimada 1; Tajima (8); Tajima (12), 1, 4, 5, 7, 9, 11, 12, 19; Tajima (13) 4; Tanaka (2); Tsubota; Yamane (1a); Yashiro (1); YB 23.

¹元信 ²狩野元信 ³大炊助 ⁴四郎次郎 ⁵永仙 ⁶玉川

Mototada (Genchū)[1] (fl. c. 1565). *N.*: Kanō Mototada (Genchū).[2] **Biog.**: Kanō painter. Known to have been a pupil of Kanō Motonobu. **Bib.**: K 679, *Muromachi* (1).

¹元忠 ²狩野元忠

Motsugai Jōhan[1] (1546–1621). *Priest name:* Motsugai.[2] *Gō*: Jōhan.[3] **Biog.**: Muromachi *suiboku* painter. A priest of the Rinzai sect, founder of the Kōzen-ji in Utsunomiya. The *zenga* painter Fūgai Ekun is said to have studied under him. Known as a painter of plum trees. **Bib.**: K 772, NB (S) 47.

¹物外紹播 ²物外 ³紹播

Muboku[1] (1832–93). *N.*: Nagao Sen.[2] *Gō*: Muboku.[3] **Biog.**: *Nanga* painter. Pupil of Tanomura Chokunyū. Traveled in China. **Bib.**: Mitchell.

¹無墨 ²長尾渲 ³無墨

Munehiro[1] (fl. mid-12th c.). *N.*: Fujiwara no Munehiro.[2] **Biog.**: Painter. His *Zemmui Dainichi-kyō Kantoku Zu* (Subhakarasimha's Vairocana Sutra Inspiration) in the Fujita Museum is the only Heian painting extant of which the artist's name is known. **Coll.**: Fujita. **Bib.**: Ienaga.

¹宗弘 ²藤原宗弘

Munehiro[1] (fl. 1848–67). *N.*: Hasegawa Munehiro.[2] **Biog.**: Printmaker. Probably a pupil of Utagawa Hirosada; worked in Ōsaka. Designed actor prints. **Coll.**: Philadelphia, Victoria. **Bib.**: Keyes.

¹宗広 ²長谷川宗広

Munehisa[1] (fl. c. 1200). *N.*: Kose no Munehisa.[2] **Biog.**: Kose painter. Son of Kose no Arimune; represents eleventh

generation of main Kose line. Known only from records as the holder of various court positions.

¹宗久 ²巨勢宗久

Munenobu[1] (1514–62). *N.*: Kanō Munenobu.[2] *F.N.*: Shirojirō.[3] *Gō*: Yūsei,[4] Yūsetsu.[5] **Biog.**: Kano painter. Eldest son and pupil of Kanō Motonobu; third generation of the Kanō school. Served the Ashikaga shoguns Yoshiharu and Yoshiteru. Received title of *hōgen*. **Coll.**: Museum (3), Tōkyō (1). **Bib.**: K 359; M 124, 125; Morrison 1; UG 15.

¹宗信 ²狩野宗信 ³四郎次郎 ⁴祐清 ⁵祐雪

Muneshige[1] (fl. c. 1090). *N*: Kose no Muneshige.[2] **Biog.**: Kose painter. Son of Kose no Nobushige. Edokoro *azukari* at the imperial court. Given rank of assistant governor of Noto Province. Specialized in Buddhist subjects.

¹宗茂 ²巨勢宗茂

Munetada (Sōchū)[1] (1720–73). *N.*: Nishimura Munetada (Sōchū).[2] *F.N.*: Hikobei.[3] *Gō*: Zōhiko.[4] **Biog.**: Lacquerer. Worked in Kyōto. A master *makie* artist; his works are known for their gracefulness and beauty. His most famous single work was a *makie* representation of Fugen Bosatsu riding an elephant, a work that was dedicated to his family temple in Kyōto and made him so well known that he came to be called Zōhiko (Elephant Boy). This name was formally adopted by his descendants at the eighth generation as their family name; they are among the largest manufacturers and dealers in lacquerwares in Japan. **Bib.**: Casal, Herberts, Jahss, Sawaguchi.

¹宗忠 ²西村宗忠 ³彦兵衛 ⁴象彦

Murakami Hōko[1] (1880–1956). **Biog.**: Japanese-style painter. Born in Ehime-ken. First studied under Matsumoto Fūko, then Kawai Gyokudō. Exhibited with the Bunten from 1907. Also showed with other organizations.

¹村上鳳湖

Murakami Kagaku[1] (1888–1939). *N.*: Murakami (originally Takeda)[2] Shin'ichi.[3] *Gō*: Kagaku.[4] **Biog.**: Japanese-style painter. Born in Ōsaka. Lived in Kyōto until he finally withdrew from all painting associations and lived in seclusion in Kōbe. Graduate of the Kyōto Municipal School of Fine Arts and Crafts; pupil of Takeuchi Seihō. In 1918 helped found the Kokuga Sōsaku Kyōkai. An exhibitor with the Bunten. Produced a large group of paintings on Buddhist subjects as well as landscapes and illustrations of Japanese legends rendered in a *nanga* manner. His work shows some Indian influence and far less Western influence than that of his contemporaries. Fantasy and a strong strain of romantic lyricism run through all his paintings. His brushwork varied and versatile. **Coll.**: Kyōto (1), Museum (3), National (5), Victoria, Yamatane. **Bib.**: Asano, Kawakita (3a), *Masterpieces* (4), Miyagawa, Nakamura (1), NB (H) 24, NBT 10, NBZ 6, NKKZ 22, Noma (1) 2, SBZ 11.

¹村上華岳 ²武田 ³村上震一 ⁴華岳

Murase Gyokuden[1] (1852–1917). *N.*: Murase (originally Enoki)[2] Norinaga.[3] *F.N.*: Seijirō.[4] *Gō*: Gyokuden,[5] Saiuntei.[6] **Biog.**: Japanese-style painter. Born in Kyōto. Pupil of Murase Sōseki, who adopted him at 15. After his master's death, to Tōkyō. Served as a committee member of the Nihon Bijutsu Kyōkai as well as being connected with other official groups. His major work is his painting of a peacock, now in the Tōkyō National Museum. **Coll.**: Museum (3), Tōkyō (1). **Bib.**: Mitchell, NB (S) 17.

¹村瀬玉田 ²榎 ³村瀬徳温 ⁴清次郎 ⁵玉田 ⁶彩雲亭

Murata Kōkoku[1] (1831–1912). *N.*: Murata Shuku (Yoshi).[2] *Gō*: Kōkoku,[3] Ransetsu,[4] Tekiho.[5] **Biog.**: *Nanga* painter. Also a good poet. Born in Fukuoka; son of Murata Toho, a minor *nanga* painter. First studied under his father, then with Nukina Kaioku. To Nagasaki to study with Hidaka Tetsuō. Made three trips to China. Taught at the Kyōto Municipal School of Fine Arts and Crafts. Particularly able landscape painter. **Coll.**: Victoria. **Bib.**: Mitchell.

¹村田香谷 ²村田叔 ³香谷 ⁴蘭雪 ⁵適圃

Murata Tanryō[1] (1874–1940). *N.:* Murata Tadashi.[2] *A.:* Shinshin.[3] *Gō:* Setsuei Sōsha,[4] Taizan Rōshu,[5] Tanryō,[6] **Biog.:** Japanese-style painter. Born in Kyōto. Studied Tosa painting with Kawabe Mitate. As a member of Okakura Tenshin's group, helped found the Nihon Seinen Kaiga Kyōkai in 1891; in 1898 became a member of the reorganized Nihon Kaiga Kyōkai. Showed with the first Bunten. After the Russo-Japanese War, in which he was involved, withdrew from artistic circles and lived in seclusion in the country outside Tōkyō. **Bib.:** Asano, NBZ 6.
[1]邨田丹陵 [2]邨田靖 [3]申申 [4]雪営霜舎 [5]泰山楼主 [6]丹陵

Murayama Kaita[1] (1896–1919). **Biog.:** Western-style painter. Born in Yokohama; lived in Tōkyō. First interested in literary matters, then turned to Western painting. His works won much praise when shown at the Nihon Bijutsuin and the Nikakai. Painted in both oil and water color somewhat in the manner of Derain. **Coll.:** National (5). **Bib.:** Asano, NBZ 6, NKKZ 8, SBZ 11.
[1]村山槐多

Mureki[1] (1832–?). *N.:* Kiyohara Mureki.[2] *F.N.:* Sendō.[3] **Biog.:** *Nanga* painter. Born in Bungo Province. His subjects included landscapes and birds-and-flowers. **Bib.:** Mitchell.
[1]無暦 [2]清原無暦 [3]宣道

Myōchin Tsuneo[1] (1882–1940). **Biog.:** Sculptor. Born in Nagano. First studied with Takamura Kōun. Graduated in 1913 from the Tōkyō School of Fine Arts and soon after was given a position at the Nihon Bijutsuin. A specialist in the repair of ancient sculpture and author of books on Buddhist sculpture. **Bib.:** Asano.
[1]明珍恒男

Myōe[1] (1173–1232). **Biog.:** Painter. Also a calligrapher and author. Famous priest of the Kegon sect, restored the Kōzan-ji and made it a center for training priests of the Kegon and Shingon sects as well as, apparently, a center for priests interested in painting. Specialized in painting *mandara.* **Bib.:** Toda (2).
[1]明恵

Myōen (Meien)[1] (?–1199). **Biog.:** Sculptor. Worked in Kyōto. Leader of the En school of Buddhist sculptors, with title of *dai busshi* at the Sanjō Bussho. In 1166 received title of *hokkyō* and in 1174 of *hōgen.* Also *dai busshi* at the Kōfuku-ji. Patronized by the Taira clan until they were destroyed in the Heike wars. His statues of the Go Dai Myōō in the Daikaku-ji, Kyōto, are dated 1176. With Unkei, considered one of the originators of the dramatic Kamakura style of carving. **Coll.:** Daikaku-ji. **Bib.:** GNB 9; *Heian* (2); K 733, 734; Kidder; Kobayashi (1); *Kokuhō* 3; Kuno (1), (2) 6; Matsumoto (1); *Mōri* (1a); NBZ 3.
[1]明円

Myōjitsu (Meijitsu)[1] (?–1093). **Biog.:** Buddhist painter. A member of the Fujiwara Tomokata family, a priest at Mount Hiei. It is said that he painted a picture of Monju every day.
[2]明実

Myōjun[1] (?–1118). **Biog.:** Buddhist painter. Another vague figure known only from official records. Mentioned as having received an award at the dedication of the Amida Hall of the Shirakawa-in in 1114.
[1]明順

Myōshun[1] (fl. c. 1126–32). **Biog.:** Sculptor. His name, with that of Shinkai, has been found inside a Batō Kannon in the Kanzeon-ji, Fukuoka. **Coll.:** Kanzeon-ji. **Bib.:** *Heian* (2).
[1]明春

Myōtaku[1] (1307–88). *Posthumous name:* Myōtaku.[2] *Gō:* Koken Myōtaku.[3] **Biog.:** Muromachi *suiboku* painter. A Zen priest; became disciple and pupil of Musō Kokushi. Produced many paintings of Fudō Myōō (the one in the Tokiwayama Bunko is dated 1379) and of Shōki. Style close to that of Mu-ch'i and Yin T'o-lo. **Coll.:** Freer, Henjōkō-in, Tokiwayama. **Bib.:** BCM 50, *Japanese* (1), K 435, Matsushita (1a), NB (S) 63, NBT 4, Paine (4).
[1]妙沢 [2]妙沢 [3]古剣妙沢

N

Nabei Katsuyuki[1] (1888–1969). **Biog.:** Western-style painter. Born in Ōsaka. First studied Japanese painting under Suzuki Shōnen; later turned to Western-style painting, studying at the Hakubakai and at the Tōkyō School of Fine Arts, graduating in 1915. Kuroda Seiki, Okada Saburōsuke, Fujishima Takeji, and Wada Eisaku were his masters. Exhibited first with the Nikakai. In 1922–23 in Europe. On his return became a member of the Nitten and helped found various Ōsaka art organizations. In 1947 helped organize the Dai Nikikai. In 1949 won the Japan Art Academy Prize. His style resembles that of Vlaminck. Also made a few prints. **Coll.:** National (5). **Bib.:** Asano, NBZ 6.
[1]鍋井克之

Nagaaki[1] (fl. late 13th to early 14th c.). *N.:* Tosa (or Fujiwara no)[2] Nagaaki.[3] **Biog.:** *Yamato-e* painter. Son and pupil of Tosa Nagataka. Several scrolls of the *Hōnen Shōnin Eden,* dated 1307, in the Chion-in, Kyōto, are attributed to him. **Coll.:** Chion-in. **Bib.:** Okudaira (1), Yashiro (1) 2.
[1]長章 [2]藤原 [3]土佐長章

Nagahara Kōtarō[1] (1864–1930). *N.:* Nagahara Kōtarō.[2] *Gō:* Shisui.[3] **Biog.:** Western-style painter. Born in Gifu-ken, lived in Tōkyō. Studied under Koyama Shōtarō and Harada Naojirō; influenced by Kuroda Seiki. Taught at Tōkyō School of Fine Arts. Member of Hakubakai and of the Teiten hanging committee. Exhibited with the Bunten. His work decorative, with impressionist touches. **Coll.:** National (5), Tōkyō (2). **Bib.:** Asano, *Kurashina* (2), NBZ 6.
[1]長原孝太郎 [2]長原孝太郎 [3]止水

Nagaharu[1] (fl. late 18th to early 19th c.). *N.:* Hirose Nagaharu.[2] *Gō:* Nagamitsu.[3] **Biog.:** Lacquerer. **Bib.:** Herberts, Jahss.
[1]永治 [2]広瀬永治 [3]永光

Nagaharu[1] (fl. 19th c.). *N.:* Kōami Nagaharu.[2] **Biog.:** Lacquerer. Worked in Kyōto. Minor member of the Kōami school. **Coll.:** Victoria. **Bib.:** Herberts, Jahss.
[1]永治 [2]幸阿弥永治

Nagahide (Chōshū)[1] (fl. c. 1804–48). *N.:* Nakamura Aritsune[2] (or Arichika).[3] *Gō:* Chōshūsai,[4] Nagahide (Chōshū),[5] Yūrakusai.[6] **Biog.:** Ukiyo-e printmaker. Worked in the Kyōto-Ōsaka area for a long period, during which his style changed so considerably that some critics have considered him as two different artists. Produced prints in which mica and metal pigments were used; also worked in the popular Ōsaka technique of *kappa-suri.* Excellent *bijinga, nishiki-e,* actor prints. His early style similar to that of Ryūkōsai and Shōkōsai, though more exaggerated. **Coll.:** Andrew, British, Fitzwilliam, Honolulu, Musées, Philadelphia, Staatliche, Victoria, Worcester. **Bib.:** Binyon (1), Ficke, Keyes, Kurth (3), NHBZ 3, Schmidt, *Ukiyo-e* (3) 19.
[1]長秀 [2]中邑 (中村) 有恒 [3]有慎 [4]長秀斎 [5]長秀 [6]有楽斎

Nagai Umpei[1] (1833–99). *N.:* Nagai Umpei.[2] *F.N.:* Genjirō.[3] *Gō:* Engan,[4] Gokō,[5] Keizan,[6] Ranka Sanjin.[7] **Biog.:** *Nanga* painter. Studied in Nagasaki with Itsuun and with Priest Tetsuō. After their death, went to China and studied with Hsu Yu-t'ing and Lu Ying-hsiang. Returned in 1869 to live

in Tōkyō. In his old age became a recluse. His subjects included orchids, bamboo, and landscapes. **Bib.:** Asano, SBZ 11.

<div align="center">¹長井雲坪 ²長井雲坪 ³元次郎
⁴淵岩 ⁵呉江 ⁶桂山 ⁷蘭華山人</div>

Nagamitsu¹ (fl. c. 1570). *N.:* Kimura Nagamitsu.² *Priest name:* Zenryō.³ **Biog.:** Kanō painter. Said to have been a pupil of Kanō Motonobu and a good painter of *kachōga;* is best known as the father of Kanō Sanraku. Entered the priesthood toward the end of his life, taking the name of Zenryō. It is doubtful if any of his work exists today. **Bib.:** Morrison 1.

<div align="center">¹永光 ²木村永光 ³善了</div>

Nagamochi (Nagaari)¹ (fl. c. 1240). *N.:* Kose (originally Ki)² no Nagamochi (Nagaari).³ *F.N.:* Kurando.⁴ **Biog.:** Kose painter. Son of Kose no Munehisa; twelfth generation of the Kose main line. Specialized in Buddhist subjects.

<div align="center">¹永有 ²紀 ³巨勢永有 ⁴蔵人</div>

Nagano Sōfū¹ (1885–1949). *N.:* Nagano Moriyuki.² *Gō:* Sōfū.³ **Biog.:** Japanese-style painter. Born in Tōkyō. At age of 14 studied with Murata Tanryō; later with Kawabata Gyokudō. Became a member of the Kojikai. An exhibitor with the Bunten, winning a prize at the first show and an honorable mention at the seventh. In 1914 helped revive the Inten. In 1923 and 1925 traveled in China. **Coll.:** National (5). **Bib.:** Asano.

<div align="center">¹長野草風 ²長野守敬 ³草風</div>

Naganobu¹ (1577–1654). *N.:* Kanō Naganobu.² *F.N.:* Genshichiro.³ *Gō:* Kyūhaku.⁴ **Biog.:** Kanō painter. Generally known as Naganobu, since three of his descendants used the *gō* Kyūhaku. Fourth son of Kanō Shōei, youngest brother of Eitoku. Said to have been placed in care of Honkyo family, returning to Kanō family only when of age; hence some Kanō biographies consider him illegitimate. Worked for the shogun Ieyasu, following him to Edo and becoming the first Kanō painter to settle in Edo. Founded the Okachimachi branch of the Kanō family. Served the shogun until his death. Best known for the pair of screens *Merrymaking Under the Cherry Blossoms,* now in the Tōkyō National Museum. Colorful decorative Kanō painter. **Coll.:** Museum (3), Nezu, Tōkyō (1). **Bib.:** BK 37; GK 12; GNB 13; K 423, 504, 583; *Kokuhō* 6; Kondō (6); Morrison 1; NBT 5; NKZ 46; Noma (1) 2; Yamane (1a).

<div align="center">¹長信 ²狩野長信 ³源七郎 ⁴休伯</div>

Naganuma Moriyoshi (Shukei)¹ (1857–1942). **Biog.:** Western-style sculptor. Studied in Venice from 1881 to 1887. In 1888, with six Western-style painters, founded the Meiji Bijutsukai, becoming the leading advocate of Western-style sculpture in Japan. In 1899 became first instructor of Western-style sculpture at the Tōkyō School of Fine Arts but resigned after several years. Awarded a gold medal at the International Exhibition in Paris in 1900. From 1907 to 1913 served as a juror for the Bunten. After 1914 lived quietly at Tateyama, Chiba-ken. His style late-19th-century European academic with some influence from Rodin and Meunier. **Coll.:** Tōkyō (2). **Bib.:** Asano; BK 163, 188; GNB 28; M 203; NB (H) 24; NBT 10; NBZ 6; SBZ 11; Uyeno.

<div align="center">¹長沼守敬</div>

Nagase Yoshirō¹ (1891–). **Biog.:** Printmaker. Born in Ibaraki-ken; works in Tōkyō. Left sculpture department of Tōkyō School of Fine Arts in midcourse to study both oil painting and Japanese-style painting. Influenced by Munch and the fauves. Studied printmaking by himself; eventually becoming a pioneer modern Japanese print artist. Joined Creative Print Club in 1916; in 1918 helped found the Nihon Sōsaku Hanga Kyōkai. From 1929 to 1936 in France. Showed with the Kokuga Sōsaku Kyōkai, Nikakai, Shun'yōkai, and Teiten. Published a technical work on printmaking and wrote *To the Printmaker.* His prints reflect a highly personal delicate style, imbued with considerable

fantasy. Also works in oil and water color. **Bib.:** Asano; Fujikake (1); Kawakita (1); NBZ 6; NHBZ 7, 8; UG 4, 8.

<div align="center">¹永瀬義郎</div>

Nagataka¹ (fl. late 13th c.). *N.:* Tosa (originally Fujiwara no)² Nagataka.³ *Priest name:* Kaishin⁴ (or Kaikan).⁵ **Biog.:** Yamato-e painter. Son and pupil of Tosa Tsunetaka. The *Moko Shūrai Ekotoba* (Scroll of the Mongolian Invasion), dated 1293, in the Imperial Household Collection, has been traditionally attributed to him and to his son Nagaaki, an attribution that is no longer generally accepted. Also ascribed to him is the *Sumiyoshi Monogatari Emaki* in the Tōkyō National Museum. **Coll.:** Tōkyō (1). **Bib.:** K 49, 53, 240, 272, 320; Morrison 1; NKZ 72; Okudaira (1); Tajima (12) 8, 13; Tajima (13) 2; Toda (2); Yashiro (1) 2.

<div align="center">¹長隆 ²藤原 ³土佐長隆 ⁴快心 ⁵快閑</div>

Nagatochi Hideta¹ (1873–1942). **Biog.:** Western-style painter. Born in Yamaguchi-ken. Pupil of Matsuoka Hisashi. Later studied at the Meiji Bijutsukai. In 1902 helped found the Taiheiyō Gakai. From 1907 exhibited with the Bunten; in 1927 became a juror for the Teiten. Taught at the cadet schools of both navy and army. **Bib.:** Asano, BK 201.

<div align="center">¹永地秀太</div>

Nahiko¹ (1723–82). *N.:* Katori (originally Inō)² Nahiko.³ (originally Kagetoyo;⁴ later, Kageyoshi).⁵ *F.N.:* Moemon.⁶ *Gō:* Chishōan.⁷ Seiran.⁸ **Biog.:** *Nanga* painter. Born in Katori in Shimōsa Province, later calling himself Katori after his birthplace. Pupil of Kumashiro Yūhi and Tatebe Ryōtai; teacher of Kubo Shumman. Studied classics under Kamo no Mabuchi; excelled at *haikai.* Painted in a free and extemporaneous manner, specializing in plum blossoms and carp.

<div align="center">¹魚彦 ²伊能 ³楫取魚彦 ⁴景豊
⁵景良 ⁶茂右衛門 ⁷茅生庵 ⁸青藍</div>

Naitō Shin¹ (1882–1967). **Biog.:** Japanese-style sculptor. Born in Shimane-ken. Graduate in 1904 of Tōkyō School of Fine Arts; pupil of Takamura Kōun. First exhibited with the Bunten, then transferred to the Inten, of which he became a member. Also a member and juror of the Teiten. In 1931 founded the Nihon Mokuchōkai to promote interest in wood sculpture. Worked in wood, in a moderately contemporary style. **Bib.:** Asano, NBZ 6.

<div align="center">¹内藤伸</div>

Naizen¹ (1570–1616). *N.:* Kanō Shigesato.² *F.N.:* Kyūzō.³ *Gō:* Ichiō,⁴ Naizen.⁵ **Biog.:** Kanō painter. Pupil of Kanō Shōei. Father of Kanō Ikkei Shigenaga. Served the shogun Hideyoshi. A *namban* screen in the Kōbe Municipal Art Museum bears his signature, as does a pair of screens (dated 1606) depicting the festival at the Toyokuni-jinja in Kyōto. Although he was trained in the orthodox Kanō manner, became a pioneer of genre painting. **Coll.:** Kōbe; Museu (1), Toyokuni-jinja. **Bib.:** BCM 50; Fujikake (3) 1; GNB 13; Grilli (1); Kondō (1); *Namban;* NBT 5; NBZ 4; *Nikuhitsu* (1) 1; Noma (1) 2; Okamoto (2); *Pictorial* (1) 3, (2) 1; *Rakuchū;* SBZ 8; Shimada 2; Tajima (7) 1; Tanaka (9); Yamane (1a).

<div align="center">¹内膳 ²狩野重郷 ³久蔵 ⁴一翁 ⁵内膳</div>

Nakabayashi Sen¹ (1879–1937). **Biog.:** Western-style painter. Born in Kyōto. Studied first under Itō Yoshihiko, then Asai Chū. Later to Tōkyō to study at the Taiheiyō Kenkyūsho. From about 1909 showed with the Bunten. Taught at the Nihon Bijutsuin and, from 1919, at a girls' high school at Matsumoto, Nagano-ken. A contributor to the journal *Chūō Bijutsu.* **Bib.:** Asano.

<div align="center">¹中林儚</div>

Nakagawa Hachirō¹ (1877–1922). **Biog.:** Western-style painter. Born in Ehime-ken; lived in Tōkyō. Pupil of Matsubara Sangorō and Koyama Shōtarō. In 1899 to Europe for study. In 1902 helped found the Taiheiyō Gakai. In Europe the following year, and again late in his life; also traveled in America. A frequent exhibitor and prize winner at the Bunten; also showed with the Teiten. Specialized in painting

landscapes in a romantic academic manner with some impressionist touches. **Coll.**: Detroit, Herron, National (5). **Bib.**: Asano, BK 201, Elisséev, Harada Minoru, NB (S) 30, NBZ 6.

¹中川八郎
Nakagawa Kazumasa[1] (1893–). **Biog.**: Western-style painter. Born in Tōkyō. Self-taught artist. Member of the Sōdosha and, later, a founding member of the Shun'yōkai. Served as juror for the Bunten. Once a member of the Nikakai, then of the Fusainkai. Has traveled in North and South America, Europe, and China. His style strongly expressionist. **Coll.**: Kanagawa, National (5), Ohara (1). **Bib.**: Asano, NBT 10, NBZ 6, SBZ 11.

¹中川一政
Nakagawa Kigen[1] (1892–1972). *N.*: Nakagawa (originally Ariga)[2] Kigenji.[3] *Gō:* Kigen.[4] **Biog.**: Western-style painter. Born in Nagano-ken. Studied at the Tōkyō School of Fine Arts and under Ishii Hakutei and Masamune Tokusaburō. From 1919 studied and traveled in Europe for ten years, working for a while under Matisse. Member of and exhibitor at the Nikakai; in 1947 helped found the Dai Nikikai. His Western-style work typically fauve, with strong influence from Matisse. Also works in the Japanese manner. **Coll.**: National (5). **Bib.**: Asano, NBZ 6, SBZ 11.

¹中川紀元 ²有賀 ³中川紀元次 ⁴紀元
Nakahara Minoru[1] (1893–). **Biog.**: Western-style painter. Graduated from Harvard University in 1918; trained as a dentist; served in the medical corps of the French army. Later studied painting in France. On his return to Japan in 1921, divided his time between teaching dentistry and painting. Member of the Nikakai. A surrealist artist. **Bib.**: Asano, NBZ 6.

¹中原実
Nakahara Teijirō[1] (1881–1921). **Biog.**: Western-style sculptor. Born in Hokkaidō. In 1905 to Tōkyō to study Western-style painting at the Hakubakai and the Taiheiyō Kenkyū-sho; turned to sculpture under influence of Ogiwara Morie. Studied under Shinkai Taketarō. Exhibitor with the Inten. Worked in style of Rodin. **Coll.**: National (5), Tōkyō (2). **Bib.**: BK 163, GNB 28, *Masterpieces* (4), NB (H) 24, NBT 10, NBZ 6, SBZ 11.

¹中原悌二郎
Nakamaru Seijūrō[1] (1841–96). *N.*: Nakamaru Seijūrō.[2] *Gō:* Kimpō.[3] **Biog.**: Western-style painter. Born in Yamanashi-ken; lived in Tōkyō. First studied Japanese-style painting in Kyōto under Hine Taizan: then Western-style painting in Tōkyō under Kawakami Tōgai and Antonio Fontanesi. Portraits, chiefly of army officers, were his specialty; also painted landscapes. His style is academic, his competence minor. **Coll.**: Bridgestone, Tōkyō (1). **Bib.**: Asano, Harada Minoru, Mitchell, NB (H) 24.

¹中丸精十郎 ²中丸精十郎 ³金峰
Nakamuda Sanjirō[1] (1892–1930). **Biog.**: Western-style sculptor. His work is rather impressionist. **Bib.**: NBZ 6.

¹中牟田三治郎
Nakamura Daizaburō[1] (1898–1947). **Biog.**: Japanese-style painter. Born and worked in Kyōto. Graduate of Kyōto Municipal School of Fine Arts and Crafts. Studied under Nishiyama Suishō. His work at the second and fourth Teiten exhibitions drew special mentions. Later, served as a juror for the Teiten. A distinguished genre painter, specializing in *bijinga;* a delicate, detailed, rather intentionally naive style. **Coll.**: Kyōto (1), National (5). **Bib.**: Asano, Elisséev, Kondō (6), NBZ 6, Sullivan.

¹中村大三郎
Nakamura Fusetsu[1] (1866–1943). *N.*: Nakamura Sakutarō.[2] *Gō:* Eiju Ryōkosai,[3] Fusetsu,[4] Gōcho Sensei,[5] Kanzan,[6] Kōkotei.[7] **Biog.**: Western-style painter. Born in Tōkyō. Studied with Koyama Shōtarō, and, on going to Europe in 1901, with Jean-Paul Laurens. After his return to Japan in

1905 joined the Taiheiyō Gakai, having resigned from the Meiji Bijutsukai, where he had taught. Active in the Bunten. Member of the Art Committee of the Imperial Household. Usually painted historical subjects, often taken from Chinese history. His style late-19th-century European academic. Noted for his calligraphy and his books on painting. **Coll.**: National (5). **Bib.**: Asano, BK 201, Elisséev, Harada Minoru, Mitchell, NBZ 6, Uyeno.

¹中村不折 ²中村鉌太郎 ³永寿霊壺斎
⁴不折 ⁵豪猪先生 ⁶環山 ⁷孔固亭
Nakamura Gakuryō[1] (1890–1969). *N.*: Nakamura Tsune-kichi.[2] *Gō:* Gakuryō.[3] **Biog.**: Japanese-style painter. Born in Izu in Shizuoka-ken. Studied Japanese-style painting under Kawabe Mitate. In 1912 graduated from Tōkyō School of Fine Arts. As a member of the Kojikai took part in the movement to establish a new Japanese-style painting. For a long time a member of the Saikō Nihon Bijutsuin and a leading figure in the Nitten. Member of the Japan Art Academy. In 1960 awarded the Mainichi and Asahi Shimbun prizes; in 1962 received the Order of Cultural Merit. His quite strongly colored paintings show much Western influence, yet remain basically Japanese in the revived *yamato-e* tradition. **Coll.**: Kanagawa, National (5), Shitennō-ji. **Bib.**: Asano, Kondō (6), Nakamura (1), NBZ 6.

¹中村岳陵 ²中村恒吉 ³岳陵
Nakamura Ken'ichi[1] (1895–1967). **Biog.**: Western-style painter. Born in Fukuoka-ken. In 1920 graduated from Tōkyō School of Fine Arts. Pupil of Okada Saburōsuke and Fujishima Takeji. In 1921 showed for the first of many times at the Teiten, where his paintings generally received special mention. From 1923 to 1928 in France, where he studied painting and became a member of the Salon d'Automne. On his return, served as juror for the Bunten, Teiten and Nitten. Member of the Kōfūkai, and the Japan Art Academy. Served in the armed forces during World War II, recording many battle scenes. In 1942 received Asahi Culture Prize. His style influenced by School of Paris of the 20s. **Bib.**: Asano, NBZ 6.

¹中村研一
Nakamura Takuji[1] (1897–). **Biog.**: Western-style painter. Born in Fukuoka-ken; works in Kamakura. Graduate of Tōkyō University. Exhibitor at the Nikakai and the Tōkyō Biennial. Member of the Issuikai and the Nitten. In 1953 received the Education Minister's Prize for Fostering the Arts. His figurative paintings are done in a strong, simplified manner. **Coll.**: National (5).

¹中村琢二
Nakamura Tsune[1] (1887–1924). **Biog.**: Western-style painter. Born in Mito; lived in Tōkyō. Entered an officers' training school at 14, but had to leave three years later when he contracted tuberculosis. Began painting for plesaure; at 19 studied at the Hakubakai under Kuroda Seiki, and the next year at the Taiheiyō Kenkyūsho. Later studied under Nakamura Fusetsu and Mitsutani Kunishirō. Exhibited with the Taiheiyō Gakai and the Bunten, frequently winning prizes at the latter and serving as juror for both this organization and the Teiten. Style at first close to Renoir; later more angular as he became interested in Cézanne. One of the best Western-style artists of his time. **Coll.**: Bridgestone, National (5), Ohara (1), Tōkyō (1). **Bib.**: Asano, Harada Minoru, *Masterpieces* (4), Miyagawa, NB (H) 24, NB (S) 30, NBT 10, NBZ 6, NKKZ 10, SBZ 11, Tanaka (7a) 37.

¹中村彝
Nakanishi Toshio[1] (1900–1948). **Biog.**: Western-style painter. Born in Tōkyō. Graduated from Tōkyō School of Fine Arts in 1927. From 1928 to 1930 studied in Europe. Exhibited with the Nihon Suisaigakai and the Teiten. From 1936 belonged to the Shinseisaku Kyōkai. **Coll.**: National (5). **Bib.**: Asano, NBT 10, NBZ 6.

¹中西利雄

Nakano Kazutaka[1] (1896–1965). **Biog.**: Western-style painter. Born in Ehime-ken. In 1914 to Tōkyō to study under Kuroda Seiki. In 1916 entered the Tōkyō School of Fine Arts, graduating in 1921; studied under Okada Saburōsuke. Then from 1923 to 1927 in France. On his return exhibited with the Teiten and the 1930 Association, which he helped found. In 1932 became a juror for the Teiten; after 1945 a member and juror of the Nitten and a member of the Sōgenkai. In 1957 won the Japan Art Academy Prize. His painting is quite realistic. **Bib.**: Asano, NBZ 6.

<div align="center">[1]中野和高</div>

Nakano Keiju[1] (1893–1965). **N.**: Nakano Kensaku.[2] **Gō**: Keiju.[3] **Biog.**: Sculptor. Born in Aomori-ken. In 1918 to Tōkyō to study first at the Taiheiyō Kenkyūsho, then at the Tōkyō School of Fine Arts, graduating in 1921. Next studied with Naitō Shin. After 1918 a frequent exhibitor at government shows. In his later years a member of the Nitten and the Taiheiyō Gakai. Since 1931 a leading member of the Nihon Mokuchōkai. A leading sculptor working in wood. **Coll.**: National (5). **Bib.**: Asano.

<div align="center">[1]中野桂樹 [2]中野健作 [3]桂樹</div>

Nakayama Masami (1898–). **Biog.**: Western-style printmaker. Born in Kōbe. Studied murals and copperplate engraving in France from 1924 to 1927. Exhibited at the Salon d'Automne. Returned to Japan and showed at government exhibitions in 1931. Then silent for twenty years. Member of Nihon Hanga Kyōkai. Private shows in 1958 and 1959. Works in a surrealist style. **Bib.**: Kawakita (1), NHBZ 8.

<div align="center">[1]中山正実</div>

Nakayama Takashi[1] (1893–). **Biog.**: Western-style painter. Born in Okayama. In 1920 graduated from the Tōkyō School of Fine Arts, where he studied under Fujishima Takeji. From 1922 to 1928 in France, working under Vlaminck. On his return to Japan exhibited—and won an award—at the Nikakai and with the 1930 Association. In 1930 helped found the Dokuritsu Bijutsu Kyōkai. In 1952 won the Japan Art Academy Prize. His style shows the influence of Vlaminck and the School of Paris. **Bib.**: Asano, NBZ 6.

<div align="center">[1]中山巍</div>

Nakazato Muan[1] (originally Taroemon)[2] (1895–). **Biog.**: Potter. A prominent artist who has made an intensive study of the old kiln sites, working in Karatsu in a contemporary version of the traditional Karatsu style. **Coll.**: National (4). **Bib.**: *Masterpieces* (4).

<div align="center">[1]中里無庵 [2]太郎右衛門</div>

Nakazawa Hiromitsu[1] (1874–1964). **Biog.**: Western-style painter. Born in Tōkyō. Graduated from Tōkyō School of Fine Arts in 1900 after studying under Soyama Sachihiko, Horie Masaaki, and Kuroda Seiki. Exhibited with the Hakubakai; also with the Bunten where he won prizes at the first three shows and served as juror for the fourth. Also frequently judged at the Teiten and the Nitten. In 1912 helped found the Kōfūkai. In Europe from 1921 to 1922. In 1924, with Tomita On'ichirō, established the Hakujitsukai. His paintings, romantic in vein, generally academic in style but with some traces of impressionism. **Coll.**: Kyōto (1), National (5), Tōkyō (2). **Bib.**: Asano, Harada Minoru, *Kurashina* (2), NB (H) 24, NB (S) 30, NBZ 6.

<div align="center">[1]中沢弘光</div>

Nammei (Nanmei)[1] (1795–1878). **N.**: Haruki Shūki[2] (later Ryū).[3] **A.**: Keiichi;[4] later, Shishū.[5] **F.N.**: Unosuke.[6] **Gō**: Donsanrō,[7] Kōun Gyosha,[8] Kōun Shōsha,[9] Nammei (Nanmei).[10] **Biog.**: Japanese-style painter. Lived in Edo. Son and pupil of Haruki Nanko. An able painter of landscapes and *kachōga*. His style, though based on *nanga*, was eclectic. A less brilliant colorist than his father. **Coll.**: Ashmolean,

Kōbe, Museum (3), Victoria. **Bib.**: Asano, Mitchell, Morrison 2, *Pictorial* (2) 5.

<div align="center">[1]南溟 [2]春木秀熙 [3]竜 [4]敬一 [5]子緝 [6]卯之助
[7]呑山楼 [8]耕雲漁者 [9]耕雲樵者 [10]南溟</div>

Nampō[1] (fl. c. 1840). **N.**: Oda Kan.[2] **A.**: Shishō.[3] **Gō**: Nampō.[4] **Biog.**: *Nanga* painter. Studied first under Okamoto Toyohiko, then turned to the *nanga* manner. **Bib.**: Mitchell.

<div align="center">[1]南豊 [2]小田煥 [3]子章 [4]南豊</div>

Nan'en[1] (fl. c. 1830–44). **N.**: Seki Nan'en.[2] **Biog.**: Shijō painter. Born in Kokura, Fukuoka-ken. Pupil of Okamoto Toyohiko. **Coll.**: Museum (3).

<div align="center">[1]南淵 [2]石南淵</div>

Nangai[1] (fl. early 19th c.). **N.**: Iwaki Chikatora.[2] **A.**: Shikyō.[3] **F.N.**: Kimbei.[4] **Gō**: Nangai.[5] **Biog.**: Painter. Worked in Nagoya. **Bib.**: Mitchell.

<div align="center">[1]南崖 [2]岩城親寅 [3]子恭 [4]金兵衛 [5]南崖</div>

Nangai[1] (fl. c. 1840). **N.**: Tanaka Choku.[2] **A.**: Kampu.[3] **Gō**: Nangai.[4] **Biog.**: Shijō painter. Pupil of Suzuki Nanrei. Lived and worked in Edo. **Bib.**: Mitchell.

<div align="center">[1]南涯 [2]田中直 [3]寛夫 [4]南涯</div>

Nangaku[1] (1767–1813). **N.**: Watanabe Iwao (Gen).[2] **A.**: Iseki.[3] **F.N.**: Isaburō[4], Kozaemon.[5] **Gō**: Nangaku.[6] **Biog.**: Maruyama painter. Born and lived in Kyōto. Pupil of Maruyama Ōkyo; later influenced by Kōrin. His work also shows traces of ukiyo-e influence. Late in his career moved to Edo, introducing the Maruyama style to the Kantō region. Eventually returned to Kyōto, where he died. Specialized in paintings of *bijin* and carp. Well known for his impromptu sketches. **Coll.**: Ashmolean, Freer, Museum (3), Stanford, Tōkyō (2), Victoria. **Bib.**: Brown; Hillier (3), (4) 3; K 278; Mitchell; Morrison 2; NBZ 5; Tajima (3) 2.

<div align="center">[1]南岳 [2]渡辺巌 [3]維石 [4]猪三郎 [5]小佐衛門 [6]南岳</div>

Nanka[1] (1819–66). **N.**: Haruki Rin.[2] **F.N.**: Sennosuke.[3] **Gō**: Dokugasai,[4] Empa Chōto,[5] Empa Gyoto,[6] Kaigasai,[7] Nanka.[8] **Biog.**: Japanese-style painter. Native of Edo. Son and pupil of Haruki Nammei. Specialized in *kachōga* and landscapes. **Bib.**: Mitchell.

<div align="center">[1]南華 [2]春木鱗 [3]扇之助 [4]読画斎
[5]烟波釣徒 [6]烟波漁徒 [7]絵画斎 [8]南華</div>

Nankai[1] (1677–1751). **N.**: Gion Mitsugu[2] (originally Seikei,[3] then Yu).[4] **A.**: Hakugyoku,[5] Johin,[6] Jomin.[7] **F.N.**: Yoichi,[8] Yoichirō.[9] **Gō**: Hōrai,[10] Kanraitei,[11] Kikyo,[12] Nankai,[13] Rishōhin,[14] Shōun,[15] Tekkan Dōjin,[16] Tekkanjin.[17] **Biog.**: *Nanga* painter. Lived in Wakayama. Son of a doctor; a Confucian of the daimyo clan of Kii Province. Became a teacher of Confucianism; by 1713 was head of a school of Confucian learning. Exiled from Wakayama for about ten years. On his return, concentrated on painting and calligraphy. Is known primarily as a calligrapher; also excelled as poet and author. Received title of *hōin*. His earliest paintings date from 1719. Knew *The Mustard-Seed Garden* in a Chinese edition—the book that became the primary source for the development of *bunjinga* and influenced his style. He said he followed Chao Ming-fu in calligraphy and T'ang Yin in painting; was also influenced by I Fu-chiu. His paintings, largely of flowers and plants and a few landscapes, were generally rendered in few colors and with dry brushstrokes. A major artist in the *bunjinga* tradition and one of the founders of the *nanga* school. **Coll.**: Tōkyō (1). **Bib.**: BI 9, 34; BK 127; Cahill; GNB 18; Jahss; K 223, 416, 684, 706, 811, 834, 858, 943; Minamoto (1); Murayama (2); NB (H) 23; NB (S) 4; NBT 5; NBZ 5; *Nihon* (2), (3); Noma (1) 2; OA 13; Paine (4); Rosenfield (2); Tajima (13) 7; Yonezawa.

<div align="center">[1]南海 [2]祇園貫 [3]正郷 [4]瑜 [5]伯玉（白玉） [6]汝斌
[7]汝珉 [8]与一 [9]与一郎 [10]蓬莱 [11]観雷亭 [12]箕踞
[13]南海 [14]履昌斌 [15]湘雲 [16]鉄冠道人 [17]鉄冠人</div>

Nankai[1] (fl. c. 1840). **N.**: Naruishi Tomonori.[2] **A.**: Shii.[3] **Gō**: Nankai.[4] **Biog.**: Painter. Lived and worked in Edo. **Bib.**: Mitchell.

<div align="center">[1]南海 [2]成石友儀 [3]士彝 [4]南海</div>

Nankaku[1] (1683–1759). *N.:* Hattori Genkyō.[2] *A.:* Shisen.[3] *F.N.:* Koemon.[4] *Gō:* Fukyokan,[5] Kan'ō,[6] Nankaku,[7] Shūsetsu.[8] Biog.: *Nanga* painter. Also a Confucian scholar. Born in Kyōto. At age of 14 to Edo to study under the Confucianist Ogyū Sorai. Later held a minor position in the *bakufu*. On his own, studied the paintings of Shūbun and Sesshū. Specialized in landscape and portraiture, working in the Chinese Ch'ing style based on album paintings that had reached Japan through Nagasaki. A pioneer *nanga* painter. Bib.: Mitchell, Yonezawa.
　　　　　[1]南郭　[2]服部元喬　[3]子遷　[4]小右衛門
　　　　　[5]芙蕖館　[6]観翁　[7]南郭　[8]周雪

Nankei[1] (fl. c. 1802). *N.:* Nishimura Seiko.[2] *A.:* Sankyō.[3] *Gō:* Nankei.[4] Biog.: Painter. Lived and worked in Kyōto. Bib.: Mitchell.
　　　　　[1]南渓　[2]西村正候　[3]三彊　[4]南渓

Nanko[1] (1759–1839). *N.:* Haruki Kon.[2] *A.:* Shigyo.[3] *F.N.:* Mon'ya.[4] *Gō:* Dombokuō,[5] Enka Chōsō,[6] Enka Gyosō,[7] Nanko,[8] Yūsekitei.[9] Biog.: *Nanga* painter. Born in Edo. At first in the service of Masuyama Setsusai, a member of the clan ruling at Tsu in Ise Province. Then became a pupil of Kimura Kenkadō. Later studied in Nagasaki at the expense of his patron and his teacher and there learned the Chinese manner. In his day was as well known a *nanga* painter as Tani Bunchō. Painted landscapes and *kachōga;* also left an illustrated diary called *Diary of a Journey to Western Japan.* Famous as a colorist. Coll.: Andrew, Art (1). Bib.: Mitchell, Morrison 2.
　　　　　[1]南湖　[2]春木鯤　[3]子魚　[4]門弥　[5]呑墨翁
　　　　　[6]烟霞釣叟　[7]烟霞漁叟　[8]南湖　[9]幽石亭

Nankoku[1] (1844–?). *N.:* Ozawa Nankoku.[2] Biog.: *Nanga* painter. Pupil of Okamoto Shūki. Worked in Edo. Coll.: Freer, Victoria. Bib.: Mitchell.
　　　　　[1]南谷　[2]小沢南谷

Nanrei[1] (1775–1844). *N.:* Suzuki Jun.[2] *A.:* Shishin.[3] *F.N.:* Isaburō.[4] *Gō:* Kansuiken,[5] Nanrei.[6] Biog.: Shijō painter. Born in Edo. Studied first under Maruyama Ōkyo's pupil Watanabe Nangaku; then to Kyōto, where he worked under Azuma Tōyō and Okamoto Toyohiko. Much later, served as official painter to the Makino, feudal lords in Tamba Province. Produced landscapes and *kachōga* marked by considerable lyricism. His best work is in album-size paintings. Coll.: Ashmolean, Musées, Museum (3), Victoria. Bib.: Brown; Hillier (2), (3), (4) 3; *Kunst;* Mitchell; Morrison 2.
　　　　　[1]南嶺　[2]鈴木順　[3]子信　[4]猪三郎　[5]観水軒　[6]南嶺

Nanreisai[1] (1771–1836). *N.:* Hara Harukata.[2] *Gō:* Nanrei,[3] Nanreidō,[4] Nanreisai.[5] Biog.: Nagasaki painter. Born in Nagasaki. Pupil of Yamamoto Jakurin. Adept in painting in both the Chinese and the Western manners, producing landscapes and figures. Coll.: Nagasaki.
　　　　　[1]南嶺斎　[2]原治堅　[3]南嶺　[4]南嶺堂　[5]南嶺斎

Nantei[1] (1775–1834). *N.:* Nishimura Yoshō.[2] *A.:* Shifū.[3] *Gō:* Nantei.[4] Biog.: Maruyama painter. Either a Kyōto or an Ōsaka man. Pupil of Maruyama Ōkyo. Painted figures, portraits, and *kachōga.* Coll.: Ashmolean, Rhode Island. Bib.: ARTA 6; Brown; Hillier (3), (4) 3; Holloway; Mitchell.
　　　　　[1]楠亭　[2]西村予章　[3]士風（子風）　[4]楠亭

Nantō[1] (1823–?). *N.:* Kanamori Kasei.[2] *Gō:* Nantō.[3] Biog.: *Nanga* painter. Pupil of Haruki Nanko. Specialized in figure painting. Lived into the Meiji era, but exact date of his death unknown. Bib.: Mitchell.
　　　　　[1]南塘　[2]金森可清　[3]南塘

Naokata[1] (1756–1833). *N.:* Shirai Naokata.[2] *A.:* Shisai.[3] *F.N.:* Chūhachirō.[4] *Gō:* Bunkyo.[5] Biog.: Maruyama painter. Worked in Kyōto. Pupil of Maruyama Ōkyo. Somewhat influenced by ukiyo-e school. Painted in a delicate manner, specializing in *kachōga* and paintings of animals, particularly white mice. A minor artist, also known as a calligrapher.

Coll.: Museum (3). Bib.: K 81, 98, 122, 797; Mitchell; Morrison 2; Tajima (12) 4.
　　　　　[1]直賢　[2]白井直賢　[3]子斎（士斎）　[4]忠八郎　[5]文挙

Naonobu[1] (1607–50). *N.:* Kanō Naonobu[2] (originally Kazunobu,[3] Ienobu).[4] *F.N.:* Shume,[5] Shumenosuke.[6] *Gō:* Jitekisai,[7] Shinsetsusai.[8] Biog.: Kanō painter. Born in Kyōto; worked in Kyōto and Edo. Son of Kanō Takanobu, younger brother of Tan'yū; pupil of both. Also studied under Kanō Kōi. In 1623 appointed *goyō eshi* to shogun's court. In 1626 worked with Tan'yū for Iemitsu in Nijō Castle. Summoned to Edo in 1630, where he was given an estate and founded the Kobikichō branch of the Kanō family. Instructed the shogun Hidetada in painting. He and Tan'yū the two great Kanō artists of the early Edo period. Painted in ink, using broad free brush strokes and light color washes. A painter of considerable elegance. Coll.: Art (1a), Brooklyn, Chidō, Chion-in, Freer, Honolulu, Musée (2), Museum (3), Nanzenji (Konchi-in), Nijō, Tokiwayama, Tōkyō (1), Victoria. Bib.: BI 52; Doi (1); *Freer; Japanese* (1), (1a); K 139, 159, 270, 274, 281, 304, 328, 340, 414, 422, 562, 580, 682; *Kanō-ha;* Morrison 1; NB (H) 14; NBZ 4; *One* (2); Paine (2) 2, (3), (4); SBZ 9; Tajima (12) 12, 18; Tajima (13) 5.
　　　　　[1]尚信　[2]狩野尚信　[3]一信　[4]家信
　　　　　[5]主馬　[6]主馬助　[7]自適斎　[8]真説斎

Naotaka[1] (1753–1807). *N.:* Awataguchi Naotaka.[2] *Gō:* Kakusai,[3] Keiju,[4] Keiu,[5] Shakukaisai.[6] Biog.: Sumiyoshi painter. Son and pupil of Awataguchi Keiu Naoyoshi. A minor artist in the service of the shogunate.
　　　　　[1]直隆　[2]粟田口直隆　[3]蝮斎　[4]慶受
　　　　　[5]慶羽（珪羽）　[6]尺蝮斎

Naotake[1] (1749–80). *N.:* Odano Naotake.[2] *A.:* Shibetsu.[3] *F.N.:* Busuke.[4] *Gō:* Gyokusen,[5] Uyō.[6] Biog.: *Yōga* painter. Lived in Akita as a retainer of Satake Shozan, daimyo of Akita. Considerable talent from an early age. Studied Western-style painting under Hiraga Gennai, who had been invited to Akita by the daimyo, learning the theory and methods of the new art. Became a leading member of the *yōga* school in Akita, acting as teacher to his lord. Also associated with Japanese scholars of Dutch learning when he was in Edo. His *kachōga* are rendered in a decidedly Western manner. Also illustrated a book on Western medicine. His work a competent mixture of East and West, with more quality than most of the school. Coll.: Akita, Kōbe. Bib.: BI 70; GNB 25; K 789, 849, 938; M 187; Mody; Moriya; NB (H) 24; NBZ 5; Noma (1) 2; *Pictorial* (2) 2; Sohō; TBS 2; YB 49.
　　　　　[1]直武　[2]小田野直武　[3]子別
　　　　　[4]武助　[5]玉泉（玉川）　[6]羽陽

Naotomo[1] (?–1597?). *N.:* Isshiki Naotomo.[2] *Gō:* Getsuan,[3] Rosetsu.[4] Biog.: Muromachi *suiboku* painter. Lived in Mikawa; a minor member of the Isshiki family, feudal lords in Musashi Province. Said to have studied Sesshū's technique and that of the Chinese painter Yü-chien; also followed the style of Toki Tōbun, to whom he may have been related. Noted for his landscapes and *kachōga.* Also a poet. Bib.: BK 12; K 124, 276, 346; Matsushita (1a); NKZ 12.
　　　　　[1]直朝　[2]一色直朝　[3]月庵　[4]蘆雪

Naritoki[1] (941–95). *N.:* Fujiwara no Naritoki.[2] Biog.: Painter. Another of the early figures in Japanese art history known only from literary records. A high-ranking courtier, served as Edokoro *azukari*. Said to have done some of the paintings at the imperial palace.
　　　　　[1]済時　[2]藤原済時

Natori Shunsen[1] (1886–1960). Biog.: Printmaker, illustrator. Worked for various newspapers, specializing in caricatures of actors. Coll.: National (5), Staatliche. Bib.: Fujikake (1), Schmidt.
　　　　　[1]名取春仙

Neagari Tomiji[1] (1895–). Biog.: Japanese-style painter. Born in Yamagata-ken. Graduated from the Tōkyō School of

Fine Arts in 1922. Founding member of the Nihongain. **Coll.**: National (5). **Bib.**: Asano.

¹根上冨治

Nichokuan¹ (fl. first half 17th c.). *N.:* Soga Tsugu.² *F.N.:* Sahei.³ *Gō:* Chokuanni,⁴ Nichokuan.⁵ **Biog.:** Soga painter. Lived in Sakai. Son and pupil of Soga Chokuan, who founded the Soga school. Some of his paintings have inscriptions by the famous Zen priest Takuan, a favorite of the shogun Iemitsu. Used the same seal as his father; as a result, their paintings are often confused. Specialized in painting falcons; his reputation almost as great as his father's. **Coll.:** Baltimore, Daitoku-ji, Freer, Museum (3), Ōkura, Staatliche. **Bib.:** ARTA 5; BK 66; GNB 13; K 20, 92, 127, 138, 365, 400, 576, 599; Minamoto (2); Morrison 1; NB (H) 14; NKZ 4; Paine (4); Shimada 2; Tajima (12) 10, (13) 5.

¹二直庵 ²曽我嗣 ³左兵衛 ⁴直庵二 ⁵二直庵

Niiro Chūnosuke¹ (1868–1954). *Gō:* Kosetsu.² **Biog.:** Sculptor. Born in Kagoshima. In 1894 graduated from the Tōkyō School of Fine Arts, teaching there as an assistant the following year. In 1898 in charge of the sculpture section of the Nihon Bijutsuin. Noted for his knowledge about the preservation of antiquities and ancient buildings. After 1945 was largely engaged in repairing and making copies of National Treasures. **Bib.:** Asano, BK 184, NB (H) 24.

¹新納忠之助 ²古拙

Nikka¹ (?–1845). *N.:* Tanaka Nikka.² *A.:* Hakki (Hakuki).³ *F.N.:* Benji.⁴ *Gō:* Fumei,⁵ Getcho,⁶ Tsuki-o-nagisa.⁷ **Biog.:** Shijō painter. Born in Kyōto. Pupil of Okamoto Toyohiko. An able painter of *kachōga*, landscapes, portraits. **Coll.:** Ashmolean, Museum (3). **Bib.:** Brown, *Dessins,* Holloway, Mitchell.

¹日華 ²田中日華 ³伯暉 ⁴弁二 ⁵不明 ⁶月渚 ⁷月を渚

Ninkai¹ (953–1046). *N.:* Miyamichi.² *Priest name:* Ono.³ *Gō:* Ninkai.⁴ **Biog.:** Buddhist painter. Priest at the Daigo-ji, founder of the Ono Zuishin-in. Given nickname of Ame Sōjo⁵ because of his success in praying for rain. Tradition says he was a good painter of portraits and *mandara*.

¹仁海 ²宮道 ³小野 ⁴仁海 ⁵雨僧正

Ninkai¹ (1696–1761). *A.:* Kaiun.² *Gō:* Hakuka,³ Mugaishi.⁴ **Biog.:** Buddhist painter. A priest at the Zōjo-ji, Edo. Painter of Buddhist subjects. Also a calligrapher.

¹忍海 ²海雲 ³日華 ⁴無礙子

Ninsei¹ (c. 1574–1660/6). *N.:* Nonomura Seiemon.² *F.N.:* Seibei,³ Seisuke.⁴ *Gō:* Ninsei.⁵ **Biog.:** Painter, potter. Born in Nonomura, Tamba Province; lived and worked in Kyōto. With Kenzan and Mokubei, the "Three Great Potters of Kyōto." Originator of the Kyōto school of art potters. Allowed to use the character *nin* in his *gō* by the abbot of the Ninna-ji, who was his patron and in front of whose temple he had his kiln. First made wares for the tea ceremony; then turned to refined pottery decorated with bright enamels and gold and silver, producing large storage jars as well as a great variety of small objects. His style became the ideal of Kyōto potters and has been continued by many of them, with decreasing taste. Great technical ability; either learned the technique of *kyō-yaki* (use of enamels on pottery) from the Awataguchi kilns or invented it himself. His designs owe much to contemporary Kanō and Rimpa schools of painting: the use of a black ground in lacquerwares, of a gold ground in screens. Perhaps the most admired ceramic artist of Japan. His work at times suffers from too much gold and opaque color, but it is always striking and reflects the gorgeousness of the Momoyama period. Also made a Shigaraki-type ware with simple designs in strong contrast to his more usual highly decorated pieces. **Coll.:** Atami, Freer, Fujita, Hakone, Hatakeyama, Idemitsu, Ishikawa, Kinkaku-ji, Manshu-in, Matsunaga, Metropolitan, Museum (3), Newark, Nezu, Ninna-ji, Ōkura, Philadelphia, Tokiwayama, Tōkyō (1), Umezawa, Worcester, Yamato. **Bib.:**

BK 30, 83, 141, 216; *Ceramic* (1); Feddersen; *Freer;* Fujioka; GK 12; GNB 19; Hayashiya (1); Jenyns (1); K 208, 813; KO 29, 39; *Kokuhō* 6; Koyama (1), (1a), (3), (5); Leach; Lee (1), (2); M 111, 144, 172; Mayuyama; Mikami; Miller; NB (S) 14, 28, 71; NBT 6; NBZ 5; *Nihon* (1), (8); Noma (1) 2; Okuda (1), (2); *One* (1); P 4; Satō; SBZ 9; *Selected;* Shimada 2; STZ 5, 7; Tanaka (10); TZ (K) 24; Yamada; Yashiro (1) 2; YB 3, 35, 36.

¹仁清 ²野々村清右衛門 ³清兵衛 ⁴清助 ⁵仁清

Nipponsai¹ (fl. early 19th c.). **Biog.:** Ukiyo-e printmaker. Lived and worked in Kyōto. Member of the Kamigata-e school, his actor prints are in the style of Ryūkōsai. It is possible this is the *gō* of another artist. **Bib.:** NHBZ 3.

¹日本斎

Nishii Keigaku¹ (1880–1937). *N.:* Nishii Keijirō.² *Gō:* Keigaku.³ **Biog.:** Japanese-style painter. Born in Fukui-ken. Pupil of Yamamoto Shunkyo. Exhibited with various organizations in Gifu and Kyōto and, after 1907, with the Bunten.

¹西井敬岳 ²西井敬次郎 ³敬岳

Nishimura Goun¹ (1877–1938). *N.:* Nishimura Genjirō.² *Gō:* Goun.³ **Biog.:** Japanese-style painter. Lived in Kyōto. Pupil first of Kishi Chikudō, later of Takeuchi Seihō. Showed with the Nihon Bijutsu Kyōkai and then with the Zenkoku Kaiga Kyōshinkai. Prize winner at the first Bunten; member of and frequent juror for the Teiten. Also a member of the Imperial Art Academy. Professor at various Kyōto art schools. His subjects included flowers, fish, animals, and birds. Second-generation modern Kyōto school, heir to Seihō's manner. **Coll.:** Kyōto (1), National (4), Tōkyō (2), Yamatane. **Bib.:** Asano, Elisséev, NB (H) 24, NB (S) 17, NBZ 6, Uyeno.

¹西村五雲 ²西村源次郎 ³五雲

Nishimura Zengorō¹ (?–1558). **Biog.:** Potter. A Shintō priest who founded a family of potters, known much later under the name of Eiraku.² At least thirteen generations followed him. The early members of the family made pottery images and charcoal braziers near Nara. Later, probably in late 17th or early 18th century, the family moved to Kyōto and made tea-ceremony wares. See under Hozen and Wazen. **Bib.:** Jenyns (2), NB (S) 71.

¹西村善五郎 ²永楽

Nishiyama Suishō¹ (1879–1958). **Biog.:** Japanese-style painter. Born and worked in Kyōto. Pupil and son-in-law of Takeuchi Seihō. Exhibitor with the Teiten; frequent prize winner. With Kikuchi Keigetsu, one of the important figures in the Kyōto art world. Head of the Kyōto College of Fine Arts. Member of the Nihon Bijutsuin, the Imperial Art Academy, and the Art Committee for the Imperial Household. In 1957 received Order of Cultural Merit. Painted landscapes and figures. An interesting colorist whose works contrast flat areas of color with careful attention to details and some hint of Western modeling. Strong Shijō influence. **Coll.:** Kyōto (1); National (4), (5). **Bib.:** Asano, Elisséev, Kondō (6), NB (H) 24, NBZ 6.

¹西山翠嶂

Nishizawa Tekiho¹ (1889–1965). *N.:* Nishizawa (originally Ishikawa)² Kōichi.³ *Gō:* Tekiho.⁴ **Biog.:** Japanese-style painter. Adopted by the Nishizawa family on marrying a daughter of the family. In 1913 became a pupil of Araki Kampo; then, on Kampo's death, studied under Araki Juppo. From 1915 exhibited with the Bunten, becoming a juror for the society in 1934. Known for his study of dolls. In 1935–36 traveled in the South Pacific to study the local sculpture. After 1945 became a member and exhibitor with the Nitten. Also a member of the National Commission for the Protection of Cultural Properties. His paintings have much charm and novelty. **Coll.:** National (5). **Bib.:** Asano.

¹西沢笛畝 ²石川 ³西沢昻一 ⁴笛畝

Niten¹ (1584–1645). *N.:* Miyamoto Masana.² *A.:* Shichino-

suke;[3] later, Tomojirō.[4] *Gō:* Dōraku,[5] Genshinsai,[6] Musashi,[7] Niten.[8] **Biog.:** Kanō painter. Also sculptor, calligrapher, metalworker, swordsman. Son of Shimmen Munisai, a samurai of Harima Province. Orphaned by war, adopted by daimyo family of Miyamoto. In the last years of his life, lived in Kumamoto and served the Hosokawa family. Pupil of Kaihoku Yūshō. Often painted shrikes and fighting cocks. About ten of his paintings still exist. A far greater artist than the usual Kanō painter of his time. His painting, in ink only, very spontaneous, individual, yet close to Tōhaku and Yūshō; also shows influence of Sung-Yüan painting. A famous swordsman and fencer; hence Japanese critics see something aggressive, sharp, and keen in his line. **Coll.:** Eisei, Matsunaga, Philadelphia, Tokugawa. **Bib.:** BK 58, 74; *Exhibition* (1); Fontein (2); GNB 11; Grilli (1); Hisamatsu; HS 1, 3, 6, 12; K 62, 117, 183, 194, 251, 267, 318, 358, 485, 579, 581, 704; KO 5, 7, 32; Lee (1); Moriya; Morrison 1; NBT 5; NBZ 4; NKZ 67, 75, 84; Noma (1) 2; SBZ 9; Tajima (12) 3, 6; Tajima (13) 5.

¹二天　²宮本政名　³七之助　⁴友次郎　⁵道楽
⁶玄信斎　⁷武蔵（無三四）　⁸二天

Nittō[1] (1817–73). *N.:* Hishida Nittō.[2] *Gō:* Raisei,[3] Rinsen.[4] **Biog.:** Shijō painter. Born in Kyōto. Studied under Tanaka Nikka and Nakajima Raishō. Specialized in landscapes and *kachōga.* **Coll.:** Ashmolean. **Bib.:** Mitchell.

¹日東　²菱田日東　³来成　⁴林泉

Niwa Rimpei[1] (1870–1919). **Biog.:** Western-style painter. Born in Tōkyō. Studied first at Yamamoto Hōsui's school the Seikōkan, then at Kuroda Seiki's and Kume Keiichirō's school the Tenshin Dōjō. Eventually graduated from the Tōkyō School of Fine Arts in 1898. Member of the Hakubakai. **Bib.:** Asano, NBZ 6.

¹丹羽林平

Nōami[1] (1397–1471). *N.:* Nakao Shinnō.[2] *F.N.:* Nōami.[3] *Gō:* Ōsai,[4] Shūhō,[5] Shun'ōsai.[6] **Biog.:** Muromachi *suiboku* painter. A courtly aesthete, master of all the arts: poet, tea master, landscape gardener. Lived in Kyōto. Father of Geiami, grandfather of Sōami; the three generations known as the San'ami. Pupil of Shūbun; influenced by Mu-ch'i. Copied works of Ma Lin and Reien Mokuan. A painter in his leisure time. First served the Asakura family in Echizen; then returned to Kyōto and became a sort of priest-in-waiting to Ashikaga Yoshimasa, serving also as a judge of paintings and calligraphy (he was a *dōbōshū,* or cultural adviser, to the Ashikaga shogun's household) and cataloguing the shogun's collection. It is said that by his family's example, art criticism became a hereditary profession in Japan. Also repaired old paintings. Specialized in landscapes; few authentic works have survived. **Coll.:** British, Metropolitan, Museum (3), Staatliche, Tokiwayama, Tōkyō (1), Victoria. **Bib.:** *Ausgewählte;* Awakawa; BK 53; GNB 11; HS 1, 7; *Japanese* (1); K 41, 154, 261; KO 36; Matsushita (1), (1a); Morrison 1; NB (S) 13; NBT 4; Noma (1) 1; *One* (2); Paine (4); PTN 1971; SBZ 7; Tajima (12) 3, 7; Tajima (13) 3; Tanaka (2); Yashiro (1); Yoshimura.

¹能阿弥　²中尾真能　³能阿弥　⁴鴎斎　⁵秀峰　⁶春鴎斎

Nobufusa[1] (fl. 1716–36). *N.:* Okumura Nobufusa.[2] **Biog.:** Ukiyo-e printmaker. Pupil of Masanobu. Made prints in black-and-white, adding touches of lacquer. **Coll.:** Staatliche. **Bib.:** Schmidt.

¹信房　²奥村信房

Nobuharu[1] (fl. late 16th to early 17th c.). *N.:* Hasegawa Nobuharu.[2] *Gō:* Tōhaku.[3] **Biog.:** Hasegawa painter. Considerable confusion surrounds this name. Has been considered to be three different people: 1) the same person as Hasegawa Kyūzō, but the portraits and Buddhist paintings bearing his signature differ in style from Kyūzō's accepted work; 2) a son of Tōhaku, working as a professional portrait painter who may have used his father's *gō* of Tōhaku late in life; and 3) Tōhaku himself. The second theory is generally thought the more probable. **Coll.:** Jōkei-in, Myōkoku-ji, Seikei-in, Shōgaku-in, Tōkyō (1), University (2). **Bib.:** Akiyama (2); BB 19; BI 45; GNB 13; K 712, 810; NBT 5; NBZ 4; Noma (1) 2; *Pictorial* (1) 3; SBZ 8; Shimada 2.

¹信春　²長谷川信春　³等伯

Nobuhiro[1] (fl. c. 1830–44). *N.:* Hasegawa Nobuhiro.[2] **Biog.:** Ukiyo-e printmaker. Lived and worked in Ōsaka. Pupil of Hasegawa Sadanobu. **Coll.:** Musées, Victoria.

¹信広　²長谷川信広

Nobukata[1] (fl. late 16th to early 17th c.). **Biog.:** *Yōga* painter. Copied Western prints and produced some of the best Western-style painting of the late 16th to early 17th century. The name Nobukata, if the reading is correct, comes from a seal found on these paintings. However, nothing is really known of his life, though it has been suggested that he was a seminarian in a Jesuit school who learned Western painting techniques and who was later converted to Buddhism. **Coll.:** Kōbe, Yamato. **Bib.:** BK 39, 126; K 792; *Namban;* SBZ 8; *Selected;* Sullivan; YB 3.

¹信方

Nobukatsu[1] (fl. c. 1830–44). *N.:* Utagawa Nobukatsu.[2] *Gō:* Tessai.[3] **Biog.:** Ukiyo-e printmaker. Pupil of Utagawa Sadamasu and Yanagawa Shigenobu. Worked in Ōsaka, producing prints of actors and *bijin.* **Coll.:** Victoria. **Bib.:** *Ukiyo-e* (3) 19.

¹信勝　²歌川信勝　³哲斎

Nobukazu[1] (fl. late 19th c.). *N.:* Watanabe Nobukazu.[2] *F.N.:* Jirō.[3] *Gō:* Yōsai.[4] **Biog.:** Printmaker. Pupil of Toyohara Chikanobu. Portrayed the Sino-Japanese War of 1894–95. **Coll.:** Victoria.

¹延一　²渡辺延一　³次郎　⁴楊斎

Nobukiyo[1] (fl. 1711–36). *N.:* Kawashima Nobukiyo.[2] **Biog.:** Ukiyo-e illustrator. Lived in Kyōto. Influenced by Sukenobu. Illustrated many of the popular novels of his time. **Bib.:** Brown.

¹叙清（信清）　²川島叙清（川島信清）

Nobumasa[1] (1607–58). *N.:* Kanō Nobumasa.[2] *F.N.:* Mansuke;[3] later, Geki.[4] *Gō:* Sosen.[5] **Biog.:** Kanō painter. Son of Kanō Soyū Hidenobu; pupil of his father and Kanō Eitoku. Son-in-law of Tan'yū. Became second generation of the Saruyamachi branch of the Kanō school and *goyō eshi* to the shogunate. Painted landscapes and portraits. **Coll.:** Chion-in, Museum (3), Rijksmuseum (2), Tōkyō (1), Victoria. **Bib.:** Doi (1).

¹信政　²狩野信政　³万助　⁴外記　⁵素川

Nobuo[1] (1601–39). *N.:* Kawakubo Nobuo.[2] **Biog.:** Painter. Born in Kai Province, son of a samurai. Became an official of the *bakufu* and was given the nominal title of governor of Echizen Province. Studied painting by himself. Specialized in pictures of falcons.

¹信雄　²河窪信雄

Nobusada[1] (fl. early 12th c.). *N.:* Kose Nobusada.[2] **Biog.:** Court painter. His surname is given as Kose, though he is not included in the Kose genealogy. According to records, painted events at court in 1108 and sliding partitions for a new palace building in 1113.

¹信貞　²巨勢信貞

Nobushige[1] (fl. mid-11th c.?). *N.:* Kose no Nobushige.[2] **Biog.:** Kose painter. According to the Kose genealogical chart, seems to have been a son of Kose no Koreshige and grandson of Kose no Hirotaka; but some sources give him a date a century later, saying he worked in collaboration with Ōgen (fl. 1132–40). Became Edokoro *azukari* at the imperial court and is recorded as having painted a portrait of the famous poet Kakinomoto no Hitomaro.

¹信茂　²巨勢信茂

Nobutada[1] (1565–1614). *N.:* Konoe Nobusuke[2] (originally Nobumoto).[3] *Priest name:* Sammyakuin.[4] *Gō:* Nobutada.[5] **Biog.:** *Zenga* painter. Also a calligrapher. Lived in Kyōto; son of the courtier Sakihisa, member of the aristocracy of the

imperial court; held position of *sadaijin* (Minister of the Left). One of the three greatest calligraphers of the Muromachi and early Edo periods. In painting he used the broad, sketchy, almost amateurish style typical of the *zenga* spirit. **Coll.:** Detroit, Itsuō, Tokiwayama, Zenrin-ji. **Bib.:** Awakawa, Brasch (2), *Japanese* (1), SBZ 8.

¹信尹 ²近衛信輔 ³信基 ⁴三藐院 ⁵信尹

Nobuyuki[1] (fl. early 18th c.). *N.:* Kūmeidō Nobuyuki.[2] **Biog.:** Ukiyo-e painter. Known from the signature on a few paintings of *bijin* in the Kaigetsudō manner. Perhaps a follower of Kaigetsudō Ando. **Bib.:** M 18, Tajima (7) 3.

¹信之 ²空明堂信之

Nobuzane[1] (1176–1265). *N.:* Fujiwara no Nobuzane.[2] *Priest name:* Jakusai.[3] **Biog.:** *Yamato-e* painter. Son and pupil of Fujiwara no Takanobu. Eventually retired to become a priest, taking the name of Jakusai. Believed to have spent some time at the Kōzan-ji. No existing painting can definitely be ascribed to him; the most likely attribution is the series of *The Thirty-six Poets,* now scattered in various collections. Among the paintings attributed to him (some doubtfully) are *Kegon Engi* (Kōzan-ji); *Zuishin Teiki Emaki,* with an inscription saying it was painted by Nobuzane c. 1247 (Ōkura); *Kitano Tenjin Engi* (Kitano Temmangū); *Murasaki Shikibu Nikki Emaki* (Gotō and Fujita); a portrait of the cloistered emperor Gotoba (Minase-jingū). Known as the most eminent court painter of his time, specialized in portraits done in a manner known as *nise-e* ("painting that resembles reality"). Was also famous for his fine line drawing. **Coll.:** Freer, Fujita, Gotō, Kitano, Kōzan-ji, Metropolitan, Minase-jingū, Ōkura, Yamato. **Bib.:** AA 14; BI 21; Buhot, *Exhibition* (1); *Freer,* Ienaga; K 27, 36, 42, 86, 679, 750, 751, 754; *Kokuhō* 3; Minamoto (1); Morrison 1; NB (H) 10; NBT 4; NEZ 8; Okudaira (1); *One* (2); Paine (4); Tajima (12) 3, 17; Tajima (13) 2; Tanaka (2); Toda (2); YB 25.

¹信実 ²藤原信実 ³寂西

Noda Hideo[1] (1908–39). **Biog.:** Western-style painter. Born in California. His short life was divided between America and Japan. Worked on the murals at Rockefeller Center, New York, and was a frequent prize winner at exhibitions. Member of the Shinseisaku Kyōkai. His work shows the influence of the School of Paris, particularly of Pascin. **Coll.:** National (5). **Bib.:** Asano, NBZ 6, SBZ 11.

¹野田英夫

Noda Kyūho[1] (1879–1971). *N.:* Noda Dōsan.[2] *Gō:* Kyūho.[3] **Biog.:** Japanese-style painter. Graduate of Tōkyō School of Fine Arts; also studied Western-style painting at the Hakuba-kai. Pupil of Terazaki Kōgyō. At one time worked for the Asahi Shimbun in Ōsaka. Showed with the Bunten and the Nitten. Founding member of the Nihongain; member of Japan Art Academy. Painted both historical and Buddhist subjects. Although his technique is basically Japanese, there is much Western influence in his work. **Coll.:** National (5). **Bib.:** Asano, NB (S) 17, NBZ 6.

¹野田九浦 ²野田道三 ³九浦

Noguchi Kenzō[1] (1901–44). **Biog.:** Western-style painter. Born in Shiga-ken. In 1924 graduated from the Tōkyō School of Fine Arts. After 1929 showed with the Teiten; in 1943 became a juror for the Bunten. Member of Tōkōkai. Eventually returned to Shiga-ken. An able landscape painter. **Coll.:** National (4). **Bib.:** Asano.

¹野口謙蔵

Noguchi Shōhin[1] (1847–1917). *N.:* Noguchi (originally Matsumura)[2] Chikako.[3] *A.:* Seien.[4] *Gō:* Shōhin.[5] **Biog.:** Japanese-style painter. Born in Ōsaka; daughter of a doctor. Moved to Kyōto, where she was a pupil of Hine Taizan. In 1871 moved to Tōkyō. Taught painting to several children of the imperial household. Exhibited with the Nihon Bijutsu Kyōkai and the Bunten. Member of the Art Committee of the Imperial Household. She and Okuhara Seiko regarded as the two distinguished women painters in the *nanga* field. Specialized in landscape, working, with considerable talent, in the *nanga* manner. **Bib.:** Asano, Mitchell, Morrison 2, NB (S) 17, NBZ 6, Uyeno.

¹野口小蘋 ²松村 ³野口親子 ⁴清婉 ⁵小蘋

Noguchi Yatarō[1] (1899–). **Biog.:** Western-style painter. Born in Tōkyō. Studied at the Kawabata Kenkyūsho. Showed with the Nikakai. In 1926 joined the 1930 Association. In France from 1929 to 1933; exhibited at several of the Paris salons. On his return to Tōkyō became a member of the Dokuritsu Bijutsu Kyōkai. Exhibited at the Tōkyō Biennial. In Europe again in 1960–62. In 1964 received the Mainichi Art Prize. Also a lithographer. His style shows the influence of the School of Paris of the 20s. **Coll.:** Kanagawa, National (5). **Bib.:** Asano, NB (H) 24, NBT 10, NBZ 6.

¹野口弥太郎

Nohara Teimei[1] (1868–1911). *N.:* Nohara Ishigorō.[2] *Gō:* Teimei.[3] **Biog.:** Sculptor, lacquerer. Born in Musashino Province. Studied the art of lacquer under a member of the Nakayama family and sculpture with Ishikawa Kōmei. Excelled in the carving of horn. **Coll.:** Tōkyō (2).

¹野原貞明 ²野原石五郎 ³貞明

Nomura Bunkyo[1] (1854–1911). *N.:* Nomura Shiyū.[2] *A.:* Shiyū.[3] *Gō:* Bunkyo,[4] Sekisen.[5] **Biog.:** Japanese-style painter. Born in Kyōto. Studied under Umekawa Tōkyo; then under Shiokawa Bunrin and Mori Kansai. In 1880 taught at the Kyōto Prefectural School of Painting. In 1889 moved to Tōkyō; became a professor at the Peers' School. A prize winner at the first Bunten and a juror for several subsequent shows. Commissioned to work at the Tōkyō Imperial Palace. His specialty was landscapes painted in ink. **Coll.:** Ashmolean, Metropolitan. **Bib.:** Asano, Mitchell, Morrison 2, NB (S) 17, NBZ 6.

¹野村文挙 ²野村子融 ³子融 ⁴文挙 ⁵石泉

Nomura Yoshikuni[1] (1855–1903). *N.:* Nomura Yoshikuni.[2] *F.N.:* Yoshichi.[3] *Gō:* Ichiyōtei,[4] Shōō.[5] **Biog.:** Ukiyo-e printmaker. Born in Kyōto. Pupil of Nakajima Yoshiume, influenced by Hasegawa Sadanobu. Specialized in scenes of Kyōto and Ōsaka. His style varies from traditional ukiyo-e to part Western. **Coll.:** Musée (2), Musées, Victoria. **Bib.:** NHBZ 7.

¹野村芳国 ²野村芳国 ³与七 ⁴一陽亭 ⁵笑翁

Nonagase Banka[1] (1888–1965). *N.:* Nonagase Hiro-o.[2] *Gō:* Banka.[3] **Biog.:** Japanese-style painter. First studied painting in Ōsaka when he was fifteen; later to Kyōto to study under Taniguchi Kōkyō. Also studied at the Kyōto College of Fine Arts, graduating in 1911. Never showed at any of the government-sponsored exhibitions. In 1918, with Tsuchida Bakusen, Ono Chikkyō, Murakami Kagaku, Irie Hakō and Sakakibara Shihō, established the Kokuga Sōsaku Kyōkai. Studied in Paris from 1921 to 1923. **Bib.:** Asano, NBZ 6.

¹野長瀬晩花 ²野長瀬弘男 ³晩花

Norinobu[1] (1692–1731). *N.:* Kanō Suenobu[2] (later, Naganobu or Eishin;[3] then, Sukemori;[4] finally, Eishin).[5] *F.N.:* Shirojirō.[6] *Gō:* Norinobu.[7] **Biog.:** Kanō painter. Eldest son of Kanō Eishuku. Became tenth-generation head of the Nakabashi branch of the Kanō line. **Coll.:** Museum (3).

¹憲信 ²狩野季信 ³永信 ⁴祐盛 ⁵永真 ⁶四郎次郎 ⁷憲信

Norisue[1] (fl. c. 1175). **Biog.:** Lacquerer. One of the earliest recorded Japanese lacquer artists. **Bib.:** Herberts, Jahss.

¹則季

Nousu Kōsetsu[1] (1885–). *N.:* Nousu Nobuta.[2] *Gō:* Kōsetsu.[3] **Biog.:** Japanese-style painter. Born in Kagawa-ken. Graduated from Tōkyō School of Fine Arts. Specialized in Buddhist painting. In 1932 to Benares, India, and to Sarnath, where he painted a mural of the life of the Buddha. Also painted a mural at the Zenkō-ji, Nagano. **Coll.:** Zenkō-ji. **Bib.:** Asano.

¹野生司香雪 ²野生司述太 ³香雪

Nozaki Hōsei[1] (1821–1910). *N.:* Nozaki Shin'ichi.[2] *Gō:* Hōsei.[3] **Biog.:** Painter. Follower of Hōitsu. **Coll.:** Ashmolean. **Bib.:** Mitchell.

<div align="center">[1]野崎抱青 [2]野崎真一 [3]抱青</div>

Numata Kashū[1] (1838–1901). *N.:* Numata Masayuki.[2] *Gō:* Bokusai,[3] Kashū.[4] **Biog.:** Japanese-style painter. A nobleman from Owari Province; probably lived most of his life in Nagoya. Pupil of his grandfather Numata Gessai, who had studied ukiyo-e under Maki Bokusen and *bunjinga* under Baiitsu. In 1888 helped decorate the Meiji-era Imperial Palace. **Coll.:** Victoria. **Bib.:** Mitchell.

<div align="center">[1]沼田荷舟 [2]沼田正之 [3]朴斎 [4]荷舟</div>

Numata Kazumasa[1] (1873–1954). **Biog.:** Potter. Born in Fukui-ken. Studied sculpture under Takeuchi Kyūichi. Then to France, where at the Sèvres porcelain factory he studied the European technique of ceramic sculpture, which he later introduced into Japan. Taught at the Tōkyō School of Fine Arts; served as juror for the Teiten. **Coll.:** Tōkyō (1), (2). **Bib.:** NBZ 6.

<div align="center">[1]沼田一雅</div>

Nuribe no Otomaro[1] (fl. 8th c.). **Biog.:** Sculptor. His name was discovered in 1918 in an inscription on the pedestal of the figure of Roshana Buddha in the Kondō of the Tōshōdai-ji, Nara; the inscription states that the statue was carved by him. Nothing known about his life. **Coll.:** Tōshōdai-ji. **Bib.:** Yashiro (1) 1.

<div align="center">[1]漆部弟麿</div>

O

Oana Ryūichi[1] (1894–1966). **Biog.:** Western-style painter. Born in Nagasaki; worked in Tōkyō. Studied at the Taiheiyō Kenkyūsho. First showed with the Nikakai, then with the Shun'yōkai. His paintings, rendered with a light palette, are quite realistic. **Bib.:** Asano.

<div align="center">[1]小穴隆一</div>

Ōbun[1] (1833–87). *N.:* Kunii Ōbun.[2] *A.:* Chūshitsu.[3] *Gō:* Sansansai.[4] **Biog.:** Maruyama painter. Born in Edo. His mother was the younger sister of Maruyama Ōshin; he was, hence, in direct Maruyama line and came to be considered as head of the fifth Maruyama generation. Studied under Maruyama Ōritsu; carried Maruyama tradition into the Meiji era. Worked on paintings for the Kyōto Imperial Palace when it was rebuilt in the 1850s. An able painter of landscapes and *kachōga*. Followed by his son Ōyō[5] (1868–1923), who was adopted by the Maruyama family and became the sixth-generation head. **Coll.:** Ashmolean. **Bib.:** Mitchell.

<div align="center">[1]応文 [2]国井応文 [3]仲質 [4]彬々斎 [5]応陽</div>

Ōchi Shōkan[1] (1882–1958). *N.:* Ōchi Tsuneichi.[2] *Gō:* Shōkan.[3] **Biog.:** Japanese-style painter. Born in Aichi-ken. Graduated from Tōkyō School of Fine Arts in 1902. In 1913 received a prize at the Bunten. Showed with the Inten, becoming very active with that group. In 1930 to Europe on a cultural mission. After 1945 showed with the Nitten. Member of the Japan Art Academy. His paintings, executed in quite a detailed manner and with considerable Western feeling, are often quite romantic. **Coll.:** National (5). **Bib.:** Asano.

<div align="center">[1]大智勝観 [2]大智恒一 [3]勝観</div>

Ōchi Yoshinori[1] (fl. Muromachi period). **Biog.:** Sculptor. Recorded as having specialized in female masks for the Nō theater. No works can be definitely assigned to him.

<div align="center">[1]越智吉舟</div>

Ochiai Rōfū[1] (1896–1937). *N.:* Ochiai Heijirō.[2] *Gō:* Rōfū.[3] **Biog.:** Japanese-style painter. Born in Tōkyō. Pupil of Komura Taiun. Exhibited with the Bunten, the Inten, the Teiten and the Seiryūsha. Finally founded his own Meirō Bijutsu Remmei. Famous for his painting called *Eva.* Style at first simple and lyrical; developed into a decorative stylization. **Coll.:** National (5). **Bib.:** Asano, NBZ 6.

<div align="center">[1]落合朗風 [2]落合平治郎 [3]朗風</div>

Oda Kazumaro[1] (1882–1956). **Biog.:** Printmaker. Born in Tōkyō. Studied Western painting under Kawamura Kiyo-o. Founding member of Nihon Sōsaku Hanga Kyōkai and the Yōfū Hangakai. Also known as a scholar of ukiyo-e, publishing two books on the subject: *Ukiyo-e Jūhachi Kō* and *Ukiyo-e to Sashie Geijutsu.* Showed with the Bunten and the Teiten and, after 1945, with the Nitten. A leading printmaker of the 20s and 30s, working largely in color lithographs, depicting city and country scenes in a largely realistic Western manner, with Japanese touches and impressionist coloring. A soft, calm, lyric style. **Coll.:** Cincinnati, Musées, National (5), Staatliche, University (2). **Bib.:** Asano; Fujikake (1); NBZ 6; NHBZ 7; Schmidt; UG 4, 11.

<div align="center">[1]織田一磨</div>

Odake Chikuha[1] (1878–1936). *N.:* Odake Somekichi.[2] *Gō:* Chikuha.[3] **Biog.:** Japanese-style painter. Born in Niigata-ken; older brother of the painter Odake Kokkan. First studied the *nanga* style; then to Tōkyō to become a pupil of Kawabata Gyokushō. A frequent exhibitor and prize winner at the Bunten; later became active in the Teiten. Painted in a delicate traditional manner. **Coll.:** National (5), Philadelphia. **Bib.:** Asano, NBZ 6.

<div align="center">[1]尾竹竹坡 [2]尾竹染吉 [3]竹坡</div>

Odake Etsudō[1] (1868–1931). *N.:* Odake Kumatarō.[2] *Gō:* Etsudō.[3] **Biog.:** Japanese-style painter. Born in Niigata-ken. Older brother of Odake Kokkan. Took an active part in the Naikoku Kaiga Kyōshinkai, the Ōsaka Art Association, and the Nihon Bijutsuin.

<div align="center">[1]尾竹越堂 [2]尾竹熊太郎 [3]越堂</div>

Odake Kokkan (Kokukan, Kunimi)[1] (1880–1945). *N.:* Odake Kamekichi.[2] *Gō:* Kokkan (Kokukan, Kunimi).[3] **Biog.:** Japanese-style painter. Born in Niigata-ken; younger brother of Odake Chikuha. Studied under Kobori Tomone. A prize winner at various exhibitions. Specialized in historical subjects. **Coll.:** National (5). **Bib.:** Asano, NBZ 6.

<div align="center">[1]尾竹国観 [2]尾竹亀吉 [3]国観</div>

Ogata Gekkō[1] (1859–1920). *N.:* Ogata (originally Tai)[2] Masanosuke.[3] *F.N.:* Nagami Shōnosuke.[4] *Gō:* Gekkō,[5] Kagyōsai,[6] Meikyōsai,[7] Nen'yū,[8] Rōsai.[9] **Biog.:** Japanese-style painter, printmaker. Also a decorator of pottery and lacquer. Born and lived in Tōkyō. Founding member of the Bunten and frequent prize winner at its exhibitions. Served as an illustrator during the Sino-Japanese War. Followed first the style of Kikuchi Yōsai, then studied the ukiyo-e manner by himself. Evolved his own amusing way of treating genre subjects, which he applied to paintings as well as to illustrations for magazines and newspapers. **Coll.:** Cincinnati; Minneapolis; Musées; Newark; Staatliche; Tōkyō (1), (2); Victoria. **Bib.:** Asano, K 236, *Kurashina* (1), Mitchell, Morrison 2, NB (S) 17, NBZ 6, Schmidt, Takahashi (2).

<div align="center">[1]尾形月耕 [2]田井 [3]尾形正之助 [4]名鏡正之助 [5]月耕 [6]華暁斎 [7]名鏡斎 [8]年邑 [9]楼斎</div>

Ogawa Sen'yō[1] (1882–1971). **Biog.:** Japanese-style painter. Born in Kyōto. First studied Buddhist painting. Then became a pupil of Asai Chū, showing his Western-style work at the Nikakai and the Inten. In Europe from 1913 to 1914. On his return, turned to Japanese-style painting and became active in the Inten and the Nihon Nangain. His work much in the Chinese manner. **Bib.:** Asano, Mitchell.

<div align="center">[1]小川千甕</div>

Ogawa Usen[1] (1868–1938). *N.:* Ogawa Mokichi.[2] *Gō:*

Tengyorō,[3] Usen.[4] **Biog.**: Japanese-style painter. Lived in Ibaraki-ken. First studied Western-style painting under Honda Kinkichirō; then taught himself *nanga* style. Produced caricatures for the paper *Choya*. Member of Nihon Bijutsuin. On the surface, an amusing and at times eccentric painter who loved to depict imaginary animals from Japanese folklore; underneath, a serious artist. Also painted landscapes, his style reflecting his *nanga* training. **Coll.**: National (5), Yamatane. **Bib.**: Asano, *Cent-cinquante, Masterpieces* (4), Mitchell, NB (H) 24, NBT 10, NBZ 6, NKKZ 19, SBZ 11.

[1]小川芋銭 [2]小川茂吉 [3]天魚楼 [4]芋銭

Ōgen[1] (fl. c. 1132–40). **Biog.**: Painter. Another dim figure known only from literary sources. Although he is recorded as having worked on many palaces for both the imperial court and wealthy aristocrats, no work by him is known today. Said to have been given title of *hōgen*.

[1]応源

Ogishima Yasuji[1] (1895–1939). **Biog.**: Sculptor. Specialized in figures; his work resembles the shop mannequins of the 1920s. **Bib.**: NBZ 6.

[1]荻島安二

Ogiwara Morie[1] (1879–1910). **N.**: Ogiwara Morie.[2] **Gō**: Rokuzan.[3] **Biog.**: Western-style sculptor. Born in Nagano-ken. First studied painting under Koyama Shōtarō at his school Fudōsha. In 1901 to America, then to France, where he studied at the Académie Julian. Under the influence of Rodin, whom he frequently visited, turned to sculpture. On his return to Japan in 1908 introduced Rodin's style, which deeply influenced his own. Exhibited with the Bunten. A pioneer in introducing Western-style sculpture to Japan. **Coll.**: National (5), Tōkyō (1). **Bib.**: Asano; BK 163, 235, 264, 266, 274, 279; GNB 28; M 30, 203, 207; *Masterpieces* (4); NB (H) 24; NBT 10; NBZ 6; SBZ 11; Sullivan; Uyeno.

[1]荻原守衛 [2]荻原守衛 [3]碌山

Ogura Sōjirō[1] (1846–1913). **Biog.**: Western-style sculptor. Studied under Ragusa at the Kōbu Daigaku Bijutsu Gakkō in Tōkyō, where Ōkuma Ujihiro and Fujita Bunzō were his fellow pupils. Frequently worked in marble; specialized in portraits. A pioneer in the Western manner; his style is academic. **Bib.**: Asano.

[1]小倉惣次郎

Ogura Uichirō[1] (1881–1962). **Biog.**: Sculptor. Born in Kagawa-ken. Graduated from sculpture department of Tōkyō School of Fine Arts in 1907. To Europe from 1920 to 1921. Exhibited with the Bunten; served as juror for the Teiten. A conservative artist. **Bib.**: Asano.

[1]小倉右一郎

Ogura Yuki[1] (1895–). **Biog.**: Japanese-style painter. Born at Ōtsu, Shiga-ken. Graduated from Nara Girls' Higher Normal School. Studied under Yasuda Yukihiko. Showed with the Inten. In 1954 won the Education Minister's Prize for Fostering the Arts and in 1956 the Mainichi Art Prize. One of the most prominent contemporary women painters, known for her portraits of women, her still lifes, and her genre scenes. **Coll.**: National (4), (5). **Bib.**: Asano, Kondō (6), *Masterpieces* (4), NBT 10, SBZ 11.

[1]小倉遊亀

Ogyū Tensen[1] (1882–1945). **N.**: Ogyū Moritoshi.[2] **Gō**: Tensen.[3] **Biog.**: Japanese-style painter. Born in Fukushima-ken. Pupil of Hashimoto Gahō. After graduating from Tōkyō School of Fine Arts, taught for a time. Showed with various societies such as the Bijutsu Kenseikai (of which he became a committee member) and with the Bunten from 1907, as well as with the Inten. **Coll.**: National (5).

[1]荻生天泉 [2]荻生守俊 [3]天泉

Ohara Shōson[1] (1877–1945). **N.**: Ohara Matao.[2] **Gō**: Koson,[3] Shōson.[4] **Biog.**: Japanese-style painter, printmaker. Pupil of Suzuki Kason. Taught at Tōkyō School of Fine Arts; served as adviser to Tōkyō National Museum. At Fenollosa's

suggestion made several woodblock prints, specializing in *kachōga* and landscapes. About 1911, changed his *gō* from Koson to Shōson and devoted himself to painting. In 1926 returned to woodblock printing. His work realistic, based mainly on his own sketches. **Coll.**: Cincinnati, Fine (California), Honolulu, Minneapolis, Musées, Museum (3), Newark, Staatliche, University (2). **Bib.**: Boller, Fujikake (1), Schmidt.

[1]小原祥邨 [2]小原又雄 [3]古邨 [4]祥邨

Ōhashi Suiseki[1] (1865–1945). **N.**: Ōhashi Uichirō.[2] **Gō**: Suiseki.[3] **Biog.**: *Nanga* painter. Born in Gifu-ken. To Kyōto to study under Amano Hōko and, in 1886, to Tōkyō to study under Watanabe Shōka. Lived mainly at Suma, Hyōgo-ken. In 1895 received a prize at the Naikoku Kangyō Hakurankai; in 1900, a gold medal at the Paris Exposition. In 1918, with Hashimoto Kansetsu, established the Kōbe Kaiga Kyōkai. Active in the promotion of *nanga* painting in the Kōbe area. Showed also with the Bunten and the Teiten. Specialized in painting tigers and lions. **Bib.**: Asano.

[1]大橋翠石 [2]大橋宇一郎 [3]翠石

Ōho[1] (1808–41). **N.**: Sakai Senshin.[2] **Gō**: Hansei Shigen,[3] Ōho,[4] Ukaan II.[5] **Biog.**: Rimpa painter. Born in Edo; son of a priest. Adopted by Sakai Hōitsu; allowed to take his surname as well as his *gō* Ukaan, calling himself Ukaan II. Studied painting and literature with Hōitsu, carrying on his master's tradition in a minor way. **Coll.**: Museum (3), Seattle, Yale. **Bib.**: *Kōrin-ha* (2), Mitchell, *Sōtatsu-Kōrin-ha*.

[1]鶯蒲 [2]酒井詮真 [3]伴清獅現 [4]鶯蒲 [5]雨華庵二世

Ōi[1] (fl. c. 1850). **N.**: Nakajima Aei.[2] **Gō**: Ōi.[3] **Biog.**: Ukiyo-e painter, printmaker. Third daughter of Hokusai. Painted a portrait of her father. Worked in her father's manner but also adopted the light and shade of the West. **Coll.**: Museum (3). **Bib.**: Hillier (4) 2, *Nikuhitsu* (1) 2, Shimada 3, Takahashi (1).

[1]応為 [2]中島阿栄 [3]応為

Ōide Tōkō[1] (1841–1905). **N.**: Ōide Aya.[2] **A.**: Sokō.[3] **F.N.**: Aijirō.[4] **Gō**: Kagyūkutsu,[5] Tōkō.[6] **Biog.**: *Nanga* painter. Born in Edo. Pupil of Tōdō Ryōun. Exhibited at the Naikoku Kaiga Kyōshinkai in 1896, receiving a silver medal. Also showed with the Naikoku Kangyō Hakurankai and the Nihon Bijutsu Kyōkai; at one time served as juror for the latter. Some of his works were purchased by the imperial household. His subject mainly birds-and-flowers.

[1]大出東皋 [2]大出絢 [3]素巧 [4]愛次郎 [5]蝸牛窟 [6]東皋

Ōju[1] (1777–1815). **N.**: Kinoshita (originally Maruyama)[2] Naoichi.[3] **A.**: Kunrai.[4] **F.N.**: Naokazu.[5] **Gō**: Ōju,[6] Suiseki.[7] **Biog.**: Maruyama painter. Lived in Kyōto. Second son and pupil of Maruyama Ōkyo; took his maternal grandfather's name Kinoshita. Father of Ōshin, who was adopted by his uncle Maruyama Ōzui and continued the Maruyama line, and of Ōka, who continued the Kinoshita line. Excelled in the painting of *kachōga* and pictures of animals, working with much skill and delicacy. **Coll.**: Ashmolean, Itsuō. **Bib.**: Hillier (1), (2), (4) 3; Mitchell; Morrison 2.

[1]応受 [2]円山 [3]木下直一 [4]君賚
[5]直一 [6]応受 [7]水石

Ōka[1] (1813–47). **N.**: Kinoshita Ōka.[2] **Biog.**: Maruyama painter. Son and pupil of Maruyama Ōju, he carried on the Kinoshita line of painting.

[1]応夏 [2]木下応夏

Oka Seiichi[1] (1868–1944). **Biog.**: Western-style painter. Born in Ōsaka. Studied under Asai Chū, Honda Kinkichirō, and, at the Fudōsha, Koyama Shōtarō. From 1889 a member of and exhibitor with the Meiji Bijutsukai. In 1901 to America; in 1903 to London; then to France, where he studied in Paris at the Académie Julian under Jean-Paul Laurens. Returned to Japan in 1908. Member of the Taiheiyō Gakai, teaching at the society's Kenkyūsho. **Bib.**: Asano, BK 188, NBZ 6.

[1]岡精一

Oka Shikanosuke[1] (1898–). **Biog.:** Western-style painter. Born in Tōkyō. In 1923 graduated from Tōkyō School of Fine Arts. To France, where he lived and exhibited at various salons from 1924 to 1940. Again in Europe from 1959 to 1961. In 1941 became a member of the Shun'yōkai. Won the Education Minister's Prize for Fostering the Arts in 1952 and the Mainichi Art Prize in 1957; in 1972 received Order of Cultural Merit. His style shows the influence of the more conservative side of the School of Paris. **Coll.:** National (5). **Bib.:** Asano, Kung, NBT 10, NBZ 6.

[1]岡鹿之助

Okada Saburōsuke[1] (1869–1939). **Biog.:** Western-style painter. Born in Saga-ken, lived in Tōkyō. Pupil of Kume Keiichirō, Soyama Sachihiko, and Kuroda Seiki. In 1895 received an award at the Naikoku Kangyō Hakurankai. From 1897 to 1901 in France, where he studied under Raphael Collin. Taught at Tōkyō School of Fine Arts for a year when its Department of Western Art was opened in 1896 and again on his return from France, when he succeeded Kuroda Seiki. Superintendent of the Hongō Gakai Ken-kyūsho, founder of Yōfū Hangakai, first president of Nihon Hanga Kyōkai. Member of the Art Committee for the Imperial Household and of the Imperial Art Academy. In 1937 received Order of Cultural Merit. Specialized in figure painting, collecting old Japanese costumes and often painting his models in them. His style academic, realistic, and quiet, with touches of plein air. **Coll.:** Bridgestone; Kyōto (1); National (5); Ohara (1); Tōkyō (1), (2). **Bib.:** Asano; BK 188, 192; Fujikake (1); Harada Minoru; Kondō (6); *Kurashina* (2); *Masterpieces* (4); NB (H) 24; NB (S) 30; NBT 10; NBZ 6; NHBZ 7; SBZ 11; Uyeno.

[1]岡田三郎助

Okakura Shūsui[1] (1867–?). **Biog.:** Japanese-style painter. Born in Fukui. Nephew of Okakura Tenshin. In 1889 became a pupil of Hashimoto Gahō and Kanō Hōgai, from whom he learned the Kanō style. Also entered the Tōkyō School of Fine Arts. Member of various art organizations. Moved from Tōkyō to Kyōto after the 1923 earthquake. **Coll.:** Museum (3). **Bib.:** Asano.

[1]岡倉秋水

Okano Sakae[1] (1880–1942). **Biog.:** Western-style painter. Born in Tōkyō. Studied first under Kuroda Seiki at the Hakubakai; then entered the Tōkyō School of Fine Arts, graduating in 1902. Taught for many years at a girls' school. Helped to found the Kōfūkai in 1912. From 1925 to 1926 in Europe on a research mission for the Imperial Household Agency. **Bib.:** Asano, Mitchell.

[1]岡野栄

Okazaki Sessei[1] (1854–1921). **Biog.:** Western-style sculptor. Born in Yamashiro Province. Taught at the Tōkyō School of Fine Arts. More noted as the leading bronze caster of the Meiji era than as a sculptor. His own work is quite realistic. **Bib.:** NBZ 6, SBZ 11, Uyeno.

[1]岡崎雪声

Okinobu[1] (?–1787). **N.:** Kanō Okinobu.[2] **Gō:** Shunsen.[3] **Biog.:** Kanō painter. Son and pupil of Kanō Shunshō II, whom he predeceased. Member of the Kanō Yamashita line.

[1]意信 [2]狩野意信 [3]春仙

Ōkōchi Yakō[1] (1893–1957). **N.:** Ōkōchi Masanobu.[2] **Gō:** Yakō.[3] **Biog.:** Japanese-style painter. Born in Yamanashi-ken. Graduated from Kyōto College of Fine Arts; then studied under Kikuchi Keigetsu. In 1926 exhibited for the first time with the Teiten. His style at first a combination of *nanga* and *yamato-e,* which was not well received by the Kyōto art circles. Later made his name as a painter of Buddhist themes. **Coll.:** National (5).

[1]大河内夜江 [2]大河内正宜 [3]夜江

Ōkubo Sakujirō[1] (1890–). **Biog.:** Western-style painter. Born in Ōsaka, works in Tōkyō. Graduated from the Tōkyō School of Fine Arts in 1915. Studied in Europe from 1923 to 1927. Has shown at government exhibitions since 1916 and recently with the Nitten. Founding member of the Shinseiki Bijutsu Kyōkai. In 1959 won the Japan Art Academy Prize. His figurative style derives from such French artists as Derain. **Coll.:** National (5). **Bib.:** Asano, NBZ 6.

[1]大久保作次郎

Okuhara Seiko[1] (1837–1913). **N.:** Okuhara (originally Ikeda)[2] Setsuko.[3] **Gō:** Seiko,[4] Tōkai Seiko.[5] **Biog.:** *Nanga* painter. Born in Furukawa, Shimōsa Province. Daughter of a high-ranking samurai in the service of the lord of Koga. Adopted into the Okuhara family; lived in Tōkyō and in Kumagaya in Saitama-ken. Taught herself to paint in the manner of the Ch'ing literati style, studying Ming and Ch'ing paintings. An unconventional individual, she was called the "Amazon" of recent Japanese painting. Her work very popular until the taste for Western-style painting grew; retired to Kumagaya to continue painting in her own late *nanga* manner with slight traces of Western influence. Many imitations of her work. **Coll.:** Tōkyō (1). **Bib.:** Asano, *Japanische* (2), Mitchell, NB (S) 17, NBZ 6, Umezawa (2), Uyeno.

[1]奥原晴湖 [2]池田 [3]奥原節子 [4]晴湖 [5]東海晴湖

Okuhara Seisui[1] (1854–1921). **N.:** Okuhara Teruko.[2] **Gō:** Seisui.[3] **Biog.:** *Nanga* painter. Born in Rikuzen Province. Studied under Okuhara Seiko, who adopted her as her successor. Showed with the Bunten.

[1]奥原晴翠 [2]奥原輝子 [3]晴翠

Ōkuma Ujihiro[1] (1856–1934). **Biog.:** Western-style sculptor. Born in Edo. Studied under Vincenzo Ragusa at the Kōbu Daigaku Bijutsu Gakkō, where his fellow student and future colleague was Fujita Bunzō; graduated in 1882 and later went to Rome for further study. Member of the Nihon Bijutsu Kyōkai and the Tōkyō Chōkōkai; served frequently as a juror for the Bunten and other government exhibitions. Known for his portraits in bronze, sometimes quite monumental in size, in the manner of Western academic realism. One of his major works is the statue of Ōmura Masujirō (1893) in front of the Yasukuni Shrine, Tōkyō. **Bib.:** Asano, M 203, NBZ 6, Sullivan, Uyeno.

[1]大熊氏広

Okumura Togyū (Dogyū)[1] (1889–). **N.:** Okumura Yoshizō.[2] **Gō:** Togyū (Dogyū).[3] **Biog.:** Japanese-style painter. Born in Tōkyō. A pupil of Kajita Hanko in the last year of that artist's life; then of Kobayashi Kokei. First became known when his painting won a prize at the 1928 Inten exhibition; continued to show constantly with this society. From 1944 to 1951 taught at the Tōkyō University of Arts. Member of the Japan Art Academy; recipient of the Order of Cultural Merit in 1962. Painted figures and portraits only occasionally; primarily a painter of birds, animals, landscapes. Worked in a pleasant decorative manner in light colors and with few details. **Coll.:** National (5), Tōkyō (1), Yamatane. **Bib.:** Asano, Nakamura (1), NBZ 6.

[1]奥村土牛 [2]奥村義三 [3]土牛

Ōkurakyō[1] (fl. 13th c.). **Biog.:** Painter. A shadowy figure. The name Ōkurakyō is actually a court title meaning "finance minister." It is possible there was a painter known by this name in the retinue of the priest Nichiren, whose portrait in the Myōhokke-ji, Shizuoka-ken, is attributed to him, but there is no proof.

[1]大蔵卿

Okuse Eizō[1] (1891–). **Biog.:** Western-style painter. Born in Mie-ken. Studied at the Taiheiyō Kenkyūsho under Nakamura Fusetsu. Showed with the Taiheiyō Gakai, the Bunten, the Teiten, and the Nitten. In 1947 withdrew from the Taiheiyō Gakai and helped found the Shigenkai, remaining a member of that as well as of the Nitten. His landscapes are rendered in a solid, heavily outlined manner. **Bib.:** Asano.

[1]奥瀬英三

Ōkyo[1] (1733–95). *N.:* Maruyama Masataka.[2] *A.:* Chūkin,[3] Chūsen.[4] *F.N.:* Iwajirō,[5] Mondo.[6] *Gō:* Isshō,[7] Kaiun,[8] Kaun,[9] Ōkyo,[10] Ōsui Gyofu,[11] Rakuyō Sanjin,[12] Seishūkan,[13] Senrei,[14] Sensai,[15] Settei,[16] Untei.[17] **Biog.:** Painter. Born at Anafuto in Tamba Province; son of a farmer. As a youth to Kyōto to study under the Kanō master Ishida Yūtei. Too poor to have had any formal education, was patronized by Yūjō, head of the Emman-in, Ōtsu, and was able to study at the monastery, from 1765 to 1775, its collection of ancient paintings. (In 1766 took name of Ōkyo.) Became acquainted with Western perspective (to which he was first introduced when he saw a European peepshow) as well as with Ming and, especially, late Ch'ing painting; may also have owed something to Shen Nan-p'in. In 1793 contracted an eye disease but continued painting until he died. Painted a famous set of *makimono* for the Emman-in: *Seven Calamities* and *Seven Felicities*. Very important in history of Japanese painting: a popular, easily understood artist; founded the Maruyama school, in which his style, a combination of Muromachi *suiboku* and close, accurate observation of nature, was continued. Advised his pupils to sketch directly from nature; several of his own sketchbooks with detailed studies of nature still exist. By slanting his brush, able to make a graduated line that helped give an impression of realism, but his realism never allowed to interfere with the decorative aspect of his big, bold screens and is only comparative, being much less noticeable to a Westerner than to a Japanese. A vast number of forgeries and copies of his work. **Coll.:** Allen; Art (1), (2); Center; Cincinnati; Daijō-ji (2); Emman-in; Enkō-ji (Kanshi-in); Freer; Homma; Itsukushima; Itsuō; Kōbe; Kimbell; Kongō-ji; Kotohira; Kōzō-ji; Kyōto (2); Los Angeles; Metropolitan; Minneapolis; Musée (2); Museum (3); Nelson; Newark; Nezu; Ninna-ji; Nishi; Ōkura; Philadelphia; Rietberg; Sōdō-ji; Stanford; Tokugawa; Tōkyō (1); University (2); Victoria. **Bib.:** AA 14; Akiyama (5); *Art* (1a); BI 59; BK 14, 21, 22, 33, 34, 36, 91; Brown; Covell; *Exhibition* (1); Fenollosa; Fontein (1); *Freer;* GNB 18; Grilli (1); Hillier (1), (2), (4) 3; Iijima; K 21, 28, 68, 88, 95, 100, 114, 116, 121, 128, 135, 143, 146, 149, 154, 171, 176, 181, 183, 193, 220, 235, 236, 239, 243, 248, 253, 255, 260, 270, 274, 279, 280, 283, 286, 288, 292, 295, 299, 303, 308, 313, 318, 331, 338, 343, 367, 375, 382, 397, 404, 424, 429, 430, 451, 458, 465, 502, 517, 527, 545, 555, 584, 590, 591, 597, 666, 681, 707, 724, 750, 783, 807, 809, 815, 818, 828, 830, 840, 885, 936; KO 27, 31; *Kokuhō* 6; Kondō (6); Lee (1); M 18, 126, 127, 145; Mayuyama; Mitchell; Morrison 2; NB (H) 24; NB (S) 36, 39; NBT 5; NBZ 5; *Nikuhitsu* (1) 2; NKZ 2, 11, 19, 37, 43, 64, 77; Noma (1) 2; *Ōkyo; One* (2); *Pictorial* (2) 4; SBZ 10; *Shijō-ha;* Shimada 2; Sullivan; Tajima (3) 1, 2; Tajima (12) 3, 4, 5, 6, 8, 9, 10, 11, 12, 14, 15, 16, 18, 19; Tajima (13) 6; Toda (1); YB 30.

¹応挙 ²円山応挙 ³仲均 ⁴仲選 ⁵岩次郎 ⁶主水 ⁷一嘯 ⁸懐雲 ⁹夏雲 ¹⁰応挙 ¹¹鴨水漁夫 ¹²洛陽山人 ¹³星聚館 ¹⁴仙嶺 ¹⁵儒斎 ¹⁶雪可 ¹⁷雲亭

Omoda Seiju[1] (1891–1933). *N.:* Omoda (originally Kojima)[2] Mokichi.[3] *Gō:* Seiju.[4] **Biog.:** Japanese-style painter. Born in Saitama-ken to the Kojima family; later adopted by the Omoda family. To Tōkyō to study under Matsumoto Fūko. Exhibitor and member of the Nihon Bijutsuin and the Shakuyōkai. His carefully executed paintings have a decorative approach combined with a detailed realism. **Coll.:** National (5), Yamatane. **Bib.:** Asano, NBZ 6.

¹小茂田青樹 ²小島 ³小茂田茂吉 ⁴青樹

Onchi Kōshirō[1] (1891–1955). **Biog.:** Painter, printmaker. Born in Tōkyō of an aristocratic family. Educated under the auspices of the imperial household. Studied at the Tōkyō School of Fine Arts until 1914. Rebelled against the academic teaching of oil painting; became an assistant to the printmaker Takehisa Yumeji. Founding member of the Nihon

Sōsaku Hanga Kyōkai, to which he was devoted all his life and in the development of which he was a great force: the "grand old man" of the *hanga* movement. Also an illustrator and book designer, by which occupations he made his living. Founded the monthly magazine *Tsukubae,* which published poetry and prints. Showed with the Teiten, the Nihon Sōsaku Hanga Kyōkai, the Shun'yōkai and, after 1945, at many international exhibitions. His work much influenced by Kandinsky; a pioneer in the field of nonobjective painting. A sensitive artist, at his best the finest Western-style abstract artist in Japan. **Coll.:** Art (1a), (1); Cincinnati; Fine (California); Honolulu; Musées; Museum (3); National (5); Newark; Philadelphia. **Bib.:** Asano; Fujikake (1); *Japanese* (1a); *Kōshirō;* Lane; Michener (1), (3); Munsterberg (1); NBT 10; NBZ 6; NHBZ 7; Statler; UG 4, 11, 14.

¹恩地孝四郎

Ono Chikkyō (Chikukyō)[1] (1889–). *N.:* Ono Eikichi.[2] *Gō:* Chikkyō (Chikukyō).[3] **Biog.:** Japanese-style painter. Born in Okayama. Graduate of Kyōto College of Fine Arts. Pupil of Takeuchi Seihō. Showed with the Bunten and the Kokuga Sōsaku Kyōkai, becoming a member of the latter. Traveled in Europe 1921–22. His landscapes show much Western influence. **Coll.:** Kyōto (1), National (5). **Bib.:** Asano, NB (H) 24, NBZ 6.

¹小野竹喬 ²小野英吉 ³竹喬

Ōno Takanori[1] (1886–1945). **Biog.:** Western-style painter. Born in Chiba-ken. Studied at Tōkyō School of Fine Arts under Wada Eisaku and Nagahara Kōtarō, graduating in 1911. An exhibitor with the Bunten and the Teiten. To Europe from 1922 to 1924; showed at the Salon Nationale des Beaux Arts in Paris. After returning to Japan became a member of the Kōfūkai and, in 1931, founded his own school, the Ōno Yōga Kenkyūsho, dedicating himself to teaching. **Bib.:** Asano.

¹大野隆徳

Ōritsu[1] (1817–75). *N.:* Maruyama Ōryu.[2] *A.:* Shidō.[3] *F.N.:* Katsujirō,[4] Mondo;[5] later, Tatsuo.[6] *Gō:* Beisai,[7] Ōritsu,[8] Saiko,[9] Seishukan.[10] **Biog.:** Maruyama painter. Born in Kyōto. Son of Terai Kyujirō, an artisan working as a *yūzen* dyer. Adopted first by Shimada Omi no Kami, an official of the imperial household, then by Maruyama Ōshin, whose pupil he was. Became the head of the fourth generation of the Maruyama school and a loyal exponent of the style. Teacher of Ōbun, His subjects included figures and birds-and-flowers. Not much of an artist. **Coll.:** Imperial (1). **Bib.:** Mitchell, Morrison 2, Tajima (12) 17.

¹応立 ²円山応立 ³子道 ⁴勝次郎 ⁵主水 ⁶多都雄 ⁷米斎 ⁸応立 ⁹才壺 ¹⁰星衆館

Ōshin[1] (1790–1838). *N.:* Maruyama Ōshin.[2] *A.:* Chūkyō;[3] later, Mondo.[4] *Gō:* Hōko,[5] Hyakuri,[6] Seishūkan.[7] **Biog.:** Maruyama painter. Son of Kinoshita Ōju; pupil and adopted son of Maruyama Ōzui. Became head of third generation of the Maruyama school. Lived in Kyōto. Also studied under Komai Genki. Specialized in landscapes and *kachōga* done in a slightly realistic manner, following generally in the family tradition. **Coll.:** Art (1), Ashmolean, Museum (3), Tōkyō (1). **Bib.:** Mitchell, Morrison 2.

¹応震 ²円山応震 ³仲恭 ⁴主水 ⁵方壺 ⁶百里 ⁷星聚館

Ōshita Tōjirō[1] (1870–1912). **Biog.:** Western-style painter. Born and lived in Tōkyō. Studied water colors under Nakamaru Seijūrō and, after Seijūrō's death, with Harada Naojirō at his private school the Shōbikan. In 1898 to Australia. In 1902 helped found the Taiheiyō Gakai. From 1902 to 1903 in Europe. Edited the monthly *Mizu-e* to promote spread of water-color painting. His landscapes academic, with some impressionist touches. **Coll.:** National (5). **Bib.:** Asano, BK 201, Harada Minoru, NB (S) 30, NBZ 6.

¹大下藤次郎

Ōshun[1] (1796–1838). *N.:* Maruyama Ōshun.[2] **Biog.:** Maruyama painter. Son and pupil of Maruyama Ōzui. **Coll.:** Museum (3).
¹応春　²円山応春

Ōta Chōu[1] (1896–1958). *N.:* Ōta Eikichi.[2] *Gō:* Chōu.[3] **Biog.:** Japanese-style painter. Born in Sendai. At 13 a pupil of Kawabata Gyokushō; later of Maeda Seison. An exhibitor with the Inten, juror for the Nitten. Professor at Tōkyō University of Arts. His chief subject matter the manners and customs of his day, which he rendered by using traditional line-drawing technique. **Coll.:** Kyōto (1), National (5). **Bib.:** Asano.
¹太田聴雨　²太田栄吉　³聴雨

Ōta Kijirō[1] (1883–1951). **Biog.:** Western-style painter. Born in Kyōto. After graduating in 1908 from the department of Western painting of the Tōkyō School of Fine Arts, went abroad to study; returned in 1913. Showed with the 1914 Bunten, receiving second prize; the following year again received second Prize. Often served as juror for the Bunten and the Teiten; taught at several Kyōto institutions. His paintings are bright, colorful, and quite realistic. **Coll.:** Kyōto (1), National (5). **Bib.:** Asano.
¹太田喜二郎

Ōta Saburō[1] (1884–). **Biog.:** Western-style painter, printmaker. Born in Aichi-ken. Studied under Kuroda Seiki at the Hakubakai. An exhibitor and prize winner at the Bunten from 1910 and the Teiten from 1919. In Europe from 1920 to 1921. Member of the Kōfūkai. Director of the Aichiken Bijutsukan. **Bib.:** Asano, NHBZ 7.
¹太田三郎

Ōta Ten'yō[1] (1884–1946). **Biog.:** Japanese-style painter. Born in Tōkyō. Studied Japanese-style painting with Yamana Tsurayoshi and Kobori Tomone, and water colors with Ōshita Tōjirō. Graduated from the Tōkyō School of Fine Arts in 1913. Exhibited with the Teiten. **Coll.:** National (5). **Bib.:** Asano.
¹太田天洋

Ōta Wamaro[1] (fl. late 8th c.). **Biog.:** Sculptor. His name is found on some of the Gigaku masks in the Shōsō-in. According to the inscriptions on these masks, they were made after 752. **Coll.:** Shōsō-in. **Bib.:** Harada.
¹太田和麻呂

Ōta Yamatomaro[1] (fl. 8th c.). **Biog.:** Sculptor. This name is found on a Gigaku mask in the Shōsō-in. Life unknown. **Coll.:** Shōsō-in. **Bib.:** Kleinschmidt, *Shōsō-in*.
¹太田和万呂

Otomaru Kōdō[1] (1898–). **Biog.:** Lacquerer. Born in Takamatsu. One of the leading lacquer artists of the 20th century; was designated a Living National Treasure in 1955. Specializes in *chōshitsu*. **Coll.:** National (4). **Bib.:** Ragué, Sugimura.
¹音丸耕堂

Ōtsuki Genji[1] (1904–71). **Biog.:** Western-style painter. Graduated in 1927 from the Tōkyō School of Fine Arts. Exhibited with the Issuikai first in 1937; a prize winner there in 1943, as well as at the Bunten in the same year. **Bib.:** Asano.
¹大月源二

Ōuchi Seiho[1] (1898–). **Biog.:** Sculptor. Born and works in Tōkyō. In 1922 graduated from the Tōkyō School of Fine Arts. Pupil of Takamura Kōun and Takamura Kōtarō. Has shown with the Nihon Bijutsuin, the Bunten, and the Nitten; won a prize at the 1960 Inten. Member of the Nihon Bijutsuin. Generally carves Buddhist figures but also produces Japanese-style paintings and woodcuts. **Coll.:** National (5). **Bib.:** Asano.
¹大内青圃

Oyazu Ningyū[1] (1901–66). *N.:* Oyazu Saburō.[2] *Gō:* Ningyū.[3] **Biog.:** Japanese-style painter. Born in Tōkyō. Son of a pawnshop owner; thus had a chance to study art objects of good quality. Pupil of Kobayashi Kokei. Graduated from the Nihon Daigaku. In 1938 showed with the Inten; from 1946 a member of the Nihon Bijutsuin. A good painter of portraits, *kachōga*, and landscapes.
¹小谷津任牛　²小谷津三郎　³任牛

Ōyō[1] (?–1879). *N.:* Toichi Ōyō.[2] **Biog.:** *Nanga* painter. Born in Bungo Province. Son and pupil of Toichi Sekkoku. On his own, studied Tanomura Chikuden's paintings. Later, in Nagasaki, studied under Hidaka Tetsuō. Worked in the *nanga* manner. **Bib.:** Mitchell.
¹王洋　²十市王洋

Ōzui[1] (1766–1829). *N.:* Maruyama Ōzui.[2] *A.:* Gihō.[3] *F.N.:* Ukon;[4] later, Mondo.[5] *Gō:* Ishindō.[6] **Biog.:** Maruyama painter. Eldest son and pupil of Ōkyo, whom he succeeded as second generation of the Maruyama school. Adopted Ōshin, son of his brother Ōju, as his son. In the 1790s was commissioned to paint some of the *fusuma* for the restoration of the Imperial Palace in Kyōto. Followed his father's style faithfully; became particularly skillful in the use of gold dust and silver dust. **Coll.:** Ashmolean, Daijō-ji (2), Itsuō, Museum (3). **Bib.:** Hillier (4) 3; Mitchell; Morrison 2; Tajima (12) 10, (13) 6.
¹応瑞　²円山応端　³儀鳳　⁴右近　⁵主水　⁶怡真堂

R

Raidō[1] (fl. c. 1751–79). **Biog.:** Ukiyo-e painter. His pictures of *bijin* show the influence of Sukenobu. **Bib.:** *Nikuhitsu* (2).
¹籟堂

Raien[1] (fl. late 12th c.). **Biog.:** Buddhist painter. Perhaps the son of Raigen. Member of the Rai school. An inscription on the *Kegon-kyō Mandara* at the Tōdai-ji carrying his name (but dated 1294) has led to the theory that he may have painted it.
¹頼円

Raigen[1] (fl. 1142–83). **Biog.:** Buddhist painter. Son of Raijo. Received title of *hōgen*. Records list his paintings in some detail, but no actual work is known today. All his descendants used *gō* with the *kanji* reading "Rai"; hence Japanese art historians refer to them as the Rai school.
¹頼源

Raijo[1] (1044–1119). **Biog.:** Sculptor. Possibly a son and pupil of Kakujo. Member of Shichijō Bussho. Also a *dai busshi* of the sculptors' workshop at the Kōfuku-ji. Received title of *hokkyō* in 1103. Nothing can be attributed to him with any accuracy. **Bib.:** *Kokuhō* 3, Kuno (1).
¹頼助

Raijo[1] (fl. c. 1150). **Biog.:** Buddhist painter. Known only from historical records. Father of Raigen. Received title of *hōgen*.
¹頼助

Raisei[1] (fl. late 12th c.). **Biog.:** Painter. Son of Raigen. Known from a record stating he was made *hokkyō* and painted a Fugen for the emperor's palace in 1191.
¹頼成

Raishō[1] (1796–1871). *N.:* Nakajima Raishō.[2] *A.:* Shikei.[3] *Gō:* Shintsūdō,[4] Shumbunsai,[5] Tōkō[6] (for *haiku*). **Biog.:** Maruyama painter. Born in Ōtsu. Pupil of Watanabe Nangaku and, later, of Maruyama Ōzui. Late-Edo exponent of the Maruyama manner. Kōno Bairei and Kawabata Gyokushō were his pupils. Splendid pictures of swimming

fish. **Coll.:** Ashmolean, Imperial (1), Museum (3), Victoria, Yale. **Bib.:** Mitchell, Morrison 2, NBZ 6, Tajima (12) 18.

¹来章 ²中島来章 ³子慶 ⁴神通堂 ⁵春分斎 ⁶鴗江

Raishū[1] (fl. mid-19th c.). *N.:* Yasuda Naoyoshi.[2] *A.:* Shimpo (Shinpo).[3] *F.N.:* Sadakichi;[4] later, Mohei.[5] *Gō:* Bajō,[6] Bunkaken,[7] Raishū.[8] **Biog.:** *Yōga* printmaker. Born in Edo. First studied under Hokusai; then, having perhaps been influenced by Aōdō Denzen and Shiba Kōkan, worked in copperplates and made book illustrations and views of Tōkyō in a quite Western but not very competent manner. Also copied Western prints. Engraved *The Fifty-three Stations of the Tōkaidō;* also made various prints of the damage done by the earthquake of 1855. **Coll.:** Homma, Kōbe, Tōkyō (1). **Bib.:** Fujikake (3) 3, GNB 25, Mody, NB (S) 36, NBZ 5, *Nikuhitsu* (2), *Pictorial* (2) 2.

¹雷洲 ²安田尚義 ³信甫 ⁴定吉（真吉） ⁵茂平 ⁶馬城 ⁷文華軒 ⁸雷洲

Rakan[1] (1784–1866). *N.:* Gamō (originally Fujita)[2] Hyō.[3] *Gō:* Rakan,[4] Rakan Sanjin,[5] Zaike Bosatsu.[6] **Biog.:** Painter. Born in Fukushima-ken. An able painter of Buddhist pictures as well as of landscapes. Also made some small statues of Rakan.

¹羅漢 ²藤田 ³蒲生豹 ⁴羅漢 ⁵羅漢山人 ⁶在家菩薩

Raku[1] (fl. 16th to 20th c.). A family of potters working in Kyōto and producing a ware that has always been intended for tea-ceremony use. A soft light pottery, kneaded by hand, fired at very low temperature, covered with many thin layers of red, black, or white glaze. The family name, from the time of Chōjirō until the Meiji era, was Tanaka;[2] the studio name, Kichizaemon.[3] After the Restoration, began to use the name Raku. For all the following, see individual entries.

Chōjirō[4] (1516–92). *Gō:* Chōyū.[5]

Sōkei[6] (fl. 16th c.). Assistant to Chōjirō.

Jōkei[7] (1561–1635). Son of Sōkei. First to use the Raku seal.

Dōnyū[8] (1599–1656). Son of Jōkei.

Sōmi[9] (1573–1672). Identity uncertain.

Ichinyū[10] (1640–96). Son of Dōnyū.

Sōnyū[11] (1664–1716). Adopted son of Ichinyū.

Sanyū[12] (1685–1739). Adopted son of Sōnyū.

Chōnyū[13] (1714–70). Son of Sanyū.

Tokunyū[14] (1745–74). Son of Chōnyū.

Ryōnyū[15] (1756–1834). Second son of Chōnyū.

Tannyū[16] (1795–1854). Second son of Ryōnyū.

Keinyū[17] (1817–1902). Adopted son of Tannyū.

Kōnyū[18] (1857–1932). Son of Keinyū.

Shōnyū[19] (1887–1944). Son of Kōnyū.

¹楽 ²田中 ³吉左衛門 ⁴長次郎（朝次郎） ⁵長祐 ⁶宗慶 ⁷常慶 ⁸道入 ⁹宗味 ¹⁰一入 ¹¹宋入 ¹²左入 ¹³長入 ¹⁴得入 ¹⁵了入 ¹⁶旦入 ¹⁷慶入 ¹⁸弘入 ¹⁹惺入

Randō[1] (1736–1819). *N.:* Shimada (originally Ki no)[2] Motonao.[3] *A.:* Shihō.[4] *Gō:* Kōsoken,[5] Randō,[6] Shigen.[7] **Biog.:** Maruyama painter. Born in Kyōto. Pupil of Ōkyo. Adopted by Shimada family. Received a court rank and held a nominal position at the imperial court. According to the official appraisal of painters made in 1817, ranked higher than Okamoto Toyohiko. A good painter of *kachōga*.

¹鸞洞 ²紀 ³島田元直 ⁴子方 ⁵後素軒 ⁶鸞洞 ⁷子玄

Ran'ei[1] (fl. c. 1840). *N.:* Itakura Masanao.[2] *Gō:* Raku Sambō,[3] Ran'ei,[4] Shūkyokusai.[5] **Biog.:** Painter. Lived and worked in Edo. **Coll.:** Museum (3).

¹蘭暎 ²板倉政直 ³楽山房 ⁴蘭暎 ⁵秀旭斎

Ranga[1] (1821–69). *N.:* Hayashi Yūfu.[2] *Gō:* Ranga.[3] **Biog.:** Shijō painter. Born in Kyōto. Pupil of Okamoto Shigehiko. **Bib.:** Mitchell.

¹蘭雅 ²林有孚 ³蘭雅

Rangai[1] (fl. c. 1840). *N.:* Kawakubo Rangai.[2] **Biog.:** *Nanga* painter. Pupil of Takahisa Aigai. **Bib.:** Mitchell.

¹蘭涯 ²川窪蘭涯

Rankei[1] (1813–65). *N.:* Hasegawa Sen.[2] *A.:* Hōkei.[3] *Gō:* Chō Rankei,[4] Rankei.[5] **Biog.:** *Nanga* painter. Born in Echigo Province. Went to Edo as a youth; studied Confucianism as well as the *nanga* style of painting with Haruki Nanko; also studied ancient Chinese paintings. Moved to Sendai, where he studied under Tōsai Baikan. Produced acceptable landscapes in the Chinese manner. **Coll.:** Ashmolean, Museum (3). **Bib.:** K 627.

¹嵐渓 ²長谷川筌 ³芳渓 ⁴張嵐渓 ⁵嵐渓

Rankō[1] (1730–99). *N.:* Yoshida Rankō.[2] *Gō:* Tōgyūsai.[3] **Biog.:** Painter. Little known about him save that he lived in Edo. Style a mixture of Maruyama and *nanga*. **Coll.:** Rinnō-ji (2). **Bib.:** Hillier (1), Mitchell.

¹蘭香 ²吉田蘭香 ³東牛斎

Rankō[1] (1766–1830). *N.:* Nakai Tadashi.[2] *A.:* Hakuyō.[3] *F.N.:* Yōsei.[4] *Gō:* Rankō,[5] Shiko.[6] **Biog.:** Painter. Also a poet and tea master. Born in Ōsaka. In painting, pupil of Shitomi Kangetsu; in literature of Nakai Chikuzan. Illustrated *kyōka* and books on travel. His work also shows the influence of the Maruyama school. **Coll.:** Ashmolean. **Bib.:** Brown, Mitchell.

¹藍江 ²中井直 ³伯養 ⁴養清 ⁵藍江 ⁶師古

Rankoku[1] (?–1707). *Priest name:* Genjō.[2] *Gō:* Rankoku.[3] **Biog.:** *Zenga* painter. Trained as a priest of the Rinzai sect; later joined the Ōbaku sect, living in Kyōto in rather a worldly manner. Eventually became third abbot of the Chokushian in Saga. A skilled engraver of seals as well as a painter; worked in the style of Kita Genki. **Bib.:** NB (S) 47.

¹蘭谷 ²元定 ³蘭谷

Rankōsai[1] (fl. 1805). **Biog.:** Ukiyo-e printmaker. A follower of Ryūkōsai, worked in Ōsaka. Is known for one *hosoban* triptych of actors. This could possibly be the *gō* of another print artist. **Coll.:** Philadelphia. **Bib.:** Keyes.

¹蘭好斎

Ransai[1] (1740?–1801). *N.:* Mori Bunshō.[2] *A.:* Shitei.[3] *Gō:* Kyūkō,[4] Meikaku,[5] Ransai.[6] **Biog.:** Nagasaki painter. Born in Echigo Province. Studied under Kumashiro Yūhi, who taught him the style of Shen Nan-p'in. In the last years of his life lived in Edo. Painted *kachōga* in an elaborate rococo style. **Bib.:** Mitchell, Mody.

¹蘭斎 ²森文祥 ³子禎 ⁴九江 ⁵鳴鶴 ⁶蘭斎

Ransai[1] (fl. late 19th c.). *N.:* Kumasaka Ransai.[2] **Biog.:** Japanese-style painter, illustrator. Pupil of his elder brother Kumasaka Tekizan. Painted orchids and bamboo. Also worked as an illustrator of books.

¹蘭斎 ²熊坂蘭斎

Ransen[1] (fl. c. 1840). *N.:* Nakamura Raichō.[2] *A.:* Hakumin.[3] *Gō:* Ransen,[4] Senryūsai.[5] **Biog.:** Shijō painter. First studied the Kanō manner, then became a pupil of Matsumura Keibun. Specialized in *kachōga*. **Bib.:** Mitchell.

¹藍川 ²中村来潮 ³伯民 ⁴藍川 ⁵仙竜斎

Ranshū[1] (1739–1816). *N.:* Yoshimura Itoku.[2] *A.:* Shijō.[3] *Gō:* Ranshū.[4] **Biog.:** Maruyama painter. Fellow pupil with Maruyama Ōkyo under Ishida Yūtei. Lived and worked in Kyōto. **Bib.:** Mitchell.

¹蘭洲 ²吉村彝徳 ³子乗 ⁴蘭洲

Rantei[1] (fl. early 19th c.). *N.:* Nukaya Ryō.[2] *A.:* Shisei.[3] *Gō:* Rantei,[4] Ryōho.[5] **Biog.:** *Nanga* painter. **Bib.:** Mitchell.

¹蘭汀 ²糠谷良 ³子正 ⁴蘭汀 ⁵良圃

Rantei[1] (fl. early to mid-19th c.). *N.:* Yamamoto Naohide.[2] *Gō:* Rantei,[3] Yūshūsai.[4] **Biog.:** Painter. Studied painting with a minor Kanō artist. Though he was not the equal of Yamamoto Baiitsu, it appears that Baiitsu studied under him. Said to have lived to a great age, but his actual dates unknown.

¹蘭亭 ²山本直秀 ³蘭亭 ⁴有秀斎

Reien[1] (fl. c. 1365). Sculptor. **Biog.:** Known for a seated figure of Jizō in the Hōkai-ji, Kamakura, dated 1365. **Coll.:** Hōkai-ji (1).

¹霊円

Reietsu[1] (fl. late 16th to early 17th c.). **Biog.**: Painter. Life unknown. Specialized in painting warrior deities and Buddhist figures. Worked in the Muromachi *suiboku* tradition. **Bib.**: K 699, Matsushita (1a).
¹荔関

Reigen[1] (1721–85). *Priest name*: Etō.[2] *Gō*: Reigen.[3] **Biog.**: *Zenga* painter. A pupil of Hakuin. A priest at the Zenshō-ji at Mineyama in Tamba Province and later at the Tenryū-ji, Kyōto. His few paintings show the influence of his master and also of Genro Suiō. **Bib.**: Awakawa, Brasch (2), NB (S) 47.
¹霊源 ²慧桃 ³霊源

Reisai (Ryōsai)[1] (fl. 1430–50). **Biog.**: Muromachi *suiboku* painter. Little known about his life. A priest-painter at the Tōfuku-ji, Kyōto, known only by his signatures and seals. Some of his paintings are of Buddhist subjects. One of Minchō's most gifted pupils, a faithful follower of his master's style. A good painter, working in ink with some color. **Coll.**: Daizōkyō-ji, Fujita, Gotō, Tōkyō (1), Umezawa. **Bib.**: BK 87; *Exhibition* (1); Fontein (2); GNB 11; HS 2, 12; K 264, 292, 542, 680, 693; Matsushita (1), (1a); *Muromachi* (1); NB (S) 13; NBZ 3; Shimada 1; Tajima (12) 12, (13) 3; Tanaka (2); Watanabe; Yashiro (1).
¹霊彩

Reisai[1] (fl. 19th c.). *N.*: Shibata Reisai.[2] **Biog.**: Lacquerer. Son of Shibata Zeshin. A well-known lacquerer, much influenced by his father's style. **Bib.**: Herberts, Jahss.
¹令哉 ²柴田令哉

Reitan[1] (1782–1817). *N.*: Suzuki.[2] *A.*: Kimin.[3] *F.N.*: Fujinoshin.[4] *Gō*: Reitan.[5] **Biog.**: Rimpa painter. Born in Himeji of a minor samurai family. Pupil of Sakai Hōitsu. Painted some charming landscapes and *kachōga*.
¹蠣潭 ²鈴木 ³規民 ⁴藤之進 ⁵蠣潭

Rekidō[1] (fl. c. 1860). *F.N.*: Ichijūrō.[2] *Gō*: Rekidō.[3] **Biog.**: Painter. Specialized in figures and *kachōga*. **Coll.**: Museum (3).
¹櫟堂 ²市重郎 ³櫟堂

Remmyō[1] (fl. late 13th c.). **Biog.**: Sculptor. A portrait statue by him in the Kongōrin-ji in Shiga-ken is dated 1286. **Coll.**: Kongōrin-ji.
¹蓮妙

Rengetsu[1] (1791–1875). *N.*: Ōtagaki.[2] *Gō*: Rengetsu,[3] Rengetsu Ni.[4] **Biog.**: Shijō painter. Also calligrapher, potter, and poet. Born in Tajima Province. Became a Buddhist nun (*ni*) after her husband's death. Best known as a poet, but she was also a talented potter, inscribing her poems on her wares, which were generally tea bowls or teapots of unglazed clay. Painted in a charming and delicate way, somewhat in the Shijō manner. **Coll.**: Tōkyō (1), University (2). **Bib.**: *Japanische* (2), Jenyns (2), *Nihon* (8), Rosenfield (1a).
¹蓮月 ²大田垣 ³蓮月 ⁴蓮月尼

Rengyō[1] (fl. c. 1298). *Priest name*: Rengyō.[2] *F.N.*: Rokurobei.[3] **Biog.**: *Yamato-e* painter. Nothing known about his life. On the *Tōsei Eden* scrolls (The Voyage of Priest Ganjin from China to Japan), dated 1298 and in the Tōshōdai-ji, Nara, the artist's name appears as Rokurobei Nyūdō Rengyō.[4] These scrolls show the influence of Chinese Sung painting. **Coll.**: Tōshōdai-ji. **Bib.**: *Chūsei*; K 207; Morrison 1; NEZ 21; NKZ 20; Okudaira (1), (1a); SBZ 6; Tajima (12) 4, (13) 2.
¹蓮行 ²蓮行 ³六郎兵衛 ⁴六郎兵衛入道蓮行

Renzan[1] (1805–59). *N.*: Gan (Kishi) (originally Aoki)[2] Toku[3] (or Shōtoku).[4] *A.*: Shidō,[5] Shishin.[6] *F.N.*: Tokujirō.[7] *Gō*: Banshōrō,[8] Renzan.[9] **Biog.**: Kishi painter. Lived in Kyōto. Pupil of his father-in-law Kishi Ganku, by whom he was adopted. Took the first character *gan* of his father-in-law's name and the *toku* of his own given name and came to be known as Gantoku. Specialized in landscapes and *kachōga*, producing many of the most charming paintings of the school. With Gantai, a leader of the Kishi school after

Ganku's death. Painted the walls of the Room of the Wild Geese in the Kyōto Imperial Palace. **Coll.**: Ashmolean, Fogg, Freer, Imperial (1), University (2), Victoria. **Bib.**: Brown; K 719; Mitchell; Morrison 2; Tajima (12) 12, (13) 6.
¹連山 ²青木 ³岸徳 ⁴昌徳 ⁵士道
⁶士進 ⁷徳次郎 ⁸万象楼 ⁹連山

Ri Sampei[1] (?–1655). *N.*: Yi Sam-p'yong (Korean; in Japanese, Ri Sampei).[2] **Biog.**: Potter. A Korean, said to have been brought to Japan by the lords of Nabeshima after Hideyoshi's second Korean campaign. It is generally believed that he was the one to discover good kaolin near Arita in 1616 or earlier and that he made the first porcelain in Japan, presumably at the Tengudani kiln in Arita. No certain examples of his work survive. Once thought to have been a shadowy and perhaps legendary figure, the recent discovery in the Ryūsen-ji, Nishi Arita, of the registration of his death in 1655 confirms his existence. **Bib.**: BMFA 45, *Ceramic* (1), Jenyns (1), Koyama (1a), Mikami, Miller, NB (S) 71, STZ 4, *Two*, TZ (K) 22.
¹李参平 ²李参平

Rifū[1] (fl. c. 1730). *N.*: Tōsendō Rifū.[2] **Biog.**: Ukiyo-e painter, printmaker. Member of the Kaigetsudō school. Life unknown. Subject matter standing *bijin*. May also have been influenced by Hishikawa Moronobu; later his paintings came closer to the realistic style of Matsuno Chikanobu. **Coll.**: Tōkyō (1). **Bib.**: Jenkins; Kaneko; Kondō (1), (2), (6); M 18; Morrison 2; *Nikuhitsu* (2); Tajima (7) 3; Takahashi (3); *Ukiyo-e* (3) 3.
¹里風 ²東川堂里風

Rigen[1] (fl. late Muromachi period). **Biog.**: Muromachi *suiboku* painter. Follower and perhaps grandson of Sesshū. Received title of *hokkyō*. **Coll.**: Tōkyō (1). **Bib.**: *Chūsei*.
¹李元

Rihei[1] (?–1678). *N.*: Morishima Shigetoshi.[2] *F.N.*: Sakubei.[3] *Gō*: Kita Rihei,[4] Rihei.[5] **Biog.**: Potter. Born in Kyōto; trained at the Awataguchi kilns there. About 1650 invited by the lord of Takamatsu to start the Takamatsu kiln and began to use the *gō* of Kita Rihei. His wares, of pottery decorated with overglaze enamels and reflecting the style of early Kyōto ware, were known as Ko Rihei. His descendants used the same name, making it almost impossible to differentiate between the several artists working under this name. Made tea-ceremony utensils as well as everyday ware. **Coll.**: Tekisui. **Bib.**: Mikami, NB (S) 71, NBZ 5, Satō.
¹理兵衛 ²森島重利 ³作兵衛 ⁴紀太理兵衛 ⁵理兵衛

Rihei (Ribei)[1] (1688–1766). *N.*: Yamamoto Taketsugu.[2] *Gō*: Rihei (Ribei).[3] **Biog.**: Lacquerer. Born in Tamba Province. About 1710 to Kyōto; became a pupil of a lacquerer whose store name was Kichimonjiya.[4] In 1714 opened his own studio-store; soon became famous. In 1746 received an order to produce a set of lacquer for the accession of Emperor Momozono. **Bib.**: Herberts, Jahss.
¹利兵衛 ²山本武継 ³利兵衛 ⁴吉文字屋

Rihei (Ribei) II[1] (1743–91). *N.*: Yamamoto Shūzō.[2] *Gō*: Rihei (Ribei).[3] **Biog.**: Lacquerer. Son of Yamamoto Taketsugu. In 1771 worked on a set of *makie* that was presented to Emperor Gomomozono on his accession. **Bib.**: Herberts.
¹利兵衛二代 ²山本周三 ³利兵衛

Rihei (Ribei) III[1] (1770–1838). *N.*: Yamamoto Mitsuharu.[2] *Gō*: Reigetsu,[3] Rihei (Ribei).[4] **Biog.**: Lacquerer. Son of Yamamoto Shūzō (Rihei II), under whom he studied the *makie* technique. Also studied under the Kanō painter Yoshida Genchin. In 1817 worked under an imperial order on a set of *makie* objects to be presented at the accession of Emperor Ninkō. **Bib.**: Herberts.
¹利兵衛三代 ²山本光春 ³嶺月 ⁴利兵衛

Rikō[1] (fl. 16th c.). **Biog.**: Muromachi *suiboku* painter. Life unknown. His style resembles that of Sesson; hence thought

to be his contemporary. **Coll.**: Museum (3), Tokiwayama. **Bib.**: *Japanese* (1), Matsushita (1), (1a).

¹利光
Rinken[1] (fl. 1536–91). *N.*: Shiba Rinken.[2] **Biog.**: Tosa painter. Worked for the Kōfuku-ji and the Tōdai-ji (which owns his *Daibutsu Engi,* dated 1536) and, as a member of the Kasuga Edokoro, for the Kasuga Shrine. Received title of *hōgen.* Last of the great names associated with religious painting; a conservative painter of Buddhist subjects. **Coll.**: Tōdai-ji. **Bib.**: Morrison 1; *Muromachi* (1); Okudaira (1), (1a); *Pictorial* (1) 3; SBZ 7.

¹琳賢 ²芝琳賢
Rinkoku[1] (1779–1843). *N.*: Hosokawa (originally Hirose)[2] Kiyoshi.[3] *A.*: Hyōko.[4] *Gō:* Fukakokusai,[5] Hakuhatsu Shōji,[6] Nintōan,[7] Rin Dōjin,[8] Rinkoku,[9] Sanshōō,[10] Tennen Gasen,[11] Yūchiku.[12] **Biog.**: Painter, seal engraver. Worked in Edo. Better known as a seal engraver, but an able painter of orchids and bamboo. **Bib.**: Mitchell.

¹林谷 ²広瀬 ³細川潔 ⁴氷壺 ⁵不可刻斎 ⁶白髪小児
⁷忍冬庵 ⁸林道人 ⁹林谷 ¹⁰三生翁 ¹¹天然画仙 ¹²有竹
Rinkyo[1] (fl. 16th c.). **Biog.**: Muromachi *suiboku* painter. His family name and details of his life unknown. Work close to that of Sōami. **Bib.**: HS 12.

¹林居
Rinsai[1] (1791–1865). *N.*: Okajima Sokō.[2] *F.N.*: Buzaemon.[3] *Gō:* Hansen,[4] Rinsai.[5] **Biog.**: Kanō painter. Lived in Edo. Pupil of Kanō Sōsen Akinobu. Specialized in pictures of Fujisan. Developed a style of his own. **Coll.**: Newark, Victoria. **Bib.**: Mitchell.

¹林斎 ²岡島素岡 ³武左衛門 ⁴半仙 ⁵林斎
Rinshin[1] (fl. early 19th c.). *N.*: Denkyūji Gikyō.[2] *A.*: Shitei.[3] *Gō:* Rinshin.[4] **Biog.**: Painter. Lived in Edo. Received title of *hokkyō.* **Coll.**: Museum (3).

¹麟振 ²伝久寺義境 ³子諦 ⁴麟振
Ritsugaku (Ryūgaku)[1] (1827–90). *N.*: Kimura Masatsune.[2] *Gō:* Ritsugaku (Ryūgaku).[3] **Biog.**: Kanō painter. Born in Etchū Province; a member of the clan ruling the Toyama fief. To Edo to study painting with Kanō Seisen'in and Kanō Shōsen'in. Much influenced by the work of the Chinese artist Ch'iu Ying. In the late Edo period worked in the *hommaru* (keep) of the shogun's castle in Edo (destroyed during the Meiji Restoration). After the Restoration helped decorate the emperor's palace and various government buildings in Tōkyō; also worked for the agricultural and library bureaus of the government. Late in life, moved to Yokohama, where he died. His competent Kanō-style paintings are specially noted for their elaborate palace-style buildings, derived from Chinese paintings, placed in a landscape setting. **Coll.**: Freer, Museum (3). **Bib.**: Mitchell, Paine (2) 2.

¹立嶽 ²木村雅経 ³立嶽
Ritsuō[1] (1663–1747). *N.*: Ogawa (originally Kinya)[2] Kan.[3] *A.*: Shōkō (Naoyuki).[4] *F.N.*: Heisuke.[5] *Gō:* Bōkanshi,[6] Hanabusa Issen,[7] Haritsu (Haryū),[8] Kanshi,[9] Muchūan,[10] Ritsuō,[11] Sōu,[12] Ukanshi.[13] **Biog.**: Painter, potter, lacquerer. Born in Ise; lived in Edo. Entered the service of the daimyo of Tsugaru in Mutsu. Said to have learned painting from Hanabusa Itchō, *haiku* from Bashō, lacquering in the Kōetsu tradition. His painting, covering a variety of subjects, a mixture of academic Tosa and tea-taste styles. Worked as illustrator on the *Chichi no On* (a book of *haiku*), printed in 1730 to commemorate the actor Ichikawa Danjūrō I. In lacquer, working often with rough wood as a base, introduced a new vocabulary of materials—glazed ceramic pieces, nacre, lead, and a kind of oil pigment—in the decoration of the lacquered ground. Also reproduced, in raised lacquer, surfaces resembling bronze, tile, ink sticks, pottery: a decoration known as Haritsu-saiku. His work tends to be elaborate and far from the tradition of true Japanese lacquer, resembling more the wares of Chinese Ming and Ch'ing

handicrafts. Many imitators. **Coll.**: Bashō; Center; Collections; Freer; Metropolitan; Museum (1), (2), (3); Ōkura; Portland; Rijksmuseum (1), (2); Stanford; Suntory; Tōkyō (1), (2); Victoria; Walters; Worcester. **Bib.**: Binyon (2); Casal; Herberts; Hillier (3), (4) 1; Jahss; K 13, 74, 273, 593; Kümmel; Lee (2); M 188; Morrison 1; Ragué; Sawaguchi; Speiser (2); Tajima (12) 3, 12, 16; Tajima (13) 5; Takahashi (2); Waterhouse.

¹笠翁 ²金弥 ³小川観 ⁴尚行 ⁵平助
⁶卯観子 ⁷英一蝉 ⁸破笠 ⁹観子 ¹⁰夢中庵
¹¹笠翁 ¹²宗羽（宗宇、宗有） ¹³卯観子
Rochō[1] (1748–1836). *N.*: Mizuno Kojūrō.[2] *A.*: Genkyū.[3] *Gō:* Chōkōsai Rochō,[4] Hanrinsai,[5] Rochō,[6] Seisenkan,[7] Suirochō.[8] **Biog.**: Ukiyo-e painter, printmaker. A samurai. Pupil of Kitao Shigemasa. Produced prints of *bijin* in the style of Kiyonaga; also illustrated collections of *haiku.* **Coll.**: Museum (3). **Bib.**: K 717, *Nikuhitsu* (2), Shimada 3.

¹蘆朝 ²水野小十郎 ³元休 ⁴鳥巷斎路眺
⁵攀鱗斎 ⁶蘆朝（芦朝） ⁷清線館 ⁸水蘆朝
Rōen[1] (?–c. 1810). *N.*: Hayashi Shin.[2] *A.*: Nisshin.[3] *F.N.*: Shūzō.[4] *Gō:* Banryūdō,[5] Rōen,[6] Shōrei.[7] **Biog.**: *Nanga* painter. An Ōsaka man, pupil of Fukuhara Gogaku; also studied Ming and Ch'ing painting. His subjects included landscapes, birds-and-flowers, and figures. Not an orthodox *nanga* painter, for some of his work shows the apparent influence of the Shijō school. **Coll.**: Victoria. **Bib.**: Hillier (1), Shimada 3.

¹閬苑 ²林新 ³日新 ⁴秋蔵 ⁵幡竜洞 ⁶閬苑 ⁷章齢
Roho[1] (fl. mid-19th c.). *N.*: Nagasawa Michikazu.[2] *A.*: Nukio.[3] *Gō:* Rohō.[4] **Biog.**: Shijō painter. Son and pupil of Nagasawa Roshū, grandson of Rosetsu. Worked in the Imperial Palace in Kyōto. A mild painter in the Shijō tradition. **Coll.**: Victoria. **Bib.**: Morrison 2, Tajima (12) 17.

¹蘆鳳 ²長沢道一 ³貫夫 ⁴蘆鳳
Rokkaku Shisui[1] (1867–1950). **Biog.**: Lacquerer. In 1893 one of first graduates of the Tōkyō School of Fine Arts. Studied under Ogawa Shōmin and Shirayama Shōsai. An associate of Fenollosa and Okakura Tenshin, he accompanied them on their travels all over Japan when they were inspecting ancient art objects. Went with Okakura to Boston in 1904 when the latter became a curator at the Boston Museum of Fine Arts. After his return to Japan, took part in the excavations of the Lolang site in Korea. In 1917, appointed lecturer at Tōkyō School of Fine Arts, later becoming professor there. Member of Japan Art Academy and Imperial Academy of Art. Important Meiji lacquerer; wrote a history of Far Eastern lacquer. Influenced by Han dynasty wares, created a complex technique of *makie,* applying incised patterns and *kimetsuke* to his wares. His decoration is in a realistic Western-inspired style. **Bib.**: Herberts, Jahss, NBZ 6, Ragué, Uyeno, Yoshino.

¹六角紫水
Rokō[1] (fl. late 18th to early 19th c.). **Biog.**: Ukiyo-e printmaker. Lived in Ōsaka. Member of the Kamigata-e school. Pupil of either Shōkōsai or Ryūkōsai. Specialized in actor prints. His style unusual in that the heads of his figures are big, the bodies small, details few. **Coll.**: Victoria. **Bib.**: Keyes, NHBZ 3.

¹露好
Rokō[1] (fl. c. 1810). *N.*: Miguma Rokō.[2] **Biog.**: Painter. Pupil of Matsumura Goshun, she specialized in painting cherry blossoms. **Bib.**: Mitchell.

¹露香 ²三熊露香
Rokubei[1] (1733?–99). *N.*: Shimizu (Kiyomizu) Rokubei.[2] *Gō:* Gusai.[3] **Biog.**: Potter. Born in Settsu; worked in Kyōto. First of a long line of potters, all using the name Rokubei. Studied under Ebiya Kiyobei. Protégé of the cloistered prince Myōhō, who, to show his pleasure when given one of Rokubei's black tea bowls, presented him with a hexagonal seal, which the artist then used (together with its variation of

his name Sei in the hexagon) in place of his early mark, Roku. A friend of Maruyama Ōkyo and Matsumura Goshun, whose inscriptions appear on a number of his works. Specialized in decorated faience, imitations of *gosu aka-e,* and blue-and-white. The line of succession is as follows:

Rokubei II (c. 1797–1860). *Gō:* Seisai.[4] Son of Rokubei.

Rokubei III (?–1883). *Gō:* Shōun.[5] Son of Rokubei.

Rokubei IV (1842–1914). *Gō:* Shōrin.[6] Son of Rokubei III.

Rokubei V (1874–1959). Son of Rokubei IV.

Rokubei VI (1901–). One of most famous potters now working in Kyōto.

In the second and following generations, a double line of the hexagon was used to distinguish their work from that of the first-generation artist. The following list of collections and bibliography refers to all the above artists. **Coll.:** Ashmolean, Brooklyn, Freer, Kyōto (1), Metropolitan, National (4), Tōdai-ji, Tōkyō (1), Yale. **Bib.:** Gorham, Jenyns (1), *Masterpieces* (4), NB (S) 71, NBZ 6, *Nihon* (8), Okada, Uyeno.

¹六兵衛 ²清水六兵衛 ³愚斎 ⁴静斎 ⁵祥雲 ⁶祥麟

Rokuzan[1] (1759–1833). *N.:* Kuratani Tsuyoshi.[2] *A.:* Shiben,[3] Shikyō.[4] *Gō:* Rokuzan.[5] **Biog.:** Painter. Born near Nambu to a samurai in the service of the lords of Nambu. Sent as a young man to Nagasaki, probably to learn the military arts, and there studied calligraphy and painting as well. On his return home, became head of the school established by the lord of Nambu.

¹鹿山 ²倉谷強 ³子勉 ⁴子強 ⁵鹿山

Rosetsu[1] (1754–99). *N.:* Nagasawa Gyo.[2] *A.:* Hyōkei.[3] *F.N.:* Kazue.[4] *Gō:* Gyosha,[5] Inkyo,[6] Kanshū,[7] Rosetsu.[8] **Biog.:** Maruyama painter. Born and raised in the family of a low-ranking samurai of the Yodo clan in Yamashiro. An intimate friend of Minagawa Kien. An eccentric and violent character. One of the best of Ōkyo's pupils and in many ways one of his most remarkable followers, but was expelled from Ōkyo's studio and eventually developed his own style. In 1787 toured Wakayama to paint *fusuma* in various temples there—work that shows his individual style, free from Ōkyo's influence. An extraordinarily versatile artist, at times close to the *suiboku* style; at others borrowed themes from ukiyo-e masters, painting famous *bijin.* Also fond of animal subjects. Often combined bold composition of Rimpa school with humor of *zenga.* Frequently used a flat brush, or held the brush in a slanting position, using different tones of ink in the same broad stroke. Occasionally worked in a sort of Western technique called *doro-e,* a mushy, thick paint mixed with Chinese white. **Coll.:** Ashmolean, Art (2), British, Cleveland, Daijō-ji (2), Fine (M. H. De Young), Fogg, Freer, Itsukushima, Itsuō, Jōju-ji, Kotohira, Metropolitan, Museum (3), Muryō-ji, Nezu, Sōdō-ji, Stanford, Tōkyō (1), University (2), Worcester. **Bib.:** ARTA 5; BK 36; Fontein (1); GNB 18; Grilli (1); Hillier (1), (2), (4) 3; K 34, 49, 94, 109, 111, 112, 167, 202, 238, 251, 263, 271, 332, 360, 381, 401, 413, 464, 536, 537, 543, 560, 565, 577, 609, 636, 641, 733, 837, 860, 865, 930, 935, 942, 945; KO 18, 34; M 172; Mitchell; Mizuo (3); Morrison 2; NB (S) 39; NBT 5; NBZ 5; Noma (1) 2; *One* (2); SBZ 10; Shimada 2; Suzuki (7a); Tajima (3) 2; Tajima (12) 6, 11, 12; Tajima (13) 6.

¹蘆雪 ²長沢魚 ³氷計 ⁴主計 ⁵漁者
⁶引裾 ⁷干州（干緝） ⁸蘆雪

Roshū[1] (1699–1757). *N.:* Fukae Shōroku.[2] *Gō:* Roshū,[3] Seihakudō,[4] Yūroshi.[5] **Biog.:** Rimpa painter. Son of Fukae Shōzaemon, an official at the government mint. Left Kyōto at an early age when his father was sent into exile because of a scandal. Knew Kōrin, who was a friend of his father, but was too young to have been his pupil before he was forced to leave Kyōto. Rest of his life unknown. His style shows he was more influenced by Sōtatsu than by Kōrin. His rare paintings include flowers, figures, and animals. Superb

unconventional use of color; little interested in the detailed appearance of nature; great decorative sense. **Coll.:** Cleveland, Freer, Umezawa. **Bib.:** BCM 10; Fujikake (3) 3; K 168, 762, 767, 801, 819, 928; KO 22; Lee (1), (2); Mayuyama; Mizuo (2a), (4); Morrison 2; Murase; NBZ 5; *Rimpa;* SBZ 9; Shimada 2; *Sōtatsu-Kōrin* (3); Stern (3); Tajima (3), (6); YB 31.

¹蘆舟 ²深江庄六 ³蘆舟 ⁴青白堂 ⁵有蘆子

Roshū[1] (1767–1847). *N.:* Nagasawa Rin.[2] *A.:* Donkō.[3] *Gō:* Roshū.[4] **Biog.:** Maruyama painter. Pupil and adopted son of his father-in-law Nagasawa Rosetsu. A minor artist. **Bib.:** Mitchell, Morrison 2.

¹蘆洲 ²長沢鱗 ³呑江 ⁴蘆洲

Roshū[1] (1807–79). *N.:* Kinoshita Naoyuki.[2] *Gō:* Roshū.[3] **Biog.:** Painter. Lived and worked in Ōsaka. Pupil of Hayashi Bunha. **Bib.:** Mitchell.

¹蘆洲 ²木下直行 ³蘆洲

Rosui[1] (?–c. 1829). *N.:* Tsuruoka Rosui.[2] *F.N.:* Kinji.[3] *Gō:* Suishōsai.[4] **Biog.:** Printmaker. Life unknown save that he lived in Edo. Two scrolls of hand-colored prints, *Sumidagawa Ryōgan Ichiran,* are in the British Museum collection. **Coll.:** British.

¹蘆水 ²鶴岡蘆水 ³金次 ⁴翠松斎

Rōtetsu[1] (1793–1852). *N.:* Kojima.[2] *F.N.:* Tomoshichirō.[3] *Gō:* Rōtetsu,[4] Saifū Gaishi.[5] **Biog.:** Painter. Born in Nagoya. First studied under Yoshikawa Yoshinobu; later under Yamamoto Baiitsu. Also studied Chinese Ming and Yüan painting on his own.

¹老鉄 ²小島 ³友七郎 ⁴老鉄 ⁵采風外史

Rōzan[1] (1718–77). *N.:* Numanami Shigenaga.[2] *F.N.:* Gozaemon.[3] *Gō:* Rōzan.[4] **Biog.:** Potter. Born in Ise Province. A wealthy merchant and amateur potter. Made (or caused to be made) a ware called Edo Banko, decorated with pictorial and floral designs in colored enamels. Tall thin-necked ewers are particularly associated with his name. Copied a variety of styles, including those of Kenzan and Ninsei, and of Korean, Kochi, and Wan Li wares. Worked first at Kuwana, near Nagoya; then at Edo, at the request of the shogun; at the end of his life, again at Kuwana. **Bib.:** Jenyns (2), NB (S) 71, NBZ 5, STZ 5.

¹弄山 ²沼波重長 ³五左衛門 ⁴弄山

Rōzan[1] (1830–82). *N.:* Yasuda Yō.[2] *Gō:* Banriō,[3] Rōzan.[4] **Biog.:** *Nanga* painter. Born in Gifu-ken. Liking painting as a child, refused to follow his father's profession of doctor. To Nagasaki, where he studied painting under Hidaka Tetsuō. About 1864 to China, working under Chinese masters until 1873, when he settled in Tōkyō. Skillful painter of landscapes; also well known as a poet and calligrapher. His work is very much in the Chinese literati manner. **Coll.:** Tōkyō (1), Victoria, Worcester. **Bib.:** Asano, Mitchell, NB (H) 24, NB (S) 17, NBZ 6, Uyeno.

¹老山 ²安田養 ³万里翁 ⁴老山

Ryōen[1] (fl. 1131–71?). **Biog.:** Sculptor. *Full title:* Dai Busshi Sasakino Hōin Ryōen. In 1131 made the Amida Nyorai for the Daisen-in, Tottori, and in 1147 completed a set of statues for the emperor. Worked in the style of Jōchō. **Bib.:** Kuno (1).

¹良円

Ryōfu[1] (fl. c. 1580). *N.:* Kanō Jibu[2] (or Jibukyō).[3] *Gō:* Ryōfu.[4] **Biog.:** Kanō painter. Son of Kanō Shinshō. Known only from the Kanō genealogy.

¹了不 ²狩野治部 ³治部卿 ⁴了不

Ryōga[1] (fl. 1202–17). *N.:* Takuma Ryōga.[2] **Biog.:** Takuma painter. Pupil, and perhaps son, of Takuma Shōga. Specialized in Buddhist subjects. Recorded as having worked on the *Taima Shin Mandara* and another *mandara* of the Taimadera, Nara, and with Sonchi on paintings for the pagoda of the Hosshō-ji near Nara. **Coll.:** Taima-dera. **Bib.:** Morrison 1.

¹良賀 ²宅磨良賀

Ryōgen[1] (fl. c. 1163). **Biog.:** Sculptor. Also a priest. Served the Taira clan. **Coll.:** Bujō-ji. **Bib.:** *Heian* (2).
<div align="center">[1]良元</div>

Ryōkan[1] (1757–1831). *Priest name:* Ryōkan.[2] *Gō:* Taigu.[3] **Biog.:** *Zenga* painter, calligrapher. A well-known priest of the Sōtō sect, famous for his eccentric behavior. Pupil of Kokusen at the Entsū-ji. At 39 retired to a hut at the Gogō-an on Mount Kugami in Echigo and from there made journeys all over Japan. A calligrapher and poet; occasionally painted in a simple, unaffected manner, but such paintings are generally additions to his spidery calligraphy. **Coll.:** Ryōkan. **Bib.:** Awakawa; BO 7, 14, 85, 88, 89, 99, 141, 143, 163, 167, 174, 189, 190, 191, 206, 208, 210, 211, 213, 216; Fontein (2); Hisamatsu; NB (S) 47; *Ryōkan;* TBS 1; YB 35.
<div align="center">[1]良寛 [2]良寛 [3]大愚</div>

Ryōkei[1] (?–1645). *N.:* Kanō (originally Watanabe)[2] Ryōkei.[3] **Biog.:** Kanō painter. Worked in Kyōto; died in Hirado. Pupil of Kanō Mitsunobu, was allowed to use the Kanō name. A fairly recently discovered good Kanō artist who served as official painter to the Nishi Hongan-ji, Kyōto. The screens in the Hiunkaku attributed to him are in the Kanō manner of the early Edo period: birds, trees, flowers rendered in bright, clear colors decoratively placed on a gold ground. **Coll.:** Honolulu, Kennin-ji, Kōdai-ji, Museum (3), Nishi Hongan-ji (Hiunkaku). **Bib.:** Doi (6), GNB 13, K 735, Murase, NB (H) 14, Shimada 2.
<div align="center">[1]了慶 (了敬, 了桂) [2]渡辺 [3]狩野了慶 (了敬, 了桂)</div>

Ryōnyū[1] (1756–1834). *N.:* Tanaka.[2] *Priest name:* Ryōnyū.[3] *F.N.:* Sōjirō;[4] later, Sōkichirō.[5] *Gō:* Shūjin;[6] later, Setsuma.[7] *Studio name:* Kichizaemon.[8] *Posthumous name:* Yoshimochi.[9] **Biog.:** Raku potter. Second son of Chōnyū; became ninth generation in the Raku line, succeeding to the name Kichizaemon as head of the family on his father's death in 1770, his elder brother Tokunyū having retired at the same time. In 1789 distributed 200 "red bowls" on the occasion of the two-hundredth memorial service for Chōjirō. In 1791 compiled a work on the genealogy of the Raku family. In 1811 became a monk, taking the name of Ryōnyū. A prolific potter, a man of varied taste interested in poetry, tea ceremony, calligraphy, painting, and Shintō thought and practice. Produced both experimental and conventional work. **Coll.:** Freer; Museum (1), (3); Philadelphia; Tōkyō (1); Victoria; Yale. **Bib.:** Castile, Jenyns (2), NB (S) 14.
<div align="center">[1]了入 [2]田中 [3]了入 [4]惣治郎 [5]惣吉郎
[6]秀人 [7]雪馬 [8]吉左衛門 [9]喜全</div>

Ryōsai[1] (1683–1763). *N.:* Takada Eishin.[2] *F.N.:* Tahei.[3] *Gō:* Boku Ōko[4] (Chinese-style name), Genryō,[5] Gusan,[6] Ryōsai,[7] Shingyō,[8] Sonseisai,[9] Tarōan.[10] **Biog.:** Kanō painter. Born in Nagoya. Pupil of Kanō Tsunenobu. Versed in the tea ceremony as well as in painting. Good at landscapes and portraiture. **Coll.:** Museum (3).
<div align="center">[1]良斎 [2]高田栄信 [3]多兵衛 [4]朴黄狐 [5]源良
[6]具三 [7]良斎 [8]信暁 [9]存生斎 [10]太郎庵</div>

Ryōsei[1] (fl. mid-12th c.). **Biog.:** Sculptor. In 1143 made a portrait statue of Chishō Daishi for the Shōgo-in, Kyōto—a copy of the one in the Mii-dera, Ōtsu. **Coll.:** Shōgo-in. **Bib.:** *Heian* (2).
<div align="center">[1]良成</div>

Ryōsei[1] (1597–1665). *N.:* Kōami Ryōsei.[2] *Gō:* Seibei.[3] **Biog.:** Lacquerer. Eldest son of Kōami Chōgen; member of the Kōami school. An able artist. **Bib.:** Herberts, Jahss.
<div align="center">[1]良清 [2]幸阿弥良清 [3]清兵衛</div>

Ryōsen[1] (fl. late 14th to early 15th c.). **Biog.:** Muromachi *suiboku* painter. Details of his life unknown save that he was a Zen priest at the Tōfuku-ji. Has been confused with Kaō[2] and Ryōzen.[3] Specialized in Buddhist subjects, done in both ink and color. **Bib.:** K 161; NB (S) 13; NBZ 3; NKZ 50, 69.
<div align="center">[1]良詮 [2]可翁 [3]良全</div>

Ryōsen[1] (fl. c. 1539). *N.:* Kojima Ryōsen.[2] *Gō:* Ekkei,[3] Hakushi.[4] **Biog.:** Muromachi *suiboku* painter. Born perhaps

in Echizen; according to a tradition, a member of a collateral branch of the Soga family. Disciple of Shūbun. His work extremely rare. Is said to have painted *kachōga* and portraits in ink alone or with slight color. **Coll.:** Tōkyō (2). **Bib.:** BK 61, HS 6.
<div align="center">[1]亮仙 (亮僊) [2]小島亮仙 (亮僊) [3]越渓 [4]白紙</div>

Ryōsetsu[1] (fl. c. 1760). *N.:* Seki Ryōsetsu.[2] *Gō:* Jinensai,[3] Sanraku,[4] Tōgaku Dōjin.[5] **Biog.:** Painter. A Shintō priest, son and pupil of the priest Ryōgetsu. A *sumi-e* artist; also followed the styles of Sesshū and Mu-ch'i. **Coll.:** Museum (3).
<div align="center">[1]良雪 [2]関良雪 [3]自然斎 [4]三楽 [5]東岳道人</div>

Ryōshi[1] (?–1660). *N.:* Watanabe Ryōshi.[2] *F.N.:* Kyūbei.[3] *Gō:* Habokusai.[4] **Biog.:** Kanō painter. Lived in Fukui. Son and pupil of Watanabe Ryōkei; married a daughter of Kanō Kōi. Painted landscapes and portraits.
<div align="center">[1]了之 [2]渡辺了之 [3]九兵衛 [4]破墨斎</div>

Ryōshin[1] (1704–85). *N.:* Kanō Eishin[2] (or Rakushin).[3] *Gō:* Ryōshin.[4] **Biog.:** Kanō painter. Successor in the Negishi Miyukimatsu line to Yūho Enshin. Is said to have studied the style of either Kanō Mitsunobu or Kanō Eitoku. **Coll.:** Museum (3), Victoria.
<div align="center">[1]良信 [2]狩野栄信 [3]楽信 [4]良信</div>

Ryōshō (Ryōjō)[1] (1539–1617). *N.:* Kanō Hideyuki[2] (or Hidemoto).[3] *F.N.:* Chibu,[4] Chōroku,[5] Hayato.[6] *Gō:* Ryōshō (Ryōjō).[7] **Biog.:** Kanō painter. Son and pupil of Kanō Shinshō. Served the shogunate as *omote eshi,* working in Edo. His descendants were given a house in Ueno Yamashita and came to be known as the Yamashita branch of the Kanō family.
<div align="center">[1]了承 (了乗) [2]狩野秀之 [3]秀元 [4]治部
[5]長六 [6]隼人 [7]了承 (了乗)</div>

Ryōshō[1] (?–1686). *N.:* Kanō Yasusue[2] (or Suemasa).[3] *F.N.:* Tamon,[4] Uzaemon.[5] *Gō:* Ryōshō.[6] **Biog.:** Kanō painter. Served the imperial court. His work follows closely that of Kanō Yasunobu.
<div align="center">[1]了昌 [2]狩野安季 [3]季政 [4]多門 [5]宇左衛門 [6]了昌</div>

Ryōshō[1] (1768–1846). *N.:* Kanō Katanobu.[2] *Gō:* Ryōshō.[3] **Biog.:** Kanō painter. Son of Kanō Baishō Moronobu; pupil of Kanō Tanshin. Member of the Fukugawa Kanō line.
<div align="center">[1]了承 [2]狩野賢信 [3]了承</div>

Ryōson[1] (?–1327). *N.:* Takuma Ryōson.[2] **Biog.:** Painter. Member of the Takuma family of Buddhist painters, noted for the influence of Chinese art on their work. Other than his name and the date of his death nothing seems to be known about him.
<div align="center">[1]了尊 [2]宅磨了尊</div>

Ryōtai[1] (1719–74). *N.:* Tatebe (originally Kitamura)[2] Ryōsoku.[3] *A.:* Chōkō,[4] Mōkyō.[5] *F.N.:* Kingo.[6] *Gō:* Ayata,[7] Ayatari[8] (for *waka*), Kan'yōsai[9] (for painting), Kyūroan,[10] Ryōtai,[11] Ryōtai[12] (for *haiku*). **Biog.:** *Nanga* painter, illustrator. Also a poet and novelist. Born in Mutsu Province; second son of Kitamura Shoi, a retainer of the daimyo of Hirosaki. Studied painting under Sakaki Hyakusen in Kyōto. To Nagasaki to study under Kumashiro Yūhi. At one time, a priest at the Tōfuku-ji, Kyōto, but returned to the lay world and poetry, teaching *haiku* in Edo. Illustrated the *Kanyōsai Gafu* and *Kenshi Gaen*. Wrote a textbook—*Kanga Shin'on*—on painting in the Chinese style. His illustrations are both bold and amusing. **Coll.:** British, Brooklyn, Museum (3), Tokiwayama. **Bib.:** AAA 21, Brown, *Dessins,* Holloway, *Japanese* (1), *Japanische* (2), K 708, Mitchell, Toda (1), Waterhouse.
<div align="center">[1]凌岱 [2]喜多村 [3]建部凌岱 [4]長江 [5]孟喬 [6]金吾
[7]綾太 [8]綾足 [9]寒葉斎 [10]吸露菴 [11]凌岱 [12]涼袋</div>

Ryōtaku[1] (fl. late 17th c.). **Biog.:** Buddhist painter. Worked in Kyōto for the Hongan-ji. Is recorded as having done some screens for the imperial court in 1674. All information about

this artist is, so far, from literary sources only; no works of his are known.

¹了琢
Ryōtaku¹ (fl. 1790). *N.:* Kimura Hirotoshi.² *A.:* Chūfu.³ *Gō:* Hōkaku,⁴ Ryōtaku.⁵ **Biog.:** Painter. Born in Kyōto; lived in Edo. Received title of *hokkyō*. Specialized in Buddhist subjects. **Coll.:** Tōshō-gū. **Bib.:** M 237.

¹了琢 ²木村広俊 ³仲父 ⁴鳳郭 ⁵了琢
Ryōun¹ (1809–86). *N.:* Tōdo Ryōki.² *A.:* Senri.³ *Gō:* Ryōun.⁴ **Biog.:** *Nanga* painter. Born in Ise. Pupil of Yamamoto Baiitsu. Served as a retainer to the daimyo of Ise. Moved to Edo after 1868. An able painter of *kachōga*. **Bib.:** Mitchell.

¹凌雲 ²藤堂良驥 ³千里 ⁴凌雲
Ryōzan¹ (1755–1814). *N.:* Kuroda Ryōken.² *Gō:* Ryōzan.³ **Biog.:** Painter. Born in Sanuki Province. Studied under Fukuhara Gogaku. At first worked in Bizen, then in Tamashima in Bitchū Province, where Okamoto Toyohiko was his pupil. Earliest artist to transmit *nanga* style to the provinces of Bizen and Bitchū. **Coll.:** Museum (3). **Bib.:** BI 20, Paine (2) 1.

¹綾山 ²黒田良顕 ³綾山
Ryōzen (Ryōsen)¹ (fl. 1348–55). **Biog.:** Painter. Born in Chikuzen Province. An early *suiboku* painter of the late Kamakura school and a monk of high ecclesiastical rank. Worked in Kyōto; may have been the *azukari* at the Tōfuku-ji about 1350. Received title of *hōin*. His paintings, practically all of Buddhist subjects, in ink and light colors, are still close in style and iconography to Buddhist polychrome painting, following the style of Takuma Shōga and Eiga. In the past this artist has been confused with Kaō² and Ryōsen,³ but contemporary scholars tend to say these are three different artists. **Coll.:** Freer, Kennin-ji, Myōkō-ji, Seichō-ji. **Bib.:** BCM 50; BI 12; *Chūsei; Exhibition* (1); Fontein (2); *Freer;* GNB 11; HS 1; *Japanese* (1); K 393, 442, 762; Matsushita (1a); Morrison 1; *Muromachi* (1); NB (H) 13; NB (S) 69; NBT 4; Paine (4); Tajima (12) 3; Tanaka (2).

¹良全 ²可翁 ³良詮
Ryōzen¹ (?–1841). *N.:* Eiraku (originally Nishimura)² Ryōzen.³ *F.N.:* Zengorō.⁴ **Biog.:** Potter. Learned his profession from the Raku potter Ryōnyū. Made wares for the tea ceremony in the "Cochin China" manner; also produced everyday objects. **Coll.:** Tōkyō (1).

¹了全 ²西村 ³永楽了全 ⁴善五郎
Ryūchin¹ (fl. c. 1840). *N.:* Matsukawa Ryūchin.² **Biog.:** Shijō painter. Born in Kyōto. Pupil of Keibun. Painted figures and birds-and-flowers. **Coll.:** Victoria. **Bib.:** Mitchell.

¹竜椿 ²松川竜椿
Ryūden¹ (1756–1811). *N.:* Nakano Kan.² *A.:* Kibun.³ *Gō:* Ryūden.⁴ **Biog.:** Painter. calligrapher. Also a Confucian scholar. Born in Owari Province. When grown, studied Confucianism in Kyōto. Is said to have been a good landscape painter, working in the manner of earlier masters. **Bib.:** Mitchell.

¹竜田 ²中野換 ³季文 ⁴竜田
Ryūdō¹ (fl. early 19th c.). *N.:* Tanabe Fumikiyo.² *A.:* Shishō.³ *F.N.:* Bumpei.⁴ *Gō:* Ryūdō.⁵ **Biog.:** *Nanga* painter. Born in Ōsaka. **Bib.:** Mitchell.

¹柳堂 ²田辺文清 ³子章 ⁴文平 ⁵柳堂
Ryūei¹ (1647–98). *N.:* Momoda Morimitsu.² *F.N.:* Buzaemon.³ *Gō:* Ryūei,⁴ Yūkōsai.⁵ **Biog.:** Kanō painter. Lived in Edo. Doctor as well as painter. One of Tan'yū's four most famous pupils. Worked with Tan'yū's sons Tanshin and Tansetsu after their father's death. Works very rare. An amusing, light painter. **Coll.:** Kyōto (2), Museum (3), Tōkyō (2). **Bib.:** *Kanō-ha,* Morrison 1, SBZ 9.

¹柳栄 ²桃田守光 ³武左衛門 ⁴柳栄 ⁵幽香斎
Ryūen¹ (fl. 13th c.). **Biog.:** Sculptor. Member of the En school. Had title of *dai busshi hōin*. According to temple records, was often engaged in making repairs on earlier statues as well as producing works of his own. From 1223

to 1224 repaired pedestals of statues in the Shakadō, Enryaku-ji, Mount Hiei. Known to have received a prize in 1253 or 1254 for the work he did for the Amidadō at the Hōshō-ji, Nara.

¹隆円
Ryūhaku¹ (1666–1722). *N.:* Kanō Sadanobu.² *F.N.:* Kumejirō.³ *Gō:* Ryūhaku.⁴ **Biog.:** Kanō painter. Third son of Kanō Ujinobu; adopted by his elder brother Ryūsetsusai, whom he succeeded in the Odawarachō branch of the Kanō school.

¹柳伯 ²狩野定信 ³粂次郎 ⁴柳伯
Ryūho (Rippo)¹ (1599–1669). *N.:* Hinaya (originally Nonoguchi)² Chikashige.³ *F.N.:* Beniya Shōemon,⁴ Ichibei,⁵ Jirozaemon,⁶ Sōzaemon.⁷ *Gō:* Ryūho (Rippo),⁸ Shōō,⁹ Shōsai.¹⁰ **Biog.:** Ukiyo-e painter, illustrator. Also well known as a poet and calligrapher. Lived in Kyōto. Hinaya was the name of a doll shop of which he was proprietor. In painting, a pupil of Tan'yū and Sōtatsu; also studied the Tosa school, by which he was much influenced. Studied both *waka* and *haiku*, the latter under Teitoku. One of the first artists to produce *haiga*. As a painter of *kyōga* and of genre, can be considered a forerunner of the ukiyo-e manner in the Kansai district. **Coll.:** Seattle. **Bib.:** *Japanische* (2), K 852, Morrison 2, Shimada 3, Tajima (7) 5, Yamane (1a).

¹立圃 ²野々口 ³雛屋親重 ⁴紅屋庄右衛門 ⁵市兵衛 ⁶次郎左衛門 ⁷宗左衛門 ⁸立圃 ⁹松翁 ¹⁰松斎
Ryūho¹ (1820–89). *N.:* Fukushima Nei (Yasushi).² *A.:* Shichoku.³ *F.N.:* Shigejirō.⁴ *Gō:* Mokudō,⁵ Mokushin Sōdō,⁶ Ryūho.⁷ **Biog.:** Japanese-style painter. Born in Kanagawa-ken; later lived in Tōkyō. First studied Maruyama style painting; then became a pupil of Shibata Zeshin. Also studied Chinese painting by himself. Influenced by *nanga* style. Painted landscapes and *kachōga*. **Coll.:** Victoria. **Bib.:** Mitchell.

¹柳圃 ²福島寧 ³子直 ⁴重次郎 ⁵黙堂 ⁶黙神艸堂 ⁷柳圃
Ryūhō¹ (fl. c. 1840). *N.:* Itami Masanobu.² *A.:* Gai.³ *F.N.:* Inosuke.⁴ *Gō:* Ryūhō,⁵ Suikōrō.⁶ **Biog.:** Painter, calligrapher. Born and worked in Edo. **Bib.:** Mitchell.

¹柳峰 ²伊丹雅信 ³亥 ⁴猪之助 ⁵柳峰 ⁶翠光楼
Ryūjo¹ (fl. early 18th c.). *N.:* Yamazaki Ryūjo.² *Gō:* Joryū,³ Ryū.⁴ **Biog.:** Ukiyo-e painter. Born in Edo. A precocious artist, she began to paint at 7 and by 15 displayed a remarkable talent. Her style shows a strong influence of Moronobu. Known for her paintings of *bijin*. **Coll.:** Idemitsu, Museum (3). **Bib.:** ACASA 16, Binyon (3), Lane, *Nikuhitsu* (2), Paine (4).

¹竜女 ²山崎竜女 ³女竜 ⁴竜
Ryūkei¹ (fl. mid-13th c.). *N.:* Kose no Ryūkei.² **Biog.:** Kose painter. Son of Kose no Genkei. Details of his life unknown, but one branch of the Kose family descended from him.

¹隆慶 ²巨勢隆慶
Ryūkei¹ (?–1688). *N.:* Shimizu Kyūbei.² *Gō:* Ryūkei.³ **Biog.:** Lacquerer. Worked for Lord Maeda in Kanazawa. Pupil of Igarashi Dōho I. Great delicacy of style, though less elegant than Dōho. **Bib.:** Jahss, M 188, Ragué, Sawaguchi, Yoshino.

¹柳景 ²清水九兵衛 ³柳景
Ryūkei¹ (1659–1720). Also known as Shimizu Ryūkei.² **Biog.:** Sculptor. Born in Edo; worked in Kyōto. An orthodox priest, who, when his teacher Tankai died in 1717, turned from making Buddhist images to carving thousands of rough wooden figurines of the townspeople of Kyōto, working from living models: a rare enterprise prior to the 19th century. **Coll.:** Museum (3). **Bib.:** M 191, Noma (1) 2.

¹隆慶 ²清水隆慶
Ryūkei¹ (?–1742). *N.:* Kanō Yūshin.² *F.N.:* Kumesaburō.³ *Gō:* Ryūkei.⁴ **Biog.:** Kanō painter. Adopted son and pupil of Kanō Ryūhaku of the Odawarachō line.

¹柳渓 ²狩野邑信 ³粂三郎 ⁴柳渓
Ryūkei¹ (1742–1800). *N.:* Kanō Tomonobu.² *Gō:* Ryūkei.³ **Biog.:** Kanō painter. Son and pupil of Kanō Ryūsetsu;

member of the Odawarachō line. In 1796 changed the second *kanji* of his *gō* as noted in the parenthetical references below.

¹柳渓（柳慶）　²狩野共信　³柳渓（柳慶）

Ryūkei[1] (fl. c. 1840–50). *N.:* Yoshida Ryūkei.[2] *F.N.:* Gozaemon.[3] **Biog.:** Painter. **Bib.:** Mitchell.

¹柳蹊　²吉田柳蹊　³五左衛門

Ryūko[1] (1801–59). *N.:* Takahisa (originally Hata,[2] then Kawakatsu)[3] Takatsune.[4] *A.:* Jutsuji,[5] *U.*[6] *F.N.:* Onoshirō.[7] *Gō:* Baiju,[8] Baisai,[9] Ekiu,[10] Kiryū,[11] Kō Ryūko,[12] Mudō Dōsha,[13] Mudō Sanjin,[14] Ryūko,[15] Udō.[16] **Biog.:** *Yamato-e* painter. Born in Fukushima-ken. At an early age became a pupil of Yoda Chikkoku, under whom he studied Tani Bunchō's style. Then moved to Edo, where he studied under Takahisa Aigai, by whom he was adopted and whose name he took. In his middle years to Kyōto, where he studied *yamato-e* painting under Watanabe Shūkei and Ukita Ikkei and took the name of Kō Ryūko. Specialized in historical subjects. His style a curious but charming crossing of *nanga* and *yamato-e*. **Bib.:** K 87, 678, 689, 690; Mitchell; Tajima (12) 14.

¹隆古　²秦　³川勝　⁴高久隆恒　⁵述而　⁶迂　⁷斧四郎
⁸梅樹　⁹梅斎（楳斎）　¹⁰亦迂　¹¹希竜　¹²高隆古
¹³無道道者　¹⁴無道山人　¹⁵隆古　¹⁶迂道

Ryūkoku[1] (fl. early 19th c.). *N.:* Hishikawa Ryūkoku.[2] *Gō:* Enshunsai,[3] Shungyōsai,[4] Tanseisai.[5] **Biog.:** Ukiyo-e painter, printmaker. Relatively small number of paintings and prints. Specialized in *bijinga*. Much influenced by the style of Utamaro. **Note:** Has been confused with Hishikawa Shunkyō, probably because of the similarity of their names. **Coll.:** British, Musées, Victoria, Worcester. **Bib.:** Binyon (1), (3); Hillier (4) 1; NHBZ 4; Tamba (2a); UG 19, 28.

¹柳谷　²菱川柳谷　³円春斎　⁴春暁斎　⁵丹青斎

Ryūkōsai[1] (fl. 1772–1816). *N.:* Taga Jokei.[2] *F.N.:* Jihei.[3] *Gō:* Ryūkōsai.[4] **Biog.:** Ukiyo-e painter, printmaker, illustrator. A rare artist, one of the founders of the Ōsaka school. Perhaps a pupil of Shitomi Kangetsu; influenced by the Katsukawa school. Work generally confined to book illustrations and paintings; also made actor prints, most of them *hosoban* full-length portraits. Work rather scarce. Biting in his portraiture. **Coll.:** Art (1), Philadelphia. **Bib.:** Fujikake (3) 3; Hillier (1); Keyes; *Kunst*; NHBZ 3; *Nikuhitsu* (1) 2; Stern (2); UG 8, 13; *Ukiyo-e* (3) 19.

¹流光斎　²多賀女圭　³治平（慈平）　⁴流光斎

Ryūkyō[1] (fl. early 16th c.). *Gō:* Ryūkyō,[2] Shikibu.[3] **Biog.:** Muromachi *suiboku* painter. Nothing known of his life, nor is his surname known. Possibly he is the same artist as Terutada Shikibu, who used a *gō* reading Ryūkyō.[4] His comparatively numerous paintings reveal an artist of unusual talent with a style close to that of Shōkei and, like him, influenced by the work of Mu-ch'i or at least by the Chinese Sung style. **Coll.:** Center, Museum (3). **Bib.:** Art (2); K 701, 801; M 205; Matsushita (1a); Mayuyama; Shimada 1.

¹竜杏　²竜杏　³式部　⁴竜杏

Ryūmondō Yasuhei[1] (1780–1841). **Biog.:** Potter. Close friend of Aoki Mokubei. Known for his wares decorated in red. **Bib.:** NB (S) 71, NBZ 5.

¹竜文堂安平

Ryūsen (Tomonobu)[1] (?–c. 1715). *N.:* Ishikawa Toshiyuki.[2] *F.N.:* Izaemon.[3] *Gō:* Gahaiken,[4] Kamatsuken Ryūshū,[5]

Ryūsen (Tomonobu),[6] Ryūshū.[7] **Biog.:** Ukiyo-e painter, printmaker. Lived in Edo. Pupil of Hishikawa Moronobu. Known for his illustrations in *Yamato Kōsaku Eshō* (Illustrations of Japanese Agriculture) and other books. **Coll.:** Art (1), Tōkyō (1). **Bib.:** Jenkins, Lane, UG 3.

¹流宣　²石川俊之　³伊左衛門　⁴画俳軒
⁵河末軒流舟　⁶流宣　⁷流舟

Ryūsetsu[1] (1729–74). *N.:* Kanō Nakanobu.[2] *Gō:* Ryūsetsu.[3] **Biog.:** Kanō painter. Son and pupil of Kanō Ryūkei Yūshin; member of the Odawarachō Kanō line.

¹柳雪　²狩野中信　³柳雪

Ryūsetsusai[1] (1647–72). *N.:* Kanō Hidenobu.[2] *F.N.:* Geki,[3] Naishō.[4] *Gō:* Ryūsetsusai.[5] **Biog.:** Kanō painter. Son and pupil of Kanō Ujinobu; member of the Odawarachō Kanō line. **Coll.:** Museum (3).

¹柳雪斎　²狩野秀信　³外記　⁴内匠　⁵柳雪斎

Ryūshō[1] (fl. 18th c.). *N.:* Kajikawa Ryūshō.[2] **Biog.:** Kajikawa lacquerer. **Coll.:** Museum (3). **Bib.:** Herberts.

¹柳章　²梶川柳章

Ryūson[1] (fl. 1880–90). *N.:* Ogura Ryūson.[2] **Biog.:** Ukiyo-e printmaker. A skillful Meiji artist who, influenced by Kiyochika, fused the ukiyo-e manner with some of the realism and atmospheric quality of Western art and produced prints of considerable imagination and poetic feeling. However, his work is rare, and nothing is known of his life. Specialized in night scenes, particularly moonlight. Sometimes varnished his prints to make them look like Western oil paintings. **Coll.:** Fine (California), Riccar, Tōkyō (1). **Bib.:** Fujikake (1), Kikuchi, Michener (3), NBZ 6, NHBZ 7.

¹柳村　²小倉柳村

Ryūsui (Ryōsui)[1] (1711–96). *N.:* Katsuma Antei[2] (or Shinsen).[3] *Gō:* Haikōrin,[4] Kōhairin,[5] Ryūsui (Ryōsui),[6] Ryūsuiō,[7] Sekijudō,[8] Sekijukan,[9] Shūkoku.[10] **Biog.:** Illustrator, calligrapher. Also an engraver of seals. Lived in Edo. Studied calligraphy under Ikenaga Dōun and later taught it to the neighborhood children. As an artist, seems to have been a member of Harunobu's circle. His illustrations for the *Umi no Sachi* (Treasures of the Sea), printed in 1762, and for the *Yama no Sachi* (Treasures of the Mountains), printed in 1765, are among the finest examples of early polychrome printing. Also a poet, illustrating books of *haiku*. **Coll.:** British. **Bib.:** Binyon (3), OZ (new series) 7, Waterhouse.

¹竜水　²勝間安定　³新泉　⁴俳耕林　⁵耕俳林
⁶竜水　⁷竜水翁　⁸石寿堂　⁹石寿観　¹⁰秀国

Ryūtō[1] (fl. 1468). **Biog.:** Muromachi *suiboku* painter. Studied style of Shūbun and Sesshū. Particularly skillful at painting landscapes, plum blossoms, and bamboo. **Coll.:** Victoria. **Bib.:** M 166, Matsushita (1a).

¹竜登

Ryūunsai[1] (fl. c. 1788). *N.:* Fujiwara (originally Tōyama)[2] Masatake.[3] *Gō:* Ryūunsai.[4] **Biog.:** Ukiyo-e printmaker. Perhaps an amateur. Seems to have been a follower of Torii Kiyonaga. Made prints of actors and *bijin;* very small production. **Coll.:** Tōkyō (1).

¹竜雲斎　²遠山　³藤原政武　⁴竜雲斎

Ryūzan[1] (1785–1850). *N.:* Ōkura Takeshi.[2] *A.:* Kokuhō.[3] *Gō:* Ryūzan,[4] Yoshikuni.[5] **Biog.:** *Nanga* painter. Son of a rich peasant in Yamato. To Edo, where he studied poetry under Rai Sanyō and painting with Nakabayashi Chikutō. An able artist. **Coll.:** Victoria. **Bib.:** Brasch (1a), Mitchell.

¹笠山　²大倉毅　³国宝　⁴笠山　⁵義邦

S

Saburi Makoto[1] (1898–1936). **Biog.:** Western-style painter. Born in Nagoya. In his early teens moved to Tōkyō. Graduated from the Kawabata Gagakkō and, in 1922, from the Western-painting department of the Tōkyō School of Fine Arts. From 1927 until about 1932 traveled in France, Italy, Holland, England, and Spain, studying the painters of the Dutch school and the works of Gustave Courbet and Cézanne. On his return showed with the Teiten as well as with the

Kōfūkai and the Hakujitsukai, of which he was a member. In 1934 commissioned by the Tōhō Theater to do a wall painting. In 1936 committed suicide. **Coll.:** National (5).

¹佐分真

Sadafusa¹ (fl. 1825–50). *N.:* Utagawa (originally Ōsawa)² Sadafusa.³ *Gō:* Gofūtei,⁴ Gohyōtei,⁵ Gokitei,⁶ Shinsai,⁷ Tōchōrō.⁸ **Biog.:** Ukiyo-e printmaker. Lived first in Edo, then moved to Ōsaka. Pupil of Kunisada, working much in the same style. Made prints of *bijin*. **Coll.:** Cincinnati, Musées, Newark, Rhode Island, Riccar, Victoria. **Bib.:** Ficke, Keyes, NHBZ 6, Strange (2).

¹貞房 ²大沢 ³歌川貞房 ⁴五楓亭
⁵五瓢亭 ⁶五亀亭 ⁷震斎 ⁸桶蝶楼

Sadaharu¹ (fl. c. 1830–44). *N.:* Hasegawa Sadaharu.² *Gō:* Goryūtei,³ Goshōtei.⁴ **Biog.:** Ukiyo-e printmaker. Worked in Ōsaka. Specialized in actor prints. **Coll.:** Musées, Victoria.

¹貞春 ²長谷川貞春 ³五柳亭 ⁴五蕉亭

Sadahide¹ (1807–73). *N.:* Utagawa (originally Hashimoto)² Kenjirō.³ *Gō:* Gountei,⁴ Gyokuō,⁵ Gyokuran,⁶ Gyokuransai,⁷ Gyokurantei,⁸ Sadahide.⁹ **Biog.:** Ukiyo-e printmaker. Worked in Edo and Yokohama. Pupil of Kunisada. A prolific but minor printmaker and illustrator, producing some theatrical prints in the Ōsaka manner as well as prints of traditional Japanese subjects and, after Yokohama was opened to the West, of contemporary industrial scenes and foreigners. Also made political cartoons and copied many works by earlier artists. One of the eleven Japanese printmakers who presented their works at the Paris Exposition of 1866, receiving the Légion d'Honneur for his part in the exhibition. Sometimes called a member of the Yokohama school. One of the last to depict ukiyo-e subjects. His effective and decorative prints show the influence of Western perspective and chiaroscuro. **Coll.:** Albertina, Art (1), British, Brooklyn, Cincinnati, Fogg, Grunwald, Honolulu, Metropolitan, Musée (2), Musées, Newark, Philadelphia, Rhode Island, Riccar, Östasiatiska, Staatliche, Tōkyō (1), University (2), Victoria, Worcester. **Bib.:** Binyon (1), (3); Crighton; *Dessins;* Ficke; *Foreigners;* Hillier (9); Kikuchi; Mody; Morrison 2; NHBZ 7; *Nikuhitsu* (2); Nonogami; Sansom (2); Schmidt; Tamba (2a), (3).

¹貞秀 ²橋本 ³歌川兼次郎 ⁴五雲亭 ⁵玉翁
⁶玉蘭 ⁷玉蘭斎 ⁸玉蘭亭 ⁹貞秀

Sadahiro¹ (fl. 1825–75). *N.:* Utagawa (originally Nanakawa)² Sadahiro.³ *Gō:* Gochōtei,⁴ Gokitei,⁵ Gorakutei,⁶ Gosōtei,⁷ Kōgadō.⁸ **Biog.:** Ukiyo-e printmaker. About 1826 seems to have studied under the Shijō painter Ueda Kōchō; about 1828 studied in Edo under Utagawa Kunisada. Worked in Edo and Ōsaka. From 1835 to 1852 may have been proprietor of the publishing firm Tenki. In mid-1847 apparently changed his name briefly to Hirokuni and, immediately afterward, to Hirosada; hence may be the same person as Utagawa Hirosada (q.v.). Actor prints among his subjects. **Coll.:** Musées, Museum (3), Newark, Philadelphia, Rhode Island, Riccar, Tōkyō (1), Victoria, Worcester. **Bib.:** Binyon (3), Keyes, *Kunst,* NHBZ 3, *Ukiyo-e* (3) 19.

¹貞広 ²南々川 ³歌川貞広 ⁴五蝶亭
⁵五輝亭 ⁶五楽亭 ⁷五粽亭 ⁸好画堂

Sadahisa¹ (fl. c. 1356). *N.:* Kose no Sadahisa.² **Biog.:** Kose painter. Son of Kose no Arishige. Sometimes listed as Munehisa.³ Held various court positions.

¹定久 ²巨勢定久 ³宗久

Sadakage¹ (fl. c. 1818–44). *N.:* Utagawa (originally Kojima)² Sadakage.³ *F.N.:* Shōgorō.⁴ *Gō:* Gokotei.⁵ **Biog.:** Ukiyo-e printmaker. Worked first in Edo; later, and chiefly, in Ōsaka. Pupil of Kunisada. Specialized in *bijinga;* also made some of the "blue prints" and some *ōkubi-e*. A graceful, expressive line. **Coll.:** British, Cincinnati, Fitzwilliam, Musées, Newark, Riccar, Tōkyō (1), Victoria. **Bib.:** Binyon (1), Ficke, Keyes, Strange (2), UG 28.

¹貞景 ²小島 ³歌川貞景 ⁴庄五郎 ⁵五湖亭

Sadamaru¹ (fl. c. 1833). *N.:* Utagawa Sadamaru² (originally Sadamaro).³ **Biog.:** Ukiyo-e printmaker. Lived in Ōsaka. Specialized in actor prints. **Bib.:** Keyes, *Ukiyo-e* (3) 19.

¹貞丸 ²歌川貞丸 ³貞麿

Sadamasa¹ (fl. c. 1830–44). *N.:* Hasegawa Sadamasa.² **Biog.:** Ukiyo-e printmaker. Pupil of Hasegawa Sadanobu. Worked in Ōsaka, specializing in actor prints. **Bib.:** Strange (2).

¹貞政 ²長谷川貞政

Sadamasu II¹ (fl. c. 1830–40). *N.:* Utagawa Sadamasu.² *Gō:* Gochōtei.³ **Biog.:** Ukiyo-e printmaker. A pupil of either Kunisada or Kunimasu. A minor Ōsaka actor-print designer. **Coll.:** Philadelphia. **Bib.:** Keyes.

¹貞升二代 ²歌川貞升 ³蝶亭

Sadanobu¹ (1597–1623). *N.:* Kanō Sadanobu.² *F.N.:* Sakon,³ Sakon Shōkan,⁴ Shirojirō,⁵ Toshinobu,⁶ Ukyōnoshin,⁷ Ukyōnosuke.⁸ **Biog.:** Kanō painter. Son and pupil of Kanō Mitsunobu, represented seventh generation of the Kanō school. Served the shogun Hidetada. Little known of his short life save that he worked at Nagoya Castle, where his screens are in the typical Momoyama style: bold designs, strong color, naturalistic detail, much use of gold—all features made popular by his grandfather Eitoku. **Coll.:** Emman-in, Honolulu, Nagoya. **Bib.:** BK 164, *Exhibition* (1), Morrison 1, NB (H) 14, Takeda (1), Yamane (1a).

¹貞信 ²狩野貞信 ³左近 ⁴左近将監
⁵四郎次郎 ⁶寿信 ⁷右京進 ⁸右京亮

Sadanobu¹ (fl. first half 18th c.). *N.:* Tamura Sadanobu.² **Biog.:** Ukiyo-e printmaker. A minor artist, working in the manner of Okumura Masanobu and Kiyomasu II. **Coll.:** Metropolitan, Musées. **Bib.:** AO 5, Fujikake (3) 2, Kurth (4).

¹貞信 ²田村貞信

Sadanobu¹ (1758–1829). *N.:* Matsudaira Sadanobu.² *A.:* Teikyō.³ *Gō:* Kyokuhō,⁴ Rakuō.⁵ **Biog.:** Painter, calligrapher. Born into ruling Tokugawa family, grandson of eighth shogun, Yoshimune. At 12 adopted by Sadakuni, lord of Shirakawa, member of the Matsudaira family. Very active in all government affairs. Man of many interests: artist, calligrapher, garden designer, author, Confucian scholar. In 1790 supervised the rebuilding of the Kyōto Imperial Palace: a careful archaeological reconstruction of the original Heian building. **Bib.:** Rosenfield (1a).

¹定信 ²松平定信 ³貞卿 ⁴旭峯 ⁵楽翁

Sadanobu¹ (1809–79). *N.:* Hasegawa Bunkichi² (later Tokubei).³ *Gō:* Kinkadō,⁴ Nansō,⁵ Nansōrō,⁶ Ryokuitsusai,⁷ Sadanobu,⁸ Sekkaen,⁹ Shin'ō,¹⁰ Shinten'ō.¹¹ **Biog.:** Ukiyo-e printmaker. First a pupil of the Shijō painter Ueda Kōchō. In early 1830s became a pupil of Utagawa Sadamasu. Member of the Ōsaka school. Late in his career designed landscapes, *kachōga,* and a series of miniature copies of prints by Hiroshige. Also made prints of actors (the first of which appeared in 1834) and *bijin*. **Coll.:** British, Honolulu, Musée (1), Newark, Ōsaka (1), Philadelphia, Rhode Island, Riccar, Tōkyō (1), Victoria, Worcester. **Bib.:** Binyon (1), (3); Crighton; Ficke; Keyes; Kikuchi; Mitchell; Stewart; Strange (2); *Ukiyo-e* (3) 19.

¹貞信 ²長谷川文吉 ³徳兵衛 ⁴金花堂 ⁵南窓 ⁶南窓楼
⁷緑一斎 ⁸貞信 ⁹雪花園 ¹⁰信춍 ¹¹信天翁

Sadanobu¹ (fl. c. 1850). *N.:* Kanō Sadanobu.² *Gō:* Baishun.³ **Biog.:** Kanō painter. Son and pupil of Kanō Baiei, a minor artist of the Fukugawa Kanō school.

¹貞信 ²狩野貞信 ³梅春

Sadatora¹ (fl. c. 1825). *N.:* Utagawa Sadatora.² *F.N.:* Yonosuke.³ *Gō:* Gofūtei.⁴ **Biog.:** Ukiyo-e printmaker. Worked in Ōsaka. Pupil of Kunisada. Made prints of *kachō* and *bijin*. **Coll.:** Albertina, Cincinnati, Musées, Newark, Rhode Island, Riccar, Tōkyō (1), Victoria. **Bib.:** Ficke, Tamba (2a).

¹貞虎 ²歌川貞虎 ³与之助 ⁴五風亭

Sadatoshi¹ (fl. 1716–36). **Biog.:** Ukiyo-e printmaker, illus-

trator. Worked in Kyōto. **Coll.**: Art (1), Victoria. **Bib.**: Brown, Toda (1).

¹定年

Sadatsune (Teikyō)¹ (fl. c. 1242). *N.*: Fujiwara Sadatsune (Teikyō).² **Biog.**: Lacquerer. Known from the inscription as the lacquerer of doors for a shrine in the Taima-dera, Nara, dated 1242. The doors have charming designs of lotuses, still showing much influence of the Heian period. **Coll.**: Taima-dera. **Bib.**: Herberts, Ragué.

¹貞経　²藤原貞経

Sadayoshi¹ (fl. 1837–50). *N.*: Utagawa Sadayoshi.² *F.N.*: Higoya Sadashichirō.³ *Gō*: Baisōen,⁴ Baisōen Kinkin⁵ (as author), Gofūtei,⁶ Gohyōtei,⁷ Kaishuntei,⁸ Kokuhyōtei.⁹ **Biog.**: Ukiyo-e printmaker. Also an author. Little known about him save that he worked in Ōsaka. **Coll.**: Musées, Philadelphia, Victoria. **Bib.**: Keyes.

¹貞芳　²歌川貞芳　³肥後屋貞七郎　⁴梅窓園
⁵梅窓園琴金　⁶五瓢亭　⁷五瓢亭　⁸魁春亭　⁹国瓢亭

Saeki Yūzō¹ (1898–1928). **Biog.**: Western-style painter. Born in Ōsaka. Studied first at the Kawabata Gagakkō. After graduating in 1923 from Tōkyō School of Fine Arts, where he was a pupil of Fujishima Takeji, went to France. Studied under Vlaminck, painting Paris street scenes and buildings in the style of his master. Friend of Utrillo. In 1925 exhibited at the Salon d'Automne. Returned to Japan in 1927, having shown in 1926 with the Nikakai some 20 of the paintings done in Paris and having received an award. Haunted by Paris, returned to France almost immediately and died there in 1928. Paintings received little recognition until after his death. **Coll.**: Bridgestone, Nagaoka, National (5). **Bib.**: Asano, *Masterpieces* (4), Miyagawa, NB (H) 24, NBT 10, NBZ 6, NKKZ 10, SBZ 11, Tanaka (7a) 42.

¹佐伯祐三

Saian¹ (fl. late 15th to early 16th c.). **Biog.**: Muromachi *suiboku* painter. Nothing known of his life save that he was probably a Zen priest at the Shōkoku-ji, Kyōto. Is recorded as having painted a set of eight views (probably of Lake Tung-t'ing) in a style close to that of the Ma-Hsia school in China. **Bib.**: BK 47; HS 1; K 128, 257, 504; *Muromachi* (1).

¹柴ің

Saichi¹ (fl. 13th c.). **Biog.**: Sculptor. Details of his life unknown. An inscription dated 1270 on a bronze Shō Kannon in the Boston Museum of Fine Arts bears his name. Also the rubbings of inscriptions from a bronze flower vase and an incense burner (once in the Hokkedō of the Tōdai-ji, Nara, but lost in a fire) state that these pieces were made by him, the former bearing the date of 1265. **Coll.**: Museum (3). **Bib.**: BK 57, Fontein (3), KO 35, Mayuyama.

¹西智

Saichō¹ (1763–1849). *N.*: Ki (originally Nogiwa)² Saichō.³ *A.*: Hakuki.⁴ *Gō*: Hakusetsu,⁵ Sekiko.⁶ **Biog.**: *Nanga* painter. Pupil of Noro Kaiseki. Became official painter to the daimyo of Kishū. Specialized in landscapes. **Bib.**: Mitchell.

¹蔡徴　²野際　³紀蔡徴　⁴伯亀　⁵白雪　⁶石湖

Saidō¹ (1786–1837). *N.*: Kaitani Zemmei.² *A.*: Kōki.³ *F.N.*: Kichibei.⁴ *Gō*: Saidō.⁵ **Biog.**: *Nanga* painter. Born in Aichi-ken. Pupil of Chō Gesshō. **Bib.**: Mitchell.

¹采堂　²貝谷善名　³公器　⁴吉兵衛　⁵采堂

Saigō Kogetsu¹ (1873–1912). *N.*: Saigō Tadasu.² *Gō*: Kogetsu.³ **Biog.**: Japanese-style painter. Graduated in the first class of the Tōkyō School of Fine Arts; classmate and associate of Taikan, Gyokudō, and Kanzan. Exhibitor and prize winner as well as teacher at the Nihon Bijutsuin. A rather delicate conservative artist. **Coll.**: Tōkyō (2), Victoria. **Bib.**: Asano, K 659, *Kurashina* (1), NB (S) 17, NBZ 6, Uyeno.

¹西郷孤月　²西郷規　³孤月

Saijirō¹ (1634–1704). *N.*: Gotō Saijirō.² **Biog.**: Potter. Several members of the Gotō family bore the name Saijirō,

but it is said to have been this one who was sent to Arita by Maeda Toshiharu to learn the secret of making porcelain and who was later connected with the establishment of the Kutani kiln and the manufacture of porcelain there. According to one tradition, he found the secret too well guarded at Arita and went to Nagasaki, where he became acquainted with Chinese refugee potters, bringing them home with him and with their aid producing the first Kutani ware. Other accounts say he married the daughter of the first Kakiemon in order to learn the secret of porcelain making; still others, that he went to China. The whole story is filled with confusion and hearsay, and even the exact date for the opening of the Kutani kiln is in dispute, ranging as it does from 1639 to 1661. No Kutani pieces can be attributed with any certainty to Saijirō. **Bib.**: BMFA 44, 60; *Ceramic* (1); Jenyns (1); Koyama (1a); Mikami; Munsterberg (2); NB (S) 71; TOCS 1945–46; TZ (K) 8.

¹才次郎　²後藤才次郎

Saikaku¹ (1642–93). *N.*: Ihara Saikaku.² *Gō*: Man'ō,³ Nimandō,⁴ Shōjuken.⁵ **Biog.**: Illustrator. A famous writer, known for his *ukiyo-zōshi* (genre literature). Illustrated works by other writers as well as his own. **Bib.**: Brown.

¹西鶴　²井原西鶴　³万翁　⁴二万堂　⁵松寿軒

Saikō¹ (1787–1861). *N.*: Ema Tahoko.² *A.*: Ryokugyoku.³ *Gō*: Kizan,⁴ Saikō,⁵ Shōmu.⁶ **Biog.**: *Nanga* painter. Born in Mino Province, daughter of a doctor. Moved to Kyōto, where she associated with painters and writers. Studied poetry under Rai Sanyō, painting under Uragami Shunkin and Yamamoto Baiitsu. Became a leading woman painter of the *nanga* school. Flowers her specialty. **Coll.**: Victoria. **Bib.**: Mitchell.

¹細香　²江馬多保子　³緑玉　⁴箕山　⁵細香　⁶湘夢

Saiseki¹ (fl. late 18th c.). **Biog.**: Ukiyo-e painter. Apparently an ukiyo-e artist who made no prints. No certain information as to his family name or the details of his life is at present available. **Bib.**: K 485, 630.

¹斎夕

Saishin¹ (?–1829). *N.*: Kanō Saishin.² *Gō*: Genshin,³ Tōju.⁴ **Biog.**: Kanō painter. Son and pupil of Kanō Tōrin Yoshinobu; member of the Saruyamachi Kanō line. **Coll.**: Victoria.

¹采信　²狩野采信　³言信　⁴洞寿

Saitō Sogan¹ (1889–). *N.*: Saitō Tomo-o.² *Gō*: Sogan.³ **Biog.**: Sculptor. Born in Tōkyō. Graduated in 1912 from the painting department of the Tōkyō School of Fine Arts. Then went to London and, turning to sculpture, studied at the Royal Academy there. On his return to Japan exhibited with the Bunten, the Teiten, and, later, the Nitten. One of the founders in 1926 of the Kozōsha, a sculptors' group. Member of the Nitten and the Japan Art Academy. His work, frequently in relief, is rather academic. **Coll.**: National (5). **Bib.**: Asano, NBZ 6.

¹斎藤素巌　²斎藤知雄　³素巌

Saitō Toyosaku¹ (1880–1951). **Biog.**: Western-style painter. Born in Saitama-ken. Graduated from the Tōkyō School of Fine Arts (Western-painting extension course) in 1905. To Paris in 1906 and there studied for the next six years under Raphael Collin. On his return, exhibited with the Kōfūkai and then with the Bunten. Later joined the Nikakai, becoming a member and serving as a juror. His work is based on the French impressionist school. **Coll.**: National (5). **Bib.**: Asano, NB (H) 24, NBZ 6.

¹斎藤豊作

Saitō Yori¹ (1885–1959). *N.*: Saitō Yoriji.² *Gō*: Yori.³ **Biog.**: Western-style painter. Pupil of Asai Chū. From 1906 to 1909 studied in Paris under Jean-Paul Laurens. Influenced by the impressionists as well as by the fauves. On his return exhibited with the Taiheiyō Gakai, the Fusainkai (which he founded), the Bunten, and the Teiten, becoming a juror for the last in 1934. In 1929 helped found the Enjusha; later

a founder of the Tōkōkai. Worked in a style of distorted forms and strong colors. **Bib.:** Asano, Harada Minoru, NB (H) 24, NBZ 6.

¹斎藤与里 ²斎藤与里治 ³与里

Sakaguchi Usami¹ (1895–1937). **Biog.:** Western-style painter. Born in Karatsu, Saga-ken. Studied at the Taiheiyō Kenkyūsho and the Nihon Bijutsuin. Became a member of the Inten in 1914. Later showed with the Shun'yōkai. An invalid toward the end of his life. A minor figure. **Bib.:** Asano.

¹坂口右左視

Sakai Sanryō¹ (1897–1969). **Biog.:** Japanese-style painter. Born in Fukushima-ken; worked in Tōkyō. An exhibitor with and member of the Nihon Bijutsuin. Also exhibited with the Nitten. In 1952 received the Education Minister's Prize for Fostering the Arts. A traditional painter, generally of landscapes. **Coll.:** National (5). **Bib.:** Asano.

¹酒井三良

Sakaida Kakiemon XII¹ (1878–1963). **Biog.:** Potter. Born in Arita. Studied at the Arita Apprentice School under his father Kakiemon XI. Worked in the family tradition of porcelain decorated with overglaze enamels, restoring the quality of *aka-e* porcelain, which had sadly deteriorated. In 1917 became twelfth generation to hold name of Kakiemon (q.v.). **Bib.:** Hayashiya (1), Jenyns (1), *Masterpieces* (4), Munsterberg (2), STZ 16.

¹酒井田柿右衛門

Sakaki Teitoku¹ (1858–1939). **Biog.:** Western-style painter. Born in Nagasaki. In 1872 to Tōkyō and studied at Takahashi Yuichi's school, the Tenkai Gakusha. Four years later entered the Kōbu Daigaku Bijutsu Gakkō, working under Fontanesi in lithography and design. From 1893 to 1901 continued his studies in Europe. Returned to Nagasaki, moving later to Tōkyō. Joined no art groups. **Bib.:** Asano.

¹彭城貞徳

Sakakibara Shihō¹ (1887–1971). **Biog.:** Japanese-style painter. Born in Kyōto. Elder brother of Sakakibara Taizan. Studied at the Kyōto Municipal School of Fine Arts and Crafts, exhibiting while still a student with the Bunten. Taught at the Kyōto College of Fine Arts. Founding member of the Kokuga Sōsaku Kyōkai. Worked in a decorative manner with much attention to detail. **Coll.:** National (5). **Bib.:** Asano, NB (H) 24, NBZ 6, SBZ 11.

¹榊原紫峰

Sakakibara Taizan¹ (1892–1963). **Biog.:** Japanese-style painter. Younger brother of Sakakibara Shihō. Born in Kyōto. Graduate of Kyōto Municipal School of Fine Arts and Crafts. Pupil of Takeuchi Seihō. Exhibited with the Bunten. Quite decorative manner, with realistic details. **Coll.:** National (5). **Bib.:** Elisséev.

¹榊原苔山

Sakamoto Hanjirō¹ (1882–1969). **Biog.:** Western-style painter. Born in Kurume. In 1902 to Tōkyō. With his school friend Aoki Shigeru studied at the Fudōsha under Koyama Shōtarō. Exhibited first with the Bunten, then with the Nikakai, of which he was one of the founders in 1914. From 1921 to 1924 in France, after which he returned to Kurume. In the 1930s painted animals, in the 40s still lifes. After 1945 belonged to no art group. In 1953 received the Mainichi Award and, later, the Asahi Award; also given the Order of Cultural Merit. His postwar works are fairly representational, with delicate colors and imbued with a vague romanticism; in spirit, very Japanese; in style, showing the influence of Bonnard. **Coll.:** Bridgestone, Nagaoka, Ohara (1). **Bib.:** Asano, Fujikake (1), Harada Minoru, *Masterpieces* (4), Miyagawa, NB (H) 24, NB (S) 30, NBT 10, NBZ 6, NKKZ 12, SBZ 11.

¹坂本繁二郎

Sakata Kazuo¹ (1889–1956). **Biog.:** Western-style painter. Born in Okayama. In 1914 to Tōkyō to study with Okada Saburōsuke and Fujishima Takeji. In 1921 to France, where he studied under Othon Friesz and Fernand Léger; later acted as assistant in their ateliers. Showed at various salons. Returned to Japan in 1933 to live in Okayama, where he became the leader of an avant-garde group. Many of his paintings were destroyed by floods. **Coll.:** Bridgestone, National (5), Ohara (1). **Bib.:** Asano.

¹坂田一男

Sakei¹ (fl. c. 1764). *Gō:* Sakei,² Suikōdō.³ **Biog.:** Ukiyo-e printmaker. Known to have been an illustrator of calendars, for which he used the seal Suikōdō. **Coll.:** Tōkyō (1). **Bib.:** Kikuchi.

¹莎鶏 ²莎鶏 ³水光洞

Sakesō¹ (fl. mid-16th c.). **Biog.:** Sculptor. An inscription on the inside of a mask in the Hakusan-jinja, Gifu, carries the date 1542 and gives his name as the artist. **Coll.:** Hakusan-jinja. **Bib.:** *Muromachi* (1).

¹酒惣

Sakon¹ (1602–46). *N.:* Kanō (originally Kusumi)² Tanetsugu.³ *Gō:* Sakon,⁴ Sōsen.⁵ **Biog.:** Kanō painter. Younger son of Kanō Sōshin Tanenaga. Served the shogunate as a minor court painter. A member of the Odawarachō Kanō line.

¹左近 ²久隅 ³狩野種次 ⁴左近 ⁵宗仙

Sakon¹ (fl. first half 17th c.). *N.:* Hasegawa Sakon.² **Biog.:** Hasegawa painter. Life and career obscure; has been confused with various other members of the school, including Hasegawa Tōchō (fl. 1624–43), who is also thought to have been a relative of Tōhaku, but is generally believed to have been third son and chief follower of Hasegawa Tōhaku. His work shows influence of early Kanō style; also owes something to Sōtatsu. **Coll.:** Metropolitan, Museum (3). **Bib.:** Mayuyama, NB (H) 14, Paine (2) 1, Rosenfield (2), Shimada 2.

¹左近 ²長谷川左近

Sakuma Bungo¹ (1868–1940). **Biog.:** Western-style painter. Born in Fukushima-ken. Pupil of Yamamoto Hōsui and Koyama Shōtarō. An exhibitor at the Meiji Bijutsukai as well as at the Hakubakai, of which he later became a member. Style that of late-19th-century academic realism. **Bib.:** Asano, Uyeno.

¹佐久間文吾

Sakuma Tetsuen¹ (1850–1921). *N.:* Sakuma Takehisa.² *Gō:* Tetsuen.³ **Biog.:** Japanese-style painter. Born in Sendai. Son of a minor *nanga* artist, Sakuma Seigaku. Wanted to become a statesman and went to Tōkyō to study for such a career but failed to reach his goal. Became instead an influential artist. In 1907, with Takashima Hokkai, Mochizuki Kimpō, Araki Juppo, Komuro Suiun, Tanaka Raishō, and Masuzu Shunnan, founded the Seiha Dōshikai (a short-lived exhibiting society). From 1910 to 1913 served as a juror for the Bunten. **Coll.:** Victoria. **Bib.:** Asano.

¹佐久間鉄園 ²佐久間健寿 ³鉄園

Sakurai Chūgō¹ (fl. late 19th to early 20th c.). **Biog.:** Western-style painter. Studied under the pioneer Western-style painter Kawamura Kiyo-o. Exhibited first in 1887 at a government-sponsored show at Ueno; also showed at the opening exhibition of the Meiji Bijutsukai in 1889 and a year later at the Naikoku Kangyō Hakurankai. In 1901 helped found the Kansai Bijutsukai. Took an active part in Kansai art circles. **Bib.:** Asano, NBZ 6.

¹桜井忠剛

Samboku¹ (fl. late 17th to early 18th c.). *N.:* Kanō Ryōji.² *Gō:* Fukyūshi,³ Samboku.⁴ **Biog.:** Kanō painter. Lived in Kyōto. Seems to have based his style on that of Kanō Sanraku, who was a distant relative.

¹山卜 ²狩野良次 ³不及子 ⁴山卜

Sanda Yasushi¹ (1900–1968). **Biog.:** Western-style painter. Born in Ōtsu. Graduated from Tōkyō School of Fine Arts in 1922, having studied with Fujishima Takeji. Exhibited

with the Teiten, often receiving awards. In 1936 helped found the Shinseisaku Kyōkai. **Bib.**: Asano, NBZ 6.

¹三田康

Sankōbō[1] (fl. late 16th c.). *Priest name:* Sankō.[2] *Gō:* Sankōbō.[3] **Biog.**: Sculptor. Originally a priest, came to Mount Hiei from the Heisen-ji in Echizen. Famous as a carver of masks. Founder of the Deme school.

¹三光坊 ²三光 ³三光坊

Sankurō[1] (fl. 1673–83). *N.:* Yamauchi Sankurō.[2] **Biog.**: Lacquerer. Worked first in Hida, then moved to Noshiro in Akita-ken. Said to have been the inventor of Noshiro-shunkei. **Bib.**: Herberts, Jahss.

¹三九郎 ²山打三九郎

Sannojō[1] (1610–96). *N.:* Imamura Shōichi.[2] *Gō:* Sannojō.[3] **Biog.**: Potter. Son of a Korean potter who founded the Hirado-yaki kiln. In 1641 was given the name of Imamura by Lord Matsuura of Hizen. Succeeded in creating a white porcelain.

¹三之丞 ²今村正一 ³三之丞

Sano Akira[1] (1866–?). **Biog.**: Western-style sculptor. Graduated from the Kōbu Daigaku Bijutsu Gakkō in 1882, having studied under Vincenzo Ragusa. Joined the Hakubakai in 1896. His principal work *Umashi Made no Mikoto* (Prince of the Beautiful Hands) was presented to the emperor Meiji on his twenty-fifth wedding anniversary. Worked in the European academic style of his master. **Bib.**: Asano.

¹佐野昭

Sanraku[1] (1559–1635). *N.:* Kanō (originally Kimura)[2] Mitsuyori.[3] *F.N.:* Heizō,[4] Shuri.[5] *Gō:* Sanraku.[6] **Biog.**: Kanō painter. Born in Shiga-ken, son of Kimura Nagamitsu (pupil of Motonobu). As a boy, served Hideyoshi, who had him taught by Kanō Eitoku, whose son-in-law he became and who later adopted him. Faithful to Hideyoshi's survivors, fled to the Takinomotobō monastery, Otokoyama, after fall of Ōsaka Castle in 1615; pardoned by Ieyasu, returned to Kyōto and became a monk using name of Sanraku. After other Kanō painters moved to Edo, became head of the Kyō Kanō branch. Many temples in Kyōto have paintings by him, not all of which have been authenticated. Never signed his genre paintings. After Eitoku, considered most gifted artist of Kanō school. His themes frequently Chinese. His work, typical of Momoyama painting, less flamboyant than Eitoku's, less grandiose, more careful, more ordered, more subtle and restrained. Frequently allows the frame to cut his designs for dramatic effect. Versatile artist, working occasionally in the *yamato-e* manner, sometimes in ink alone, or in the decorative style combining strong color on gold ground. **Coll.**: Allen, British, Daigo-ji (Sambō-in), Daihōon-ji, Daikaku-ji, Daitsū-ji, Hompō-ji, Metropolitan, Museum (3), Myōhō-in, Myōshin-ji (Tenkyū-in), Nanzen-ji, Ninna-ji, Portland, Shitennō-ji, Shōden-ji, Tōkyō (1). **Bib.**: Akiyama (3), (4); *Art* (1a); BB 15; BI 13, 52; Binyon (2); BK 1, 40, 52, 81; Covell (2); Doi (2), (3), (4), (7), (8); *Exhibition* (1); *Freer;* GNB 14; Gray (2); Grilli (1); HS 9, 10; K 32, 37, 49, 98, 111, 117, 209, 212, 239, 242, 260, 460, 508, 626, 646, 668, 733, 752, 839, 902, 903, 938; Lee (1); Minamoto (1), (2); Morrison 1; NB (H) 14; NBT 5; NBZ 4; NKZ 63; Noma (1) 2; Okamoto (1); *One* (2); Paine (2) 1, (4); SBZ 8; Shimada 2; Tajima (12) 2, 3; Tajima (13) 4; Tanaka (3); Tsuji; *Ukiyo-e* (3) 20; Yamane (1a); YB 48.

¹山楽 (三楽) ²木村 ³狩野光頼
⁴平三 ⁵修理 ⁶山楽(三楽)

Sansai[1] (fl. c. 1840). *N.:* Satō Sansai.[2] *Gō:* Raian.[3] **Biog.**: Painter. Worked in Edo. **Bib.**: Mitchell.

¹山斎 ²佐藤山斎 ³懶菴

Sansetsu[1] (1590–1651). *N.:* Kanō (originally Senga)[2] Mitsuie.[3] *Court title:* Nuidononosuke.[4] *Gō:* Jasokuken,[5] Sansetsu,[6] Shōhaku Sanjin,[7] Tōgenshi.[8] **Biog.**: Kanō painter. Born in Hizen, son of Senga Dōgan. About 1604 to Kyōto;

studied under Kanō Sanraku, married his daughter, and was adopted by him into the Kanō family, eventually becoming head of the second generation of the Kyō Kanō school. In 1647 given title of *hokkyō*. The leading Kanō artist in Kyōto of his time. His style in painting follows the Kanō tradition of decorative splendor established in the Momoyama period, but his drawing is rather more elaborate. **Coll.**: British, Freer, Kiyomizu-dera, Minneapolis, Musée (2), Museum (3), Myōshin-ji (Tenkyū-in), Nezu, Seattle, Sennyū-ji, Staatliche, Tōkyō (1), Yoshimizu-jinja. **Bib.**: AA 14; Akiyama (3); *Ausgewählte;* BB 20; Binyon (2); Covell (2); Doi (3), (8); GNB 13; K 839; KO 2, 21, 36; M 112; Minamoto (2); Morrison 1; NB (H) 14; NBZ 4; Noma (1) 2; Paine (2) 2, (4); SBZ 8; Shimada 2; Tajima (12) 7, 8, 9, 18; Tajima (13) 5; Tsuji.

¹山雪 ²千賀 ³狩野光家 ⁴縫殿助 ⁵蛇足軒
⁶山雪 ⁷松柏山人 ⁸桃源子

San'yō[1] (1780–1832). *N.:* Rai Jō.[2] *A.:* Shisei.[3] *F.N.:* Kyūtarō.[4] *Gō:* Sanjūroppō Gaishi,[5] San'yō.[6] **Biog.**: *Nanga* painter. Also calligrapher, poet, scholar. Born in Aki Province, son of the famous Confucian scholar of Hiroshima, Rai Shunsui. Lived in Kyōto. One of the outstanding writers of his time, publishing many books. Painting for him was primarily a hobby, and, indeed, his landscapes have no great merit. **Bib.**: GNB 18; K 246, 290, 365, 406, 421, 451, 459, 470, 706, 816; Mitchell; Murayama (2); NB (H) 23; NB (S) 4; NBZ 5; *Nihon* (3); Yonezawa.

¹山陽 ²頼襄 ³子成 ⁴久太郎 ⁵三十六峰外史 ⁶山陽

Sanyū[1] (1685–1739). *N.:* Tanaka (originally Yamatoya)[2] Sōkichi.[3] *Posthumous name:* Yoshiakira.[4] *Studio name:* Kichizaemon.[5] *Gō:* Sanyū.[6] **Biog.**: Raku potter. Adopted son of Sōnyū. In 1708 given name of Kichizaemon and succeeded Sōnyū as head of the sixth generation of the Raku line. Retired in 1728 to become a monk, taking the name of Sanyū. In 1738, for the 150th memorial service for Chōjirō, made 150 red-glazed bowls and distributed them to his friends. **Coll.**: Tōkyō (1), Victoria. **Bib.**: Castile, Jenyns (2), NB (S) 14.

¹左入 ²大和屋 ³田中惣吉 ⁴嘉顕 ⁵吉左衛門 ⁶左入

Sanzaemon[1] (fl. 1624–44). *N.:* Narita Sanzaemon.[2] **Biog.**: Lacquerer. Lived in Takayama, Hida Province. Invented Hida-shunkei. **Bib.**: Herberts, Jahss.

¹三左衛門 ²成田三左衛門

Sasaki Taiju[1] (1889–). *N.:* Sasaki Chōjirō.[2] *Gō:* Taiju.[3] **Biog.**: Sculptor. Born in Toyama-ken. In 1913 graduated from Tōkyō School of Fine Arts, having studied under Takeuchi Kyūichi. After 1920 showed with government exhibitions. Also studied woodcarving with Sawada Seikō and Tominaga Chōdō. Member of the Nitten. In 1928 received the Imperial Fine Arts Academy Prize. **Bib.**: Asano.

¹佐々木大樹 ²佐々木長次郎 ³大樹

Sashū[1] (1802–75). *N.:* Seki Hakuku.[2] *Gō:* Sashū.[3] **Biog.**: Painter. Born in Ōsaka. Pupil of Kamata Ganshō. Painter of landscapes, figures, *kachōga*. **Coll.**: Museum (3).

¹襄州 ²関白駒 ³襄州

Satake Eiko[1] (1835–1909). *N.:* Satake (originally Katō)[2] Kintarō.[3] *A.:* Shishō.[4] *Gō:* Eiko,[5] Kaikaidō Sanjin,[6] Taiga.[7] **Biog.**: Japanese-style painter. Lived in Tōkyō; studied under Oki Ichiga and, after his death, under Satake Eikai, whose eldest daughter he married, taking the name of Satake. Member of Nihon Bijutsu Kyōkai. A frequent prize winner. Versed in the Kanō, Tosa, and *nanga* styles. **Coll.**: Victoria. **Bib.**: Mitchell.

¹佐竹永湖 ²加藤 ³佐竹金太郎
⁴子璋 ⁵永湖 ⁶巍々堂山人 ⁷泰峨

Satake Eiryō[1] (1872–1937). *N.:* Satake (originally Kuroda)[2] Ginjūrō.[3] *Gō:* Eiryō.[4] **Biog.**: Japanese-style painter. Pupil and adopted son of Satake Eiko. Lived in Tōkyō. After 1888 showed with various organizations, including the Nihon

Bijutsu Kyōkai and Nihongakai, for both of which he served as a committee member and a juror.

¹佐竹永陵 ²黒田 ³佐竹銀十郎 ⁴永陵

Satake Eison[1] (1841–1922). *N.:* Satake.[2] *A.:* Sempo.[3] *F.N.:* Takematsu.[4] *Gō:* Eison.[5] **Biog.:** Japanese-style painter. Born in Fukushima-ken. Pupil first of Gamō Rakan, then of Satake Eikai. On marrying the second daughter of Eikai, began to use the name Satake. Member of Nihon Bijutsu Kyōkai and Nihongakai. Many awards at various exhibitions. Skillful painter of landscapes. **Bib.:** Mitchell.

¹佐竹徳 ²佐竹 ³千畝 ⁴竹松 ⁵永邨

Satake Toku[1] (1897–). *N.:* Satake Tokujirō.[2] *Gō:* Toku.[3] **Biog.:** Western-style painter. Born in Ōsaka; works in Tōkyō. Studied at the Kansai Bijutsuin and the Kawabata Gakkō. Then became a pupil of Kanokogi Takeshirō and Fujishima Takeji. Member of and exhibitor with the Nitten; also showed at government exhibitions. His paintings, usually landscapes, are somewhat academic. **Coll.:** National (5). **Bib.:** Asano.

¹佐竹徳 ²佐竹徳次郎 ³徳

Satō Chōzan[1] (1888–1963). *N.:* Satō Seizō.[2] *Gō:* Aundō,[3] Chōzan,[4] Gengen.[5] **Biog.:** Western-style sculptor. Born in Fukushima. Studied under Yamazaki Chōun; then, in Tōkyō, under Takamura Kōun. Member of the Japan Art Academy. In 1922 to France, where he was greatly influenced by Bourdelle. In 1940 received Asahi Culture Prize. Worked in wood. His later works are very much in Bourdelle's manner. Produced some remarkably tasteless Buddhist sculpture. **Coll.:** Tōkyō (1). **Bib.:** Asano, GNB 28, *Masterpieces* (4), NB (H) 24, NBT 2, SBZ 11.

¹佐藤朝山 ²佐藤清蔵 ³阿吽洞 ⁴朝山 ⁵玄玄

Satomi Katsuzō[1] (1895–). **Biog.:** Western-style painter. Born in Kyōto. Graduate of the Tōkyō School of Fine Arts in 1919. From 1921 to 1925 studied in France; much influenced by Vlaminck. On his return exhibited with the Nikakai. One of the founders of the Dokuritsu Bijutsu Kyōkai and of the 1930 Association; member of the Kokugakai. Again in Europe from 1955 to 1958. Style very fauve. **Bib.:** Asano, NB (H) 24, NBZ 6.

¹里見勝蔵

Sawada Seikō[1] (1894–). *N.:* Sawada Torakichi.[2] *Gō:* Seikō.[3] **Biog.:** Western-style sculptor. Born in Atami. Studied first at the Taiheiyō Kenkyūsho and with Yamamoto Zuiun. A graduate of the Tōkyō School of Fine Arts. After 1921 showed with the Teiten (serving as a juror in 1931) and with various other government-sponsored exhibitions; after 1945, with the Nitten, of which he became a member. Also a member of several sculptural organizations. Winner of the Education Minister's Prize for Fostering the Arts in 1951; in 1952 received the Japan Art Academy Award. Style shows influence of Bourdelle and Maillol. **Bib.:** Asano, NBZ 6, Yanagi (1a).

¹沢田政広 ²沢田寅吉 ³政広

Sawada Sōtaku[1] (1830–1915). *N.:* Sawada Jisaku[2] (later Sōji).[3] *Gō:* Sōtaku,[4] Sōtakusai.[5] **Biog.:** Lacquerer. Born in Kanazawa. Studied under Umeda Sangorō, a minor lacquerer, and became a competent Meiji artist with considerable skill in Kaga-makie. His eldest son, Ryōtarō,[6] succeeded him as Sōtakusai II. **Bib.:** Jahss, NBZ 6, Ragué, Uyeno.

¹沢田宗沢 ²沢田次作 ³宗次
⁴宗沢 ⁵宗沢斎 ⁶良太郎

Seia[1] (fl. 1764–79). **Biog.:** Ukiyo-e printmaker. **Coll.:** Tōkyō (1). **Bib.:** Kikuchi.

¹井蛙

Seiami (Jōami)[1] (fl. middle to late 16th c.). *Gō:* Seiami,[2] Shōho.[3] **Biog.:** Lacquerer. A well-known artist of Kyōto, specializing in lacquer tea-ceremony utensils. Worked for the famous tea master Sen no Rikyū and, later, for Furuta Oribe, as well as for Hideyoshi, who gave him the title *tenkaichi* in recognition of his outstanding work. Followed by three generations. **Coll.:** Hatakeyama. **Bib.:** Herberts, Jahss.

¹盛阿弥 ²盛阿弥 ³紹甫

Seibei[1] (fl. early 17th c.). **Biog.:** Potter. Well-known artist working at the Yasaka kiln just south of Awataguchi, Kyōto. Impossible to identify any of his work today. **Bib.:** Satō.

¹清兵衛

Seibei[1] (fl. 1704–11). *F.N.:* Makie-shi.[2] **Biog.:** Lacquerer. Lived and worked in Ōsaka. Famous for his *inrō*. On the way to Edo to work for the shogun was killed in a fall from his horse. A careful, precise craftsman. **Bib.:** Herberts, Jahss.

¹清兵衛 ²巻絵師

Seichō[1] (fl. 1180–94). **Biog.:** Sculptor. Son and pupil of Kōchō. Member of Shichijō Bussho in Nara. Worked at the Kōfuku-ji after the fire of 1180 and, from 1185, at the Shōchōju-in in Kamakura; among the first of the Kansai sculptors to work in the new capital. Returned to the Kōfuku-ji before his death, receiving title of *hokkyō* in 1194. No extant works known. **Bib.:** Mōri (1a).

¹成朝

Seifū Yohei[1] (1803–61). **Biog.:** Potter. Born in Kanazawa. First of a family of potters working at a kiln at Gojōzaka (a district of Kyōto). Studied in Kyōto under Dōhachi; set up his kiln sometime between 1818 and 1830. Was followed by Seifū Yohei II (1844–78) and Seifū Yohei III (1851–1914), one of the best-known modern porcelain artists. Produced various kinds of porcelain at Gojōzaka, all in the Chinese tradition, including blue-and-white, monochrome decoration or "brocade" enamel glazes, and plant forms in low relief under the glaze, on a pure white body. **Coll.:** Brooklyn, Metropolitan, Museum (3), Newark, Yale. **Bib.:** GNB 28; Jenyns (1); M 203; Munsterberg (2); NB (S) 41, 71; NBZ 5, 6; Uyeno.

¹清風与平

Seigai[1] (1786–1851). *N.:* Sakurama Kan.[2] *A.:* Zentotsu.[3] *F.N.:* Zenjirō.[4] *Gō:* Seigai,[5] Sōjunken,[6] Usai,[7] Usen,[8] Utei,[9] Zennō.[10] **Biog.:** *Nanga* painter. Lived in Edo; adopted by relatives of the same name who were members of the samurai class. A retainer of Lord Honda of Okazaki. First a pupil of Katagiri Tōin, later of Watanabe Kazan, who esteemed him highly; much influenced by Tani Bunchō. Had the reputation of being a heavy drinker and the hero of numerous adventures. In 1824 began to use the *gō* Seigai. Landscapes, painted in a very Chinese manner, his forte, but *kachōga* a close second. **Coll.:** Tōkyō (1), Victoria. **Bib.:** BK 67; Cahill; *Cent-cinquante;* K 136, 342, 531; Mitchell; Morrison 2; NB (S) 4; *Nihon* (2); SBZ 10; Tajima (13) 7; Umezawa (2).

¹青厓 ²桜間威 ³善訥 ⁴善次郎 ⁵青厓
⁶蒼潤軒 ⁷迂斎 ⁸雨仙 ⁹迂亭 ¹⁰善訥

Seigan[1] (1789–1858). *N.:* Yanagawa Mōi.[2] *A.:* Hakumen,[3] Kōto,[4] Mushō.[5] *F.N.:* Shinjurō.[6] *Gō:* Hyakuhō,[7] Ōseki Shōin,[8] Rōryūan,[9] Seigan,[10] Tenkoku.[11] **Biog.:** *Nanga* painter. Born in Mino Province. First to Edo, then to Kyōto, where he lived a secluded life. The Confucian scholars Koga Seiri and Yamamoto Hokuzan were his mentors and may have had much to do with his poetic talent. Best known as a poet and traveler. **Coll.:** Ashmolean. **Bib.:** Umezawa (2).

¹星巌 ²梁川孟緯 ³伯兔 ⁴公図 ⁵無象 ⁶新十郎
⁷百峯 ⁸鴨沜小隠 ⁹老竜庵 ¹⁰星巌 ¹¹天谷

Seigen[1] (fl. 14th c.). **Biog.:** Sculptor. Also a painter of statues. Member of the Tsubai Bussho. Received title of *hokkyō*. His name is on the statue of Fudō Myōō (dated 1373) in the Tōdai-ji, Nara. Also made, with Shunkei, a statue (dated 1380) in the Hōryū-ji. **Coll.:** Hōryū-ji (Gomadō), Tōdai-ji. **Bib.:** *Muromachi* (2), NBZ 3, *Pictorial* (1) 3, SBZ 7.

¹清玄

Seigyō[1] (fl. Muromachi period). **Biog.:** Muromachi *suiboku* painter. Life unknown; according to one theory, a Korean

by birth. Said to have painted several pictures of Daruma. **Bib.:** HS 10.

¹性暁

Seiichi¹ (1835–82). *N.:* Suzuki Motochika.² *Gō:* Seiichi.³ **Biog.:** Rimpa painter. Son and pupil of Suzuki Kiichi. A good painter of flowers, birds, and animals.

¹誠一　²鈴木元親　³誠一

Seiken (Masakane, Shōken)¹ (fl. 19th c.). *N.:* Shunshō (originally Yamamoto)² Seiken (Masakane, Shōken).³ **Biog.:** Lacquerer. Second son of Seishū (Shunshō VIII); became head of the tenth generation of the Shunshō lacquer family. **Bib.:** Herberts, Jahss.

¹正兼　²山本　³春正正兼

Seiki¹ (1793–1865). *N.:* Yokoyama Seiki² (originally Kizō).³ *A.:* Seibun.⁴ *F.N.:* Shōsuke,⁵ Shume.⁶ *Gō:* Gogaku,⁷ Kajō,⁸ Kibun.⁹ **Biog.:** Shijō painter. Born and lived in Kyōto. One of Keibun's best pupils. Did some of the paintings in the Kyōto Imperial Palace when it was rebuilt in 1855. Also a painter of *kachōga.* **Coll.:** Art (1), Ashmolean, Museum (3), Victoria. **Bib.:** Mitchell, Morrison 2.

¹清暉　²横山清暉　³暉三　⁴成文
⁵詳介　⁶主馬　⁷五岳　⁸霞城　⁹奇文

Seikō (Masayuki)¹ (1654–1740). *N.:* Shunshō (originally Yamamoto)² Seikō (Masayuki).³ *Gō:* Jōshō.⁴ **Biog.:** Lacquerer. Son of Shunshō Keishō; eventually became Shunshō III. Worked in Kyōto. A talented lacquer artist. **Bib.:** Herberts, Jahss.

¹政幸　²山本　³春正政幸　⁴常照

Seiko¹ (fl. early 19th c.). *N.:* Haruki Hidesada.² *A.:* Kiun.³ *Gō:* Seiko,⁴ Ungai Nōfu.⁵ **Biog.:** *Nanga* painter. Second son and pupil of Haruki Nanko. Worked in Edo. **Bib.:** Mitchell.

¹西湖　²春木秀定　³其雲　⁴西湖　⁵雲外農夫

Seikō¹ (fl. c. 1840). *N.:* Hashimoto Seikō.² **Biog.:** *Nanga* painter. She lived and worked in Ōsaka. **Bib.:** Mitchell.

¹青江　²橋本青江

Seikō¹ (1828–77). *N.:* Okajima.² *Gō:* Seikō.³ **Biog.:** Shijō painter. Born in Kanazawa; lived in Kyōto. Pupil of Yokoyama Seiki. Able painter of landscapes and *kachōga.* **Coll.:** Ashmolean, Museum (3). **Bib.:** Mitchell.

¹清曠　²岡島　³清曠

Seikon¹ (1691–1774). *Priest name:* Taihō.² *Gō:* Seikon,³ Shōō.⁴ **Biog.:** Painter. A priest of the Ōbaku sect. In 1721 emigrated from China to Nagasaki, becoming the head priest of the Tokusai-ji, Nagasaki. Eventually became fifteenth abbot of the Mampuku-ji. Regarded as a founder of a branch of the Nagasaki school of painting. Particularly able painter of bamboo. **Bib.:** NB (S) 47.

¹正鯤　²大鵬　³正鯤　⁴笑翁

Seimiya Hitoshi¹ (1886–1969). **Biog.:** Western-style painter, printmaker. Born in Hiroshima-ken. Studied oil painting at the Hakubakai; self-taught as a print artist. In 1912 helped found the Fusainkai and in 1915 the Sōdosha. Member of the Nihon Sōsaku Hanga Kyōkai. A traditional artist. **Bib.:** Asano, Fujikake (1), NBZ 6, UG 11.

¹清宮彬

Seirei (Masayoshi)¹ (1734–1803). *N.:* Shunshō (originally Yamamoto)² Seirei (Masayoshi).³ *Gō:* Jirobei.⁴ **Biog.:** Lacquerer. Became head of the fifth generation of the Shunshō school. Moved from Kyōto to Nagoya. A talented artist. **Coll.:** Victoria. **Bib.:** Herberts, Jahss.

¹正令　²山本　³春正正令　⁴次郎兵衛

Seiryō¹ (?–1869). *Priest name:* Seiryō.² *Gō:* Gyokurei.³ **Biog.:** Painter. A priest attached to the Sōrin-ji, Kyōto. **Coll.:** Musées. **Bib.:** Mitchell.

¹清亮　²清亮　³玉嶺

Seisen'in¹ (1796–1846). *N.:* Kanō Yasunobu (Osanobu, Yōshin).² *F.N.:* Shōzaburō,³ Osanobu.⁴ *Gō:* Gyokusen,⁵ Kaishinsai (Eshinsai),⁶ Seisen,⁷ Seisen'in.⁸ **Biog.:** Kanō painter. Represented the eighth generation of the Kobikichō branch of the Kanō school. Son and pupil of Kanō Isen'in,

became in his turn *goyō eshi* and did much work at Edo Castle. Also made copies of earlier paintings. In 1819, given title of *hōgen;* in 1834 that of *hōin,* at which time he began to use the *gō* of Seisen'in. Author of a well-known diary, *Kaishinsai Nenki,* which is essential for the study of the Kanō school. Toward the end of his life, took orders. Produced exaggerated Chinese-type rococo landscapes. **Coll.:** Metropolitan, Museum (3), Philadelphia, Tōkyō (1), Victoria. **Bib.:** ARTA 1957, *Kanō-ha,* M 61, Morrison 1, *Nihon* (7).

¹晴川院　²狩野養信　³庄三郎　⁴養信
⁵玉川　⁶会心斎　⁷晴川　⁸晴川院

Seishi (Masayuki)¹ (1774–1831). *N.:* Shunshō (originally Yamamoto)² Seishi (Masayuki).³ *Gō:* Keidō.⁴ **Biog.:** Lacquerer. Worked in Nagoya. Son of Shunshō Seirei. Became head of the sixth generation of the Shunshō family. **Bib.:** Herberts, Jahss.

¹正之　²山本　³春正正之　⁴敬道

Seishō (Shōshō, Masaaki)¹ (?–1878). *N.:* Shunshō (originally Yamamoto)² Seishō (Shōshō, Masaaki).³ **Biog.:** Lacquerer. Little known of his life or work, since he was forced to retire by illness. Known as Shunshō IX. **Bib.:** Herberts, Jahss.

¹正章　²山本　³春正正章

Seishū¹ (fl. c. 1820). *N.:* Asai Seishū.² **Biog.:** Shijō painter. Pupil of Shibata Gitō. **Coll.:** Museum (3).

¹星洲　²浅井星洲

Seishū (Shōshū, Masachika)¹ (1819–77/80). *N.:* Shunshō (originally Yamamoto)² Seishū (Shōshū, Masachika).³ **Biog.:** Lacquerer. May have been the younger brother of Shunshō Seitoku. Became Shunshō VIII. **Bib.:** Herberts, Jahss.

¹正周　²山本　³春正正周

Seitoku¹ (1781–1829?). *A.:* Hakuryū.² *Gō:* Gion Seitoku,³ Seitoku.⁴ **Biog.:** Ukiyo-e painter. Lived in Kyōto. May have been the owner, whose given name was Tokuemon,⁵ of the Izutsuya⁶ studio in the Gion quarter of Kyōto. An able but eccentric painter of genre scenes. **Coll.:** Idemitsu, Musée (2). **Bib.:** AA 14; Fujikake (3) 2; Keyes; *Nikuhitsu* (1) 2, (2); Shimada 3; *Ukiyo-e* (3) 19.

¹井特　²伯立　³祇園井特　⁴井特　⁵特右衛門　⁶井筒屋

Seitoku (Masanori)¹ (?–1871). *N.:* Shunshō (originally Yamamoto)² Seitoku (Masanori).³ *Gō:* Bokusai,⁴ Seiichian.⁵ **Biog.:** Lacquerer. Became head of the seventh generation of the Shunshō family. A talented artist. **Bib.:** Herberts, Jahss.

¹正徳　²山本　³春正正徳　⁴卜斎　⁵静一庵

Seizan¹ (?–1858). *N.:* Mimura Yōjitsū.² *Gō:* Kinsai,³ Rakushinsai,⁴ Seizan.⁵ **Biog.:** Kanō painter. Studied in Edo under Kanō Seisen'in Yasunobu. Served Lord Sanada of Matsushiro, producing landscapes, portraits, and *kachōga.* **Coll.:** Victoria.

¹晴山　²三村養実　³金斎　⁴楽真斉　⁵晴山

Sekichō¹ (fl. 1770–80). *Gō:* Ensensha,² Sekichō.³ **Biog.:** Ukiyo-e painter, printmaker. Pupil of Toriyama Sekien. Known for *surimono* he made for the new year of 1772 and for illustrations of *haiku* published in 1774. **Bib.:** Morrison 2.

¹石鳥　²燕川舎　³石鳥

Sekiden¹ (1818–87). *N.:* Gotō Mamoru.² *A.:* Shinshu.³ *Gō:* Sekiden.⁴ **Biog.:** *Nanga* painter. Born in Bungo Province. Pupil of Tanomura Chikuden. A wealthy man, he was able to buy expensive sketches and copybooks and thus make himself an authority on *nanga* painting in the Kyūshū area. A good landscape painter.

¹碩田　²後藤守　³真守　⁴碩田

Sekien¹ (1712–88). *N.:* Toriyama (originally Sano)² Toyofusa.³ *Gō:* Gessō,⁴ Gyokujuken,⁵ Reiryōdō,⁶ Sekien,⁷ Sengetsudō,⁸ Sentandō.⁹ **Biog.:** Kanō painter, ukiyo-e printmaker. Lived in Edo. Pupil of Kanō Gyokuen and Kanō Chikanobu; produced many paintings that were dedicated to Buddhist temples and Shintō shrines. After 1770 worked as a book illustrator, designing albums of considerable refine-

ment; his *Sekien Gafu,* published in 1773, is one of the finest of its period. Subject matter includes ghosts, monsters, hobgoblins. Not a great artist, but a good draftsman and creator of a technique of color graduation in printing produced by wiping the blocks after the color had been applied to them. He is, however, best known as perhaps the father and certainly the master of Utamaro as well as the master of Momokawa Chōki. **Coll.:** Art (1), British, Freer, Staatliche. **Bib.:** Binyon (1), (3); Brown; Hillier (4) 1; NHBZ 3, 6; Schmidt; Shimada 3; Stern (4); Tajima (7) 3; UG 6; Waterhouse.

¹石燕　²佐野　³鳥山豊房　⁴月窓　⁵玉樹軒
⁶零陵洞　⁷石燕　⁸船月堂　⁹船丹堂

Sekiga[1] (fl. 1772–81). *Gō:* Kinchōdō,[2] Sekiga.[3] **Biog.:** Ukiyo-e printmaker. Pupil of Toriyama Sekien. Very minor artist, producing actor prints of mediocre quality. **Coll.:** Tōkyō (1). **Bib.:** Binyon (3), Ficke, Kikuchi, NHBZ 3.

¹石賀　²金長洞　³石賀

Sekiho[1] (fl. second half 18th c.). *N.:* Okano Tōru.[2] *A.:* Genshin.[3] *Gō:* Sekiho,[4] Unshin.[5] **Biog.:** *Nanga* painter. Born in Ise; known to have been living in Kyōto about 1768. Doctor by profession; painted as a hobby. Primarily a landscape artist; greatly influenced by Ming painting. Though he is said to have written two or three books, none remain, and of the twenty-odd works said to be by him not all can be authenticated. Considered a pioneer in the field of *nanga* painting. Most of his pictures are small in size; the larger ones are less successful. **Bib.:** BK 42, 60.

¹石圃　²岡野享　³元震　⁴石圃　⁵雲津

Sekihō[1] (fl. early 19th c.). **Biog.:** Ukiyo-e printmaker. Pupil of Toriyama Sekien; much influenced by Utamaro. **Bib.:** Hillier (7).

¹石蜂　(石峰)

Sekihō[1] (1823–87). *N.:* Kuriyama Ju.[2] *Gō:* Sekihō.[3] **Biog.:** Painter. Born in Edo. Pupil of Aizawa Sekko. Later moved to Ōsaka. Painted figures, *kachōga,* and especially dragons. **Bib.:** Mitchell.

¹石宝　²栗山寿　³石宝

Sekijō[1] (fl. c. 1800–1807). *N.:* Juka Sekijō[2] (originally Kajio Gorobei).[3] *Gō:* Hyakusai.[4] **Biog.:** Ukiyo-e printmaker. Samurai of the Yamagata fief. Moved to Edo and became a chapbook writer. Dropped his samurai status and adopted Juka as his family name. In his few prints is seen to have been a follower of Toriyama Sekien and much influenced by Utamaro. **Coll.:** British, Fitzwilliam, Newark, Rhode Island, Tōkyō (1), Worcester. **Bib.:** Binyon (1), Hillier (7), Kikuchi, NHBZ 4, UG 6.

¹石上　²樹下石上　³梶尾五郎兵衛　⁴百斎

Sekine Shōji[1] (1899–1919). **Biog.:** Western-style painter. Born in Fukushima-ken; lived in Tōkyō. Studied at the Taiheiyō Kenkyūsho for a short time; largely self-taught. Exhibited with the Nikakai. Style quite fauve. **Coll.:** Bridgestone, Ohara (1). **Bib.:** Asano, NB (H) 24, NBT 10, NBZ 6, NKKZ 8, SBZ 11.

¹関根正二

Sekino Shōun[1] (1889–1947). **Biog.:** Sculptor. Born in Kanagawa-ken. Pupil of Takamura Kōun. Graduated from Tōkyō School of Fine Arts in 1911. Began teaching there as assistant professor in 1921; resigned as full professor in 1944, having served the school as chairman of the sculpture department. Exhibited with the Bunten and the Teiten, serving as a juror for the latter. Worked almost exclusively in wood. **Bib.:** Asano.

¹関野聖雲

Sekiran[1] (1834–95). *N.:* Okumura.[2] *F.N.:* Gengo[3]. *Gō:* Sekiran.[4] **Biog.:** Painter. Born in Owari Province; a retainer of the daimyo of Owari. Studied first under Nomura Gyokkei, then, in Kyōto, under Yokoyama Seiki. **Bib.:** Mitchell.

¹石蘭　²奥村　³源吾　⁴石蘭

Sekisui[1] (1776–1833). *N.:* Watanabe Kō.[2] *A.:* Hakka

(Hakuka).[3] *Gō:* Sekisui.[4] **Biog.:** *Nanga* painter. Born in Edo; second son and pupil of Watanabe Gentai. Painted landscapes and *kachōga.* **Bib.:** Mitchell.

¹赤水　²渡辺昴　³伯頴　⁴赤水

Sekkan[1] (fl. 1555–58). **Biog.:** Muromachi *suiboku* painter. Born in Iwaki Province. Life unknown save that he studied under Sesson. Painted landscapes, portraits, *kachōga.* **Coll.:** Tōkyō (1). **Bib.:** Matsushita (1a), NB (S) 63.

¹雪閑

Sekkan[1] (1715–90). *N.:* Sakurai Kan.[2] *A.:* Jōō.[3] *Gō:* Sankō,[4] Sekkan,[5] Sesshi.[6] **Biog.:** Painter. Born in Hitachi Province. Son and pupil of the painter Sakurai Tan,[7] who had studied Sesshū's style. Went to Edo and continued to follow the style of Sesshū. An able portrait painter. **Bib.:** BI 78.

¹雪館　²桜井館　³常翁　⁴山興　(三江)
⁵雪館　⁶雪志　⁷桜井担

Sekkei[1] (1644–1732). *N.:* Yamaguchi Sōsetsu.[2] *Gō:* Baian,[3] Hakuin,[4] Sekkei.[5] **Biog.:** Kanō painter. Lived in Kyōto. Pupil of Kanō Einō; later tried to emulate Sesshū and Much'i, and his *gō* Sekkei is in fact a combination of his two mentors' names. A well-known Kanō artist and considerable colorist whose *kachōga* are in the style of Sesshū. **Coll.:** Daigo-ji, Museum (3), Rijksmuseum (2). **Bib.:** K 255, 871; KO 35; Morrison 2; Tajima (12) 12.

¹雪渓　²山口宗雪　³梅庵　⁴白隠　⁵雪渓

Sekkei[1] (fl. early 19th c.). *N.:* Tsukioka Sekkei.[2] **Biog.:** Painter. Second son of Tsukioka Settei; worked in his father's manner, presumably in Ōsaka.

¹雪渓　²月岡雪渓

Sekkō[1] (fl. early 17th c.). *N.:* Hasegawa Sekkō.[2] *Gō:* Nobuchika,[3] Sōhaku,[4] Tensokuken.[5] **Biog.:** Hasegawa painter. Has sometimes been confused with Hasegawa Tōhaku. Received title of *hokkyō.* Worked in the manner of Sesshū. **Coll.:** Ashmolean, Museum (3), Victoria. **Bib.:** K 629.

¹雪江　²長谷川雪江　³信近　⁴宗伯　⁵添足軒

Sekko (Sekiko)[1] (1806–47). *N.:* Aizawa Ban.[2] *A.:* Bun'ei.[3] *Gō:* Kangarō,[4] Sekko (Sekiko).[5] **Biog.:** *Nanga* painter. Pupil of Tani Bunchō and Haruki Nanko. Lived and worked in Edo. **Bib.:** Mitchell.

¹石湖　²相沢万　³文英　⁴観画楼　⁵石湖

Sekkō[1] (fl. 1830–40). *N.:* Hasegawa Tōei.[2] *Gō:* Chōsōan,[3] Sekkō,[4] Tokutokusai.[5] **Biog.:** Painter. Born in Edo. Produced landscapes, figures, *kachōga.* **Coll.:** Victoria.

¹雪貢　²長谷川等英　³若幕庵　⁴雪貢　⁵徳徳斎

Sekkoku (Sekikoku)[1] (1777–1853). *N.:* Toichi Yori.[2] *A.:* Shigen.[3] *Gō:* Joho (Josuke),[4] Sekkoku (Sekikoku).[5] **Biog.:** Painter. A retainer to the daimyo of Bungo Province. A self-taught artist; studied traditional Japanese painting and then established himself as an independent artist. **Coll.:** Tōkyō (1).

¹石谷　²十市賚　³子元　⁴恕輔　⁵石谷

Sekkyakushi[1] (fl. early 15th c.). *Priest name:* Kandensu.[2] *Gō:* Sekkyakushi.[3] **Biog.:** Muromachi *suiboku* painter. A priest-painter apparently connected with the Tōfuku-ji; some of his paintings carry inscriptions by the abbot Koshin of the Tōfuku-ji, whose death in 1414 gives a clue to the period of Sekkyakushi's activity. Painted Buddhist deities and portraits; is said to have painted a ceiling in the Sammon of the Tōfuku-ji. His work much influenced by Minchō. **Coll.:** Center, Freer, Musée (2). **Bib.:** Fontein (2); *Freer;* GNB 11; K 58, 633, 667, 802; M 166; Matsushita (1); Morrison 1; *Muromachi* (1); NB (S) 13; Shimada 1; Tanaka (2).

¹赤脚子　²寒殿司　³赤脚子

Sekkyō[1] (fl. late 18th to early 19th c.). *N.:* Sawa.[2] *Gō:* Sekkyō.[3] **Biog.:** Ukiyo-e printmaker. Pupil of Tsutsumi Tōrin: probably a member of the Tsutsumi school. Made a few prints of birds, landscapes, and figures. Known for his

use of perspective. **Coll.**: Musées, Nelson, Staatliche, Victoria. **Bib.**: Binyon (3), Schmidt, Tamba (2a).

¹雪崎 ²沢 ³雪崎

Sen'ami[1] (fl. mid-13th c.). *N.*: Fujiwara no Sen'ami.[2] *F.N.*: Hakamadono.[3] **Biog.**: Painter. Son of Fujiwara no Nobuzane; a great admirer of Shinran. Known for his portrait of Priest Shinran, now in the Nishi Hongan-ji, which carries an inscription dated 1310. **Coll.**: Nishi Hongan-ji. **Bib.**: *National, Pictorial* (1) 2, SBZ 6.

¹専阿弥 ²藤原専阿弥 ³袴殿

Senchō[1] (fl. c. 1830–50). *N.*: Kikugawa Kichizō.[2] *Gō*: Seichōtei,[3] Senchō,[4] Sogetsuen,[5] Teisai.[6] **Biog.**: Ukiyo-e printmaker. Life unknown. A minor follower of the Toyokuni tradition, a pupil of Ikeda Eisen. Produced *bijinga* in the style of his master. Also made illustrations for chapbooks and *nishiki-e*. **Coll.**: Cincinnati, Musées, Newark, Victoria. **Bib.**: Binyon (3), Hillier (7), *Japanese* (2), Kikuchi.

¹泉晃 ²菊川吉蔵 ³青蔦亭 ⁴泉晃 ⁵素月園 ⁶貞斎

Sengai[1] (1750–1837). *Priest name:* Gibon.[2] *A.*: Sengai.[3] *Gō*: Ayō,[4] Hyakudō,[5] Kyohaku,[6] Muhōsai,[7] Taiho,[8] Temmin.[9] **Biog.**: *Zenga* painter. Born in Mino Province; died at Hakata. At 11 entered the Seitai-ji in Mino; eight years later received permission to go on an *angya* and studied for thirteen years with the Zen master Gessen Zenji at the Tōki-an, near present-day Yokohama. After a second *angya,* was invited to the Shōfuku-ji in Hakata, where he became the 123rd abbot (1790–1811). (During this period, had a pupil known as Tōfuya Sengai who was the owner of a neighboring *tōfu* shop and whom he allowed to use his seal, which has subsequently led to considerable confusion.) For the last twenty-six years of his life, lived as a layman in Hakata. Known for his independence, friendliness, lack of pretension. The epitome of the eccentric Zen painter. Most of his paintings, many of which survive, date from his retirement. It is not known who his painting teacher was, but it may have been his Zen master Gessen. His subjects—encompassing folklore, religious themes, landscapes, animals, plants and often accompanied by crazy verses of his own composition—are all executed in ink alone with quick, free, and often wild brush strokes. A zany humor runs through all his work, which is often classified as *haiga* rather than *zenga*. **Coll.**: Ashmolean, Brooklyn, Dazaifu, Idemitsu, Los Angeles, Rietberg, Seattle, Tokiwayama. **Bib.**: *Au-delà;* Awakawa; BO 110, 114, 151; Brasch (2); *Cent-cinquante;* Fontein (2); Furuta; *Japanese* (1); *Japanische* (1); M 166; Mitchell; Munsterberg (4); NB (S) 47; NBT 2; Rosenfield (2); *Sengai;* Suzuki (1a); Umezawa (2).

¹仙崖 ²義梵 ³仙崖 ⁴啞羊 ⁵百堂
⁶虚白 ⁷無法斎 ⁸退歩 ⁹天民

Senka[1] (fl. 1520–30). *Gō*: Ryōō,[2] Senka,[3] Sōsetsu.[4] **Biog.**: Muromachi *suiboku* painter. Little known of his life. Said to have lived in Kyōto and Kamakura. Studied the style of Shōkei and Shūbun, following the former in his orthodox landscapes. Some of his paintings have inscriptions on them by priests of the Kenchō-ji, Kamakura. His signature Sōsetsu is placed in a rectangular seal and his signature Ryōō in a circular seal. A good painter of landscapes, using some slight color. **Coll.**: Gotō, Tōkyō (1). **Bib.**: BK 19; HS 9; K 127, 211, 651, 678; NB (S) 13, 63.

¹僊可 ²領翁 ³僊可 ⁴巣雪

Sensan[1] (fl. early 16th c.). **Biog.**: Sculptor. There are two statues by him in the Saidai-ji, Nara, dated 1504 and 1514 respectively, done in the smoothed-out style so typical of Muromachi sculpture. **Coll.**: Saidai-ji. **Bib.**: *Muromachi* (2).

¹仙算

Senshū[1] (1807–76). *N.*: Araki Hajime.[2] *A.*: Seman.[3] *F.N.*: Senjūrō.[4] *Gō*: Senshū,[5] Shogidō,[6] Shōgi Shujin,[7] Shuntan.[8] **Biog.**: Nagasaki painter. Born at Nagasaki. Pupil of Watanabe Kakushū; also studied Kumashiro Yūhi's paintings. In 1826 appointed *kara-e mekiki;* in 1854 became head of the

office. In 1851 edited the *Zoku Nagasaki Gajinden* on order of the government. An able painter of *kachōga* and portraits.

¹千洲 ²荒木一 ³世万 ⁴千十郎
⁵千洲 ⁶従宜堂 ⁷従宜主人 ⁸春潭

Sen'yū[1] (fl. mid-14th c.). *N.*: Kose no Sen'yū.[2] **Biog.**: Kose painter. Son of Kose no Yukiari, with whom he collaborated in 1345 on the painting *Death of the Buddha,* now in the Nezu Museum. Also recorded as having worked in 1367 at the Kasuga-jinja, Nara. Received title of *hokkyō* and was known as Chikuzen Hokkyō.[3] **Coll.**: Nezu. **Bib.**: *Nezu Bijutsukan.*

¹専有 ²巨勢専有 ³筑前法橋

Senzan[1] (fl. c. 1840). *N.*: Mamiya Hakkei.[2] *A.*: Shinrin.[3] *Gō*: Kitsunanken,[4] Senzan.[5] **Biog.**: Painter. Worked in Edo. **Bib.**: Mitchell.

¹鮮山 ²間宮白圭 ³信倫 ⁴橘南軒 ⁵鮮山

Senzan[1] (1820–62). *N.*: Nagamura Kan[2] (originally Hasegawa Jusaburō).[3] *A.*: Saimō.[4] *Gō*: Juzan,[5] Senzan.[6] **Biog.**: *Nanga* painter. Born in Edo; son of the Tokugawa *bakufu* scribe Hasegawa Zenjirō. Adopted by the Nagamura family. Pupil of Watanabe Kazan and Tsubaki Chinzan. When young, was considered a genius but was too frivolous to become a serious artist. **Coll.**: Victoria. **Bib.**: K 149, Mitchell, Morrison 2.

¹茜山 ²永村寛 ³長谷川寿三郎 ⁴済猛 ⁵寿山 ⁶茜山

Seppo[1] (1753?–1824). *N.*: Sakurai Seppo.[2] *Gō*: Keigetsu,[3] Shōunkoku,[4] Shūzan.[5] **Biog.**: Painter. Born in Edo. Daughter and pupil of Sakurai Sekkan; continued the Sesshū tradition learned from him. **Bib.**: BI 77, 78.

¹雪保 ²桜井雪保 ³桂月 ⁴小雲谷 ⁵秋山

Sessa[1] (fl. c. 1840). *N.*: Sano Shihō.[2] *A.*: Kiken.[3] *Gō*: Sessa.[4] **Biog.**: Painter. Worked in Edo. **Bib.**: Mitchell.

¹雪槎 ²佐野此宝 ³希賢 ⁴雪槎

Sessai[1] (1755–1820). *N.*: Masuyama Masakata.[2] *A.*: Kunsen.[3] *Gō*: Chōshū,[4] Gusan,[5] Gyokuen,[6] Kan'en,[7] Katsunō,[8] Sekiten Dōjin,[9] Sessai,[10] Setsuryo,[11] Shōshūen,[12] Shōtei,[13] Sōkyū Sanjin,[14] Tenten'ō.[15] **Biog.**: Nagasaki painter. Daimyo of Nagashima in Ise; later lived in Edo. Studied technique of Shen Nan-p'in. Also skillful writer of poetry and prose; knew and entertained the literati of the day. A talented amateur artist, painting landscapes, animal pictures, and *kachōga* in the spare, austere manner of the Nagasaki school. **Bib.**: Hillier (3), (4) 3; K 107, 784; KO 24; Mitchell; Umezawa (2).

¹雪斎 ²増山正賢 ³君選 ⁴長州 ⁵愚山 ⁶玉淵
⁷灌園 ⁸括嚢 ⁹石顛道人 ¹⁰雪斎 ¹¹雪旅
¹²松秀園 ¹³蕉亭 ¹⁴巣丘山人 ¹⁵顛々翁

Sessai[1] (?–1839). *N.*: Tsukioka Shūei.[2] *A.*: Taikei.[3] *Gō*: Kaikōsai,[4] Sessai.[5] **Biog.**: Ukiyo-e painter. Born in Ōmi Province; lived in Ōsaka. Son and pupil of Tsukioka Settei. Received rank of *hokkyō;* later that of *hōgen.* Apparently produced no prints; genre painting his specialty. Worked in his father's manner, including such details as the use of red outline for face and limbs. A competent artist, producing some attractive work, particularly his flower pictures. **Coll.**: Metropolitan, Museum (3). **Bib.**: Fujikake (3) 3; Hillier (4) 1; Lane; Mitchell; Morrison 2; *Nikuhitsu* (1) 2, (2); Tajima (7) 5; *Ukiyo-e* (3) 19.

¹雪斎 ²月岡秀栄 ³大渓 ⁴巍江斎 ⁵雪斎

Sessen[1] (fl. c. 1820). *N.*: Mitsue Santei.[2] *F.N.*: Hambei.[3] *Gō*: Sessen.[4] **Biog.**: Painter. Worked in Edo. Pupil of Sakurai Sekkan. **Coll.**: Victoria. **Bib.**: Mitchell.

¹雪餞 ²三枝算貞 ³半平衛 ⁴雪餞

Sesshin[1] (fl. late 15th c.). **Biog.**: Muromachi *suiboku* painter. Details of his life unknown. In painting, a follower of Sesshū's style. **Bib.**: Matsushita (1a).

¹雪津

Sesshin[1] (1777–1839). *N.*: Kakimoto Sesshin.[2] **Biog.**: Shijō painter. Born in Ise. Studied poetry and Chinese literature and history as well as painting in Kyōto, the last under

Matsumura Goshun. Also known as an author. **Bib.:** Mitchell.

¹雪臣 ²垣本雪臣

Sesshō (1802–77). *N.:* Hashimoto Sojun.² *Gō:* Sesshō.³ **Biog.:** *Nanga* painter. Born in Miyagi-ken. To Edo to study under Tani Bunchō and Uragami Shunkin. Returned home to take up his duties as a landowner. In 1876 when Emperor Meiji made a tour of the area, Sesshō presented him with a painting that was, the records say, greatly appreciated. **Bib.:** Mitchell.

¹雪蕉 ²橋本素淳 ³雪蕉

Sesshō¹ (1827–95). *N.:* Sugitani Sesshū.² **Biog.:** Unkoku painter. Born a samurai in Kumamoto. Giving up his feudal duties, he turned to painting, studying first the Unkoku-school manner and then the *bunjinga.* In 1887 to Tōkyō under the patronage of the Hosokawa family. In 1889 became a court artist. A good painter of landscapes and *kachōga.* **Bib.:** Asano.

¹雪蕉 ²杉谷雪蕉

Sesshū¹ (1420–1506). *N.:* Oda.² *Posthumous name:* Tōyō.³ *Gō:* Beigenzan Shujin,⁴ Sesshū,⁵ Sessō Tōyō,⁶ Unkokuken,⁷ Yōchikaku.⁸ **Biog.:** Muromachi *suiboku* painter. Born in Bitchū Province. At 11 entered a Zen monastery; ordained early as a priest. Moved to Kyōto; lived in the Shōkoku-ji and became Shūbun's pupil. Adopted the *gō* Sesshū between 1462 and 1465. In Yamaguchi, where he lived from before 1463 until he went to China in 1467/8, patronized by the Ōuchi family and lived in their family temple, the Unkoku-an. After three years in China, where he was honored as a Zen priest and traveled to Peking, returned to Japan, living in the north to avoid the Ōnin War in Kyōto. From 1481 to 1484 traveled widely in Japan, then settled again in Yamaguchi and later in Ōita under the patronage of the Ōtomo family and finally again in Suō Province. Also a designer of gardens, including one at the Mampuku-ji, Kyōto; one at the Ikō-ji in Masuda, Shimane-ken; one called Kiseki-bō at Hikosan, Fukuoka-ken; and one at the Joei-ji near Yamaguchi. Studied Chinese Sung and Yüan paintings (Li T'ang and Hsia Kuei for landscape; Yü Chien and Liang K'ai for *suiboku;* Ming paintings for *kachōga*) but developed his own style, not only painting Chinese landscape in Chinese style, but also painting actual Japanese scenes. Greatest Muromachi *suiboku* painter. Had two styles: the one termed "crackling," which is sharp, angular, using complex brushwork; and the other termed *haboku* ("flung ink"), which uses soft, wet brushwork, almost a shorthand, and which developed in the late 15th century. His art is brittle, brilliant, mannered; the strength of his brushwork and brilliance of handling of ink justify his high position in Japanese art. Freed ink painting from its close bonds with China, making it Japanese, while the decorative placing of elements in his *kachōga* points the way to the later decorative school. There are many false attributions, and no youthful work known under the name of Sesshū. The latter fact has led contemporary scholars to say that Sessō Tōyō (q.v.) was Sesshū's early name. **Coll.:** Art (1), British, Center, Cleveland, Freer, Hatakeyama, Ishikawa, Kyōto (2), Matsunaga, Musée (2), Museum (3), Nezu, Sainen-ji (2), Seattle, Tokiwayama, Tōkyō (1), Umezawa, Victoria. **Bib.:** AA 6, 14; Akiyama (2); *Art* (1a); ARTA 14; *Au-delà;* BK 3, 14, 48, 52, 62, 63, 81, 106, 135, 155, 185; Covell (3); *Exhibition* (1), (2); *Freer;* GK 11; GNB 11; Grilli (1), (2); Hasumi (1); Hisamatsu; HS 3, 4, 5, 8, 9, 10, 11; K 2, 9, 12, 18, 52, 60, 71, 90, 97, 102, 111, 122, 128, 138, 156, 184, 185, 189, 200, 210, 214, 279, 290, 310, 390, 399, 410, 414, 444, 471, 700, 784; *Kokuhō* 6; Kubota; Kuck; Kumagai; Lee (1); M 62, 64, 70, 163, 199, 205, 209, 252; Matsushita (1), (1a); Mayuyama, Minamoto (1); Morrison 1; NB (S) 13; NBT 4; NBZ 3; NKZ 2, 20, 47, 65, 71, 78; Noma (1) 1; *One* (2); OZ 8; Paine (2) 1, (4); PTN 2; SBZ 7; *Sesshū;* Shimada 1; Tajima

(5), (10); Tajima (12) 2, 5, 7, 9, 10, 14, 15, 17, 18; Tajima (13) 4; Tanaka (2); Yashiro (1); YB 22; Yoshimura.

¹雪舟 ²小田 ³等楊 ⁴米元山主人 ⁵雪舟 ⁶拙宗等楊 ⁷雲谷軒 ⁸楊智客

Sessō (Setsusō)¹ (fl. c. 1502). **Biog.:** Muromachi *suiboku* painter. Said to have been a pupil of Sesshū, but details of his life and work are lacking. **Bib.:** NB (S) 69.

¹雪窓

Sessō¹ (1794–1857). *N.:* Kaneko Daibi.² *A.:* Fugen.³ *Gō:* Biō,⁴ Jinkai Ryōsha,⁵ Kakuhan Dōjin,⁶ Sessō,⁷ Yūjō Chisha.⁸ **Biog.:** Japanese-style painter. Born in Edo to a samurai family; adopted by the Kaneko family. In the service of Masuyama Sessai, the lord of Ise, under whom he studied painting and who gave him the *gō* of Sessō. Later studied *nanga* painting with Kushiro Unzen as well as the Chinese classics with Ōkubo Shibutsu. A good painter of *kachōga* and landscapes. **Bib.:** Mitchell.

¹雪操 ²金子大美 ³不言 ⁴美翁 ⁵塵海漁舎（塵海漁者） ⁶各半道人 ⁷雪操 ⁸有情痴者

Sessō Tōyō¹ (fl. second half 15th c.). **Biog.:** Muromachi *suiboku* painter. Once regarded as that of an independent artist, this name is now quite widely accepted as an early *gō* of Sesshū, used by him before his voyage to China. The stylistic difference between paintings signed Sessō Tōyō and the main body of Sesshū's work could be accounted for by the influence on his work of his travels and studies in China. In any event, a skillful artist. **Coll.:** Museum (3). **Bib.:** BK 52; BMFA 52; Fontein (3); Hasumi (1); HS 13; Matsushita (1), (1a); Mayuyama; *Muromachi* (1); NB (S) 13; NBZ 3; PTN 2; Shimada 1; Tajima (12) 14, 16, 19; Tajima (13) 4.

¹拙宗等楊

Sesson¹ (1504–89?). *N.:* Satake Shūkei.² *F.N.:* Heizō.³ *Gō:* Jokei,⁴ Kakusen Rōjin,⁵ Ken'yakusai,⁶ Sesson,⁷ Shūkyosai.⁸ **Biog.:** Muromachi *suiboku* painter. Born in Hitachi Province. Lived remote from any art center, first at Hetari in Hitachi, later at Aizn in Iwashiro. Scion of famous Satake family. Saidtoh ave written a short treatise on painting in 1542; in 1546 instructed the local daimyo of Aizu in care and handling of paintings. By 1573 at Tamura in Iwashiro, where he lived the solitary life of a Zen monk for the last years of his life. Self-taught; studied Sung and Yüan painting and Sesshū's work. In Japanese painting occupies a place just below Sesshū: his painting not as strong as Sesshū's, but more elegant, more decorative; very graceful brush. Toward end of his life, used more color. **Coll.:** Art (1); British; Cleveland; Denver; Freer; Hatakeyama; Kashima-jinja; Koto-hira; Kyōto (2); Minneapolis; Nezu; Philadelphia; Seattle; Sendai; Tokiwayama; Tōkyō (1); Victoria; Yamato. **Bib.:** AA 6, 14; *Art* (1a); BCM 47; BK 87, 198; *Exhibition* (1); Fontein (1); *Freer;* GNB 11; HS 7, 10, 11, 12, 13; K 3, 22, 58, 65, 74, 89, 109, 121, 129, 134, 137, 148, 208, 212, 240, 400, 546, 591, 737, 815, 821, 859; KO 2, 22, 29; Lee (1), (2); M 244, 270; Matsushita (1), (1a); Mayuyama; Minamoto (1); Morrison 1; NB (S) 13, 63; NBZ 3; NBT 4; NKZ 28; Noma (1) 1; *One* (2); Paine (4); *Selected;* Shimada 1; Tajima (12) 3, 6, 8, 9, 11, 12, 14, 18; Tajima (13) 4; Tanaka (2); Yashiro (1); YB 6, 30, 46.

¹雪村 ²佐竹周継 ³平蔵 ⁴如圭 ⁵鶴仙老人 ⁶倹箸斎 ⁷雪村 ⁸舟居斎

Setsuan¹ (1809–89). *N.:* Yoshizawa Bunkō.² *Gō:* Setsuan,³ Shōzōkaro.⁴ **Biog.:** *Nanga* painter. Lived in Edo. Pupil of Tozaka Bun'yō. Specialized in landscapes and *kachōga.* **Bib.:** Mitchell.

¹雪庵 ²吉沢文行 ³雪庵 ⁴小造化廬

Setsudō¹ (fl. c. 1810). *N.:* Kimura Sei.² *A.:* Fukyū.³ *Gō:* Setsudō.⁴ **Biog.:** Painter. Worked in Kyōto. **Bib.:** Mitchell.

¹雪堂 ²木村静 ³不求 ⁴雪堂

Setsugai¹ (fl. late 15th to early 16th c.). **Biog.:** Muromachi *suiboku* painter. Details of life unknown; may have been a Korean who emigrated to Japan. Said to have studied

Sesshū's style. His paintings also show the influence of contemporary Korean and Chinese painting. **Coll.:** Myōkō-ji.

¹雪崖

Setsugaku[1] (fl. 19th c.). *N.:* Ueno Yasushi.[2] *A.:* Katsujō.[3] *Gō:* Setsugaku.[4] **Biog.:** *Nanga* painter. Pupil of Yamamoto Baiitsu. Worked in a manner so close to that of his teacher that some art dealers change the seal on his paintings and sell them as works by Baiitsu. **Coll.:** Victoria. **Bib.:** Mitchell.

¹雪岳 ²上野恭 ³克譲 ⁴雪岳

Setsuyō[1] (fl. mid-19th c.). *N.:* Kubota Kuni (Hō).[2] *Gō:* Kigen,[3] Setsuyō.[4] **Biog.:** Painter. Perhaps lived in Kyōto. Technique suggests a relationship with both the Shijō and the *nanga* schools. Tomioka Tessai may have been one of his pupils. **Coll.:** Museum (3). **Bib.:** K 674.

¹雪鷹 ²窪田邦 ³起元 ⁴雪鷹

Setsuzan (Setsusan, Sessan)[1] (fl. c. 1530). *N.:* Hirowatari Setsuzan (Setsusan, Sessan).[2] **Biog.:** Muromachi *suiboku* painter. Born in Hizen Province. Said to have been a pupil of either Sesson or Sesshū. Good at plum and bamboo themes. **Coll.:** Andrew, Victoria. **Bib.:** K 76.

¹雪山 ²広渡雪山

Settan[1] (1778–1843). *N.:* Hasegawa (originally Gotō)[2] Munehide (Sōshū).[3] *F.N.:* Moemon.[4] *Gō:* Gakutei,[5] Gangakusai,[6] Gangakutei,[7] Ichiyōan,[8] Ichiyōsai,[9] Settan.[10] **Biog.:** Ukiyo-e printmaker, illustrator. Lived in Edo. Pupil of Toyokuni. Received rank of *hokkyō.* Particularly well known for his illustrations in *Edo Meisho Zue* (Famous Places in Edo) and in *Tōto Saijiki* (Annual Festivals of Edo). **Coll.:** British, Musées, Museum (3), Victoria. **Bib.:** AA 14, Binyon (1), Brown, Mitchell, Morrison 1.

¹雪旦 ²後藤 ³長谷川宗秀 ⁴茂右衛門 ⁵岳亭
⁶巌岳斎 ⁷巌岳亭 ⁸一陽菴 ⁹一陽斎 ¹⁰雪旦

Settei[1] (1710–86). *N.:* Tsukioka (originally Kida)[2] Masanobu.[3] *A.:* Daikei.[4] *F.N.:* Tange.[5] *Gō:* Kindō,[6] Rojinsai,[7] Settei,[8] Shinten'ō,[9] Tōki.[10] **Biog.:** Painter, printmaker, illustrator. Born in Ōmi Province; lived in Ōsaka. Pupil of Takada Keiho, from whom he learned the Kanō manner. Developed an independent style, a combination of that of Moronobu and Sukenobu, with traces of aristocratic refinement. A prolific painter and book illustrator, especially well known for his graceful and elegant erotica. His paintings generally date after 1771 and are quite unlike those of his orthodox ukiyo-e contemporaries. **Coll.:** Art (1), Freer, Honolulu, Idemitsu. **Bib.:** Brown; Fujikake (3) 3; Hillier (1), (3), (4) 1, (9); K 519; Keyes; Lane; Morrison 2; NHBZ 3; *Nikuhitsu* (1) 2, (2); Stern (4); Tajima (7) 5; UG 19; *Ukiyo-e* (3) 19.

¹雪鼎 ²木田 ³月岡昌信 ⁴大渓 ⁵丹下
⁶錦童 ⁷露仁斎 ⁸雪鼎 ⁹信天翁 ¹⁰桃漪

Settei[1] (1819–82). *N.:* Hasegawa Sōichi.[2] *Gō:* Baikō,[3] Ganshōsai,[4] Settei,[5] Shōsai.[6] **Biog.:** Japanese-style painter. Born in Edo. Son and pupil of Hasegawa Settan. Specialized in genre painting and in views of famous places. **Coll.:** Victoria. **Bib.:** Mitchell.

¹雪堤（雪汀） ²長谷川宗一 ³梅紅
⁴巌松斎 ⁵雪堤（雪汀） ⁶松斎

Setten[1] (1735–90). *N.:* Katsura Tsunemasa.[2] *A.:* Setten.[3] *F.N.:* Gengorō,[4] Sōshin.[5] *Gō:* Bizan,[6] Tsūjin Dōjin.[7] **Biog.:** Ukiyo-e painter, printmaker, illustrator. Lived in Ōsaka. Pupil of Tsukioka Settei. **Bib.:** UG 20.

¹雪典 ²桂常政 ³雪典 ⁴源五郎
⁵宗信 ⁶眉山 ⁷通神道人

Shabaku[1] (fl. second half 16th c.). *Priest name:* Shabaku.[2] *Gō:* Gessen.[3] **Biog.:** Muromachi *suiboku* painter. An obscure priest-artist. Said to have studied the style of Shūbun and recorded as having been good at portraiture, landscapes, and *kachōga.* Worked in ink and light colors. Very few

paintings by him are known. **Coll.:** Ashmolean, Tōkyō (2). **Bib.:** Fontein (2), K 539, Matsushita (1a), OA 13.

¹遮莫 ²遮莫 ³月船

Shami Kūgaku[1] (fl. c. 1357). **Biog.:** Lacquerer. His name appears, together with the date of 1357, on a clothes chest now in the Tōkyō National Museum. **Coll.:** Tōkyō (1). **Bib.:** M 111, Ragué.

¹沙弥空覚

Shamoku-shi[1] (fl. mid-8th c.). **Biog.:** Sculptor. His name appears on the backs of two Gigaku masks in the Shōsō-in. **Coll.:** Shōsō-in, Tōdai-ji. **Bib.:** Kleinschmidt, Noma (4), Warner (4).

¹捨目師

Sharaku[1] (fl. 1794–95). *Gō:* Sharaku,[2] Tōshūsai.[3] **Biog.:** Ukiyo-e printmaker. Nothing known about him save he lived in Edo. Has been identified by some scholars with Saitō Jūrobei,[4] a Nō actor in the employ of the lord of Awa, but there is no concrete proof of this. Specialized in portraits of actors, usually large-scale *ōkubi-e,* frequently on a mica ground, done with a sharp, biting, satirical wit. All his prints (some 159 are known) were done in ten months in 1794–95 and are unique in the annals of Japanese art. For so stunning an artist, it is curious that so little information about him is available. **Coll.:** Albertina; Allen; Art (1); Atami; Baltimore; Bibliothèque; British; Brooklyn; City; Cleveland; Denver; Fine (California); Fitzwilliam; Fogg; Honolulu; Metropolitan; Minneapolis; Musée (1), (2); Musées; Museum (1), (3); Nelson; New York; Newark; Östasiatiska; Österreichisches; Philadelphia; Portland; Rhode Island; Riccar; Rietberg; Rijksmuseum (1); Staatliche; Tōkyō (1); Victoria; Worcester; Yale. **Bib.:** Binyon (1), (3); Blunt; BMFA 37, 60; Boller; Crighton; Fontein (1); Fujikake (3) 2; Gentles (2); GNB 17, 24; Hempel; Henderson; Hillier (1), (7), (9); K 661, 837; Kikuchi; Kondō (5); *Kunst;* Kurth (5); Lane; Ledoux (5); M 226, 250; Michener (1), (3); Morrison 2; Narazaki (2), (13) 2; NBT 5; NBZ 5; NHBZ 4; Noguchi (4a); Noma (1) 2; Paine (4); Rumpf (2); Schmidt; SBZ 10; Stern (2); Suzuki (2); Takahashi (2); Tanaka (7a) 13; UG 8, 13, 14, 17, 22, 25, 31, 32, 33; *Ukiyo-e* (2) 7, (3) 14; Vignier 3; Yoshida (3).

¹写楽 ²写楽 ³東洲斎 ⁴斎藤十郎兵衛

Shen (Ch'en) Nan-p'in (Japanese: Chin Nampin)[1] (fl. mid-18th c.). **Biog.:** Painter. He does not, by birth, belong in this dictionary, but his importance to Japanese painting was so great that he has been included. A Chinese artist from Wu Hsing who came to Nagasaki in 1731 and stayed for two years, he exerted a great influence on the artists in Nagasaki, and one branch of the Nagasaki school stems from his teaching. After returning to China, was asked to send paintings back to Japan. Considerable talent in painting *kachōga* in a realistic, charming manner. **Coll.:** Kōbe, Nezu. **Bib.:** BMFA 44; K 272, 601, 632; Mitchell; Mody; Morrison 2; NB (S) 4; NBZ 5; Noguchi (1a); Noma (1) 2; Paine (4); *Pictorial* (2) 5; Tajima (12) 7, 11, 14, 16, 17, 20; Umezawa (2).

¹沈南蘋

Shibakuni[1] (fl. 1821–26). *Gō:* Saikōtei,[2] Shibakuni.[3] **Biog.:** Printmaker. Perhaps a pupil of Yoshikuni. An Ōsaka artist. Produced some quite interesting actor prints. Above the average artist of this school. **Coll.:** Philadelphia, Victoria. **Bib.:** Keyes.

¹芝国（志葉国） ²西光亭 ³芝国（志葉国）

Shibayama[1] (fl. late 18th c. to 19th c.). Lacquerers. A family of *inrō* artists founded at end of 18th century. Works distinguished by minute encrustations of various materials. This technique differed from earlier, more subtle one of Chinese tradition where the decoration was set flush with the lacquered surface; in this later work the inlay was set in high relief and elaborately carved to give a three-dimensional effect. Quality of later work much inferior, since gaudiness

of color and elaborateness of design replaced subtlety of coloring and tastefulness of design. Almost no information about individual members of this school; all works signed with family name only. For starred names among the following, see individual entries.

*Dōshō[2] (fl. late 18th c.)
*Ekisei (Yasumasa)[3] (fl. early 19th c.; grandson of Dōshō)
Sōichi[4] (fl. 19th c.)
Yasumune[5] (fl. 19th c.)
Yasunao[6] (fl. 19th c.)
Yasuyuki[7] (fl. 19th c.)

Coll.: Walters. **Bib.:** Boyer, Casal, Herberts, Jahss, Ragué.

[1]芝山 [2]道笑 [3]易政 [4]宗一 [5]易宗 [6]易尚 [7]易行

Shibuemon[1] (fl. late 17th to early 18th c.). *N.:* Sakaida Shibuemon.[2] **Biog.:** Potter. Younger brother of Kakiemon V, guardian of Kakiemon VI. Worked at the Arita Minami Kawara kiln. A master craftsman who did much to restore the prestige of the Sakaida family. His style, typical of the Genroku era (1688–1703), consists of carefully shaped pieces with elegant overglaze designs. Some of his pieces bear inscriptions in underglaze blue on the bases and a mark reading "Kaki." A few works ascribed to the sixth Kakiemon were actually made by Shibuemon. **Coll.:** Umezawa. **Bib.:** *Ceramic* (1); Hayashiya (1); Jenyns (1); Miller; Munsterberg (2); NB (S) 71; Okuda (1) 10, (2); SBZ 9; STZ 4; TZ (K) 6.

[1]渋右衛門 [2]酒井田渋右衛門

Shibutsu[1] (1766–1837). *N.:* Ōkubo Gyō.[2] *A.:* Temmin.[3] *F.N.:* Ryūtarō.[4] *Gō:* Kōzan Sho-oku,[5] Shibutsu,[6] Shiseidō,[7] Sōbai.[8] **Biog.:** *Nanga* painter. Born in Hitachi Province; lived in Edo. Considerable reputation as a poet. Friend of Tani Bunchō. Painting his hobby. Said to have traveled to Kōzuke disguised as Tani Bunchō and painting in his name; it is therefore possible that some of the pictures attributed to Bunchō that come from this area could be by Shibutsu. Favorite subject, bamboo. **Bib.:** Mitchell.

[1]詩仏 [2]大窪行 [3]天民 [4]柳太郎
[5]江山書屋 [6]詩仏 [7]詩聖堂 [8]痩梅

Shibuya Osamu[1] (1900–1963). **Biog.:** Western-style painter. Born in Ishikawa-ken. To Tōkyō in 1917 to study painting privately. In the 1920s active in various avant-garde groups. **Bib.:** Asano, NBZ 6.

[1]渋谷修

Shigan[1] (fl. second half 18th c.). *N.:* Sō Shigan (Chinese: Sung Tzu-yen).[2] *Gō:* Sekikō (Shakukō). **Biog.:** Painter. Born in China. Recorded as having come to Nagasaki in 1758; remained in Japan. Among his pupils was Sō Shiseki. **Coll.:** Museum (3). **Bib.:** BMFA 44.

[1]紫岩 (紫巖) [2]宋紫岩 [3]石耕

Shige Shuntō[1] (1833–1900). *N.:* Shige Jikō.[2] *A.:* Hakuseki.[3] *Gō:* Gosō,[4] Shuntō,[5] Tankō.[6] **Biog.:** Japanese-style painter. Born in Kyōto. Pupil of Kawakita Shunkoku. In 1880 taught at Kyōto Prefectural School of Painting. Exhibitor and prize winner at the Naikoku Kangyō Hakurankai. Founding member of the Nihon Nanga Kyōkai in 1897; active in *nanga* art circles. **Bib.:** Asano, Mitchell, Morrison 2.

[1]重春塘 [2]重自厚 [3]薄責 [4]梧叟 [5]春塘 [6]単香

Shigefusa[1] (fl. 1744–64). *N.:* Terai Shigefusa.[2] *Gō:* Sesshōsai,[3] Shōsen;[4] later, Naofusa.[5] **Biog.:** Ukiyo-e illustrator. Perhaps a pupil of Nishikawa Sukenobu, whose style his work resembles. Illustrated a number of books in 1749, 1757, and 1761. **Coll.:** Musées, Victoria. **Bib.:** Brown, Keyes.

[1]重房 [2]寺井重房 [3]雪樵斎 [4]尚選 [5]尚房

Shigeharu[1] (1803–53). *N.:* Yamaguchi (originally Takigawa)[2] Yasuhide[3] (originally Kunishige).[4] *F.N.:* Jinjirō.[5] *Gō:* Baigansai,[6] Gyokuryūsai,[7] Gyokuryūtei,[8] Kiyōsai[9] Kiyōtei,[10] Nagasaki,[11] Ryūsai,[12] Ryūtei,[13] Shigeharu.[14] **Biog.:** Ukiyo-e printmaker. Born in Nagasaki. Pupil of Yanagawa Shigenobu and perhaps of Hokusai. Contemporary accounts refer to him as the only full-time professional designer of actor prints in Ōsaka. His first print, signed Nagasaki

Kunishige, published in Ōsaka at age of 17. In 1826 changed his name to Ryūsai Shigeharu. Said to have returned to Nagasaki after the civil disturbances in the mid-1830s. May have gone back to Ōsaka in the late 1840s and, once again using the name of Kunishige, designed the bust portraits bearing this name. An indifferent artist. **Coll.:** Allen, British, Musées, Newark, Philadelphia, Tōkyō (1), Victoria. **Bib.:** Binyon (1), Crighton, Hillier (7), Keyes, Kikuchi, Mody, NHBZ 3, Strange (2), *Ukiyo-e* (3) 19, UG 28.

[1]重春 [2]滝川 [3]山口安秀 [4]国重 [5]甚次郎
[6]梅丸斎 [7]玉柳斎 [8]玉柳亭 [9]崎陽斎
[10]崎陽亭 [11]長崎 [12]柳斎 [13]柳亭 [14]重春

Shigehiko[1] (1808–44). *N.:* Okamoto Shigehiko.[2] *A.:* Gochū.[3] *F.N.:* Same.[4] *Gō:* Gōkei.[5] **Biog.:** Shijō painter. Born in Kyōto. Pupil of Okamoto Toyohiko. Held a minor court position. Painted figures and *kachōga*. **Bib.:** Mitchell, Morrison 2.

[1]茂彦 [2]岡本茂彦 [3]吾仲 [4]左馬 [5]合敬

Shigemaru[1] (fl. 1848–53). *N.:* Utagawa Shigemaru.[2] **Biog.:** Ukiyo-e printmaker. Pupil of Hiroshige. Specialized in landscapes. **Coll.:** Riccar.

[1]重丸 [2]歌川重丸

Shigemasa[1] (1739–1820). *N.:* Kitabatake Shigemasa.[2] *F.N.:* Kyūgorō.[3] *Studio name:* Kitao.[4] *Gō:* Hekisui,[5] Hokuhō,[6] Hokusu Dempu,[7] Ichiyōsei,[8] Itsujin,[9] Karan,[10] Kitao Shigemasa,[11] Kōsuifu,[12] Kōsuiken,[13] Kōsuisai,[14] Kyūkaikyo,[15] Shigureoka Itsumin,[16] Suihō,[17] Tairei.[18] **Biog.:** Ukiyo-e painter, printmaker. Also a poet. Eldest son of Suharaya Saburobei, a book dealer in Edo. Largely self-taught, though perhaps a late pupil of Nishimura Shigenaga; influenced by Harunobu. Illustrated many books, designed relatively few prints; work rare, paintings even rarer. Specialized in *bijinga* and actor prints; also did topographical scenes. One of his best-known books, *Seirō Bijin Awase Sugata Kagami* (Mirror of Beautiful Women of the Green Houses), was done in collaboration with Shunshō in 1776. His style generally reflected what was fashionable at the moment: at one time like Harunobu, later like Shunshō in manner. Early work in two colors influenced by Kiyomitsu. After 1775 created his own style of large-scale designs of *bijin*. His figures a trifle massive, his color used in broad opaque masses. An excellent technician, but much greater repute as a calligrapher. **Coll.:** Allen, Art (1), Ashmolean, British, Cincinnati, Fitzwilliam, Freer, Fogg, Honolulu, Metropolitan, Musée (2), Musées, Museum (1), Nelson, Newark, Portland, Östasiatiska, Österreichisches, Rhode Island, Riccar, Rietberg, Staatliche, Stanford, Tōkyō (1), Victoria, Worcester, Yale. **Bib.:** Binyon (3); Brown; Crighton; Ficke; Fujikake (1) 2; Gentles (1); GNB 17; Hillier (3), (4) 1, (7); *Images;* K 250, 738; Kikuchi, *Kunst;* Lane; Ledoux (1); M 233; Michener (3); Meissner; Morrison 2; Narazaki (2); NBZ 5; NHBZ 3; *Nikuhitsu* (2); SBZ 10; Schmidt; Shibui (1); Tajima (7) 4; Takahashi (2), (5), (6) 6; Tamba (2a); UG 28; Vignier 3; Waterhouse.

[1]重政 [2]北畠重政 [3]久五郎 [4]北尾 [5]碧水
[6]北峰 [7]北鄒田夫 [8]一陽井 [9]逸人 [10]花藍
[11]北尾重政 [12]恒酔夫 [13]紅翠軒 [14]紅翠斎
[15]弓虀居 [16]時雨岡逸民 [17]酔放 [18]台嶺

Shigemasu[1] (fl. 1740–50). *N.:* Nishimura Shigemasu.[2] **Biog.:** Ukiyo-e painter, printmaker. Almost nothing known about him. Follower of Nishimura Shigenaga. Made prints of *bijin* in *urushi-e*. **Coll.:** Fine (California), Minneapolis.

[1]重倍 [2]西村重倍

Shigemitsu[1] (fl. c. 1850). *Given name:* Shigemitsu.[2] **Biog.:** Ukiyo-e printmaker. Pupil of Yanagawa Shigenobu. Specialized in prints of warriors. **Coll.:** Musées, Victoria.

[1]重光 [2]重光

Shigenaga[1] (1697?–1756). *N.:* Nishimura Shigenaga.[2] *F.N.:* Magojirō,[3] Magosaburō.[4] *Gō:* Eikadō,[5] Hyakuju,[6] Senkadō.[7] **Biog.:** Ukiyo-e painter, printmaker. Born in Edo. An

important ukiyo-e artist, an innovator, and a great teacher. His work shows the influence of Torii Kiyonobu, Okumura Masanobu, and Nishikawa Sukenobu. With Masanobu, one of the first artists to use perspective bird's-eye views and to show his figures partially nude; also one of the first to produce triptychs. Made *urushi-e* (some of which are signed Magojirō) and prints from stone blocks as well as two- and three-color woodblock prints. Specialized in *bijinga* but also produced *kachōga*, scenic views, and actor prints. Kitao Shigemasa, Utagawa Toyoharu, Ishikawa Toyonobu, and perhaps Harunobu among his best-known pupils. Forms a bridge between the primitive period of *sumi-e* and two-color prints and the full-color period inaugurated by Harunobu in 1764. A wayward genius. **Coll.:** Allen, Andrew, Art (1), British, Cincinnati, Fine (California), Honolulu, Ishikawa, Kanagawa, Kōbe, Metropolitan, Musées, Museum (3), Nelson, Newark, Östasiatiska, Philadelphia, Portland, Rhode Island, Riccar, Rietberg, Staatliche, Tōkyō (1), Victoria, Worcester, Yale. **Bib.:** AO 5; Binyon (1), (3); Crighton; Ficke; Fujikake (3) 2; Gunsaulus (1); Hillier (1), (7); *Images;* Jenkins; Kikuchi; *Kunst;* Kurth (4); Lane; Michener (1), (3); Morrison 2; NB (S) 68; NBZ 5; NHBZ 2; OA 9; *Pictorial* (2) 4; Schmidt; Shibui (1); Stern (2); Tajima (7) 3; Tamba (2a); UG 28; Waterhouse.

 ¹重長 ²西村重長 ³孫二郎 ⁴孫三郎
 ⁵影花堂 ⁶百寿 ⁷仙花堂
Shigenao[1] (fl. 1824–41). *N.:* Utagawa (originally Yanagawa)[2] Shigenao.[3] *Gō:* Gokyōtei,[4] Nobukatsu,[5] Ryūkyōtei,[6] Tessai.[7] **Biog.:** Ukiyo-e printmaker. One of the Kamigata-e artists; worked in Ōsaka. Pupil of Yamaguchi Shigeharu and Utagawa Kunimasu. Specialized in actor prints. **Coll.:** Musées, Philadelphia. **Bib.:** Keyes, NHBZ 3.

 ¹重直 ²柳川 ³歌川重直 ⁴五狂亭
 ⁵信勝 ⁶柳狂亭 ⁷哲斎
Shigenobu[1] (fl. 1620–40). *Given name:* Shigenobu.[2] *Gō:* Sōgen.[3] **Biog.:** Kanō painter. Pupil of Kanō Sōshū. A decorative painter, close to Sanraku, known only by his seal reading "Shigenobu," which he was apt to place upside down. **Coll.:** Art (1), Kimbell, Seattle. **Bib.:** BK 97, K 601, Mayuyama, Shimada 2.

 ¹重信 ²重信 ³宗眼
Shigenobu[1] (fl. mid-17th c.). *N.:* Kanō Shigenobu.[2] *Gō:* Shunsetsu.[3] **Biog.:** Kanō painter. Son and pupil of Kanō Yūeki, whom he predeceased. Member of the Kanda Kanō school.

 ¹重信 ²狩野重信 ³春説
Shigenobu[1] (fl. c. 1716–36). *N.:* Hirose Shigenobu.[2] Ukiyo-e printmaker. Made prints, to which lacquer was added, of *bijin* in the series *Courtesans of Three Cities* in the manner of the Torii school. It is possible this is the same artist as Tsunekawa Shigenobu (q.v.). **Bib.:** Fujikake (3) 2, UG 3.

 ¹重信 ²広瀬重信
Shigenobu[1] (fl. 1716–36). *N.:* Takizawa Shigenobu.[2] *Gō:* Ryūkadō Shigenobu,[3] Shigenobu.[4] **Biog.:** Ukiyo-e painter. A later, but direct, follower of Kaigetsudō Ando. Probably part of the circle that included Baiyūken Katsunobu. Specialized in pictures of *bijin;* so far, nine of his paintings are known. Called himself a *yamato-e* artist. **Coll.:** Idemitsu. **Bib.:** Hillier (1), M 18, Takahashi (3), *Ukiyo-e* (3) 3.

 ¹重信 ²滝沢重信 ³柳花堂重信 ⁴重信
Shigenobu[1] (fl. 1720–40). *N.:* Tsunekawa Shigenobu.[2] **Biog.:** Ukiyo-e printmaker. A minor artist, working in imitation of Masanobu and Kiyomasu II, depicting *bijin* and actors. Prints by him are exceedingly rare; only dated one, 1729. This may also be another signature used by Hirose Shigenobu (q.v.). **Coll.:** Museum (3). **Bib.:** AO 5, NHBZ 2, UG 3.

 ¹重信 ²常川重信
Shigenobu[1] (fl. c. 1724–35). *N.:* Nishimura Shigenobu.[2] **Biog.:** Ukiyo-e printmaker. A rare artist, known for prints of *bijin* and actors. Considerable uncertainty about his identity;

generally considered as the early name of Ishikawa Toyonobu (q.v.), but it is also possible that he never existed and was a name created by a publishing house as a signature for Masanobu-like prints. Figures in prints with the signature Nishimura Shigenobu have long bodies, small heads. **Coll.:** Art (1), Honolulu, Metropolitan, Museu (1), Museum (3), Riccar, Staatliche, Tōkyō (1). **Bib.:** Binyon (3), BMFA 59, Ficke, Gunsaulus (1), Jenkins, Kikuchi, *Kunst,* Michener (3), Shibui (1), Schmidt, Stern (2), Tajima (7) 3.

 ¹重信 ²西村重信
Shigenobu[1] (fl. 1724–44). *N.:* Kawashima Shigenobu.[2] *Gō:* Ichiichidō,[3] Ryūkadō.[4] **Biog.:** Ukiyo-e painter. Produced paintings of *bijin* in the manner of the Nishikawa school.

 ¹重信 ²川島重信 ³一々堂 ⁴柳花堂
Shigenobu[1] (fl. c. 1764–79). *N.:* Hanabusa Shigenobu.[2] **Biog.:** Ukiyo-e printmaker. Produced prints of *bijin* in the style of Harunobu.

 ¹重信 ²花房重信
Shigenobu[1] (fl. 1770–80). *N.:* Yamamoto Shigenobu.[2] **Biog.:** Ukiyo-e illustrator. Worked as an illustrator of picture books.

 ¹重信 ²山本重信
Shigenobu[1] (1787–1832). *N.:* Yanagawa (originally Suzuki)[2] Shigenobu.[3] *F.N.:* Jūbei.[4] *Gō:* Kinsai,[5] Raito,[6] Rinsai (Reisai),[7] Ushōsai.[8] **Biog.:** Ukiyo-e printmaker. Born in Yanagawa; hence his name. Worked in Edo and, for a short time, in Ōsaka. Originally a puppetmaker. Then became successively pupil, son-in-law, and adopted son of Hokusai; on his marriage to Hokusai's daughter took his master's *gō* Raito. Popular as a good book illustrator. Specialized in *bijinga* and landscapes; particularly well known as a designer of *surimono*. **Coll.:** Ashmolean, British, Fitzwilliam, Musées, Östasiatiska, Philadelphia, Portland, Rhode Island, Riccar, Staatliche, Tōkyō (1), Victoria, Worcester. **Bib.:** Binyon (1), (3); Brown; Ficke; Hillier (3), (4) 2; Keyes; Meissner; Morrison 2; NHBZ 3; *Nikuhitsu* (1) 2; Schmidt; Takahashi (6) 10; Tamba (2a).

 ¹重信 ²鈴木 ³柳川重信 ⁴重兵衛
 ⁵琴斎 ⁶雷斗 ⁷鈴斎 ⁸雨蕉斎
Shigenobu II[1] (fl. c. 1820). *N.:* Yanagawa Shigenobu[2] (originally Tanishiro Shigeyama).[3] *A.:* Shiki.[4] *F.N.:* Kisanta.[5] *Gō:* Sesshōsai,[6] Shōei.[7] **Biog.:** Ukiyo-e printmaker, illustrator. Pupil of Yanagawa Shigenobu. A minor artist.

 ¹重信二代 ²柳川重信 ³谷城重山
 ⁴子儀 ⁵季三太 ⁶雪蕉斎 ⁷松影
Shigeyoshi (Jūbi)[1] (fl. c. 1781). *N.:* Hasegawa Shigeyoshi (Jūbi).[2] *Gō:* Kyosensai.[3] **Biog.:** Lacquerer. Native of Tsuyama. A skillful artist producing gold-lacquered *inrō* and lacquered *netsuke*. Famous for his *togidashi* and *takamakie* in color. Belonged to Kajikawa school and often used a similar seal: a small vase with handles. **Coll.:** Metropolitan. **Bib.:** Herberts, Jahss, M 188.

 ¹重美 ²長谷川重美 ³巨鮮斎
Shihō[1] (fl. c. 1810). *N.:* Ōoka Seichō.[2] *A.:* Shihō.[3] **Biog.:** Maruyama painter. One of the ten best pupils of Maruyama Ōkyo. **Bib.:** Mitchell.

 ¹士豊 ²大岡盛兆 ³士豊
Shiken[1] (fl. early 19th c.). *N.:* Taga Shiken.[2] *Gō:* Bokusen.[3] **Biog.:** *Nanga* painter. Born in Ōsaka. Son of Taga Ryūkōsai, an Ōsaka ukiyo-e painter and printmaker. Said to have died young. **Bib.:** Mitchell.

 ¹子健 ²多賀子健 ³朴山
Shikibu[1] (fl. early 16th c.). *N.:* Terutada (Kichū) Shikibu.[2] *Gō:* Ryūkyō.[3] **Biog.:** Muromachi *suiboku* painter. Life unknown. An artist of considerable talent, working in a style close to that of Shōkei. May be the same person as Ryūkyō[4] (q.v.). **Coll.:** Center, Kyōto (2), Museum (3). **Bib.:** GNB 11; Matsushita (1), (1a); *Muromachi* (1); NB (S) 13, 63; Shimada 1; Tanaka (2).

 ¹式部 ²輝忠式部 ³竜杏 ⁴竜杏

Shikibu[1] (fl. c. 1567). **Biog.:** Sculptor. Late Muromachi member of the Tsubai Bussho. Known for a Jūichimen Kannon dated 1567, a work very much in the traditional manner. **Bib.:** *Muromachi* (2).

¹式部

Shikimaro[1] (fl. c. 1810). **N.:** Kitagawa Shikimaro[2] (originally perhaps Tōkairin Heijiemon).[3] **Biog.:** Ukiyo-e printmaker. Lived in Edo. Pupil of Kitagawa Tsukimaro, from whom he took the name of Kitagawa. An able follower of Utamaro's last and least successful manner. Illustrated books as well as publishing single-sheet prints. **Coll.:** British, Cincinnati, Minneapolis, Musées, Nelson, Newark, Tōkyō (1), University (2), Victoria. **Bib.:** Binyon (1), (3); Hillier (4) 1; Kikuchi; Morrison 2; NHBZ 4.

¹式麿 ²喜多川式麿 ³東海林平次右衛門

Shikō[1] (1683–1755). **N.:** Watanabe Kyūma.[2] **F.N.:** Sanai;[3] later, Motome.[4] **Gō:** Shikō,[5] Shōken,[6] Soshin.[7] **Biog.:** Painter. Lived in Kyōto. A *rōnin,* became a retainer of the Konoe family in 1709, serving Prince Iehiro. Took up painting rather late in life. First studied under a Kanō artist; then became a follower of Kōrin and one of his most important pupils. Also collaborated with Kenzan; his *gō* Soshin appears on the back of some of Kenzan's pottery. Could also work in the Tosa manner, reserving this for *emaki.* Used the Kanō style for landscapes, the Rimpa style (which with him was more naturalistic, less essentially decorative than with Kōrin) for *kachōga.* Much esteemed by Ōkyo. A mild and elegant painter, with a splendid sense of color. **Coll.:** Ashmolean, Baltimore, British, Cleveland, Daikaku-ji, Detroit, Freer, Itsuō, Lake, Metropolitan, Museum (3), Nezu, Suntory, Tōkyō (1), University (2). **Bib.:** BCM 42; GNB 17; Hillier (3); K 80, 85, 215, 240, 269, 282, 542, 831, 861; KO 39; *Kōrin-ha* (1); M 51, 84; Mayuyama; Mizuo (2a), (4); Morrison 2; NBZ 5; OA 17; Paine (2) 1, (4); *Rimpa;* SBZ 9; Shimada 2; *Sōtatsu-Kōrin* (2); Stern (3); Tajima (2) 3, (12) 5, (13) 5; YB 23.

¹如興 ²渡辺求馬 ³左内 ⁴求馬
⁵如興 ⁶松軒 ⁷素信

Shikō (Sō Shikō)[1] (1781–1850). **N.:** Kusumoto Rin.[2] **A.:** Gyokurin.[3] **Gō:** Chōshōdō,[4] Sekkei,[5] Shikō,[6] Sō Shikō.[7] **Biog.:** Nagasaki painter. Pupil and perhaps adopted son of Sō Shizan, whose style he followed.

¹紫岡 (宋紫岡) ²楠本琳 ³玉林
⁴聴松堂 ⁵雪渓 ⁶紫岡 ⁷宋紫岡

Shima[1] (1862–87). **N.:** Yoshimura Shima.[2] **Gō:** Tōsui.[3] **Biog.:** Painter. Born in Edo. She was a minor pupil of Shibata Zeshin. **Bib.:** Mitchell.

¹島 ²吉村島 ³島水

Shima Seien[1] (1893–1970). **N.:** Shima Narie.[2] **Gō:** Seien.[3] **Biog.:** Painter. Lived and worked in Ōsaka. She was a pupil of Kitano Tsunetomi. Exhibited with the Bunten and, later, with the Teiten. Painter of *bijin* in a romantic half-Western, half-Japanese manner. **Coll.:** Ōsaka (2). **Bib.:** Asano.

¹島成円 ²島成栄 ³成円

Shimada Bokusen[1] (1867–1943). **N.:** Shimada Toyo (Yutaka).[2] **Gō:** Bokusen.[3] **Biog.:** Japanese-style painter. Son and pupil of a Maruyama school painter, Shimada Sekkoku, who was a retainer of the Fukui fief in Echizen. Later studied under Hashimoto Gahō. Member of the Nihon Bijutsuin. In 1925 became a committee member of the Teiten; in 1942 received the Imperial Art Academy Prize. Specialized in portraits of historical figures, working in a revived *yamato-e* style. **Coll.:** National (5), Tōkyō (1). **Bib.:** Asano, NBZ 6.

¹島田墨仙 ²島田豊 ³墨仙

Shimano Shigeyuki[1] (1902–66). **Biog.:** Western-style painter. Born at Hikone. In 1927 graduated from the Tōkyō School of Fine Arts, Western-painting division. Pupil of Okada Saburōsuke. While still in school, exhibited with the Kōfūkai and Teiten, becoming a member of the former in 1930.

Also showed with the Bunten and the Nitten, serving as a juror for the latter. His painting is academic.

¹島野重之

Shimazaki Keiji[1] (1907–44). **Biog.:** Western-style painter. In 1920 studied at the Kawabata Gagakkō. In 1926 moved to Gifu-ken. Two years later exhibited with the Nikakai. From 1929 to 1932 in Europe. On his return, again showed with the Nikakai. Attached to the armed forces as an artist, was killed in an airplane accident. **Coll.:** Kanagawa. **Bib.:** Asano.

¹島崎鶏二

Shimazaki Ryūu[1] (1865–1937). **N.:** Shimazaki Tomosuke.[2] **Gō:** Bokusui Gyofu,[3] Kukutei Sanjin,[4] Ryūu.[5] **Biog.:** Japanese-style painter. First studied Western-style painting; then turned to Japanese-style painting and studied under Matsumoto Fūko and Kawabata Gyokushō. Exhibited for the first time in 1887 with an organization for the promotion of Japanese painting; then with the Nihon Bijutsu Kyōkai, where he received an award. A frequent exhibitor and prize winner at the Bunten, the Nihon Bijutsu Kyōkai, and other government-sponsored shows. In his later years, a committee member and juror for the Nihon Bijutsu Kyōkai. **Coll.:** Tōkyō (1). **Bib.:** Asano, NB (S) 17.

¹島崎柳塢 ²島崎友輔 ³墨水漁夫
⁴栩久亭山人 ⁵柳塢

Shimbei (Shinbei)[1] (fl. late 16th to early 17th c.). **N.:** Ariki Shimbei (Shinbei).[2] **Biog.:** Potter. Native of Kyōto. Trader in foreign goods. Studied tea ceremony with Kobori Enshū and potted tea caddies and tea bowls in the manner of Kyōto, Shigaraki, Mino, Bizen, Karatsu, and Satsuma wares. **Bib.:** Hisamatsu, Jenyns (2), STZ 3.

¹新兵衛 ²有来新兵衛

Shimizu Takashi[1] (1897–). **Biog.:** Sculptor. Born in Nagano-ken. From 1923 to 1928 studied in France at the Académie Grande Chaumière and with Bourdelle, meanwhile exhibiting at various Paris salons. On his return to Japan showed with the Nikakai and the Shun'yōkai; member of the Nitten, the Shinjukai, and the Japan Art Academy. In 1952 won the Education Minister's Prize for Fostering the Arts and in 1953 the Japan Art Academy Award. His work is traditional, with influence from Bourdelle. **Bib.:** Asano, NBT 10, NBZ 6, Yanagi (1a).

¹清水多嘉示

Shimizu Toshi[1] (1896–1945). **Biog.:** Western-style painter. Born in Tochigi-ken. As a young man, studied at the National Academy of Design in New York. In 1925 to Europe. On his return to Japan in 1927 exhibited with the Nikakai and, in 1930, helped to establish the Dokuritsu Bijutsu Kyōkai. His paintings show the influence of the School of Paris of the 20s. **Coll.:** Kanagawa, National (5). **Bib.:** Asano, NBZ 6.

¹清水登之

Shimizu Yoshio[1] (1891–1954). **Biog.:** Western-style painter. Born in Tōkyō. Graduated from the Tōkyō School of Fine Arts, Western-painting division, in 1916. Showed with the Bunten while in school and for two years following his graduation. Then showed with the Teiten and, after 1924, served as juror for that association. Member of the Kōfūkai. After 1945, lecturer at Hiroshima University. **Coll.:** National (5). **Bib.:** Asano.

¹清水良雄

Shimomura Izan[1] (1865–1949). **N.:** Shimomura (originally Futagami)[2] Sumitaka.[3] **Gō:** Fukoan,[4] Izan,[5] Jakuro,[6] Rukidō. **Biog.:** Painter. Born in Matsuyama, Shikoku. Studied Western-style painting first under Honda Kinkichirō, then Koyama Shōtarō. In 1889 and 1891 showed with the Meiji Bijutsukai; in 1890 received second prize at the Naikoku Kangyō Hakurankai. Later changed to Japanese-style painting, producing *haiga.* In 1918, with Maruyama

Banka, established the Shin Nihonga Kyōkai. An able painter of *kachōga*. **Bib.:** Asano, Mitchell.

¹下村為山 ²二神 ³下村純孝 ⁴不瓵庵
⁵為山 ⁶雀廬 ⁷留幾洞

Shimomura Kanzan¹ (1873–1930). *N.:* Shimomura Seizaburō.² *Gō:* Kanzan.³ **Biog.:** Japanese-style painter. Born in Wakayama-ken. Pupil of Kanō Hōgai and Hashimoto Gahō. Graduated in the first class of the Tōkyō School of Fine Arts; later taught there until he resigned in 1898. Except for a period in Europe from 1903 to 1905, worked with Hishida Shunsō and Yokoyama Taikan under the leadership of Okakura Tenshin to establish and maintain the Nihon Bijutsuin and the revival of Japanese-style painting. Showed constantly with the Inten. With Taikan, was considered one of the best artists of this group. Member of the Art Committee of the Imperial Household. His subject matter from Japanese legend and history; known for his line drawings inspired by the 12th-century scrolls from the Kōzan-ji. One of the three painters commissioned to make the copy of the *Amida Raigō* at Kōyasan. Painted landscapes and *kachōga* in a delicate, colorful, competent Kanō style, with traces of Western-inspired realistic detail and considerable Rimpa influence. A fine draftsman. **Coll.:** Museum (3); National (5); Sanzen-in; Tōkyō (1), (2); Yamatane. **Bib.:** *Art* (1a); Asano; Binyon (2); Grilli (1); K 835; Kondō (6); *Kurashina* (1); M 11, 54; *Masterpieces* (4); Miyagawa; Morrison 1; NB (H) 24; NB (S) 17; NBT 10; NBZ 6; NKKZ 18; Noma (1) 2; Okamoto (1); SBZ 11; Uyeno; YB 38.

¹下村観山 ²下村晴三郎 ³観山

Shindō Reimei¹ (1897–). *N.:* Shindō Shigehiko.² *Gō:* Reimei.³ **Biog.:** Japanese-style painter. Born in Kumamoto-ken; works in Kyōto. Studied first at the Taiheiyō Kenkyūsho, then with Yasuda Yukihiko and Katayama Nampū. In 1921 to China; from 1929 to 1930 in America and Europe, exhibiting at the Salon d'Automne in Paris. Member of and exhibitor with the Nihon Bijutsuin. His paintings are very colorful. **Coll.:** National (5). **Bib.:** Asano.

¹真道黎明 ²真道重彦 ³黎明

Shin'etsu (Chinese: Hsin Yüeh)¹ (1639–96 or 1642–99). *Priest name:* Kōchū.² *Gō:* Shin'etsu;³ Tōkō.⁴ **Biog.:** *Zenga* painter. A famous Chinese Zen monk of the Sōtō sect who came to Nagasaki in 1677 at the invitation of a priest of the Kōfuku-ji; eventually became abbot of a new temple, the Gion-ji, at Mito, at the invitation of Tokugawa Mitsukuni, lord of the Mito clan. Had many religious disciples and gave a strong stimulus to the Sōtō sect. Painted *kachōga* and portraits of figures associated with Zen Buddhism. Also well known as a calligrapher. **Bib.:** Awakawa, NB (S) 47, Yonezawa.

¹心越 ²興儔 ³心越 ⁴東皋

Shingō¹ (fl. 16th c.). **Biog.:** Muromachi *suiboku* painter. Life unknown but probably a provincial painter. There is another artist of this name to whom a 14th-century date has been given. **Bib.:** K 642, Matsushita (1a).

¹神毫

Shinkai¹ (fl. c. 1126–32). **Biog.:** Sculptor. His name has been found, together with that of Myōshun, inside a Batō Kannon in the Kanzeon-ji, Fukuoka. **Coll.:** Kanzeon-ji. **Bib.:** *Heian* (2).

¹真快

Shinkai¹ (fl. 1278–87). *N.:* Fujiwara.² *Priest name:* Shinkai.³ **Biog.:** Painter. Son of Fujiwara no Nobuzane. Probably served as a priest at the Daigo-ji, Kyōto, as his signature appears on several sketches in the temple collection: an iconographic painting dated 1282, a *Bishamonten* of 1278, and a *Kongō Dōji* of 1280. **Coll.:** Daigo-ji. **Bib.:** BB 70; *Exhibition* (1); K 339, 383; Minamoto (1); NB (S) 33, 55; NBT 4; NKZ 8; P 1; SBZ 6; Tanaka (2).

¹信海 ²藤原 ³信海

Shinkai¹ (fl. 17th c.). *N.:* Hirowatari.² *Go:* Shinkai.³ **Biog.:** Kanō painter. Also a priest. Said to have come from Saga. Pupil of Kanō Tōun. From 1674 to 1676 worked at the Shishinden of the Kyōto Imperial Palace with his master Tōun and Kanō Tsunenobu. Later went to Nagasaki. Founder of the Hirowatari family of painters. Received title of *hokkyō*.

¹心海 ²広渡 ³心海

Shinkai Sōden¹ (fl. late 16th to early 17th c.). *N.:* Shinkai Shintarō.² *Gō:* Sōden.³ **Biog.:** Potter. Korean by birth, has a vague claim to have been the first to make porcelain in Japan (the foremost claimant is Ri Sampei; the next, Takahara Goroshichi). Is said to have made a rough blue-and-white at the Uchida kiln near Arita; however, no porcelain has been reliably identified as his. **Bib.:** FC 3, Jenyns (1).

¹深海宗伝 ²深海新太郎 ³宗伝

Shinkai Taketarō¹ (1868–1927). **Biog.:** Western-style sculptor. Born in Yamagata-ken. Started out in the army but, having a penchant for sculpting horses, resigned from the army and studied sculpture under Ogura Sōjirō. In 1900 to Germany for further study under Professor Herter at the Berlin Academy. Returned to Japan in 1902. Member and juror of the first Bunten in 1907. Headed the sculpture section of the Taiheiyō Kenkyūsho. Member of the Imperial Fine Arts Academy. His work is quite realistic, with touches of impressionism. **Coll.:** National (5). **Bib.:** Asano; GNB 28; M 30, 203; *Masterpieces* (4); NB (H) 24; NBT 10; NBZ 6; SBZ 11; Uyeno.

¹新海竹太郎

Shinkai Takezō¹ (1897–1968). **Biog.:** Sculptor. Born in Yamagata-ken. Worked in Tōkyō. Studied under his uncle, Shinkai Taketarō. Showed with the Bunten, Teiten, and Inten and also at the Tōkyō Biennial. In 1954 received the Education Minister's Prize for Fostering the Arts. His figure work done in a sensitive, realistic manner. **Coll.:** National (5). **Bib.:** Asano, GNB 28, NBT 10, NBZ 6.

¹新海竹蔵

Shinken¹ (1179–1261). **Biog.:** Buddhist painter. A Shingon priest, learned the doctrine of Esoteric Buddhism from Seiken. Founded the Jizō-in at the Daigo-ji, Kyōto, which once had some of his paintings. **Bib.:** NB (S) 55, NBT 4, NKZ 79.

¹深賢

Shinren (Nobukado)¹ (?–1582). *N.:* Takeda Nobutsuna.² *Priest name:* Kaiten Nyūdō.³ *F.N.:* Magoroku,⁴ Rokurō.⁵ *Gō:* Shinren,⁶ Shōyōken.⁷ **Biog.:** Painter. Third son of Takeda Nobutora and younger brother of the famous warrior Takeda Shingen, the feudal ruler of the province of Kai and the opponent of Nobunaga. Shōyōken is often, but mistakenly, given as his priest name; actually, it is the name of the hut in which he lived after taking his Buddhist vows. Specialized in portraits and is well known for those of his parents. Also painted Buddhist subjects. Worked in the Kanō manner. **Coll.:** Chōzen-ji, Daisen-in, Tokiwayama. **Bib.:** K 573, Matsushita (1a), Tanaka (2).

¹信廉 ²武田信綱 ³海天入道 ⁴孫六
⁵六郎 ⁶信廉 ⁷逍遙軒

Shinryū¹ (1804–56). *N.:* Yoshihara (Yoshiwara) Nobuyuki.² *F.N.:* Yosaburō.³ *Gō:* Ōhō,⁴ Shinryū,⁵ Tōin.⁶ **Biog.:** Ukiyo-e painter. Born in Bungo Province. Studied painting in Kyōto under Mihata Jōryū. Received title of *hōgen* and had the privilege of visiting the Kyōto Imperial Palace. Late in life, returned to his birthplace. Specialized in paintings of *bijin*. **Bib.:** *Nikuhitsu* (2).

¹真竜 ²吉原信行 ³与三郎 ⁴王峰 ⁵真竜 ⁶桃隠

Shinsai¹ (fl. 1434–90). *N.:* Igarashi Shinsai.² **Biog.:** Lacquerer. About 1470 founded the Igarashi school, serving as official lacquerer to the Ashikaga shogun Yoshimasa. The pieces he produced under this patronage were considered classical *makie* and were called Higashiyama-dono Gyobutsu

(Treasures of Higashiyama Palace). **Bib.:** Herberts, Jahss, Ragué, Sawaguchi.

[1]信斎 [2]五十嵐信斎

Shinsai[1] (1760–1823). *N.:* Fuchino Seryū.[2] *A.:* Gyokurin.[3] *Gō:* Shinsai,[4] Teien,[5] Unzansō.[6] **Biog.:** *Nanga* painter. Born in Kyūshū. First studied under a Kanō artist, then became a pupil of Watanabe Gentai. Official painter to the lord of Oka in the province of Bungo. Traveled with his master, sketching on the way. Teacher of Chikuden. Painter of landscapes, birds, animals. **Coll.:** Victoria.

[1]真斎 [2]淵野世竜 [3]玉麟 [4]真斎 [5]樗円 [6]雲山叟

Shinsai[1] (1764?–1820). *Given name:* Masayuki.[2] *F.N.:* Hanji,[3] Hanjirō,[4] Mannō.[5] *Gō:* Ryūkaen,[6] Ryūryūkyo,[7] Ryūryūkyo Shinsai,[8] Shinsai.[9] **Biog.:** Ukiyo-e painter, printmaker. Lived in Edo. Studied first under Tawaraya Sōri, then under Hokusai, who at that time called himself Tatsumasa and who gave him the *gō* of Shinsai in 1800. Ryūryūkyo was a *gō* used by Sōri, who gave him permission to use it. Adopted the *gō* belonging to both his masters, calling himself Ryūryūkyo Shinsai. Illustrated some books; designed numerous *surimono* and *nishiki-e*. His best-known book, *Ehon Shinsen Kyōga Gojūnin Isshu* (A New Selection of Fifty *Kyōga* Poets), was published in 1803; his finest work is the series of *surimono*, *Kasen Awase*. Noted for his landscape prints in semi-European style with Western shading and perspective. **Coll.:** Albertina, Allen, British, Fitzwilliam, Fogg, Freer, Honolulu, Kōbe, Metropolitan, Musées, Newark, Portland, Rhode Island, Staatliche, Suntory, Tōkyō (1), Victoria, Worcester. **Bib.:** Binyon (1), (3); Crighton; Fujikake (3) 3; Hillier (3), (4) 2; Morrison 2; Meissner; NB (S) 68; *Pictorial* (2) 4; Schmidt; Tajima (7) 4; Tamba (2a).

[1]辰斎 [2]正之 [3]半二 [4]半次郎 [5]満納
[6]柳花園 [7]柳々居 [8]柳々居辰斎 [9]辰斎

Shinsai[1] (fl. 19th c.). *N.:* Shibata Shinsai.[2] **Biog.:** Lacquerer. Son of Shibata Zeshin, brother of Reisai. Followed his father's style. **Bib.:** Herberts, Jahss.

[1]真哉 [2]柴田真哉

Shinshō[1] (fl. mid-16th c.). *N.:* Kanō Hidemasa[2] (or Hidenobu).[3] *Gō:* Chibu,[4] Shinshō.[5] **Biog.:** Kanō painter. Son of Kanō Hideyori, grandson of Kanō Motonobu. Known for his fan paintings. **Coll.:** Tokiwayama. **Bib.:** *Japanese* (1), K 845.

[1]真笑 [2]狩野秀政 [3]秀信 [4]治部 [5]真笑

Shinshun[1] (fl. c. 1570). *N.:* Hasegawa Shinshun.[2] **Biog.:** Painter. Specialized in Buddhist subjects but also produced a few *kachōga*. This may well be an early *gō* used by Hasegawa Tōhaku. **Coll.:** Tōkyō (1). **Bib.:** K 893, 937; Yamane (1a).

[1]信春 [2]長谷川信春

Shinsō[1] (1435–85). *N.:* Shiba Yoshikado.[2] *Gō:* Shinsō.[3] **Biog.:** Muromachi *suiboku* painter. Generally thought to have been the son of Yamana Sōzen, one of the instigators of the Ōnin War. Led an active political life. Is known to have left several landscape paintings. **Note:** The article in *Kokka* 875 advances the theory that Shinsō is not a *gō* of Shiba Yoshikado but represents another artist, active during the first half of the 16th century. **Bib.:** K 875, Matsushita (1a).

[1]心叟 [2]斯波義廉 [3]心叟

Shin'yō[1] (?–1801). *N.:* Kitayama (or Ma)[2] Dōryō.[3] *Gō:* Shin'yō.[4] **Biog.:** *Nanga* painter. Son of a Chinese immigrant; father of Ma Kangan. Lived in Edo.

[1]晋陽 [2]馬 [3]北山道良 [4]晋陽

Shinzei[1] (fl. 800–860). **Biog.:** Painter. Born in Kyōto. Disciple of Kūkai. Became second abbot of the Jingo-ji and director of painting at the Tō-ji. Known to have painted a number of portraits of Kūkai. The Daigo-ji owns some works that are attributed to him and are known as *Shinzeibon*.

[1]真済

Shirai Uzan[1] (1864–1928). *N.:* Shirai Yasujirō.[2] *Gō:* Uzan.[3] **Biog.:** Sculptor. Born in Ehime-ken. First studied painting

under Mochizuki Gyokusen, then turned to sculpture, graduating in 1893 from the sculpture department of the Tōkyō School of Fine Arts. Taught at his alma mater from 1898 to 1920, except for 1901–2, when he was the first student sent to Paris under a Ministry of Education grant. From 1907 served as a juror for the Bunten. **Coll.:** National (5). **Bib.:** Asano, BK 184, NBZ 6.

[1]白井雨山 [2]白井保次郎 [3]雨山

Shirakura Kanyū[1] (1896–). **Biog.:** Japanese-style painter. Born in Niigata-ken; works in Kyōto. First studied at the Nihon Suisaiga Kenkyūsho and exhibited at the Western-style section of the Bunten in 1914. Then studied with the *nanga* painters Tachika Chikuson and Komuro Suiun. Traveled frequently to China. Showed at government exhibitions and with the Nitten. His landscapes owe much to the *nanga* tradition. **Coll.:** National (5). **Bib.:** Asano.

[1]白倉嘉入

Shirataki Ikunosuke[1] (1873–1960). **Biog.:** Western-style painter. Born in Hyōgo-ken. Studied with Yamamoto Hōsui and also with Kuroda Seiki at his Tenshin Dōjō. Graduated from the Tōkyō School of Fine Arts in 1898. Joined the Hakubakai. Traveled in Europe and America from 1904 to 1910. An exhibitor with official groups and a promoter of Western-style oil painting. In 1951 the Japan Art Academy awarded him the Imperial Prize. An academic illustrative realist using light color. **Coll.:** Bridgestone, Tōkyō (2). **Bib.:** Asano, Harada Minoru, *Kurashina* (2), NB (H) 24, NB (S) 30, NBZ 6, Uyeno.

[1]白滝幾之助

Shirayana Shōsai[1] (1853–1923). *N.:* Shirayama Fukumatsu.[2] *Gō:* Shōsai.[3] **Biog.:** Lacquerer. Born in Edo. As a young man, worked for the famous lacquer firm of Kiritsu Kōshō Kaisha. Was one of the artists called in to work on the lacquer decoration for the Imperial Palace in Tōkyō from 1886 to 1889. Also helped found the Nihon Shikkōkai (Japan Lacquer Society) in 1889. Became a professor at the Tōkyō School of Fine Arts in 1905 and, the following year, a member of the Art Committee of the Imperial Household. Worked in many techniques: *makie*, carved lacquer, inlaid lacquer; was particularly noted for his *togidashi*. His work is in the traditional style; his technique superb. **Coll.:** Atami, Collections, Metropolitan, National (4), Philadelphia, Tōkyō (1). **Bib.:** Herberts, Jahss, M 203, NB (S) 41, NBT 7, NBZ 6, Ragué, Uyeno, Yoshino.

[1]白山松哉 [2]白山福松 [3]松哉

Shirobei[1] (fl. 1688–1703). **Biog.:** Lacquerer. Worked in Kyōto. Skillful employment of encrustation of nacre. Many followers. **Bib.:** Herberts, Jahss.

[1]四郎兵衛

Shiseki (Sō Shiseki)[1] (1712–86). *N.:* Kusumoto Shiseki.[2] *A.:* Kunkaku.[3] *F.N.:* Kōhachirō.[4] *Gō:* Katei,[5] Sekkei,[6] Sekko,[7] Sōgaku,[8] Sō Shiseki.[9] **Biog.:** Nagasaki painter, printmaker. Born in Edo. Pupil of the Nagasaki artists Kumashiro Yūhi and Sō Shigan (from whom he got the *sō* and the *shi* of his name). Carried the Nagasaki style to Edo, where he quickly gained a great reputation. Shiba Kōkan and Sakai Hōitsu among his pupils; Sō Shizan his son. Books after his designs—for example, the *Sō Shiseki Gafu*, published in 1765—were among the earliest printed from multiple-color blocks. Produced prints in the Chinese literati style. His *kachōga*, for which he is best known, are in the full-colored style of Shen Nan-p'in. Also worked in ink and light colors and painted in ink with a bold brush. **Coll.:** Art (1), Ashmolean, British, Itsukushima, Kōbe, Museum (3), Tōkyō (1), Victoria. **Bib.:** BMFA 44; Brown; Hillier (3), (4) 3; Holloway; K 162, 272, 372, 703, 708; M 187; Mitchell; Morrison 2; NBZ 5; NHBZ 3; OA 13; *Pictorial* (2) 5; Tajima (13) 7; Waterhouse.

[1]紫石 (宋紫石) [2]楠本紫石 [3]君赫 [4]幸八郎
[5]霞亭 [6]雪渓 [7]雪湖 [8]宋岳 [9]宋紫石

Shishin[1] (fl. 1760–70). **Biog.**: Ukiyo-e painter. To date, only his paintings—generally of *bijin* or of the flowers of the four seasons—are known. Worked in the style of Harunobu. **Bib.**: Hillier (3), (4) 1; *Nikuhitsu* (2).

¹至信

Shitan[1] (fl. early 14th c.). **Biog.**: Painter. Life unknown. His brushwork is close to that technique found in the screen paintings seen in Muromachi scrolls, suggesting that his background was that of the *yamato-e* school. **Coll.**: Kyōto (2). **Bib.**: BCM 50, K 669, KO 2, M 166, NB (S) 69, NBT 4, NBZ 3.

¹思堪

Shizan (Sō Shizan)[1] (1733–1805). **N.**: Kusumoto Hakkei.[2] *A.*: Kunshaku,[3] Manju.[4] *Gō*: Sekko,[5] Shizan,[6] Sō Shizan,[7] Taikei.[8] **Biog.**: Nagasaki painter. Lived in Edo. Son and pupil of Sō Shiseki. Specialized in *kachōga* and landscapes. **Coll.**: Victoria. **Bib.**: Mitchell.

¹紫山（宋紫山） ²楠本白圭 ³君錫 ⁴万寿
⁵雪湖 ⁶紫山 ⁷宋紫山 ⁸苔渓

Shizan[1] (?–1857?). **N.**: Shirakawa Keikō.[2] *Gō*: Gyokushōan,[3] Shizan.[4] **Biog.**: Painter. Born in Kyōto. Died at age of 92. **Bib.**: Mitchell.

¹芝山 ²白川景皓 ³玉蕉菴 ⁴芝山

Shōan[1] (fl. late 15th to early 16th c.). *Priest name:* Shōan.[2] *Gō*: Baian.[3] **Biog.**: Muromachi *suiboku* painter. Lived in Ōta in Hitachi Province. A Zen priest. Said to have been a pupil of Kenkō Shōkei. According to tradition, told his followers not to build a tomb for him but to plant a pine tree. Specialized in *kachōga* and landscapes, the latter in the style of Shūbun. **Bib.**: NB (S) 63.

¹性安 ²性安 ³梅菴

Shōbei[1] (fl. late 17th c.). **N.**: Igarashi Shōbei.[2] **Biog.**: Lacquerer. The best pupil of Igarashi Dōho I; was allowed to use his master's family name of Igarashi. Succeeded by his son, who called himself Igarashi Chōzaemon Michihiro[3] and who died in 1768. **Bib.**: M 71, Ragué.

¹庄兵衛 ²五十嵐庄兵衛 ³五十嵐長左衛門道広

Shōbō[1] (832–909). **Biog.**: Sculptor. Shingon Buddhist priest, founder of the Daigo-ji, Kyōto. Said to have been a prolific sculptor and to have made the statues of Kannon and the Shitennō in the Jikidō of the Tō-ji. It is much more likely that, as an influential priest, he directed the making of such statues. May also have been responsible for the repairs to some of the works attributed to him. **Coll.**: Tō-ji (Jikidō). **Bib.**: K 848.

¹聖宝

Shōchiku[1] (1781–1851). **N.**: Shinozaki Tasuku.[2] *A.*: Shōsuke.[3] *F.N.*: Chōzaemon.[4] *Gō*: Idō,[5] Shōchiku.[6] **Biog.**: *Nanga* painter. Son of an Ōsaka doctor, was adopted by the Confucianist Shinozaki. To Edo, where he studied painting, calligraphy, and poetry. Returned to Ōsaka; became a Confucianist and a painter of landscapes and of the "four princely plants" as well as a calligrapher and author. An important figure in Kansai literary circles. His name is also mentioned in almost all Japanese art dictionaries. In spite of his importance in his own time, nothing more is known of his life. A follower of the *bunjinga* school.

¹小竹 ²篠崎弼 ³承弼 ⁴長左衛門 ⁵畏堂 ⁶小竹

Shōda Kakuyū[1] (1879–1947). **N.**: Shōda Tsuneyoshi.[2] *Gō*: Gyōkan,[3] Kakuyū.[4] **Biog.**: Japanese-style painter. Born in Nara-ken. To Kyōto to study under Yamamoto Shunkyo. In 1898 graduated from the Kyōto Municipal School of Fine Arts and Crafts; later became a professor at the Kyōto School of Painting. Member of the Kyōto Bijutsu Kyōkai. After 1907 exhibited frequently with the Bunten. A good landscape painter. **Coll.**: National (5). **Bib.**: Asano, Elisséev.

¹庄田鶴友 ²庄田常喜 ³暁観 ⁴鶴友

Shōdai Tameshige[1] (1863–1951). **Biog.**: Western-style painter. Born in Saga. Trained in Edo as both a scientist and a painter. To Paris for two years. Held various teaching positions. Founding member of Hakubakai. Style rather impressionist. **Coll.**: Tōkyo (2). **Bib.**: Asano, *Kurashina* (2).

¹小代為重

Shōdō[1] (1776–1841). **N.**: Murakami Shigeatsu[2] (or Genkō).[3] *A.*: Tokugō.[4] *Gō*: Kōdai,[5] Shōdō.[6] **Biog.**: Kishi painter. Born in Kyōto. Lived and worked in Edo. Pupil of Kishi Ganku. Later studied the Tosa manner. An able painter of figures and landscapes, working in a carefully finished, pompous style as well as in a delicate witty manner. **Coll.**: Ashmolean, Museum (3). **Bib.**: Mitchell.

¹松堂 ²村上茂篤 ³元厚 ⁴徳合 ⁵広大 ⁶松堂

Shōei[1] (1519–92). **N.**: Kanō Tadanobu (Naonobu)[2] (or Mikinobu).[3] *F.N.*: Genshichirō,[4] Ōinosuke.[5] *Gō*: Shōei.[6] **Biog.**: Kanō painter. Presumably third son of Kanō Motonobu; father of Kanō Eitoku. Lived in Kyōto, serving the Ashikaga shogunate. In 1566 worked with his son Eitoku at the Jukō-in, Daitoku-ji. In 1562, on the death of his older brother Munenobu, became head of the family and fourth generation of the Kanō school; also received title of *hōgen*. After becoming a priest, used *gō* of Shōei. Less celebrated than his father or his son, but an able representative of the Kanō tradition and important in the development of the Kanō style. Pleasant, straightforward work with fine brushwork and often monumental composition. **Coll.**: Art (1a), Daitoku-ji (Jukō-in), Freer, Museum (3), Nanzen-ji, Reiun-in (Shoin), Tokiwayama. **Bib.**: Binyon (2); BK 243; GNB 13; *Japanese* (1), (1a); K 30, 80, 168, 331, 785; Mayuyama; Morrison 1; NB (H) 14; NBZ 4; Paine (2) 1, (4); Shimada 2; Tajima (12) 10, (13) 4; Tanaka (1).

¹松栄 ²狩野直信 ³幹信 ⁴源七郎 ⁵大炊助 ⁶松栄

Shōga[1] (fl. 1168–1209?). **N.**: Takuma Shōga.[2] **Biog.**: Takuma painter. Lived in Kyōto. Son of Takuma Tametō. Given rank of *hōgen*. The *Jūniten* (dated 1191) and the *Ryōkai Mandara* in the Tō-ji, Kyōto, and the *Jūniten* in the Jingo-ji, Kyōto, are attributed to him. **Coll.**: Jingo-ji, Tō-ji. **Bib.**: Akiyama (2); BCM 50; BI 36; K 212, 818; Minamoto (1); Morrison 1; *National* (2), NBT 4; NKZ 18; *One* (2); Paine (4); SBZ 6; Tajima (12) 2, 6, 13; Tajima (13) 2; Tanaka (2).

¹勝賀 ²宅磨勝賀

Shōgetsu[1] (fl. second half 19th c.). **N.**: Kojima Katsumi.[2] *Gō*: Shōgetsu,[3] Tōshū.[4] **Biog.**: Ukiyo-e printmaker. His subject matter includes genre scenes and scenes from the 1894–95 war with China. **Coll.**: Honolulu, Museum (3), Victoria. **Bib.**: Nonogami.

¹勝月 ²小島勝美 ³勝月 ⁴東洲

Shōgyō[1] (fl. late 15th c.?). **Biog.**: Muromachi *suiboku* painter. It is possible that this was another name used by Sōtan, but the matter is by no means clear. However, the artist working under this *gō* was a good *suiboku* painter. See also Seigyō. **Coll.**: Tōkyo (1). **Bib.**: HS 10.

¹性暁

Shōgyoku[1] (1840–91). **N.**: Kanō Terunobu.[2] *Gō*: Shōgyoku.[3] **Biog.**: Kanō painter. Son of Kanō Sadanobu, pupil of Kanō Shōsen'in. A minor member of the Fukugawa Kanō school. Worked for the shogunate. **Coll.**: Museum (3). **Bib.**: Mitchell.

¹勝玉 ²狩野照信 ³勝玉

Shōha[1] (fl. c. 1765). **N.**: Ueno Shōha.[2] **Biog.**: Ukiyo-e printmaker. Made calendar prints in the style of Harunobu for the year 1765. No other information known. **Coll.**: Tōkyo (1). **Bib.**: Binyon (3), Kikuchi.

¹章波 ²上野章波

Shōhaku[1] (fl. mid-17th c.). **N.**: Kuno Shōhaku.[2] *Gō*: Sōhaku.[3] **Biog.**: Potter. Born in Ōsaka. In 1653 invited by Lord Tosa to open the Odo kiln at Ozu in Kōchi.

¹正柏（松柏） ²久野正柏（久野松伯） ³宗伯

Shōhaku[1] (1730–81). **N.**: Soga Shiryū[2] (originally Kiyū[3] or Kiichi).[4] *Gō*: Hiran,[5] Jasokuken,[6] Joki,[7] Kishinsai,[8] Ranzan,[9] Shōhaku.[10] **Biog.**: Soga painter. Born in Ise; lived in Kyōto. Studied under the Kanō artist Takada Keiho; a contemporary but an enemy of Ōkyo. A dominant figure

in the art world of Kyōto, though many of his contemporaries considered him mad, a fanatic, since his behavior did not conform to that of Kyōto's polite society. As an artist, much neglected in his lifetime. An independent, proud man, he developed his own style; used a seal reading "Soga Jasokuken" and thereby showed his dependence on the style of Soga Jasoku. Some landscapes, but more generally figure pieces of a wild fantasy; subjects drawn from Chinese legends, rendered with dynamic, vigorous, sweeping brushwork—a style too coarse to be widely appreciated by his contemporaries, even though they admitted the strength of his brushwork. **Coll.:** Baltimore; Fogg; Freer; Herron; Itsuō; Kōshō-ji; Metropolitan; Museum (3); Ōkura; Tokiwayama; Tōkyō (1), (2); University (1), (2). **Bib.:** BK 53; BMFA 36; Brasch (2); *Freer;* Hillier (3), (4) 3; K 4, 39, 60, 118, 125, 138, 279, 283, 509, 882, 905; KO 34, 39, 40; Mayuyama; Mitchell; Morrison 1, 2; NB (S) 39; NBZ 5; *One* (2); Paine (2) 1, 2; Paine (4); Rosenfield (2); SBZ 10; Shimada 2; Suzuki (7a); Tajima (12) 6, 7, 16, 20; Tajima (13) 5.

¹蕭白 ²曽我師竜 ³暉雄 ⁴暉一 ⁵飛鸞 ⁶蛇足軒 ⁷如鬼 ⁸鬼神斎 ⁹鸞山 ¹⁰蕭白

Shōjumaru¹ (fl. 13th c.). *N.:* Sumiyoshi Shōjumaru.² **Biog.:** *Yamato-e* painter. Son of Sumiyoshi Keinin. His name and that of his father appear in the postscript of the Kamakura-period scroll of the *Kako Genzai Inga-kyō* as the illustrators of these scrolls, which were finished in 1254. **Coll.:** Gotō, Nezu. **Bib.:** *Illustrated* (2), (3); Lee (1); SBZ 6.

¹聖聚丸 ²住吉聖聚丸

Shōka¹ (fl. early 18th c.). *N.:* Nakae Tochō.² *A.:* Chōkō.³ *Gō:* Goteki,⁴ Katei Dōjin,⁵ Shōka.⁶ **Biog.:** *Nanga* painter. Born in Ōmi Province; lived in Kyōto. Pupil of Ido Kyūjo. An engraver of seals, painter, poet, calligrapher, and musician; hence the name Goteki, meaning "skillful in five arts." A good landscape artist. **Bib.:** Mitchell.

¹松寠 ²中江杜徴 ³徴公 ⁴五適 ⁵華亭道人 ⁶松寠

Shōka¹ (1835–87). *N.:* Watanabe Kai.² *A.:* Shōkei.³ *F.N.:* Shunji.⁴ *Gō:* Shōka.⁵ **Biog.:** Japanese-style painter. Lived in Edo. Second son of Watanabe Kazan. After his father's death, studied with Tsubaki Chinzan and then with Fukuda Hanko. Also a student of history and literature. Often received prizes when his paintings were shown at the early-Meiji-era exhibitions. Helped found the Tōyō Kaiga Kyōkai. Specialized in *kachōga,* working in the *nanga* tradition. Painter of considerable talent, though his later work showed a decline in quality. **Bib.:** Asano, Mitchell, Morrison 2.

¹小華 ²渡辺諧 ³韶郷 ⁴舜治（舜次） ⁵小華

Shōkadō¹ (1584–1639). *N.:* Nakanuma.² *F.N.:* Shikibu.³ *Gō:* Seiseiō,⁴ Shōjō,⁵ Shōkadō.⁶ **Biog.:** Painter, calligrapher. Born in Sakai. Became a *shasō* (Shintō-Buddhist priest) at the Otokoyama Hachiman-gū in Yamashiro. Knew the literary men and the tea masters prominent in the intellectual world of Kyōto. A contemporary of Kōetsu and member of his circle. Studied under Sanraku. Also studied Chinese Ming and Yüan paintings. Finally created his own style. With Nobuhiro and Kōetsu, one of the three great calligraphers of his time. At the end of his life retired to a hut that he called the Shōkadō, using its name as one of his *gō.* His painting is very much in tea-ceremony style: simple, spare, spontaneous ink sketches done with a forceful and witty brush. **Coll.:** Allen, Art (1), British, Fogg, Hatakeyama, Homma, Metropolitan, Museum (3), Nelson, Philadelphia, Tokiwayama, Tokugawa, Umezawa, Victoria. **Bib.:** Binyon (2); BK 63; Hillier (2), (3), (4) 3; *Japanese* (1); K 32, 69, 144, 176, 185, 195, 257, 454, 459, 498, 501, 506, 552, 557, 595, 861, 881; Moriya; Morrison 1; NBT 5; NBZ 4; Noma (1) 2; Paine (4); Rosenfield (1a),ʼ(2); SBZ 9; Tajima (12) 3, 14, 16; Tajima (13) 5.

¹松花堂 ²中沼 ³式部 ⁴惺々翁 ⁵昭乗 ⁶松花堂

Shōkasai¹ (fl. early 19th c.). *N.:* Shibayama.² *Gō:* Shōkasai.³

Biog.: Lacquerer. Member of the Kajikawa family by birth; worked frequently with members of the Shibayama family, from which he took his name. **Bib.:** Herberts, Jahss.

¹松花斎 ²芝山 ³松花斎

Shokatsukan¹ (1719–90). *N.:* Shimizu Kan.² *A.:* Shibun.³ *F.N.:* Bunzaburō,⁴ Matashirō,⁵ Sango.⁶ *Gō:* Kogadō,⁷ Seisai,⁸ Shokatsukan.⁹ **Biog.:** Nagasaki painter. Lived in Edo. Either entirely self-taught or studied for a while under Kumashiro Yūhi; also studied Chinese Yüan, Ming, and Ch'ing painting, particularly the style of Shen Nan-p'in. His subjects consisted of birds-and-flowers, landscapes, and bamboo. **Coll.:** Kōbe. **Bib.:** Mitchell, *Pictorial* (2) 5.

¹諸葛監 ²清水監 ³士文（子文） ⁴文三郎 ⁵又四郎 ⁶三五 ⁷古画堂 ⁸静斎 ⁹諸葛監

Shōkei¹ (fl. first half 14th c.). **Biog.:** Sculptor. Listed in 1315 as a member of the Sanjō Bussho, with title of *hōin.* Known for a seated Fugen, dated 1334, in the Shina-jinja, Shiga-ken. **Coll.:** Shina-jinja. **Bib.:** *Muromachi* (2).

¹性慶

Shōkei¹ (fl. c. 1478–1506). *N.:* Kenkō Shōkei.² *F.N.:* Sekkei.³ *Gō:* Hinrakusai,⁴ Kei Shoki.⁵ **Biog.:** Muromachi *suiboku* painter. Born in Utsunomiya, Shimotsuke Province. A priest at the Kenchō-ji, Kamakura. Said to have been a pupil of Chūan Shinkō. In 1478 to Kyōto and studied under Geiami, copying ancient paintings in the shogun's collection. Three years later returned to Kamakura and the Kenchō-ji, where he held the office of *shoki* (secretary-scribe); hence his name of Kei Shoki. Among his pupils at the Kenchō-ji may have been Keison and Senka. Painted landscapes as well as pictures of Taoist and Buddhist saints and priests. Style like that of Geiami, but more rigid and dry: a crisp rendition of Southern Sung style. Particularly skillful in black-and-white. Most important Kamakura painter of his time. **Coll.:** Cleveland; Fujita; Hakutsuru; Kyōto (2); Metropolitan; Museum (2), (3); Nanzen-ji; Nezu; Seattle; Tokugawa; Tōkyō (1); Umezawa. **Bib.:** *Exhibition* (1); Fontein (2), (3); Fuller; GNB 11; HS 3, 8, 11, 12; K 6, 33, 39, 50, 60, 84, 91, 100, 113, 118, 133, 149, 165, 222, 248, 285, 302, 649, 699, 816; KO 2; M 191; Matsushita (1), (1a); Mayuyama; Minamoto (1); Morrison 1; NB (S) 13, 63; NBZ 3; NKZ 18; *One* (2); Paine (4); Shimada 1; Tajima (12) 6, 18; Tajima (13) 3; Tanaka (2); TBS 9; Yashiro (1) 2.

¹祥啓 ²賢江祥啓 ³雪渓 ⁴貧楽斎 ⁵啓書記

Shōkei¹ (1628–1717). *N.:* Katayama Chikanobu.² *Priest name:* Shōkei.³ *F.N.:* Yahei.⁴ **Biog.:** Kanō painter. Pupil of Kanō Naonobu. Served the Matsuura family first in Hirado, later in Kyōto. Worked in the imperial palace and gained the emperor's favor. Received rank of *hokkyō.* At end of his life returned to Hirado. **Coll.:** Museum (3).

¹尚景 ²片山親信 ³尚景 ⁴弥兵衛

Shōkei Ten'yū¹ (fl. 1440–60). **Biog.:** Muromachi *suiboku* painter. Details of his life unknown. Some paintings bearing his seal Shōkei have a second seal reading "Ten'yū," and for this reason he is usually listed as Shōkei Ten'yū. The paintings with his seal show him to have been a sensitive and quite lyrical painter who was well acquainted with Sung and Yüan paintings. One of a group of painters influenced by Shūbun. **Coll.:** Hakutsuru, Tokugawa. **Bib.:** GNB 11; K 66, 266, 695; Matsushita (1a); *Muromachi* (1); Rosenfield (2); Shimada 1; Tajima (12) 2, 3; Tanaka (2), (5).

¹松谿天遊

Shōko¹ (fl. late 15th c.). **Biog.:** Muromachi *suiboku* painter. Details of his life and his surname unknown. From his painting would seem to have been a follower of Sesshū. **Coll.:** Umezawa. **Bib.:** Matsushita (1a).

¹承虎

Shōkoku¹ (fl. c. 1860). *N.:* Yoshikawa Yone (Bei).² *A.:* Meikei.³ *Gō:* Shōkoku.⁴ **Biog.:** Painter. Worked first in Edo, then in Ōsaka. **Bib.:** Mitchell.

¹松谷（小穀） ²吉川米 ³明啓 ⁴松谷（小穀）

Shōkōsai (Shōkō)[1] (fl. 1795–1809). *F.N.*: Hambei (Hanbei).[2] *Gō*: Shōkōsai (Shōkō).[3] **Biog.**: Ukiyo-e printmaker. Lived in Ōsaka. Pupil of Ryūkōsai. Regarded as one of the founders of the Kamigata-e school. Had many pupils, including Hokushū. Illustrated books, the first one of which was published in 1798, and made prints of actors. **Coll.**: Philadelphia. **Bib.**: Fujikake (3) 3, Keyes, NHBZ 3, Takahashi (2), *Ukiyo-e* (3) 19.

[1]松好斎 (松好)　[2]半兵衛　[3]松好斎 (松好)

Shōmin[1] (1847–91). *N.*: Ogawa Shōmin.[2] **Biog.**: Lacquerer. Born in Edo. Studied painting under Ikeda Koson. At 16 became a pupil of Nakayama Komin to learn technique of *makie*. In 1876 traveled to the United States. In 1889 helped organize the Nihon Shikkōkai, and in 1890 became professor at the Tōkyō School of Fine Arts, which he helped to found and where he established the Lacquer Art Department. A traditional artist, he excelled at reproducing classical *makie*, which he made both as a means of studying ancient techniques and as a reply to the uncritical imitation of Western art that was rampant in the early Meiji era. Known also for his lacquer imitations of bamboo and other woods. One of the best lacquerers of his time. His designs much influenced by the Rimpa school. **Coll.**: Metropolitan; Tōkyō (1), (2); Walters. **Bib.**: Boyer, Casal, Herberts, Jahss, M 203, NB (S) 41, NBZ 6, Ragué, Uyeno, Yoshino.

[1]松民　[2]小川松民

Shōmosai[1] (fl. late 18th to early 19th c.). *Gō*: Masamitsu,[2] Shōmosai.[3] **Biog.**: Lacquerer. Often worked with members of the Shibayama school, who made encrustations for his *inrō*. **Bib.**: Herberts, Jahss.

[1]松茂斎　[2]正光　[3]松茂斎

Shōnyū[1] (1887–1944). *N.*: Tanaka Sōkichi.[3] *Studio name:* Kichizaemon.[3] *Posthumous name:* Yoshihide.[4] *Gō*: Shōnyū,[5] Sōkitsu.[6] **Biog.**: Raku potter. Eldest son of Kōnyū, inherited the name Kichizaemon and became thirteenth generation of the Raku family on his father's retirement in 1919. Worked for the Sen family of tea masters. From 1935 to 1942 published a magazine on tea (*Chadō Seseragi*). His pottery shows the influence of Oribe, Shino, Bizen, Karatsu, and Hagi wares. **Bib.**: Castile.

[1]惺入　[2]田中惣吉　[3]吉左衛門　[4]喜英　[5]惺入　[6]双橘

Shōrakusai[1] (fl. late 18th to early 19th c.). *Gō*: Shōju,[2] Shōrakusai.[3] **Biog.**: Ukiyo-e painter. Life and family name unknown. An Ōsaka painter who also made some prints. **Coll.**: Freer. **Bib.**: Keyes.

[1]松楽斎　[2]松寿　[3]松楽斎

Shōran[1] (fl. first half 19th c.). *N.*: Takenouchi Chika.[2] *A.*: Sakin.[3] *Gō*: Shōran.[4] **Biog.**: Kishi painter. Studied first under Maruyama Ōzui, then turned to the Kishi school. Landscapes, *bijin*, dragons, tigers among her subjects. **Bib.**: Morrison 2.

[1]小鸞　[2]竹内千賀　[3]左琴　[4]小鸞

Shōran[1] (fl. c. 1840). *N.*: Yabashi Heiryō.[2] *A.*: Shion.[3] *F.N.*: Kajirō.[4] *Gō*: Shōran.[5] **Biog.**: Painter. Born in Edo. **Bib.**: Mitchell.

[1]松嵐　[2]矢橋平良　[3]士温　[4]佳二郎　[5]松嵐

Shōri Uonari[1] (fl. 8th c.). **Biog.**: Sculptor. This name is found in an inscription on a Gigaku mask in the Shōsō-in. **Coll.**: Shōsō-in. **Bib.**: Harada, *Shōsō-in*, Tajima (13) 15.

[1]将李魚成

Shōroku[1] (1779–1845). *N.*: Takao Nobuyasu.[2] *F.N.*: Einojō.[3] *Gō*: Hokōsai,[4] Shōroku,[5] Suimutei.[6] **Biog.**: Ukiyo-e painter. Born to a samurai family in Edo. Pupil of Hosoda Eishi. Painter of *bijin*. **Bib.**: *Nikuhitsu* (2), UG 19.

[1]蕉鹿　[2]高尾信保　[3]栄之丞　[4]葉巷斎　[5]蕉鹿　[6]酔夢亭

Shōryō[1] (fl. first half 16th c.). **Biog.**: Muromachi *suiboku* painter. Life unknown. His name known only from his seal on a few paintings. **Bib.**: K 620.

[1]尚量

Shōryū[1] (1824–98). *N.*: Kawada Ikaku.[2] *A.*: Shōryō.[3] *Gō*:

Banzan,[4] Shōryū.[5] **Biog.**: Japanese-style painter. Born in Kōchi-ken. To Kyōto to study under Kanō Eigaku. Later changed to the *nanga* school, studying under Shinozaki Shōchiku and Nakabayashi Chikutō. A good painter of *kachōga*, landscapes, and pictures of dragons.

[1]小竜　[2]河田維鶴　[3]小梁　[4]幡山　[5]小竜

Shōsen (Zōsen)[1] (fl. 15th c.?). **Biog.**: Muromachi *suiboku* painter. Details of life unknown. May have been the same person as Shōsen Bonchō,[2] a priest at the Shōkoku-ji, Kyōto. His style like that of Minchō.

[1]象先　[2]象先梵超

Shōsen[1] (fl. first half 16th c.). *N.*: Soga Shōsen.[2] **Biog.**: Muromachi *suiboku* painter. Life very obscure. Said to have been a pupil (and perhaps son) of Soga Jasoku. Studied Southern Sung painting. Connected with the Daitoku-ji, Kyōto. The hawk his favorite subject. Painting in the Nezu with an inscription dated 1523. **Coll.**: Nezu, Tokiwayama, Tōkyō (2). **Bib.**: GNB 11, *Japanese* (1), K 630, KO 38, M 53, Matsushita (1), NB (S) 13.

[1]紹仙　[2]曽我紹仙

Shōsen'in[1] (1823–80). *N.*: Kanō Masanobu (Tadanobu)[2] (originally Eijirō).[3] *Gō*: Rekidō,[4] Shōko,[5] Shōsen,[6] Shōsen'in,[7] Shōsōsai.[8] **Biog.**: Kanō painter. Pupil of his father Kanō Seisen'in Osanobu; succeeded him as ninth generation of the Kobikichō branch of the Kanō school. On receiving title of *hōin*, took name of Shōsen'in. Teacher of Hashimoto Gahō and Kanō Hōgai. Produced a large number of eccentric paintings as well as some delicately colored rather tight landscapes; his style close to that of his father. **Coll.**: Art (1). **Bib.**: *Kanō-ha*, Morrison 1.

[1]勝川院　[2]狩野雅信　[3]栄次郎　[4]櫟堂　[5]尚古　[6]勝川　[7]勝川院　[8]素尚斎

Shōshō[1] (fl. second half 16th c.). *N.*: Soga Shōshō.[2] **Biog.**: Muromachi *suiboku* painter. Son of Soga Shōsen. Born in Echizen Province. Specialized in *kachōga*. Carried on the family painting tradition.

[1]紹祥　[2]曽我紹祥

Shōshun[1] (fl. mid-19th c.). *N.*: Arai Chūjun.[2] *Gō*: Shōshun.[3] **Biog.**: Tosa painter. Lived in Edo. Teacher of Arihara Kogan.

[1]尚春　[2]荒井忠純　[3]尚春

Shōtoku[1] (fl. c. 1610). **Biog.**: Kaihō painter. Details of his life unknown, save that he came from the Western part of Japan. Pupil of Kanō Eitoku and Kaihō Yūshō; his style resembles that of the latter.

[1]松徳

Shōun[1] (1637–1702). *N.*: Kanō (originally Iwamoto)[2] Suenobu.[3] *F.N.*: Ichiemon,[4] Shirō.[5] *Gō*: Chōshinsai,[6] Shōun.[7] **Biog.**: Kanō painter. Lived largely in Edo. Adopted son of Kanō Ryōshō; pupil of Kanō Yasunobu. About 1690 to Fukuoka to serve the governor. Later returned to Edo to become guardian of Kanō Eishuku; worked for the shogunate court and other feudal lords. Also commissioned to work for temples and shrines at Nikkō. **Coll.**: Metropolitan, Museum (3), Rinnō-ji (1), Victoria.

[1]昌運　[2]岩本　[3]狩野季信　[4]市右衛門　[5]四郎　[6]釣深斎　[7]昌運

Shōyō[1] (fl. c. 1510). *Gō*: Shōyō,[2] Shugyoku.[3] **Biog.**: Muromachi *suiboku* painter. Pupil of Sesshū. Also a priest. A good landscape painter. **Bib.**: Matsushita (1a), M 166.

[1]照陽　[2]照陽　[3]朱玉

Shozan[1] (1748–85). *N.*: Satake Yoshiatsu.[2] *Gō*: Shozan,[3] Tairei.[4] **Biog.**: *Yōga* painter. The daimyo of Akita. Learned Western-style painting from Hiraga Gennai, the painter and expert on Western science whom he brought from Nagasaki in 1773 to improve the output of the copper mines. Was also taught by Odano Naotake. Wrote two books on style and technique of Western art. His style (known as Akita *ranga*) a mixture of East and West: Chinese subjects with Western shading and weight. **Coll.**: Akita, Kōbe. **Bib.**: GNB 25,

Mody, NB (H) 24, NB (S) 36, NBZ 5, Noma (1) 2, *Pictorial* (2) 2, Rosenfield (1a), Sohō, TBS 2, YB 49.

¹曙山 ²佐竹義敦 ³曙山 ⁴泰嶺

Shōzan¹ (1811–64). *N.:* Sakuma Kei.² *A.:* Shimei.³ *F.N.:* Keinosuke,⁴ Shuri.⁵ *Gō:* Shōzan.⁶ **Biog.:** Japanese-style painter. A great political figure and an expert on firearms. As a painter, primarily an amateur, working in the *nanga* manner for only a few years before he was assassinated. **Coll.:** Musée (2). **Bib.:** Umezawa (2).

¹象山 ²佐久間啓 ³子明 ⁴啓之助 ⁵修理 ⁶象山

Shuben¹ (fl. mid-14th c.). **Biog.:** Sculptor. A *dai busshi*, working in Kyōto and holding the titles of *hokkyō* and *hōgen*, the second of which he received in 1355. Known for a statue of a Bosatsu in the Ichiino-ji, Ichiino, Shiga-ken, dated 1340. **Coll.:** Ichiino-ji. **Bib.:** *Muromachi* (2).

¹秀弁

Shuboku¹ (fl. c. 1560). *N.:* Kanō (originally Hōjō)² Ujinao.³ *Gō:* Isshuboku,⁴ Shuboku.⁵ **Biog.:** Kanō painter. Lived in Odawara. Said to have been elder brother of Kanō Gyokuraku. Pupil of Motonobu. **Bib.:** K 722.

¹殊牧 ²北條 ³狩野氏直 ⁴一殊牧 ⁵殊牧

Shūboku¹ (1662–1756). *N.:* Watanabe Genkichi.² *A.:* Genju.³ *Gō:* Izen Koji,⁴ Kokei,⁵ Shūboku.⁶ **Biog.:** Nagasaki painter. Born in Nagasaki. Son and pupil of Watanabe Shūseki. Like his father, held position of *kara-e mekiki* for the *bakufu*. Specialized in *kachōga* and landscapes.

¹秀朴 ²渡辺源吉 ³元寿 ⁴己然居士 ⁵壺渓 ⁶秀朴

Shūbun¹ (fl. mid-15th c.). *N.:* Ri Shūbun (in Korean: Yi Su-min).² **Biog.:** Muromachi *suiboku* painter. A Korean who came to Japan in 1424. As official painter to the Asakura daimyo of Echizen, played an important part in the development of Japanese ink painting. Influenced the Soga family of painters and is sometimes considered the founder of the Soga school. Paintings bearing his name have been known for some time, but his identity has been only recently established. **Bib.:** BK 80, 83; GNB 11; K 366; Matsushita (1); Morrison 1; NB (S) 13; Shimada 1; Tanaka (2); Watanabe.

¹秀文 ²李秀文

Shūbun¹ (fl. 1414–63). *N.:* Tōkei.² *A.:* Tenshō.³ *Gō:* Ekkei,⁴ Shūbun.⁵ **Biog.:** Muromachi *suiboku* painter. Monk and, at one time, abbot at the Shōkoku-ji, Kyōto. According to tradition, Josetsu was his master, Sesshū and Sōtan his pupils. Chief painter to the shogun; in 1423 or 1424 went on an official trip to Korea as member of the shogun's embassy. From 1430 to 1440 connected with reconstruction of the Shōkoku-ji, where he served as secretary and produced carvings and paintings. (The *Ten Oxherding Stages* in the temple's collection are traditionally ascribed to him.) Referred to in a temple document of 1436 in connection with the sculpture, presumably as supervisor and painter. About 1440 was in charge of installation of statues at the Ungo-ji, Higashiyama. No paintings can be categorically proven to be by him: all are generally listed as attributed to him. Ranks with Sesshū as one of the two great painters of his age. Was model for all mid-Muromachi painters. He took still amateurish Japanese monochrome Zen painting and transformed it into a large-scale, thoroughly accomplished style. **Coll.:** Cleveland, Freer, Fujita, Musée (2), Museum (3), Nezu, Seattle, Shōkoku-ji (Jishō-in), Taisan-ji, Tokiwayama, Tōkyō (1), Umezawa, Yamato. **Bib.:** Akiyama (2); *Art* (1a); ARTA 14; *Au-delà*; BCM 46; BK 55, 80, 83, 103; *Exhibition* (1); Fontein (1), (2); GK 11; Grilli (1); HS 1, 2, 5, 6, 9, 11, 12, 13; K 6, 17, 43, 70, 145, 177, 197, 252, 287, 304, 305, 313, 632, 709, 751, 793, 794; KO 8; *Kokuhō* 6; Lee (2); M 14, 90, 191; Matsushita (1), (1a); Mayuyama; Morrison 1; NB(S) 13; Noma (1) 1; *One* (2); Paine (4); *Selected;* Shimada 1; Tajima (12) 3, 6, 7, 10, 11, 13, 14, 20; Tajima (13) 3; Tanaka (2); Watanabe; Yashiro (1) 2; Yoshimura; YB 46.

¹周文 ²等慶 ³天章 ⁴越渓 ⁵周文

Shūchō¹ (fl. c. 1790–1803). *N.:* Tamagawa Shūchō.² **Biog.:**

Ukiyo-e printmaker. Once thought to have been a pupil of Utamaro; now known to have studied under Ippitsusai Bunchō. A minor artist, following in the wake of Utamaro. His style lies between that of Utamaro and Momokawa Chōki. **Coll.:** Allen, Art (1), British, Fine (California), Honolulu, Musées, Nelson, Rhode Island, Riccar, Tōkyō (1), Victoria. **Bib.:** Binyon (1), Hillier (7), Kikuchi, Michener (3), NHBZ 4, Takahashi (6) 10, UG 3.

¹舟調 ²玉川舟調

Shūgaku¹ (fl. early 15th c.). *A.:* Rinshū.² *Gō:* Shūgaku.³ **Biog.:** Muromachi *suiboku* painter. A Buddhist artist. His painting in the style of Tenshō Shūbun. **Coll.:** Art (1). **Bib.:** BAIC April 1931.

¹秋岳 ²林周 ³秋岳

Shūgaku¹ (1644–1734). *N.:* Watanabe (originally Iwakawa)² Shūgaku.³ *A.:* Gen'ei.⁴ *F.N.:* Saburobei.⁵ *Gō:* Ansai.⁶ **Biog.:** Nagasaki painter. Pupil of Watanabe Shūseki. Also known as a fine horseman and a good shot and swordsman.

¹秀岳 ²岩川 ³渡辺秀岳 ⁴元英 ⁵三郎兵衛 ⁶安斎

Shūgen¹ (fl. 1480). **Biog.:** Muromachi *suiboku* painter. Painted many pictures of Daruma. A follower of Sesshū's style.

¹周元

Shūgen¹ (fl. c. 1840). *N.:* Kanō Sadanobu.² *Gō:* Shūgen.³ **Biog.:** Kanō painter. Son of Kanō Shūsui. A minor artist. **Bib.:** Mitchell.

¹秀元 ²狩野貞信 ³秀元

Shūgetsu¹ (1440?–1529). *N.:* Taki (Takashiro) Kantō (Gonnokami).² *Gō:* Shūgetsu,³ Tōkan.⁴ **Biog.:** Muromachi *suiboku* painter. Son of Taki Shigekane, a vassal of Lord Shimazu in Satsuma Province. In 1462 took Buddhist vows and became a pupil of Sesshū, living in Yamaguchi. In 1492 called back to Satsuma by Lord Shimazu and lived at the Fukushō-ji. Said to have accompanied Sesshū to China. His style very close to that of Sesshū, but his brushwork less powerful. **Coll.:** British, Denver, Fogg, Freer, Honolulu, Ishikawa, Museum (3), Tokiwayama, Tōkyō (1), Umezawa. **Bib.:** BK 60; GNB 11; HS 2, 6; K 8, 61, 73, 194, 232, 333, 359, 386; M 62, 199, 205; Matsushita (1), (1a); Morrison 1; NB (S) 13; NBT 4; NKZ 63; *One* (2); Paine (4); Tajima (12) 4, 17; Tajima (13) 4; Tanaka (2); Wakita.

¹秋月 ²高城権頭 ³秋月 ⁴等観

Shūgo¹ (fl. c. 1350). **Biog.:** Muromachi *suiboku* painter. Also a Zen priest. His painting resembles that of Tokusai. **Bib.:** NB (S) 69.

¹周豪

Shūhei¹ (1783–1839). *N.:* Ogata Shūhei.² **Biog.:** Potter. Younger brother of Nin'ami Dōhachi. Apprenticed to the Hōzan kiln at Awataguchi. Teacher of Kashū Mimpei. Worked at Awaji, specializing in *aka-e* porcelain, stoneware tea bowls in underglaze blue, and pottery teapots in Mokubei's style. **Coll.:** Metropolitan, Tōkyō (1). **Bib.:** Fujioka, GNB 19, Jenyns (1), NB (S) 71, NBZ 5, *Nihon* (8), Okuda (1) 5, TZ (K) 30.

¹周平 ²尾形周平

Shūhō¹ (fl. 15th c.). **Biog.:** Muromachi *suiboku* painter. An obscure artist. Two theories regarding his identity: either an independent personality or the same person as Nōami, since a seal reading "Shūhō" is found on paintings by Nōami. **Coll.:** Tokiwayama. **Bib.:** *Japanese* (1), M 166, Matsushita (1a).

¹秀峰

Shūhō¹ (1738–1823). *N.:* Mori Takanobu.² *A.:* Kishin.³ *Gō:* Shūhō,⁴ Shōshūsai.⁵ **Biog.:** Painter. Born in Ōsaka. Elder brother of Mori Sosen. At first studied under a minor Kanō artist, Yoshimura Shūzan; then under Tsukioka Settei. Given honorary title of *hokkyō* and, later, of *hōgen*. Painted landscapes and *kachōga*. Talented, but lesser artist than his brother. **Coll.:** Ashmolean, Victoria. **Bib.:** Mitchell, Morrison 2.

¹周峰 ²森貴信 ³貴信 ⁴周峰 ⁵鐘秀斎

Shūhō[1] (fl. 19th c.). *N.*: Ishida Shūhō.[2] **Biog.**: Painter. Born in Ōmi Province. Pupil of Shirai Kayō. **Bib.**: K 411.

¹秀峰 ²石田秀峰

Shūi[1] (fl. 1346–69). *Priest name*: Shūi.[2] *Gō*: Mutō.[3] **Biog.**: Muromachi *suiboku* painter. Often referred to as Mutō Shūi. A Zen priest at the Tenryū-ji, Kyōto; disciple of Musō Kokushi, whose portrait by him is in the Myōchi-in of the Tenryū-ji. Generally thought of as specializing in *chinsō*, but is also recorded as having painted a hand scroll portraying the Ten Oxherding Stages as well as pictures of carp. The first Zen monk-painter who can with some confidence be regarded as a professional painter. **Coll.**: Tenryū-ji (Myōchi-in). **Bib.**: BCM 50; BK 75; Fontein (2); K 317, 347; NB (S) 69; NBT 4; SBZ 7; Tanaka (2); Watanabe.

¹周位 ²周位 ³無等

Shūkei[1] (fl. 15th c.). **Biog.**: Sculptor. Also a priest. The statue of Daruma in the Daruma-dera, Nara, dated 1430, was carved by him. Tradition says it was painted by Shūbun. His work has the feeling of smoothness typical of Muromachi sculpture. **Coll.**: Daruma-dera. **Bib.**: Fontein (1), Matsumoto (1), Minamoto (1), SBZ 7.

¹集慶

Shūkei[1] (?–1751). *N.*: Watanabe Mototoshi.[2] *A.*: Genshun.[3] *F.N.*: Bunjirō.[4] *Gō*: Gatokusai,[5] Shūkei.[6] **Biog.**: Nagasaki painter. Adopted son and heir of Watanabe Shūboku, succeeding him on his retirement as *kara-e mekiki* for the *bakufu* in Nagasaki.

¹秀渓 ²渡辺元俊 ³元俊 ⁴文治郎 ⁵雅徳斎 ⁶秀渓

Shūkei[1] (1778–1861). *N.*: Watanabe Kiyoshi.[2] *F.N.*: Daisuke.[3] *Gō*: Setchōsai,[4] Shūkei.[5] **Biog.**: *Fukko yamato-e* painter. Born in Nagoya. To Kyōto to study under Tosa Mitsusada and Tanaka Totsugen. Had great knowledge of ancient customs and manners, but as a painter was only a minor exponent of the revived *yamato-e* style. **Coll.**: Newark, Seattle. **Bib.**: *Fukko*, Mitchell.

¹周渓 ²渡辺清 ³代助 ⁴雪朝斎 ⁵周渓

Shuken[1] (fl. early 16th c.). **Biog.**: Muromachi *suiboku* painter. It is recorded that he painted Buddhist subjects; his work resembles that of Unkei in style and subject matter. Presumed to have been a follower of Sesshū, though details of his life unknown. **Bib.**: KO 29, Matsushita (1a).

¹殊賢

Shūken[1] (1809–29). *N.*: Watanabe.[2] *A.*: Genson.[3] *F.N.*: Ken.[4] *Gō*: Genshū,[5] Shūken.[6] **Biog.**: Nagasaki painter. Son and pupil of Watanabe Kakushū. In addition to the Watanabe style, also studied Chinese painting styles, particularly that of Shen Nan-p'in. Specialized in *kachōga*. Talented, but died young.

¹秀乾 ²渡辺 ³元巽 ⁴乾 ⁵竈洲 ⁶秀乾

Shūki[1] (1807?–62). *N.*: Okamoto Ryūsen.[2] *A.*: Hakuki.[3] *F.N.*: Sukenojō.[4] *Gō*: Fujiwara Ryūsen,[5] Shūki,[6] Shūō.[7] **Biog.**: *Nanga* painter. Studied under Ōnishi Keisai until his death; then became one of chief followers of Watanabe Kazan. Lived in Edo as retainer of Lord Ōkubo of Odawara; in later years served the Doi clan. Famous for his *kachōga* painted in a style close to that of Tsubaki Chinzan and Kanzan: bold, gorgeous color, realistic detail. Also versed in the military arts. **Coll.**: Los Angeles, Museum (3), Odawara, Tōkyō (1). **Bib.**: K 181, 371, 544, 650, 716, 752, 873, 928; Morrison 2; Murayama (2); NB (S) 4; Paine (2) 1; Shimada 2.

¹秋暉 ²岡本隆仙 ³柏樹 ⁴祐之丞 ⁵藤原隆仙 ⁶秋暉 ⁷秋翁

Shukō (Jukō)[1] (1422–1502). *Priest name*: Shukō (Jukō).[2] *F.N.*: Murata Mokichi.[3] *Gō*: Dokuryoken,[4] Kōrakuan,[5] Nansei.[6] **Biog.**: Muromachi *suiboku* painter. Also a priest and tea master. Entered priesthood at the Shōmyō-ji, Nara; studied Zen under Ikkyū, painting and *ikebana* under Nōami. Said to have lived in a hermitage in Sanjō area of Kyōto. Served as tea master to the shogun Yoshimasa, refining the tea cult, laying down rules for it, introducing the four-and-a-half-mat room for tea drinking: under him the tea ceremony became a Japanese art. Also a connoisseur of art and, with Nōami and others, helped Yoshimasa form a rich collection of paintings and porcelain. Painting a hobby. **Coll.**: Freer. **Bib.**: Castile, GNB 11, Hisamatsu, K 244, NB (H) 15, NBZ 3, Tanaka (2), Yoshimura.

¹珠光 ²珠光 ³村田茂吉 ⁴独廬軒 ⁵香楽庵 ⁶南星

Shūkō[1] (fl. late 15th to early 16th c.). **Biog.**: Muromachi *suiboku* painter. Lived at Tōnomine, Nara-ken. A priest. Follower of Sesshū; by tradition is said to have gone to China. Painted landscapes, pictures of animals, and *kachōga* in ink with occasional color. Excelled at *haboku*. **Coll.**: Chion-in, Freer, Metropolitan, Museum (3), Tōkyō (2). **Bib.**: GNB 11; HS 7; K 13, 53, 163; M 254; Matsushita (1); Mayuyama; *Muromachi* (1); NB (S) 13; Paine (4); Shimada 1.

¹周耕

Shukuya[1] (?–1789). *N.*: Aoki (originally Yo)[2] Shummei (Toshiaki).[3] *A.*: Daisho,[4] Shifū.[5] *F.N.*: Sōemon.[6] *Gō*: Hachigaku,[7] Shukuya,[8] Shuntō.[9] **Biog.**: *Nanga* painter. Born in Ise, perhaps of Korean parents; lived in Kyōto. Adopted by Nakagawa Tenju as his son. Pupil of Ikeno Taiga and lived in Taiga's house after his death. A pleasant but not very original painter, closely following Taiga's style. **Coll.**: Honolulu, University (2). **Bib.**: BK 28; Cahill; K 351, 513, 580; Mitchell; Morrison 2; Murayama (2); *Nihon* (3); Tajima (13) 7; Umezawa (2).

¹夙夜 ²余 ³青木俊明 ⁴大初 ⁵士風 ⁶荘右衛門 ⁷八岳 ⁸夙夜 ⁹春塘

Shumboku (Shunboku)[1] (1680–1763). *N.*: Ōoka Aiyoku (Aitō).[2] *Gō*: Ichiō,[3] Jakushitsu,[4] Setsujōsai,[5] Suishō,[6] Shumboku (Shunboku).[7] **Biog.**: Painter, illustrator. Born in Ōsaka, lived in Edo. First trained as a Kanō painter, then studied Chinese Yüan and Ming paintings, basing his final style largely on these. Published books of copies of the more celebrated pictures by ancient Chinese and Japanese masters. In 1746 published *Minchō Seido*, a particularly beautiful example of color printing and in its first edition one of rarest of all Japanese color-print books. Best known for his Chinese-style book illustrations, which greatly influenced Hokusai. Received title of *hōgen*, an unusual achievement for a self-taught artist. **Coll.**: British, Seattle, Staatliche. **Bib.**: Brown, Mitchell, Morrison 1, Schmidt, Strange (2), Toda (1), Waterhouse.

¹春卜（春朴）²大岡愛翼（愛董）³一翁 ⁴雀吒 ⁵雪静斎 ⁶翠松 ⁷春卜（春朴）

Shumman (Shunman)[1] (1757–1820). *N.*: Kubo (originally Kubota)[2] Toshimitsu.[3] *F.N.*: Yasubei.[4] *Gō*: Issetsu Senjō (Hitofushi Chizue),[5] Kōzandō,[6] Kubo Shumman,[7] Nandaka Shiran,[8] Sashōdō,[9] Shōsadō,[10] Shumman (Shunman).[11] **Biog.**: Ukiyo-e painter, printmaker. Also an author. Born and lived in Edo. Pupil of Katori Nahiko and Kitao Shigemasa, but more influenced by Torii Kiyonaga. Changed the *shun* in his *gō* from the character for "spring"[12] to the character for "excellence"[13] to distinguish himself from the numerous followers of Shunshō.[14] Seems to have devoted most of his efforts to book illustrations and to writing under such names as Issetsu Senjō, Nandaka Shiran, and Shōsadō; famous for his light verses and satires. A man of great sophistication, a bon vivant. As a printmaker, specialized in *surimono;* his other prints are scarce. His more plentiful paintings are generally of *bijin* in a landscape setting. In his art an experimenter in color, using silvery grays and light touches of soft colors, and in light and shade. A most original painter. **Coll.**: Allen; Art (1), (1a); Ashmolean; British; Brooklyn; Cleveland; Fitzwilliam; Freer; Fujita; Herron; Honolulu; Idemitsu; Kōbe; Metropolitan; Musée (2); Musées; Museu (1); Museum (1), (3); Nelson; Newark; Östasiatiska; Portland; Rhode Island; Riccar; Tōkyō (1);

Victoria; Worcester; Yale. **Bib.:** Binyon (1); Brown; Crighton; Fujikake (3) 3; GNB 17; Hillier (1), (2), (3), (4) 1, (7), (9); *Japanese* (1a); K 127, 358; Kikuchi; *Kunst;* Ledoux (1); Meissner; Narazaki (2); NBZ 5; NHBZ 3; *Nikuhitsu* (1) 2, (2); *Pictorial* (2) 4; Shibui (1); Shimada 3; Stern (2), (4); Tajima (7) 4; Takahashi (2), (6) 6; UG 28; *Ukiyo-e* (3) 11.

¹俊満（春満）　²窪田　³窪俊満　⁴安兵衛
⁵一節千杖　⁶黄山堂　⁷窪春満　⁸南陀伽紫蘭
⁹左尚堂　¹⁰尚左堂　¹¹俊満（春満）
¹²春　¹³俊　¹⁴春章

Shummei (Shunmei)¹ (1700–1781). **N.:** Igarashi (originally Sano)² Shummei (Shunmei).³ **A.:** Hōtoku.⁴ **Gō:** Bokuō,⁵ Chikuken,⁶ Gempō,⁷ Go Shummei (Shunmei),⁸ Kohō.⁹ **Biog.:** Kanō painter. Born and worked in Niigata; later to Kyōto to study Confucianism under Yamazaki Ansai. In painting a pupil of Kanō Ryōshin; also studied the Tosa and Chinese Sung styles of painting. Used the *gō* Go Shummei for a short time in middle age. Late in life given title of *hokkyō* and, later, of *hōgen*. Painted landscapes, figures, flowers; work very rare. Also a poet and calligrapher. **Coll.:** Honolulu. **Bib.:** Morrison 1.

¹俊明　²佐野　³五十嵐俊明　⁴方徳（方篤）
⁵穆翁　⁶竹軒　⁷絃峯　⁸呉俊明　⁹弧峯（孤峯）

Shunchō¹ (fl. c. 1780–95). **N.:** Katsukawa Shunchō.² **F.N.:** Kichizaemon.³ **Gō:** Chūrinsha,⁴ Kichisadō,⁵ Shien,⁶ Tōshien,⁷ Yūbundō,⁸ Yūshidō.⁹ **Biog.:** Ukiyo-e printmaker. Lived in Edo. Originally a pupil of Katsukawa Shunshō, then drawn to Torii Kiyonaga's style. (It is said that, having quarreled with Shunshō, he was drawn to Shumman, even changing the writing of *shun* in his *gō* to follow that of his new mentor.) About 1790 came under the influence of Utamaro. Later in life, gave up printmaking and turned to writing novels. Specialized first in actor prints, then in *bijinga* done with a subtle sense of light and color. Good compositions of figures in diptychs and triptychs. **Coll.:** Albertina; Allen; Andrew; Art (1); Ashmolean; Baltimore; Bibliothèque; British; Brooklyn; Cincinnati; Denver; Fine (California); Fitzwilliam; Freer; Fogg; Herron; Honolulu; Metropolitan; Minneapolis; Musée (1), (2); Musées; Museum (1), (3); Nelson; Newark; Östasiatiska; Portland; Rhode Island; Riccar; Rietberg; Staatliche; Suntory; Tōkyō (1); Victoria; Yale. **Bib.:** Binyon (3); Boller; Crighton; Fujikake (3) 3; GNB 17; Hillier (1), (7), (9); Kikuchi; *Kunst;* Lane; Ledoux (1); Meissner; Michener (3); Morrison 2; Narazaki (2); NHBZ 3; *Nikuhitsu* (1) 2; SBZ 10; Schmidt; Shibui (1); Shimada 3; Stern (2), (4); Tajima (7) 2; Takahashi (2), (6) 6; UG 28; Vignier 3.

¹春潮　²勝川春潮　³吉左衛門　⁴中林舎　⁵吉左堂
⁶紫園　⁷東紫園　⁸雄文堂　⁹雄芝堂

Shunchōsai¹ (fl. 1772–1801). **N.:** Takehara (originally Matsumoto)² Nobushige.³ **Gō:** Hokushō,⁴ Shunchōsai.⁵ **Biog.:** Ukiyo-e printmaker. Pupil of Ōoka Shumboku. Known for several series of views of famous places in Kyōto and the Kansai district. **Bib.:** Brown.

¹春朝斎　²松本　³竹原信繁　⁴北升　⁵春朝斎

Shundō¹ (fl. 1780–92). **N.:** Katsukawa Shundō.² **Gō:** Rantokusai.³ **Biog.:** Ukiyo-e painter, printmaker. Life unknown save that he was first a pupil of Miyagawa Shunsui, whose surname he used for a while, and then of Katsukawa Shunshō, from whom he took the surname of Katsukawa. Made actor prints in *hoso-e* format. Many book illustrations; prints rare. A good painter of considerable talent. (There was also a later Shundō who studied under Katsukawa Shun'ei but about whom nothing is known.) **Coll.:** British, Musées; Tōkyō (1), Victoria. **Bib.:** Binyon (1); Kikuchi; Morrison 2; NHBZ 3; Tajima (7) 2.

¹春童（春道）　²勝川春童（勝川春道）　³蘭徳斎

Shun'ei¹ (1762–1819). **N.:** Katsukawa (originally Isoda)² Kyūjirō.³ **F.N.:** Kyūjirō.⁴ **Gō:** Kyūtokusai,⁵ Shun'ei.⁶ **Biog.:** Ukiyo-e painter, printmaker. A man of diverse interests: a

musician, a devotee of the theater, a painter of witty sketches and caricatures. Lived in Edo. Brilliant pupil of Katsukawa Shunshō, whose surname he adopted. Specialized in actor prints and scenes from plays, giving an individual and at times biting characterization to his portraits. May have started the fashion for *ōkubi-e* of actors, though many critics credit Shunkō with this innovation. At his best from 1791 to 1795, influencing both Sharaku and Toyokuni. Regarded as almost the equal of his master, but his work is more versatile and has a wider range. Also illustrated books, including the seven volumes of *Shibai Kimmō Zui* (an encyclopedia of the theater). By 1800 one of most prominent ukiyo-e figures and leader of the Katsukawa school. His work characterized by strong macabre designs, somber color schemes. **Coll.:** Allen; Art (1); Atami; British; Brooklyn; Cincinnati; Cleveland; Detroit; Fine (California); Fogg; Freer; Grunwald; Honolulu; Metropolitan; Minneapolis; Musée (1), (2); Musées; Museum (1), (3); Nelson; Östasiatiska; Portland; Rhode Island; Riccar; Rietberg; Staatliche; Tōkyō (1); University (2); Victoria; Worcester; Yale. **Bib.:** Binyon (1), (3); Boller; Ficke; Fujikake (3) 2; GNB 17; Hempel; Hillier (1), (7), (9); Kikuchi; *Kunst;* Lane; Ledoux (5); Meissner; Michener (1), (3); Morrison 2; Narazaki (2); NBZ 5; NHBZ 3; Paine (4); SBZ 10; Schmidt; Shibui (1); Shimada 3; Stern (2), (4); Tajima (7) 2; Takahashi (2), (5); UG 3; *Ukiyo-e* (3) 13.

¹春英　²磯田　³勝川久次郎
⁴久次郎　⁵九徳斎　⁶春英

Shun'ei¹ (fl. late 18th to early 19th c.). **N.:** Tani Shun.² **A.:** Shōka.³ **Gō:** Shūkō,⁴ Shun'ei.⁵ **Biog.:** *Nanga* painter. Lived in Edo. Sister of Tani Bunchō. A good landscape and *kachōga* painter. **Coll.:** Worcester. **Bib.:** K 644, Mitchell.

¹舜英（舜瑛）　²谷舜　³小香　⁴秋香　⁵舜英（舜瑛）

Shun'en¹ (fl. 1780–1800). **N.:** Katsukawa Shun'en.² **Biog.:** Ukiyo-e printmaker. A little-known artist. Pupil of Katsukawa Shunshō. His actor prints, generally *hosoban*, are close to the work of Shunkō and Shun'ei. **Coll.:** Victoria. **Bib.:** Fujikake (3) 2, *Kunst.*

¹春艶　²勝川春艶

Shunga¹ (fl. 1201–32). *Priest name:* Shunga.² **Biog.:** Painter. Probably a member of the Takuma school. Closely connected with the Jingo-ji, Kyōto. Known to have been active in the painting of Buddhist images after Chinese models from 1201 to 1232 for the Kōzan-ji, Kyōto, at Priest Myōe's request. The paintings portraying the Sixteen Rakan, which he copied from T'ang models, were in the Kōzan-ji until the Muromachi period. **Coll.:** Jingo-ji. **Bib.:** BI 8, K 818, NBT 4, NEZ 7, Tanaka (2).

¹俊賀　²俊賀

Shungaku¹ (1766–1811). **N.:** Kanae Genshin.² **A.:** Sehō.³ **F.N.:** Taroemon.⁴ **Gō:** Shungaku.⁵ **Biog.:** *Nanga* painter. Born and worked in Ōsaka. Pupil of Fukuhara Gogaku. Later taught himself further by copying his master's works. Admired by Chikuden. **Coll.:** Ashmolean. **Bib.:** Mitchell.

¹春岳　²鼎元新　³世宝　⁴太郎右衛門　⁵春岳

Shungyō¹ (fl. late 18th to early 19th c.). **N.:** Katsukawa Shungyō.² **Gō:** Kakusensai.³ **Biog.:** Ukiyo-e painter, printmaker. Nothing known of his life. His style enough like that of Katsukawa Shunshō to warrant the supposition that he studied under this master; also signed some of his work Katsukawa Shungyō. Known for a few excellent paintings and fewer book illustrations. **Coll.:** Fitzwilliam, Freer, Tōkyō (1). **Bib.:** Tajima (7) 2.

¹春暁　²勝川春暁　³鶴遷斎

Shungyōsai¹ (1760?–1823). **N.:** Hayami Tsuneaki.² **F.N.:** Hikosaburō.³ **Gō:** Shungyōsai.⁴ **Biog.:** Ukiyo-e painter, illustrator. Born in Ōsaka. A noted book illustrator, producing illustrations of Japanese festivals and folk tales as well as pictures of the fashions and customs of Kyōto. Among his books are *Nenjū Gyōji Taisei, Hakone Reigen Ki,*

Miyako Fūzoku Keshōden. A follower of the style of Gyoku-zan. **Coll.:** Worcester. **Bib.:** Brown, Keyes.

¹春暁斎 ²速水恒章 ³彦三郎 ⁴春暁斎

Shunjō¹ (?–1787). *N.:* Katsukawa (originally Yasuda)² Iwazō.³ *Gō:* Shunjō.⁴ **Biog.:** Ukiyo-e printmaker, illustrator. Pupil of Katsukawa Shunshō, from whom he took the name Katsukawa. First illustrated *kibyōshi;* about 1784–5 produced actor prints. His grave site is the same as that of Shun'ei, which has given rise to the theory that he may have been a relative of Shun'ei. **Coll.:** Allen, British, Fitzwilliam, Honolulu, Metropolitan, Nelson, Newark, Portland, Riccar, Staatliche, Tōkyō (1). **Bib.:** Binyon (1), (3); Fujikake (3) 2; Kikuchi; Lane; NHBZ 3; *Nikuhitsu* (2); Schmidt.

¹春常 ²安田 ³勝川岩蔵 ⁴春常

Shunkaku¹ (fl. 1789–1801). *N.:* Katsukawa Shunkaku.² **Biog.:** Ukiyo-e painter, printmaker. Pupil of Katsukawa Shunshō. Specialized in paintings and prints of actors.

¹春鶴 ²勝川春鶴

Shunkei¹ (fl. c. 1375). **Biog.:** Sculptor. Also a priest. Member of the Tsubai Bussho. Known as an assistant in the carving of a figure of Kōbō Daishi dated 1375 in the Hōryū-ji and as the sculptor of a Fudō with two attendants, also for the Hōryū-ji, dated 1380. **Coll.:** Hōryū-ji. **Bib.:** Muromachi (2).

¹舜慶

Shunkei¹ (fl. late 14th c.). **Biog.:** Lacquerer. Lived in Sakai. Is said to have invented the transparent lacquer technique known as Shunkei-nuri. **Bib.:** Herberts, Jahss.

¹春慶

Shunkei¹ (?–1499). **Biog.:** Sculptor. Well-known Muromachi artist, received rank of *hokkyō,* later of *hōgen.* The statue of Monju riding a lion dated 1459 and in the Hōryū-ji is by him. **Coll.:** Hōryū-ji. **Bib.:** NBZ 3.

¹春慶

Shunkei¹ (fl. early 16th c.). **Biog.:** Sculptor. Known for a Jūichimen Kannon in the Jimyō-ji, Nara. **Coll.:** Jimyō-ji. **Bib.:** Muromachi (2).

¹舜慶

Shunkei (Harutsugu)¹ (1703–70). *N.:* Shunshō (originally Yamamoto)² Shunkei (Harutsugu).³ *Gō:* Chōzen,⁴ Sekizan.⁵ **Biog.:** Lacquerer. Son of Shunshō Seikō; became Shunshō IV. Worked in Kyōto, continuing the family tradition of fine lacquerwares. **Bib.:** Herberts, Jahss.

¹春継 ²山本 ³春正春継 ⁴澄善 ⁵積山

Shunkei¹ (fl. 1800–1820). *N.:* Mori Yūkō.² *A.:* Chūkō.³ *Gō:* Shunkei.⁴ **Biog.:** Japanese-style painter. Lived in Ōsaka. Pupil of Mori Sosen; like his master, known for his paintings of animals. Also produced albums of *kachōga.* **Coll.:** Dayton, Staatliche, Victoria. **Bib.:** *Kunst,* Mitchell, Schmidt.

¹春渓 ²森有煌 ³仲光 ⁴春渓

Shunkei¹ (fl. c. 1840). *Gō:* Baikōsai,² Shunkei.³ **Biog.:** Ukiyo-e printmaker. An Ōsaka artist, specializing in actor prints. **Coll.:** Musées, Victoria.

¹春敬 ²梅好斎 ³春敬

Shunkin¹ (1779–1846). *N.:* Uragami Sen.² *A.:* Hakukyo,³ Jissen.⁴ *F.N.:* Kiichirō.⁵ *Gō:* Bunkyōtei,⁶ Nikei,⁷ Shunkin,⁸ Suian.⁹ **Biog.:** *Nanga* painter. Born in Bizen; worked in Kyōto. Eldest son and pupil of Uragami Gyokudō; also studied Chinese Ming and Yüan paintings. Joined conservative *bunjin* group of Rai San'yō. Sometimes collaborated with Yamamoto Baiitsu. His paintings are quite elaborate. His style is more lyrical and gentle than that of his father and shows at times some influence of the naturalism of the Maruyama school as well as of the Nagasaki *kachōga* painters. **Coll.:** Art (1a), British, Musées, University (2). **Bib.:** BK 38; GNB 18; *Japanese* (1a); *Japanische* (2); K 376, 408, 479, 932; Mitchell; Morrison 2; Murayama (2); NB (S) 4; Rosenfield (2); Tajima (12) 19, (13) 7.

¹春琴 ²浦上選 ³伯挙 ⁴十千 ⁵喜一郎 ⁶文鏡亭 ⁷二卿 ⁸春琴 ⁹睡庵

Shunkō¹ (1743–1812). *N.:* Katsukawa (originally Kiyokawa)²

Shunkō.³ *F.N.:* Denjirō.⁴ *Gō:* Sahitsuan,⁵ Sahitsusai.⁶ **Biog.:** Ukiyo-e painter, printmaker. Lived in Edo. Pupil of Katsukawa Shunshō; like him, used a jar-shaped seal; hence known as Kotsubo (Little Jar).⁷ Continued the Katsukawa tradition, becoming a leader of the school. Noted for his actor prints, generally *hosoban.* Is also thought to have originated the *ōkubi-e* in the latter part of his career. After a mild stroke at 45, worked with his left hand, using the *gō* Sahitsusai (Studio of the Left Brush). Eventually entered the priesthood. Style close to that of his master in both manner and quality. **Coll.:** Albertina, Allen, Ashmolean, Atami, British, Brooklyn, Cincinnati, City, Fine (California), Fitzwilliam, Freer, Grunwald, Honolulu, Metropolitan, Minneapolis, Musée (2), Nelson, Newark, Östasiatiska, Portland, Rhode Island, Riccar, Rietberg, Staatliche, Stanford, Suntory, Tōkyō (1), Victoria, Worcester, Yale. **Bib.:** Binyon (1), (3); Boller; Crighton; Fujikake (3) 2; GNB 17; Hillier (1), (2), (3), (4) 1, (7); Kikuchi; *Kunst;* Lane; Ledoux (1); Meissner; Michener (3); Morrison 2; Narazaki (2); NBZ 5; NHBZ 3; OA 13; Schmidt; Shibui (1); Shimada 3; Stern (2), (4); Tajima (7) 2; Takahashi (5); *Ukiyo-e* (3) 13.

¹春好 ²清川 ³勝川春好 ⁴伝次郎 ⁵左筆庵 ⁶左筆斎 ⁷小壺

Shunkoku¹ (1811–70). *N.:* Kawakita Fusatora.² *Gō:* Shunkoku.³ **Biog.:** Painter. Born in Kyōto. Good at landscape and *kachōga.* **Bib.:** Mitchell.

¹春谷 ²河北房虎 ³春谷

Shunkyō¹ (fl. early 19th c.). *N.:* Hishikawa (originally Katsukawa)² Ryūkoku.³ *Gō:* Shunkyō.⁴ **Biog.:** Ukiyo-e printmaker, illustrator. Pupil of Katsukawa Shunshō and, perhaps, of Katsukawa Shuntei. Specialized in illustrations for storybooks. **Coll.:** Fitzwilliam, Musées, Victoria.

¹春喬 ²勝川 ³菱川柳谷 ⁴春喬

Shunkyo¹ (fl. early 19th c.). *N.:* Matsuura Kanando.² *Gō:* Shunkyo.³ **Biog.:** Maruyama painter. Born in Tokushima-ken. Pupil of Maruyama Ōkyo. **Bib.:** Morrison 2.

¹舜挙 ²松浦要人 ³舜挙

Shunkyoku¹ (fl. 1772–1800). *N.:* Katsukawa Shunkyoku.² **Biog.:** Ukiyo-e printmaker. Pupil of Katsukawa Shunshō. Specialized in actor prints and program illustrations as well as *kibyōshi.* **Coll.:** Musées. **Bib.:** NHBZ 3.

¹春旭 ²勝川春旭

Shun'ō¹ (fl. c. 1840). *N.:* Gondai Morisada.² *A.:* Shimpō (Shinpō).³ *F.N.:* Tamenoshin.⁴ *Gō:* Shun'ō.⁵ **Biog.:** Painter. Worked in Edo. **Bib.:** Mitchell.

¹春鷗 ²権代盛貞 ³晋風 ⁴為之進 ⁵春鷗

Shun'oku¹ (1529–1611). *Priest name:* Sōen.² *Gō:* Shun'oku.³ **Biog.:** *Zenga* painter. Priest of the Rinzai sect; became 111th abbot of Daitoku-ji, Kyōto. Served as teacher of Zen practice to the great tea masters Kobori Enshū and Furuta Oribe and to the courtier and aesthete Mitsuhiro. His paintings all of Zen subjects; his calligraphy highly valued by his contemporaries. **Bib.:** Awakawa, Fontein (2).

¹春屋 ²宗園 ³春屋

Shunrei¹ (fl. late 19th c.). *N.:* Ōtsuka.² *Gō:* Shunrei.³ **Biog.:** Japanese-style painter. Lived and worked in Ōsaka in the early Meiji era. A painter in the ukiyo-e tradition, to which he added some Western influence. **Coll.:** Ōsaka (2).

¹春嶺 ²大塚 ³春嶺

Shunri¹ (fl. late 18th c.). *N.:* Katsukawa Shunri.² **Biog.:** Ukiyo-e printmaker. Pupil of Katsukawa Shunshō. Designed *hosoban* actor prints. **Coll.:** Tōkyō (1).

¹春里 ²勝川春里

Shunrin¹ (fl. 1784–1800). *N.:* Katsukawa Shunrin.² **Biog.:** Ukiyo-e printmaker. Pupil of Katsukawa Shunshō. Specialized in *bijinga.* Also worked as an illustrator. **Coll.:** Museum (3). **Bib.:** Shimada 3.

¹春林 ²勝川春林

Shunsa¹ (1818–58). *N.:* Tachihara Kuri² (or Haruko).³ *A.:*

Sasa,[4] Shunsa.[5] **Biog.:** *Nanga* painter. Daughter and pupil of Kyōsho. When about 14, studied under Watanabe Kazan. In 1839 entered the service of Lady Maeda at Kaga and remained there until her death. **Bib.:** K 588.

¹春沙 ²立原栗（久里） ³春子 ⁴沙々 ⁵沙沙
Shunsai[1] (fl. c. 1840). *N.:* Kurihara Jun'ei.[2] *A.:* Shukka.[3] *F.N.:* Heizō.[4] *Gō:* Hōzan,[5] Shunsai.[6] **Biog.:** *Nanga* painter. Lived in Edo. Pupil of Tani Bunchō. **Bib.:** Mitchell.

¹春斎 ²栗原順英 ³叔華 ⁴平蔵 ⁵芳山 ⁶春斎
Shunsen[1] (1719–73). *N.:* Ōoka Sukemasa.[2] *F.N.:* Tange.[3] *Gō:* Shunsen.[4] **Biog.:** Painter, illustrator. Adopted son and pupil of Ōoka Shumboku. Illustrated several picture books. Received title of *hōgen.* **Bib.:** Brown.

¹春川（春泉） ²大岡甫政 ³丹下 ⁴春川（春泉）
Shunsen[1] (1762–c. 1830). *N.:* Katsukawa Seijirō.[2] *Gō:* Kashōsai,[3] Shunrin,[4] Shunsen;[5] later, Shunkō II,[6] Tōryūsai.[7] **Biog.:** Ukiyo-e printmaker, illustrator. Studied first under Tsutsumi Tōrin III and used *gō* of Shunrin; then under Katsukawa Shun'ei, from whom he took the name Katsukawa; in 1806 began to use *gō* of Shunsen. Particularly noted for his book illustrations, but also produced prints of *bijin,* genre scenes, and landscapes. About 1823 gave up printmaking and turned to the decoration of porcelain, calling himself Shunkō II. A minor artist. **Note:** The lack of *kanji* in certain of the references to this artist can lead to his being confused with the other Katsukawa Shunsen[8] (q.v.). **Coll.:** Ashmolean; British; Cincinnati; Fine (California); Herron; Honolulu; Musée (1), (2); Musées; Museum (3); Nelson; Newark; Portland; Rhode Island; Riccar; Staatliche; Tōkyō (1); University (2); Victoria; Worcester; Yale. **Bib.:** Binyon (1), (3); Brown; Crighton; Kikuchi; Morrison 2; NHBZ 3; *Nikuhitsu* (2); Schmidt; Shimada 3; Takahashi (2); Tamba (2a).

¹春扇 ²勝川清次郎 ³可笑斎 ⁴春琳 ⁵春扇
⁶春好（二代） ⁷登龍斎 ⁸勝川春泉
Shunsen[1] (fl. c. 1790). *N.:* Katsukawa Shunsen.[2] **Biog.:** Ukiyo-e printmaker. Pupil of Katsukawa Shunshō. Made *hosoban* actor prints. **Note:** The lack of *kanji* in certain of the references to this artist can lead to his being confused with the other Katsukawa Shunsen[3] (q.v.). **Coll.:** Fitzwilliam, Tōkyō (1). **Bib.:** Binyon (3), Fujikake (3) 2.

¹春泉 ²勝川春泉 ³勝川春扇
Shunsen[1] (1800–1816). *N.:* Kanō Akinobu.[2] *Gō:* Riunsai,[3] Shunsen.[4] **Biog.:** Kanō painter. Son and pupil of Kanō Yūsen Hiranobu, fifth generation of the Hamachō Kanō line; older brother of Kanō Yūsen Sukenobu. So far, no works by him have been identified.

¹舜川 ²狩野昭信 ³梨雲斎 ⁴舜川
Shunsetsu[1] (1614–91). *N.:* Kanō Nobuyuki.[2] *F.N.:* Hayato.[3] *Gō:* Shunsetsu.[4] **Biog.:** Kanō painter. Son and pupil of Kanō Hidenobu. Carried on the tradition of the Yamashita branch of the Kanō family. **Coll.:** Museum (3).

¹春雪 ²狩野信之 ³隼人 ⁴春雪
Shunshi (Harushiba)[1] (fl. early 19th c.). *Gō:* Gatōken,[2] Shunshi (Harushiba),[3] Tōryūsai.[4] **Biog.:** Ukiyo-e printmaker. Pupil of Hokushū. Worked in Ōsaka in the late ukiyo-e manner. An artist of minor importance, making actor prints. **Coll.:** Musée (2), Musées, Victoria. **Bib.:** Fujikake (3) 3, Keyes, NHBZ 3, Strange (2).

¹春芝 ²画登軒 ³春芝 ⁴登龍斎
Shunshō[1] (fl. 17th to 19th c.). One of the most important schools of lacquer artists. Their *togidashi* work noted for its refinement and delicacy of coloring and its perfection of craftsmanship and finish. Early members of the school rarely signed their works, or used only the family name or seal, making it almost impossible to distinguish individual artists. The later ones began to use ukiyo-e subjects for their designs, producing striking but gaudy pieces. For the following members, see individual entries under first *gō* listed for each.

Shunshō I: Shunshō (Harumasa),[2] Shūboku[3] (1610–82)
Shunshō II: Keishō (Kagemasa)[4] (?–1707)
Shunshō III: Seikō (Masayuki),[5] Jōshō[6] (1654–1740)
Shunshō IV: Shunkei (Harutsugu),[7] Sekizan,[8] Chōzen[9] (1703–70)
Shunshō V: Seirei (Masayoshi),[10] Jirobei[11] (1734–1803)
Shunshō VI: Seishi (Masayuki),[12] Keidō[13] (1774–1831)
Shunshō VII: Seitoku (Masanori),[14] Bokusai,[15] Seiichian[16] (?–1871)
Shunshō VIII: Seishū (Shōshū, Masachika)[17] (1819–77/80)
Shunshō IX: Seishō (Shōshō, Masaaki)[18] (?–1878)
Shunshō X: Seiken (Masakane, Shōken)[19] (fl. 19th c.)
Bib.: Casal, Feddersen, Herberts, Jahss, Kümmel, M 188, Ragué, Sawaguchi, Speiser (2), Yoshino.

¹春正 ²春正 ³舟木 ⁴景正 ⁵政幸 ⁶常照
⁷春継 ⁸積山 ⁹澄善 ¹⁰正令 ¹¹次郎兵衛
¹²兵之 ¹³敬道 ¹⁴正徳 ¹⁵卜斎 ¹⁶静一庵
¹⁷正周 ¹⁸正章 ¹⁹正兼
Shunshō[1] (1610–82). *N.:* Yamamoto Harumasa.[2] *Gō:* Shūboku,[3] Shunshō.[4] **Biog.:** Lacquerer. Having first studied poetry and Chinese literature, turned to making lacquer. Worked in Kyōto. Brought the technique of *togidashi,* which had been subordinated to *hiramakie* and *takamakie,* to a high level. Usually worked on a red ground. A talented artist, followed by a long line of lacquerers, all bearing the name of Shunshō, of which the first four are the most important. **Coll.:** Metropolitan, Museum (2), Tōkyō (1). **Bib.:** Feddersen, Herberts, Jahss, Kümmel, M 188, Ragué, Sawaguchi, Speiser (2), Yoshino.

¹春正 ²山本春正 ³舟木 ⁴春正
Shunshō[1] (1646–1715). *N.:* Kanō Sukenobu.[2] *F.N.:* Motome.[3] *Gō:* Shunshō.[4] **Biog.:** Kanō painter. Second son and pupil of Kanō Shunsetsu. Continued the tradition of the Yamashita branch of the Kanō school.

¹春笑 ²狩野亮佐 ³求馬 ⁴春笑
Shunshō[1] (1726–92). *N.:* Katsukawa (originally Miyagawa)[2] Shunshō.[3] *F.N.:* Yūsuke.[4] *Gō:* Jūgasei,[5] Kyokurōsai,[6] Kyokurōsei,[7] Ririn,[8] Rokurokuan,[9] Shuntei,[10] Yūji.[11] **Biog.:** Ukiyo-e painter, printmaker. Lived in Edo. First studied under the painters Katsukawa Shunsui and Kō Sūkoku; then turned to prints. Little known about his personal life; taught many pupils, including Shunchō, Shundō, Shun'ei, Shunjō, Shunkō, Shunzan, Hokusai (all these artists with "Shun" in their names—Hokusai changed his later—are usually grouped as the Katsukawa school). He used a seal on which the name Hayashi appears as inscribed on the side of a jar (*tsubo*); hence called Tsubo.[12] A considerable number of his paintings are extant, usually of genre scenes peopled with *bijin.* Abandoning the tradition of a school that had kept entirely to painting, began to design color prints and became one of the great ukiyo-e print designers. At first much influenced by Harunobu, but his great contribution came with his prints of actors (which are among the finest of his day) and, occasionally, of wrestlers. Done as *hosoban,* the actors were represented both on the stage in their leading roles and in their dressing rooms, with individual features given to each actor. In 1776, with Kitao Shigemasa, illustrated the famous book *Seirō Bijin Awase Sugata Kagami* (Mirror of Beautiful Women of the Green Houses). A prolific and popular artist, one of the most important of his period, he dominated the actor-print field in his time. Level of his work very high—though there are some monotonous and uninspired prints—with subtle overall designs and striking color combinations. A painter of power and delicacy. **Coll.:** Albertina; Allen; Andrew; Art (1); Ashmolean; Atami; Baltimore; British; Brooklyn; Cincinnati; City; Cleveland; Denver; Fine (California); Fitzwilliam; Freer; Grunwald; Herron; Honolulu; Idemitsu; Kōbe; Los Angeles; Metropolitan; Musée (1), (2); Musées; Museum (1), (3); Nelson; Newark; Östasiatiska;

Österreichisches; Portland; Rhode Island; Riccar; Rietberg; Staatliche; Stanford; Tōkyō (1), (2); University (2); Victoria; Waseda; Worcester; Yale. **Bib.:** Binyon (1), (3); Blunt; Boller; Brown; Crighton; Ficke; Fujikake (3) 2; Gentles (2); GNB 17, 24; Hempel; Hillier (1), (3), (4) 1, (7), (9); *Images;* K 19, 24, 51, 87, 170, 231, 281, 530, 531, 664; Kikuchi; KO 34; *Kunst;* Lane; Ledoux (2); Meissner; Michener (1), (3); Morrison 2; Narazaki (2); NB (S) 68; NBT 5; NBZ 5; NHBZ 3; *Nikuhitsu* (1) 2, (2); Noma (1) 2; *One* (2); Paine (4); *Pictorial* (2) 4; Rosenfield (2); SBZ 10; Schmidt; Shibui (1); Shimada 3; Stern (2), (4); Succo (1); Tajima (7) 2, (13) 6; Takahashi (2), (5), (6) 6; Tamba (2a); UG 28; *Ukiyo-e* (2) 3; *Ukiyo-e* (3) 8, 9; Vignier 2; Waterhouse.

¹春章 ²宮川 ³勝川春章 ⁴祐助（勇助）
⁵縦画生 ⁶旭朗斎 ⁷旭朗井 ⁸李林
⁹六々庵 ¹⁰春亭 ¹¹酉爾 ¹²壺

Shunshō II[1] (1730–97). *N.:* Kanō Norinobu.[2] *Gō:* Shunshō.[3] **Biog.:** Kanō painter. Son and pupil of Kanō Shunsui, whom he succeeded in the Yamashita Kanō line in 1756.

¹春笑二代 ²狩野宣信 ³春笑

Shunshō III[1] (1755–1819). *N.:* Kanō Tomonobu.[2] *Gō:* Shunshō,[3] Shuntei.[4] **Biog.:** Kanō painter. Son and pupil of Kanō Shunshō II. Succeeded to the Yamashita line of the Kanō school in 1787, at which time he changed his *gō* from Shuntei to Shunshō.

¹春笑三代 ²狩野與信 ³春笑 ⁴春貞

Shunshō[1] (fl. c. 1830–54). *N.:* Utagawa Shunshō.[2] *Gō:* Hōrai,[3] Kochōen,[4] Matsuo Shunshō.[5] **Biog.:** Ukiyo-e printmaker. Specialized in prints of *bijin.* **Coll.:** Musées, Victoria. **Bib.:** Strange (2).

¹春升 ²歌川春升 ³蓬来 ⁴胡蝶園 ⁵松尾春升

Shunsō[1] (1750–1835). *Priest name:* Shōshu.[2] *Gō:* Shunsō.[3] **Biog.:** *Zenga* painter. Priest of the Rinzai sect. Native of Bungo Province. Became a religious student at 16; later studied under various Zen masters, including Reigen and Suiō, former pupils of Hakuin. Entered on his priestly duties at the Jikō-ji, Awa Province. An active if not very skillful or original painter; his work is thought to show Suiō's influence. **Bib.:** Awakawa, NB (S) 47.

¹春叢 ²紹珠 ³春叢

Shunsui[1] (1682–1756). *N.:* Kanō Meishin.[2] *F.N.:* Kennojō,[3] Motome.[4] *Gō:* Gembokusai,[5] Shunsui.[6] **Biog.:** Kanō painter. Son and pupil of Kanō Shunshō, whom he succeeded as head of the Yamashita Kanō line.

¹春水 ²狩野命信 ³兼之丞 ⁴求馬 ⁵元牧斎 ⁶春水

Shunsui[1] (fl. 1744–64). *N.:* Katsukawa (originally Miyagawa)[2] Shunsui.[3] *F.N.:* Tōshirō.[4] **Biog.:** Ukiyo-e painter, printmaker. Pupil of Miyagawa Chōshun, who may have been his father. (Is said to have changed his name to Katsukawa when Chōshun was disgraced and exiled.) Teacher of Katsukawa Shunshō. Like most of Chōshun's followers, a painter rather than a printmaker (only a few prints by him are known) but may have been the first of the family to design prints. An average genre painter, important because of his link between the Miyagawa and Katsukawa groups. **Coll.:** Freer, Museum (3), Staatliche, Tōkyō (1), Victoria. **Bib.:** Fujikake (3) 2; Hillier (3), (4) 1; *Japanese* (2); K 129; Morrison 2; *Nikuhitsu* (2); Schmidt; Shimada 3; Stern (4); Tajima (7) 2; UG 28; *Ukiyo-e* (3) 3.

¹春水 ²宮川 ³勝川春水 ⁴藤四郎

Shuntai[1] (1799–1878). *N.:* Katō Sōshirō.[2] *Gō:* Shuntai.[3] **Biog.:** Potter. Son of Katō Shunzan. The last of the Katō line of potters and the best of those with the character *shun* in their names. Worked as a young man at the Ofuke kiln near Nagoya Castle; in 1851 was dismissed and opened a kiln at Imao; in 1855 was pardoned and returned to Nagoya. Imitated Seto, Takatori, Oribe, Shino, Korean, Karatsu, and Tamba wares as well as making Ofuke ware. **Coll.:**

Allen, Freer, Metropolitan, Östasiatiska, Tōkyō (1). **Bib.:** FC 18, Fujioka, Fukui, Jenyns (2), *Nihon* (8), STZ 6.

¹春岱 ²加藤宗四郎 ³春岱

Shuntan[1] (?–1807). *N.:* Katō Magoemon.[2] *Gō:* Shunfuku.[3] Shuntan.[4] **Biog.:** Seto potter. Born in Owari Province. Third son of the nineteenth-generation Katō; was adopted by Katō Shuntei (the twenty-first generation) and became head of the twenty-second generation. Worked in the family tradition. **Coll.:** Ashmolean, Tōkyō (1). **Bib.:** *Nihon* (8), STZ 5.

¹春丹 ²加藤孫右衛門 ³春福 ⁴春丹

Shuntan[1] (fl. c. 1820). *N.:* Morisaki.[2] *F.N.:* Seikurō.[3] *Gō:* Shuntan.[4] **Biog.:** Painter. Born in Awa Province. Studied works of Ōoka Shunsen. **Coll.:** Ashmolean.

¹春旦 ²森崎 ³清九郎 ⁴春旦

Shuntei[1] (1770–1820). *N.:* Katsukawa Shuntei[2] (originally Yamaguchi Chōjūrō).[3] *Gō:* Gibokuan,[4] Shōkōsai,[5] Shōkyūko,[6] Suihō Itsujin.[7] **Biog.:** Ukiyo-e printmaker. Pupil of Katsukawa Shun'ei. Produced book illustrations, *surimono,* and other types of prints. His subject matter included actors, *bijin,* battle scenes, warriors, and landscapes; the last show strong Western influence, those of actors and *bijin* the influence of his master. **Coll.:** Allen, Ashmolean, British, Fine (California), Fitzwilliam, Honolulu, Kōbe, Metropolitan, Musées, Newark, Portland, Rhode Island, Riccar, Staatliche, Tōkyō (1), Victoria, Worcester. **Bib.:** Binyon (1), (3); Ficke; Kikuchi; Lane; *Kunst;* Meissner; *Nikuhitsu* (2); *Pictorial* (2) 4; Tamba (2a).

¹春亭 ²勝川春亭 ³山口長十郎 ⁴戯墨庵
⁵松高斎 ⁶勝汲壺 ⁷酔放逸人

Shuntoku[1] (fl. 1818–30). *N.:* Katsukawa Sentarō.[2] *Gō:* Shuntoku.[3] **Biog.:** Ukiyo-e printmaker. One of Katsukawa Shun'ei's pupils. Specialized in warrior subjects. **Coll.:** Tōkyō (1). **Bib.:** Kikuchi, Morrison 2.

¹春徳 ²勝川千太郎 ³春徳

Shuntōsai[1] (fl. late 18th c.). *N.:* Okada.[2] *Gō:* Shuntōsai.[3] **Biog.:** *Yōga* printmaker. His copperplate engravings of Nagasaki and its foreigners are in a style imitating Western prints. **Bib.:** NHBZ 3.

¹春燈斎 ²岡田 ³春燈斎

Shun'yō[1] (fl. c. 1818–30). *N.:* Katsukawa Shun'yō.[2] **Biog.:** Ukiyo-e printmaker. Pupil of Katsukawa Shun'ei. **Coll.:** Museum (3), Victoria. **Bib.:** Strange (2).

¹春陽 ²勝川春陽

Shunzan[1] (fl. c. 1782–98). *N.:* Katsukawa Shunzan.[2] *Gō:* Izumi Shōyū,[3] Shōyū.[4] **Biog.:** Ukiyo-e printmaker. Life obscure. The *gō* of Izumi Shōyū and Shōyū were used only about 1787. First a pupil of Katsukawa Shunshō, producing actor prints and historical scenes in the Katsukawa manner. Later, under the influence of Torii Kiyonaga, made *bijinga* in the style of Kiyonaga. **Coll.:** Albertina, Allen, Andrew, British, Brooklyn, Cleveland, Fitzwilliam, Fogg, Honolulu, Minneapolis, Musée (2), Musées, Nelson, Portland, Rhode Island, Riccar, Rietberg, Östasiatiska, Staatliche, Tōkyō (1), Victoria, Worcester. **Bib.:** Binyon (1), (3); Ficke; Hillier (7); Kikuchi; Morrison 2; NHBZ 3; *Nikuhitsu* (2); Schmidt; Tajima (7) 2; Tamba (2a); UG 20, 28.

¹春山 ²勝川春山 ³泉昌有 ⁴昌有

Shunzan[1] (fl. early 19th c.). *N.:* Katō Shunzan.[2] **Biog.:** Potter. One of the many members of the Katō school of potters who have the character *shun* in their names and who are generally indistinguishable from each other. Was the father of the better-known Katō Shuntai. **Coll.:** Metropolitan. **Bib.:** Jenyns (2).

¹春山 ²加藤春山

Shunzō[1] (fl. late 19th c.). *N.:* Fujikawa Shunzō.[2] **Biog.:** Lacquerer. Worked in Takamatsu. Younger brother of Fujikawa Zōkoku. **Bib.:** Jahss, Ragué.

¹舜造 ²藤川舜造

Shūran[1] (1797–1866). *N.:* Yoshida Shūran.[2] **Biog.:** *Nanga*

painter. She was born in Kyōto. Pupil of Rai San'yō in calligraphy and of Nakabayashi Chikutō in painting. Skillful painter of landscapes, plum blossoms, and bamboo. **Coll.:** Museum (3). **Bib.:** Mitchell.

¹袖蘭 ²吉田袖蘭

Shurei¹ (1751–90). *N.:* Yamamoto (originally Kameoka)² Kaneaki.³ *A.:* Shifū,⁴ Shiki.⁵ *Gō:* Shurei,⁶ Yūtei.⁷ **Biog.:** Kanō painter. Adopted son and pupil of Yamamoto Tansen. Also studied under Maruyama Ōkyo, working as his assistant when Ōkyo painted the screens for the Daijō-ji at Kasumi-machi. Good at portraiture and *kachōga*. Some confusion over his dates, since second tradition says he died in 1834. **Coll.:** Victoria.

¹守礼 ²亀岡 ³山本予章 ⁴子風
⁵子敬 ⁶守礼 ⁷猶亭

Shūrin¹ (fl. 16th c.). *Priest name:* Shūrin.² *Gō:* Kogetsu.³ **Biog.:** Muromachi *suiboku* painter. Also a Zen priest. Life unknown. Native of Satsuma Province. Said to have been a pupil of Sesshū and to have studied Shūbun's style. The few paintings of figures and flowers known to be by him certainly owe something to Sesshū, but there are also touches of fresh, light color. **Coll.:** Tokiwayama, Tōkyō (1). **Bib.:** HS 9, *Japanese* (1), K 659, M 166, Matsushita (1a).

¹周林 ²周林 ³弧月

Shūsai¹ (fl. early 18th c.). *N.:* Ariiso Shūsai.² **Biog.:** Lacquerer. His development of the *hontsuishu* and Zonsei techniques—or refinements on *makie* and Kamakura-bori wares—was a great contribution to the development of *makie*. **Bib.:** Sawaguchi.

¹周斎 ²有磯周斎

Shūsai¹ (?–1761). *N.:* Watanabe Shūsai.² *A.:* Genso.³ *F.N.:* Tanji.⁴ *Gō:* Bunsai.⁵ **Biog.:** Nagasaki painter. Born in Nagasaki. Son and pupil of Watanabe Shūkei. Inherited the family position of *kara-e mekiki* for the *bakufu*.

¹秀彩 ¹渡辺秀彩 ³元素 ⁴丹治 (丹次) ⁵文斎

Shūsai¹ (fl. 19th c.). **Biog.:** Ukiyo-e printmaker. A fair artist. **Bib.:** NHBZ 6.

¹秋斎

Shūsei (Hidemori)¹ (?–1459). **Biog.:** Muromachi *suiboku* painter. Life unknown. Style rather close to that of Sesson, with whom he is sometimes confused, but he was probably a different, and somewhat inferior, artist. Sometimes called Hidemori, though it would have been most unlikely for a Muromachi painter to use this reading of the characters for his name. **Coll.:** Tokiwayama. **Bib.:** BG 69, HO 79, *Japanese* (1), KO 2, Matsushita (1), SBZ 7.

¹秀盛

Shūseki¹ (1639–1707). *N.:* Watanabe Motoaki.² *A.:* Genshō.³ *Gō:* Chikyū,⁴ Enka,⁵ Jinjusai,⁶ Ran Dōjin,⁷ Shūseki,⁸ Yūran Dōjin.⁹ **Biog.:** Nagasaki painter. Lived in Nagasaki. Pupil of Itsunen. Generally painted scenes of the Dutch establishment at Nagasaki; also did flower pictures in the Chinese manner. Served the *bakufu* as *kara-e mekiki*. **Coll.:** Kōbe, Nagasaki. **Bib.:** BK 12, Mody, *Pictorial* (2) 2, 5.

¹秀石 ²渡辺元章 ³元昭 ⁴池丘 ⁵烟霞
⁶仁寿斎 ⁷嫺道人 ⁸秀石 ⁹有嫺道人

Shūsen¹ (fl. c. 1745). *N.:* Kanō Reishin² (or Harunobu).³ *Gō:* Shūsen.⁴ **Biog.:** Kanō painter. Son and pupil of Kanō Sokuyo; member of the Shiba Atagoshita line.

¹舟川 ²狩野令信 ³晴信 ⁴舟川

Shūsen¹ (1736–1824). *N.:* Watanabe (originally Sekishin)² Hideaki.³ *A.:* Genyu.⁴ *F.N.:* Kichijurō;⁵ later, Shōsuke.⁶ *Gō:* Ishōdō,⁷ Jitekisai,⁸ Shūsen.⁹ **Biog.:** Nagasaki painter. Adopted son of Watanabe Shūsai. Pupil of Ishizaki Genshō and Ishizaki Gentoku. In 1761, on Shūsai's death, inherited position of *kara-e mekiki* at Nagasaki. Painted landscapes, birds-and-flowers, figures, tigers.

¹秀詮 ²石津 ³渡辺秀詮 ⁴元喩 ⁵吉十郎
⁶正助 ⁷為章道 ⁸自適斎 ⁹秀詮

Shusetsu¹ (fl. mid-15th c.). **Biog.:** Muromachi *suiboku*

painter. A Zen priest, known as Shusetsu Dōjin,² or Shusetsu the Enlightened One. Studied under Shūbun. A distinguished *suiboku* artist. His known paintings show the influence of both Shūbun and the Ma-Hsia school of Sung China. **Coll.:** Daitoku-ji (Shinju-an), Staatliche. **Bib.:** *Ausgewählte*, HU 1932, Mayuyama, Shimada 1.

¹守拙 ²守拙道人

Shūshō¹ (1821–70). *N.:* Watanabe (originally Tomita)² Seijirō.³ *A.:* Genshi.⁴ *F.N.:* Kiyojirō.⁵ *Gō:* Seishū,⁶ Shūshō.⁷ **Biog.:** Nagasaki painter. Adopted son of Watanabe Kakushū; pupil of Murata Kakusai, who had studied under Kakushū. Painted *kachōga* and pictures of animals.

¹秀彰 ²富田 ³渡辺清次郎 ⁴元史 (元施)
⁵喜代二郎 (喜代次郎) ⁶晴洲 ⁷秀彰

Shūsui¹ (fl. c. 1840). *N.:* Kanō Motonobu.² *Gō:* Shūsui,³ Sōsetsuan.⁴ **Biog.:** Kanō painter. Lived in Edo. A minor member of the Kanō school.

¹秀水 ²狩野求信 ³秀水 ⁴蒼雪庵

Shūsui¹ (1795–1876). *N.:* Murase Yoshi.² *A.:* Seiyū.³ *Gō:* Kankō;⁴ later, Shūsui.⁵ **Biog.:** Japanese-style painter. Born in Minō Province. Studied first with Chō Gesshō, then with Noro Kaiseki. Later to Nagasaki and became a pupil of Hidaka Tetsuō. Author of several books.

¹秋水 ²村瀬微 ³世紀 ⁴韓江 ⁵秋水

Shūtei¹ (fl. c. 1820). **Biog.:** Ukiyo-e printmaker. Worked in Kyōto. Made actor prints, colored with the aid of stencils (*kappa-suri*). **Coll.:** Musées, Victoria.

¹秋亭

Shūtoku¹ (fl. first half of 16th c.). *Gō:* Ikei (Suikei),² Shūtoku.³ **Biog.:** Muromachi *suiboku* painter. Also a Zen priest. There are several other painter-priests, but of little importance, with the name of Shūtoku. The style of the paintings bearing the seal of this artist shows that he belonged to the Ami school and was also influenced by Sesshū. **Coll.:** Metropolitan, Myōshin-ji (Taizō-in). **Bib.:** BK 54, *Chūsei*, HS 7, K 65, Matsushita (1), Tajima (13) 4, Tanaka (2).

¹周徳 ²惟馨 ³周徳

Shūyo¹ (fl. mid-18th c.). *N.:* Kanō Chikanobu.² *Gō:* Shūyo.³ **Biog.:** Kanō painter. Son and pupil of Kanō Shusen; member of the Shiba Atagoshita line of the Kanō school.

¹周誉 ²狩野親信 ³周誉

Shūzan¹ (fl. 1780–90). *N.:* Kumashiro Akira.² *A.:* Hibun.³ *F.N.:* Zeniya Rizaemon.⁴ *Gō:* Shūzan.⁵ **Biog.:** Nagasaki painter. Son and pupil of Kumashiro Yūhi, whose style he followed closely. A fair artist. **Coll.:** Stanford. **Bib.:** Brown, Mody, Morrison 2, NHBZ 6.

¹繡山 ²熊代章 ³斐文 ⁴銭屋利左衛門 ⁵繡山

Sōami¹ (1485?–1525). *N.:* Nakao Shinsō.² *F.N.:* Sōami.³ *Gō:* Kangaku,⁴ Shōsetsusai.⁵ **Biog.:** Muromachi *suiboku* painter. One of the three "Ami" artists: pupil and possibly son of Geiami, grandson of Nōami. Also famous as tea master, poet, art critic, designer of gardens. (The garden of the Ginkaku-ji and that of the Daisen-in at Kyōto were, according to tradition, designed by him—a tradition without contemporary evidence to support it and, in the case of the first, an attribution made three hundred years after the garden was built and, in the second, one hundred years later.) Lived in Kyōto, serving, as did his father and grandfather, the Ashikaga shoguns as adviser and curator for art objects imported from China (*karamono bugyō*). Continued the *Kundaikan Sa-u Chōki*, a catalogue of the shoguns' collection of Chinese paintings, finishing it in 1511. Edited *Okazari Ki*, a book of notes on decoration. Was the arbiter of taste in his time. Most of his pictures are landscapes. In painting, followed the tradition of Mu-ch'i; probably popularized the soft, misty style of ink painting in Japan. **Coll.:** Center, Cleveland, Daitoku-ji (Daisen-in), Freer, Kyōto (2), Metropolitan, Museum (3), Myōshin-ji, Victoria. **Bib.:** AA 6, 14; *Art* (1a); BCM 50; BK 53; GNB 11; Hisamatsu; HS 1, 4; K

2, 20, 64, 85, 135, 159, 169, 199, 249, 723, 799, 886; KO 2, 36; Kuck; Lee (1); Matsushita (1), (1a); Mayuyama; Mina-moto (1); Morrison 1; Murase; NB (S) 13; *One* (2); Paine (4); Shimada 1; Tajima (12) 2, 5, 10; Tanaka (2); Yashiro (1); Yoshimura.

¹相阿弥 ²中尾真相 ³相阿弥 ⁴鑑岳 ⁵松雪斎

Sōchi[1] (fl. c. 1620). *N.*: Kanō Shigenobu² (or Shigetsugu).³ *Gō*: Sōchi.⁴ **Biog.**: Kanō painter. Son and pupil of Kanō Sōya; member of the Kanda Kanō school.

¹宗知 ²狩野重信 ³重次 ⁴宗知

Sōchō[1] (fl. first half 17th c.). *N.*: Seki (no) Sōchō.² *Gō*: Hōsunsai.³ **Biog.**: Lacquerer. Worked in Kyōto. Perhaps the first to use lacquer for his signature; earlier artists either engraved or etched their names in the lacquer. **Bib.**: Her-berts, Jahss.

¹宗長 ²関宗長 ³法寸斎

Sōchō[1] (?–1816?). *N.*: Tatebe (Takebe) Hidechika.² *A.*: Shōho,³ Zokufu.⁴ *Gō*: Kominoan,⁵ Saiō,⁶ Shūkōan,⁷ Sō-chō.⁸ **Biog.**: *Haiga* painter. Lived in Edo. One of the three great *haiku* poets of his time. So well known, and so popular, as a painter that he was already faked during his life. In painting, a pupil of Tani Bunchō. Later his style close to Buson's. Always added his *haiku* to his paintings. Sometimes known as Kantō Buson (Buson of the East). Few works left, as much was destroyed by fire. An amusing, lively artist, but far better known as a poet. **Coll.**: Museum (3), Tōkyō (2). **Bib.**: Brasch (1a), *Japanische* (2), Mitchell.

¹巣兆 ²建部英親 ³松甫 ⁴族父
⁵小簑庵 ⁶菜翁 ⁷秋香庵 ⁸巣兆

Soei[1] (fl. early 16th c.). **Biog.**: Muromachi *suiboku* paint-er. Pupil and follower of Sesson. His paintings of land-scapes and his *kachōga* are in the style of his master. His figure paintings show the influence of Chinese painting. **Bib.**: HS 2, M 166, NB (S) 63.

¹祖栄

Soei[1] (fl. early 16th c.?). **Biog.**: Muromachi *suiboku* painter. Details of life unknown. May be same artist as the preceding Soei. **Bib.**: K 683.

¹祖永

Sōen[1] (fl. 1489–1500). *Priest name*: Sōen.² *A.*: Josui (Nyosui).³ **Biog.**: Muromachi *suiboku* painter. Born in Sagami Prov-ince. A Zen priest, lived for a while at the Engaku-ji, Kamakura. Then to Yamaguchi in Suō Province to stay at the Unkoku-an and study under Sesshū until 1495; became his favorite pupil and an able follower, bringing his master's style to the Kantō *suiboku* school when he returned to the Engaku-ji. **Coll.**: Engaku-ji, Tōkyō (1). **Bib.**: *Au-delà;* GNB 11; HS 6; K 37; M 62, 206; Matsushita (1), (1a); Morrison 1; *Muromachi* (1); NB (S) 13, 63; NBT 4; Shimada 1; Tajima (12) 3.

¹宗淵 ²宗淵 ³如水

Sōen[1] (fl. c. 1620). *N.*: Hasegawa Sōen.² **Biog.**: Painter. Life unknown. Recorded as having painted portraits of famous poets. **Bib.**: *Nikuhitsu* (1) 1.

¹宗圓 ²長谷川宗圓

Sōen[1] (?–1828). *N.*: Sakuma Akira.² *A.*: Shukutoku.³ *Gō*: Fushunkan,⁴ Keisō,⁵ Sōen.⁶ **Biog.**: Shijō painter. Born in Kyōto. Pupil of Matsumura Goshun. Received title of *hokkyō*. Painted landscapes and *kachōga*. **Coll.**: Victoria. **Bib.**: Mitchell.

¹草偃 ²佐久間顕 ³叔徳 ⁴富春館 ⁵経草 ⁶草偃

Sōetsu[1] (fl. c. 1688–1704). *N.*: Tsuchida Sōetsu.² *Gō*: Hanro-ku.³ **Biog.**: Lacquerer. Born in Kyōto, where he worked at first. Later worked in Edo. Influenced by Kōetsu and Kōrin. Like Kōrin, used much shell, nacre, and pewter inlay. One of the most celebrated lacquerers of the 17th century. His followers all used the name Sōetsu. **Coll.**: Nezu. **Bib.**: Her-berts, Jahss, Ragué, Yoshino.

¹宗悦 ²土田宗悦 ³半六

Sōha[1] (fl. mid-15th c.). **Biog.**: Muromachi *suiboku* painter.

A representative artist of his time; his monochrome ink painting is stylistically related to work by such artists as Keishaku. **Coll.**: Los Angeles. **Bib.**: Mayuyama.

¹宗巴

Sōhaku (Munenori)[1] (1483–1557). *N.*: Kōami Sōhaku (Munenori).² **Biog.**: Kōami lacquerer. Younger brother of Sōshō. Represents the fifth generation of the Kōami school. **Bib.**: Herberts, Jahss, Ragué, Yashiro (1) 2.

¹宗伯 ²幸阿弥宗伯

Sōhan Fukuki[1] (fl. 8th c.). **Biog.**: Sculptor. A Gigaku mask in the Shōsō-in carries an inscription saying it was made by this artist. **Coll.**: Shōsō-in. **Bib.**: Kleinschmidt.

¹葱坂福貴

Sōhei[1] (1802–33). *N.*: Takahashi U.² *A.*: Takumin.³ *F.N.*: Genkichi.⁴ *Gō*: Sōhei.⁵ **Biog.**: *Nanga* painter. Born to a merchant family in Bungo Province. Showed an early talent for painting and became a pupil of Tanomura Chikuden at age of 19, traveling with him to Kyōto, Ōsaka, Settsu, and Onomichi. Also studied the technique of Chinese painting. His few works are characterized by a strong sense of de-sign and, in his flower paintings, considerable beauty. A gifted artist, close to his master in manner. **Coll.**: Homma, Idemitsu, Metropolitan, Tōkyō (1). **Bib.**: Cahill; *Cent-cinquante; GNB 18; K 319, 397, 409, 437, 503, 576, 588, 724, 735, 757, 840, 861; KO 38; M 48, 52, 92; Mitchell; Murayama (2); NB (H) 23; NB (S) 4; *Nihon* (2), (3); Yonezawa.

¹草坪 ²高橋雨 ³沢民 ⁴元吉 ⁵草坪

Sōhen[1] (1624–1708). **Biog.**: Potter. Perhaps born in Kyōto. Pupil of Ninsei. In 1662 studied under the tea master Sōtan.

¹宗編

Sōkan[1] (1809–52). *N.*: Yamada (originally Iehara)² Kayū.³ *F.N.*: Chōzaemon.⁴ *Gō*: Heisai,⁵ Ranga,⁶ Sōkan.⁷ **Biog.**: Japanese-style painter. Also a Confucian scholar and a poet. Born in Kyōto. Painted *kachōga* and portraits.

¹宗閑 ²家原 ³山田嘉猷 ⁴長左衛門
⁵箟斎 ⁶蘭雅 ⁷宗閑

Sōkei[1] (fl. late 15th c.). *N.*: Oguri Sōkei.² **Biog.**: Muromachi *suiboku* painter. Son of Oguri Sōtan (and may be the same person as Oguri Sōritsu), follower of Shūbun. Succeeded his father as painter to the shogunate. The twenty-eight *fusuma* painted by him in 1492 and owned by the Yōtoku-in of the Daitoku-ji, Kyōto, until the early Meiji era are now in the Kyōto National Museum. A moderately good artist, his style close to that of Mu-ch'i, but also worked in the manner of Hsia Kuei. **Coll.**: Kyōto (2). **Bib.**: BI 55, GNB 11, M 191, Matsushita (1), *Muromachi* (1), NB (S) 13, Tanaka (2).

¹宗継 ²小栗宗継

Sōkei[1] (fl. 16th c.). *N.*: Tanaka (originally Ameya)² Sōkei.³ **Biog.**: Potter. An ambiguous figure, said to have been born either in Korea or Ming China and to have come to Japan as a young refugee. Patronized by the Sasaki family, given the name Yakichi,⁴ which he later changed to Sōkei and used as his *gō*. Has been called Chōjirō's father; more probably a talented assistant. First used the studio name Ameya, then the name Tanaka (which he may have received from the Sen family). Tradition says he made pottery without using a potter's wheel. It is probable that he was the founder of the Raku (Tanaka) family through his second son Jōkei. At present, there are seven pieces attributed to Sōkei; his work close to Chōjirō's in manner. **Coll.**: Tōkyō (1), Umezawa. **Bib.**: Castile, Fujioka, GNB 19, Jenyns (2), M 168, Mika-mi, NB (S) 14.

¹宗慶 ²阿米夜 (飴也, 飴爺, 阿米爺) ³田中宗慶 ⁴弥吉

Sōken[1] (1621–87). *N.*: Ogata Sōsui.² *Gō*: Kōsai,³ Sōken.⁴ **Biog.**: Painter. A rich Kyōto draper, patronized by the nobility. His chief fame today lies in his having been the father of Kōrin and Kenzan. The few paintings by him in

existence bear out the tradition that he studied both the Tosa and Kanō styles. **Bib.:** BI 49, 51; K 612.

　　¹宗謙　　²尾形宗惟　　³浩斎　　⁴宗謙

Soken[1] (fl. c. 1683–1706). *N.:* Yamamoto Moritsune.[2] *F.N.:* Kazuma,[3] Rihei.[4] *Gō:* Soken.[5] **Biog.:** Painter. Born in Kyōto. Son and pupil of Yamamoto Sotei; also studied Kanō painting under Tan'yū. Received title of *hokkyō*. He and his father are said to have been Kōrin's first teachers; it is supposed that Kōrin learned from the *yamato-e* tradition from the Tosa elements in their work. **Coll.:** Imperial (1). **Bib.:** BI 49; K 787, 788, 802, 803.

　　¹素軒　　²山本守常　　³数馬　　⁴理兵衛（利兵衛）　　⁵素軒

Soken (Sojun)[1] (1759–1818). *N.:* Yamaguchi Soken (Sojun).[2] *A.:* Hakugo,[3] Hakuryō.[4] *F.N.:* Takejirō.[5] *Go:* Sansai.[6] **Biog.:** Maruyama painter. Lived in Kyōto. One of Maruyama Ōkyo's ten best pupils. His work also shows traces of uki-yo-e influence. A good figure painter, specialized in *bijinga;* painted landscapes, genre scenes, and *kachōga* as well. Known also for his illustrations, reproduced in woodblock prints, in such books as the *Yamato Jimbutsu Gafu* of 1800, the *Yamato Jimbutsu Gafu Kohen* of 1804, and the *Soken Jimbutsu Gafu* in three volumes. **Note:** Sometimes he is called Sojun in the West. **Coll.:** Art (1), British, Brooklyn, Museum (3), Nezu, Tōkyō (1), Victoria. **Bib.:** Brown; *Dessins;* Hillier (3), (4) 3; Holloway; K 166, 221, 266, 282, 307, 311, 374, 391, 415, 684, 802, 803, 945; Mitchell; Morrison 2; *Nikuhitsu* (1) 2; Shimada 3; Tajima (3) 2, (13) 6.

　　¹素絢　　²山口素絢　　³伯後　　⁴伯陵　　⁵武次郎　　⁶山斎

Sokō[1] (1777–1813). *N.:* Hayashi Chōu.[2] *A.:* Seppu,[3] Shiyo-ku.[4] *F.N.:* Chōjirō.[5] *Gō:* Sokō.[6] **Biog.:** Painter. Born in Mito. Intending to be a Confucian scholar, studied in Mito under the Confucianist Tachihara Suiken. Later to Edo, where he stayed for about six months studying painting and earning his living by painting *ema* (small pictures to be dedicated at temples and shrines). Returned to Mito, where he died. Tradition says that he was discovered by Tani Bunchō.

　　¹十江　　²林長羽　　³雪夫　　⁴子翼　　⁵長次郎　　⁶十江

Sokō[1] (1831–85). *N.:* Ochiai (originally Ōkami)[2] Yosahachi.[3] *F.N.:* Yosaji.[4] *Gō:* Seirensai,[5] Sokō.[6] **Biog.:** Painter. Born in Nagasaki. Adopted by the Ochiai family. Said to have studied under Charles Wirgman. A most versatile artist, painting in oil in the Western manner, in water color, and in the style of the Kanō school. Also known as an able craftsman in tortoise shell.

　　¹素江　　²大神　　³落合与三八　　⁴与三治　　⁵清蓮斎　　⁶素江

Sokuhi[1] (1616–71). *Priest name:* Nyoitsu.[2] *Gō:* Sokuhi.[3] **Biog.:** *Zenga* painter. Studied Rinzai Zen Buddhism under Ingen Ryūki in China, becoming a priest in 1651. In 1657 to Japan and joined the Ōbaku sect, which had been founded by Ingen. Associated with the Zen temples Sōfuku-ji in Fukuoka and Mampuku-ji near Kyōto. Founded the Fuku-shū-ji on Kojusan, Hyūga Province. Several elegant drawings of great simplicity by him are known. Also much esteemed as a calligrapher. **Bib.:** BO 105, NB (S) 47.

　　¹即非　　²如一　　³即非

Sokuyo[1] (fl. 1716–36). *N.:* Kanō Toyonobu[2] (or Tanenobu).[3] *Gō:* Sokuyo.[4] **Biog.:** Kanō painter. Son of Kanō Yūeki; founder of the Shiba Atagoshita branch of the Kanō school. In the service of Lord Maeda of Kaga; hence sometimes known as Kaga no Sokuyo.[5] **Coll.:** Museum (3), Victoria. **Bib.:** *Kanō-ha.*

　　¹即誉　　²狩野豊信　　³種信　　⁴即誉　　⁵加賀の即誉

Sokuyo II[1] (fl. c. 1835). *N.:* Kanō Moriaki.[2] *Gō:* Sokuyo.[3] **Biog.:** Kanō painter. Son and pupil of Kanō Tan'en. Sixth generation of the Shiba Atagoshita line of the Kanō school.

　　¹即誉二代　　²狩野守尚　　³即誉

Sōkyū[1] (fl. 1459). *N.:* Oguri Sōkyū.[2] **Biog.:** Muromachi *suiboku* painter. Probably son of Oguri Sōritsu and grandson

and pupil of Oguri Sōtan. **Coll.:** Ōsaka (2), Tōkyō (1). **Bib.:** HS 10.

　　¹宗休　　²小栗宗休

Somada (Somata)[1] (fl. 18th to 19th c.). A school of lacquer-ers that began in the mid-18th century. The early Somada artists were lacquerers to the Maeda family in Kaga. Special-ized in skillful, intricate mosaic encrustations of rich, highly colorful *aogai* shell, often with additions of small pieces of gold and silver foil—an elaborate and, in later periods, overornate type of decoration of tremendous technical skill. For starred names among the following, see individual entries.

　　*Gempo[2] (fl. c. 1815)
　　Hisamitsu[3] (fl. early 19th c.; brother of Mitsuaki)
　　*Kiyosuke[4] (1716–35)
　　Mitsuaki[5] (fl. 19th c.; younger brother of Hisamitsu and Mitsumasa)
　　Mitsuhisa[6] (fl. mid-19th c.)
　　*Mitsumasa[7] (1795–1856)

Bib.: Herberts, Jahss, Yoshino.

　　¹杣田　　²玄甫　　³久光　　⁴清輔　　⁵光明　　⁶光久　　⁷光正

Sōmi[1] (1573–1672). **Biog.:** Raku potter. Confusion surrounds the identity and the dates of this artist. There are three traditions: the first, that he was the younger brother of Dōnyū and established his own kiln at Sakai near Ōsaka; the second, that he was the younger brother of Chōjirō; the third, that Sōmi was the priest name of Jōkei Kichizaemon.[2] The uninscribed Black Raku ware known as Sōmi ware was produced in Sakai during the century from 1573 to 1672. Given the time span, it is possible that there were several artists of this name working at that kiln. **Bib.:** Jenyns (2).

　　¹宗味　　²常慶吉左衛門

Somiya Ichinen[1] (1893–). *N.:* Somiya Kishichi.[2] *Gō:* Ichinen.[3] **Biog.:** Western-style painter. Born in Fujinomiya, Shizuoka-ken. Worked in Tōkyō. First studied water-color painting with Ōshita Tōjirō. In 1916 graduated from Tōkyō School of Fine Arts, where he studied under Fujishima Takeji. Member of the Nikakai, Dokuritsu Bijutsu Kyōkai, and Kokugakai. Occasional juror for the Bunten and the Nitten. His landscapes are heavy and somber. **Bib.:** Asano, NBZ 6.

　　¹曾宮一念　　²曾宮喜七　　³一念

Sonchi[1] (fl. early 13th c.). **Biog.:** Buddhist painter. Worked first in Kyōto, later in Nara, where he was the official painter of the Ichijō-in at the Kōfuku-ji. He is recorded as having painted for the Hōryū-ji in 1222 and for the Shitennō-ji in 1224. It is also recorded that he worked with Takuma Ryōga on paintings for the pagoda of the Hosshō-ji near Nara. Received the rank of *hōgen*. No work can today be assigned to him with certainty; however, a painting of Shōtoku Taishi in the Hōryū-ji has been traditionally ascribed to him, as have the illustrations of the *Kitano Tenjin Engi.* **Bib.:** NEZ 8.

　　¹尊智

Sonkai[1] (fl. 1443). **Biog.:** Buddhist painter. Attached to the Kōfuku-ji, Nara. Known to have been a good painter of Buddhist themes and of portraits and to have worked for the Tōdai-ji as well as the Kōfuku-ji. Received title of *hōgen*. No painting can be definitely ascribed to him at the present.

　　¹尊海

Sonsho[1] (1771–1836). *N.:* Yagi Michi.[2] *A.:* Mōshin.[3] *F.N.:* Heita.[4] *Gō:* Sonsho.[5] **Biog.:** *Nanga* painter. Also a calligrapher and a student of epigraphy. Born in Awa Province. To Ōsaka to study under Kimura Kenkadō. Studied Chinese Ch'ing painting by himself. Specialized in slightly colored *kachōga* and landscapes.

　　¹巽所　　²八木迪　　³孟津　　⁴平太（兵太）　　⁵巽所

Sōnyū[1] (1664–1716). *N.:* Tanaka Sōkichi.[2] *Studio name:* Kichizaemon.[3] *Gō:* Sōnyū.[4] **Biog.:** Raku potter. Adopted son of Ichinyū, whom he succeeded in 1691 to become fifth generation of the Raku line, and inheriting the name of Kichizaemon. Made the ridge-end tiles (still *in situ*) for the

Zangetsu-tei at the Fushin-an belonging to the Omote Senke school of tea in Kyōto. Restored the Chōjirō style. His bowls are characterized by their light weight, their thick potting, and their silvery black glaze. Retired in 1708, became a monk, and took the name of Sōnyū. **Coll.:** Fujita, Metropolitan, Philadelphia, Staatliche, Tōkyō (1). **Bib.:** *Ausgewählte,* Castile, Jenyns (2), Mayuyama, NB (S) 14, *Nihon* (8).

¹宋入　²田中惣吉　³吉左衛門　⁴宋入

Soraku[1] (fl. c. 1795). **Biog.:** Ukiyo-e printmaker. Life unknown. **Coll.:** Tōkyō (1).

¹素楽

Sōri[1] (fl. c. 1764–80). *N.:* Tawaraya Sōri.[2] *F.N.:* Genchi.[3] *Gō:* Hyakurin,[4] Ryūryūkyo,[5] Seisei.[6] **Biog.:** Rimpa painter. Studied first with Sumiyoshi Hiromori; then came under the influence of Kōrin's style. **Coll.:** Freer. **Bib.:** K 438; *Kōrin-ha* (1), (2); Morrison 2; *Rimpa;* Tajima (2) 3.

¹宗理　²俵屋宗理　³元知　⁴百琳　⁵柳々居　⁶青々

Sōri III[1] (fl. late 18th to early 19th c.). *N.:* Hishikawa (originally Tawaraya)[2] Sōji.[3] *Gō:* Sōri.[4] **Biog.:** Ukiyo-e printmaker. An early pupil of Hokusai, who gave him his name of Hishikawa Sōri in 1798 when he discarded it himself. Is regarded as Sōri III, the Rimpa painter Tawaraya Sōri being Sōri I and Hokusai being Sōri II. In 1807 illustrated a novel in collaboration with Utagawa Toyohiro. His prints closely resemble the work of Hokusai when he was using the *gō* Shunrō, and his paintings are sometimes mistaken for those done by Hokusai when he used the *gō* Sōri. Was followed by two more generations, both called Sōri. **Note:** Since Sōri I and III are frequently confused, the references may share the same confusion. **Coll.:** Art (1), British, Fitzwilliam, Metropolitan, Victoria. **Bib.:** Binyon (1), (3); Shimada 3; Tajima (7) 4.

¹宗理三代　²俵屋　³菱川宗二　⁴宗理

Sōri Gyosei[1] (fl. c. 752). **Biog.:** Sculptor. An inscription on a Gigaku mask in the Tōdai-ji, Nara, says it was made by Sōri Gyosei and gives the date of May 26, 752. **Coll.:** Shōsō-in, Tōdai-ji. **Bib.:** Kleinschmidt, Warner (4).

¹相李魚成

Sorin[1] (fl. early 19th c.). *Gō:* Rekisentei.[2] **Biog.:** Ukiyo-e printmaker. Designed *bijinga.* **Coll.:** Portland.

¹素隣（素潾，素鱗）　²礫川亭

Sōritsu[1] (fl. middle to late 15th c.). *N.:* Oguri Sōritsu.[2] **Biog.:** Muromachi *suiboku* painter. Born in Wakasa Province; lived at the Daitoku-ji, Kyōto. Son and pupil of Oguri Sōtan (and may have been the same person as Oguri Sōkei). Used a seal reading "Geiai"[3] (some scholars have suggested that Geiai is a separate artist) and another reading "Tonshu."[4] Specialized in painting animals and birds-and-flowers. **Coll.:** Freer, Kyōto (2), Museum (3), Tōkyō (1). **Bib.:** BI 55; K 125, 157, 199, 704, 826; Matsushita (1), (1a); Morrison 1; *Muromachi* (1); NB (S) 13; Shimada 1.

¹宗栗　²小栗宗栗　³芸愛　⁴頓首

Sōseki[1] (1822–77). *N.:* Murase (originally Tachibana)[2] Gyo.[3] *Gō:* Saiun,[4] Sōseki.[5] **Biog.:** Shijō painter. Born in Kyōto. Pupil of Keibun, then of Yokoyama Seiki. Worked in Edo. **Bib.:** Mitchell.

¹雙石　²橘　³村瀬魚　⁴彩雲　⁵雙石

Sōsen[1] (fl. 1624–43). **Biog.:** Rimpa painter. Little known of his life. May have been a relative of Nonomura Sōtatsu and perhaps worked in his studio. Specialized in figure and flower painting. **Coll.:** Philadelphia. **Bib.:** Shimada 2, Stern (3).

¹宗山

Sōsen[1] (1679–1760). *N.:* Yamamoto Morifusa.[2] *F.N.:* Kazuma.[3] *Gō:* Sōsen,[4] Tanchōsai.[5] **Biog.:** Painter. Born in Kyōto. Adopted son and pupil of Yamamoto Soken. Received rank of *hōgen.*

¹宗川　²山本守房　³数馬　⁴宗川　⁵探釣斎

Sosen[1] (fl. c. 1730). *N.:* Kanō Narinobu.[2] *F.N.:* Tatsuno-

suke.[3] *Gō:* Sosen.[4] **Biog.:** Kanō painter. Son and pupil of Kanō Kagenobu. After his father's death in 1726, continued the tradition of the Kanda branch of the Kanō school.

¹素仙　²狩野成信　³辰之助　⁴素仙

Sosen[1] (1747–1821). *N.:* Mori Morikata (Shushō).[2] *A.:* Shukuga.[3] *F.N.:* Hanaya Hachibei.[4] *Gō:* Jokansai,[5] Reibyōan,[6] Reimyōan,[7] Sosen.[8] **Biog.:** Painter. Little known about his life. Born either in Nagasaki or in Nishinomiya near Ōsaka; lived in Ōsaka. First studied Kanō painting under Yamamoto Joshunsai; later changed his style to one based on close observation of nature (even lived for a while in the woods to observe animals in their free state) and is hence considered a member of the Shijō school. Specialized in painting monkeys (best known Japanese artist for this subject) but also painted other animals. In his later years changed the *so* of his name Sosen from the character for "ancestor"[9] to a character that has one meaning of "monkey."[10] **Coll.:** Allen, British, Center, Cleveland, Detroit, Fogg, Freer, Honolulu, Itsuō, Metropolitan, Museum (3), National (3), Newark, Nezu, Philadelphia, Stanford, Victoria. **Bib.:** AA 6; *Dessins;* Hillier (2), (3), (4) 3; *Illustrated* (1); K 18, 46, 110, 131, 416, 498, 632, 745, 759; KO 11; Mitchell; Morrison 1; *One* (2); Paine (2) 1, (3); Shimada 2; Tajima (12) 3, 11, 15, 17; Tajima (13) 6.

¹祖仙（狙仙）　²森守象　³叔牙　⁴花屋八兵衛　⁵如寒斎
⁶霊猫菴　⁷霊明菴　⁸祖先（狙仙）　⁹祖　¹⁰狙

Sosen[1] (1820–1900). *N.:* Kanō Toshinobu (Jushin).[2] *Gō:* Chōonsai,[3] Sanryō,[4] Sosen.[5] **Biog.:** Kanō painter. Born in Edo. Son of the minor Kanō artist Kanō Hakuju Yukinobu; became ninth generation head of the Saruyamachi Kanō family. Served the shogunate as the last of the *goyō eshi.* In 1893 edited two books on painters and their seals: *Honchō Gaka Jimmei Jisho* and *Honchō Gaka Rakkan Impu.*

¹素川　²狩野寿信　³朝音斎　⁴三龍　⁵素川

Sōsetsu[1] (fl. mid-17th c.). *N.:* Kitagawa Sōsetsu.[2] *A.:* Inen.[3] **Biog.:** Rimpa painter. Little known of his life. Said to have been born in Kanazawa; it is assumed he was younger brother of Sōtatsu. By 1639 had taken over the direction of the Sōtatsu workshop; sometime before 1642 received the title of *hokkyō.* The most important of Sōtatsu's followers, he used Sōtatsu's seal Inen. Known for his decorative paintings of flowers and grasses. Worked in his master's manner, but his work, which is filled with a springlike charm, is less strong. **Coll.:** Center; Cleveland; Fogg; Freer; Honolulu; Kyōto (2); Metropolitan; Museum (3); Nelson; Nezu; Philadelphia; Seattle; Tōkyō (1), (2); Victoria. **Bib.:** Akiyama (2); BK 125; *Freer;* K 934; KO 19, 26; *Kōrin-ha* (1); Lee (2); Mizuo (2a), (4); NBZ 5; P 2; *Rimpa;* SBZ 9; Shimada 2; *Sōtatsu-Kōrin* (3); Stern (3).

¹相説　²喜多川相説　³伊年

Sōsetsu[1] (fl. 1639–50). *N.:* Nonomura (originally Tawaraya)[2] Sōsetsu.[3] *A.:* Inen.[4] **Biog.:** Rimpa painter. Once thought to be the same person as Kitagawa Sōsetsu (q.v.), but now regarded as an independent artist. May have been a relative of Nonomura Sōtatsu and perhaps the teacher of Kitagawa Sōsetsu. Like both these artists, used a seal reading "Inen."[5] His style a somewhat inferior version of that of Sōtatsu. **Coll.:** Cleveland, Kyōto (2), Tōkyō (1). **Bib.:** K 505, Morrison 2, NBZ 5, *Rimpa, Sōtatsu-Kōrin* (3).

¹宗雪　²俵屋　³野々村宗雪　⁴伊年　⁵伊年

Sosetsu[1] (fl .1818–30). *N.:* Mori Kihō.[2] *Gō:* Sosetsu.[3] **Biog.:** Maruyama painter. Son of Mori Tetsuzan. A painter of animals in the manner of his grandfather, Mori Sosen. **Bib.:** Morrison 2.

¹祖雪　²森貴峰　³祖雪

Sōshin[1] (1568–1620). *N.:* Kanō (originally Kusumi)[2] Tananaga.[3] *F.N.:* Takuminosuke.[4] *Gō:* Sōshin.[5] **Biog.:** Kanō painter. Studied under Kanō Shōei and Kanō Eitoku. Mem-

ber of the Odawarachō branch of the Kanō school. Worked as painter for the shogunate. **Coll.:** Nezu.

¹宗心（宗進，宗信） ²久隅 ³狩野種永
⁴内匠助 ⁵宗心（宗進，宗信）

Soshin¹ (1818–62). *N.:* Yamagata Soshin.² *Gō:* Yōgetsuan.³ **Coll.:** Victoria. **Biog.:** Painter. Lived in Edo. **Bib.:** Mitchell.

¹素真 ²山形素真 ³揺月菴

Sōshō (Sōsei, Munemasa)¹ (1479–1553). *N.:* Kōami Sōshō (Sōsei, Munemasa).² **Biog.:** Lacquerer. Eldest son of Kōami Sōzen; succeeded him as Kōami IV. **Bib.:** Herberts, Jahss.

¹宗正 ²幸阿弥宗正

Soshoku¹ (1778–1859). *Priest name:* Yōzan.² *Gō:* Rodō,³ Shōkūken,⁴ Soshoku.⁵ **Biog.:** Nanga painter. Priest of the Rinzai sect; member of the third generation of followers of Hakuin. As a young man studied poetry and calligraphy as well as Zen. Friend of Nakabayashi Chikutō and Yamamoto Baiitsu. Considered one of the leading *bunjinga* artists of his time. **Bib.:** NB (S) 47.

¹楚軾 ²暘山 ³魯堂 ⁴蕉空軒 ⁵楚軾

Sōshū¹ (1551–1601). *N.:* Kanō Suenobu.² *F.N.:* Jinnosuke.³ *Gō:* Sōshū.⁴ **Biog.:** Kanō painter. Second son of Kanō Shōei Tadanobu, younger brother of Eitoku, father of Motohide. Pupil of his father and brother. Lived in Kyōto, serving Toyotomi Hideyoshi. Although an important Kanō artist, little is known about his work. His name has been associated with a seal reading "Motohide (Genshū),"⁵ but this same seal was also used by his son. Known to have painted *fusuma* for the Katsura Villa. **Coll.:** Center, Freer, Katsura, Museum (3), Nanzen-ji, Toyokuni-jinja, Victoria. **Bib.:** BK 147; K 56, 902, 903; Morrison 1; NB (H) 14; NBZ 4; SBZ 8; Shimada 2; YB 4; Yamane (1a).

¹宗周 ²狩野季信（狩野秀信） ³甚之助 ⁴宗周 ⁵元秀

Sōshun¹ (fl. 14th c.). **Biog.:** *Yamato-e* painter. A priest at the Kōraku-ji, Nagano-ken. Collaborated with Enjaku in the painting of the four scrolls of the *Shinran Shōnin Eden Emaki* (known as the *Hongan-ji Shōnin Den-e*) in the Higashi Hongan-ji, Kyōto, and dated 1343. **Coll.:** Higashi. **Bib.:** Okudaira (1).

¹宗舜

Sōsui¹ (1720–67). *N.:* Watanabe Jū.² *A.:* Shūhon.³ *F.N.:* Jinzō.⁴ *Gō:* Bansen Shujin,⁵ Jounken,⁶ Sōsui,⁷ Zuishun.⁸ **Biog.:** Nagasaki painter. Born in Edo; moved to Nagasaki. Follower of the Shen Nan-p'in school of painting. Adopted Gentai as his son.

¹湊水 ²渡辺従 ³周本 ⁴甚蔵
⁵欒磚主人 ⁶鋤雲軒 ⁷湊水 ⁸随春

Sōtaku¹ (fl. first half 16th c.). *N.:* Goto Sōtaku.² **Biog.:** Sculptor. The statue of Lady Hōjō Uchitsuna in the Daichō-ji, Kamakura, has an inscription saying it was made by Sōtaku in 1549. Is also known to have repaired the head of the Benzaiten in the Enoshima Shrine, Kamakura, in 1513. **Coll.:** Daichō-ji. **Bib.:** M 110.

¹宗琢 ²後藤宗琢

Sōtaku¹ (fl. c. mid-17th c.). *N.:* Hasegawa Sōtaku.² **Biog.:** Hasegawa painter. Second son and pupil of Hasegawa Tōhaku. Given rank of *hokkyō*. Paintings attributed to him can be found in Kyōto in the Daigo-ji (Sambō-in), the Kitano Temman-gū and the Nanzen-ji. **Coll.:** Daigo-ji (Sambō-in), Kitano Temman-gū, Nanzen-ji. **Bib.:** NB (H) 14; NBZ 4.

¹宗宅 ²長谷川宗宅

Sōtan¹ (1413–81). *N.:* Oguri Sukeshige.² *F.N.:* Kojirō.³ *Gō:* Jiboku,⁴ Sōtan.⁵ **Biog.:** Muromachi *suiboku* painter. Lived in Kyōto; in the service of the Ashikaga shogun Yoshimasa. At 30, a priest at the Shōkoku-ji. Pupil of Shūbun, whom he succeeded as official painter to the *bakufu* about 1463. Considered by all Japanese art historians as one of the greatest Muromachi painters despite lack of work that can definitely be ascribed to him. All attributions are

tentative, and there is little agreement as to what his oeuvre consists of. Great reputation as a painter of falcons and as a colorist. **Coll.:** Cleveland, Fujita, Kyōto (2), Metropolitan, Portland, Seattle, Tokugawa, Tōkyō (1). **Bib.:** AA 6, 14; ARTA 14; GNB 11; HS 7, 8; *Illustrated* (1); K 21, 82, 120, 132, 684; Matsushita (1); Morrison 1; NB (S) 13; *One* (2); Paine (2) 2, (4); Rosenfield (2); Tajima (12) 5, 15; Tajima (13) 3; Tanaka (2).

¹宗湛（宗丹，宗覃） ²小栗助重 ³小二郎
⁴自牧 ⁵宗湛（宗丹，宗覃）

Sōtatsu¹ (?–1643?). *N.:* Nonomura (originally Tawaraya)² Ietsu.³ *A.:* Inen.⁴ *Gō:* Sōtatsu,⁵ Taiseiken.⁶ **Biog.:** Rimpa painter. Born in Noto Province; son of a wealthy merchant named Tawaraya whose studio made fans as well as pictures to be placed on folding screens. His teacher unknown. First worked in Kyōto with Kōetsu, perhaps marrying his cousin; later served the Maeda family in Kaga Province, where he died. By 1630 had received title of *hokkyō*. Won favor of Kyōto nobility, first artist from the merchant class to achieve this distinction. Mastered art of *yamato-e,* studied early Chinese painting, also painted in *suiboku* manner. Is known to have restored the 12th-century sutras of the Itsukushima Shrine and to have been acquainted with the 13th-century scroll of *Ten Fast Bulls.* Painted subjects from the *Genji Monogatari,* the *Heiji Monogatari,* and the *Ise Monogatari;* decorated fans with scenes borrowed from the narrative scrolls of the Kamakura and Muromachi periods. Much influenced by Kōetsu, under whose tutelage he made the Rimpa school one of the greatest and most individual in all Japanese art. Forgotten during the 18th century, perhaps because he died in the provinces; was rediscovered in the 19th century, and recent research has given him his rightful place as a great creative master of the decorative school. His seal Inen⁷ was used by many of his followers, thereby causing endless confusion in the game of attributions. Preferred simplified shapes, almost abstract display of color and gold in his decorative painting; in his monochrome work turned back to Chinese Ming models, producing a number of ink paintings of hermits and the founders of Buddhism. Complete absence of outline, pigments of best quality (even using gold as a pigment), transparent brushwork of freely brushed color mark his decorative work. **Coll.:** Art (1), Atami, Bridgestone, British, Chōmyō-ji, Cleveland, Daigo-ji, Fine (M. H. De Young), Fogg, Freer, Gotō, Hatakeyama, Hōkai-ji (2), Honolulu, Ishikawa, Itsukushima, Itsuō, Kennin-ji, Kōun-ji, Kyōto (2), Matsunaga, Metropolitan, Minneapolis, Museum (3), Myōhō-in, Nelson, Philadelphia, Sambō-in (Daigo-ji), Seattle, Staatliche, Stanford, Suntory, Tōkyō (1), Umezawa, Victoria, Yamakawa, Yamato, Yōgen-in. **Bib.:** AA 6, 14; AAA 21; Akiyama (3); AO 9; *Art* (1a); BI 31, 33; BK 2, 10, 20, 23, 73, 85, 90, 98, 101, 162, 176, 215; *Exhibition* (1); Fontein (1); *Freer;* GK 12; GNB 14; Gray (2); Grilli (1), (3); Hillier (2); Ienaga; K 14, 33, 40, 62, 101, 143, 192, 196, 205, 280, 309, 348, 357, 363, 364, 368, 373, 454, 461, 469, 483, 492, 497, 545, 562, 721, 769, 785, 793, 805, 814, 833, 897, 934, 940, 958; KO 6, 8, 18, 20, 23, 27, 30, 33, 39; *Kokuhō* 6; *Kōrin-ha* (1); Leach; Lee (1), (2); M 1, 48; Mayuyama; Minamoto (1); Mizuo (2a), (3), (4); Moriya; Morrison 2; Murashige; NB (H) 14; NB (S) 13, 31, 53; NBT 5; NBZ 5; *Nihon* (7) 3; NKZ 13, 82; Noma (1) 2; *One* (2); Paine (2) 1, (3), (4); *Rimpa;* Rosenfield (2); SBZ 8, 9; Shimada 2; *Sōtatsu* (1), (2), (3); Stern (3); Tajima (12) 2, 5, 10, 11, 12, 17, 20; Tajima (13) 5; Tanaka (7a) 4; TBS 12; *Ukiyo-e* (3) 20; Yamane (3); Yashiro (1), (3); YB 8, 10, 11, 26, 30.

¹宗達 ²俵屋 ³野々村以悦 ⁴伊年
⁵宗達 ⁶対青軒 ⁷伊年

Sōtei¹ (fl. late 16th c.). **Biog.:** Sculptor. Known for a Shaka Nyorai in the Denkō-ji, Nara. Transmitted the Kaikei style

to the late Muromachi period. Made the Daibutsu, which no longer exists, for the Hōkō-ji, Kyōto, in 1586. **Coll.:** Denkō-ji. **Bib.:** *Muromachi* (2), NBZ 4.

<p align="center">¹宗貞</p>

Sōtei[1] (1590–1662). *N.:* Kanda Munenobu[2] (originally Nobusada).[3] *F.N.:* Shōshichi.[4] *Gō:* Sōtei.[5] **Biog.:** Buddhist painter. Worked for the Rinnō-ji in Edo. The *gō* Sōtei was also used by his descendants.

<p align="center">¹宗庭　²神田宗信　³信定　⁴庄七　⁵宗庭</p>

Sōtei[1] (fl. late 17th c.). *N.:* Yamamoto Moritsugu.[2] *Gō:* Chōsetsu,[3] Sōtei.[4] **Biog.:** Kanō painter. Father of Yamamoto Soken. Pupil of Tan'yū. Worked in Kyōto. Received title of *hokkyō*. Said to have been the first teacher of Kōrin.

<p align="center">¹素程　²山本守次　³釣雪　⁴素程</p>

Sōtetsu[1] (1617–95). *N.:* Nakamura Sōtetsu.[2] *Gō:* Gempitsu,[3] Hachirobei,[4] Hōso,[5] Hōsunsai,[6] Kōyū,[7] Shitsuō,[8] Yūzan.[9] **Biog.:** Lacquerer. Born in Kyōto. Pupil of Kōetsu. Became an intimate friend of the great tea master Fujimura Yoken; also established a partnership with the Sen family of tea-masters, a patronage that continued through his many followers. Specialized in *yozakura-nuri* (cherry-blossoms-at-night lacquer), a technique in which the contours of the cherry tree are painted with a mixture of black lacquer and *nashiji* on a black ground. When dry, the whole surface is covered with a thin layer of black lacquer and the cherry tree appears as if blended into the night. The Sōtetsu line of lacquer artists, of which the third-generation head is the best known, is as follows:

Sōtetsu II (?–1706). *Gō:* Gentetsu,[10] Yūsai.[11]

Sōtetsu III (1699–1776). *Gō:* Kyūsai,[12] Shittō,[13] Shō-boku,[14] Yūsai.[15]

Sōtetsu IV (1742–91). *Gō:* Shinsai,[16] Shitsuō.[17]

Sōtetsu V (fl. c. 1800). *Gō:* Hyōsai,[18] Shippō.[19]

Sōtetsu VI (fl. c. 1800). *Gō:* Chōsai.[20]

Sōtetsu VII (fl. c. 1820). *Gō:* Bakusai,[21] Tokugen.[22]

Coll.: Hatakeyama. **Bib.:** Fujioka, Herberts, Jahss, Sawaguchi.

<p align="center">¹宗哲　²中村宗哲　³源弼　⁴八郎兵衛　⁵彭祖
⁶方寸斎　⁷公遊　⁸漆翁　⁹勇山　¹⁰元哲　¹¹勇斎
¹²汲斎　¹³漆桶　¹⁴紹朴　¹⁵勇斎　¹⁶深斎　¹⁷漆翁
¹⁸豹斎　¹⁹漆畝　²⁰蝶斎　²¹獏斎　²²得玄</p>

Sōtoku (Shūtoku)[1] (fl. late 16th c.). *N.:* Kanō Mataemon.[2] *Gō:* Ko Ukyō,[3] Sōtoku (Shūtoku).[4] **Biog.:** Kanō painter. Pupil of Kanō Eitoku. **Bib.:** M 141.

<p align="center">¹宗徳　²狩野又兵衛門　³古右京　⁴宗徳</p>

Sōun[1] (fl. 17th c.). *N.:* Kita Sōun.[2] **Biog.:** Nagasaki painter. Specialized in painting portraits of the priests Ingen, Dōja, and Mokuan. Style close to that of the Chinese painter Yang Tao-chen (Japanese: Yō Dōtei); his work also shows some Western influence in the coloring. Can be considered a precursor of the Ōbaku type of Zen portraiture. Rather realistic. **Coll.:** Kōbe. **Bib.:** Nishimura, *Pictorial* (2) 5.

<p align="center">¹宗雲　²喜多宗雲</p>

Sōun[1] (1815–98). *N.:* Tazaki Un[2] (originally Gei).[3] *Gō:* Baikei,[4] Hakuseki Sambō,[5] Hakusekisei,[6] Kenden Nōfu,[7] Rentai Sanjin,[8] Shichiri Kōsōdō,[9] Sōun.[10] **Biog.:** *Nanga* painter. Born in Edo into a samurai family that served the daimyo of Ashikaga. Interested in painting from childhood, soon left his lord's service to travel and study the work of such Chinese Ming artists as Ch'iu Ying, Liu Sung-nien, and Shen Chou. Also studied under Kanai Ushū, Katō Baiō, Haruki Nammei and Tani Bunchō. From these studies, evolved his own version of the *nanga* style. Teacher of Komuro Suiun; member of the Imperial Fine Arts Academy. Entrusted with the decoration of the ceilings and *fusuma* for one of the emperor Meiji's palaces. His work is now highly regarded. Worked in a style based largely on that of Nammei, with certain Chinese influence. **Coll.:**

Metropolitan. **Bib.:** Asano, *Cent-cinquante,* Mitchell, NB (S) 17, NBT 10, NBZ 6, Umezawa (2), Uyeno.

<p align="center">¹草雲　²田崎雲　³芸　⁴梅溪　⁵白石山房　⁶白石生
⁷硯田農夫　⁸蓮岱山人　⁹七里香草堂　¹⁰草雲</p>

Sōya[1] (or **Sōha**)[2] (fl. late 16th c.). *N.:* Kanō Sōya[3] (or Sōha).[4] *F.N.:* Genshichirō.[5] **Biog.:** Kanō painter. Son of Kanō Shōei, younger brother of Eitoku. Founder of Kanda branch of Kanō school. **Bib.:** Morrison 1.

<p align="center">¹宗也　²宗巴　³狩野宗也　⁴宗巴　⁵源七郎</p>

Sōya[1] (fl. first half 17th c.). *N.:* Hasegawa Sōya.[2] **Biog.:** Hasegawa painter. Biography most obscure: has been called either illegitimate or second son of Hasegawa Tōhaku, or identified with Sakon or Nobuharu. A screen in the Boston Museum of Fine Arts attributed to Sōya shows the Hasegawa style continued in color. **Coll.:** Museum (3). **Bib.:** BB 19, NB (H) 14, Noma (1) 2, Paine (2) 1, Shimada 2.

<p align="center">¹宗也　²長谷川宗也</p>

Soyama Yukihiko[1] (1859–92). *N.:* Soyama (originally Ōno)[2] Yukihiko.[3] **Biog.:** Western-style painter. Born in Kagoshima, lived in Tōkyō. Studied under Sangiovanni, then became an assistant professor at the Kōbu Daigaku Bijutsu Gakkō. Also taught at his own private school. A pioneer exponent of Western-style painting; his style was one of academic realism. **Coll.:** Tōkyō (1). **Bib.:** Asano, BK 188, Harada Minoru, NB (S) 30, NBZ 6.

<p align="center">¹曽山幸彦　²大野　³曽山幸彦</p>

Soyū[1] (1556–1617). *N.:* Kanō (originally Kudō)[2] Hidenobu[3] (or Hidemasa[4] or Hideie).[5] *F.N.:* Geki,[6] Shin'emon.[7] *Gō:* Soyū.[8] **Biog.:** Kanō painter. Born in Ōsaka. Adopted by Kanō Shōei, under whom he studied. Also a pupil of Kanō Eitoku. Served Toyotomi Hideyoshi as official painter; is said to have been given name Hideie by Hideyoshi's son, Hideyori. Moved to Edo to serve the shogunate as *omote eshi* and founded the Saruyamachi branch of the Kanō school. Has sometimes been confused with Kanō Gyokuraku and Maejima Sōyū (q.v.). Painted in a hard, tight manner. **Bib.:** K 693, YB 48.

<p align="center">¹祖酉　²工藤　³狩野秀信　⁴秀政
⁵秀家　⁶外記　⁷新右衛門　⁸祖酉</p>

Sōyū[1] (fl. 16th c.). *N.:* Maejima.[2] *Gō:* Sōyū.[3] **Biog.:** Kanō painter. Considerable confusion about his life and, indeed, about his surname, which is sometimes given as Kanō[4] because of his presumed Kanō connections; also used the pretentious surname of Fujiwara.[5] He has been considered the same person as Kanō Gyokuraku, one of whose *gō* is Sōyū, or as Kanō Soyū Hidenobu, but the more generally accepted tradition is that he was an individual artist. Also said to have been the nephew of Kanō Motonobu, under whom he studied. A fair Kanō artist, specializing in *kachōga,* with a hard, angular style. **Coll.:** Ōkura, Staatliche. **Bib.:** *Ausgewählte; HS 5; K 317, 442, 510, 594, 605, 693; Matsu-shita (1a); NB (S) 63; SBZ 7; Shimada 1; Tajima (13) 4; YB 48.*

<p align="center">¹宗祐　²前島　³宗祐　⁴狩野　⁵藤原</p>

Sōzen[1] (1457–1527). *N.:* Kōami Sōzen.[2] *Gō:* Sōkin (Mune-kane).[3] **Biog.:** Lacquerer. Grandson of Kōami Dōchō. Worked for the Ashikaga shogunate. Became head of the third generation of the Kōami school. **Bib.:** Herberts, Jahss.

<p align="center">¹宗全　²幸阿弥宗全　³宗金</p>

Suda Kōchū[1] (1908–64). *N.:* Suda Zenji.[2] *Gō:* Kōchū.[3] **Biog.:** Japanese-style painter. Born in Fukushima-ken. In 1934 graduated from Tōkyō School of Fine Arts, having studied under Maeda Seison; taught there from 1951. While still a student, exhibited with the Teiten. Member of Nihon Bijutsuin and an exhibitor with the Inten.

<p align="center">¹須田珙中　²須田善二　³珙中</p>

Suda Kunitarō[1] (1891–1961). **Biog.:** Western-style painter. Born in Kyōto. After graduating in 1916 from faculty of fine arts of Kyōto University, studied Western painting at the Kansai Bijutsuin from 1916 to 1918. From 1919 to 1923

in Europe, particularly in Spain, where he was much influenced by the work of El Greco. On his return taught at various institutions. In 1934 became a member of the Dokuritsu Bijutsu Kyōkai, with which he exhibited. In 1947 made a member of the Japan Art Academy; in 1959 received the Mainichi Art Award. His work reflects the postimpressionist tendencies of the 20s. **Coll.:** Kyōto (1), Nagaoka, National (5), Ohara (1). **Bib.:** Asano, Kung, *Masterpieces* (4), NB (H) 24, NBT 10, NBZ 6, SBZ 11.

¹須田国太郎

Suga Tatehiko[1] (1878–1963). *N.:* Suga Tōtarō.[2] *Gō:* Tatehiko.[3] **Biog.:** Japanese-style painter. Born in Tottori-ken; moved as a young man to Ōsaka. Self-taught painter, having studied the *yamato-e* style paintings of the Tosa school. Particularly fond of genre subjects. An exhibitor with and member of the Nitten. Won a number of prizes, including the Imperial Prize in 1957. His sketches are light and amusing. **Coll.:** Meiji, National (5), Ōsaka (2). **Bib.:** Asano.

¹菅楯彦 ²菅藤太郎 ³楯彦

Sūgakudō[1] (fl. 1850–60). *N.:* Nakayama Sūgakudō.[2] **Biog.:** Ukiyo-e printmaker. Pupil of Hiroshige. A good designer of *kachōga*, known for two sets of prints: *Shiki no Kachō* (Birds and Flowers of the Four Seasons) of 1861; and *Shō Utsushi Shijū-hachi Taka* (Exact Reproductions of Forty-eight Hawks) of 1858. **Coll.:** Andrew, Ashmolean, British, Fine (California), Honolulu, Musée (1), Musées, Newark, Portland, Victoria, Worcester. **Bib.:** Binyon (1), (3); Hillier (7); Stewart; Turk.

¹嵩岳堂 ²中山嵩岳堂

Sugimura Jihei[1] (fl. c. 1680–98). *N.:* Sugimura Jihei.[2] *Gō:* Masataka.[3] **Biog.:** Ukiyo-e painter, printmaker. Life unknown. The most prolific and successful of Moronobu's pupils. Illustrated many of the typical books of the day; also made some of the first *ichimai-e* (single-sheet prints). His work once confused with that of Moronobu and only since the 20s has it been properly identified following the discovery that the prints were signed with the character *mura*[4] appearing as a *mon* or part of the decoration, or with the name Jihei[5] inconspicuously placed. About two-thirds of his designs are erotic. His style close to that of Moronobu but at times a bit softer. **Coll.:** Art (1), Honolulu, Idemitsu, Metropolitan, Musée (2), Museum (3), Portland, Riccar, Staatliche, Worcester. **Bib.:** Brown; Gentles (2); Gunsaulus (1); Hillier (7), (9); *Kunst*; Lane; Ledoux (4); Michener (3); Narazaki (2); NHBZ 2; OA 5; Schmidt; Shibui (1); Takahashi (6) 5.

¹杉村治兵衛 ²杉村治兵衛 ³正高 ⁴村 ⁵治兵衛

Suian[1] (1844–90). *N.:* Hirafuku Un.[2] *F.N.:* Junzō.[3] *Gō:* Bunchi;[4] later, Suian.[5] Japanese-style painter. Born in Akita-ken; son of a dyer. First studied under Takemura Bunkai, a local painter; then to Kyōto for further training. In later life lived in both Akita and Tōkyō. In 1881 showed with the Ryūchikai and in 1884 and 1890 with the Naikoku Kangyō Hakurankai. Specialized in painting animals. **Coll.:** Tōkyō (1). **Bib.:** Asano, Mitchell, NB (S) 17, NBZ 6.

¹穂菴 ²平福芸 ³順蔵 ⁴文池 ⁵穂菴

Suichiku[1] (1808–86). *N.:* Nakano Gyōkyō.[2] *F.N.:* Shin'ichirō.[3] *Gō:* Suichiku.[4] **Biog.:** *Nanga* painter. Born in Nagoya. First a pupil of Yamamoto Baiitsu, then of Nakabayashi Chikutō. In 1839 became a *goyō eshi* to the shogunate. Teacher of Ishikawa Ryūjo. **Bib.:** Mitchell.

¹水竹 ²中野尭教 ³進一郎 ⁴水竹

Suifutei[1] (fl. c. 1782). *Given name:* Kunitaka.[2] *A.:* Shito.[3] *Gō:* Suifutei.[4] **Biog.:** Ukiyo-e painter, printmaker. Member of the Kamigata school. Lived in Ōsaka. As a printmaker, known for a book of portraits of Kansai actors (1782) that bordered on caricature and had a great influence on Ryūkōsai and other members of the Kamigata school. Painted in the Maruyama style. **Bib.:** NHBZ 3.

¹翠釜亭 ²邦高 ³子登 ⁴翠釜亭

Suigaku[1] (fl. c. 1840). *N.:* Seki Shigeoki.[2] *F.N.:* Saburobei.[3] *Go:* Suigaku.[4] **Biog.:** Painter. Lived in Edo. Official artist to the Suzaka clan. **Coll.:** Victoria. **Bib.:** Mitchell.

¹翠岳 ²関重起 ³三郎兵衛 ⁴翠岳

Suigetsu[1] (fl. c. 1780). *N.:* Ōnishi Suigetsu.[2] *A.:* Kitan.[3] **Biog.:** Painter. Biography largely unknown. Pupil of Mochizuki Gyokusen Makoto. A painter of figures and birds-and-flowers; however, his chief claim to fame is as a teacher of Matsumura Goshun. **Bib.:** Paine (1).

¹酔月 ²大西酔月 ³希胆

Suikei[1] (1780–1833). *N.:* Komatsubara Tei.[2] *A.:* Kakudai.[3] *F.N.:* Sadashirō.[4] *Gō:* Kikoan,[5] Suikei.[6] **Biog.:** Painter. Born in Wakasa Province. Son of a Confucian scholar in the service of the daimyo of Wakasa. Specialized in figures, painting very much in the Chinese manner. **Coll.:** Museum (3). **Bib.:** Holloway, Mitchell.

¹翠渓 ²小松原貞 ³廓大 ⁴貞四郎 ⁵希虎菴 ⁶翠渓

Suiko[1] (fl. 1827–59). *N.:* Komatsubara Seibi.[2] *A.:* Gyōgen.[3] *Gō:* Kitōan,[4] Suiko.[5] **Biog.:** Painter. Born in Edo. Son of Komatsubara Suikei. Painted figures, grasses, flowers. **Coll.:** Ashmolean, Victoria. **Bib.:** Mitchell.

¹翠湖 ²小松原誠美 ³行源 ⁴希唐菴 ⁵翠湖

Suiō[1] (fl. c. 1680–1730). *N.:* Tamura Suiō.[2] *Gō:* Bōkanshi.[3] **Biog.:** Ukiyo-e painter. Worked in Kyōto. Pupil of Hanabusa Itchō, from whom he got the Kanō elements in his style. A painter of considerable charm; specialized in painting *bijin*, but also did genre scenes. Work very rare. Mature style resembles that of Hishikawa Moronobu, but more elegant; there is also some Tosa influence in his painting. **Coll.:** Art (1a), Freer, Idemitsu, Nelson, Victoria. **Bib.:** Fujikake (3) 2; Hillier (1); *Japanese* (1a); K 44, 126, 142, 413, 435, 729; Narazaki (3); *Nikuhitsu* (1) 1; OA 13; Shimada 3; Stern (4); UG 17, 28.

¹水鴎 ²田村水鴎 ³卯観子

Suiō[1] (1716–89). *Priest name:* Genro Eiboku.[2] *Posthumous names:* Kōei,[3] Myōken,[4] Zenji.[5] *Gō:* Suiō.[6] **Biog.:** *Zenga* painter. Priest of the Rinzai sect. Born in Kōzuke Province. First studied painting under Ikeno Taiga. In 1746 to Hara (Shizuoka-ken) as Hakuin's pupil at the Shōin-ji, became his disciple and senior pupil looking after his master's affairs. After Hakuin's death, became abbot of the Shōin-ji. His work has many of the eccentricities of late Zen painting, with all its apparent tongue-in-cheek manner of depicting religious subjects, but it lacks the forcefulness of his master's style and is more conventional. **Coll.:** Fogg. **Bib.:** *Au-delà*, Awakawa, BO 100, Brasch (2), *Japanische* (1), M 166, NB (S) 47.

¹遂翁（酔翁） ²元盧慧牧 ³宏慧 ⁴妙顕 ⁵禅師 ⁶遂翁（酔翁）

Suiun[1] (fl. c. 1840). *N.:* Yamamoto Kōei.[2] *A.:* Sōan.[3] *F.N.:* Yaso.[4] *Gō:* Suiun.[5] **Biog.:** Painter. Lived in Edo. Known for her *sumi-e* of plum blossoms. **Bib.:** Mitchell.

¹翠雲 ²山本江英 ³痩庵 ⁴屋蘇 ⁵翠雲

Sūjiku[1] (fl. end of Muromachi period). **Biog.:** Muromachi *suiboku* painter. In the past it has been customary to attribute all colored *kachō* paintings of the Muromachi age to Oguri Sōtan even when one such painting had a seal reading "Sūjiku"; it has now been suggested that Sūjiku is not the same artist as Sōtan and worked considerably later. **Bib.:** M 166.

¹崇竺

Sūkaku[1] (fl. c. 1840). *N.:* Sakurai Sojun.[2] *A.:* Reikei.[3] *Gō:* Seikinsha,[4] Sūkaku.[5] **Biog.:** Painter. Born in Edo. First studied the Kanō style; later followed the manner of Hanabusa Itchō. **Bib.:** Mitchell.

¹嵩鶴 ²桜井素絢 ³礼卿 ⁴清筠舎 ⁵嵩鶴

Sukehiko[1] (1823–83). *N.:* Okamoto (originally Oguri)[2] Chō.[3] *A.:* Shirō.[4] *F.N.:* Shiba.[5] *Gō:* Gyōsuien,[6] Hansei,[7] Sukehiko.[8] **Biog.:** Shijō painter. Son of a samurai. To Kyōto to study painting under Okamoto Toyohiko, taking the name

of Okamoto on his teacher's death. Spent his last years in travel. Painter of landscapes and *kachōga*. **Coll.:** Imperial (1), Victoria. **Bib.:** Mitchell.

¹亮彦 ²小栗 ³岡本澄 ⁴子朗
⁵司馬 ⁶暁翠園 ⁷畔生 ⁸亮彦

Sūkei[1] (1762–1817). *N.:* Kō Yoshinobu.[2] *Gō:* Sūkei,[3] Suiunshi.[4] **Biog.:** Hanabusa painter. Adopted son and pupil of Kō Sūkoku. Painted a great many *ema*. **Bib.:** Morrison 1; Tajima (7) 5, (12) 17.

¹嵩渓 ²高宜信 ³嵩渓 ⁴睡雲子

Sukenobu[1] (1671–1751). *N.:* Nishikawa (originally Fujiwara)[2] Sukenobu.[3] *F.N.:* Magoemon,[4] Ukyō,[5] Yūsuke.[6] *Gō:* Bunkadō,[7] Jitokusai,[8] Jitokusō.[9] **Biog.:** Ukiyo-e painter, printmaker, illustrator. Born and lived in Kyōto. First a pupil of Kanō Einō (or of his son, Kanō Eikei); then studied under Tosa Mitsusuke; finally turned to ukiyo-e, studying the work of Yoshida Hambei. An important member of the Kyōto ukiyo-e school, enjoying a great reputation in his lifetime. An immense output, consisting almost entirely of fine illustrated books and albums published in Ōsaka and Kyōto from 1710 until his death; also produced a number of paintings and a few prints. His everyday scenes of *bijin* are all done with the delicacy and quiet grace typical of the Kyōto ukiyo-e. His books also illustrate historical scenes and legendary events. **Coll.:** Albertina, Allen, Andrew, Art (1), Ashmolean, Atami, British, Cincinnati, Fogg, Freer, Honolulu, Idemitsu, Kanagawa, Metropolitan, Minneapolis, Musée (1), Musées, Museum (3), Newark, Östasiatiska, Philadelphia, Portland, Rhode Island, Rietberg, Staatliche, Suntory, Tōkyō (1), Victoria, Worcester, Yale. **Bib.:** Binyon (1), (3); Boller; Brown; Crighton; Fujikake (3) 2; Gunsaulus (1); Hillier (1), (4) 1, (7), (9); Jenkins; K 37, 75, 480, 515, 728, 870, 961; Keyes; KO 30; Kondō (2); *Kunst;* Lane; M 70; Michener (3); Morrison 2; Narazaki (3); NHBZ 2; *Nikuhitsu* (1) 2; OA 13; *One* (2); SBZ 9; Schmidt; Shimada 3; Stern (4); Tajima (7) 5, (13) 6; Takahashi (2), (5); UG 2, 28; *Ukiyo-e* (3) 4; Waterhouse.

¹祐信 ²藤原 ³西川祐信 ⁴孫右衛門 ⁵右京
⁶祐助 ⁷文華堂 ⁸自得斎 ⁹自得叟

Suketada[1] (1706–62). *N.:* Nishikawa Suketada.[2] *F.N.:* Sukezō (Yūzō).[3] *Gō:* Bunseidō,[4] Suketada,[5] Tokuyūsai.[6] **Biog.:** Ukiyo-e painter. Son and pupil of Nishikawa Sukenobu. A much less able artist than his father, he is really of little significance as a painter. **Coll.:** Staatliche. **Bib.:** Schmidt.

¹祐尹 ²西川祐尹 ³祐蔵 ⁴文生堂 ⁵祐尹 ⁶得祐斎

Sukeyasu[1] (fl. c. 1500). *N.:* Kaida Sukeyasu.[2] *F.N.:* Unemenosuke.[3] **Biog.:** Tosa painter. Famous as the artist of the scroll *Saigyō Monogatari,* which has disappeared but which is known from a copy made by Sōtatsu. **Bib.:** K 76, Morrison 1.

¹相保 ²海田相保 ³采女祐

Sūkoku[1] (1730–1804). *N.:* Kō (originally Takaku or Takahisa)[2] Kazuo.[3] *A.:* Shiei.[4] *Gō:* Korensha,[5] Rakushisai,[6] Suiundō,[7] Sūkoku,[8] Toryūō.[9] **Biog.:** Painter. Lived in Edo. Pupil (and perhaps son) of Sawaki Sūshi, a follower of Hanabusa Itchō; later studied the technique of Tan'yū. Specialized in pictures illustrating quasi-historical or legendary tales as well as the manners and customs of townspeople. His style a mixture of Kanō and ukiyo-e; quite the best follower of Itchō. **Coll.:** Museum (3), Sensō-ji, Suntory. **Bib.:** Hillier (4) 3; K 80, 155, 523, 662, 843; Mitchell, Tajima (7) 5.

¹嵩谷 ²高久 ³高一雄 ⁴子盈 ⁵湖蓮舎
⁶楽只斎 ⁷翠雲堂 ⁸嵩谷 ⁹屠竜翁

Sūryō[1] (1800–1875). *N.:* Kō Sūryō.[2] *Gō:* Sūryō;[3] later, Sūkoku.[4] **Biog.:** Hanabusa painter. Born in Edo; son and pupil of Kō Sūkei. Moved to Ōsaka. Not to be confused with his grandfather Kō Sūkoku, who also used the *gō* Sūkoku.[5]

¹嵩嶜 ²高嵩嶜 ³嵩嶜 ⁴嵩谷 ⁵嵩谷

Sūsetsu[1] (1736–1804). *N.:* Sawaki Kuraji.[2] *Gō:* Chūgakusai,[3]

Kanta,[4] Suiundō,[5] Sūsetsu,[6] Yoshirō.[7] **Biog.:** Kanō painter. Son of Sawaki Sūshi. An able painter of *kachōga,* landscapes, portraits. **Coll.:** Museum (3). **Bib.:** Paine (2) 1.

¹嵩雪 ²佐脇倉治 ³中岳斎 ⁴貫多
⁵翠雲堂 ⁶嵩雪 ⁷仔止楼

Sūshi[1] (1707–72). *N.:* Sawaki (sometimes Sa)[2] Sūshi[3] (originally Michikata).[4] *A.* Shigaku.[5] *F.N.:* Jinnai,[6] Jinzō.[7] *Gō:* Chūgakudō,[8] Dōken,[9] Issuisai,[10] Kōkōkan,[11] Shunsōō,[12] Tōshuku,[13] Yūkōtei.[14] **Biog.:** Kanō painter. Father of Sawaki Sūsetsu. Studied under Hanabusa Itchō, which seems to be his only claim to fame.

¹嵩之 ²佐 ³佐脇嵩之 ⁴道賢 ⁵子岳 (子嶽)
⁶甚内 ⁷甚蔵 ⁸中岳堂 ⁹道賢 ¹⁰一翠斎
¹¹杲々観 ¹²春窓翁 ¹³東宿 ¹⁴幽篁亭

Susumu[1] (fl. late 19th c.). *N.:* Yoshikawa Susumu.[2] **Biog.:** Painter. Lived and worked in Ōsaka. Illustrator of Ōsaka scenes in a part Western, part Japanese manner. **Coll.:** Temman-gū.

¹進 ²吉川進

Suteyuki[1] (fl. c. 1810). *N.:* Fukuhara Suteyuki.[2] *A.:* Kyosen.[3] *Gō:* Tōgaku.[4] **Biog.:** Painter. Native of Ōsaka. Specialized in figure painting. **Coll.:** Ashmolean. **Bib.:** Mitchell.

¹棄之 ²福原棄之 ³挙舳 ⁴東岳

Suwa Kanenori[1] (1897–1932). **Biog.:** Western-style printmaker. Produced a few poetic prints. **Bib.:** UG 14.

¹諏訪兼紀

Suwa Sozan[1] (1852–1922). *N.:* Suwa Yoshitake.[2] *Gō:* Sozan.[3] **Biog.:** Potter. Born in Kanazawa. Studied ceramics with Saiunrō Kyokuzan. After working in Tōkyō, returned to his native town to improve pottery making there and took over the direction of the industrial school. In 1900 moved to Kyōto, working first at the Kinkōzan kiln in the Awata district and then at his own kiln in Gojōzaka. About 1912 began studying Korean ceramics of the Koryŏ period, making frequent trips to Korea. Member of the Imperial Fine Arts Academy. His work quite varied; includes Kutani ware and pieces inspired by Chinese Ting ware and Korean Koryŏ ware. **Bib.:** NB (S) 41; NBZ 6, Uyeno.

¹諏訪蘇山 ²諏訪好武 ³蘇山

Suzuki Chikuma[1] (1894–). **Biog.:** Western-style painter. Born in Fukui-ken. Graduated from Tōkyō School of Fine Arts in 1921. Showed at the sixth and seventh Teiten exhibitions, receiving highest honors, and with the Nitten. Studied in Europe for two years. Member of the 1930 Association, the Kōfūkai and the Nitten. Helped organize the Sōgenkai. In 1957 won the Japan Academy Prize. His style a subjective, simplified expressionsim. **Coll.:** National (5). **Bib.:** Asano, NBZ 6.

¹鈴木千久馬

Suzuki Kason[1] (1860–1919). *N.:* Suzuki Sōtarō.[2] *Gō:* Kason.[3] **Biog.:** Japanese-style painter. Born in Edo. First studied the Maruyama style, then the Tosa and ukiyo-e styles; remained basically true to his early Maruyama training. Received a prize at the first Bunten exhibition, an honorable mention at the third. Member of the Imperial Fine Arts Academy. Good at *kachōga* and landscapes. **Coll.:** Itsuō, Museum (3), Victoria. **Bib.:** Asano, Mitchell, Morrison 2, Uyeno.

¹鈴木華邨 ²鈴木惣太郎 ³華邨

Suzuki Kimpei[1] (1896–). **Biog.:** Western-style painter. Born in Mie-ken. In 1911 entered the Hakubakai, studying under Kuroda Seiki. The next year joined the Fusainkai. Also studied under Nakamura Tsune. Showed with the Taiheiyō Gakai, the kofūkai and the Bunten. In 1923 joined the Ōgensha and, after 1945, served as a juror for this organization. **Bib.:** Asano.

¹鈴木金平

Suzuki Makoto[1] (1897–1969). **Biog.:** Western-style painter. On graduating from Tōkyō School of Fine Arts in 1922, went to France, where he stayed until 1927, studying under

Derain and others. On his return to Japan, exhibited with the Kōfūkai and the Teiten. In 1936 helped establish the Shinseisaku Kyōkai. His style shows the influence of the School of Paris of the 20s. **Bib.:** Asano.

¹鈴木誠

Suzuki Shintarō¹ (1895–). **Biog.:** Western-style painter. Born in Tōkyō. Studied at the Hakubakai; pupil of Kuroda Seiki and Ishii Hakutei. First exhibited with the Bunten; later became a member of the Nikakai. In 1955 helped found the Ichiyōkai. Won the Japan Art Academy Prize in 1959. His painting done in a straightforward objective manner. **Coll.:** National (5). **Bib.:** Asano, NBT 10.

¹鈴木信太郎

Suzuki Shōnen¹ (1849–1918). **N.:** Suzuki Shōnen.² **F.N.:** Hyakutarō.³ **Gō:** Hyakusen.⁴ **Biog.:** Japanese-style painter. Born and lived in Kyōto. Son and pupil of Suzuki Hyakunen; also studied at the Kyōto Prefectural School of Painting, where he began to teach in 1886. Specialized in landscapes and *kachōga*. Painted the rather mediocre dragons in the main building of the Tenryū-ji, Kyōto, and landscape screens

of considerable charm in the Ryōgen-in of the Daitoku-ji. **Coll.:** Ashmolean, British, Daitoku-ji (Ryōgen-in), Honolulu, Sanzen-in, Tenryū-ji, Victoria. **Bib.:** Asano, Brown, Mitchell, Morrison 2, NB (S) 17, NBZ 6.

¹鈴木松年 ²鈴木松年 ³百太郎 ⁴百僊

Suzuki Tsugio¹ (1894–). **Biog.:** Western-style painter. Graduated in 1921 from the Tōkyō School of Fine Arts. While still a student, showed with the Nikakai and became a member in 1928. Also exhibited with the 1930 Association. A founding member of the Dokuritsu Bijutsu Kyōkai. **Bib.:** Asano, NBZ 6.

¹鈴木亜夫

Suzuki Yasunori¹ (1891–). **Biog.:** Western-style painter. Born in Tōkyō. Graduated from the Tōkyō School of Fine Arts in 1916. Studied under Kuroda Seiki and Fujishima Takeji. Exhibitor and prize winner at the Nikakai; a founding member and constant exhibitor at the Dokuritsu Bijutsu Kyōkai. His style tends toward expressionism. **Bib.:** Asano, NBZ 6.

¹鈴木保徳

T

Tachika Chikuson¹ (1864–1922). **N.:** Tachika Iwahiko.² **Gō:** Chikuson.³ **Biog.:** *Nanga* painter. Born in Ōita-ken. At 18 to Kyōto where he studied with Tanomura Chokunyū. Graduated from the Kyōto Prefectural School of Painting. Won honorable mention at the Naikoku Kangyō Hakurankai. Also won prizes at the early Bunten shows. Exhibited with the Teiten. An important member of Kyōto art circles and a founding member of the Nihon Nangain. **Bib.:** Asano.

¹田近竹邨 ²田近岩彦 ³竹邨

Tadakuni¹ (1757–1830). **N.:** Tashiro Kunitsuna.² **Gō:** Kindai Sanjin,³ Shunjūan,⁴ Tadakuni,⁵ Ummu.⁶ **Biog.:** *Yōga* painter. Born in Akita, a samurai of the Satake family. His painting shows a close connection with the *yōga* school of Akita. **Coll.:** Kōbe. **Bib.:** GNB 25, *Pictorial* (2) 2.

¹忠国 ²田代国綱 ³金台山人 ⁴春秋庵 ⁵忠国 ⁶雲夢

Tadamitsu¹ (fl. 1716–35). **N.:** Kōami Tadamitsu.² **Biog.:** Lacquerer. A minor member of the Kōami family. Skilled at decorating *inrō*. **Bib.:** Herberts, Jahss.

¹忠光 ²幸阿弥忠光

Tadanaga¹ (fl. c. 1250). **N.:** Kose no Tadanaga.² **Biog.:** Kose painter. Son of Kose no Ryūkei. So far, known only from the Kose genealogy.

¹忠長 ²巨勢忠長

Taguchi Seigo¹ (1897–1943). **Biog.:** Western-style painter. Born in Akita-ken; son of the literary and art critic Kikutei. In 1921 graduated from Tōkyō School of Fine Arts. Pupil of Ishii Hakutei and Yasui Sōtarō. From 1929 to 1932 in France. Member of Nikakai, exhibitor with the Teiten. Lecturer at the Tōkyō School of Fine Arts. **Bib.:** Asano.

¹田口省吾

Taiga¹ (1723–76). **N.:** Ikeno Mumei² (or Tsutomu).³ **A.:** Taisei.⁴ **F.N.:** Shūhei.⁵ **Gō:** Chikukyo,⁶ Fukochōsō,⁷ Gyokukai,⁸ Ike Taiga (Ikeno Taiga),⁹ Kashō,¹⁰ Kyūka Sanshō,¹¹ Sangaku Dōja,¹² Taiga,¹³ Taigadō,¹⁴ Taikadō.¹⁵ **Note:** This is only a selection of the more common *gō*. There are some 113 known seals and *gō*, all of which can be found in the supplement of Tanaka Ichimatsu's *Ikeno Taiga Gafu*. **Biog.:** *Nanga* painter, calligrapher. Born and lived in Kyōto. In 1742 took name of Taiga; in 1746 married the painter Gyokuran. First studied Tosa painting, but was soon drawn to the *nanga* school; studied with Yanagisawa Kien and Sakaki Hyakusen, learning finger painting. About 1750 studied Chinese painting in Edo; was obviously familiar with the *Mustard-Seed Garden*, the manual for all *bunjinga* artists. Also a student of Zen and calligraphy: a disciple of

Hakuin, a collaborator of Buson. An independent man disregarding family ties and obligations to superiors, traveled all over Japan between 1748 and 1760, depicting Fuji, Hakusan, Tateyama, and other mountains of central Japan. A prolific artist, famous in his lifetime and a great favorite of writers for the *Kokka*. First painted in the Rimpa manner; about 1750 his style became quite *nanga*. About 1755 worked in small scale; a few years later increased the size of his paintings. Best work from 1759 to 1765. A gay, witty, daring, inventive painter. Although a *nanga* artist, did many paintings of actual places. The *Taigadō Gahō*, a compendium of his painting methods, was published in woodblock-print form after his death. **Coll.:** Art (1), (1a); Ashmolean; Atami; British; Brooklyn; Cleveland; Fogg; Freer; Henjōkō-in; Honolulu; Idemitsu; Ikeno; Kotohira; Mampuku-ji; Metropolitan; Museum (3); Newark; Philadelphia; Rhode Island; Seattle; Stanford; Suntory; Tenrin-ji; Tōkyō (1), (2); Umezawa; University (2). **Bib.:** *Art* (1a); BI 9, 34; BK 41, 49, 50, 51, 57, 73, 89, 94, 99, 113, 134, 163, 197, 201; Brown; Cahill; *Cent-cinquante;* Covell (1); *Exhibition* (1); Fontein (1); *Freer;* GK 12; GNB 18; Grilli (1); Holloway; *Japanese* (1a); K 116, 150, 156, 179, 216, 271, 296, 330, 339, 344, 361, 367, 381, 392, 486, 515, 522, 528, 540, 553, 571, 582, 587, 646, 653, 666, 685, 698, 702, 706, 709, 710, 721, 723, 728, 729, 756, 762, 766, 767, 780, 795, 799, 802, 803, 804, 811, 817, 821, 822, 828, 831, 838, 840, 842, 844, 846, 852, 853, 857, 864, 866, 880, 884, 938; KO 2, 20, 39; *Kokuhō* 6; Kosugi; Lee (1); M 30, 41, 75, 117, 175, 208; Matsushita Hidemaro; Mayuyama; Mitchell; Moriya; Morrison 2; Murayama (2); *National* (1); NB (H) 23, 24; NB (S) 4; NBT 5; NBZ 5; *Nihon* (3), (4), (5); NKZ 33, 64, 68, 73, 84; Noma (1) 2; OA 13; *One* (2); Paine (2) 2, (4); Rosenfield (2); SBZ 10; Shimada 2; Suzuki (8); Tajima (9) 1, (13) 7; Tanaka (6); Umezawa (2); YB 24; Yonezawa; Yoshizawa (4).

¹大雅 ²池野無名 ³勤 ⁴貸成 ⁵秋平 ⁶竹居
⁷鳧潗釣叟 ⁸玉海 ⁹池大雅 ¹⁰霞樵 ¹¹九霞山樵
¹²三岳道者 ¹³大雅 ¹⁴大雅堂 ¹⁵待賈堂

Taigaku¹ (fl. first half 19th c.). **N.:** Endō Han'emon.² **Gō:** Keisai,³ Taigaku,⁴ Unkaku.⁵ **Biog.:** Ukiyo-e printmaker. Pupil of Hokusai. **Coll.:** Rhode Island, Victoria, Worcester. **Bib.:** Ficke.

¹戴岳 ²遠藤半右衛門 ³渓斎 ⁴戴岳 ⁵雲鶴

Taigan¹ (1773–1850). *Priest name:* Taigan.² **Gō:** Kōsetsu,³ Senkōjin,⁴ Unge,⁵ Ungein.⁶ **Biog.:** *Nanga* painter. Born in Bizen. To Kyōto, where he studied Confucianism. Taught

for a while at the Takakura Gakuryō (College of Confucianism) in Kyōto. Attached as a priest to the Mantoku-ji, Ōita-ken, which belongs to the Higashi Hongan-ji, Kyōto. Friend of Tanomura Chikuden. An amateur painter and grower of orchids; specialized in painting bamboo and orchids. **Coll.**: University (2). **Bib.**: K 679.

¹大含　²大含　³鴻雪　⁴染香人　⁵雲華　⁶雲華院

Taihō (Daihō)¹ (1813–73). *N.*: Takemura Toku.² *Gō*: Taihō (Daihō).³ **Biog.**: Shijō painter. Born in Yamashiro Province. To Kyōto to study under Keibun. Skilled at *kachōga*. **Bib.**: Mitchell.

¹大鳳　²竹村徳　³大鳳

Taiitsu¹ (1804–81). *N.*: Murase Taiichi² (originally Rei).³ *Gō*: Taiitsu.⁴ **Biog.**: Japanese-style painter. Came from Gifu-ken to Kyōto to join the circle of Rai San'yō. Then to Nagoya, where he established a private school. Largely self-taught as a painter. **Bib.**: K 928.

¹太乙　²村瀬泰一　³黎　⁴太乙

Tairō¹ (fl. beginning 19th c.). *N.*: Ishikawa Tairō.² *F.N.*: Shichizaemon.³ *Gō*: Jōka,⁴ Kunshōken.⁵ **Biog.**: Kanō-*yōga* painter. A minor official of the shogunate and a member of Dr. Siebold's circle in Nagasaki. Copied foreign prints. An artist of no great talent. **Coll.**: Kōbe. **Bib.**: GNB 25; M 187, 227, 228, 268; Mody; *Pictorial* (2) 2.

¹大浪　²石川大浪　³七左衛門　⁴乗加　⁵薫窣軒

Taito II¹ (fl. 1810–53). *N.*: Katsushika (originally Fujiwara,² then Kondō)³ Fumio.⁴ *F.N.*: Ban'emon,⁵ Kisaburō.⁶ *Gō*: Beikasai,⁷ Beika Dōjin,⁸ Beika Sanjin,⁹ Dōteisha,¹⁰ Genryūsai,¹¹ Hokusen,¹² Shōzan,¹³ Taito,¹⁴ Toenrō.¹⁵ **Biog.**: Ukiyo-e painter, printmaker, illustrator. Born in Edo of a samurai family from Kyūshū. Pupil of Katsushika Hokusai, who in 1820 gave him his own *gō* Taito; from that date signed his work Katsushika Taito or Genryūsai Taito. Collaborated with Hokusai on the second volume of the *Manga*, which appeared in 1815 (at which time he was known as Toenrō Hokusen).¹⁶ Lived and worked in Edo from 1830 to 1843 and in Ōsaka from 1843 to 1853. Prolific book illustrator. At one point, forged Hokusai's signature on some of his own designs; was found out and called Inu Hokusai (Dog Hokusai). Also known as Ōsaka Hokusai. Not much of an artist, though his painting is an able imitation of that of his master. **Coll.**: Ashmolean, British, Brooklyn, Fogg, Museum (3), Portland, Rhode Island, Staatliche, Victoria, Worcester. **Bib.**: Binyon (1), (3); Brown; Crighton; Hillier (4) 2, (5), (7); Keyes; Morrison 2; Schmidt; Strange (2).

¹戴斗二代　²藤原　³近藤　⁴葛飾文雄
⁵伴右衛門　⁶喜三郎　⁷米華斎　⁸米華同人
⁹米華山人　¹⁰洞庭舎　¹¹玄竜斎　¹²北泉
¹³昇山　¹⁴戴斗　¹⁵斗円楼　¹⁶斗円楼北泉

Taizan (Daizan)¹ (1751–1813). *N.*: Hirose Seifū.² *A.*: Bokuhō.³ *F.N.*: Katsuhachi,⁴ Shūzō⁵ (originally Gitarō),⁶ Undayū.⁷ *Gō*: Hakuunka,⁸ Rokumusai,⁹ Shogasai,¹⁰ Taizan (Daizan).¹¹ **Biog.**: *Nanga* painter. A feudal retainer to the Tsuyama fief. Held an official position in Ōsaka, later in Edo. Finally resigned and devoted himself to traveling and painting. Studied the *nanga* style under Fukuhara Gogaku; also Chinese Sung, Yüan, and Ming paintings. **Coll.**: Ashmolean. **Bib.**: K 338, 569, 578, 665; Mitchell; NB (S) 4; Umezawa (2).

¹台山　²広瀬清風　³穆甫　⁴勝八　⁵蔵蔵　⁶義太郎
⁷雲太夫　⁸白雲窩　⁹六無斎　¹⁰書画斎　¹¹台山

Taizan¹ (1813–69). *N.*: Hineno (or Hine)² Morinaga.³ *A.*: Seigen,⁴ Shōnen.⁵ *Gō*: Bōkai (Chikai),⁶ Dōrakuen,⁷ Kinrinshi,⁸ Taizan.⁹ **Biog.**: *Nanga* painter. Born in Hine village, near Ōsaka; lived in Kyōto. Studied calligraphy and probably painting under Nukina Kaioku; also copied the *nanga* style of Hidaka Tetsuō. A well-known figure in *nanga* circles in the Kansai region. Excellent landscape painter, working in a rather tight, precise manner. **Coll.**: Ashmolean, Brooklyn, Royal (1), Stanford, Tōkyō (2), University (2).

Bib.: Asano; Brown; *Japanische* (2); K 337, 358, 929; Mitchell; Morrison 2; NBZ 6; Tajima (12) 15, 18; Tajima (13) 7; Umezawa (2); Uyeno.

¹対山　²日根　³日根野盛長　⁴成言　⁵小年
⁶茅海　⁷同楽園　⁸錦林子　⁹対山

Taizan¹ (fl. mid-19th c.). *N.*: Takahashi Yohei.² *Gō*: Taizan.³ **Biog.**: Potter. Head of ninth and last generation of the Takahashi family of Awata potters. The first generation worked from c. 1673 to c. 1680. The family specialized in tea utensils, blue-glazed pottery, porcelains with celadon glazes, and pottery with overglaze enamels. This artist, with Kinkōzan IV, started the exportation of their products in 1872. **Coll.**: Tōkyō (1). **Bib.**: Jenyns (2).

¹帯山　²高橋与兵衛　³帯山

Tajirō¹ (fl. late 19th c.). *N.*: Igarashi Tajirō.² **Biog.**: Lacquerer. Worked in Kanazawa, specializing in Kaga-makie. **Bib.**: NBZ 6, Ragué.

¹他次郎　²五十嵐他次郎

Takaaki¹ (?–1351). *N.*: Fujiwara no Takaaki.² *Priest name*: Kakuchi.³ **Biog.**: *Yamato-e* painter. Served the Gion Shrine as a painter. One of two artists (the other, Takamasa) of the *Boki Ekotoba*, dated 1351, owned by the Nishi Hongan-ji, Kyōto. **Coll.**: Nishi Hongan-ji. **Bib.**: *Chūsei, Muromachi* (1), NBT 4, Okudaira (1), YB 48.

¹隆章　²藤原隆章　³覚智

Takabatake (Takahata) Tatsushirō¹ (1895–). **Biog.**: Western-style painter. Born in Tōkyō. Studied first at Keio University; then, from 1921 to 1927, in Paris, where he showed at the Salon d'Automne. A member of the Kokugakai and founding member of the Dokuritsu Bijutsu Kyōkai. In 1951 won the Mainichi Art Prize. Again in Europe from 1954 to 1955. His work shows the influence of the School of Paris, with certain naive touches. **Coll.**: Kanagawa, National (5). **Bib.**: Asano, NB (H) 24, NBT 10, NBZ 6.

¹高畠達四郎

Takachika¹ (fl. mid-12th c.). *N.*: Fujiwara no Takanari (Takashige).² *Gō*: Kasuga,³ Takachika.⁴ **Biog.**: *Yamato-e* painter. Son of Fujiwara no Takayoshi. Recorded as being a painter, but his life, except for his nominal court positions, and his works are unknown.

¹隆親　²藤原隆成　³春日　⁴隆親

Takagi Yasunosuke¹ (1891–1941). **Biog.**: Japanese-style painter. Born in Tōkyō. First studied under Kawabata Gyokushō at his school, the Kawabata Gagakkō. Later graduated from the extension course of the Japanese-painting division of the Tōkyō School of Fine Arts, having studied under Matsuoka Eikyū. Member of Shinkō Yamato-e-kai. Showed with the Bunten, the Teiten, the Kokugain and the Nihongain. **Bib.**: Asano.

¹高木保之助

Takahashi Genkichi¹ (1861–1913). *N.*: Takahashi (originally Yanagi)² Genkichi.³ **Biog.**: Western-style painter. Adopted son and pupil of Takahashi Yuichi. Studied under Antonio Fontanesi at the Kōbu Daigaku Bijutsu Gakkō. In 1884 joined the Jūichikai. Helped establish the Meiji Bijutsukai. After considerable activity in early Meiji era, retired from all art circles and traveled around Japan, dying in Miyagi-ken while on a trip. **Bib.**: Asano, BK 188, NB (H) 24, NBZ 6.

¹高橋源吉　²柳　³高橋源吉

Takahashi Hiroaki¹ (1871–1944). *N.*: Takahashi.² *F.N.*: Katsutarō.³ *Gō*: Hiroaki,⁴ Shōtei.⁵ **Biog.**: Japanese-style painter, printmaker. Born in Tōkyō in the house of his uncle the painter Matsumoto Fūko, under whom he trained as a painter. Made illustrations for scientific textbooks, magazines, and newspapers and, after 1907, prints, chiefly of temples, for export to Europe and America. His early *gō* was Shōtei; after 1921 used the *gō* of Hiroaki. The blocks for his prints were destroyed in the great earthquake of 1923. **Bib.**: Fujikake (1), Schmidt.

¹高橋弘明　²高橋　³勝太郎　⁴弘明　⁵松亭

Takahashi Kōko[1] (1875–1912). *N.:* Takahashi (originally Urata)[2] Kyūma.[3] *Gō:* Kōko.[4] **Biog.:** Japanese-style painter. Born in Kumamoto-ken. First studied the Unkoku manner, then the *nanga* style. Moved to Tōkyō and studied under Matsumoto Fūko. Specialized in historical subjects, rendered in a modified *yamato-e* manner. **Coll.:** Los Angeles. **Bib.:** Asano, Lane, NBZ 6, Uyeno.

¹高橋広湖 ²浦田 ³高橋久馬 ⁴広湖

Takahashi Shūsō[1] (1900–1964). **Biog.:** Japanese-style painter. Born in Aichi-ken. In 1921 became a pupil of Hayami Gyoshū. After years of hardship, a painting of his was accepted for exhibition by the Inten in 1928; from then on, an almost constant exhibitor. In 1948 resigned from the Inten and, in 1951, joined the Shinseisaku Kyōkai. A typical Japanese-style painter of the recent past.

¹高橋周桑

Takahashi Yuichi[1] (1828–94). *N.:* Takahashi Yuichi.[2] *Gō:* Kain Itsujin,[3] Ransen.[4] **Biog.:** Western-style painter. Born and worked in Edo. Studied in the painting department of the Bansho Shirabesho (later the Kaiseijo, or European Culture Research Institute) under Kawakami Tōgai and also under Charles Wirgman and Antonio Fontanesi. To Shanghai to meet the Western painters living there. Exhibited at the 1867 Paris Exposition, the 1872 World's Fair in Vienna, the Japan Fair in 1877, the Paris Fair of 1878. In 1870 became professor at the Daigaku Nankō (Ministry of Public Instruction's School of Higher Learning); in 1873 resigned and founded his own art school, Tenkai Gakusha, which had a great success. Among his pupils was Harada Naojirō. Member of Hakubakai. In 1880 started publication of the first art magazine known in Japan. Frequently painted Tōkyō scenes. An important Western-style artist of the early Meiji era. Also worked in water colors. His portraits and landscapes in the European academic style of the period are competent. **Coll.:** National (5); Tōkyō (1), (2). **Bib.:** Asano; BK 59, 160, 206; Elisséev; Harada Minoru; K 786; Kurashina (2); M 133, 203; NB (H) 24; NB (S) 30; NBT 10; NBZ 6; NHBZ 7; SBZ 11; Sullivan; Uyeno.

¹高橋由一 ²高橋由一 ³華陰逸人 ⁴籃川

Takai Hakuyō[1] (1895–1951). **Biog.:** Lacquerer. Worked in a traditional style. A well-known modern lacquerer. **Bib.:** NBZ 6, Yoshino.

¹高井白楊

Takakane[1] (fl. 1309–30). *N.:* Takashina (originally Tosa[2] or Kasuga)[3] Takakane.[4] **Biog.:** *Yamato-e* painter. May have been a son of Tosa Kunitaka. Served as Edokoro *azukari.* Painted the twenty scrolls of the *Kasuga Gongen Genki-e,* dated 1309 and dedicated to the Kasuga Shrine, now in the Imperial Household Agency Collection. The first three scrolls of the *Ishiyama-dera Engi* at the Ishiyama-dera are attributed to him, as are those of the *Hossō-shū Hiji Ekotoba* and a section of the *Genjō Sanzō Emaki* at the Fujita Museum. The Kasuga scrolls show him to be an accurate, charming, gay, entertaining, but hardly impressive illustrator of indoor and outdoor scenes, following in the main the traditional style in his court scenes, but with more animation in the facial expressions. **Coll.:** Fujita, Ishiyama-dera. **Bib.:** Akiyama (2); Ienaga; K 31, 164, 241; Morrison 1; NEZ 14, 15, 22; NKZ 64; Okudaira (1), (1a); *One* (2); SBZ 6; Seckel (2); Tajima (12) 2, 5, 8, 15, 18; Tajima (13) 2; YB 30.

¹隆兼 ²土佐 ³春日 ⁴高階隆兼

Takama Sōshichi[1] (1889–). **Biog.:** Western-style painter. Born in Tōkyō; lived in Yokohama. In 1916 graduated from the Tōkyō School of Fine Arts. Frequent exhibitor and prize winner at the Bunten and Teiten. Later a member of the Dokuritsu Bijutsu Kyōkai. Style quite abstract. **Coll.:** Kanagawa. **Bib.:** Asano, NBZ 6.

¹高間惣七

Takamasa[1] (fl. mid-14th c.). *N.:* Fujiwara no Takamasa.[2] **Biog.:** *Yamato-e* painter. One of two painters (the other,

Takaaki) of the *Boki Ekotoba,* of 1351, owned by the Nishi Hongan-ji, Kyōto. **Coll.:** Nishi Hongan-ji. **Bib.:** *Chūsei, Muromachi* (1), Okudaira (1), SBZ 7.

¹隆昌 ²藤原隆昌

Takamitsu[1] (fl. early 15th c.). *N.:* Awataguchi Takamitsu.[2] **Biog.:** *Yamato-e* painter. May have been the third son of Tosa Mitsuaki; took his name from the Awataguchi district of Kyōto, in which he lived. One of the artists—together with Rokkaku Jakusai, Tosa Mitsukuni, Tosa Yukihiko, Tosa Eishun, Kasuga Yukihide—whose signatures are on the scroll *Yūzū Nembutsu Engi,* dated 1414, in the Seiryō-ji, Kyōto. Said to have painted the fifth scroll of the *Ishiyama-dera Engi* now in the collection of the Ishiyama-dera, Shiga-ken. Specialized in Buddhist subjects. **Coll.:** Ishiyama-dera, Seiryō-ji. **Bib.:** K 246; Morrison 1; NEZ 22; NKZ 32, 64; Okudaira (1); Tajima (12) 1, 10; Tajima (13) 3.

¹隆光 ²栗田口隆光

Takamitsu[1] (fl. late 18th c.). *N.:* Tatsuke Takamitsu.[2] *Gō:* Kōkyō.[3] **Biog.:** Lacquerer. Well-known *inrō* artist, working in Kyōto. His *inrō* are often large and of unusual shape. Known to have been still active at age of 83. **Bib.:** Herberts, Jahss.

¹高光 ²田付高光 ³工鏡

Takamori[1] (fl. 1356). *N.:* Takashina (originally Fujiwara no)[2] Takamori.[3] **Biog.:** *Yamato-e* painter. Son and pupil of Takashina Takakane. Another vague figure known only from literary sources. Held various nominal governorships.

¹隆盛 ²藤原 ³高階隆盛

Takamori Saigan[1] (1847–1917). *N.:* Takamori Toshi (Bin)[2] (originally Sōnosuke).[3] *A.:* Shinō.[4] *F.N.:* Yūzō.[5] *Gō:* Jichisai,[6] Jikō,[7] Kikuhari Garō,[8] Kyūsenkaku,[9] Mokusui Sanjin,[10] Nirin Sōsha,[11] Saigan,[12] Shakoku Inshi,[13] Shichishō Enshu,[14] Suigan.[15] **Biog.:** *Nanga* painter. Born in Kazusa Province. Pupil of Yamamoto Kinkoku. Studied ancient Chinese and Japanese paintings; great admirer of Yosa Buson. An able painter of *kachōga,* landscapes, and portraits. **Bib.:** Umezawa (2).

¹高森砕巌 ²高森敏 ³宗之助 ⁴子吶 (子訥) ⁵有造 ⁶自知斎 ⁷杂香 ⁸菊梁画楼 ⁹九僊閣 ¹⁰木燧山人 ¹¹二林草舎 ¹²砕巌 ¹³射谷隠士 ¹⁴七松園主 ¹⁵翠嵒

Takamura Kōtarō[1] (1883–1956). **Biog.:** Western-style painter, sculptor. Born in Tōkyō. Son of Takamura Kōun. After graduating from the Tōkyō School of Fine Arts, traveled and studied from 1906 to 1909 in Europe and America. Greatly influenced by the styles of Rodin and Maillol. In 1912, with other artists, organized the Fusainkai. His sculpture reflects the style of Rodin. **Coll.:** Kanagawa, National (5), Tōkyō (2). **Bib.:** Asano; BK 163, 184; GNB 28; M 130; *Masterpieces* (4); NB (H) 24; NBT 2, 10; NBZ 6; SBZ 11; Sullivan.

¹高村光太郎

Takamura Kōun[1] (1852–1934). **Biog.:** Japanese-style sculptor. Born in Asakusa, Tōkyō. Apprenticed to and later adopted by the Buddhist sculptor Takamura Tōun. Began teaching at Tōkyō School of Fine Arts soon after it was established in 1889. A great figure in the sculpture world of the late Meiji era: a juror for the Nitten, member of the Art Committee of the Imperial Household, member of the Imperial Fine Arts Academy. In 1907 helped found the Nihon Chōkokukai. In addition to sculpture in ivory and especially wood, produced a number of monumental bronze portrait statues and, in his last years, a number of Buddhist images. His highly realistic figure *Old Monkey* drew much attention at the Chicago World's Fair in 1893. His style related to the decorative sculpture of Nikkō, but far more realistic. Contributed much to the revival of traditional Japanese wood-carving. **Coll.:** Tōkyō (1). **Bib.:** Asano; GNB 28; M 192, 203; *Masterpieces* (3), (4); NB (H) 24; NBZ 5; Noma (1) 2; SBZ 11; Sullivan; Uyeno.

¹高村光雲

Takamura Shimpu (Shinpu)[1] (1876–1953). **Biog.**: Western-style painter. Born in Nagaoka, worked in Tōkyō. Studied painting under Koyama Shōtarō at the Fudōsha. Exhibited with the Taiheiyō Gakai and became active in its organization. Also showed with the Bunten when it opened in 1907. In Europe from 1914 to 1916; on his return took an active part in the Teiten. His painting is of the academic realistic manner of the European school of the turn of the century, with a trace of romantic historicism. **Coll.**: Nagaoka. **Bib.**: Asano.

<div align="center">[1]高村真夫</div>

Takamura Tōun[1] (?–1879). **Biog.**: Buddhist sculptor. Born in Edo. Pupil of Takahashi Hōun. His adopted son was the well-known sculptor Takamura Kōun. Specialized in Buddhist subjects, particularly in small-size figures that appealed to the Western taste of the time.

<div align="center">[1]高村東雲</div>

Takanari[1] (fl. c. 1360). *N.*: Tosa Takanari.[2] **Biog.**: Painter. A son of Tosa Mitsuaki, but details of his life unknown. The name may also refer to Fujiwara no Takachika, whose given name was Takanari and who lived in the 12th century. **Bib.**: Morrison 1.

<div align="center">[1]隆成　[2]土佐隆成</div>

Takano Shōzan[1] (1889–). **Biog.**: Lacquerer. Born in Kumamoto. Studied at Tōkyō School of Fine Arts under Shirayama Shōsai. Member of the Nitten, juror for the Teikoku Bijutsuin exhibition. Has been designated a Living National Treasure. An expert in *makie*, works in a traditional manner. **Coll.**: National (4), (5). **Bib.**: *Masterpieces* (4), Ragué, SBZ 11, Sugimura, Yoshino.

<div align="center">[1]高野松山</div>

Takanobu[1] (1142–1205). *N.*: Fujiwara no Takanobu.[2] **Biog.**: *Yamato-e* painter. Son of Fujiwara no Tametaka, a courtier. Lived in Kyōto as a court noble. Pupil of Kasuga Takachika. Portraits of Minamoto no Yoritomo, Fujiwara no Mitsuyoshi, and Taira no Shigemori in the Jingo-ji are attributed to him; though there is no positive evidence to support this attribution, the paintings are, at least, of the period. Also famous as a poet. He and his son Nobuzane are considered by Japanese art historians as Japan's greatest portraitists. **Coll.**: Jingo-ji. **Bib.**: Akiyama (2); *Art* (1a), (2); BK 47; *Exhibition* (1); Ienaga; K 162, 230, 248, 280; *Kokuhō* 4; Minamoto (1); Morrison 1; NB (H) 10; NKZ 1; Noma (1) 1; *One* (2); SBZ 6; Tajima (13) 2; *Trésors*.

<div align="center">[1]隆信　[2]藤原隆信</div>

Takanobu[1] (1571–1618). *N.*: Kanō Takanobu.[2] *F.N.*: Ukon.[3] **Biog.**: Kanō painter. Second son and pupil of Kanō Eitoku; father of Tan'yū, Naonobu, and Yasunobu. Lived and worked in Kyōto. Employed in the decoration of the castles and palaces erected at that time, but of such work little remains. Received title of *hōgen*. A good typical artist of Momoyama period; combined traditional Kanō figure style with strong color and sumptuous gold background: a mixture of Kanō and *yamato-e*. **Coll.**: Imperial (1), Museum (3), Nanzen-ji, Ninna-ji, Seattle, Sennyū-ji, Tokugawa. **Bib.**: BK 164, 169; GNB 13; K 31, 371, 653; *Kanō-ha;* Morrison 1; NB (H) 14; NBZ 4; Yamane (1a).

<div align="center">[1]孝信　[2]狩野孝信　[3]右近</div>

Takanobu[1] (fl. c. 1730). *N.*: Kanō (originally Haga)[2] Takanobu.[3] *Gō*: Kyūshin.[4] **Biog.**: Kanō painter. First a pupil of Kanō Gyokuen, then of Kanō Eishuku. **Coll.**: Victoria.

<div align="center">[1]隆信　[2]羽賀　[3]狩野隆信　[4]休真</div>

Takanori[1] (1757–1833). *N.*: Tatsuke Takanori.[2] **Biog.**: Lacquerer. Member of the Tatsuke family. Worked in Edo. Also a talented painter of the Kanō school. Specialized in *inrō*. **Coll.**: Museum (3). **Bib.**: Herberts, Jahss.

<div align="center">[1]孝則　[2]田付孝則</div>

Takashima Hokkai (Hokukai)[1] (1850–1931). *N.*: Takashima Tokuzō.[2] *Gō*: Hokkai (Hokukai).[3] **Biog.**: *Nanga* painter. Born in Yamaguchi-ken. A forester by profession. Studied

painting under Ōba Gakusen. Committee member of Nihon Bijutsu Kyōkai. After 1908 served as juror for the Bunten. Numerous illustrated publications: *Shazan Yoketsu* (Sketches of Mountains), *Ōshū Sansui Kishō* (Famous Scenery in Europe), *Nihon Shokubutsu Tai* (Japanese Plants), *Nihon Sansui Kishō* (Famous Scenery of Japan), *Kaeisen* (Flowers). An excellent landscape artist, particularly in the depiction of mountains. **Coll.**: National (5), Victoria. **Bib.**: Asano, NBZ 6.

<div align="center">[1]高島北海　[2]高島得三　[3]北海</div>

Takasuke[1] (fl. early 14th c.). *N.*: Fujiwara no Takasuke.[2] **Biog.**: *Yamato-e* painter. Said to have been son and pupil of Tosa Nagataka. No signed work by him is known, but the *Ise Shin Meisho Utaawase Emaki* at the Jingū Museum of Antiquities, Ise, is attributed to him. **Coll.**: Jingū, Umezawa. **Bib.**: K 107, Okudaira (1), Toda (2).

<div align="center">[1]隆相　[2]藤原隆相</div>

Takatada[1] (fl. early 19th c.). *N.*: Noro Takatada.[2] *A.*: Shūho.[3] *Gō*: Kaikan.[4] **Biog.**: Painter. Adopted son and pupil of Noro Kaiseki. **Bib.**: Mitchell.

<div align="center">[1]隆忠　[2]野呂隆忠　[3]周輔　[4]介干</div>

Takatori Wakanari[1] (1867–1935). *N.*: Takatori Kumao.[2] *Gō*: San'ō,[3] Sanroko,[4] Wakanari.[5] **Biog.**: Sumiyoshi painter. Born in Saga. Studied under Yamana Kangi and, later, under Matsubara Saku, who trained him in the ancient styles of painting. An exhibitor and prize winner at a variety of exhibitions, including the Paris World's Fair and the Bunten. Also served as juror for the Teiten. One of his major works, *Haisho no Kitan* (Miracle at the Exiled Emperor's Palace), was bought by the emperor Meiji. Faithful to the Sumiyoshi tradition, painted historical scenes and literary subjects in the revived *yamato-e* manner. **Coll.**: National (5). **Bib.**: Asano, Elisséev.

<div align="center">[1]高取稚成　[2]高取熊夫　[3]山桜　[4]山楼戸　[5]稚成</div>

Takayoshi[1] (fl. early 12th c.). *N.*: Fujiwara no (or Kasuga)[2] Takayoshi.[3] **Biog.**: *Yamato-e* painter. Son of Fujiwara no Motomitsu. Famous court painter, serving as Edokoro *azukari* at the imperial palace. The scrolls of the *Genji Monogatari* in the Gotō and Tokugawa museums are traditionally ascribed to him, but the attribution is now questioned, and the scrolls are considered to be the work of several hands; however, they date from the time when he was active. **Coll.**: Gotō, Tokugawa. **Bib.**: Lee (1); Morrison 1; *One* (2); P 1; Paine (4); Okudaira (1); Seckel (2); Tajima (12) 3, 15; Toda (2); Yashiro (4).

<div align="center">[1]隆能　[2]春日　[3]藤原隆能</div>

Takehisa Yumeji[1] (1884–1934). *N.*: Takehisa Shigejirō.[2] *Gō*: Yumeji.[3] **Biog.**: Painter, printmaker. Born in Okayama-ken; to Tōkyō in 1901. Dropped out of Waseda Business School to be an illustrator. Studied commercial art in the United States. Then to Europe, and finally to Taiwan. In addition to his painting, produced prints and illustrations for books and magazines for the young. In his paintings, which were in oils, water colors, or ink, generally depicted *bijin*, which earned him the name of the "modern Utamaro." Very popular in the Taishō era. Combined the influence of Western art of the turn of the century with Japanese feeling and ukiyo-e style. **Coll.**: Museum (3). **Bib.**: Asano, BK 232, Kondō (6), M 52, NB (H) 24, NBZ 6, NHBZ 7, NKKZ 8, UG 4, SBZ 11.

<div align="center">[1]竹久夢二　[2]竹久茂次郎　[3]夢二</div>

Takei Naoya[1] (1893–1940). **Biog.**: Sculptor. Born in Nagano-ken. Graduated from the Tōkyō School of Fine Arts in 1920. From 1924 to 1927 studied under Bourdelle in France. Member of the Inten, exhibiting with that organization until he resigned in 1936. Also exhibited with the Bunten. His work is basically realistic, but with impressionistic touches in the handling of the surface. **Coll.**: National (5). **Bib.**: Asano, GNB 28, NBT 10, NBZ 6.

<div align="center">[1]武井直也</div>

Takei Takeo[1] (1894–). **Biog.**: Western-style printmaker.

Born in Okaya, Nagano-ken. In 1919 graduated from the Western-painting division of the Tōkyō School of Fine Arts. Member of the Nihon Hanga Kyōkai. Also an illustrator of children's books. Specialized in intentionally naive designs in a manner close to surrealism. **Coll.:** Fine (California). **Bib.:** Kawakita (1), NHBZ 8, Statler, UG 11.

¹武井武雄

Takemoto Hayata[1] (1848–92). **Biog.:** Potter. Born in Edo, working there after a stay in Ōsaka, where he by chance became interested in pottery. An active employer of Western ceramic methods, planned the first French-style vertical round kiln; also experimented with new glazes. Combined Western design with traditional Japanese techniques. **Coll.:** Metropolitan, Tōkyō (1). **Bib.:** M 203, NB (S) 41, NBZ 6, Uyeno.

¹竹本隼太

Takemune (Busō)[1] (fl. c. 1689). **N.:** Enami (or Tanami)[2] Takemune (Busō).[3] **Biog.:** Lacquerer. One of the lacquer artists summoned to work on the decoration of the Tōshō-gū at Nikkō in 1689. **Bib.:** Herberts, Jahss.

¹武宗 ²田南 ³江南武宗

Takeshirō[1] (1818–88). **N.:** Matsuura Hiroshi.[2] **Gō:** Takeshirō.[3] **Biog.:** Nanga painter. Born in Ise. Also known as an author. **Bib.:** Mitchell.

¹武四郎 (多気志楼) ²松浦弘 ³武四郎 (多気志楼)

Takeuchi Ginshū[1] (1832–1913). **Biog.:** Kutani potter. Studied under Iidaya Hachirōemon. Learned Western ceramic techniques from Gottfried Wagner and endeavored to improve the quality of Kutani ware. A well-known artist of the school. **Bib.:** NBZ 6.

¹竹内吟秋

Takeuchi Keishū[1] (1861–1943). **N.:** Takeuchi Gimpei.[2] **Gō:** Keishū.[3] **Biog.:** Japanese-style painter. Born in Edo, son of a samurai in the service of one of the lords of Kii Province. Pupil of Kanō Eitoku. An able artist in the fields of genre painting, pottery decorating, and ukiyo-e painting. **Coll.:** Musées.

¹武内桂舟 ²武内銀平 ³桂舟

Takeuchi Kyūichi (Hisakazu)[1] (1857–1916). **N.:** Takeuchi Kyūichi (Hisakazu).[2] **Gō:** Kyūen.[3] **Biog.:** Japanese-style sculptor. First studied ivory carving. His admiration for ancient sculpture led him to make wood sculpture with painted decoration, an imitation of the earlier styles. Showed at the Chicago World's Fair of 1893. A leading figure in sculpture circles of the late Meiji era. Taught at the Tōkyō School of Fine Arts after its founding in 1889 and served as juror for the Bunten after 1907. Member of the Art Committee of the Imperial Household. **Coll.:** Tōkyō (2). **Bib.:** Asano, GNB 28, NB (H) 24, NBZ 6, Uyeno.

¹竹内久一 ²竹内久一 ³久遠

Takeuchi Seihō[1] (1864–1942). **N.:** Takeuchi Tsunekichi.[2] **Gō:** Seihō[3] (originally Seihō,[4] with a different character for the sei). **Biog.:** Japanese-style painter. Born and worked in Kyōto. At 14 came under the influence of the Shijō school; studied with Kōno Bairei in 1881 and the following year received prizes at several exhibitions. In 1900 to Europe; influenced by color of Turner and Corot. On returning, painted what he believed to be a synthesis of Western and Chinese landscape traditions. Became patriarch of Kyōto painting and one of founders of modern Kyōto school. Taught at Kyōto Municipal School of Fine Arts and Crafts. When the Bunten was established in 1907, was appointed a member of its selection committee and often showed at its exhibitions. Member of Imperial Art Academy; awarded Order of Cultural Merit in 1937. Immensely successful in his lifetime, but his reputation has faded a little since his death. Obvious, but charming, delicate style, combining realism of West with Japanese line and decorative flatness of design, his paintings rather simplified in use of brush and color. A brilliant craftsman. **Coll.:** Atami; Center; Higashi;

Kyōto (1); Metropolitan; Musée (3); Museum (2), (3); National (5); Nishi; Sanzen-in; Tōkyō (1); Yamatane. **Bib.:** Art (1a), Asano, Elisséev, Grilli (1), Masterpieces (4), Mitchell, Miyagawa, Morrison 2, Munsterberg (1), Nakamura (1), NB (H) 24, NB (S) 17, NBT 10, NBZ 6, NKKZ 17, Noma (1) 2, SBZ 11, Sullivan.

¹竹内栖鳳 ²竹内恒吉 ³栖鳳 ⁴棲鳳

Taki Katei[1] (1830–1901). **N.:** Taki (originally Ryūgū)[2] Ken.[3] **A.:** Shichoku.[4] **Gō:** Katei,[5] Randen.[6] **Biog.:** Nanga painter. Lived in Tokyo; son of a samurai. Studied painting under Araki Kankai and, later, Ōoka Umpō; also studied Chinese painting in Nagasaki. Traveled widely in Japan. His paintings were shown at the Vienna Exposition of 1873. Member of the Art Committee of the Imperial Household. Much neglected as a result of the disturbances surrounding the Restoration. Admirable painter of kachōga. Called a nanga painter, but his style close to that of the revived Japanese school plus some Western influence; a good colorist. **Coll.:** Ashmolean, Royal (1), Toledo. **Bib.:** Asano; Elisséev; K 15, 188; Mitchell; Morrison 2; NB (S) 17; NBZ 6; Uyeno.

¹滝和亭 ²滝宮 ³滝謙 ⁴子直 ⁵和亭 ⁶蘭田

Takuan[1] (1573–1645). Priest name: Hideki.[2] **Gō:** Boō,[3] Shūhō (Sōhō),[4] Shun'o,[5] Takuan.[6] **Biog.:** Zenga painter, calligrapher. Born in Izushi, Hyōgo-ken. Famous priest of the Rinzai sect; also a tea master and poet. Entered the Daitoku-ji, Kyōto, at 21, and after visits to other temples became abbot there in 1608. Banished to Kaminoyama in 1629 for infringing the shogunate's ruling about ceremonial dress; allowed to return to Edo in 1632. At the request of the shogun Iemitsu, founded the Tōkai-ji in Shinagawa in 1638 and finally died there. His paintings, in ink, of Zen subjects are very delicate and elegant, less eccentric than later Zen work. His fame, however, really rests on his calligraphy. **Coll.:** Hatakeyama, Ishikawa, Tōkyō (1). **Bib.:** Au-delà, Awakawa, Brasch (2), Fontein (2), Japanische (1), M 166, NB (S) 47, Noma (1) 2, Rosenfield (2).

¹沢庵 ²秀喜 ³暮翁 ⁴宗彭 ⁵春翁 ⁶沢庵

Takuchi[1] (fl. early 19th c.). **N.:** Tsuruta Takuchi.[2] **F.N.:** Yosaemon.[3] **Gō:** Ransō.[4] **Biog.:** Painter. **Bib.:** Mitchell.

¹卓池 ²鶴田卓池 ³与三右衛門 ⁴藍叟

Takudō[1] (fl. c. 1840). **N.:** Hamanaka Eishin.[2] **F.N.:** Ryōsuke.[3] **Gō:** Baishin,[4] Rakuten'ō,[5] Takudō.[6] **Biog.:** Painter. Also known as a poet. **Bib.:** Mitchell.

¹琢堂 ²浜中英信 ³良輔 ⁴梅信 ⁵楽天翁 ⁶琢堂

Takugan[1] (1747–1824). **N.:** Katsuyama Chūki.[2] **Gō:** Kakureishi,[3] Takugan.[4] **Biog.:** Kanō painter. Born in Kyōto. Son and pupil of Katsuyama Takushū. Received title of hōgen; must therefore have been regarded by his contemporaries as an artist of considerable ability.

¹琢眼 ²勝山仲超 ³鶴齢子 ⁴琢眼

Takuho[1] (1652–1714). Priest name: Zenryō.[2] **Gō:** Takuhō.[3] **Biog.:** Kanō painter. Lived in Kyōto; chief priest at the Bukkoku-ji. Pupil of Kanō Tan'yū. **Bib.:** K 135.

¹卓峯 ²善良 ³卓峯

Takujū[1] (1760–1833). **N.:** Suzuki.[2] Priest name: Kosen.[3] **Gō:** Takujū.[4] **Biog.:** Zenga painter. Priest of Rinzai sect. Born near Nagoya. Started his Zen studies at 15 at the Sōken-ji, Nagoya. Later joined Gasan Jito, Hakuin's pupil, at the Toki-an near Edo. After 14 years received his certificate, returned to the Sōken-ji, and studied for another 20 years. Appointed abbot of the Myōshin-ji, Kyōto; very successful lecturer on Zen, with many pupils and followers. Returned to the Sōken-ji with his pupils. A skillful painter of Zen subjects, including many pictures of Bodhidharma; also well known as a calligrapher. **Bib.:** Awakawa, NB (S) 47.

¹卓洲 ²鈴木 ³胡僊 ⁴卓洲

Takushū[1] (?–1788). **N.:** Katsuyama Akifumi.[2] **Gō:** Takushū.[3] **Biog.:** Kanō painter. Born in Kyōto. First studied under

Yamazaki Ryūjo. Later came under the influence of the *yamato-e* style. Became *azukari* at the Kasuga-jinja. Received title of *hōgen*.

¹琢舟 ²勝山章翰 ³琢舟

Tamamura Zennosuke¹ (1893–1951). *N.:* Tamamura Zennosuke.² *Gō:* Hōkuto.³ **Biog.:** Japanese-style painter. Born in Kyōto. Graduate of Kyōto Municipal School of Fine Arts and Crafts. Pupil of Kikuchi Hōbun. Showed with the Inten from 1915 to 1923. In 1930 established the Hokutōsha, his own school. Known for his scrolls illustrating the *Ugetsu Monogatari* and the *Heike Monogatari*. **Coll.:** Staatliche. **Bib.:** Asano, NBZ 6, Schmidt.

¹玉村善之助 ²玉村善之助 ³方久斗

Tamaya Shunki¹ (1880–1946). *N.:* Tamaya Hidejirō (Shūjirō).² *Gō:* Gagyū,³ Shunki.⁴ **Biog.:** Japanese-style painter. Born in Gifu. First studied under Hara Zaisen, then Yamamoto Shunkyo. Member of Kyōto Bijutsu Kyōkai. In 1913 showed with the Bunten, winning a prize. Later joined the Jiyū Gadan. **Coll.:** Victoria. **Bib.:** Asano, Elisséèv.

¹玉舎春輝 ²玉舎秀次郎 ³臥牛 ⁴春輝

Tambi¹ (1840–93). *N.:* Kanō Moritaka.² *Gō:* Tambi.³ **Biog.:** Japanese-style painter. Lived in Tōkyō. Son and pupil of Kanō Tan'en, the eighth-generation head of the Kajibashi branch of the Kanō school; younger brother of Kanō Tansen. Served in the Tokugawa Edokoro; was given rank of *hokkyō*. After the Meiji Restoration had an official position at court. Painted screens and walls at the Tōkyō Imperial Palace. Later served on various art juries and became a member of the Committee on National Treasures. Specialized in painting landscapes and *kachōga*. **Coll.:** Metropolitan. **Bib.:** *Kanō-ha*, NBZ 6.

¹探美 ²狩野守貴 ³探美

Tamboku (Tanboku)¹ (1760–1832). *N.:* Kanō Morikuni.² *F.N.:* Zusho.³ *Gō:* Tamboku (Tanboku).⁴ **Biog.:** Kanō painter. Eldest son and pupil of Kanō Tanrin. Sixth-generation head of the Kajibashi Kanō line. Served the shogunate as *oku eshi*. **Coll.:** Museum (3).

¹探牧（探朴） ²狩野守邦 ³図書 ⁴探牧（探朴）

Tamechika¹ (?–1172). *N.:* Fujiwara no Tamechika.² **Biog.:** Painter. Son of Fujiwara no Chikataka, a member of the court. Known only from records as a good painter as well as a courtier.

¹為親 ²藤原為親

Tamechika (Tametaka, Tameyasu)¹ (1823–64). *N.:* Okada (originally Reizei)² Tamechika (Tametaka, Tameyasu).³ *F.N.:* Saburō,⁴ Shinzō.⁵ *Gō:* Matsudono.⁶ **Biog.:** *Fukko yamato-e* painter. Born in Kyōto. At 5, adopted by Kanō Eigaku, from whom he learned the Kanō style; also studied the Toba Sōjō scrolls at the Kōzan-ji. At 28, adopted by the Okada family, which was connected with the imperial court; received title of Lord of Ōmi, but was forced to take refuge during the political war between the shogunate and the loyalists and was finally assassinated by a lordless samurai. At an early age became interested in *yamato-e* and eventually, with Tanaka Totsugen and Ukita Ikkei (by whom he was influenced), strove to revive this style. (The theory of *fukko yamato-e* was associated with the restoration of the court, and Tamechika was a fervent monarchist.) At 33 painted a number of *fusuma* for the Imperial Palace, Kyōto. His subjects included Buddhist themes as well as scenes of court life. Technically a Tosa painter, he was much inclined to realism; his *sumi-e* quite impressionistic. His attempted revival of *yamato-e* unsuccessful; his paintings in that manner are stiff, hard and unattractive. **Coll.:** Atami, Daiju-ji, Fujita, Imperial (1), Itsuō, Nezu, Ōkura. **Bib.:** BK 17; *Fukko;* K 64, 92, 112, 227, 284, 297, 327, 361, 466, 475, 486, 503, 533, 608, 615, 694, 702, 728, 757, 773, 781, 844, 851, 880; M 48, 84; Minamoto (1); Morrison 1; NBT 5;

NBZ 4; NKZ 57; Paine (4); SBZ 10; Tajima (12) 17, (13) 5; *Tamechika; Ukiyo-e* (3) 20.

¹爲恭 ²冷泉 ³岡田爲恭 ⁴三郎 ⁵晋三 ⁶松殿

Tamehisa¹ (fl. c. 1184–85). *N.:* Takuma Tamehisa.² **Biog.:** Takuma painter. Third son of Takuma Tametō, younger brother of Takuma Shōga. Summoned by the shōgun Yoritomo from Kyōto to Kamakura to execute paintings for the temples there. Recorded as having produced a painting of Shō Kannon and a *raigō* painting. **Bib.:** Morrison 1.

¹為久 ²宅磨為久

Tameie¹ (1198–1275). *N.:* Fujiwara no Tameie.² *Priest name:* Seishin Yūkaku.³ *Gō:* Seishin,⁴ Yūkaku.⁵ **Biog.:** Painter, calligrapher. Son of the famous poet, Fujiwara no Teika, was also a well-known poet, holding many court positions. Became a priest in 1256. Though better known to history for a famous lawsuit conducted by his wife, he also had considerable reputation as a calligrapher and a compiler of poetry anthologies. Specialized in painting portaits of horses and their riders. **Coll.:** Ōkura. **Bib.:** Morrison 1, Rosenfield (1a), Shimada 1, Tajima (13) 2.

¹為家 ²藤原為家 ³静真融覚 ⁴静真 ⁵融覚

Tamenari¹ (fl. c. 1053). *N.:* Takuma Tamenari.² **Biog.:** Takuma painter. Lived in Kyōto. Perhaps the son of Takuma Tameuji. The wall paintings in the Phoenix Hall, Byōdō-in, Uji, have long been attributed to him, but as they are in the native *yamato* style and the Takuma artists were influenced by Chinese models, this attribution has been questioned. **Bib.:** K 3, 25; Minamoto (1); Morrison 1; *One* (2); Paine (4); Tajima (12) 4.

¹為成 ²宅磨為成

Tamenobu¹ (fl. 1264–1306). *N.:* Fujiwara no Tamenobu.² *Priest name:* Jakuyū.³ **Biog.:** *Yamato-e* painter. Son of Fujiwara no Korenobu. At first held an official position at court; in 1306, entered the priesthood and took name of Jakuyū. It is recorded that sometime between 1264 and 1275 he painted a scroll, *Festival of the Kamo Shrine,* in a contest held in the presence of the emperor Kameyama. A scroll in the Imperial Household Collection, *Tennō Sekkan Daijin Ei,* is ascribed to him and Gōshin. **Coll.:** Museum (3). **Bib.:** Morrison 1, Okudaira (1).

¹為信 ²藤原為信 ³寂融

Tamenori¹ (?–1011). *N.:* Minamoto Tamenori.² **Biog.:** Painter. Known as a governor of various provinces; the records also refer to him as a good painter.

¹為憲 ²源為憲

Tametō¹ (fl. c. 1132–74). *N.:* Takuma Tametō.² *Priest name:* Shōchi.³ **Biog.:** Takuma painter. Born in Kyūshū. Became a Buddhist monk; attained rank of *hōin*. Lived for a while in Kyōto, serving the emperor Konoe (1141–55); was commissioned by him to paint the walls of the Kakuō-in on Kōyasan. Lived for many years on Kōyasan. The works most substantially attributed to him are delicately colored Buddhist iconographic drawings. **Coll.:** Tōkyō (1), University (2), Yamato. **Bib.:** Morrison 1; Rosenfield (1), (1a), (2); *Selected;* Tanaka (5); YB 12.

¹為遠 ²宅磨為遠 ³勝智

Tametsugu¹ (?–1266). *N.:* Fujiwara no Tametsugu.² **Biog.:** Painter. Son and pupil of Fujiwara no Nobuzane. Courtier and poet as well as painter. **Coll.:** Nishi Hongan-ji. **Bib.:** K 4, Tanaka (2).

¹為継 ²藤原為継

Tameuji¹ (?–987). *N.:* Fujiwara no (or Takuma)² Tameuji.³ **Biog.:** Takuma painter. Contemporay of Asukabe no Tsunenori, with whom he collaborated on a screen for the imperial consort of the emperor Murakami (946–67). However, no authenticated work now known. Is regarded as the ancestor of the Takuma clan of painters. **Bib.:** Morrison 1.

¹為氏 ²宅磨 ³藤原為氏

Tameyuki¹ (fl. c. 1231). *N.:* Takuma Tameyuki.² **Biog.:** Takuma painter. Born in Kyōto. Said to have been a son of

Takuma Tamehisa. According to literary sources, became a painter for the imperial court and eventually received title of Sakon Shogen. In 1231, at request of the Kamakura shogunate, went to Kamakura and worked as a painter. Later took Buddhist vows and was given title of *hōgen*. No known works extant, but recorded as having produced many *butsuga* and portraits of notables of earlier times. **Bib.:** Morrison 1.

¹為行 ²宅磨為行

Tamikichi¹ (1772–1824). *N.:* Katō Tamikichi.² **Biog.:** Potter. Founder of the Seto porcelain kilns. During the mid-Tokugawa period the Seto pottery kilns (one of the most important sources of revenue for the local daimyo) lost their popularity, and many potters changed their profession. The daimyo, trying to protect the remaining potters, sent Tamikichi to Arita in 1801 to learn the technique of making porcelain. Eventually acquired the technique and returned to Seto in 1807 to reactivate the local kilns. Worked frequently in blue-and-white. **Bib.:** GNB 19; Jenyns (1), (2); Koyama (1a); Munsterberg (2); STZ 6.

¹民吉 ²加藤民吉

Tampo¹ (fl. 1764–71). *N.:* Tsujiya Tampo.² **Biog.:** Lacquerer. A Kyōto artist who moved to the Takaoka district. Specialized in *chōshitsu*. **Bib.:** Herberts, Jahss.

¹丹甫 ²辻屋丹甫

Tamura Gōko¹ (1873–1946). *N.:* Tamura Daikichi.² *Gō:* Gōko,³ Kosokuken.⁴ **Biog.:** *Nanga* painter. Pupil first of Aoki Suizan, then of Satake Eiko. Also studied both southern and northern schools of Chinese painting. Exhibitor and prize winner at the Bunten. Served as a committee member of the Bijutsu Kenseikai and the Nihongakai. A good painter of landscapes and *kachōga*.

¹田村豪湖 ²田村代吉 ³豪湖 ⁴孤足軒

Tamura Saiten¹ (1889–1933). **Biog.:** Japanese-style painter. Pupil of Terazaki Kōgyo. Frequent exhibitor and prize winner with the Teiten.

¹田村彩天

Tamura Sōritsu¹ (1846–1918). *N.:* Tamura Sōritsu.² *Gō:* Gesshō,³ Taikyō.⁴ **Biog.:** Western-style painter. As a child, studied *nanga* and Buddhist painting in Kyōto. Became interested in Western-style painting and went to Yokohama to study under Charles Wirgman. Received a medal at the Kyōto Hakurankai in 1875. Taught Western-style painting at the Kyōto Prefectural School of Painting in the 1880s. A founding member of many societies in Kyōto and a pioneer and one of the best exponents of Western-style painting in the Kansai region. His style is academic. **Bib.:** Asano, BK 206, NBZ 6.

¹田村宗立 ²田村宗立 ³月樵 ⁴大狂

Tanabe Itaru¹ (1886–1968). **Biog.:** Western-style painter. Born in Tōkyō. Graduated from the Tōkyō School of Fine Arts in 1910; pupil of Kuroda Seiki, Wada Eisaku, and Nagahara Kōtarō. Studied in Europe from 1922 to 1924. Later became professor at his alma mater, teaching etching when the print division was established. Served as juror for the Bunten and the Teiten. His rather realistic style shows some influence from Derain. **Bib.:** Asano, Fujikake (1), NBZ 6.

¹田辺至

Tanabe Miematsu¹ (1897–1971). **Biog.:** Western-style painter. Born in Hokkaidō; worked in Tōkyō. Studied under Ishii Hakutei, Yasui Sōtarō, and Kojima Zenzaburō. Originally a member of the Nikakai; became a founding member of the Kōdō Bijutsu Kyōkai. His landscapes are painted in a rather heavy simplified manner. **Coll.:** National (5). **Bib.:** Asano.

¹田辺三重松

Tanaka Ichian¹ (1893–1958). *N.:* Tanaka Kenjirō.² *Gō:* Ichian,³ Tossaishū.⁴ **Biog.:** Japanese-style painter. Born in Tōkyō; son of a merchant. In 1909 became a pupil of Matsumoto Fūko; studied ancient paintings on his own. Contemporary and friend of Imamura Shiko and Hayami

Gyoshū. In 1923 joined the Shun'yōkai and in 1929 the Nihon Nangain. After 1950 served as a juror for the Nitten. Spent some time in Korea on a sketching trip. An able landscape painter. **Bib.:** Asano.

¹田中以知庵（一庵） ²田中兼次郎
³以知庵（一庵） ⁴咄哉州

Tanaka Keinyū¹ (1817–1902). *N.:* Tanaka (originally Ogawa)² Keinyū.³ *Studio name:* Kichizaemon.⁴ **Biog.:** Raku potter. Third son of Ogawa Naohachi, a vintner. In 1827 adopted by the Raku potter Tannyū; eventually became the eleventh in the Raku line. In 1845 was given the name Kichizaemon and succeeded Tannyū. In 1846 presented his first wares. Rebuilt the present Raku family house after a fire in 1857. In 1865 made a famous *hibachi* on the order of the emperor Kōmei, with a design based on a work by Kanō Eigaku. In 1871 retired, taking the name Keinyū. In 1890 held the 300th memorial service for Chōjirō, the founder of the Raku school. A tasteful, elegant potter. **Coll.:** Metropolitan, Museum (3), Yale. **Bib.:** Castile, Jenyns (1).

¹田中慶入 ²小川 ³田中慶入 ⁴吉左衛門

Tanaka Raishō¹ (1868–1940). *N.:* Tanaka Daijirō.² *Gō:* Raishō.³ **Biog.:** Japanese-style painter. Born in Shimane-ken. Studied under Mori Kansai and later, in Tōkyō, under Kawabata Gyokushō. Showed (and won prizes) at the Bunten after 1907, later with the Teiten and the Nihon Bijutsu Kyōkai. Served as a juror for the Teiten. Noted for his landscapes in the manner of Gyokushō. **Bib.:** Asano.

¹田中頼璋 ²田中大治郎 ³頼璋

Tanaka Saichirō¹ (1900–1967). **Biog.:** Western-style painter. Born in Kyōto. First studied Japanese painting, graduating from the Kyōto College of Fine Arts in 1925. Then turned to oil painting and studied at the Kawabata School. Exhibited at the Teiten and with the Nikakai and the Dokuritsu Bijutsu Kyōkai, of which he became a member in 1933. In 1932 in France. **Bib.:** Asano.

¹田中佐一郎

Tanaka Shigekichi¹ (1898–). **Biog.:** Western-style painter. Born in Fukuoka-ken. In 1921 graduated from the Tōkyō School of Fine Arts, where he had studied under Fujishima Takeji. In 1922 showed at the Teiten. From 1926 to 1928 in Europe and again in 1957 and 1958. Member of the Nitten and the Sōgenkai. His quite realistic style shows some influence of Derain. **Bib.:** Asano.

¹田中繁吉

Tanaka Zennosuke¹ (1889–1946). **Biog.:** Western-style painter. Born in Kyōto. As a young man studied Japanese-style painting. Joined the Shōgoin Yōga Kenkyūsho when Asai Chū founded it in Kyōto. In 1908 showed with the Bunten; later with the Kansai Bijutsuin. From 1920 to 1923 in Europe. On his return, joined the Shun'yōkai. Active in Kyōto Western-style painting circles. **Bib.:** Asano.

¹田中善之助

Tanami Gakushō¹ (1876–1928). **Biog.:** Shijō painter. Born in Mie-ken. Pupil of Kōno Bairei and, later, of Kubota Beisen and Nomura Bunkyo. In 1911 showed at the Bunten for the first time. Member of the Nihon Bijutsu Kyōkai and the Jitsugetsukai. A good painter of landscapes and *kachōga*.

¹田南岳嶂

Taneharu¹ (fl. c. 1848–64). *N.:* Kiyokawa Taneharu.² *Gō:* Ikkōsai.³ **Biog.:** Ukiyo-e printmaker. Produced theatrical programs and posters. **Bib.:** *Nikuhitsu* (2).

¹種春 ²清川種春 ³一興斎

Tan'en¹ (?–c. 1790). *N.:* Kanō Tanenobu² (or Moritane³ or Morinobu).⁴ *Gō:* Tan'en.⁵ **Biog.:** Kanō painter. Second son of Kanō Tanjō, was adopted by Kanō Tan'yō. Served the shogunate as *goyō eshi*. Member of the Shiba Atagoshita Kanō line.

¹探円 ²狩野胤信 ³守胤 ⁴守信 ⁵探円

Tan'en¹ (1805–53). *N.:* Kanō Morizane (Shushin).² *Gō:*

Tan'en.[3] **Biog.:** Kanō painter. Son of Kanō Tanshin Morimichi; eighth-generation head of the Kajibashi branch of the Kanō family. One of the *goyō eshi* to the Tokugawa shogunate. Received title of *hōgen*. **Coll.:** Museum (3).

¹探淵 ²狩野守真 ³探淵

Tanenobu[1] (1600–1638). *N.:* Kanō (originally Kusumi)[2] Tanenobu.[3] *Priest name:* Sōkei,[4] Sōsen.[5] *F.N.:* Jinjūrō;[6] later, Takumi.[7] **Biog.:** Kanō painter. Eldest son and pupil of Kanō Sōshin Tanenaga. A minor member of the Odawara-chō branch of the Kanō line. *Goyō eshi* to the shogunate. Became a priest and took the names of Sōkei and Sōsen.

¹種信 ²久隅 ³狩野種信 ⁴宗恵
⁵宗仙 ⁶甚十郎 ⁷内匠

Tanga[1] (fl. c. 1340). **Biog.:** Sculptor. Pupil of Tankō. The statue of Shōtoku Taishi in the Bukkoku-ji, Kyōto, may be by him. **Coll.:** Bukkoku-ji. **Bib.:** BI 39.

¹湛賀

Tangei[1] (1688–1769). *N.:* Tsuruzawa Moriyoshi.[2] *Gō:* Tangei.[3] **Biog.:** Kanō painter. Son and pupil of Tsuruzawa Tanzan. Served as *goyō eshi* to the imperial court. Given title of *hōgen*. His descendants continued his tradition of Kanō-inspired painting down to the Meiji era.

¹探鯨（探鯢） ²鶴沢守美 ³探鯨（探鯢）

Tangen[1] (fl. 1670–80). *N.:* Kanō Kagenobu.[2] *Gō:* Shōshisai,[3] Tangen.[4] **Biog.:** Served the Hosokawa clan of Kumamoto. Follower of Tan'yū's style. **Bib.:** K 827.

¹探玄 ²狩野景信 ³尚志斎 ⁴探玄

Tangen[1] (1679–1767). *N.:* Kanō (originally Kimura)[2] Tokikazu.[3] *F.N.:* Morihiro,[4] Muraemon.[5] *Gō:* Daini,[6] Jōtokudō,[7] Sangyōan,[8] Seiin (Jōin),[9] Tangen,[10] Tangensai.[11] **Biog.:** Kanō painter. Born in Satsuma Province. Went to Edo and had considerable success there after studying under Kanō Tanshin and being adopted by a Kanō master of the Tan'yū line. Invited to return to Satsuma by the daimyo of the Shimazu clan and commissioned to add painted designs to the pottery made in the daimyo's private kiln. Became the major Kanō artist in Kyūshū in the 18th century; also known as Satsuma Tangen. Received title of *hokkyō*. His figures rendered in heavy brushstrokes. **Coll.:** Kagoshima, Museum (3), National (3), Philadelphia, Sennyū-ji. **Bib.:** BK 13, K 723, *Kanō-ha*, Morrison 1, Noma (1) 2, *Tangen*.

¹探元 ²木村 ³狩野時員 ⁴守広 ⁵村右衛門 ⁶大弐
⁷浄徳堂 ⁸三暁庵 ⁹静隠 ¹⁰探元 ¹¹探元斎

Tangen[1] (fl. mid-19th c.). *N.:* Kanō Moriaki.[2] *Gō:* Tangen.[3] **Biog.:** Kanō painter. Son of Kanō Sokuyo Moriaki. Seventh-generation head of the Shiba Atagoshita Kanō line.

¹探玄 ²狩野守明 ³探玄

Tangen[1] (1829–66). *N.:* Kanō Moritsune.[2] *Gō:* Tangen.[3] **Biog.:** Kanō painter. Son and pupil of Kanō Tan'en; became the ninth-generation head of the Kajibashi Kanō line. Served the shogunate as *oku eshi*. A fair painter in the Kanō tradition. **Bib.:** *Kanō-ha*.

¹探原 ²狩野守経 ³探原

Tangetsu[1] (1821–96). *N.:* Higuchi Moriyasu.[2] *Gō:* Tangetsu.[3] **Biog.:** Japanese-style painter. Born in Satsuma Province. Moved to Edo; became a pupil of Kanō Tan'en. Taught Goseda Iwakichi. Specialized in figures and landscapes. **Coll.:** Victoria.

¹探月 ²樋口守保 ³探月

Taniguchi Kōkyō[1] (1864–1915). *N.:* Taniguchi (originally Tsuji)[2] Tsuchinosuke.[3] *Gō:* Kōkyō.[4] **Biog.:** Japanese-style painter. Second son of Tsuji Kyūjirō, a cloth merchant; adopted by the Taniguchi family. Pupil of Kōno Bairei. One of the founders of the modern Kyōto school. Taught at the Kyōto Municipal School of Fine Arts and Crafts and the Kyōto College of Fine Arts. An exhibitor and juror at the Bunten. Received an award at the Naikoku Kangyō Hakurankai and at the Paris World's Fair. Illness cut short his career. Painted landscapes, birds-and-flowers, and historical

subjects. **Coll.:** Staatliche, Victoria. **Bib.:** Asano, Mitchell, NB (S) 17, NBZ 6, Schmidt.

¹谷口香嶠 ²辻 ³谷口槌之助 ⁴香嶠

Tanjō[1] (1706–56). *N.:* Kanō Moritomi.[2] *Gō:* Tanjō.[3] **Biog.:** Kanō painter. Born in Edo. Second son and pupil of Kanō Tanshin. After the death of his elder brother Tansen, succeeded him as head of the family, becoming fourth-generation head of the Kajibashi branch. Worked for the Tokugawa *bakufu* as *oku eshi*. **Coll.:** Museum (3).

¹探常 ²狩野守富 ³探常

Tankai[1] (1629–1716). *Priest name:* Hōzan Tankai.[2] **Biog.:** Sculptor. A Buddhist priest, founder of the Hōzan-ji, Nara, which owns his statue of Fudō Myōō. There is also a seated Fudō Myōō by him in the Tōshōdai-ji, Nara. Given title of *risshi*. Serious competent sculpture with marked religious feeling: far better than average craftsman's work of the period. **Coll.:** Hōryū-ji, Hōzan-ji, Tōshōdai-ji. **Bib.:** Kuno (1); Matsumoto (1); NBZ 4; SBZ 9; Tajima (12) 6, (13) 15.

¹湛海 ²宝山湛海

Tankei[1] (1173–1256). **Biog.:** Sculptor. Eldest son and pupil of Unkei. Head of Shichijō Bussho. Received rank of *hokkyō* about 1194, *hōgen* in 1208, and *hōin* in 1213. Worked with his father as early as 1198 on the Niō for the Tō-ji, Kyōto. Among his known works are: Senju Kannon (dated 1254), in which he was assisted by Kōen and Kōsei, in the Hondō of the Rengeō-in; Bishamonten and two attendants in the Sekkei-ji, Kōchi-ken. Carried the Unkei style further in the direction of realism; all his work shows traces of the new influence of Sung art. **Coll.:** Myōhō-in (Rengeō-in), Rokuhara Mitsu-ji, Sekkei-ji. **Bib.:** *Art* (2); BK 2; Buhot; GK 8; GNB 9; Hasumi (2); Kidder; *Kokuhō* 3, 4; Kuno (1), (2); Matsumoto (1); Mōri (1a); NBZ 3; OZ 13; SBZ 6; Tajima (13) 15; Watson (1); YB 12.

¹湛慶

Tankō[1] (fl. early 14th c.). **Biog.:** Sculptor. Some scholars have said that according to an inscription found in the statue of Shōtoku Taishi (dated 1320) in the Bukkoku-ji, Kyōto, the sculptor was Tankō and the painter Gen'en. It is more probable that the sculptor was Tankō's pupil Tanga (q.v.). **Coll.:** Bukkoku-ji. **Bib.:** BI 39.

¹湛幸

Tannyū[1] (1795–1854). *N.:* Tanaka Tannyū.[2] *F.N.:* Ichisaburō;[3] later, Sōjirō.[4] *Studio name:* Kichizaemon.[5] *Gō:* Shūjin.[6] **Biog.:** Raku potter. Second son of Ryōnyū; became tenth-generation head of the Raku line. In 1811 succeeded to the name of Kichizaemon on becoming head of the family. In 1858 held the 250th memorial service for the founder of the line, Chōjirō, distributing 250 black bowls. In 1845, following the family tradition, retired to become a monk, calling himself Tannyū. A prolific potter. **Coll.:** Metropolitan, Philadelphia, Tōkyō (1), Victoria. **Bib.:** Castile, Jenyns (2).

¹旦入 ²田中旦入 ³市三郎 ⁴惣治郎 ⁵吉左衛門 ⁶秀人

Tanoguchi Seikō[1] (1897–1965). *N.:* Tanoguchi Jinsaku.[2] *Gō:* Seikō.[3] **Biog.:** Japanese-style painter. Born in Hyōgo-ken. Graduated from Kyōto School of Painting in 1929. Became a pupil of Nishimura Goun and, after his death, of Yamaguchi Kayō. Worked for the Mitsukoshi Department Store in Ōsaka. In 1930 showed with the Teiten for the first time. A good traditional painter of birds-and-flowers and fish. **Coll.:** National (5).

¹田之口青晃 ²田之口甚作 ³青晃

Tanomura Chokunyū[1] (1814–1907). *N.:* Tanomura (originally Sannomiya)[2] Chi.[3] *Gō:* Chokunyū,[4] Incha Shujin,[5] Ryūō (Kasaō),[6] Sanshō,[7] Seiwan,[8] Seiwan Gyorō,[9] Shōko,[10] Shōko Sanjin.[11] **Biog.:** *Nanga* painter. Born in Bungo Province; worked in Kyōto. Pupil and adopted son of Tanomura Chikuden, who was in the service of the same daimyo as Chokunyū's father. As a student, copied many late Chinese paintings. Helped establish the Kyōto Municipal School of Fine Arts and Crafts, was its first director, and left that

position to found the Nihon Nanga Kyōkai. A leading exponent of the *nanga* tradition in the Meiji era; a juror for many exhibitions and with numerous pupils. Often painted in imitation of Chinese artists of various periods; also a calligrapher and poet. A worthy follower of his master. **Coll.:** Ashmolean, British, Idemitsu, Museum (3), Yamatane. **Bib.:** Asano, *Kunst,* Mitchell, Morrison 2, NB (S) 17, NBZ 6, Paine (2) 2, Umezawa (2), Uyeno.

¹田能村直入　²三宮　³田能村癡　⁴直入
⁵飯茶主人　⁶笠翁　⁷山樵　⁸青椀
⁹青灣漁老　¹⁰小虎　¹¹小虎散(山)人

Tanrei[1] (?–1847). *N.:* Oka Tanrei.[2] *F.N.:* Tetsusaburō.[3] **Biog.:** Shijō painter. Followed the manner of Suzuki Nanrei. **Bib.:** Mitchell.

¹旦嶺　²岡旦嶺　³鉄三郎

Tanrin[1] (1732–77). *N.:* Kanō Morimi (Moriyoshi).[2] *Gō:* Tanrin.[3] **Biog.:** Kanō painter. Son and pupil of Kanō Tanjō Moritomi; became fifth-generation head of the Kajibashi Kanō line. Served the shogunate as *oku eshi.* Worked in a rather tight, dry style. **Bib.:** *Kanō-ha.*

¹探林　²狩野守美　³探林

Tanryū[1] (?–1855). *N.:* Tsuruzawa Moriteru.[2] *Gō:* Tanryū.[3] **Biog.:** Painter. *Goyō eshi* to the shogunate. Son of Tsuruzawa Tansaku; became head of sixth generation of the Tsuruzawa family.

¹探龍　²鶴沢守照　³探龍

Tansaku[1] (?–1797). *N.:* Tsuruzawa Moriteru.[2] *Gō:* Tansaku.[3] **Biog.:** Painter. Son and pupil of Tsuruzawa Tangei. Early teacher of Maruyama Ōkyo. Followed the family tradition of Kanō painting. **Coll.:** Museum (3).

¹探索　²鶴沢守照　³探索

Tansen[1] (1686–1728). *N.:* Kanō Akinobu.[2] *Gō:* Tansen.[3] **Biog.:** Kanō painter. Son and pupil of Kanō Tanshin. Is known to have painted *byōbu* sent by the shogun to the king of Korea. In 1709 painted *fusuma* for the imperial palace. In 1719 succeeded his father as third-generation head of the Kajibashi branch of the Kanō family in Edo and as *goyō eshi* to the shogunate. A good Kanō painter.

¹探船　²狩野章信　³探船

Tansen[1] (1721–80). *N.:* Yamamoto Morinari.[2] *F.N.:* Kazuma.[3] *Gō:* Tansen.[4] **Biog.:** Painter. Born in Kyōto. Son and pupil of Yamamoto Sōsen. Little known of his life save that he was given title of *hōgen.*

¹探川　²山本守業　³数馬　⁴探川

Tansen[1] (?–1816). *N.:* Tsuruzawa Moriyuki.[2] *Gō:* Tansen.[3] **Biog.:** Kanō painter. Son and pupil of Tsuruzawa Tansaku. Carried on the family tradition of painting in the Kanō manner. **Coll.:** Museum (3).

¹探泉　²鶴沢守之　³探泉

Tansetsu[1] (1654–1713). *N.:* Kanō Morisada.[2] *F.N.:* Tonomo.[3] *Gō:* Mōrinsai,[4] Tansetsu.[5] **Biog.:** Kanō painter. Second son and pupil of Kanō Tan'yū. *Goyō eshi* to the shogunate, on whose order he painted *byōbu* to be sent as a gift to the king of Korea. Formed an independent branch of the Kanō line, which, however, died out with the premature death of his son. Able painter in his father's style, but less of an artist than his brother Tanshin. **Coll.:** Museum (3), Victoria. **Bib.:** *Kanō-ha,* Morrison 1.

¹探雪　²狩野守定　³主殿　⁴孟隣斎　⁵探雪

Tanshin[1] (1653–1718). *N.:* Kanō Morimasa.[2] *F.N.:* Senchiyo,[3] Zusho.[4] *Gō:* Chūshū,[5] Tanshin.[6] **Biog.:** Kanō painter. Eldest son and pupil of Kanō Tan'yū. In 1674, on his father's death, succeeded him as chief painter of the Edokoro, becoming second-generation head of the Kajibashi Kanō family. Received title of *hōgen* in 1715. Teacher of Kanō Tangen Tokikazu. Painted in the manner of his father; his work characterized by a light, gay style, with an exquisite sense of color. **Coll.:** Metropolitan, Shūgaku-in, Tōkyō (1). **Bib.:** Binyon (2), *Kanō-ha,* Morrison 1.

¹探信　²狩野守政　³仙千代　⁴図書　⁵忠洲　⁶探信

Tanshin[1] (1785–1835). *N.:* Kanō Morimichi.[2] *Gō:* Kōsai,[3] Tanshin.[4] **Biog.:** Kanō painter. Eldest son and pupil of Kanō Tamboku Morikuni; brother of Kanō Kuninobu Tanshū. Born in Edo. Became seventh-generation head of the Kajibashi Kanō. Employed by the shogunate as *oku eshi.* Given title of *hōgen.* Must not be confused with Kanō Tanshin Morimasa, eldest son of Kanō Tan'yū. Painted rather tight landscapes in a standard Kanō manner. **Coll.:** Daitoku-ji, Museum (3), Philadelphia. **Bib.:** *Kanō-ha,* Tajima (12) 3.

¹探信　²狩野守道　³興斎　⁴探信

Tanshin[1] (1834–93). *N.:* Tsuruzawa Moriyasu.[2] *Gō:* Kyūsaikan,[3] Tangen,[4] Tanshin.[5] **Biog.:** Painter. Born in Kyōto. Son and pupil of Tsuruzawa Tanryū; seventh-generation head of the Tsuruzawa family. Received title of *hokkyō* in 1853 and of *hōgen* in 1861. In 1877 moved to Tōkyō and was given an official position at court and at the Imperial Household Museum. His style in part Kanō, following the family tradition. **Coll.:** Imperial (1). **Bib.:** Asano.

¹探真　²鶴沢守保　³九皐館　⁴探玄　⁵探真

Tan'yō[1] (?–1771). *N.:* Kanō Moriyasu.[2] *Gō:* Tankyō,[3] Tan'yō.[4] **Biog.:** Kanō painter. Son and pupil of Kanō Shūyo. Member of the Shiba Atagoshita Kanō school. **Coll.:** Museum (3).

¹探葉　²狩野守安　³探恭　⁴探葉

Tan'yū[1] (1602–74). *N.:* Kanō Morinobu.[2] *F.N.:* Shirojirō,[3] Uneme.[4] *Gō:* Byakurenshi,[5] Hippō Daikoji,[6] Seimei,[7] Tan'yū,[8] Tan'yūsai.[9] **Biog.:** Kanō painter. Eldest son of Kanō Takanobu, grandson of Kanō Eitoku; studied under Kanō Kōi. In 1614 moved from Kyōto to Edo. Patronized by the shogun Hidetada, eventually became Edokoro *azukari,* founding the branch of the Kanō school known as the Kajibashi after the district in which he lived. In 1636, on the shogun's orders, became a priest and changed his name from Morinobu to Tan'yū. In 1638 received title of *hōgen,* in 1665 that of *hōin.* Often gave opinions on quality, authenticity, and monetary value of paintings brought to his studio. Called the "revitalizer of the Kanō school," he established the Kanō style at the Edokoro; but his famous scroll *Tōshōgū Engi* was painted in the Tosa style, and he also worked at times in the Muromachi *suiboku* manner. Foremost artist of his day; frequently and deceptively imitated. **Coll.:** Andrew; Art (1), (1a); British; Brooklyn; Chidō; Daitoku-ji (Kohō-an); Fogg; Freer; Hatakeyama; Kamakura; Kyōōgokoku-ji; Kyōto; Metropolitan; Museum (3); Nagoya; Nanzen-ji; Nelson; Newark; Nezu; Nijō; Ōkura; Tokiwayama; Tokugawa; Tōkyō (1), (2); University (2); Victoria; Yale. **Bib.:** AA 6, 14; Binyon (2); BK 4, 8, 116; Boller; Covell (2); *Exhibition* (1); *Japanese* (1a); K 8, 32, 51, 100, 113, 126, 139, 154, 162, 171, 181, 184, 190, 200, 203, 214, 216, 236, 241, 244, 278, 282, 294, 301, 305, 321, 327, 338, 358, 368, 389, 400, 409, 416, 428, 439, 446, 457, 462, 478, 491, 502, 531, 547, 553, 564, 568, 569, 578, 588, 596, 602, 621, 676, 748, 902, 903; *Kanō-ha;* KO 2; M 18, 205; Mayuyama; Moriya; NB (H) 14; NBT 5; NBZ 4; NEZ 12; NKZ 66, 71; Noma (1) 2; *One* (2); Rosenfield (2); SBZ 9; Shimada 2; Tajima (12) 2, 8, 11, 13, 15, 16, 17, 19; Tajima (13) 5; Takeda (1); *Ukiyo-e* (3) 20; Yamane (1a).

¹探幽　²狩野守信　³四郎次郎　⁴采女　⁵白蓮子
⁶筆峯大居士　⁷生明　⁸探幽　⁹探幽斎

Tan'yū[1] (1815–45). *N.:* Mori Masatomo.[2] *F.N.:* Shōsaku.[3] *Gō:* Tan'yū,[4] Yūgensai.[5] **Biog.:** Painter. A samurai, serving the Maeda clan. Lived in Edo. Became a pupil of Hasegawa Settan. Also studied *haiku.* Died unexpectedly in Nara while on a trip with his feudal lord. **Bib.:** Mitchell.

¹旦猷 (旦遊)　²森正朝　³昌作　⁴旦猷 (旦遊)　⁵有元斎

Tanzan[1] (1655–1729). *N.:* Tsuruzawa Kanenobu (Kenshin)[2] (or Ryōshin[3] or Shuken).[4] *Gō:* Tansen,[5] Tanshun,[6] Tanzan,[7] Yūsen.[8] **Biog.:** Kanō painter. Lived in Kyōto. A distinguished pupil of Kanō Tan'yū and a *goyō eshi* at the imperial court. Received title of *hōgen.* His descendants, all car-

rying the surname of Tsuruzawa and *gō* beginning with *tan*, were also court painters. A good standard Kanō painter, with forceful brushwork. **Bib.:** *Kanō-ha,* Morrison 1.

¹探山 ²鶴沢兼信 ³良信 ⁴守見
⁵探川 ⁶探春 ⁷探山 ⁸幽泉

Tatehata Taimu¹ (1880–1942). **Biog.:** Western-style sculptor. Born in Wakayama-ken. Began his career as a doctor. Drawn to sculpture, graduated from both the Kyōto School of Fine Arts and the Tōkyō School of Fine Arts and eventually taught at the latter for many years. Member of the Imperial Art Academy. An exhibitor with the Bunten. Once organized an exhibition of sculpture for children to further their interest in that art. His work is in the academic realistic tradition. **Coll.:** National (5). **Bib.:** Asano, GNB 28, NBT 10, NBZ 6, Uyeno.

¹建畠大夢

Tatsu¹ (fl. 1818–29). *N.:* Katsushika Tatsu.² **Biog.:** Ukiyo-e painter. Pupil and perhaps a daughter of Hokusai. Painted *bijin* in the 1810 manner of Hokusai, but a bit more delicately. Is sometimes known as Tatsujo.³ **Coll.:** Los Angeles. **Bib.:** *Japanese* (2), Lane, Shimada 3, *Ukiyo-e* (2) 9.

¹辰 ²葛飾辰 ³辰女

Tatsuemon¹ (fl. Muromachi period). *N.:* Ishikawa.² *Gō:* Tatsuemon.³ **Biog.:** Sculptor. Specialized in making *onna men* (women's masks). Said to have lived in Echizen and also to have worked in Kyōto. Many of the Muromachi female masks extant today are considered to be his work.

¹龍右衛門 ²石川 ³龍右衛門

Tatsuke¹ (fl. late 17th to 19th c.). One of the less famous families of lacquer artists but producers of works of great taste and high quality. For starred names among the following, see individual entries.

 *Chōbei² (fl. 1661–81).
 Chōbei³ (Tatsuke Hirotada)⁴ (fl. c. 1667)
 *Eisuke⁵ (fl. 18th c.)
 Jofu⁶ (fl. c. 1850)
 Jōho⁷ (fl. 18th c.)
 Kazutsune⁸
 Kōkōsai⁹ (Tatsuke Jōshō)¹⁰ (fl. 19th c.)
 Kōsai¹¹ (Tatsuke Yasutsune)¹² (fl. late 18th c.)
 Shō(jo)¹³ (1781–?; daughter of Takanori)
 Soshō¹⁴ (fl. 19th c.)
 *Takamitsu¹⁵ (fl. c. 1800)
 Takamori (Ryūsei)¹⁶ (fl. c. 1800)
 *Takanori¹⁷ (1757–1833)
 *Toshihide (Hisahide)¹⁸ (1756–1829)
 *Toshihide II¹⁹ (fl. late 18th to early 19th c.)

Bib.: Casal, Herberts, Jahss.

¹田付 ²長兵衛 ³長兵衛 ⁴田付広忠 ⁵栄助
⁶恕封 ⁷常甫 ⁸和常 ⁹幸々斎 ¹⁰田付常祥
¹¹幸斎 ¹²田付安常 ¹³セウ(女) ¹⁴索祥 ¹⁵高光
¹⁶隆盛 ¹⁷孝則 ¹⁸寿秀 ¹⁹寿秀二代

Tazaki Hirosuke¹ (1898–). **Biog.:** Western-style painter. Born in Fukuoka-ken, works in Tōkyō. Studied at the Kansai Bijutsuin; pupil of Sakamoto Hanjirō and Yasui Sōtarō. From 1922 to 1924 studied in Paris. Member of the Nikakai from 1926 to 1930; then joined the Nitten and the Issuikai. Has exhibited with the Nitten, the Tōkyō Biennial, and the Salon d'Automne in Paris. After 1949, a juror and official of the Nitten. His work reflects his prewar training in Paris. His landscapes are generally done in a broad, simplified manner. Also works in the Japanese style. **Coll.:** National (5). **Bib.:** Asano.

¹田崎広助

Teiji (Sadaji)¹ (fl. mid-19th c.). **Biog.:** Lacquerer. Also a potter and maker of *netsuke*. Pupil of Ritsuō. Used ceramic inlays to decorate his lacquer ware and placed his signature on an inlaid ceramic plaque. **Bib.:** Herberts, Jahss.

¹貞二

Teiko¹ (1848–97). *N.:* Ishii (originally Suzuki)² Shigetaka.³

Gō: Teiko.⁴ **Biog.:** Painter. Born in Edo. Second son and pupil of Suzuki Gako; adopted by the Ishii family. Father of Ishii Hakutei and Ishii Tsuruzō. When about 30, began to study Western painting at Kunisawa Shinkurō's school, the Shōgidō. Also became interested in etching and colored lithography. Juror for the Nihon Bijutsu Kyōkai; member of the Meiji Bijutsukai. In 1890 showed with the Naikoku Kangyō Hakurankai. **Bib.:** Asano, BK 188, Mitchell.

¹鼎湖 ²鈴木 ³石井重賢 ⁴鼎湖

Teiun¹ (fl. first half 18th c.). *N.:* Iwasa Teiun.² **Biog.:** Tosa painter. An artist unknown until recently, his signature has now been found on several screens. Though he signs himself as a follower of the Tosa school, there is some Kanō influence in his brushwork. May be a lineal as well as an artistic descendant of Iwasa Matabei. **Coll.:** Newark. **Bib.:** ACASA 18.

¹貞雲 ²岩佐貞雲

Tekizan¹ (1796–1864). *N.:* Kumasaka Shō.² *Gō:* Tekizan.³ **Biog.:** Japanese-style painter. Born in Fukushima-ken. Pupil of Kakizaki Hakyō; later to Kyōto to study under Uragami Shunkin. Served Lord Matsumae as official painter. A good painter of *kachōga* and landscapes. **Coll.:** Musées. **Bib.:** Mitchell.

¹適山 ²熊坂昌 ³適山

Temmin (Tenmin)¹ (fl. early 19th c.). *N.:* Shimizu Kan.² *A.:* Shitetsu,³ Kōkan.⁴ *Gō:* Temmin (Tenmin).⁵ **Biog.:** Painter. Born in Shiga-ken. To Kyōto, where he first studied under Ichikawa Kunkei and then Kishi Ganku. Eventually moved to Edo. Painted figures and *kachōga*. **Bib.:** Mitchell.

¹天民 ²清水鑑 ³士徹 ⁴公鑑 ⁵天民

Tengaku¹ (fl. mid-19th c.). *N.:* Kishi Tengaku.² *F.N.:* Shumpei (Shunpei).³ *Gō:* Tengaku.⁴ **Biog.:** Kishi painter. Born in Hizen Province. Pupil of Kishi Ganku. **Bib.:** Morrison 2.

¹天岳 ²岸天岳 ³俊平 ⁴天岳

Tenju¹ (?–1795). *N.:* Nakagawa Tenju.² *A.:* Dainen.³ *F.N.:* Chōshirō.⁴ *Gō:* Kantenju,⁵ Suishinsai,⁶ Tenju,⁷ Ton'usai.⁸ **Biog.:** *Nanga* painter. Born and lived in Matsuzaka in Ise; visited Edo and Kyōto, where he knew Ikeno Taiga and Kō Fuyō. Produced a number of illustrated books; painted small landscapes. Also a good engraver of seals. **Coll.:** Victoria. **Bib.:** Umezawa (2).

¹天寿 ²中川天寿 ³大年 ⁴長四郎
⁵韓天寿 ⁶酔晋斎 ⁷天寿 ⁸頓迂斎

Tenryū Dōjin¹ (1718–1810). *Priest name:* Tenryū Dōjin.² *A.:* Kōyu.³ *Gō:* Ōkin.⁴ **Biog.:** Nagasaki painter. Born in Nagasaki. Spent first half of his life trying to revive the imperial regime; failed, and retired to Lake Suwa, Nagano-ken, where he became a priest, painter, poet, and engraver of seals. Specialized in the painting of vines, even writing an essay on the subject: *Budō Gasoku* (Rules for Drawing Grapes). **Bib.:** BK 3; Hillier (1); K 660, 667, 668, 669; Mitchell.

¹天龍道人 ²天龍道人 ³公瑜 ⁴王瑾

Terajima Shimei¹ (1896–). *N.:* Terajima Tokushige.² *Gō:* Shimei.³ **Biog.:** Japanese-style painter. Born in Hyōgo-ken; works in Nishinomiya. Pupil of Kaburagi Kiyokata. Has exhibited his paintings, frequently of *bijin* in traditional Japanese dress, at government exhibitions and with the Nitten. **Coll.:** National (5). **Bib.:** Asano, Kondō (6).

¹寺島紫明 ²寺島徳重 ³紫明

Teramatsu Kunitarō¹ (1875–1943). *N.:* Teramatsu Kunitarō.² *Gō:* Tansai.³ **Biog.:** Western-style painter. Born in Okayama-ken. In 1900 to Tōkyō to study at the Fudōsha. In 1902 passed state examination qualifying him as an art teacher in a secondary school; returned home to teach. When Asai Chū moved to Kyōto, went there to study under him. From 1908 exhibited with the Bunten. When Asai Chū died, helped his successor at the Kansai Bijutsuin, Kanokogi

Takeshirō, promote art education in the Kansai district. **Bib.:** Asano.

¹寺松国太郎 ²寺松国太郎 ³担斎
Terauchi Manjirō[1] (1890–1964). **Biog.:** Western-style painter. Born in Ōsaka. In 1916 graduated from the Tōkyō School of Fine Arts, Western-painting division. In 1918 showed with the Bunten. In 1919 became a juror for the Teiten; in 1929 a member of the Kōfūkai. From 1943 to 1950 taught at his alma mater, from 1952 at Tōkyō Kyōiku Daigaku (University of Education), and from 1959 at Niigata University. In 1950 received the Japan Art Academy Prize, becoming a member of the Academy in 1960. His style is quite realistic in the academic tradition. **Coll.:** National (5). **Bib.** Asano.

¹寺内萬治郎
Terazaki Kōgyō[1] (1866–1919). *N.:* Terazaki Hironari.[2] *A.:* Norisato.[3] *F.N.:* Chūtarō.[4] *Gō:* Kōgyō,[5] Shūsai,[6] Sōzan (Shūzan),[7] Tenrai Sanjin,[8] Tōryūken.[9] **Biog.:** Japanese-style painter. Born in Akita. To Tōkyō in 1888; studied many styles of Japanese and Chinese painting, finally creating his own rather eclectic manner. Taught at the Tōkyō School of Fine Arts until he left with Okakura Tenshin, Hashimoto Gahō, Shimomura Kanzan, and Yokoyama Taikan to found the Nihon Bijutsuin. When Okakura retired from this group, Kōgyō returned to the Tōkyō School of Fine Arts. Member of the Nihon Bijutsuin and the Art Committee of the Imperial Household. Served as a war correspondent during the Russo-Japanese war, producing prints. His landscapes are delicately colored and in the Japanese style, yet show much Western influence. **Coll.:** Cincinnati, Minneapolis, Musées, Museum (3), National (5), Newark, Tōkyō (2), Victoria. **Bib.:** Asano, BK 75, Elisséev, *Kurashina* (1), NB (H) 24, NB (S) 17, NBZ 6, Umezawa (2), Uyeno.

¹寺崎広業 ²寺崎広業 ³徳郷 ⁴忠太郎 ⁵広業
⁶秀斎 ⁷宗山 ⁸天籟散人 ⁹騰竜軒
Terazaki Takeo[1] (1883–1967). **Biog.:** Printmaker. In 1919 graduated from Tōkyō School of Fine Arts. Studied abroad from 1919 to 1923 and again in 1930, at which time he studied fresco painting. Worked from copperplates as well as wood blocks. **Bib.:** Fujikake (1), NBZ 6.

¹寺崎武男
Terunobu[1] (fl. 1716–35). *N.:* Nishikawa Terunobu.[2] **Biog.:** Ukiyo-e painter. Known primarily as a painter of *bijin* in a style that blends the Kaigetsudō manner and the influence of Sukenobu. His courtesans are shown with eyebrows painted high on their foreheads—a fashion of the day—as was noted by Okumura Masanobu in his *Ehon Fuga Nana Komachi* of 1744. Work rare. **Coll.:** Tōkyō (1). **Bib.:** Hillier (4) 1, Kikuchi, M 18, Takahashi (3), *Ukiyo-e* (3) 3.

¹照信 ²西川照信
Terunobu (Hidenobu)[1] (1717–63). *N.:* Kanō Terunobu (Hidenobu).[2] *F.N.:* Genshichirō.[3] *Gō:* Jotekisai,[4] Yūsei.[5] **Biog.:** Kanō painter. Born in Edo. Second son of Kanō Eishuku; pupil of his brother Kanō Norinobu, who became tenth-generation head of the Nakabashi Kanō. Greatly favored by the shogun Ieharu, was given the title of a samurai serving the shogun directly and became *oku eshi* to the shogunate. Received honorary title of *hōgen,* later of *hōin.* Eventually adopted by Norinobu and became eleventh-generation head of the Nakabashi Kanō line. **Coll.:** Museum (3).

¹英信 ²狩野英信 ³源七郎 ⁴如適斎 ⁵祐清
Terushige[1] (fl. 1715–25). *N.:* Katsukawa Terushige.[2] **Biog.:** Ukiyo-e printmaker. Life unknown. Perhaps a pupil of Torii Kiyonobu; known for a few rare actor prints of unusual merit. **Coll.:** Art (1), Honolulu, Tōkyō (1), Victoria. **Bib.:** Gunsaulus (1), Kikuchi, Michener (3), Shibui (1).

¹輝重 ²勝川輝重
Tetsugai[1] (fl. c. 1840). *N.:* Nakamura Kōsei.[2] *A.:* Shisei.[3] *Gō:* Gakuren,[4] Mugen Dōjin,[5] Tetsugai.[6] **Biog.:** Painter.

Samurai of the daimyo of Kakegawa. Known for his paintings of Fujisan. **Bib.:** Mitchell.

¹轍外 ²中村公成 ³子成 ⁴岳蓮 ⁵無限道人 ⁶轍外
Tetsuō[1] (1791–1871). *N.:* Hidaka Tetsuō.[2] *A.:* Tetsuō.[3] *Gō:* Somon.[4] **Biog.:** *Nanga* painter. Born and lived in Nagasaki. Zen monk at the Shuntoku-ji, Nagasaki, for 35 years; eventually became 14th abbot. Later retired to the Unryū-an. Pupil of Ishizaki Yūshi; studied *bunjinga* under the recently arrived Chinese painter Chiang Chia-pu. With Kinoshita Itsuun and Miura Gomon, considered one of Nagasaki's three great *nanga* painters of his time. Orchids his specialty, but also a skillful painter of landscapes and *kachōga*. **Coll.:** Nagasaki. **Bib.:** K 497, 607, 711; Mitchell; NBZ 5; Rosenfield (2).

¹鉄翁 ²日高鉄翁 ³鉄翁 ⁴祖門
Tetsuseki (Tesseki)[1] (1817–63). *N.:* Fujimoto (originally Yamanaka)[2] Makane.[3] *A.:* Chūkō.[4] *F.N.:* Tsunosuke.[5] *Gō:* Baisaiō,[6] Tekkanshi,[7] Tetsumon,[8] Tetsuseki (Tesseki),[9] Tomon.[10] **Biog.:** *Nanga* painter. Lived in Kyōto; a samurai from Okayama. A Loyalist, was killed fighting for the Loyalists near Nara. Skilled in calligraphy, the military arts, Chinese literature, and history. Studied the style of Chinese Sung painting. **Coll.:** British, Tōkyō (1), University (2). **Bib.:** K 732, NB (S) 4.

¹鉄石 ²山中 ³藤本真金 ⁴鋳公 ⁵津之助
⁶売菜翁 ⁷鉄寒士 ⁸鉄門 ⁹鉄石 ¹⁰都門
Tetsuzan (Tessan)[1] (1775–1841). *N.:* Mori Shushin.[2] *A.:* Shigen.[3] *Gō:* Tetsuzan (Tessan).[4] **Biog.:** Maruyama painter. Born in Kyōto; adopted by his uncle, Mori Sosen. One of Maruyama Ōkyo's ten best pupils. Moved to Edo, bringing the Maruyama style to the Kantō region. His paintings, often excellent ones, are of tall colorful *bijin* or of skillfully rendered birds and animals. **Coll.:** Art (1), Ashmolean, British, Cincinnati, Daijō-ji, Detroit, Museum (3), Stanford, Tōkyō (1). **Bib.:** Asano; Fenollosa; Hillier (1); K 123, 316, 449, 628, 945; Mitchell; Morrison 2; OA 2; Tajima (3) 2; Tajima (12) 9, 11; Tajima (13) 6.

¹徹山 ²森守真 ³子玄 ⁴徹山
Tobari Kogan[1] (1882–1927). **Biog.:** Western-style sculptor, illustrator, wood engraver. Born in Tōkyō. First worked as an office boy in a bank. In 1901 to New York, where he learned water-color technique while employed as a servant by an American artist. On returning to Japan in 1906, met Ogiwara Morie and became interested in sculpture. Showed with the Nihon Bijutsuin and, later, with the Teiten. In 1917 became an associate member of the Nihon Bijutsuin. With Ishii Hakutei organized the Suisaigakai; one of the founders of the Nihon Sōsaku Hanga Kyōkai. Known for his many small bronze figures, which show the influence of Rodin. Also made woodblock prints and illustrations for newspapers. His prints, in the French manner of the 1900s, pleasantly illustrative. **Coll.:** Tōkyō (1). **Bib.:** Asano, Fujikake (1), GNB 28, *Masterpieces* (4), NHBZ 7, NBT 10, NBZ 6, SBZ 11, UG 4.

¹戸張孤雁
Tōbei[1] (fl. early 19th c.). *N.:* Shibata Tōbei.[2] **Biog.:** Lacquerer. Worked in Kyōto. Teacher of Kimura Hyōsai. **Bib.:** Herberts, Jahss.

¹藤兵衛 ²柴田藤兵衛
Tōbun (Dōbun)[1] (1502–82). *N.:* Toki Raigei.[2] *Gō:* Bunkan,[3] Sōgei,[4] Sōgen,[5] Tōbun (Dōbun),[6] Tokushūsai.[7] **Biog.:** Muromachi *suiboku* painter. Member of Toki clan of Mino Province. Also a poet. Little other information on his life save that he is said to have traveled all over Japan at the time of the fall of the Ashikaga shogunate. A good *suiboku* painter, he specialized in the painting of hawks but also did portraits, landscapes, and *kachōga;* worked in various styles, including Chinese and *yamato-e.* Regarded, with Takeda Shinren, as the typical warrior painter. **Note:** Although Raigei is usually thought to be his given name, some scholars

suggest that this may refer to some other artist. It is also thought that Tōbun may be the same person as Toki Tomikage (q.v.). **Coll.:** Museum (3), Tōkyō (1). **Bib.:** K 178, 639, 751, 792; NB (S) 63; NBZ 3; Shimada 1; Tajima (13) 4.

¹洞文　²土岐頓芸　³文閑（文官）
⁴宗芸　⁵宗源　⁶洞文　⁷徳秀斎

Tōchi¹ (fl. c. 1750). *N.:* Unkoku Tōchi.² **Biog.:** Unkoku painter. A minor artist of this school. **Bib.:** K 820.

¹等知　²雲谷等知

Tōchō¹ (fl. 1624–43). *N.:* Hasegawa Tōchō.² *F.N.:* Sakon.³ **Biog.:** Hasegawa painter. A relative of Hasegawa Tōhaku. Continued the family tradition in painting. Has sometimes been confused with Hasegawa Sakon (q.v.).

¹等重　²長谷川等重　³左近

Tōeki¹ (1591–1644). *N.:* Unkoku Motonao.² *Gō:* Tōeki.³ **Biog.:** Unkoku painter. Second son and pupil of Unkoku Tōgan. Lived first in Kyōto, but on his father's death in 1618 succeeded him as official painter to the Mōri family in Suō Province. Known as Sesshū IV. In 1626 received honorary title of *hokkyō*. An artist of considerable talent, specializing in landscapes and figures. Worked in the Unkoku tradition with an admixture of the rich Momoyama decorative manner; an elaborate style of considerable elegance but lacking his father's strength. **Coll.:** Denver; Detroit; Freer; Joei-ji; Metropolitan; Museum (1), (3); University (2). **Bib.:** BK 82; BMFA 1933; K 132, 603, 616, 820, 847; M 62, 64, 252; Morrison 1; NB (H) 14; Shimada 2; Tajima (12) 8, 15.

¹等益　²雲谷元直　³等益

Tōeki¹ (?–1841). *N.:* Kanō Harunobu.² *Gō:* Tōeki.³ **Biog.:** Kanō painter. Pupil of his father-in-law, Kanō Tōhaku Chikanobu, whom he succeeded as sixth-generation head of the Surugadai branch of the Kanō school in Edo. Served as *goyō eshi* to the shogunate. **Bib.:** Tajima (12) 8, 15.

¹洞益　²狩野春信　³洞益

Tōetsu¹ (fl. last quarter 15th c.). *Gō:* Umpō (Unpō),² Tōetsu.³ **Biog.:** Muromachi *suiboku* painter. A priest, who was said to have been a pupil of Sesshū and to have received a sketchbook from him. An able painter of landscapes and figures. **Coll.:** Metropolitan.

¹等悦　²雲峰　³等悦

Tōetsu¹ (fl. c. 1675). *N.:* Hasegawa.² *Gō:* Tōetsu,³ Untaku.⁴ **Biog.:** Unkoku painter. Nothing more known about him; quite possibly the same person as Mitani Tōetsu (q.v.).

¹等悦　²長谷川　³等澤　⁴雲澤

Tōetsu¹ (fl. c. 1675). *N.:* Mitani Nobushige.² *F.N.:* Tokuzaemon.³ *Gō:* Tōetsu,⁴ Untaku.⁵ **Biog.:** Unkoku painter. Possibly a descendant of the Tōetsu who was thought to have been a pupil of Sesshū; son of Mitani Tōtetsu and possibly the same artist as Hasegawa Tōetsu (q.v.). **Bib.:** K 798.

¹等悦　²三谷信重　³徳左衛門　⁴等悦　⁵雲澤

Tōgai¹ (1827–81). *N.:* Kawakami (originally Kishi)² Kan.³ *A.:* Shiritsu.⁴ *F.N.:* Mannojō.⁵ *Gō:* Muhen Shunshokugaya,⁶ Tainen,⁷ Tōgai.⁸ **Biog.:** Western-style painter. Born in Nagano-ken, lived in Tōkyō; adopted into the Kawakami family. Professor at the former Imperial University. Studied Shijō painting with Ōnishi Chinnen, *nanga* and Western oil painting on his own. Much influenced (through books) by Dutch painters, particularly Ruysdael. In 1857 became inspector of painting in the Bureau for the Inspection of Foreign Documents under the *bakufu,* with task of studying Western painting methods. (This bureau finally became the Kaisei School and was later incorporated into Tōkyō University; a painting office was set up within the Kaisei School with Tōgai later becoming director.) In 1869 opened his own school, the Chōkō Dokugakan. In 1871 published a guide to Western-style painting; in 1872 produced the first lithographs made in Japan. On the hanging committee of the first Naikoku Kangyō Hakurankai exhibition. A pioneer in the field of Western painting in his day, but his

work now seems to Western eyes of little artistic value, reflecting as it does the European academic tradition without a trace of his Japanese heritage. However, among the few paintings that have survived there are also some in Japanese style. **Coll.:** Ashmolean, Tōkyō (1). **Bib.:** Asano; BK 79, 206, 279; Harada Minoru; K 764; M 133; Mitchell; NB (H) 24; NB (S) 30; NBZ 6; Sullivan; Umezawa (2); Uyeno.

¹冬崖　²岸　³川上寛　⁴子栗　⁵万之丞
⁶無辺春色画屋　⁷大年　⁸冬崖

Tōgan¹ (1547–1618). *N.:* Unkoku Tōgan.² *F.N.:* Hara Jihei.³ **Biog.:** Unkoku painter. Probably a pupil of Kanō Shōei, but took Sesshū for his model. Toward the end of the 16th century his patron, Mōri Terumoto (a daimyo in Suō Province), allowed him to live in the Unkoku-an, Sesshū's studio. There he studied and copied Sesshū's famous landscape scroll of 1486, writing an inscription in it in 1593. Eventually claimed artistic descent from Sesshū, won a law case against Hasegawa Tōhaku, who had similar claims, and took Sesshū's *gō* Unkoku as his family name, passing it on to the school he founded; called himself Sesshū III. Received title of *hokkyō*. Style at times close to Sesshū's, though it lacks the strong line and is at times softer and more naturalistic than that of the earlier artist. Also did some decorative paintings in bright colors and some genre works. **Coll.:** British, Center, Daitoku-ji (Ōbai-in), Freer, Herron, Kongō-ji, Kyōto (2), Lake Biwa, Museum (3), Portland, Seattle, Tōkyō (1). **Bib.:** AA 6; *Au-delà;* Covell (2); Gray (2); GNB 13; Grilli (1); Hillier (4) 3; HS 11; *Japanische* (1); K 87, 197, 262, 329, 551, 570, 575, 613, 628, 631, 728, 750, 807, 820, 877, 923; M 252; Matsushita (1); Morrison 1; Murase; NB (H) 14; NB (S) 13; NBT 5; NBZ 4; Noma (1) 2; *One* (2); Paine (2) 2, (4); SBZ 8; Shimada 2; Tajima (13) 4; Yamane (1a).

¹等顔　²雲谷等顔　³原治平（原治兵衛）

Tōgan¹ (fl. 1596–1615). *N.:* Fujishige Tōgan.² **Biog.:** Lacquerer. Worked in Nara. Son of Tōgen,³ a *makie* craftsman who specialized in making lacquer tea-ceremony objects. Known as a master artist; invented the technique of *nakatsugi,* a method of uniting separate pottery pieces with lacquer. In 1615, at the command of Tokugawa Ieyasu, he and his son were called to repair various antique ceramics—masterpieces that had been used in the tea ceremony and had been found in the ruins of Ōsaka Castle. So successful were they that they were summoned again a little later for the same purpose. The first known examples of repairing broken ceramics with lacquer. **Bib.:** Herberts, Jahss, Sawaguchi.

¹藤厳　²藤重藤厳　³藤元

Tōgan¹ (1653–1736). *N.:* Sakuma Yoshikazu² (or Masumoto).³ *A.:* Shigan.⁴ *F.N.:* Hikoshirō.⁵ *Gō:* Chikkoku,⁶ Taihaku Sanjin,⁷ Tōgan,⁸ Yōken.⁹ **Biog.:** Kanō painter. Born in Sendai. Adopted by Sakuma Yūtoku, the official painter to the lord of Sendai. Pupil of Kanō Tōun Masunobu, studying under him in Edo. Succeeded Yūtoku in the service of the lord of Sendai. A good painter of landscapes and portraits.

¹洞巌　²佐久間義和　³益元　⁴子崇　⁵彦四郎
⁶竹谷　⁷太白山人　⁸洞巌　⁹容軒

Tōgei¹ (fl. 16th c.). **Biog.:** Painter. Studied both Sesshū's and Shūgetsu's styles. Worked in the manner of Sesshū. **Coll.:** Museum (3).

¹等芸

Tōgen (Dōgen)¹ (1643–1706). *N.:* Kanō Kuninobu.² *F.N.:* Kumanosuke,³ Kumenosuke.⁴ *Gō:* Tōgen (Dōgen).⁵ **Biog.:** Kanō painter. Second son of Kanō Sosen Nobumasa. Pupil of Kanō Tōun Masunobu. Member of the Saruyamachi Kanō line. Served the shogunate as *omote eshi.* **Coll.:** Victoria.

¹洞元　²狩野邦信　³久馬之介　⁴久米之助　⁵洞元

Tōgetsudō[1] (fl. c. 1740). **Biog.:** Ukiyo-e printmaker. Follower of Masanobu. Known chiefly for a sixfold screen of a theatrical scene, now in the collection of the Freer Gallery of Art. **Coll.:** Freer. **Bib.:** Fujikake (3) 2.

[1]東月堂

Tōgo Seiji[1] (1897–). *N.:* Tōgō Tetsuharu.[2] *Gō:* Seiji.[3] **Biog.:** Western-style painter. Born in Kagoshima-ken. Studied in France from 1919 to 1928. Member of the Nikakai, which he helped reorganize after the war, and of the Japan Art Academy. In 1956 won the Japan Art Academy Prize. His manner strongly influenced by the decorative cubism prevalent in Paris in the 20s. **Coll.:** National (5). **Bib.:** Asano, NB (H) 24, NBT 10, NBZ 6, SBZ 11.

[1]東郷青児 [2]東郷鉄春 [3]青児

Tōha[1] (fl. early 16th c.?). **Biog.:** Muromachi *suiboku* painter. A priest attached to a temple in Kyūshū. Pupil of Shūgetsu, whose style he followed but whose equal he was far from being.

[1]等坡

Tōhaku[1] (1539–1610). *N.:* Hasegawa (originally Okumura)[2] Kyūroku.[3] *Gō:* Nobuharu (Shinshun),[4] Tōhaku.[5] **Biog.:** Painter. Born in Nanao, Noto Province, to a family of dyers, vassals of the Hatakeyama family. Adopted by the Hasegawa family. About 1570 to Kyōto to study Kanō painting; said to have been a pupil of Shōei or Eitoku. Also studied Chinese Sung and Yūan paintings. Admired Sesshū, calling himself fifth-generation successor to Sesshū until he lost a lawsuit to Unkoku Tōgan (q.v.). Eventually led revolt against the Kanō school, founding Hasegawa school. Lived at the Hompō-ji, Kyōto, and with his son Kyūzō ran a big studio for decoration of interiors. In his last years, called to Edo by Ieyasu and died there. Received title of *hōgen.* His opinions on art were collected in the *Tōhaku Gasetsu,* compiled by an admirer. Many of his early works are now in the Daihō-ji, Takaoka. An original and daring painter, especially in his black-and-white work, which shows some Zen influence; also did gold screens in more typical Momoyama manner. **Coll.:** Atami; Chishaku-in; Daihō-ji (1), (2); Daitoku-ji (Jukō-in, Sangen-in, Shinju-an); Entoku-in; Hompō-ji; Kennin-ji (Ryōsoku-in); Metropolitan; Museum (3); Myōshin-ji (Rinka-in, Ryūsen-an, Tenkyū-in); Nanzen-ji (Konchi-in, Tenju-an); Shōkoku-ji; Tōkyō (1). **Bib.:** *Art* (1a); *Au-delà;* BB 19; BG 69; BI 1, 45; BK 25, 56; Covell (2); Doi (10); *Exhibition* (1); Fontein (1), (3); GK 12; GNB 11, 13; Gray (2); Grilli (1); Hisamatsu; HS 1, 2, 4; K 47, 198, 337, 394, 445, 513, 529, 655, 656, 712, 810, 814, 847, 850, 866, 879, 893; *Kanō-ha;* KO 35; *Kokuhō* 6; Lee (1); M 64, 262; Matsushita (1); Mizuo (1); Moriya; Morrison 1; NB (H) 14; NB (S) 13; NBT 5; NBZ 4; NKZ 30, 66, 72; Noma (1) 1, 2; *One* (2); Paine (2) 1, (4); SBZ 8; Shimada 2; Tajima (12) 6, (13) 4; Tanaka (1), (2); TBS 8; Yashiro (1).

[1]等伯 [2]奥村 [3]長谷川久六 [4]信春 [5]等伯

Tōhaku (Dōhaku)[1] (1772–1821). *N.:* Kanō Chikanobu (Yoshinobu).[2] *Gō:* Tōhaku (Dōhaku).[3] **Biog.:** Kanō painter. Son and pupil of Kanō Tōshun Yoshinobu, succeeding his father as fifth-generation head of the Surugadai Kanō. Served the shogunate as *omote eshi.* Given honorary title of Ōkurakei. In 1813 received rank of *hōgen.* Painted *byōbu* sent as a gift to the ruler of Korea. A fair Kanō painter, working in rather a tight traditional manner. **Coll.:** Museum (3). **Bib.:** *Kanō-ha.*

[1]洞白 [2]狩野愛信 [3]洞白

Tōhaku (Dōhaku)[1] (?–1851). *N.:* Kanō Chinshin.[2] *Gō:* Tōhaku (Dōhaku).[3] **Biog.:** Kanō painter. Son and pupil of either Kanō Tōhaku Chikanobu or Kanō Tōeki Harunobu. Became head of the seventh generation of the Surugadai branch of the Kanō school. **Coll.:** Ōkura. **Bib.:** *Kanō-ha.*

[1]洞白 [2]狩野陳信 [3]洞白

Tōhan[1] (1635–1724). *N.:* Unkoku Tōhan.[2] **Biog.:** Unkoku painter. Grandson of Unkoku Tōgan; youngest son of

Unkoku Tōeki, under whom he studied. Succeeded his brother Tōyo as head of the family, calling himself Sesshū VI. Received rank of *hōgen.* His work more in the rich decorative Momoyama manner than in the traditional Unkoku style. **Coll.:** Museum (3), Newark, Tōkyō (1). **Bib.:** K 64, 621, 820; Morrison 1.

[1]等璠 [2]雲谷等璠

Tōho[1] (fl. c. 1650). *N.:* Unkoku Tōho.[2] *Gō:* Soken.[3] **Biog.:** Unkoku painter. Second son of Unkoku Tōtaku. Served the Hosokawa family as their official painter.

[1]等甫 [2]雲谷等甫 [3]素軒

Tōho[1] (?–1788). *N.:* Naitō Seisan[2] (or Seisei).[3] *Gō:* Kansui,[4] Kōkōsha,[5] Senri,[6] Tōho,[7] Zekin.[8] **Biog.:** Painter. Born in Nagoya. Studied the Kanō manner. **Bib.:** Mitchell.

[1]東甫 [2]内藤正参 [3]正誠 [4]閑水 [5]好々舎 [6]千里 [7]東甫 [8]是琴

Tōin[1] (fl. c. 1620). *N.:* Hasegawa Tōin.[2] **Biog.:** Painter. Details of his life unknown. Painted doors at the Zuigan-ji, Matsushima. **Coll.:** Zuigan-ji. **Bib.:** NB (H) 14.

[1]等胤 [2]長谷川等胤

Tōin[1] (1744–1807/24). *N.:* Katagiri In.[2] *A.:* Shoō.[3] *Gō:* Hakuzensō,[4] Nichinichian,[5] Ransekiken,[6] Tōin.[7] **Biog.:** Painter. First studied with Kanō Eisen'in II, then with Watanabe Gentai. Also studied ancient Chinese painting. Specialized in *kachōga* and landscapes. **Bib.:** Mitchell.

[1]桐隠 [2]片桐隠 [3]所翁 [4]泊然叟 [5]日々庵 [6]蘭石軒 [7]桐隠

Tōin[1] (fl. c. 1850). *N.:* Azuma In.[2] *A.:* Mokusei.[3] *F.N.:* Toshitsugu.[4] *Gō:* Chōgetsu,[5] Tōin,[6] Tōrai.[7] **Biog.:** Painter. Son and pupil of Azuma Tōyō. His work lies between the *nanga* and the Shijō styles. **Bib.:** Hillier (4) 3, Mitchell.

[1]東寅 [2]東寅 [3]木星 [4]俊次 [5]長月 [6]東寅 [7]東来

Tōinshi[1] (fl. late 15th to early 16th c.). *Priest name:* Kaboku.[2] *A.:* Chōryūsai.[3] *Gō:* Tōinshi.[4] **Biog.:** Painter. A priest who lived first at the Kenchō-ji, Kamakura, where he was a pupil of Kenkō Shōkei; later moved to Mito. Painted in the manner of Shōkei. **Coll.:** Museum (3). **Bib.:** NB (S) 63, TBS 9.

[1]棟隠子 [2]可卜 [3]長柳斎 [4]棟隠子

Tōji[1] (fl. early 17th c.). *N.:* Unkoku Tōji.[2] **Biog.:** Unkoku painter. Second son and pupil of Unkoku Tōeki. Known for the copy of a landscape scroll by Sesshū that he made for the edification of his younger brother Tōhan, to demonstrate Sesshū's technique to him. Given rank of *hokkyō.* **Bib.:** M 75, Morrison 1.

[1]等爾 [2]雲谷等爾

Tōjin (Tōnin)[1] (fl. early 17th c.). *N.:* Hasegawa Tōjin (Tōnin).[2] **Biog.:** Hasegawa painter. Pupil of Hasegawa Tōhaku. The paintings by him in the Freer Gallery of Art are the only ones known so far. **Coll.:** Freer. **Bib.:** *Freer,* K 821.

[1]等仁 [2]長谷川等仁

Tōjō Shōtarō[1] (1865–1929). **Biog.:** Western-style painter, illustrator. Born in Tōkyō. Pupil of Kawamura Kiyo-o. In 1889 became a member of the Meiji Bijutsukai. Served as a war artist during the Sino-Japanese and Russo-Japanese wars. **Bib.:** Asano, NBZ 6.

[1]東城鉦太郎

Tōju[1] (fl. c. 1688–1703). *N.:* Ikoma Katsumasa.[2] *Gō:* Min'ō,[3] Tōju.[4] **Biog.:** Unkoku painter. Apparently connected with the Unkoku school, but details of his life unknown. His work is marked by the use of strong colors.

[1]等寿 [2]生駒勝政 [3]眠翁 [4]等寿

Tōju[1] (?–1777). *N.:* Kanō Katsunobu.[2] *Gō:* Tōju.[3] **Biog.:** Kanō painter. Son and pupil of Kanō Tōrin. Member of the Saruyamachi branch of the Kanō school. Studied Eitoku's manner. **Coll.:** Museum (3).

[1]洞寿 [2]狩野克信 [3]洞寿

Tōju[1] (fl. c. 1800). *Gō:* Kanshōsai,[2] Tōju,[3] Tōjusai.[4] **Biog.:** Lacquerer. Pupil of Iizuka Tōyō, often using his master's *gō*

of Kanshōsai. A very skillful artist. **Coll.:** Metropolitan, Victoria. **Bib.:** Herberts, Jahss.

¹桃寿 ²観松斎 ³桃寿 ⁴桃寿斎

Tōkaku[1] (fl. 18th c.). *N.:* Unkoku Tōkaku.[2] **Biog.:** Unkoku painter. Son of Unkoku Tōhan, whom he succeeded, calling himself Sesshū VII. Given rank of *hokkyō*.

¹等鶴 ²雲谷等鶴

Tōkei[1] (1760-1822). *N.:* Niwa Motokuni.[2] *A.:* Hakushō.[3] *Gō:* Tōkei.[4] **Biog.:** Printmaker. Lived in Ōsaka. Known for his illustrations of scenes from all over Japan; among them *Kodō Zuroku,* an illustrated book on copper mining. **Coll.:** Musées, Victoria.

¹桃溪 ²丹波元国 ³伯照 ⁴桃溪

Tōki[1] (1777-1839). *N.:* Yamawaki (or Ki [no])[2] Hironari (Hiroshige, Kōsei).[3] *A.:* Shikō.[4] *F.N.:* Shiken.[5] *Gō:* Bodai.[6] Jikaku,[7] Kihaku,[8] Tōki.[9] **Biog.:** Shijō painter. Born in Kyōto. Pupil of Matsumura Goshun. Toward the latter part of his life, as a devout Buddhist, turned to painting Buddhist subjects. At one time used the name Ki (no) Hironari (Hiroshige), which can also be read "Ki Kōsei" in Sino-Japanese. A skillful painter of landscapes and *kachōga.* **Coll.:** Ashmolean, Musée (2). **Bib.:** AA 14, Hillier (4) 3, Mitchell.

¹東暉 ²紀 ³山脇広成 ⁴子工 ⁵子憲
⁶菩提 ⁷自覚 ⁸既白 ⁹東暉

Tōki[1] (fl. c. 1840). *N.:* Morimura San.[2] *A.:* Sempu (Senpu).[3] *F.N.:* Jusaburō.[4] *Gō:* Chōsashi,[5] Tōki.[6] **Biog.:** Painter. Born in Edo. **Bib.:** Mitchell.

¹桃磯 ²守村粲 ³鮮夫 ⁴寿三郎 ⁵長茶子 ⁶桃磯

Tokinari[1] (fl. 1804-18). *Gō:* Fūryūan,[2] Tokinari.[3] **Biog.:** Ukiyo-e painter. Specialized in *bijinga,* working in a stye influenced by Kikugawa Eizan. **Coll.:** Dayton.

¹時成 ²風柳庵 ³時成

Tokinobu[1] (1642-78). *N.:* Kanō Tokinobu.[2] *F.N.:* Shirojirō,[3] Ukyō;[4] later, Kuranosuke.[5] **Biog.:** Kanō painter. Adopted son and pupil of Kanō Eishin Yasunobu, the founder of the Nakabashi Kanō line. Worked in Edo; became chief *oku eshi* to the shogunate. In 1674 with his father to Kyōto to paint some of the screens for the Shishinden of the Imperial Palace. Because of his early death there are few works extant. **Coll.:** British, Itsuō, Museum (3), Victoria. **Bib.:** Morrison 1, Tajima (12) 10.

¹時信 ²狩野時信 ³四郎次郎 ⁴右京 ⁵内蔵助

Tōkō[1] (1785-1846). *N.:* Kuroda Bunshō.[2] *F.N.:* Rokunojō.[3] *Gō:* Tōkō,[4] Tōyō.[5] **Biog.:** *Nanga* painter. Lived first in Tottori; later moved to Edo. Younger brother of Hayashi Genzaburō, belonged to a samurai family of the Tottori clan, was adopted by the Kuroda family. Pupil of Hijikata Tōrei. Excelled in the military arts. Noted for his realistic paintings of carp. **Coll.:** Andrew, Freer, Metropolitan, Museum (3), Tōkyō (2). **Bib.:** K 23, 27, 35, 293, 663, 693.

¹稲阜 ²黒田文祥 ³六之丞 ⁴稲阜 ⁵稲葉

Tōkoku[1] (1834-90). *N.:* Yamamoto Ryō.[2] *A.:* Chūkan.[3] *F.N.:* Yasunosuke.[4] *Gō:* Shunkō,[5] Tōkoku.[6] **Biog.:** Maruyama painter. Born in Kyōto. Pupil of Kawakita Shunkoku and Komai Kōrei. Painted landscapes, portraits, and *kachōga.*

¹桃谷 ²山本漁 ³仲鑑 ⁴安之丞 ⁵舜興 ⁶桃谷

Tokonami Seisei[1] (1842-97). **Biog.:** Western-style painter. Born in Kagoshima. First studied Kanō painting; then in 1865, when he went to Nagasaki to study military arts, became acquainted with Western-style painting. In 1877 to Tōkyō, where he became a judge, moving later to Sendai. Painting his hobby; worked in a naive manner. **Bib.:** Asano, BK 206, Harada Minoru, NB (S) 30.

¹床次正清

Tokuda Rinsai[1] (1880-1947). *N.:* Tokuda Jintarō.[2] *Gō:* Rinsai.[3] **Biog.:** Japanese-style painter. Born in Kyōto. First studied under Maekawa Bunrei, then with Takeuchi Seihō. Taught at Kyōto College of Fine Arts. Showed with the

Naikoku Kangyō Hakurankai and the Bunten. **Coll.:** National (5), Victoria. **Bib.:** Asano.

¹徳田隣斎 ²徳田甚太郎 ³隣斎

Tokuemon[1] (fl. first half 17th c.). *N.:* Tōshima Tokuemon.[2] **Biog.:** Potter. An Arita pottery merchant, said to have been the first Japanese to learn from a Chinese at Nagasaki the technique of painting on ceramics in overglaze enamels. It was apparently this knowledge that enabled his foreman, Sakaida Kakiemon, to produce the porcelain decorated in overglaze enamels that has always been associated with the Kakiemon name. **Bib.:** Jenyns (1), Mikami, NB (S) 71, *Nihon* (1).

¹徳右衛門 ²東島徳右衛門

Tokuemon[1] (fl. c. 1693). *N.:* Kobayashi Tokuemon.[2] *Studio name:* Kagiya.[3] **Biog.:** Potter. The second-generation head of the Kobayashi family, working at Awataguchi, Kyōto. **Note:** From the third generation on, the family used the *gō* of Kinkōzan.[4]

¹徳右衛門 ²小林徳右衛門 ³鍵屋 ⁴錦光山

Tokunō[1] (fl. second half 16th c.). *Priest name:* Tokunō.[2] **Biog.:** Muromachi *suiboku* painter. Life obscure. A priest who may have been connected with the Nanzen-ji. **Bib.:** K 635.

¹犢農 ²犢農

Tokunyū[1] (1745-74). *N.:* Tanaka.[2] *F.N.:* Sōkichi.[3] *Studio name:* Kichizaemon.[4] *Posthumous name:* Yoshitada.[5] **Biog.:** Raku potter. Eldest son of Chōnyū. In 1762 succeeded to the name of Kichizaemon and the family business, becoming eighth in the Raku line. A man of frail health, retired in 1770 to become a monk, taking the name of Sahei[6] and was succeeded by his brother Sōjirō. At the twenty-fifth memorial service for him, was given the name of Tokunyū. His work was in the traditional Raku manner. **Coll.:** Metropolitan, Tōkyō (1), Victoria. **Bib.:** Castile, Jenyns (2), NB (S) 14.

¹得入 ²田中 ³惣吉 ⁴吉左衛門 ⁵喜制 ⁶佐兵衛

Tokuō[1] (fl. late 17th c.). **Biog.:** Buddhist painter. The only definite biographical information is that he was given title of *hokkyō* and later of *hōgen,* that he worked in Kyōto, and that he painted portraits of Buddhist patriarchs. **Coll.:** Victoria. **Bib.:** K 776.

¹徳應

Tokuoka Shinsen[1] (1896-1972). *N.:* Tokuoka Tokijirō.[2] *Gō:* Shinsen.[3] **Biog.:** Japanese-style painter. Born in Kyōto. Graduated from the Kyōto College of Fine Arts, having studied with Takeuchi Seihō. Received special mention at a Teiten exhibition in the 20s and at the Bunten in 1939. Had many one-man shows. Member of the Japan Art Academy and of the Board of Directors of the Nitten. Awarded the Japan Art Academy Prize in 1950 and the Mainichi Art Prize two years later. In 1966 awarded the Order of Cultural Merit. His beautifully colored paintings, often of a few flowers, trees, or fish enveloped in a slight mist, have a quietness and a sense of otherworldliness that is almost unique in contemporary Japanese painting. **Coll.:** National (5). **Bib.:** Asano, Nakamura (1), NBT 10, NBZ 6.

¹徳岡神泉 ²徳岡時次郎 ³神泉

Tokusai[1] (?-1366). *Priest name:* Tokusai.[2] *Gō:* Tesshū.[3] **Biog.:** Muromachi *suiboku* painter. Born in Shimotsuke Province. A Zen priest, disciple of the famous priest Musō Kokushi. Went to China; perhaps studied directly under P'u-ming, or was at least conversant with his work. Returned to Japan in 1342. Lived at the Tenryū-ji until he retired to the Ryūkō-in in Saga. Excellent calligrapher and poet. Wide range of subject matter in his paintings: landscape, animals, flowers, birds, bamboo. In his own time was criticized for the realism of his rendering of geese and other birds: an attempt to break away from the conventional *suiboku* style. Particularly well known as a painter of orchids. **Coll.:** Gotō. **Bib.:** BCM 50; Fontein (2); GNB 11; K 824; KO 38,

40; M 98; Matsushita (1a); NB (S) 13, 69; Shimada 1; Tanaka (2).

¹徳済 ²徳済 ³鉄舟

Tokusei[1] (?–1537). **Biog.:** Muromachi *suiboku* painter. Life unknown. **Coll.:** Tokiwayama. **Bib.:** *Japanese* (1), Matsushita (1), (1a).

¹得栖

Tokuwaka[1] (fl. Muromachi period). *N.:* Tokuwaka Tadamasa.[2] **Biog.:** Sculptor. A carver of Nō masks; regarded by Seami as the great carver of female masks, which Seami described in his book *Sarugaku Dangi* (Talks about Nō).

¹徳若 ²徳若忠政

Tokuzan[1] (1755–1837). *Priest name:* Enjō.[2] *Gō:* Hōkaan,[3] Jigen,[4] Tokuzan,[5] Tokuzansō.[6] **Biog.:** Potter. Also a Buddhist priest. Using Shigaraki clay, produced a kind of Raku pottery at the Kōgen-ji, Edo, that was called Tokuzan-yaki. His early works have a stamped inscription; the later ones, an engraved inscription.

¹特山 ²円乗 ³放下庵 ⁴似眼 ⁵特山 ⁶特山叟

Tōkyo[1] (1828–69). *N.:* Umegawa Tōkyo.[2] **Biog.:** Japanese-style painter. Lived in Kyōto. Teacher of Nomura Bunkyo. Also made landscape and figure prints. **Coll.:** Victoria. **Bib.:** Keyes, Mitchell, Morrison 2.

¹東居（東挙） ²梅川東居（梅川東挙）

Tomikage[1] (fl. late 15th to early 16th c.). *N.:* Toki (Doki) Tomikage.[2] **Biog.:** Muromachi *suiboku* painter. Some scholars say this is the same artist as Toki Tōbun (q.v.). Lived in Mino Province; a samurai of the Toki clan. Influenced by Shūbun. Good amateur painter, specializing in hawks; his usual style close to the realistic Chinese Sung academic manner. **Coll.:** Tōkyō (1). **Bib.:** GNB 11; K 516, 677.

¹富景 ²土岐富景

Tomimoto Kenkichi[1] (1886–1963). **Biog.:** Potter, printmaker. Born in Ando, Nara-ken. After graduating from Tōkyō School of Fine Arts, to England; saw the ceramics at the Victoria and Albert Museum and decided to be a potter. Before First World War worked in Japan with Bernard Leach, sharing with him the title of Kenzan VII. At first, under influence of Korean ceramics of the Yi dynasty, produced pottery; later made porcelains decorated with overglaze enamels, gold and silver, and underglaze blue. Worked first in Ando, later in Tamagawa, then in Tōkyō, and, toward the end of his life, in Kyōto. Always did his own potting. Perfected a cobalt-blue underglaze and some unusual overglazes. Most distinguished present-day ceramist to work in porcelain. At one time, head of Kyōto College of Fine Arts; later of the Shinshōkai. Helped found Kokugakai and headed its handicraft section. Also played an important part in early print movement. With Minami Kunzō and Tobari Kogan believed the print artist should carry through the whole process of printmaking. Member of Japan Art Academy. In 1955 named a Living National Treasure; in 1961 received Order of Cultural Merit. **Coll.:** National (4), (5); Ohara (2); Tōkyō (1). **Bib.:** Fujikake (1); GNB 28; Jenyns (1); Koyama (1), (1a); Leach; *Masterpieces* (4); Miller; NB (H) 24; NBT 6; NBZ 6; Noma (1) 2; Okada; STZ 16; UG 4; YB 44.

¹富本憲吉

Tōmin[1] (fl. c. 1670). *N.:* Unkoku Tōmin.[2] **Biog.:** Unkoku painter. Son of Unkoku Tōtetsu. Followed the family tradition. **Coll.:** Freer, Museum (3).

¹等珉 ²雲谷等珉

Tominaga Chōdō[1] (1897–). *N.:* Tominaga Ryōzaburō.[2] *Gō:* Chōdō.[3] **Biog.:** Sculptor. Born in Fukuoka. In 1915 to Tōkyō, where he studied under Yamazuki Chōun, specializing in sculpture in wood. First showed in 1924 at the Teiten; until 1940 continued to show with government exhibitions, but after 1945 showed with the Nitten and became a member

of this group in 1958. The leading sculptor in Fukuoka. **Bib.:** Asano.

¹富永朝堂 ²富永良三郎 ³朝堂

Tominobu[1] (fl. mid-18th c.). *N.:* Miyagawa Tominobu.[2] **Biog.:** Ukiyo-e printmaker. Life unknown. He is recorded as having made a drawing of one Nakamura Matsue in the 1750s or 60s. May possibly be the same artist as Miyagawa Isshō (q.v.). **Coll.:** Musées. **Bib.:** K 708.

¹富信 ²宮川富信

Tomioka Eisen[1] (1864–1905). *N.:* Tomioka Eisen.[2] *F.N.:* Hidetarō.[3] *Gō:* Mosai.[4] **Biog.:** Painter, illustrator. Born in Nagano-ken. About 1877 to Tōkyō to study to be a draftsman; from 1878 employed by the Army Staff Office as a civilian. In 1882 became a pupil of Kobayashi Eitaku; in 1900 resigned from the army office to become an independent painter. Many illustrations for newspapers and monthly journals. Teacher of Kiritani Senrin. **Coll.:** Musées, Victoria. **Bib.:** NBZ 6, Takahashi (2).

¹富岡永洗 ²富岡永洗 ³秀太郎 ⁴藻斎

Tomioka Tessai[1] (1836–1924). *N.:* Tomioka Hyakuren.[2] *A.:* Muken.[3] *Gō:* Tessai,[4] Tetsugai,[5] Tetsujin,[6] Tetsushi,[7] Yūken.[8] **Biog.:** *Nanga* painter. Born in Kyōto; son of a wealthy dealer in priests' robes. As the family fortunes declined, was sent to live at the Rokuson'ō Shrine, thus laying the foundation for his profound knowledge of Shintō. Also studied Buddhism, Confucianism, classical Japanese literature. No particular painting teacher, though a friend of Okada Tamechika and Ukita Ikkei. Closely allied to those working for the Restoration, fled to Nagasaki in 1859 to escape arrest and while there began serious study of *nanga* painting. From 1872 to 1882 served as a Shintō priest. In 1896 organized the Nihon Nangakai, remaining an important member until his death. Traveled widely in Japan, generally on foot and painting on the way. Member of Art Committee of Imperial Household and, in 1919, of Imperial Fine Arts Academy. An enormously prolific artist, produced over 20,000 paintings (many of which have been copied; there are also many forgeries), largely of subjects taken from Chinese and Japanese classical literature and legend. The last great exponent of the *nanga* school, yet showing much individuality and independence. His best work, on which his international reputation is based, is from his later years. Paintings are vigorous, with an undisciplined appearance; the brushwork and color free and bold; no trace of Western perspective. **Coll.:** Chion-in, Dayton, Hakodate, Honolulu, Musée (2), Museum (3), National (5), Nelson, Seattle, Seichō-ji, Tōkyō (1), Victoria, Yamato. **Bib.:** *Art* (1a); Asano; BK 65, 70, 71, 82, 106, 107, 108; BMFA 52; Cahill; *Cent-cinquante;* K 399, 650; *Masterpieces* (4); Mitchell; Miyagawa; Munsterberg (1); Nakamura (1); NB (H) 24; NB (S) 17; NBT 10; NBZ 6; *Nihon* (2); NKKZ 14; Noma (1) 2; OA 5; Odakane (2); Sakamoto; SBZ 11; *Tessai; Works* (2); YB 38, 40.

¹富岡鉄斎 ²富岡百錬 ³無倦 ⁴鉄斎
⁵鉄崖 ⁶鉄人 ⁷鉄史 ⁸裕軒

Tomita Keisen[1] (1879–1936). *N.:* Tomita Shigegorō.[2] *Gō:* Kei Sanjin,[3] Keisen,[4] Kyūkoan,[5] Kyūko Sanjin.[6] **Biog.:** Japanese-style painter. Born in Fukuoka; lived in Kyōto. First studied Kanō painting, then became a pupil of the Shijō artist Tsuji Kakō; also studied Heian Buddhist painting and *nanga* painting and received instruction in the practice of Zen. Member of the Imperial Fine Arts Academy in 1935. Showed first with the Naikoku Kangyō Hakurankai, then with the Bunten; finally changed over to the Inten, of which he became a member. His style, a personal version of a mixture of traditional Japanese schools, including the *yamato-e,* also owes something to Tomioka Tessai and the *nanga* school. Quite a charming painter. **Coll.:** Kyōto (1); Museum (3); National (4), (5); Yamatane. **Bib.:** Asano,

Cent-cinquante, Masterpieces (4), Mitchell, NB (H) 24, NBT 10, NBZ 6, NKKZ 19, Saitō (1), SBZ 11.

[1]富田渓仙 [2]富田鎮五郎 [3]渓山人
[4]渓仙 [5]久鼓庵 [6]久鼓山人

Tomita On'ichirō[1] (1887–1954). **Biog.:** Western-style painter. Born in Ishikawa-ken. In 1911 graduated from Tōkyō School of Fine Arts, Western-painting division. In 1913 showed for the first time with the Bunten; continued to show at government-sponsored exhibitions. With Nakazawa Hiromitsu established the Hakujitsukai in 1924. From 1945 served as a juror for the Nitten. **Coll.:** National (5). **Bib.:** Asano.

[1]富田温一郎

Tomitori Fūdō[1] (1892–). **Biog.:** Japanese-style painter. Born in Chiba-ken, works in Tōkyō. Pupil of Matsumoto Fūko. Has shown with the Nihon Bijutsuin since 1914 and, since 1945, with the Nitten. Recipient in 1966 of the Award of the Minister of Culture. His paintings, sometimes of flowers done in a boldly decorative manner, have much traditional charm. **Coll.:** National (5). **Bib.:** Asano.

[1]富取風堂

Tomiyuki[1] (fl. mid-19th c.). *Gō:* Rokkatei,[2] Senkintei,[3] Tomiyuki.[4] **Biog.:** Ukiyo-e printmaker. An Ōsaka man. **Coll.:** Victoria. **Bib.:** Crighton.

[1]富雪 [2]六花亭（緑華亭） [3]千錦亭 [4]富雪

Tomofusa[1] (fl. 1688–1704). *N.:* Hishikawa Tomofusa.[2] **Biog.:** Ukiyo-e painter. Minor pupil of Hishikawa Moronobu. His figures of *bijin* are rather attenuated, his coloring and brushwork rather rough. **Bib.:** Tajima (7) 1.

[1]友房 [2]菱川友房

Tomoharu[1] (fl. 1804–29). **Biog.:** Lacquerer. Worked first in Kyōto, later in Edo. Died at age of 80. Follower of the Rimpa school. **Bib.:** Herberts, Jahss.

[1]友春

Tomonobu[1] (fl. c. 1558–69). *N.:* Kanō Tomonobu.[2] **Biog.:** Kanō painter. Nothing known of his family. Pupil of Kanō Motonobu, but a painting by him in the Boston Museum of Fine Arts shows he had also assimilated the Tosa style. **Coll.:** Museum (3). **Bib.:** Paine (2) 1, Shimada 2.

[1]友信 [2]狩野友信

Tomonobu[1] (1686–1771). *N.:* Yoshikawa.[2] *F.N.:* Koemon.[3] *Gō:* Kogetsudō,[4] Tomonobu.[5] **Biog.:** Kanō painter. Born in Edo. Pupil of Kiyono Yōzan. Father of Yōetsu, grandfather of Ikkei, great-grandfather of Kunkei. Painted landscapes and portraits.

[1]知信 [2]吉川 [3]小右衛門 [4]孤月堂 [5]知信

Tomonobu[1] (1757–1824). *N.:* Iwakura Junko.[2] *Gō:* Kakyū,[3] Tomonobu.[4] **Biog.:** Painter, calligrapher. Followed the style of Maruyama Ōkyo. **Bib.:** Mitchell.

[1]具選 [2]岩倉淳古 [3]可汲 [4]具選

Tomonori[1] (1531–76). *N.:* Kitabatake Tomonori.[2] **Biog.:** Muromachi *suiboku* painter. Also a warrior. Painted landscapes and portraits in the *suiboku* manner; also produced Zen-inspired pictures of Daruma. His style generally close to that of Yūshō. **Bib.:** M 240.

[1]具教 [2]北畠具教

Tonan[1] (1706–82). *N.:* Asai Tadashi.[2] *A.:* Iin (Koretora).[3] *F.N.:* Tanomo.[4] *Gō:* Tonan.[5] **Biog.:** Painter. Born in Owari Province; lived in Kyōto. A doctor by family profession, studied painting as a hobby. Good at bamboo.

[1]図南 [2]浅井直 [3]維寅（惟寅） [4]頼母 [5]図南

Tōnan[1] (1797–1866). *N.:* Umegawa Shigekata.[2] *Gō:* Kōkosai,[3] Tōnan.[4] **Biog.:** Painter. Born in Kyōto. **Coll.:** Musées, Victoria. **Bib.:** Mitchell.

[1]東南 [2]梅川重覧 [3]好古斎 [4]東南

Ton'ichi[1] (fl. c. 1810). *N.:* Kamei Ton'ichi.[2] *A.:* Tōhaku.[3] *Gō:* Inkei.[4] **Biog.:** Painter. Specialized in flower paintings. **Bib.:** Mitchell.

[1]嗽一 [2]亀井嗽一 [3]東白 [4]筥渓

Tonouchi (Touchi) Mishō[1] (1891–1964). *N.:* Tonouchi

(Touchi) Shōkichi.[2] *Gō:* Mishō.[3] **Biog.:** Japanese-style painter. Born in Nagano-ken. Graduated from Kyōto College of Fine Arts in 1925. Afterwards studied under Kikuchi Keigetsu and Terazaki Kōgyō. From 1920 showed at government-sponsored exhibitions. In 1929 became a juror for the Teiten. After World War II was associated with the Nitten. **Coll.:** National (5). **Bib.:** Asano.

[1]登内微笑 [2]登内正吉 [3]微笑

Tonshū (Donshū)[1] (?–1857). *N.:* Ōhara Kon.[2] *Gō:* Konron,[3] Tonshū (Donshū).[4] **Biog.:** Shijō painter. Son of Ōhara Donkei. Followed the style of Shibata Gitō, painting landscapes. **Coll.:** Ashmolean, Museum (3). **Bib.:** Brown, Mitchell, Morrison 2.

[1]呑舟 [2]大原鯤 [3]崑嵩 [4]呑舟

Tōoku[1] (?–1615). *N.:* Unkoku Tōoku.[2] **Biog.:** Unkoku painter. Eldest son and pupil of Unkoku Tōgan. Served Fukushima Masanori, the lord of Aki, as his official painter. Predeceased his father, who was succeeded by Tōeki, younger brother of Tōoku, thus causing considerable confusion in the Unkoku genealogy.

[1]等屋 [2]雲谷等屋

Tōrei[1] (1735–1807). *N.:* Hijikata Hirosuke[2] (originally Gotō Hirokuni).[3] *Gō:* Gakoken,[4] Tōrei.[5] **Biog.:** Maruyama painter. Born in Tottori. To Kyōto, becoming first a pupil of Maruyama Ōkyo, then of Sō Shiseki. Also followed the tradition of late Ming and Ch'ing realistic painting. Returned to Tottori and served as official painter to Lord Ikeda of the Tottori fief. Good painter of carp and birds-and-flowers, the Maruyama influence predominates in his style. **Coll.:** Museum (3). **Bib.:** K 44, 78, 649, 659, 743, 943; Mitchell.

[1]稲嶺 [2]土方広輔 [3]後藤広邦 [4]臥虎軒 [5]稲嶺

Tōrei (1808–81). *N.:* Shimada Masataka.[2] *A.:* Shishū.[3] *F.N.:* Hikonoshin.[4] *Gō:* Tōrei.[5] **Biog.:** Maruyama painter. Born in Kyōto. From the Tokugawa *bakufu* received the title of Echizen Daijō. Pupil of Maruyama Ōzui and Ōshin. A good painter of portraits and *kachōga.*

[1]桃嶺 [2]嶋田雅喬 [3]子秀 [4]彦之進 [5]桃嶺

Tōrei Enji[1] (1721–92). *Priest name:* Tōrei Enji.[2] **Biog.:** *Zenga* painter. Born in Ōmi Province. Entered the monastic life at an early age; became a priest of the Rinzai sect. At 23 visited Hakuin at the Shōin-ji in Hara, Suruga Province, became his best pupil, and painted a portrait of him. Built the Ryūtaku-ji in Izu; spent the last years of his life at the Reisen-ji in Mito. Wrote a treatise on the theory that Shintō, Buddhism, and Confucianism are basically identical. Made great use of symbolism, particularly of the circle (*ensō*). His *zenga*, reflecting his master's influence, is very unconventional but less cartoonlike than much of Hakuin's. **Bib.:** *Au-delà,* Awakawa, BO 100, Brasch (2), M 166, NB (S) 47.

[1]東嶺円慈 [2]東嶺円慈

Tōreki[1] (fl. c. 1640). *N.:* Unkoku Tōreki.[2] *Gō:* Tōun.[3] **Biog.:** Unkoku painter. Son of Unkoku Tōsaku. Continued the family painting tradition.

[1]等璨 [2]雲谷等璨 [3]等云

Tōretsu[1] (?–1741). *N.:* Unkoku Tōretsu.[2] **Biog.:** Unkoku painter. Fifth-generation head of the Unkoku school after Tōgan. His painting a mixture of the Unkoku manner and a mildly decorative Kanō style. **Coll.:** Tōkō-ji. **Bib.:** K 820.

[1]等列 [2]雲谷等列

Tōretsu[1] (1786–1837). *N.:* Yamazaki (originally Ido)[2] Kika.[3] *A.:* Mukei.[4] *Gō:* Fuden,[5] Kaiundō,[6] Kisui,[7] Tōretsu.[8] **Biog.:** Nagasaki painter. Pupil of Sō Shiseki and Tō Kyūjo, and perhaps son of the latter. Specialized in landscapes and *kachōga,* working in the style of Shen Nan-p'in. **Bib.:** Mitchell.

[1]董烈 [2]井戸 [3]山崎其華 [4]无競
[5]甫田 [6]槐雲堂 [7]其莘 [8]董烈

Tori[1] (fl. early 7th c.). *N.:* Shiba Kuratsukuri no Obito Tori.[2] **Biog.:** Sculptor. Grandson of Shiba Tatsutō,[3] who

came from Korea or China to Japan in 522, and son of Shiba Tasuna, also a sculptor. Won the favor of Prince Shōtoku; became best-known sculptor of his time and first artist in Japan to whom works have been definitely assigned. Received title of *busshi*, indicating that he was head of a school of sculptors; also given a court rank and an estate. Is recorded as having made two Buddha images in 605 on imperial order. The Shaka in the Kondō of the Gangō-ji in Asuka, Nara-ken, dated 606 and so badly damaged that only the face is intact, and the Amida Triad of 623 in the Kondō of the Hōryū-ji are generally accepted as his work though he may only have been the supervisor of the sculptors making these statues. The last group is very close in style to that of the sculpture of the Northern Wei dynasty in China, especially that of the Lung-men caves in Honan. **Coll.:** Gangō-ji (Kondō), Hōryū-ji (Kondō). **Bib.:** BI 8, 29; Buhot; GK 1; Glaser; GNB 2; Hasumi (2); K 942; Kidder; *Kokuhō* 1; Kuno (1); Lee (1); *Masterpieces* (3); Noma (1) 1, (2) 2; P 3; Warner (1), (3); Watson (1); Yashiro (1) 1.

 [1]止利 [2]司馬鞍作首止利 [3]司馬達等

Torii Kiyosada[1] (1844–1901). *N.:* Torii (originally Watanabe,[2] then Saitō)[3] Chōhachi.[4] *F.N.:* Matsujirō.[5] *Gō:* Kiyosada.[6] **Biog.:** Ukiyo-e painter, printmaker. Pupil of Torii Kiyomine. Worked as manager of the Edo theater Hisamatsu-za. Produced pictures of actors. **Coll.:** Victoria. **Bib.:** Morrison 2.

 [1]鳥居清貞 [2]渡辺 [3]斎藤 [4]鳥居長八 [5]松次郎 [6]清貞

Torii Kiyotada VII[1] (1875–1941). *N.:* Torii (originally Saitō)[2] Chōkichi.[3] *Gō:* Gekigadō,[4] Kiyotada,[5] Kunsai,[6] Manjinoya,[7] Nanryō,[8] Suisha.[9] **Biog.:** Painter, printmaker. Born in Edo; son of Torii Kiyosada. At 18 became a pupil of Kawabe Mitate to study Tosa painting. A year later began producing pictures of actors and advertisements for theaters. Worked for the Kabuki-za, Shintomi-za, Meiji-za. **Coll.:** Victoria.

 [1]鳥居清忠七代目 [2]斎藤 [3]鳥居長吉 [4]劇雅堂
 [5]清忠 [6]薫斎 [7]卍廼舎 [8]南陵 [9]粋舎

Tōrin[1] (fl. c. 1580). *N.:* Hasegawa (originally Ono)[2] Tōrin.[3] **Biog.:** Hasegawa painter. Son of Hasegawa Tōteki. Adopted by Hasegawa Tōhaku, whose style he continued.

 [1]等林 [2]小野 [3]長谷川等林

Tōrin[1] (1679–1754). *N.:* Kanō Hashin.[2] *Gō:* Tōrin.[3] **Biog.:** Kanō painter. Adopted son and pupil of Kanō Tōgen. Official painter to the *bakufu.* Member of the Saruyamachi branch of the Kanō family. Carried on the manner of Eitoku.

 [1]洞琳 [2]狩野波信 [3]洞林

Tōrin[1] (fl. 18th c.). *N.:* Tsutsumi Magoji.[2] *Gō:* Tōrin,[3] Rō (Tsumbo) Tōrin.[4] **Biog.:** Painter, printmaker. Founder of the Tsutsumi school. Chiefly known as a painter of lanterns and ex-voto. Of minor importance as an artist. Produced some poetic landscapes in the Japanese style. Friend of ukiyo-e artists; also made prints, but not in ukiyo-e manner. **Coll.:** British, Musées, Museum (3). **Bib.:** Binyon (1), *Dessins,* Morrison 2, Turk.

 [1]等琳 [2]堤孫二 [3]等琳 [4]聾等琳

Tōrin II[1] (fl. 1789–1801). *N.:* Tsukioka (or Moro-oka)[2] Ginji.[3] *F.N.:* Chiyomatsu.[4] *Gō:* Tōrin.[5] **Biog.:** Painter, printmaker. Pupil of Tsutsumi Tōrin; was allowed to use the Tsutsumi name. Of minor importance as an artist. **Bib.:** Morrison 2.

 [1]等琳二代 [2]諸岡 [3]月岡吟二 [4]千代松 [5]等琳

Tōrin III[1] (c. 1743–1820). *N.:* Akizuki Tōrin.[2] *Studio name:* Shinsensai.[3] *Gō:* Sekkan,[4] Setsuzan (Sessan),[5] Shūei,[6] Shūgetsu.[7] **Biog.:** Painter, printmaker. The thirteenth "brush descendant" of Sesshū, might therefore be considered as belonging to the Unkoku school. Much influenced by Toriyama Sekien. Pupil of Tsutsumi Tōrin; was allowed to use the name Tsutsumi. Received title of *hokkyō.* A lively artist; his paintings of scenes of contemporary life are in several styles, including the Chinese, all rendered in colors

with a flat brush. **Coll.:** British, Freer, Honolulu, Museum (3). **Bib.:** Binyon (1), Morrison 2, *Nihon* (9).

 [1]等琳三代 [2]秋月等琳 [3]深川斎
 [4]雪館 [5]雪山 [6]秋栄 [7]秋月

Tōrin[1] (fl. c. 1840). *N.:* Abe Kan.[2] *F.N.:* Hayatarō.[3] *Gō:* Tōrin,[4] Yōsetsu.[5] **Biog.:** Painter. Born and worked in Edo. A painter of *kachōga.* **Bib.:** Mitchell.

 [1]董琳 [2]阿部貫 [3]隼太郎 [4]董琳 [5]養拙

Tōsaku[1] (fl. early 17th c.). *N.:* Hasegawa Tōsaku.[2] **Biog.:** Unkoku painter. Probably the son of Tōoku and grandson of Tōgan (or at least a descendant of Tōoku). Is said to have been adopted by Hasegawa Tōrin.

 [1]等作 [2]長谷川等作

Tōsatsu[1] (1516–85). *N.:* Yuge Tōsatsu.[2] *Gō:* Hagetsu.[3] **Biog.:** Muromachi *suiboku* painter. Son of a samurai. Considered a follower of Sesshū and is said to have lived at the Unkoku-an. Also influenced by Shūgetsu's work. His paintings are based on Sesshū's style of *kachōga* but also show traces of Kanō style. **Coll.:** National (2). **Bib.:** K 640, 787; M 199.

 [1]等薩 [2]弓削等薩 [3]波月

Tōsei[1] (fl. c. 1470). **Biog.:** Muromachi *suiboku* painter. Followed Sesshū's style. His work has often been confused with that of Sesson. **Bib.:** NB (S) 63.

 [1]等清

Tōseki[1] (fl. early 16th c.). *N.:* Akizuki Tōseki.[2] **Biog.:** Muromachi *suiboku* painter. Served the lord of Satsuma. Worked in the style of Sesshū. Used a seal reading Bokuun.[3] **Bib.:** Matsushita (1a), Morrison 1.

 [1]等碩 [2]秋月等碩 [3]牧雲

Tōsen[1] (1811–71). *N.:* Kanō Nakanobu.[2] *F.N.:* Tōshirō.[3] *Gō:* Kōsen,[4] Shikibu,[5] Yorakusai,[6] Zenrakusai;[7] later, Tōsen.[8] **Biog.:** Kanō painter. Son and pupil of Kanō Isen'in Naganobu, who was head of the Kobikichō Kanō. Adopted by Kanō Yūsen Sukenobu, who was childless, and succeeded him as head of the Hamachō Kanō line, the eighth and last generation of this branch of the Kanō family. Employed by the shogunate as *oku eshi.* Received title of *hōgen* in 1844. A fair Kanō painter. **Coll.:** Museum (3). **Bib.:** *Kanō-ha.*

 [1]董川 [2]狩野中信 [3]董四郎 [4]幸川
 [5]式部 [6]余楽斎 [7]全楽斎 [8]董川

Tōsen[1] (1817–93). *N.:* Yamazaki (originally Yabashi)[2] Tōsen.[3] *A.:* Shitatsu.[4] *Gō:* Kokotsu Dōjin,[5] Seichūin Dōjin.[6] **Biog.:** Japanese-style painter. Worked in Tōkyō. Studied under Yamazaki Tōretsu. Specialized in painting flowering plants and peacock feathers.

 [1]董淬 [2]矢橋 [3]山崎董淬
 [4]始達 [5]古骨道人 [6]青虫寅道人

Tōsetsu[1] (fl. c. 1715). *N.:* Unkoku Tōsetsu.[2] **Biog.:** Unkoku painter. Son of Unkoku Tōtatsu. Known only from the Unkoku genealogy.

 [1]等節 [2]雲谷等節

Toshihide I (Hisahide, Jushū, Nagahide)[1] (1756–1829). *N.:* Tatsuke Toshihide (Hisahide, Jushū, Nagahide).[2] *Gō:* Tōkei.[3] **Biog.:** Lacquerer. Member of Tatsuke family of lacquer artists. Born and worked in Kyōto. **Coll.:** Metropolitan, Rijksmuseum (1). **Bib.:** Herberts, Jahss, Speiser (2).

 [1]寿秀一代 [2]田付寿秀 [3]東渓

Toshihide II (Hisahide, Jushū, Nagahide)[1] (fl. late 18th to early 19th c.). *N.:* Tatsuke Toshihide (Hisahide, Jushū, Nagahide).[2] *Gō:* Tōrei.[3] **Biog.:** Lacquerer. Nothing known save that he was younger brother of Tatsuke Tōkei Toshihide and used a seal of Hirokuni.[4] **Bib.:** Herberts.

 [1]寿秀二代 [2]田付寿秀 [3]稲嶺 [4]広邦

Toshihisa[1] (fl. c. 1362). *N.:* Kose no Toshihisa.[2] **Biog.:** Kose painter. Perhaps the son of the minor 14th-century Kose painter Sadahisa. Recorded as having been an able member of the Kose school.

 [1]俊久 [2]巨勢俊久

Toshimasa[1] (fl. c. 1560). *N.:* Kanō Toshimasa.[2] *Gō:* Shin-

shun.[3] **Biog.**: Kanō painter. Pupil of Kanō Motonobu. Lived in Kyōto. Painted figures and birds-and-flowers in a manner close to that of his master. **Coll.**: Victoria.

[1]敏昌 [2]狩野敏昌 [3]信春

Toshinaga[1] (1648–1716). *N.*: Kinoshita (originally Toyotomi)[2] Toshinaga.[3] *F.N.*: Uemon Tayū.[4] *Gō*: Dainen,[5] Shunfūrō.[6] **Biog.**: Painter. Lord of a castle in Bungo Province, held a government position. Studied painting under Kanō Tsunenobu. An able artist whose subjects included pictures of Kannon as well as of fishermen and woodcutters. **Bib.**: BI 46.

[1]俊長 [2]豊臣 [3]木下俊長 [4]右衛門大夫 [5]大年 [6]春風楼

Toshinaga[1] (fl. early 19th c.). *Gō*: Toshinaga.[2] **Biog.**: Ukiyo-e painter, printmaker. Life unknown. **Coll.**: Freer.

[1]寿長 [2]寿長

Toshinobu[1] (fl. 1716–35). **Biog.**: Ukiyo-e painter. His paintings of *bijin* are in the manner of the Kaigetsudō school. **Bib.**: M 18, *Ukiyo-e* (3) 3.

[1]俊信

Toshinobu[1] (fl. c. 1717–50). *N.*: Okumura Toshinobu.[2] *Gō*: Kakugetsudō Bunzen.[3] **Biog.**: Ukiyo-e printmaker. Pupil and perhaps adopted son of Okumura Masanobu. Also influenced by the Torii school. Specialized in pictures of standing *bijin* of great charm, his prints almost always elaborately colored by hand and with some use of lacquer. Considerable talent. **Coll.**: Allen, Art (1), Ashmolean, British, Cincinnati, Detroit, Fogg, Honolulu, Kanagawa, Metropolitan, Östasiatiska, Österreichisches, Portland, Rhode Island, Riccar, Rietberg, Staatliche, Tōkyō (1), Victoria, Worcester. **Bib.**: Binyon (1), (3); Boller; Crighton; Fujikake (3) 2; GNB 17; Gunsaulus (1); Hillier (1), (7), (9); Kikuchi; Kurth (4); Lane; M 4; Michener (3); Morrison 2; Narazaki (2); NHBZ 2; Schmidt; Shibui (1); Stern (2); Tajima (7) 4; Takahashi (2), (5); UG 28.

[1]利信 [2]奥村利信 [3]鶴月堂文全

Toshinobu[1] (1857–86). *N.*: Yamazaki Shinjirō.[2] *F.N.*: Tokusaburō.[3] *Gō*: Sensai,[4] Shunkō,[5] Toshinobu.[6] **Biog.**: Ukiyo-e printmaker. Pupil first of Kunisada, then of Yoshitoshi. Lived in Tōkyō and Yokohama. Member of the Yokohama school of printmakers. Also worked as an illustrator of books and newspapers. **Coll.**: Musées.

[1]年信 [2]山崎信次郎 [3]徳三郎 [4]仙斎 [5]春香 [6]年信

Tōshirō[1] (fl. 13th c.). *N.*: Katō Shirozaemon.[2] *Gō*: Kagemasa,[3] Tōshirō.[4] **Biog.**: Potter. Worked in Seto. Traditionally said to have gone to China in 1223 and to have spent six years there visiting kilns. On his return founded Japanese ceramic industry at Seto and was hence called "Father of Japanese Ceramics." Credited with making imitations of Chinese *chien* ware (Japanese: *temmoku*). This tradition is now questioned, since there is no evidence to support it. However, a long line of potters named Katō worked in Seto, the last, Katō Sōshirō (Shuntai), dying in 1878. **Bib.**: *Ceramic* (1); Feddersen; Jenyns (1), (2); Koyama (1a); Kümmel; Miller; Munsterberg (2).

[1]藤四郎 [2]加藤四郎左衛門 [3]景正 [4]藤四郎

Tōshū[1] (fl. c. 1630). *N.*: Hasegawa Tōshū.[2] **Biog.**: Unkoku painter. Son of Hasegawa Tōhaku. Recorded as having painted at the Ryūgen-in, Daitoku-ji, Kyōto.

[1]等周 [2]長谷川等周

Tōshū[1] (?–1785). *N.*: Kanō Yoshiaki.[2] *Gō*: Tōshū.[3] **Biog.**: Kanō painter. Pupil of Kanō Gensen and, on Gensen's death, of his son Tōshun. Served the lord of Fukuoka as official painter.

[1]洞秀 [2]狩野美章 [3]洞秀

Tōshū[1] (fl. c. 1800). *N.*: Murakami Nariaki.[2] *A.*: Shūhi.[3] *Gō*: Tōshū.[4] **Biog.**: Maruyama painter. Lived in Kyōto. Studied first with a pupil of Mochizuki Gyokusen,[5] then learned the Maruyama style. Received title of *hokkyō*. An able painter of landscapes and figures, his style a blend of the

Maruyama and *nanga*. **Coll.**: Museum (3), Victoria. **Bib.**: Hillier (4) 3, Mitchell.

[1]東洲 [2]村上成章 [3]秀斐 [4]東洲 [5]玉蟾

Tōshū[1] (1795–1871). *N.*: Tamate Tōshū. **Biog.**: Painter. Lived in Ōsaka. Pupil of Nakai Rankō. **Bib.**: Mitchell.

[1]棠州 [2]玉手棠洲

Tōshū[1] (fl. c. 1850). *N.*: Iizuka Tōshū.[2] *Gō*: Kanshōsai.[3] **Biog.**: Lacquerer. Grandson of Iizuka Tōyō, in whose manner he worked and whose *gō* he used. **Bib.**: Herberts, Jahss.

[1]桃秀 [2]飯塚桃秀 [3]観松斎

Tōshuku[1] (1577–1654). *N.*: Mitani Morinao.[2] *Gō*: Tōshuku.[3] **Biog.**: Unkoku painter. Pupil of Unkoku Tōgan. Specialized in pictures of hawks but also painted pictures of Daruma. A minor artist, sometimes confused with Unkoku Tōyū[4] because of the similarity of the *kanji*. **Bib.**: K 593, 820.

[1]等宿 [2]三谷盛直 [3]宿 [4]雲谷等宥

Tōshun[1] (fl. 1506–42). *Gō*: Shutchū,[2] Tōshun.[3] **Biog.**: Muromachi *suiboku* painter. Considerable confusion about his life. According to one tradition, was born in Bizen Province, where he was discovered as a groom by Shūbun, who at once recognized his talent for drawing horses and took him back to Kyōto as his pupil. Another tradition made him the pupil of Sesshū, who discovered him as a carpenter's apprentice at the Tōdai-ji, Nara. Present scholarship says he was connected with the Ōuchi family, feudal lords in Suō Province, with which Sesshū was also connected, and was at one time a pupil of Sesshū, from who he learned landscape painting; at the same time also learned Sesson's style for *kachōga*. His few extant works show him to have been an important link between Sesshū and Tōhaku. **Coll.**: Umezawa. **Bib.**: Fontein (2); GNB 11; K 888, 890; M 62, 204; Matsushita (1), (1a); Morrison 1; NB (S) 13; Tanaka (2).

[1]等春 [2]出中 [3]等春

Tōshun (Dōshun)[1] (?–1723). *N.*: Kanō Fukunobu (Tominobu)[2] (originally Kanenobu,[3] Masanobu,[4] Yoshinobu).[5] *Gō*: Shuseisai (Shujōsai),[6] Tōshun (Dōshun).[7] **Biog.**: Kanō painter. Lived in Edo. Grandson by adoption of Kanō Tan'yū; pupil of his father-in-law Kanō Tōun. In 1694 was made successor to the artistic line of the Kanō school, becoming head of the second generation of the Kanō branch at Surugadai, and was appointed *goyō eshi* to the shogun's court. Followed Tōun's style, equally elegant but less powerful. Occasionally produced court scenes in the Tosa manner. **Bib.**: *Kanō-ha*, Morrison 1.

[1]洞春 [2]狩野福信 [3]兼信 [4]政信 [5]義信 (良信) [6]守静斎 [7]洞春

Tōshun[1] (1747–97). *N.*: Kanō Yoshinobu.[2] *F.N.*: Sanshirō.[3] *Gō*: Tōshun.[4] **Biog.**: Kanō painter. Son of Kanō Gensen; became fourth-generation head of the Kanō branch at Surugadai in Edo. Pupil of Kanō Tōshu. It is recorded that he painted a screen as a gift to the king of Korea from the *bakufu*; also known to have worked on the ceilings and walls of the Rinnō-ji in Edo. Given title of *hōgen*. Worked in the styles of Tan'yū and Sesshū. **Coll.**: Museum (3). **Bib.**: *Kanō-ha*.

[1]洞春 [2]狩野美信 [3]三四郎 [4]洞春

Tōtai[1] (fl. 1532–54). *N.*: Kubota Tōtai.[2] *F.N.*: Tōemonnojō.[3] **Biog.**: *Yamato-e* painter. Worked mainly for temples in Kyōto. Is recorded as having painted five scrolls of the *Nichiren Shōnin Chūgasan* for the Chōgen-ji near Kyōto. **Note**: The name Kubota is found on paintings from the early Muromachi to the Momoyama period and probably indicates a school of painters. **Coll.**: Honkoku-ji, Museum (3). **Bib.**: Okudaira (1).

[1]統泰 [2]窪田統泰 [3]藤右衛門尉

Tōtaku[1] (?–1683?). *N.*: Unkoku Tōtaku.[2] **Biog.**: Unkoku painter. According to the Unkoku genealogy, the grandson of Unkoku Tōgan and perhaps son of Tōoku. Very few of

his paintings are known. Much influenced by Chinese Yüan and Ming painting. **Bib.:** K 820.

¹等宅 ²雲谷等宅

Tōtatsu[1] (fl. c. 1680). *N.:* Unkoku Tōtatsu.[2] **Biog.:** Unkoku painter. Son of Unkoku Tōmin. Known only from the Unkoku genealogy.

¹等達 ²雲谷等達

Tōtei[1] (fl. 1772–81). *N.:* Kanō Kyōshin.[2] *Gō:* Tōtei.[3] **Biog.:** Kanō painter. Son and pupil of Kanō Tōju. Member of the branch line of the Saruyamachi Kanō school. His delicate work has traces of ukiyo-e influence. **Coll.:** Museum (3). **Bib.:** *Kanō-ha.*

¹洞庭 ²狩野興信 ³洞庭

Tōtei[1] (fl. late 18th c.). *N.:* Ninomiya Tōtei.[2] **Biog.:** Lacquerer. A physician by profession. Specialized in *chinkinbori,* using rats' teeth to achieve his very delicate, thin lines. His usual decoration consisted of flowers and foliage, but he also made a peacock design famous for its fine detail. **Bib.:** Jahss, Ragué, Sawaguchi.

¹桃亭 ²二宮桃亭

Tōteki[1] (?–1626). *N.:* Hasegawa (originally Ono)[2] Tōteki.[3] **Biog.:** Unkoku painter. Pupil, and perhaps son, of Hasegawa Tōhaku, the contemporary and rival of Unkoku Tōgan. Although Tōgan had won the suit against Tōhaku over the right to use the name Unkoku, Tōteki used seals that read "Unkoku Tōteki."[4] **Coll.:** Metropolitan, Museum (3). **Bib.:** K 762.

¹等的 ²小野 ³長谷川等的 ⁴雲谷等的

Tōtetsu[1] (?–1630). *N.:* Mitani Tōtetsu.[2] **Biog.:** Painter. Follower of the Sesshū tradition. After serving the Masanori clan, became a *rōnin.*

¹等哲 ²三谷等哲

Tōtetsu[1] (fl. second half 17th c.). *N.:* Unkoku Tōtetsu.[2] **Biog.:** Unkoku painter. Third son of Unkoku Tōeki, grandson of Tōgan. Received title of *hokkyō.* Work shows influence of contemporary Kanō decorative style: far from original Unkoku manner. **Coll.:** Museum (3). **Bib.:** K 595, 618; Morrison 1.

¹等哲 ²雲谷等哲

Totori Eiki[1] (1873–1943). **Biog.:** Western-style painter. Born in Chiba-ken. To Tōkyō to study under his cousin Asai Chū. When the latter moved to Kyōto, followed him and taught at the same school, the Kyōto Kōgei Gakkō, as an assistant to him. Active in Kansai art circles; member of the Kansai Bijutsuin and the Shogoin Yōga Kenkyūsho. From 1907 showed at government-sponsored exhibitions. Drafted during the Russo-Japanese war, was injured; painted some war scenes. In 1919 to Paris, returning to Japan and his post at the Kyōto Kōgei Gakkō in 1921. **Bib.:** Asano, NBZ 6.

¹都鳥英喜

Totsugen[1] (1760–1823). *N.:* Tanaka Bin.[2] *A.:* Kotō.[3] *Gō:* Chiō,[4] Daikōsai,[5] Kafukyūshi,[6] Kaison,[7] Kimpei,[8] Kyūmei,[9] Tokuchū,[10] Totsugen.[11] **Biog.:** *Fukko yamato-e* painter. Born in Nagoya; lived in Kyōto. First a pupil of the Kanō painter Ishida Yūtei; then under Tosa Mitsusada studied the manner of the *yamato-e* school of the Kamakura period. One of founders of the *fukko* (revived) *yamato-e* school. In 1790 made some paintings for the walls of the Imperial Palace in Kyōto. Also made copies of the paintings on the doors at the Byōdō-in, Uji. Became blind in his old age and committed suicide. Specialized in historical subjects, painting at times with considerable charm. Much variety of manner. **Coll.:** Itsuō. **Bib.:** *Fukko;* Hillier (4) 3; Ienaga; K 72, 83, 95, 683, 688, 721; Mitchell; Morrison 1; NBZ 4; SBZ 10; Tajima (12) 12, 20; Tajima (13) 5; *Totsugen.*

¹訥言 ²田中敏 ³虎頭 ⁴痴翁 ⁵大孝斎 ⁶過不及子 ⁷晦存 ⁸均平 ⁹求明 ¹⁰得中 ¹¹訥言

Tōun[1] (fl. c. 1620). *N.:* Hasegawa Tōun.[2] **Biog.:** Unkoku

painter. Son of Hasegawa Sōen. Followed the tradition of the Unkoku school.

¹等雲 ²長谷川等雲

Tōun (Dōun)[1] (1625–94). *N.:* Kanō Masunobu.[2] *F.N.:* Sanzaburō.[3] *Gō:* Hakusakenshi,[4] Hakuyūken,[5] Shōinshi,[6] Sōshin Dōjin,[7] Tōun (Dōun).[8] **Biog.:** Kanō painter. Born and worked in Edo. Son of the metalworker Gotō Ritsujō Mitsuyori; pupil and son-in-law of Kanō Tan'yū, who admired his painting and probably adopted him. Worked for the shogun as *goyō eshi* to the *bakufu.* When Tan'yū's own sons were born, Tōun established a branch of the Kanō family at Surugadai. Received rank of *hōgen* in 1691. Ranks with Tsunenobu in importance in the Kanō school. As well as standard Kanō painting, produced works with the Kanō line and landscape but with Tosa coloring and figures. **Coll.:** Museum (3), Victoria. **Bib.:** Binyon (2); K 145, 314, 472; *Kanō-ha;* Morrison 1.

¹洞雲 ²狩野益信 ³山三郎 ⁴薄左軒子 ⁵薄友軒 ⁶松隠子 ⁷宗深道人 ⁸洞雲

Toun[1] (?–1789). *Gō:* Santosai,[2] Santoun,[3] Toun.[4] **Biog.:** Ukiyo-e printmaker. Designed *bijinga* in the style of Kiyonaga. **Coll.:** Tōkyō (1).

¹吐雲 ²山吐斎 ³山吐雲 ⁴吐雲

Tōwa[1] (?–1841). *N.:* Maemura Aitoku.[2] *Gō:* Tōwa.[3] **Biog.:** Kanō painter. Born in Hongō (a section of Edo) to a poor merchant. Became a pupil of Kanō Tōhaku; eventually assumed the name of Maemura (or was adopted by the Maemura family). Entered the service of the Yamanouchi clan, daimyo of the present Kōchi-ken, as official painter. Early teacher of Kawanabe Kyōsai. **Coll.:** Museum (3), Victoria.

¹洞和 ²前村愛徳 ³洞和

Tōyama Gorō[1] (1888–1928). **Biog.:** Western-style painter. Born in Fukuoka-ken; lived in Tōkyō. Graduated from Tōkyō School of Fine Arts in 1914; then traveled in Europe and America, studying in France at the Académie Julian in 1920.

¹遠山五郎

Tōyo[1] (1612–?). *N.:* Unkoku Tōyo.[2] **Biog.:** Unkoku painter. Son and pupil of Unkoku Tōeki, grandson of Unkoku Tōgan. Lived in Bizen. Famous during his lifetime. According to documentary records did some work in Kyōto. Made *hokkyō,* later *hōgen.* Called himself Sesshū V. An eclectic artist, following Sesshū's style but with both Kanō and Tosa influences. **Coll.:** Daishō-in. **Bib.:** BK 32; K 593, 648, 820; Morrison 1.

¹等與 ²雲谷等與

Tōyo[1] (fl. 1779). *N.:* Iizuka Tōyō.[2] *F.N.:* Gembun.[3] *Gō:* Kanshōsai.[4] **Biog.:** Lacquerer. Worked in Edo, making lacquer for the Hachisuka family of Shikoku and for the lord of Awa. A skillful gold lacquerer; his larger pieces are marked by an exterior gorgeousness and an interior refinement. Famous for his furniture but also made *inrō* noted for their harmonious colors. His pupils and followers, all using the *gō* of Kanshōsai, were active until the mid-19th century. **Coll.:** Ashmolean, Museum (1), Metropolitan, Nezu, Royal (1), Walters. **Bib.:** Boyer, Casal, Herberts, M 188, Ragué, Speiser (2), Yamada, Yoshino.

¹桃葉 ²飯塚桃葉 ³源文 ⁴観松斎

Tōyo[1] (1755–1839). *N.:* Azuma Tōyō.[2] *A.:* Taiyō.[3] *F.N.:* Gizō,[4] Shuntarō (Toshitarō).[5] *Gō:* Gyokuga,[6] Hakurokuen.[7] **Biog.:** Maruyama painter. Born in Mutsu Province. Served the lord of the Sendai fief as official painter. First studied Kanō painting in Edo under Kanō Baishō; later to Kyōto, where his style changed under the influence of Buson, Ōkyo, and Goshun. Received title of *hōgen.* Specialized in landscapes and figures. **Coll.:** Museum (3). **Bib.:** Hillier (4) 3, Mitchell, Paine (1) 1.

¹東洋 ²東東洋 ³大洋 ⁴儀蔵 ⁵俊太郎 ⁶玉峨 ⁷白鹿園

Toyohara Chikanobu[1] (1838–1912). *N.:* Toyohara (originally

Hashimoto)² Naoyoshi.³ *Gō:* Chikanobu,⁴ Ikkakusai Kunitsuru II,⁵ Yōshū.⁶ **Biog.:** Ukiyo-e painter. Born in Takada, Niigata-ken. First studied the Kanō style of painting. Became a minor member of the *bakufu*. After the Restoration studied under Toyohara Kunichika, whose surname he later used. Specialized in historical subjects and in pictures of women and children of the Meiji era. Also did illustrations for newspapers. **Coll.:** Allen, Fine (California), Honolulu, Musées, Seattle, Victoria. **Bib.:** ACASA 10; NBZ 6; NHBZ 7; Nonogami; Tamba (2), (2a).

¹豊原周延 ²橋本 ³豊原直義 ⁴周延 ⁵一鶴斎国鶴二代 ⁶楊洲

Toyoharu¹ (1735–1814). *N.:* Utagawa Masaki.² *F.N.:* Shin'emon,³ Tajimaya Shōjirō.⁴ *Gō:* Ichiryūsai,⁵ Sen'ō,⁶ Senryūsai,⁷ Shōjirō,⁸ Shōju,⁹ Toyoharu.¹⁰ **Biog.:** Ukiyo-e painter, printmaker. Born in Bungo Province. First moved to Kyōto, where he studied under the Kanō master Tsuruzawa Tangei; about 1763 moved to Edo, where he was a pupil of Shigenaga and Toriyama Sekien; also influenced by Ishikawa Toyonobu. Founder of Utagawa school; teacher of Toyohiro and Toyokuni. About 1770 produced some large and striking *uki-e* in which he used the perspective and other conventions of Western art. In 1796 became chief of the painters engaged in the repairing of the mausoleum at Nikkō. His earliest works were prints, but in the 1780s and 90s made a great impression with his paintings, pioneering in views of foreign lands, even including a picture of the Forum in Rome. Perhaps better as a painter than as a printmaker. Some of his prints were adapted from Dutch and German engravings. One of the first to emphasize the landscape print, with interest in landscape or architectonic backgrounds in perspective and in good relation to figures. Many designs of teahouses and theater interiors. A good colorist. **Coll.:** Allen; Andrew; Art (1); Ashmolean; Atami; British; Freer; Grunwald; Hakone; Honolulu; Idemitsu; Kōbe; Metropolitan; Musée (1), (2); Musées; Museum 3); Nelson; Philadelphia; Portland; Rhode Island; Riccar; Rietberg; Staatliche; Tōkyō (1); University (2); Victoria; Worcester. **Bib.:** Binyon (1), (3); Boller; Crighton; *Freer;* Fujikake (3) 2; Gentles (1); GNB 17; Hillier (1), (4) 1, (7); K 105, 713; Kikuchi; Kondō (6); Lane; M 233; Meissner; Michener (3); Mody; Morrison 2; Narazaki (2); NB (S) 36, 68; NHBZ 3, 4; *Nikuhitsu* (1) 2, (2); OA 13; *Pictorial* (2) 4; SBZ 10; Schmidt; Shibui (1); Shimada 3; Stern (2), (4); Sullivan; Tajima (7) 4, (13) 6; Takahashi (1), (2), (6) 6; Tamba (2a); UG 28; *Ukiyo-e* (3) 10; Waterhouse.

¹豊春 ²歌川昌樹 ³新右衛門 ⁴但馬屋庄次郎 ⁵一竜斎 ⁶潜翁 ⁷潜竜斎 ⁸松爾楼 ⁹昌樹 ¹⁰豊春

Toyohide¹ (fl. 19th c.). *N.:* Kitagawa Toyohide.² *Gō:* Ichiryūtei,³ Isshintei.⁴ **Biog.:** Ukiyo-e printmaker. An Ōsaka artist, specializing in actor prints. **Coll.:** Musées, Victoria.

¹豊秀 ²北川豊秀 ³一流亭 ⁴一信亭

Toyohiko¹ (1773–1845). *N.:* Okamoto Toyohiko.² *A.:* Shigen.³ *F.N.:* Shiba,⁴ Shume.⁵ *Gō:* Chōshinsai,⁶ Kōson,⁷ Rikyō,⁸ Tangaku Sanjin.⁹ **Biog.:** Shijō painter. Born in Bitchū Province; studied painting there under Kuroda Ryōzan. Then to Kyōto, where he became Matsumura Goshun's best pupil. After Goshun's death he and Matsumura Keibun were the leading Kyōto painters of the Shijō school. Shiokawa Bunrin and Shibata Zeshin among his pupils. Was commissioned to repair the door of the Zoroku-an at the Shūgakuin imperial villa, which had been painted by a Kanō artist. Received title of *hōgen*. Generally painted landscapes but was also an excellent painter of figures. Much influenced by early Chinese paintings. **Coll.:** Art (1), Ashmolean, Metropolitan, Museum (3), Victoria. **Bib.:** BK 43; Brown; Hillier (3), (4) 3; K 38, 223, 376, 402, 675; Mitchell; Moriya; Morrison 2; *One* (2); Paine (2) 1; SBZ 5; Tajima (12) 8, 16; Tajima (13) 6.

¹豊彦 ²岡本豊彦 ³子彦 ⁴司馬 ⁵主馬 ⁶澄神斎 ⁷荘村 ⁸鯉喬 ⁹丹岳山人

Toyohiro¹ (1773–1828). *N.:* Utagawa Toyohiro² (originally Okajima [or Okazaki]³ Tōjirō).⁴ *F.N.:* Tōjirō.⁵ *Gō:* Ichiryūsai.⁶ **Biog.:** Ukiyo-e painter, printmaker. Born and lived in Edo. With Toyokuni, studied under Utagawa Toyoharu, whose studio he entered about 1782. Was given the name of Utagawa Toyohiro and allowed to use his master's *gō* of Ichiryūsai. Also studied Kanō painting. In the print field designed *hosoban* and *surimono* and helped the development of the landscape print, which influenced his pupil Hiroshige. *Bijin* and landscape his usual themes; his major works, designed mostly in the 1790s, are comparatively rare. His style close to that of Eishi, his figures having the same attenuated grace. In history of ukiyo-e chiefly distinguished for having had Hiroshige among his pupils. His paintings quite elegant; a good landscape artist. Also an able illustrator of story books. **Coll.:** Allen, Art (1), Ashmolean, British, Brooklyn, Cincinnati, Fine (California), Fitzwilliam, Freer, Honolulu, Idemitsu, Metropolitan, Musée (1), Musées, Museum (3), Nelson, Newark, Ōstasiatiska, Portland, Rhode Island, Riccar, Staatliche, Tōkyō (1), University (1), Victoria, Worcester. **Bib.:** Binyon (1); Crighton; Fujikake (3) 3; GNB 17; Hillier (1), (3), (4) 1, (7), (9); K 122, 698, 732; Kikuchi; *Kunst;* Lane; Meissner; Morrison 2; Narazaki (2); NHBZ 4; *Nikuhitsu* (1) 2, (2); OA 13; Schmidt; Shibui (1); Shimada 3; Stern (4); Succo (2); Takahashi (1), (2), (6) 10; Tamba (2a); UG 28; *Ukiyo-e* (3) 10.

¹豊広 ²歌川豊広 ³岡崎 ⁴岡島藤次郎 ⁵藤次郎 ⁶一柳斎 (一竜斎)

Toyohisa¹ (fl. 1801–18). *N.:* Utagawa Toyohisa.² *Gō:* Baikatei.³ **Biog.:** Ukiyo-e printmaker. Pupil of Utagawa Toyoharu. Produced actor prints and playbills. Teacher of Toyohisa II (fl. c. 1830). **Coll.:** Musées, Victoria. **Bib.:** Morrison 2, NB (S) 36, *Nikuhitsu* (2).

¹豊久 ²歌川豊久 ³梅花亭

Toyokuni¹ (1769–1825). *N.:* Utagawa (originally Kurahashi)² Toyokuni.³ *F.N.:* Kumaemon,⁴ Kumakichi.⁵ *Gō:* Ichiyōsai.⁶ **Biog.:** Ukiyo-e painter, printmaker. Lived and worked in Edo. Son of a sculptor of puppets. Pupil of Utagawa Toyoharu. Influenced by almost every well-known contemporary print artist: a thorough eclectic, but with a number of personal mannerisms. His most typical work consisted of actor prints in which he showed the actors both in their stage roles and in private life. Also illustrated books by Santo Kyōden and other writers. Most prominent and popular member of the Utagawa school, but his work unequal and, about 1805, began to show a marked and rapid decline. Said to have been the originator of *azuma nishiki-e*. At his best, a brilliant draftsman and designer. Had many, and frequently incompetent, followers. **Coll.:** Albertina; Allen; Art (1); Art (1a); Ashmolean; Atami; British; Brooklyn; Cincinnati; City; Detroit; Fine (California); Fitzwilliam; Fogg; Freer; Herron; Honolulu; Idemitsu; Kinsuien; Kōbe; Metropolitan; Minneapolis; Musée (1), (2); Musées; Museu (1); Museum (1), (3); Naritasan; National (3); Nelson; Ōstasiatiska; Österreichisches; Philadelphia; Portland; Rhode Island; Riccar; Rietberg; Staatliche; Tōkyō (1); University (2); Victoria; Worcester; Yale. **Bib.:** Binyon (1), (3); BMFA 60; Boller; Crighton; Fujikake (3) 3; GNB 17; Hempel; Hillier (1), (3), (7); *Japanese* (1a); K 673; Keyes; Kikuchi; *Kunst;* Lane; Ledoux (5); Lee (2); M 93; Meissner; Michener (3); Morrison 2; Narazaki (2); NBZ 5; NHBZ 4; *Nikuhitsu* (1) 2; Nonogami; *Pictorial* (2) 4; PTN 1970; SBZ 10; Schmidt; Shibui (1); Shimada 3; Stern (2), (4); Succo (2); Takahashi (1), (2), (5), (6) 10; Tajima (7) 4; UG 8, 28, 33; *Ukiyo-e* (2) 9, (3) 14; Vignier 6.

¹豊国 ²倉橋 ³歌川豊国 ⁴熊右衛門 ⁵熊吉 ⁶一陽斎

Toyokuni II¹ (1777–1835). *N.:* Utagawa Toyoshige.² *F.N.:* Genzō.³ *Gō:* Gosotei (Kōsotei),⁴ Gosotei Toyokuni,⁵ Ichibetsusai,⁶ Ichieisai,⁷ Ichiryūsai,⁸ Kunishige,⁹ Toyokuni.¹⁰ **Biog.:** Ukiyo-e painter, illustrator. Lived in Hongō

in Edo, working as a pottery dealer. Pupil and son-in-law of Toyokuni. After the death of his master in 1825, called himself Toyokuni II but was challenged by other followers of Toyokuni and changed his name to Toyoshige. From 1826 signed Toyokuni or Gosotei Toyokuni, commonly known as Hongō Toyokuni[11] after the district in which he lived. In later years, resumed name of Toyoshige. His prints of actors and *bijin* in Toyokuni's manner, and often confused with his work, have little merit, but in his landscape series, which owe much to Hokuju and Hokusai, he can be compared to Hiroshige. Also illustrated storybooks. **Coll.:** Albertina, Allen, Ashmolean, British, Cincinnati, Fine (California), Minneapolis, Portland, Staatliche, Tōkyō (1), Victoria, Waseda, Worcester. **Bib.:** Binyon (1), (3); Hillier (4) 1; Kikuchi; *Kunst;* Lane; Meissner; *Nikuhitsu* (2); Nonogami; Schmidt; Shibui (1); Shimada 3; Succo (2); Takahashi (2); Tamba (2a); UG 15, 28.

[1]豊国二代　[2]歌川豊重　[3]源蔵　[4]後素亭　[5]後素亭豊国
[6]一鷺斎　[7]一瑛斎　[8]一竜斎　[9]国重　[10]豊国　[11]本郷豊国

Toyomaro[1] (fl. 1804–18). *Gō:* Kimpūsha (Kinpūsha),[2] Toyomaro.[3] **Biog.:** Ukiyo-e painter. Specialized in *bijinga.* **Bib.:** *Nikuhitsu* (2), Shimada 3.

[1]豊麿　[2]琴風舎　[3]豊麿

Toyomaru (**Shunrō II**)[2] (fl. 1785–97). *N.:* Utagawa Toyomaru[3] (later, Katsukawa Shunrō).[4] *Gō:* Jutei,[5] Kusamura.[6] **Biog.:** Ukiyo-e printmaker. Pupil of Utagawa Toyoharu and, later, of Katsukawa Shunshō. About 1796, when Hokusai abandoned the *gō* Shunrō, Toyomaru began to sign his work Katsukawa Shunrō and was known as Shunrō II. Produced actor prints and book illustrations. **Coll.:** British, Musées, Worcester. **Bib.:** Binyon (1), (3); Ficke; Morrison 1; NHBZ 3; Shimada 3.

[1]豊丸　[2]春郎二代　[3]歌川豊丸　[4]勝川春郎　[5]寿亭　[6]叢

Toyomasa[1] (fl. 1770–80). *N.:* Ishikawa Toyomasa.[2] **Biog.:** Ukiyo-e printmaker. Pupil and probably son of Ishikawa Toyonobu. Influenced first by Harunobu, then by Shigemasa. Produced *nishiki-e,* particularly of children. **Coll.:** Art (1), British, Honolulu, Musées, Newark, Östasiatiska, Portland, Rhode Island, Staatliche, Tōkyō (1), Victoria, Worcester. **Bib.:** Binyon (1), (3); Fujikake (3) 2; Gentles (1); Hillier (7); NHBZ 6; Schmidt; Waterhouse.

[1]豊雅　[2]石川豊雅

Toyonobu[1] (?–1732). *N.:* Kawaeda Toyonobu.[2] *Gō:* Rakkatei.[3] **Biog.:** Ukiyo-e painter, printmaker. Worked in Kyōto, making prints and paintings of *bijin* in the manner of the Nishikawa school. **Bib.:** Fujikake (3) 2, *Nikuhitsu* (2).

[1]豊信　[2]川枝豊信　[3]洛下亭

Toyonobu[1] (1711–85). *N.:* Ishikawa Toyonobu[2] (or Nishimura Shigenobu).[3] *A.:* Magosaburō.[4] *F.N.:* Nukaya Shichibei.[5] *Gō:* Meijōdō,[6] Shūha.[7] **Biog.:** Ukiyo-e painter, printmaker, illustrator. Born and lived in Edo. Some scholars find that the problem concerning the identity of this artist is still unsolved. The artist known as Ishikawa Toyonobu was born into the Ishikawa family, feudal retainers of the Hōjō clan. Married the daughter of an innkeeper from whose inn, known as the Nukaya, he took his nickname of Nukaya Shichibei. (After he inherited his father-in-law's inn, his output decreased, and after 1765 he made almost no prints.) He is believed to have studied under Nishimura Shigenaga and until 1730 used the name of Nishimura Magosaburō; from 1730 until about 1747 that of Nishimura Shigenobu (q.v.); after 1747 that of Ishikawa Toyonobu. However, the difference in style between the prints signed Shigenobu, which are in the Torii manner, and those signed Toyonobu, which are more svelte and more elegant, has made some critics believe that two artists are involved. Toyonobu's subjects included lovers, *bijin*, marionette players. A master of design for *hashira-e.* His work is vigorous and of remarkable technical skill. **Coll.:** Allen; Art (1); Ashmolean; British; Cincinnati; City; Detroit; Fine

(California); Fitzwilliam; Fogg; Freer; Grunwald; Honolulu; Metropolitan; Minneapolis; Musée (1), (2); Museum (1), (3); Nelson; Newark; Portland; Rhode Island; Riccar; Rietberg; Staatliche; Tōkyō (1); University (2); Victoria; Worcester; Yale. **Bib.:** ACASA 15; Binyon (1), (3); BK 70; Boller; Brown; Fujikake (3) 2; GNB 17; Gunsaulus (1); Hillier (1), (3), (4) 1, (7); Jenkins; K 115, 356; Kikuchi; *Kunst;* Lane; Ledoux (4); Lee (2); Morrison 2; Narazaki (2); NBZ 5; NHBZ 2; *Nikuhitsu* (1) 1; SBZ 9; Schmidt; Shibui (1); Shimada 3; Stern (2), (4); Tajima (7) 3; Takahashi (2), (5), (6) 1; UG 28; *Ukiyo-e* (3) 4; Waterhouse.

[1]豊信　[2]石川豊信　[3]西村重信　[4]孫三郎
[5]糠屋七兵衛　[6]明樵堂　[7]秀葩

Toyonobu[1] (fl. 1770–80). *N.:* Utagawa Toyonobu.[2] **Biog.:** Ukiyo-e printmaker. Some scholars feel that this is merely an early name for Utagawa Toyoharu; others regard him as identical with Ishikawa Toyonobu; still others think he was a pupil of Ishikawa Toyonobu. It is probable that he was a fellow-artist—and possibly a brother—of Toyoharu. Prints with this signature *very* rare: only six or so have survived. **Coll.:** Art (1). **Bib.:** Gentles (1), Morrison 2, UG 3.

[1]豊信　[2]歌川豊信

Toyonobu[1] (?–1886). *N.:* Utagawa Toyonobu.[2] *Gō:* Kōchōrō.[3] **Biog.:** Ukiyo-e printmaker. Son of Utagawa Kunihisa; grandson of Kunisada. Worked as an illustrator for the *Kaishin Shimbun.* Good at *nishiki-e.* **Coll.:** Musées.

[1]豊宣　[2]歌川豊宣　[3]香蝶楼

Toyosuke[1] (1788?–1858). *N.:* Ōki Toyosuke.[2] **Biog.:** Lacquerer. Came from Owari Province. Originally a potter. Known for his designs of lacquer applied to glazed and colored pottery, a technique known as Toyosuke-raku or Horaku-yaki, which he introduced in 1830. In 1844 began applying this technique to the decoration of porcelain. Versed in the tea ceremony and in composing *haiku.* His style in lacquerwork had, fortunately, few followers. **Bib.:** Herberts, Jahss, *Pictorial* (1) 4, Ragué, SBZ 10, Yoshino.

[1]豊助　[2]大喜豊助

Toyotane[1] (fl. mid-18th c.). *N.:* Sakakibara Toyotane.[2] *Gō:* Riei.[3] **Biog.:** Sumiyoshi painter. Member of a branch of the Sumiyoshi school. Two scrolls by him, *Shōkoku-ji Kuyōki,* have colophons written in 1745. Good at depicting the customs of his time. **Coll.:** Suntory.

[1]豊種　[2]榊原豊種　[3]理栄

Tōyū[1] (fl. second half 17th c.). *N.:* Hatano Tōyū.[2] *F.N.:* Hachirobei.[3] **Biog.:** Unkoku painter. Pupil of Unkoku Tōho. Painted landscapes and *kachōga.*

[1]等有　[2]波多野等有　[3]八郎兵衛

Tōyū[1] (fl. early 18th c.). *N.:* Unkoku Tōyū.[2] **Biog.:** Unkoku painter. Son of Tōji; fourth-generation head of Unkoku family. A minor artist, often confused with Mitani Tōshuku[3] because of the similarity of the *kanji.* **Coll.:** Tōkō-ji. **Bib.:** K 593, 820.

[1]等有　[2]雲谷等有　[3]三谷等宿

Tōzen[1] (fl. c. 1444–52). *N.:* Matsuura Tōzen.[2] *Gō:* Hosetsu.[3] **Biog.:** Muromachi *suiboku* painter. Probably a priest; may have lived in Kyūshū. Said to have been a follower of Sesshū, but some scholars find that the style of his painting looks older than that of Sesshū and shows rather the influence of the Chinese Southern Sung school and the Japanese Ami school. The dates given are those suggested by the *Dai Nihon Shoga Meika Taikan.* **Coll.:** Honolulu, Museum (3), Tokiwayama, Tōkyō (1). **Bib.:** GNB 11; *Japanese* (1); K 107, 783; Lee (3); M 199, 205; *Muromachi* (1).

[1]等禅　[2]松浦等禅　[3]甫雪

Tōzen[1] (fl. late 17th to early 18th c.). *N.:* Unkoku Tōzen.[2] **Biog.:** Unkoku painter. Known only from the genealogy of the Unkoku family. Received title of *hokkyō.*

[1]等全　[2]雲谷等全

Tōzō[1] (fl. mid-17th c.). *N.:* Kimura Tōzō.[2] **Biog.:** Lacquerer. In 1643 was brought by Hoshina Masayuki, then lord of the

Aizu fief, to Aizu from Kyōto to help reorganize the local lacquer industry. **Bib.:** Sawaguchi.

¹藤蔵 ²木村藤蔵

Tsū¹ (1559–1616). *N.:* Ono Tsū.² **Biog.:** Kanō painter. Lived in Kyōto; after the death of her husband, served first in the retinue of Oda Nobunaga and later in that of Yodogimi, concubine of Toyotomi Hideyoshi. Specialized in figure painting, working in the Kanō manner. Better known as a writer. **Coll.:** Museum (3).

¹通 ²小野通

Tsubai¹ (fl. c. 1378). **Biog.:** Sculptor. A *busshi*, known for a figure of Monju riding a lion, dated 1378, in the Jōdo-ji, Hiroshima. **Coll.:** Jōdo-ji (1). **Bib.:** NBZ 3.

¹椿井

Tsubaki Nizan¹ (1873–1905). *N.:* Tsubaki Takashi.² *Gō:* Nizan.³ **Biog.:** *Nanga* painter. Born in Tōkyō. Grandson of Tsubaki Chinzan; pupil of Noguchi Yūkoku. A good painter of *kachōga*.

¹椿二山 ²椿隆 ³二山

Tsubaki Sadao¹ (1896–1957). **Biog.:** Western-style painter. Born in Yonezawa, Yamagata-ken. At 19 to Tōkyō. Studied under Kishida Ryūsei and with him and Kimura Shohachi founded the Sōdosha in 1916. Exhibited with the Sōdosha, Tatsumigakai, Inten, Nikakai. Member of Shun'yōkai, changing later to the Kokugakai. Academic in style. **Coll.:** National (5). **Bib.:** Asano, NBZ 6.

¹椿貞雄

Tsubata Michihiko¹ (1868–1938). *N.:* Tsubata Kai.² *F.N.:* Tametarō.³ *Gō:* Kageinoya,⁴ Michihiko.⁵ **Biog.:** Japanese-style painter. Born in Niigata-ken. In 1886 to Tōkyō to study under Yamana Tsurayoshi and Fukushima Ryūho. Showed with the Nihon Bijutsu Kyōkai. In 1908 won a prize at the Bunten. From 1909 taught at the Kawabata Gagakkō. Specialized in historical subjects.

¹津端道彦 ²津端魁 ³為太郎 ⁴佳芸乃舎 ⁵道彦

Tsuchida Bakusen¹ (1887–1936). *N.:* Tsuchida Kinji.² *Gō:* Bakusen.³ **Biog.:** Japanese-style painter. Born on Sado Island. To Kyōto in 1903 to study under Suzuki Shonen and Takeuchi Seihō. In 1909 entered special section of the Kyōto College of Fine Arts. Was several times awarded a prize at the Bunten; later showed with the Teiten. From 1921 to 1923 in Europe, where he studied Western-style painting. With Murakami Kagaku, was one of the founders in 1918 of the Kokuga Sōsaku Kyōkai. Member of the Imperial Fine Arts Academy. The *maiko* of Kyōto his favorite theme. Attempted to blend Japanese decorative style with a little realism to form a new Japanese style; his figures quite realistic, the backgrounds stylized. **Coll.:** Kyōto (1); Museum (3); National (4), (5); Yamatane. **Bib.:** AAA 21, Asano, BK 232, Kondō (6), *Masterpieces* (4), Miyagawa, Nakamura (1), NB (H) 24, NBT 10, NBZ 6, NKKZ 22, SBZ 11, Tanaka (7a) 21.

¹土田麦僊 ²土田金二 ³麦僊

Tsuda Seifū¹ (1880–). *N.:* Tsuda Kamejirō.² *Gō:* Seifū.³ **Biog.:** Western-style painter. Born in Kyōto. First studied Japanese-style painting under Taniguchi Kōkyo, then Western-style painting under Asai Chū and Kanokogi Takeshirō. In 1907 to France, where he studied under Jean-Paul Laurens; returned to Japan in 1911. Became a juror for the Bunten and a founding member of the Nikakai. In later life returned to the Japanese style of painting. His Western manner shows the influence of the School of Paris. **Coll.:** Bridgestone, National (5). **Bib.:** Asano, Mitchell, NB (H) 24, NBZ 6.

¹津田青楓 ²津田亀次郎 ³青楓

Tsuda Seishū¹ (1907–52). **Biog.:** Western-style painter. Born in Kyōto. Graduated from the Kyōto College of Fine Arts. In France from 1929 to 1933 and again from 1935 to 1936; exhibited at the Salon d'Automne and the Salon des Indépendants. In Japan, active in avant-garde circles. After

1945 taught in Manchuria. Died in Harbin. **Coll.:** Kanagawa. **Bib.:** Asano, NBZ 6.

¹津田正周

Tsuishu¹ (fl. mid-14th c. to present). The name (*tsui* means "heaped," and *shu* means "red") of a school of lacquerers specializing in carved red lacquer of the Chinese Ming style as well as in hairline engraving on lacquer filled in with gold dust. (The term is used, especially in Europe, to designate any carved red lacquer; it is actually red lacquer on a yellow ground, not deeply carved.) In Japan, *tsuishu* is supposed to have been first produced by the artist Monnyū (q.v.). According to the (probably legendary) family tree, the school began in the mid-14th century when the then shogun gave to the head of this family the name of Yōsei (or Yōzei),² made up of one character each from the Japanese versions of the names of two Chinese *tsuishu* artists of the time: Yōmo (Yang Mao) and Chōsei (Chang Cheng). In addition to the school name Tsuishu the name Yōsei was used by all the succeeding artists of the school. From the tenth generation, represented by Chōze (1683–1719), until the Meiji Restoration the family worked for the Tokugawa shogunate. The lacquerwork of this school has great richness of color, variation of design, and skill of carving.

Yōsei I: Chōjū (Nagamichi)³ (fl. 1356–61). Served Ashikaga shogun Yoshiakira.

Yōsei II: Chōshin (Nagatatsu)⁴ (fl. 1381–84).

Yōsei III: Chōtei (Nagasada)⁵ (fl. 1487–88).

Yōsei IV: Chōshi (Nagatsugu)⁶ (fl. 1492–1500).

Yōsei V: Chōhan (Nagashige)⁷ (fl. 1501–20).

Yōsei VI: Chōhō (Nagafusa)⁸ (fl. 1521–55). Served Ashikaga shogun Yoshiharu.

Yōsei VII: Chōshin (Nagachika)⁹ (fl. late 16th c.). Served Hideyoshi. Moved to Kamakura, where he died.

Yōsei VIII: Chōsō (Nagamune)¹⁰ (?–1654). *Gō:* Heijūrō.¹¹ Invented a technique of inlaying *tsuishu* with green shell, known as Kamakura-tsuishu.

Yōsei IX: Chōzen (Nagayoshi)¹² (?–1680).

Yōsei X: Chōze (Nagakore)¹³ (1683–1719). At request of Tokugawa Tsunayoshi moved to Edo, where he died.

Yōsei XI: Chōsei (Nagamori)¹⁴ (?–1735). An outstanding lacquer artist.

Yōsei XII: Chōin¹⁵ (?–1765).

Yōsei XIII: Chōri (Nagatoshi)¹⁶ (?–1779).

Yōsei XIV: Chōkin¹⁷ (?–1791).

Yōsei XV: Chōryū (Nagataka)¹⁸ (?–1812). *Gō:* Chōin (Nagakage).¹⁹

Yōsei XVI: Chōei (Nagahide)²⁰ (?–1848).

Yōsei XVII: Chōhō (Nagakuni)²¹ (?–1858). Around 1850 was given name Nagato²² by Tokugawa Ieyoshi, for whom he worked. Signed his works Tsuishu Yōsei Nagato.

Yōsei XVIII: Kokuhei.²³ *Gō:* Nagato.²⁴ (?–1890). From 1861 worked on repair of the shrines at Nikkō.

Yōsei XIX: (fl. 1870–98).

Yōsei XX: Tsuishu Yōsei²⁵ (1880–1952). *Gō:* Toyogorō.²⁶ One of the most talented of the family. Member of Japan Art Academy.

Coll.: Staatliche; Tōkyō (1), (2); Victoria; Walters. **Bib.:** *Ausgewählte*, Boyer, GNB 28, Herberts, Jahss, K 684, M 188, Ragué, Sawaguchi, Speiser (2), Yoshino.

¹堆朱 ²楊成 ³長充 ⁴長辰 ⁵長貞 ⁶長嗣 ⁷長繁
⁸長房 ⁹長親 ¹⁰長宗 ¹¹平十郎 ¹²長善 ¹³長是
¹⁴長盛 ¹⁵長韻 ¹⁶長利 ¹⁷長均 ¹⁸長隆 ¹⁹長蔭
²⁰長英 ²¹長邦 ²²長門 ²³国平 ²⁴長門
²⁵堆朱楊成 ²⁶豊五郎

Tsuji Aizō¹ (1895–1964). **Biog.:** Western-style painter, printmaker. Born in Ōsaka. First studied with Akamatsu Rinsaku in Ōsaka; in 1915 to Tōkyō to study at the Taiheiyō Kenkyūsho. An exhibitor with the Inten and the Shun'yōkai. Taught at the Ōsaka Municipal Art Studio. Painted in a free

and sketchy manner. Also worked in the Japanese manner. Produced a number of woodcuts. **Bib.**: Asano.

¹辻愛造
Tsuji Hisashi[1] (1884–). **Biog.**: Western-style painter. Born in Shikoku. Graduate of the Tōkyō School of Fine Arts; pupil of Kuroda Seiki. In Europe from 1921 to 1922. On his return showed with the Bunten and the Kōfūkai; served as a juror for the Teiten. After 1945, a member of the Nitten. His style is Western in technique but somewhat in the Japanese decorative tradition in spirit. **Coll.**: National (5). **Bib.**: Asano, NBZ 6.

¹辻永
Tsuji Kakō[1] (1870–1931). *N.*: Tsuji Yoshikage.[2] *F.N.*: Tsuji Unosuke.[3] *Gō*: Kakō.[4] **Biog.**: Japanese-style painter. Lived in Kyōto. Pupil of Kōno Bairei, under whom he studied the Shijō manner. Served as director of the Kyōto Municipal School of Fine Arts and Crafts. Juror for the Teiten and several Kyōto exhibition groups. A frequent exhibitor and prize winner at the Bunten. Member of Imperial Art Academy. Specialized in figures and *kachōga*. One of the founders of the modern Kyōto school. **Coll.**: Museum (3). **Bib.**: Asano, Mitchell, NB (S) 17, NBZ 6.

¹都路華香 ²都路良景 ³辻宇之助 ⁴華香
Tsujimura Shōka[1] (1867–1929). **Biog.**: Lacquerer. Combines East and West in his lacquer designs. One of best of late-Meiji lacquer artists. **Bib.**: Herberts, Uyeno.

¹辻村松華
Tsukimaro[1] (fl. ?–1830). *N.*: Kitagawa (originally Ogawa)[2] Jun.[3] *A.*: Shitatsu.[4] *F.N.*: Rokusaburō,[5] Sensuke.[6] *Gō*: Bokutei,[7] Kansetsusai,[8] Kikumaro,[9] Tsukimaro,[10] Yūsai.[11] **Biog.**: Ukiyo-e painter, printmaker. Lived in Edo; Utamaro's best pupil. Illustrated *kusazōshi*. First signed his works Kikumaro; after 1804, Tsukimaro. After 1818 ceased making prints and took name of Kansetsu.[12] **Coll.**: Albertina, British, Cincinnati, Cleveland, Fine (California), Fitzwilliam, Musées, Nelson, Newark, Portland, Rhode Island, Riccar, Seattle, Staatliche, Tōkyō (1), Victoria, Worcester. **Bib.**: Binyon (1), (3); Crighton; Fujikake (3) 3; Kikuchi; Morrison 2; NHBZ 4; *Nikuhitsu* (2); Schmidt; Shimada 3; Takahashi (2), (6) 8; UG 6.

¹月麿 ²小川 ³喜多川潤 ⁴士達 (子達)
⁵六三郎 ⁶千助 ⁷墨亭 ⁸観雪斎
⁹喜久麿 (菊麿) ¹⁰月麿 ¹¹遯斎 ¹²観雪
Tsukioka Kōgyo[1] (1869–1927). *N.*: Tsukioka (originally Hanyū)[2] Sadanosuke.[3] *Gō*: Kōgyo,[4] Kohan,[5] Nenkyū.[6] **Biog.**: Ukiyo-e printmaker. Born in Edo. His mother married Tsukioka Yoshitoshi, under whom he first studied and whose surname he took. Later, a pupil of Matsumoto Fūko and Ogata Gekkō. Specialized in illustrations of Nō plays. **Coll.**: Musées, Victoria. **Bib.**: Crighton.

¹月岡耕漁 ²羽生 ³月岡弁之助 ⁴耕漁 ⁵湖畔 ⁶年久
Tsunemasa[1] (fl. 1716–48). *N.*: Kawamata Tsunemasa.[2] **Biog.**: Ukiyo-e painter. Probably worked in Kyōto. Pupil of Kawamata Tsuneyuki. Specialized in *bijinga* and paintings on literary themes. More of his paintings have survived than by other artists in the Kawamata group; his style shows he was much influenced by Sukenobu. May have been a printmaker, but no prints by him are known to exist. **Coll.**: Art (1), Freer, Metropolitan, Tōkyō (1), Victoria, Yale. **Bib.**: Fujikake (3) 2; Hillier (1), (3), (4) 1; K 43, 352; Lane; Morrison 2; Nikuhitsu (1) 1, (2); Shimada 3; Stern (4).

¹常正 ²川又常正
Tsunemitsu[1] (fl. early 15th c.). *N.*: Awataguchi Tsunemitsu.[2] **Biog.**: Tosa painter. Son of Awataguchi Takamitsu; his painting career contemporary with that of his father. Received title of *hōgen*.

¹経光 ²粟田口経光
Tsunenobu[1] (1636–1713). *N.*: Kanō Tsunenobu.[2] *F.N.*: Ukon.[3] *Gō*: Bokusai,[4] Kan'unshi,[5] Kōcho Sanjin,[6] Kōkansai,[7] Kosen,[8] Kosensō,[9] Rōgōken,[10] Seihakusai,[11] Sen'oku,[12]

Shibiō,[13] Yōboku.[14] **Biog.**: Kanō painter. Born in Kyōto. Son of Kanō Naonobu. At age 15, on his father's death, became pupil of his uncle Tan'yū. Succeeded to the Kanō estate at Kobikichō; in attendance at the Sentō Palace as court painter. Also a connoisseur of old paintings. In 1704 given rank of *hōgen;* later received that of *hōin*. In 1709, at order of the emperor, painted the *Kensho Shōji* (portraits of Confucius, Mencius, and other sages) in the Shishinden of the Imperial Palace. A leading artist of the Kanō school, he brought the Kobikichō branch to a position of prominence. His paintings are eminently pleasant, charming in color, delicate in tone. Excelled also in literature. **Coll.**: Andrew; Art (1); British; Brooklyn; Lake; Metropolitan; Museum (3); Nelson; Newark; Ōkura; Tōkyō (1), (2); Victoria. **Bib.**: Binyon (2); BK 93; GNB 13; Hillier (1); K 22, 33, 57, 97, 115, 323, 335, 360, 418, 477, 552, 567, 652, 931; *Kanōha;* M 18, 205; Moriya; Morrison 1; NBZ 4; *One* (2); Paine (2) 2; Tajima (12) 10, 11, 20; Tajima (13) 5.

¹常信 ²狩野常信 ³右近 ⁴朴斎 ⁵寒雲子
⁶篁渚散人 ⁷耕寛斎 ⁸古川 ⁹古川叟 ¹⁰弄毫軒
¹¹青白斎 ¹²潜屋 ¹³紫微翁 ¹⁴養朴
Tsunenori[1] (fl. mid-10th c.). *N.*: Asukabe no Tsunenori.[2] **Biog.**: *Yamato-e* painter. Lived in Kyōto. One of most famous court painters of his time; recorded as having worked on commissions for the emperor Murakami. In painting, is regarded as highly as Ono no Tōfū is in calligraphy; however, no work known to be by him now exists, though he is credited with the illustrations in the *Utsubo Monogatari Emaki*. Alexander Soper, in *The Art and Architecture of Japan*, says he may be the same person as the architect Tsunenori who rebuilt the Kondō of the Myōraku-ji on Mount Tonomine in Yamato in 972. **Bib.**: Akiyama (2), Ienaga, Morrison 1, Okudaira (1a), Paine (4).

¹常則 ²飛鳥部常則
Tsuneoka Bunki[1] (1898–). **Biog.**: Japanese-style painter. Born in Hyōgo-ken, works in Tōkyō. In 1922 graduated from the Tōkyō School of Fine Arts. Pupil of Yūki Somei. His traditional paintings, often of flowers, have been seen at many government exhibitions as well as at the Nitten. **Coll.**: National (5). **Bib.**: Asano.

¹常岡文亀
Tsunetaka[1] (fl. late 12th or early 13th c.). *N.*: Tosa (originally Fujiwara)[2] Tsunetaka.[3] **Biog.**: *Yamato-e* painter. Great-grandson of Takayoshi, son of Mitsunaga. Seems to have served the court as official painter; appointed to the rank of Tosa Gon no Kami (vice-lord of Tosa) and may have been the first to use Tosa as a family name. (The use of Tosa as an art name properly began with either Yukimitsu or his son Yukihiro.) Few works attributed to him. **Coll.**: Metropolitan, Tokugawa, Tōkyō (2). **Bib.**: AA 14; *Illustrated* (1); K 26, 146; Morrison 1; Okudaira (1); *One* (2); Tajima (12) 12, (13) 2; Toda (2).

¹経隆 ²藤原 ³土佐経隆
Tsunetatsu (Tsunetoki)[1] (fl. 1751–64). *N.*: Kawamata Tsunetatsu (Tsunetoki).[2] **Biog.**: Ukiyo-e painter. Specialized in paintings of *bijin*. **Bib.**: Stern (4).

¹常辰 ²川又常辰
Tsuneyoshi[1] (fl. c. 882). *N.*: Kudara Tsuneyoshi.[2] **Biog.**: Painter. No certain knowledge of his life or his work. Said to have been a descendant of Kawanari because of his name Kudara, but in the 9th century anyone from Paechke might have this name. Sugawara Michizane in his diary has an entry giving this name and the artist's status and his title.

¹常良 ²百済常良
Tsuneyuki[1] (1676?–1741?). *N.*: Kawamata Tsuneyuki.[2] **Biog.**: Ukiyo-e painter. Lived in Edo; may have worked in Kyōto. Very little known about him. Specialized in *bijinga* but also painted famous historical and literary themes, as well as travesties of them. No prints by him are known so far. Generally followed the style of Sukenobu; has much of

his grace and charm. **Coll.:** Fogg, Freer, Metropolitan. **Bib.:** Lane, *Nikuhitsu* (2), Stern (4).

¹常行 ²川又常行

Tsurao[1] (1810–68). *N.:* Itabashi Korechika[2] (or Sadatoki).[3] *F.N.:* Magosaburō.[4] *Gō:* Gyokushō,[5] Kikunoya,[6] Seiyōken,[7] Tsurao.[8] **Biog.:** Painter. Pupil of Sumiyoshi Hirotsura. Much of the ancient Tosa manner in his work. **Bib.:** Mitchell.

¹貫雄 ²板橋惟親 ³定時 ⁴孫三郎
⁵玉松 ⁶菊殖舎 ⁷清容軒 ⁸貫雄

Tsuruta Gorō[1] (1890–). **Biog.:** Western-style painter. Born in Tōkyō. Studied at the Hakubakai and the Taiheiyō Kenkyūsho with Nakamura Fusetsu and Kurata Hakuyō as his teachers. In 1912 to Korea and Manchuria. In 1920 exhibited with the Teiten. To Europe in 1930. Served as an artist for the army during World War II. Member of the Nitten and the Taiheiyō Gakai. **Bib.:** Asano.

¹鶴田五郎

Tsutaya Ryūkō[1] (1868–1933). *N.:* Tsutaya Kōsaku.[2] *Gō:* Ryūkō.[3] **Biog.:** Japanese-style painter. Born in Aomori-ken. In 1910 graduated from the Japanese-painting division of the extension course of the Tōkyō School of Fine Arts; pupil of Terazaki Kōgyo. In 1915 showed with the Bunten, serving as a committee member for the society after 1924. In 1929 became a juror for the Teiten. **Bib.:** Asano.

¹蔦谷竜岬 ²蔦谷幸作 ³竜岬

U

Uchida Iwao[1] (1900–1953). **Biog.:** Western-style painter. Born in Tōkyō. Graduate of Western-style painting division of the Tōkyō School of Fine Arts in 1926; pupil of Fujishima Takeji. In 1930 to Paris for further study. On his return showed with the Kōfūkai. In 1936 helped to establish the Shinseisaku Kyōkai. A writer as well as a painter. His style the social-realist one of the political left-wing artist. **Coll.:** Kanagawa, National (5). **Bib.:** Asano, NBZ 6.

¹内田巌

Uda Tekison[1] (1896–). *N.:* Uda Zenjirō.[2] *Gō:* Tekison.[3] **Biog.:** Japanese-style painter. Born in Mie-ken. First studied with Kikuchi Hōbun; then graduated from the Kyōto College of Fine Arts and became a pupil of Kikuchi Keigetsu. Showed with the Teiten; later with the Nitten, of which he became a councilor. A good artist of traditional decorative *kachōga* and landscape painting, showing some Rimpa influence: a typical Kyōto-school painter. **Coll.:** National (5), Ōkura. **Bib.:** Asano, NBZ 6.

¹宇田荻邨 ²宇田善次郎 ³荻邨

Ueda Kōchū[1] (1819–1911). *N.:* Ueda Kōchū.[2] *F.N.:* Manjirō.[3] **Biog.:** Maruyama painter. Born in Kyōto. Son and pupil of Ueda Kōfu. In 1832, after his father's death, moved to Ōsaka; became a pupil of Nagayama Kōin. A great traveler, made many sketches of the scenery. At the age of 92 painted the screens in the Temman-jingū in Ōsaka. A prominent figure in Ōsaka art circles. **Coll.:** Itsuō, Museum (3). **Bib.:** Mitchell.

¹上田耕沖 ²上田耕沖 ³万次郎

Ueda Manshū[1] (1869–1952). *N.:* Ueda Minotarō.[2] *Gō:* Manshū,[3] Ryūgai.[4] **Biog.:** Japanese-style painter. Born in Kyōto. Graduate of the Kyōto Municipal School of Fine Arts and Crafts. Pupil of Imao Keinen. First showed with the Naikoku Kangyō Hakurankai, then a frequent exhibitor and prize winner at the Bunten; also an exhibitor with the Teiten. Active in Kyōto art circles. His style a mixture of *nanga* and a little of the Western influence that tinged all Japanese painting of his period. **Coll.:** National (5). **Bib.:** Asano, Elisséèv.

¹上田万秋 ²上田巳之太郎 ³万秋 ⁴柳外

Uematsu Hōbi[1] (1872–1933). **Biog.:** Lacquerer. A competent lacquer artist, pupil of his father Uematsu Hōmin. An independent artist, working in a traditional manner; knew many of the painters of the *fukko yamato-e* school, whose style influenced his work. **Coll.:** Atami. **Bib.:** Herberts, Jahss, NB (S) 41, NBZ 6, Ragué, Yoshino.

¹植松抱美

Uematsu Hōmin[1] (?–1902). **Biog.:** Lacquerer. Born and worked in Tōkyō. Studied under the mid-19th-century lacquer artist Ueda Kisaburō. An important Meiji-era artist. **Bib.:** Herberts, Jahss, NBZ 6, Yoshino.

¹植松抱民

Uemura Shōen[1] (1875–1949). *N.:* Uemura Tsuneko.[2] *Gō:* Shōen.[3] **Biog.:** Japanese-style painter. Born and worked in Kyōto. First entered Kyōto Prefectural School of Painting, studying with Suzuki Shōnen; then studied with Takeuchi Seihō and Kōno Bairei. An exhibitor and frequent prize winner at the Bunten. Member of Japan Art Academy and Art Committee of the Imperial Household; first woman to receive Order of Cultural Merit. Second-generation artist of the modern Kyōto school. Her elegant, calm, graceful figures of historical personages or Kyōto *bijin,* dressed in late-Edo or Meiji costumes and painted in a Japanese style with some Western overtones, have an obvious appeal. **Coll.:** Kyōto (1); National (5); Ōsaka (2); Tōkyō (1), (2); Yamatane. **Bib.:** Asano; BK 195; Elisséèv; Kondō (6); M 40, 52, 202; *Masterpieces* (4); Nakamura (1); *National* (1); NB (H) 24; NBT 10; NBZ 6; NKKZ 17; SBZ 11; Tanaka (7a) 18; Uyeno; YB 38.

¹上村松園 ²上村常子 ³松園

Uenaka Chokusai[1] (1885–). **Biog.:** Japanese-style painter. Born in Nara-ken. Studied under Yamamoto Shunkyo in Kyōto. Won a third prize at the first Bunten in 1907. A constant exhibitor at government-sponsored shows. **Coll.:** National (5). **Bib.:** Asano.

¹植中直斎

Uenoyama Kiyotsugu[1] (1889–1960). **Biog.:** Western-style painter. Born in Hokkaidō. To Tōkyō to study at the Taiheiyō Kenkyūsho. Later became a pupil of Kuroda Seiki and Okada Saburōsuke. In 1925 exhibited for the first of many times with the Teiten. Active in Hokkaidō art circles. **Bib.:** Asano.

¹上野山清貢

Ujinobu[1] (1616–69). *N.:* Kanō Ujinobu.[2] *F.N.:* Daigaku.[3] **Biog.:** Kanō painter. Son and pupil of Kanō Sōshin. Third in line in the Odawarachō branch of the Kanō school. Served the shogunate as *omote eshi*. **Coll.:** Museum (3).

¹氏信 ²狩野氏信 ³大学

Umehara Ryūzaburō[1] (1888–). **Biog.:** Western-style painter. Born in Kyōto, works in Tōkyō. The "grand old man" of Japanese painting in the Western style. Student of Asai Chū at the Kansai Bijutsuin. From 1908 to 1913 in Paris, studying first at the Académie Julian, later with Renoir; also visited Spain and Italy. Much influenced by Gauguin, Matisse, and the German expressionists, especially Nolde. First showed under the auspices of the Shirakabakai. In 1914 helped found the Nikakai, remaining active in the society until 1917. From 1920 to 1921 again in France. In 1922 took part in establishing the Shun'yōkai, but soon withdrew as a member. In 1926 became a member of Western section of the Kokugakai; a director of the society until 1951. In 1929 to China, from 1933 to 1935 in Taiwan. In 1935 made a member of the Imperial Fine Arts Academy. In Peking from 1939 to 1943. From 1944 to 1952 professor at Tōkyō School of Fine Arts. Member of Japan Art Academy. In 1952

received Order of Cultural Merit and in 1956 Asahi Culture Prize. Painter of nudes and landscapes as well as of views of the imperial palaces and street scenes in Peking. His work, rather fauve in feeling, outwardly derives from European painting, but his sense of design and flat colors are in the Japanese tradition. **Coll.:** Bridgestone, Kanagawa, Kyōto (1), Nagaoka, National (5), Ohara (1). **Bib.:** *Art* (1), Asano, Fujikake (1), Harada Minoru, Kondō (6), M 30, *Masterpieces* (4), Miyagawa, Munsterberg (1), NB (H) 24, NB (S) 30, NBT 10, NBZ 6, NHBZ 7, NKKZ 13, SBZ 11, Sullivan, *Umehara.*

<center>¹梅原竜三郎</center>

Umeharu¹ (fl. 1818–44). *Gō:* Umeharu.² **Biog.:** Ukiyo-e printmaker. Member of the Ōsaka Kamigata-e school. Produced only a few actor prints. **Bib.:** Keyes, NHBZ 3.

<center>¹梅春 ²梅春</center>

Umezawa Ryūshin¹ (1874–1955). **Biog.:** Lacquerer. Born in Tōkyō; son of Shibata Zeshin, pupil of Ikeda Taishin. Carried on the Zeshin tradition, adding new lacquer colors and using new materials as the base for his wares. **Bib.:** Herberts, Jahss, NBZ 6, Yoshino.

<center>¹梅沢隆真</center>

Umin¹ (fl. c. 1850). *N.:* Arai Tei.² *A.:* Sūtoku.³ *F.N.:* Koemon.⁴ *Gō:* Kiseki,⁵ Umin.⁶ **Biog.:** *Nanga* painter. Lived and worked in Edo. **Bib.:** Mitchell.

<center>¹羽民 ²荒井貞 ³崇徳 ⁴小右衛門 ⁵畎石 ⁶羽民</center>

Umpo (Unpo)¹ (fl. 15th c.). *Priest name:* Ryōin.² *Gō:* Shūku,³ Umpo (Unpo),⁴ Umposai (Unposai).⁵ **Biog.:** Muromachi *suiboku* painter. No details of his life known save that he was a pupil of Shūbun. **Bib.:** K44, Matsushita (1a), Morrison 1.

<center>¹雲甫 ²良因 ³周苦 ⁴雲甫 ⁵雲甫斎</center>

Umpō (Unpō)¹ (1765–1848). *N.:* Ōoka Narihiro (Jōkan).² *A.:* Kōritsu.³ *F.N.:* Jihei.⁴ *Gō:* Umpō (Unpō).⁵ **Biog.:** *Nanga* painter. Pupil of the famous sealmaker Taka Fuyō,⁶ who was a friend of Ikeno Taiga; this connection obviously influenced Umpō's style. Served as a retainer to the Tokugawa shogunate. Lived at Ōbanchō, Yotsuya, in Edo, from which he took his nickname Yotsuya Nampin.⁷ Worked in the traditional *nanga* style. **Coll.:** Ashmolean. **Bib.:** Mitchell, Morrison 2, *Nihon* (2).

<center>¹雲峯 ²大岡成寛 ³公寛 ⁴治兵衛
⁵雲峯 ⁶高芙容 ⁷四谷南蘋</center>

Unchiku¹ (1632–1703). *N.:* Kitamuki (originally Hayashi)² Kan³ (or Seijitsu).⁴ *F.N.:* Hachirōemon.⁵ *Gō:* Gyokurandō,⁶ Keiō,⁷ Taikyoan,⁸ Unchiku.⁹ **Biog.:** *Nanga* painter. Lived in Kyōto. Also known as a writer of *haiku*. In later life, took Buddhist orders. Specialized in painting bamboo.

<center>¹雲竹 ²林 ³北向観 ⁴正実 ⁵八郎右衛門
⁶玉蘭堂 ⁷渓翁 ⁸太虚庵 ⁹雲竹</center>

Unchō¹ (fl. c. 1362). **Biog.:** Sculptor. Probably lived in Kamakura. Achieved rank of *hōin*. Worked, to judge from his statue of Shaka Nyorai in the Kōgon-ji, in a style influenced by Sung sculpture: the surface is smooth, hard, and rather stiff, but the figure has a mild and gentle air. **Coll.:** Kōgon-ji. **Bib.:** Minamoto (1), NBZ 3.

<center>¹運朝</center>

Unchō¹ (fl. late 18th c.). **Biog.:** Painter. Nothing is known of the life of this artist, and it has been assumed that Unchō is a pseudonym of a samurai in the service of the shogunate. This name appears on an ukiyo-e painting, dated 1796, depicting the famous "Looking-back Willow" at the exit of the Yoshiwara quarter in Edo. The quality of this work indicates the artist was a painter of considerable merit. **Bib.:** K 894, Shimada 3.

<center>¹雲潮</center>

Unchō¹ (1821–?). *N.:* Samukawa.² *Gō:* Unchō.³ **Biog.:** *Nanga* painter. Adopted son and pupil of Samukawa Yōsai; also a pupil of Ōoka Umpō. Born and worked in Edo. **Bib.:** Mitchell.

<center>¹雲晁 ²寒川 ³雲晁</center>

Un'en¹ (?–1852). *N.:* Anzai Oto.² *A.:* Sankun.³ *F.N.:* Torakichi.⁴ *Gō:* Shūsetsu,⁵ Un'en.⁶ **Biog.:** *Nanga* painter. Born and worked in Edo. First employed in a bookshop. His love of literature and painting led him to write *Kinsei Meika Shogadan,* a discussion of contemporary literature and painting. Took up painting in middle age and became a pupil of the Nagasaki painter Hidaka Tetsuō. **Bib.:** Mitchell.

<center>¹雲烟 ²安西於菟（於兎） ³山君 ⁴虎吉 ⁵舟雪 ⁶雲烟</center>

Unga¹ (fl. first half 13th c.). **Biog.:** Sculptor. Son and pupil of Unkei. Member of Shichijō Bussho. An inscription on the pedestal of the Miroku Bosatsu in the Kōfuku-ji, Nara, implies that the figure of Seshin in the Kōfuku-ji was made by Unkei's son Unga; it is, however, assumed that the figure was made under Unkei's guidance. Received title of *hokkyō*. **Coll.:** Kōfuku-ji, Museum (3). **Bib.:** *Kokuhō* 4, OZ 13.

<center>¹雲賀</center>

Unjo¹ (fl. late 12th to early 13th c.). **Biog.:** Sculptor. Sixth son of Unkei. From 1190 to 1199 took part in the carving of the Niō and Niten for the Tō-ji. In 1208 was among those artists producing a group of statues for the Kōfuku-ji. Received title of *hokkyō*. Worked in his father's style. **Bib.:** Kidder, Kuno (1), Mōri (1a).

<center>¹運助</center>

Unkei¹ (1151–1223). **Biog.:** Sculptor. Son of the *dai busshi* Kōkei. Head of the Shichijō Bussho. For more than forty years active in the restoration of the statues at the Tōdai-ji and Kōfuku-ji, Nara. Also worked at the Tō-ji and Hōshō-ji in Kyōto and for the Kamakura *bakufu* at various periods. Rank of *hokkyō* around 1193, *hōgen* in 1195, *hōin* by 1208. Had six sons, all sculptors. Among his extant works are a Dainichi Nyorai (under his father's supervision) dated 1176 in the Enjō-ji, Nara; an Amida Nyorai (1186–89), a Fudō Triad (1186–89), and a Bishamonten in the Ganjōju-in, Shizuoka-ken; an Amida Triad, a Fudō Myōō, and a Bishamonten (1189) in the Jōraku-ji, Yokosuka-shi, Kanagawa-ken; a Miroku Bosatsu, a portrait statue of the priest Muchaku (1208), and one of the priest Seshin in the Hokuendō of the Kōfuku-ji, Nara; the Fudō and Acolytes in the Kongōbu-ji, Kōyasan. (In 1934, when repairs were being made in the Hokuendō, Kōfuku-ji, an inscription was found saying that the Miroku, Shitennō, Muchaku, and other Buddhist images came from the hand of Unkei and his circle.) The Kongō Rikishi (1199–1203) in the Nandaimon, Tōdai-ji, Nara, were made in collaboration with Kaikei. The Jizō Bosatsu (1213–18) in the Rokuhara Mitsu-ji, Kyōto, is attributed to him. Greatest of Kamakura sculptors, leader of the revival of the art. His work clear and positive: the epitome of the new Kamakura realism, combining classic Nara style with his own spiritual feeling. **Coll.:** Enjō-ji, Ganjōju-in, Jōraku-ji, Kōfuku-ji, Kongōbu-ji, Myōhō-in, Rokuhara Mitsu-ji, Tōdai-ji. **Bib.:** *Art* (1a); BB 18; BG 13, 43, 84; BK 204; Buhot; GK 8; GNB 9; Glaser; Hasumi (2); K 544, 545, 604, 800, 940; Kidder; Kobayashi (1), (2); *Kokuhō* 4; Kuno (1), (2), (3); Lee (1); M 14, 115, 116, 244; Matsumoto (1); Minamoto (1); Mōri (1a); NB (H) 11; NB (S) 40, 62; NBZ 3; *Nihon* (6); Noma (1) 1; Ōoka; OZ 4; Paine (4); SBZ 6; Tajima (12) 2, (13) 15; Warner (1), (2); Watson (1); YB 11.

<center>¹運慶</center>

Unkei¹ (fl. 1504–20). *Gō:* Eii,² Unkei.³ **Biog.:** Muromachi *suiboku* painter. A Zen priest, said to have lived at Kōyasan; no other personal history known. Follower of Sesshū and, to judge from a painting in the Tokiwayama collection, much influenced by Ming painting. **Coll.:** Seinan-in, Tokiwayama. **Bib.:** AA 14; HO 19; *Japanese* (1); M 166; Matsushita (1a); *Muromachi* (1); SBZ 7; Tajima (12) 11, (13) 4.

<center>¹運渓 ²永怡 ³運渓</center>

Unkei¹ (fl. c. 1830–50). *N.:* Murata Nagatoshi.² *A.:* Hakkei.³ *F.N.:* Shōshichi.⁴ *Gō:* Baikatoi,⁵ Unkei.⁶ **Biog.:** Painter.

Lived and worked in Edo. Fond of painting plum blossoms. **Bib.:** Mitchell.

¹雲渓 ²村田永年 ³伯慶 ⁴正七 ⁵梅花都尉 ⁶雲渓

Unkyo (Ungo) Kiyō (Keyō)[1] (1582–1659). *Priest name:* Kiyō (Keyō).[2] *A.:* Unkyo (Ungo).[3] *F.N.:* Ohama (Kohama).[4] *Gō:* Hafujuken.[5] **Biog.:** *Zenga* painter. A Zen monk, the first abbot of the Zuigan-ji in Matsushima. Only a few paintings by him are known; they show the typical Zen themes rendered in the typical *zenga* brushwork. **Bib.:** Brasch (2), NB (S) 47.

¹雲居希膺 ²希膺 ³雲居 ⁴小浜 ⁵把不住軒

Uno Sōyō[1] (1888–). **Biog.:** Potter. Graduate in 1908 of the Municipal Laboratory of Ceramic Art, Kyōto. Specialized in blue-glazed wares that resemble the Kuan wares of Sung China. Member of Nihon Mingeikan. **Bib.:** *Masterpieces* (4), STZ 16.

¹宇野宗甕

Unseki[1] (fl. c. 1840). *N.:* Utsumi Unseki.[2] **Biog.:** Painter. Lived in Kyōto. Specialized in landscapes and *kachōga*. **Coll.:** Ashmolean.

¹雲石 ²内海雲石

Unsen (Unzen)[1] (1759–1811). *N.:* Kushiro Shū.[2] *A.:* Chūfu.[3] *F.N.:* Bumpei.[4] *Gō:* Rairaku Koji,[5] Rikuseki,[6] Taigaku,[7] Unsen (Unzen).[8] **Biog.:** *Nanga* painter. Born at Shimabara in Hizen Province; moved to Nagasaki. Studied under Chinese artists. After his father's death traveled extensively, meeting many famous colleagues. Finally settled in Niigata and led a secluded life. Became famous as a local painter, specializing in landscapes. His work, in the Chinese manner of the 18th century, is quite elegant. **Bib.:** K 297, 356, 403, 706, 960; Morrison 2; Murayama (2); NB (S) 4; *Nihon* (3); Tajima (13) 7.

¹雲泉 ²釧就 ³仲孚 ⁴文平
⁵磊落居士 ⁶六石 ⁷岱岳 ⁸雲泉

Unsen[1] (?–1832). *N.:* Nakayama Unsen.[2] **Biog.:** Painter. Lived in Ōsaka. Pupil of Mori Sosen. **Coll.:** Ashmolean. **Bib.:** Mitchell.

¹雲川 ²中山雲川

Unsen[1] (fl. c. 1875). **Biog.:** Printmaker. Specialized in the depiction of Western mechanical inventions, particularly Western ships. **Coll.:** Fine (California).

¹雲僊

Unshitsu[1] (1753–1827). *N.:* Takeda Ryōki[2] (originally Kōzen).[3] *A.:* Gengi;[4] later, Kōhan.[5] *Gō:* Sekisō,[6] Unshitsu.[7] **Biog.:** *Nanga* painter. Born at the Kōren-ji in Shinshū (the present Nagano-ken). A priest, went at 17 to the Kōmyō-ji in Edo and there studied Confucianism, literature, and painting, the last with Shimizu Shokatsukan and Tani Bunchō. Later studied the paintings of I Fu-chiu on his own. Also investigated Chinese painting of earlier periods. Developed his own style. In addition, a talented writer of prose and poetry; founded the Shōfukyūginsha, a society of poets. Wrote several essays on art. A good painter of *kachōga*. **Bib.:** Brown, K 176, Mitchell.

¹雲室 ²武田了軌 ³鴻漸 ⁴元儀 ⁵公範 ⁶石窓 ⁷雲室

Unsho[1] (1812–65). *N.:* Makita (Maita) Ryō.[2] *A.:* Kōhitsu.[3] *Gō:* Unsho.[4] **Biog.:** *Nanga* painter. Born in Fukui in Echizen Province. A samurai in the service of the feudal lord of Fukui, traveled to Ōsaka, Kyōto, and Edo. On returning to Fukui, gave up his official position to devote himself to cultural pursuits. Because of an injury to his right arm, painted with his left hand. Specialized in depicting landscapes and bamboo. **Coll.:** Museum (3). **Bib.:** Mitchell.

¹雲処 ²蒔田亮 ³公弼 ⁴雲処

Unshō[1] (1823–86). *N.:* Ikeda Masataka.[2] *A.:* Kōi.[3] *Gō:* Hansen,[4] Ran'un Shōfu,[5] Unshō.[6] **Biog.:** *Nanga* painter. Born in Mie-ken. Pupil of Nakanishi Kōseki and Maeda Yōdō. Served the Tōdō family (lords of Iga) as an official painter. Exhibited at the Naikoku Kaiga Kyōshinkai in its early period; later moved to Kyōto. Father of Ikeda Keisen.

Specialized in *kachōga* and landscapes. **Bib.:** Asano, Brown, Mitchell.

¹雲樵 ²池田正敬 ³公維 ⁴半僊（半仙）
⁵欝雲樵夫 ⁶雲樵

Untan[1] (1782–1852). *N.:* Kaburagi Yoshitane (Shōin).[2] *A.:* Sankitsu.[3] *Gō:* Shōsadō,[4] Shōsasei,[5] Untan.[6] **Biog.:** *Nanga* painter. Lived in Edo. The son of a Confucian scholar, was adopted by the painter Kaburagi Baikei; became the pupil of Tani Bunchō. Generally painted landscapes and bamboo. **Coll.:** Victoria. **Bib.:** Mitchell.

¹雲潭 ²鏑木祥胤 ³三吉 ⁴尚左堂 ⁵尚左生 ⁶雲潭

Untei[1] (1803–77). *N.:* Sekine Untei.[2] **Biog.:** *Nanga* painter. Pupil of Ōoka Umpō. His works can be found in a number of illustrated books. **Bib.:** Mitchell.

¹雲停 ²関根雲停

Untō (Undō)[1] (1814–91). *N.:* Kaburagi Shōin.[2] *A.:* Shukushō.[3] *F.N.:* Yasaburō.[4] *Gō:* Untō (Undō).[5] **Biog.:** *Nanga* painter. Son and pupil of Kaburagi Untan. Good painter of birds-and-flowers. **Bib.:** Mitchell.

¹雲洞 ²鏑木祥胤 ³叔昌 ⁴弥三郎 ⁵雲洞

Untō (Undō)[1] (fl. 1850–60). *N.:* Okada Untō (Undō).[2] *F.N.:* Eizō.[3] **Biog.:** Painter. Lived in Echigo Province. **Bib.:** Mitchell.

¹雲洞 ²岡田雲洞 ³栄蔵

Unzan[1] (1761–1837). *N.:* Yamazaki Ryūkichi.[2] *A.:* Genshō.[3] *Gō:* Bunken,[4] Unzan.[5] **Biog.:** *Nanga* painter. Born in Noto; lived in Kyōto. Intimate friend of the writer Rai San'yō and the priest Geppō. Noted for his landscapes and his paintings of bamboo and cherries; his work much influenced by that of Ikeno Taiga. **Coll.:** Victoria.

¹雲山 ²山崎竜吉 ³元祥 ⁴文軒 ⁵雲山

Urushibara Mokuchū[1] (1888–1953). **Biog.:** Printmaker. Born in Tōkyō. Learned woodblock printing as a youth. At 19 to Greece. From 1908 to 1934 almost continuously in London or Paris. In 1910 demonstrated woodblock printing at a joint English-Japanese exhibition in London. After 1945, exhibited in America. Many of his prints are of picturesque European scenes. **Coll.:** National (5). **Bib.:** Asano.

¹漆原木虫

Ushida Keison[1] (1890–). **Biog.:** Japanese-style painter. Born in Yokohama. Worked at first for an oil firm in Yokohama. Then turned to Japanese-style painting, studying in 1907 under Matsumoto Fūko. An exhibitor with the Bunten and the Inten. Joined the Kojikai, and then the Sekiyokai after the former dissolved. Active in promoting Japanese-style painting. His early paintings are pleasantly illustrative; his more recent work connected with the stage. **Bib.:** Asano.

¹牛田鶏村

Ushū[1] (1796–1857). *N.:* Kanai Tai[2] (originally Tokitoshi [Jibin]).[3] *A.:* Shishū.[4] *F.N.:* Hikobei,[5] Sachūta.[6] *Gō:* Bantaiō,[7] Kuchikiō,[8] Ringaku,[9] Shunzanrō,[10] Tochigiō,[11] Uryū,[12] Ushū.[13] **Biog.:** *Nanga* painter. Born in Kōzuke Province; lived in Edo. Pupil of Haruki Nanko. Also studied early Chinese painting. Known for his landscapes and *kachōga*. Also a distinguished calligrapher. **Bib.:** NB (S) 4.

¹鳥洲 ²金井泰 ³時敏 ⁴子修 ⁵彦兵衛
⁶左忠太 ⁷晩泰翁 ⁸朽木翁 ⁹林学 ¹⁰春山楼
¹¹栃木翁 ¹²雨笠 ¹³鳥洲

Uson[1] (1845–99). *N.:* Ōkura Gyo (Kō).[2] *A.:* Kogen.[3] *F.N.:* Kingo.[4] *Gō:* Uson.[5] **Biog.:** *Nanga* painter. Son of a doctor in Niigata. Studied first under a minor local artist; then to Nagasaki to study under Hidaka Tetsuō. In 1872 to China. Served as an official at the Japanese Consulate in Shanghai for fifteen years, continuing his studies of *nanga* painting. On his return to Japan taught many pupils. **Bib.:** Mitchell.

¹雨村 ²大倉行 ³顧宣 ⁴謹吾 ⁵雨村

Utagawa Yoshihide[1] (1832–1902). *N.:* Utagawa Yoshihide.[2] *Gō:* Ikkyōsai,[3] Sanjuen,[4] Sessō,[5] Shiidō.[6] **Biog.:** Printmaker. Pupil of Kunisada. In the late 1840s and 50s produced prints of actors and warriors; in the 60s learned how to do historical subjects from Kikuchi Yōsai. In the Meiji era became

a collector of antiques. **Coll.**: Victoria. **Bib.**: *Nikuhitsu* (2), Tamba (2a).

¹歌川吉秀 ²歌川吉秀 ³一旭斎
⁴三樹園 ⁵雪窓 ⁶紫衣堂

Utagawa Yoshiiku[1] (1833–1904). *N.*: Utagawa (or Ochiai)[2] Yoshiiku.[3] *F.N.*: Ikujirō.[4] *Gō*: Chōkarō,[5] Ikkeisai,[6] Keiami,[7] Keisai,[8] Sairakusai.[9] **Biog.**: Ukiyo-e printmaker, illustrator. Born in Edo, son of the proprietor of a teahouse in the Yoshiwara. Apprenticed to the owner of a pawnshop; soon left to become a pupil of Utagawa Kuniyoshi. After the Meiji Restoration became a popular and well-known newspaper illustrator, working in 1874 for the *Tōkyō Nichinichi Shimbun* as an illustrator and, in 1875, for the *Tōkyō Eiri Shimbun* as a cartoonist. His subjects included actors and *bijin* and, particularly, ghostly scenes, done in the exaggerated manner and harsh colors of the mid-19th century. Also illustrated numerous books. **Coll.**: British, Fine (California), Honolulu, Musée (1), Musées, Newark, Philadelphia, Staatliche, Tōkyō (1), Victoria. **Bib.**: Binyon (1), (3); *Foreigners; Kunst;* NBZ 6; Nonogami; Schmidt; Tamba (2a), (3).

¹歌川吉幾 ²落合 ³歌川吉幾 ⁴幾次郎 ⁵朝霞楼
⁶一蕙斎 ⁷喜阿弥 ⁸蕙斎 ⁹晒落斎

Utakuni[1] (1777–1827). *N.*: Hamamatsu.[2] *F.N.*: Busuke,[3] Nunoya Ujisuke,[4] Seibei.[5] *Gō*: Utakuni.[6] **Biog.**: Ukiyo-e printmaker, illustrator. Worked in Ōsaka; member of the Kamigata-e school. Made actor prints; also wrote Kyōgen. **Bib.**: Keyes, NHBZ 3.

¹歌国 ²浜松 ³武助 ⁴布屋氏助 ⁵清兵衛 ⁶歌国

Utamaro[1] (1754–1806). *N.*: Kitagawa (originally Toriyama)[2] Shimbi.[3] *A.*: Toyoaki (Hōshō).[4] *F.N.*: Yūsuke;[5] later, Yūki.[6] *Gō*: Entaisai,[7] Issōshurichōsai,[8] Mokuen,[9] Sekiyō,[10] Utamaro.[11] *Studio name:* Murasakiya,[12] Shibaya.[13] **Biog.**: Ukiyo-e painter, printmaker. Lived in Edo. Son (?) and pupil of Toriyama Sekien; influenced by Kitao Masanobu and Torii Kiyonaga. One of the central figures in the Edo world of artists and writers. Little, however, known of his life other than that he was arrested and imprisoned in 1804 by the shogunate for publishing a triptych that violated a government prohibition. One of the first Japanese artists to be known in Europe; had considerable influence on such Western artists as Toulouse-Lautrec. In 1788 two of his most important works appeared: *Mushi Erabi* (Insect Book) and *Uta Makura* (Pillow of Poems). His early prints of actors and young courtesans were in the manner of Kiyonaga, but he soon developed his own personal style. The themes of the prints for which he is best known were taken largely from the lives of women, both in the home and in the licensed quarter. These he depicted in his distinctive, attractive, elegant style: the features generally small, the figures tall and graceful. Also

made many *ōkubi-e*. The colors are clear and fresh; so appealing was his style it dominated the print world for a generation. **Coll.**: Albertina; Allen; Andrew; Art (1), (1a); Ashmolean; Atami; Bibliothèque; British; Brooklyn; Cincinnati; City; Cleveland; Denver; Detroit; Fine (California); Fitzwilliam; Fogg; Freer; Grunwald; Herron; Honolulu; Idemitsu; Kōbe; Metropolitan; Minneapolis; Musée (1), (2); Musées; Museu (1); Museum (1), (3); National (2), (3); Nelson; New York; Östasiatiska; Österreichisches; Philadelphia; Portland; Rhode Island; Riccar; Rietberg; Staatliche; Stanford; Suntory; Tōkyō (1); University (2); Victoria; Worcester; Yale. **Bib.**: ARTA 9; Binyon (1), (3); Blunt; Boller; Crighton; Fontein (1); Fujikake (3) 3; Gentles (2); GNB 17, 24; Hempel; Hillier (1), (2), (3), (4) 1, (7), (8), (11); *Japanese* (1a); K 31, 419, 452, 462, 635; Kikuchi; Kondō (3), (6); *Kunst;* Kurth (7); Lane; Ledoux (1); M 55, 228; Meissner; Michener (3); Morrison 2; Narazaki (2), (10), (13) 5; NB (S) 68; NBT 5; NBZ 5; NHBZ 4; *Nikuhitsu* (1) 2; Noguchi (6); Noma (1) 2; OA 8, 13; *Pictorial* (2) 4; SBZ 10; Schmidt; Shibui (1), (2); Shimada 3; Stern (2), (4); Tajima (7) 5, (13) 6; Takahashi (2), (6) 7, 8; Tamba (2); Tanaka (7a) 10; Trotter; UG 6, 7, 28; *Ukiyo-e* (2) 5, 6; *Ukiyo-e* (3) 12; Vignier 4; Yoshida (3).

¹歌麿 ²鳥山 ³北川信美 ⁴豊章 ⁵勇助 ⁶勇記 ⁷燕岱斎
⁸一窓主裡町斎 ⁹木燕 ¹⁰石要 ¹¹歌麿 ¹²紫屋 ¹³柴屋

Utamaro II[1] (?–1831?). *N.*: Kitagawa[2] (originally Ogawa,[3] then Koikawa).[4] *F.N.*: Ichitarō.[5] *Gō*: Baigadō Utamaro,[6] Harumachi Nisei,[7] Riteitei Yukimichi,[8] Utamaro II.[9] **Biog.**: Ukiyo-e printmaker. First the pupil of Koikawa Harumachi, the successful popular author of his time; after his death, adopted his name and called himself Koikawa Harumachi Nisei. Is said to have married the widow of Kitagawa Utamaro, eventually calling himself Utamaro Nidai. Is also believed to have worked with Utamaro on some of the latter's prints. A minor figure, feebly imitating the great master. **Coll.**: Allen, Fitzwilliam, Honolulu, Museum (3), Östasiatiska, Tōkyō (1), Victoria, Worcester. **Bib.**: Binyon (3); Crighton; Ficke; GNB 17; Michener (3); Shimada 3; Takahashi (2), (6) 8; Tamba (2a); UG 6.

¹歌麿二代 ²北川 ³小川 ⁴恋川 ⁵市太郎 ⁶梅雅堂歌麿
⁷春町二世 ⁸李庭亭行町 (李庭亭雪町) ⁹歌麿二代

Utsumi Kichidō[1] (1852–1925). *N.*: Utsumi Fuku.[2] *A.*: Kyūkei.[3] *F.N.*: Karoku.[4] *Gō*: Kenkayōryūshitsu Shujin,[5] Kichidō.[6] **Biog.**: *Nanga* painter. Born in Tsuruga, Echizen Province. Pupil of Shiokawa Bunrin. From 1877 to 1882 in China. Showed with the Nihon Bijutsu Kyōkai; at sixth Bunten received a prize and a favorable mention at the seventh. After 1890 painted in the *nanga* style. **Bib.**: Asano, Mitchell.

¹内海吉堂 ²内海復 ³休卿 ⁴鹿六 ⁵蒹霞楊柳室主人 ⁶吉堂

Wada Eisaku[1] (1874–1959). **Biog.**: Western-style painter. Born in Kagoshima-ken; worked in Tōkyō. Studied under Harada Naojirō and Soyama Yukihiko and, later, with Kuroda Seiki. Graduate of the Tōkyō School of Fine Arts. From 1899 to 1903 in France, where he studied under Raphael Collin. On his return, taught at various schools. Became active in the Bunten and the Hakubakai. In France again twice between the World Wars, each time receiving a decoration. From 1932 to 1935 director of the Tōkyō School of Fine Arts. In 1943 received Order of Cultural Merit. His style one of academic realism with overtones of the Barbizon school. **Coll.**: Bridgestone, National (5), Tōkyō (2). **Bib.**: Asano; BK 192, 201; Harada Minoru; *Kurashina* (2); NB (H) 24; NB (S) 30; NBZ 6; Uyeno.

¹和田英作

Wada Sanzō[1] (1883–1967). **Biog.**: Western-style painter,

printmaker. Born in Hyōgo-ken. First studied at the Hakubakai under Kuroda Seiki; then at the Tōkyō School of Fine Arts, graduating in 1904. In 1909 to Europe for further study, returning in 1916 by way of India and the South Seas. Later became a professor at the Tōkyō School of Fine Arts and member of the Japan Art Academy; also served as juror for both the Bunten and the Teiten. Interested in the study of color, organized the Color Standard Institute of Japan. Painted romantic subjects in a realistic illustrative manner; his painting *South Wind* made a great stir when shown at the first Bunten in 1907. Late in life, produced some prints, part Western and part Japanese in style. **Coll.**: Kyōto (1), National (5), Tōkyō (2). **Bib.**: Asano, Harada Minoru, *Masterpieces* (4), NB (S) 30, UG 16, Uyeno.

¹和田三造

Wagen[1] (fl. 1716–35). *N.*: Hanekawa (Hagawa) Wagen.[2]

Biog.: Ukiyo-e printmaker. Born and worked in Edo. Usually considered an obscure pupil of Hanekawa Chinchō, even though his technique is quite different. Made calendar prints, using *urushi-e*. **Coll.:** Art (1), Honolulu. **Bib.:** Gunsaulus (1), Michener (3), OA 9.

¹和元 ²羽川和元

Wakasa¹ (fl. late 14th c.). **Biog.:** Sculptor. Given title of *hōgen*. Known for a figure of Jizō in the Hōkō-ji, Saitamaken, dated 1386. A Kamakura sculptor; his work shows the influence of Chinese Sung sculpture. **Coll.:** Hōkō-ji. **Bib.:** *Muromachi* (2).

¹若狭

Wake Kitei¹ (fl. 18th c.). *N.:* Kameya Heikichi.² *Gō:* Wake Kitei.³ **Biog.:** Potter. Worked in Kyōto. Possible founder of a line of potters, all using the name Kameya, making excellent blue-and-white porcelain, that lasted for seven generations into the mid-20th century. The studio name was Kameya; the kiln, at Gojōzaka in Kyōto, was opened in the first half of the 18th century. The third generation is said to have worked with Rokubei in the first half of the 19th century; the fourth generation produced overglaze painted porcelains as well as blue-and-white. **Bib.:** Jenyns (1).

¹和気亀亭 ²亀屋平吉 ³和気亀亭

Waō¹ (fl. c. 1711). *N.:* Hishikawa² (originally Kuwahara [Kuwabara]).³ *Gō:* Hōyōken,⁴ Sōshi Shikun,⁵ Waō.⁶ **Biog.:** Ukiyo-e painter. Lived in Edo. Is said to have made illustrations for satirical literature written by Yamaguchi Sōrin, as a result of which he was exiled from Edo and the author was executed. Seems to have belonged to the Moronobu school. There is a theory that because the third way of writing his *gō* Waō is identical with that of writing Hanabusa Itchō's *gō* Waō, he is the same person, despite the difference in style. **Bib.:** Tajima (7) 1.

¹和翁 (和応、和央) ²菱川 ³桑原 ⁴鳳葉軒
⁵桑子師薫 ⁶和翁 (和応、和央)

Watanabe Bunzaburō¹ (1853–1936). *N.:* Watanabe Bunzaburō.² *Gō:* Bizan.³ **Biog.:** Western-style painter. Born in Okayama-ken. First studied Maruyama style of painting, but in 1872 became a pupil in oil painting of Goseda Hōryū. Showed at the first and second Naikoku Kangyō Hakurankai, at the first Bunten and with the Taiheiyō Gakai. Taught at the Tōkyō School of Fine Arts. In 1889 became a trustee of the Meiji Bijutsukai, showing with this group. Painted realistic landscapes. Later returned to Japanese-style painting. **Coll.:** Tōkyō (1). **Bib.:** Asano, BK 213, Harada Minoru, NB (S) 30.

¹渡辺文三郎 ²渡辺文三郎 ³薇山

Watanabe Kōkan¹ (1878–1942). *N.:* Watanabe Kōhei.² *Gō:* Kōkan.³ **Biog.:** Japanese-style painter. Born in Ōtsu; worked in Kyōto. Pupil of Morikawa Sōbun. Showed at the Bunten and other official exhibitions. His style a flat, decorative, idealized rendering of genre scenes. **Bib.:** Elisséev.

¹渡辺公観 ²渡辺耕平 ³公観

Watanabe Osao¹ (1874–1952). **Biog.:** Sculptor. Born in Ōita-ken. Elder brother of Asakura Fumio; pupil of Yamada Kisai. In 1897 graduated from the Tōkyō School of Fine Arts. Good at portraits; his most famous piece a statue of General Nogi. Started a new movement of Western-style untraditional sculpture, working in rather an impressionist manner. **Bib.:** BK 184, NBZ 6.

¹渡辺長男

Watanabe Shin'ya¹ (1875–1950). **Biog.:** Western-style painter. Born at Ōgaki. Pupil of Asai Chū and Matsuoka Hisashi at the Meiji Bijutsukai. Graduated in 1894 and the next year showed with that organization's exhibition. Became an official of the Ministry of Education in charge of the fine-arts division of the textbook committee. Also an exhibitor at and member of the Taiheiyō Gakai. **Bib.:** Asano, BK 201, NBZ 6.

¹渡辺審也

Watanabe Shōtei (Seitei)¹ (1851–1918). *N.:* Watanabe (originally Yoshikawa)² Yoshimata.³ *F.N.:* Ryōsuke.⁴ *Gō:* Shōtei (Seitei).⁵ **Biog.:** Japanese-style painter. Born and lived in Tōkyō; adopted by the Watanabe family. Pupil of Kikuchi Yōsai. Traveled in Europe and America; in 1878 was awarded a silver medal for a painting shown at the Paris Exposition. Wrote several books on painting and edited *Bijutsu Sekai* (Art World) and *Kachō Gafu* (Bird-and-Flower Painting). Above all, a painter of *kachōga,* for which he was quite famous. Also made prints, Japanese in technique, Western in feeling; emphasis on realistic detail. His technically brilliant style owes much to Western water colors. **Coll.:** Art (1), Ashmolean, Fogg, Metropolitan, Musées, Museum (3), National (5), Tōkyō (1), Victoria. **Bib.:** Asano, Brown, Mitchell, Morrison 2, NB (S) 17, NBZ 6.

¹渡辺省亭 ²吉川 ³渡辺義復 ⁴良助 ⁵省亭

Watanabe Yohei¹ (1889–1912). *N.:* Watanabe (originally Miyazaki)² Yohei.³ **Biog.:** Western-style painter. Born in Nagasaki. Adopted by the Watanabe family on his marriage to Watanabe Fumiko, who was also a painter. Graduated from the Kyōto Municipal School of Fine Arts and Crafts in 1906. Afterward to Tōkyō to study Western painting. Exhibited at Bunten for first time in 1908. Member of Taiheiyō Gakai. **Bib.:** Asano.

¹渡辺与平 ²宮崎 ³渡辺与平

Watanabe Yoshitomo¹ (1889–1963). **Biog.:** Sculptor. Born in Tōkyō. Studied at the Tōkyō School of Fine Arts. An exhibitor and prize winner at the Nikakai in the 20s. In 1932 in France, where he came under the influence of Bourdelle. On his return to Japan continued to exhibit with the Nikakai until he resigned in 1946. **Coll.:** National (5). **Bib.:** Asano, GNB 28, NBZ 6.

¹渡辺義知

Watanabe Yūkō¹ (1856–1942). **Biog.:** Painter. Daughter of Goseda Hōryū. Pupil of her father and of her brother Yoshimatsu. Wife of Watanabe Bunzaburō. Showed with the Naikoku Kangyō Hakurankai and other government-sponsored exhibitions. Taught Western-style painting at a girls' school; became a pioneer in women's education. Specialized in portraiture, but also made lithographs of genre scenes. **Bib.:** Asano, BK 213.

¹渡辺幽香

Wazen¹ (1823–96). *N.:* Eiraku Wazen.² *F.N.:* Zengorō.³ **Biog.:** Potter. Son of Eiraku Hozen. Worked primarily in Kyōto. Specialized in producing ceramics with textures similar to patterned cloth. **Coll.:** Brooklyn, Ishikawa, Metropolitan, Tōkyō (1). **Bib.:** GNB 19, Jenyns (1), Koyama (1), M 235, NB (S) 14, NBZ 5, *Nihon* (8), STZ 5, Uyeno.

¹和全 ²永楽和全 ³善五郎

Y

Yabe Tomoe¹ (1892–). **Biog.:** Western-style painter. Born in Niigata. In 1918 graduated from the Tōkyō School of Fine Arts. For the next four years was in America and France. In 1926–27 in Russia. On his return, endeavored to introduce Soviet art to Japan. In 1946 joined the Nihon Bijutsukai. **Bib.:** Asano, NBZ 6.

¹矢部友衛

Yachō¹ (1782–1825). *N.:* Yano Masatoshi.² *A.:* Chūkan.³

F.N.: Monoatsume.[4] *Gō:* Yachō.[5] **Biog.:** Shijō painter. Born in Kyōto. Pupil of Matsumura Goshun. A student of antiquities, a painter of figures and birds-and-flowers. **Coll.:** Ashmolean, Museum (3), Victoria. **Bib.:** Mitchell.

[1]夜潮 [2]矢野正敏 [3]仲観 [4]物集女 [5]夜潮

Yagioka Shunzan[1] (1879–1941). *N.:* Yagioka Ryōnosuke.[2] *Gō:* Mokuan,[3] Shunzan.[4] **Biog.:** Japanese-style painter. Born in Tōkyō. Began as a follower of the Kanō school, then became interested in Sung and Yüan painting. More or less self-taught, though a pupil for a while of Shimojō Keikoku. Member of Nihon Bijutsu Kyōkai. From 1902 received prizes from various exhibitions, including the Bunten. Committee member of the Nihon Bijutsu Kyōkai's Japanese-style painting division. In 1939 showed at the New York World's Fair. **Coll.:** National (5). **Bib.:** Asano.

[1]八木岡春山 [2]八木岡亮之助 [3]牧庵 [4]春山

Yaheita[1] (fl. late 17th c.). *N.:* Matsumura Yaheita.[2] **Biog.:** Potter. Born on Tsushima Island; was in the service of the Sō family. Sent to a Japanese-managed Korean kiln—located in an extraterritorial area and known as the Pusan kiln (Japanese: Fuzanyō)—where he worked for both the Sō family and the shogunate. **Coll.:** Rijksmuseum (1).

[1]弥平太 [2]松村弥平太

Yamada Bunkō[1] (1846–1902). *N.:* Yamada Wahei.[2] *A.:* Wahei.[3] *F.N.:* Heizaburō.[4] *Gō:* Bunkō,[5] Gayū,[6] Kijitsuan,[7] Seika,[8] Shunka,[9] Sōchikusai,[10] Yōsosai.[11] **Biog.:** Shijō painter. Born in Kyōto. Pupil of Shiokawa Bunrin. In 1880 enrolled at the Kyōto Prefectural School of Painting; in 1889 became a teacher there. Painted landscapes and birds-and-flowers. **Coll.:** Victoria. **Bib.:** Mitchell.

[1]山田文厚 [2]山田和平 [3]和平 [4]平三郎 [5]文厚 [6]臥遊 [7]其日庵 [8]晴霞 [9]春霞 [10]雙竹斎 [11]養素斎

Yamada Kaidō[1] (1869–1924). *N.:* Yamada Misaburō.[2] *Gō:* Kaidō.[3] **Biog.:** *Nanga* painter. Born in Fukuoka. At an early age studied under a Chinese artist; later, a pupil of Tanomura Chokunyū. Also studied Tomioka Tessai's style on his own. Exhibited first at 1911 Bunten. An important *nanga* figure. **Bib.:** Asano.

[1]山田介堂 [2]山田巳三郎 [3]介堂

Yamada Keichū[1] (1868–1934). *N.:* Yamada (originally Shimane)[2] Chūzō.[3] *Gō:* Katoku,[4] Keichū.[5] **Biog.:** Japanese-style painter. Born in Tōkyō. Pupil of Kawabata Gyokushō, encouraged by Okakura Tenshin. Took part in the founding of the Nihon Bijutsuin. Showed with the Bunten and served as juror for the Teiten. Held teaching positions in Tōkyō and Kanazawa. His strongly painted landscapes are quite romantic. **Coll.:** Idemitsu, Tōkyō (2). **Bib.:** Asano, *Kurashina* (1), NB (S) 17, NBZ 6.

[1]山田敬中 [2]島根 [3]山田忠蔵 [4]可得 [5]敬中

Yamada Kisai[1] (1864–1901). *N.:* Yamada Tsunekichi (Jōkichi).[2] *Gō:* Kisai.[3] **Biog.:** Sculptor. Born in Fukui-ken. At 13 began to study painting; a year later changed to sculpture, studying under his father, who was a sculptor of Buddhist statues. Later, began experimenting with sculpture in relation to modern architecture. Closely associated with Okakura Tenshin, whose sister he married. When Tōkyō School of Fine Arts was established in 1887, became a teacher of the art of wood sculpture. Member of Tōkyō Chōkōkai. In 1888 became a member of the committee to decide on Japanese National Treasures. Awarded many prizes. Showed at the Chicago World's Fair of 1893. Because of his early study of classic art, his works were much influenced by Japanese traditional art, but he was also greatly interested in Western sculptural techniques and styles. **Coll.:** Tōkyō (1). **Bib.:** Asano, M 84, NBZ 6.

[1]山田鬼斎 [2]山田常吉 [3]鬼斎

Yamada Kōun[1] (1878–). *N.:* Yamada Isaburō.[2] *Gō:* Kōun.[3] **Biog.:** Japanese-style painter. Born in Kyōto. Studied the Shijō style with Kikuchi Hōbun. Won third prize at the

fifth Naikoku Kangyō Hakurankai, as well as prizes at various Bunten exhibitions. **Coll.:** National (5). **Bib.:** Asano.

[1]山田耕雲 [2]山田伊三郎 [3]耕雲

Yamaguchi Hōshun[1] (1893–1971). *N.:* Yamaguchi Saburō.[2] *Gō:* Hōshun.[3] **Biog.:** Japanese-style painter. Born in Hokkaidō. Graduate of both Western- and Japanese-style courses at the Tōkyō School of Fine Arts; also studied *yamato-e* with Matsuoka Eikyū as well as other traditional styles. Exhibitor at and juror for the Teiten in the 1920s; member of the Japan Art Academy and the Nitten. One of the leading Japanese-style painters. His work varies from the charming and intimate to the large-scale, strongly colored, and decorative. His more recent painting shows considerable Western influence. **Coll.:** Kanagawa, National (5), Ryōkan, Staatliche, Tōkyō (2), Yamatane. **Bib.:** Asano, *Masterpieces* (4), Nakamura (1), NBT 10, NBZ 6, Schmidt, *Yamaguchi*.

[1]山口蓬春 [2]山口三郎 [3]蓬春

Yamaguchi Kaoru[1] (1907–68). **Biog.:** Western-style painter. Born in Takasaki, Gumma-ken. Graduated in 1930 from department of Western-style painting of the Tōkyō School of Fine Arts. From 1930 to 1933 in Europe. Member of no official Japanese government group. With Hasegawa Saburō, helped to organize the Shinjukai in 1947; in 1950 one of the founders of the Modern Art Kyōkai. Worked first in the manner of the School of Paris, then became quite abstract. **Coll.:** National (4), (5). **Bib.:** Asano, NBZ 6, *Posthumous* (2).

[1]山口薫

Yamaguchi Kayō[1] (1899–). *N.:* Yamaguchi Yonejirō.[2] *Gō:* Kayō.[3] **Biog.:** Japanese-style painter. Born and works in Kyōto. Graduate of the Kyōto College of Fine Arts; pupil of Nishimura Goun. Showed at government exhibitions and with the Nitten, of which he was a member. In 1955 received Japan Art Academy Prize. Generally painted animals. **Coll.:** National (5). **Bib.:** Asano, NBZ 6.

[1]山口華楊 [2]山田米次郎 [3]華楊

Yamaguchi no Ōguchi no Atai[1] (fl. 7th c.). **Biog.:** Sculptor. This name appears in the inscription carved on the back of the halo of the Kōmokuten on the platform in the Kondō, Hōryū-ji. Is thought to be the same artist as the one mentioned under the same name in the *Nihon Shoki* as having carved 1,000 Buddhas in 650. **Coll.:** Hōryū-ji (Kondō). **Bib.:** Kidder, Kuno (1), Matsumoto (1).

[1]山口大口費

Yamaguchi Susumu[1] (1897–). **Biog.:** Western-style printmaker. Born in Nagano-ken. Studied water colors under Kuroda Seiki at the Aoibashi School of Western Painting. Showed with the Shun'yōkai and at government exhibitions; after 1945 his work was also shown at international exhibitions. Member of Nihon Hanga Kyōkai. His prints, usually showing the graining of the wood block, are often of dramatic landscapes, rendered in a strong, simplified manner. His early work shows much cubist influence. **Coll.:** Newark. **Bib.:** Fujikake (1); Kawakita (1); NHBZ 7, 8; Statler.

[1]山口進

Yamakawa Shūhō[1] (1898–1944). *N.:* Yamakawa Yoshio.[2] *Gō:* Shūhō.[3] **Biog.:** Japanese-style painter. Born in Kyōto. Pupil of Kaburagi Kiyokata and Ikegami Shūho. Showed with the Teiten. Strongly influenced by the ukiyo-e tradition, but his line is quieter and his colors less stylized than in earlier ukiyo-e artists. **Coll.:** National (5). **Bib.:** Asano, Elisséev.

[1]山川秀峰 [2]山川喜雄 [3]秀峰

Yamakita Jirata[1] (1897–1965). **Biog.:** Western-style painter. Born in Fukuoka-ken. Graduate of Tōkyō School of Fine Arts; pupil of Fujishima Takeji. In 1934 exhibited with the Teiten; after 1945 served as juror for the Nitten. Member of Kōfūkai. Worked in oil in an abstract manner, but creating the effect of *sumi-e* by using a great deal of black pigment.

[1]山喜多二郎太

Yamamoto Baisō[1] (1846–1921). *N.:* Yamamoto Kurazō.[2]

A.: Shiya.³ *Gō*: Baisō,⁴ Hanson.⁵ **Biog.**: *Nanga* painter. Born in Aichi-ken. Studied *nanga* style with a pupil of Nukina Kaioku; also studied Yüan and Ming paintings by himself. Showed with Nihon Bijutsu Kyōkai and other societies, winning many awards. Exhibited with the 1907 Bunten and after 1912 served as a juror for this group. Specialized in landscapes. In his time, was considered with Kodama Katei and Yoshitsugu Haizan as one of the three *nanga* masters. **Coll.**: Ashmolean. **Bib.**: Mitchell, Morrison 2.
¹山本梅荘 ²山本倉蔵 ³子野 ⁴梅荘 ⁵半村
Yamamoto Hōsui¹ (1850–1906). *N.*: Yamamoto Tameno-suke.² *Gō*: Hōsui,³ Seikō.⁴ **Biog.**: Western-style painter. Born in Gifu-ken. First studied *nanga* painting in Kyōto; then to Yokohama, where he worked under Goseda Hōryū and Charles Wirgman; next studied with Antonio Fontanesi at the Kōbu Daigaku Bijutsu Gakkō; in 1878 to Paris to study under Gérôme. On his return in 1887 opened his own art school, the Seikōkan. In 1889 helped found the Meiji Bijutsukai and in 1896 the Hakubakai. Served as an artist during the Sino-Japanese war. From 1903 until his death worked as a stage designer. His style is that of the Barbizon school. A mediocre imitator of Western art, he nevertheless held an important place in Meiji art circles. **Coll.**: Museum (3), Tōkyō (2). **Bib.**: Asano; BK 188, 239; Harada Minoru; *Kurashina* (2); NB (H) 24; NB (S) 30; NBZ 6; NHBZ 7.
¹山本芳翠 ²山本為之助 ³芳翠 ⁴生巧
Yamamoto Kanae¹ (1882–1946). **Biog.**: Western-style painter, printmaker. Born in Okazaki, Aichi-ken. Graduated from the department of Western painting at the Tōkyō School of Fine Arts in 1906; in 1912 to France for further study. Returned in 1917 and became a member of Nihon Bijutsuin. Founding member of the Shun'yōkai and, in 1918, of the Nihon Sōsaku Hanga Kyōkai, for which he arranged the first exhibition of prints in 1919. Produced woodblock prints (cutting the blocks himself), wrote books on the technique of painting, edited the art review *Hōsun,* and promoted various educational movements, himself serving as a teacher of children and farmers. His paintings are postimpressionist; his prints, which show the influence of Van Gogh and Gauguin, had a revolutionary effect on Japanese print-making. **Coll.**: Cincinnati, Fine (California), Honolulu, Nelson, Ohara (1). **Bib.**: Asano; Fujikake (1); Michener (3); NBZ 6; NHBZ 7; *Pictorial* (1) 4; SBZ 11; Statler; Sullivan; UG 4, 11.
¹山本鼎
Yamamoto Morinosuke¹ (1877–1928). **Biog.**: Western-style painter. Born in Nagasaki; lived in Tōkyō. At first a pupil of Yamanouchi Gusen in Ōsaka and then, in 1895 in Tōkyō, of Asai Chū and Yamamoto Hōsui. Later studied Western-style painting at the Tōkyō School of Fine Arts and with Kuroda Seiki at his Tenshin Dōjō. Frequent exhibitor with and occasional juror for the Bunten; in 1912 helped found the Kōfūkai. His style is impressionist, with a touch of academic romanticism. **Coll.**: National (5), Tōkyō (2). **Bib.**: Asano, Harada Minoru, K 212, *Kurashina* (2), NB (H) 24, NB (S) 30, Uyeno.
¹山本森之助
Yamamoto Shōun¹ (1870–1965). *N.*: Yamamoto Mosaburō.² *Gō*: Shōkoku³ (as an illustrator), Shōun.⁴ **Biog.**: Painter, illustrator. Born in Kōchi-ken. At 13 to Tōkyō to study *nanga* painting under Taki Watei. From 1902 showed with various organizations including the Nihon Bijutsu Kyōkai, Bunten, and Teiten. From age of 20 worked on illustrations for the *Fūzoku Gahō,* a pictorial journal, concentrating on the subject "popular places in Tōkyō." Produced land-scapes, portraits, and *kachōga*. His major works include ceiling paintings and portraits at the Eihei-ji, scrolls at the Katori-jinja, a phoenix at the Ōtori-jinja. **Coll.**: Eihei-ji, Katori-jinja, Museum (3), Ōtori-jinja.
¹山本昇雲 ²山本茂三郎 ³松谷 ⁴昇雲

Yamamoto Shunkyo¹ (1871–1933). *N.*: Yamamoto Kin'-emon.² *Gō*: Shunkyo.³ **Biog.**: Japanese-style painter. Born in Shiga-ken; lived in Kyōto. Pupil of Kōno Bairei, Nomura Bunkyo, and Mori Kansai. Professor at the Kyōto College of Fine Arts. Exhibitor with the Bunten. One of the founders of modern Kyōto school; a great figure in Kyōto art circles. Member of the Imperial Art Committee and of the Teikoku Bijutsuin. His style at first that of the Shijō school; later became more eclectic, painting landscapes with considerable traces of Western influence. His subjects also included Buddhist themes. **Coll.**: Kyōto (1), Museum (3), National (5), Sanzen-in, Yamatane. **Bib.**: Asano, Elisséev, Mitchell, Morrison 2, NB (H) 24, NB (S) 17, NBT 10, NBZ 6, Oka-moto (1), Uyeno.
¹山元春挙 ²山元金右衛門 ³春挙
Yamamoto Sōkyū¹ (1893–). **Biog.**: Japanese-style painter. Born in Kōchi-ken; works in Kyōto. Graduate of the Kyōto Municipal School of Fine Arts and Crafts. Pupil of Yama-moto Shunkyo and Dōmoto Inshō. Has exhibited with the Nitten, the Tōkyō Biennial, and various government-sponsored exhibitions. His paintings are in the traditional Japanese technique but show considerable contemporary influence. **Coll.**: National (5).
¹山本倉丘
Yamamoto Toyoichi¹ (1899–). *N.*: Yamamoto Minoru.² *Gō*: Toyoichi.³ **Biog.**: Western-style sculptor. Born in Tōkyō. Studied first under Tobari Kogan, then from 1924 to 1929 to France to study under Maillol. Active for a short time about 1921 in the Nihon Bijutsuin. Professor at Tōkyō University of Arts; member of Japan Art Academy, of the Kokugakai, and of the Nitten. In 1957 awarded the Educa-tion Minister's Prize for Fostering the Arts, and in 1958 the Mainichi Art Prize. A sensitive figurative sculptor known for his nudes executed in dry lacquer. His style that of the School of Paris. **Coll.**: National (5). **Bib.**: Asano, *Master-pieces* (4), NBT 10, NBZ 6, Yanagi (1a).
¹山本豊市 ²山本豊 ³豊市
Yamamoto Zuiun¹ (1867–1941). **Biog.**: Sculptor. Born in Atami, Shizuoka-ken. In 1882 to Tōkyō and became a pupil of Takamura Kōun. Showed with the Naikoku Kangyō Hakurankai and the Tōkyō Chōkōkai. In 1893 won a bronze medal for his piece at the Chicago World's Fair. In 1917 established a sculptors' association, the Sendansha. His major work the Shō Kannon at the Daien-ji, Bunkyō-ku, Tōkyō. **Coll.**: Daien-ji.
¹山本瑞雲
Yamamura Kōka¹ (1886–1942). *N.*: Yamamura Toyonari.² *Gō*: Kōka.³ **Biog.**: Japanese-style painter, printmaker. Pupil of Ogata Gekkō; graduate of Tōkyō School of Fine Arts in 1909. By 1922 had produced 12 prints of celebrated actors, all *ōkubi-e* on a mica ground, showing the influence of Sharaku. Made about 30 actor prints all together. His work was shown at various exhibitions of the Bunten and the Inten. Member of Nihon Bijutsuin. A painter of manners and customs. His work shows much ukiyo-e influence; his style half traditional, half Western. **Note:** His paintings bear the seal Kōka, his prints the seal Toyonari. **Coll.**: Riccar. **Bib.**: Asano, Elisséev, Fujikake (1), NBZ 6, NHBZ 7, UG 4.
¹山村耕花 ²山村豊成 ³耕花
Yamana Tsurayoshi (Kangi)¹ (1836–1902). *N.*: Yamana Yukimasa² (originally Hiromasa).³ *F.N.*: Daisuke.⁴ *Gō*: Tsurayoshi (Kangi).⁵ **Biog.**: Japanese-style painter. Born in Sambanchō, Edo. Learned to paint under Sumiyoshi Hirotsura. In 1873 became a surveyor for the Meiji govern-ment and traveled all over Japan. In 1881 resigned from the government; the following year became a member of the Naikoku Kangyō Hakurankai and two years later won a prize at this society's exhibition. In 1888 served as a mem-ber of the commission to study the question of National Treasures; in 1898 became a professor at the Tōkyō School

of Fine Arts in charge of the painting section concerned with the Tosa school. Commissioned to make the copy of the 12th-century *Shigisan Engi* scrolls now in the Tōkyō National Museum. Like his father, Yamana Daisuke, famous as an expert in ancient pictures of the Tosa and Sumiyoshi schools. Specialized in painting historical subjects. **Coll.:** British; Tōkyō (1), (2). **Bib.:** Asano, Elisséev; *Illustrated* (1), *Kurashina* (1), Mitchell, Morrison 1, NB (S) 17, NBZ 6.

¹山名貫義 ²山名行雅 ³広政 ⁴大助 ⁵貫義
Yamanaga Kōho[1] (1889–). **Biog.:** Lacquerer. A native of Gifu-ken. Specialized in dried lacquer. **Bib.:** Ragué.

¹山永光甫
Yamanaka Kotō (Kodō)[1] (1869–?). *N.:* Yamanaka (originally Satō)[2] Kotō (Kodō).[3] **Biog.:** Japanese-style painter. Studied under Tsukioka Yoshitoshi, Kumagai Naohiko, and Arihara Kogan. Exhibited in 1895 with the Naikoku Kangyō Hakurankai, receiving an honorable mention; later showed with the Ugōkai. Specialized in figure painting, working in a revived ukiyo-e manner. **Bib.:** Asano, BK 209.

¹山中古洞 ²佐藤 ³山中古洞
Yamanouchi Gusen[1] (1866–1927). *N.:* Yamanouchi Sadao.[2] *Gō:* Gusen.[3] **Biog.:** Western-style painter. Born in Edo. First a pupil of Takahashi Yuichi; later studied under Goseda Hōryū and Watanabe Bunzaburō. In 1890 employed by the Ōsaka Asahi Press. In 1901 founded the Kansai Bijutsuin. Traveled for a while in France; on his return was active in promoting art in the Ōsaka area. His style is academic. **Bib.:** Asano, NB (H) 24, NBZ 6.

¹山内愚仙 ²山内貞郎 ³愚仙
Yamanouchi Tamon[1] (1878–1932). *N.:* Yamanouchi Tamon.[2] *Gō:* Toshū.[3] **Biog.:** Japanese-style painter. Born in Miyazaki, where he studied under Nakahara Nankei, a Kanō-school painter. In 1899 to Tōkyō; studied under Hashimoto Gahō and later under Kawai Gyokudō. An exhibitor with the Bunten, a juror for the Teiten. His work shows influence of Western realism and a close observation of nature wedded to a Japanese technique. **Coll.:** Miyazaki, National (5). **Bib.:** Asano, Elisséev, NBZ 6.

¹山内多門 ²山内多門 ³都州
Yamaoka Beika[1] (1868–1914). *N.:* Yamaoka Naoki.[2] *A.:* Shikei.[3] *Gō:* Beika,[4] Shōkin Sōdō.[5] **Biog.:** *Nanga* painter. Born in Tosa, Kōchi-ken. Studied there under Nagusa Ippo, a minor *nanga* artist; then to Tōkyō to study under Kawamura Ukoku and Satake Eison. Also studied in China, investigating the origin of the Japanese *nanga* style. A great admirer of the work of Kaiseki, Kazan, and Chinzan. Served as juror for the Bunten in its early period. Worked to promote the *nanga* style by helping found various *nanga* groups. **Bib.:** Asano, Morrison 2, NBZ 6.

¹山岡米華 ²山岡尚樹 ³子敬 ⁴米華 ⁵小董草堂
Yamashita Kōsetsu[1] (1894–). *N.:* Yamashita.[2] *Gō:* Kōsetsu.[3] **Biog.:** Lacquerer. Worked in Kyōto. A priest, who began to study lacquer making as a young man. Particularly skilled at *tsuishu;* specialized in tea-ceremony objects. **Bib.:** Herberts, Jahss.

¹山下光雪 ²山下 ³光雪
Yamashita Rin[1] (1857–1939). **Biog.:** Western-style painter. Baptized as a young girl into the Greek Orthodox Church. Entered the Kōbu Daigaku Bijutsu Gakkō in 1876; studied under Antonio Fontanesi. After graduation, to Russia to study Russian icons. On her return made icons for the Orthodox churches in Japan—not, however, in the traditional manner but in a not too competent mid-19th-century Western style. One of earliest modern oil painters in Japan. **Bib.:** BK 258, 274, 279.

¹山下りん
Yamashita Shintarō[1] (1881–1966). **Biog.:** Western-style painter. Born in Tōkyō. Graduated from the Tōkyō School of Fine Arts in 1904; in 1905 to France, where he studied under Raphael Collin and Fernand Cormon. After five years

returned to Japan with a large corpus of work. In 1914, with Ishii Hakutei, Sakamoto Hanjirō, and others, founded the Nikakai. To France again in 1931–32, receiving the Legion d'Honneur. In 1936 helped start the Issuikai. After 1945 served as a director of and a juror for the Nitten and a trustee of the Tōkyō National Museum of Modern Art. One of the Japanese artists who introduced French impressionism to Japan. Painted Western subjects in a late-19th-century academic style, but with many touches of plein-air and some influence from Derain and Renoir. **Coll.:** Bridgestone, National (5). **Bib.:** Asano, Harada Minoru, Kondō (6), NB (H) 24, NB (S) 30, NBT 10, NBZ 6, Uyeno.

¹山下新太郎
Yamawaki Shintoku[1] (1886–1952). **Biog.:** Western-style painter. Born in Kōchi-ken. Graduated from the Tōkyō School of Fine Arts in 1910. Gained some fame for his exhibit of work in the style of Monet at the 1909 Bunten. From 1911 to 1917 taught painting at a school in Shiga-ken, showing at the same time with the Bunten and the Inten. From 1925 to 1929 in Europe. Member of the Kokugakai, and a frequent exhibitor at the exhibitions of that organization during the 1920s. In his later years retired to live in Kōchi. Painted in the impressionist manner. **Coll.:** Kōchi. **Bib.:** Asano, Harada Minoru, NB (H) 24, NB (S) 30, NBZ 6, *Pictorial* (1) 4, SBZ 11.

¹山脇信徳
Yamazaki Chōun[1] (1867–1954). **Biog.:** Sculptor. Born in Fukuoka. Pupil of Takamura Kōun. Became a great exponent of traditional Japanese wood sculpture. In 1895 showed at the Naikoku Kangyō Hakurankai; from 1907 an exhibitor with the Bunten and, later, with the Teiten. A founding member of the Nihon Chōkokukai. Member of the Art Committee of the Imperial Household and of the Japan Art Academy; received the Order of Cultural Merit. His subjects, often taken from Japanese myth and legend, are rendered in a traditional Japanese sculptural style to which he added a slightly impressionist Rodin-like technique. At times his work is close to Western academic realism. **Coll.:** Kyōto (1); National (5); Tōkyō (1), (2). **Bib.:** Asano; BK 190; GNB 28; M 203; *Masterpieces* (3), (4); NB (H) 24; NBT 2; NBZ 6; SBZ 11; Uyeno.

¹山崎朝雲
Yamazaki Kakutarō[1] (1899–). **Biog.:** Lacquerer. Works in colored lacquers in a contemporary manner. **Bib.:** GNB 28, NBZ 6, Ragué, Yoshino.

¹山崎覚太郎
Yamazaki Shōzō[1] (1893–1943). **Biog.:** Japanese-style painter. Born in Yokosuka. In 1914 studied at the Nihon Bijutsuin's Western-painting department; soon after showed with the Inten. Became a member of the Shun'yōkai in 1923. In Europe from 1929 to 1930. Left the Shun'yōkai in 1936 and showed with the Bunten. **Bib.:** Asano.

¹山崎省三
Yanagi Keisuke[1] (1881–1923). *N.:* Yanagi (originally Yamada)[2] Keisuke.[3] **Biog.:** Western-style painter. Born in Chiba-ken; lived in Tōkyō. First studied Western-style painting at the Tōkyō School of Fine Arts, but left the course in 1903 to continue his studies at the Hakubakai under Kuroda Seiki. In 1905 to America, where he studied under Robert Henri and William Merritt Chase in New York, and then to England and France. Returned to Japan in 1909. Exhibited with the Bunten and the Teiten. The Mitsukoshi Department Store in Tōkyō was having a memorial exhibition of his work in September, 1923, when the great earthquake took place and the store was burned down. Particularly known as a portrait painter; worked in an impressionist manner. **Bib.:** Asano, NB (H) 24, NBZ 6, SBZ 11.

¹柳敬助 ²山田 ³柳敬助
Yanase Masamu[1] (1900–1945). **Biog.:** Western-style painter, cartoonist. Born in Matsuyama. To Tōkyō in 1914 to study

at the Nihon Suisaiga Kenkyūsho. Showed with the Inten in 1915. By 1920 was working as a cartoonist for the *Yomiuri Shimbun,* but soon became active in avant-garde and left-wing political groups. **Bib.:** Asano, NBZ 6.

¹柳瀬正夢

Yano Kyōson¹ (1890–1965). *N.:* Yano Kazutomo.² *Gō:* Kyōson.³ **Biog.:** *Nanga* painter. Born in Ehime-ken. Pupil of Nakamatsu Shun'yō. Exhibitor with the Bunten and the Teiten, serving as a juror for the latter from 1930 on. Worked to establish the Nihon Nangain; also founded the Ōsaka Art School, of which he became president. Member of the Nitten after 1945. **Coll.:** National (5). **Bib.:** Asano.

¹矢野橋村 ²矢野一智 ³橋村

Yano Tetsuzan¹ (1894–). *N.:* Yano Tamio.² *Gō:* Tetsuzan.³ **Biog.:** Japanese-style painter. Born in Ehime-ken, works in Ōsaka. Graduate of the Ōsaka Art School. In Tōkyō studied under Komuro Suiun. Has shown at government exhibitions, the Nitten, and special shows of *nanga* paintings. His work, reflecting the style of his teacher, shows much *nanga* influence. **Coll.:** National (5). **Bib.:** Asano.

¹矢野鉄山 ²矢野民雄 ³鉄山

Yasuaki¹ (1747–1811?). *N.:* Kobayashi Yasuaki.² **Biog.:** Lacquerer. Worked for the daimyo of Yanagawa. Specialized in *inrō.* **Coll.:** Victoria. **Bib.:** Herberts, Jahss.

¹安明 ²小林安明

Yasubei¹ (fl. 1818–29). *N.:* Yamamoto Yasubei.² **Biog.:** Lacquerer. Particularly skillful in the technique of mosaic lacquer. **Bib.:** Herberts, Jahss.

¹安兵衛 ²山本安兵衛

Yasuda Hampo¹ (1889–1947). *N.:* Yasuda Tarō.² *Gō:* Hampo,³ Kōken.⁴ **Biog.:** Japanese-style painter. Born in Niigata-ken Pupil of Kodama Katei, Himeshima Chikugai, and Mizuta Chikuho. From 1917 showed with the Bunten; in 1921 helped found the Nihon Nangain, where he was a constant exhibitor. Specialized in landscapes. **Coll.:** National (5), Victoria. **Bib.:** Asano.

¹安田半圃 ²安田太郎 ³半圃 ⁴光見

Yasuda Ryūmon¹ (1891–1965). *N.:* Yasuda Jūemon.² *Gō:* Ryūmon.³ **Biog.:** Western-style sculptor. Born in Wakayama-ken. Graduated from the Western painting department of the Tōkyō School of Fine Arts in 1917. Having developed an interest in sculpture, entered the sculpture section of the Nihon Bijutsuin Kenkyūsho and became a member of the society in 1920. Then to America and Paris, studying in Paris under Bourdelle and Maillol. Returned to Japan in 1923. Showed with the Inten. After 1945 was connected with educational and artistic activities in Wakayama and Ōsaka. His style shows the influence of his teachers. **Coll.:** National (5). **Bib.:** Asano, GNB 28.

¹保田竜門 ²保田重右衛門 ³竜門

Yasuda Yukihiko¹ (1884–). *N.:* Yasuda Shinzaburō.² *Gō:* Yukihiko.³ **Biog.:** Japanese-style painter. Born in Tōkyō. At 15 began studying the Tosa style under Kobori Tomone at the Tōkyō School of Fine Arts. Was later sent by Okakura Tenshin to Nara to study classic Japanese arts. In 1902, with other painters, formed the Kōjikai. In 1914 helped found the Saikō Nihon Bijutsuin. In 1941 received the Asahi Culture Prize. From 1944 to 1951 taught at the Tōkyō School of Fine Arts. In 1948 received Order of Cultural Merit. One of the artists of Okakura Tenshin's "second generation." Had a special interest in historical subjects and in the story of the Zen priest Ryōkan, often painting scenes of his life. His style, based on the Tosa school, is archaistic. **Coll.:** Bridgestone, National (5), Ryōkan, Tōkyō (1). **Bib.:** Asano, BK 160, M 11, *Masterpieces* (4), Miyagawa, Nakamura (1), NB (H) 24, NB (S) 17, NBT 10, NBZ 6, NKKZ 23, Noma (1) 2, SBZ 11, YB 38.

¹安田靫彦 ²安田新三郎 ³靫彦

Yasui Sōtarō¹ (1888–1955). **Biog.:** Western-style painter, printmaker. Born in Kyōto; worked in Tōkyō. Studied at

Kansai Bijutsuin and also under Asai Chū. In 1907 to Paris, studying first with Jean-Paul Laurens, then at the Académie Julian. Influenced by Pisarro, Cézanne, Matisse. Returned to Japan in 1914. Member of the Nikakai and, in 1935, member of the Imperial Fine Arts Academy. In 1936 helped found the Issuikai. From 1944 to 1952 taught at the Tōkyō School of Fine Arts. In 1952 received Order of Cultural Merit. Painted still lifes, landscapes, and particularly portraits. Work completely dominated by the School of Paris, with no traditional Japanese influence. **Coll.:** Bridgestone, Jingū, Kanagawa, Kyōto (1), Nagaoka, National (5), Ohara (1). **Bib.:** Asano, Fujikake (1), Harada Minoru, Kondō (6), *Masterpieces* (4), Miyagawa, Munsterberg (1), NB (H) 24, NB (S) 30, NBT 10, NBZ 6, NHBZ 7, NKKZ 6, SBZ 11, Sullivan, *Yasui.*

¹安井曽太郎

Yasuji¹ (1864–89). *N.:* Inoue Yasuji.² *F.N.:* Yasujirō.³ *Gō:* Tankei⁴ (after 1884). **Biog.:** Ukiyo-e printmaker. Born in Kawagoe in Saitama-ken; lived in Tōkyō. Had he not died so young, might have revived the ukiyo-e school. Pupil of Torii Kiyochika; like his master, combined the ukiyo-e approach with the new realism and atmospheric effects of the West. His prints are carefully made, his colors restrained. Specialized in landscapes. Also known as Yasuharu.⁵ **Coll.:** Fine (California), Honolulu, Museum (3), Riccar, Tōkyō (1). **Bib.:** Fujikake (1), Kikuchi, Michener (3), NBZ 6, NHBZ 7, Nonogami, Takahashi (2).

¹安治（安次，安二） ²井上安治（井上安次，井上安二）
³安治郎 ⁴探景 ⁵安治

Yasukiyo¹ (fl. c. 1818–30). *N.:* Utagawa Yasukiyo.² **Biog.:** Ukiyo-e printmaker. Pupil of Utagawa Kuniyasu. **Coll.:** Museum (3).

¹安清 ²歌川安清

Yasukuni¹ (fl. late 17th c.). *N.:* Koma Yasukuni.² **Biog.:** Lacquerer. Member of the famous Koma family of lacquer artists. Took part as a master *makie* craftsman in the work under way at the Tōshō-gū at Nikkō in 1689. **Bib.:** Jahss, Sawaguchi.

¹安国 ²古満安国

Yasukuni¹ (1717–92). *N.:* Tachibana Daisuke.² *Gō:* Kōso,³ Yasukuni.⁴ **Biog.:** Kanō painter. Born in Ōsaka. Son and pupil of Tachibana Morikuni. Given the title of *hokkyō.* A good genre painter. **Bib.:** Brown.

¹保国 ²橘大助 ³後素 ⁴保国

Yasuma Sodō¹ (1882–1960). *N.:* Yasuma Yoshitarō.² *Gō:* Sodō.³ **Biog.:** Japanese-style painter. Studied under Hashimoto Gahō, Terazaki Kōgyō, and Takeuchi Seihō. **Coll.:** Kyōto (1), National (5).

¹保間素堂 ²保間芳太郎 ³素堂

Yasumasa¹ (fl. late 18th to early 19th c.). *N.:* Koma Yasumasa.² **Biog.:** Lacquerer. A minor artist, specializing in the production of *inrō.* Probably a member of the Koma school. **Coll.:** Nelson, Tokugawa, Victoria. **Bib.:** Herberts, Jahss.

¹安政 ²古満安政

Yasunami Settai¹ (1887–1940). *N.:* Yasunami (originally Komura)² Taisuke.³ *Gō:* Settai.⁴ **Biog.:** Japanese-style painter, illustrator. In 1901 to Tōkyō, where he stayed with the Yasunami family, by whom he was adopted. In 1903 became a pupil of Araki Kampo. In 1904 entered Tōkyō School of Fine Arts, where he studied under Shimomura Kanzan and from which he graduated in 1907. Became a pupil of Matsuoka Eikyū. Employed by the Kokkakai, making copies of old paintings for them. In 1909 adopted the Yasunami name, but preferred his original family name for professional use. In 1924, at the request of the Tōkyō School of Fine Arts, was engaged in copying such *emakimono* as the *Kitano Tenjin Engi* (this copy is still kept at the Tōkyō School of Fine Arts). In 1935 joined the Kokugain, which Matsuoka Eikyū had established. Showed consider-

able talent both as printmaker and illustrator. **Coll.:** National (5). **Bib.:** Asano.

¹安並雪岱 ²小村 ³安並泰助 ⁴雪岱

Yasunobu¹ (1613–85). *N.:* Kanō Yasunobu.² *F.N.:* Genshirō,³ Shirojirō,⁴ Ukyōnoshin.⁵ *Gō:* Bokushinsai,⁶ Eishin,⁷ Ryōfusai,⁸ Seikanshi.⁹ **Biog.:** Kanō painter. Son of Kanō Takanobu, who died when he was a child. Studied under Kanō Kōi and his elder brother Tan'yū. First worked in Kyōto; then moved to Edo with Tan'yū, who founded there the Kajibashi branch of the Kanō family. Became *goyō eshi* to the shogun, founding the Nakabashi Kanō school. But was later adopted by Kanō Sadanobu as his heir; hence also regarded as the eighth-generation head of the main Kyōto Kanō line. A connoisseur of paintings, signed many certificates of authentication for Kanō paintings. Achieved rank of *hōgen*. Worked on the walls of the Shishinden Seiken of the Imperial Palace, Kyōto. Also painted landscapes, figures, birds-and-flowers, Buddhist subjects. Not as famous or as able as his brothers Tan'yū and Naonobu; nevertheless, a sound Kanō artist. **Coll.:** Allen, British, Brooklyn, Daitoku-ji (Kōtō-in), Fogg, Kotohira, Museum (3), Newark, Ōkura, Tōkyō (2). **Bib.:** Binyon (2); K 62, 139, 300, 350, 424, 442; Moriya; Morrison 1; NB (H) 14; Paine (2) 2, (4); UG 28.

¹安信 ²狩野安信 ³源四郎 ⁴四郎次郎 ⁵右京進
⁶牧心斎 ⁷永真 ⁸了浮斎 ⁹静閑子

Yasunobu¹ (1767–98). *N.:* Kanō Toshinobu.² *Gō:* Eiken,³ Yasunobu.⁴ **Biog.:** Kanō painter. Eldest son of Kanō Eitoku Takanobu; became thirteenth-generation head of the Nakabashi Kanō. Served the shogunate as *oku eshi;* received title of *hōgen*. Known as a painter of birds-and-flowers.

¹泰信 ²狩野利信 ³永賢 ⁴泰信

Yasushige¹ (fl. c. 1818–30). *N.:* Utagawa Yasushige.² **Biog.:** Ukiyo-e printmaker. Another minor pupil of Utagawa Kuniyasu. **Coll.:** Museum (3).

¹安重 ²歌川安重

Yayū¹ (1702–83). *N.:* Yokoi Bosui² (originally Heimei,³ then Junnei).⁴ *F.N.:* Magozaemon.⁵ *Gō:* Yayū.⁶ **Biog.:** *Haiga* painter. Samurai of a high rank in the service of the lord of Owari. Primarily a *haiku* poet; his paintings always accompany a poem. Had neither teacher nor pupils. An enchanting artist. **Bib.:** Brasch (1a), *Japanische* (2).

¹也有 (野有) ²横井暮水 ³並明
⁴順寧 ⁵孫左衛門 ⁶也有 (野有)

Yazaki Chiyoji¹ (1872–1947). **Biog.:** Western-style painter. Born in Yokosuka. Pupil of Soyama Yukihiko. Graduated from the Tōkyō School of Fine Arts, Western-painting division, in 1902. Went abroad a number of times, visiting the United States, Europe, China, Southeast Asia. From 1909 showed with the Bunten and also with the Teiten. Often worked in pastels. **Bib.:** Asano, NB (H) 24, NBZ 6.

¹矢崎千代二

Yazawa Gengetsu¹ (1886–1952). *N.:* Yazawa Sadanori.² *Gō:* Gengetsu.³ **Biog.:** Japanese-style painter. Born in Suwa, Nagano-ken. Graduated from the Tōkyō School of Fine Arts in 1911. Pupil of Terazaki Kōgyō. Became a lecturer at his alma mater, a member of the Nihongain. Showed with the Teiten; after 1945 served as a juror for the Nitten. Member of the 1929 Japanese Exhibition Committee in Paris; also served as a juror for exhibitions in Korea and Taiwan. Known as a painter specializing in landscapes. **Coll.:** National (5). **Bib.:** Asano.

¹矢沢弦月 ²矢沢貞則 ³弦月

Yō Kanji¹ (1898–1935). **Biog.:** Sculptor. Born in Tōkyō. While studying ivory carving, met Ogura Uichirō and studied sculpture under him. Showed with the Bunten in 1918 and with the Teiten after 1922. His work was at first very realistic but soon began to reflect the tendencies of the School of Paris of the 20s. **Bib.:** Asano, GNB 28, NBZ 6.

¹陽威二

Yōdai¹ (fl. c. 1840). *N.:* Nakao Tadasada.² *A.:* Tokukei.³ *F.N.:* Tokutarō.⁴ *Gō:* Suigetsuō,⁵ Yōdai.⁶ **Biog.:** Painter. Born and worked in Edo. Good at landscapes. Also a calligrapher and poet. **Bib.:** Mitchell.

¹庸台 ²中尾忠貞 ³篤卿 ⁴篤太郎 ⁵酔月翁 ⁶庸台

Yōeki¹ (?–1834). *N.:* Mimura Koreyoshi.² *Gō:* Jikansai,³ Yōeki.⁴ **Biog.:** Kanō painter. Pupil of Kanō Yōsen'in Korenobu. Worked for Lord Sanada of Matsushiro, Nagano-ken. Father of Mimura Seizan.

¹養益 ²三村惟芳 ³自閑斎 ⁴養益

Yōetsu¹ (1736–1811). *N.:* Yoshikawa Hidenobu.² *Gō:* Kōō,³ Yōetsu.⁴ **Biog.:** Kanō painter. Son and pupil of Yoshikawa Tomonobu. Worked in Edo, painting landscapes and portraits.

¹養悦 ²吉川英信 ³幸翁 ⁴養悦

Yōfu¹ (fl. c. 1545). *Priest name:* Yōfu.² *A.:* Shunkō.³ **Biog.:** Painter. A priest of the Tenyū-ji in Hizen Province who is said to have studied under Sesshū. Painted landscapes and figures of Daruma. **Coll.:** Museum (3).

¹楊富 ²楊富 ³春岡

Yōfuku¹ (1805–49). *N.:* Nakayama Yōfuku.² *F.N.:* Yuji.³ **Biog.:** Kanō painter. Pupil of Kanō Seisen'in Yasunobu. Lived and worked in Awa Province, where he was in the service of Lord Hachisuka.

¹養福 ²中山養福 ³瑜次

Yōgetsu¹ (fl. c. 1485). *Priest name:* Yōgetsu.² *Gō:* Wagyoku.³ **Biog.:** Muromachi *suiboku* painter. Born in Satsuma; a priest at the Kasagi-dera near Nara. Little known about his life. Perhaps a disciple of Sesshū; influenced by Shūbun and Bokkei. Painted landscapes, figures, birds-and-flowers. Used seal of Shinsō Yōgetsu.⁴ Quite a number of extant works, characterized by light, free brush strokes. Worked in the style of Mu-ch'i. **Coll.:** Hōju-in, Kennin-ji (Zenkyō-an), Metropolitan, Museum (3), Tōkyō (1), Umezawa. **Bib.:** BK 12, 43, 49; Fontein (2); GNB 11; HS 3, 4; K 164, 213, 714, 773; Matsushita (1), (1a); Morrison 1; NB (S) 13; Tajima (12) 5.

¹楊月 ²楊月 ³和玉 ⁴臣僧楊月

Yōho¹ (?–1655). *N.:* Kanō Yōho.² *Gō:* Yōho.³ **Biog.:** Kanō painter. Son and pupil of Kanō Kōshi. Became *goyō eshi* to the Nagoya branch of the Tokugawa clan.

¹養甫 ²狩野養甫 ³養甫

Yōhō¹ (1809–80). *N.:* Yoshizaka Chigen.² *F.N.:* Tōzaburō.³ *Gō:* Yōhō.⁴ **Biog.:** Maruyama painter. Born in Kyōto. Pupil of Maruyama Ōshin. Painted *kachōga* and portraits.

¹鷹峰 ²吉阪推言 ³藤三郎 ⁴鷹峰

Yōi¹ (?–1743). *N.:* Sasayama (originally Nakamura)² Jōden³ (or Jō).⁴ *Gō:* Ensai,⁵ Issai,⁶ Risai,⁷ Yōi,⁸ Zuiei.⁹ **Biog.:** Kanō painter. Pupil of Kanō Tsunenobu. Given rank of *hokkyō*. Official painter to the Mōri clan.

¹養意 ²中村 ³笹山常伝 ⁴篠 ⁵遠斎
⁶逸斎 ⁷利斎 ⁸養意 ⁹随永

Yoka Shinkō¹ (?–1437). **Biog.:** Muromachi *suiboku* painter. Known to have been a painter-priest at the Tōfuku-ji, Kyōto. **Bib.:** *Muromachi* (1).

¹与可心交

Yōkei¹ (?–1808). *N.:* Takezawa Korefusa.² *Gō:* Yōkei.³ **Biog.:** Kanō painter. Born in Edo. Pupil of Kanō Yōsen'in Korenobu. An able judge of old paintings.

¹養渓 ²竹沢惟房 ³養渓

Yokobue (Yokofue)¹ (fl. mid-18th c.). *N.:* Nagano Yokobue (Yokofue).² *F.N.:* Jirobei.³ **Biog.:** Lacquerer. Lived in Kyōto. Made tea-ceremony objects. Succeeded by his son Yokobue II,⁴ who also worked in Kyōto, specializing in lacquer furniture and almost never producing any small objects. **Bib.:** Herberts, Jahss.

¹横笛 ²長野横笛 ³次郎兵衛 ⁴横笛二代

Yokoe Yoshizumi (Kajun)¹ (1887–1962). **Biog.:** Western-style sculptor. Born in Toyama-ken. Graduated from the Kyōto Municipal School of Fine Arts and Crafts; then studied at

the Tōkyō School of Fine Arts and in Europe. Showed at government exhibitions, serving at various times as a juror for them. In 1950 won the Asahi Culture Prize. Worked in marble in the academic realistic manner. **Coll.:** Kyōto (1). **Bib.:** Asano.

<div align="center">¹横江嘉純</div>

Yokoi Kōzō¹ (1890–1965). **Biog.:** Western-style painter. Born in Tōkyō; lived mainly in Nagano-ken. Studied Western-style painting independently. In 1915 won a prize at the Nikakai exhibition. Became a member of the Issuikai in 1962. Also known as an author. **Bib.:** Asano, NBZ 6.

<div align="center">¹横井弘三</div>

Yokoi Reii¹ (1886–). *N.:* Yokoi Reiichi.² *Gō:* Reii.³ **Biog.:** Western-style painter. Born in Aichi-ken. In 1902 graduated from the Tōkyō School of Fine Arts; also studied at the Hakubakai under Kuroda Seiki. An early exhibitor with the Bunten; from 1917 showed with the Nikakai. In 1928 moved to Nagoya. In 1947 helped organize the Nikikai. His recent work is bright in color and intentionally naive. **Bib.:** Asano, NBZ 6.

<div align="center">¹横井礼以　²横井礼一　³礼以</div>

Yōkoku¹ (1760–1801). *N.:* Katayama (originally Dō,² then Nakayama)³ Yoshio.⁴ *A.:* Gyokujo.⁵ *F.N.:* Sōma.⁶ *Gō:* Gazenkutsu,⁷ Yōkoku.⁸ **Biog.:** Nagasaki painter. Born in Nagasaki of partly Chinese ancestry. Lived in Tottori-ken, where he was adopted by the Nakayama family on marrying a daughter of the family; later adopted by the tea master Katayama Sōha, whose heir he became. Studied the Shen Nan-p'in style. Rather an eccentric artist, with a great fondness for sakè; specialized in painting *kachōga*. **Bib.:** Mody.

<div align="center">¹楊谷　²洞　³中山　⁴片山義夫
⁵玉如　⁶宗馬　⁷画禅窟　⁸楊谷</div>

Yokoyama Matsusaburō¹ (1838–84). *N.:* Yokoyama Matsusaburō² (later, Bunroku).³ **Biog.:** Western-style painter. Born in the Kurile Islands; lived in Tōkyō. Pupil of a Russian artist who came to Japan and of Shimo-oka Renjō, under whom he learned the techniques of lithography and photography, which he taught at the Military Academy. Founded a private art school in Tōkyō. Specialized in portraits. Style one of rather naive Western realism. **Coll.:** Tōkyō (1). **Bib.:** Asano, BK 206, Harada Minoru, NB (S) 30, NBZ 6.

<div align="center">¹横山松三郎　²横山松三郎　³文六</div>

Yokoyama Taikan¹ (1868–1958). *N.:* Yokoyama (originally Sakai)² Hidemaro.³ *Gō:* Taikan.⁴ **Biog.:** Japanese-style painter. Born in Mito, Ibaraki-ken; worked in Tōkyō. His family had long been vassals of the Tokugawa daimyo of Mito; as an artist, took his mother's family name of Yokoyama. Pupil of Hashimoto Gahō. From 1889 to 1893 studied at Tōkyō School of Fine Arts. In 1895 taught at Kyōto Municipal School of Fine Arts and Crafts; from 1897 to 1898 professor at Tōkyō School of Fine Arts. Eventually resigned and, with Shimomura Kanzan and Hishida Shunsō, helped Okakura Tenshin (who had been dismissed from the School of Fine Arts) found the Nihon Bijutsuin; became a leading figure in that organization when, with Shimomura Kanzan and others, he helped to reestablish it in 1914. In 1903 to India; in 1904 to Europe and America with Hishida Shunsō; in 1910 to China; in 1930 to Rome. In 1931 appointed court artist and member of Imperial Fine Arts Academy; in 1933 received Asahi Culture Prize; in 1937 first recipient of the Order of Cultural Merit. Very well known, always independent, a central figure in the campaign to protect and revitalize traditional Japanese painting. About 1900, with Hishida Shunsō, created the "dimness style": an abandonment of linear drawing, a painting without contours; much criticized, he later abandoned this technique. His eventual style a mixture of Chinese, Japanese, and Western methods; very eclectic and showy, often working in ink alone but also used color in a realistic manner, with large, bold, striking landscapes and figure compositions. After

World War II, during which he was a fervent supporter of Japan's policies, his art declined. **Coll.:** Ashmolean; Atami; Fogg; Jingū; Museum (3); National (5); Ōkura; Tōkyō (1), (2); Yamatane. **Bib.:** Asano; Grilli (1); K 835; Kawakita (4); Kondō (6); *Kurashina* (1); M 70, 85, 102; *Masterpieces* (4); Miyagawa; Munsterberg (1); Nakamura (1); NB (H) 24; NB (S) 17; NBT 10; NBZ 6; NKKZ 15; Noma (1) 2, (5), (6); Saitō (2), (3); SBZ 11; Sullivan; *Taikan* (1), (2), (3), (4), (5), (6); Uyeno; Yoshizawa (1), (2).

<div align="center">¹横山大観　²酒井　³横山秀麿　⁴大観</div>

Yokyō (Yokō)¹ (1753–1817). *N.:* Yamamoto Yoshitomo (Michi).² *Gō:* Yokyō (Yokō).³ **Biog.:** Potter. A doctor by profession in the service of the Murai family, whose head was chancellor to Lord Maeda of Kaga. Turned to pottery making as a hobby and became one of the finest potters of the Kaga Raku-yaki (or Ōhi-yaki) school. His works are said to resemble those of Ichinyū, a member of the Raku family. **Coll.:** Tōkyō (1).

<div align="center">¹与與　²山本美知　³与興</div>

Yomogida Heiemon¹ (1880–1947). **Biog.:** Printmaker. An active exhibitor in the print shows of the late 20s and early 30s. His work consists largely of industrial and working-class themes, rendered in a rather simplified half Western, half Japanese manner. **Bib.:** NHBZ 7.

<div align="center">¹蓬田兵衛門</div>

Yonehara Unkai¹ (1869–1925). **Biog.:** Japanese-style sculptor. Born in Shimane-ken; moved to Tōkyō and became a pupil of Takamura Kōun. Studied painting under Hashimoto Gahō. First exhibited in 1895 at the fourth Naikoku Kangyō Hakurankai show. With his colleagues Hiragushi Denchū and Yamazaki Chōun, founded the Nihon Chōkokukai in 1907. A frequent exhibitor and prize winner at the Bunten. Assistant instructor at the Tōkyō School of Fine Arts and an adviser to the Nihon Bijutsu Kyōkai. Generally worked in wood in a lively, fresh, amusing style. **Coll.:** National (5), Tōkyō (1). **Bib.:** Asano, BK 190, GNB 28, M 203, *Masterpieces* (3), NB (H) 24, NBT 2, NBZ 6, Uyeno.

<div align="center">¹米原雲海</div>

Yorozu Tetsugorō¹ (1885–1927). **Biog.:** Western-style painter, printmaker. Born in Iwate-ken; lived in Tōkyō. Graduated from Tōkyō School of Fine Arts in 1912. Showed with the Inten, the Nikakai, and the Shun'yōkai, of which he was a founder. Active in the Nihon Suisaigakai, member of the Fusainkai. From 1915 to 1918 worked as a cubist, but his major style was based on the fauves, and he was one of the first artists to introduce this style to Japan. Rather late in his career, became interested in *nanga* painting. Also made a few woodblock prints. **Coll.:** Kanagawa, Nagaoka, National (5), Ohara (1). **Bib.:** Asano; BK 255, 258, 262, 273; Harada Minoru; *Masterpieces* (4); Miyagawa; NB (H) 24; NBT 10; NBZ 6; NHBZ 7; NKKZ 9; SBZ 11; UG 4.

<div align="center">¹万鉄五郎</div>

Yosabei¹ (fl. early 19th c.). *N.:* Mizukoshi (originally Shimizu)² Yoshisuke.³ *Gō:* Chōwaken,⁴ Yosabei.⁵ **Biog.:** Potter. Perhaps born in Kyōto. About 1818 opened a studio known as the Iseya at Gojōzaka in Kyōto, where he produced Raku-style ware. A famous potter, was succeeded by two generations of potters, both of whom used the name Yosabei. **Coll.:** Tōkyō (1), *Nihon* (1).

<div align="center">¹与三兵衛　²清水　³水越義資　⁴調和軒　⁵与三兵衛</div>

Yosabei II¹ (fl. mid-19th c.). *N.:* Mizukoshi.² *Gō:* Yosabei.³ **Biog.:** Potter. Working at his predecessor's studio, the Iseya, in Gojōzaka, Kyōto, produced pottery using gold and enamels in a technique known as *jukkinde*. **Coll.:** Metropolitan.

<div align="center">¹与三兵衛二代　²水越　³与三兵衛</div>

Yōsai¹ (fl. c. 1840). *N.:* Samukawa Yōsai.² **Biog.:** Kanō painter. Worked in Edo. Pupil of Kanō Shōsen'in.

<div align="center">¹養斎　²寒川養斎</div>

Yōsai¹ (1788–1878). *N.:* Kikuchi (originally Kawabara)²

Takeyasu.[3] *F.N.*: Ryōhei.[4] *Gō*: Yōsai.[5] **Biog.**: Japanese-style painter. Born and lived in Edo; son of a minor government official. First a pupil of a Kanō painter, but soon evolved his own eclectic style: a mixture of *yamato-e;* the influence of such painters as Tan'yū, Ōkyo, and Tani Bunchō; and a dash of Western realism. Investigated all styles of painting in Japan, spending several years touring the country and studying the works of old masters stored in temples. Devoted himself almost entirely to historical figure painting, but also painted quite charming, slight, atmospheric landscapes. In 1876 won an award at the American Centennial Exposition. Was given title of Nihon Gashi (Painter-Knight of Japan). Once highly appreciated, now little esteemed. The publication *Zenken Kojitsu,* in twenty volumes (1836–68), contains over 500 woodcuts after his drawings of great figures in Japanese history. **Coll.**: Freer, Metropolitan, Museum (3), Staatliche, Victoria. **Bib.**: *Ausgewählte;* Elisséev; Hillier (3), (4) 3; K 104, 108, 116, 301, 526; Mitchell; Morrison 2; NB (S) 17; NBZ 6.

[1]容斎 [2]河原 [3]菊池武保 [4]量平 [5]容斎

Yōsaku[1] (?–1824). *N.*: Kamiya (originally Kikuchi)[2] Koremoto.[3] *F.N.*: Takesaburō,[4] Eisuke (Eisa).[5] *Gō*: Yōsaku.[6] **Biog.**: Japanese-style painter. Pupil of a minor artist, Kamiya Senkei, who adopted him. Painted landscapes and figures.

[1]養朔 [2]菊地 [3]神谷惟因 [4]竹三郎 [5]栄佐 [6]養朔

Yōsei[1] (?–1773). *N.*: Hayashi (originally Yoshimine)[2] Tsunetaka.[3] *F.N.*: Sakunojō.[4] *Gō*: Yōsei.[5] **Biog.**: Kanō painter. Pupil of Kanō Tsunenobu; after completing his training called himself Kanō Yōsei and became official painter to the Makino clan of Echigo Province.

[1]養清 [2]良峯 [3]林常喬 [4]作之丞 [5]養清

Yōsen'in[1] (1753–1808). *N.*: Kanō Korenobu.[2] *F.N.*: Eijirō.[3] *Gō*: Genshisai,[4] Yōsen,[5] Yōsen'in.[6] **Biog.**: Kanō painter. Born in Musashi Province. Son and pupil of Kanō Eisen'in Sukenobu. Sixth-generation head of Kobikichō Kanō family. Served the shogunate as *oku eshi*. In 1781 given title of *hōgen;* in 1794 that of *hōin,* at which time he took *gō* of Yōsen'in. A standard Kanō artist. **Coll.**: Musée (2), Museum (3), Victoria. **Bib.**: Hillier (4) 3, *Kanō-ha*.

[1]養川院 [2]狩野惟信 [3]栄次郎 [4]玄止斎 [5]養川 [6]養川院

Yōsetsu[1] (fl. c. 1569). *N.*: Kanō Munesuke[2] (or Essen).[3] *Gō*: Yōsetsu.[4] **Biog.**: Kanō painter. Either an adopted son (or son-in-law) or pupil of Kanō Motonobu. A painter of landscapes, birds-and-flowers, and figures. **Coll.**: Museum (3). **Bib.**: Morrison 1.

[1]養拙 (養雪, 養説) [2]狩野宗輔 [3]悦仙 [4]養拙 (養雪, 養説)

Yoshichika[1] (fl. 11th c.). **Biog.**: Painter. According to literary sources is recorded as having painted a cloth screen for a chapel belonging to Fujiwara Sanesuke in 1023 and another for his house in 1028. No other information available.

[1]良親

Yoshida Genjūrō[1] (1896–1958). **Biog.**: Lacquerer. Born in Kōchi-ken. A well-known contemporary lacquer artist, in 1943 became a member of the Japan Art Academy. **Bib.**: Herberts, Jahss, NBZ 6, Ragué, Yoshino.

[1]吉田源十郎

Yoshida Hakurei[1] (1871–1942). *N.*: Yoshida Rihei.[2] *Gō*: Hakurei.[3] **Biog.**: Western-style sculptor. Born in Tōkyō. A businessman who became much interested in sculpture and in 1901 began to study independently. Showed with the seventh Bunten and later with the Inten, of which he became a member. Also a member of the Nihon Chōkokukai. Worked in wood, in an academic realistic manner. **Bib.**: Asano.

[1]吉田白嶺 [2]吉田利兵衛 [3]白嶺

Yoshida Hiroshi[1] (1876–1950). **Biog.**: Western-style painter, printmaker. Born in Kurume; lived in Tōkyō. Studied under Tamura Sōritsu in Kyōto and Koyama Shōtarō in Tōkyō.

Hleped found the Taiheiyō Gakai; active in the Bunten. First painted landscapes in oil but won his early fame as a water-colorist. About 1920 became interested in prints and, under influence of the print publisher S. Watanabe, revived woodblock printmaking, depicting Japanese and foreign scenes—among the latter a series of Swiss and American views made after a trip to Europe and America—in a technically proficient European style, either cutting the blocks himself or closely supervising all the steps. His Japanese subjects included scenes of the countryside and daily life; also did a series *Ten Views of Fuji.* His style resembles that of an English 19th-century water-colorist applied to Japanese themes. A romantic-realist. **Coll.**: Art (1a), Cincinnati, Detroit, Fogg, Honolulu, Minneapolis, Museum (3), National (5), Nelson, Newark, Riccar, Toledo, University (2). **Bib.**: ARTA 14, Asano, BK 201, Blakeney, Fujikake (1), Harada Minoru, *Japanese* (1a), Munsterberg (1), NB (S) 30, NBZ 6, Statler, UG 4.

[1]吉田博

Yoshida Jun'ichirō[1] (1898–). **Biog.**: Lacquerer. A well-known contemporary lacquer artist. **Bib.**: NBZ 6, Yoshino.

[1]吉田醇一郎

Yoshida Kenkichi[1] (1897–). **Biog.**: Western-style painter, stage designer. Born in Tōkyō. Graduated from Tōkyō School of Fine Arts in 1922. Interested in avant-garde art, joined the "Action" group. Also worked as a stage designer for the whole field of Western-style theater. Member of various theatrical associations; an author of books on the stage and stage design. **Bib.**: Asano, NBZ 6.

[1]吉田謙吉

Yoshida Saburō[1] (1889–1962). **Biog.**: Sculptor. Born in Kanazawa. Graduated from the Tōkyō School of Fine Arts in 1912. Pupil of Aoki Sotokichi and Takamura Kōun. Showed constantly at government-sponsored exhibitions and with the Nitten after 1945. Awarded the Japan Art Academy Prize in 1949. His principal work, a figure piece called *The Old Miner,* is Rodinesque in style. **Coll.**: National (5), Tōkyō (1). **Bib.**: Asano, GNB 28, NBZ 6.

[1]吉田三郎

Yoshida Shūkō[1] (1887–1946). *N.*: Yoshida Seiji.[2] *Gō*: Shūkō.[3] **Biog.**: Japanese-style painter. Born in Kanazawa. In 1910 graduated from the Tōkyō School of Fine Arts; pupil of Terazaki Kōgyō. Showed with the Bunten and the Teiten. Member of the Nihongain and the Tomoekai. His style that of the *fukko yamato-e* school. **Coll.**: Metropolitan, National (5). **Bib.**: Asano, Elisséev.

[1]吉田秋光 [2]吉田清二 [3]秋光

Yoshida Tōkoku[1] (1883–1962). *N.*: Yoshida Kiyoji.[2] *Gō*: Tōkoku.[3] **Biog.**: Japanese-style painter. Born in Ōhara, Chiba-ken. In 1899 moved to Tōkyō. Studied first with a *nanga* painter and later with Matsubayashi Keigetsu. From 1920 showed with the Teiten. In 1946 received special mention at the Nitten, for which he served as juror in 1952 and a member of its council after 1959. In 1953 received the Kawai Gyokudō prize. A delicate, decorative style. **Coll.**: National (5). **Bib.**: Asano.

[1]吉田登穀 [2]吉田喜代二 [3]登穀

Yoshifuji[1] (1828–87). *N.*: Utagawa (originally Nishimura)[2] Tōtarō.[3] *Gō*: Ippōsai (Ichihōsai),[4] Yoshifuji.[5] **Biog.**: Ukiyo-e painter. A minor pupil of Utagawa Kuniyoshi, from whom he got the name Utagawa. Specialized in pictures of warriors and in so-called *omocha-e* (paintings of toys); the latter earned him the nickname Omocha Yoshifuji.[6] Also illustrated children's books. Only a fair artist. **Coll.**: Fine (California), Minneapolis, Musées, Philadelphia, Rhode Island, Staatliche, Stanford, Victoria. **Bib.**: Binyon (3), *Foreigners,* NHBZ 6, Nonogami, Schmidt, Tamba (3).

[1]芳藤 [2]西村 [3]歌川藤太郎 [4]一鵬斎 (一宝斎) [5]芳藤 [6]おもちゃ芳藤

Yoshifusa[1] (fl. 1837–60). *N.*: Utagawa Yoshifusa.[2] *F.N.*:

Daijirō.³ *Gō:* Ippōsai.⁴ **Biog.:** Ukiyo-e printmaker. Pupil of Kuniyoshi. Member of the Yokohama school of printmakers. **Coll.:** Victoria. **Bib.:** Nonogami.

¹芳房 ²歌川芳房 ³大次郎 ⁴一宝斎（一芳斎）

Yoshiharu¹ (fl. late 17th c.). *N.:* Nanjō.² *Gō:* Yoshiharu.³ **Biog.:** Painter. His subjects consisted of genre scenes with special emphasis on "Kambun Beauties." **Bib.:** Narazaki (3).

¹義治 ²南城 ³義治

Yoshiharu¹ (1828–88). *N.:* Utagawa (originally Kida)² Ikusaburō.³ *Gō:* Chōkarō,⁴ Ichibaisai,⁵ Ippōsai,⁶ Yoshiharu.⁷ **Biog.:** Ukiyo-e printmaker, illustrator. Pupil of Kuniyoshi. Lived in Tōkyō save for a short period in Ōsaka. A minor figure, illustrating books and working for newspapers. **Coll.:** Musées, Philadelphia, Victoria. **Bib.:** *Foreigners,* Keyes, Nonogami, Tamba (2a).

¹芳春（芳晴） ²生田 ³歌川幾三郎 ⁴朝華楼
⁵一梅斎 ⁶一峰斎 ⁷芳春（芳晴）

Yoshikage¹ (?–1892). *N.:* Utagawa Yoshikage.² *F.N.:* Saitō Kamekichi.³ **Biog.:** Ukiyo-e printmaker. Pupil of Kuniyoshi. Worked in Yokohama, making a number of prints for export.

¹芳景 ²歌川芳景 ³斎藤亀吉

Yoshikata¹ (?–947?). *N.:* Yoshimine (Ryōhō) no Yoshikata.² **Biog.:** Painter. Recorded as having been *azukari* of the court Edokoro in 941.

¹義方 ²良峯義方

Yoshikata¹ (fl. 1841–64). *N.:* Utagawa (originally Ōtomo)² Yoshikata.³ *F.N.:* Kuranosuke.⁴ *Gō:* Isshinsai.⁵ **Biog.:** Ukiyo-e printmaker. Minor pupil of Kuniyoshi. Specialized in prints of warriors. **Coll.:** Musées, Tōkyō (1), Victoria. **Bib.:** NHBZ 6, Tamba (2a).

¹芳形 ²大伴 ³歌川芳形 ⁴庫之助 ⁵一震斎

Yoshikatsu¹ (fl. mid-19th c.). *N.:* Utagawa Yoshikatsu.² *F.N.:* Ishiwatari Shōsuke;³ later, Ishiwatari Yūsuke.⁴ *Gō:* Isseisai,⁵ Isshūsai.⁶ **Biog.:** Ukiyo-e printmaker. Originally a maker of soy sauce. Became a pupil and minor follower of Utagawa Kuniyoshi. **Coll.:** Victoria. **Bib.:** Crighton.

¹芳勝 ²歌川芳勝 ³石渡庄助
⁴石渡勇助 ⁵一勢斎 ⁶一秀斎

Yoshikawa¹ (fl. c. 1740). *N.:* Yoshikawa.² *Gō:* Shōgindō.³ **Biog.:** Ukiyo-e printmaker. One of the many, and minor, followers of Okumura Masanobu. **Coll.:** Art (1). **Bib.:** Shimada 3.

¹吉川 ²吉川 ³松吟堂

Yoshikazu¹ (fl. 1850–70). *N.:* Utagawa Yoshikazu.² *F.N.:* Jirobei,³ Jirokichi.⁴ *Gō:* Ichijusai,⁵ Ichikawa Yoshikazu,⁶ Issen,⁷ Isshunsai.⁸ **Biog.:** Ukiyo-e printmaker. Born and lived in Edo. Pupil of Utagawa Kuniyoshi. One of the major early printmakers of the Yokohama school; his subject matter included foreigners and foreign customs and manners as well as landscapes and warriors. Also a book illustrator. His original name unknown; used the surname of his master and often signed Ichikawa Yoshikazu, Ichikawa being a name of his own choosing to give the whole name the look of that of a samurai. **Coll.:** British; Brooklyn; Fine (California); Honolulu; Metropolitan; Musée (1), (2); Musées; Museum (3); Ōstasiatiska; Philadelphia; Rhode Island; Staatliche; Stanford; Victoria; Worcester. **Bib.:** Binyon (1), (3); Nonogami; Schmidt; Shimada 3; Strange (2); Tamba (2), (2a), (3).

¹芳員 ²歌川芳員 ³次郎兵衛 ⁴次郎吉
⁵一寿斎 ⁶一川芳員 ⁷一川 ⁸一春斎

Yoshikiyo¹ (fl. 1701–16). *N.:* Ōmori Yoshikiyo.² **Biog.:** Ukiyo-e painter, illustrator. Introduced style of Torii school of Edo to Kyōto. Left a few ukiyo-e paintings and illustrated some twenty books. A minor artist of little talent. **Coll.:** Art (1), Detroit, Honolulu, Rietberg, Victoria. **Bib.:** Binyon (3), Brown, Jenkins, Keyes, Lane, *Nikuhitsu* (1) 2.

¹善清 ²大森善清

Yoshikuni¹ (fl. 1803–40?). *N.:* Toyokawa (originally Takagi)² Yoshikuni.³ *Gō:* Ashimaro (Yoshimaro),⁴ Ashimaru,⁵ Jukōdō,⁶ Kō Yoshikuni,⁷ Kōjōdō.⁸ **Biog.:** Ukiyo-e printmaker. Also a poet. Born and worked in Ōsaka. Pupil of Asayama Ashikuni; minor follower of Utamaro. Produced posters and actor prints. From 1803 to 1807 signed Yoshikuni;⁹ from 1808 to 1813 signed Yoshikuni;¹⁰ from 1814 to 1828 signed Toyokawa (or Kō)¹¹ Yoshikuni;¹² from 1830 to around 1840 used Kōjōdō.¹³ **Coll.:** British, Musées, Philadelphia, Worcester, Victoria. **Bib.:** Binyon (1), Ficke, Hillier (7), Keyes, NHBZ 3, *Ukiyo-e* (3) 19.

¹芳国（芳州、よし国） ²高木（高城）
³豊川芳国（豊川芳州、豊川よし国） ⁴芦麿 ⁵芦丸
⁶寿好堂 ⁷高よし国 ⁸岡丈堂 ⁹芳国 ¹⁰芳州 ¹¹高
¹²豊川よし国 ¹³岡丈堂

Yoshimaro¹ (fl. 1807–40). *N.:* Ogawa Yoshimaru.² **Biog.:** Ukiyo-e printmaker. Pupil of Tsukimaro. Also studied under Utamaro and was allowed to use the name Kitagawa Yoshimaro.³ After Utamaro's death, studied under Kitao Masayoshi, who give him permission to call himself Kitao Masayoshi II⁴ or Kitao Shigemasa II.⁵ A minor artist. **Coll.:** British, Victoria, Worcester. **Bib.:** Binyon (1), (3).

¹美麿 ²小川美丸 ³喜多川美麿
⁴北尾正美二代 ⁵北尾重政二代

Yoshimi¹ (1749–1800). *N.:* Satake Yoshihiro.² *Gō:* Ikkentei,³ Kawachi,⁴ Shōgetsutei,⁵ Shukei,⁶ Tsūdai,⁷ Unshō,⁸ Yoshimi.⁹ **Biog.:** *Yōga* painter. Member of the daimyo family of the Akita fief. Learned the Akita *ranga* style of painting from Hiraga Gennai and Odano Naotake. **Coll.:** Kōbe. **Bib.:** GNB 25, Mody, M 231, *Pictorial* (2) 2, YB 49.

¹義躬 ²佐竹義寛 ³一謙亭 ⁴河内
⁵嘯月亭 ⁶主計 ⁷通大 ⁸雲松 ⁹義躬

Yoshimi Rogetsu¹ (1808–1909). *N.:* Yoshimi Hiroshi.² *Gō:* Nanzan,³ Rogetsu.⁴ **Biog.:** Maruyama painter. Pupil of Nagasawa Roshū; helped revive the Maruyama school. **Coll.:** Fitzwilliam. **Bib.:** Morrison 2.

¹吉見蘆月 ²吉見寛 ³南山 ⁴蘆月

Yoshimine¹ (fl. 16th c.). **Biog.:** Muromachi *suiboku* painter. His work shows the influence of Kanō Motonobu. **Bib.:** Matsushita (1a).

¹吉岑

Yoshimine¹ (fl. c. 1855–75). *N.:* Utagawa (originally Takebe)² Yoshimine.³ *F.N.:* Yasubei.⁴ *Gō:* Gyokutei,⁵ Ichibaisai,⁶ Kochōrō,⁷ Kyokutei.⁸ **Biog.:** Printmaker. Worked in Ōsaka. Pupil of Yoshiume. Made small-size actor prints. **Coll.:** Musée (1), Musées, Philadelphia. **Bib.:** Keyes.

¹芳峰 ²武部 ³歌川芳峰 ⁴安兵衛
⁵玉亭 ⁶一梅斎 ⁷胡蝶楼 ⁸旭亭

Yoshimitsu¹ (fl. 1307–20). *N.:* Tosa (originally Fujiwara no)² Yoshimitsu.³ **Biog.:** *Yamato-e* painter. Said to have been a son of Tosa Nagataka. Served as Edokoro *azukari.* Some of the scrolls of the *Hōnen Shōnin Eden* (1307–c. 1317) owned by the Chion-in, Kyōto, and those of the same title owned by the Taima-dera, Nara, are (very doubtfully) attributed to him. **Bib.:** K 58; Morrison 1; NEZ 13; Okudaira (1); Tajima (12) 8, (13) 2; Toda (2).

¹吉光 ²藤原 ³土佐吉光

Yoshimochi¹ (1386–1428). *N.:* Ashikaga Yoshimochi.² **Biog.:** Muromachi *suiboku* painter. The fourth Ashikaga shogun. Intellectually, an ardent student of Zen and a leading figure among the intellectuals of his day; materially, active in promoting the interests of the Zen sect and in building Zen temples. Studied painting with Minchō. As an amateur artist is known for his light, witty, Zen-inspired ink paintings. **Coll.:** Atami, Jakuō-ji, Matsunaga, Museum (3), Seattle. **Bib.:** Awakawa, Brasch (2), Hisamatsu, Matsushita (1a), Mayuyama, Morrison 1, *Muromachi* (1), Shimada 1.

¹義持 ²足利義持

Yoshimori¹ (1830–84). *N.:* Taguchi (originally Miki)² Saku-

zō.[3] *Gō:* Ikkōsai,[4] Kōsai,[5] Kuniharu,[6] Sakurabō,[7] Yoshimori.[8] **Biog.:** Ukiyo-e printmaker. Lived first in Edo, later in Yokohama. Pupil of Utagawa Kuniyoshi. Specialized in scenes of Yokohama and *kachōga*. Worked mostly for the export market. His compositions are crowded. **Coll.:** Musée (1), Musées, Philadelphia, Rhode Island, Victoria, Yale. **Bib.:** Crighton; *Foreigners;* NHBZ 6; Nonogami; Tamba (2a), (3).

[1]芳盛 [2]三木 [3]田口作蔵 [4]一光斎
[5]光斎 [6]国晴 [7]さくら坊 [8]芳盛

Yoshimune[1] (1817–80). *N.:* Utagawa (originally Kashima)[2] Yoshimune.[3] *Gō:* Isshōsai,[4] Shōsai.[5] **Biog.:** Ukiyo-e printmaker. Born in Edo. Pupil of Utagawa Kuniyoshi. His prints almost all of warriors or scenes of Yokohama. **Coll.:** Victoria.

[1]芳宗 [2]鹿嶋 [3]歌川芳宗 [4]一松斎 [5]松斎

Yoshimura Tadao[1] (1898–1952). **Biog.:** Japanese-style painter. Born in Fukuoka-ken. Graduated from Tōkyō School of Fine Arts in 1919 and became a pupil of Matsuoka Eikyū. Showed with and served as a juror for the Teiten. Known as a scholar of manners and customs of the Nara and Heian periods; his subject matter primarily historical themes. **Coll.:** National (5). **Bib.:** Asano.

[1]吉村忠夫

Yoshimura Yoshimatsu[1] (1886–1965). **Biog.:** Western-style painter. Born in Tōkyō. Graduated from the Western-painting division of the Tōkyō School of Fine Arts. From 1925 showed with the Teiten; in 1943 became a juror for the Shin Bunten. In 1955 helped establish the Shinseiki Bijutsu Kyōkai.

[1]吉村芳松

Yōshin[1] (?–1726). *N.:* Hasegawa Tsunetoki.[2] *Gō:* Kankaidō,[3] Yōshin.[4] **Biog.:** Kanō painter. Pupil of Kanō Tsunenobu. Painted landscapes and portraits.

[1]養辰 [2]長谷川常時 [3]観海堂 [4]養辰

Yōshin[1] (1730–1822). *N.:* Mori Yōshin.[2] *Gō:* Eishunsai.[3] **Biog.:** Painter. Elder brother of Mori Sosen; pupil of Kushibashi Eishunsai. His work lacks the distinction of that of his brother. **Bib.:** Morrison 2.

[1]陽信 [2]森陽信 [3]永春斎

Yoshinari[1] (fl. early 14th c.). *Studio name:* Shakuzuru;[2] later, Ittōsai.[3] *Gō:* Ittō,[4] Yoshinari.[5] **Biog.:** Sculptor. A well-known carver of masks. At one point was exiled to Sado Island, after which he changed his studio name from Shakuzuru to Ittōsai. Particularly good at devil masks. **Coll.:** Noma (4).

[1]吉成 [2]赤鶴 [3]一透斎 [4]一刀 [5]吉成

Yoshinobu[1] (1552–1640). *N.:* Kanō Yoshinobu.[2] *Priest name:* Shōan.[3] *F.N.:* Kyūzaemon,[4] Samon.[5] **Biog.:** Kanō painter. Grandson of either Kanō Motonobu or his younger brother Yukinobu; pupil of Eitoku. Lived for a while in Edo, then returned to Kyōto. Worked for the imperial court, specializing in *kachōga* and genre scenes illustrating various trades and professions. Late in life, on becoming a priest, used *gō* of Shōan. Had many connections with the ukiyo-e artists. Little work survives. Worked in a rigid, antiquated manner, following the style of Motonobu; a good colorist. **Coll.:** Art (1), Kita-in, Nanzen-ji (Konchi-in), Tōkyō (1). **Bib.:** BI 46; Fontein (1); K 11, 290, 707; Kondō (1), (2); M 141; Morrison 1; NBT 5; NBZ 4; *Nikuhitsu* (1) 2; NKZ 62; SBZ 8.

[1]吉信 [2]狩野吉信 [3]昌庵（昌安）[4]久左衛門 [5]左門

Yoshinobu[1] (fl. 1730–40). *N.:* Fujikawa Yoshinobu.[2] **Biog.:** Ukiyo-e printmaker. Perhaps a follower of Torii Kiyonobu; certainly closely connected with the Torii school. **Coll.:** Tōkyō (1). **Bib.:** Jenkins, Kikuchi, Shibui (1).

[1]吉信 [2]藤川吉信

Yoshinobu[1] (fl. 1745–58). *N.:* Yamamoto Yoshinobu.[2] *F.N.:* Heishirō.[3] **Biog.:** Ukiyo-e printmaker, illustrator. Little known about his life save that he was possibly a pupil

of Nishimura Shigenaga. Produced two-color prints; also illustrated various Kyōgen, *Chūshingura,* and a number of other books. **Coll.:** Honolulu, Metropolitan, Riccar. **Bib.:** Ficke.

[1]義信 [2]山本義信 [3]平四郎

Yoshinobu[1] (fl. 1765–70). *N.:* Komai Yoshinobu.[2] **Biog.:** Ukiyo-e printmaker. Follower of Harunobu and perhaps his assistant. His work is rare. His quite attractive style derives wholly from Harunobu. **Coll.:** Art (1), Museum (3), Nelson, Staatliche, Tōkyō (1). **Bib.:** Ficke, Gentles (1), Kikuchi, Morrison 2, NBZ 5, NHBZ 2, Schmidt, UG 26.

[1]美信 [2]駒井美信

Yoshinobu[1] (?–1820). *N.:* Kanō Yoshinobu.[2] *F.N.:* Kumekichi,[3] Kyōnosuke.[4] *Gō:* Genrin,[5] Tōrin.[6] **Biog.:** Kanō painter. Son of Kanō Tōtei; member of the Saruyamachi Kanō school.

[1]由信 [2]狩野由信 [3]久米吉
[4]鏡之助 [5]元琳 [6]洞琳（洞隣）

Yoshinobu[1] (1774–1826). *N.:* Kanō Yoshinobu[2] (originally Yoshizawa Yūhei).[3] *Gō:* Kansei,[4] Rinshisai.[5] **Biog.:** Kanō painter. Pupil and adopted son of Kanō Yūho, whom he succeeded as head of the Negishi Miyukimatsu Kanō line.

[1]良信 [2]狩野良信 [3]吉沢融平 [4]寛静 [5]隣芝斎

Yoshinobu[1] (1838–90). *N.:* Matsumoto Yoshinobu.[2] *F.N.:* Yasaburō.[3] *Gō:* Ichiunsai,[4] Ikkeisai,[5] Ikkyōsai.[6] **Biog.:** Ukiyo-e painter. Lived in Edo. Studied under a pupil of Hiroshige, then with Utagawa Kuniyoshi. Painted pictures of warriors and badgers. Unsuccessful as an artist, gave up painting for ceramic decorating and worked in Nagoya. Finally became a restaurant owner in Tōkyō.

[1]芳延 [2]松本芳延 [3]弥三郎
[4]一雲斎 [5]一桂斎 [6]一侠斎

Yoshinobu[1] (fl. 1848–64). *Gō:* Ichireisai,[2] Ikkeisai,[3] Yoshinobu.[4] **Biog.:** Ukiyo-e printmaker. Lived in Edo. Pupil of Utagawa Kuniyoshi. A minor figure. **Bib.:** Nonogami.

[1]芳信 [2]一礼斎 [3]一慶斎 [4]芳信

Yoshio[1] (1659–1703). *N.:* Ōishi Yoshio.[2] *F.N.:* Kuranosuke.[3] **Biog.:** Painter. Leader of the Forty-seven Rōnin (the forty-seven samurai of Akō who killed Lord Kira to avenge the death of their feudal lord). Painting his hobby.

[1]良雄 [2]大石良雄 [3]内蔵之助

Yoshishige[1] (fl. 17th c.). *N.:* Yano Yoshishige.[2] *F.N.:* Rokurobei,[3] Saburobei.[4] **Biog.:** Kanō painter. A samurai serving the Hosokawa clan in Kumamoto. Pupil of Hatano Tōyū. Excelled at painting battle scenes; his most famous works are screens depicting the battle of Ichinotani in the Gempei War and the battle of the Uji River. **Bib.:** K 638.

[1]吉重 [2]矢野吉重 [3]六郎兵衛 [4]三郎兵衛

Yoshitaka[1] (fl. c. 1850). *N.:* Utagawa Yoshitaka.[2] *Gō:* Ippōsai.[3] **Biog.:** Ukiyo-e printmaker. **Coll.:** Minneapolis.

[1]芳鷹 [2]歌川芳鷹 [3]一峯斎

Yoshitaki[1] (1841–99). *N.:* Utagawa (originally Nakai)[2] Yoshitaki.[3] *F.N.:* Tsunejirō.[4] *Gō:* Handenshakyo,[5] Hōgyoku,[6] Ichiyōsai,[7] Ichiyōtei,[8] Ittensai,[9] Jueidō,[10] Noriya,[11] Satonoya,[12] Yōsui.[13] **Biog.:** Ukiyo-e printmaker. Pupil of Yoshiume. Worked in Edo and Ōsaka; a member of the Kamigata-e school. Exhibitor and prize winner at the Naikoku Kaiga Kyōshinkai. From about 1860 to 1880, the leading designer of actor prints in Ōsaka. His work, however, did not escape the general decline of quality in the print field that set in during the second half of the 19th century. **Coll.:** British, Musées, Philadelphia, Tōkyō (1), Victoria. **Bib.:** Binyon (1), Keyes, NHBZ 3.

[1]芳滝 [2]中井 [3]歌川芳滝 [4]恒次郎 [5]版田舎居
[6]豊玉 [7]養斎 [8]養亭 [9]一点斎 [10]寿栄堂
[11]糊家 [12]里の家 [13]養水

Yoshitomi[1] (fl. mid-19th c.). *N.:* Utagawa (originally Hagiwara)[2] Yoshitomi.[3] *Gō:* Ichigeisai.[4] **Biog.:** Ukiyo-e printmaker. Pupil of Utagawa Kuniyoshi. It is recorded that he moved to Yokohama in 1873 and changed his name to

Hōshū.[5] Generally listed as a member of the Yokohama school of printmakers. **Coll.**: Musée (2), Musées, Tōkyō (1), Victoria. **Bib.**: Nonogami.

¹芳富　²萩原　³歌川芳富　⁴一芸斎　⁵芳州

Yoshitora[1] (fl. c. 1850–80). **N.**: Utagawa (originally Nagashima)[2] Yoshitora.[3] **F.N.**: Tatsugorō;[4] later, Tatsunosuke,[5] Tatsusaburō.[6] **Gō**: Ichimōsai,[7] Kinchōrō,[8] Mōsai[9] (after 1874). **Biog.**: Ukiyo-e printmaker. Born and worked in Edo. Pupil of Utagawa Kuniyoshi. Made prints of Tōkyō scenes, of foreigners in Yokohama, and of foreign scenes, all in the late ukiyo-e manner. It is obvious, however, that he never saw any of the foreign scenes he depicted and, instead, copied them from Western engravings. The prints have considerable naive charm. **Coll.**: Art (1); British; Cincinnati; Fine (California); Honolulu; Musée (1), (2); Musées; Newark; Philadelphia; Riccar; Staatliche; Tōkyō (1); University (2); Victoria; Worcester. **Bib.**: Binyon (1), (3); Crighton; Kikuchi; Morrison 2; NHBZ 6, 7; Nonogami; Schmidt; Stewart; Strange (2); Takahashi (2); Tamba (2a), (3); Turk.

¹芳虎　²永島　³歌川芳虎　⁴辰五郎　⁵辰之助
⁶辰三郎　⁷一猛斎　⁸錦朝楼　⁹孟斎

Yoshitoshi[1] (1839–92). **N.**: Tsukioka (originally Yoshioka)[2] Kinzaburō.[3] **F.N.**: Yonejirō.[4] **Gō**: Gyokuōrō,[5] Ikkaisai,[6] Kaisai,[7] Ōju,[8] Sokatei,[9] Yoshitoshi.[10] (After 1873 changed his family name to Taiso.)[11] **Biog.**: Ukiyo-e printmaker. Lived in Tōkyō. Pupil of Utagawa Kuniyoshi; also studied with Kikuchi Yōsai and was adopted by Tsukioka Sessai. In the 1870s worked as a newspaper illustrator. Author of many series of prints depicting *bijin,* aspects of the moon, historical heroes. In 1887 illustrated *Ukigumo* (The Drifting Cloud) by Futabatei Shimei, regarded as Japan's first modern novel. Died mentally deranged. Very popular: one of last of true ukiyo-e artists working in the mainstream of the late ukiyo-e tradition. Made prints of historical and heroic subjects as well as scenes of contemporary life and its increasing Westernization. Best work from 1873 until his death; general work uneven and sometimes even bad; a mixture of ukiyo-e, *yamato-e,* and an ever increasing Western influence. An artist of considerable imagination; his drawings particularly fine. His tremendous popularity could explain the posthumous dates on some of his prints. **Coll.**: Art (1), Ashmolean, Cincinnati, City, Fine (California), M. H. De Young, Honolulu, Musées, Newark, Philadelphia, Riccar, Staatliche, Tōkyō (1), Victoria. **Bib.**: Asano; Crighton; *Foreigners;* Hillier (3), (4) 1; Kikuchi; Meissner; Mody; Morrison 2; Narazaki (2); NBZ 6; NHBZ 6, 7; *Nikuhitsu* (1) 2; SBZ 10; Schamoni; Schmidt; Stewart; Takahashi (1), (2), (5); Tamba (2a), (3); UG 1, 20, 28.

¹芳年　²吉岡　³月岡金三郎　⁴米次郎　⁵玉桜楼
⁶一魁斎　⁷魁斎　⁸応需　⁹咀華亭　¹⁰芳年　¹¹大蘇

Yoshitoyo[1] (fl. 1840–50). **N.**: Uehara Yoshitoyo.[2] **A.**: Hokusui.[3] **F.N.**: Heizō.[4] **Biog.**: Ukiyo-e printmaker. Worked in Ōsaka, producing actor prints and theatrical posters as well as portraits in *nishiki-e.* Also a poet. May be the same artist as Fukuyama Yoshitoyo (q.v.). **Coll.**: Philadelphia. **Bib.**: Keyes.

¹芳豊　²上原芳豊　³北粋　⁴兵三

Yoshitoyo[1] (1830–66). **N.**: Fukuyama Kanekichi.[2] **Gō**: Ichieisai,[3] Ichiryūsai,[4] Yoshitoyo.[5] **Biog.**: Ukiyo-e printmaker. Pupil first of Kunisada, then of Kuniyoshi. Lived and worked in Edo, and for a while in Ōsaka, where he was a member of the Kamigate-e group. Produced prints of warriors and designs for kites. Many of his compositions tend to be overdramatic. May be same artist as Uehara Yoshitoyo (q.v.). **Coll.**: Metropolitan, Philadelphia, Staatliche. **Bib.**: *Foreigners;* NHBZ 3, 6; Nonogami; Schmidt.

¹芳豊　²福山兼吉　³一英斎　⁴一竜斎　⁵芳豊

Yoshitsugu Haizan[1] (1846–1915). **N.**: Yoshitsugu Tatsu.[2] **Gō**: Dokuhiō,[3] Dokushōan,[4] Dokushō Koji,[5] Haizan,[6] Hidarite Haizan,[7] So Dōjin.[8] **Biog.**: *Nanga* painter. Born in

Fukuoka. Son of a minor *nanga* painter; pupil of Nakanishi Kōseki. In 1871 injured his right hand; from then on, a left-handed artist, hence his *gō* Hidarite Haizan. About 1878 to China to study painting. Painted landscapes and *kachōga.*

¹吉嗣拝山　²吉嗣達　³独臂翁　⁴独掌庵
⁵独掌居士　⁶拝山　⁷左手拝山　⁸蘇道人

Yoshitsuna[1] (fl. c. 1848–68). **N.**: Utagawa Yoshitsuna.[2] **Gō**: Ittosai.[3] **Biog.**: Ukiyo-e printmaker, illustrator. Pupil of Utagawa Kuniyoshi. **Coll.**: Musées, Victoria.

¹芳綱　²歌川芳綱　³一登斎

Yoshitsuru[1] (fl. c. 1840–50). **N.**: Utagawa Yoshitsuru.[2] **Gō**: Isseisai,[3] Ittensai.[4] **Biog.**: Ukiyo-e printmaker, illustrator. Pupil of Kunisada. Specialized in warrior prints. **Coll.**: Musées, Victoria.

¹芳鶴　²歌川芳鶴　³一声斎　⁴一天斎

Yoshitsuya[1] (1822–66). **F.N.**: Kōko Mankichi.[2] **Gō**: Hōon,[3] Ichieisai,[4] Yoshitsuya.[5] **Biog.**: Ukiyo-e printmaker, illustrator. A minor pupil of Utagawa Kuniyoshi. Good at pictures of warriors; also illustrated chapbooks and made designs for tattooing. **Coll.**: Fine (California), Musée (1), Musées, Staatliche, Tōkyō (1), Victoria. **Bib.**: Binyon (3); NHBZ 6; Nonogami; Schmidt; Tamba (2a), (3).

¹芳艶　²甲胡万吉　³芳艶　⁴一栄斎（一英斎）　⁵芳艶

Yoshitsuya II[1] (fl. late 19th c.). **N.**: Miwa Yoshitsuya.[2] **Gō**: Ichieisai,[3] Issensha Kison.[4] **Biog.**: Ukiyo-e printmaker. Pupil of Yoshitsuya.

¹芳艶（二代）　²箕輪芳艶　³一英斎　⁴一仙舎其村

Yoshiume[1] (1819–79). **N.**: Nakajima Tōsuke.[2] **Gō**: Ichiōsai,[3] Yabairō,[4] Yoshiume.[5] **Biog.**: Ukiyo-e printmaker, illustrator. Lived mainly in Ōsaka. To Edo in 1847 to study under Kunisada, returning to Ōsaka in 1857. Most of his actor prints date from 1841 onward. Also a book illustrator. **Coll.**: Fitzwilliam, Victoria. **Bib.**: Keyes, NHBZ 3.

¹芳梅　²中島藤助　³一鶯斎　⁴夜梅楼　⁵芳梅

Yoshiyuki[1] (fl. c. 1689). **N.**: Nomura Shirobei.[2] **Gō**: Yoshiyuki.[3] **Biog.**: Lacquerer. Founder of the Nomura school of lacquer artists. **Bib.**: Herberts, Jahss.

¹嘉之　²野村四郎兵衛　³嘉之

Yoshiyuki[1] (fl. c. 1848–64). **N.**: Utagawa Yoshiyuki.[2] **Gō**: Ichireisai.[3] **Biog.**: Ukiyo-e printmaker. Pupil of Utagawa Kuniyoshi. Specialized in prints of warriors. A minor artist. **Coll.**: Tōkyō (1).

¹芳雪　²歌川芳雪　³一嶺斎

Yoshiyuki[1] (1835–79). **N.**: Mori Yoshiyuki.[2] **F.N.**: Hanjirō,[3] Yonejirō.[4] **Gō**: Keisetsu,[5] Nansui,[6] Rokkaen,[7] Rokkaken.[8] **Biog.**: Ukiyo-e printmaker. Born and lived in Ōsaka until 1868, when he moved to Tōkyō. Pupil of Yoshiume. Made prints of actors, landscapes (such as the series *One Hundred Views of Ōsaka*), and Yokohama-e. **Coll.**: Art (1), Musées, Philadelphia, Victoria. **Bib.**: Keyes; Tamba (2a), (3).

¹芳雪　²森芳雪　³半次郎　⁴米次郎
⁵蕙雪　⁶南粋　⁷六花園　⁸六花軒

Yōshun[1] (?–1819). **N.**: Yamamura (or Yamanouchi)[2] Yōshun.[3] **Biog.**: Kanō painter. Pupil of Kanō Yōsen'in Korenobu. In the service of the Mito cadet branch of the Tokugawa family.

¹養春　²山内　³山村養春

Yōyūsai[1] (1772–1845). **N.**: Hara Yōyūsai.[2] **F.N.**: Kumejirō.[3] **Gō**: Kōzan.[4] **Biog.**: Lacquerer. Born and worked in Edo. Under patronage of Lord Matsudaira, for whom he made many pieces. Much influenced by Kōrin; teacher of Nakayama Komin and Ogawa Shōmin. Specialized in *hira-makie;* one of most skillful lacquer artists of his time. Often used sketches by Hōitsu for his designs. Many forgeries of his work. Another, but minor, artist of the same name worked in Edo in the second half of the 19th century. **Coll.**: Ashmolean, Metropolitan, Museum (3), Tōkyō (1), Walters. **Bib.**: Boyer, Herberts, Jahss, M 188, Minamoto (3), Ragué, Rokkaku, SBZ 10, Yoshino.

¹羊遊斎　²原羊遊斎　³久米次郎　⁴更山（交山）

Yōzan[1] (fl. c. 1690). *N.*: Kiyono Issei.[2] *Gō:* Yōzan.[3] **Biog.**: Kanō painter. Pupil of Kanō Tsunenobu. Served as an official painter to a feudal clan in Owari Province.
¹養山 ²清野一成 ³養山

Yōzan[1] (1776?–1846). *N.*: Kotō (Kofuji) Koreaki.[2] *Gō:* Shōsetsusai,[3] Yōzan.[4] **Biog.**: Kanō painter. Pupil of Kanō Yōsen'in Korenobu. Became the official painter to the daimyo of the Satsuma fief.
¹養山 ²古藤惟旭 ³松雪斎 ⁴養山

Yuasa Ichirō[1] (1868–1931). **Biog.**: Western-style painter. Born in Gumma-ken; lived in Tōkyō. Pupil of Yamamoto Hōsui, Kume Keiichirō, Kuroda Seiki. Graduated from the Western-style-painting division at the Tōkyō School of Fine Arts in 1898. Showed first with the Hakubakai in 1896, where his work received favorable attention. From 1906 to 1909 traveled and studied in Europe. On his return, exhibited with the Bunten and took an active part in the Nikakai, which he helped to establish. His style based on that of his teachers: a romantic impressionism. **Bib.**: Asano, NB (H) 24, NBZ 6.
¹湯浅一郎

Yūbi[1] (fl. late 19th c.). *N.*: Tanaka Shigekazu.[2] *Gō:* Yūbi.[3] **Biog.**: Japanese-style painter. Born and worked in Kyōto; later moved to Tōkyō. **Coll.**: Itsuō. **Bib.**: Mitchell.
¹有美 ²田中重一 ³有美

Yūchiku[1] (1654–1728). *N.*: Kaihō Dōshin (Michichika)[2] (originally Gantei, Gentei, Motosada).[3] *A.*: Yūchiku.[4] *F.N.*: Gombei.[5] *Gō:* Dōkō.[6] **Biog.**: Kaihō painter. Lived in Kyōto. Studied under his father Kaihō Yūsetsu, whose style he followed. Served as official painter to the ex-emperors Reigen and Higashiyama. **Coll.**: Museum (3).
¹友竹 ²海北道親 ³元貞 ⁴友竹 ⁵権兵衛 ⁶道香

Yuda Gyokusui[1] (1879–1929). *N.*: Yuda Kazuhei.[2] *Gō:* Aizu Sanjin,[3] Gyokusui.[4] **Biog.**: Japanese-style painter. In 1903 arrived in Tōkyō; at first a pupil of Kawabata Gyokushō, but later changed to *nanga* style. Member of the Nihon Nangain; showed with the Bunten and then with the Teiten, of which he became a member in 1927. **Bib.**: Asano.
¹湯田玉水 ²湯田和平 ³会津山人 ⁴玉水

Yūeki[1] (fl. c. 1660). *N.*: Kanō Ujinobu.[2] *F.N.*: Kumenosuke.[3] *Gō:* Yūeki.[4] **Biog.**: Kanō painter. Son of Kanō Sōchi; member of the Kanda Kanō school. In 1660 was called to work in the shogun's palace in Edo; afterwards served the daimyo of Kaga.
¹友益 ²狩野氏信 ³久米之助 ⁴友益

Yūen[1] (fl. c. 1384). **Biog.**: Buddhist painter. Evidently a Buddhist priest-painter attached to one of the Nambu temples. Known only from an inscription on a painting of Jizō, dated 1384, in the Hōju-in, Kōyasan. **Coll.**: Hōju-in. **Bib.**: NKZ 20.
¹祐圓

Yūga[1] (1824–66). *N.*: Nemoto Narimasa.[2] *Gō:* Yūga.[3] **Biog.**: Kanō painter. Studied under Oki Ichiga in Edo. Served the daimyo of Tottori as official painter. A good painter, but little known outside his home province. **Coll.**: Kyōto (2), Metropolitan. **Bib.**: K 647.
¹幽峨 ²根本誠正 ³幽峨

Yūgaku[1] (1762–1833). *N.*: Oka Bunki.[2] *A.*: Seishō.[3] *Gō:* Yūgaku.[4] **Biog.**: Painter. Born in Ōsaka. Pupil of Fukuhara Gogaku; later based his style on Chinese Ming painting. **Coll.**: Ashmolean. **Bib.**: Mitchell.
¹熊岳 ²岡文暉 ³世昌 ⁴熊岳

Yūgen[1] (fl. late 13th c.). *N.*: Kose no Yūgen.[2] **Biog.**: Kose painter. Son of Kose no Yukiari; like his father, a priest attached to the Daijō-in, Kōfuku-ji, Nara. Received title of *hōin*; was known as Iga no Hōin.[3]
¹有厳 ²巨勢有厳 ³伊賀法印

Yūhaku[1] (fl. early 17th c.). *N.*: Katsuta Yūhaku.[2] **Biog.**: Kaihō painter. Life unknown. His style shows him to have

been a close follower of Kaihō Yūshō. **Coll.**: Tokiwayama. **Bib.**: BI 57, *Japanese* (1), K 703.
¹友柏 ²曾田友柏

Yūhi[1] (1693/1713–72). *N.*: Kumashiro Hi (Akira).[2] *A.*: Kisen.[3] *F.N.*: Hikonoshin,[4] Jinzaemon.[5] *Gō:* Shūkō,[6] Yūhi.[7] **Biog.**: Nagasaki painter. Born in Nagasaki, son of an official interpreter of Chinese. (If the alternate date of 1693 is accepted for his birth, he could have studied first under Watanabe Shūseki, as is sometimes stated.) Became the most prominent of Shen Nan-p'in's pupils and a leading figure of the Nagasaki school, which introduced Chinese and Western painting techniques to Kyōto and Edo. Studied many Chinese styles; his own based largely on the late Ming-Ch'ing rather realistic manner. His paintings could often be easily mistaken for Chinese ones. A painter of considerable quality. **Coll.**: Art (1), Kōbe, Museum (3), Nagasaki, Stanford, Tokugawa, Tōkyō (1). **Bib.**: BK 44; BMFA 44; K 708, 794, 798, 843; Mitchell; Mody; NBT 5; NBZ 5; *Pictorial* (2) 5; Tajima (13) 7; Umezawa (2).
¹熊斐 ²熊代斐 ³洪瞻 ⁴彦之進 ⁵甚左衛門 ⁶鏽江 ⁷熊斐

Yūhibun[1] (fl. late 18th c.). *N.*: Kumashiro Yūhibun.[2] **Biog.**: Nagasaki painter. Eldest son of Yūhi. His style is close to that of his father. **Coll.**: Kōbe, Nagasaki. **Bib.**: *Pictorial* (2) 5.
¹熊斐文 ²熊代熊斐文

Yūhimei[1] (fl. late 18th c.). *N.*: Kumashiro Yūhimei.[2] **Biog.**: Nagasaki painter. Son of Kumashiro Yūhi. Like his elder brother, Yūhibun, a follower of his father's style.
¹熊斐明 ²熊代熊斐明

Yūho[1] (?–1762). *N.*: Kanō Enshin.[2] *Gō:* Yūho.[3] **Biog.**: Kanō painter. Pupil and probably adopted son of Kanō Ansen Harunobu, whom he succeeded in 1717 in the service of the shogun. Member of the Negishi Miyukimatsu line of the Kanō school. His work is light, sketchy, amusing. **Bib.**: *Kanō-ha.*
¹友甫 ²狩野宴信 ³友甫

Yūho[1] (1752–1820). *N.*: Kanō Baishin.[2] *Gō:* Yūho.[3] **Biog.**: Kanō painter. Son of Kanō Ansen Jishin; pupil of Kanō Baishō. Became head of the Negishi Miyukimatsu Kanō line in 1802.
¹祐甫 ²狩野梅信 ³祐甫

Yūji (Tomoharu, Tomoji)[1] (fl. 1711–36). *N.*: Nagata Yūji (Tomoharu, Tomoji).[2] **Biog.**: Rimpa lacquerer. Lived in Kyōto. In his *taka-makie*, invented the use of powdered tin, a technique that became known as Yūji-age. A skilled craftsman and a follower of Kōrin's style but without the freshness of the master. **Coll.**: Museum (1), (2;) Metropolitan; Rijksmuseum (2); Tōkyō (1). **Bib.**: Feddersen, Herberts, Jahss, M 188, Minamoto (3), Ragué, Rokkaku, SBZ 10, Speiser (2), Yoshino.
¹友治 ²永田友治

Yūjō[1] (1723–73). *N.*: Nijō Yana.[2] *Gō:* Gessho,[3] Yūjō.[4] **Biog.**: Maruyama painter. Took Buddhist vows at age of 12. Studied first at the Mii-dera, moving later to the Emman-in in Ōtsu. Pupil of Ōkyo. Painted landscapes and portraits.
¹祐常 ²二条梁 ³月渚 ⁴祐常

Yūjō[1] (fl. 1789–1804). *N.*: Fūsetsu Yūjō.[2] *Gō:* Tōko.[3] **Biog.**: Painter. Worked in Kyōto. Pupil of Naitō Tōho. **Bib.**: Mitchell.
¹有丈 ²風折有丈 ³東湖

Yūki Masaaki[1] (1834–1904). *N.*: Yūki (originally Tsubokawa)[2] Masaaki.[3] **Biog.**: Japanese-style painter. Born in Toyama-ken; at 19 to Edo. Pupil of Kanō Shōsen'in Masanobu; fellow student of Kanō Hōgai and Hashimoto Gahō. Also studied engraving. In 1888 became a teaching assistant at the Tōkyō School of Fine Arts; resigned in 1892 because he and Okakura Tenshin were not compatible. Specialized in painting historical scenes. **Bib.**: Asano, NBZ 6.
¹結城正明 ²壺川 ³結城正明

Yūki Somei[1] (1875–1957). **Biog.**: Japanese-style painter.

Born and worked in Tōkyō. Studied first under Kawabata Gyokushō. Graduated from the Tōkyō School of Fine Arts in 1897; turned for a short time to Western-style painting. While still at school, showed with the Nihongakai. An early exhibitor and frequent prize winner at the Bunten. In 1900, with Hirafuku Hyakusui and others, helped found the Museikai and in 1917 was one of the founders of the Kinreisha. A frequent juror for the Teiten from its foundation in 1919. From 1923 to 1925 in Europe; on his return, taught at his alma mater. His work at times decorative, at times illustrative, shows considerable Western influence. **Coll.:** Musée (2), National (5). **Bib.:** Asano, BK 184, Mitchell, NB (H) 24, NB (S) 17, NBZ 6, NHBZ 7.

¹結城素明

Yukiari (Gyōyū)¹ (fl. mid-14th c.). *N.:* Kose no Yukiari (Gyōyū).² **Biog.:** Kose painter. A priest and member of the Kose school of Buddhist painters attached to the Daijō-in, Kōfuku-ji, Nara. Known for a painting of the death of the Buddha, dated 1345 and now in the Nezu Museum, which he did in collaboration with his sons Kaiyū and Sen'yū. Also recorded as having worked in 1367 at the Kasuga-jinja, Nara. Received the title of *hōgen;* was known as Shinano Hōgen.³ **Coll.:** Nezu. **Bib.:** *Nezu Bijutsukan.*

¹行有 ²巨勢行有 ³信濃法眼

Yūkichi¹ (fl. 1804–29). *N.:* Ishii Yūkichi.² **Biog.:** Lacquerer. Worked in Takaoka. Specialized in making lacquerware inlaid with jewels in the Chinese style, known as *yusuki* ware. **Bib.:** Jahss, Sawaguchi.

¹勇吉 ²石井勇吉

Yukihide¹ (fl. c. 1430). *N.:* Tosa (originally Fujiwara no)² Yukihide.³ *Court title:* Shurinosuke.⁴ *Gō:* Kasuga Yukihide.⁵ **Biog.:** Tosa painter. Pupil of his father, Tosa Yukihiro. Patronized by the Ashikaga shogun, member of the Edokoro. The *Yūzū Nembutsu Engi* scrolls, dated 1414, in the Seiryō-ji, Kyōto, are signed by him as well as by Rokkaku Jakusai, Awataguchi Takamitsu, Tosa Mitsukuni, Tosa Yukihiro, and Tosa Eishun. To judge by the Seiryō-ji scrolls and other recorded work, he was able to apply the small-scale decorative Tosa manner to a larger scale; a sensitive and original use of color. **Coll.:** Seiryō-ji. **Bib.:** K 47, 169; Morrison 1; NKZ 32; *One* (2); Paine (4); Tajima (12) 1, 4, 17.

¹行秀 ²藤原 ³土佐行秀 ⁴修理亮 ⁵春日行秀

Yukihiro¹ (fl. 1406–34). *N.:* Tosa (originally Fujiwara no)² Yukihiro.³ **Biog.:** Tosa painter. Son of Yukimitsu. In 1406 an official painter at the imperial court; in a document of that date, is referred to with his title Shōgen,⁴ and is sometimes known as Tosa Shōgen. Also had titles of general of the imperial guard and governor of Tosa Province. Took the name of Tosa from the latter and was probably the first to use this name to denote an artistic rather than a family lineage; from this time on the Tosa school, whose earlier artistic genealogy was a later invention, was on a firm footing. Later became a monk. Was one of the six artists—along with Rokkaku Jakusai, Awataguchi Takamitsu, Tosa Mitsukuni, Tosa Eishun, and Kasuga Yukihide—who are listed as the painters of the scroll *Yūzū Nembutsu Engi,* dated 1414, in the Seiryō-ji, Kyōto. **Coll.:** Seiryō-ji. **Bib.:** Akiyama (2); BK 127, 128; Ienaga; Morrison 1; NKZ 32; Paine (4); SBZ 7; Tajima (12) 1, 5; Tajima (13) 3; Toda (2).

¹行広 ²藤原 ³土佐行広 ⁴将監

Yukimaro¹ (fl. 1780–90). *N.:* Kitagawa Yukimaro.² **Biog.:** Ukiyo-e printmaker, illustrator. Pupil of Utamaro. Noted for his illustrations of chapbooks. **Bib.:** Binyon (3), *Nikuhitsu* (2).

¹行麿 ²喜多川行麿

Yukimaro¹ (1797–1856). *N.:* Kitagawa (originally Tanaka)² Yukimaro.³ *F.N.:* Zenzaburō.⁴ *Gō:* Bokusentei,⁵ Keitansha,⁶ Yukimaro.⁷ Ukiyo-e painter, printmaker. Born to a samurai family in Echigo Province. Lived in Edo. Pupil of

Kitagawa Tsukimaro. Said to have given up painting for writing in his later years. His prints show the general influence of Utamaro. **Coll.:** Riccar, Tōkyō (1). **Bib.:** Takahashi (6) 8.

¹雪麿 ²田中 ³喜多川雪麿 ⁴善三郎 ⁵墨川亭 ⁶敬丹舎 ⁷雪麿

Yukimatsu Shunho (Shumpo)¹ (1897–1962). *N.:* Yukimatsu Inomu.² *Gō:* Shunho (Shumpo).³ **Biog.:** Japanese-style painter. Born in Ōita-ken. A pupil of the Ōsaka painter Himeshima Chikugai and of Komura Suiun; later studied with Mizuta Chikuho. In 1920 began to show with the Teiten. Member of the Nihon Nangain and, after 1945, of the Nitten. His style is pleasantly traditional. **Coll.:** National (5). **Bib.:** Asano.

¹幸松春浦 ²幸松猪六 ³春浦

Yukimitsu¹ (fl. 1352–89). *N.:* Fujiwara no Yukimitsu.² **Biog.:** Tosa painter. According to the unreliable Tosa family lineage, may have been a son of Yoshimitsu; is certainly the artistic heir of Mitsuaki. Regarded as the founder of the Tosa line, but in his lifetime was still called Fujiwara. His son Yukihiro generally regarded as first to carry Tosa name to denote an artistic tradition. However, since the Tosa family genealogy was compiled only in the mid-Tokugawa period with an eye to the grandeur and antiquity of the Tosa school, the alleged earlier origins of the school are now regarded as false. Yukimitsu was given title Lord of Echizen, and when the court was at Yoshino, he was the leading *yamato-e* painter, serving as Edokoro *azukari.* Records refer to a considerable output, but today no painting can be more than attributed to him. The two scrolls of the Kōan version of the *Kitano Tenjin Engi* in the Kitano Temman-gū, Kyōto, and the two in the Tōkyō National Museum are among these attributions. **Bib.:** Akiyama (2); BK 87; Okudaira (1); SBZ 7; Tajima (12) 5, 14, 17, 19.

¹行光 ²藤原行光

Yukinaga¹ (fl. early 14th c.). *N.:* Fujiwara Yukinaga.² **Biog.:** *Yamato-e* painter. Known only from a colophon on the scroll *Egara Tenjin Engi,* dated 1319, now in the Maeda Ikutokukai Foundation. The authorship of the scroll has not yet been established. **Bib.:** K 65, NHBZ 3, Okudaira (1), Tajima (12) 19, Toda (2).

¹行長 ²藤原行長

Yukinobu¹ (c. 1513–75). *N.:* Kanō Yukinobu.² *F.N.:* Utanosuke.³ *Gō:* Bōin (Mōin).⁴ **Biog.:** Kanō painter. Son of Kanō Masanobu, much younger brother of Motonobu; pupil of both. He and his brother left Kyōto for Ōtsu to escape civil war, staying at the Mii-dera in Ōtsu and painting fans for their livelihood. After the fall of the Ashikaga family, returned to Kyōto; lived at the Daitoku-ji, painting walls and screens. Leader of the Kanō school in the Momoyama period. The painting *Agriculture* (owned by the Daisen-in, Daitoku-ji, Kyōto, but generally kept at the Kyōto National Museum) is by him; a painting in the Museum of Fine Arts, Boston, is attributed to him. His work is very rare. A man of lesser talent than his brother, but still a distinguished artist. Painted particularly fine *kachōga.* **Coll.:** Daitoku-ji (Daisen-in), Museum (3), Tōkyō (1). **Bib.:** Binyon (2); BMFA 36; HS 9; K 20, 152, 189, 262, 689; Morrison 1; NBZ 3; NKZ 6; *One* (2); Paine (2) 1, (4); Rosenfield (2); Tajima (12) 3, 6, 11; Tajima (13) 4; Yamane (1a).

¹之信 ²狩野之信 ³雅楽之助 ⁴ㄱ隠

Yukinobu (Sesshin)¹ (1643–82). *N.:* Kiyohara (or Kanō)² Yuki.³ *Gō:* Yukinobu (Sesshin).⁴ **Biog.:** Kanō painter. According to the Kanō genealogy, she is said to have been a daughter of Tan'yū's niece and Kusumi Morikage; wife of Kiyohara Hirano Morikiyo, a pupil of Tan'yū. Her work also owes much to Tosa Mitsuoki, being a combination of Kanō and Tosa elements. Best woman painter of the Tokugawa period; a charming, delicate artist specializing in female figures. **Coll.:** Art (1a), Metropolitan, Museum (3).

Bib.: *Japanese* (1a); K 63, 597, 605, 712, 829; *Kanō-ha;* Morrison 1; Tajima (12) 17, 20; Tajima (13) 5.
¹雪信 ²狩野 ³清原雪 ⁴雪信

Yukinobu¹ (fl. late 18th to early 19th c.). *N.:* Kanō Yukinobu.² *Gō:* Hakuju.³ **Biog.:** Kanō painter. Son and pupil of Kanō Juseki Keishin; eighth in the Saruyamachi line. A follower of the style of Eitoku.
¹行信 ²狩野行信 ³伯寿

Yukitada¹ (fl. second half 14th c.). *N.:* Kose no Yukitada.² **Biog.:** Kose painter. Son and pupil of Kose no Arihisa, succeeding him as Edokoro *azukari* at the Tō-ji in 1363. About 1375 became Edokoro *azukari* for the Northern imperial court. According to the records of the Tō-ji, worked with his son Hisayuki and others from 1374 to 1379 on twelve scrolls called *Kōbō Daishi Gyōjō Emaki* (Scroll of the Deeds of Priest Kūkai); also worked at the same time on screens for the new emperor's accession ceremony in 1375. No works by him are known today.
¹行忠 ²巨勢行忠

Yūkoku¹ (1827–98). *N.:* Noguchi Tsuzuku.² *F.N.:* Minosuke.³ *Gō:* Warakudō,⁴ Yūkoku.⁵ **Biog.:** *Nanga* painter. Lived in Tōkyō. Pupil of Tsubaki Chinzan. Member of the Nihon Bijutsu Kyōkai and of the Art Committee for the Imperial Household. Leading *nanga* painter of the early Meiji era; specialized in *kachōga.* **Coll.:** Ashmolean, Tōkyō (1). **Bib.:** Asano, Elisséev, Mitchell, NB (S) 17, NBZ 6, SBZ 11, Umezawa (2), Uyeno.
¹幽谷 ²野口続 ³巳之助 ⁴和楽堂 ⁵幽谷

Yumishō¹ (fl. 1781–89). *N.:* Katsukawa Yumishō.² **Biog.:** Ukiyo-e printmaker. Worked in the Torii manner, making prints of actors and *bijin.* **Bib.:** NHBZ 3.
¹由美章 ²勝川由美章

Yunoki Hisata¹ (1885–1970). **Biog.:** Western-style painter. Born in Okayama-ken. Studied in Tōkyō with Mitsutani Kunishirō and Nakamura Fusetsu at the Taiheiyō Kenkyūsho. From 1911 to 1915 in Paris, where he studied under Laurens at the Académie Julian. On his return, showed with the Bunten, then with the Teiten. After 1945 showed with the Nitten, becoming a member of this group as well as of the Shinseiki Bijutsu Kyōkai. His landscapes are painted in a solid, broad manner. **Bib.:** Asano.
¹柚木久太

Yūrin¹ (?–1811). *N.:* Doi (or Sakaki)² Genseki.³ *A.:* Sokō.⁴ *F.N.:* Kyōsuke.⁵ *Gō:* Yūrin.⁶ **Biog.:** Nagasaki painter. Born in Nagasaki. Pupil of Ishizaki Yūshi. Good portrait painter; also produced ukiyo-e paintings and sketches. **Coll.:** Kōbe. **Bib.:** Kuroda, *Pictorial* (2) 2.
¹有隣 ²榊 ³土井元積 ⁴岨高 ⁵京助 ⁶有隣

Yūsai¹ (fl. first half 19th c.). *N.:* Ishizaki Yūsai.² *A.:* Seibi.³ *Gō:* Gyokuho,⁴ Shuhō,⁵ Yūsai.⁶ **Biog.:** Nagasaki painter. Born in Nagasaki; son and pupil of Ishizaki Yūshi. Good painter of portraits, landscapes, and *kachōga.* **Coll.:** British, Kōbe. **Bib.:** Mody, OA 2, *Pictorial* (2) 5.
¹融済 ²石崎融済 ³世美 ⁴玉浦 ⁵手峰 ⁶融済

Yūsen¹ (1778–1815). *N.:* Kanō Hironobu.² *Gō:* Seigosai,³ Yūsen.⁴ **Biog.:** Kanō painter. Son and pupil of Kanō Kansen; fifth-generation head of Hamachō Kanō. In 1792 entered the service of the shogunate as *oku eshi:* in 1808 received court title of *shikibukei* and was made *hōgen.* On the shogun's order, painted a set of *byōbu* on the theme of *Ōmi Hakkei* (Eight Views of Ōmi) to be given to the Korean royal house. Quarreled with the chief painter of the Edokoro, who wanted him to use more gold dust, insisting it would ruin the balance of his work, and committed suicide. Hence known as Harakiri Yūsen or Harakiri Hōgen. An indifferent artist. **Coll.:** Metropolitan, Museum (3). **Bib.:** *Kanō-ha.*
¹融川 ²狩野寛信 ³青梧斎 ⁴融川

Yūsen¹ (?–1831). *N.:* Kanō Sukenobu.² *Gō:* Seihakusai,³ Yūsen.⁴ **Biog.:** Kanō painter. Younger son and pupil of Kanō Yūsen Hiranobu. Succeeded his elder brother, Shunsen, who

died young, as *oku eshi* to the shogunate. Represents the seventh generation of the Hamachō Kanō.
¹友川 ²狩野助信 ³青白斎 ⁴友川

Yūsetsu¹ (1598–1677). *N.:* Kaihō Dōki.² *F.N.:* Chūzaemon.³ *Gō:* Dōkisai,⁴ Yūsetsu.⁵ **Biog.:** Kaihō painter Lived first in Kyōto, later in Edo. Son and pupil of Kaihō Yūshō; after Yūshō's death studied the Kanō manner, perhaps under Tan'yū, and, for financial reasons, changed his vocation to that of *eya,* a newly developed profession whose members differed from regular painters of the time in that they were engaged chiefly in applied arts, dealing in both ready-made and made-to-order. Later regained the social position of a professional painter. During his period as *eya* called himself Eya Chūzaemon.⁶ No work of this period known. Painted some genre scenes and some good *kachōga* but was primarily a landscape painter of charm and distinction. **Coll.:** Dayton, Museum (3), Ōkura, Tokiwayama, Tōkyō (1). **Bib.:** BI 48; GNB 13; *Japanese* (1); K 19, 149, 614, 690; KO 40; Morrison 1; NB (H) 14; *Rakuchū;* Tajima (12) 7, (13) 5; Yamane (1a).
¹友雪 ²海北道暉 ³忠左衛門 ⁴道暉斎 ⁵友雪 ⁶絵屋忠左衛門

Yūsetsu¹ (1808–82). *N.:* Mori Yūsetsu.² *F.N.:* Yogoemon.³ **Biog.:** Potter. Born in Kuwana, Ise Province. A woodcarver and a dealer in bric-a-brac and wastepaper; discovered Numanami Rōzan's formulas for making Banko ware, bought Rōzan's seal and stamp, and revived the making of Banko ware, now called Yūsetsu Banko. The ware has a light or dark-gray crackled glaze often decorated with landscape designs in red and green. **Bib.:** Jenyns (2).
¹有節 ²森有節 ³与五右衛門

Yūshi¹ (1768–1846). *N.:* Ishizaki (originally Araki)² Keitarō.³ *Gō:* Hōrei,⁴ Shisai,⁵ Yūshi.⁶ **Biog.:** Yōga painter. Son and pupil of Araki Gen'yū; also studied under Ishizaki Gentoku. Lived in Nagasaki as a government official holding two positions: *goyō eshi* and *kara-e mekiki.* When Gentoku's heir died, leaving no son to succeed him, the Ishizaki family adopted Yūshi. His subject matter included landscape and birds-and-flowers, painted both in oils and in the Chinese manner. Also excelled in engraving seals and in composing prose and poetry. **Coll.:** Kōbe, Nagasaki. **Bib.:** BK 12, GNB 25, Kuroda, Mody, NBZ 5, Nishimura, *Pictorial* (2) 2, Sullivan.
¹融思 ²荒木 ³石崎慶太郎 ⁴鳳嶺（放齢） ⁵士斎 ⁶融思

Yūshō¹ (1533–1615). *N.:* Kaihō Shōeki.² *A.:* Yūshō.³ *Gō:* Josetsusai,⁴ Yūkeisai,⁵ Yūtoku.⁶ **Biog.:** Kaihō painter. Born in Ōmi Province; son of a military man. At an early age became a page at the Tōfuku-ji, Kyōto; later, with misgivings, a lay priest. At 41 in the service of the abbot of the Tōfuku-ji, associating with other leading Zen priests of Kyōto. Turned to painting; became a pupil of Kanō Motonobu. Under the patronage of Hideyoshi, for whom he worked in Juraku-dai; also served the emperor Goyōzei. At first, patterned his work after Sung painter Liang K'ai, doing only monochrome ink paintings. Later worked in fashionable rich colors and gold leaf. In his monochrome work used a "reduced brush stroke" (*gempitsu*), relying more on ink washes than sharp hard strokes. His figure pieces called *fukuro-e* because of scarcity of strokes. Artistically on a level with Hasegawa Tōhaku and Kanō Eitoku; gave his name Kaihō to the style of painting he and his followers practiced. **Coll.:** Atami, British, Brooklyn, City, Detroit, Fine (M. H. De Young), Freer, Hakone, Kennin-ji (Reidō-in, Zenkyō-an), Kitano, Lake, Museum (3), Myōshin-ji, Nelson, Suntory, Tōkyō (1). **Bib.:** Akiyama (3), (4); *Art* (2); *Au-delà;* BB 15; BG 74, 77; BI 63; Binyon (2); BK 5, 79, 128, 157; *Exhibition* (1); Fontein (1); GNB 11, 13; Grilli (1); HS 7, 8; K 76, 159, 160, 168, 187, 221, 374, 590, 596, 602, 607, 614, 625, 652, 666, 688, 894, 960; KO 30; Matsushita (1), (1a); Mayuyama; Minamoto (2); Moriya; Morrison 1; *National* (1); NB (H) 14; NB (S) 13; NBT 5; NBZ 4; Noma (1) 2; *One* (2); Paine

(4); SBZ 8; Shimada 2; Tajima (12) 2, 6, 12, 14; Tajima (13) 4; Takeda (2); Yamane (1a).

¹友松 ²海北昭益 ³友松 ⁴如切斎 ⁵友景斎（有景斎） ⁶友徳

Yūshō¹ (1817–68). *N.:* Kaihō Yūshō.² *A.:* Jomon.³ *Gō:* Shōgen,⁴ Yokumon,⁵ Yūshō.⁶ **Biog.:** Japanese-style painter. Born in Kyōto. Son and pupil of Kaihō Yūtoku. Seventh-generation descendant of Kaihō Yūshō (1533–1615). **Coll.:** Ashmolean.

¹友樵 ²海北友樵 ³如聞 ⁴将監 ⁵抑聞 ⁶友樵

Yūshū¹ (fl. late 16th c.). **Biog.:** Muromachi *suiboku* painter. History unknown. To date, two paintings bearing his seal have been found. The *Honchō Gashi* describes his work as close to that of Sesson. **Coll.:** Tokiwayama. **Bib.:** HS 5, *Japanese* (1), KO 17, Matsushita (1a), NB (S) 63.

¹祐周 ²巨勢有尊

Yūson¹ (fl. c. 1248). *N.:* Kose no Yūson.² **Biog.:** Kose painter. Son of Kose no Nagamochi. A priest attached to the Daijō-in, Kōfuku-ji, Nara. A minor member of the Kose school.

¹有尊 ²巨勢有尊

Yūsuke¹ (fl. late 19th c.). *N.:* Ishii Yūsuke.² **Biog.:** Lacquerer. Worked in Takaoka. A good craftsman; his wares are known as Yūsuke-nuri. **Bib.:** NBZ 6, Sawaguchi.

¹勇助 ²石井勇助

Yūtei¹ (1721–86). *N.:* Ishida Morinao.² *Gō:* Yūtei.³ **Biog.:** Kanō painter. Lived in Kyōto. Pupil of Tsuruzawa Tangei. Eventually created his own style by combining the elements of several schools. Best known, however, as the teacher of Ōkyo. An accomplished technician of little inspiration. **Coll.:** Daigo-ji (Sambō-in), Museum (3). **Bib.:** Mizuo (2), Morrison 1, NB (H) 24, NBZ 5, Tajima (12) 16.

¹幽汀 ²石田守直 ³幽汀

Yūtei¹ (1754–93). *N.:* Ishida Moriyoshi.² *Gō:* Yūtei.³ **Biog.:** Painter. Son and pupil of Ishida Yūtei Morinao.

¹遊汀 ²石田守善 ³遊汀

Yūtei¹ (1756–1815). *N.:* Ishida Yoshiaki.² *Gō:* Yūtei.³ **Biog.:**

Kanō painter. Born in Kyōto; son and pupil of Ishida Yūtei Morinao. Received title of *hokkyō*.

¹友汀 ²石田叔明 ³友汀

Yūtei¹ (1795–1869). *N.:* Ishida Nobuaki.² *Gō:* Yūtei.³ **Biog.:** Painter. Son and pupil of Ishida Yūtei Yoshiaki.

¹悠汀 ²石田信明 ³悠汀

Yūten¹ (1637–1718). *Priest name:* Gushin.² *Gō:* Ken'yo,³ Yūten.⁴ **Biog.:** Buddhist painter. Born in Mutsu Province. At 12 to Edo and became a priest. By 1661 head priest at the Denzū-in; in 1771 abbot of Zōjō-ji, Edo. Patronized by the shogunate. Painter of Buddhist icons and, especially, pictures of Fudō.

¹祐天 ²愚心 ³顕誉 ⁴祐天

Yūtoku¹ (fl. c. 1680). *N.:* Sakuma Yūtoku.² **Biog.:** Kanō painter. Served the Date clan in Sendai as official painter.

¹友徳 ²佐久間友徳

Yūtoku¹ (1763–1841). *N.:* Kaihō Terumichi.² *F.N.:* Saino-suke.³ *Gō:* Yūtoku.⁴ **Biog.:** Kaihō painter. Born in Kyōto. Son of a minor artist, Kaihō Yūsan.

¹友徳 ²海北照道 ³斎之助 ⁴友徳

Yūtoku¹ (1813–71). *N.:* Ishida Yūtoku.² **Biog.:** Painter. Son and pupil of Ishida Yūtei Yoshiaki. A good painter of landscapes and *kachōga*.

¹友篤 ²石田友篤

Yūzan¹ (1790–1849). *N.:* Imaōji Genshū.² *Gō:* Yūzan.³ **Biog.:** *Nanga* painter. Son of an official of the Shōgo-in, Kyōto. Pupil of Nakabayashi Chikutō. Received title of *hōgen*. A good painter of landscapes and *kachōga*.

¹悠山 ²今大路源秀 ³悠山

Yūzen¹ (?–1758). *N.:* Miyazaki Yūzen.² **Biog.:** Rimpa painter, dyer. Born in Kyōto; lived and worked in Kanazawa. Best known for having either invented or vastly improved the technique of resist dyeing of cloth with many colors and elaborate designs that came to be known as Yūzen dyeing. **Coll.:** Allen, Museum (3), Victoria. **Bib.:** K 285, *Kōrin-ha* (2), Nomura.

¹友禅 ²宮崎友禅

Z

Zaemon¹ (1569–1643). *N.:* Kōrai Zaemon.² *Korean name:* Ri Kei.³ **Biog.:** Potter. Born in Korea. Came to Japan after the Korean war of 1592, probably in the wake of the Japanese army. Entered the service of the Mōri family, the feudal lords of Hagi. Sometime before 1614 started the Hagi kiln at Matsumoto.

¹左衛門 ²高麗左衛門 ³李敬

Zaichū¹ (1750–1837). *N.:* Hara Chien.² *A.:* Shichō.³ *Gō:* Gayū,⁴ Zaichū.⁵ **Biog.:** Painter. Lived and worked in Kyōto. Studied first under Ishida Yūtei, then under Maruyama Ōkyo, and, finally, the technique of Ming and Ch'ing as well as Tosa painting. Split off from the Maruyama group to found his own school, which lies between Kanō, *nanga,* and Maruyama. Worked on the wall decorations of the rebuilt Kyōto Imperial Palace. Chiefly famous in his early days as a painter of pictures in Chinese Ming style. With Ganku and Ōzui considered among the leading painters of his day. Excellent colorist. **Coll.:** Daitoku-ji (Sangen-in), Museum (3), Stanford. **Bib.:** Hillier (4) 3, K 120, Morrison 2.

¹在中 ²原致遠 ³子重 ⁴臥遊 ⁵在中

Zaifuku-shi¹ (fl. mid-8th c.). **Biog.:** Sculptor. A mask carver, particularly famous for his Gigaku masks of old people. **Coll.:** Shōsō-in, Tōdai-ji. **Bib.:** Harada, Kleinschmidt.

¹財福師

Zaimei¹ (1778–1844). *N.:* Hara Chikayoshi.² *A.:* Shitoku.³ *Gō:* Shashō,⁴ Zaimei.⁵ **Biog.:** Painter. Lived in Kyōto. Second son and pupil of Hara Zaichū. Like his father, worked on the decoration of the Kyōto Imperial Palace; also like

his father, an independent artist. **Coll.:** Museum (3). **Bib.:** Hillier (4) 3, Mitchell, Morrison.

¹在明 ²原近義 ³子徳 ⁴写照 ⁵在明

Zaisei¹ (?–1810). *N.:* Hara Chidō.² *A.:* Shiei.³ *Gō:* Zaisei.⁴ **Biog.:** Painter. Born in Kyōto. Son and pupil of Hara Zaichū, whose style he followed during his brief life. **Coll.:** Museum (3). **Bib.:** Mitchell, Morrison 2.

¹在正 ²原致道 ³子栄 ⁴在正

Zaishō¹ (1813–71). *N.:* Hara Shisha.² *A.:* Shisha.³ *Court title:* Ōminosuke.⁴ *Gō:* Kanran,⁵ Nankei,⁶ Sekiran,⁷ Zaishō.⁸ **Biog.:** Painter. Lived and worked in Kyōto; son and pupil of Hara Zaimei. With his father and grandfather worked on the decoration of the Kyōto Imperial Palace. A good painter of landscapes and *kachōga*. His style, like that of his father, nontraditional, but with overtones of the Maruyama school. **Coll.:** Imperial (1). **Bib.:** Mitchell, Morrison 2.

¹在照 ²原子写 ³子写 ⁴近江介 ⁵観瀾 ⁶南荊 ⁷夕鸞 ⁸在照

Zean¹ (fl. late 15th to early 16th c.). *N.:* Shiken.² *Gō:* Jiboku,³ Saidō,⁴ Shōoku Rōjin,⁵ Zean.⁶ **Biog.:** Muromachi *suiboku* painter. No details of his life known save that he was a priest of the Sōkoku-ji, Kyōto. Worked in the manner of Nōami. Also a good calligrapher. Has sometimes been confused with Oguri Sōtan because they both have the *gō* Jiboku.⁷ **Coll.:** Museum (3). **Bib.:** Matsushita (1a).

¹是菴 ²子建 ³自牧 ⁴西堂 ⁵松尾老人 ⁶是菴 ⁷自牧

Zean¹ (1578–1638). *N.:* Waku Shun'ei.² *F.N.:* Hanzaemon.³ *Gō:* Zean;⁴ later, as a monk, Sōze.⁵ **Biog.:** Buddhist painter.

First served Toyotomi Hideyori as painter and calligrapher; after the fall of Hideyori, served Lord Date Masamune in Sendai. Painted landscapes and birds-and-flowers as well as Buddhist subjects. **Coll.:** Museum (3).

¹是安 ²和久俊英 ³半左衛門 ⁴安 ⁵宗是

Zen'en[1] (fl. first half 13th c.). **Biog.:** Sculptor. Made small, exquisite figures in the Fujiwara style. An Aizen Myōō in the Aizendō, Saidai-ji, Nara, is by him and is dated 1247. The Shaka Nyorai in the Sashizudō, Tōdai-ji, Nara, is dated 1225. **Coll.:** Saidai-ji, Tōdai-ji. **Bib.:** BK 240, GNB 9, NB (H) 11, NBZ 3.

¹善円

Zen'etsu[1] (fl. c. 1730). *N.:* Okamoto Toyohisa.[2] *F.N.:* Zenzō.[3] *Gō:* Zen'etsu.[4] **Biog.:** Kanō painter. Born in Kii Province, where he was in the service of the local daimyo. Studied under a pupil of Kanō Tsunenobu. Appointed *goyō eshi* to the shogunate in Edo. In 1730 was asked to copy the paintings of Sesshū owned by the Hosokawa family. Specialized in painting hawks.

¹善悦 ²岡本豊久 ³善蔵 ⁴善悦

Zenkei[1] (1196–1258). **Biog.:** Sculptor. Worked in Nara. Perhaps a pupil of Zen'en. Worked under the patronage of Priest Eison of the Saidai-ji, which owns his Shaka Nyorai, dated 1249. A statue by him of Yakushi Nyorai, dated 1249, is in the Shōfuku-ji, Hyōgo. **Coll.:** Saidai-ji, Shōfuku-ji. **Bib.:** NB (H) 11, SBZ 6.

¹善慶

Zensetsu[1] (1599–1680). *N.:* Tokuriki Yukikatsu.[2] *F.N.:* Kotarō,[3] Kohei.[4] *Priest name:* Zensetsu.[5] *Gō:* Sanden.[6] **Biog.:** Kanō painter. Lived in Kyōto; said to have been a pupil of Kanō Sansetsu. Attached as a priest to the Nishi Hongan-ji, with rank of *azukari* of the temple Edokoro. Was entrusted with the task of repairing the *Shinran Shōnin Eden;* also painted a series of scrolls of the life of Kōbō Daishi. His style close to that of the academic Chinese *kachōga* that were still in the temple in his time. **Coll.:** Nishi Hongan-ji, Tōkyō (1). **Bib.:** K 53, 668, 795, 819, 867; Tanaka (2); YB 31.

¹善雪 ²德力之勝 ³小太郎 ⁴小兵衛 ⁵善雪 ⁶山田

Zenshirō[1] (?–1786). *N.:* Tsuchiya Yoshikata.[2] *Gō:* Zenshirō.[3] **Biog.:** Potter. Born in Matsue. First-generation head of a family of well-known potters. Worked at the Fushina kiln producing Rakuzan ware for which he became famous. Used the seal Unzen.[4] The second-generation potter, Tsuchiya Masayoshi[5] (d. 1821), was patronized by Lord Matsudaira Fumai of Matsue, who allowed him to use the *gō* Unzen.[6] **Bib.:** *Tōki.*

善四郎 ²土屋芳方 ³善四郎 ⁴雲善 ⁵土屋政芳 ⁶雲善

Zenshō[1] (1493–1583). *N.:* Tokuriki (originally Miyoshi)[2] Genson.[3] *F.N.:* Kotarō.[4] *Gō:* Zenshō.[5] **Biog.:** Painter. Born in Awa Province. Became *azukari* at the Edokoro of the Hongan-ji, Kyōto. Grandfather of Tokuriki Zensetsu.

¹善章 ²三好 ³德力元存 ⁴小太郎 ⁵善章

Zenshun[1] (fl. second half 13th c.). **Biog.:** Sculptor. Son and pupil of Zenkei. Worked in Nara. His known works include a statue of Shōtoku Taishi, dated 1268, in the Genko-ji, Nara; the Daikokuten in the Saidai-ji, dated 1276, and the portrait of his patron, Priest Eison, dated 1280, in the Aizendō, Saidai-ji. His work is in the realistic style of the Kamakura period. **Coll.:** Genkō-ji, Saidai-ji. **Bib.:** GNB 9, Ōoka, *Pictorial* NBZ 3, (1) 2, SBZ 6.

¹善春

Zensō (1549–1637). *N.:* Tokuriki Sonshi.[2] *Gō:* Zensō.[3] **Biog.:** Buddhist painter. Son of Tokuriki Zenshō. After a brief military career, was attached to the Hongan-ji in Kyōto. Then spent some time visiting the famous places in the Ōsaka region. Eventually returned to Kyōto and became well known for his portraits of priests.

¹善宗 ²德力存之 ³善宗

Zeshin[1] (1807–91). *N.:* Shibata Junzō[2] (originally Kametarō).[3] *A.:* Tanzen (Senzen).[4] *Gō:* Chinryūtei,[5] Koma,[6]

Reiya,[7] Tairyūkyo,[8] Zeshin.[9] **Biog.:** Shijō painter, printmaker, lacquerer. Born and lived in Edo. Son of a sculptor. As a child, apprenticed to a lacquer craftsman; studied painting under Suzuki Nanrei and, in Kyōto, under Okamoto Toyohiko to improve his ability in design; also trained in lacquer techniques by Koma Kansai II. Member of the Nihon Bijutsu Kyōkai and the Art Committee of the Imperial Household. Became a court painter in 1890. Greatest lacquerer of the 19th century; particularly skillful in *urushi-e*, producing charming, delicate works. Also painted equally delightful pictures, usually with the addition of lacquer. His eldest son, Reisai,[10] carried on the family lacquer business; the younger son Umezawa Ryūshin[11] worked in the family tradition. **Coll.:** Allen; Ashmolean; Art (1); British; Brooklyn; Center; Cincinnati; City; Collections; Detroit; Fine (M. H. De Young); Fogg; Freer; Honolulu; Hoppō; Itsuō; Metropolitan; Museés; Museum (1), (2), (3); Newark; Nezu; Philadelphia; Rhode Island; Royal (1); Seattle; Stanford; Suntory; Tōkyō (1), (2); Toledo; University (2); Victoria; Worcester; Yamatane. **Bib.:** Asano; Binyon (1); Casal; GNB 28; Herberts; Hillier (1), (2), (3), (4) 3; *Kunst;* Ledoux (5); M 203; Mayuyama; Meissner; Mitchell; Mizuo (3); Morrison 2; NB (S) 17, 41; NBZ 6; Speiser (2); Ragué; Uyeno; Yoshino.

¹是真 ²紫田順蔵 ³亀太郎 ⁴僴然 ⁵沈柳亭 ⁶古満
⁷令哉 ⁸対柳居 ⁹是真 ¹⁰令哉 ¹¹梅沢隆真

Zōami[1] (fl. late 14th c.). **Biog.:** Sculptor. Worked as a mask carver under the patronage of Ashikaga Yoshimitsu. His specialty was female masks, which were known as *zō onna* (female portraits).

¹増阿弥

Zōkoku[1] (1805–69). *N.:* Tamakaji[2] (originally Fujikawa).[3] *F.N.:* Tamezō.[4] *Gō:* Shisei,[5] Zōkoku.[6] **Biog.:** Lacquerer. Born and worked in Takamatsu. Son of Fujikawa Uemon, a lacquer artist. Studied Siamese and Burmese lacquer techniques; finally perfected a type of carved red-and-black lacquer called Zōkoku-nuri (or Sanuki-bori) and made Takamatsu a center for carved lacquerware. Worked for Lord Matsudaira; was given rank of samurai (in recognition of his talent) and the name Tamakaji. Also a good ceramist, sometimes using ceramic decorations on his lacquer. **Coll.:** Metropolitan, Tōkyō (1), Victoria, Walters. **Bib.:** Boyer, Casal, Herberts, Jahss, M 188, Ragué, Sawaguchi, SBZ 10, Yoshino.

¹象谷 ²玉楮 ³藤川 ⁴為三 ⁵子成 ⁶象谷

Zōsan[1] (fl. beginning of 16th c.). **Biog.:** Muromachi *suiboku* painter. Life unknown. Only four works with his seal are known. The style is a combination of Muromachi *suiboku* with a new decorative approach foreshadowing the Rimpa school. The *Honchō Gashi* says that Sōtan's seal is the same as Zōsan's; Fontein (op. cit.) says that this is incorrect and that Sōtan and Zōsan were probably two different artists. **Coll.:** Museum (3), Tokiwayama. **Bib.:** BI 3, BMFA 51, Fontein (3), *Japanese* (1), M 191, Matsushita (1a), Mayuyama, Shimada 1.

¹蔵三

Zōtaku[1] (1772–1802). *N.:* Yoshida.[2] *F.N.:* Kyūdayū.[3] *Gō:* Zōtaku.[4] **Biog.:** Painter. A samurai of the Matsuyama fief. Good painter of bamboo, with considerable reputation in Matsuyama but unknown outside his home territory. **Bib.:** K 877.

¹蔵澤 ²吉田 ³久太夫 ⁴蔵澤

Zōzen[1] (fl. early 12th c.). **Biog.:** Sculptor. A mask carver, known from an inscription of 1102 on a mask in the Hōryū-ji. **Coll.:** Hōryū-ji. **Bib.:** *Heian* (2), Noma (4).

¹増善

Zuisen[1] (1692–1745). *N.:* Kanō Kuninobu[2] (later Sukenobu or Yoshinobu).[3] *F.N.:* Kichinojō;[4] later, Gunji.[5] *Gō:* Seiryūsai,[6] Zuisen.[7] **Biog.:** Kanō painter. Said to have been third son of Kanō Tsunenobu; was adopted by Kanō Minenobu,

who had no children. Pupil of both Tsunenobu and Mineno-bu. Served the shogunate as *oku eshi*. Became second-genera-tion head of the Hamachō Kanō line. Carried on Tsuneno-bu's tradition of painting. **Bib.:** *Kanō-ha*.

[1]随川 [2]狩野邦信 [3]甫信 [4]吉之丞
[5]君治 [6]青柳斎 [7]随川

Zuishun[1] (?–1758). *N.:* Takeuchi.[2] *F.N.:* Shinroku,[3] Yo-shinori.[4] *Gō:* Zuishun.[5] **Biog.:** Kanō painter. Pupil of Kanō Zuisen Yoshinobu. Employed by Lord Matsue in Izumo. Received title of *hokkyō*. A good painter of landscapes and *kachōga*.

[1]随春 [2]竹内 [3]新六 [4]甫紀 [5]随春

Zuizan[1] (1829–65). *N.:* Takechi Otate.[2] *F.N.:* Hampeita.[3] *Gō:* Meikan,[4] Suizan,[5] Zuizan.[6] **Biog.:** *Nanga* painter. Born in Tosa Province; samurai of Lord Yamanouchi. An activist during the later Tokugawa period, was arrested and com-mitted suicide while in jail; better known as a political figure than as an artist. Was, however, a good painter of land-scapes, portraits, *kachōga*, and, particularly, *bijinga*. **Bib.:** Umezawa (2).

[1]瑞山 [2]武市小楯 [3]半平太 [4]茗磵 [5]吹山 [6]瑞山

Appendix 1
Collections

As explained in the Preface, when initial words are the same in two or more of the following entries, numerals are inserted in parentheses immediately after such words and serve as reference numbers in the body of the book. If the city name is included in the name of the collection, the name is not repeated.

Abuhari-jinsha, Abuhari, Shiga-ken
Akita City Art Museum, Akita-ken
Albertina: Graphische Sammlung, Vienna
Albright-Knox Art Gallery, Buffalo, New York
Allen Memorial Art Museum, Oberlin College, Oberlin, Ohio
Andrew Dickson White Museum of Art, Cornell University, Ithaca, New York
Ango-in, see Gangō-ji
Anrakuju-in, see Imperial Palace (1)
Art (1a) Gallery of Greater Victoria, Canada
Art (1) Institute of Chicago, Illinois
Art (2) Museum, Princeton University, New Jersey
Asakura Chōsokan Museum, Tōkyō
Ashmolean Museum, Oxford
Atami Art Museum, Shizuoka-ken

Baltimore Museum of Art, Maryland
Bashō Memorial Hall, Ueno, Mie-ken
Bibliothèque Nationale, Paris
Bridgestone Art Museum, Tōkyō
British Museum, London
Brooklyn Museum, New York
Bujō-ji, Kyōto
Bukkoku-ji, Kyōto
Byakugō-ji, Nara-ken
Byōdō-in, Uji, Kyōto-fu

California Palace of the Legion of Honor, see Fine Arts Museums of San Francisco
Center of Asian Art and Culture: Avery Brundage Collection, San Francisco
Chidō Museum, Tsuruoka, Yamagata-ken
Chion-in Treasure House, Kyōto
Chishaku-in, Kyōto
Chōfuku-ji, Kyōto
Chōfu Museum, Shimonoseki
Chōkō-ji, Koromo, Aichi-ken
Chōkyū-ji, Kitayamato-mura, Nara-ken
Chōmei-ji, Shima-mura, Shiga-ken
Chōmyō-ji, Kyōto
Chōzen-ji, Kōfu, Yamanashi-ken
Cincinnati Art Museum, Ohio
City Art Museum of St. Louis, Missouri
Cleveland Museum of Art, Ohio
Collections Baur, Geneva

Daichō-ji, Kamakura
Daien-ji, Bunkyō-ku, Tōkyō
Daigo-ji, Kyōto
Daigyō-ji, Kyōto
Daihō-ji (1), Kyōto
Daihō-ji (2), Toyama-ken
Daihoon-in, Kyōto
Daijō-ji (1), Fukuoka
Daijō-ji (2), Kasumi-mura, Hyōgo-ken
Daiju-ji, Okazaki, Aichi-ken
Daikaku-ji, Kyōto
Daikō-ji, Sadowara, Miyazaki-ken
Daikōmyō-ji, Kyōto
Dairyū-ji, Gifu-ken
Daisen-in, see Daitoku-ji
Daisen-in, Yamanashi-ken
Daishō-in, Higashi Hagi, Yamaguchi-ken
Daitoku-ji, Kyōto
Daitōkyū Kinen Bunko, Tōkyō
Daitsū-ji, Nagahama, Shiga-ken

Daizōkyō-ji, Okabe-mura, Yamanashi-ken
Daruma-dera, Ōji-machi, Nara-ken
Dayton Art Institute, Ohio
Dazaifu Temman-gū Treasure House, Tsukushi-gun, Fukuoka-ken
Denver Art Museum, Colorado
Detroit Institute of Arts, Michigan
Dōmoto Art Museum, Kyōto
Dōshū-in, see Tōfuku-ji
Duncan Phillips Collection, Washington, D.C.

Eihei-ji, Fukui-ken
Eikyū-ji, Nara
Eisei Bunko, Tōkyō
Emman-in, Ōtsu, Shiga-ken
Empuku-in, Zeze-machi, Shiga-ken
Engaku-ji, Kamakura
Enjō-ji, Soyokami-gun, Nara-ken
Enkō-ji, Kyōto
Ennō-ji, Kamakura
Entoku-in, Kyōto
Entsū-ji, Yamaguchi-ken

Fine Arts Museums of San Francisco, California
Fitzwilliam Museum, Cambridge, England
Fogg Art Museum, Cambridge, Massachusetts
Freer Gallery of Art, Washington, D.C.
Fudōdō, see Shinshō-ji
Fujita Art Museum, Ōsaka
Fukushō-ji, Kōbe
Fusai-ji, Tachikawa, Tōkyō
Fuse Art Museum, Ika-gun, Shiga-ken
Futaarasan Shrine, Nikkō, Tochigi-ken

Gangō-ji, Asuka, Nara-ken
Ganjōju-in, Shizuoka-ken
Gankō-ji, Gifu-ken
Genkō-ji, Nara
Gotō (Gotoh) Art Museum, Tōkyō
Grunwald Graphic Arts Foundation, University of California, Los Angeles
Guhō-ji, Sakamoto, Shiga-ken
Gyokudō Art Museum, Ōme, Tōkyō
Gyokuryū-in, see Shōkoku-ji

Hakodate Municipal Museum, Hokkaidō
Hakone Art Museum, Gōra, Kanagawa-ken
Hakusan-jinja, Gifu-ken
Hakutsuru Art Museum, Kōbe
Hannya-ji, Nara
Hase-dera, Nara-ken
Hatakeyama Museum, Tōkyō
Henjōkō-in, Kōyasan, Wakayama-ken
Henshō-ji, Mōka-shi, Tochigi-ken
Henshōkō-in, see Henjōkō-in
Herron Museum of Art, Indianapolis, Indiana
Higashi Hongan-ji, Kyōto
Hirado Kankō Historical Hall, Nagasaki-ken
Hiunkaku, see Nishi Hongan-ji
Hogaku-ji, Akita-ken
Hōju-in, Kōyasan, Wakayama-ken
Hōkai-ji (1), Kamakura
Hōkai-ji (2), Kyōto
Hōki-in, Kōyasan, Wakayama-ken
Hōkō-in, Nara
Hōkō-ji, Saitama-ken

Hōkoku-jinja, *see* Toyokuni-jinja
Hōkongō-in, Ukyō-ku, Kyōto
Homma Art Museum, Sakata, Yamagata-ken
Hompō-ji, Kyōto
Hōnen-in, Kyōto
Honkō-ji, Washizu, Shizuoka-ken
Honkoku-ji, Kyōto
Honolulu Academy of Arts, Hawaii
Hoppō Bunka Museum, Nakakambara-gun, Niigata-ken
Hōrin-ji, Yamanashi-ken
Hōryū-ji Treasure House, Nara-ken
Hōshō-ji, Niigata-ken
Hōzan-ji, Nara

Ichiino-ji, Ichiino, Shiga-ken
Idemitsu Art Gallery, Tōkyō
Ikeno Taiga Art Museum, Kyōto
Imperial Palace (1), Kyōto
Imperial Palace (2), Tōkyō
Ishikawa Prefectural Art Museum, Kanazawa
Ishiyama-dera, Ōtsu-shi, Shiga-ken
Itsukushima Shrine Treasure House, Miyajima, Hiroshima-ken
Itsuō Art Museum, Ōsaka
Izumo Taisha Treasure House, Shimane-ken

Jakuō-ji, Kyōto
Jakushō-ji, Ise Yamada, Mie-ken
Jihō-ji, Kyōto
Jimyō-ji, Nara
Jingo-ji, Takao, Kyōto
Jingū Museum of Antiquities, Ise, Mie-ken
Jishō-in, *see* Shōkoku-ji
Jizō-in (1), Kōyasan, Wakayama-ken
Jizō-in (2), Kyōto
Jōdō, *see* Hōryū-ji
Jōdo-ji (1), Onomichi, Hiroshima-ken
Jōdo-ji (2), Onomachi, Hyōgo-ken
Jōei-ji, Yamaguchi-ken
Jōfuku-ji, Kyōto
Jōju-ji, Wakayama-ken
Jōkei-in, Kōyasan, Wakayama-ken
Jonen-ji, Kyōto
Jōraku-ji, Kamakura
Jōruri-ji, Kyōto
Jōshin-ji, Tōkyō
Jukō-in, *see* Daitoku-ji

Kagoshima Municipal Art Museum, Kagoshima-ken
Kaihō-ji, Kyōto
Kakuon-ji, Kamakura
Kamakura National Treasure House
Kamman-ji, Akita-ken
Kanagawa Prefectural Museum of Modern Art, Kamakura
Kangaku-in, *see* Onjō-ji
Kanju-ji, Kyōto
Kankikō-ji, Kyōto
Kannondō (1), Nara
Kannondō (2), Niigata-ken
Kannon-ji (1), Shiga-ken
Kannon-ji (2), Tōkyō
Kanzeon-ji, Tsukushi-gun, Fukuoka-ken
Kashima-jinja, Sawara, Chiba-ken
Kasuga Shrine Treasure House, Nara
Katori-jinja, Sawara, Chiba-ken
Katsura Imperial Villa, Kyōto
Katte-jinja, Yoshino, Nara-ken
Kazan Bunko Museum, Aichi-ken
Keiun-ji, Himeji, Hyōgo-ken
Kempuku-ji, Nagano-ken
Kenchō-ji, Kamakura
Kennin-ji, Kyōto
Kimbell Art Museum, Fort Worth, Texas
Kimpusen-ji, Yoshino, Nara-ken
Kinkaku-ji, *see* Rokuon-ji
Kinsuien Art Museum, Beppu, Ōita-ken
Kita-in, Kawagoe, Saitama-ken
Kitano Temman-gū Treasure House, Kyōto
Kiyomizu-dera, Kyōto
Kōbe Municipal Art Museum

Kōchi City Hall, Kōchi-ken
Kōdai-ji, Kyōto
Kōdō, *see* Tōdai-ji
Kōfuku-ji (1) Treasure Hall, Nara
Kōfuku-ji (2), Tōkyō
Kōfuku-ji (3), Nagasaki
Kōgon-ji, Tōkyō
Kohō-an, *see* Daitoku-ji
Kōjaku-ji, Aichi-ken
Kokeidō, *see* Tōdai-ji
Kōkoku-ji, Yura, Hidaka-gun, Wakayama-ken
Konchi-in, *see* Nanzen-ji
Kondō, *see* Hōryū-ji
Kongōbu-ji, Kōyasan, Wakayama-ken
Kongōchō-ji, Kōchi-ken
Kongō-in, Kyōto
Kongō-ji, Ōsaka
Kongōrin-ji, Matsudera, Shiga-ken
Kōrin-ji, Nara
Kōryū-ji, Kyōto
Kōshō-ji, Kyōto
Kotohira Shrine Museum, Kagawa-ken
Kōun-ji, Kyōto
Kōzan-ji (1), Togano-o, Kyōto
Kōzan-ji (2), Wakayama
Kōzō-ji Museum, Setoda-machi, Hiroshima-ken
Kudara-dera, Shiga-ken
Kurama-dera, Kyōto
Kuwanomi-dera, Shiga-ken
Kyōōgokoku-ji, *see* Tō-ji
Kyōto (1) City Art Museum
Kyōto (2) National Museum

Lake Biwa Cultural Hall, Ōtsu
Los Angeles County Museum of Art, California

Mampuku-ji, Kyōto
Manju-in, Kyōto
Manju-ji (1), Kyōto
Manju-ji (2), Mie-ken
Matsunaga Memorial Hall, Odawara, Kanagawa-ken
Matsuno-o-dera, Nara-ken
Matsuura Local Historical Museum, Hirado
Meiji Shrine, Tōkyō
Metropolitan Museum of Art, New York
M. H. De Young Museum, *see* Fine Arts Museums of San Francisco
Minase-jingū, Ōsaka
Minatogawa-jinja, Kōbe
Minneapolis Institute of Arts, Minnesota
Miyazaki Prefectural Museum
Monju-in, Abeno, Nara-ken
Muryō-ji, Wakayama-ken
Musée (1) d'Art et d'Histoire, Geneva
Musée (2) Guimet, Paris
Musée (3) National d'Art Moderne, Paris
Musées Royaux d'Art et d'Histoire, Brussels
Museu (1) Calouste Gulbenkian, Lisbon
Museu (2) Nacional de Arte Antigua, Lisbon
Museum (1) für Kunst und Gewerbe, Hamburg
Museum (2) für Ostasiatische Kunst, Cologne
Museum (2a) für Völkerkunde, Vienna
Museum (3) of Fine Arts, Boston, Massachusetts
Museum (4) of Modern Art, New York
Museum (5) voor Land- en Volkenkunde, Rotterdam
Myōgun-ji, Aichi-ken
Myōhō-in, Kyōto
Myōkō-ji, Aichi-ken
Myōkoku-ji, Okayama-ken
Myōō-ji, Okayama-ken
Myōshin-ji, Kyōto

Nagaoka Contemporary Art Museum, Niigata-ken
Nagasaki Municipal Museum
Nagoya Castle Treasure House
Nandaimon, *see* Tōdai-ji
Nanzen-ji, Kyōto
Nara National Museum
Narazuhiko-jinja, Nara

Naritasan History Hall, Shinshō-ji, Narita, Chiba-ken
National (1) Gallery of Canada, Ottawa
National (2) Gallery of Victoria, Melbourne
National (3) Museum, Copenhagen
National (4) Museum of Modern Art, Kyōto Branch
National (5) Museum of Modern Art, Tōkyō
Neiraku Museum, Nara
Nelson Gallery–Atkins Museum, Kansas City
Nembutsudō, *see* Tōdai-ji
Newark Museum, New Jersey
New York Public Library
Nezu Art Museum, Tōkyō
Nijō Castle, Kyōto
Ninna-ji, Kyōto
Nishi Hongan-ji, Kyōto

Ōbai-in, *see* Daitoki-ji
Odawara Castle Museum, Kanagawa-ken
Ohara (1) New Art Museum, Kurashiki, Okayama-ken
Ohara (2) Pottery Hall, Kurashiki, Okayama-ken
Okayama Art Museum, Okayama-ken
Ōkura Shūko-kan, Tōkyō
Onjō-ji, Ōtsu-shi, Shiga-ken
Ōsaka (1) Castle Tower
Ōsaka (2) Municipal Art Museum
Östasiatiska Museet, Stockholm
Österreichisches Museum für Angewandte Kunst, Vienna
Ōtori-jinja, Meguro-ku, Tōkyō
Otsune Goten, *see* Imperial Palace (1)
Ōzō-ji, Gifu-ken

Philadelphia Museum of Art, Pennsylvania
Portland Art Museum, Oregon

Raifu-ji, Imba-gun, Chiba-ken
Rakan-ji, Tōkyō
Reidō-in, *see* Kennin-ji
Reiun-in, *see* Myōshin-ji
Rengeō-in, *see* Myōhō-in
Rhode Island School of Design, Providence
Riccar Art Museum (Rikka Bijutsukan), Tōkyō
Rietberg Museum, Zurich
Rijksmuseum (1), Amsterdam
Rijksmuseum (2) voor Volkenkunde, Leiden
Rinka-in, *see* Myōshin-ji
Rinnō-ji (1), Nikkō
Rinnō-ji (2), Ueno, Tōkyō
Rokuhara Mitsu-ji, Kyōto
Rokuō-in, Saga, Kyōto
Rokuon-ji, Kyōto
Royal (1) Ontario Museum, Toronto
Royal (2) Scottish Museum, Edinburgh
Ryōgen-in, *see* Daitoku-ji
Ryōkan Memorial Collection, Izumozaki-machi, Niigata-ken
Ryōsoku-in, *see* Kennin-ji
Ryūden-ji, Saga-ken
Ryūgaku-ji, Nagano-ken
Ryūsen-an, *see* Myōshin-ji
Ryūshi Kinenkan, Tōkyō
Ryūtaku-ji, Shizuoka-ken

Saidai-ji, Nara
Saifuku-ji, Ōsaka
Saihō-in, Nara
Saikō-in, Nara
Saikō-ji, Aichi-ken
Sainen-ji (1), Nara
Sainen-ji (2), Tokoname, Aichi-ken
Sambō-in, *see* Daigo-ji
Sangen-in, *see* Daitoku-ji
Sanjūsangendō, *see* Myōhō-in
Sanzen-in, Kyōto
Sata-jinja, Ōsaka
Seattle Art Museum, Washington
Seichō-ji Tomioka Tessai Gallery, Takarazuka, Hyōgo-ken
Seikei-in, Wakayama-ken
Seinan-in, Kōyasan, Wakayama-ken
Seiryō-ji, Kyōto
Seishō-ji, Kyōto

Sekigan-ji, Hyōgo-ken
Sekkei-ji, Kōchi-ken
Sendai Municipal Museum, Miyagi-ken
Senjū-ji, Mie-ken
Senkō-ji, Gifu-ken
Sennyū-ji, Kyōto
Sensō-ji, Tōkyō
Shina-jinja, Shiga-ken
Shin Daibutsu-ji, Mie-ken
Shinju-an, *see* Daitoku-ji
Shinshō Gokuraku-ji, Kyōto
Shinshō-ji, Narita, Chiba-ken
Shishinden, *see* Imperial Palace (1)
Shitennō-ji, Ōsaka
Shōden-ji, Kyōto
Shōfuku-ji, Kōbe
Shōgaku-in, Ishikawa-ken
Shōgo-in, Kyōto
Shōin, *see* Rokuon-ji
Shōin-ji, Shizuoka-ken
Shōju-in, Kyōto
Shōkoku-ji, Kyōto
Shōraku-ji, Wakayama-ken
Shōsō-in Treasure House, Tōdai-ji, Nara
Shōtaku-in, Kyōto
Shūgakuin Detached Palace, Kyōto
Shunjōdō, *see* Tōdai-ji
Shūon-an, Kyōto
Smith Art Gallery, Northampton, Massachusetts
Sōdō-ji, Wakayama-ken
Sōfuku-ji, Nagasaki
Sonju-ji, Mie-ken
Springfield Museum, Massachusetts
Staatliche Museen Berlin, Ostasiatische Kunstabteilung
 (West Berlin)
Stanford University Art Gallery and Museum, California
Suntory Art Gallery, Tōkyō

Taihei-ji, Nagoya
Taima-dera, Shimoda, Nara-ken
Taisan-ji, Tarumi-ku, Kōbe
Taizō-in, *see* Myōshin-ji
Takano-jinja, Tsuyama, Okayama-ken
Takayama Local Museum, Gifu-ken
Tamon-in, Inzai, Chiba-ken
Tekisui Art Museum, Ashiya, Hyōgo-ken
Temman-gū, Ōsaka
Tempuku-ji, Chiba-ken
Tenju-an, *see* Nanzen-ji
Tenkyū-in, *see* Myōshin-ji
Tenrin-ji, Lake Shinji, Shimane-ken
Tenryū-ji, Kyōto
Tenshō-ji, Kyōto
Tōdai-ji, Nara
Tōfuku-ji, Kyōto
Tō-ji, Kyōto
Tōju-in, Okayama-ken
Tōkai-an, *see* Myōshin-ji
Tokiwa-jinja, Mito, Ibaraki-ken
Tokiwayama Collection, Kamakura
Tōkō-ji, Hagi, Yamaguchi-ken
Tokugawa Art Museum, Nagoya
Tokuyu-ji, Nara
Tōkyō (1) National Museum
Tōkyō (2) University of Arts Exhibition Hall
Toledo Museum of Art, Ohio
Tōshōdai-ji, Nara
Tōshō-gū, Kawagoe, Saitama-ken
Toyokuni-jinja, Kyōto

Uesugi Shrine Treasure House, Yonezawa, Yamagata-ken
Umezawa Kinenkan, Tōkyō
University (1) Art Museum, University of California, Berkeley
University (2) of Michigan Museum of Art, Ann Arbor

Victoria and Albert Museum, London

Wadsworth Atheneum, Hartford, Connecticut
Walters Art Gallery, Baltimore

Waseda University Tsubouchi Memorial Theatre Museum,
 Tōkyō
Whitney Museum, New York
Worcester Art Museum, Massachusetts

Yakuō-in, Saitama-ken
Yakushidō, *see* Daigo-ji
Yakushidō (1), Nagoya
Yakushidō (2), Shiga-ken
Yakushidō (3), Tochikubo, Tochigi
Yakushi-ji, Nara
Yale University Art Gallery, New Haven
Yamagata Art Museum, Yamagata-ken
Yamakawa Foundation of Art, Ishikawa-ken

Yamatane Museum of Art, Tōkyō
Yamato Bunkakan, Nara
Yasaka-jinja, Kyōto
Yawataden, *see* Tōdai-ji
Yōgen-in, Kyōto
Yōgo-ji, Ōita-ken
Yoshimizu-jinja, Yoshino

Zenkō-ji, Nagano, Nagano-ken
Zenkyō-an, *see* Kennin-ji
Zenrin-ji, Kyōto
Zenshō-ji, Kyōto
Zuigan-ji, Matsushima, Miyagi-ken
Zuishin-in, Kyōto

Appendix 2
Art Organizations and Institutions

Académie Colarossi. A painting academy in Paris much frequented by Japanese artists in the late 19th and early 20th centuries.

Académie Julian. Well-known art school in Paris of the 19th and early 20th centuries.

Art Committee of the Imperial Household. In charge of all arts for the imperial household. From 1868 known as the Teishitsu Gigeiin; after 1945, as the Gyobutsu-gakari.

Bijutsu Bunka Kyōkai (Art and Culture Association). Founded in 1939 by 40 Western-style painters, former members of the Dokuritsu Bijutsu Kyōkai, Nikakai, etc. Headquarters near Ueno in Tōkyō. Publishes an annual magazine and holds an annual open exhibition in Tōkyō, Nagoya, and the Kansai district.

Bijutsuka Remmei (Artists' Union League). Founded about 1945 by Ihara Usaburō.

Bunka Gakuin. Nonaccredited liberal arts school in Tōkyō.

Bunten (Mombushō Bijutsu Tenrankai). Started in 1907 under the sponsorship of the minister of education, holding an annual exhibition. In 1919, became the Teiten (Imperial Art Academy Exhibition); except for 1923, annual exhibition until 1934; crafts section added in 1927, prints in 1932. In 1935 and again in 1937, reorganized and called Shin Bunten; held exhibitions until 1943 and a special War Exhibition in 1944. In 1946, name changed to Nihon Bijutsu Tenrankai (Nitten) and included Japanese- and Western-style painting and sculpture as well as crafts; calligraphy added in 1948. From 1949 to 1957 under joint sponsorship of Nitten organizing committee and Nihon Geijutsuin. In 1958 became independent; called Nippon Bijutsu Tenrankai, but exhibition still known as Nitten.

Daiichi Bijutsu Kyōkai. Established in 1929 as a society of oil painters; in 1952, arts-and-crafts section added. Annual exhibitions, one open, another for members only. Many members all over Japan.

Dai Nikikai. Established in 1947 by former members of the Nikakai.

Dokuritsu Bijutsu Kyōkai (Independent Art Association). Organized in 1930 by 14 painters who left the Nikakai; first exhibition held in 1931, annual show still held. Members interested in surrealism left in 1939 to organize the Bijutsu Bunka Kyōkai.

Enjusha. Founded in 1924 by Kanazawa Shigeharu, Kumaoka Yoshihiko, Makino Torao, and Saitō Yori.

Fudōsha. Koyama Shōtarō's private school in Tōkyō.

Fusainkai. First postimpressionist group in Japan. Founded by Saitō Yori in 1912 in opposition to more academic Japanese groups and to promote the style of the fauves. Two exhibitions: 1912, 1913. After second show, society disbanded because of dissension among members; nevertheless, of great influence.

Gyobutsu-gakari. *See* Art Committee of the Imperial Household.

Hakubakai (White Horse Society). School and artists' association of Western-style painters. Founded in 1896 by Kuroda Seiki, Kume Keiichirō, and Andō Nakatarō. Promoted Western art, particularly plein-airism. Dissolved in 1910. Successor to the Meiji Bijutsukai as dominant school of Western art.

Hakujitsukai. Established in 1924 by oil painters and sculptors from the circles of former government exhibitions; first show in 1925.

Ichiyōkai. Society of oil painters and sculptors, established in 1955 by artists who seceded from the Nikakai.

Imperial Art Academy. *See* Teikoku Bijutsuin.

Imperial Fine Arts Academy. *See* Teikoku Geijutsuin.

Inten. *See* Nihon Bijutsuin.

Issen Bijutsu. Established in 1951 by oil painters and sculptors.

Issuikai. Organized in 1936 by artists from the Teiten "to honor pure and correct art." First show in 1937. Exhibits Western-style painting of rather conservative tendencies together with pottery.

Japan Art Academy. *See* Nihon Geijutsuin.

Japan Art Institute (Inten). *See* Nihon Bijutsuin.

Japan Handicrafts Association. *See* Nihon Kōgeikai.

Japan Painting Society. *See* Nihongakai.

Jiyū Bijutsuka Kyōkai. Founded in 1936 by Hasegawa Saburō and others.

Jiyū Gadan (Free Art Circle). Founded by Matsuura Baisō.

Jounsha. Founded in 1865; Mori Kansai one of the founders.

Jūichikai (Society of Eleven). Founded in 1878 by a group of students from the Kōbu Daigaku Bijutsu Gakkō, including Asai Chū, Koyama Shōtarō, Takahashi Genkichi, and others.

Kangakai (Painting Appreciation Society). Founded in 1884 by Fenollosa, Okakura Tenshin, Hashimoto Gahō and Kanō Hōgai to promote Japanese-style painting.

Kansai Art Academy. *See* Kansai Bijutsuin.

Kansai Bijutsuin. Founded in 1901.

Kawabata Gagakkō. School founded in Tōkyō in 1909 by Kawabata Gyokushō.

Kinreisha. Founded in 1917 by Kaburagi Kiyokata.

Kōbe Kaiga Kyōkai (Kōbe Painters' Society). Founded in 1918 by Ōhashi Suiseki and Hashimoto Kansetsu.

Kōbu Daigaku Bijutsu Gakkō (Technical Art School). Attached to the College of Engineering, founded by the government in

1876 to educate artists in the Western style. A. Fontanesi and A. Sangiovanni invited from Italy to teach. Closed in 1883.

Kōdō Bijutsu Kyōkai. Art society founded after 1945.

Kōfūkai. Established in 1912 by Atomi Tai, Nakasawa Hiromitsu, Yamamoto Morinosuke, and Miyake Katsumi, all originally members of the Hakubakai who had connections with the Teiten. Still holds annual exhibitions of Western-style art.

Kojikai (Artists' Discussion Group). Founded in 1898 by Hayamizu Yoshi, Imamura Shikō, Yasuda Yukihiko, and Isoda Chōshū. Dissolved in 1913.

Kokuga Gyokuseikai. Founded by a few painters who were dissatisfied with the Bunten and wanted to promote Japanese-style painting. Members rejoined the Bunten at time of third Bunten show.

Kokugakai. Organized in Kyōto in 1918 as the Kokuga Sōsaku Kyōkai (National Creative Painting Association) by Japanese-style painters. In 1925 a section of Western-style painting added and in 1931 a print section under Hiratsuka Un'ichi. In 1928 all Japanese-style artists left, in 1939 the sculptors left; section of Western oil painting survived and holds an annual exhibition.

Kokuga Sōsaku Kyōkai. See Kokugakai.

Kyōshinkai. Competitive prize exhibition.

Kyōto Bijutsu Kyōkai (Kyōto Art Association). Organized in 1890.

Kyōto College of Fine Arts. See Kyōto Prefectural School of Painting.

Kyōto Municipal School of Fine Arts and Crafts (Kyōto Bijutsu Kaiga Kōgei Gakkō). See Kyōto Prefectural School of Painting.

Kyōto Prefectural School of Painting. Founded in 1880. Offered four divisions: east course: *yamato-e* and realistic painting; west course: European painting; north course: Kanō and Sesshū schools of painting with Kōno Bairei as teacher; south course: *bunjinga*. In 1894 reorganized and called Kyōto Municipal School of Fine Arts and Crafts. By 1900, four divisions reduced to two: European and Oriental painting. European section finally dropped as result of growing nationalism. In 1910 school came to be known as Kyōto College of Fine Arts.

Meiji Bijutsukai (Meiji Art Society). Founded in 1888 by Asai Chū, Harada Naojirō, Koyama Shōtarō, and others. First exhibition in Ueno in 1889. Dissolved in 1900; reestablished in 1902 as Taiheiyō Gakai (q.v.).

Meirō Bijutsu Remmei. Art society founded by Ochiai Rōfū.

Modern Art Kyōkai. Established in 1950. From 1951 an annual exhibition of painting and sculpture. Members include painters, sculptors, printmakers, designers, photographers. Publishes an annual magazine.

Museikai. Founded in 1900 by a group of pupils of Kawabata Gyokushō "to uphold naturalism as opposed to the romanticism of the Nihon Bijutsuin." Subjects included genre scenes, pictures of workers and peasants. Held exhibitions until 1913.

Naikoku Kaiga Kyōshinkai (Domestic Painting Competitive Exhibition). Established in 1882.

Naikoku Kangyō Hakurankai (Domestic Exposition). Founded in 1887; closed in 1903.

Nihon Bijutsuin (Japan Art Institute, or Inten). Founded in 1898 by Okakura Tenshin, Hashimoto Gahō, Yokoyama Taikan, Shimomura Kanzan, and Hishida Shunsō for the study of art and the holding of exhibitions. In 1914, after Okakura's death, reorganized as Saikō Nihon Bijutsuin (q.v.) and was called Inten; until 1920 included Western art; until 1961 included sculpture. From 1961, two exhibitions a year of Japanese-style painting only.

Nihon Bijutsukai (Japan Art Society). Established in 1946 "to create art among the public, defend peace, oppose bureaucratic administration." Annual exhibition: Independent Art Exhibition.

Nihon Bijutsu Kyōkai (Japan Art Association). The Ryūchikai (q.v.) became this organization in 1887. A conservative group; has its own building in Ueno Park. Annual exhibition, sponsored by several business firms, until 1961.

Nihon Chōkokukai (Japanese Sculpture Association). Founded in 1907 by Hiragushi Denchū and others.

Nihon Chōsoka Kurabu (Japanese Sculptors' Society). Established in 1947; became Nihon Chōsokai in 1961.

Nihon Chōsokai See Nihon Chōsoka Kurabu.

Nihongain. Founded in 1938 by a group of Japanese-style painters as a successor to the Nihongakai.

Nihongakai. Founded in 1897 by Kaburagi Kiyokata.

Nihon Geijutsuin (Japan Art Academy). In 1947 the Teikoku Bijutsuin became this organization. An honorary institution of 100 life members. Awards the Imperial Prize and the Japan Art Academy Prize.

Nihon Hanga Kyōkai (Japanese Print Association). Founded in 1931. A fusion of the Nihon Sōsaku Hanga Kyōkai, the Yōfū Hangakai, and other groups of printmakers. Annual exhibition.

Nihon Jiyū Gakai (Japanese Independent Painting Association). Dissolved in 1929.

Nihon Mokuchōkai. Founded in 1931 by Naitō Shin to promote interest in wood sculpture.

Nihon Nangain. Founded in 1921 in Kyōto; held exhibitions until 1940. After 1945 the Nangain was organized, and in 1960 all the *nanga* painters formed the Nippon Nangain. Annual exhibitions in Kyōto and Ōsaka.

Nihon Nanga Kyōkai. Founded in 1897 by painters of the *nanga* school.

Nihon Seinen Kaiga Kyōkai. Founded in 1891; no longer exists.

Nihon Sōsaku Hanga Kyōkai. Established in 1918 by a group of print artists. Four objectives: diffusion of knowledge of art of engraving; promotion of the art through exhibitions; campaign to have prints exhibited at the Teiten; establishment of Department of Engraving at Tōkyō School of Fine Arts.

Nihon Suisaigakai (Japanese Watercolor Society). Founded by Nakagawa Hiromitsu, Ishii Hakutei, and Tobari Kogan in 1913. Annual exhibition open to nonmembers.

Nihon Suisaiga Kenkyūsho (Japan Watercolor Institute). Founded in 1907 by Ōshita Tōjirō and others. The school is run by the Nihon Suisaigakai.

Nikakai. Organized in 1914 by a group of dissident oil painters in opposition to the Bunten: the first nongovernment-sponsored Western-style painters' group. Sculpture added in 1919. Reorganized in 1945 to include crafts, photography, commercial art. Annual exhibition.

Nikikai. See Dai Nikikai.

Nineteen Thirty Association. Founded in 1926 under the leadership of Saeki Yūzō and Maeda Kanji; dissolved in 1930.

Nippon Bijutsu Tenrankai. See Bunten.

Nitten. See Bunten.

Ōgenkai. See Ōgensha.

Ōgensha. Founded in 1933 by Makino Torao and his pupils; disbanded during World War II. Reconstituted in 1946 as Ōgenkai; holds annual painting exhibition.

Order of Cultural Merit. One of Japan's most distinguished awards, given annually by the government since 1937.

Ryūchikai. Founded in 1879 to restore traditional art. In 1887 expanded and became Nihon Bijutsu Kyōkai.

Ryūkikai. Inaugurated in 1949 by 18 oil painters.

Saikō Nihon Bijutsuin (Inten). Reestablished Japan Art Institute, set up in 1914 by Yokoyama Taikan, Shimomura Kanzan, Imamura Shikō, and Yasuda Yukihiko. Three divisions: Japanese-style painting; oil painting (abolished in 1920); sculpture. In 1938 eight members of the Nihon Bijutsuin joined; in 1958 became a juridical foundation. Annual exhibition.

Seiha Dōshikai (Orthodox Society). Founded in 1907.

Seikokan. School founded in 1887 by Yamamoto Hōsui.

Seiryūsha. Founded in 1929 by Kawabata Ryūshi and former members of the Nihon Bijutsuin to further Japanese-style painting. Held annual exhibition at Nihombashi Mitsukoshi until death of Ryūshi in 1966, after which members formed a new organization, the Tōhō Bijutsu Kyōkai.

Sekiyokai. Artists' discussion and exhibition group, founded in 1914 by Imamura Shikō; disbanded on his death in 1916.

Shigenkai. Established in 1947 by a group of oil painters. Annual exhibition.

Shin Bunten. See Bunten.

Shinjukai. Established in 1947 by a group of 13 artists. Annual exhibition.

Shinkō Yamato-e-kai. Revived Yamato school of painting.

Among the founders were Endō Kyōzō and Matsuoka Eikyū. Disbanded in 1931.

Shin Nihonga Kyōkai (New Japan Painting Association). Established in 1918 by Shimomura Izan, Maruyama Banka, and Ibaki Inokichi.

Shinseiki Bijutsu Kyōkai (New Century Art Association). Established in 1955 by oil painters from the Nitten. Annual exhibition.

Shin Seisaku Kyōkai. Established in 1936 by a group of oil painters. In 1939 seven sculptors joined, in 1949 seven architects, and in 1951 a group of Japanese-style painters who were members of the Sōzō Bijutsu Kyōkai, an organization formed in 1948. Very active; annual exhibits in Tōkyō and other major cities.

Shinshokai (New Craftsman's Group). Made up of artists working in ceramics, lacquer, and fabrics.

Shirakabakai. Humanist literary group, active in introducing the work of French artists to Japan.

Shobikan. Harada Naojirō's private school.

Shōgidō Gajuku. Kunisawa Shinkurō's private school.

Shōgoin Yōga Kenkyūsho. Started in Kyōto by Asai Chū.

Shun'yōkai. Founded in 1922 by dissidents from the Nihon Bijutsuin, Western painting division, and those newly returned from Europe, plus some dissidents from the Sōdosha. Shows Western-style art in exhibitions open to nonmembers.

Sōdosha (Grass and Earth Society). Founded in 1916 by Kimura Shōhachi and others.

Sōgenkai. Founded in 1941 by Western-style painters from the Bunten. Annual exhibition. Members also show with the Nitten.

Suisai Remmei. Established in 1940 by a group of water-color painters. Annual exhibition.

Taiheiyō Gakai. Started in 1902 as a successor to the Meiji Bijutsukai. Runs the Taiheiyō Kenkyūsho. Now called Taiheiyō Bijutsukai. Annual exhibition in Tōkyō and other major cities.

Teikoku Bijutsuin (Imperial Art Academy). Organized in 1937 by the government as a practical continuation of the Teikoku Geijutsuin, with the addition of two new divisions of literature and music.

Teikoku Geijutsuin (Imperial Fine Arts Academy). Established in 1919 by imperial order as a successor to the Fine Art Selection Committee, which had been founded in 1907 by imperial decree and which selected works of art to be shown in exhibitions subsequently organized by the Ministry of Education.

Teiten. See Bunten.

Tenkai Gakusha. Private school founded by Takahashi Yuichi.

Tenshin Dōjō. Kuroda Seiki's private school founded in 1894.

Tōdai Chōsokai (Tōdai Sculptors' Association). Founded by Aoki Sotokichi. No longer exists.

Tōhō Bijutsu Kyōkai. Founded in 1967 as a successor to the Seiryūsha.

Tōhō Chōsoin (Eastern Sculptors' Association). Founded in 1935 by Hasegawa Eisaku.

Tōkōkai. Organized in 1932 by oil painters from the Teiten; since 1933 its exhibition open to nonmembers as well as members.

Tōkyō Bijutsu Gakkō (Tōkyō School of Fine Arts). Founded by the government in 1887 to teach Japanese-style art; in 1896 a Western art department was added. Fenollosa, Okakura Tenshin, and Hashimoto Gahō active in its founding. Continues today as the Art Department of Tōkyō University of Arts.

Tōkyō Chōkokukai (Tōkyō Sculptors' Association). Founded in 1886.

Tōkyō Hangakai (Tōkyō Print Society). Organized in 1912 by Hiroshima Kōho.

Tōkyō School of Fine Arts. See Tōkyō Bijutsu Gakkō.

Tōkyō University of Arts (Tōkyō Geijutsu Daigaku). Founded in 1949.

Tomoekai. Established in 1902.

Ugōkai (Society of Cormorants). Organized by Kaburagi Kiyokata in 1901 for ukiyo-e and Western-style artists. Dissolved in 1912.

Women's Art School. Established in Tōkyō in 1900; after 1949 known as Women's Art College.

Yōfū Hangakai (Western-Style Print Artists' Society). Chiefly lithographers. Disbanded in 1931 to make way for the larger society of the Nihon Hanga Kyōkai.

Appendix 3
Art Periods of Japan, Korea, and China

The controversy over dating Oriental art periods seems endless. The three tables given below follow, in general, those in Sherman Lee's *History of Far Eastern Art*.

ART PERIODS OF JAPAN

Archaeological Age, c. 4000 B.C. to A.D. 552
 Jōmon, c. 4000 B.C. (?) to c. 200 B.C.
 Yayoi, c. 200 B.C. to c. A.D. 250
 Kofun, c. 250 to 552
Asuka, 552–645
Nara, 645–794
 Hakuhō (Early Nara), 645–710
 Tempyō (Late Nara), 710–794
Heian, 794–1185
 Jōgan (Early Heian), 794–897
 Fujiwara (Late Heian), 897–1185
Kamakura, 1185–1336
Nambokuchō, (Northern and Southern Courts) 1336–92
Muromachi (Ashikaga), 1392–1573
Momoyama, 1573–1615
Edo (Tokugawa), 1615–1868
Meiji, 1868–1912
Taishō, 1912–26
Shōwa, 1926–

ART PERIODS OF KOREA

Three Kingdoms, 57 B.C. to A.D. 668
 Koguryo dynasty, 37 B.C. to A.D. 668
 Paekche dynasty, 18 B.C. to A.D. 668
 Old Silla dynasty, 57 B.C. to A.D. 668
United Silla, 668–935
Koryō period, 918–1392
Yi dynasty, 1392–1910
Period of Japanese rule, 1910–45
Republic, 1945–

ART PERIODS OF CHINA

Shang or Yin dynasty, c. 1500 B.C. to c. 1100 B.C.
Chou dynasty, c. 1100 B.C. to 221 B.C.
 Period of the Warring States, 481–221 B.C.
Ch'in dynasty, 221–206 B.C.
Han dynasty, 206 B.C. to A.D. 221
Six Dynasties, 221–589
Sui dynasty, 589–618

T'ang dynasty, 618–906
Five Dynasties, 906–960
Sung dynasty, 960–1280
Yüan dynasty, 1280–1368

Ming dynasty, 1368–1644
Ch'ing dynasty, 1644–1912
Republic, 1912–

Appendix 4
Japanese Provinces and Prefectures

Each item of the following listing gives the name of a pre-Meiji province followed by the name(s) of the modern prefecture(s) that contain(s) all or part of that province's area.

Aki = Hiroshima
Awa (on Honshū) = Chiba
Awa (on Shikoku) = Tokushima
Awaji = Ōsaka
Bingo = Hiroshima
Bitchū = Okayama
Bizen = Okayama
Bungo = Ōita
Buzen = Fukuoka, Ōita
Chikugo = Fukuoka
Chikuzen = Fukuoka
Echigo = Niigata
Echizen = Fukui
Etchū = Toyama
Harima = Hyōgo
Hida = Gifu
Higo = Kumamoto
Hitachi = Ibaraki

Hizen = Saga, Nagasaki
Hōki = Tottori
Hyūga = Miyazaki
Iga = Mie
Iki = Nagasaki
Inaba = Tottori
Ise = Mie
Iwaki = Fukushima, Miyagi
Iwami = Shimane
Iwashiro = Fukushima
Iyo = Ehime
Izu = Shizuoka
Izumi = Ōsaka
Izumo = Shimane
Kaga = Ishikawa
Kai = Yamanashi
Kawachi = Ōsaka
Kazusa = Chiba
Kii = Wakayama, Mie

Kōzuke = Gumma
Mikawa = Aichi
Mimasaka = Okayama
Mino = Gifu
Musashi = Saitama, Tōkyō, Kanagawa
Mutsu = Aomori, Iwate, Akita
Nagato = Yamaguchi
Noto = Ishikawa
Oki = Shimane
Ōmi = Shiga
Ōsumi = Kagoshima
Owari = Aichi
Rikuchū = Iwate
Rikuzen = Miyagi, Iwate
Sado = Niigata
Sagami = Kanagawa
Sanuki = Kagawa

Satsuma = Kagoshima
Settsu = Ōsaka, Hyōgo
Shima = Mie
Shimōsa = Chiba, Ibaraki
Shimotsuke = Tochigi
Shinano = Nagano
Suō = Yamaguchi
Suruga = Shizuoka
Tajima = Hyōgo
Tamba = Kyōto, Hyōgo
Tango = Kyōto
Tosa = Kōchi
Tōtōmi = Shizuoka
Tsushima = Nagasaki
Ugo = Akita
Uzen = Yamagata
Wakasa = Fukui
Yamashiro = Kyōto
Yamato = Nara

Glossary

Aizen Myōō: a manifestation of Dainichi Nyorai or of Kongō Satta.

ajari (literally, "holy man"): a Buddhist title.

aka-e: painting in red on porcelain.

Akita *ranga* style: name given to the type of pseudo-Western painting done in Akita in the 18th century, which combined the Western chiaroscuro and perspective of Dutch engravings with the detailed naturalism of some Chinese 18th-century painting.

Ami: the name of the family of hereditary artistic advisers and painters to the shogunate in the 15th and 16th centuries. Nōami, his son Geiami, and his grandson Sōami were the most important members.

Amida: the Buddha Amida, Lord of Infinite Light; the most widely worshiped of all the manifestations of the Buddha.

Amida triad: the Buddha Amida between two Bodhisattvas.

angya: a pilgrimage made by a disciple from one Zen master to another.

Asahi-yaki: ceramics made at Asahi, near Uji. An ancient kiln, producing nothing of importance until Kobori Enshū had tea wares made there c. 1640.

azukari: chief artist and director of the Edokoro. He had a number of assistants who in turn had inferior officers—probably mounters—below them. He combined functions of court painter and keeper of the imperial collection of paintings.

Azuma nishiki-e (literally, "eastern embroidered pictures"): paintings in many colors resembling silk embroideries from Azuma, or eastern Japan.

bakufu: military government under a shogun.

Batō Kannon: the Horse-headed Kannon.

beni-e: a black-line hand-colored print in which the dominant color is *beni* (a tawny yellow dye extracted from petals of safflowers) applied with a brush.

benizuri-e: primitive polychrome print, at first pink and green, later with addition of yellow and purple.

Benzaiten: female deity of speech and learning. Depicted as a beautiful woman, she bestows ability, wisdom, and good fortune.

bijin: a beautiful woman: a "beauty."

bijinga: pictures of beautiful women.

bijutsu: art.

Bishamonten: one of the Shi Tennō, also called Tamonten. Holds a pagoda in his left hand, a spear in his right; guards the north.

Bodhidharma (Japanese: Daruma): Indian monk who came to China in 520 and founded the Ch'an (Zen) sect of Buddhism.

Bodhisattva (Japanese: Bosatsu): Buddhist deity who has renounced Buddhahood in order to work for the salvation of all beings.

bonshi: Buddhist title. When prefixed to a name, it indicates that the individual had been previously attached to a heretical sect before accepting Buddhism.

Bonten: Japanese name for Brahma.

-bori: see *-hori*.

Bosatsu: *see* Bodhisattva.

Brahma: Indian deity, the supreme god of the Brahmans; worshiped in Japan as Bonten, guardian of the Buddhist law and protector of the world.

Bugaku: ancient court dance of a semireligious nature in which masks covering only the face were worn. *See also* Gigaku.

bunjinga (Chinese: *wen jen hua*): literary men's painting. See *nanga*.

busshi (literally, "Buddhist master"): professional sculptors who generally produced statues only for Buddhist temples. Each group, or guild, of sculptors had a hereditary chief known as the *dai busshi*.

bussho: a workshop of Buddhist sculptors.

butsuga: paintings on Buddhist themes.

byōbu: a folding screen.

Ch'an: the meditative sect of Buddhism, introduced in the 13th century from China to Japan, where it was called Zen.

chapbook: name used for the publications of popular literature, cheap in price and illustrated with woodblock prints.

chinkin-bori: a lacquer technique in which the fine lines of a design engraved on a lacquer ground are filled in with powdered gold or lacquer of another color.

chinsō: portrait of a Zen priest.

chōshitsu: Chinese carved lacquer: also known as cinnabar lacquer.

chūban: a medium-sized print, about 8 by 12 inches.

dai busshi: a master Buddhist sculptor. See also *busshi*.

daigaku: university.

Dainichi Nyorai: the Supreme and Eternal Buddha in Esoteric Buddhism.

Daitō Kokushi (14th c.): prominent priest, founder and first abbot of the Daitoku-ji, Kyōto, the most active center of the Zen sect in Japan.

Daruma: *see* Bodhidharma.

-dera: suffix meaning (Buddhist) temple.

ebusshi: Buddhist painter.

Edo: early name of Tōkyō and name of the historical period 1615–1868.

Edokoro: Office of Painting. It consisted of a group of officially appointed artists, established at the court as early as the 9th century, and produced paintings commissioned by the court for both private and official purposes. In the Kamakura period similar groups were established at temples and shrines. In the 15th century, the Ashikaga shoguns set up an Edokoro to serve the requirements of their household, a system continued by the succeeding Tokugawa regime when it fostered the celebrated Tosa and Kanō schools.

ema: votive painting.

emaki: see *emakimono*.

emakimono: horizontal scroll painting.

e mekiki: inspector of imported paintings and other works of art; a position in Nagasaki under the Tokugawa *bakufu*. See also *kara-e mekiki*.

Emma: in Buddhist iconography, a king of hell.

En school: *see* Sanjō Bussho.

eshi: master painter.

Fenollosa, Ernest F. (1853–1908): Harvard graduate who went to Japan in 1878 to lecture on philosophy, political science, and economics. As a great supporter of Japanese traditional art, he helped establish the system for classifying National Treasures.

Fontanesi, Antonio (1818–81): an Italian painter working in the Barbizon style. Came from the Turin Royal Academy of Art; was invited to teach at the Kōbu Daigaku Bijutsu Gakkō. A great influence on early Japanese Western-style painting.

Fudō: *see* Fudō Myōō.

Fudō Myōō: chief of the Go Dai Myōō; a manifestation of Dainichi Nyorai. Represented with a fierce expression, he holds a sword and a rope and stands against a background of flames.

Fugen Bosatsu: the Bodhisattva of the Highest Good or Universal Wisdom; usually depicted riding an elephant.

Fujiwara: the ruling family of Japan in the 10th and 11th centuries. Also a family of painters of the *yamato-e* school. *See under* Fujiwara *for individual artists*.

fukko yamato-e: the conscious revival of *yamato-e* painting in the 19th century.

Fukūkensaku Kannon: the Kannon with the Never Empty Net.

fusuma: sliding doors, made on a wooden frame and covered with thick paper that is sometimes decorated with paintings or calligraphy. The doors can either divide rooms or close off cupboards.

gauffrage: in woodblock printing, embossing achieved by printing from uncolored blocks.

geijutsu: fine arts.

Gempin: a ware made in Owari Province by a Korean who came to Japan and settled in Seto about the beginning of the 17th century. Roughly painted with cobalt under the glaze, which is a whitish-gray color. The style perished with the founder.

gengyō scrolls ("seed" scrolls): sutras dealing with spiritual manifestations.

Genji Monogatari (The Tale of Genji): the greatest novel in early Japanese literature, written in the first decade of the 11th century by Lady Murasaki; it mirrors the court life and the aesthetic preoccupations of the Heian aristocracy.

genre: representations of scenes from everyday life.

Genroku: the name of the era (*nengō*) from 1688–1704, noted for its luxury.

Gigaku: ancient dance in which masks covering the entire head were worn. *See also* Bugaku.

gō: pseudonym used by an artist.

Go Dai Myōō: the Five Great Kings, deities of fierce and terrifying mien who serve as guardians of the Buddhist faith.

gofun: a white pigment made from either lead white or pulverized oyster shells.

goyō eshi: a master painter employed by the court or *bakufu.*

grass script: the cursive script, called *sōsho* in Japanese, in which the characters are extremely abbreviated.

-gū: suffix meaning (Shintō) shrine.

guri-bori: a lacquer technique of making V-shaped cuts into layers of different color lacquer to reveal the layers.

gyōbu: a lacquer term derived from the name of the lacquer artist. It refers to the use of large particles—either "crumbs" of a gold-silver alloy or "flakes," possibly of crumpled sheet gold—applied separately to the lacquer. It is found only on lacquer pieces of great technical excellence.

haboku: in monochrome ink painting, the "flung-ink" technique.

Hachiman: Shintō deity, god of war.

haiga: painting plus *haiku.*

haikai: a short verse form, limited to 17 syllables arranged in the pattern of 5-7-5, brought to perfection by Matsuo Bashō (1644–94). At present, *haiku* is the more popular term for this type of verse, *haikai* the more academic.

haiku: see *haikai.*

hanga: woodblock print.

Han Shan (Japanese: Kanzan): one of two (the other is Shih Te) Chinese comic sages and practitioners of Ch'an Buddhism who lived in a Chinese monastery in the 7th century. They are regarded as incarnations of Bodhisattvas.

Hasegawa: the school of painting founded by Hasegawa Tōhaku, who claimed artistic descent from Sesshū. This school was an outgrowth of Muromachi *suiboku* painting. The style of the later members can hardly be distinguished from contemporary Kanō painting. *See under* Hasegawa *for individual artists.*

hashira-e: pillar print or painting. A long, narrow picture hung on an interior post as a decoration.

Heian: early name of Kyōto and of the historical period 794–1185.

Heiji Monogatari: the story of the Heiji insurrection in 1159, which began the struggle between the Taira and Minamoto families.

hibachi: ceramic, metal, or wood brazier in which charcoal is burned to warm a room.

Hidetada: son of Ieyasu, father of Iemitsu; second Tokugawa shogun; ruled 1616–23.

Hideyoshi (Toyotomi Hideyoshi; 1536–98): military dictator. Born a peasant, served Oda Nobunaga, and in 1582 became ruler of Japan.

hōgen: "eye of the law." Second honorary ecclesiastical rank, at first for priests, later for Buddhist sculptors, still later for painters. See also *hōin* and *hokkyō.*

hōin: "seal of the law." Top honorary ecclesiastical rank, at first for priests, later for Buddhist sculptors, still later for painters. See also *hōgen* and *hokkyō.*

hokkyō: "bridge of the law." Lowest honorary ecclesiastical rank, at first for priests, later for Buddhist sculptors, still later for painters. See also *hōgen* and *hōin.*

Hondō: the building in a Buddhist temple devoted to religious ceremonies as opposed to those buildings comprising the priests' living quarters.

Hōnen Shōnin (1133–1212): founder of the Jōdo (Pure Land or Amida's Paradise) sect of Buddhism.

-hori (-bori): carving, chiseling, or engraving of lacquer.

hosoban: a narrow vertical print, about 6 by 13 inches.

hoso-e: see *hosoban.*

Hossō: Buddhist sect introduced from China about 650. It claims that the only reality is consciousness.

Hossō Rokuso: the Six Patriarchs of the Hossō Sect, who, according to tradition, lived during the Nara period (646–794) and were active in establishing the Hossō sect in Japan. There is little historical evidence about them.

Hotei: Japanese name for P'u Tai.

Hsia Kuei: *see* Ma Yüan.

Ieharu: tenth Tokugawa shogun; ruled 1760–86.

Iemitsu: third Tokugawa shogun; ruled 1623–51.

Ietsuna: fourth Tokugawa shogun; succeeded Iemitsu in 1651.

Ieyasu (1542–1616): member of the Tokugawa family; prominent in the armies of Nobunaga, became master of Japan after Hideyoshi's death; founder and greatest head of the Tokugawa shogunate.

iji-iji-nuri: lacquer decoration of faint and delicately executed designs.

Ikkyū (1394–1481): Zen priest known for his learning, his poetry, and his unconventional behavior; was once chief abbot of the Daitoku-ji, Kyōto.

-in: suffix meaning (Buddhist) temple.

inrō: a small box, usually of lacquer, for holding drugs or ointment, carried at the waist by men of the Edo period.

In school: *see* Shichijō Ōmiya Bussho.

Japanese-style painting; this term refers to the work of those painters who, from about the mid-19th century to the present, have painted Japanese subjects in Japanese media and as a rule have not belonged to any of the older schools of painting.

-ji: suffix meaning (Buddhist) temple.

Jie Daishi: Priest Ryōgen (912–85), posthumously called Gangan Daishi or Jie Daishi: a high priest of the Tendai sect.

Jikokuten: one of the Shi Tennō, guardian of the east.

-jingū: suffix meaning (Shintō) shrine.

-jinja: suffix meaning (Shintō) shrine.

Jittoku: one of two famous Zen practitioners (the other is Kanzan) usually represented as Chinese sages. Japanese name for Shih Te.

Jizō: frequently represented Buddhist deity shown as a priest with a shaven head; generally regarded as the patron of children and of those in trouble.

Jōdo: Buddhist sect founded by Hōnen Shōnin. Also called the Pure Land sect. It teaches that salvation lies in invoking the name of Amida Buddha.

Jūichimen Kannon: Eleven-headed Kannon.

Jūni Shinshō: the twelve guardians of Yakushi Nyorai.

Jūniten: the Twelve Guardian Deities: a group of 12 non-Buddhist heavenly beings who were incorporated into Buddhism as protective gods.

Kabuki: the popular Japanese theater. It originated from dance shows given in Kyōto in the 17th century. Kabuki actors served as a principal theme for ukiyo-e printmakers.

kachō: flowers and birds.

kachōga: bird-and-flower pictures.

Kaga-makie: a kind of *makie* made in Kaga.

Kaihō: a school of painting founded by Kaihō Yūshō, who had studied Kanō painting but departed from Kanō precepts. *See under* Kaihō *for individual artists.*

kakebotoke: hanging circular plaque with Buddhist figures in high relief.

kakemono: vertical scroll painting, made to hang on a wall.

Kako Genzai Inga-kyō (Sutra of Past and Present, Cause and Effect): a sutra relating events in the incarnations of the Buddha.

Kamakura-bori: type of lacquer made in Kamakura by carving and polishing layers of red *urushi* over an underlayer of black, applied to a thin base of wood.

kamban: theatrical signboards or posters.

"Kambun Beauties": pictures of *bijin* dating from the Kambun era (1661–73).

Kamigata-e: the name of the school of printmakers and book illustrators who worked in Kyōto and Ōsaka, generally in the ukiyo-e manner, in the 18th and 19th centuries. However, some of the artists were members of the Kanō and *nanga* schools.

Kannon: Japanese name for Kuan Yin.

Kanō: a school of painting that started in the mid-15th century, based on the Muromachi *suiboku* school plus a few elements of the Tosa manner. In the Edo period it became the official school of the shogunate. It was founded by Masanobu and put on a firm basis by Motonobu. Hereditary members all carried the name Kanō. *See under* Kanō *for individual artists.*

Kanzan: one of two famous Zen practitioners (the other is Jittoku) usually represented as Chinese sages. Japanese name for Han Shan.

kappa-suri: stencil painting.

kara-e mekiki: inspector of Chinese paintings; an official position under the *bakufu* at Nagasaki. See also *e mekiki.*

Katsukawa school: a name derived from that of Katsukawa Shunshō (1726–93), who dominated the field of theatrical prints from about 1770 until the late 1780s. His pupils all took the name of Katsukawa. *See under* Katsukawa *for individual artists.*

Kegon-kyō (The Flower Wreath Sutra): a voluminous sutra setting forth the practices of a Bodhisattva and serving as the basic doctrine of the Kegon sect.

Kegon sect (in Chinese, Hua-yen-tsung): a Buddhist sect based on the *Kegon Sutra* and introduced into Japan from China in 736. Its doctrines, expounded by a priest from the Korean kingdom of Silla in 740, have to do with the worship of the Buddha Rushana (Vairocana), much favored by the Japanese court in the 8th century.

Kei school: *see* Shichijō Bussho.

kibyōshi: yellow-cover books. Generally cheap popular novels, so called because they were always bound in yellow covers.

Kichijōten: goddess of fortune, depicted as a beautiful woman in ceremonial dress.

kimetsuke: a lacquer technique of *makie* in relief, studded with patterns in gold or silver flakes.

kinrande: literally, "gold brocade." In ceramics it refers to wares elaborately decorated in colored overglaze enamels and gold.

kirigane: kiri (cut) + *kane* (gold, metal). Sheet gold, or gold foil, cut to form decorations and laid into lacquer. Originally it was cut in small rectangles.

Kishi: a school of painting founded by Kishi Ganku, whose style was influenced by both Ch'ing bird-and-flower painting and the contemporary Shijō school. *See under* Kishi *for individual artists.*

Kōbō Daishi (744–835): founder of the Shingon (Esoteric) sect of Buddhism. His real name was Kūkai, Kōbō Daishi being his posthumous title.

Kobori Enshū (1570–1646): famous tea master and designer of gardens.

kōchi: an imitation of so-called Cochin-China ware—a green, aubergine, yellow-glazed ware, sometimes with molded designs, from a site still unknown but probably in South China.

Kōdō: lecture hall of a Buddhist temple.

Kondō: main hall of a Buddhist temple.

Kongō Satta: a Bosatsu, shown holding a pestle and a bell, found in the pantheon of Esoteric Buddhism.

Kose: a long line of painters descended from Kose no Kanaoka. In the hands of pupils coming from other families, the Kose school developed into the great national, or Tosa, school of painting. *See under* Kose *for individual artists.*

koto: a kind of zither with a long, narrow sounding board and strings of twisted silk.

Kuan Yin: the most popular Bodhisattva, generally represented as the god of mercy; in China and Japan, usually considered a female deity.

kuro-hon: books in black covers; cheap, popular novels.

-kyō (or *-gyō*): suffix usually meaning "sutra."

kyōga: "crazy" drawing; comic sketches.

Kyōgen: comic interludes between performances of Nō plays.

kyōka: comic or satirical poems.

Kyō Kanō school: founded by Kanō Sanraku, it continued the Kanō tradition in Kyōto through the 19th century.

Kyō-yaki: Kyōto ware. The name generally refers to ceramics made in Kyōto from the mid-17th through the 19th century.

maiko: a young girl in training to become a *geisha.*

Maitreya: the Buddha of the Future; sometimes depicted as a Bosatsu.

makie: maki (to sprinkle) + *e* (picture). Gold or silver powder is sprinkled on the still wet lacquer ground or on the design already drawn on the background, in alternating layers of lacquer and metal powders.

makie-shi: master lacquer artist.

mandara: a mandala, or schematic diagram of Buddhist deities, usually in the form of a painting and intended to explain the doctrines of Esoteric Buddhism.

mandorla: in Buddhist art, a large shield or screen placed behind a Buddhist figure. It is generally either almond-shaped or pointed at the top and straight at the bottom, with curving sides.

Manjusri: the Bodhisattva who represents wisdom; often depicted riding a lion.

Maruyama: a school of painting founded by Maruyama Ōkyo, who first studied Kanō painting, then turned to realistically detailed bird-and-flower painting in Ch'ing style, was also interested in Western perspective, and advocated making preliminary sketches from nature. *See under* Maruyama *for individual artists.*

Ma Yüan (c. 1190–1224): famous painter of the Southern Sung Academy at Hangchow. His name is often linked with that of Hsia Kuei, and together their work gave rise to the Ma-Hsia school.

Michinaga (966–1027): member of the Fujiwara family who controlled the Kyōto court for almost thirty years.

Minamoto Yoritomo (d. 1199): leader of the Minamoto clan and founder of the military dictatorship of the Kamakura period.

mingei: folk art.

Miroku: Japanese name for Maitreya.

mon: family crest, sometimes placed on ceremonial kimono or objects of lacquer.

Monju Bosatsu: Japanese name for Manjusri.

monogatari: a story.

Mu-ch'i: Chinese painter and Ch'an priest of the first half of the 13th century. His monochrome ink paintings are preserved mostly in Japan.

Muromachi *suiboku* school: a school that originated under the influence of Chinese Sung and Yüan dynasty paintings brought to Japan by Zen monks in the 14th century. At first, the Japanese paintings were very close to the Chinese models, with Chinese themes and in ink alone; but soon the tendency to use Japanese landscape themes and more color and to pay more attention to human figures became evident.

Musō Kokushi (1275–1351): leading Zen prelate of his day, head of the Rinzai sect. He first served Emperor Godaigo but then, when this emperor went to Yoshino, transferred his loyalty and became adviser to Ashikaga Takauji. His actual name was Musō Soseki, and Kokushi, or "National Master," was his title.

Musō Soseki: see Musō Kokushi.

Mustard-Seed Garden (Chieh-tzu Yüan Hua-ch'üan): Chinese painter's manual published in 1679. It featured color prints illustrating Chinese painting methods and subjects.

Myōe Shōnin (1173–1232): priest and founder of the Kōzan-ji, Kyōto; contributor to the revival of Kegon Buddhism at the beginning of the Kamakura period. His actual name was Kōben, and Myōe Shōnin was an honorary title.

Myōō (literally," Shining King"): *see* Go Dai Myōō.

naga-e: a long, narrow print.

Nagasaki-e: pictures made in Nagasaki presenting the Japanese view of foreigners and their ships.

Nagasaki school: a type of painting based on the Chinese models consisting of brightly colored bird-and-flower paintings and portraits noted for realistic detail. The naturalized Chinese artist Itsunen is regarded as the founder; its members were largely from Nagasaki.

naiki: an official of the central secretariat. He was in charge of drafting edicts and recording official court affairs. Usually a good calligrapher was appointed to this office.

namban (literally, "southern barbarian"): a term applied to the first Europeans to appear in Japan (mid-16th century).

nanga: the literary men's school of painting. Originally influ-

enced by 18th-century Chinese painting. Also called *bunjinga* (q.v.). Its members, like their Chinese predecessors, sought to be individual in their painting; they were frequently Confucian scholars, poets, and calligraphers. Unlike almost all other schools of painting in Japan, it was not dependent on family relationship.

nashiji: nashi (Japanese pear) + *ji* (ground). A gold lacquer ground, owing its name to its similarity to the granular skin of the Japanese pear. In Europe, often called aventurine lacquer.

natsume: a tea caddy made of lacquer.

Negoro-nuri: a kind of lacquer in which a coating of black lacquer is painted over the priming and is then covered with a coat of vermilion lacquer.

netsuke: toggle used in suspending an *inrō* or a tobacco pouch from the obi.

Nichiren (1222–82): priest and founder of the Nichiren sect of Buddhism.

Nihon: Japan.

Niō: Benevolent Kings. Temple-gate guardians, also called Kongō Rikishi.

nishiki-e: elaborate polychrome print in more than ten colors.

Nobunaga (Oda Nobunaga; 1534–82): first of the three military heroes of the 16th century (the others were Hideyoshi and Ieyasu) to dominate the contending clans and temple strongholds and to unify Japan.

Nō: the classic Japanese drama.

nuidononosuke (nuidonosuke): deputy supervisor of the sewing department (including embroidery) at the imperial court.

nuri: lacquer coating.

Nyorai: a Buddha; the name of the particular Buddha precedes it.

Ōbaku sect: a sect of Zen Buddhism, founded by the Chinese priest Ingen (1592–1673), who became a naturalized Japanese.

Okakura Tenshin (Okakura Kakuzō; 1862–1913): art critic and teacher. He had a tremendous influence on the development of traditional Japanese art. With Fenollosa and Hashimoto Gahō, he was put in charge of the Tōkyō School of Fine Arts when it opened in 1889. In the same year, with Takahashi Kenzō, he began publication of the journal *Kokka.* In 1897, following a bitter quarrel, he resigned from the art school with a number of the professors and former students; eventually established the Nihon Bijutsuin (Japan Art Institute).

ōkubi-e: a painting or print showing either only the head or the head and upper part of the torso.

oku eshi: painter of the inner court. The *oku eshi* were a subgroup of the *goyō eshi.* They worked only for aristocratic clients and received an annual stipend of 100 *koku* (about 500 bushels) of rice—enough to feed 20 people for a year.

omote eshi: painter of the outer court. The *omote eshi* were a subgroup of the *goyō eshi* and were official government painters available to all levels of the urban bourgeoisie.

Ōsaka print school: a group of artists who devoted themselves almost entirely to theatrical subjects. The prints are easily recognized by a certain hardness of treatment, combined with brilliance of coloring. In their training, many of the artists owed allegiance to Shun'ei, Hokusai, and Kunisada. Their whole output was probably produced between 1820 and 1845. Issues of 2- and 4-sheet prints were a specialty of Ōsaka (Edo prints were in 3 or 5 sheets). They also specialized in *kappasuri.*

pillar print: see *hashira-e.*

P'u Tai (in Japanese, Hotei): a gay wandering monk, a favorite subject in Ch'an painting. He symbolizes the carefree life of one who, through the study of Ch'an, has overcome the troubles of everyday life.

raigō: the descent of the Buddha to this world.

Rakan: Japanese name for Lohan, a Buddhist sage who has achieved enlightenment and is endowed with supernatural powers obtained through religious austerities; depicted often as an ascetic, singly or in groups of 16, 18, or 500.

Raku: a type of hand-molded, generally thickly glazed pottery, particularly tea bowls.

ranga: Western-style painting. See *yōga.*

Rimpa school: the decorative school of art of the 17th, 18th, and 19th centuries, founded by Sōtatsu. It emphasized asym-

metrical compositions, simple silhouettes, and a great variety of color. Formerly known as the Sōtatsu-Kōrin school.

Rinzai sect: a sect of Zen Buddhism, introduced into Japan by Eisai (1141–1215) on his return from China. Patronized by the emperor, the shogunate, the nobility, and the warriors of the Kamakura and Muromachi periods. Many famous temples were built in its name.

risshi: "teacher of the law." A Buddhist title.

Rokujō Marikōji Bussho: Kamakura-period school of sculptors in Kyōto, founded by Inchō; *dai busshi:* Inshō.

Ryūtōki: goblin holding a lantern.

Sakyamuni (Japanese: Shaka Nyorai): the historical Buddha; also called Gautama.

Sanjō Bussho: Kamakura-period school of sculpture in Kyōto. Said to have been established by Chōsei in the 11th century. Myōen was a leading member. It is also known as the En school (Empa), since many of the members had names employing the character *en* (円).

sencha: tea ceremony using leaf tea instead of powdered tea.

Senju Kannon: Thousand-armed Kannon.

Sen no Rikyū (1520–91): famous connoisseur, tea master, arbiter of taste, expert in flower-arrangement, adherent of Zen.

Shaka Nyorai: Japanese name for Sakyamuni.

Shichijō Bussho: sculptors' studio founded in Kyōto by Kakujō and continued there by his son Injō. Another son, Raijō, went to Nara and estabilshed the Shichijō Bussho there, where it became the headquarters of the Kei school under Kōkei and his followers, all of whom employed the character *kei* (慶) in their names.

Shichijō Ōmiya Bussho: the continuation of the Shichijō Bussho in Kyōto under Injō; headquarters of the In (or Impa) school of sculptors, many of whom employed the character *in* (院) in their names.

Shih Te (Japanese: Jittoku): one of two (the other is Han Shan) comic sages and famous practitioners of Ch'an Buddhism who lived in a Chinese monastery in the 7th century. They are regarded as incarnations of Bodhisattvas.

Shijō: school of painting founded by Goshun. It was really an offshoot of the Maruyama school and lasted well into the 19th century. It differed from the parent school in its softer and more gentle approach to *kachōga* and landscape.

Shingon: the Esoteric sect of Buddhism introduced from China by Kōbō Daishi.

Shinran (1173–1262): priest, follower of Hōnen, founder of Jōdo Shinshū (True Sect of Jōdo).

Shintō (literally, "the way of the gods"): the national religion of Japan.

Shi Tennō (literally, "Four Heavenly Kings"): the four guardians of the Buddhist world.

shitōga: finger-tip painting; one of the special conceits of *bunjinga.*

shō busshi: a minor Buddhist sculptor.

shogun (Japanese: *shōgun):* title of the military dictators of Japan from the Kamakura period through the Edo period.

Shō Kannon: the ordinary form of Kannon.

Shōki: the devil fighter; a figure from Chinese Taoism.

shōnin: priest, saint.

Shonzui: Japanese name for Cochin-China ware.

Shōtoku Taishi (572–622): prince regent for the empress Suiko; promoted the growth of Buddhism, developed relations with China, and laid down lines for political reforms.

-shū: suffix usually meaning "anthology" or "collection."

shunga (literally, "spring pictures"): a name for prints or paintings of erotic scenes.

Shunkei-nuri: a lacquer technique using transparent lacquer.

Shun'oku Myōha (1311–88): a Buddhist priest.

Sōgyō Hachiman: the Shintō god Hachiman as a Buddhist monk.

Sōtatsu-Kōrin school: see Rimpa school.

Sōtō sect: a Zen sect, founded by Dōgen (1200–1253). It generally appealed to farmers and warriors. It teaches that enlightenment is sudden, not gradual, and insists on self-discipline and introspection. The Eihei-ji, Fukui-ken, is the head temple.

Sugawara Michizane (845–903): man of letters, scholar of Chinese literature, and adviser to the Kyōto court. As the victim of an intrigue, he was banished to Kyūshū, where he died. He was posthumously deified and is worshiped as the god of learning and calligraphy.

suiboku (literally, "water and ink"): the leading Muromachi school of painting. The paintings are done in ink with light washes of color used only occasionally.

sumi-e: painting done in Chinese ink.

Sumiyoshi school: founded by Sumiyoshi Jokei, this hereditary school carried on the Tosa style.

sumizuri-e: a black-and-white print.

sumō: Japanese traditional wrestling.

surimono: a deluxe print made for a special occasion in a limited edition, usually inscribed with a poem composed for the occasion.

sutra: Buddhist sacred literature; a book of the Buddhist canon.

Taishakuten: Buddhist deity, Lord of the Thirty-three Heavens; one of the Jūniten.

Takuma: a family school of painters of the late Heian and Kamakura periods. Some of the most distinguished members of this school were actually scions of the Kose line. They specialized in Buddhist subjects and worked in Kyōto in a new manner influenced by the Chinese Sung style and its freer postures of the figures and variations in thickness of line. *See under* Takuma *for individual artists.*

Tamonten: one of the Shi Tennō and of the Jūniten; guardian of the northern quarter of the Buddhist heaven. *See* Bishamonten.

tan-e: hand-colored print in which *tan* (red lead) is the dominant pigment.

tanka: a short poem of 31 syllables, divided 5-7-5-7-7. The form appears among the early poems of the *Man'yōshū.*

temmoku: the name by which Chinese *chien* ware is known in Japan.

Ten (literally, "heavenly or divine being"): the Ten were originally gods and goddesses of Brahmanism and Hinduism and were later assimilated into Buddhism.

Tendai: the Esoteric Buddhist sect introduced from China by Saichō (767–822), the priest who studied in China from 804 to 805.

Tentōki: a goblin holding a lantern.

Thirty-six Poets: in Japanese classical literature, the best known poets prior to the 11th century. They became a favorite subject for painters.

togidashi: designs executed in lacquer by means of metallic powders or lacquers of pulverized colors. The finished result produces a decoration similar to water-color painting.

tōji: ceramics.

tōki: pottery or porcelain.

Torii school: the name refers to a family of printmakers who, beginning with Torii Kiyonobu, set the style for prints of actors and dominated this branch of printmaking from about 1695 until the rise of Katsukawa Shunshō about 1770.

Tosa: a school of painting founded in the early years of the Muromachi period. It carried on the Japanese painting tradition, known as *yamato-e,* of the Heian and Kamakura narrative scrolls. The name of the school, however, came into use in the first half of the 13th century, when it was adopted by Tsunetaka. *See under* Tosa *for individual artists.*

Tsubai Bussho: a Muromachi school of sculptors.

Tsugaru-nuri: a technique involving many layers of colored lacquer, which, when polished, produce a mottled effect.

Tsunayoshi: fifth Tokugawa shogun, in office from 1680 to 1709; noted for his Confucian scholarship and artistic taste as well as for his cruelty.

Uesugi Shigefusa: military lord of the Kamakura period; founder of the Uesugi family, members of which were advisers to the shoguns.

uki-e: painting in which a bird's-eye perspective is used to show the inside of a building or the whole of a landscape from above.

ukiyo-e school: from *ukiyo-e* (literally, "pictures of the floating world"). It refers to the large number of painters and printmakers who depicted the gay plebeian world of the Edo period.

Unkoku school: founded by Unkoku Tōgan in the Momoyama period. Its members served the Mōri clan as *kakae-eshi* (painters sponsored by a daimyo). Many of them lived in or near Hagi, Suō Province, the feudal capital of the clan. The style of painting was based on that of Sesshū. The school continued into the 18th century. The names of the artists usually begin with the character *tō* (等). *See under* Unkoku *for individual artists.*

urushi: lacquer

urushi-e: literally, "lacquer picture." In narrowest sense, the term refers to true lacquer painting, in which lacquer serves as a binding agent; more broadly, to all lacquer painting techniques as opposed to "sprinkled" (*makie*) techniques. Also, a hand-colored print in which transparent glue is used to create a lacquerlike effect.

Utagawa school: most prolific of the ukiyo-e schools. Founded by Utagawa Toyoharu in the late 18th century, it was continued by his pupils in the 19th century. Toyohiro and Toyokuni are among the best-known members. *See under* Utagawa *for individual artists.*

Vairocana (Vairochana): central figure in the Kegon pantheon.

waka: Japanese poetry.

Western-style painting: the term refers to the work produced by artists working both technically and aesthetically in the Western manner from the early Meiji era to the present.

yakusha-e: painting or print of an actor.

Yakushi Nyorai: the Buddha of Healing.

yamato-e: the national school of painting from Yamato, the old name for Nara Prefecture. Developed in the Heian period, it used purely Japanese subject matter derived from Japanese poetry and romances and was totally free from any Chinese influence.

Yin T'o-lo: painter of the Sung dynasty, member of the Southern Sung Academy at Hangchow; better known in Japan than in China.

yōga: literally, "foreign painting." The term refers to the work done by the artists who were influenced by the Christian art objects brought to Japan by the missionaries in the Momoyama period; to the artists who, after the expulsion of the missionaries early in the Edo period, were influenced by illustrated books and engravings imported in the course of the trade with Holland; and to the artists who studied European art early in the Meiji era. The last, however, are generally known as Western-style artists.

Yoritomo: see Minamoto Yoritomo.

Yoshimasa (1435–90): Ashikaga shogun from 1449 to 1473; noted for his weak administration and his lavish building.

Yoshimochi (1386–1428): Ashikaga shogun from 1408 to 1423 and from 1425 to 1428.

Yoshimune: eighth Tokugawa shogun, in office from 1716 to 1745; considered to have been, after Ieyasu, the greatest of the Tokugawa shoguns.

Yoshiwara: name of the licensed quarter in Edo.

Yūzū Nembutsu Engi (Stories of the Origin of Yūzū Nembutsu Buddhism): a picture scroll.

Zen: Japanese for Ch'an.

zenga: Zen painting. The term usually refers to the intentionally naive, eccentric, and often zany painting of the Zen monks of the Edo period.

Zōchōten: one of the Shi Tennō; guardian of the south.

Bibliography

As explained in the Preface, where initial words are the same in two or more of the following entries, numerals are inserted in parentheses immediately after such words and serve as reference numbers in the body of the book.

Adachi, Barbara. *Living Treasures of Japan.* Tōkyō, New York, San Francisco: Kōdansha International, 1973

Akiyama (1) Terukazu. *Heian Jidai Sezokuga no Kenkyū* (Secular Painting of the Heian Period). Tōkyō: Yoshikawa Kōbunkan, 1964

———— (2). *La peinture japonaise.* Geneva: Editions d'Art, Albert Skira, 1961

Akiyama (3) Teruo. *Kimpeki Sōshokuga-shū* (Collection of Gold-Ground Decorative Paintings), 4 vols. Tōkyō: Jurakusha, 1930–35

———— (4). *Momoyama Jidai Shōhekiga Zushū* (Collection of Momoyama Wall Paintings). Tōkyō: Jurakusha, 1939

———— (5). *Nihon Bijutsu Ronkō* (A Study of Japanese Art). Tōkyō: Daiichi Shobō, 1943

Art (1) d'Umehara: oeuvres choisies par lui-même, L'. Tōkyō: Yomiuri Shimbunsha, 1960

Art (1a) japonais à travers les siècles, L' (catalogue). Paris: Musée Nationale d'Art Moderne, 1958

Art (2) Treasures from Japan (catalogue). Tōkyō: Kodansha International, 1965

Asai Chū Meisaku Ten (Exhibition of Masterpieces by Asai Chū) (catalogue). Tōkyō: Bridgestone Museum of Art, 1969

Asano Nagatake, Kobayashi Yukio, and Hosokawa Moritatsu, eds. *Genshoku Meiji Hyakunen Bijutsukan* (Color Reproductions of Meiji Centennial Exhibition). Tōkyō: Asahi Shimbunsha, 1967

Au-delà dans l'art japonais, L' (catalogue). Paris: Petit Palais, 1963

Ausgewählte Werke ostasiatischer Kunst (catalogue). Berlin: Staatliche Museen für Ostasiatische Kunst, 1970 (second edition)

Awa Gajin Meika (Famous Painters of Awa). Tokushima: Tokushima-ken Kyōikukai, 1968

Awakawa Yasuichi. *Zen Painting* (translated by John Bester). Tōkyō and Palo Alto, California: Kōdansha International, 1970

Binyon (1), Laurence. *A Catalogue of Japanese and Chinese Woodcuts Preserved in the Sub-Department of Oriental Prints and Drawings in the British Museum.* London: British Museum, 1916

———— (2). *Japanese Art.* London, Berlin, and Paris: The International Art Publishing Co., (n.d.)

Binyon (3), Laurence, and Sexton, J. J. O'Brien. *Japanese Colour Prints.* London: Faber and Faber, 1960

Blakeney, Ben Bruce. *Yoshida Hiroshi: Print-Maker.* Tōkyō: The Foreign Affairs Association of Japan, 1953

Blunt, Wilfred. *Japanese Colour Prints, from Harunobu to Utamaro.* London: Faber and Faber, 1952

Boller, Willy. *Masterpieces of the Japanese Colour Woodcut.* London: Elek Books, 1957

Bowie, Theodore. *The Drawings of Hokusai.* Bloomington, Indiana: Indiana University Press, 1964

Boyer, Martha. *Catalogue of Japanese Lacquers.* Baltimore: The Walters Art Gallery, 1970

Brasch (1a), Heinz. *Peinture à l'encre du Japon (Nanga et Haiga)* (catalogue). Geneva: Collections Baur, 1968

Brasch (1), Kurt. *Hakuin und die Zenmalerei.* Tōkyō: Deutsche Gesellschaft für Natur- und Völkerkunde Ostasiens, 1957

———— (2). *Zenga.* Tōkyō and Hamburg: Deutsche Gesellschaft für Natur- und Völkerkunde Ostasiens, 1961

Brown, Louise Norton. *Block Printing and Book Illustration in Japan, from the Earliest Period to the Twentieth Century.* London: George Routledge and Sons, 1924

Buhot, Jean. *Histoire des arts du Japon,* vol. 1. Paris: Van Oest, 1949

Bummei Kaika Nishiki-e-shū: Yokohama-e to Kaika. See Nonogami Keiichi.

Bunjinga Santaikan-shū (Three Bunjinga Masters). Tōkyō: Shimbi Shoin, 1909

Buson Meigafu (Famous Paintings by Buson). Tōkyō: Yahankai, 1933

Butsuzō Chōkoku Annai (A Guide to Buddhist Sculpture). Nara Teishitsu Hakubutsukan, ed. Kyōto: Benridō, 1939

Cahill, James. *Scholar Painters of Japan: The Nanga School.* New York: The Asia Society, 1972

Casal, U. A. *Japanese Art Lacquers.* Tōkyō: Sophia University, 1961

Castile, Rand. *The Way of Tea.* New York and Tōkyō: Weatherhill, 1971

Cent-cinquante ans de peinture au Japon: de Gyokudō à Tessai (catalogue of an exhibition held at the Petit Palais, Paris). Paris: Petit Palais, 1962

Ceramic (1) Art of Japan: One Hundred Masterpieces from Japanese Collections (catalogue). Seattle: Seattle Art Museum, 1972

Ceramic (2) Art of Kitaōji Rosanjin: Three American Collections (catalogue). Tōkyō and Kyōto: Benridō, 1964

Ceramic (3) Art of Yaichi Kusube, The. Tōkyō: Chūō Kōron Bijutsu Shuppan, 1968

Chūsei Shōbyōga (Special Exhibition of Medieval Painting) (catalogue). Kyōto: Kyōto National Museum, 1969

Conder, Josiah. *Paintings and Studies by Kawanabe Kyōsai.* Tōkyō: Maruzen, 1911

Contemporary Japanese Ceramic Art (catalogue). Kyōto: National Museum of Modern Art, 1963

Covell (1), Jon Carter. *Japanese Landscape Painting.* New York: Crown Publishers, 1962

———— (2). *Masterpieces of Japanese Screen Painting, the Momoyama Period.* New York: Crown Publishers, 1962

———— (3). *Under the Seal of Sesshū.* New York: De Pamphilis Press, 1941 (privately printed)

Crighton, R. A. *The Floating World: Japanese Popular Prints, 1700–1900* (catalogue). London: Victoria and Albert Museum, 1973

Daijō-in Jisha Zōjiki, 1472 (Diaries and Memoranda of the Daijō-in, 1472). Tsuji Zennosuke, ed. Tōkyō: Ushio Shobō, 1931–37

Dailey, Merlin C. *The Raymond A. Bidwell Collection of Prints by Utagawa Kuniyoshi (1789–1861)* (catalogue). Springfield, Massachusetts: Museum of Fine Arts, 1968

Dessins et livres japonais des XVIIIe et XIXe siècles (catalogue). Geneva: Musée d'Art et d'Histoire, Cabinet des Estampes, 1972

Doi (1) Tsugiyoshi. *Chion-in,* in the series Shōhekiga Zenshū (Collection of Wall Paintings). Tōkyō: Bijutsu Shuppan-sha, 1969

———— (2). *Daikaku-ji,* in the series Shōhekiga Zenshū (Collection of Wall Paintings). Tōkyō: Bijutsu Shuppan-sha, 1964

———— (3). *Kanō Sanraku to Kanō Sansetsu ni Tsuite* (Concerning Kanō Sanraku and Kanō Sansetsu). Kyōto: Kyōto National Museum, 1940

———— (4). *Kyōto Bijutsu Taikan* (General Outline of Fine Arts in Kyōto: Paintings). Tōkyō: Tōhō Shoin, 1933

———— (5). *Momoyama Shōhekiga no Kanshō* (An Appreciation of Momoyama Wall Painting). Tōkyō: Hōunsha, 1943

———— (6). *Nishi Hongan-ji,* in the series Shōhekiga Zenshū (Collection of Wall Paintings). Tōkyō: Bijutsu Shuppan-sha, 1968

——— (7). *Sanraku-ha Gashū* (Paintings of the Sanraku School). Kyōto: Bunshōdō, 1944

——— (8). *Sanraku to Sansetsu* (Sanraku and Sansetsu). Kyōto: Kuwana Benseidō, 1943

——— (9). *Shōhekiga* (Wall Paintings), in the series Nihon Rekishi Shinsho. Tōkyō: Shibundō, 1966

——— (10). *Tōhaku,* in the series Nihon no Meiga (Famous Japanese Paintings). Tōkyō: Heibonsha, 1956

Ebara Jun. *Enkū, His Life and Work.* Tōkyō: Sansaisha, 1961

Elisséev, Serge. *La Peinture contemporaine au Japon.* Paris: E. de Boccard, 1923

Emakimono Gaisetsu (Outline of Scroll Paintings), in the series Iwanami Kōza Nihon Bungaku. Tōkyō: Iwanami Shoten, 1932

Exhibition (1) *of Japanese Painting and Sculpture Sponsored by the Japanese Government* (catalogue). Tōkyō: 1953

Exhibition (2) *of Kanjirō Kawai* (catalogue). Kyōto: Kyōto National Museum of Modern Art, 1968

Feddersen, Martin. *Japanese Decorative Art* (translated by Katherine Watson). London: Faber and Faber, 1962

Fenollosa, Ernest F. *Epochs of Chinese and Japanese Art,* 2 vols. New York: Dover Publications, 1963 (reprint)

Ficke, Arthur Davison. *Chats on Japanese Prints.* London: T. Fisher Unwin, 1922 (reprinted, Rutland, Vermont and Tōkyō: Tuttle, 1958)

Focillon, Henri. *Hokusai.* Paris: Librairie Félix Alcan, 1914

Fontein (1), Jan, and Hempel, Rose. *China, Korea, Japan.* Berlin: Propyläen Verlag, 1968

Fontein (2), Jan, and Hickman, Money L. *Zen Painting and Calligraphy.* Boston: Museum of Fine Arts, 1970

Fontein (3), Jan, and Pal, Pratapaditya, eds. *Museum of Fine Arts Boston: Oriental Art.* Boston: Museum of Fine Arts, 1969

Foreigners in Japan: Yokohama and Related Woodcuts in the Philadelphia Museum (catalogue). Philadelphia: Philadelphia Museum of Art, 1972

Franks, Augustus W. *Japanese Pottery.* London: His Majesty's Stationery Office, 1906 (2nd edition)

Freer Gallery of Art: II Japan, The. Washington: Freer Gallery; Tōkyō: Kōdansha, 1972

French, Calvin L. *Shiba Kōkan: Artist, Innovator, and Pioneer in the Westernization of Japan.* New York and Tōkyō: Weatherhill, 1974

Fujikake (1a) Shizuya. *Harunobu.* Tōkyō, 1939

——— (1). *Japanese Wood-Block Prints,* no. 10 in the series Tourist Library (translated by M. G. Mori). Tōkyō: Japan Travel Bureau, 1962 (7th edition)

——— (2). *Ukiyo-e.* Tōkyō: Yūzankaku, 1924

——— (3). *Ukiyo-e no Kenkyū* (Studies of Ukiyo-e), 3 vols. Tōkyō: Yūzankaku, 1943

Fujimori Seikichi. *On Watanabe Kazan as a Painter* (translated by F. Hawley). Tōkyō: Nippon Bunka Chūō Remmei, 1939

Fujioka Ryōichi. *Tea Ceremony Utensils,* no. 3 in the series Arts of Japan (translated and adapted by Louise Allison Cort). New York and Tōkyō: Weatherhill/Shibundō, 1973

Fukko Yamato-e-shū (Collected Works of the Neo-Yamato-e School). Tōkyō: Ōtsuka Kōgeisha, 1931

Fukui Kikusaburō. *Japanese Ceramic Art.* Tōkyō: privately printed, 1926

Fuller, Richard E. *Japanese Art in the Seattle Art Museum.* Seattle: Seattle Art Museum, 1960

Furuta Shōkin. *Sengai.* Tōkyō: Idemitsu Bijutsukan, 1966

Gahō-shū (Collected Works of Gahō), 8 vols. Tōkyō: Zauhō Kankōkai, 1933–34

Genshoku Meiji Hyakunen Bijutsukan. See Asano Nagatake et al.

Gentles (1), Margaret O. *The Clarence Buckingham Collection of Japanese Prints, Vol. II: Harunobu, Koryūsai, Shigemasa, and Contemporaries.* Chicago: Chicago Art Institute, 1965

——— (2). *Masters of the Japanese Print: Moronobu to Utamaro* (catalogue). New York: The Asia Society, 1964

Glaser, Kurt. *Ostasiatische Plastik.* Berlin: Bruno Cassirer, 1925

Gomotsu Jakuchū Dōshoku Saie Seiei (Paintings by Jakuchū). Saitō Shobō, ed. Tōkyō: Tōkyō Imperial Household, 1940

Gorham, Hazel H. *Japanese and Oriental Ceramics.* Rutland, Vermont and Tōkyō: Tuttle, 1971 (reprint)

Gray (1), Basil. *Hokusai* (catalogue). London: Lund Humphries, 1949

——— (2). *Japanese Screen Painting.* London: Faber and Faber, 1955

Grilli (1), Elise. *The Art of the Japanese Screen.* New York and Tōkyō: Weatherhill and Bijutsu Shuppan-sha, 1970

——— (2). *Sesshū Tōyō,* no. 10 in the series Kōdansha Library of Japanese Art (edited by Tanio Nakamura). Rutland, Vermont and Tōkyō: Tuttle, 1957

——— (3). *Tawaraya Sōtatsu,* no. 6 in the series Kōdansha Library of Japanese Art (edited by Ichimatsu Tanaka). Rutland, Vermont and Tōkyō: Tuttle, 1956

Gunsaulus (1), Helen C. *The Clarence Buckingham Collection of Japanese Prints, Vol. 1: The Primitives.* Chicago: Chicago Art Institute, 1955

——— (2). *Japanese Prints by Early Masters from the Clarence Buckingham Collection.* Chicago: Chicago Art Institute, 1946

Gyokudō Kawai. Committee for the Posthumous Works of Gyokudō Kawai, ed. Tōkyō: Bijutsu Shuppan-sha, 1958

Hanabusa Itchō (catalogue). Paris: Galerie Janette Ostier, 1964

Harada Jirō. *English Catalogue of Treasures in the Imperial Repository Shōsō-in.* Tōkyō: Imperial Household Museum, 1932

Harada Minoru. *Meiji Western Painting,* no. 6 in the series Arts of Japan (translated and adapted by Akiko Murakata and Bonnie F. Abiko). New York and Tōkyō: Weatherhill/Shibundō, 1974

Hase Akihisa and Seckel, Dietrich. *Emaki.* Zurich: Max Niehans, 1959

Hashimoto Hidekuni, ed. *Gahō Iboku-shū* (Collected Works of Gahō). Tōkyō: Nan'yōdō Honten, 1920

Hasumi (1) Shigeyasu. *The Study of Sesshū Tōyō.* Tokyo: Chikuma Shobō, 1961

Hasumi (2) Toshimitsu. *Nihon no Chōkoku* (Japanese Sculpture). Tōkyō: Bijutsu Shuppan-sha, 1960. German translation: *Japanische Plastik.* Munich: Bruckmann, 1961

Hayashiya (1) Seizō. *Artistic Development of Japanese Ceramics.* Tōkyō: Kawade Shobō, 1960

Hayashiya (2) Tatsusaburō. *Kōetsu.* Tōkyō: Daiichi Hōki Shuppan, 1965

Heian (1) *Jidai no Bijutsu* (Fine Arts of the Heian Period). Kyōto National Museum, ed. Kyōto: Benridō, 1958

Heian (2) *Jidai no Chōkoku* (Japanese Sculpture of the Heian Period) (catalogue). Tōkyō: Tōkyō National Museum, 1972

Hempel, Rose. *Ōkubi-e: Porträte im japanischen Farbholzschnitt.* Stuttgart: Chr. Belser, 1964

Henderson, Harold, and Ledoux, Louis V. *The Surviving Works of Sharaku.* New York: The Society for Japanese Studies, 1939

Herberts, Kurt. *Das Buch der ostasiatischen Lackkunst.* Düsseldorf: Econ-Verlag, 1959

Higuchi Hiroshi. *Bakumatsu Meiji no Ukiyo-e Shūsei* (Ukiyo-e of the Late Edo and Meiji Periods). Tōkyō: Mitōshoya, 1962 (revised)

Hillier (1), J. *Catalogue of the Japanese Paintings and Prints in the Collection of Mr. and Mrs. Richard P. Gale.* London: Routledge and Kegan Paul, 1970

——— (2). *Great Drawings of the World: Japanese Drawings, from the Seventeenth to the End of the Nineteenth Century.* Plainview, New York: Shorewood Publishers, 1965

——— (3). *The Harari Collection of Japanese Paintings and Drawings* (catalogue). London: Arts Council, 1970

——— (4). *The Harari Collection of Japanese Paintings and Drawings,* 3 vols. London: Lund Humphries, 1970–73

——— (5). *Hokusai: Paintings, Drawings and Woodcuts.* London: Phaidon Press, 1955

——— (6). *Hokusai Drawings.* London: Phaidon Press, 1966

——— (7). *Japanese Colour Prints.* London: Phaidon Press, 1966

——— (8). *Japanese Masters of the Colour Print.* London: Phaidon Press, 1954

——— (9). *The Japanese Print: A New Approach.* London: G. Bell and Sons, 1960

——— (10). *Suzuki Harunobu* (catalogue). Philadelphia: Philadelphia Museum of Art, 1970

——— (11). *Utamaro: Colour Prints and Paintings.* London: Phaidon Press, 1961

Hirano Chie. *Kiyonaga, A Study of His Life and Works.* Cambridge: Harvard University Press, 1939

Hisamatsu Shin'ichi. *Zen and the Fine Arts* (translated by Gishin Tokiwa). Tōkyō and Palo Alto, California: Kōdansha International, 1971

Hōan Gashū (Collection of Paintings by Hōan). Tōkyō: Sansaisha, 1960

Hōgai Sensei Iboku Zenshū (Complete Works of Hōgai), 2 vols. Tōkyō: Saitō Shobō, 1921

Hokusai (introduction and notes by Peter C. Swann; based on the Japanese text of Sadao Kikuchi). London: Faber and Faber, 1959

Holloway, Owen E. *Graphic Art of Japan: the Classical School.* London: Alec Tiranti, 1957

Hyaku-gojū Kaikishin Tenkan Harunobu Zuroku (150th Anniversary Exhibition of Harunobu's work) (catalogue). Tōkyō: 1925

Ienaga Saburō. *Painting in the Yamato Style,* vol. 10 in the series Heibonsha Survey of Japanese Art (translated by John M. Shields). New York and Tōkyō: Weatherhill/Heibonsha, 1973

Ihara Ungai. *Fugai Zenji-shū Kessaku-shū* (Masterpieces by the Zen Master Fugai). Tōkyō: Yamato Bunkadō, 1920

Iijima Isamu. *Ōkyo.* Tōkyō: Misuzu Shobō, 1958

Illustrated (1) *Catalogue of a Special Loan Exhibition of Art Treasures from Japan.* Boston: Museum of Fine Arts, 1936

Illustrated (2) *Catalogue of Famous Masterpieces in the Collection of the Nezu Museum, An.* Tōkyō: Nezu Museum, 1955

Illustrated (3) *Masterpieces from the Collection of the Gotoh Museum.* Tōkyō: Gotoh [Gotō] Museum, 1960

Images du temps qui passe (catalogue). Paris: Musée des Arts Decoratifs, Palais du Louvre, 1966

Imaizumi (1) Atsuo. *The Works of Kokei Kobayashi.* Tōkyō: Chūō Kōron Bijutsu Shuppan, 1960

Imaizumi (2) Atsuo, Oka Shikanosuke, and Takiguchi Shūzō. *Nihon no Chōkoku* (Japanese Sculpture), 6 vols. Tōkyō: Bijutsu Shuppan-sha, 1951–52

―――― (2a). *Nihon no Chōkoku: Jōko-Kamakura* (Japanese Sculpture from Ancient Times Through the Kamakura Period). Tōkyō: Bijutsu Shuppan-sha, 1960

Imaizumi (3) Osaku and Komori Hikoji. *Zōho Teisei Nihon Tōji Shi* (History of Japanese Pottery, Enlarged and Revised). Tōkyō: Yūzankaku, 1929 (for all potters' genealogies)

Jahss, Melvin and Betty. *Inrō and Other Miniature Forms of Japanese Lacquer Art.* Rutland, Vermont and Tōkyō: Tuttle, 1971

Jakuchū: Tokubetsu Tenkan (Special Exhibition of Paintings by Itō Jakuchū) (catalogue). Tōkyō: Tōkyō National Museum, 1971

Japanese (1a) *Art at the Art Gallery of Greater Victoria.* John Vollmer and Glenn T. Webb, eds. Toronto: Royal Ontario Museum, 1972

Japanese (1) *Ink Painting and Calligraphy from the Collection of the Tokiwayama Bunko* (catalogue). New York: Brooklyn Museum, 1967

Japanese (2) *Painters of the Floating World* (catalogue of an exhibition at the Andrew Dickson White Museum of Art). Ithaca, New York: Cornell University, 1966

Japanese (3) *Twentieth-Century Prints* (catalogue). Cambridge: Fogg Art Museum, Harvard University Press, 1966

Japanische (1) *Kunst des späten Zen* (catalogue of an exhibition for the Berlin Festival at the Academy of Arts, Berlin). Berlin: 1965

Japanische (2) *Tuschmalerei, Nanga und Haiga: Sammlung Heinz Brasch* (catalogue). Zurich: Kunstgewerbemuseum, 1962

Jenkins, Donald. *Ukiyo-e Prints and Paintings: The Primitive Period, 1680–1745* (catalogue of an exhibition in memory of Margaret O. Gentles). Chicago: The Art Institute of Chicago, 1971

Jenyns (1), Soame. *Japanese Porcelain.* London: Faber and Faber, 1965

―――― (2). *Japanese Pottery.* London: Faber and Faber, 1971

Kamakura no Bijutsu (Art of the Kamakura Period). Tōkyō: Asahi Shimbunsha, 1958

Kaneko Fusui. *Ukiyo-e Nikuhitsu Gashū* (Collection of Ukiyo-e Paintings). Tōkyō: Ryokuen Shobō, 1964

Kanō-ha Taikan (General View of Kanō Painting), 2 vols. Saitō Ken, ed. Tōkyō: Kanō-ha Taikan Hokkō-jō, 1912–14

Katayama Kurōemon, ed. *Kanze-ke Denrai Nōmen-shū* (Noh Masks Belonging to the Kanze Family). Tōkyō: Hinoki Shobō, 1954

Kawabata Moshō, ed. *Gyokushō-ō Iboku-shū* (collection of Gyokushō's Paintings). Tōkyō: Kōgeisha, 1931

Kawakita (1) Michiaki. *Contemporary Japanese Prints* (translated by John Bester). Tōkyō and Palo Alto, California: Kōdansha International, 1967

―――― (2). *Kobayashi Kokei,* no. 11 in the series Kōdansha Library of Japanese Art (translated and adapted by Roy Andrew Miller). Rutland, Vermont and Tōkyō: Tuttle, 1957

―――― (3). *Meiji-Taishō no Gadan* (Art Circles of the Meiji and Taishō Eras). Tōkyō: NHK Books, 1964

―――― (3a). *Murakami Kagaku Gashū* (Paintings by Murakami Kagaku). Tōkyō: Chūō Kōron Bijutsu Shuppan, 1962

―――― (4). *Taikan.* Tōkyō: Heibonsha, 1962

Kazan Chūgyo-jō (Paintings by Kazan in the Yoshida Collection). Compiled by J. Murayama. Tōkyō: Kokkasha, 1908

Kenzan (catalogue). Tōkyō: Tokugawa and Nezu Museums, 1968

Keyes, Roger S., and Mizushima Keiko. *The Theatrical World of Ōsaka Prints.* Philadelphia: Philadelphia Museum of Art, 1973

Kidder, J. Edward. *Masterpieces of Japanese Sculpture.* Tōkyō and Rutland, Vermont: Bijutsu Shuppan-sha/Tuttle, 1961

Kikuchi Sadao. *A Treasury of Japanese Wood Block Prints: Ukiyo-e* (translated by Don Kenny). New York: Crown Publishers, 1969

Kinami Takiuchi. *Jiun no Sho* (Calligraphy of Jiun). Ōsaka: Kitagawa Hakushudō, 1963

Kindai Nihon no Kaiga to Chōkoku (Modern Japanese Painting and Sculpture). Tōkyō: National Museum of Modern Art, 1962

Kishida Ryūsei (catalogue). Tōkyō: National Museum of Modern Art, 1966

Kleinschmidt, Peter. *Die Masken der Gigaku, der ältesten Theaterform Japans.* Wiesbaden: Otto Harrassowitz, 1966

Kobayashi (1) Takeshi. *Nihon Chōkokushi Kenkyū* (A Study of Japanese Sculptural History). Tōkyō: Yōtokusha, 1947

―――― (2). *A Study of the Life and Works of the Buddhist Sculptor Unkei* (Japanese text, English summary). Nara: Nara State Institute for Cultural Materials, monograph no. 1, 1954

Kōetsu-ha Sammeika-shū (Three Masters of the Kōetsu School). Tōkyō: Shimbi Shoin, 1915

Kokuhō (National Treasures), 6 vols. Tōkyō: Mainichi Shimbunsha, 1963–69

Kondō (1) Ichitarō. *Japanese Genre Paintings of the "Early Modern" Period* (catalogue). Tōkyō: Tōkyō National Museum, 1957

―――― (2). *Japanese Genre Painting: The Lively Art of Renaissance Japan* (translated by Roy Andrew Miller). Rutland, Vermont and Tōkyō: Tuttle, 1961

―――― (3). *Kitagawa Utamaro,* no. 5 in the series Kōdansha Library of Japanese Art (English adaptation by Charles S. Terry). Rutland, Vermont and Tōkyō: Tuttle, 1956

―――― (4). *Suzuki Harunobu,* no. 7 in the series Kōdansha Library of Japanese Art (translated and adapted by Kaoru Ōgimi). Rutland, Vermont and Tōkyō: Tuttle, 1956

―――― (5). *Tōshūsai Sharaku,* no. 2 in the series Kōdansha Library of Japanese Art (English adaptation by Paul C. Blum). Rutland, Vermont and Tōkyō: Tuttle, 1955

Kondō (6) Ichitarō and Kawakita Michiaki. *Feminine Beauty in Japanese Painting.* Tōkyō: Tōto Bunka Co., 1955

Kongō G. *Nōgaku Komen Taikan* (Ancient Noh Masks). Tōkyō: Nihon Tosho Kankōkai, 1932

Kōrin (1) *Ha Meiga-shū* (Masterpieces of the Kōrin School), 2 vols. Kyōto Shoin, ed. Kyōto: Kyōto Shoin, 1952

Kōrin (2) *Ha Semmenga-shū* (Fan Paintings of the Kōrin School). Kyōto Shoin, ed. Kyōto: Kyōto Shoin, 1953

Kōrin (3) *Meisaku Ten* (Exhibition of Masterpieces by Kōrin) (catalogue of a special exhibition commemorating the 250th anniversary of Kōrin's death). Tōkyō: Nihon Keizai Shimbunsha, 1965

Kōshirō Onchi, Woodcuts (catalogue). San Francisco: Achenbach Foundation for the Graphic Arts, California Palace of the Legion of Honor, 1964

Kosugi Hōan (catalogue). Tōkyō: Idemitsu Bijutsukan, 1971

Kosugi Hōan et al. *Ikeno Taiga Sakuhin-shū* (Collected Works of Ikeno Taiga). Tōkyō: Chūō Kōron Bijutsu Shuppan, 1960

Koyama (1a) Fujio. *The Heritage of Japanese Ceramics* (trans-

lated and adapted by John Figgess). New York, Tōkyō, and Kyōto: Weatherhill/Tankōsha, 1973.

—— (1). *Japanese Ceramics* (catalogue). Oakland: The Oakland Art Museum, 1961

—— (2). *Tōgei* (Ceramic Art), no. 6 in the series Nihon Bijutsu Taikei (Compendium of Japanese Arts). Tōkyō: Kōdansha, 1960

—— (3). *Nihon Meitō Hyakusen* (One Hundred Masterpieces of Japanese Ceramics). Tōkyō: Nihon Keizai Shimbun, 1962

—— (4), ed. *Tōki Zenshū* (Collection of Ceramics), 32 vols. Tōkyō: Heibonsha, 1958–66

—— (5). *Tōyō Kotōji* (Ancient Oriental Ceramics), 7 vols. Tōkyō: Bijutsu Shuppan-sha, 1954–57

Kubota Kanroku. *Masterpieces by Sesshū*. Tōkyō: Shimbi Shoin, 1913

Kuck, Loraine. *The World of the Japanese Garden*. New York and Tōkyō: Walker/Weatherhill, 1968

Kumagai Nobuo. *Sesshū Tōyō*. Tōkyō: Tōkyō Daigaku Shuppankai, 1958

Kumamoto Kenjirō. *The Collected Works of Kuroda Seiki*, in the series Nihon Kindai Kaiga Zenshū (Modern Japanese Art). Tōkyō: Kōdansha, 1962

Kümmel, Otto. *Das Kunstgewerbe in Japan*. Berlin: Richard Carl Schmidt and Co., 1922

Kung, David. *The Contemporary Artist in Japan*. Tōkyō: Bijutsu Shuppan-sha; Honolulu: East-West Center Press, 1966

Kuno (1) Takeshi, ed. *A Guide to Japanese Sculpture*. Tōkyō: Mayuyama and Co., 1963

—— (2). *Kamakura Period*, vol. 6 in the series A History of Japanese Sculpture. Tōkyō: Bijutsu Shuppan-sha, 1953

—— (3). *Kantō Chōkoku no Kenkyū* (Study of the History of Japanese Sculpture in the Kantō District). Tōkyō: Gakuseisha, 1964

Kunst aus Japan: Ukiyo-e (catalogue). Essen: Villa Hügel, 1972

Kunstschätze aus Japan (catalogue). Cologne: Museum für Ostasiatische Kunst, 1970

Kurashina (1) *Zuroku Kindai Nihonga* (Catalogue of Japanese-Style Paintings Owned by the Tōkyō University of Arts). Tōkyō: Tōkyō Geijutsu Daigaku, 1954.

Kurashina (2) *Zuroku Kindai Seiyōga* (Catalogue of Modern Western-Style Paintings Owned by the Tōkyō University of Arts). Tōkyō: Tōkyō Geijutsu Daigaku, 1955

Kuroda Genji. *Nagasaki-kei Yōga* (Paintings of Foreigners at Nagasaki). Tōkyō: Sōgansha, 1932

Kurth (1), Julius. *Die Geschichte des japanischen Holzschnittes*, 3 vols. Leipzig: Hiersemann, 1925–29

—— (2). *Der japanische Holzschnitt*. Munich: R. Piper and Co., 1922

—— (3). *Von Moronobu bis Hiroshige*. Berlin: Josef Altman, 1924

—— (4). *Die Primitiven des Japanholzschnittes*. Dresden: Wolfgang Jess, 1922

—— (5). *Sharaku*. Munich: R. Piper and Co., 1922

—— (6). *Suzuki Harunobu*. Munich: R. Piper and Co., 1923

—— (7). *Utamaro*. Leipzig: F. A. Brockhaus, 1907

Lane, Richard. *Masters of the Japanese Print*. London: Thames and Hudson, 1962

Leach, Bernard. *Kenzan and His Tradition: The Lives and Times of Kōetsu, Sōtatsu, Kōrin and Kenzan*. London: Faber and Faber, 1966

Ledoux (1), Louis V. *Japanese Prints, Bunchō to Utamaro, in the Collection of Louis V. Ledoux*. New York: E. Weyhe, 1948

—— (2). *Japanese Prints by Harunobu and Shunshō in the Collection of Louis V. Ledoux*. New York: E. Weyhe, 1945

—— (3). *Japanese Prints, Hokusai and Hiroshige, in the Collection of Louis V. Ledoux*. Princeton: Princeton University Press, 1951

—— (4). *Japanese Prints of the Primitive Period in the Collection of Louis V. Ledoux*. New York: E. Weyhe, 1942

—— (5). *Japanese Prints, Sharaku to Toyokuni, in the Collection of Louis V. Ledoux*. Princeton: Princeton University Press, 1950

Lee (1), Sherman E. *A History of Far Eastern Art*. London: Thames and Hudson, 1964

—— (2). *Japanese Decorative Style*. Cleveland: The Cleveland Museum of Art, 1961

—— (3). *Tea Taste in Japanese Art* (catalogue). New York: The Asia Society, 1963

Machida Kōichi. *Gaisetsu Nihon Bijutsushi* (Outline of Japanese Art History). Tōkyō: Yoshikawa Kōbunkan, 1965

Maruyama Shōichi. *Enkū no Chōkoku* (Enkū's Sculpture). Tōkyō: Kinokuniya Shoten, 1961

Masterpieces (1) *in the Fujita Museum of Art*. Osaka: Fujita Museum, 1954

Masterpieces (2) *of Asian Art in American Collections II* (catalogue). New York: The Asia Society, 1970

Masterpieces (3) *of Japanese Art*. Tōkyō: Bunka Kōryū Kurabu, 1949

Masterpieces (4) *of Modern Japanese Art* (catalogue). Tōkyō: National Museum of Modern Art, 1964

Matsumoto (1) Narashige. *Ancient Sculpture of Japan*. Kyōto: Mitsumura Suiko Shoin Co., 1963

Matsumoto (2) Satarō. *Kutani Tōji Shikō Sō* (History of Old Kutani). Kanazawa: Ko Kutani Kenkyūkai, 1928

Matsushita Hidemarō. *Ikeno Taiga*. Tōkyō: Shunjūsha, 1967

Matsushita (1) Takaaki. *Ink Painting*, no. 7 in the series Arts of Japan (translated and adapted by Martin Collcutt). New York and Tōkyō: Weatherhill/Shibundō, 1974

—— (1a). *Muromachi Suibokuga* (Muromachi Ink Painting). Tōkyō: Ōtsuka Kōgeisha, 1960

Mayuyama Junkichi, ed. *Japanese Art in the West*. Tōkyō: Mayuyama and Co., 1966

Meissner, Kurt. *Japanese Woodblock Prints in Miniature: The Genre of Surimono*. Rutland, Vermont and Tōkyō: Tuttle, 1970

Memorial Exhibition of Hiroshige's Works, The. Compiled and published by S. Watanabe. Tōkyō: Ukiyo-e Association, 1918

Michener (1), James A. *The Floating World*. New York: Random House, 1954

—— (2). *The Hokusai Sketchbooks: Selections from the Manga*. Rutland, Vermont and Tōkyō: Tuttle, 1958

—— (3). *Japanese Prints from the Early Masters to the Modern*. Rutland, Vermont and Tōkyō: Tuttle, 1959

—— (4). *The Modern Japanese Print: An Appreciation*. Rutland, Vermont and Tōkyō: Tuttle, 1968

Mikami Tsugio. *The Art of Japanese Ceramics*, vol. 29 in the series Heibonsha Survey of Japanese Art (translated by Ann Herring). New York and Tōkyō: Weatherhill/Heibonsha, 1972

Miller, Roy Andrew. *Japanese Ceramics* (after the Japanese text by Seiichi Okada, Fujio Koyama, Seizō Hayashiya, and others). Rutland, Vermont and Tōkyō: Tuttle and Tōto Shuppansha, 1960

Minamoto (1) Hōshu. *An Illustrated History of Japanese Art* (translated by Harold G. Henderson). Kyōto: Hoshino Shoten, 1935

—— (2), ed. *Momoyama Byōbu Taikan* (Momoyama Screen Paintings). Kyōto: Kokumin Shimbunsha, 1936

Minamoto (3) Hōshu, Mitsuoka Tadanari, and Yoshimura Moto-o, eds. *Rimpa Kōgei Senshū* (Selected Works of the Rimpa School). Kyōto: Kōrinsha Shuppan, 1966

Minamoto (4) Toyomune, ed. *Kōetsu Shikishi-chō* (Poem Cards by Kōetsu). Kyōto: Kōrinsha Shuppan, 1966

Mitchell, C. H. *The Illustrated Books of the Nanga, Maruyama, Shijō, and other Related Schools of Japan: A Bibliography*. Los Angeles: Dawson's Book Shop, 1972

Mitsuoka (1) Tadanari. *Ceramic Art of Japan*, no. 8 in the series Tourist Library. Tōkyō: Japan Travel Bureau, 1953

—— (2), ed. *Rimpa Kōgei Senshū-zoku* (Selections from the Industrial Arts of the Rimpa School). Kyōto: Kōrinsha Shuppan, 1969

Miyagawa Torao. *Modern Japanese Painting: An Art in Transition* (translated and adapted by Toshizō Imai). Tōkyō and Palo Alto, California: Kōdansha International, 1967

Miyake Kyūnosuke. *Gyokudō*. Tōkyō: Bijutsu Shuppan-sha, 1956

Miyama Susumu. *Kamakura no Chōkoku* (Kamakura Sculpture). Tōkyō: Chūnichi Shimbun Shuppan-kyoku, 1966

Mizoguchi Yasumaro. *Torii Kiyonaga* (Kiyonaga, Master of Ukiyo-e). Tōkyō: Mitōshoya, 1962

Mizuno Tadatake, ed. *Kōrin-ha Semmenga-shū* (Fan Paintings of the Kōrin School). Kyōto: Nakajima Taise-ikaku, 1935

Mizuo (1) Hiroshi. *Chishaku-in*, in the series Shōhekiga Zenshū

(Collection of Wall Paintings). Tōkyō: Bijutsu Shuppan-sha 1966

—— (2). *Daigo-ji, Sambō-in,* in the series Shōhekiga Zenshū (Collection of Wall Paintings). Tōkyō: Bijutsu Shuppan-sha, 1972

—— (2a). *Edo Painting: Sōtatsu and Kōrin,* vol. 18 in the series Heibonsha Survey of Japanese Art (translated by John M. Shields). New York and Tōkyō: Weatherhill/Heibonsha, 1972

—— (3). *Ōgi-e Meihin-shū* (Famous Fan Paintings). Kyōto: Tankōsha, 1967

—— (4), ed. *Sōtatsu-Kōrin-ha Gaisetsu* (Study of the Sōtatsu-Kōrin School). Kyōto: Kōrinsha Shuppan, 1966

Mody, N. H. N. *A Collection of Nagasaki Colour Prints and Paintings.* Rutland, Vermont and Tōkyō: Tuttle, 1969

Mōri (1) Hisashi. *Busshi Kaikei Ron* (Essay on the Buddhist Sculptor Kaikei). Tōkyō: Yoshikawa Kōbunkan, 1961

—— (1a). *Sculpture of the Kamakura Period,* vol. 11 in the series Heibonsha Survey of Japanese Art. New York and Tōkyō: Weatherhill/Heibonsha, 1974

Mori (2) Senzō. *Watanabe Kazan.* Tōkyō: Sōgensha, 1941

Moriya Kenji. *Die japanische Malerei.* Wiesbaden: F. A. Brockhaus. 1953

Morrison, Arthur. *The Painters of Japan,* 2 vols. London and Edinburgh: T. C. and E. C. Jack, 1911

Morse, Edward S. *Catalogue of the Morse Collection of Japanese Pottery.* Cambridge, Massachusetts: Riverside Press, 1901

Munsterberg (1), Hugo. *The Arts of Japan.* Rutland, Vermont and Tōkyō: Tuttle, 1957

—— (2). *The Ceramic Art of Japan: A Handbook for Collectors.* Rutland, Vermont and Tōkyō: Tuttle, 1964

—— (3). *The Folk Arts of Japan.* Rutland, Vermont and Tōkyō: Tuttle, 1958

—— (4). *Zen and Oriental Art.* Rutland, Vermont and Tōkyō: Tuttle, 1965

Murase Miyeko. *Byōbu: Japanese Screens from New York Collections* (catalogue). New York: The Asia Society, 1971

Murashige Yasushi. *Sōtatsu,* in the series Tōyō Bijutsu Sensho. Tōkyō: Sansaisha, 1970

Murayama (1) Jungo. *Kōrin-Kenzan Meisaku-shū* (Selected Masterpieces of Kōrin and Kenzan). Tōkyō: The Kokka Co., 1906

—— (2), ed. *Nanga-shū* (Collection of Nanga Painting). Tōkyō: Kokkasha, 1919

Muromachi (1) *Jidai Bijutsuten Zuroku* (Special Exhibition of Art Treasures of the Muromachi Period). Kyōto: Kyōto National Museum, 1968

Muromachi (2) *Jidai no Butsuzō* (Buddhist Sculpture of the Muromachi Period) (catalogue). Nara: Nara National Museum, 1967

Nagassé Takeshirō (Nagase Takeshirō). *Le paysage dans l'art de Hokuçai.* Paris: Les Editions d'Art et d'Histoire, 1937

Nakamura (1) Tanio. *Contemporary Japanese-Style Painting* (translated and adapted by Mikio Itō). New York: Tudor Publishing Co., 1969

—— (2). *Eitoku.* Tōkyō: Heibonsha, 1957

—— (3). *Sumie no Bi* (The Beauty of Ink Painting). Tōkyō: Meiji Shoten, 1959

Namban Art (catalogue). Washington: International Exhibitions Foundation, 1973

Nanga-shū. See Murayama Jungo.

Narazaki (1) Muneshige. *Hokusai to Hiroshige,* 8 vols. Tōkyō: Kōdansha, 1964

—— (2). *The Japanese Print: Its Evolution and Essence.* (English adaptation by C. H. Mitchell). Tōkyō and Palo Alto, California: Kōdansha International, 1966

—— (3). *Masterworks of Ukiyo-e: Early Paintings* (English adaptation by Charles A. Pomeroy). Tōkyō and Palo Alto, California: Kōdansha International, 1967

—— (4). *Masterworks of Ukiyo-e: Hiroshige: Famous Views* (English adaptation by Richard L. Gage). Tōkyō and Palo Alto, California: Kōdansha International, 1968

—— (5). *Masterworks of Ukiyo-e: Hiroshige: The 53 Stations of the Tōkaidō* (English adaptation by Gordon Sager). Tōkyō and Palo Alto, California: Kōdansha International, 1968

—— (6). *Masterworks of Ukiyo-e: Hokusai: The 36 Views of Mt. Fuji* (English adaptation by John Bester). Tōkyō and Palo Alto, California: Kōdansha International, 1968

—— (7)., *Masterworks of Ukiyo-e: Hokusai: Sketches and Paintings* (English adaptation by John Bester). Tōkyō and Palo Alto, California: Kōdansha International, 1969

—— (8). *Masterworks of Ukiyo-e: Kiyonaga* (English translation by John Bester). Tōkyō and Palo Alto, California: Kōdansha International, 1969

—— (9). *Masterworks of Ukiyo-e: Studies in Nature: Hokusai, Hiroshige* (translated by John Bester). Tōkyō and Palo Alto, California: Kōdansha International, 1970

Narazaki (10) Muneshige and Kikuchi Sadao. *Masterworks of Ukiyo-e: Utamaro* (translated by John Bester). Tōkyō and Palo Alto, California: Kōdansha International, 1970

Narazaki (11) Muneshige and Kikuchi Sadao. *Nikuhitsu Ukiyo-e* (Ukiyo-e Painting), vol. 1. Tōkyō: Kōdansha, 1962–63

Narazaki (12) Muneshige and Yoshida Teruji, eds. *Nikuhitsu Ukiyo-e* (Ukiyo-e Painting). Tōkyō: Kōdansha, 1970

Narazaki (13) Sōju. *Zaigai Hihō: Ō-Bei Shūzō Ukiyo-e Shūsei* (Treasures from Abroad: Ukyio-e Prints in European and American Collections), 6 vols. Tōkyō: Gakken, 1972–73

National (1) *Museum, Tōkyō,* in the series Great Museums of the World. New York, Sydney, and Toronto: Paul Hamlyn, 1969

National (2) *Treasures in Kyōto.* Kyōto: Kyōto Association for 10th Anniversary of Enforcement of Cultural Property Protection Law, 1960

Nezu Bijutsukan Meihin Mokuroku (Catalogue of Masterpieces in the Nezu Museum). Tōkyō: Nezu Bijutsukan, 1968

Nezu Kaichirō, ed. *Seizanshō Seishō* (Illustrated Catalogue of the Nezu Collection), 10 vols. Tōkyō: Benridō, 1939–43

Nihon (1) *Kotō Meihin-shū* (Famous Ancient Japanese Pottery). Ōsaka: Yamanaka Shōkai, 1933

Nihon (2) *Nanga-shū* (Japanese Nanga Painting) (catalogue). Tōkyō National Museum, ed. Tōkyō: Benridō, 1951

Nihon (3) *no Bunjinga* (Japanese Literati Painting) (catalogue). Ōsaka: Nihon Keizai Shimbunsha, 1971

Nihon (4) *no Bunjinga* (Japanese Literati Painting) (catalogue). Tōkyō National Museum, ed. Tōkyō: Benridō, 1966

Nihon (5) *no Bunjinga-ten Mokuroku* (Exhibition of Japanese Literati Painting) (catalogue). Tōkyō: Tōkyō National Museum, 1965

Nihon (6) *no Chōkoku.* See Imaizumi Atsuo et al.

Nihon (7) *no Koten: Kaiga-hen* (Japanese Classic Art: Painting Series), 6 vols. Tōkyō: Bijutsu Shuppan-sha, 1955–59

Nihon (8) *no Tōji: Tōkyō Kokuritsu Hakubutsukan Zuhan Mokuroku* (Japanese Ceramics: Illustrated Catalogue of the Tōkyō National Museum). Tōkyō: Tōkyō National Museum, 1966

Nihon (9) *no Ukiyo-e Shi* (History of Japanese Ukiyo-e). Tōkyō: Daiichi Shobō, 1930

Nikuhitsu (1) *Ukiyo-e* (Ukiyo-e Painting), 2 vols. Vol 1: Narazaki Muneshige and Kikuchi Sadao; vol. 2: Yoshida Teruji and Akai Tatsuro, eds. Tōkyō: Kodansha, 1962–63

Nikuhitsu (2) *Ukiyo-e* (Ukiyo-e Painting). Narazaki Muneshige and Yoshida Teruji, eds. Tōkyō: Kōdansha, 1970

Nishimura Teishiki. *Nihon Shoki Yōga no Kenkyū* (A Study of Early Western-Style Painting in Japan). Kyōto: Zenkoku Shobō, 1945

Noguchi (1a) Shumbi, ed. *Chin Nampin Dōshoku-chō* (Animals and Plants by Shen Nan-p'in). Tōkyō: Shimbi Shoin, 1936

Noguchi (1) Yone. *Harunobu.* Tōkyō: Daiichi Shobō, 1927

—— (2). *Hiroshige.* Tōkyō: Maruzen, 1940

—— (3). *Hokusai,* in the series L'Art du Japon. Paris and Brussels: Les Editions G. Van Oest, 1928

—— (3a). *Hokusai.* Tōkyō: Seibundō Publishing Co., 1932

—— (4). *Kōrin,* in the series L'Art du Japon. Paris and Brussels: Les Editions G. Van Oest, 1926

—— (4a). *Sharaku.* Tōkyō: Seibundō Publishing Co., 1932

—— (5). *The Ukiyo-e Primitives.* Tōkyō: privately printed, 1933

—— (6). *Utamaro,* in the series L'Art du Japon. Paris and Brussels: Les Editions G. Van Oest, 1928

Noma (1) Seiroku. *The Arts of Japan,* 2 vols. (vol. 1 translated and adapted by John T. Rosenfield; vol. 2 translated and adapted by Glenn T. Webb). Tōkyō and Palo Alto, California: Kōdansha International, 1966–67

—— (2). *Asuka Period,* vol. 2 in the series A History of Japanese Sculpture. Tōkyō: Bijutsu Shuppan-sha, 1965

—— (3). *Heian Period,* vol. 5 in the series A History of Japanese Sculpture. Tōkyō: Bijutsu Shuppan-sha, 1952

—— (4). *Nihon Kogakumen* (an illustrated catalogue of **a**

special exhibition held at the Imperial Household Museum). Tōkyō: Jurakusha, 1935

—— (5). *Taikan*. Tōkyō: Kōdansha International, 1956

—— (6). *Yokoyama Taikan*, no. 4 in the series Kōdansha Library of Japanese Art (English adaptation by Meredith Weatherby). Rutland, Vermont and Tōkyō: Tuttle, 1956

Nomura Masajirō. *Yūzen Kenkyū* (Study of Yūzen). Kyōto: Unsōdō, 1920

Nonogami Keiichi. *Bummei Kaika Nishiki-e-shū: Yokohama-e to Kaika* (Color Prints of the Late Tokugawa and Early Meiji Periods in the Nonogami Collection). Tōkyō: Tarumi Shobō, 1967

Odakane (1) Tarō. *Hirafuku Hyakusui*. Tōkyō: Tōkyōdō, 1948

—— (2). *Tessai: Master of the Literati Style* (translation and adaptation by Money L. Hickman). Tōkyō and Palo Alto, California: Kōdansha International, 1965

Okada Yuzuru. *Japanese Handicrafts*, no. 21 in the series Tourist Library. Tōkyō: Japan Travel Bureau, 1959

Okamoto (1) Tōyō and Takakuwa Gisei. *Shōji: The Screens of Japan*. Kyōto: Mitsumura Suiko Shoin, 1961

Okamoto (2) Yoshitomo. *The Namban Art of Japan*, vol. 19 in the series Heibonsha Survey of Japanese Art (translated by Ronald K. Jones). New York and Tōkyō: Weatherhill/ Heibonsha, 1972

Okuda (1) Seiichi, ed. *Tōyō Tōjiki Shūsei* (Catalogue of Oriental Ceramics), 12 vols. Tōkyō: Institute of Oriental Ceramics, 1932

Okuda (2) Seiichi, Koyama Fujio, and Hayashiya Seizō, eds. *Nihon no Tōji* (Japanese Ceramics). Tōkyō: Tōto Bunka Co., 1954

Okudaira (1) Hideo. *Emaki: Japanese Picture Scrolls*. Rutland, Vermont and Tōkyō: Tuttle, 1962

—— (1a). *Narrative Picture Scrolls*, no. 5 in the series Arts of Japan (translation adapted by Elizabeth ten Grotenhuis). New York and Tōkyō: Weatherhill/Shibundō, 1973

—— (2), ed. *Nihon Bijutsu Benran* (Handbook of Japanese Art). Tōkyō: Bijutsu Shuppan-sha, 1952

Ōkyo Meiga-fu (Masterpieces by Ōkyo). Kyōto: Kobayashi Shashin Seihen, 1936

One (1) *Hundred Masterpieces from the Collection of the Tōkyō National Museum*. Tōkyō: Tōkyō National Museum, 1959

One (2) *Hundred Masterpieces of Japanese Pictorial Art Selected by Members of the Faculty of the Tōkyō Fine Art School*. Tōkyō: Shimbi Shoin, 1909

Ono Gemmyō. *Bukkyō no Bijutsu to Rekishi* (Buddhist Art and History). Tōkyō: Busshō Kenkyūkai, 1916

Ōoka Minoru. *Temples of Nara and Their Art*, vol. 7 in the series Heibonsha Survey of Japanese Art (translated by Dennis Lishka). New York and Tōkyō: Weatherhill/Heibonsha, 1973

Ozaki Shūdō. *Katsushika Hokusai*. Tōkyō: Nihon Keizai Shimbunsha, 1967

Paine (1), Robert T. *Japanese Landscape Painting*, vol. 1. Boston: Museum of Fine Arts, 1935

—— (2). *Japanese Screen Paintings*, 2 vols. (catalogue). Boston: Museum of Fine Arts, 1935, 1938

—— (3). *Ten Japanese Paintings in the Museum of Fine Arts*. New York: The Japan Society, 1939

Paine (4), Robert Treat, and Soper, Alexander. *The Art and Architecture of Japan*. London: Penguin Books, 1955

Perzyński, Friedrich. *Japanische Masken*. Berlin and Leipzig: Walter de Gruyter and Co., 1925

Pictorial (1) *Encyclopedia of the Oriental Arts, A: Japan*, 4 vols. New York: Crown Publishers, 1969

Pictorial (2) *Record of Kōbe City Museum of Namban Art*, 5 vols. Kōbe: Kōbe City Museum, 1968–72

Posthumous (1) *Exhibition of Four Artists* (catalogue). Tōkyō: National Museum of Modern Art, 1965

Posthumous (2) *Exhibition of Yamaguchi Kaoru* (catalogue). Tōkyō: National Museum of Modern Art, 1971

Ragué, Beatrix von. *Geschichte der japanischen Lackkunst*. Berlin: Walter de Gruyter and Co., 1967

Rakuchū Rakugai Zu (Paintings of Sights In and Around Kyōto). Kyōto National Museum, ed. Tōkyō: Kadokawa Shoten, 1966

Randall, Doanda. *Kōrin*. New York: Crown Publishers, 1959

Rimpa (catalogue). Tōkyō: Tōkyō National Museum, 1972

Rimpa Kōgei Senshū. See Minamoto Hōshu et al.

Robinson (1), B. W. *Hiroshige*. London: Blandford Press, 1964

—— (2). *Japanese Landscape Prints of the Nineteenth Century*. London: Faber and Faber, 1957

—— (3). *Kuniyoshi*. London: Her Majesty's Stationery Office, 1961

Rokkaku Shisui. *Tōyō Shikkō-shi* (History of Oriental Lacquer). Tōkyō: Yūzankaku, 1960

Rosanjin (catalogue). New York: The Japan Society, 1971

Rosenfield (1), John. *Japanese Arts of the Heian Period: 794–1185* (catalogue). New York: Asia House Gallery, 1967; Cambridge, Massachusetts: Fogg Art Museum, Harvard University, 1968

Rosenfield (1a), John, and Cranston, Fumiko and Edwin. *The Courtly Tradition in Japanese Art and Literature* (catalogue). Tōkyō: Kōdansha International, 1973

Rosenfield (2), John, and Shimada, Shūjirō. *Traditions of Japanese Art. Selections from the Kimiko and John Powers Collection*. Cambridge: Fogg Art Museum, Harvard University, 1970

Rumpf (1), Fritz. *Meister des japanischen Farbenholzschnittes*. Berlin and Leipzig: Walter de Gruyter and Co., 1924

—— (2). *Sharaku*. Berlin: Lankwitz-Wurfel Verlag, 1932

Ryerson, Egerton. *The Netsuke of Japan*. London: G. Bell and Sons, 1958

Ryōkan, in the series Tōyō Bijutsu Senshō (Collection of Far Eastern Art). Miya Eiji, ed. Tōkyō: Sansaisha, 1969

Saitō Ken. *Kanō-ha Taikan* (Survey of Kanō Painting), 3 vols. Tōkyō: Kanō-ha Taikan Hakkōjō, 1912–14

Saitō (1) Ryūzō. *Keisenjin Iboku-shū* (Collection of Keisen's Work). Tōkyō: Ōtsuka Kōgeisha, 1937

—— (2). *Yokoyama Taikan*. Tōkyō: Chūō Kōron-sha, 1958

—— (3). *Zoku Taikan Sakuhin-shū* (Further Paintings by Taikan). Tōkyō: Ōtsuka Kōgeisha, 1928

Sakamoto Kōsō. *Sekai no Tessai* (The Universal Tessai). Ōsaka: Naniwasha, 1965

Sansom (1), George B. *Japan: A Short Cultural History*. New York: The Century Co., 1932

—— (2). *The Western World and Japan*. London: The Cresset Press, 1950

Satō Masahiko. *Kyōto Ceramics*, no. 2 in the series Arts of Japan (translated and adapted by Anne Ono Towle and Usher P. Coolidge). New York and Tōkyō: Weatherhill/ Shibundō, 1973

Sawaguchi Goichi. *Nihon Shikkō no Kenkyū* (A Study of Japanese Lacquer). Tōkyō: Bijutsu Shuppan-sha, 1966

Schamoni, Wolfgang, et al. *Yoshitoshi* (catalogue). Cologne: Museum für Ostasiatische Kunst, 1971

Schmidt, Steffi. *Katalog der chinesischen und japanischen Holzschnitte im Museum für ostasiatische Kunst, Berlin*. Berlin: Bruno Hessling, 1971

Seckel (1), Dietrich. *Buddhistische Kunst Ostasiens*. Stuttgart: W. Kohlhammer, 1957

Seckel (2), Dietrich, and Hase Akihisa. *Emakimono: The Art of the Japanese Painted Handscroll* (translated from the German by J. Maxwell Brownjohn). London: Jonathan Cape; New York: Pantheon Books, 1959

Selected Catalogue of the Museum Yamato Bunkakan. Nara: Yamato Bunkakan, 1964

Sengai (catalogue, in German). Tōkyō: Kokusai Bunka Shinkōkai, 1961

Sesshū (catalogue). Tōkyō National Museum, ed. Tōkyō: Benridō, 1956

Shiba (1) Kōkan. *Diary of the Trip to the West*. Tōkyō: Hambon Shoten, 1927

Shiba (2) *Kōkan-ten* (Exhibition of Works by Shiba Kōkan) (catalogue). Nara: Yamato Bunkakan, 1969

Shibui (1) Kiyoshi et al. *Ukiyo-e* (Ukiyo-e Masterpieces), 2 vols. Tōkyō: Nihon Keizai Shimbunsha, 1969

Shibui (2) Kiyoshi. *Utamaro no Sekai* (The World of Utamaro). Tōkyō: Nihon Keizai Shimbunsha, 1952

Shijō-ha Gashū (Paintings of the Shijō School). Tōkyō: Shimbi Shoin, 1924

Shimada Shūjirō, ed. *Zaigai Hihō* (Japanese Art Treasures in Western Collections), 3 vols. Tōkyō: Gakushū Kenkyūsha, 1969

Shōhekiga Zenshū (Encyclopedia of Wall Paintings). Tanaka Ichimatsu, Doi Tsugiyoshi, and Yamane Yūzō, eds. 10 vols. Tōkyō: Bijutsu Shuppan-sha, 1960–66

Shoki Ukiyo-e Shuhō. See Tanaka Kisaku and Kishida Ryūsei.

Shōsō-in no Kaiga (Treasures of the Shōsō-in). Shōsō-in Office, ed. Tōkyō: Asahi Shimbun Publishing Co., 1961

Sohō Yukihito, ed. *Nihon Yōga no Shokō* (Western-Style Painting in Japan). Tōkyō: Iwanami Shoten, 1930

Sōtatsu (1) (catalogue). Tōkyō: Nihon Keizai Shimbunsha, 1966

Sōtatsu (2) *Gashū* (Collection of Sōtatsu's Work). Tōkyō: Nihon Bijutsu Kyōkai, 1930

Sōtatsu (3) *Kōrin-ha Zuroku* (Illustrated Catalogue of the Exhibition of the Sōtatsu-Kōrin School). Tōkyō National Museum, ed. Kyōto: Benridō, 1952

Speiser (1), Werner. *Kuniyoshi* (catalogue). Bad Wildungen: Siebenburg Verlag, 1969

——— (2). *Lackkunst in Ostasien*. Baden-Baden: Holle Verlag, 1965

Statler, Oliver. *Modern Japanese Prints*. Rutland, Vermont and Tōkyō: Tuttle, 1960

Stern (1), Harold P. *Hokusai: Paintings and Drawings in the Freer Gallery of Art*. Washington: Freer Gallery of Art, 1960

——— (2). *Master Prints of Japan: Ukiyo-e Hanga*. New York: Harry N. Abrams, 1969

——— (3) *Rimpa: Masterworks of the Japanese Decorative School* (catalogue). New York: The Japan Society,1971

——— (4). *Ukiyo-e Painting* (catalogue: Freer Gallery of Art 50th Anniversary Exhibition). Washington: Smithsonian Institution, 1973

——— (5). *Ukiyo-e Painting: Selected Problems*. Ann Arbor: University of Michigan Press, 1960

Stewart, Basil. *Japanese Colour-Prints*. London: Kegan Paul, Trench, Trubner and Co., 1920

Strange (1), Edward F. *The Colour Prints of Hiroshige*. London: Cassell and Co., 1925

——— (2). *Japanese Colour Prints*. London: Victoria and Albert Museum, for His Majesty's Stationery Office by Wyman and Sons, 1931

Succo (1), Friedrich. *Katsukawa Shunshō (Haruaki)*. Plauen: C. F. Schulz and Co., 1922

——— (2). *Utagawa Toyokuni und seine Zeit*, 2 vols. Munich: R. Piper and Co., 1924 (2nd edition)

Suganuma Teisaburō. *Kazan no Kenkyū* (Study of Kazan). Tōkyō: Mokujisha, 1969

Sugimura Tsune and Ogawa Masakata. *The Enduring Crafts of Japan*. New York and Tōkyō: Walker/Weatherhill, 1968

Sullivan, Michael. *The Meeting of Eastern and Western Art from the Sixteenth Century to the Present Day*. London: Thames and Hudson, 1973

Suzuki (1a) Daisetz T. *Sengai, the Zen Master*. London: Faber and Faber, 1971

Suzuki (1) Jūzō. *Katsushika Hokusai*. Tōkyō: Ryokuen Shobō, 1963

——— (2). *Masterworks of Ukiyo-e: Sharaku* (translated by John Bester). Tōkyō and Palo Alto, California: Kōdansha International, 1968

——— (3). *Utagawa Hiroshige*. Tōkyō: Nihon Keizai Shimbunsha, 1970

Suzuki (4) Jūzō and Oka Isaburō. *Masterworks of Ukiyo-e: "The Decadents"* (translated by John Bester). Tōkyō and Palo Alto, California: Kōdansha International, 1969

Suzuki (5) Keiun. *Nō no Men* (Noh Masks). Tōkyō: Wan'ya Shoten, 1960

Suzuki (6) Susumu. *Buson*. Tōkyō: Nihon Keizai Shimbunsha, 1958

——— (7). *Chikuden*. Tōkyō: Nihon Keizai Shimbunsha, 1963

———(7a). *Kinsei Itan no Geijutsu* (Unorthodox Painting). Tōkyō: Mariya Shobō, 1973

———(8). *Taiga*. Tōkyō: Misuzu Shobō, 1958

———(9). *Uragami Gyokudō Gashū* (Paintings by Uragami Gyokudō). Tōkyō: Nihon Keizai Shimbunsha, 1956

Taikan (1) *Byōbu-shū* (Taikan's Screens). Tōkyō: Ōtsuka Kōgeisha, 1954

Taikan (2) *Fugaku-shū* (Collection of Taikan's Paintings of Mount Fuji). Tōkyō: Ōtsuka Kōgeisha, 1954

Taikan (3) *Gadan* (Taikan's Memoirs). Tōkyō: Kōdansha, 1951

Taikan (4) *Gagyō Rokujūnen Zuroku* (Pictorial Record of Sixty Years of Taikan's Painting). Tōkyō: Ōtsuka Kōgeisha, 1951

Taikan (5) *Sakuhin-shū* (Collected Works of Taikan). Tōkyō: Ōtsuka Kōgeisha, 1925

Taikan (6) *Yokoyama*. Committee for Posthumous Work of Taikan Yokoyama, ed. Tōkyō: 1957

Tajima (1) Shiichi. *Jakuchū Meigashū* (Masterpieces by Jakuchū) Tōkyō: Shimbi Shoin, 1902

——— (2). *Kōrin-ha Gashū* (Masterpieces from the Kōrin School), 5 vols. Tōkyō: Shimbi Shoin, 1903–6

——— (3), ed. *Maruyama-ha Gashū* (Paintings of the Maruyama School), 2 vols. Tōkyō: Shimbi Shoin, 1907

——— (4). *Masterpieces by Jakuchū*. Ōsaka: Kansai Photograph Co., 1904

——— (5), ed. *Masterpieces by Sesshū*. Tōkyō: Shimbi Shoin, 1910

——— (6). *Masterpieces Selected from the Maruyama School, with Biographical Sketches of the Artists*. Tōkyō: Shimbi Shoin, 1911 (revised edition)

——— (7). *Masterpieces Selected from the Ukiyo-e School*, 5 vols. Tōkyō: Shimbi Shoin, 1907–9

——— (8), ed. *Motonobu Gashū* (Works of Motonobu), 3 vols. Tōkyō: Shimbi Shoin, 1903–7

——— (9). *Nanga Jūdaika-shū* (Ten Masters of the Nanga School), 2 vols. Tōkyō: Shimbi Shoin, 1909–10

——— (10), ed. *Sesshū Gashū* (Paintings by Sesshū). Tōkyō: Shimbi Shoin 1907

——— (11), ed. *Shijō-ha Gashū* (Paintings of the Shijō School). Tōkyō: Shimbi Shoin, 1911

——— (12), ed. *Shimbi Taikan* (Selected Relics of Japanese Art) (text in Japanese and English), 20 vols. Tōkyō: Nippon Bukkyō Shimbi Kyōkai, 1899–1908

——— (13), ed. *Tōyō Bijutsu Taikan* (Masterpieces Selected from the Fine Arts of the Far East), 15 vols. Tōkyō: Shimbi Shoin, 1908–18

Takahashi (1) Seiichirō. *Evolution of Ukiyo-e* (translated by Ryōzō Matsumoto). Yokohama: H. Yamagata, 1955

——— (2). *The Japanese Woodblock Print Through Two Hundred and Fifty Years* (translated by Ryōzō Matsumoto). Chūō Kōron Bijutsu Shuppan, 1961 (revised edition)

——— (3), ed. *Kaigetsudō*, no. 13 in the series Kōdansha Library of Japanese Art (English text by Richard Lane). Rutland, Vermont and Tōkyō: Tuttle, 1959

——— (4). *Masterworks of Ukiyo-e: Harunobu* (English adaptation by John Bester). Tōkyō and Palo Alto, California: Kōdansha International, 1968

——— (5). *Traditional Woodblock Prints of Japan*, no. 22 in the series Heibonsha Survey of Japanese Art (translated by Richard Stanley-Baker). New York and Tōkyō: Weatherhill/Heibonsha, 1972

——— (6). *Ukiyo-e: Hiraki Collection* (English adaptation by Harry Packard), 10 vols. Tōkyō: The Mainichi Newspapers, 1970

Takamizawa Tadao. *Namban Byōbu* (Namban Screens). Tōkyō: Kajima Kenkyūjo Shuppankai, 1970

Takeda (1) Tsuneo. *Nagoya-jō*, in the series Shōhekiga Zenshū (Collection of Wall Paintings). Tōkyō: Bijutsu Shuppan-sha, 1967

Takeda (2) Tsuneo and Kawai Masatomo. *Kennin-ji*, in the series Shōhekiga Zenshū (Collection of Wall Paintings). Tōkyō: Bijutsu Shuppan-sha, 1968

Takeuchi Naoji. *Hakuin*. Tōkyō: Chikuma Shobō, 1964

Tamba (1) Tsuneo. *Hiroshige Ichidai* (Art of Hiroshige). Tōkyō: Asahi Shimbunsha, 1968

——— (2). *Nishiki-e ni Miru Meiji Tennō to Meiji Jidai* (The Emperor Meiji and the Meiji Period Seen in Prints). Tōkyō: Asahi Shimbunsha, 1963

——— (2a). *Ukiyo-e: Edo kara Hakone made* (Ukiyo-e: from Edo to Hakone). Tōkyō: Asahi Shimbunsha, 1963

——— (3). *Yokohama Ukiyo-e*. Tōkyō: Asahi Shimbunsha, 1962

Tamechika Gashū (Paintings by Tamechika). Kyōto: Benridō, 1929

Tanaka (1a) Denzaburō. *Kazan Sensei Gafu* (Paintings by the Master Kazan). Tōkyō: Benridō, 1928

Tanaka (1) Ichimatsu. *Daitoku-ji*, in the series Shōhekiga Zenshū (Collection of Wall Paintings). Tōkyō: Bijutsu Shuppan-sha, 1971

——— (2). *Japanese Ink Painting: Shūbun to Sesshū*, vol. 12 in the series Heibonsha Survey of Japanese Art (translated by

Bruce Darling). New York and Tōkyō: Weatherhill/Heibonsha, 1972
—— (3). *Momoyama no Bi* (Art of the Momoyama Period) (English summary by Sasaguchi Rei). Tōkyō: Nihon Keizai Shimbun, 1957
—— (4). *Nihon Emakimono Shūsei* (Collected Japanese Scroll Paintings), 29 vols. Tōkyō: Yūzankaku, 1929–43
—— (5). *Nihon Kaiga-shi Ronshū* (Essays on the History of Japanese Painting). Tōkyō: Chūō Kōron Bijutsu Shuppan, 1966
Tanaka (6) Ichimatsu et al., eds. *Ikeno Taiga Gafu* (Paintings by Ikeno Taiga), 5 vols. Tōkyō: Chūō Kōron Bijutsu Shuppan, 1959
—— (7). *Kōrin*. Tōkyō: Nihon Keizai Shimbunsha, 1965
—— (7a). *Nihon no Meiga* (Famous Paintings of Japan). Tōkyō: Kōdansha, 1973-
Tanaka (8) Ichimatsu, Doi Tsugiyoshi, and Yamane Yūzō, eds. *Shōhekiga Zenshū* (Collection of Wall Paintings), 10 vols. Tōkyō: Bijutsu Shuppan-sha, 1960–71
Tanaka (9) Kisaku and Kishida Ryūsei, eds. *Shoki Ukiyo-e Shuhō* (Masterpieces of Early Ukiyo-e). Tōkyō: Tanryokudō, 1927
Tanaka (10) Sakutarō. *Ninsei*. Tōkyō: Heibonsha, 1960
Tangen Gashū (Paintings by Tangen). Tōkyō: Shimbi Shoin, 1926
Terry, Charles S. *Hokusai's Thirty-six Views of Mount Fuji*. Rutland, Vermont and Tōkyō: Tuttle, 1960
Tessai. Tōkyō: Chikuma Shobō, 1957
Toda (1) Kenji. *Descriptive Catalogue of Japanese and Chinese Illustrated Books in the Ryerson Library of the Art Institute of Chicago*. Chicago: Chicago Art Institute, 1931
—— (2). *Japanese Scroll Painting*. Chicago: The University of Chicago Press, 1935
Togari Sushin'an. *Chikuden Meiseki Dai Zushi* (Album of Famous Works by Chikuden). Kyōto: Benridō, 1945
Tōki Kōza (Lectures on Pottery). Tōkyō: Yūzankaku, 1935–37
Tokutomi Iichirō, ed. *Isshi Oshō Iboku-shū* (Collection of Works by Priest Isshi), 2 vols. Tōkyō: (privately printed), 1940
Tōkyō Geijutsu Daigaku Zōhin Mokuroku (Catalogue of the Collection of the Tōkyō University of Arts), 5 vols. Tōkyō: Tōkyō Geijutsu Daigaku, 1954–61
Tosa Mitsunori. Watanabe Shōzaburō, compiler and publisher. Tōkyō: 1933 (limited edition)
Totsugen Gashū (Paintings by Totsugen). Tōkai Bijutsu Kyōkai, ed. Kyōto: Nakajima Kyōeisha, 1931
Trésors de la peinture japonaise (catalogue). Paris: Musée du Louvre, 1966
Trotter, Massey. *Catalogue of the Work of Kitagawa Utamaro in the Collection of the New York Public Library*. New York: New York Public Library, 1950
Tsubota K., ed. *Motonobu Gashū* (Paintings by Motonobu). Tōkyō: Shimbi Shoin, 1917
Tsuji Koreo. *Myōshin-ji Tenkyū-in*, in the series Shōhekiga Zenshū (Collection of Wall Paintings). Tōkyō: Bijutsu Shuppan-sha, 1967
Turk, Frank A. *The Prints of Japan*. Worcester and London: Arco Publications, 1966
Two Hundred Years of Japanese Porcelains (catalogue). St. Louis: City Art Museum of St. Louis; Kansas City: Nelson Gallery and Atkins Museum, 1970

Uchida Minoru. *Hiroshige*. Tōkyō: Iwanami Shoten, 1918
Ukiyo-e (1) *Hanga-hen: Tōkyō Kokuritsu Hakubutsukan Zuhan Mokuroku* (Ukiyo-e Prints: Illustrated Catalogue of the Tōkyō National Museum), 3 vols. Tōkyō: Tōkyō National Museum, 1960–63
Ukiyo-e (2) *Taikei*, 12 vols. Tōkyō: Shūeisha, 1973
Ukiyo-e (3) *Taikei Shūsei* (Collection of the Masters of the Ukiyo-e School), 20 vols. Sasagawa Rimpu, ed. Tōkyō: Taihokaku Shobō, 1931–32
Umehara Ryūzaburō, in the 3-volume set Nihon Kindai Gaka Sen (A Selection of Modern Japanese Artists). Tokudaiji K., ed. Tōkyō: Bijutsu Shuppan-sha, 1953–54 (vol. 1 only reissued in 1957)
Umezawa (1) Seiichi. *Hōgai to Gahō* (Hōgai and Gahō). Tōkyō: Junsei Bijutsusha, 1920
—— (2). *Nihon Nanga-shi* (History of Japanese Nanga Painting). Tōkyō: Nan'yōdō Shoten, 1919
Uyeno Naoteru, ed. *Japanese Arts and Crafts in the Meiji Era*

(English adaptation by Richard Lane). Tōkyō: Pan-Pacific Press, 1958

Vignier, Charles, and Inada Hogitarō. *Estampes japonaises*, 6 vols. (catalogue). Koechlin, R., ed. Paris: Longuet, 1909–14

Wada Eisaku. *Kuroda Seiki Sakuhin Zenshū* (Complete Works of Kuroda Seiki). Tōkyō: Shimbi Shoin, 1925
Wakita Hidetarō. *Nihon Kaiga Kinseishi* (History of Modern Japanese Art). Tōkyō: Shūbunkan, 1943
Warner (1), Langdon. *The Craft of the Japanese Sculptor*. New York: McFarlane, Ward, McFarlane, 1936
—— (2). *The Enduring Art of Japan*. Cambridge: Harvard University Press, 1952
—— (3). *Japanese Sculpture of the Suiko Period*. New Haven: Yale University Press, 1923
—— (4). *Japanese Sculpture of the Tempyō Period*. Cambridge: Harvard University Press, 1964
Watanabe Hajime. *Higashiyama Suibokuga no Kenkyū* (A Study of Ink Painting in the Higashiyama Period). Tōkyō: Zauhō Kankōkai, 1948
Waterhouse, D. B. *Harunobu and His Age*. London: The Trustees of the British Museum, 1964
Watson (1), William. *Sculpture of Japan from the Fifth to the Fifteenth Century*. London: The Studio Limited, 1959
—— (2). *Yosa no Buson* (catalogue). London: Faber and Faber, 1960
Works (1) *of Shōji Hamada: 1921–69, The* (introduction by Bernard Leach and Hamada Shōji). Tōkyō: Asahi Shimbunsha, 1969
Works (2) *of Tomioka Tessai, The* (catalogue of the collection of Abbot Sakamoto at the Seichō-ji, Takarazuka, Hyōgo-ken). Kokusai Bunka Shinkōkai, ed. Tōkyō: Benridō, 1966

Yamada Chisaburoh and Sackheim, Eric, eds. *Decorative Arts of Japan*. Tōkyō: Kōdansha International, 1964
Yamaguchi Hōshun Sakuhin-shū (Collected Works of Yamaguchi Hōshun). Tōkyō: Sansaisha, 1964
Yamane (1) Yūzō. *The Life and Work of Kōrin*, vol. 1: "The Konishi Collection." Tōkyō: Chūō Kōron Bijutsu Shuppan, 1962
—— (1a). *Momoyama Genre Painting*, vol. 17 in the series Heibonsha Survey of Japanese Art (translated by John M. Shields). New York and Tōkyō: Weatherhill/Heibonsha, 1973
—— (2). *Nihon Iro-e Kotō-shū* (Old Japanese Colored Porcelain). Kyōto: Kyōto Shoin, 1953
—— (3). *Sōtatsu*. Tōkyō: Nihon Keizai Shimbunsha, 1962
Yanagi (1a) Ryō. *Gendai Chōkoku no Jūnin* (Ten Modern Sculptors). Tōkyō: Nichidō, 1959
Yanagi (1) Sōetsu. *Mokujiki Shōnin* (Priest Mokujiki). Tōkyō: Mokujiki Gogyō Kenkyūkai, 1925
—— (2). *Mokujiki Shōnin Chōkoku* (Sculpture by Priest Mokujiki). Tōkyō: Nihon Mingei Kyōkai, 1943
—— (3), ed. *Hamada Shōji Sakuhin-shū* (Collection of Works by Hamada Shōji). Tōkyō: Asahi Shimbunsha, 1966
Yashiro (1), Yukio, ed. *Art Treasures of Japan*, 2 vols. Tōkyō: Kokusai Bunka Shinkōkai, 1960
—— (2). *Kazan*. Tōkyō: Nakayama Shimbun Shuppan Kyoku, 1962
—— (3). *Tōyō Bijutsu Ronkō* (Studies in Chinese and Japanese Art in the United States and Europe). Tōkyō: Zauhō Kankōkai, 1942
—— (4). *Two Thousand Years of Japanese Art*. Edited by Peter Swann. London: Thames and Hudson, 1958
Yasui Sōtarō. Tōkyō: Bijutsu Shuppan-sha, (n.d.)
Yokokawa Kiichirō. *Fukuda Heihachirō*. Tōkyō: Bijutsu Shuppan-sha, 1949
Yonezawa Yoshiho and Yoshizawa Chū. *Japanese Painting in the Literati Style*, vol. 23 in the series Heibonsha Survey of Japanese Art (translated and adapted by Betty Iverson Monroe). New York and Tōkyō: Weatherhill/Heibonsha, 1974
Yoshida (1a) Susumu. *Kiyochika*. Tōkyō: Ryokuen Shobō, 1964
Yoshida (1) Teruji. *Harunobu*. Tōkyō: 1953
—— (2). *Harunobu Zenshū* (Collection of Harunobu's Works). Tōkyō: Takamizawa, 1942
—— (3). *Tōshūsai Sharaku*. Tōkyō: Hokkō Shobō, 1943
—— (4). *Utamaro Zenshū* (Collection of Utamaro's Works). Tōkyō: Takamizawa, 1941
Yoshida (5) Teruji and Akai Tatsurō. *Nikuhitsu Ukiyo-e* (Uki-

yo-e Paintings), vol. 2. Tōkyō and Palo Alto, California: Kō-
dansh a International, 1962–63

Yoshimura Teiji. *Higashiyama Bunka* (Art of the Higashiyama
Period). Tōkyō: Bijutsu Shuppan-sha, 1968

Yoshino Tomio. *Japanese Lacquer Ware*, no. 25 in the series
Tourist Library. Tōkyō: Japan Travel Bureau, 1959

Yoshizawa (1) Chū. *Yokoyama Taikan no Geijutsu* (The Art of
Yokoyama Taikan). Tōkyō: Bijutsu Shuppan-sha, 1958

—— (2). *Yokoyama Taikan*. Tōkyō: Kōdansha International,
1962

—— (3). *Nanga*. Tōkyō: Misuzu Shobō, 1958

—— (4). *Taiga*. Tōkyō: Heibonsha, 1957

Zōhin Zuroku. See *Tōkyō Geijutsu Daigaku Zōhin Mokuroku*.

JOURNALS AND SERIAL PUBLICATIONS

AAA *Archives of Asian Art*. New York: The Asia Society,
1966–. (Originally *Archives of the Chinese Art So-
ciety of America*)

ACASA *Archives of the Chinese Art Society of America*, 19
vols. New York: Chinese Art Society of New York,
1946–66

AA *Ars Asiatica:* études et documents publiés sous la
direction de Victor Goloubew, 18 vols. Paris and
Brussels: G. van Oest et Cie., 1914–35

AO *Ars Orientalis: The Arts of Islam and the East*.
Washington: Freer Gallery of Art; Ann Arbor:
University of Michigan, 1954–

ARTA *Artibus Asiae*. Vols. I–III, Dresden: Avalun-Verlag
Hellerau, 1925–29; vols. IV-VII, Leipzig: Richard
Hadl, 1930–32; vol. VIII, Basel: Erasmushaus,
1940; vols. IX-, Ascona: Artibus Asiae, 1946–

BK *Bijutsu Kenkyū* (Journal of Art Studies). Tōkyō:
Tōkyō Kokuritsu Bukagai Kenkyūjo, 1932–

BI *Bijutsushi* (quarterly journal of the Japan Art History
Society) Bijutsushigaku-kai, ed. Kyōto: Benridō,
1950–

BO *Bokubi* (periodical, largely on calligraphy). Kyōto:
Bokubisha, 1951–

BB *Bukkyō Bijutsu* (quarterly review of Buddhist art).
Nara: Bukkyō Bijutsu-sha, 1924–

BG *Bukkyō Geijutsu* (Ars Buddhica) (quarterly review of
Buddhist art). Tōkyō: Mainichi Shimbunsha, 1948–

BAIC *Bulletin of the Art Institute of Chicago*. Chicago: Art
Institute

BCM *Bulletin of the Cleveland Museum of Art*. Cleveland:
Cleveland Museum of Art

BMM *Bulletin of the Metropolitan Museum of Art*. New
York: Metropolitan Museum of Art

BMFA *Bulletin of the Museum of Fine Arts*. Boston: Museum
of Fine Arts

FC *Far Eastern Ceramic Bulletin,* 12 vols. Boston:
Museum of Fine Arts; Ann Arbor: University of
Michigan, 1948–60

G *Gasetsu* (Talks on Art). Tōkyō: Tōkyō Bijutsu Ken-
kyūjo, 1937–44

GNB *Genshoku Nihon no Bijutsu* (Color Reproductions of
Japanese Art), 30 vols. Tōkyō: Shōgakukan, 1967

GK *Genshokuban Kokuhō* (Color Reproductions of Na-
tional Treasures), 12 vols. + handbook Tōkyō:
Mainichi Shimbunsha, 1968–69

HS *Higashiyama Suiboku Gashū* (Collection of Ink Paint-
ings of the Higashiyama Period), 13 vols. Tōkyō:
Jurakusha, 1933–36

HO *Hōshun* (monthly periodical). Tōkyō: Nihon Bijutsu
Shimpōsha, 1953–

HU *Hōun* (periodical). Tōkyō: Hōun-sha, 1932–41

KO *Kobijutsu* (quarterly review of the arts). Tōkyō:
Sansaisha, 1963–

K *Kokka* (illustrated monthly journal of Oriental art).
Tōkyō: Kokkasha, 1889–

M *Museum* (monthly publication of the Tōkyō National
Museum). Tōkyō: Tōkyō National Museum 1951–

NB (H) *Nihon no Bijutsu* (Japanese Art), 29 vols. Tōkyō:
Heibonsha, 1964–69

NB (S) *Nihon no Bijutsu* (Japanese Art). Tōkyō National
Museum, Kyōto National Museum, and Nara

National Museum, eds. Tōkyō: Shibundō, 1960–

NBT *Nihon Bijutsu Taikei* (Compendium of Japanese
Art), 11 vols. Tōkyō: Kōdansha, 1959–61

NBZ *Nihon Bijutsu Zenshū* (Collection of Japanese Fine
Art), 6 vols. Fujita Tsuneo, ed. Tōkyō: Bijutsu
Shuppan-sha, 1969

NEZ *Nihon Emakimono Zenshū* (Collection of Japanese
Scroll Paintings), 29 vols. Tōkyō: Kadokawa Sho-
ten, 1958–64

NHBZ *Nihon Hanga Bijutsu Zenshū* (Collection of Japanese
Prints), 9 vols. Tōkyō: Kōdansha, 1961–62

NKKZ *Nihon Kindai Kaiga Zenshū* (Collection of Modern
Japanese Paintings), 24 vols. Tōkyō: Kōdansha,
1962–63

NKZ *Nihon Kokuhō Zenshū* (Collection of Japanese Nation-
al Treasures), 84 vols. Ministry of Education, ed.
Tōkyō: Nihon Kokuhō Zenshū Kankōkai, 1924–39

OA *Oriental Art* (quarterly journal). Peter C. Swann, ed.
London: The Oriental Art Magazine, 1955–

OZ *Ostasiatische Zeitschrift*. Vols. 1–10, Berlin: Oester-
held and Co. Verlag, 1912–23; new series: vols.
1–16, Berlin and Leipzig: Verlag von Walter de
Gruyter and Co., 1924–40

P *Pageant of Japanese Art*, 6 vols. Tōkyō National
Museum, ed. Tōkyō: Tōtō Bunka Co., 1952–54

PTN *Proceedings of the Tōkyō National Museum*. Tōkyō:
Tōkyō National Museum, 1965–

SBZ *Sekai Bijutsu Zenshū: Nihon-hen* (Collection of
World Art: Japan), 11 vols. Egami Namio et al.,
eds. Tōkyō: Kadokawa Shoten, 1960–67

STZ *Sekai Tōji Zenshū* (Collection of World Ceramics),
16 vols. Vols. I-VII, edited by Koyama Fujio et al.
Tōkyō: Zauhō Press and Kawade Shobō, 1955–58

T *Tōji* (Oriental Ceramics). Tōkyō: Tōyō Tōji Ken-
kyūjo, 1928–43

TZ (K) *Tōki Zenshū* (Collection of Ceramics). 32 vols. Ko-
yama Fujio, ed. Tōkyō: Heibonsha, 1958–66

TZ (T) *Tōki Zenshū* (Collection of Ceramics), 30 vols. Tōki
Zenshū Hensankai, ed. Tōkyō: Hōunsha, 1931–37

TBS *Tōyō Bijutsu Senshō* (Collection of Far Eastern Art),
13 vols. Tōkyō: Sansaisha, 1969–71

TOCS *Transactions of the Oriental Ceramic Society*. London:
The Oriental Ceramic Society, 1921–

UG *Ukiyo-e Geijutsu* (Ukiyo-e Art). Tōkyō: Nihon Uki-
yo-e Kyōkai, 1962–

YB *Yamato Bunka* (quarterly journal of the Yamato
Bunkakan). Ōsaka: Yamato Bunkakan, 1951–

ZNBT *Zusetsu Nihon Bunka-shi Taikei* (Illustrated Cultural
History of Japan), 14 vols. Tōkyō: Shōgakukan,
1958

DICTIONARIES AND ENCYCLOPEDIAS

Bijutsu Meiten (Masterpieces of Art). Tōkyō: Bijutsu Shuppan-
sha, 1961

Dai Nihon Shoga Meika Taikan (General Survey of Masters of
Japanese Painting and Calligraphy). Tōkyō: Dai Nihon Shoga
Meika Taikan Kankōkai, 1934

Higuchi Hiroshi. *A Complete Collection of Nagasaki Prints*.
Tōkyō: Mitōshoya, 1971

Hori Naonari and Kurokawa Harumura. *Fusō Meiga Den*
(Biographies of Japanese Painters). Revised by Kurokawa
Mamichi. 2 vols. Tōkyō: Tetsugaku Shoin, 1899

Index of Japanese Painters, compiled by the Society of Friends of
Eastern Art. Rutland, Vermont and Tōkyō: Tuttle, 1958
(reprint)

Inoue Kazuo. *Ukiyo-e Shiden* (Biographical Dictionary of
Ukiyo-e Artists). Tōkyō: Watanabe Hangaten, 1931

Ishida Seitarō, ed. *Nihon Shoga Meika Hennen Shi* (Chronologi-
cal History of Masters of Japanese Painting and Calligraphy).
Tōkyō: 1914

Katō Tōkurō. *Genshoku Tōji Daijiten* (Dictionary of Ceramics in
Color). Kyōto: Tankōsha, 1972

——. *Shinsen Tōki Jiten* (New Dictionary of Ceramics). Tō-
kyō: Kōgyō Tosho, 1937

Kawasaki Tsuneyuki, Morisue Yoshiaki, and Wakamori Tarō.
Nihon Bunkashi Jiten (Dictionary of Japanese Cultural His-
tory). Tōkyō: Asakura Shoten, 1962

Kokuhō Jiten (Dictionary of National Treasures). Bunkazai Hogo Iinkai, ed. Kyōto: Benridō, 1968

Kurokawa Harumura. *Kōko Gafu* (Catalogue of Ancient Paintings in Japan). Revised edition *Teisei Zōho Kōko Gafu,* included in *Kurokawa Mayori Zenshū* (Complete works of Kurokawa Mayori), 6 vols. Tōkyō: Kokusho Kankōkai, 1910

Kurokawa Harumura. *Rekidai Dai Busshi-fu* (Biographies and Genealogies of Japanese Buddhist Sculptors). Tōkyō: Yoshikawa Hanshichi, 1899

Nihon Rekishi Daijiten (Encyclopedia of Japanese History), 12 vols. Tōkyō: Kawade Shobō Shinsha, 1968–70 (revised edition)

Nihonga Taisei (Comprehensive Illustrated Survey of Japanese Painting), 55 vols. Tōkyō: Tōhō Shoin, 1930–

Ono Ken'ichirō, ed. *Tōki Daijiten* (Encyclopedia of Ceramics), 6 vols. Compiled by Tōki Zenshū Kankōkai. Tōkyō: Fuzambō, 1934–6

Ōta Kin. *Zōtei Koga Bikō* (*Koga Bikō,* rev. ed.), 4 vols. Tōkyō: Yoshikawa Kōbunkan, 1905

Sakazaki Shizuka. *Nihon Garon Taikan* (collection of classical essays on painting in Japan, including the *Honchō Gashi*), 2 vols. Tōkyō: Ars, 1926–28

Satō Aiko. *Nihon Meigaka Den* (Biographies of Famous Japanese Painters). Tōkyō: Seiabō, 1967

Sawada Akira, ed. *Nihon Gaka Daijiten* (Dictionary of Japanese Painters), 2 vols. Tōkyō: Kigensha, 1927

Shimizu Tōru. *Ukiyo-e Jimmei Jiten* (Dictionary of Ukiyo-e Names). Tōkyō: Bijutsu Kurabu Shuppan, 1954

Tamagawa Hyakka Daijiten. Tōkyō: Tamagawa Daigaku Shuppan, 1959

Tani Shin'ichi and Noma Seiroku. *Nihon Bijutsu Jiten* (Dictionary of Japanese Art). Tōkyō: Tōkyōdō Shuppan, 1967

Ukiyo-e Zenshū (illustrated catalogue of ukiyo-e prints), 6 vols. Tōkyō: Kawade Shobō, 1957–58

Yoshida Teruji, ed. *Ukiyo-e Jiten* (Ukiyo-e Dictionary), 3 vols. Tōkyō: Ryokuen Shobō (vols. 1 & 2), Gabundō (vol. 3), 1965-71

Yoshida Teruji, ed. *Ukiyo-e Taisei* (Encyclopedia of Ukiyo-e Prints and Paintings), 12 vols. Tōkyō: Tōhō Shoin, 1931–35

Yoshida Teruji and Sasagawa Taneo, eds. *Ukiyo-e Taika Shūsei* (Survey of Ukiyo-e Masters), 20 vols. Tōkyō: Hōkaku Shobō, 1931–32

Zōho Ukiyo-e-shi Jimmei Jisho (Revised Dictionary of Ukiyo-e Painters and Printmakers). Kyōto: Geisōdō, 1930

Index of Alternate Names

Each of the entries in this index consists of 1) the alternate name of an artist, 2) an equal mark, and 3) the name under which the artist is treated in the dictionary.

Abe Kan = Tōrin (Abe)
Adachi Ginkō = Ginkō
Adachi Heishichi = Ginkō
Aguri Kawanari = Kawanari
Aiai = Keiu (Matsuoka)
Aichiku Sōdō = Kawamura Ukoku
Aijirō = Ōide Tōkō
Aikawa Hidenari = Minwa
Aikawa Mitsurō = Ai Mitsu
Aikawatei = Minwa
Aisetsu = Eikai (Satake)
Aisetsurō = Eikai (Satake)
Aizawa Ban = Sekko (Aizawa)
Aizu Sanjin = Yuda Gyokusui
Ajibō = Gesshin
Akabane Shōshin = Keisai (Kuwagata)
Akagawa Tarō = Bansui
Akatsuka Heizaemon = Akatsuka Jitoku
Akisuke = Aigai
Akizuki Tōrin = Tōrin III
Akizuki Tōseki = Tōseki
Amano Shun = Hōko
Amemori Moritora = Keitei
Ameya Sōkei = Sōkei (Tanaka)
Ammei = Kyūhaku (Koma)
An'ami Butsu = Kaikei
Andō Hiroshige = Hiroshige
Andō Katsusaburō = Kōkan (Shiba)
Andō Kichijirō = Kōkan (Shiba)
Andō Tokubei = Hiroshige III
An'ei Tōrin = Bokkei
Angadō = Matsumoto Fūko
Angyūsai = Enshi
Anko = Kyūhaku (Koma)
Ankyō = Kyūhaku (Koma)
Ansai = Shūgaku (Watanabe)
Anshō = Kyūzō II (Koma)
Anzai Oto = Un'en
Aō Chinjin = Aōdō Denzen
Aogai Chōbei = Chōbei (Aogai)
Aogai Tarozaemon = Kanshichi
Aoki Gensa = Mokubei
Aoki Hōshū = Goshichi
Aoki Shōtoku = Renzan
Aoki Shummei = Shukuya
Aoki Toku = Renzan
Aoki Toshiaki = Shukuya
Aone Kai = Kyūkō (Aone)
Aoya Gen'emon = Gen'emon (Aoya)
Arai Chūjun = Shōshun
Arai Jōshō = Kanchiku
Arai Kanjurō = Arai Kampō
Arai Katsutoshi = Arai Shōri
Arai Tei = Umin
Arai Tsunetsugu = Kanchiku
Arakawa Yasohachi = Kunichika
Araki Gen'yū = Gen'yū (Araki)
Araki Hajime = Senshū
Araki Jogen = Jogen
Araki Jōtarō = Kanō Tanrei
Araki Keitarō = Yūshi
Araki Shinkei = Kunsen (Araki)
Araki Shuhō = Genkei (Araki)
Araki Shun = Kankai
Araki Teijirō = Araki Juppo
Araki Yoshi = Araki Kampo
Ariga Kigenji = Nakagawa Kigen

Arihara Shigehisa = Arihara Kogan
Arihara Shigetoshi = Arihara Kogan
Ariiso Shūsai = Shūsai (Ariiso)
Ariki Shimbei = Shimbei
Ariki Shinbei = Shimbei
Arisaka = Hokuba
Arishima Mibuma = Arishima Ikuma
Aritsune = Hattori Aritsune
Asada Iwakichi = Goseda Hōryū
Asai Ichigō = Asai Ichimō
Asai Ryū = Asai Hakuzan
Asai Seishū = Seishū (Asai)
Asai Tadashi = Tonan (Asai)
Asano Nagamura = Baidō
Asaoka Kōtei = Kōtei (Asaoka)
Asayama = Ashikuni
Ashigadō = Ashiyuki
Ashihisa = Ashitaka
Ashikaga Yoshimochi = Yoshimochi
Ashimaro = Yoshikuni (Toyokawa)
Ashimaru = Yoshikuni (Toyokawa)
Ashimi = Hironobu II
Ashinao = Ashitaka
Ashinoya = Hironobu
Ashizuka Eishō = Jakuhō
Ashuku = Geshin
Asuka Genchō = Genchō
Asukabe no Tsunenori = Tsunenori
Atomi Katsuko = Atomi Gyokushi
Atomi Tamae = Atomi Gyokushi
Atomi Tatsuno = Atomi Kakei
Atomi Yutaka = Atomi Tai
Atsujin = Etsujin
Aundō = Satō Chōzan
Awashima Ujihei = Chingaku
Awataguchi Naoki = Keiu (Awataguchi Naoki)
Awataguchi Nao-oki = Keiu (Awataguchi Naoki)
Awataguchi Naotaka = Naotaka
Awataguchi Naoyoshi = Keiu (Awataguchi Naoyoshi)
Awataguchi Takamitsu = Takamitsu (Awataguchi)
Awataguchi Tsunemitsu = Tsunemitsu
Ayami = Konoshima Ōkoku
Ayata = Ryōtai
Ayatari = Ryōtai
Ayō = Sengai
Azuma In = Tōin (Azuma)
Azuma Taiji = Fūgai (Honkō)
Azuma Tōyō = Tōyō (Azuma)

Baian = Sekkei (Yamaguchi); Shōan
Baidō = Kunisada II
Baidō Hōsai = Kunisada III
Baien = Masakazu
Baiga = Kyōsai
Baiga Dōjin = Kyōsai
Baiga Kyōsha = Kyōsai
Baigadō Utamaro = Utamaro II
Baigaku = Einō
Baigansai = Shigeharu
Baihōken = Mitsunobu (Hasegawa)
Baiju = Ryūko
Baiju Hōnen = Baiju (Kunitoshi)
Baika = Baiitsu; Baitei

Baikaen = Baiō
Baikan Sanjin = Baikan
Baikatei = Toyohisa
Baikatoi = Unkei (Murata)
Baikei = Sōun (Tazaki)
Baikō = Settai (Hasegawa)
Baikōsai = Shunkei
Baikyūken = Jakugen
Baiō = Baiju (Kunitoshi); Masanobu (Okumura)
Baiōken = Eishun (Hasegawa); Mitsunobu (Hasegawa)
Baisai = Ryūko
Baisaiō = Tetsuseki
Baisaku = Kyōsui
Baisen = Hirai Baisen; Kayō (Shirai)
Baisen Garō = Kayō (Shirai)
Baishin = Takudō; Yūho (Kanō Baishin)
Baishun = Sadanobu (Kanō Baishun Sadanobu)
Baishurō = Kaikai
Baiso Gengyo = Gengyo
Baisō = Kakutei (Jōkō); Matsumura Baisō; Yamamoto Baisō
Baisōen = Sadayoshi
Baisōen Kinkin = Sadayoshi
Baison = Gyokudō (Kurohara)
Baisotei = Gengyo
Baisuiken = Mitsunobu (Hasegawa)
Baiyūken = Katsunobu (Baiyūken)
Bajō = Raishū
Bakusai = Sōtetsu
Bakusen = Fukuda Bisen; Tsuchida Bakusen
Ban'an = Kuniteru (Yamashita)
Ban'emon = Taito II
Banka = Maruyama Banka; Nonagase Banka
Bankadō = Inose Tōnei
Banki = Harumasa (Koikawa)
Banki Harumasa = Harumasa (Koikawa)
Banriō = Rōzan (Yasuda)
Banryūdō = Rōen
Bansen Shujin = Sōsui
Banshōrō = Renzan
Bansui = Eigaku
Bansuirō = Migita Toshihide
Bantaiō = Ushū
Banzan = Kansai (Mori); Shōryū
Basei = Bumpō
Beigenzan Shujin = Sesshū
Beika = Yamaoka Beika
Beika Dōjin = Taito II
Beikasai = Taito II
Beika Sanjin = Taito II
Beiō = Beisanjin; Kunichika
Beisai = Ōritsu
Beisen = Kubota Beisen
Beniya Shōemon = Ryūho (Hinaya)
Benji = Nikka
Benzō = Kunkei (Ishikawa)
Bimpatsu Sanjin = Kōzan (Ishikawa)
Biō = Sessō (Kaneko)
Bisen = Fukuda Bisen
Bizan = Setten; Watanabe Bunzaburō
Bodai = Tōki (Yamawaki)
Bōgakurō = Kaian

233

Chōzen = Shunkei (Harutsugu); Tsuishu (Yōsei IX)
Chōzō = Hakuei
Chū Teki = Kōyō (Nakayama)
Chūan = Chūan Bonshi; Chūan Shinkō
Chūfu = Ryōtaku (Kimura); Unsen (Kushiro)
Chūgakudō = Sūshi
Chūgakugashi = Fuyō (Kō)
Chūgakusai = Sūsetsu
Chūgō = Haran
Chūgorō = Inose Tōnei
Chūgyo = Kyūjo (Tō)
Chūhachirō = Naokata
Chūji = Bun'yū
Chūjirō = Kanrin (Okada)　　　⌈Yachō
Chūkan = Kanzan (Fukushima); Tōkoku;
Chūkanshi = Eikei
Chūki = Bairi Sanjin
Chūkin = Ōkyo
Chūkō = Shunkei (Mori); Tetsuseki
Chūkyō = Ōshin
Chūren = Morohoshi Seishō
Chūri = Kōi
Chūrinsha = Shunchō
Chūryū = Gogaku (Moro)
Chūsai = Koshū (Hirowatari)
Chūsen = Ōkyo
Chūshin = Chinchō
Chūshitsu = Ōbun
Chūshū = Tanshin (Kanō Morimasa)
Chūta = Aōdō Denzen; Chinzan
Chūtan = Chikutō
Chūtarō = Terazaki Kōgyō
Chūzaemon = Bashō; Yūsetsu (Kaihō)

Dai Busshi Jōkei = Jōkei
Daichin'ō = Hyakunen
Daigaku = Kōzan (Matsumoto); Ujinobu
Daigaku Shōsha = Kaiseki
Daigensai = Akinobu
Daigoryū = Kaiseki
Daigu = Ryōkan
Daihō = Taihō
Daijirō = Yoshifusa
Daikei = Settei (Tsukioka)
Daikōsai = Totsusen
Dainen = Kinzan; Tenju; Toshinaga (Kinoshita)
Daini = Tangen (Kanō Tokikazu)
Daishin Gitō = Gitō (Daishin)
Daisho = Shukuya
Daisuke = Chikutō; Gogaku (Fukuhara); Hiromasa; Shūkei (Watanabe Kiyoshi); Yamana Tsurayoshi
Daiwashi = Ishii Rinkyō
Daizan = Taizan (Hirose)
Dasoku = Jasoku
Deizō = Mashimizu Zōroku II
Denjirō = Baiken (Kanō Kazunobu); Goseda Hōryū; Shunkō
Denkyūji Gikyō = Rinshin
Dennai = Michinobu
Denzen = Aōdō Denzen
Denzō = Masanobu (Iwase)
Dewajirō = Kagenobu (Kanō Dewajirō)
Dō Yoshio = Yōkoku
Dōbun = Tōbun
Dodo Eifu = Hirotoshi
Dodo Gyokusen = Gyokusen (Dodo)
Dodo Gyokuō = Gyokuō
Dōga = Kōran
Dōgai = Kōami XIV
Dōgen = Tōgen
Dogyū = Okumura Togyū
Dōhaku = Tōhaku (Kanō Chikanobu); Tōhaku (Kanō Chinshin)
Dōho II = Dōho
Doi Genseki = Yūrin

Dōjun = Kyūzō (Hasegawa)
Dōkan = Buzen
Dōken = Sūshi
Doki Tomikage = Tomikage
Dōkisai = Yūsetsu (Kaihō)
Dōkō = Isshi (Iwakura); Jakushi; Yūchiku
Dōkōkan = Ganku; Gantai
Dokugasai = Nanka
Dokuhiō = Yoshitsugu Haizan
Dokuryoken = Shukō
Dokushōan = Yoshitsugu Haizan
Dokushō Koji = Yoshitsugu Haizan
Dokushōrō = Hankō (Okada)
Dokusuisha = Kuninao; Kuniteru (Ōta)
Dombokuō = Nanko
Dōminshi = Gyokushitsu
Donkaishi = Kien (Minagawa)
Donkō = Roshū (Nagasawa)
Donsanrō = Nammei
Donshū = Tonshū
Dōraku = Niten
Dōrakuen = Taizan (Hineno)
Dōryū = Gōchō
Dōshun = Tōshun (Kanō Fukunobu)
Dōsū = Kōrin
Dōsū Koji = Kōrin
Dōteisha = Taito II
Dōun = Matabei (Iwasa); Tōun (Kanō)
Dozō Eishō = Eishō (Dozō)
Dozō Eisū = Eisū

Ebikiyo = Kiyobei
Ebisei = Kiyobei
Ebiya Kiyobei = Kiyobei
Edogawa = Hokki
Egoshi Ryū = Kinga
Ehō Tokutei = Ehō
Eichū = Kawai Eichū
Eihō = Hashimoto Eihō
Eii = Unkei (Eii)
Eijirō = Isen'in; Yōsen'in
Eiju Ryōkosai = Nakamura Fusetsu
Eijusai = Eiju (Chōtensai)
Eikadō = Shigenaga
Eikanshi = Imao Keinen
Eikasai = Chikkoku
Eiken = Yasunobu (Kanō Toshinobu)
Eiko = Satake Eiko
Eikyū = Matsuoka Eikyū
Einojō = Shōroku
Einosuke = Kenzan (Sanada)
Eiraku = Nishimura Zengorō
Eiraku Hozen = Hozen
Eiraku Ryōzen = Ryōzen (Eiraku)
Eiraku Wazen = Wazen
Eiryō = Satake Eiryō
Eisa = Yōsaku
Eisai = Hokutai
Eisen = Eisen'in; Eisen'in II; Motonobu; Tomioka Eisen
Eishin = Hidenobu (Eishin); Yasunobu (Kanō Yasunobu)
Eishōsai = Chōki
Eishunsai = Yōshin (Mori)
Eison = Satake Eison
Eisuke = Yōsaku
Eitaku = Bankei (Eitaku)
Eitatsu = Kakutei (Jōkō); Koyama Eitatsu
Eizō = Kiyomitsu III; Untō (Okada)
Eizon = Eison
Ejōsai = Chinchō
Ekiō = Kunkei (Yoshikawa)
Ekisei = Dōshō (Ōnogi)
Ekiu = Ryūko
Ekkei = Ryōsen (Kojima); Shūbun (Tenshō)
Eleonora Ragusa = Kiyohara Tama

Ema Tahoko = Saikō
Emori Kunikiyo = Kunikiyo I
Empa Chōto = Nanka
Empa Gyoto = Nanka
En = Kyokkō (Fuchigami)
Enami Takemune = Takemune
Endō Han'emon = Taigaku
Endō Naiki = Kōken
Endō Sadanori = Etsujin
Endō Shin = Endō Shūgaku
Engan = Nagai Umpei
Enichibō = Jōnin
Enjin Sōdō = Kyōson (Takahashi)
Enjō = Tokuzan
Enka = Shūseki
Enka Chōsō = Nanko
Enka Gyosō = Nanko
Enka Sanjin = Jakushi
Enkei = Kyōsho
Enki = Gentai
Enkinshi = Enkin
Enoki Norinaga = Murase Gyokuden
Enryūrō = Kuninao
Ensai = Yōi
Ensen = Ichiga
Ensensha = Sekichō
Enshun = Hironobu (Kanō)
Enshunsai = Ryūkoku
Entaisai = Utamaro
Entsū-ji Fūgai = Fūgai (Honkō)
Enzan = Gen'yū (Araki)
Eshin Sōzu = Genshin
Eshinsai = Seisen'in
Etō = Reigen
Etsudō = Odake Etsudō

Fubō Sanjin = Kunisada (Tsunoda)
Fuchigami = Kyokkō (Fuchigami)
Fuchino Seryū = Shinsai (Fuchino)
Fuchisoku Sanjin = Hyakki
Fuchōan = Kunisada (Tsunoda)
Fuden = Tōretsu (Yamazaki)
Fudeya Gisaburō = Fudeya Tōkan
Fūen = Gengyo
Fūgai Dōjin = Fūgai (Ekun)
Fūgai Ekun = Fūgai (Ekun)
Fūgai Honkō = Fūgai (Honkō)
Fūgai Mokushitsu = Fūgai (Ekun)
Fugen = Atomi Kakei; Sessō (Kaneko)
Fugen'an = Atomi Gyokushi; Etsujin
Fugen Dōjin = Kōkan (Shiba)
Fuji Masazō = Fuji Gazō
Fujii Kōsuke = Fujii Kōyū
Fujii Yoshitarō = Kobayashi Tokusaburō
Fujikawa = Zōkoku
Fujikawa Shunzō = Shunzō
Fujikawa Yoshinobu = Yoshinobu (Fujikawa)
Fujimoto Makane = Tetsuseki
Fujinoshin = Reitan
Fujishige Tōgan = Tōgan (Fujishige)
Fujita Hyō = Rakan
Fujita Ken = Gokō (Fujita)
Fujita Shunshin = Eiju (Kanō)
Fujita Tsuguharu = Fujita Tsuguji
Fujiwara = En'en; Shinkai
Fujiwara Fumio = Taito II
Fujiwara Gyōkō = Jūsui
Fujiwara Hakushin = Masanobu (Kanō)
Fujiwara Hisakuni = Hisakuni
Fujiwara Hisanobu = Hisanobu (Fujiwara)
Fujiwara Jibukyō Tokitomi = Eishi
Fujiwara Junryō = Mokujiki (Fujiwara)
Fujiwara Kagenobu = Kagenobu (Kanō Dewajirō)
Fujiwara Masatake = Ryūunsai
Fujiwara no Chinkai = Chinkai

Fujiwara no Genjō = Genjō
Fujiwara no Gōshin = Gōshin
Fujiwara no Gyōkai = Gyōkai
Fujiwara no Kakuen = Kakuen (Fujiwara)
Fujiwara no Korenobu = Korenobu
Fujiwara no Kurokami = Genjō
Fujiwara no Kyōkai = Kyōkai
Fujiwara no Mitsuhide = Mitsuhide
Fujiwara no Mitsunaga = Mitsunaga
Fujiwara no Mitsunori = Mitsunori (Fujiwara)
Fujiwara no Mitsushige = Mitsushige (Fujiwara)
Fujiwara no Morimitsu = Motomitsu
Fujiwara no Motomitsu = Motomitsu
Fujiwara no Munehiro = Munehiro
Fujiwara no Nagaaki = Nagaaki
Fujiwara no Nagataka = Nagataka
Fujiwara no Naritoki = Naritoki
Fujiwara no Nobuzane = Nobuzane
Fujiwara no Sen'ami = Sen'ami
Fujiwara no Takaaki = Takaaki
Fujiwara no Takamasa = Takamasa (Fujiwara)
Fujiwara no Takamori = Takamori
Fujiwara no Takanari = Takachika
Fujiwara no Takanobu = Takanobu (Fujiwara)
Fujiwara no Takashige = Takachika
Fujiwara no Takasuke = Takasuke
Fujiwara no Takayoshi = Takayoshi
Fujiwara no Tamechika = Tamechika (Fujiwara)
Fujiwara no Tameie = Tameie
Fujiwara no Tamenobu = Tamenobu
Fujiwara no Tametsugu = Tametsugu
Fujiwara no Tameuji = Tameuji
Fujiwara no Tsunetaka = Tsunetaka
Fujiwara no Yoshimitsu = Yoshimitsu
Fujiwara no Yukihide = Yukihide
Fujiwara no Yukihiro = Yukihiro
Fujiwara no Yukimitsu = Yukimitsu
Fujiwara Ryūsen = Shūki
Fujiwara Sadatsune = Sadatsune
Fujiwara Sukenobu = Sukenobu
Fujiwara Teikyō = Sadatsune
Fujiwara Yukinaga = Yukinaga
Fukada = Fukada Chokujō
Fukae Shōroku = Roshū (Fukae)
Fukakokusai = Rinkoku
Fukao = Hokui
Fukei = Jakushi
Fūko = Matsumoto Fūko
Fukoan = Shimomura Izan
Fukochōsō = Taiga
Fukuchi = Hakuei
Fukuda Han = Fukuda Kinkō
Fukuda Kitsu = Hankō (Fukuda)
Fukuda Kōji = Fukuda Kōko
Fukuda Shūtarō = Fukuda Bisen
Fukuda Susumu = Fukuda Kinkō
Fukudō = Kunimatsu
Fukuhara Genso = Gogaku (Fukuhara)
Fukuhara Suteyuki = Suteyuki
Fukui Joyō = Joyō
Fukui Shinnosuke = Fukui Kōtei
Fukunai Kigai = Gennai
Fukuoka Yoshio = Fukuoka Seiran
Fukushima Masayuki = Kanzan (Fukushima)
Fukushima Nei = Ryūho (Fukushima)
Fukushima Yasushi = Ryūho (Fukushima)
Fukuyama Kanekichi = Yoshitoyo (Fukuyama)
Fukuzensai = Kagen (Niwa)
Fukyokan = Nankaku
Fūkyōshi = Jakushi

Fukyū = Setsudō
Fukyūshi = Samboku
Fumei = Nikka
Fuminori = Etsujin
Fumin Sambō = Fuyō (Kō)
Fumitomo = Bun'yū
Funzen = Ganku
Fūra = Bashō
Fūrai Sanjin = Gennai
Furuya Shigehisa = Arihara Kogan
Furuya Shigetoshi = Arihara Kogan
Furuyama Moromasa = Moromasa
Furuyama Moronobu = Moronobu
Furuyama Moroshige = Moroshige
Furuyama Morotane = Morotane
Furuyama Morotsugu = Morotsugu
Furyū = Kenzan (Ogata)
Fūryūan = Tokinari
Fusakichi = Gesshin
Fusen = Jasoku
Fusenkyo = Hokusai
Fusetsu = Nakamura Fusetsu
Fūsetsu Yūjō = Yūjō (Fūsetsu)
Fushimi Toshirō = Kanō Natsuo
Fushunkan = Sōen (Sakuma)
Futagami Sumitaka = Shimomura Izan
Futami Sato = Itō Shōha
Futō Sanjin = Kanokogi Takeshirō
Fuyuki Eiri = Eiri (Kikugawa)
Fuzan'ō = Etsujin

Gakakusai = Bunchō (Tani)
Gagyū = Tamaya Shunki
Gahaiken = Ryūsen
Gahō = Hashimoto Gahō
Gai = Ryūhō (Itami)
Gajin = Kōsaka Gajin
Gaki = Kyōsai
Gakoken = Tōrei (Hijikata)
Gako Sanjin = Gako
Gakubaisai = Aigai
Gakuho = Baikan
Gakuren = Tetsugai
Gakuryō = Nakamura Gakuryō
Gakuseidō = Gogaku (Fukuhara)
Gakushō = Tanami Gakushō
Gakusō = Geiami
Gakutei = Settan
Gakutei Gogaku = Gakutei
Gakuzan = Gakutei
Gakyōjin = Hokumei; Hokusai
Gakyō Rōjin = Hokusai
Gamō Hyō = Rakan
Gamō Morimasa = Morimasa (Gamō)
Gampi = Ganhi
Gan Shōtoku = Renzan
Gan Toku = Renzan
Ganchū = Hironao
Gangakusai = Settan
Gangakutei = Settan
Gangōji Genchō = Genchō
Gan'iku = Baitei
Ganjōsai = Kunihiro
Gansei Dōjin = Kōyō (Nakayama)
Ganseki = Hironatsu
Ganshōsai = Settei (Hasegawa)
Gantei = Kantei
Gantoku = Renzan
Gasammaisai = Kansai (Mori)
Gasendō = Buson; Hyakunen
Gasenken = Koson
Gatōken = Shunshi
Gatokusai = Shūkei (Watanabe Mototoshi)
Gaunrō = Ganryō
Gayū = Yamada Bunkō; Zaichū
Gazenkutsu = Yōkoku
Geiai = Sōritsu
Gejō Masao = Gejō Keikoku

Geki = Akinobu; Gyokuen (Kanō); Nobumasa; Ryūsetsusai; Soyū (Kanō)
Gekigadō = Torii Kiyotada VII
Gekkei = Goshun
Gekkō = Ogata Gekkō
Gekkōtei = Bokusen (Maki)
Gekkyo = Hida Shūzan
Gembei = Katsushige
Gembokusai = Shunsui (Kanō)
Gembun = Tōyō (Iizuka)
Gempachi = Masanobu (Okumura)
Gempitsu = Sōtetsu
Gempō = Shummei
Gen'an = Gukei (Ue)
Genchi = Sōri (Tawaraya)
Genchō = Kōdō
Genchū = Keitoku; Mototada
Gen'ei = Shūgaku (Watanabe)
Gengen = Satō Chōzan
Gengendō II = Matsuda Ryokuzan
Gengen'ō = Jōen (Okamoto)
Gengenshi = Jōen (Okamoto)
Gengetsu = Yazawa Gengetsu
Gengi = Unshitsu
Gengo = Sekiran
Gengorō = Setten
Genji = Kangetsu
Genjirō = Goseda Hōryū; Kangetsu; Kensai; Nagai Umpei
Genjō = Rankoku
Genju = Shūboku (Watanabe)
Genjusai = Eigyō
Genkei = Gesshō
Genki = Kohyō; Koma
Genkichi = Sōhei; Takahashi Genkichi
Genkō = Koshū (Hirowatari)
Genkyū = Rochō
Genkyū Mitsunaga = Deme
Gennai = Baiu; Isshū (Hanabusa Nobusuke)
Genrin = Yoshinobu (Kanō Genrin Yoshinobu)
Genro Eiboku = Suiō (Genro)
Genroku = Kawasaki Senko; Masanobu (Okumura)
Genryō = Ryōsai
Genryūsai = Taito II
Gensaku = Kenseki
Gensei = Kakushū
Genshi = Shūshō
Genshichirō = Naganobu; Shōei; Sōya (Kanō); Terunobu (Kanō)
Genshin = Saishin; Sekiho (Okano)
Genshinsai = Niten
Genshirō = Eitoku (Kanō Kuninobu); Mitsunobu (Kanō); Yasunobu (Kanō Yasunobu)
Genshisai = Yōsen'in
Genshō = Shūseki; Unzan
Genshōsai = Isen'in
Genshū = Motohide; Shūken (Watanabe); Sōshū
Genshun = Hidenobu (Kanō); Hiroyasu; Shūkei (Watanabe Mototoshi)
Genso = Shūsai (Watanabe)
Genson = Shūken (Watanabe)
Gensuke = Kikaku
Gensuke Hidemitsu = Deme
Gentetsu = Sōtetsu
Gen'yō Kinto = Himeshima Chikugai
Genyu = Shūsen
Genzaburō = Kyūho (Nomura)
Genzaemon = Mitsuyoshi (Tosa Kyūyoku)
Genzaemon no Jō = Mitsunori (Tosa)
Genzō = Chikuitsu; Koma; Toyokuni II
Genzui = Gentai
Gepparō = Kunisada (Tsunoda)
Geppo = Hakukō

Gessen = Shabaku
Gessho = Yūjō (Nijō)
Gesshō = Tamura Sōritsu
Gessō = Sekien
Getcho = Nikka
Getchō Koteki = Koteki
Getchūsai = Ganhi
Getsuan = Gyokusen (Mochizuki Shige-
 mori); Naotomo
Getsugen = Gyokusen (Mochizuki Shige-
 mori)
Getsugetsudō = Moromasa
Getsuko = Gekko
Gibokuan = Shuntei
Gibon = Sengai
Gigadō = Ashiyuki
Gihei = Gengendō; Kaibi; Kōri
Gihō = Kihō (Yamada); Ōzui
Gikyō = Hanzan (Matsukawa)
Ginsetsu = Fusanobu
Ginzō = Gyokudō (Kurihara)
Gion Mitsugu = Nankai (Gion)
Gion Seitoku = Seitoku (Gion)
Gion Seikei = Nankai (Gion)
Gion Yu = Nankai (Gion)
Giryō = Higashiyama
Gisai = Haisen
Gitarō = Taizan (Hirose)
Gizō = Tōyō (Azuma)
Go Shummei = Shummei
Gochiku Sōdō = Himeshima Chikugai
Gochōsai = Kunimasu
Gōcho Sensei = Nakamura Fusetsu
Gochōtei = Kunimasu; Kuniteru (Ōta);
 Sadahiro; Sadamasu II
Gochū = Shigehiko
Gofūtei = Sadafusa; Sadatora; Sadayoshi
Gogaku = Gakutei; Seiki
Gogyō = Miyake Gogyō
Gohotei = Hironobu
Gohyōtei = Sadafusa; Sadayoshi
Goitsu = Kihō (Kawamura)
Gojian = Kakutei (Jōkō)
Gōkei = Gōkoku; Shigehiko
Gokitei = Sadafusa; Sadahiro
Gokō = Nagai Umpei
Gōko = Tamura Gōko
Gokotei = Sadakage
Gōkura Yoshio = Gōkura Senjin
Gokyōtei = Shigenao
Gombei = Yūchika
Gompei = Kenzan (Ogata)
Gondai Morisada = Shun'ō
Gondayū = Kien (Yanagisawa)
Gonnosuke = Kangan; Kien (Yanagi-
 sawa)
Gorakuken = Iehiro
Gorakutei = Sadahiro
Gorei = Bokusai (Nagayama)
Gorō = Jozan
Gorohachi = Hokuba
Goryūken = Hokuju (Shunshōsai)
Goryūtei = Sadaharu
Gosai = Migita Toshihide
Gosairō = Kunimaru
Gosan = Gesshin
Goseda Iwakichi = Goseda Hōryū
Goseidō = Busei
Gōsetsu = Kakunyo
Goshōtei = Sadaharu
Gosō = Shige Shuntō
Gosoen = Kuninao
Gosotei = Toyokuni II
Gosōtei = Hirosada; Sadahiro
Gosotei Toyokuni = Toyokuni II
Gosuke = Kyoroku
Gotei = Jakuhō
Goteki = Shōka (Nakae)
Gotō Hirokuni = Tōrei (Hijikata)

Gotō Mamoru = Sekiden
Gotō Munehide = Settan
Gotō Saijirō = Saijirō
Gotō Seijirō = Gotō Yoshikage
Gotō Sōshū = Settan
Gotō Sōtaku = Sōtaku (Gotō)
Gotō Torakichi = Hiroshige III
Gototei = Kunisada (Tsunoda)
Goun = Nishimura Goun
Gountei = Ichigen; Sadahide
Goyō = Hashiguchi Goyō
Goyōtei = Hironobu
Goyū = Bumpō
Gozaemon = Rōzan (Numanami); Ryū-
 kei (Yoshida)
Gozan = Gesshin; Ishikawa Gozan
Gugoku = Gukyoku
Gūkaidō = Kazan (Watanabe)
Gukei = Kōya
Gumbatei = Hokusai
Gun'atei = Kenseki
Gunji = Zuisen
Guō = Kōya
Gusai = Rokubei
Gusan = Ryōsai; Sessai (Masuyama)
Gusen = Yamanouchi Gusen
Gushin = Yūten
Gyōbu = Kōya
Gyobutsu = Hokusai
Gyōgen = Suiko
Gyōgon = Gyōgen
Gyōkan = Shōda Kakuyū
Gyokkei = Kien (Yanagisawa); Mochi-
 zuki Gyokusen Shigemine
Gyokuan = Gyokusen (Mochizuki Shige-
 mori)
Gyokuden = Murase Gyokuden
Gyokudō = Kawai Gyokudō
Gyokudō Kinshi = Gyokudō (Uragami)
Gyokuen = Bompō; Sessai (Masuyama)
Gyokuga = Tōyō (Azuma)
Gyokuho = Yūsai
Gyokuhō = Gogaku (Fukuhara)
Gyokujo = Yōkoku
Gyokujo = Gessen; Masuda Gyokujō
Gyokujo Sanjin = Haisen
Gyokujo Sansho = Haisen
Gyokujuken = Minkō; Sekien
Gyokukai = Taiga
Gyokukei = Bompō; Gyokkei (Nomura);
 Kien (Yanagisawa)
Gyokukō Itsujin = Matsubayashi Keige-
 tsu
Gyokukosai = Koteki
Gyokuō = Sadahide
Gyokuon Toyoko = Gyokuon
Gyokuōrō = Yoshitoshi
Gyokuran = Sadahide
Gyokurandō = Unchiku
Gyokuransai = Sadahide
Gyokurantei = Sadahide
Gyokurei = Seiryō
Gyokuren = Morohoshi Seishō
Gyokurin = Shikō (Sō); Shinsai (Fuchi-
 no)
Gyokuryūsai = Shigeharu
Gyokuryūtei = Shigeharu
Gyokusei = Gessen
Gyokusen = Kōga; Mochizuki Gyokusen
 Shigemine; Motonobu; Naotake; Sei-
 sen'in
Gyokushi = Atomi Gyokushi
Gyokushō = Kawabata Gyokushō;
 Tsurao
Gyokushōan = Shizan (Shirakawa)
Gyokushū = Daiō Gyokushū; Kawai
 Gyokudō
Gyokusōsha = Kyōsho
Gyokusui = Yuda Gyokusui

Gyokutei = Yoshimine (Utagawa)
Gyokuyō = Kurihara Gyokuyō
Gyokuzen = Baiitsu
Gyōmusei = Hankō (Fukuda)
Gyōsai = Hankō (Fukuda); Kyōsai
Gyosha = Rosetsu
Gyoshū = Hayami Gyoshū
Gyōsuien = Sukehiko
Gyōun = Itchō
Gyōyū = Yukiari

Habokusai = Ryōshi
Hachiemon = Kogetsu (Hirowatari)
Hachigaku = Shukuya
Hachiman Yonsen Bonnō Shujin = Gō-
 chō
Hachirō = Chikudō (Kishi)
Hachirobei = Genshū; Sōtetsu; Tōyū
 (Hatano)
Hachirōemon = Unchiku
Hachisuka = Kuniaki II
Hachisuke = Kōga
Hachiya Hironari = Hironari
Hafujuken = Unkyo Kiyō
Haga Takanobu = Takanobu (Kanō)
Hagawa Wagen = Wagen
Hagetsu = Tōsatsu
Hagiwara Yoshitomi = Yoshitomi
Hagura Ryōshin = Katei (Hagura)
Hahōsai = Kunio
Haichiku Dōjin = Asai Hakuzan
Haida Sei = Masanobu (Iwase)
Haikōrin = Ryūsui
Haisha = Matora
Haizan = Yoshitsugu Haizan
Hajin = Buson
Hajintei = Bunchō (Ippitsusai)
Hakamadono = Sen'ami
Hakka = Eishō (Toki); Sekisui
Hakkei = Unkei (Murata)
Hakki = Bummei; Nikka
Hakkyō = Kien (Minagawa)
Hakō = Irie Hakō
Hakubō = Goshun
Hakuchisō = Kazunobu (Kanō)
Hakuen = Kagenobu (Kanō)
Hakugo = Soken (Yamaguchi)
Hakugyoku = Nankai (Gion)
Hakugyokusai = Eisen'in II
Hakuhatsu Shōji = Rinkoku
Hakuho = Mori Hakuho
Hakuhō = Hironobu II
Hakuin = Sekkei (Yamaguchi)
Hakuju = Einō; Yukinobu (Kanō Haku-
 ju Yukinobu)
Hakuka = Ninkai (Kaiun); Sekisui
Hakukei = Hakkei
Hakuki = Nikka; Saichō; Shūki
Hakukyo = Shunkin
Hakukyō = Kien (Minagawa)
Hakumei = Chikutō
Hakumen = Seigan
Hakumin = Ransen
Hakumurō = Fudeya Tōkan
Hakurei = Yoshida Hakurei
Hakurokuen = Tōyō (Azuma)
Hakuryo = Soken (Yamaguchi)
Hakuryū = Seitoku (Gion)
Hakuryūdō = Bumpō
Hakuryū Sanjin = Hakuryū
Hakusakenshi = Tōun (Kanō)
Haku Sanjin = Hokui
Hakusan Yajin = Kazunobu (Kanō)
Hakuseki = Shige Shuntō
Hakuseki Sambō = Sōun (Tazaki)
Hakusekisei = Sōun (Tazaki)
Hakusetsu = Saichō
Hakushi = Ryōsen (Kojima)
Hakushō = Kunzan; Tōkei

Higoya Sadashichirō = Sadayoshi
Higuchi Moriyasu = Tangetsu
Hijikata Hirosuke = Tōrei (Hijikata)
Hikakimoto Shichirō = Hikaimoto Shichirō
Hikobei = Beisanjin; Hankō (Okada); Munetada; Ushū
Hikokan = Hakukō
Hikonoshin = Tōrei (Shimada); Yūhi
Hikosaburō = Isshū (Hanabusa Nobutane); Kuniteru (Yamashita); Shungyōsai
Hikoshirō = Kaikai; Tōgan (Sakuma)
Himeshima Jun = Himeshima Chikugai
Hinaya Chikashige = Ryūho (Hinaya)
Hine Morinaga = Taizan (Hineno)
Hineno Morinaga = Taizan (Hineno)
Hinrakusai = Shōkei (Kenkō)
Hippō Daikoji = Tan'yū (Kanō)
Hirafuku Teizō = Hirafuku Hyakusui
Hirafuku Un = Suian
Hiraga Kunitomo = Gennai
Hirai Hidezō = Hirai Baisen
Hirai Ikkan = Ikkan
Hirai Shin = Kensai
Hiran = Shōhaku (Soga)
Hirano Bunkei = Gogaku (Hirano)
Hirano Manabu = Mochizuki Kimpō
Hirasawa = Kuniaki I; Kuniaki II
Hirashima Yoshikazu = Jakunyū
Hiroaki = Takahashi Hiroaki
Hirochika = Hirotaka
Hirokane = Hirochika
Hirokata = Hirochika
Hirokuni = Hironobu II; Toshihide II
Hiromichi = Jokei
Hirosane = Hirotaka
Hirose Akira = Hakuen
Hirose Hitoshi = Hirose Tōho
Hirose Jishō = Kain
Hirose Junko = Junko
Hirose Kiyoshi = Rinkoku
Hirose Nagaharu = Nagaharu (Hirose)
Hirose Seifū = Taizan (Hirose)
Hirose Shigenobu = Shigenobu (Hirose)
Hiroshima Shintarō = Hiroshima Kōho
Hirotada = Tatsuke
Hirotaka = Keishu (Itaya Hirotaka)
Hirowatari Bansuke = Koshun
Hirowatari Gi = Ganhi
Hirowatari Ikko = Ikko
Hirowatari Kogetsu = Kogetsu (Hirowatari)
Hirowatari Koheita = Kotei (Hirowatari)
Hirowatari Koteki = Koteki
Hirowatari Sessan = Setsuzan
Hirowatari Setsusan = Setsuzan
Hirowatari Setsuzan = Setsuzan
Hirowatari Shinkai = Shinkai (Hirowatari)
Hirowatari Tomosuke = Koshun
Hirowatari Yaheiji = Koshū (Hirowatari)
Hirozumi = Gukei (Sumiyoshi)
Hisahide = Toshihide I, II
Hisako = Kajiwara Hisako
Hisamitsu = Somada
Hishida Mioji = Hishida Shunsō
Hishida Nittō = Nittō
Hishikawa = Waō
Hishikawa Morofusa = Morofusa
Hishikawa Morohira = Morohira
Hishikawa Moromasa = Moromasa
Hishikawa Moronaga = Moronaga
Hishikawa Moronobu = Moronobu
Hishikawa Moroshige = Moroshige
Hishikawa Moroyasu = Moroyasu
Hishikawa Ryūkoku = Ryūkoku; Shunkyō (Hishikawa)
Hishikawa Sōji = Sōri (Hishikawa)

Hishikawa Sōri = Hokusai
Hishikawa Tomofusa = Tomofusa
Hitofushi Chizue = Shumman
Hitomi Yūichi = Hitomi Shōka
Hitsuan = Kiitsu
Hōan = Kosugi Hōan
Hoashi En = Kyōu
Hōbun = Kikuchi Hōbun
Hōchiku Shujin = Kaioku
Hōdō = Ishikawa Kakuji
Hōgetsudō = Masanobu (Okumura)
Hōgokujin = Fūyō
Hōgyoku = Yoshitaki
Hōhaku = Miyake Hōhaku
Hōji Dōjin = Hōji (Matsumoto)
Hōjō Ujinao = Shuboku (Kanō)
Hōkaan = Tokuzan
Hōkaku = Ryōtaki (Kimura)
Hōkei = Rankei
Hokkai = Takashima Hokkai
Hōko = Murakami Hōko; Ōshin
Hokōsai = Shōroku
Hōkosai = Jakuyū
Hokubaiko = Kunisada (Tsunoda)
Hokugō = Eisen (Ikeda)
Hokuhō = Ganrei; Shigemasa
Hokukai = Takashima Hokkai
Hokuki = Hokki
Hokumei = Masamochi
Hokusen = Bokusen (Maki); Taito II
Hokushō = Shunchōsai
Hokusōō = Itchō
Hokusu Dempu = Shigemasa
Hokusui = Yoshitoyo (Uehara)
Hokutei = Bokusen (Maki); Eisen (Ikeda)
Hōkuto = Tamamura Zennosuke
Hokuzan Mōki = Kangan
Hōkyō = Gakutei
Hon'ami Kōetsu = Kōetsu (Hon'ami)
Hon'ami Kōho = Kūchū
Hon'ami Kōsa = Kōsa
Honchōan = Kunimaru
Honda Sadakichi = Honda Teikichi
Honda Sasuke = Honda Tenjō
Hongō Toyokuni = Toyokuni II
Hōon = Yoshitsuya
Hoppo = Bairei
Hora Sanjin = Dōhachi
Hōrai = Nankai (Gion); Shunshō (Utagawa)
Hōrai Sanjin Kiyū = Goshichi
Hōraisha = Kunisada II
Hōrei = Yūshi
Horikawa Tarō = Gakutei
Hōrindō = Kimei
Hōryū = Goseda Hōryū
Hōsai = Bōsai; Gorei; Gotō Yoshikage; Kuniaki II
Hōsei = Nozaki Hōsei
Hōsei Gajin = Kankai
Hosetsu = Tōzen (Matsuura)
Hōsetsu = Gogaku (Moro); Masatada
Hosetsuro = Chikuden
Hoshino = Hokuba
Hōshinsai = Kikaku
Hōshō = Itchō; Utamaro
Hōshū = Bunha; Hasegawa Eisaku; Fujimaro; Goshichi; Hyakusen; Yoshitomi
Hōshuku = Kōrin
Hōshun = Yamaguchi Hōshun
Hōshunrō = Kunichika
Hōso = Sōtetsu
Hosoda = Eiri (Rekisentei)
Hosoda Eishō = Eishō (Hosoda)
Hosoda Eisui = Eisui
Hosoda Jibukyō Tokitomi = Eishi
Hosoi = Eishi
Hosoi Eishi = Eishi

Hosokawa Kiyoshi = Rinkoku
Hōsui = Yamamoto Hōsui
Hosunsai = Sōchō (Seki); Sōtetsu
Hōtei = Gosei; Hokuga (Sanda)
Hōtoku = Shummei
Hōun'in = Mitsuhiro (Karasumaru)
Hōyōken = Waō
Hōzan = Morimitsu; Shunsai
Hōzan Dōjin = Hōzan (Tsuji)
Hōzan Taihei = Hōzan XVI
Hōzan Tankai = Tankai
Hozumi Harunobu = Harunobu
Hsin Yüeh = Shinetsu
Hyakkoku = Kaisen
Hyakudō = Sengai
Hyakufuchi Dōji = Jiun
Hyakuhō = Seigan
Hyakuju = Mashimizu Zōroku; Shigenaga
Hyakuki = Fusanobu; Hyakki
Hyakukoku = Kaisen
Hyakuri = Ōshin
Hyakurin = Sōri (Tawaraya)
Hyakuroku Sanjin = Mokubei
Hyakusai = Bokusen (Maki); Hisanobu (Hyakusai); Sekijō
Hyakusen = Suzuki Shōnen
Hyakushō = Isshū (Hanabusa Nobusuke)
Hyakushōdō = Goshun
Hyakushū = Kōkei (Ueda)
Hyakusōkyo = Kishinami Hyakusōkyo
Hyakusui = Hirafuku Hyakusui
Hyakutake Kaneyuki = Hyakutake Kenkō
Hyakutarō = Suzuki Shōnen
Hyōbu = Kagetane
Hyōbu Bokkei = Bokkei
Hyōchūan = Bashō
Hyōe = Kumagai Naohiko
Hyōemon = Gyokudō (Uragami)
Hyōgaku Sanjin = Fuyō (Kō)
Hyōkei = Rosetsu
Hyōko = Rinkoku
Hyōsai = Sōtetsu
Hyōsai II = Hyōsai
Hyōsho = Bunji

I Fukyū = I Fu-chiu
Ichian = Tanaka Ichian
Ichibaisai = Chikashige; Yoshiharu (Utagawa); Yoshimine (Utagawa)
Ichibei = Kiyonaga; Ryūho (Hinaya)
Ichibetsusai = Toyokuni II
Ichieisai = Migita Toshihide; Toyokuni II; Yoshitoyo (Fukuyama); Yoshitsuya; Yoshitsuya II
Ichiemon = Shōun
Ichien = Ippō II (Hanabusa)
Ichiensai = Kunimaro I; Kunimaro II; Kunimaru; Kuninao
Ichigaku = Baiei; Baishun
Ichigeisai = Yoshitomi
Ichigen = Kakutei (Tamaki)
Ichihōsai = Yoshifuji
Ichiichidō = Shigenobu (Kawashima)
Ichiichisai = Fumai
Ichijo = Bunchō (Tani)
Ichijuen = Kunimasu
Ichijūrō = Rekidō
Ichijusai = Kunimasa; Kunisada II; Yoshikazu
Ichijutei = Kunimasu
Ichikawa Kunsen = Kunsen (Ichikawa)
Ichikawa Teki = Kunkei (Ichikawa)
Ichikawa Yoshikazu = Yoshikazu
Ichimōsai = Yoshitora
Ichinen = Somiya Ichinen
Ichinojō = Ichidayū
Ichinose Jogen = Jogen

Kanō Nagataka = Eikei
Kanō Nagatsune = Eijō
Kanō Nagayoshi = Eiryō
Kanō Nakanobu = Ryūsetsu; Tōsen (Kanō)
Kanō Naonobu = Naonobu; Shōei
Kanō Narinobu = Sosen (Kanō Narinobu)
Kanō Nobumasa = Nobumasa
Kanō Nobuyoshi = Kōtei (Asaoka)
Kanō Nobuyuki = Shunsetsu
Kanō Norinobu = Shunshō II
Kanō Okinobu = Okinobu
Kanō Okiyuki = Kōshi
Kanō Osanobu = Seisen'in
Kanō Raishin = Keiun
Kanō Rakushin = Ryōshin
Kanō Reishin = Shūsen (Kanō)
Kanō Ryōji = Samboku
Kanō Ryōkei = Ryōkei
Kanō Sadanobu = Eiun; Kōi; Ryuhaku; Sadanobu (Kanō); Sadanobu (Kanō Baishun Sadanobu); Shūgen (Kanō)
Kanō Saishin = Saishin
Kanō Shigenaga = Ikkei (Kanō Shigenaga)
Kanō Shigenobu = Eitoku (Kanō Kuninobu); Morifusa; Shigenobu (Kanō); Sōchi
Kanō Shigenojō = Kazunobu (Kanō)
Kanō Shigesato = Naizen
Kanō Shigetsugu = Sōchi
Kanō Shigeyoshi = Ikkei (Kanō Shigenaga)
Kanō Shikibu = Gessan
Kanō Shōshin = Hideyori
Kanō Shunshin = Eiju (Kanō)
Kanō Shushin = Chikanobu (Kanō); Tan'en (Kanō Morizane)
Kanō Sōha = Sōya (Kanō)
Kanō Sōya = Sōya (Kanō)
Kanō Suemasa = Ryōshō (Kanō Yasusue)
Kanō Suenobu = Gyokuen (Kanō); Norinobu; Shōun; Sōshū
Kanō Sukekiyo = Kuninobu (Kanō)
Kanō Sukemori = Norinobu
Kanō Sukenobu = Eisen'in II; Gensen; Shunshō (Kanō Sukenobu); Yūsen (Kanō Sukenobu); Zuisen
Kanō Tadanobu = Shōei; Shōsen'in
Kanō Takanobu = Ansen (Kanō Takanobu); Eitoku II (Kanō Takanobu); Takanobu (Kanō); Takanobu (Kanō Ukon)
Kanō Takenobu = Hakuju
Kanō Tamanobu = Gyokuraku
Kanō Tamenobu = Baiun
Kanō Tanenaga = Sōshin
Kanō Tanenobu = Baiju; Sokuyo: Tan'en (Kanō Tanenobu); Tanenobu
Kanō Tanetsugu = Sakon (Kanō)
Kanō Tanshū = Kuninobu (Kanō)
Kanō Tatsunobu = Eitoku (Kanō Tatsunobu)
Kanō Terunobu = Shōgyoku; Terunobu (Kanō)
Kanō Tokikazu = Tangen (Kanō Tokikazu)
Kanō Tokinobu = Tokinobu
Kanō Tominobu = Baiken (Kanō Tominobu); Tōshun (Kanō Fukunobu)
Kanō Tomonobu = Baiei; Kyūseki; Ryūkei (Kanō Tomonobu); Shunshō III; Tomonobu (Kanō)
Kanō Toshimasa = Toshimasa
Kanō Toshinobu = Eishuku; Sosen (Kanō Toshinobu); Yasunobu (Kanō Toshinobu)
Kanō Toyonobu = Sokuyo

Kanō Tsunenobu = Tsunenobu
Kanō Ujinao = Shuboku (Kanō)
Kanō Ujinobu = Ujinobu; Yūeki
Kanō Yasunobu = Kansen; Seisen'in; Yasunobu (Kanō Yasunobu)
Kanō Yasusue = Ryōshō (Kanō Yasusue)
Kanō Yōho = Yōho (Kanō)
Kanō Yōsei = Yōsei
Kanō Yoshiaki = Tōshū (Kanō)
Kanō Yōshin = Seisen'in
Kanō Yoshinobu = Einō; Ikkei (Kanō Yoshinobu); Tōhaku (Kanō Chikanobu); Tōshun (Kanō Fukunobu); Tōshun (Kanō Yoshinobu); Yoshinobu (Kanō); Yoshinobu (Kanō Genrin Yoshinobu); Yoshinobu (Kanō Kansei Yoshinobu); Zuisen
Kanō Yosuke = Dōmi
Kanō Yuki = Yukinobu (Kiyohara)
Kanō Yukinobu = Baiun II; Jōsen; Yukinobu (Kanō Bōin Yukinobu); Yukinobu (Kanō Hakuju Yukinobu)
Kanō Yūshin = Ryūkei (Kanō Yūshin)
Kanraitei = Nankai (Gion)
Kanran = Zaishō
Kansai II = Kansai (Koma)
Kansai III = Kansai (Koma)
Kansei = Kōrin; Yoshinobu (Kanō Kansei Yoshinobu)
Kansen = Ishikawa Gozan; Kita Takeshirō
Kansendō = Kyokkō (Koike)
Kansetsu = Hashimoto Kansetsu; Itchō
Kansetsusai = Tsukimaro
Kanshi = Ritsuō
Kanshōkyo = Kosaka Shiden
Kanshōsai = Tōju (Kanshōsai); Tōshū; Tōyō (Iizuka)
Kanshū = Rosetsu
Kansui = Mitsubumi; Tōho (Naitō)
Kansuiken = Nanrei
Kansuke = Koma
Kanta = Sūsetsu
Kantan no Kyo = Fuyō (Kō)
Kantenju = Tenju
Kanto = Hisanobu (Hyakusai)
Kantōkyo = Fuyō (Kō)
Kan'unshi = Ando; Tsunenobu
Kan'yōsai = Ryōtai
Kan'yūsai = Morimitsu
Kanzan = Hankō (Okada); Nakamura Fusetsu; Shimomura Kanzan
Kaō = Chinnen; Kōga
Kaō Shūnen = Kaō
Kaō Sōnen = Kaō
Karaku Sanjin = Kenzan (Ogata)
Karan = Shigemasa
Karasumaru Mitsuhiro = Mitsuhiro (Karasumaru)
Kareian = Komuro Suiun
Kariganeya Tōjūrō = Kōrin
Karoku = Utsumi Kichidō
Karyō = Gomon; Kawabe Mitate
Karyōsai = Hokuga (Katsuchika)
Karyū = Hammu
Kasaō = Tanomura Chokunyū
Kasentei = Kunitomi
Kasetsudō = Gyokushū (Kuwayama)
Kashima Yoshimune = Yoshimune
Kashiwaya Buhei = Buhei
Kashō = Taiga
Kashōsai = Shunsen (Katsukawa Seijirō)
Kashu = Isshō (Hanabusa)
Kashū = Numata Kashū
Kashū Mimpei = Mimpei
Kason = Suzuki Kason
Kasuga = Takachika
Kasuga Motomitsu = Motomitsu
Kasuga Takakane = Takakane

Kasuga Takayoshi = Takayoshi
Kasuga Yukihide = Yukihide
Kasuke = Kisuke
Katagiri In = Tōin (Katagiri)
Katayama Chikanobu = Shōkei (Katayama)
Katayama Kumaji = Katayama Nampū
Katayama Yoshio = Yōkoku
Katei = Haisen; Hamboku; Kodama Katei; Shiseki; Taki Katei
Katei Dōjin = Shōka (Nakae)
Katen = Goshun; Kaigaku
Katō Kintarō = Satake Eiko
Katō Kitōta = Katō Kensei
Katō Magoemon = Shuntan (Katō)
Katō Masatsugu = Baiō
Katō Moriyuki = Entaku
Katō Shirozaemon = Kagenobu (Katō); Tōshirō
Katō Shunzan = Shunzan (Katō)
Katō Sōshirō = Shuntai
Katō Taiyū = Bunrei
Katō Tamikichi = Tamikichi
Katoku = Yamada Keichū
Katori Kageyoshi = Nahiko
Katori Nahiko = Nahiko
Katōshi = Gengyo
Katsuda Hisatarō = Kunihisa
Katsudo = Eiryū
Katsuha = Kohyō
Katsuhachi = Taizan (Hirose)
Katsujirō = Ōritsu
Katsujō = Setsugaku
Katsukawa Iwazō = Shunjō
Katsukawa Kyūjirō = Shun'ei (Katsukawa)
Katsukawa Ryūkoku = Shunkyō (Hishikawa)
Katsukawa Seijirō = Shunsen (Katsukawa Seijirō)
Katsukawa Sentarō = Shuntoku
Katsukawa Shunchō = Shunchō
Katsukawa Shundō = Shundō
Katsukawa Shun'en = Shun'en
Katsukawa Shungyō = Shungyō
Katsukawa Shunkaku = Shunkaku
Katsukawa Shunkō = Shunkō
Katsukawa Shunkyoku = Shunkyoku
Katsukawa Shunri = Shunri
Katsukawa Shunrin = Shunrin
Katsukawa Shunrō = Hokusai; Toyomaru
Katsukawa Shunsen = Shunsen (Katsukawa)
Katsukawa Shunshō = Shunshō (Katsukawa)
Katsukawa Shunsui = Shunsui (Katsukawa)
Katsukawa Shuntei = Shuntei
Katsukawa Shun'yō = Shun'yō
Katsukawa Shunzan = Shunzan (Katsukawa)
Katsukawa Terushige = Terushige
Katsukawa Yumishō = Yumishō
Katsuma Antei = Ryūsui
Katsuma Shinsen = Ryūsui
Katsumochi = Matabei (Iwasa)
Katsunō = Sessai (Masuyama)
Katsuno Hanko = Hanko (Katsuno)
Katsura Tsunemasa = Setten
Katsuragi Sanjin = Jiun
Katsuroku = Kōrin
Katsushika = Hokki; Hokuichi
Katsushika Fumio = Taito II
Katsushika Gorō = Hokuun
Katsushika Hokumei = Hokumei
Katsushika Hokutai = Hokutai
Katsushika Nobuyuki = Hokuga (Katsushika)

Saimō =Senzan (Nagamura)
Sainosuke = Yūtoku (Kaihō)
Saiō = Sōchō (Tatebe)
Sairakusai = Utagawa Yoshiiku
Sairyū = Bōsai
Saiten = Tamura Saiten
Saitō Chōhachi = Torii Kiyosada
Saitō Chōkichi = Torii Kiyotada VII
Saitō Jūrobei = Sharaku
Saitō Kamekichi = Yoshikage (Utagawa)
Saitō Tomo-o = Saitō Sogan
Saitō Yono = Kōgyoku
Saitō Yoriji = Saitō Yori
Saitō Yoshi = Kenseki
Saiun = Sōseki
Saiunrō Kyokuzan = Kyokuzan
Saiuntei = Murase Gyokuden
Sakagami Kō = Kōfu
Sakai Chūbei = Kyozan
Sakai Hidemaro = Yokoyama Taikan
Sakai Senshin = Ōho
Sakai Tadamoto = Hōitsu
Sakaida Kakiemon = Kakiemon I
Sakaida Shibuemon = Shibuemon
Sakaki Genseki = Yūrin
Sakaki Shin'en = Hyakuren
Sakaki Tanemichi = Hokuen
Sakakibara Nagatoshi = Bunsui
Sakakibara Toyotane = Toyotane
Sakakibara Yuriko = Ikeda Shōen
Sakamoto Chokudai = Kōsetsu (Saka-
 moto)
Sakanobu = Baishō
Sakanouchi Jūbei = Kansai (Koma)
Sakenosuke = Hiroyasu
Sakenoue no Furachi = Harumachi
Sakin = Shōran (Takenouchi)
Sakingo = Donkyō
Sakon = Sadanobu (Kanō); Tōchō
Sakon Shōkan = Sadanobu (Kanō)
Sakon Shōsō = Ganrei
Sakubei = Rihei (Morishima)
Sakuhi Koji = Kazan (Watanabe)
Sakuma Akira = Sōen (Sakuma)
Sakuma Kei = Shōzan (Sakuma)
Sakuma Masumoto = Tōgan (Sakuma)
Sakuma Takehisa = Sakuma Tetsuen
Sakuma Yoshikazu = Tōgan (Sakuma)
Sakuma Yūtoku·= Yūtoku (Sakuma)
Sakunojō = Moronaga; Yōsei
Sakura Bunkyō = Bunkyō
Sakurabō = Yoshimori
Sakuragawa Jihinari = Bunkyō
Sakurai Kan = Sekkan (Sakurai)
Sakurai Seppo = Seppo
Sakurai Sojun = Sūkaku
Sakurama Kan = Seigai
Sakutō = Haisen
Samboku = Eishun (Kanō)
Same = Shigehiko
Sammyakuin = Nobutada
Samon = Yoshinobu (Kanō)
Sampō = Gansei
Sampū = Ichigan
Samukawa = Unchō (Samukawa)
Samukawa Yōsai = Yōsai (Samukawa)
Sanada Choku = Kenzan (Sanada)
Sanai = Gyokushū (Kuwayama); Shikō
 (Watanabe)
Sanda = Hokuga (Sanda)
Sanden = Zensetsu
San'emon = Hyakki
Sangaku Dōja = Taiga
Sango = Shokatsukan
Sangyōan = Tangen (Kanō Tokikazu)
Sanjin = Kyūkoku
Sanjirō = Keisai (Kuwagata); Kōtei
 (Asaoka)
Sanjuen = Utagawa Yoshihide

Sanjūroppō Gaishi = San'yō
Sanka = Buson
Sankandō = Kaioku
Sankitsu = Untan
Sankō = Sankōbō; Sekkan (Sakurai)
Sankōdō = Kōga
Sankoku Sanshō = Kensai
Sankokuan = Chikkoku
Sankun = Un'en
Sankyō = Nankei
Sannomiya Chi = Tanomura Chokunyū
San'ō = Takatori Wakanari
Sano Chōkan = Chōkan (Sano)
Sano Shihō = Sessa
Sano Shummei = Shummei
Sano Toyofusa = Sekien
San'ōshi = Fukuda Kōko
Sanraku = Kanō Sanraku; Kōtei (Asa-
 oka); Ryōsetsu
Sanrakuki = Kanō Sanraku
Sanrei = Kunimune
Sanreidō = Kiyotada III
Sanritsu = Kyozan
Sanrōko = Takatori Wakanari
Sanryō = Eigaku; Eihaku; Sosen (Kanō
 Toshinobu)
Sanryū = Eijō
Sansai = Soken (Yamaguchi)
Sansansai = Ōbun
Sansei = Einō
Sanseidō = Masunobu (Tanaka)
Sanseisai = Eiryō
Sanshirō = Tōshun (Kanō Yoshinobu)
Sanshō = Tanomura Chokunyū
Sanshōō = Rinkoku
Sanshōtei = Kunihiro
Sanshū = Bun'yū
Sanshu Kashitsu = Bairei
Sansōdō = Buson
Santō Kyōden = Masanobu (Iwase)
Santōan = Kyōsui
Santosai = Toun (Santosai)
Santoun = Toun (Santosai)
Sanzaburō = Tōun (Kanō)
Sanzanshi = Ishikawa Kakuji
Sasa = Shunsa
Sasaki Chōjirō = Chōjirō; Sasaki Taiju
Sasaki Matabei = Matabei (Sasaki)
Sasaya = Ikkan
Sasayama Jō = Yōi
Sasayama Jōden = Yōi
Sashōdō = Shumman
Sasuiō = Itchō
Sasuke = Haisen
Satake = Satake Eison
Satake Eishi = Eikai (Satake)
Satake Ginjūrō = Satake Eiryō
Satake Kintarō = Satake Eiko
Satake Sadakichi = Kaikai
Satake Seii = Hōhei
Satake Shūkei = Sesson
Satake Teikichi = Kaikai
Satake Tokujirō = Satake Toku
Satake Yoshiatsu = Shozan (Satake)
Satake Yoshihiro = Yoshimi
Satō Kodō = Yamanaka Kotō
Satō Kotō = Yamanaka Kotō
Satō Masamochi = Masamochi
Satō Masuyuki = Gyodai; Masuyuki
Satō Sansai = Sansai
Satō Seizō = Satō Chōzan
Satō Shi = Baiu
Satonoya = Yoshitaki
Satsuemon = Kinkoku (Yamamoto)
Sawa = Sekkyō
Sawa Jisaku = Sawada Sōtaku
Sawada Sōji = Sawada Sōtaku
Sawada Torakichi = Sawada Seikō
Sawaki Kuraji = Sūsetsu

Sawaki Michikata = Sūshi
Sawaki Sūshi = Sūshi
Sehō = Shungaku
Sei = Kiyohara Sei
Sei Sōjin = Kiyohara Sei
Seian = Gyokusen (Mochizuki Shige-
 mori)
Seibei = Kiyobei; Ninsei; Ryōsei (Kō-
 ami); Utakuni
Seibei I = Koma
Seibei II = Koma
Seibi = Yūsai
Seibun = Seiki
Seibunsai = Eitoku II (Kanō Takanobu)
Seichōken = Kiyoshige
Seichōtei = Senchō
Seichūin Dōjin = Tōsen (Yamazaki)
Seiemon = Etsujin; Kōyō (Nakayama)
Seien = Noguchi Shōhin; Shima Seien
Seifu = Chikudō (Ki)
Seifū = Tsuda Seifū
Seifū Yohei II = Seifū Yohei
Seifū Yohei III = Seifū Yohei
Seigadō = Kangetsu
Seigen = Taizan (Hineno)
Seigi = Masayoshi
Seigosai = Yūsen (Kanō Hironobu)
Seigyū = Chōdō (Maeda)
Seihakudō = Roshū (Fukae)
Seihakusai = Tsunenobu; Yūsen (Kanō
 Sukenobu)
Seihasai = Kansen
Seihō = Takeuchi Seihō
Seii = Issai
Seiichian = Seitoku (Shunshō VII)
Seiin = Tangen (Kanō Tokikazu)
Seiji = Tōgō Seiji
Seijirō = Murase Gyokuden
Seiju = Omoda Seiju
Seika = Bummei; Gyokushu (Itō); Kō-
 kin; Yamada Bunkō
Seika Zembō = Bairei
Seikai Gentarō = Gentarō
Seikai Tarozaemon = Kanshichi
Seikanshi = Yasunobu (Kanō Yasunobu)
Seikei = Kōsetsu (Yamada)
Seiki = Hōgyoku; Kogetsu (Hirowatari);
 Kuroda Seiki
Seikinsha = Sūkaku
Seiko = Okuhara Seiko
Seikō = Hyōgyoku; Keishō; Sawada
 Seikō; Tanoguchi Seikō; Yamamoto
 Hōsui
Seikoku = Charakusai
Seikurō = Shuntan (Morisaki)
Seikyō = Heishū
Seimei = Tan'yū (Kanō)
Seimuken = Baigai
Seinin = Jōnin
Seirai = Mokubei
Seiran = Fukuoka Seiran; Nahiko
Seirensai = Sokō (Ochiai)
Seiryūkan = Bairei
Seiryūken = Kiyomitsu II
Seiryūsai = Morikawa Sōbun; Zuisen
Seisai = Ichiga; Kōfu; Rokubei; Shoka-
 tsuan
Seisai Sambō = Kōfu
Seisei = Atomi Kakei; Kiitsu; Masanari;
 Sōri (Tawaraya)
Seiseian = Kyōsai
Seiseidō = Kōrin
Seiseiō = Shōkadō
Seiseisai = Kimei; Kyōsai
Seisen = Seisen'in
Seisendō = Matsuda Ryokuzan
Seisenkan = Rochō
Seisetsusai = Eitoku (Kanō Tatsunobu)
Seishin = Tameie

Tsuruzawa Ryōshin = Tanzan
Tsuruzawa Shuken = Tanzan
Tsutaya Kōsaku = Tsutaya Ryūko
Tsutsumi Magoji = Tōrin (Tsutsumi)

U = Ryūko
Uchida Ei = Gentai
Uchida Magosaburō = Isoda Chōshū
Uchihashi Yoshihira = Han'u
Uda Zenjirō = Uda Tekison
Udō = Ryūko
Ue = Gukei (Ue)
Ueda Kō = Kōfu
Ueda Kōchō = Kōchō (Ueda)
Ueda Kōkei = Kōkei (Ueda)
Ueda Masanobu = Masanobu (Ueda)
Ueda Minotarō = Ueda Manshū
Uehara Yoshitoyo = Yoshitoyo (Uehara)
Uemon Tayū = Toshinaga (Kinoshita)
Uemonsaku = Emosaku
Uemura Tsuneko = Uemura Shōen
Ueno Michimasa = Jakugen
Ueno Shōha = Shōha
Ueno Taisuke = Jakuzui
Ueno Yasushi = Setsugaku
Uesugi = Keiō
Uheiji = Eiju (Kanō)
Uji Sōjō = Kakuen (Fujiwara)
Uka = Kodama Katei
Ukaan = Hōitsu
Ukaan II = Ōho
Ukan = Kyoroku
Ukanshi = Ritsuō
Ukei = Gukei (Ue)
Ukita Kiminobu = Ikkei (Ukita)
Ukita Yoshitame = Ikkei (Ukita)
Ukiyo Masatoshi = Masatoshi
Ukiyo Matahei = Matahei
Ukiyoan = Kuninao
Ukoku = Kawamura Ukoku
Ukon = Chikanobu (Kanō); Ōzui;
 Takanobu (Kanō Ukon); Tsunenobu
Ukyō = Mitsunobu (Kanō); Sukenobu;
 Tokinobu
Ukyōnoshin = Mitsunobu (Kanō);
 Sadanobu (Kanō); Yasunobu (Kanō
 Yasunobu)
Ukyōnosuke = Mitsunobu (Kanō);
 Sadanobu (Kanō)
Umegawa Shigekata = Tōnan (Umegawa)
Umegawa Tōkyo = Tōkyo
Umehara Kōritsusai = Kōryūsai (Umehara)
Umehara Kōryūsai = Kōryūsai (Umehara)
Umesaku = Kyōsai
Ummu = Tadakuni
Umon = Kōga
Umpō = Ganrei; Tōetsu (Umpō)
Umposai = Umpo (Ryōin)
Umpōsai = Emosaku
Umpu = Jikkō
Undayū = Taizan (Hirose)
Undō = Buson; Itchō; Untō (Kaburagi);
 Untō (Okada)
Uneme = Tan'yū (Kanō)
Unemenosuke = Sukeyasu
Ungai Nōfu = Seiko (Haruki)
Unge = Taigan
Ungein = Taigan
Ungeisai = Hidenobu (Eishin)
Ungo = Unkyo Kiyō
Ungo Keyō = Unkyo Kiyō
Unhōsai = Emosaku
Unkadō = Chinnen
Unkaku = Taigaku
Unkei = Donkyō
Unkoku Motonao = Tōeki (Unkoku)
Unkoku Tōchi = Tōchi

Unkoku Tōgan = Tōgan (Unkoku)
Unkoku Tōhan = Tōhan
Unkoku Tōho = Tōho (Unkoku)
Unkoku Tōji = Tōji
Unkoku Tōkaku = Tōkaku
Unkoku Tōmin = Tōmin
Unkoku Tōoku = Tōoku
Unkoku Tōreki = Tōreki
Unkoku Tōretsu = Tōretsu (Unkoku)
Unkoku Tōsetsu = Tōsetsu
Unkoku Tōtaku = Tōtaku
Unkoku Tōtatsu = Tōtatsu
Unkoku Tōteki = Tōteki
Unkoku Tōtetsu = Tōtetsu (Unkoku)
Unkoku Tōyo = Tōyo (Unkoku)
Unkoku Tōyū = Tōyū (Unkoku)
Unkoku Tōzen = Tōzen (Unkoku)
Unkokuken = Sesshū
Unkyaku = Asai Hakuzan
Unkyo = Unkyo Kiyō
Un'ō = Matabei (Iwasa)
Uno Mitsutsugu = Mitsutsugu
Unosuke = Nammei
Unpo = Umpo (Ryōin)
Unpō = Tōetsu (Umpō); Umpō (Ōoka)
Unposai = Umpo (Ryōin)
Unri = Bun'yū
Unrin'in = Hōzan (Unrin'in); Hōzan IX,
 XI, XV, XVI
Unsai = Buson
Unshin = Sekiho (Okano)
Unshō = Bunrin; Kyūjō (Yamada);
 Yoshimi
Untaku = Tōetsu (Hasegawa); Tōetsu
 (Mitani)
Untei = Ōkyo
Unzansō = Shinsai (Fuchino)
Unzen = Unsen (Kushiro); Zenshirō
Uoya Hokkei = Hokkei
Uozumi Ki = Keiseki
Uragami Hitsu = Gyokudō (Uragami)
Uragami Sen = Shunkin
Urano Shigekichi = Ken'ya (Ogata)
Urata Kyūma = Takahashi Kōko
Uryū = Ushū
Usai = Seigai
Usen = Ogawa Usen; Seigai
Ushimaro = Itchō
Ushōsai = Shigenobu (Yanagawa)
Utagawa Hidehisa = Kunisada III
Utagawa Hirokage = Hirokage
Utagawa Hirosada = Hirosada
Utagawa Ikusaburō = Yoshiharu (Utagawa)
Utagawa Kenjirō = Sadahide
Utagawa Kinjirō = Kuniteru (Ōta)
Utagawa Kunifusa = Kunifusa
Utagawa Kunihiro = Kunihiro
Utagawa Kunikazu = Kunikazu
Utagawa Kunikiyo = Kunikiyo I; Kunikiyo II
Utagawa Kunimaro = Kunimaro I
Utagawa Kunimaru = Kunimaru
Utagawa Kunimasa = Kunimasa
Utagawa Kunimasu = Kunimasu
Utagawa Kunimatsu = Kunimatsu
Utagawa Kunimitsu = Kunimitsu
Utagawa Kunimori = Kunimori I; Kunimori II
Utagawa Kuninaga = Kuninaga
Utagawa Kuninobu = Kuninobu (Utagawa)
Utagawa Kunisada = Kunisada (Tsunoda)
Utagawa Kunisato = Kunisato
Utagawa Kuniteru = Kuniteru (Yamashita)
Utagawa Kunitomi = Kunitomi
Utagawa Kunitora = Kunitora

Utagawa Kunitoshi = Kunitoshi
Utagawa Kunitsugu = Kunitsugu
Utagawa Kunitsuna = Kunitsuna
Utagawa Kuniyoshi = Kuniyoshi
Utagawa Kuniyuki = Kuniyuki
Utagawa Masaki = Toyoharu
Utagawa Matsugorō = Kunimune
Utagawa Munehisa = Kunisada II
Utagawa Nobukatsu = Nobukatsu
Utagawa Sadafusa = Sadafusa
Utagawa Sadahiro = Sadahiro
Utagawa Sadakage = Sadakage
Utagawa Sadamaro = Sadamaro
Utagawa Sadamaru = Sadamaru
Utagawa Sadamasu = Kunimasu; Sadamasu II
Utagawa Sadatora = Sadatora
Utagawa Sadayoshi = Sadayoshi
Utagawa Seima = Fusatane
Utagawa Shigemaru = Shigemaru
Utagawa Shigenao = Shigenao
Utagawa Shunshō = Shunshō (Utagawa)
Utagawa Taizō = Kuninao
Utagawa Tōshirō = Kuniteru (Okada)
Utagawa Tōtarō = Yoshifuji
Utagawa Toyohiro = Toyohiro
Utagawa Toyohisa = Toyohisa
Utagawa Toyokuni = Toyokuni
Utagawa Toyokuni III = Kunisada (Tsunoda)
Utagawa Toyomaru = Toyomaru
Utagawa Toyonobu = Toyonobu (Utagawa); Toyonobu (Utagawa Kōchōrō)
Utagawa Toyoshige = Kunimatsu; Toyokuni II
Utagawa Yasugorō = Kuniyasu
Utagawa Yasukiyo = Yasukiyo
Utagawa Yasushige = Yasushige
Utagawa Yoshifusa = Yoshifusa
Utagawa Yoshikage = Yoshikage (Utagawa)
Utagawa Yoshikata = Yoshikata (Utagawa)
Utagawa Yoshikatsu = Yoshikatsu
Utagawa Yoshikazu = Yoshikazu
Utagawa Yoshimine = Yoshimine (Utagawa)
Utagawa Yoshimune = Yoshimune
Utagawa Yoshitaka = Yoshitaka
Utagawa Yoshitaki = Yoshitaki
Utagawa Yoshitomi = Yoshitomi
Utagawa Yoshitora = Yoshitora
Utagawa Yoshitsuna = Yoshitsuna
Utagawa Yoshitsuru = Yoshitsuru
Utagawa Yoshiyuki = Yoshiyuki (Utagawa)
Utamasa = Bokusen (Maki); Gessai; Gessai II
Utanosuke = Ganku; Ganryō; Yukinobu (Kanō Bōin Yukinobu)
Utei = Seigai
Utsumi Fuku = Utsumi Kichidō
Utsumi Unseki = Unseki
Uyō = Naotake
Uyūshi = Mitsuhiro (Karasumaru)
Uzaemon = Hankō (Okada); Ryōshō (Kanō Yasusue)
Uzan = Imei; Shirai Uzan

Wada Kōki = Gesshin
Wada Shigenojō = Kazunobu (Kanō)
Wagyoku = Yōgetsu
Wahei = Yamada Bunkō
Waibai = Kaiseki
Wakanari = Takatori Wakanari
Wakasugi Isohachi = Isohachi
Wake Enchin = Chishō
Waku Shun'ei = Zean (Waku)
Wakun = Ishibashi Wakun

Character Index

This index is intended for readers of Japanese texts who need to look up the readings of artists' names with which they are unfamiliar. The readings of the names presented here in *kanji* are the same as those appearing in the dictionary entries and in the Index of Alternate Names. In case there are two or more readings of a name, the reading preferred in the body of the dictionary is given here if only one artist is involved. For example, the artist Gako has an alternate name that can be read either "Suzuki Takeshi" or "Suzuki Yū," but only the former is given here, although both readings appear in the Index of Alternate Names. Alternate readings are given only if different artists are involved, leading to more than one dictionary entry. For example, there is the name that can be read either "Suzuki Harunobu" or "Suzuki Harushige," and both readings are given in this index because they lead to different dictionary entries, the former to "Harunobu" and the latter to "Kōkan." It should also be pointed out that even if a name has only one reading, it may be the alternate name of several artists. For this reason, in the case of any given reading of a name appearing here, the reader is advised to consult both the dictionary itself and the Index of Alternate Names in order to arrive at the proper dictionary entry.

The arrangement of the names in this index follows the order of *kanji* in Andrew N. Nelson's *Modern Reader's Japanese-English Character Dictionary*—that is, the order of the 214 radicals for the first (or only) *kanji* of a specific name and the order of the increasing number of strokes for succeeding *kanji* when there are two or more names with the same first *kanji*. When the succeeding *kanji* have the same number of strokes, the order of the 214 radicals is followed. For all practical purposes the radicals 140 and 162 are each considered to have three strokes. Names written entirely in *kana*, or in *kana* followed by *kanji*, are placed at the beginning of the index.

あし友	Ashitomo	一昇斎	Isshōsai	一絲	Isshi	一嶺斎	Ichireisai
おもちゃ芳藤	Omocha Yoshifuji	一松斎	Isshōsai	一絲文守	Isshi Bunshu	一謙亭	Ikkentei
さくら坊	Sakurabō	一英斎	Ichieisai	一朝	Itchō	一鮮斎	Issensai
セウ	Shō	一青斎	Isseisai	一遊斎	Ichiyūsai	一曜斎	Ichiyōsai
トトヤ北渓	Totoya Hokkei	一幽斎	Ichiyūsai	一閑	Ikkan	一瀬如元	Ichinose Jogen
ノンコウ	Nonkō	一侠斎	Ikkyōsai	一閑子	Ikkanshi	一鵬斎	Ippōsai
ヒカキモト七郎	Hikakimoto Shichirō	一信	Kazunobu	一閑散人	Ikkan Sanjin	一麗斎	Ichireisai
ヒカ井モト七郎	Hikaimoto Shichirō	一信亭	Isshintei	一陽井	Ichiyōsei	一飄齋	Ippyōsai
よし国	Yoshikuni	一勇斎	Ichiyūsai	一陽亭	Ichiyōtei	一鴬	Ichiō
		一指	Isshi	一陽菴	Ichiyōan	一鶯斎	Ichiōsai
——— RAD.—1 ———		一政	Kazumasa	一陽斎	Ichiyōsai	一鶴斎国鶴	Ikkakusai
		一春斎	Isshunsai	一雄	Kazuo	二代	Kunitsuru II
一九	Ikku	一柳斎	Ichiryūsai	一雄斎	Ichiyūsai	一鼈斎	Ichibetsusai
一入	Ichinyū	一栄斎	Ichieisai	一雲斎	Ichiunsai	与一	Yoichi
一刀	Ittō	一点斎	Ittensai	一勢斎	Isseisai	与一郎	Yoichirō
一刀斎	Ittōsai	一茶	Issa	一楊斎	Ichiyōsai	与七	Yoshichi
一々堂	Ichiichidō	一翁	Ichiō	一楽斎	Ichirakusai	与三八	Yosahachi
一々斎	Ichiichisai	一翁斎	Ichiōsai	一源	Ichigen	与三右衞門	Yosaemon
一之	Isshi	一峨	Ichiga	一煙斎	Ichiensai	与三兵衞	Yosabei
一川	Issen	一峰斎	Ippōsai	一節千杖	Issetsu Senjō	与三兵衞二代	Yosabei II
一川芳員	Ichikawa Yoshikazu	一峯斎	Ippōsai	一蜓	Ichien	与三治	Yosaji
一天斎	Ittensai	一恕	Ichijo	一蜂	Ippō	与三郎	Yosaburō
一元	Ichigen	一桂斎	Ikkeisai	一蜂二代	Ippō II	与之助	Yonosuke
一円斎	Ichiensai	一梅斎	Ichibaisai	一蜂閑人	Ippō Kanjin	与五右衞門	Yogoemon
一丘	Ikkyū	一殊牧	Isshuboku	一鳳	Ippō	与可心交	Yoka Shinkō
一仙舎其村	Issensha Kison	一流亭	Ichiryūtei	一鳳斎	Ippōsai	与兵衞	Yohei
一礼斎	Ichireisai	一珠斎	Isshusai	一嶂	Isshō	与里	Yori
一立斎	Ichiryūsai	一珪	Ikkei	一徳	Ittoku	与與	Yokyō
一休	Ikkyū	一笑	Isshō	一睡亭	Issuitei	万之丞	Mannojō
一光斎	Ikkōsai	一笑斎	Isshōsai	一翠斎	Issuisai	万五郎	Mangorō
一旭斎	Ikkyōsai	一竜斎	Ichiryūsai	一蜩	Isshū	万月堂	Mangetsudō
一老	Ichirō	一庵	Ichian	一魁斎	Ikkaisai	万次郎	Manjirō
一舟	Isshū	一得	Ittoku	一慶斎	Ikkeisai	万寿	Manju
一色直朝	Isshiki Naotomo	一掬斎	Ikkikusai	一樂亭	Ichirakutei	万助	Mansuke
一寿斎	Ichijusai	一貫斎	Ikkansai	一樂斎	Ichirakusai	万里	Banri
一声斎	Isseisai	一渓	Ikkei	一養亭	Ichiyōtei	万里翁	Banriō
一応斎	Ichiōsai	一猛斎	Ichimōsai	一養斎	Ichiyōsai	万秋	Manshū
一秀斎	Isshūsai	一菴	Ichian	一蕙	Ikkei	万翁	Man'ō
一芳斎	Ippōsai	一透斎	Ittōsai	一蕙斎	Ikkeisai	万象楼	Banshōrō
一芸斎	Ichigeisai	一陳斎	Itchinsai	一蝶	Itchō	万鉄五郎	Yorozu Tetsugorō
一念	Ichinen	一窓主裡町斎	Issōshurichōsai	一蝶二代	Itchō II	万菊	Mangiku
一国斎	Ikkokusai	一斎	Issai	一震斎	Isshinsai	三九郎	Sankurō
一国斎二代	Ikkokusai II	一普	Ichizen	一輿斎	Ikkōsai	三十六峰外史	Sanjūroppō Gaishi
一国斎三代	Ikkokusai III	一景	Ikkei	一嘯	Isshō	三之丞	Sannojō
一宝斎	Ippōsai	一湖	Ikko	一學	Ichigaku	三山子	Sanzanshi
		一茨斎	Ichieisai	一樹亭	Ichijutei	三五	Sango
		一登斎	Ittosai	一樹園	Ichijuen	三木作蔵	Miki Sakuzō
		一筆庵	Ippitsuan	一簔烟客	Issa Enkaku	三木宗策	Miki Sōsaku
		一筆斎誠之	Ippitsusai Seishi	一穎斎	Ichieisai		
				一鷟斎	Ichiōsai		

Column 1

武市小楯	Takechi Otate
武四郎	Takeshirō
武左衛門	Buzaemon
武田了軌	Takeda Ryōki
武田正生	Takeda Seisei
武田秀平	Takeda Shūhei
武田信綱	Takeda Nobutsuna
武田彦九郎	Takeda Hikokurō
武田霞一	Takeda Shin'ichi
武田琢二	Takeda Kōzen
武次郎	Takejirō
武兵衛	Buhei
武助	Busuke
武宗	Takemune
武清	Busei
武部芳峰	Takebe Yoshimine
武禅	Buzen
武蔵	Musashi
晋三	Shinzō
晋子	Shinshi
晋風	Shimpō
晋斎	Shinsai
晋陽	Shin'yō
晋蔵	Shinzō
夏月	Kagetsu
夏雲	Kaun

———— RAD. 丨 2 ————

也有	Yayū
卍	Manji
卍山道白	Manzan Dōhaku
卍老人	Manji Rōjin
卍廼舎	Manjinoya
卍翁	Manjiō
卍楼	Manjirō
中二	Chūji
中丸精十郎	Nakamaru Seijūrō
中大路茂永	Nakaōji Shigenaga
中山元融	Nakayama Gen'yū
中山正実	Nakayama Masami
中山祐吉	Nakayama Yūkichi
中山清	Nakayama Kiyoshi
中山象先	Nakayama Zōsen
中山雲川	Nakayama Unsen
中山嵩岳堂	Nakayama Sūgakudō
中山義夫	Nakayama Yoshio
中山適	Nakayama Teki
中山養福	Nakayama Yōfuku
中山巍	Nakayama Takashi
中川一政	Nakagawa Kazumasa
中川八郎	Nakagawa Hachirō
中川天寿	Nakagawa Tenju
中川国次	Nakagawa Kunitsugu
中川紀元	Nakagawa Kigen
中川紀元次	Nakagawa Kigenji
中井直	Nakai Tadashi
中井義滝	Nakai Yoshitaki
中牟田三治郎	Nakamuda Sanjirō
中江杜徴	Nakae Tochō
中西寿	Nakanishi Hisashi
中西利雄	Nakanishi Toshio
中尾忠貞	Nakao Tadasada
中尾眞芸	Nakao Shingei
中尾真相	Nakao Shinsō
中尾真能	Nakao Shinnō
中村一作	Nakamura Issaku
中村大三郎	Nakamura Daizaburō
中村不折	Nakamura Fusetsu
中村公成	Nakamura Kōsei
中村有恒	Nakamura Aritsune
中村有慎	Nakamura Arichika
中村来潮	Nakamura Raichō

Column 2

中村岳陵	Nakamura Gakuryō
中村宗哲	Nakamura Sōtetsu
中村重助	Nakamura Jūsuke
中村恒吉	Nakamura Tsunekichi
中村研一	Nakamura Ken'ichi
中村常伝	Nakamura Jōden
中村琢二	Nakamura Takuji
中村達二	Nakamura Tatsuji
中村鈝太郎	Nakamura Sakutarō
中村簇	Nakamura Jō
中村彝	Nakamura Tsune
中沢弘光	Nakazawa Hiromitsu
中邑	Nakamura
中邑有恒	Nakamura Aritsune
中邑有慎	Nakamura Arichika
中里	Chūri
中里太郎右衛門	Nakazato Tarōemon
中里無庵	Nakazato Muan
中尾玄	Nakao Gen
中岳画史	Chūgakugashi
中岳堂	Chūgakudō
中岳斎	Chūgakusai
中林成昌	Nakabayashi Nariaki
中林成業	Nakabayashi Seigyō
中林舎	Chūrinsha
中林僊	Nakabayashi Sen
中沼	Nakanuma
中信	Nakanobu
中津	Chūshin
中剛	Chūgō
中島来章	Nakajima Raishō
中島阿栄	Nakajima Aei
中島為一	Nakajima Tamekazu
中島屋大次郎	Nakajimaya Daijirō
中島富寿	Nakajima Tomikazu
中島藤助	Nakajima Tōsuke
中原実	Nakahara Minoru
中原悌二郎	Nakahara Tcijirō
中野	Nakano
中野和高	Nakano Kazutaka
中野桂樹	Nakano Keiju
中野健作	Nakano Kensaku
中野堯敬	Nakano Gyōkyō
中野換	Nakano Kan
内田孫三郎	Uchida Magosaburō
内田英	Uchida Ei
内田巖	Uchida Iwao
内匠	Naishō; Takumi
内匠助	Takuminosuke
内海吉堂	Utsumi Kichidō
内海復	Utsumi Fuku
内海雲石	Utsumi Unseki
内記	Naiki
内蔵之助	Kuranosuke
内蔵允	Kuranosuke
内蔵助	Kuranosuke
内膳	Naizen
内藤正参	Naitō Seisan
内藤正誠	Naitō Seisei
内藤伸	Naitō Shin
由信	Yoshinobu
由美賞	Yumishō
甲胡万吉	Kōko Mankichi
甲斐荘楠音	Kainoshō Tadaoto
申申	Shinshin
旧松軒	Kyūshōken

Column 3

旧草堂	Kyūsōdō
世万	Seman
世宝	Sehō
世昌	Seishō
世祐	Seyū
世美	Seibi
世粛	Seishuku
世猷	Seiyū
世馨	Seikyō
本多天城	Honda Tenjō
本多佐輔	Honda Sasuke
本多貞吉	Honda Teikichi
本多錦吉郎	Honda Kinkichirō
本阿弥光甫	Hon'ami Kōho
本阿弥光悦	Hon'ami Kōetsu
本阿弥光瑳	Hon'ami Kōsa
本郷豊国	Hongō Toyokuni
出中	Shutchū
出目	Deme
出羽次郎	Dewajirō
出雲	Izumo
向山	Mukaiyama
印玄	Ingen
印暁	Ingyō
印勝	Inshō
印藤真栖	Indō Matate
曲江	Kyokkō
曲河	Kyokka
果亭	Katei
表斎	Hyōsai
表斎二代	Hyōsai II
甚十郎	Jinjūrō
甚之丞	Jinnojō
甚之助	Jinnosuke
甚内	Jinnai
甚太郎	Jintarō
甚右衛門	Jin'emon
甚左衛門	Jinzaemon
甚次郎	Jinjirō
甚助	Jinsuke
甚蔵	Jinzō
幽元	Yūgen
幽汀	Yūtei
幽石亭	Yūsekitei
幽谷	Yūkoku
幽宝子	Yūhōshi
幽泉	Yūsen
幽香斎	Yūkōsai
幽峨	Yūga
幽渓	Yūkei
幽賞軒	Yūshōken
幽篁亭	Yūkōtei
幽馥堂	Yūfukudō
幽讃	Yūsan
師平	Morohira
師永	Moronaga
師古	Shiko
師厚	Morofusa
師胤	Morotane
師重	Moroshige
師信	Moronobu
師保	Moroyasu
師宣	Moronobu
師政	Moromasa
師香	Moroka
師時	Morotoki
師継	Morotsugu
暢堂	Chōdō
鴨下晁湖	Kamoshita Chōko
鴨水漁夫	Ōsui Gyofu
鴨折水荘	Ōsetsu Suisō
鴨泝小隠	Ōseki Shōin

———— RAD. 丶 3 ————

必庵	Hitsuan
永玄	Eigen
永仙	Eisen

Column 4

永田友治	Nagata Yūji
永田善吉	Nagata Zenkichi
永地秀太	Nagatochi Hideta
永光	Nagamitsu
永有	Nagamochi
永寿	Eiju
永寿霊壺斎	Eiju Ryōkosai
永伯	Eihaku
永村寛	Nagamura Kan
永良	Eiryō
永邨	Eison
永邦	Eihō
永里	Eiri
永岳	Eigaku
永叔	Eishuku
永怡	Eii
永治	Nagaharu
永俊	Eishun
永春	Eishun
永春斎	Eishunsai
永洗	Eisen
永海	Eikai
永島芳虎	Nagashima Yoshitora
永真	Eishin
永納	Einō
永常	Eijō
永梨	Eiri
永陵	Eiryō
永陸	Eiriku
永悳	Eitoku
永敬	Eikei
永湖	Eiko
永琢	Eitaku
永雲	Eiun
永楽	Eiraku
永楽了全	Eiraku Ryōzen
永楽和全	Eiraku Wazen
永楽保全	Eiraku Hozen
永鯉	Eiri
永徳	Eitoku
永徳二世	Eitoku II
永歓子	Eikanshi
永賢	Eiken
永濯	Eitaku
永瀬義郎	Nagase Yoshirō
氷玉	Hyōgyoku
氷見	Himi
氷計	Hyōkei
氷壺	Hyōko
氷盤山人	Hyōgaku Sanjin
半七	Hanshichi
半二	Hanji
半三郎	Hansaburō; Hanzaburō
半山	Hanzan
半六	Hanroku
半平太	Hampeita
半平衛	Hambei
半山	Hansen
半古	Hanko
半左衛門	Hanzaemon
半田	Handen
半次郎	Hanjirō
半江	Hankō
半兵衛	Hambei
半助	Hansuke
半村	Hanson
半牧	Hamboku
半雨	Han'u
半香	Hankō
半圃	Hampo
半象外史	Hanzō Gaishi
半�	Hansen
半夢	Hammu
半農	Hannō

半蔵	Hanzō	久米吉	Kumekichi	井戸直道	Ido Naomichi	東洲	Tōshū
甫田	Fuden	久米桂一郎	Kume Keiichirō	久草国芳	Igusa Kuniyoshi	東洲斎	Tōshūsai
甫紀	Yoshinori	久米蔵	Kumezō	井原西鶴	Ihara Saikaku	東洋	Tōyō
甫雪	Hosetsu	久行	Hisayuki	井特	Seitoku	東海林平次右衛門	Tōkairin Heijiemon
甫斎	Hosai	久里	Kuri	井筒屋特右衛門	Izutsuya Tokuemon		
求明	Kyūmei	久国	Hisakuni			東海晴湖	Tōkai Seiko
求馬	Motome	久信	Hisanobu	井蛙	Seia	東海道歌重	Tōkaidō Utashige
為一	Iichi	久保田米僊	Kubota Beisen	井関家重	Iseki Ieshige	東島徳右衛門	Tōshima
為三	Tamezō	久保田金僊	Kubota Kinsen	少林	Shōrin		Tokuemon
為三堂	Isandō	久保田桃水	Kubota Tōsui	末次一湖	Suetsugu Ikko	東畝	Tōho
為久	Tamehisa	久保田満昌	Kubota Mitsumasa	未醒	Misei	東挙	Tōkyo
為之進	Tamenoshin	久保田寛	Kubota Hiroshi	朱玉	Shugyoku	東泰二	Azuma Taiji
為山	Izan	久馬之介	Kumanosuke	年久	Nenkyū	東浜	Tōhin
為五郎	Tamegorō	久高	Hisataka	年方	Toshikata	東軒	Tōken
為太郎	Tametarō	久翌	Kyūyoku	年邑	Nen'yū	東寅	Tōin
為氏	Tameuji	久野正柏	Kuno Shōhaku	年英	Toshihide	東宿	Tōshuku
為牛	Tameushi	久野松柏	Kuno Shōhaku	年信	Toshinobu	東渓	Tōkei
為吉	Tamekichi	久須見守景	Kusumi Morikage	年恒	Toshitsune	東卓	Tōkō
為成	Tamenari	久隅守景	Kusumi Morikage	寿	Ju	東窓翁	Tōsōō
為行	Tameyuki	久隅種永	Kusumi Tanenaga	寿三郎	Jusaburō	東郷銑春	Tōgō Tetsuharu
為信	Tamenobu	久隅種次	Kusumi Tanetsugu	寿山	Juzan	東郷青児	Tōgō Seiji
為家	Tameie	久隅種信	Kusumi Tanenobu	寿太郎	Jutarō	東野	Tōya
為恭	Tamechika	久鼓山人	Kyūko Sanjin	寿平	Juhei	東斎	Tōsai
為章道	Ishōdō	久鼓庵	Kyūkoan	寿石	Juseki	東湖	Tōko
為斎	Isai	久遠	Kyūen	寿好堂	Jukōdō	東紫園	Tōshien
為継	Tametsugu	久蔵	Kyūzō	寿安山人	Juan Sanjin	東雲亭	Tountei
為遠	Tametō	丸丈斎	Ganjōsai	寿米翁	Jubeiō	東暉	Tōki
為憲	Tamenori	丸山健作	Maruyama	寿秀	Toshihide	東寧	Tōnei
為親	Tamechika		Kensaku	寿秀一世	Toshihide I	東燕斎	Tōensai
単香	Tankō	丸山晩霞	Maruyama Banka	寿秀二世	Toshihide II	東嶽	Tōgaku
単庵	Tan'an	丸屋	Maruya	寿長	Toshinaga	東嶺円慈	Tōrei Enji
梵芳	Bompō	丸屋斧吉	Maruya Onokichi	寿亭	Jutei	東艶斎	Tōensai
梵林	Bonrin	千十郎	Senjūrō	寿信	Toshinobu	胤卿	Inkyō
巣丘山人	Sōkyū Sanjin	千代	Chiyo	寿栄堂	Jueidō	省亭	Shōtei
巣兆	Sōchō	千代松	Chiyomatsu	寿曙堂	Jushodō	眉山	Bizan
巣雪	Sōsetsu	千助	Sensuke	承虎	Shōko	眉仙	Bisen
叢	Kusamura	千里	Senri	承弼	Shōsuke	眉間毫翁	Miken Gōō
叢国麿	Kusamura	千里川	Senrisen	兎山清農	Tozan Seinō	乗円	Jōen
	Kunimaro	千虎	Senko	我古山人	Gako Sanjin	乗加	Jōka
叢春郎	Sōshunrō	千春	Chiharu	兵三	Heizō	乗良	Jōryō
		千洲	Senshū	兵太	Heita	乗龍	Jōryū
——— RAD. ノ 4 ———		千草左衛門	Chigusa	兵右衛門	Hyōemon	重九齋	Chōkyūsai
		大夫	Saemondaibu	兵部	Hyōbu	重丸	Shigemaru
九一郎	Kuichirō	千畝	Sempo	兵部墨渓	Hyōbu Bokkei	重田貞一	Shigeta Teiichi
九八郎	Kuhachirō	千賀光家	Senga Mitsuie	兵衛	Hyōe	重次郎	Shigejirō
九々	Kuku	千韌	Senjin	来成	Raisei	重次郎	Jūjirō
九々鱗	Kukurin	千歌述	Chikanobu	来章	Raishō	重光	Shigemitsu
九久曆	Kyūkyūshin	千歌信	Chikanobu	岳山	Gakuzan	重有	Chōyū
九左衛門	Kyūzaemon	千錦亭	Senkintei	岳亭	Gakutei	重自厚	Shige Jikō
九圭	Kukei	升信	Masunobu	岳亭五岳	Gakutei Gogaku	重兵衛	Jūbei
九如	Kyūjo	升庵	Shōan	岳翁	Gakuō	重直	Shigenao
九成堂	Kyūseidō	丹下	Tange	岳陵	Gakuryō	重厉	Shigefusa
九江	Kyūkō	丹次	Tanji	岳鼎	Gakutei	重長	Shigenaga
九老	Kyūrō	丹次郎	Tanjirō	岳蓮	Gakuren	重信	Shigenobu
九老山人	Kyūrō Sanjin	丹羽林平	Niwa Rimpei	岳崚	Gakushō	重信二代	Shigenobu II
九兵衛	Kyūbei	丹羽嘉言	Niwa Yoshitoki	岳輔	Gakuho	重宣	Shigenobu
九谷旭山	Kutani Kyokuzan	丹甫	Tampo	奉時	Hōji	重政	Shigemasa
九里四郎	Kuri Shirō	丹岳山人	Tangaku Sanjin	奉時道人	Hōji Dōjin	重春	Shigeharu
九国	Kyūkoku	丹治	Tanji	東山	Higashiyama	重春塘	Shige Shuntō
九郎次	Kurōji	丹波元国	Niwa Motokuni	東山隠士	Tōzan Inshi	重美	Shigeyoshi
九浦	Kyūho	丹波屋	Tambaya	東川堂里風	Tōsendō Rifū	重倍	Shigemasu
九華山人	Kyūka Sanjin	丹青斎	Tanseisai	東月堂	Tōgetsudō	重寅	Shigetora
九皋	Kyūkō; Kyūsai	丹家支瑞	Tanke Genzui	東毛墨客	Tōmō Bokkyaku	重閑	Jūkan
九皋館	Kyūsaikan	丹陵	Tanryō	東牛斎	Tōgyūsai	重義	Shigeyoshi
九淵	Kyūen	丹鳥斎	Tanchōsai	東台山麓	Tōdai Sanroku	殷元良	In Genryō
九畳仙史	Kyūjō Senshi	夫泉	Fusen	東玉園良客	Tōgyokuen Ryōsai	烏丸光広	Karasumaru Mi-
九僊閣	Kyūsenkaku	井上	Inoue	東白	Tōhaku	烏有子	Uyūshi ∟tsuhiro
九徳斎	Kyūtokusai	井上令徳	Inoue Reitoku	東成宰鳥	Tōsei Saichō	烏洲	Ushū
九霞山樵	Kyūka Sanshō	井上安二	Inoue Yasuji	東甫	Tōho	烏黒	Ukoku
久大夫	Kyūdayū	井上安次	Inoue Yasuji	東来	Tōrai	島	Shima
久五郎	Kyūgorō	井上安治	Inoue Yasuji	東岳	Tōgaku	島一蝶	Shima Itchō
久太郎	Kyūtarō	井上良孝	Inoue Yoshitaka	東岳道人	Tōgaku Dōjin	島水	Tōsui
久右衛門	Kyūemon	井上良斎	Inoue Ryōsai	東東洋	Azuma Tōyō	島田元旦	Shimada Gentan
久左衛門	Kuzaemon;	井上良斎二	Inoue Ryōsai II	東居	Tōkyo	島田元直	Shimada Motonao
	Kyūzaemon	代		東林	Tōrin	島田豊	Shimada Toyo
久次郎	Kyūjirō	井上達	Inoue Tatsu	東金楼	Tōkinrō	島田墨仙	Shimada Bokusen
久光	Hisamitsu	井口華秋	Iguchi Kashū	東南	Tōnan	島田廣明	Shimada Hiroaki
久米之助	Kumenosuke	井戸弘梁	Ido Kōryō	東南西	Tōnansei	島成円	Shima Seien
久米次郎	Kumejirō	井戸其華	Ido Kika	東城鉦太郎	Tōjō Shōtarō	島成栄	Shima Narie

島根忠蔵	Shimane Chūzō	二宮桃亭	Ninomiya Tōtei	市川摘	Ichikawa Teki	今村紫紅	Imamura Shikō
島崎友輔	Shimazaki Tomosuke	二卿	Nikei	市太夫	Ichidayū	今泉	Imaizumi
島崎柳塢	Shimazaki Ryūu	二尊庵	Nison'an	市太郎	Ichitarō	今泉今右衛門	Imaizumi Imaemon
島崎鶏二	Shimazaki Keiji	二橋外史	Nikyō Gaishi	市右衛門	Ichiemon	仙千代	Senchiyo
島野重之	Shimano Shigeyuki	元久	Genkyū; Motohisa	市兵衛	Ichibei	仙次郎	Senjirō
雀叱	Jakushitsu	元琳	Genrin	市重郎	Ichijūrō	仙花堂	Senkadō
雀盧	Jakuro	元史	Genshi	主一	Shuichi	仙竜斎	Senryūsai
奥田庸徳	Okuda Tsunenori	元仙	Gensen	主水	Mondo	仙崖	Sengai
奥村	Okumura	元四郎	Genshirō	主計	Kazue; Shukei	仙斎	Sensai
奥村久六	Okumura Kyūroku	元旦	Gentan	主馬	Shume	仙算	Sensan
奥村土牛	Okumura Togyū	元仲	Genchū	主馬助	Shumenosuke	仙嶺	Senrei
奥村利信	Okumura Toshinobu	元休	Genkyū	主税	Chikara	仙齢	Senrei
奥村信房	Okumura Nobufusa	元休満永	Genkyū Mitsunaga	主殿	Tonomo	仙鶴堂	Senkakudō
奥村政房	Okumura Masafusa	元次郎	Genjirō	主膳	Shuzen	令哉	Reisai; Reiya
奥村源六	Okumura Genroku	元吉	Genkichi	亦迂	Ekiu	他次郎	Tajirō
奥村義三	Okumura Yoshizō	元成	Gensei	亥	Gai	代助	Daisuke
奥村親妙	Okumura Shimmyō	元机	Genki	交山	Kōzan	伊八	Ihachi
奥貞章	Oku Teishō	元糸	Genshi	交長	Kōchō	伊三郎	Isaburō
奥原晴湖	Okuhara Seiko	元寿	Genju	交翠山房	Kōsui Sambō	伊之助	Inosuke
奥原晴翠	Okuhara Seisui	元秀	Genshū; Motohide	京水	Kyōsui	伊川	Isen
奥原節子	Okuhara Setsuko	元周	Genshū	京兆逸民	Kyōchō Itsumin	伊川院	Isen'in
奥原輝子	Okuhara Teruko	元直	Motonao	京助	Kyōsuke	伊丹雅信	Itami Masanobu
奥瀬英三	Okuse Eizō	元定	Genjō	夜半亭	Yahantei	伊左衛門	Izaemon
戯墨庵	Gibokuan	元忠	Mototada	夜半翁	Yahan'ō	伊年	Inen
戯墨斎	Gibokusai	元雨斎	Gembokusai	夜江	Yakō	伊孚九	I Fu-chiu
戯画堂	Gigadō	元知	Genchi	夜雨庵	Yosamean	伊豆之介	Izunosuke
劇雅堂	Gekigadō	元英	Gen'ei	夜梅楼	Yabairō	伊東さと	Itō Sato
厳成	Gensei	元俊	Genshun	夜潮	Yachō	伊東小坡	Itō Shōha
厳斐	Ganhi	元信	Motonobu	亮仙	Ryōsen	伊東紅雲	Itō Kōun
		元厚	Genkō	亮助	Sukehiko	伊東常辰	Itō Tsunetatsu
—— RAD. 乙 5 ——		元施	Genshi	亮僊	Ryōsen	伊東深水	Itō Shinsui
七之助	Shichinosuke	元昭	Genshō	帝塚山樵	Tezuka Sanshō	伊東陶山	Itō Tōzan
七左衛門	Shichizaemon	元昶	Genchō	袞杖	Suijō	伊亮	Iryō
七兵衛	Shichibei	元哲	Gentetsu	恋川	Koikawa	伊信	Korenobu
七里香草堂	Shichiri Kōsōdō	元祥	Genshō	恋川春町	Koikawa Harumachi	伊洲	Ishū
七松園主	Shichishō Enshu	元素	Genso	恋川春政	Koikawa Harumasa	伊島	Ishima
七草堂	Shichisōdō	元啓	Genkei	恋川春峨	Koikawa Haruga	伊能魚彦	Inō Nahiko
七衛門	Shichiemon	元規	Genki	黿摂	Gōsetsu	伊能景豊	Inō Kagetoyo
巴人	Hajin	元陳	Genchin	商山処士	Shōzan Shoshi	伊原宇三郎	Ihara Usaburō
巴人亭	Hajintei	元章	Genshō	棄之	Suteyuki	伊賀守	Iga no Kami
巴山	Hazan	元巽	Genson	豪谷	Gōkoku	伊賀法印	Iga no Hōin
巴水	Hasui	元喩	Gen'yu	豪信	Gōshin	伊勢屋伊八	Iseya Ihachi
		元賀	Genga	豪渓	Gōkei	伊藤白歳	Itō Hakusai
—— RAD. 亅 6 ——		元誠	Gensei	豪猪先生	Gōcho Sensei	伊藤汝鈞	Itō Jokin
了入	Ryōnyū	元徳	Gentoku	豪湖	Gōko	伊藤快彦	Itō Yoshihiko
了之	Ryōshi	元儀	Gengi	豪潮	Gōchō	伊藤宗瑤	Itō Sōban
了不	Ryōfu	元慶	Genkei			伊藤春教	Itō Shunkyō
了仙	Ryōsen	元震	Genshin	**—— RAD. 人 9 ——**		伊藤廉	Itō Ren
了全	Ryōzen	元興寺玄朝	Gangōji Genchō	人見小華	Hitomi Shōka	伊藤雅時	Itō Masatoki
了承	Ryōshō	元盧慧牧	Genro Eiboku	人見勇市	Hitomi Yūichi	伊藤慶之助	Itō Keinosuke
了昌	Ryōshō	元融	Gen'yū	介干	Kaikan	伊藤篤	Itō Atsushi
了乗	Ryōjō	元賓	Gempin	介石	Kaiseki	任太郎	Jintarō
了桂	Ryōkei	電洲	Genshū	介眉	Kaibi	任牛	Ningyū
了浮斎	Ryōfusai			介翁	Kaiō	任田屋徳次	Tōdaya Tokuji
了斎	Ryōsai	**—— RAD. 宀 8 ——**		介堂	Kaidō	似眼	Jigen
了尊	Ryōson	之信	Yukinobu	介庵	Kaian	伏見寿朗	Fushimi Toshirō
了敬	Ryōkei	六三郎	Rokusaburō	以十	Ijū	仲己	Chūki
了琢	Ryōtaku	六々庵	Rokurokuan	以天	Iten	仲太	Chuta
了慶	Ryōkei	六之丞	Rokunojō	以知庵	Ichian	仲太郎	Nakatarō
才次郎	Saijirō	六石	Rikuseki	仁寿斎	Jinjusai	仲父	Chūfu
才壷	Saiko	六兵衛	Rokubei	仁兵衛	Nihei	仲由	Chūyu
		六兵衛門	Rokuemon	仁阿爾	Nin'ami	仲安	Chūan
—— RAD. 二 7 ——		六花亭	Rokkatei	仁海	Ninkai	仲安眞康	Chūan Shinkō
二万堂	Nimandō	六花軒	Rokkaken	仁清	Ninsei	仲安梵師	Chūan Bonshi
二山	Nizan	六花堂	Rokkaken	仁賀	Ninga	仲光	Chūkō
二天	Niten	六角寂済	Rokkaku Jakusai	仏師僧浄如	Busshi Sō Jōnyobō	仲均	Chūkin
二代目又平	Nidaime Matahei	六角紫水	Rokkaku Shisui	房円快	Enkai	仲孚	Chūfu
二条梁	Nijō Yana	六柳	Rokuryū	今大路源秀	Imaōji Genshū	仲春	Nakaharu
二見さと	Futami Sato	六郎	Rokurō	今中素友	Imanaka Soyū	仲恭	Chūkyō
二直庵	Nichokuan	六郎兵衛	Rokurobei	今中善蔵	Imanaka Zenzō	仲連	Chūren
二林草舎	Nirin Sōsha	六病庵	Rokubyōan	今西中道	Imanishi Nakamichi	仲貫	Chūkan
二神純孝	Futagami Sumitaka	六巣	Rokusō	今尾永歓	Imao Eikan	仲斎	Chūsai
二郎左衛門	Jirozaemon	六無斎	Rokumusai	今尾猪三郎	Imao Isaburō	仲漁	Chūgyo
満照	Mitsuteru	市三郎	Ichisaburō	今尾景年	Imao Keinen	仲適	Chū Teki
		市之丞	Ichinojō	今村正一	Imamura Shōichi	仲質	Chūshitsu
		市川君泉	Ichikawa Kunsen	今村寿三郎	Imamura Jusaburō	仲選	Chūsen
		市川迪	Ichikawa Teki			仲龍	Chūryū
						仲簡子	Chūkanshi

仲観	Chūkan	佐藤山斎	Satō Sansai	佳日軒	Kajitsuken	儃然	Tanzen
仲鑑	Chūkan	佐藤正持	Satō Masamochi	佳芸乃舎	Kageinoya	優遊自在	Yūyū Jizai
伝寺義境	Denkyūji Gikyō	佐藤古洞	Satō Kotō	佳麗庵	Kareian		
伝内	Dennai	佐藤矢	Satō Shi	俊久	Toshihisa	——— RAD. 儿 10 ———	
伝次郎	Denjirō	佐藤益之	Satō Masuyuki	俊太郎	Shuntarō		
伝蔵	Denzō	佐藤清蔵	Satō Seizō	俊平	Shumpei	先楽	Senraku
休山	Kyūzan	佐藤朝山	Satō Chōzan	俊次	Toshitsugu	児玉希望	Kodama Kibō
休円	Kyūen	但馬屋庄次	Tajimaya Shōjirō	俊声	Shunsei	児玉果亭	Kodama Katei
休月斎	Kyūgetsusai	郎		俊明	Shummei	児玉省三	Kodama Shōzō
休白	Kyūhaku	伴右衛門	Ban'emon	俊長	Toshinaga	児玉道弘	Kodama Michihiro
休甫	Kyūho	伴清獅現	Hansei Shigen	俊信	Toshinobu	児島虎次郎	Kojima Torajirō
休伯	Kuhaku; Kyūhaku	伯円	Hakuen	俊満	Shumman	児島善三郎	Kojima Zenzaburō
休伯二代	Kyūhaku II	伯民	Hakumin	俊賀	Shunga		
休伯三代	Kyūhaku III	伯玉	Hakugyoku	俊蔵	Shunzō	——— RAD. 入 11 ———	
休真	Kyūshin	伯立	Hakuryū	信	Shin		
休庵	Kyūan	伯圭	Hakkei	信之	Nobuyuki	入江波光	Irie Hakō
休翠	Kyūyoku	伯寿	Hakuju	信天翁	Shinten'ō	入江貫	Irie Kan
休卿	Kyūkei	伯免	Hakumen	信尹	Nobutada	入江幾治郎	Irie Ikujirō
休意	Kyūi	伯屛	Hakubō	信方	Nobukata		
休意二代	Kyūi II	伯明	Hakumei	信広	Nobuhiro	——— RAD. 八 12 ———	
休碩	Kyūseki	伯受	Hakuju	信甫	Shimpo		
休慧	Kyūkei	伯後	Hakugo	信近	Nobuchika	八十八	Yasohachi
休蔵	Kyūzō I-V	伯恭	Hakkyō	信房	Nobufusa	八十島嘉根	Yasoshima Kane
会心斎	Kaishinsai	伯挙	Hakukyo	信茂	Nobushige	八山	Hassan
会津山人	Aizu Sanjin	伯華	Hakka	信貞	Nobusada	八木岡亮之	Yagioka
会理	Eri	伯高	Hakukō	信政	Nobumasa	助	Ryōnosuke
合川秀成	Aikawa Hidenari	伯清	Hakusei	信春	Nobuharu;	八木岡春山	Yagioka Shunzan
合川亭	Aikawatei	伯望	Hakubō		Shinshun	八木迪	Yagi Michi
合田清	Gōda Kiyoshi	伯陵	Hakuryō	信海	Shinkai	八仙堂	Hassendō
合敬	Gōkei	伯亀	Hakuki	信倫	Shinrin	八右衛門	Hachiemon
仔止楼	Yoshirō	伯挙	Hakukyo	信翁	Shin'ō	八田久左衛	Hatta Kyūzaemon
全楽堂	Zenrakudō	伯暉	Hakuki	信清	Nobukiyo	門	
全楽斎	Zenrakusai	伯照	Hakushō	信章	Shinshō	八田希賢	Hatta Kiken
佐々木又兵	Sasaki Matabei	伯照軒	Hakushōken	信斎	Shinsai	八岳	Hachigaku
衛		伯慶	Hakkei	信暁	Shingyō	八郎	Hachirō
佐々木大樹	Sasaki Taiju	伯養	Hakuyō	信勝	Nobukatsu	八重八	Yaehachi
佐々木長次	Sasaki Chōjirō	伯熙	Hakki	信賀	Shinga	八郎右衛門	Hachirōemon
郎		伯顥	Hakka	信雄	Nobuo	八郎兵衛	Hachirobei
佐々木朝次	Sasaki Chōjirō	伯吉内記	Sumiyoshi Naiki	信廉	Shinren	八島定岡	Yashima Sadaoka
郎		住吉広次	Sumiyoshi	信實	Nobuzane	八島春信	Yashima Harunobu
佐久間友徳	Sakuma Yūtoku		Hirotsugu	信濃法眼	Shinano Hōgen	八萬四千煩	Hachiman Yonsen
佐久間文吾	Sakuma Bungo	住吉広守	Sumiyoshi	保之助	Yasunosuke	悩主人	Bonnō Shujin
佐久間益元	Sakuma Masumoto		Hiromori	保田重右衛	Yasuda Jūemon	八僊堂	Hassendō
佐久間健寿	Sakuma Takehisa	住吉広行	Sumiyoshi	門		八蔵	Hachizō
佐久間啓	Sakuma Kei		Hiroyuki	保田竜門	Yasuda Ryūmon	公圭	Kōkei
佐久間義和	Sakuma Yoshikazu	住吉広芳	Sumiyoshi	保全	Hozen	公図	Kōto
佐久間鉄園	Sakuma Tetsuen		Hiroyoshi	保国	Yasukuni	公均	Kōkin
佐久間顕	Sakuma Akira	住吉広定	Sumiyoshi	保間芳太郎	Yasuma	公忠	Kintada
佐分真	Saburi Makoto		Hirosada		Yoshitarō	公知	Kōchi
佐竹	Satake	住吉広尚	Sumiyoshi Hironao	保間素堂	Yasuma Sodō	公茂	Kimmochi
佐竹正丘	Satake Seii	住吉広通	Sumiyoshi	俵屋以悦	Tawaraya Ietsu	公長	Kōchō
佐竹永邨	Satake Eison		Hiromichi	俵屋宗二	Tawaraya Sōji	公乗	Kōjō
佐竹永陵	Satake Eiryō	住吉広當	Sumiyoshi	俵屋宗理	Tawaraya Sōri	公栄	Kōei
佐竹永湖	Satake Eiko		Hiromasa	俵屋宗雪	Tawaraya Sōsetsu	公美	Kōbi
佐竹周継	Satake Shūkei	住吉広慶	Sumiyoshi	倹篇	Ken'yakusai	公宰	Kōsai
佐竹金太郎	Satake Kintarō		Hiroyoshi	俳耕林	Haikōrin	公望	Kimmochi
佐竹貞吉	Satake Teikichi	住吉広澄	Sumiyoshi	倉田白羊	Kurata Hakuyō	公栗	Kōritsu
佐竹義敦	Satake Yoshiatsu		Hirozumi	倉田重吉	Kurata Jūkichi	公弼	Kōhitsu
佐竹義寛	Satake Yoshihiro	住吉弘定	Sumiyoshi	倉谷強	Kuratani	公遊	Kōyū
佐竹徳	Satake Toku		Hirosada		Tsuyoshi	公瑜	Kōyu
佐竹徳次郎	Satake Tokujirō	住吉忠俊	Sumiyoshi	倉橋格	Kurahashi Kaku	公維	Kōi
佐竹銀十郎	Satake Ginjūrō		Tadatoshi	倉橋豊国	Kurahashi	公器	Kōki
佐竹衞司	Satake Eishi	住吉法眼	Sumiyoshi Hōgen		Toyokuni	公範	Kōhan
佐兵衛	Sahei	住吉覚超	Sumiyoshi	修理	Shuri	公龍	Kōryū
佐伯	Saeki		Kakuchō	修理亮	Shurinosuke	公嶺	Kōrei
佐伯良	Saeki Ryō	住吉聖衆丸	Sumiyoshi	條之助	Jōnosuke	公観	Kōkan
佐伯岱	Saeki Tai		Shōjumaru	倫閑斎	Tōkansai	公鑑	Kōkan
佐伯昌明	Saeki Masaaki	住吉慶忍	Sumiyoshi Keinin	停雲楼	Teiunrō	呉山	Gozan
佐伯祐三	Saeki Yūzō	住吉慶恩	Sumiyoshi Keion	偽三郎	Tamesaburō	呉江	Gokō
佐脇倉治	Sawaki Kuraji	作之丞	Sakunojō	健一郎	Ken'ichirō	呉俊明	Go Shummei
佐脇道賢	Sawaki Michikata	作兵衛	Sakubei	健四郎	Kenshirō	呉春	Goshun
佐脇嵩之	Sawaki Sūshi	余俊明	Yo Shummei	偃可	Senka	呉暁	Gogyō
佐野此宝	Sano Shihō	余楽斎	Yorakusai	偃斎	Sensai	其一	Kiitsu
佐野長寛	Sano Chōkan	余馦河成	Aguri Kawanari	僧愛石	Sō Aiseki	其角	Kikaku
佐野俊明	Sano Shummei	何帠	Kakei	儀平	Gihei	其明	Kimei
佐野昭	Sano Akira	侃斎	Kansai	儀兵衛	Gihei	其日庵	Kijitsuan
佐野豊房	Sano Toyofusa	佩川	Haisen	儀陳	Gichin	其萃	Kisui
佐道賢	Sa Michikata	依田瑾	Yoda Kin	儀鳳	Gihō	其雲	Kiun
佐嵩之	Sa Sūshi	佳二郎	Kajirō	儀蔵	Gizō	前大峰	Mae Taihō

前川	Maekawa	興之	Kōshi	周本	Shūhon	加賀の即曲	Kaga no Sokuyo
前川千帆	Maekawa Sempan	興以	Kōi	周村	Shūson	加藤土師萌	Katō Hajime
前川文嶺	Maekawa Bunrei	興甫	Kōho	周位	Shūi	加藤友太郎	Katō Tomotarō
前川晃	Maekawa Akira	興牧	Kōboku	周助	Shūsuke	加藤民吉	Katō Tamikichi
前田果	Maeda Konomi	興信	Okinobu	周延	Chikanobu	加藤正継	Katō Masatsugu
前田国丸	Maeda Kunimaru	興倩	Kōchū	周林	Shūrin	加藤四郎左	Katō Shirozaemon
前田国虎	Maeda Kunitora	興悦	Kōetsu	周苦	Shūku	衛門	
前田青邨	Maeda Seison	興教大師	Kōkyō Daishi	周重	Chikashige	加藤守行	Katō Moriyuki
前田寛治	Maeda Kanji	興斎	Kōsai	周信	Chikanobu	加藤宗四郎	Katō Sōshirō
前田廉造	Maeda Renzō	興禎	Kōtei	周奎	Shūkei	加藤英舟	Katō Eishū
前田碩一	Maeda Sekiitsu	興義	Kōgi	周春	Chikaharu	加藤金太郎	Katō Kintarō
前村愛徳	Maemura Aitoku			周省	Shūsei	加藤春山	Katō Shunzan
前島	Maejima	——— RAD. 冂 13 ———		周峰	Shūhō	加藤泰郁	Katō Taiyū
益之	Masuyuki			周耕	Shūkō	加藤孫右衛	Katō Magoemon
益田玉城	Masuda Gyokujō	円山	Enzan	周渓	Shūkei	門	
益田珠城	Masuda Tamaki	円山応立	Maruyama Ōryū	周雪	Shūsetsu	加藤唐九郎	Katō Tōkurō
益宗	Masumune	円山応春	Maruyama Ōshun	周斎	Shūsai	加藤鬼頭太	Katō Kitōta
益信	Masunobu	円山応挙	Maruyama	周豪	Shūgō	加藤源之助	Katō Gennosuke
益翁	Ekiō		Masataka	周徳	Shūtoku	加藤静児	Katō Seiji
益頭尚志	Masuzu Naoshi	円山応陽	Maruyama Ōyō	周輔	Shūho	加藤顕清	Katō Kensei
益頭峻南	Masuzu Shunnan	円山応瑞	Maruyama Ōzui	周蔵	Shūzō	助之進	Sukenoshin
兼之丞	Kennojō	円山応震	Maruyama Ōshin	周暦	Chikamaro	助五郎	Sukegorō
兼円	Ken'en	円山直一	Maruyama Naoichi	周誉	Shūyo	助衛門	Suke-emon
兼行	Kenkō	円心	Enshin			勇七	Yūshichi
兼茂	Kaneshige	円伊	En'i	——— RAD. 冖 14 ———		勇七郎	Yūshichirō
兼康	Kaneyasu	円志	Enshi			勇之助	Yūnosuke
兼慶	Genkei; Kenkei	円快	Enkai	写山楼	Shazanrō	勇山	Yūzan
曽山幸彦	Soyama Yukihiko	円空	Enkū	写真斎	Shashinsai	勇吉	Yūkichi
曽文	Sōbun	円乗	Enjō	写楽	Sharaku	勇助	Yūsuke
曽我直庵	Soga Chokuan	円俊	Enshun	写楽翁	Sharakuō	勇記	Yūki
曽我宗誉	Soga Sōyo	円春	Enshun	写照	Shashō	勇斎	Yūsai
曽我師竜	Soga Shiryū	円春斎	Enshunsai			勘七	Kanshichi
曽我紹仙	Soga Shōsen	円通寺風外	Entsū-ji Fūgai	——— RAD. 冫 15 ———		勘八	Kampachi
曽我紹祥	Soga Shōshō	円寂	Enjaku			勘右衛門	Kan'emon
曽我呷一	Soga Kiichi	円勢	Ensei	冲之丞	Okinojō	勘兵衛	Kambei
曽我呷雄	Soga Kiyū	同巧館	Dōkōkan	冲信	Chūshin; Okinobu	勘助	Kansuke
貧楽斎	Hinrakusai	同楽園	Dōrakuen	冲澹	Chūtan		
巽	Sonsho	岡丈堂	Kōjōdō	兆殿司	Chōdensu	——— RAD. 勹 20 ———	
巽斎	Sonsai	岡之丞	Okanojō	次兵衛	Jihei		
曾田友柏	Katsuta Yūhaku	岡文暉	Oka Bunki	次良兵衛	Jirobei	勾田實宏	Magata Kankō
曾我嗣	Soga Tsugu	岡本	Okamoto	次郎	Jirō		
曾宮一念	Somiya Ichinen	岡本昌房	Okamoto Masafu-	次郎三郎	Jirosaburō	——— RAD. 匕 21 ———	
曾宮喜七	Somiya Kishichi	岡本茂彦	Okamoto ˪sa	次郎左衛門	Jirozaemon		
普馨	Fukei		Shigehiko	次郎吉	Jirokichi	北一	Hokuichi
善了	Zenryō	岡本隆仙	Okamoto Ryūsen	次郎兵衛	Jirobei	北大路房次	Kitaōji Fusajirō
善十郎	Zenjūrō	岡本豊久	Okamoto Toyohisa	冷泉爲恭	Reizei Tamechika	郎	
善三郎	Zenzaburō	岡本豊彦	Okamoto Toyohiko	凌岱	Ryōtai	北大路魯山	Kitaōji Rosanjin
善五郎	Zengorō	岡本禎	Okamoto Tei	凌雲	Ryōun	人	
善円	Zen'en	岡本澄	Okamoto Chō	凌寒斎	Ryōkansai	北山孟熙	Kitayama Mōki
善右衛門	Zen'emon	岡旦嶺	Oka Tanrei			北山道良	Kitayama Dōryō
善四郎	Zenshirō	岡田	Okada	——— RAD. 几 16 ———		北川	Kitagawa
善次郎	Zenjirō	岡田三郎助	Okada Saburosuke			北川民次	Kitagawa Tamiji
善吉	Zenkichi	岡田国	Okada Koku	夙夜	Shukuya	北川信美	Kitagawa Shimbi
善伯	Zenhaku	岡田武功	Okada Bukō	鳳山	Hōzan	北川豊秀	Kitagawa Toyohide
善宗	Zensō	岡田尚友	Okada Shōyū	鳳山道人	Hōzan Dōjin	北川藤麿	Kitagawa Fujimaro
善良	Zenryō	岡田粛	Okada Shuku	鳳白	Hōhaku	北升	Hokushō
善身堂	Zenshindō	岡田爲恭	Okada Tamechika	鳳郭	Hōkaku	北出搭次郎	Kitade Tōjirō
善辰斎	Zenshinsai	岡田雲洞	Okada Untō	鳳斎	Hōsai	北代八重八	Kitashiro Yaehachi
善哉庵	Zenzaian	岡田練	Okada Ren	鳳卿	Hōkyō	北向実	Kitamuki Seijitsu
善春	Zenshun	岡田儀	Okada Gi	鳳湖	Hōko	北向観	Kitamuki Kan
善悦	Zen'etsu	岡田藤四郎	Okada Tōshirō	鳳葉軒	Hōyōken	北尾	Kitao
善納	Zennō	岡島	Okajima	鳳雲	Hōun	北尾正美二	Kitao Masayoshi
善紹	Zenshō	岡倉秋水	Okakura Shūsui	鳳嶺	Hōrei	代	II
善訥	Zentotsu	岡島素岡	Okajima Sokō			北尾政美	Kitao Masayoshi
善雪	Zensetsu	岡島藤次郎	Okajima Tōjirō	——— RAD. 凵 17 ———		北尾重政	Kitao Shigemasa
善章	Zenshō	岡崎雪声	Okazaki Sessei			北尾重政二	Kitao Shigemasa
善斎	Zensai	岡崎源七	Okazaki Genshichi	凹凸堂	Ōtotsudō	代	II
善慶	Zenkei	岡崎藤次郎	Okazaki Tōjirō			北尾政演	Kitao Masanobu
善蔵	Zenzō	岡野享	Okano Tōru	——— RAD. 刀 18 ———		北村正信	Kitamura
善鏡	Zenkyō	岡野栄	Okano Sakae				Masanobu
尊俊	Sonshun	岡鹿之助	Oka Shikanosuke	刑部	Gyōbu	北村四海	Kitamura Shikai
尊海	Sonkai	岡煥	Oka Kan	荊石	Keiseki	北村西望	Kitamura Seibō
尊智	Sonchi	岡精一	Oka Seiichi			北沢保次	Kitazawa Yasuji
與次	Yoji	周二	Shūji	——— RAD. 力 19 ———		北沢楽天	Kitazawa Rakuten
與斎	Yosai	周三郎	Shūsaburō			北岱	Hokutai
與謝信章	Yosa Nobuaki	周山	Shūzan	加地為也	Kaji Tameya	北明	Hokumei
慈平	Jihei	周元	Shūgen	加納三楽	Kanō Sanraku	北苑	Hokuen
慈雲	Jiun	周文	Shūbun	加納邦夫	Kanō Kunio	北英	Hokuei
興也	Kōya	周平	Shūhei	加納夏雄	Kanō Natsuo	北為	Hokui

北亭	Hokutei	巨勢隆慶	Kose no Ryūkei	孝礼	Kōrei	真清水蔵六	Mashimizu Zōroku
北洲	Hokushū	巨勢益宗	Kose no	孝信	Takanobu	二代	II
北海	Hokkai		Masumune	孝則	Takanori	真野紀太郎	Mano Kitarō
北泉	Hokusen	巨勢兼茂	Kose no Kaneshige	孝敬	Kōkei	真斎	Shinsai
北島淺一	Kitajima Sen'ichi	巨勢惟久	Kose no Korehisa	直一	Naoichi; Naokazu	真敬	Shinkei
北圃	Hoppo	巨勢深江	Kose no Fukae	直入	Chokunyū	真葛長造	Makuzu Chōzō
北峰	Hokuhō	巨勢博孝	Kose no Hirotaka	直水	Chokusui	真覚	Shinkaku
北畠具教	Kitabatake	巨勢堯有	Kose no Gyōyū	直芳	Naoyoshi	真道重彦	Shindō Shigehiko
	Tomonori	巨勢堯尊	Kose no Gyōson	直武	Naotake	真道黎明	Shindō Reimei
北畠重政	Kitabatake	巨勢堯厳	Kose no Gyōgen	直城	Chokujō	真瑞	Shinzui
	Shigemasa	巨勢源有	Kose no Gen'yū	直彦	Naohiko	真説	Shinsetsu
北粋	Hokusui	巨勢源尊	Kose no Genson	直翁	Chokuō; Jikiō	真説斎	Shinsetsusai
北脇昇	Kitawaki Noboru	巨勢源慶	Kose no Genkei	直庵	Chokuan	真鶴風外	Manatsuru Fūgai
北馬	Hokuba	巨関	Kyokan	直庵二	Chokuanni	乾	Ken
北條氏直	Hōjō Ujinao	巨鮮斎	Kyosensai	直朝	Naotomo	乾也	Ken'ya
北梅戸	Hokubaiko	巨寶	Kyohō	直隆	Naotaka	乾山	Kenzan
北溪	Hokkei			直照	Naoteru	乾山二代	Kenzan II
北窓翁	Hokusōō	——— RAD. 十 24 ———		直興	Nao-oki	乾哉	Ken'ya
北野恒富	Kitano Tsunetomi			直賢	Naokata	博孝	Hirotaka
北野富太郎	Kitano Tomitarō	十千	Jissen	南乙	Nan'otsu	幹幹	Kankan
北頂	Hokuchō	十友	Jūyū	南々川貞広	Nanakawa	翰運子	Kan'unshi
北斎	Hokusai	十友園	Jūyūen		Sadahiro	戴斗	Taito
北雲	Hokuun	十市王洋	Toichi Ōyō	南山	Nanzan	戴斗二代	Taito II
北僊	Hokusen	十市實	Toichi Yori	南水	Nansui	戴岳	Taigaku
北溟	Hokumei	十右衛門	Jūemon	南平堂	Nampeidō		
北雅	Hokuga	十右衛門	Jūzaemon	南江	Nankō	——— RAD. 卜 25 ———	
北鄒田夫	Hokusu Dempu	十旭	Jukkyoku	南谷	Nankoku		
北豪	Hokugō	十江	Jikkō; Sokō	南岳	Nangaku	卜山	Bokuzan
北壽	Hokuju	十兵衛	Jūbei	南陀伽紫蘭	Nandaka Shiran	卜斎	Bokusai
北蓮蔵	Kita Renzō	十返舎一九	Jippensha Ikku	南城義治	Nanjō Yoshiharu	上月飲光	Kōzuki Onkō
北輝	Hokki	十畝	Juppo	南星	Nansei	上田万秋	Ueda Manshū
北嶺	Hokurei	十時賜	Totoki Shi	南海	Nankai	上田巳之太	Ueda Minotarō
北鷺	Hokuga	十雁斎	Togansai	南荊	Nankei	郎	
北鵬	Hokuhō	古山師胤	Furuyama	南風	Nampū	上田公圭	Ueda Kōkei
			Morotane	南粋	Nansui	上田公長	Ueda Kōchō
——— RAD. 匚 22 ———		古山師重	Furuyama	南華	Nanka	上田幸	Ueda Kō
			Moroshige	南竜斎	Nanryūsai	上田政信	Ueda Masanobu
巨山	Kyozan	古山師宣	Furuyama	南崖	Nangai	上田耕沖	Ueda Kōchū
巨川	Kyosen		Moronobu	南渓	Nankei	上条機	Kamijō Nori
巨柳	Koryū	古山師政	Furuyama	南涯	Nangai	上杉	Uesugi
巨海	Kyokai		Moromasa	南窓	Nansō	上村松園	Uemura Shōen
巨勢久行	Kose no Hisayuki	古山師継	Furuyama	南窓翁	Nansōō	上村常子	Uemura Tsuneko
巨勢久高	Kose no Hisataka		Morotsugu	南窓楼	Nansōrō	上阪雅人	Kōsaka Gajin
巨勢小石	Kose Shōseki	古川	Kosen	南郭	Nankaku	上阪雅之助	Kōsaka
巨勢公忠	Kose no Kintada	古川叟	Kosensō	南陵	Nanryō		Masanosuke
巨勢公茂	Kose no Kimmochi	古川龍生	Furukawa Ryūsei	南淵	Nan'en	上原芳豊	Uehara Yoshitoyo
巨勢公望	Kose no Kimmochi	古内記	Konaiki	南湖	Nanko	上野恭	Ueno Yasushi
巨勢永有	Kose no	古右京	Ko Ukyō	南塘	Nantō	上野泰輔	Ueno Taisuke
	Nagamochi	古竹	Kochiku	南溟	Nammei	上野山清貫	Uenoyama
巨勢広高	Kose no Hirotaka	古邨	Koson	南豊	Nampō		Kiyotsugu
巨勢広貴	Kose no Hirotaka	古画堂	Kogadō	南洞	Nankan	上野章波	Ueno Shōha
巨勢弘高	Kose no Hirotaka	古径	Kokei	南薫造	Minami Kunzō	上野道昌	Ueno Michimasa
巨勢光康	Kose no Mitsuyasu	古拙	Kosetsu	南嶺	Nanrei	上龍	Jōryū
巨勢有久	Kose no Arihisa	古玩	Kogan	南嶺堂	Nanreidō	卓池	Takuchi
巨勢有行	Kose no Ariyuki	古秀	Koshū	南嶺斎	Nanreisai	卓峯	Takujū
巨勢有宗	Kose no Arimune	古屋重寿	Furuya Shigetoshi	索祥	Soshō	卓峯	Takuhō
巨勢有重	Kose no Arishige	古剣妙沢	Koken Myōtaku	索絢	Sakutō	卓堂	Takudō
巨勢有家	Kose no Ariie	古骨道人	Kokotsu Dōjin	真中元信	Manaka Motonobu	貞二	Teiji
巨勢有康	Kose no Ariyasu	古庵	Koan	真中沖信	Manaka Okinobu	貞丸	Sadamaru
巨勢有尊	Kose no Yūson	古馮	Kohyō	真田直	Sanada Choku	貞升	Sadamasu
巨勢有厳	Kose no Yūgen	古満	Koma	真匠銀光	Shinshō Ginkō	貞升二代	Sadamasu II
巨勢行有	Kose no Yukiari	古満久蔵	Koma Kyūzō	真守	Shinshu	貞四郎	Sadashirō
巨勢行忠	Kose no Yukitada	古満文斎	Koma Bunsai	真助	Shinsuke	貞広	Sadahiro
巨勢快有	Kose no Kaiyū	古満巨柳	Koma Koryū	真快	Shinkai	貞吉	Sadakichi
巨勢宗久	Kose no Munehisa	古満休意	Koma Kyūi	真村長蔵	Mamura Chōzō	貞芳	Sadayoshi
巨勢宗茂	Kose no Muneshige	古満休蔵	Koma Kyūzō	真村真敬	Mamura Shinkei	貞秀	Sadahide
巨勢定久	Kose no Sadahisa	古満安国	Koma Yasukuni	真芸	Shingei	貞房	Sadafusa
巨勢忠長	Kose no Tadanaga	古満安政	Koma Yasumasa	真実菴	Shinjitsuan	貞明	Teimei
巨勢金岡	Kose no Kanaoka	古満寛哉	Koma Kansai	真治斎	Shinchisai	貞虎	Sadatora
巨勢金起	Kose Kanaoki	古満遠舟	Koma Enshū	真虎	Matora	貞重	Sadashige
巨勢重有	Kose no Chōyū	古賀春江	Koga Harue	真相	Shinsō	貞信	Sadanobu
巨勢俊久	Kose no Toshihisa	古庵	Koryū	真能	Shinnō	貞政	Sadamasa
巨勢信茂	Kose no	古器観	Kokikan	真宰	Shinsai	貞春	Sadaharu
	Nobushige	古碩	Kokan	真笑	Shinshō	貞經	Sadatsune
巨勢信貞	Kose Nobusada	古藤惟旭	Kotō Koreaki	真竜	Shinryū	貞斎	Teisai
巨勢専有	Kose no Sen'yū	克己斎	Kokkisai	真康	Shinkō	貞景	Sadakage
巨勢是重	Kose no Koreshige	克紹	Kokushō	真済	Shinzei	貞道	Sadamichi
巨勢相見	Kose no Aimi	克譲	Katsujō	真清水蔵六	Mashimizu	貞卿	Teikyō
巨勢相覧	Kose no Aimi	孝文	Kōbun		Zōroku	貞雲	Teiun

貞蔵　Teizō

—— RAD. 卩 26 ——

卯之助　Unosuke
卯観子　Bōkanshi; Ukanshi
卸誉　Sokuyo
卸誉二代　Sokuyo II

—— RAD. 厂 27 ——

灰田醒　Haida Sei
原二　Genji
原二郎　Genjirō
原了写　Hara Shisha
原田圭岳　Harada Keigaku
原田直次郎　Harada Naojirō
原在泉　Hara Zaisen
原羊遊斎　Hara Yōyūsai
原近義　Hara Chikayoshi
原治平　Hara Jihei
原治兵衛　Hara Jihei
原堅　Hara Harukata
原致道　Hara Chidō
原致遠　Hara Chien
原熊太郎　Hara Kumatarō
原撫松　Hara Bushō
雁金屋藤重郎　Kariganeya Tōjurō

—— RAD. 厶 28 ——

允伯　Impaku
弁二　Benji
弁蔵　Benzō
台山　Taizan
台岳　Taigaku
台嶽樵者　Daigaku Shōsha
台嶺　Dairei; Tairei
能阿弥　Nōami

—— RAD. 又 29 ——

又平　Matahei
又四郎　Matashirō
又兵衛　Matabei
又兵衛二代　Matabei II
又蔵　Matazō
友七郎　Tomoshichirō
友之進　Tomonoshin
友川　Yūsen
友月　Yūgetsu
友汀　Yūtei
友次郎　Tomojirō
友竹　Yūchiku
友竹艸居　Yūchiku Sōkyo
友甫　Yūho
友房　Tomofusa
友松　Yūshō
友松庵　Yūshōan
友治　Yūji
友信　Tomonobu
友春　Tomoharu
友柏　Yūhaku
友益　Yūeki
友清　Yūsei
友盛　Yūsei
友雪　Yūsetsu
友景斎　Yūkeisai
友閑満康　Yūkan Mitsuyasu
友禅　Yūzen
友徳　Yūtoku
友樵　Yūshō
友篤　Yūtoku
叔牙　Shukuga
叔年　Shukunen
叔昌　Shukushō
叔明　Shukumei
叔和　Yoshikazu

叔保　Shukuho
叔華　Shukka
叔徳　Shukutoku
叔清　Nobukiyo
桑子師薫　Sōshi Shikun
桑山士幹　Kuwayama Shikan
桑山文爾　Kuwayama Fumitaka
桑山嗣燦　Kuwayama Shisan
桑原　Kuwahara
桑楊庵　Sōyōan
雙石　Sōseki
雙竹斎　Sōchikusai
雙松　Sōshō
雙橘　Sōkitsu

—— RAD. 口 30 ——

司馬　Shiba
司馬峻　Shiba Shun
司馬鞍作首止利　Shiba Kuratsukuri no Obito Tori
右田年英　Migita Toshihide
右田豊彦　Migita Toyohiko
右近　Ukon
右京　Ukyō
右京亮　Ukyōnosuke
右京進　Ukyōnoshin
右門　Umon
右恵　Ue
右衛門大夫　Uemon Tayū
右衛門作　Emosaku
吐雲　Toun
吸露庵　Kyūroan
呈介　Teisuke
吟光　Ginkō
吟雪　Ginsetsu
君山　Kunzan
君圭　Kunkei
君岳　Kungaku
君明　Kummei
君治　Gunji
君受　Kunju
君茂　Kummo
君泉　Kunsen
君青　Kunchū
君郁　Kun'yū
君啓　Kunkei
君常　Kunjō
君渓　Kunkei
君魚　Kungyo
君靖　Kunsei
君赫　Kunkaku
君輔　Kumpo
君賽　Kunshō
君賓　Kunrai
君選　Kunsen
君彜　Kun'i
君蜀　Kunshaku
君嶽　Kungaku
君瞻　Kunsen
君鎮　Kunchin
吹山　Suizan
咀華亭　Sokatei
咄哉州　Tossaishū
哈々　Kaikai
哲斎　Tessai
啞羊　Ayō
啓之助　Keinosuke
啓宗　Keisō
啓拙斎　Keisetsusai
啓孫　Keison
啓書記　Kei Shoki
啓釈　Keishaku
喚舟　Kanshū
鳴門　Meimon
鳴鶴　Meikaku
嘯月亭　Shōgetsutei

嘯谷　Shōkoku
喰々　Kaikai
喰々堂　Kaikaidō

—— RAD. 囗 31 ——

四休庵　Shikyūan
四谷南蘋　Yotsuya Nampin
四明　Shimei
四郎　Shirō
四郎次郎　Shirojirō
四郎兵衛　Shirobei
四碧道人　Shiheki Dōjin
囚幡　Inaba
回全　Kaizen
回春斎　Kaishunsai
図南　Tonan
図書　Zusho
国久　Kunihisa
国丸　Kunimaru
国中連公麻呂　Kuninaka no Muraji Kimimaro
国升　Kunimasu
国井応文　Kunii Ōbun
国分定胤　Kokubu Sadatane
国方林三　Kunikata Rinzō
国平　Kokuhei
国広　Kunihiro
国次　Kunitsugu
国吉康雄　Kuniyoshi Yasuo
国安　Kuniyasu
国沢新九郎　Kunisawa Shinkurō
国利　Kunitoshi
国芳　Kuniyoshi
国周　Kunichika
国直　Kuninao
国幸　Kuniyuki
国宝　Kokuhō
国宗　Kunimune
国宗二代　Kunimune II
国房　Kunifusa
国明一代　Kuniaki I
国明二代　Kuniaki II
国枝金三　Kunieda Kinzō
国松　Kokushō; Kunimatsu
国虎　Kunitora
国長　Kuninaga
国重　Kunishige
国信　Kuninobu
国貞　Kunisada
国貞二代　Kunisada II
国貞三代　Kunisada III
国政　Kunimasa
国政二代　Kunimasa II
国政三代　Kunimasa III
国政四代　Kunimasa IV
国員　Kunikazu
国清一代　Kunikiyo I
国清二代　Kunikiyo II
国盛一代　Kunimori I
国盛二代　Kunimori II
国盛義篤　Kunimori Yoshiatsu
国郷　Kunisato
国富　Kunitomi
国景　Kokukei
国晴　Kuniharu
国満　Kunimitsu
国雄　Kunio
国照　Kuniteru
国蔵　Kunitoshi
国綱　Kunitsuna
国網二代　Kunitsuna II
国輝　Kuniteru
国輝二代　Kuniteru II
国瓢亭　Kokuhyōtei
国観　Kokkan

国麿　Kunimaro
国麿一代　Kunimaro I
国麿二代　Kunimaro II
國枝基有　Kunieda Kiyū
國春楼　Kokushunrō
園部宗珀　Sonobe Sōhaku

—— RAD. 土 32 ——

土井元積　Doi Genseki
土方広輔　Hijikata Hirosuke
土牛　Togyū
土田麦僊　Tsuchida Bakusen
土田宗悦　Tsuchida Sōetsu
土田金二　Tsuchida Kinji
土佐一得　Tosa Ittoku
土佐一徳　Tosa Ittoku
土佐久吉　Tosa Hisayoshi
土佐千代　Tosa Chiyo
土佐永春　Tosa Eishun
土佐広周　Tosa Hirochika
土佐広通　Tosa Hiromichi
土佐刑部　Tosa Gyōbu
土佐吉光　Tosa Yoshimitsu
土佐光元　Tosa Mitsumoto
土佐光弘　Tosa Mitsuhiro
土佐光成　Tosa Mitsunari
土佐光孚　Tosa Mitsuzane
土佐光秀　Tosa Mitsuhide
土佐光芳　Tosa Mitsuyoshi
土佐光国　Tosa Mitsukuni
土佐光茂　Tosa Mitsushige
土佐光重　Tosa Mitsushige
土佐光信　Tosa Mitsunobu
土佐光時　Tosa Mitsutoki
土佐光起　Tosa Mitsuoki
土佐光高　Tosa Mitsutaka
土佐光清　Tosa Mitsukiyo
土佐光章　Tosa Mitsuaki
土佐光禄　Tosa Mitsutomi
土佐光親　Tosa Mitsuchika
土佐光顕　Tosa Mitsuaki
土佐行広　Tosa Yukihiro
土佐行秀　Tosa Yukihide
土佐邦隆　Tosa Kunitaka
土佐延丸　Tosa Nobumaru
土佐忠俊　Tosa Tadatoshi
土佐茂松　Tosa Shigematsu
土佐長隆　Tosa Nagataka
土佐長章　Tosa Nagaaki
土佐将監　Tosa Shōgen
土佐経隆　Tosa Tsunetaka
土佐隆成　Tosa Takanari
土佐隆兼　Tosa Takakane
土佐源三衛門　Tosa Genzaemon
土佐藤満丸　Tosa Tōmanmaru
土岐亀祐　Toki Kisuke
土岐富景　Toki Tomikage
土岐英昌　Toki Eishō
土岐頼芸　Toki Raigei
土岐四良左衛門　Toki Shirozaemon
土屋芳方　Tsuchiya Yoshikata
土屋政芳　Tsuchiya Masayoshi
土蔵榮崇　Dozō Eisū
土蔵榮昌　Dozō Eishō
土藏榮松　Dozō Eishō
圭岳　Keigaku
圭信　Keishin
圭斎　Keisai
吉人　Kitsujin
吉十郎　Kichijūrō
吉之丞　Kichinojō
吉之助　Kichinosuke
吉山　Kitsuzan
吉川　Yoshikawa

大石良雄 Ōishi Yoshio	太田三郎 Ōta Saburō	子元 Shigen	子慶 Shikei	宅麿了尊 Takuma Ryōson
大石順平 Ōishi Jumpei	太田天洋 Ōta Ten'yō	子文 Shibun	子徳 Shitoku	宅麿有信 Takuma Arinobu
大弐 Daini	太田正雄 Ōta Masao	子方 Shihō	子毅 Shiki	宅麿良賀 Takuma Ryōga
大年 Dainen; Tainen	太田定信 Ōta Sadanobu	子正 Shisei	子潤 Shijun	宅麿長賀 Takuma Chōga
大次郎 Daijirō	太田栄吉 Ōta Eikichi	子写 Shisha	子塋 Shiei	宅麿為久 Takuma Tamehisa
大西允 Ōnishi In	太田秋信 Ōta Akinobu	子玄 Shigen	子璋 Shishō	宅麿為氏 Takuma Tameuji
大西酔月 Ōnishi Suigetsu	太田喜二郎 Ōta Kijirō	子玉 Shigyoku	子緝 Shishū	宅麿為成 Takuma Tamenari
大西椿年 Ōnishi Chinnen	太田辨五郎 Ōta Bengorō	子交 Shikō	子興 Shikō	宅麿為行 Takuma Tameyuki
大寿 Taiju	太田聴雨 Ōta Chōu	子全 Shizen	子憲 Shiken	宅麿為遠 Takuma Tametō
大兵衛 Tahei	太白山人 Taihaku Sanjin	子安 Shian	子諦 Shitei	宅麿浄宏 Takuma Jōkō
大伴芳形 Ōtomo Yoshikata	太白山房 Taihaku Sambō	子成 Shisei	子賢 Shiken	宅麿勝賀 Takuma Shōga
大含 Taigan	太初 Taisho	子羽 Shiu	子融 Shiyū	宅麿澄賀 Takuma Chōga
大助 Daisuke	太岳 Taigaku	子行 Shikō	子嶽 Shigaku	字平次 Uheiji
大孝斎 Daikōsai	太青 Taisei	子別 Shibetsu	子翼 Shiyoku	字左衛門 Uzaemon
大応玉洲 Daiō Gyokushū	太郎 Tarō	子孝 Shikō	子轀 Shion	宇田荻邨 Uda Tekison
大村今 Omura Kin	太郎右衛門 Taroemon	子吶 Shinō	子籤 Shisen	宇田善次郎 Uda Zenjirō
大沢貞房 Ōsawa Sadafusa	太郎左衛門 Tarozaemon	子秀 Shishū	子藻 Shisō	宇治僧正 Uji Sōjō
大狂 Taikyō	太郎庵 Tarōan	子岳 Shigaku	子譲 Shijō	宇野宗廣 Uno Sōyō
大初 Daisho	太郎兵衛 Tarobei	子直 Shichoku	子纓 Shiei	宇野満継 Uno Mitsutsugu
大岡成寛 Ōoka Narihiro	太原庵 Taigen'an	子明 Shimei	孔年 Kōnen	宇喜多公信 Ukita Kiminobu
大岡甫政 Ōoka Sukemasa	太虚堂 Taikyodō	子和 Shiwa	孔直 Kōchoku	宇喜多為為 Ukita Yoshitame
大岡盛兆 Ōoka Seichō	奈良法眼 Nara Hōgen	子長 Shichō	孔固亭 Kōkotei	守川周重 Morikawa Chikashige
大岡愛童 Ōoka Aitō	奇文 Kibun	子重 Shichō	孔寅 Kōin	守川音次郎 Morikawa Otojirō
大岡愛翼 Ōoka Aiyoku	契山 Keizan	子亮 Shiryō	孔陽 Kōyō	守広 Morihiro
大岡藤永 Ōoka Tōei	契月 Keigetsu	子信 Shishin	存生斎 Sonseisai	
大学 Daigaku	奎文 Keibun	子保 Shiho	存白 Sompaku	
大河内正宜 Ōkōchi Masanobu		子建 Shiken	存充白 Sonjūhaku	
大河内夜江 Ōkōchi Yakō		子栄 Shiei	孟坦 Mōtan	

——— **RAD. 女 38** ———

大炊助 Ōinosuke	女竜 Joryū
大和子 Daiwashi	如一 Nyoitsu
大和屋惣吉 Yamatoya Sōkichi	如山 Jozan

(continuing index order)

大奎 Taikei	如川 Josen	子炳 Shihei	孟泉 Mōsen
大津又平 Ōtsu Matahei	如元 Jogen	子盈 Shiei	孟津 Mōshin
大洋 Taiyō	如切斎 Josetsusai	子彦 Shigen	孟斎 Takeshirō
大神与三八 Ōkami Yosahachi	如心 Joshin	子郎 Shirō	孟斎 Mōsai
大島孟彪 Ōshima Mōhyō	如水 Josui	子風 Shifū	孟喬 Mōkyō
大倉行 Ōkura Gyō	如旦 Jotan	子乗 Shijō	孟隣斎 Mōrinsai
大倉毅 Ōkura Takeshi	如石子 Josekishi	子勉 Shiben	孤月 Kogetsu
大原 Ōhara	如圭 Jokei	子修 Shishū	孤月堂 Kogetsudō
大原呑鯨 Ōhara Donkei	如來山人 Nyorai Sanjin	子益 Shieki	孤村 Koson
大原翼 Ōhara Yoku	如拙 Josetsu	子剛 Shikō	孤足軒 Kosokuken
大原鯤 Ōhara Kon	如空 Jokū	子恭 Shikyō	孤峯 Kohō
大宮俊信 Ōmiya Toshinobu	如空入堂 Nyokū Nyūdō	子恵 Shikei	孤雲 Koun
大庭 Ōba	如春斎 Joshunsai	子祥 Shishō	学仙 Gakusen
大浪 Tairō	如眉 Jobi	子容 Shiyō	学叟 Gakusō
大虚 Taikyo	如鬼 Joki	子純 Shijun	学梅斎 Gakubaisai
大虚庵 Taikyoan	如寄 Joki	子朗 Shirō	学僊 Gakusen
大野木仙蔵 Ōnogi Senzō	如寒斎 Jokansai	子栗 Shiritsu	孫二郎 Magojirō
大野木専蔵 Ōnogi Senzō	如量 Joryō	子厦 Shien	孫三郎 Magosaburō
大野幸彦 Ōno Yukihiko	如雲 Joun	子健 Shiken	孫六 Magoroku
大野隆徳 Ōno Takanori	如雲子 Jounshi	子常 Shijō	孫右衛門 Magoemon
大塚 Ōtsuka	如意山樵 Nyoi Sanshō	子強 Shikyō	孫左衛門 Magozaemon
大喜豊助 Ōki Toyosuke	如蓉 Joyō	子訥 Shinō	孫石 Sonseki
大智恒一 Ōchi Tsuneichi	如適斎 Jotekisai	子野 Shiya	孺皮 Juhi
大智勝観 Ōchi Shōkan	如閑 Jomon	子章 Shishō	
大森善清 Ōmori Yoshikiyo	如慶 Jokei	子魚 Shigyo	
大雲 Taiun	如興 Shikō	子斎 Shisai	
大愚 Taigu	如樵 Joshō	子善 Shizen	
大椿翁 Daichin'ō	如螺山人 Jora Sanjin	子卿 Shikei	
大溪 Daikei; Taikei	好々舎 Kōkōsha	子崑 Shigan	
大雅 Taiga	好古斎 Kōkosai	子順 Shijun	
大雅堂 Taigadō	好画堂 Kōgadō	子敬 Shikei; Shiki	
大鳳 Taihō	好趣 Kōyū	子残 Shizan	
大熊氏広 Ōkuma Ujihiro	妙之助 Myōnosuke	子淵 Shien	
大窪行 Ōkubo Gyō	妙沢 Myōtaku	子温 Shion	
大輔 Daisuke	妙顕 Myōken	子瑛 Shiei	
大槻清崇 Ōtsuki Seisō	始業 Shitatsu	子登 Shito	
大樹 Taiju	姿水 Shisui	子絢 Shiken	
大橋宇一郎 Ōhashi Uichirō	姫島竹外 Himeshima Chikugai	子裕 Shiyū	
大橋翠石 Ōhashi Suiseki	姫島純 Himeshima Jun	子達 Shitatsu	
大橋緒候 Ōhashi Shinkō	瀬道人 Ran Dōjin	子道 Shidō	
大蔵卿 Ōkurakyō		子幹 Shikan	
大観 Taikan		子慎 Shishin	
大鵬 Taihō		子禎 Shitei	
大蘇金三郎 Taiso Kinzaburō		子豊 Shihō	

——— **RAD. 子 39** ———

太乙 Taiitsu	子山 Shizan
太三郎 Tasaburō	子工 Shikō
太夫坊 Tayūbō	子中 Shichū

——— **RAD. 宀 40** ———

	子遠 Shien
	子飾 Shishoku
	子徴 Shichō
	子緒 Shisho
	子遷 Shisen
	子儀 Shiki

守礼	Shurei	完瑛	Kan'ei
守光	Morimitsu	宜斎	Gisai
守住定輝	Morizumi Sadateru	宝山	Hōzan
守住勇魚	Morizumi Yūgyo	宝山九代	Hōzan IX
守住輝義	Morizumi Teruyoshi	宝山十一代	Hōzan XI
		宝山十五代	Hōzan XV
守村約	Morimura Yaku	宝山十六代	Hōzan XVI
守村粲	Morimura San	宝山泰平	Hōzan Taihei
守房	Morifusa	宝山湛海	Hōzan Tankai
守拙	Shusetsu	宝来	Hōrai
守拙道人	Shusetsu Dōjin	宝来舎	Hōraisha
守昌	Morimasa	宝晋斎	Hōshinsai
守国	Morikuni	宝蕉	Hōshō
守常	Moritsune	宗一	Sōichi
守章	Moriaki	宗也	Sōya
守景	Morikage	宗丈	Sōjō
守静	Shusei	宗久	Munehisa
守静斎	Shuseisai	宗山	Sōsen; Sōzan
安二	Yasuji	宗川	Sōsen
安之丞	Yasunosuke	宗巴	Sōha
安井守常	Yasui Moritsune	宗仁	Sōnin
安井曽太郎	Yasui Sōtarō	宗丹	Sōtan
安平	Yasuhei	宗心	Sōshin
安仙	Ansen	宗正	Sōshō
安巨	Yasunaru	宗仙	Sōsen
安右衛門	Yasuemon	宗四郎	Sōshirō
安田元糸	Yasuda Genshi	宗左衛門	Sōzaemon
安田太郎	Yasuda Tarō	宗弘	Munehiro
安田半圃	Yasuda Hampo	宗立	Sōritsu
安田田騏	Yasuda Denki	宗伝	Sōden
安田直豊	Yasuda Naotoyo	宗休	Sōkyū
安田尚義	Yasuda Naoyoshi	宗全	Sōzen
安田岩蔵	Yasuda Iwazō	宗宅	Sōtaku
安田靫彦	Yasuda Yukihiko	宗宇	Sōu
安田新三郎	Yasuda Shinzaburō	宗缶	Sōkan
		宗羽	Sōu
安田養	Yasuda Yō	宗有	Sōu
安次	Yasuji	宗兵衛	Sōbei
安次郎	Yasujirō	宗伯	Sōhaku
安匡	Yasutada	宗助	Sōsuke
安宅安五郎	Ataka Yasugorō	宗沢	Sōtaku
安西於兎	Anzai Oto	宗沢斎	Sōtakusai
安西於莵	Anzai Oto	宗芸	Sōgei
安兵衛	Yasubei	宗周	Sōshū
安兵衛文造	Yasubei Bunzō	宗味	Sōmi
安並泰助	Yasunami Taisuke	宗忠	Munetada
安並雪岱	Yasunami Settai	宗知	Sōchi
安国	Yasukuni	宗茂	Muneshige
安明	Yasuaki	宗金	Sōkin
安治	Yasuji	宗長	Sōchō
安知	Anchi	宗亮	Sōryō
安阿弥佛	An'ami Butsu	宗信	Munenobu; Sōshin
安重	Yasushige	宗貞	Sōtei
安信	Yasunobu	宗是	Sōze
安度	Ando	宗祐	Sōyū
安政	Yasumasa	宗哲	Sōtetsu
安栄桃林	An'ei Tōrin	宗峰	Sōhō
安常	Yasutsune	宗庭	Sōtei
安清	Yasukiyo	宗恵	Sōkei
安章	Yasuaki	宗悦	Sōetsu
安斎	Ansai	宗純	Sōjun
安達平七	Adachi Heishichi	宗栗	Sōritsu
安達吟光	Adachi Ginkō	宗馬	Sōma
安雅堂	Angadō	宗清	Sōsei
安慶	Ankei	宗深道人	Sōshin Dōjin
安藏	Yasuzō	宗理	Sōri
安藤広重	Andō Hiroshige	宗理三代	Sōri III
安藤仲太郎	Andō Nakatarō	宗眼	Sōgen
安藤吉次郎	Andō Kichijirō	宗進	Sōshin
安藤勝三郎	Andō Katsusaburō	宗雪	Sōsetsu
安藤照	Andō Shō	宗彭	Shūhō
安藤徳兵衛	Andō Tokubei	宗湛	Sōtan
宋入	Sōnyū	宗淵	Sōen
宋岳	Sōgaku	宗琢	Sōtaku
宋紫山	Sō Shizan	宗單	Sōtan
宋紫石	Sō Shiseki	宗達	Sōtatsu
宋紫岡	Sō Shikō	宗閑	Sōkan
宋紫岩	Sō Shigan	宗雲	Sōun
宏慧	Kōei	宗園	Sōen

宗源	Sōgen	富田鎮五郎	Tomita Shigegorō
宗舜	Sōshun	富岡永洗	Tomioka Eisen
宗継	Sōkei	富岡百錬	Tomioka Hyakuren
宗誉	Sōyo	富岡鉄斎	Tomioka Tessai
宗徳	Sōtoku	富岻山房	Fumin Sambō
宗廣	Munehiro	富取風堂	Tomitori Fudō
宗慶	Sōkei	富信	Tominobu
宗縕	Sōhen	富春館	Fushunkan
宗謙	Sōken	富望山人	Fubō Sanjin
定久	Sadahisa	富眺庵	Fuchōan
定五郎	Sadagorō	富雪	Tomiyuki
定円	Jōen	富景	Tomikage
定月堂	Jōgetsudō	寒山	Kanzan
定年	Sadatoshi	寒川	Samukawa
定吉	Sadakichi	寒川養斎	Samukawa Yōsai
定国	Sadakuni	寒竹	Kanchiku
定信	Sadanobu	寒林	Kanrin
定喜	Jōki	寒松居	Kanshōkyo
定智	Jōchi	寒泉	Kansen
定朝	Jōchō	寒葉斎	Kan'yōsai
定審	Jōshin	寒雲子	Kan'unshi
定慶	Jōkei	寒殿司	Kandensu
実	Minoru	寒巌	Kangan
実清	Jitsusei	寒嚴	Kangen
宣道	Sendō	寛夫	Kampu
宰鳥	Saichō	寛之	Kan'en
容軒	Yōken	寛方	Kampō
容斎	Yōsai	寛志	Kanshi
宮之原謙	Miyanohara Ken	寛快	Kankai
宮川	Miyagawa	寛哉	Kansai
宮川正幸	Miyagawa Masayuki	寛哉二世	Kansai II
		寛哉三世	Kansai III
宮川虎之助	Miyagawa Toranosuke	寛歆	Kampo
		寛斎	Kansai
宮川長春	Miyagawa Chōshun	寛遊斎	Kan'yūsai
		寛慶	Kankei
宮川長亀	Miyagawa Chōki	寛静	Kansei
宮川春水	Miyagawa Shunsui	寛輔	Kampo
宮川春章	Miyagawa Shunshō	察右衛門	Satsuemon
宮川香山	Miyagawa Kōzan	憲円	Ken'en
宮川富信	Miyagawa Tominobu	憲信	Norinobu
		憲章	Kenshō
宮内	Kunai; Kyūnai		
宮永東山	Miyanaga Tōzan	——— RAD. 寸 41 ———	
宮本重良	Miyamoto Jūryō		
宮本政名	Miyamoto Masana	寸法	Sumpō
宮坂勝	Miyazaka Katsu	専有	Sen'yū
宮南	Kyūnan	専阿弥	Sen'ami
宮城玄魚	Miyagi Gengyo	専斎	Sensai
宮常	Kyūjō	専藏	Senzō
宮崎与平	Miyazaki Yohei		
宮崎友禅	Miyazaki Yūzen	——— RAD. 小 42 ———	
宮崎奇	Miyazaki Aya		
宮崎淳	Miyazaki Atsushi	小二郎	Kojirō
宮道	Miyamichi	小三郎	Kosaburō
家重	Ieshige	小山三造	Koyama Sanzō
家原嘉猷	Iehara Kayū	小山大月	Koyama Taigetsu
家清	Kasei	小山正太郎	Koyama Shōtarō
家熙	Iehiro	小山光造	Koyama Mitsuzō
寂西	Jakusai	小山政治	Koyama Masaji
寂明	Jakumei	小山栄達	Koyama Eitatsu
寂済	Jakusai	小山敬三	Koyama Keizō
寂照主人	Jakushō Shujin	小川	Ogawa
寂融	Jakuyū	小川千甕	Ogawa Sen'yō
寄生軒	Kiseiken	小川芋銭	Ogawa Usen
寄堂李堯夫	Kidō Rigyōfu	小川松民	Ogawa Shōmin
寅絵堂	Gūkaidō	小川茂吉	Ogawa Mokichi
富山翁	Fuzan'ō	小川美丸	Ogawa Yoshimaru
富川房信	Tomikawa Fusanobu	小川道昌	Ogawa Michimasa
		小川慶入	Ogawa Keinyū
富太郎	Tomitarō	小川潤	Ogawa Jun
富永良三郎	Tominaga Ryōzaburō	小川観	Ogawa Kan
		小太郎	Kotarō
富永朝堂	Tominaga Chōdō	小平次	Koheiji
富本憲吉	Tomimoto Kenkichi	小出楢重	Koide Narashige
		小代為重	Shōdai Tameshige
富田渓仙	Tomita Keisen	小右衛門	Koemon
富田清次郎	Tomita Seijirō	小田	Oda
富田温一郎	Tomita On'ichirō	小田原風外	Odawara Fūgai

小田野直武	Odano Naotake	小島	Kojima	光起	Mitsuoki
小田煥	Oda Kan	小島文信	Kojima Bunshin	光信	Mitsuyasu
小田瀛	Oda Ei	小島茂吉	Kojima Mokichi	光教	Mitsunori
小白	Shōhaku	小島亮仙	Kojima Ryōsen	光淳	Mitsuatsu
小石	Shōseki	小島亮儒	Kojima Ryōsen	光清	Mitsukiyo
小石居士	Shōseki Koji	小島貞景	Kojima Sadakage	光雪	Kōsetsu
小石堂	Shōsekidō	小島善太郎	Kojima Zentarō	光章	Mitsuaki
小穴隆一	Oana Ryūichi	小島勝美	Kojima Katsumi	光斎	Kōsai
小朱石	Shōshuseki	小倉右一郎	Ogura Uichirō	光琳	Kōrin
小年	Shōnen	小倉柳村	Ogura Ryūson	光禄	Mitsutomi
小寺健吉	Kodera Kenkichi	小倉惣次郎	Ogura Sōjirō	光瑤	Kōyō
小早川清	Kobayakawa Kiyoshi	小倉遊亀	Ogura Yūki	光瑳	Kōsa
小池惟則	Koike Korenori	小原又雄	Ohara Matao	光範	Mitsunori
小池紫雪	Koike Shisetsu	小原克紹	Ohara Kokushō	光親	Mitsuchika
小竹	Shōchiku	小原治五右衛門	Ohara Jigoemon	光顕	Mitsuaki
小西光是	Konishi Mitsukore			肖孚	Shōfu
小西皆雲	Konishi Kaiun	小原渓山	Ohara Keizan	肖造	Shōzō
小西巍	Konishi Takashi	小原祥邨	Ohara Shōson	向太郎	Naotarō
小兵衛	Kobei; Kohei	小柴守典	Koshiba Shuten	向古	Shōko
小佐衛門	Kozaemon	小柴錦侍	Koshiba Kinji	向古斎	Shōkosai
小坂芝田	Kosaka Shiden	小浜	Ohama	向左生	Shōsasei
小坂晴道	Kosaka Harumichi	小華	Shōka	向左堂	Shōsadō
小坂象堂	Kosaka Shōdō	小栗伯圭	Oguri Hakkei	向行	Shōkō
小杉国太郎	Kosugi Kunitarō	小栗助重	Oguri Sukeshige	向志斎	Shōshisai
小杉放庵	Kosugi Hōan	小栗宗休	Oguri Sōkyū	向房	Naofusa
小村大雲	Komura Taiun	小栗宗栗	Oguri Sōritsu	向信	Naonobu
小村泰助	Komura Taisuke	小栗宗継	Oguri Sōkei	向春	Shōshun
小村権三郎	Komura Gonzaburō	小栗澄	Oguri Chō	向量	Shōryō
		小造化廬	Shōzōkaro	向景	Shōkei
小沢定信	Ozawa Sadanobu	小竜	Shōryū	向選	Shōsen
小沢南谷	Ozawa Nankoku	小堀政伊	Kobori Masatada	常之進	Jōnoshin
小谷津三郎	Oyazu Saburō	小堀桂三郎	Kobori Keizaburō	常山	Jōsan
小谷津任牛	Oyazu Ningyū	小堀鞆音	Kobori Tomone	常川	Jōsen
小坡	Shōha	小梁	Shōryō	常川重信	Tsunekawa Shigenobu
小林	Kobayashi	小笠	Shōritsu	常心	Jōshin
小林万吾	Kobayashi Mango	小野	Ono	常正	Tsunemasa
小林氏平	Kobayashi Ujihei	小野竹喬	Ono Chikkyō	常行	Tsuneyuki
小林古径	Kobayashi Kokei	小野英吉	Ono Eikichi	常甫	Jōho
小林安明	Kobayashi Yasuaki	小野通	Ono Tsū	常良	Tsuneyoshi
小林宗兵衛	Kobayashi Sōbei	小野等林	Ono Tōrin	常辰	Tsunetatsu
小林和作	Kobayashi Wasaku	小野等的	Ono Tōteki	常岡文亀	Tsuneoka Bunki
小林茂	Kobayashi Shigeru	小壺	Kotsubo	常信	Tsunenobu
小林茂兵衛	Kobayashi Mohei	小絲源太郎	Koito Gentarō	常昭	Jōshō
小林茂雄	Kobayashi Shigeo	小董草堂	Shōkin Sōdō	常則	Tsunenori
小林柯白	Kobayashi Kahaku	小雲谷	Shōunkoku	常翁	Jōō; Tsuneō
小林清親	Kobayashi Kiyochika	小穀	Shōkoku	常真	Jōshin
小林喜兵衛	Kobayashi Kihei	小簑庵	Kominoan	常祥	Jōshō
小林徳三郎	Kobayashi Tokusaburō	小痴道人	Shōchi Dōjin	常庵	Jōan
小林徳右衛門	Kobayashi Tokuemon	小蘋	Shōhin	常覚	Jōkaku
小林徳宣	Kobayashi Tokusen	小蟹	Shōkai	常陽庵	Jōyōan
小林源右衛門	Kobayashi Gen'emon	小鸞	Shōran	常照	Jōshō
小林翠	Kobayashi Sui	光一	Kōitsu	常嘉	Jōka
小林彌太郎	Kobayashi Yatarō	光三郎	Kōzaburō	常嘉斎	Jōkasai
小林観照	Kobayashi Kanji	光久	Mitsuhisa	常慶	Jōkei
小林鐘吉	Kobayashi Shōkichi	光山	Kōzan	常盤光長	Tokiwa Mitsunaga
小松屋	Komatsuya	光元	Mitsumoto	堂本印象	Dōmoto Inshō
小松原貞	Komatsubara Tei	光文	Mitsubumi	棠洲	Tōshū
小松原誠美	Komatsubara Seibi	光正	Mitsumasa	甞草林處	Shōsō Rinsho
小松軒	Shōshōken	光広	Mitsuhiro	輝方	Terukata
小茂田茂吉	Omoda Mokichi	光弘	Mitsuhiro	輝忠式部	Terutada Shikibu
小茂田青樹	Omoda Seiju	光吉	Mitsuyoshi	輝重	Terushige
小虎	Shōko	光成	Mitsunari		
小虎山人	Shōko Sanjin	光甫	Kōho		
小虎散人	Shōko Sanjin	光学	Mitsuzane		
小門太	Komonta	光秀	Mitsuhide	尺蠖斎	Shakukaisai
小信	Konobu	光芳	Mitsuyoshi	尾竹竹坡	Odake Chikuha
小室貞次郎	Komuro Teijirō	光見	Kōken	尾竹国観	Odake Kokkan
小室翠雲	Komuro Suiun	光国	Mitsukuni	尾竹染吉	Odake Somekichi
小泉癸巳男	Koizumi Kishio	光明	Mitsuaki	尾竹亀吉	Odake Kamekichi
小泉順平	Koizumi Jumpei	光茂	Mitsushige	尾竹越堂	Odake Etsudō
小泉勝爾	Koizumi Katsuji	光長	Mitsunaga	尾竹熊太郎	Odake Kumatarō
小香	Shōka	光重	Mitsushige	尾形月耕	Ogata Gekkō
		光信	Mitsunobu	尾形正之助	Ogata Masanosuke
		光貞	Mitsusada	尾形市之亟	Ogata Ichinojō
		光祐	Mitsusuke	尾形亥八	Ogata Ihachi
		光則	Mitsunori	尾形仲由	Ogata Chūyu
		光峨	Kōga	尾形守房	Ogata Morifusa
		光悦	Kōetsu	尾形周平	Ogata Shūhei
		光時	Mitsutoki		

尾形宗惟	Ogata Sōsui
尾形茂橘	Ogata Shigekichi
尾形惟允	Ogata Koremasa
尾形惟富	Ogata Koretomi
尾村玉山	Omura Gyokuzan
居易主人	Kyoi Shujin
居易堂	Kyoidō
居翁	Kyoō
屋蘇	Yaso
屠竜	Toryū
屠竜翁	Toryūō
屓鳩斎	Shikyūsai
履昌斌	Rishōhin
山卜	Samboku
山三郎	Sanzaburō; Yamasaburō
山下	Yamashita
山下りん	Yamashita Rin
山下光雪	Yamashita Kōsetsu
山下国照	Yamashita Kuniteru
山下松五郎	Yamashita Matsugorō
山下新太郎	Yamashita Shintarō
山口三郎	Yamaguchi Saburō
山口大口費	Yamaguchi no Ōguchi no Atai
山口安秀	Yamaguchi Yasuhide
山口米次郎	Yamaguchi Yonejirō
山口国重	Yamaguchi Kunishige
山口宗雪	Yamaguchi Sōsetsu
山口長十郎	Yamaguchi Chōjūrō
山口素絢	Yamaguchi Soken
山口華楊	Yamaguchi Kayō
山口清忠	Yamaguchi Kiyotada
山口蓬春	Yamaguchi Hōshun
山口進	Yamaguchi Susumu
山口薫	Yamaguchi Kaoru
山川秀峰	Yamakawa Shūhō
山川喜雄	Yamakawa Yoshio
山中古洞	Yamanaka Kotō
山中真金	Yamanaka Makane
山内多門	Yamanouchi Tamon
山内貞郎	Yamanouchi Sadao
山内愚仙	Yamanouchi Gusen
山内養春	Yamanouchi Yōshun
山元金右衛門	Yamamoto Kin'emon
山元春挙	Yamamoto Shunkyo
山本予章	Yamamoto Kaneaki
山本元休	Yamamoto Genkyū
山本孔陽	Yamamoto Kōyō
山本正之	Yamamoto Seishi
山本正令	Yamamoto Seirei
山本正周	Yamamoto Seishū
山本正兼	Yamamoto Seiken
山本正章	Yamamoto Seishō
山本正徳	Yamamoto Seitoku
山本守次	Yamamoto Moritsugu
山本守房	Yamamoto Morifusa
山本守常	Yamamoto Moritsune
山本守業	Yamamoto Morinari
山本安兵衛	Yamamoto Yasubei

山本光春 Yamamoto Mitsuharu
山本江英 Yamamoto Kōei
山本竹雲 Yamamoto Chikuun
山本芳翠 Yamamoto Hōsui
山本武継 Yamamoto Taketsugu
山本典寿 Yamamoto Norihisa
山本周三 Yamamoto Shūzō
山本直秀 Yamamoto Naohide
山本直彦 Yamamoto Naohiko
山本房信 Yamamoto Fusanobu
山本昇雲 Yamamoto Shōun
山本茂三郎 Yamamoto Mosaburō
山本長昌 Yamamoto Nagaaki
山本為之助 Yamamoto Tamenosuke
山本重信 Yamamoto Shigenobu
山本政幸 Yamamoto Seikō
山本春正 Yamamoto Harumasa
山本春継 Yamamoto Shunkei
山本美知 Yamamoto Yoshitomo
山本倉丘 Yamamoto Sōkyū
山本倉蔵 Yamamoto Kurazō
山本梅荘 Yamamoto Baisō
山本森之助 Yamamoto Morinosuke
山本景正 Yamamoto Kagemasa
山本鼎 Yamamoto Kanae
山本瑞雲 Yamamoto Zuiun
山本義信 Yamamoto Yoshinobu
山本豊 Yamamoto Minoru
山本豊市 Yamamoto Toyoichi
山本漁 Yamamoto Ryō
山本親亮 Yamamoto Shinryō
山本謙 Yamamoto Ken
山本藤信 Yamamoto Fujinobu
山永光甫 Yamanaga Kōho
山田 Sanden
山田巳三郎 Yamada Misaburō
山田介堂 Yamada Kaidō
山田文厚 Yamada Bunkō
山田半蔵 Yamada Hanzō
山田右衛門作 Yamada Emosaku
山田伊三郎 Yamada Isaburō
山田光徳 Yamada Kōtoku
山田岐鳳 Yamada Kihō
山田次郎 Yamada Kunijirō
山田忠蔵 Yamada Chūzō
山田和平 Yamada Wahei
山田眞淵 Yamada Shin'en
山田耕雲 Yamada Kōun
山田鬼斎 Yamada Kisai
山田常吉 Yamada Tsunekichi
山田常嘉 Yamada Jōka
山田順清 Yamada Yorikiyo
山田順智 Yamada Yoritomo
山田敬中 Yamada Keichū
山田敬助 Yamada Keisuke
山田順貞 Yamada Yorisada
山川意誠 Yamada Isei
山田嘉猷 Yamada Kayū
山内三九郎 Yamauchi Sankurō

山吐斎 Santosai
山吐雲 Santoun
山寺信之 Yamadera Nobuyuki
山名広政 Yamana Hiromasa
山名行政 Yamana Yukimasa
山名行雅 Yamana Yukimasa
山名貫義 Yamana Tsurayoshi
山朴 Samboku
山君 Sankun
山形素真 Yamagata Soshin
山村 Yamamura
山村耕花 Yamamura Kōka
山村豊成 Yamamura Toyonari
山村養春 Yamamura Yōshun
山東京伝 Santō Kyōden
山東庵 Santōan
山岡 Yamaoka
山岡米華 Yamaoka Beika
山岡尚樹 Yamaoka Naoki
山岡達義 Yamaoka Tatsuyoshi
山亮 Sanryō
山前十左衛門 Yamasaki Jūzaemon
山晟斎 Sanseisai
山脇広成 Yamawaki Hironari
山脇信徳 Yamawaki Shintoku
山桜 San'ō
山崎其華 Yamazaki Kika
山崎信次郎 Yamazaki Shinjirō
山崎省三 Yamazaki Shōzō
山崎竜女 Yamazaki Ryūjo
山崎竜吉 Yamazaki Ryūkichi
山崎覚太郎 Yamazaki Kakutarō
山崎景義 Yamazaki Kageyoshi
山崎朝雲 Yamazaki Chōun
山崎董淴 Yamazaki Tōsen
山梁 Sanryō
山雪 Sanryū
山雪 Sansetsu
山斎 Sansai
山喜多二郎太 Yamakita Jirōta
山陽 San'yō
山楼戸 Sanrōko
山楽 Sanraku
山跡義淵 Yamaato Gien
山静 Sansei
山興 Sankō
山樵 Sanshō
岐鳳 Kihō
岑信 Minenobu
岨高 Sokō
岸川勝政 Kishikawa Katsumasa
岸天岳 Kishi Tengaku
岸右衛門 Kishi Uemon
岸礼 Ganrei
岸田劉生 Kishida Ryūsei
岸良 Ganryō
岸岸慶 Kishi Gankei
岸岱 Gantai
岸昌禄 Kishi Shōroku
岸昌徳 Gan Shōtoku
岸浪百艸居 Kishinami Hyakusōkyo
岸浪定司 Kishinami Sadakazu
岸浪柳渓 Kishinami Ryūkei
岸浪静司 Kishinami Seishi
岸寛 Kishi Kan
岸寛 Gansei
岸徳 Gantoku
岸慶 Gankei

岸駒 Ganku
岩川秀岳 Iwakawa Shūgaku
岩本季信 Iwamoto Suenobu
岩田正巳 Iwata Masami
岩次郎 Iwajirō
岩佐又兵衛 Iwasa Matabei
岩佐貞雲 Iwasa Teiun
岩佐勝重 Iwasa Katsushige
岩城親寅 Iwaki Chikatora
岩倉文守 Iwakura Fumimori
岩倉淳古 Iwakura Junko
岩窪辰行 Iwakubo Tatsuyuki
岩橋教章 Iwahashi Noriaki
岩瀬広隆 Iwase Hirotaka
岩瀬百鶴 Iwase Hyakkaku
岩瀬醒 Iwase Sei
岱岳 Taigaku
岷山 Minzan
岷江 Minkō
岷和 Minwa
峰麿 Minemaro
峯谷人 Hōgokujin
峯信 Minenobu
峻山 Shunzan
峻南 Shunnan
崋山 Kazan
崎陽亭 Kiyōtei
崎陽斎 Kiyōsai
崇竺 Sūjiku
崇渓 Sūkei
崇雪 Sūsetsu
崇徳 Sūtoku
崑崙 Konron
嵐渓 Rankei
嵩 Sūshi
嵩谷 Sūkoku
嵩岳堂 Sūgakudō
嵩林 Sūrin
嵩卿 Sūkei
嵩嶐 Sūryō
嵩鶴 Sūkaku
嶋田雅喬 Shimada Masataka
嶺月 Reigetsu
嚴岳亭 Gangakutei
嚴岳斎 Gangakusai
嚴松 Ganshō
嚴松斎 Ganshōsai
嚴郁 Gan'iku
巍々堂山人 Kaikaidō Sanjin
巍江斎 Kaikōsai
欟雲樵夫 Ran'un Shōfu

—— RAD. 川 47 ——

川又常正 Kawamata Tsunemasa
川又常行 Kawamata Tsuneyuki
川又常辰 Kawamata Tsunetatsu
川之辺一朝 Kawanobe Itchō
川上邦世 Kawakami Kuniyo
川上涼花 Kawakami Ryōka
川上寛 Kawakami Kan
川上澄生 Kawakami Sumio
川口直七 Kawaguchi Naoshichi
川口軌外 Kawaguchi Kigai
川口孫太郎 Kawaguchi Magotarō
川本半助 Kawamoto Hansuke
川本治兵衛 Kawamoto Jihei
川本藤平 Kawamoto Tōhei
川北源之助 Kawakita Gennosuke
川北霞峰 Kawakita Kahō
川辺御楯 Kawabe Mitate
川合玉堂 Kawai Gyokudō

川合芳三郎 Kawai Yoshisaburō
川西英 Kawanishi Hide
川村万蔵 Kawamura Manzō
川村応心 Kawamura Ōshin
川村雨谷 Kawamura Ukoku
川村信雄 Kawamura Nobuo
川村曼舟 Kawamura Manshū
川村清雄 Kawamura Kiyo-o
川枝豊信 Kawaeda Toyonobu
川島重信 Kawashima Shigenobu
川島信清 Kawashima Nobukiyo
川島叙清 Kawashima Nobukiyo
川島理一郎 Kawashima Riichirō
川原慶賀 Kawahara Keiga
川崎千虎 Kawasaki Senko
川崎小虎 Kawasaki Shōko
川崎菊子 Kawasaki Kikuko
川崎蘭香 Kawasaki Rankō
川喜田半泥子 Kawakita Handeishi
川勝隆恒 Kawakatsu Takatsune
川窪蘭涯 Kawakubo Rangai
川端玉章 Kawabata Gyokushō
川端弥之助 Kawabata Yanosuke
川端昇太郎 Kawabata Shōtarō
川端龍子 Kawabata Ryūshi
川瀬巴水 Kawase Hasui
川瀬文治郎 Kawase Bunjirō
川瀬竹春 Kawase Chikushun
順助 Junsuke
順良 Junryō
順固 Junko
順定 Juntei
順知 Junchi
順貞 Juntei
順清 Junsei
順智 Junchi
順蔵 Junzō

—— RAD. 工 48 ——

工形斎 Kōgyōsai
工藤秀信 Kudō Hidenobu
工鏡 Kōkyō
左入 Sanyū
左内 Sanai
左手拝山 Hidarite Haizan
左兵衛 Sahei
左近 Sakon
左近将曹 Sakon Shōsō
左近将監 Sakon Shōkan
左向堂 Sashōdō
左忠太 Sachūta
左金吾 Sakingo
左門 Samon
左甚五郎 Hidari Jingorō
左馬 Same
左琴 Sakin
左筆庵 Sahitsuan
左筆斎 Sahitsusai
左衛門 Saemon; Zaemon

—— RAD. 巳 49 ——

巳之助 Minosuke
巳然居士 Izen Koji
巻絵師 Makieshi

—— RAD. 巾 50 ——

布施信太郎 Fuse Shintarō

布屋氏助	Nunoya Ujisuke
布屋忠三郎	Nunoya Chūzaburō
帆足遠	Hoashi En
希虎菴	Kikoan
希胆	Kitan
希唐菴	Kitōan
希竜	Kiryū
希庵	Kian
希望	Kibō
希賢	Kiken
希膺	Kiyō
帯刀	Tatewaki
帯山	Taizan
帯次郎	Taijirō
幡竜洞	Banryūdō

—— RAD. 干 51 ——

干州	Kanshū
干絹	Kanshū

—— RAD. 幺 52 ——

幻庵	Gen'an
幾次郎	Ikujirō
幾馳	Kichi

—— RAD. 广 53 ——

広大	Kōdai
広山	Kōzan
広川居士	Kōsen Koji
広年	Hirotoshi
広守	Hiromori
広成	Hironari
広行	Hiroyuki
広均	Kōkin
広邦	Hirokuni
広周	Hirochika
広国	Hirokuni
広尚	Hironao
広忠	Hirotada
広明	Hiroaki
広重	Hiroshige
広重二世	Hiroshige II
広重三世	Hiroshige III
広信	Hironobu
広信二代	Hironobu II
広保	Hiroyasu
広貞	Hirosada
広政	Hiromasa
広紀	Kōki
広夏	Hironatsu
広島晃甫	Hiroshima Kōho
広島新太郎	Hiroshima Shintarō
広通	Hiromichi
広高	Hirotaka
広隆	Hirotaka
広卿	Kōkei
広景	Hirokage
広渡一湖	Hirowatari Ikko
広渡八平治	Hirowatari Yaheiji
広渡小平太	Hirowatari Koheita
広渡心海	Hirowatari Shinkai
広渡伴助	Hirowatari Bansuke
広渡雪山	Hirowatari Setsuzan
広渡湖月	Hirowatari Kogetsu
広渡湖笛	Hirowatari Koteki
広渡儀	Hirowatari Gi
広貴	Hirotaka
広湖	Kōko
広業	Kōgyō
広輝	Hiroteru

広澄	Hirozumi
広賢	Kōken
広瀬永治	Hirose Nagaharu
広瀬自勝	Hirose Jishō
広瀬東畝	Hirose Tōho
広瀬明	Hirose Akira
広瀬重信	Hirose Shigenobu
広瀬済	Hirose Hitoshi
広瀬清風	Hirose Seifū
広瀬順固	Hirose Junko
広瀬勝平	Hirose Katsuhei
広瀬潔	Hirose Kiyoshi
庄七	Shōshichi
庄二郎	Shōjirō
庄三郎	Shōzaburō
庄之助	Shōnosuke
庄五郎	Shōgorō
庄司	Shōji
庄田常喜	Shōda Tsuneyoshi
庄田鶴友	Shōda Kakuyū
庄兵衛	Shōbei
庄藏	Shōzō
床次正清	Tokonami Seisei
応文	Ōbun
応立	Ōritsu
応其	Ōgo
応受	Ōju
応為	Ōi
応春	Ōshun
応夏	Ōka
応挙	Ōkyo
応陽	Ōyō
応源	Ōgen
応瑞	Ōzui
応需	Ōju
応震	Ōshin
応謙	Ōken
度秀	Doshū
度辰	Doshin
度種	Doshu
度繁	Dohan
庫之助	Kuranosuke
庭拍子	Niwabyōshi
座間味庸昌	Zamami Yōshō
康円	Kōen
康正	Kōshō
康成	Kōsei
康西堂	Kōseidō
康助	Kōjo
康俊	Kōshun
康尚	Kōshō
康清	Kōsei
康勝	Kōshō
康朝	Kōchō
康運	Kōun
康誉	Kōyo
康慶	Kōkei
康辨	Kōben
庸平	Yōhei
庸台	Yōdai
廓大	Kakudai
慶入	Keinyū
慶山	Keizan
慶仲	Keichū
慶羽	Keiu
慶至	Keishi
慶舟	Keishū
慶甫	Keiho
慶忍	Keinin
慶秀	Keishū
慶受	Keiju
慶俊	Keishun
慶恩	Keion
慶賀	Keiga
慶意	Keii
慶徳	Keitoku
盧朝	Rochō
鷹峰	Yōhō
鷹峰舍	Ōhōsha

—— RAD. 廴 54 ——

廷沖	Teichū
延丸	Nobukazu
延丸	Nobumaru
延円	En'en
延均	Enkin
延均師	Enkinshi
延源	Engen
延輝	Enki
建畠大夢	Tatehata Taimu
建部英親	Tatebe Hidechika
建部凌足	Tatebe Ryōsoku

—— RAD. 弋 56 ——

式部	Shikibu
式麿	Shikimaro

—— RAD. 弓 57 ——

引削等薩	Yuge Tōsatsu
弓綱居	Kyūkaikyo
引裾	Inkyo
弘入	Kōnyū
弘円	Kōen
弘実	Hirochika
弘岩玄猊	Kōgan Gengei
弘明	Hiroaki
弘法大師	Kōbō Daishi
弘真	Kōshin
弘高	Hirotaka
弘貫	Hirotsura
弥十郎	Yajūrō
弥三郎	Yasaburō
弥千歳	Yachitoshi
弥五郎	Yagorō
弥太郎	Yatarō
弥平太	Yaheita
弥平田	Yaheita
弥左衛門	Yazaemon
弥吉	Yakichi
弥兵衛	Yahei
弧月	Kogetsu
弧峯	Kohō
弦月	Gengetsu
弦酒舍	Tsurunoya
張行貞	Chō Yukisada
張嵐渓	Chō Rankei
張景婉	Chō Keien
張寛	Chōkan
粥川伸二	Kayukawa Shinji
粥平次	Yaheiji
彌右衛門	Yaemon
彌兵衛	Yahei

—— RAD. 彡 59 ——

彩天	Saiten
彩郷	Saikyō
彩雲	Saiun
彩雲亭	Saiuntei
彩霙楼旭山	Saiunrō Kyokuzan
彩霞楼	Saikarō
彭城貞徳	Sakaki Teitoku
彭城眞淵	Sakaki Shin'en
彭祖	Hōso
須田国太郎	Suda Kunitarō
須田珙中	Suda Kōchū
須田善二	Suda Zenji
須静堂	Shuseidō
須藤桂三郎	Sudō Keizaburō
彰甫	Shōho
彰信	Akinobu
影花堂	Eikadō

—— RAD. 彳 60 ——

待賈堂	Taikadō

後素	Kōso
後素亭	Gosotei
後素亭豊国	Gosotei Toyokuni
後素軒	Kōsoken
後素堂	Kōsodō
後素園	Gosoen
後陽成	Goyōzei
後楽	Kōraku
後楽園製	Kōrakuensei
後藤才次郎	Gotō Saijirō
後藤工志	Gotō Kōshi
後藤広邦	Gotō Hirokuni
後藤守	Gotō Mamoru
後藤芳景	Gotō Yoshikage
後藤良	Gotō Naoshi
後藤宗秀	Gotō Munehide
後藤宗琢	Gotō Sōtaku
後藤貞行	Gotō Sadayuki
後藤寅吉	Gotō Torakichi
後藤清次郎	Gotō Seijirō
從宜主人	Shujin
從宜堂	Shōgidō
得入	Tokunyū
得中	Tokuchū
得玄	Tokugen
得祐斎	Tokuyūsai
得栖	Tokusei
御舟	Gyoshū
御楯	Mitate
微笑	Mishō
徳	Toku
徳力之勝	Tokuriki Yukikatsu
徳力元存	Tokuriki Genson
徳力存之	Tokuriki Sonshi
徳三郎	Tokusaburō
徳太郎	Tokutarō
徳友斎	Tokuyūsai
徳右衛門	Tokuemon
徳左衛門	Tokuzaemon
徳田甚太郎	Tokuda Jintarō
徳田隣斎	Tokuda Rinsai
徳合	Tokugō
徳次郎	Tokujirō
徳兵衛	Tokubei
徳秀斎	Tokushūsai
徳岡神泉	Tokuoka Shinsen
徳岡時次郎	Tokuoka Tokijirō
徳若	Tokuwaka
徳若忠政	Tokuwaka Tadamasa
徳宣	Tokusen
徳済	Tokusai
徳郷	Norisato
徳徳斎	Tokutokusai
徳応	Tokuō
徴人	Chōjin
徴公	Chōkō
徹山	Tetsuzan
衡	Kō

—— RAD. 心 61 ——

心月	Shingetsu
心甫	Shimpo
心海	Shinkai
心叟	Shinsō
心越	Shin'etsu
心瓏斎	Shinrōsai
心譽	Shin'yo
忍冬庵	Nintōan
忍海	Ninkai
忠八郎	Chūhachirō
忠五郎	Chūgorō
忠円	Chūen
忠太	Chūta
忠太郎	Chūtarō
忠左衛門	Chūzaemon
忠次郎	Chūjirō

—— RAD. 方 70 ——

方久斗	Hōkuto
方寸斎	Hōsunsai
方仲	Hōchū
方竹主人	Hōchiku Shujin
方信	Masanobu
方洲	Hōshū
方祝	Hōshuku
方壷	Hōko
方堂	Hōdō
方琳堂	Hōrindō
方壺	Hōko
方壺斎	Hōkosai
方徳	Hōtoku
方篤	Hōtoku
放下庵	Hōkaan
放庵	Hōan
放齢	Hōrei
族父	Zokufu

—— RAD. 无 71 ——

无競	Mukei
旡白	Kihaku
旡白山人	Kihaku Sanjin

—— RAD. 日 72 ——

日々庵	Nichinichian
日比宗信	Hibi Munenobu
日比義信	Hibi Yoshinobu
日本斎	Nipponsai
日本隠士	Nihon Inshi
日東	Nittō
日雨亭	Jitsuutei
日根盛長	Hine Morinaga
日根野盛長	Hineno Morinaga
日華	Nikka
日高鉄翁	Hidaka Tetsuō
日斎	Nissai
日新	Nisshin
日橋隠士	Nikkyō Inshi
旦入	Tannyū
旦遊	Tan'yū
旦猷	Tan'yū
旦嶺	Tanrei
旭山	Kyokuzan
旭玉山	Asahi Gyokuzan
旭江	Kyokkō
旭亭	Kyokutei
旭峯	Kyokuhō
旭朗井	Kyokurōsei
旭朗斎	Kyokurōsai
昌山	Shōzan
昌次	Masatsugu
昌安	Shōan
昌有	Shōyū
昌作	Shōsaku
昌房	Masafusa
昌庵	Shōan
昌運	Shōun
昌榮堂	Shōeidō
昌樹	Shōju
昆陽	Kon'yō
易行	Yasuyuki
易宗	Yasumune
易尚	Yasunao
易政	Ekisei
昔男軒	Sekinanken
昔男精舎	Sekinan Shōja
昇山	Shōzan
昇亭	Shōtei
昇斎	Shōsai
昇雲	Shōun
明夫	Meifu
明円	Myōen
明兆	Minchō
明光居士	Myōkō Koji
明実	Myōjitsu
明春	Myōshun
明珍恒男	Myōchin Tsuneo
明恵	Myōe
明啓	Meikei
明卿	Meikei
明順	Myōjun
明満	Myōman
明暉	Meiki
明誉	Myōyo
明篠堂	Meijōdō
呆々観	Kōkōkan
呆堂	Kōdō
昭々堂主人	Shōshōdō Shujin
昭乗	Shōjō
映丘	Eikyū
昨非居士	Sakuhi Koji
是安	Zean
是重	Koreshige
是真	Zeshin
是莚	Zean
是琴	Zekin
是閑吉満	Zekan Yoshimitsu
星山堂	Seizandō
星洲	Seishū
星華堂	Shokadō
星野	Hoshino
星衆館	Seishūkan
星聚館	Seishūkan
星巌	Seigan
春卜	Shumboku
春山	Shunzan
春山楼	Shunzanrō
春巾	Shunsen
春川芦広	Harukawa Ashihiro
春川栄山	Harukawa Eizan
春川蓬州	Harukawa Hōshū
春升	Shunshō
春分斎	Shumbunsai
春丹	Shuntan
春円	Shun'en
春日	Kasuga
春日行秀	Kasuga Yukihide
春日基光	Kasuga Motomitsu
春日隆兼	Kasuga Takakane
春日隆能	Kasuga Takayoshi
春木秀定	Haruki Hidesada
春木秀熙	Haruki Shūki
春木竜	Haruki Ryū
春木鯤	Haruki Kon
春木鱗	Haruki Rin
春水	Shunsui
春可軒	Shunkaken
春正	Shunshō
春正正之	Shunshō Seishi
春正正令	Shunshō Seirei
春正正周	Shunshō Seishū
春正正兼	Shunshō Seiken
春正正章	Shunshō Seishō
春正正徳	Shunshō Seitoku
春正政幸	Shunshō Seikō
春正春継	Shunshō Shunkei
春正景正	Shunshō Kagemasa
春仙	Shunsen
春広	Haruhiro
春旦	Shuntan
春芝	Shunshi
春次	Haruji
春好	Shunkō
春好二代	Shunkō II
春好斎	Shunkōsai
春旭	Shunkyoku
春朴	Shumboku
春江	Shunkō
春江斎	Shunkōsai
春助	Harusuke
春沙	Shunsa
春町	Harumachi
春町二世	Harumachi Nisei
春町坊	Shunchōbō
春谷	Shunkoku
春里	Shunri
春岳	Shungaku
春岡	Shunkō
春岱	Shuntai
春林	Shunrin
春松斎	Shunshōsai
春治	Haruji
春波楼	Shumparō
春若	Haruwaka
春英	Shun'ei
春英斎	Shun'eisai
春亭	Shuntei
春信	Harunobu; Harushige
春貞	Shuntei
春屋	Shun'oku
春政	Harumasa
春星	Shunsei
春泉	Shunsen
春香	Shunkō
春秋庵	Shunjūan
春草	Shunsō
春郎	Shunrō
春郎二代	Shunrō II
春風楼	Shumpūrō; Shunfūrō
春翁	Shun'ō
春峨	Haruga
春扇	Shunsen
春挙	Shunkyo
春梅亭	Shumbaitei
春梅斎	Shumbaisai
春浦	Shunho
春笑	Shunshō
春笑二代	Shunshō II
春笑三代	Shunshō III
春常	Shunjō
春済	Shunsai
春窓翁	Shunsōō
春窓斎	Shunsōsai
春雪	Shunsetsu
春章	Shunshō
春斎	Shunsai
春喬	Shunkyō
春敬	Shunkei
春暁	Shungyō
春暁斎	Shungyōsai
春満	Shumman
春琴	Shunkin
春琳	Shunrin
春童	Shundō
春朝斎	Shunchōsai
春道	Shundō
春陽	Shun'yō
春陽斎	Shun'yōsai
春園	Shun'en
春塘	Shuntō
春溪	Shunkei
春睡	Shunsui
春福	Shunfuku
春継	Shunkei
春徳	Shuntoku
春説	Shunsetsu
春輝	Shunki
春慶	Shunkei
春潭	Shuntan
春潮	Shunchō
春調斎	Shunchōsai
春鴎斎	Shun'ōsai
春樵	Shunshō
春燈斎	Shuntōsai
春嶺	Shunrei
春曙	Shunsho
春曙斎北頂	Shunshosai Hokuchō
春霞	Shunka
春叢	Shunsō
春艶	Shun'en
春鶴	Shunkaku
春鴎	Shun'ō
晃山	Kōzan
晃甫	Kōho
晏川	Ansen
晒落斎	Sairakusai
時太郎	Tokitarō
時成	Tokinari
時雨岡逸民	Shigureoka Itsumin
時信	Tokinobu
曼舟	Manshū
曹玄子	Sōgenshi
晦存	Kaison
暁斎	Gyōsai
暁雲	Gyōun
暁夢生	Gyōmusei
暁翠園	Gyōsuien
暁観	Gyōkan
量平	Ryōhei
景山	Keizan
景文	Keibun
景正	Kagemasa; Keishō
景年	Keinen
景羽	Keiu
景延	Kagenobu
景和	Keiwa
景金園	Keikin'en
景長	Kagenaga
景信	Kagenobu
景婉	Keien
景種	Kagetane
晴々斎	Seiseisai
晴山	Seizan
晴川	Seisen
晴川院	Seisen'in
晴天	Seiten
晴洲	Seishū
晴雪斎	Seisetsusai
晴湖	Seiko
晴翠	Seisui
晴蝸禅房	Seika Zembō
晴霞	Seika
智順	Chijun
智傳	Chiden
智證	Chishō
智證大師	Chishō Daishi
晩山	Banzan
晩花	Banka
晩香堂	Bankadō
晩泰翁	Bantaiō
晩庵	Ban'an
晩翠	Bansui
晩翠楼	Bansuirō
晩器	Banki
晩器春政	Banki Harumasa
晩霞	Banka
暉眞	Kishin
暘山	Yōzan
暁斎	Kyōsai
曇徴	Donchō
曨日	Ton'ichi
曜斎	Yōsai
曙山	Shozan

—— RAD. 曰 73 ——

曰人	Etsujin

—— RAD. 月 74 ——

月を渚	Tsuki-o-Nagisa
月々堂	Getsugetsudō
月山	Gessan
月心	Gesshin
月玄	Getsugen
月仲斎	Getchūsai

月光亭	Gekkōtei
月甫	Geppo
月岡弁之助	Tsukioka Sadanosuke
月岡吟二	Tsukioka Ginji
月岡秀栄	Tsukioka Shūei
月岡昌信	Tsukioka Masanobu
月岡金三郎	Tsukioka Kinzaburō
月岡耕漁	Tsukioka Kōgyo
月岡雪溪	Tsukioka Sekkei
月居	Gekkyo
月波楼	Gepparō
月香斎	Gekkōsai
月峯	Geppō
月耕	Gekkō
月庵	Getsuan
月渚	Gessho
月渓	Gekkei
月窓	Gessō
月船	Gessen
月斎	Gessai
月斎二代	Gessai II
月渚	Getcho
月湖	Gekko
月僊	Gessen
月澄湖笛	Getchō Koteki
月樵	Gesshō
月嶺	Getsurei
月麿	Tsukimaro

——— RAD. 木 75 ———

木下広国	Kinoshita Hirokuni
木下広信	Kinoshita Hironobu
木下孝則	Kinoshita Takanori
木下応夏	Kinoshita Ōka
木下杢太郎	Kinoshita Mokutarō
木下直一	Kinoshita Naoichi
木下直行	Kinoshita Naoyuki
木下俊長	Kinoshita Toshinaga
木下相宰	Kinoshita Shōsai
木下兼太郎	Kinoshita Kentarō
木下義謙	Kinoshita Yoshinori
木下衡	Kinoshita Kō
木工之助	Mokkōnosuke
木内克	Kinouchi Yoshi
木仏居士	Kibutsu Koji
木仏菴	Kibutsuan
木仏道人	Kibutsu Dōjin
木市腸	Kiitchō
木田昌信	Kida Masanobu
木田華堂	Kita Kadō
木白	Mokuhaku
木米	Mokubei
木村七右衛門	Kimura Shichiemon
木村十旭	Kimura Jukkyoku
木村五郎	Kimura Gorō
木村孔恭	Kimura Kōkyō
木村永光	Kimura Nagamitsu
木村光頓	Kimura Mitsuyori
木村表斎	Kimura Hyōsai
木村武山	Kimura Buzan
木村長明	Kimura Nagaaki
木村信太郎	Kimura Shintarō
木村香雨	Kimura Kōu
木村荘八	Kimura Shōhachi
木村時最	Kimura Tokikazu
木村雅経	Kimura Masatsune
木村静	Kimura Sei
木村廣俊	Kimura Hirotoshi

木村藤蔵	Kimura Tōzō
木花	Mokka
木谷千種	Kitani Chigusa
木屋佐兵衛	Kiya Sahei
木星	Mokusei
木食	Mokujiki
木島文治郎	Konoshima Bunjirō
木島桜谷	Konoshima Ōkoku
木庵	Mokuan
木魚	Mokugyo
木喰	Mokujiki
木燕	Mokuen
木鑾山人	Mokusui Sanjin
朶香	Jikō
朽木翁	Kuchikiō
朴山	Bokusen
朴年人	Bokunenjin
朴黄狐	Boku Ōko
朴斎	Bokusai
杢助	Mokusuke
李元	Rigen
李秀文	Ri Shūbun
李参平	Ri Sampei
李林	Ririn
李春亭	Rishuntei
李庭亭行町	Riteitei Yukimachi
李庭亭雪町	Riteitei Yukimachi
李晁	Richō
李桂翁	Ri Keiō
李堂	Ridō
李卿	Rikyō
李堯夫	Rigyōfu
李敬	Ri Kei
杏村	Kyōson
杏所	Kyōsho
杏雨	Kyōu
杏堂	Kyōdō
杣田	Somada
杣田玄甫	Somada Gempo
杣田光正	Somada Mitsumasa
杣田光明	Somada Mitsuaki
杣田清輔	Somada Seisuke
杉山平兵衛	Sugiyama Heibei
杉本	Sugimoto
杉田秀夫	Sugita Hideo
杉村治兵衛	Sugimura Jihei
杉谷雪樵	Sugitani Sesshō
杉風	Sampū
杉嶺	Sanrei
村上元厚	Murakami Genkō
村上成章	Murakami Nariaki
村上茂篤	Murakami Shigeatsu
村上華岳	Murakami Kagaku
村上鳳湖	Murakami Hōko
村上震一	Murakami Shin'ichi
村山椒	Murayama Shō
村山槐多	Murayama Kaita
村井杶	Murai Chun
村井静馬	Murai Seima
村右衛門	Muraemon
村田永年	Murata Nagatoshi
村田叔	Murata Shuku
村田宗博	Murata Munehiro
村田茂吉	Murata Mokichi
村田香谷	Murata Kōkoku
村田嘉言	Murata Kagen
村瀬玉田	Murase Gyokuden
村瀬泰一	Murase Taiichi
村瀬魚	Murase Gyo
村瀬徹	Murase Yoshi
村瀬徳温	Murase Norinaga
村瀬黎	Murase Rei
林子翼	Hayashi Shiyoku
林有孚	Hayashi Yūfu
林谷	Rinkoku

林武	Hayashi Takeshi
林武臣	Hayashi Takeomi
林周	Rinshū
林直之	Hayashi Naoyuki
林学	Ringaku
林居	Rinkyo
林波満	Hayashi Hama
林長羽	Hayashi Chōu
林重義	Hayashi Shigeyoshi
林屋	Rin'oku
林泉	Rinsen
林倭衛	Hayashi Shizue
林唯一	Hayashi Tadaichi
林常喬	Hayashi Tsunetaka
林斎	Rinsai
林道人	Rin Dōjin
林新	Hayashi Shin
林道榮	Hayashi Dōei
林観	Hayashi Kan
林薫草堂	Rinroku Sōdō
林響	Rinkyō
林儼	Hayashi Gen
松下庵	Shōkaan
松之丞	Matsunojō
松之尉	Matsunojō
松山	Shōzan
松川安信	Matsukawa Yasunobu
松川竜椿	Matsukawa Ryūchin
松井元仲	Matsui Genchū
松井代蔵	Matsui Daizō
松井昇	Matsui Noboru
松井甚八郎	Matsui Jimpachirō
松井梅	Matsui Ume
松民	Shōmin
松平定信	Matsudaira Sadanobu
松平治郷	Matsudaira Harusato
松平献	Matsudaira Ken
松本	Matsumoto
松本一雄	Matsumoto Kazuo
松本友清	Matsumoto Yūsei
松本友盛	Matsumoto Yūsei
松本芳延	Matsumoto Yoshinobu
松本良山	Matsumoto Ryōzan
松本奉時	Matsumoto Hōji
松本秀次郎	Matsumoto Hidejirō
松本信繁	Matsumoto Nobushige
松本保居	Matsumoto Yasuoki
松本姿水	Matsumoto Shisui
松本春清	Matsumoto Harukiyo
松本敦知	Matsumoto Atsutomo
松本敬忠	Matsumoto Takatada
松本竣介	Matsumoto Shunsuke
松本楓湖	Matsumoto Fūko
松本機	Matsumoto Nori
松台	Shōdai
松次郎	Matsujirō
松年	Shōnen
松好	Shōkō
松好斎	Shōkōsai

松甫	Shōho
松寿	Shōju
松吟堂	Shōgindō
松尾宗房	Matsuo Munefusa
松尾春升	Matsuo Shunshō
松村乍一郎	Matsumura Jin'ichirō
松村直治	Matsumura Naoji
松村弥平太	Matsumura Yaheita
松村梅叟	Matsumura Baisō
松村豊昌	Matsumura Toyoaki
松村親子	Matsumura Chikako
松秀園	Shōshūen
松花堂	Shōkadō
松花斎	Shōkasai
松谷	Shōkoku
松里	Shōri
松岡正訓	Matsuoka Masakuni
松岡光訓	Matsuoka Kōkun
松岡寿	Matsuoka Hisashi
松岡伯高	Matsuoka Hakukō
松岡映丘	Matsuoka Eikyū
松岡勝興	Matsuoka Katsuoki
松岡輝夫	Matsuoka Teruo
松宝斎	Shōhōsai
松林	Shōrin
松林山人	Shōrin Sanjin
松林桂月	Matsubayashi Keigetsu
松林斎	Shōrinsai
松林儼	Matsubayashi Gen
松波保真	Matsunami Hoshin
松茂斎	Shōmosai
松亭	Shōtei
松屋	Matsuya
松屋平三郎	Matsuya Heizaburō
松屋老人	Shōoku Rōjin
松哉	Shōsai
松柏	Shōhaku
松柏山人	Shōhaku Sanjin
松栄	Shōei
松風葛覃居	Shōfū Kattankyo
松翁	Shōō
松原三五郎	Matsubara Sangorō
松浦弘	Matsuura Hiroshi
松浦要人	Matsuura Kanando
松浦等禅	Matsuura Tōzen
松軒	Shōken
松高斎	Shōkōsai
松堂	Shōdō
松堂白雲	Shōdō Hakuun
松皐	Shōsai
松野栄典	Matsuno Eikō
松野親信	Matsuno Chikanobu
松雪斎	Shōsetsusai
松魚楼	Shōgyorō
松斎	Shōsai
松斎吟考	Shōsai Ginkō
松嵐	Shōran
松隠村舎	Shōin Sonsha
松雲	Shōun
松雲禅師	Shōun Zenji
松雲斎	Shōunsai
松雲斎立支	Shōunsai Risshi
松雲斎銀光	Shōunsai Ginkō
松殿	Matsudono
松園	Shōen
松塙	Shōu
松楽斎	Shōrakusai
松寉	Shōka
松爾楼	Shōjirō
松壽軒	Shōjuken
松徳	Shōtoku

池丘	Chikyū	治兵衛	Jihei
池田	Ikeda	治兵衛二代	Jihei II
池田一作	Ikeda Issaku	治郎左衛門	Jirozaemon
池田三辰	Ikeda Sanshin	治郎兵衛	Jirobei
池田正四郎	Ikeda Seishirō	治部	Chibu
池田正敬	Ikeda Masataka	治郷	Harusato
池田百合子	Ikeda Yuriko	波山	Hazan
池田勇八	Ikeda Yūhachi	波月	Hagetsu
池田桂仙	Ikeda Keisen	波多野等有	Hatano Tōyū
池田泰眞	Ikeda Taishin	波光	Hakō
池田勝次郎	Ikeda Katsujirō	波藍	Haran
池田遙邨	Ikeda Yōson	波響	Hakyō
池田源太郎	Ikeda Gentarō	河内	Kawachi
池田源兵衛	Ikeda Gembei	河内家重	Kawachi Ieshige
池田節子	Ikeda Setsuko	河井寛次郎	Kawai Kanjirō
池田義信	Ikeda Yoshinobu	河末軒流舟	Kamatsuken Ryūshū
池田輝方	Ikeda Terukata	河北房虎	Kawakita Fusatora
池田蕉園	Ikeda Shōen	河北道介	Kawakita Michisuke
池旭	Chikyoku	河田維鶴	Kawada Ikaku
池香	Chikō	河合六之助	Kawai Rokunosuke
池部鈞	Ikebe Hitoshi	河合英忠	Kawai Eichū
池野町	Ikeno Machi	河合新蔵	Kawai Shinzō
池野勤	Ikeno Tsutomu	河成	Kawanari
池野無名	Ikeno Mumei	河村若芝	Kawamura Jakushi
江山書屋	Kōzan Sho-oku	河村長昌	Kawamura Nagaaki
江戸川	Edogawa	河村泰輔	Kawamura Taisuke
江守国清	Emori Kunikiyo	河村亀	Kawamura Ki
江西	Kōsai	河村喜太郎	Kawamura Kitarō
江亭	Kōtei	河村道昌	Kawamura Michimasa
江南武宗	Enami Takemune	河村靖山	Kawamura Seizan
江南亭	Kōnantei	河村駿	Kawamura Shun
江馬多保子	Ema Tahoko	河村若芝	Kawamura Jakushi
江涯	Kōgai	河邨若芝	Kawamura Jakushi
江越竜	Egoshi Ryū	河面冬山	Kōmo Tōzan
江漢	Kōkan	河原武保	Kawabara Takeyasu
江蔵主	Kōzasu	河野秋邨	Kōno Shūson
江蔵純平	Etō Jumpei	河野通勢	Kōno Tsūsei
江鯉	Kōri	河窪信雄	Kawakubo Nobuo
汲斎	Kyūsai	河鍋陳之	Kawanabe Nobuyuki
沢	Sawa	泥藏	Deizō
沢民	Takumin	法寸斎	Hōsunsai
沢田次作	Sawada Jisaku	法雲院	Hōun'in
沢田宗次	Sawada Sōji	法螺山人	Hora Sanjin
沢田宗沢	Sawada Sōtaku	洛下亭	Rakkatei
沢田政広	Sawada Seikō	洛陽山人	Rakuyō Sanjin
沢田寅吉	Sawada Torakichi	津之	Tsunosuke
沢庵	Takuan	津田正周	Tsuda Seishū
沙々	Sasa	津田休甫	Tsuda Kyūho
沙弥空覚	Shami Kūgaku	津田応圭	Tsuda Ōkei
沖貞	Oki Tei	津田青楓	Tsuda Seifū
没倫	Motsurin	津田亀次郎	Tsuda Kamejirō
沈寿官	Chin Jukan	津端道彦	Tsubata Michihiko
沈南蘋	Shen Nan-p'in	津端魁	Tsubata Kai
沈柳亭	Chinryūtei	洞元	Tōgen
沈清	Chin Kiyoshi	洞文	Tōbun
沼田一雅	Numata Kazumasa	洞水満矩	Tōsui Mitsunori
沼田正之	Numata Masayuki	洞白	Tōhaku
沼田政民	Numata Masatami	洞白満喬	Tōhaku Mitsutaka
沼田荷舟	Numata Kashū	洞壽	Tōju
沼波重長	Numanami Shigenaga	洞秀	Tōshū
泡斎	Hōsai	洞和	Tōwa
泰	Tai	洞春	Tōshun
泰山樓主	Taizan Rōshu	洞郁	Tōiku
泰生	Taisei	洞風外	Tō Fūgai
泰次郎	Yasujirō	洞益	Tōeki
泰信	Yasunobu	洞庭	Tōtei
泰翁	Taiō	洞庭舎	Dōteisha
泰眞	Taishin	洞琳	Tōrin
泰峨	Taiga		
泰寅斎	Taigūsai		
泰寛	Taikan		
泰嶺	Tairei		
泊然叟	Hakuzensō		
治三郎	Jisaburō		
治五右衛門	Jigoemon		
治六	Jiroku		
治平	Jihei		
治右衛門	Jiemon		

洞雲	Tōun	浮世庵	Ukiyoan
洞義夫	Dō Yoshio	浮田公信	Ukita Kiminobu
洞肅	Dōshō	浮田可為	Ukita Yoshitame
洞隣	Tōrin	流光斎	Ryūkōsai
洞龍	Dōryū	流舟	Ryūshū
洞巖	Tōgan	流宣	Ryūsen
浄光	Jōkō	流草子	Ryūsōshi
浅山	Asayama	涇斎	Keisai
浅井一毫	Asai Ichimō	浄宏	Jōkō
浅井白山	Asai Hakuzan	浄賀	Jōga
浅井直	Asai Tadashi	浄徳堂	Jōtokudō
浅井忠	Asai Chū	渓山人	Kei Sanjin
浅井星洲	Asai Seishū	渓仙	Keisen
浅井龍	Asai Ryū	渓里	Keiri
浅田岩吉	Asada Iwakichi	渓翁	Keiō
浅野長祥	Asano Nagamura	渓斎	Keisai
洋峨	Yōga	渓雲	Keiun
洗鱗	Senrin	渉川	Shōsen
海天入道	Kaiten Nyūdō	済時	Naritoki
海仙	Kaisen	済猛	Saimo
海北元貞	Kaihō Gentei	涼袋	Ryōtai
海北友樵	Kaihō Yūshō	渋右衛門	Shibuemon
海北昭益	Kaihō Shōeki	渋谷修	Shibuya Osamu
海北道暉	Kaihō Dōki	添足軒	Tensokuken
海北道親	Kaihō Dōshin	淡白庵無徳	Tampakuan Mutoku
海北照道	Kaihō Terumichi	淡島氏平	Awashima Ujihei
海田相保	Kaida Sukeyasu	淡墨斎	Tambokusai
海老屋清兵衛	Ebiya Kiyobei	混斎	Konsai
海老原喜之助	Ebihara Kinosuke	混聲	Konsei
海老清	Ebikiyo; Ebisei	清	Kiyoshi
海岳	Kaigaku	清九郎	Seikurō
海客	Kaikyaku	清三郎	Seizaburō
海屋	Kaioku	清久	Kiyohisa
海叟	Kaisō	清川春好	Kiyokawa Shunkō
海眼	Kaigen	清川種春	Kiyokawa Taneharu
海棠	Kaidō	清夫	Seifu
海雲	Kaiun	清元	Kiyomoto
海僊	Kaisen	清太郎	Seitarō
浩一路	Kōichiro	清方	Kiyokata
浩雪	Kōsetsu	清水	Kiyomizu
浩斎	Kōsai	清水九兵衛	Shimizu Kyūbei
浩湖	Kōko	清水元四郎	Kiyomizu Genshirō
浩然	Kōzen	清水六兵衛	Shimizu Rokubei
浜中英信	Hamanaka Eishin	清水多嘉示	Shimizu Takashi
浜田三郎	Hamada Saburō	清水光信	Shimizu Mitsunobu
浜田世憲	Hamada Seiken	清水良雄	Shimizu Yoshio
浜田庄司	Hamada Shōji	清水宗次	Shimizu Sōji
浜田葆光	Hamada Shigemitsu	清水隆慶	Shimizu Ryūkei
浜田観	Hamada Kan	清水晃	Shimizu Ben
浜谷五郎	Hamaya Gorō	清水登之	Shimizu Toshi
浜松	Hamamatsu	清水義資	Shimizu Yoshisuke
浪雲庵	Rōun'an	清水監	Shimizu Kan
浦上弼	Uragami Hitsu	清水藏六	Shimizu Zōroku
浦上選	Uragami Sen	清水鑑	Shimizu Kan
浦田久馬	Urata Kyūma	清右衛門	Kiyoemon; Seiemon
浦野茂橋	Urano Shigekichi	清広	Kiyohiro
酒之助	Sakenosuke	清玄	Seigen
酒上不埒	Sakenoue no Furachi	清次郎	Seijirō
酒井三良	Sakai Sanryō	清兵衛	Kiyobei; Seibei
酒井田柿右衛門	Sakaida Kakiemon	清兵衛一代	Seibei I
酒井田柿右衛門十二代	Sakaida Kakiemon XII	清兵衛二代	Seibei II
酒井渋右衛門	Sakaida Shibuemon	清助	Kiyosuke; Seisuke
酒井秀麿	Sakai Hidemaro	清芳	Kiyoyoshi
酒井忠因	Sakai Tadamoto	清谷	Seikoku
酒井忠兵衛	Sakai Chūbei	清近	Kiyochika
酒井詮真	Sakai Senshin	清里	Kiyosato
酒乱斎	Shuransai	清忠	Kiyotada
酒惣	Sakesō	清忠二代	Kiyotada II
消夏楼	Shōkarō	清忠三代	Kiyotada III
浮世又平	Ukiyo Matahei	清河守光	Kiyokawa Morimitsu
浮世正歳	Ukiyo Masatoshi	清長	Kiyonaga
		清重	Kiyoshige
		清亮	Seiryō
		清信	Kiyonobu
		清信二代	Kiyonobu II

清貞	Kiyosada		
清政	Kiyomasa		
清春	Kiyoharu		
清泉堂	Seisendō		
清風与平	Seifū Yohei		
清風与平二代	Seifū Yohei II		
清風与平三代	Seifū Yohei III		
清香	Seikō		
清倍	Kiyomasu		
清倍二代	Kiyomasu II		
清原玉	Kiyohara Tama		
清原斉	Kiyohara Sei		
清原雪	Kiyohara Yuki		
清原無暦	Kiyohara Mureki		
清容軒	Seiyōken		
清宮彬	Seimiya Hitoshi		
清峯	Kiyomine		
清流斎	Seiryūsai		
清竜軒	Seiryūken		
清國	Kiyokuni		
清婉	Seien		
清経	Kiyotsune		
清野一成	Kiyono Issei		
清満	Kiyomitsu		
清満二代	Kiyomitsu II		
清満三代	Kiyomitsu III		
清筠舎	Seikinsha		
清朝	Kiyotomo		
清朝軒	Seichōken		
清菜	Seisai		
清菜山房	Seisai Sambō		
清暉	Seiki		
清夢軒	Seimuken		
清蓮斎	Seirensai		
清輔	Kiyosuke		
清輝	Seiki		
清線館	Seisenkan		
清親	Kiyochika		
清噴	Seikō		
深川斎	Shinsensai		
深水	Shinsui		
深田	Fukada		
深田直城	Fukada Chokujō		
深江	Fukae		
深江庄六	Fukae Shōroku		
深尾	Fukao		
深沢索一	Fukazawa Sakuichi		
深省	Shinsei		
深海宗伝	Shinkai Sōden		
深海新太郎	Shinkai Shintarō		
深斎	Shinsai		
深賢	Shinken		
淇園	Kien		
淇嚕	Kisen		
湊水	Sōsui		
湊吉右衛門	Minato Kichiemon		
游仙	Yūsen		
澄幸	Tankō		
澄海	Tankai		
澄慶	Tanga		
澄慶	Tankei		
淵	En; Yüan		
淵上	Fuchigami		
淵岩	Engan		
淵泉	Ensen		
淵野世竜	Fuchino Seryū		
湖月	Kogetsu		
湖辺斎	Kohensai		
湖秀	Koshū		
湖亭	Kotei		
湖春	Koshun		
湖畔	Kohan		
湖竜斎	Koryūsai		
湖窓翁	Kosōō		
湖笛	Koteki		
湖楽	Koraku		
湖蓮舎	Korensha		

湯田玉水	Yuda Gyokusui
湯田和平	Yuda Kazuhei
湯浅一郎	Yuasa Ichirō
温故斎	Onkosai
渡辺	Watanabe
渡辺了之	Watanabe Ryōshi
渡辺了桂	Watanabe Ryōkei
渡辺了敬	Watanabe Ryōkei
渡辺了慶	Watanabe Ryōkei
渡辺与平	Watanabe Yohei
渡辺元俊	Watanabe Mototoshi
渡辺元章	Watanabe Motoaki
渡辺公観	Watanabe Kōkan
渡辺文三郎	Watanabe Bunzaburō
渡辺文明	Watanabe Fumiaki
渡辺広輝	Watanabe Hiroteru
渡辺求馬	Watanabe Kyūma
渡辺秀岳	Watanabe Shūgaku
渡辺秀実	Watanabe Shūjitsu
渡辺秀彩	Watanabe Shūsai
渡辺秀詮	Watanabe Hideaki
渡辺定固	Watanabe Teiko
渡辺定静	Watanabe Sadayasu
渡辺延一	Watanabe Nobukazu
渡辺長八	Watanabe Chōhachi
渡辺長男	Watanabe Osao
渡辺幽香	Watanabe Yūkō
渡辺省亭	Watanabe Shōtei
渡辺政吉	Watanabe Masakichi
渡辺昴	Watanabe Kō
渡辺従	Watanabe Jū
渡辺耕平	Watanabe Kōhei
渡辺清	Watanabe Kiyoshi
渡辺清次郎	Watanabe Seijirō
渡辺瑛	Watanabe Ei
渡辺源吉	Watanabe Genkichi
渡辺義知	Watanabe Yoshitomo
渡辺義復	Watanabe Yoshimata
渡辺寧	Watanabe Nei
渡辺審也	Watanabe Shin'ya
渡辺諧	Watanabe Kai
渡辺厳	Watanabe Iwao
満谷国四郎	Mitsutani Kunishirō
満納	Mannō
満続	Mitsutsugu
湘雲	Shōun
湘夢	Shōmu
黎明	Reimei
滝川安秀	Takigawa Yasuhide
滝川国広	Takigawa Kunihiro
滝川国重	Takigawa Kunishige
滝沢重信	Takizawa Shigenobu
滝和亭	Taki Katei
滝宮謙	Ryūgū Ken
滝謙	Taki Ken
源七郎	Genshichirō
源八	Gempachi
源三郎	Genzaburō
源五郎	Gengorō
源内	Gennai
源六	Genroku
源太郎	Gentarō
源之	Gembun
源右衛門	Gen'emon
源四郎	Genshirō
源左衛門	Genzaemon
源左衛門尉	Genzaemon no Jo
源次郎	Genjirō

源吉	Genkichi
源有	Gen'yū
源吾	Gengo
源兵衛	Gembei
源作	Gensaku
源助	Gensuke
源助秀満	Gensuke Hidemitsu
源良	Genryō
源為憲	Minamoto Tamenori
源信	Genshin; Minamoto no Makoto
源師時	Minamoto no Morotoki
源清	Minamoto Kiyoshi
源亀	Genki
源尊	Genson
源弼	Gempitsu
源埼	Genki
源慶	Genkei
源蔵	Genzō
漆翁	Shippō
漆翁	Shitsuō
漆原木虫	Urushibara Mokuchū
漆桶	Shittō
漆部弟麿	Nuribe no Otomaro
漸造	Zenzō
漁者	Gyosha
潤声	Kansei
潤泉	Kansen
潤雪	Kansetsu
澄明	Chōmei
澄神斎	Chōshinsai
澄湖	Chōko
澄善	Chōzen
澄賀	Chōga
潤助	Junsuke
瀦窓翁	Chōsōō
潮湖	Chōko
潜屋	Sen'oku
潜翁	Sen'o
潜竜斎	Senryūsai
澶然居士	Tanzen Koji
濯纓堂	Takueidō
鴻雪	Kōsetsu
濟美	Saibi
灌園	Kan'en

——— RAD. 火 86 ———

畑仙齢	Hata Senrei
畑狂者	Hata Kyōsha
畑経長	Hata Tsunenaga
烟波釣徒	Empa Chōto
烟波漁徒	Empa Gyoto
烟霞	Enka
烟霞山人	Enka Sanjin
烟霞釣叟	Enka Chōsō
烟霞漁叟	Enka Gyosō
無二	Muni
無三	Musashi
無下斎	Mugesai
無生居士	Musei Koji
無辺春色画屋	Muhen Shunshokugaya
無名翁	Mumeiō
無名庵	Mumeian
無我道人	Muga Dōjin
無所得道入	Mushotoku Dōnyū
無法斎	Muhōsai
無空	Mukū
無限道人	Mugen Dōjin
無倦	Muken
無根叟	Mukonsō

無等	Mutō
無等周位	Mutō Shūi
無象	Mushō
無道山人	Mudō Sanjin
無道道者	Mudō Dōsha
無雲	Muun
無違	Mui
無暦	Mureki
無墨	Muboku
無聲	Musei
無聲詩屋	Musei Shioku
無廢子	Mugaishi
無礙斎	Mugesai
煙柳楼	Enryūrō
照信	Terunobu
照陽	Shōyō
熊之助	Kumanosuke
熊五郎	Kumagorō
熊太郎	Yūtarō
熊代章	Kumashiro Akira
熊代斐	Kumashiro Hi
熊代熊斐文	Kumashiro Yūhibun
熊代熊斐明	Kumashiro Yūhimei
熊右衛門	Kumaemon
熊吉	Kumakichi
熊坂昌	Kumasaka Shō
熊坂蘭斎	Kumasaka Ransai
熊谷守一	Kumagai Morikazu
熊谷直彦	Kumagai Naohiko
熊岳	Yūgaku
熊岡美彦	Kumaoka Yoshihiko
熊彦	Kumahiko
熊斐	Yūhi
熊斐文	Yūhibun
熊斐明	Yūhimei
熊蔵	Kumazō
黙神艸堂	Mokushin Sōdō
黙堂	Mokudō
黙庵	Mokuan
黙語	Mokugo

——— RAD. 爪 87 ———

爪雪	Sōsetsu
采女	Uneme
采女祐	Unemenosuke
采信	Saishin
采風外史	Saifū Gaishi
采堂	Saidō
受川	Jusen
舜川	Shunsen
舜次	Shunji
舜治	Shunji
舜英	Shun'ei
舜挙	Shunkyo
舜造	Shunzō
舜朗	Shunrō
舜瑛	Shun'ei
舜慶	Shunkei
舜興	Shunkō
愛々	Aiai
愛石	Aiseki
愛次郎	Aijirō
愛竹草堂	Aichiku Sōdō
愛雪	Aisetsu
愛雪樓	Aisetsurō

——— RAD. 父 88 ———

斧二郎	Onojirō
斧四郎	Onoshirō

——— RAD. 爿 90 ———

将李魚成	Shōri Uonari
将監	Shōgen

秋岳	Shūgaku
秋亭	Shūtei
秋栄	Shūei
秋香	Shūkō
秋香庵	Shūkōan
秋翁	Shūō
秋斎	Shūsai
秋園	Shūen
秋塘	Shūtō
秋暉	Shūki
秋輔	Akisuke
秋藏	Shūzō
秦テルヲ	Hata Teruo
秦致貞	Hata no Chitei
秦隆恒	Hata Takatsune
稚成	Wakanari
稚瞻	Chisen
稲川	Inagawa
稲光	Tōkō
稲皐	Tōkō
稲野年恒	Ineno Toshitsune
稲野孝之	Ineno Takayuki
稲葉	Tōyō
稲嶺	Tōrei
種次	Tanetsugu
種信	Tanenobu
種春	Taneharu
稻一	Tōichi
穂菴	Suian
穂積春信	Hozumi Harunobu
穉龍	Sairyū
積山	Sekizan
穆夫	Yoshio
穆甫	Bokuho
穆翁	Bokuō
穆斎	Ryosai

—— RAD. 穴 116 ——

穴山勝堂	Anayama Shōdō
空中	Kūchū
空中庵	Kūchūan
空中斎	Kūchūsai
空明堂信之	Kūmeidō Nobuyuki
空相	Kūsō
空海	Kūkai
窪田邦	Kubota Kuni
窪田俊満	Kubota Toshimitsu
窪田統泰	Kubota Tōtai
窪俊満	Kubo Toshimitsu
窪春満	Kubo Shumman

—— RAD. 立 117 ——

立川斎	Ritsusensai
立止	Risshi
立林徳	Tatebayashi Rittoku
立原久里	Tachihara Kuri
立原任	Tachihara Nin
立原春子	Tachihara Haruko
立原栗	Tachihara Kuri
立圃	Ryūho
立祥	Ryūshō
立斎	Ryūsai
立蝶楼	Ritchōrō
立嶽	Ritsugaku
彦三郎	Hikosaburō
彦之進	Hikonoshin
彦四郎	Hikoshirō
彦兵衛	Hikobei
彦国	Hikokuni
彦幹	Hikokan
端	Tan

—— RAD. 竹 118 ——

竹三郎	Takesaburō
竹下順哲	Takeshita Yoshinori
竹久茂次郎	Takehisa Shigejirō
竹久夢二	Takehisa Yumeji
竹天叟	Chikutensō
竹中茂辰	Takenaka Shigetoki
竹内	Takeuchi
竹内久一	Takeuchi Kyūichi
竹内千賀	Takenouchi Chika
竹内吟秋	Takeuchi Ginshū
竹内宗久	Takenouchi Munehisa
竹内恒吉	Takeuchi Tsunekichi
竹内栄久	Takenouchi Hidehisa
竹内栖鳳	Takeuchi Seihō
竹内駿	Takeuchi Shun
竹本隼太	Takemoto Hayata
竹外	Chikugai
竹田	Chikuden
竹石	Chikuseki
竹村徳	Takemura Toku
竹沢惟房	Takezawa Korefusa
竹沙	Chikusa
竹谷	Chikkoku
竹邨	Chikuson
竹里	Chikuri
竹坡	Chikuha
竹坪	Taketsubo
竹居	Chikukyo
竹林舎	Chikurinsha
竹松	Takematsu
竹洞	Chikutō
竹泉居	Chikusenkyo
竹翁	Chikuō
竹原五郎七	Takehara Goroshichi
竹原五郎八	Takehara Gorohachi
竹原信繁	Takehara Nobushige
竹叟	Chikusō
竹圃	Chikuho
竹軒	Chikuken
竹渓	Chikkei
竹窓	Chikusō
竹堂	Chikudō
竹逸	Chikuitsu
竹斎	Chikusai
竹喬	Chikkyō
竹雲	Chikuun
竹裏館	Chikurikan
竹園	Chikuen
竹渓	Chikkei
竹隠	Chikuin
竹隠斎	Chikuinsai
笑翁	Shōō
笠山	Ryūzan
笠松紫浪	Kasamatsu Shirō
笠翁	Ritsuō; Ryūō
笠翁二代	Ritsuō II
笠窓	Rissō
笛畝	Tekiho
笹山常伝	Sasayama Jōden
笹崎篠	Sasayama Jō
笹屋	Sasaya
第五隆	Daigoryū
筑前介	Chikuzennosuke
筑前法眼	Chikuzen Hōgen
筑前法橋	Chikuzen Hokkyō
筑陽	Chikuyō
答斎	Tōsai
等云	Tōun
等仁	Tōjin
等全	Tōzen
等列	Tōretsu
等宅	Tōtaku
等有	Tōyū
等甫	Tōho
等寿	Tōju
等伯	Tōhaku
等作	Tōsaku
等芸	Tōgei
等坡	Tōha
等周	Tōshū
等林	Tōrin
等的	Tōteki
等知	Tōchi
等胤	Tōin
等重	Tōchō
等有	Tōyū
等屋	Tōoku
等春	Tōshun
等珉	Tōmin
等益	Tōeki
等哲	Tōtetsu
等悦	Tōetsu
等宿	Tōshuku
等清	Tōsei
等斎	Tōsai
等琳	Tōrin
等琳二世	Tōrin II
等琳三世	Tōrin III
等達	Tōtasu
等雲	Tōun
等與	Tōyo
等楊	Tōyō
等禅	Tōzen
等節	Tōsetsu
等爾	Tōji
等碩	Tōseki
等慶	Tōkei
等瑤	Tōhan
等櫟	Tōreki
等薩	Tōsatsu
等観	Tōkan
等顔	Tōgan
等鶴	Tōkaku
筆谷等観	Fudeya Tōkan
筆屋儀三郎	Fudeya Gisaburō
筆峯大居士	Hippō Daikoji
筬斎	Kyōsai
節斎	Sessai
筠圃	Impo
筠渓	Inkei
箕山	Kizan
箕踞	Kikyo
箕輪芳艶	Miwa Yoshitsuya
箟斎	Heisai
篁洲	Kōshū
篁渚散人	Kōcho Sanjin
範	Han
範二郎	Hanjirō
範俊	Hanshun
範舜	Hanshun
簑笠	Sanritsu
簑翠翁	Sasuiō
篤太郎	Tokutarō
篤甫	Tokuho
篤卿	Tokukei
篤雅	Tokuga
蓬雪	Hōsetsu
篠井	Shinoi
篠崎弼	Shinozaki Tasuku
篁斎	Tansai
簡伯	Kampaku
籃川	Ransen
籟堂	Raidō

—— RAD. 米 119 ——

米山人	Beisanjin
米元山主人	Beigenzan Shujin
米次郎	Yonejirō
米翁	Beiō
米原雲海	Yonehara Unkai
米華	Beika
米華山人	Beika Sanjin
米華同人	Beika Dōjin
米華斎	Beikasai
米斎	Beisai
米僊	Beisen
粂三郎	Kumesaburō
粂次郎	Kumejirō
粋舎	Suisha
莽斎	Rinsai
糊家	Noriya
糠谷良	Nukaya Ryō
糖屋七兵衛	Nukaya Shichibei

—— RAD. 糸 120 ——

紀三	Kisan
紀元	Kigen
紀元直	Ki no Motonao
紀公忠	Ki no Kintada
紀太理兵衛	Kita Rihei
紀永有	Ki no Nagamochi
紀広成	Ki (no) Hironari
紀光康	Ki no Mitsuyasu
紀有家	Ki no Ariie
紀有康	Ki no Ariyasu
紀金岡	Ki no Kanaoka
紀益宗	Ki no Masumune
紀兼茂	Ki no Kaneshige
紀敏	Ki Bin
紀時敏	Ki Tokitoshi
紀弱	Ki Tasuku
紀寧	Ki Nei
紀蔡徴	Ki Saichō
紀德民	Ki Tokumin
紅屋庄右衛門	Beniya Shōemon
紅豆詞人	Kōtō Shijin
紅雲	Kōun
紅鮮	Kōen
紅翠軒	Kōsuiken
紅翠斎	Kōsuisai
紅霞斎	Kōkasai
紅蘭	Kōran
紋轂	Monkoku
純恵	Junkei
紙川軒	Shisenken
素川	Sosen
素友	Soyū
素月園	Sogetsuen
素仙	Sosen
素巧	Sokō
素江	Sokō
素向斎	Soshōsai
素亭	Sotei
素信	Soshin
素真	Soshin
素軒	Soken
素堂	Sodō
素程	Sotei
素絢	Soken
素絢軒	Sokenken
素絢斎	Sokensai
素園	Soen
素楽	Soraku
素濟	Sorin
素隣	Sorin
素巌	Sogan
素鱗	Sorin
紹夫	Shōfu
紹仙	Shōsen
紹朴	Shōboku
紹甫	Shōho
紹珠	Shōshu
紹祥	Shōshō
紹等	Shōtō
紹播	Jōhan
紳卿	Shinkei
絃峯	Gempō
細川潔	Hosokawa Kiyoshi

	
細井	Hosoi
細井榮之	Hosoi Eishi
細田	Hosoda
細田治部郷時富	Hosoda Jibukyō Tokitomi
細田榮水	Hosoda Eisui
細田榮昌	Hosoda Eishō
細香	Saikō
経円	Keien; Kyōen
経光	Tsunemitsu
経草	Keisō
経隆	Tsunetaka
経増	Kyōzō
絢斎	Junsai
紫山	Shizan
紫川亭	Shisentei
紫水	Shisui
紫石	Shiseki
紫光斎	Shikōsai
紫衣堂	Shiidō
紫岡	Shikō
紫岩	Shigan
紫明	Shimei
紫孤菴	Shikoan
紫屋	Murasakiya
紫紅	Shikō
紫郊	Shikō
紫峰	Shihō
紫溟	Shimei
紫園	Shien
紫微翁	Shibiō
紫翠	Shisui
紫巖	Shigan
枕泰	Tōtai
絵画斎	Kaigasai
絵情斎	Ejōsai
絶海中津	Zekkai Chūshin
結城正明	Yūki Masaaki
結城素明	Yūki Somei
經解	Keikai
維石	Iseki
維名	Imei
維明	Imei
維寅	Iin
緋佐子	Hisako
綾山	Ryōzan
綾太	Ayata
綾足	Ayatari
緑一斎	Ryokuitsusai
緑玉	Ryokugyoku
緑山	Ryokuzan
緑華亭	Rokkatei
総次郎	Sōjirō
総助	Sōsuke
縫殿助	Nuidononosuke
縦山	Kōzan
繁松	Shigematsu
繁根木山隠士	Hankon Mokusan Inshi
縦画生	Jūgasei
織之助	Orinosuke
織田一麿	Oda Kazumaro
織部柘榴園	Oribe Zakuroen
繪山	Shūzan
繪江	Shūkō
繪浦	Shūho

RAD. 网 122

	
羅漢	Rakan
羅漢山人	Rakan Sanjin

RAD. 羊 123

	
羊遊斎	Yōyūsai
美信	Yoshinobu
美翁	Biō
美麿	Yoshimaro
群馬亭	Gumbatei
群蛙亭	Gun'atei
義太郎	Gitarō
義方	Yoshikata
義兵衛	Gihei
義邦	Yoshikuni
義治	Yoshiharu
義亮	Giryō
義信	Yoshinobu
義持	Yoshimochi
義躬	Yoshimi
義梵	Gibon
義清	Yoshikiyo
義章	Gishō
義卿	Gikyō
義統	Gitō
義董	Gitō
義廉	Yoshikado
養山	Yōzan
養川	Yōsen
養川院	Yōsen'in
養元	Yōgen
養永	Yōsui
養朴	Yōboku
養竹山人	Yōchiku Sanjin
養甫	Yōho
養辰	Yōshin
養拙	Yōsetsu
養信	Osanobu
養春	Yōshun
養益	Yōeki
養悦	Yōetsu
養素斎	Yōsosai
養朔	Yōsaku
養渓	Yōkei
養清	Yōsei
養雪	Yōsetsu
養斎	Yōsai
養福	Yōfuku
養意	Yōi
養説	Yōsetsu

RAD. 羽 124

	
羽山	Uzan
羽川	Hanegawa
羽川和元	Hanekawa Wagen
羽川藤永	Hanekawa Tōei
羽民	Umin
羽生弁之助	Hanyū Sadanosuke
羽田好永	Hata Yoshinaga
羽官	Ukan
羽賀隆信	Haga Takanobu
羽陽	Uyō
羽倉良信	Hagura Ryōshin
習静堂	Shūseidō
翠石	Suiseki
翠光楼	Suikōrō
翠竹庵	Suichikuan
翠岳	Suigaku
翠松	Suishō
翠松斎	Suishōsai
翠釜亭	Suifutei
翠渓	Suikei
翠岊	Suigan
翠湖	Suiko
翠雲	Suiun
翠雲堂	Suiundō
翠煌	Suieidō
翠榮堂	Suieidō
翠簑翁	Suisaiō
翠蘭	Suiran
翻蝶庵	Honchōan

RAD. 老 125

	
老山	Rōzan
老香堂	Rōkōdō
老竜庵	Rōryūan
老蓮	Rōren
老鉄	Rōtetsu

RAD. 耒 127

	
耕夫	Kōfu
耕石	Kōseki
耕甫	Kōho
耕沖	Kōchū
耕花	Kōka
耕俳林	Kōhairin
耕雲	Kōun
耕雲山人	Kōun Sanjin
耕雲斎	Kōunsai
耕雲漁者	Kōun Gyosha
耕雲樵者	Kōun Shōsha
耕寛斎	Kōkansai
耕漁	Kōgyo
耕霞閑客	Kōka Kankyaku

RAD. 耳 128

	
耳鳥斎	Jichōsai
耳野卯三郎	Mimino Usaburō
聊自楽居	Ryōji Rakukyo
聚珍堂	Shūchindō
聴松堂	Chōshōdō
聴雨	Chōu
聴雨堂	Chōudō
聴秋	Chōshū
聴鴬	Chōō
聾盧迂人	Rōroujin

RAD. 聿 129

	
書画斎	Shogasai

RAD. 肉 130

	
有丈	Yūjō
有久	Arihisa
有元斎	Yūgensai
有毛	Yūmō
有竹	Yūchiku
有竹居	Yūchikukyo
有行	Ariyuki
有来新兵衛	Ariki Shimbei
有坂	Arisaka
有秀斎	Yūshūsai
有宗	Arimune
有茂	Arishige
有重	Arishige
有恒	Aritsune
有秋	Yūshū
有美	Yūbi
有島壬生馬	Arishima Mibuma
有島生馬	Arishima Ikuma
有家	Ariie
有造	Yūzō
有馬さとえ	Arima Satoe
有康	Ariyasu
有得斎	Yūtokusai
有情痴者	Yūjō Chisha
有尊	Yūson
有斐斎	Yūhisai
有景斎	Yūkeisai
有賀紀元次	Ariga Kigenji
有楽斎	Yūrakusai
有煌	Yūkō
有節	Yūsetsu
有隣	Yūrin
有税	Yūgen
有磯周斎	Ariiso Shūsai
有頼道人	Yūran Dōjin
有蘆子	Yūroshi
肥後法橋定慶	Higo Hokkyō Jōkei
肥後屋貞七郎	Higoya Sadashichirō
服部元喬	Hattori Genkyō
服部有恒	Hattori Aritsune
服部波山	Hattori Hazan
服部謙一	Hattori Ken'ichi
胡民	Komin
胡僊	Kosen
胡蝶庵	Kochōan
胡蝶園	Kochōen
胡蝶楼	Kochōrō
朗風	Rōfū
勝八	Katsuhachi
勝山仲起	Katsuyama Chūki
勝山章翰	Katsuyama Akifumi
勝川	Shōsen
勝川久次郎	Katsukawa Kyūjirō
勝川千太郎	Katsukawa Sentarō
勝川由美章	Katsukawa Yumishō
勝川岩蔵	Katsukawa Iwazō
勝川春山	Katsukawa Shunzan
勝川春水	Katsukawa Shunsui
勝川春好	Katsukawa Shunkō
勝川春旭	Katsukawa Shunkyoku
勝川春里	Katsukawa Shunri
勝川春林	Katsukawa Shunrin
勝川春亭	Katsukawa Shuntei
勝川春泉	Katsukawa Shunsen
勝川春郎	Katsukawa Shunrō
勝川春章	Katsukawa Shunshō
勝川春暁	Katsukawa Shungyō
勝川春童	Katsukawa Shundō
勝川春道	Katsukawa Shundō
勝川春陽	Katsukawa Shun'yō
勝川春潮	Katsukawa Shunchō
勝川春艶	Katsukawa Shun'en
勝川春鶴	Katsukawa Shunkaku
勝川柳谷	Katsukawa Ryūkoku
勝川院	Shōsen'in
勝川清次郎	Katsukawa Seijirō
勝川輝重	Katsukawa Terushige
勝六	Katsuroku
勝以	Shōi
勝太郎	Katsutarō
勝月	Shōgetsu
勝玉	Shōgyoku
勝田久太郎	Katsuda Hisatarō
勝田良雄	Katsuta Yoshio
勝田定則	Katsuta Sadanori
勝田貞寛	Katsuta Teikan
勝田哲	Katsuta Tetsu
勝田蕉琴	Katsuta Shōkin
勝次郎	Katsujirō
勝汲壺	Shōkyūko
勝利	Shōri
勝重	Katsushige
勝信	Katsunobu
勝政	Katsumasa
勝海	Shōkai
勝野范古	Katsuno Hanko
勝智	Shōchi
勝賀	Shōga
勝間安定	Katsuma Antei
勝間新泉	Katsuma Shinsen
勝園	Shōen

賢光	Kenkō	迂亭	Utei	運朝	Unchō	里見勝蔵	Satomi Katsuzō
賢江祥啓	Kenkō Shōkei	迂斎	Usai	運賀	Unga	里風	Rifū
賢信	Katanobu	迂道	Udō	運慶	Unkei	里堂	Ridō

——— RAD. 赤 155 ———

		近江介	Ōminosuke	運霞堂	Unkadō	里堂人	Ridōjin
赤川太郎	Akagawa Tarō	近衞信基	Konoe Nobumoto	遊汀	Yūtei	里薄散人	Ribo Sanjin
赤水	Sekisui	近衞信輔	Konoe Nobusuke	遊斎	Yūsai	野々口親重	Nonoguchi
赤羽紹真	Akabane Shōshin	近衞家熙	Konoe Iehiro	遜斎	Sonsai		Chikashige
赤松雲嶺	Akamatsu Unrei	近藤五郎兵	Kondō Gorobei	蓮月	Rengetsu	野々山正頭	Nonoyama Shōgan
赤松麟作	Akamatsu Rinsaku	衛		蓮月尼	Rengetsu Ni	野々村以悦	Nonomura Ietsu
赤城泰舒	Akagi Yasunobu	近藤文雄	Kondō Fumio	蓮行	Rengyō	野々村宗雪	Nonomura Sōsetsu
赤脚子	Sekkyakushi	近藤庄七	Kondō Shōshichi	蓮妙	Remmyō	野々村清右	Nonomura
赤塚平左衛	Akatsuka	近藤益尚	Kondō Masunao	蓮岱山人	Rentai Sanjin	衛門	Seiemon
門	Heizaemon	近藤浩	Kondō Hiroshi	蓮痴	Renchi	野口小蘋	Noguchi Shōhin
赤塚自得	Akatsuka Jitoku	近藤浩一路	Kondō Kōichiro	遠山五郎	Tōyama Gorō	野口続	Noguchi Tsuzuku
赤鶴	Shakuzuru	近藤清春	Kondō Kiyoharu	遠山政武	Tōyama Masatake	野口親子	Noguchi Chikako
		近藤斎宮	Kondō Saigū	遠舟	Enshū	野口彌太郎	Noguchi Yatarō

——— RAD. 走 156 ———

		近藤勝信	Kondō Katsunobu	遠坂正雄	Tōzaka Masao	野口謙蔵	Noguchi Kenzō
起元	Kigen	近藤道志	Kondō Dōshi	遠坂親夫	Tōzaka Chikao	野生司�	Nousu Nobuta
越堂	Etsudō	述而	Jutsuji	遠沢	Entaku	野生司香雪	Nousu Kōsetsu
越渓	Ekkei	逃神	Tōzen	遠斎	Ensai	野田九浦	Noda Kyūho
越智吉舟	Ochi Yoshinori	退歩	Taiho	遠卿	Enkei	野田英夫	Noda Hideo
超光騰霧楼	Chōkōtōmurō	退翁	Taiō	遠塵草堂	Enjin Sōdō	野田道三	Noda Dōsan
趙居	Chōkyo	逍遙軒	Shōyōken	遠藤内記	Endō Naiki	野有	Yayū
		速水恒章	Hayami Tsuneaki	遠藤半右衛	Endō Han'emon	野呂	Noro

——— RAD. 足 157 ———

		速水栄一	Hayami Eiichi	門		野呂隆	Noro Ryū
足立源一郎	Adachi Gen'ichirō	速水御舟	Hayami Gyoshū	遠藤定矩	Endō Sadanori	野呂隆忠	Noro Takatada
足利義持	Ashikaga	速見良致	Hayami Ryōchi	遠藤秋岳	Endō Shūgaku	野村九國	Nomura Kyūkoku
	Yoshimochi	連	Ren	遠藤教三	Endō Kyōzō	野村子融	Nomura Shiyū
跂石	Kiseki	連一郎	Ren'ichirō	遠藤椹	Endō Shin	野村文挙	Nomura Bunkyo
跡見玉枝	Atomi Gyokushi	連山	Renzan	逐斎	Tonsai	野村四郎兵	Nomura Shirobei
跡見花蹊	Atomi Kakei	通	Tsū	逐窩室	Tonkashitsu	衛	
跡見泰	Atomi Tai	通大	Tsūdai	遮莫	Shabaku	野村玉渓	Nomura Gyokkei
跡見竜野	Atomi Tatsuno	通神道人	Tsūjin Dōjin	適山	Tekizan	野村休甫	Nomura Kyūho
跡見勝子	Atomi Katsuko	逸人	Itsujin	適圃	Tekiho	野村次良兵	Nomura Jirobei
路可	Roka	逸見一信	Hayami Kazunobu			衛	
蹄斎	Teisai	逸見享	Hemmi Takashi			野村次郎	Nomura Jirō
蹄斎北馬	Teisai Hokuba	逸翁	Itsuō	#### ——— RAD. 邑 163 ———		野村芳国	Nomura Yoshikuni
		逸斎	Issai			野長瀬弘男	Nonagase Hiro-o

——— RAD. 身 158 ———

		逸然	Itsunen	邦信	Kuninobu	野長瀬晩花	Nonagase Banka
射谷隠士	Shakoku Inshi	逸雲-	Itsuun	邦高	Kunitaka	野原石五郎	Nohara Ishigorō
		逸記	Ikki	邦隆	Kunitaka	野原貞明	Nohara Teimei

——— RAD. 車 159 ———

		進	Susumu	邨田丹陵	Murata Tanryō	野崎真一	Nozaki Shin'ichi
軌外	Kigai	進一郎	Shin'ichirō	邨田靖	Murata Tadashi	野崎抱青	Nozaki Hōsei
軽挙	Keikyo	退香	Kakō	都州	Toshū	野際蔡徴	Nogiwa Saichō
軽挙道人	Keikyo Dōjin	遂翁	Suiō	都多の舎	Toda no Sha		
軽雲亭	Keiuntei	達庵	Tatsuan	都門	Tomon		
輞隠	Bōin	達斎	Tatsusai	都鳥英喜	Totori Eiki	#### ——— RAD. 金 167 ———	
轍外	Tetsugai	過不及子	Kafukyūshi	都路良恭	Tsuji Yoshikage		
		道入	Dōnyū	都路華香	Tsuji Kakō	金三郎	Kinzaburō

——— RAD. 辰 161 ———

		道八	Dōhachi	郷倉千靱	Gōkura Senjin	金子九平次	Kaneko Kuheiji
辰	Tatsu	道白	Dōhaku	郷倉吉雄	Gōkura Yoshio	金子大美	Kaneko Daibi
辰三郎	Tatsusaburō	道安	Dōan			金子允圭	Kaneko Inkei
辰々子	Shinshinshi	道安二世	Dōan II			金子弥四郎	Kaneko Yashirō
辰之助	Tatsunosuke	道安三世	Dōan III	#### ——— RAD. 酉 164 ———		金子惣次郎	Kaneko Sōjirō
辰女	Tatsujo	道光	Dōkō			金子徳褒	Kaneko Tokuhō
辰五郎	Tatsugorō	道甫	Dōho	酉星	Yūsei	金山平三	Kanayama Heizō
辰亮	Shinryō	道甫二世	Dōho II	酉爾	Yūji	金牛山人	Kingyū Sanjin
辰政	Tatsumasa	道志	Dōshi	酔月	Suigetsu	金井文彦	Kanai Bungen
辰斎	Shinsai	道味	Dōmi	酔月画生	Suigetsu Gasei	金井時敏	Kanai Tokitoshi
蜃白山人	Shimpaku Sanjin	道長	Dōchō	酔月翁	Suigetsuō	金井泰	Kanai Tai
		道信	Michinobu	酔放	Suihō	金仙茶寮	Kinsen Charyō

——— RAD. 辵 162 ———

		道香	Dōkō	酔放逸人	Suihō Itsujin	金台山人	Kindai Sanjin
辻永	Tsuji Hisashi	道喜	Michihiko	酔阿弥	Suiami	金右衛門	Kin'emon
辻宇之助	Tsuji Unosuke	道笑	Dōshō	酔晋斎	Suishinsai	金玉仙	Kingyokusen
辻村松華	Tsujimura Shōka	道華	Dōga	酔翁	Suiō	金石	Kinseki
辻弥二郎	Tsuji Yajirō	道崇	Dōsū	酔夢亭	Suimutei	金次	Kinji
辻屋丹甫	Tsujiya Tampo	道崇居士	Dōsū Koji	酔愚	Suigu	金次郎	Kinjirō
辻槌之助	Tsuji Tsuchinosuke	道淳	Dōjun	酔雷坊	Suiraibō	金吾	Kingo
辻愛造	Tsuji Aizō	道清	Dōsei	酔墨斎	Suibokusai	金兵衛	Kimbei
迂	U	道寛	Dōkan	酢屋国雄	Suya Kunio	金沢秀之助	Kanazawa
迂果	Uka	道暉斎	Dōkisai	酔花堂	Suikadō		Hidenosuke
		道楽	Dōraku	酔斎	Suisai	金沢重治	Kanazawa
		道該	Dōgai	酔楼楼	Suirōrō		Shigeharu
		道榮	Dōei	酔墨山人	Suiboku Sanjin	金花堂	Kinkadō
		道隠昌樹	Dōin Shōju	酔墨斎	Suibokusai	金谷	Kinkoku
		道賢	Dōken	酔霞堂	Suikadō	金岡	Kanaoka
		道蘊	Dōun			金弥観	Kin'ya Kan
		運助	Unjo	#### ——— RAD. 里 166 ———		金長洞	Kinchōdō
		運渓	Unkei			金重陶陽	Kaneshige Tōyō
				里の家	Satonoya	金城	Kinjō
				里兆	Richō		

金城一国斎 Kinjō Ikkokusai
金屋 Kanaya
金島正太 Kanashima Masata
金島桂華 Kanashima Keika
金剛山人 Kongō Sanjin
金剛仏子 Kongō Hossu
金剛窟 Kongōkutsu
金峰 Kimpō
金華山人 Kinka Sanjin
金陵 Kinryō
金陵斎 Kinryōsai
金斎 Kinsai
金敦居 Kintonkyo
金森可清 Kanamori Kasei
金僊 Kinsen
金鳳 Kimpō
金龍 Kinryō
金谿 Kinkei
金谿道人 Kinkei Dōjin
釧就 Kushiro Shū
釣深斎 Chōshinsai
釣雪 Chōsetsu
釣徒 Kinto
欽夫 Kimpu
欽古堂 Kinkodō
鈴木 Suzuki
鈴木千久馬 Suzuki Chikuma
鈴木元長 Suzuki Motonaga
鈴木元親 Suzuki Motochika
鈴木正左衛門 Suzuki Shōzaemon
鈴木世寿 Suzuki Seiju
鈴木亜夫 Suzuki Tsugio
鈴木松年 Suzuki Shōnen
鈴木金平 Suzuki Kimpei
鈴木重信 Suzuki Shigenobu
鈴木重賢 Suzuki Shigetaka
鈴木信太郎 Suzuki Shintarō
鈴木保徳 Suzuki Yasunori
鈴木春信 Suzuki Harunobu;
 Suzuki Harushige
鈴木華邨 Suzuki Kason
鈴木順 Suzuki Jun
鈴木惣太郎 Suzuki Sōtarō
鈴木雄 Suzuki Takeshi
鈴木雍 Suzuki Yō
鈴木誠 Suzuki Makoto
鈴木積 Suzuki Seki
鈴木鎮平 Suzuki Chimpei
鈴斎 Rinsai
鉄人 Tetsujin
鉄三郎 Tetsusaburō
鉄山 Tetsuzan
鉄史 Tetsushi
鉄石 Tetsuseki
鉄舟 Tesshū
鉄門 Tetsumon
鉄冠人 Tekkanjin
鉄冠道人 Tekkan Dōjin
鉄翁 Tetsuō
鉄崖 Tetsugai
鉄斎 Tessai
鉄寒士 Tekkanshi
鉄園 Tetsuen
鉄蔵 Tetsuzō
鉄橋 Tekkyō
鉄橋道人 Tekkyō Dōjin
銭屋利左衛門 Zeniya Rizaemon
銀蔵 Ginzō
鋤雲軒 Jounken
錦公 Chūkō
錦水 Kinsui
錦光山 Kinkōzan
錦光山二代 Kinkōzan II
錦光山三代 Kinkōzan III
錦光山四代 Kinkōzan IV
錦光山五代 Kinkōzan V
錦江 Kinkō

錦林子 Kinrinshi
錦袋舎 Kintaisha
錦童 Kindō
錦朝楼 Kinchōrō
錦賀 Kinga
錦鱗子 Kinrinshi
鍬形紹真 Kuwagata Shōshin
鍋井克之 Nabei Katsuyuki
鍵屋 Kagiya
鎌田子寛 Kamada Shikan
鏑木世胤 Kaburagi Seiin
鏑木祥胤 Kaburagi Shōin;
 Kaburagi
 Yoshitane
鏑木清方 Kaburagi Kiyokata
鏡之助 Kyōnosuke
鏡水 Kyōsui
鐘秀斎 Shōshūsai
鑑岳 Kangaku
鑑貞 Kantei

—— RAD. 長 168 ——

長入 Chōnyū
長八 Chōhachi
長八一蝶 Chōhachi Itchō
長与山人 Chōyo Sanjin
長久画房 Chōkyū Gabō
長山 Nagayama
長山孔寅 Nagayama Kōin
長井雲坪 Nagai Umpei
長六 Chōroku
長円 Chōen
長文斎 Chōbunsai
長月 Chōgetsu
長水 Chōsui
長四郎 Chōshirō
長左衛門 Chōzaemon
長汀 Chōtei
長玄 Chōgen
長田道観 Osada Dōkan
長充 Chōjū
長次郎 Chōjirō
長因 Chōin
長吉 Chōkichi
長好 Chōkō; Nagayoshi
長安 Chōan
長安堂 Chōandō
長江 Chōkō
長江軒 Chōkōken
長羽 Chōu
長行 Chōkō
長兵衛 Chōbei
長孝 Chōkō
長均 Chōkin
長尾景長 Nagao Kagenaga
長尾渲 Nagao Sen
長沢 Nagasawa
長沢魚 Nagasawa Gyo
長沢道一 Nagasawa
 Michikazu
長沢蘆鵠 Nagasawa Ekaku
長沢鱗 Nagasawa Rin
長町竹 Nagamachi Ki
長秀 Nagahide
長秀斎 Chōshūsai
長利 Chōri
長谷川 Hasegawa
長谷川三郎 Hasegawa Saburō
長谷川小信 Hasegawa Konobu
長谷川久六 Hasegawa Kyūroku
長谷川久蔵 Hasegawa Kyūzō
長谷川文吉 Hasegawa Bunkichi
長谷川永春 Hasegawa Eishun
長谷川左近 Hasegawa Sakon
長谷川光信 Hasegawa
 Mitsunobu
長谷川光春 Hasegawa
 Mitsuharu

長谷川竹次郎 Hasegawa Takejirō
長谷川寿三郎 Hasegawa Jusaburō
長谷川利行 Hasegawa
 Toshiyuki
長谷川宗一 Hasegawa Sōichi
長谷川宗也 Hasegawa Sōya
長谷川宗広 Hasegawa
 Munehiro
長谷川宗宅 Hasegawa Sōtaku
長谷川宗秀 Hasegawa
 Munehide
長谷川宗圜 Hasegawa Sōen
長谷川昇 Hasegawa Noboru
長谷川重美 Hasegawa
 Shigeyoshi
長谷川信広 Hasegawa
 Nobuhiro
長谷川信春 Hasegawa
 Nobuharu;
 Hasegawa
 Shinshun
長谷川貞政 Hasegawa
 Sadamasa
長谷川貞春 Hasegawa
 Sadaharu
長谷川春子 Hasegawa Haruko
長谷川栄作 Hasegawa Eisaku
長谷川師盈 Hasegawa Shiei
長谷川竜三 Hasegawa Ryūzō
長谷川常時 Hasegawa
 Tsunetoki
長谷川雪江 Hasegawa Sekkō
長谷川喜平次 Hasegawa Kiheiji
長谷川筌 Hasegawa Sen
長谷川等仁 Hasegawa Tōjin
長谷川等作 Hasegawa Tōsaku
長谷川等周 Hasegawa Tōshū
長谷川等林 Hasegawa Tōrin
長谷川等的 Hasegawa Tōteki
長谷川等英 Hasegawa Tōei
長谷川等胤 Hasegawa Tōin
長谷川等重 Hasegawa Tōchō
長谷川等雲 Hasegawa Tōun
長谷川義起 Hasegawa Yoshioki
長谷川路可 Hasegawa Roka
長谷川徳兵衛 Hasegawa Tokubei
長谷川潔 Hasegawa Kiyoshi
長辰 Chōshin
長邦 Chōhō
長周 Chōshū
長国 Nagakuni
長宗 Chōsō
長房 Chōhō
長松 Chōshō
長沼守敬 Naganuma
 Moriyoshi
長法 Chōhō
長英 Chōei
長門 Nagato
長重 Chōjū
長重丸 Nagashigemaru
長信 Naganobu
長貞 Chōtei
長昭 Chōshō
長是 Chōze
長春 Chōshun
長柳斎 Chōryūsai
長洲 Chōshū
長尚 Chōyū
長秋 Chōshū
長茶子 Chōsashi
長原孝太郎 Nagahara Kōtarō
長晏 Chōan
長浜屋治助 Nagahamaya Jisuke
長造 Chōzō

長崎 Nagasaki
長康 Chōkō
長教 Chōkyū
長清 Chōsei
長盛 Chōsei
長菴 Chōan
長野守敬 Nagano Moriyuki
長野草風 Nagano Sōfū
長野横笛 Nagano Yokobue
長隆 Nagataka
長章 Nagaaki
長亀 Chōki
長善 Chōzen
長喜 Chōki
長陽堂 Chōyōdō
長賀 Chōga
長道 Chōdō
長隆 Chōryū
長勢 Chōsei
長嗣 Chōshi
長寛 Chōkan
長栄軒 Chōeiken
長蔭 Chōin
長墨斎 Chōbokusai
長輝 Chōki
長嶺 Chōshin
長賢 Chōken
長繁 Chōhan
長蔵 Chōzō
長韻 Chōin

—— RAD. 門 169 ——

門入 Monnyū
門吉 Monkichi
門弥 Mon'ya
閑川 Kansen
閑水 Kansui
閑林 Kanrin
閑閑子 Kankanshi
閑観房 Kankambō
間宮白圭 Mamiya Hakkei
関口新助 Sekiguchi
 Shinsuke
関山 Kanzan
関月 Kangetsu
関牛 Kangyū
関白駒 Seki Hakuku
関良雪 Seki Ryōsetsu
関宗長 Seki (no) Sōchō
関重起 Seki Shigeoki
関根正二 Sekine Shōji
関根雲停 Sekine Untei
関根義勝 Sekine Yoshikatsu
関野聖雲 Sekino Shōun
関雪 Kansetsu
闇苑 Rōen
闇牛斎 Angyūsai

—— RAD. 卓 170 ——

阪上幸 Sakagami Kō
阿字坊 Ajibō
阿米夜宗慶 Ameya Sōkei
阿米爺宗慶 Ameya Sōkei
阿吽洞 Aundō
阿部貫 Abe Kan
阿閦 Ashuku
院成 Inshō
院助 Injo
院実 Injitsu
院尚 Inshō
院性 Inshō
院信 Inshin
院祐 In'yū
院尊 Inshō
院尊 Inson
院智 Inchi
院朝 Inchō

院覚	Inkaku
院勢	Insei
院曩	Innō
院慶	Inkei
院範	Impan
院憲	Inken
院賢	Inken
隆円	Ryūen
隆古	Ryūko
隆年	Ryūnen
隆光	Takamitsu
隆成	Takanari
隆忠	Takatada
隆昌	Takamasa
隆信	Takanobu
隆相	Takasuke
隆兼	Takakane
隆能	Takayoshi
隆盛	Takamori
隆章	Takaaki
隆慶	Ryūkei
隆親	Takachika
陳元贇	Chin Gempin
陶山	Tōzan
陶卯	Sue Bō
陶隠	Tōin
随川	Zuisen
随川院	Zuisen'in
随春	Zuishun
随柳斎	Zuiryūsai
陸山	Rikuzan
陸方山	Rikuhōzan
陸沈斎	Rikuchinsai
陸蓮子	Rikurenshi
陽岳舎	Yōgakusha
陽亭	Yōtei
陽信	Yōshin
陽威二	Yō Kanji
陽竜斎	Yōryūsai
陽渓	Yōkei
陽斎	Yōsai
隠山	Inzan
随永	Zuiei
随安居士	Zuian Koji
隣芝斎	Rinshisai
隣松庵	Rinshōan
隣秋	Rinshū
隣斎	Rinsai
隣濤庵	Rintōan

—— RAD. 隹 172 ——

隼人	Hayato
隼太郎	Hayatarō
雄文堂	Yūbundō
雄芝堂	Yūshidō
雄飛	Yūhi
雄斎	Yūsai
集慶	Shūkei
雛屋親重	Hinaya Chikashige
離吉	Rikichi

—— RAD. 雨 173 ——

雨山	Uzan
雨仙	Usen
雨村	Uson
雨谷	Ukoku
雨宮治郎	Amenomiya Jirō
雨華庵	Ukaan
雨華庵二世	Ukaan II
雨笠	Uryū
雨森盛寅	Amemori Moritora
雨蕉斎	Ushōsai
雪山	Setsuzan
雪夫	Seppu
雪月書堂	Setsugetsu Shodō
雪旦	Settan

雪汀	Settei
雪圭斎	Sekkeisai
雪州	Sesshū
雪江	Sekkō
雪舟	Sesshū
雪臣	Sesshin
雪志	Sesshi
雪村	Sesson
雪花亭	Sekkatei
雪花園	Sekkaen
雪花楼	Sekkarō
雪岳	Setsugaku
雪典	Setten
雪佁	Settai
雪信	Yukinobu
雪保	Seppo
雪津	Sesshin
雪香斎	Sekkōsai
雪貢	Sekkō
雪旅	Setsuryo
雪華	Sekka
雪馬	Setsuma
雪堂	Setsudō
雪崖	Setsugai
雪庵	Setsuan
雪渓	Sekkei
雪窓	Sessō
雪斎	Sessai
雪営霜舎	Setsuei Sōsha
雪提	Settei
雪朝	Sekko
雪朝斎	Setchōsai
雪閑	Sekkan
雪鼎	Settei
雪桃	Sessa
雪静斎	Setsujōsai
雪餞	Sessen
雪嶠	Sekkyō
雪蕉	Sesshō
雪蕉斎	Sesshōsai
雪操	Sessō
雪樵	Sesshō
雪樵斎	Sesshōsai
雪館	Sekkan
雪麿	Yukimaro
雪鷹	Setsuyō
雲の家	Kumo no Ie
雲山	Unzan
雲山叟	Unzansō
雲川	Unsen
雲夫	Umpu
雲太夫	Undayū
雲処	Unsho
雲外農夫	Ungai Nōfu
雲石	Unseki
雲竹	Unchiku
雲甫	Umpo
雲甫斎	Umposai
雲谷元直	Unkoku Motonao
雲谷軒	Unkokuken
雲谷等全	Unkoku Tōzen
雲谷等列	Unkoku Tōretsu
雲谷等宅	Unkoku Tōtaku
雲谷等甫	Unkoku Tōho
雲谷等的	Unkoku Tōteki
雲谷等知	Unkoku Tōchi
雲谷等宥	Unkoku Tōyū
雲谷等屋	Unkoku Tōoku
雲谷等珉	Unkoku Tōmin
雲谷等哲	Unkoku Tōtetsu
雲谷等達	Unkoku Tōtatsu
雲谷等與	Unkoku Tōyo
雲谷等節	Unkoku Tōsetsu
雲谷等爾	Unkoku Tōji
雲谷等瑤	Unkoku Tōhan
雲谷等璨	Unkoku Tōreki
雲谷等顔	Unkoku Tōgan
雲谷等鶴	Unkoku Tōkaku
雲居	Unkyo

雲居希膺	Unkyo Kiyō
雲林院	Unrin'in
雲松	Unshō
雲亭	Untei
雲室	Unshitsu
雲客	Unkyaku
雲津	Unshin
雲洞	Untō
雲泉	Unsen
雲翁	Un'ō
雲峰	Umpō
雲峯	Umpō
雲晁	Unchō
雲烟	Un'en
雲華	Unge
雲華院	Ungein
雲停	Untei
雲堂	Undō
雲渓	Unkei
雲章	Unshō
雲斎	Unsai
雲善	Unzen
雲卿	Unkei
雲裡	Unri
雲厓	Unsen
雲夢	Ummu
雲障	Unshō
雲潭	Untan
雲潮	Unchō
雲樵	Unshō
雲澤	Untaku
雲鵬斎	Unhōsai
雲鯨斎	Ungeisai
雲鶴	Unkaku
零陵洞	Reiryōdō
雷斗	Raito
雷洲	Raishū
雷桂子	Raikeishi
雷酔	Raisui
雷震	Raishin
震斎	Shinsai
霊円	Reien
霊明菴	Reimyōan
霊泉	Reisen
霊海	Reikai
霊華	Reika
霊彩	Reisai
霊猫菴	Reibyōan
霊淵	Reien
霊源	Reigen
霞山	Kazan
霞光	Kakō
霞居	Kakyo
霞亭	Katei
霞城	Kajō
霞翁	Kaō
霞峰	Kahō
霞舫	Kahō
霞樵	Kashō
露仁斎	Rojinsai
露好	Rokō
露亭人	Roteijin
露香	Rokō
霊川	Aizan
靆厓	Aigai
靉川光郎	Aikawa Mitsurō
靉光	Ai Mitsu

—— RAD. 青 174 ——

青々	Seisei
青々堂	Seiseidō
青山義雄	Aoyama Yoshio
青山熊治	Aoyama Kumaji
青木大乗	Aoki Daijō
青木外吉	Aoki Sotokichi
青木玄ական	

青木玄哲	Aoki Gensa
青木昌徳	Aoki Shōtoku
青木俊明	Aoki Shummei

青木蓬州	Aoki Hōshū
青木徳	Aoki Toku
青木繁	Aoki Shigeru
青牛	Seigyū
青白堂	Seihakudō
青白斎	Seihakusai
青江	Seikō
青虫寅道人	Seichūin Dōjin
青来	Seirai
青児	Seiji
青秀畔	Seishūhan
青貝太郎左衛門	Aogai Tarozaemon
青貝長兵衛	Aogai Chōbei
青邨	Seison
青厓	Seigai
青坡斎	Seihasai
青柳斎	Seiryūsai
青海太郎左衛門	Seikai Tarozaemon
青晃	Seikō
青根介	Aone Kai
青海源太郎	Seikai Gentarō
青梧斎	Seigosai
青嵐	Seiran
青椀	Seiwan
青湾漁老	Seiwan Gyorō
青陽斎	Seiyōsai
青楓	Seifū
青蔦亭	Seichōtei
青樹	Seiju
青龍館	Seiryūkan
青霞	Seika
青歸	Seiki
青藍	Seiran
静一庵	Seiichian
静山	Seizan
静水	Seisui
静所	Seisho
静真	Seishin
静真融覚	Seishin Yūkaku
静庵	Seian
静斎	Seisai
静閑子	Seikanshi
静意	Seii
静隠	Seiin

—— RAD. 非 175 ——

斐文	Hibun
斐暄	Hisen

—— RAD. 革 177 ——

靫彦	Yukihiko
鞆之舎	Tomonoya
鞆太郎	Tomotarō
鞆舎	Haisha
鞆音	Tomone

—— RAD. 韋 178 ——

韓天寿	Kantenju
韓水	Kansui
韓江	Kankō

—— RAD. 音 180 ——

音丸耕堂	Otomaru Kōdō
章羽	Shōu
章波	Shōha
章信	Akinobu
韋齢	Shōrei
意足道人	Isoku Dōjin
意信	Okinobu
意清斎	Iseisai
意精	Isei
韶郷	Shōkei

—— RAD. 頁 181 ——

頓迂斎	Ton'usai
頓首	Tonshu
頏中	Ganchū
頑石	Ganseki
領翁	Ryōō
穎川	Eisen
頼円	Raien
頼母	Tanomo
頼成	Raisei
頼助	Raijo
頼芸	Raigei
頼源	Raigen
頼襄	Rai Jō
頼璋	Raishō
顕幽斎	Ken'yūsai
顕清	Kensei
顕斎	Kensai
顕誉	Ken'yo
顧々翁	Tenten'ō
顧言	Kogen
顧亭	Kotei

—— RAD. 風 182 ——

風外	Fūgai
風外本高	Fūgai Honkō
風外道人	Fūgai Dōjin
風外慧薫	Fūgai Ekun
風外黙室	Fūgai Mokushitsu
風来山人	Fūrai Sanjin
風来散人	Fūrai Sanjin
風折有丈	Fūsetsu Yūjō
風狂子	Fūkyōshi
風柳庵	Fūryūan
風養	Fūyō
風蘿	Fūra

—— RAD. 飛 183 ——

飛田正雄	Hida Masao
飛田周山	Hida Shūzan
飛来一閑	Hirai Ikkan
飛鳥部常則	Asukabe no Tsunenori
飛鳥玄朝	Asuka Genchō
飛騨守惟久	Hida no Kami Korehisa
飛鷺	Hiran

—— RAD. 食 184 ——

飯田屋八郎右衛門	Iidaya Hachirōemon
飯田操朗	Iida Misao
飯島光峨	Iijima Kōga
飯島義明	Iijima Yoshiaki
飯塚桃秀	Iizuka Tōshū
飯塚桃葉	Iizuka Tōyō
飲茶主人	Incha Shujin
飴也宗慶	Ameya Sōkei
飴爺宗慶	Ameya Sōkei
館専助	Tate Sensuke
館順助	Tate Junsuke
館僑	Tate Shun

—— RAD. 首 185 ——

首陽館	Shuyōkan

—— RAD. 香 186 ——

香山	Kōzan
香外居主人	Kōgaikyo Shujin
香玉	Kōgyoku
香邨	Kōson
香谷	Kōkoku
香雨	Kōu

香案小史	Kōan Shōshi
香梅楼	Kōbairō
香雪	Kōsetsu
香朝楼	Kōchōrō
香雲	Kōun
香雲深處	Kōun Shinsho
香楽庵	Kōrakuan
香嶠	Kōkyō
香蝶楼	Kōchōrō
香積寺風外	Kōjaku-ji Fūgai
馨	Kei

—— RAD. 馬 187 ——

馬声	Basei
馬孟熙	Ma Mōki
馬城	Bajō
馬場不二	Baba Fuji
馬道良	Ma Dōryō
駒井文吾	Komai Bungo
駒井美信	Komai Yoshinobu
駒井埼	Komai Ki
駿三	Shunzō
駿々亭	Shunshuntei
駿々斎	Shunshunsai
駿声	Shunsei

—— RAD. 高 189 ——

高よし国	Kō Yoshikuni
高一雄	Kō Kazuo
高二	Takaji
高久一雄	Takaku Kazuo
高久隆恒	Takahisa Takatsune
高高徴	Takaku Chō
高井白揚	Takai Hakuyō
高木よし国	Takagi Yoshikuni
高木芳州	Takagi Yoshikuni
高木芳国	Takagi Yoshikuni
高木保之助	Takagi Yasunosuke
高田	Takada
高田定	Takada Tei
高田栄信	Takada Eishin
高田隆久	Takada Takahisa
高光	Takamitsu
高尾信保	Takao Nobuyasu
高村光太郎	Takamura Kōtarō
高村光雲	Takamura Kōun
高村東雲	Takamura Tōun
高村真夫	Takamura Shimpu
高芙蓉	Kō Fuyō
高宜信	Kō Yoshinobu
高志彫	Kō Mōkyō
高取稚成	Takatori Wakanari
高取熊夫	Takatori Kumao
高城よし国	Takagi Yoshikuni
高城芳州	Takagi Yoshikuni
高城芳国	Takagi Yoshikuni
高城権頭	Taki Kantō
高島千春	Takashima Chiharu
高島北海	Takashima Hokkai
高島得三	Takashima Tokuzō
高原五郎七	Takahara Goroshichi
高原五郎八	Takahara Gorohachi
高桑與共	Takakuwa Yokyō
高畠達四郎	Takabatake Tatsushirō
高野松山	Takano Shōzan
高隆古	Kō Ryūko
高森宗之助	Takamori Sōnosuke
高森砕巌	Takamori Saigan
高森敏	Takamori Toshi
高間惣七	Takama Sōshichi

高階隆兼	Takashina Takakane
高階隆盛	Takashina Takamori
高陽	Kōyō
高雲	Kōun
高嵩嶛	Kō Sūryō
高雅	Kōga
高橋九鴻	Takahashi Kyūkō
高橋与兵衛	Takahashi Yohei
高橋久馬	Takahashi Kyūma
高橋正順	Takahashi Masayori
高橋由一	Takahashi Yuichi
高橋広湖	Takahashi Kōko
高橋弘明	Takahashi Hiroaki
高橋光峙	Takahashi Mitsutoki
高橋克	Takahashi Koku
高橋周桑	Takahashi Shūsō
高橋長寛	Takahashi Chōkan
高橋雨	Takahashi U
高橋鳳雲	Takahashi Hōun
高橋源吉	Takahashi Genkichi
高麗左衛門	Kōrai Zaemon

—— RAD. 髟 190 ——

鬢髮山人	Bimpatsu Sanjin

—— RAD. 鬲 193 ——

融川	Yūsen
融思	Yūshi
融済	Yūsai
融斎	Yūsai
融覚	Yūkaku

—— RAD. 鬼 194 ——

鬼神斎	Kishinsai
鬼斎	Kisai
鬼頭鍋三郎	Kitō Nabesaburō
鬼頭甕二郎	Kitō Kamejirō
魁春亭	Kaishuntei
魁陶園	Kaitōen
魁斎	Kaisai
魁鶯斎	Kaiōsai

—— RAD. 魚 195 ——

魚大	Gyodai
魚佛	Gyobutsu
魚住毅	Uozumi Ki
魚屋北渓	Totoya Hokkei
魚彦	Nahiko
魚清	Gyosei
魯山人	Rosanjin
魯石	Roseki
魯修	Roshū
魯堂	Rodō
鮮山	Senzan
鮮夫	Sempu
鮮斎	Sensai
鯉屋平兵衛	Koiya Heibei
鯉喬	Rikyō

—— RAD. 鳥 196 ——

鳥山信美	Toriyama Shimbi
鳥山豊房	Toriyama Toyofusa
鳥文齋	Chōbunsai
鳥交齋	Chōkōsai
鳥羽僧正	Toba Sōjō
鳥居元信	Torii Motonobu
鳥居文竜斎	Torii Bunryūsai
鳥居庄七	Torii Shōshichi

鳥居沖信	Torii Okinobu
鳥居長八	Torii Chōhachi
鳥居長吉	Torii Chōkichi
鳥居清久	Torii Kiyohisa
鳥居清広	Torii Kiyohiro
鳥居清芳	Torii Kiyoyoshi
鳥居清近	Torii Kiyochika
鳥居清里	Torii Kiyosato
鳥居清忠	Torii Kiyotada
鳥居清忠七世	Torii Kiyotada VII
鳥居清重	Torii Kiyoshige
鳥清清信	Torii Kiyonobu
鳥居清貞	Torii Kiyosada
鳥居清政	Torii Kiyomasa
鳥居清春	Torii Kiyoharu
鳥居清倍	Torii Kiyomasu
鳥居清国	Torii Kiyokuni
鳥居清経	Torii Kiyotsune
鳥居清満	Torii Kiyomitsu
鳥居清朝	Torii Kiyotomo
鳥居新助	Torii Shinsuke
鳥巷斎路眺	Chōkōsai Rochō
鳥高斎	Chōkōsai
鳥園齋	Chōensai
鳥橋齋	Chōkyōsai
鳥嘯齋	Chōtensai
鳧渚釣叟	Fukochōsō
鳩杖翁	Kyūjōō
鳩巣楼	Kyūsōrō
鳩渓	Kyūkei
鷗斎	Ōsai
殀江	Tōkō
鵠	Kō
鴛湖	Gako
鶏雨	Keiu
鶯村	Ōson
鶯蒲	Ōho
鶯嘸	Ōmu
鶴川	Kakusen
鶴友	Kakuyū
鶴月堂文全	Kakugetsudō Bunzen
鶴仙老人	Kakusen Rōjin
鶴汀	Kakutei
鶴田五郎	Tsuruta Gorō
鶴田卓池	Tsuruta Takuchi
鶴吉	Tsurukichi
鶴沢守之	Tsuruzawa Moriyuki
鶴沢守見	Tsuruzawa Shuken
鶴沢守保	Tsuruzawa Moriyasu
鶴沢守美	Tsuruzawa Moriyoshi
鶴沢守照	Tsuruzawa Moriteru
鶴沢良信	Tsuruzawa Ryōshin
鶴沢兼信	Tsuruzawa Kanenobu
鶴岡逸民	Tsuruoka Itsumin
鶴岡野史	Kakukō Yashi
鶴岡蘆水	Tsuruoka Rosui
鶴亭	Kakutei
鶴洲	Kakushū
鶴翁	Kakuō
鶴峰	Kakuhō
鶴阜	Kakukō; Kakusai
鶴鹿園	Kakurokuen
鶴跡園	Kakusekien
鶴遷斎	Kakusensai
鶴嶺	Kakurei
鶴齢子	Kakureishi
鷗嶼	Ōyo
鷲山	Rogai
鷲山	Ranzan
鷲洞	Randō

———— RAD. 鹿 198 ————

鹿子木孟郎	Kanokogi Takeshirō
鹿山	Rokuzan
鹿六	Karoku
鹿嶋芳宗	Kashima Yoshimune
塵芥頭陀	Jinkaitōda
塵海漁舎	Jinkai Ryōsha
塵海漁者	Jinkai Ryōsha
麟振	Rinshin

———— RAD. 麥 199 ————

麦仙	Bakusen
麦僊	Bakusen

———— RAD. 麻 200 ————

磨墨山人	Maboku Sanjin

———— RAD. 黄 201 ————

黄山	Kōzan
黄山堂	Kōzandō
黄園	Kōen
黄盧園	Kōroen

———— RAD. 黒 203 ————

黒川安定	Kurokawa Yasusada

黒田文祥	Kuroda Bunshō
黒田良顕	Kuroda Ryōken
黒田重太郎	Kuroda Jūtarō
黒田清輝	Kuroda Seiki
黒田銀十郎	Kuroda Ginjūrō
墨川亭	Bokusentei
墨水漁夫	Bokusui Gyofu
墨仙	Bokusen
墨江斎	Sumiesai
墨江道寛	Sumie Michihiro
墨君堂	Bokukundō
墨林愚庵	Bokurin Guan
墨亭	Bokutei
墨翁道人	Bokuō Dōjin
墨流亭	Bokuryūtei
墨斎	Bokusai
墨僊	Bokusen
墨溪	Bokkei
墨谿	Bokkei

———— RAD. 鼎 206 ————

鼎元新	Kanae Genshin
鼎湖	Teiko
鼎鉉	Kanae Gen

———— RAD. 齊 210 ————

斉	Sei
斉草人	Sei Sōjin
斎之助	Sainosuke
斎夕	Saiseki
斎藤よの	Saitō Yono

斎藤十郎兵衛	Saitō Jūrobei
斎藤与里	Saitō Yori
斎藤与里治	Saitō Yoriji
斎藤知雄	Saitō Tomo-o
斎藤長八	Saitō Chōhachi
斎藤長吉	Saitō Chōkichi
斎藤素巌	Saitō Sogan
斎藤亀吉	Saitō Kamekichi
斎藤義	Saitō Yoshi
斎藤豊作	Saitō Toyosaku

———— RAD. 龍 212 ————

竜	Ryū
竜女	Ryūjo
竜文堂安平	Ryūmondō Yasuhei
竜水	Ryūsui
竜水翁	Ryūsuiō
竜田	Ryūden
竜尾	Ryūbi
竜杏	Ryūkyō
竜岬	Ryūkō
竜門	Ryūmon
竜登	Ryūtō
竜雲斎	Ryūunsai
竜椿	Ryūchin
龍子	Ryūshi
龍右衛門	Tatsuemon
龍池草堂主人	Ryūchisōdō Shujin
龍派	Ryūha

龍泉	Ryūsen
聾米	Rōbei
聾等琳	Rō Tōrin

———— RAD. 龜 213 ————

亀二	Kameji
亀之助	Kamenosuke
亀井至一	Kamei Shiichi
亀井松之助	Kamei Matsunosuke
亀井噉一	Kamei Ton'ichi
亀文主人	Kibun Shujin
亀文石主人	Kibunseki Shujin
亀玉	Kigyoku
亀田長興	Kameda Chōkō
亀年	Kinen
亀次郎	Kamejirō
亀助	Kamesuke
亀岡予章	Kameoka Kaneaki
亀岡光茂	Kameoka Mitsushige
亀屋平吉	Kameya Heikichi
亀祐	Kisuke
亀斎	Kisai
亀溪	Kikei

The "weathermark" identifies this book as a production of John Weatherhill, Inc., publishers of fine books on Asia and the Pacific. Editorial supervision by Ralph Friedrich and Akito Miyamoto. Book design and typography by Meredith Weatherby. Production supervision by Mitsuo Okado. Composition, printing, and binding by Kwangmyong Printing Company, Seoul. The typeface used is Monotype Times New Roman with Chinese characters in hand-set Mincho.